ENCYCLOPEDIA OF AFRICAN-AMERICAN CULTURE AND HISTORY

EDITORIAL BOARD

ENCYCLOPEDIA OF AFRICAN-AMERICAN CULTURE AND HISTORY

Edited by

JACK SALZMAN
DAVID LIONEL SMITH
CORNEL WEST

Volume 1

MACMILLAN LIBRARY REFERENCE USA
SIMON & SCHUSTER MACMILLAN
NEW YORK

SIMON & SCHUSTER AND PRENTICE HALL INTERNATIONAL
LONDON MEXICO CITY NEW DELHI SINGAPORE SYDNEY TORONTO

Simon & Schuster Macmillan
866 Third Avenue, New York, NY 10022

PRINTED IN THE UNITED STATES OF AMERICA

printing number

1 2 3 4 5 6 7 8 9 10

LIBRARY OF CONGRESS CATALOGING-IN-PUBLICATION DATA
Encyclopedia of African-American culture and history /
 edited by Jack Salzman, David Lionel Smith, Cornel West.
 p. cm.
 Includes bibliographical references and index.
 ISBN 0-02-897345-3 (set)
 1. Afro-Americans—Encyclopedias. 2.
Afro-Americans—History—Encyclopedias. I. Salzman,
Jack. II. Smith, David L., 1954– III. West, Cornel.
E185E54 1995
973′.0496073′003—dc20 95-33607
 CIP

This paper meets the requirements of ANSI / NISO Z39.48-1992
(Permanence of Paper)

CONTENTS

EDITORIAL AND PRODUCTION STAFF

PREFACE

The history of African Americans, beginning in 1619 with the arrival of the first slaves from Africa, is to a great extent the history of the United States. Yet, until the second half of the twentieth century too few historians made African-American culture and history their area of expertise. Because of this long neglect of a vital part of the nation's history, important knowledge about almost 15 percent of America's current population has gone unexamined or remained accessible only to a small group of scholars.

In 1989 the Center for American Culture Studies at Columbia University approached Macmillan Publishing Company with the proposal to remedy this lack of accurate, easily available information by preparing an encyclopedia that would present the lives and significance of African Americans in the broadest way possible. The result is this 1.8-million-word set covering all aspects of the African-American experience.

The Editorial Board began its work by establishing several criteria for inclusion of biographical entries in the Encyclopedia and the amount of space given to each. Perhaps the most significant was the decision that only African Americans should warrant biographies. Therefore, one will not find entries on such figures as Franklin Delano Roosevelt, Carl Van Vechten, Joel Spingarn, Harriet Beecher Stowe, or even Abraham Lincoln, even though each of these played an important role in the lives of black Americans. It was the Board's opinion that it was far more important to reserve space for information about a wide range of African Americans and to preserve a record of achievement not covered elsewhere.

Also not to be found here are entries on Africans, for example, Nelson Mandela and Wole Soyinka, even though they have exerted a great influence in North America. We did include several articles on Africa, specifically an entry on the regions from which most slaves were taken and a general anthropological overview of the continent. Also included are articles on influential West Indians and overview entries on Canada and Mexico. Among the many editorial issues requiring attention was that which led to the decision to use the terms "African American" and "black" interchangeably; "Negro" and "colored" are used only when the historical context demands their use.

About two-thirds of the 2,200 entries are biographies that range from the beginning of the seventeenth to the end of the twentieth century, from jazz greats such as Louis Armstrong to William Grant Still, composer of the opera *Troubled Island*; from the Nobel Prize–winning author Toni Morrison to Jupiter Hammon, an eighteenth-century slave and poet; from Michael Jordan to the baseball player Monte Irvin; from W. E. B. Du Bois and Martin Luther King, Jr., to Congressman Ron Dellums; and from George Washington Carver to Norbert Rillieux, inventor of the vacuum-chamber evaporation process used to produce sugar.

The remaining entries deal not with people but with events, historical eras, legal cases, areas of cultural achievement (music, architecture, the visual arts), professions, sports, and places. The Encyclopedia also includes entries for all fifty states as well as separate articles for cities with a special significance for black Americans, past or present.

One of the features that will make this Encyclopedia stand out from other reference works is the inclusion of a number of large essays by well-known scholars that examine the importance and legacy of such events as the Civil War and the various civil rights movements or discuss the role of religion in the lives of African Americans. Beyond information, these entries provide an intellectual interpretation and synthesis that will help readers to see historical events and creative accomplishments in a larger perspective. Examples are the entry on "Literature" by Arnold Rampersad and John S. Wright's article on "Intellectual Life."

We have taken the word "culture" to mean all expressions by which people define themselves and not just Art with a capital *a*. Thus the reader will find entries on "Black English Vernacular," on "Comic Strips," and on "Hair and Beauty Culture." Indeed, the reader is encouraged to review the entire list of article titles that begins on page xi to form an idea of the vast scope of this Encyclopedia.

Another important and exciting part of the Encyclopedia is the large number of illustrations—more than one thousand—that enrich these volumes. Much time and effort was spent in obtaining historical photographs from state historical societies, pictures of representative art works, and images from private photograph collections. The Photographs and Prints Division of the Schomburg Center for Research in Black Culture was the single largest source for historical images. The Moorland-Spingarn Research Center at Howard University provided many others. From the collections of the Library of Congress and the National Archives we obtained illustrations for the Civil War and civil rights eras, while commercial repositories provided up-to-date photos of athletes, politicians, and entertainers. These illustrations have never before been brought together in one publication.

The extensive Appendix in Volume 5 provides statistical information for many subjects. Among others are tables of African-American population by state and over time, lists of awards, economic data, degrees earned in education, and sports championships. This information provides rich supplemental background for many entries in the body of the Encyclopedia.

The entries have been arranged alphabetically. In addition, a system of cross-references makes it easy to find one's way through the Encyclopedia. For example, in the entry titled "Elaine, Arkansas, Race Riot of 1919," references to the "Red Summer,"

"World War I," and the "National Association for the Advancement of Colored People" are set in small capital letters, indicating that there are separate entries for these terms. By reading these additional articles, one becomes aware of the political climate during which the riot took place.

The *Encyclopedia of African-American Culture and History* does not claim to be a complete record of the history of African Americans. It will take many more years of intensive scholarship to unearth all the riches in forgotten or neglected archives. We will consider ourselves successful in our work if the material presented here inspires future students of history to complete the task.

A work of this magnitude calls for appropriate words of thanks to those who supported its development over several years. We offer collective thanks to the many who made this work possible. At the same time, we would like to single out one person and dedicate this work to the historian John Hope Franklin, who turned eighty as we neared completion of the Encyclopedia. His has been a remarkable life, as he has been and remains a remarkable human being. It is impossible to count the number of people who have been touched and inspired by him, and we consider ourselves fortunate to be among them. This work is dedicated to John Hope Franklin because his scholarship provided so much of what we know about African-American history and because his teaching—at North Carolina Central University, Howard University, Brooklyn College, the University of Chicago, Duke University, or as an expert witness before the U.S. Supreme Court—made us understand the importance of doing what we do with our lives.

Jack Salzman
David Lionel Smith
Cornel West

PUBLISHER'S NOTE

To say that the production of this Encyclopedia required a cast of thousands is only a slight exaggeration. People too numerous to name contributed in one way or another to the making of what will surely be a milestone in the historiography of African Americans. What follows can be only a partial list of individuals and institutions without whose help this Encyclopedia could not have been published.

Our first thanks go to Martin Meisel, past vice president for arts and sciences at Columbia University, who was instrumental in securing the University's support of the project by allowing its Center for American Culture Studies to act as administrative headquarters.

At the Center, a small army of staff and graduate students performed yeoman's work in dealing with the details of maintaining contact with the contributors and making sure that the manuscripts arrived in a timely fashion. We would like to thank especially Lisa Hacken, Richard Newman, Peter Eisenstadt, Walter Friedman, Greg Robinson, and Benjamin Scott for years of dedicated and enthusiastic service.

The entries were written by more than 600 contributors. We thank them for their scholarship and for their cooperation. When the final deadline for manuscripts drew near and we decided to commission several articles on new topics to reflect recent events, these men and women delivered their manuscripts in record time. In addition, many individuals and institutions gave valuable and generous advice over the years, glad that they could contribute to this monumental undertaking.

As the Editors have already mentioned in their Preface, the Schomburg Center for Research in Black Culture, a branch of the New York Public Library, provided us with more photographs than any other source. Many thanks are due to Howard Dodson, director of the Schomburg Center, and to Mary Yearwood, curator, and James Huffman, assistant curator, of the Photographs and Prints Division at the Schomburg. Their great contribution was to make us aware of images that we did not know existed.

Donna M. Wells, Prints and Photographs Librarian at the Moorland-Spingarn Research Center, Howard University, also was instrumental in making important visual resources available to this project.

The staff of the Center for Black Music Research at Columbia College in Chicago made a valuable contribution by suggesting subjects to be included in the Encyclopedia as well as contributors to write the entries.

In the area of the visual arts the Studio Museum of Harlem proved to be an incomparable house of treasures, which its staff was eager to share with us. We thank them for their advice and for making images of the art available to us.

We want to single out three individuals who acted in an advisory capacity and never tired of our requests for help: Sally Sommer, dance historian at New York University; Margaret Washington, professor of history at Cornell University; and Deborah Willis-Thomas of the National African-American Museum project in Washington, D.C., who was our photography consultant. We are grateful for their generous gifts of talent and time.

Simon & Schuster Macmillan is proud to be the publisher of the *Encyclopedia of African-American Culture and History*.

ALPHABETICAL LIST OF ARTICLES

DIRECTORY OF CONTRIBUTORS

A

Marian Aguiar
Amherst, Massachusetts
BIRTH CONTROL
NATIONAL FEDERATION OF AFRO-AMERICAN WOMEN
THIRD WORLD WOMEN'S ALLIANCE

Siraj Ahmed
Columbia University
AI (AI OGAWA, FLORENCE)
ALEXANDER, SADIE TANNER MOSSELL
ATLANTA LIFE INSURANCE COMPANY
BOUSFIELD, MIDIAN OTHELLO
BOWEN, JOHN WESLEY EDWARD
BOYD, RICHARD HENRY
BRAGG, GEORGE FREEMAN, JR.
BURKE, YVONNE BRATHWAITE
CAMPBELL, THOMAS MONROE
CARNEY, WILLIAM H.
COLEMAN, BESSIE
CRUM, WILLIAM D.
DALY, MARIE M.
DE GRASSE, JOHN VAN SURLY
DEMBY, WILLIAM E., JR.
FARD, WALLACE D.
FREEDOM NATIONAL BANK
HALL, LLOYD AUGUSTUS
HAWKINS, WALTER LINCOLN
HEALY FAMILY
HILL, HENRY AARON
HILYER, ANDREW FRANKLIN
HINTON, WILLIAM AUGUSTUS
HURLEY, RUBY
INDEPENDENCE FEDERAL SAVINGS BANK
MATZELIGER, JAN EARNST
MOSSELL, NATHAN FRANCIS
MOTLEY, CONSTANCE BAKER
MOTLEY, MARION "TANK"
MURRAY, PAULI
NORTH CAROLINA MUTUAL LIFE INSURANCE COMPANY
RILLIEUX, NORBERT
ROBESON, ESLANDA CARDOZO GOODE
ROGERS, JOEL AUGUSTUS

SEAWAY NATIONAL BANK
SPAULDING, CHARLES CLINTON
TOLTON, AUGUSTUS
WALKER, A'LELIA
WHARTON, CLIFTON REGINALD, JR.
WHARTON, CLIFTON REGINALD, SR.

Philip N. Alexander
Massachusetts Institute of Technology
ABBOTT, ANDERSON RUFFIN
ADAMS, NUMA POMPILIUS GARFIELD
BARNES, ROBERT PERCY
BARNES, WILLIAM HARRY
BENTLEY, CHARLES EDWIN
BUGGS, CHARLES WESLEY
CALLOWAY, NATHANIEL OGLESBY
CANNON, GEORGE DOWS
CANNON, GEORGE EPPS
COMER, JAMES PIERPONT
CORNELY, PAUL BERTAU
FLEXNER REPORT
FREEMAN, ROBERT TANNER
GILES, ROSCOE CONKLING
HEALTH LEGISLATION
HEALTH PROFESSIONS
HEALTH SURVEYS
KENNEY, JOHN ANDREW
LEWIS, JULIAN HERMAN
LICENSING AND ACCREDITATION
MAYNARD, AUBRE DE LAMBERT
MCBAY, HENRY CECIL RANSOM
MCKINNEY-STEWARD, SUSAN MARIA SMITH
PATENTS AND INVENTIONS
PERRY, JOHN EDWARD
PHARMACY
PODIATRY
SCIENCE EDUCATION
SCIENTIFIC ASSOCIATIONS
SCIENTIFIC INSTITUTIONS
STILL, JAMES
TROPICAL DISEASES
UNDERTAKERS, EMBALMERS, MORTICIANS
VETERINARY MEDICINE

YOUNG, JAMES EDWARD
YOUNG, MOSES WHARTON

Anita LaFrance Allen
Georgetown University Law School
AFFIRMATIVE ACTION

Josephine Allen
Cornell University
ATLANTA, GEORGIA

Zita Allen
New York, New York
ALLEN, DEBBIE
FAISON, GEORGE
FORT, SYVILLA
HINKSON, MARY
HOLDER, GEOFFREY
JOHNSON, VIRGINIA ALMA FAIRFAX
RODGERS, ROD AUDRIAN
WILLIAMS, LAVINIA

Derek M. Alphran
Atlanta, Georgia
JACKSON, MAYNARD HOLBROOK, JR.

Jervis Anderson
New York, New York
RANDOLPH, ASA PHILIP

Tonnia L. Anderson
Yale University
ROBERTS, RICHARD SAMUEL

William L. Andrews
University of Kansas
AUTOBIOGRAPHY
SLAVE NARRATIVES

Stephen W. Angell
Florida A & M University
TURNER, HENRY MCNEAL

Eric Arnesen
University of Illinois, Chicago
LABOR AND LABOR UNIONS
SOCIALISM

Elizabeth Fortson Arroyo
Carleton College
EVERS, MEDGAR WYLIE
JAMES, DANIEL "CHAPPIE," JR.
KNIGHTS OF THE WHITE CAMELLIA
PORT ROYAL EXPERIMENT
RUFFIN, JOSEPHINE ST. PIERRE
SMALLS, ROBERT
WAR OF 1812

Arthur R. Ashe, Jr.
Deceased
AMERICAN TENNIS ASSOCIATION
GIBSON, ALTHEA
TENNIS

Alvin Aubert
Wayne State University
MCCLANE, KENNETH

Allan D. Austin
Amherst, Massachusetts
AFRICAN MUSLIMS IN ANTEBELLUM AMERICA
AMERICAN REVOLUTION
WEBB, FRANK J.

Michael Awkward
Princeton University
WALKER, ALICE

B

R. Reid Badger
University of Alabama
EUROPE, JAMES REESE

Hans A. Baer
University of Arkansas, Little Rock
SPIRITUAL CHURCH MOVEMENT

Jane Sung-ee Bai
Columbia University
HOPKINS, PAULINE ELIZABETH
JOHNSON, HELEN V. "HELENE"

William J. Baker
University of Maine, Orono
ABDUL-JABBAR, KAREEM
BASKETBALL
OWENS, JAMES CLEVELAND "JESSE"
RUSSELL, WILLIAM FENTON "BILL"

Lewis V. Baldwin
Vanderbilt University
AFRICAN UNION METHODISM

Jane L. Ball
Wilberforce University
HAMILTON, VIRGINIA

Whitney Balliett
New York, New York
CATLETT, SIDNEY "BIG SID"

Randall Balmer
New York, New York
DEBERRY, WILLIAM NELSON

William C. Banfield
Detroit, Michigan
CARTER, BENNETT LESTER "BENNY"
CARTER, RONALD LEVIN "RON"
HAVENS, RICHARD PIERCE "RICHIE"
HENDRICKS, JOHN CARL "JON"
TERRY, CLARK
WILLIAMS, JOSEPH GOREED "JOE"

Gretchen G. Bank
New York, New York
ARCHITECTURE

James A. Banks
University of Washington
BLACK STUDIES

Manley Elliott Banks II
Virginia Commonwealth University
BARRY, MARION SHEPILOV, JR.
WILDER, LAWRENCE DOUGLAS

Rae Banks
Cornell University
DRUGS

Cameron Bardrick
Columbia University
DUMAS, HENRY LEE
KELLEY, WILLIAM MELVIN
MOTLEY, WILLARD FRANCIS
MURRAY, ALBERT L.
WHITE, PAULETTE CHILDRESS
YERBY, FRANK GARVIN

William Barlow
Howard University
RADIO

Timothy Bates
New School for Social Research
BLACK BUSINESS COMMUNITY

Thomas C. Battle
Fort Washington, Maryland
WASHINGTON, D.C.

Calvert Bean
Nashville, Tennessee
ANDERSON, THOMAS JEFFERSON "T.J."
SMITH, HALE
WILSON, OLLY WOODROW

Herman Beavers
University of Pennsylvania
MCPHERSON, JAMES ALAN
WIDEMAN, JOHN EDGAR

LeRoy Bechler
Sarasota, Florida
MENNONITES

Silvio A. Bedini
Washington, D.C.
BANNEKER, BENJAMIN
HILL, PETER

Robert A. Bellinger
Suffolk University, Boston
BOSTON, MASSACHUSETTS
HASTIE, WILLIAM HENRY

Neal Benezra
Smithsonian Institution
PURYEAR, MARTIN

Ira Berger
Brooklyn, New York
APOLLO THEATER
BERRY, LEON BROWN "CHU"
PRICE, SAMUEL BLYTHE "SAMMY"

Edward A. Berlin
Queensborough Community College
JOPLIN, SCOTT
RAGTIME

Ira Berlin
University of Maryland, College Park
FREE BLACKS, 1619–1860

Martin G. Bernal
Cornell University
ANTIQUITY

Jack W. Berryman
University of Illinois, Urbana-Champaign
BULLOCK, MATTHEW WASHINGTON

Esme Bhan
Annapolis, Maryland
HOWARD UNIVERSITY

Andrew Bienen
Columbia University
JOHN HENRY
MOORE, HARRY R. "TIM"
PLEASANT, MARY ELLEN "MAMMY"

Rodger C. Birt
Oakland, California
VANDERZEE, JAMES AUGUSTUS

David W. Blight
Amherst College
CIVIL WAR
EMANCIPATION

Marcellus Blount
University of Pennsylvania
HAYDEN, ROBERT EARL

Barbara Blumberg
Teaneck, New Jersey
WORKS PROJECT ADMINISTRATION (WPA)

Peter Bodo
New York, New York
ASHE, ARTHUR ROBERT, JR.

Grissel Bordoni–Seijo
Columbia University
SANTERIA

Joseph Boskin
Cambridge, Massachusetts
STEREOTYPES

Joshua Botkin
Columbia University
ABBOTT, ROBERT SENGSTACKE
BARBER, JESSE MAX
CHICAGO DEFENDER

Horace Clarence Boyer
Amherst, Massachusetts
CLEVELAND, JAMES EDWARD
DORSEY, THOMAS ANDREW
GOSPEL MUSIC
JACKSON, MAHALIA

Sylvia Trimble Bozeman
Spelman College
GRANVILLE, EVELYN BOYD

James Bradley
Brooklyn, New York
BROWN, JESSE
COLEMAN, WILLIAM THADDEUS, JR.
DINKINS, DAVID NORMAN
HARRIS, PATRICIA ROBERTS
O'LEARY, HAZEL ROLLINS
PIERCE, SAMUEL RILEY

Newell G. Bringhurst
College of Sequoias
MORMONS

Jennifer De Vere Brody
Philadelphia, Pennsylvania
NICHOLAS BROTHERS

Debi Broome
Columbia University
ATLANTA UNIVERSITY CENTER
CLARK-ATLANTA UNIVERSITY
COUNCILL, WILLIAM HOOPER
HARRIS, BARBARA CLEMENTINE
HOLINESS MOVEMENT
INTERDENOMINATIONAL THEOLOGICAL CENTER
JACKSON, LUTHER PORTER
PRICE, JOSEPH CHARLES
VARICK, JAMES
WILLIAMS, PETER, JR.
WILLIAMS, PETER, SR.

Anthony Brown
Berkeley, California
BLACKWELL, EDWARD JOSEPH
BLAKEY, ART (BUHAINA, ABDULLAH IBN)
CLARKE, KENNETH SPEARMAN "KENNY"
COLE, WILLIAM RANDOLPH "COZY"

DODDS, WARREN "BABY"
JONES, ELVIN RAY
JONES, JONATHAN "PAPA JO"
JONES, JOSEPH RUDOLPH "PHILLY JOE"
NEWTON, JAMES, JR.
ROACH, MAXWELL LEMUEL "MAX"
SINGLETON, ARTHUR JAMES "ZUTTY"
WEBB, WILLIAM HENRY "CHICK"
WILLIAMS, ANTHONY "TONY"

Claudine Brown
Smithsonian Institution
SCURLOCK, ADDISON

Ernest Brown
Williams College
LATEEF, YUSEF
McGHEE, WALTER BROWN "BROWNIE"
POZO, CHANO (POZO y GONZALES, LUCIANO)
SANTAMARIA, MONGO RAMON
SUN RA (BLOUNT, HERMAN "SONNY")

Jacqueline Brown
Wilberforce University
WILBERFORCE UNIVERSITY

Karen McCarthy Brown
New York, New York
VOODOO

Millicent E. Brown
Tallahassee, Florida
CHARLESTON, SOUTH CAROLINA

Rae Linda Brown
University of California, Irvine
BONDS, MARGARET ALLISON
DAVIS, ANTHONY
LEE, EVERETT
LEE, SYLVIA OLDEN
PRICE, FLORENCE BEATRICE SMITH

Elizabeth Brown-Guillory
University of Houston
BAMBARA, TONI CADE
CHILDRESS, ALICE
EVANS, MARI E.

Dickson D. Bruce, Jr.
University of California, Irvine
DIALECT POETRY
DUNBAR, PAUL LAURENCE
GRIMKÉ, ANGELINA WELD
GRIMKÉ, ARCHIBALD HENRY
GRIMKÉ, CHARLOTTE L. FORTEN

Matthew Buckley
Columbia University
DELANY, CLARISSA SCOTT
LITERARY MAGAZINES
McDANIEL, HATTIE
WILLIAMS, SAMM-ART

Kathy White Bullock
Berea College
CAESAR, SHIRLEY
CAMPBELL, DELOIS BARRETT
MARTIN, SALLIE

A'Lelia Perry Bundles
Alexandria, Virginia
WALKER, MADAM C. J.

Orville Vernon Burton
University of Illinois, Urbana-Champaign
SOUTH CAROLINA

Keith E. Byerman
Indiana State University
JONES, GAYL

W. Michael Byrd
Boston, Massachusetts
DERMATOLOGY
MEDICAL ASSOCIATIONS

C

Heather Caines
New York, New York
CHILDREN'S LITERATURE

John F. Callahan
Lewis & Clark College
HARPER, MICHAEL STEVEN

Mary Schmidt Campbell
Tisch School of the Arts
BEARDEN, ROMARE

Stanley W. Campbell
Baylor University
FUGITIVE SLAVES

Delores Carpenter
Howard University
RELIGIOUS EDUCATION

Patrick J. Carroll
Corpus Christi State University
MEXICO

Clayborne Carson
Stanford University
BLACK PANTHER PARTY FOR SELF-DEFENSE
KING, MARTIN LUTHER, JR.: LIFE
STUDENT NONVIOLENT COORDINATING COMMITTEE

Emmett D. Carson
Ford Foundation, New York
PHILANTHROPY AND FOUNDATIONS

Dan T. Carter
Emory University
SCOTTSBORO CASE

Ivy V. Carter
Columbus, Ohio
WINGS OVER JORDAN

Marva Griffin Carter
Decatur, Georgia
BECHET, SIDNEY JOSEPH
COLE, ROBERT ALLEN "BOB"
COOK, WILL MARION
JOHNSON, FRANCIS HALL
JOHNSON, JOHN ROSAMOND
SISSLE, NOBLE

John G. Cawelti
University of Kentucky
FORREST, LEON

Suzanne Ellery Greene Chapelle
Baltimore, Maryland
BALTIMORE, MARYLAND
MARYLAND

Barbara Chase-Riboud
Paris, France
BAKER, JOSEPHINE
HEMINGS, SALLY

John Brown Childs
University of California, Santa Cruz
ACCOMMODATIONISM
MESSIANISM

Yvonne P. Chireau
Princeton University
FOLK RELIGION

Robert Chrisman
University of Michigan
BLAXPLOITATION FILMS
LEE, SHELTON JACKSON "SPIKE"

Barbara T. Christian
University of California, Berkeley
ANGELOU, MAYA
CRITICISM, FEMINIST
JORDAN, JUNE

Linda A. Clayton
Boston, Massachusetts
DERMATOLOGY

William S. Cole
Stamford, Connecticut
COLTRANE, JOHN WILLIAM
DAVIS, MILES DEWEY, III
ELDRIDGE, ROY DAVID
NAVARRO, THEODORE "FATS"
PARKER, CHARLES CHRISTOPHER "CHARLIE"

Ronald G. Coleman
University of Utah
UTAH

James H. Cone
Union Theological Seminary
LIBERATION THEOLOGY
MALCOLM X
THEOLOGY, BLACK

Michael A. Cooke
University of South Carolina, Spartanburg
CITIZENSHIP SCHOOLS
MISSISSIPPI FREEDOM DEMOCRATIC PARTY
VOTER EDUCATION PROJECT

Wayne F. Cooper
Springvale, Maine
MCKAY, CLAUDE

Douglas J. Corbin
Brooklyn, New York
PETERSON, OSCAR EMMANUEL
SMITH, JAMES OSCAR "JIMMY"
TATUM, ARTHUR, JR., "ART"
TAYLOR, CECIL PERCIVAL

Thomas Cripps
Morgan State University
FILM

Jeffrey J. Crow
Archives and History Division, State of North Carolina
NORTH CAROLINA

George P. Cunningham
New York, New York
JOHNSON, JAMES WELDON
NEW NEGRO

Valerie Cunningham
University of New Hampshire
NEW HAMPSHIRE

Rebecca T. Cureau
Southern University
JAMES, WILLIS LAURENCE
WORK, JOHN WESLEY, III

D

Deborah L. Dandridge
University of Kansas
KANSAS

David D. Daniels III
McCormick Theological Seminary
PENTECOSTALISM

Douglas Henry Daniels
University of California, Santa Barbara
YOUNG, LESTER

William A. Darity, Jr.
University of North Carolina
HARRIS, ABRAM LINCOLN, JR.
REPARATIONS

Jannette L. Dates
Baltimore, Maryland
ADVERTISING
COSBY, WILLIAM HENRY, JR. "BILL"
PUBLIC RELATIONS

Charles M. Davidson
Columbia University
WRIGHT, CHARLES STEVENSON

Cullom Davis
Lincoln Legal Papers, Old State Capitol
ILLINOIS

Cyprian Davis
Saint Meinrad School of Theology
ROMAN CATHOLICISM

Thadious M. Davis
Brown University
LARSEN, NELLA

Otha Day
Williamstown, Massachusetts
HARRISON, HAZEL
HINDERAS, NATALIE LEOTA HENDERSON
WATTS, ANDRÉ

Jeffrey Louis Decker
University of California, Los Angeles
MADHUBUTI, HAKI R. (LEE, DON L.)

Thomas F. DeFrantz
New York, New York
AILEY, ALVIN
BALLET
BORDE, PERCIVAL SEBASTIAN
BREAKDANCING
CUMMINGS, BLONDELL
DANCE THEATER OF HARLEM
DOVE, ULYSSES
JAMISON, JUDITH
JOHNSON, LOUIS
MILLER, BEBE
MITCHELL, ARTHUR ADAMS, JR.
SOLOMONS, GUS, JR.
TOMLINSON, MEL
TRUITTE, JAMES
WATERS, SYLVIA
WILLIAMS, DUDLEY
WILSON, WILLIAM ADOLPHUS "BILLY"
WOOD, DONNA

James de Jongh
City College, City University of New York
FISHER, RUDOLPH JOHN CHAUNCEY
WALCOTT, DEREK ALTON
WILLIAMS, JOHN ALFRED

Dominique-René de Lerma
Lawrence University
ANDERSON, MARIAN
CONCERT MUSIC
DETT, ROBERT NATHANIEL
FREEMAN, PAUL DOUGLAS
NORMAN, JESSYE
OPERA
PRICE, MARY VIOLET LEONTYNE

Jane M. DeLuca
Brooklyn, New York
SICKLE-CELL DISEASE

Gina Dent
Columbia University
DOVE, RITA
KINCAID, JAMAICA

Dorothy Desir-Davis
New York, New York
EDMONDSON, WILLIAM
JOHNSON, SARGENT
PROPHET, NANCY ELIZABETH

Scott DeVeaux
University of Virginia
BYAS, DON (WESLEY, CARLOS)
HANCOCK, HERBERT JEFFREY "HERBIE"
MODERN JAZZ QUARTET
MONK, THELONIOUS SPHERE
STEWART, LEROY ELLIOTT "SLAM"

Amina Dickerson
Chicago Historical Society
MUSEUMS

Dennis C. Dickerson
Williams College
AFRICAN METHODIST EPISCOPAL CHURCH
MAYS, BENJAMIN ELIJAH

Kenya Dilday
Columbia University
BROWN, CLAUDE
BRYANT, HAZEL
DIXON, IVAN, III
FOOD
GUNN, MOSES
KING, WOODIE, JR.
LANGFORD, SAMUEL E.
MARKHAM, DEWEY "PIGMEAT"
ROBERTSON, OSCAR
ROBINSON, FRANK
ROLLE, ESTHER
SCOTT, HAZEL
STEWART, ELLEN
WILLIAMS, SPENCER, JR.
WINFREY, OPRAH GAIL

Otis Dismukes
Birmingham, Alabama
BIRMINGHAM, ALABAMA

Quinton H. Dixie
Union Theological Seminary
NOBLE DREW ALI
PAN-AFRICAN ORTHODOX CHURCH (THE SHRINE OF THE BLACK MADONNA)
PERRY, RUFUS LEWIS

Bill Dixon
Bennington College
CHERRY, DONALD EUGENE "DON"
COLEMAN, ORNETTE
JORDAN, CLIFFORD LACONIA, JR.
SANDERS, FARRELL PHAROAH

Jualynne Dodson
Schomburg Center for Research in Black Culture, New York Public Library
COPPIN, FRANCES "FANNY" JACKSON
HEDGEMAN, ANNA ARNOLD
SMITH, AMANDA BERRY

James A. Donaldson
Howard University
BLACKWELL, DAVID HAROLD
WILKINS, J. ERNEST, JR.

Jeff R. Donaldson
Howard University
AFRICOBRA

Richard Dozier
Pikesville, Maryland
ARCHITECTURE

David C. Driskell
University of Maryland
TANNER, HENRY OSSAWA

Laurel Tucker Duplessis
Bronx, New York
LEWIS, NORMAN WILFRED

Jill Dupont
Chicago, Illinois
JOHNSON, EARVIN, JR., "MAGIC"
LEWIS, CARL

Sherry Sherrod DuPree
Santa Fe Community College
CHURCH OF GOD IN CHRIST

Margaret L. Dwight
New York, New York
WELLS-BARNETT, IDA BELL

Mervyn Dymally
United States Congress
DEMOCRATIC PARTY
POLITICS AND POLITICIANS
PRESIDENTS OF THE UNITED STATES

Michael Eric Dyson
Providence, Rhode Island
JACKSON, JESSE LOUIS

Doris Dziwas
Berlin, Germany
BELL, GEORGE
HAMMON, BRITON
MARRANT, JOHN

E

Gerald Early
Washington University
ALI, MUHAMMAD
BOXING
CULLEN, COUNTEE
LOUIS, JOE (BARROW, JOE LOUIS)

James Kenneth Echols
Lutheran Theological Seminary at Philadelphia
LUTHERANISM

Brent Edwards
Columbia University
GRIGGS, SUTTON ELBERT
YOUNG, ALBERT JAMES "AL"

Lillie Johnson Edwards
Drew University
EPISCOPALIANS

Peter Eisenstadt
Columbia University
BANKS, ERNEST "ERNIE"
CONSERVATISM
JACKSON, REGINALD MARTINEZ "REGGIE"
RHYTHM AND BLUES
URBANIZATION

Melvin Patrick Ely
Yale University
AMOS 'N' ANDY

Jeff Encke
Columbia University
DEVEAUX, ALEXIS
HARRISON, PAUL CARTER

Dena J. Epstein
Chicago, Illinois
FOLK MUSIC
SPIRITUALS

Alana J. Erickson
Columbia University
ALPHA SUFFRAGE CLUB
BRIMMER, ANDREW FELTON
COUNCIL ON AFRICAN AFFAIRS
DELARGE, ROBERT CARLOS
HARALSON, JEREMIAH
HILL, T. ARNOLD

HYMAN, JOHN ADAMS
LEAGUE OF REVOLUTIONARY BLACK WORKERS
LLEWELLYN, JAMES BRUCE
LONG, JEFFERSON FRANKLIN
NASH, WILLIAM BEVERLY
RAPIER, JAMES THOMAS
RED SUMMER
TURNER, BENJAMIN STERLING
UNITED STATES COMMISSION ON CIVIL RIGHTS
WASHINGTON, MARGARET MURRAY

Noel Leo Erskine
Emory University
REFORMED CHURCH IN AMERICA, THE

F

Geneviève Fabre
Paris, France
FESTIVALS

Michel Fabre
Paris, France
ALLAIN, THÉOPHILE T.
ANTOINE, CAESAR CARPETIER
BRADLEY, DAVID HENRY, JR.
COUVENT INSTITUTE
CREOLE
DESDUNES, RODOLPHE LUCIEN
DIXON, MELVIN
DUNBAR-NELSON, ALICE
EXPATRIATES
GENTRY, HERBERT
JOHN REED CLUBS
LANUSSE, ARMAND
LES CENELLES
MAJOR, CLARENCE
MATHEUS, JOHN FREDERICK
PINCHBACK, PINCKNEY BENTON STEWART
WRIGHT, RICHARD

Nancy J. Fairley
New York, New York
ANTHROPOLOGISTS

Anne Fausto-Sterling
Brown University
ANATOMY

Tamara L. Felton
Richmond, Virginia
DRISKELL, DAVID
SAAR, BETYE IRENE
SIMPSON, MERTON DANIEL
SMITH, VINCENT

Gerard Fergerson
Washington, D.C.
BOUCHET, EDWARD ALEXANDER
COBB, JEWEL PLUMMER
COLE, REBECCA J.
EPIDEMIOLOGY

EUGENICS
RACE, SCIENTIFIC THEORIES OF

Earline Rae Ferguson
Rockville, Maryland
INDIANA

Henry J. Ferry
Howard University
GRIMKÉ, FRANCIS JAMES

Clarence H. Fielder
Los Cruces, New Mexico
NEW MEXICO

Paul Finkelman
Virginia Polytechnic Institute
ANTELOPE CASE
BLACK CODES
BROWN V. BOARD OF EDUCATION OF TOPEKA, KANSAS
COMPROMISE OF 1850
DECLARATION OF INDEPENDENCE
DRED SCOTT V. SANDFORD
FUGITIVE SLAVE LAWS
GRADUAL EMANCIPATION STATUTES
MISSOURI COMPROMISE
PLESSY V. FERGUSON
SLAVERY AND THE CONSTITUTION

Tom Finkelpearl
Department of Cultural Affairs, New York
HAMMONS, DAVID

Roy E. Finkenbine
Hampton University
ATTUCKS, CRISPUS
CHRISTIANA REVOLT OF 1851
NAMES CONTROVERSY
NELL, WILLIAM COOPER
NEWBY, WILLIAM H.
PAYNE, DANIEL ALEXANDER
SLATER FUND

Leroy Fitts
Baltimore, Maryland
BAPTISTS
CAREY, LOTT
NATIONAL BAPTIST CONVENTION, U.S.A.

Michael W. Fitzgerald
Saint Olaf College
BUREAU OF REFUGEES, FREEDMEN, AND ABANDONED LANDS
COMPROMISE OF 1877
FIFTEENTH AMENDMENT
GRANDFATHER CLAUSE
SECESSION
THIRTEENTH AMENDMENT
UNION LEAGUE OF AMERICA

Suzanne Flandreau
Center for Black Music Research, Chicago
MUSIC COLLECTIONS, BLACK

Marvin E. Fletcher
Ohio University
DAVIS, BENJAMIN OLIVER, JR.
DAVIS, BENJAMIN O., SR.
HOUSTON, 1917
INDIAN WARS
MEXICAN PUNITIVE EXPEDITION
PHILIPPINE-AMERICAN WAR
SPANISH-AMERICAN WAR
WORLD WAR I

William T. Fletcher
North Carolina Central University
BROWNE, MARJORIE LEE

Samuel A. Floyd, Jr.
Columbia College, Chicago
JOHNSON, FRANK
POSTLEWAITE, JOSEPH WILLIAM

Walter Earl Fluker
Harvard University
THURMAN, HOWARD

Barbara Clare Foley
Rutgers University, Newark
FEDERAL WRITERS' PROJECT

Elizabeth V. Foley
Columbia University
ANDERSON, EDDIE "ROCHESTER" (EDMUND LINCOLN)
GOSSETT, LOUIS, JR.
PARKS, GORDON, JR.
PARKS, SUZAN-LORI
PRIMUS, PEARL
VAN PEEBLES, MELVIN

Eric Foner
Columbia University
CARPETBAGGERS
RECONSTRUCTION
SCALAWAGS

Robert Elliot Fox
Southern Illinois University
DELANY, SAMUEL R.
SCIENCE FICTION

Jimmie Lewis Franklin
Purdue University
COPPIN, LEVI JENKINS
EARLY, JORDAN WINSTON
LAWSON, JAMES MORRIS

John Hope Franklin
Duke University
LYNCH, JOHN ROY
WILLIAMS, GEORGE WASHINGTON

C. Gerald Fraser
New York, New York
BUNCHE, RALPH JOHNSON

Gertrude J. Fraser
Charlottesville, Virginia
MIDWIFERY

Harris Friedberg
New Haven, Connecticut
JACKSON, MICHAEL, AND THE JACKSON FAMILY
MOTOWN

Tami J. Friedman
Columbia University
FORTUNE, TIMOTHY THOMAS
GRANGER, LESTER BLACKWELL
GUARDIAN, THE
HOPE, JOHN
JONES, EUGENE KINCKLE
MESSENGER, THE
SOUTHERN TENANT FARMERS' UNION
TROTTER, JAMES MONROE
TROTTER, WILLIAM MONROE
VOTING RIGHTS ACT OF 1965
YOUNG, WHITNEY MOORE, JR.

Walter Friedman
Columbia University
ELDER, ROBERT LEE
FORTY ACRES AND A MULE
FOURTEENTH AMENDMENT
INSURANCE COMPANIES
LIBERATOR, THE
MALONE, ANNIE TURNBO
MEXICAN WAR
MOVE
SANTERIA

Sabrina Fuchs
Columbia University
ALLENSWORTH, ALLEN
BARRETT, JANIE PORTER
BEAVERS, LOUISE
BENNETT, GEORGE HAROLD "HAL"
BRAWLEY, EDWARD MCKNIGHT
CRAFT, ELLEN AND WILLIAM
DAVIDSON, OLIVIA AMERICA
EDELMAN, MARIAN WRIGHT
FITZHUGH, H. NAYLOR
FREEMAN, MORGAN
FULLER, CHARLES HENRY, JR.
GLOVER, DANNY
JASPER, JOHN
JEFFERSON, ISAAC
JONES, JAMES EARL
LAWRENCE, MARGARET CORNELIA MORGAN
MASON, BIDDY BRIDGET
MATTHEWS, VICTORIA EARLE (SMITH)
PAUL, NATHANIEL
PROCTOR, HENRY HUGH

RAINEY, JOSEPH HAYNE
RAY, CHARLES BENNETT
ROGERS, ELYMAS PAYSON
SLOWE, LUCY DIGGS
STEWARD, WILLIAM HENRY
STEWART, JOHN
TEMPLE, LEWIS
THOMAS, FRANKLIN AUGUSTINE
TOBIAS, CHANNING HEGGIE
TYSON, CICELY
WALKER, MAGGIE LENA
WELLS, MARY ESTHER
WHARTON, CLIFTON REGINALD, JR.

Timothy E. Fulop
Harvard University
ABYSSINIAN BAPTIST CHURCH
BROWN, MORRIS
BRYAN, ANDREW
COKER, DANIEL
PRIMITIVE BAPTISTS

G

Nancy Gagnier
Columbia University
JAMES, CYRIL LIONEL RICHARD

Jane Gaines
Duke University
MICHEAUX, OSCAR

Vanessa Northington Gamble
University of Wisconsin, Madison
DICKENS, HELEN OCTAVIA
HOSPITALS, BLACK
NATIONAL HOSPITAL ASSOCIATION
PROVIDENT HOSPITAL

Phyl Garland
Columbia University
JOURNALISM

Reebee Garofalo
Sommerville, Massachusetts
RECORDING INDUSTRY

David J. Garrow
Virginia Foundation for the Humanities
KING, MARTIN LUTHER, JR.: LEGACY
SOUTHERN CHRISTIAN LEADERSHIP CONFERENCE (SCLC)

Willard B. Gatewood
University of Arkansas
SKIN COLOR

Kyra D. Gaunt
Ann Arbor, Michigan
BLEDSOE, JULIUS C. "JULES"
ESTES, SIMON LAMONT
ROBINSON, WILLIAM, JR. "SMOKEY"
SUPREMES, THE

TEMPTATIONS, THE
TURNER, TINA
WARWICK, DIONNE
WONDER, STEVIE (MORRIS, STEVLAND)

Raymond Gavins
Duke University
DURHAM, NORTH CAROLINA

Carol V. R. George
Baldwinsville, New York
CONGRESS OF RACIAL EQUALITY (CORE)
RUSTIN, BAYARD
SIT-INS

Reginald Gibbons
Evanstown, Illinois
COLTER, CYRUS

Jonathan Gill
Columbia University
ABRAMS, MUHAL RICHARD
ASSOCIATION FOR THE ADVANCEMENT OF CREATIVE
 MUSICIANS (AACM)
BAILEY, DEFORD
BRAXTON, ANTHONY
BROWN, LAWRENCE
CHESS
CLINTON, GEORGE
COASTERS, THE
COTTEN, ELIZABETH
DANNER, MARGARET ESSIE
DE PASSE, SUZANNE
DIDDLEY, BO (MCDANIEL, ELIAS)
DIXON, WILLIE
FOOD
GILLESPIE, JOHN BIRKS "DIZZY"
GORDY, BERRY, JR.
HOGAN, ERNEST (CROWDERS, REUBEN)
HOPKINS, LIGHTNIN' (SAM)
HUMES, HELEN
HYERS SISTERS
INK SPOTS, THE
JACOBS, MARION WALTER "LITTLE WALTER"
JAMES, ELMORE
JEFFERSON, "BLIND" LEMON
JOHNSON, ALONZO "LONNIE"
JOHNSON, "BLIND" WILLIE
JOHNSON, ROBERT LEROY
JONES, QUINCY DELIGHT, JR.
KING, ALBERT
LAKE, OLIVER
LAST POETS
LEDBETTER, HUDSON WILLIAM "LEADBELLY"
LUCA FAMILY SINGERS
LUNCEFORD, JAMES MELVIN "JIMMIE"
MCPHATTER, CLYDE LENSLEY
MERCER, MABEL ALICE WADHAM
MUSICAL INSTRUMENTS
NUMBERS GAMES
PATTON, CHARLEY

PRIDE, CHARLEY FRANK
PROFESSOR LONGHAIR (BYRD, HENRY ROELAND
 "ROY")
RHYTHM AND BLUES
SAVOY BALLROOM
SCOTT, JAMES SYLVESTER
SHORT, ROBERT WALTRIP "BOBBY"
SMITH, CLARA
SMITH, CLARENCE "PINETOP"
STONE, SLY
TAMPA RED (WHITTAKER, HUDSON)
THEATER OWNERS BOOKING ASSOCIATION
 (TOBA)
WALKER, AARON THIBEAUX "T-BONE"
WALROND, ERIC DERWENT
WHITE, JOSHUA DANIEL "JOSH"
WILLIAMS, MARION
WILSON, JACKIE
ZYDECO

Cindy Himes Gissendanner
Towson State University
GRIFFITH-JOYNER, FLORENCE DELOREZ
WOODARD, LYNETTE

Lawrence A. Glasco
University of Pittsburgh
PITTSBURGH, PENNSYLVANIA

Jacqueline Goggin
Boston, Massachusetts
ASSOCIATED PUBLISHERS
ASSOCIATION FOR THE STUDY OF AFRO-AMERICAN LIFE
 AND HISTORY
BLACK HISTORY MONTH / NEGRO HISTORY WEEK
JOURNAL OF NEGRO HISTORY, THE
WOODSON, CARTER GODWIN

Leonard Goines
New York, New York
JAZZ

Robert Alan Goldberg
University of Utah
KU KLUX KLAN

Neil Goldstein
Columbia University
CHAVIS, JOHN
DAY, THOMAS
GILLIAM, SAM
GRIMES, LEONARD ANDREW
MILLER, KELLY
MITCHELL, JUANITA JACKSON
POWERS, GEORGIA
ROBINSON, RUBY DORIS
SHUTTLESWORTH, FRED L.

Paul Goodman
University of California, Davis
WALKER, DAVID

Enid Gort
New York, New York
AMBASSADORS AND DIPLOMATS
CARRINGTON, WALTER C.
PHELPS-STOKES FUND
WILLIAMS, FRANKLIN HALL

Sandra Y. Govan
University of North Carolina, Charlotte
BENNETT, GWENDOLYN BENNETTA
BUTLER, OCTAVIA ESTELLE

Maryemma Graham
Northeastern University
WALKER, MARGARET

Joanne Grant
New York, New York
BAKER, ELLA J.

John Graziano
Flushing, New York
BLAKE, JAMES HUBERT "EUBIE"

Mildred Denby Green
Memphis, Tennessee
NICKERSON, CAMILLE LUCIE

Jonathan D. Greenberg
New York, New York
SIMMONS, JAKE, JR.

Larry Greene
Seton Hall University
NEW YORK CITY
NEW YORK STATE

Farah Jasmine Griffin
Trinity College, Hartford, Connecticut
BURNETT, CHARLES
DASH, JULIE

James R. Grossman
Chicago, Illinois
CHICAGO, ILLINOIS

Betty Kaplan Gubert
New York, New York
ALSTON, CHARLES HENRY
ART COLLECTIONS
BURKE, SELMA HORTENSE
CLARK, EDWARD, JR.
CORTOR, ELDZIER
DELANEY, BEAUFORD
HARLESTON, EDWIN AUGUSTUS
HUTSON, JEAN BLACKWELL
JENNINGS, WILMER ANGIER
JOSEPH, RONALD
JULIAN, HUBERT FAUNTLEROY
KAISER, ERNEST DANIEL
RINGGOLD, FAITH

Ed Guerrero
Newark, Deleware
POITIER, SIDNEY

L. Ray Gunn
University of Utah
LYNCHING

Lawrence Gushee
University of Illinois, Urbana-Champaign
MORTON, FERDINAND JOSEPH "JELLY ROLL"
NOONE, JIMMIE
OLIVER, JOSEPH "KING"
ORY, EDWARD "KID"

H

Robert L. Hall
Northeastern University
AMISTAD MUTINY
FLORIDA

Marilyn Halter
Boston University
IMMIGRATION

Dona Cooper Hamilton
Lehman College
GREAT DEPRESSION AND THE NEW DEAL

Thomas D. Hamm
Earlham College
SOCIETY OF FRIENDS (QUAKERS)

Leslie King Hammond
Maryland Institute, College of Art
PAINTING AND SCULPTURE

Evelynn M. Hammonds
Massachusetts Institute of Technology
YOUNG, ROGER ARLINER

D. Antoinette Handy
National Endowment for the Arts
INTERNATIONAL SWEETHEARTS OF RHYTHM
WILLIAMS, MARY LOU (SCRUGGS, MARY ELFRIEDA)

Jocelyn Bryant Harden
Washington, D.C.
AVERY NORMAL INSTITUTE
DOBBS, MATTIWILDA

Karen Bennett Harmon
Smithsonian Institution
JET
ROSS, DIANA

Othello Harris
Miami University of Ohio
POLLARD, FREDERICK DOUGLASS "FRITZ"

Robert L. Harris, Jr.
Cornell University
HISTORIANS / HISTORIOGRAPHY

Wesley L. Harris
University of Tennessee Space Institute
AEROSPACE

William J. Harris
Pennsylvania State University
REED, ISHMAEL

Daphne Duval Harrison
Columbia, Maryland
HUNTER, ALBERTA
RAINEY, GERTRUDE PRIDGETT "MA"
SMITH, BESSIE

John Edward Hasse
National Museum of American History
ANDERSON, IVIE MARIE
BIGARD, LEON ALBANY "BARNEY"
GREER, WILLIAM ALEXANDER "SONNY"
MUSIC MUSEUMS AND HISTORICAL SITES
NANCE, RAY WILLIS
STEWART, WILLIAM, JR., "REX"
WEBSTER, BENJAMIN FRANCIS "BEN"

James V. Hatch
New York, New York
MITCHELL, LOFTEN

Robert C. Hayden
Boston, Massachusetts
BEARD, ANDREW JACKSON
BRANSON, HERMAN RUSSELL
DREW, CHARLES RICHARD
EDELIN, KENNETH C.
FERGUSON, ANGELA DOROTHEA
FITZBUTLER, HENRY
FREDERICK, RIVERS
HARRIS, WESLEY LEROY
JACKSON, SHIRLEY ANN
LAWLESS, THEODORE K.
MASSEY, WALTER E.
MASSIE, SAMUEL PROCTOR, JR.
MCNAIR, RONALD ERWIN
MORGAN, GARRETT AUGUSTUS
POUSSAINT, ALVIN FRANCIS
TURNER, CHARLES HENRY
WHITE, AUGUSTUS AARON, III
WILLIAMS, DANIEL HALE
WOODS, GRANVILLE T.
WRIGHT, JANE COOKE
WRIGHT, LOUIS TOMPKINS

Wil Haygood
Cambridge, Massachusetts
POWELL, ADAM CLAYTON, JR.

Marcia Ethel Heard
Hackensack, New Jersey
DAFORA, ASADATA

Michael F. Hembree
Johnson County Community College
AFRICAN CIVILIZATION SOCIETY (AfCS)
ALLEN, WILLIAM G.
ANDERSON, OSBORNE PERRY
ANTEBELLUM CONVENTION MOVEMENT
BEMAN, AMOS GERRY
BROWN, HENRY "BOX"
CHRISTIAN RECORDER
DOUGLASS, SARAH MAPPS
FREDERICK DOUGLASS'S PAPER
FREEDOM'S JOURNAL
GARDNER, CHARLES W.
HAITIAN REVOLUTION
HENSON, JOSIAH
LANGSTON, CHARLES HENRY
LANGSTON, JOHN MERCER
NEW YORK CITY DRAFT RIOT OF 1863
PURVIS, HARRIET FORTEN
QUARLES, BENJAMIN
RAM'S HORN
REMOND, CHARLES LENOX
SANDERSON, JEREMIAH BURKE
SMITH, JAMES MCCUNE
WEEKLY ADVOCATE
WRIGHT, THEODORE SEDGWICK

David Henderson
New York, New York
BERRY, CHARLES EDWARD ANDERSON "CHUCK"
HENDRIX, JAMES MARSHALL "JIMI"
PRINCE (NELSON, PRINCE ROGERS)

Mae G. Henderson
University of Chicago
THURMAN, WALLACE

Vernon J. Henderson
University of California, Davis
CURTIS, AUSTIN MAURICE
SURGERY

Kenneth E. Henry
Atlanta, Georgia
DISCIPLES OF CHRIST

Constance Valis Hill
Albany, New York
BATES, CLAYTON "PEG LEG"
BRADLEY, CLARENCE "BUDDY"
BRIGGS, BUNNY
BUBBLES, JOHN
COLES, CHARLES "HONI"
COLLINS, LEON
COOK, CHARLES "COOKIE"
COPASETICS, THE
COVAN, WILLIAM MCKINLEY "WILLIE"
FOUR STEP BROTHERS, THE
GREEN, CHUCK
HINES, GREGORY
JACKSON, LAURENCE DONALD "BABY LAURENCE"

LANE, WILLIAM HENRY
LETANG, HENRY
MYERS, MILTON
NUGENT, PETE
RECTOR, EDDIE
ROBINSON, BILL "BOJANGLES" (ROBINSON, LUTHER)
ROBINSON, LAVAUGHN
SIMS, HOWARD "SANDMAN"
SLYDE, JIMMY
TAP DANCE
WALKER, DIANNE
WHITMAN SISTERS

Errol G. Hill
Hanover, New Hampshire
ALDRIDGE, IRA

Robert A. Hill
University of California, Los Angeles
AFRICAN BLOOD BROTHERHOOD
BRIGGS, CYRIL VALENTINE
GARVEY, MARCUS MOSIAH
UNIVERSAL NEGRO IMPROVEMENT ASSOCIATION

Betty Hillmon
Dorchester, Massachusetts
JENKINS, EDMUND THORNTON

Darlene Clark Hine
Michigan State University
NURSING

John M. Hoberman
University of Texas, Austin
OLYMPIC MOVEMENT, THE

Charles Hobson
New York, New York
TELEVISION

Martha E. Hodes
University of California, Santa Cruz
DOUGLASS, ANNA MURRAY
MISCEGENATION AND INTERMARRIAGE
PEAKE, MARY S.
PRINCE, LUCY TERRY
TAYLOR, SUSIE BAKER KING

Graham Russell Hodges
Ithaca, New York
AFRICAN FREE SCHOOL
FREE BLACKS IN THE NORTH
HODGES, WILLIS AUGUSTUS
LOYALISTS IN THE AMERICAN REVOLUTION
RUGGLES, DAVID
RUSSWURM, JOHN BROWN

Antonio F. Holland
Lincoln University
MISSOURI

Juanita Marie Holland
Brooklyn, New York
BANNISTER, EDWARD MITCHELL
SIMPSON, WILLIAM H.

Timothy W. Holley
Detroit, Michigan
NEGRO STRING QUARTET
SYMPHONY OF THE NEW WORLD

Joseph E. Holloway
California State University, Northridge
AFRICANISMS
NAMES AND NAMING, AFRICAN

John O. Holzheuter
State Historical Society of Wisconsin
WISCONSIN

Robert E. Hood
New York, New York
MILLER, GEORGE FRAZIER

Dwight N. Hopkins
Oakland, California
CONE, JAMES HAL
SLAVE RELIGION

Gerald Horne
University of California, Santa Barbara
BRADLEY, THOMAS "TOM"
NATIONAL NEGRO CONGRESS

Sharon M. Howard
*Schomburg Center for Research in Black Culture,
 New York Public Library*
HARLEM WRITERS GUILD

Theodore R. Hudson
Silver Spring, Maryland
BOLDEN, CHARLES JOSEPH "BUDDY"
FLETCHER, THOMAS "TOM"
HANDY, WILLIAM CHRISTOPHER "W.C."
MOTEN, BENJAMIN "BENNIE"
RUSHING, JAMES ANDREW "JIMMY"
VODERY, WILLIAM HENRY BENNETT "WILL"

Jean McMahon Humez
University of Massachusetts
JACKSON, REBECCA COX

Horace Huntley
University of Alabama, Birmingham
ALABAMA

Marshall Hyatt
New York, New York
DYER BILL
HARLEM, NEW YORK
LEWIS, JOHN
MOSES, ROBERT PARRIS
POOR PEOPLE'S CAMPAIGN

I

David B. Igler
Palo Alto, California
ARCHY LEE INCIDENT
BASSETT, EBENEZER DON CARLOS
BROOKS, ARTHUR
SIMMONS, WILLIAM J.
WILLIAMS, PAUL REVERE

M. Thomas Inge
Randolph-Macon College
COMIC STRIPS
HARRINGTON, OLIVER WENDELL "OLLIE"
HERRIMAN, GEORGE

Qadri Ismail
Columbia University
BELL, JAMES MADISON
BOLIN, JANE MATHILDA
FEELINGS, THOMAS
FOREIGN POLICY
LUCY FOSTER, AUTHERINE
MOODY, ANNE
QUINN, WILLIAM PAUL
WEST, HAROLD DADFORTH

J

Irene V. Jackson
Port Chester, New York
MARTIN, ROBERTA WINSTON
THARPE, "SISTER" ROSETTA
TINDLEY, CHARLES ALBERT

Reuben Jackson
Washington, D.C.
HINTON, MILTON JOHN "MILT"

Travis Jackson
New York, New York
ART ENSEMBLE OF CHICAGO
BARRON, WILLIAM, JR. "BILL"
FOSTER, FRANK BENJAMIN, II
JORDAN, LOUIS
NANTON, JOSEPH "TRICKY SAM"
THREADGILL, HENRY LUTHER
TIZOL, JUAN (MARTINEZ, VINCENTE)
WORLD SAXOPHONE QUARTET

Mary Jane Jacob
Chicago, Illinois
CONWILL, HOUSTON

Donald M. Jacobs
Northeastern University
ANTI-ABOLITIONISM
FREDERICK WILKINS SLAVE RESCUE
MASSACHUSETTS

Margaret D. Jacobs
Martinez, California
BETHUNE-COOKMAN COLLEGE
BLAIR EDUCATION BILL

EARLY AFRICAN-AMERICAN WOMEN'S ORGANIZATIONS
ELLIOTT, ROBERT BROWN
HARRIS, ANDREW
MOYNIHAN REPORT
SHADD, ABRAHAM DORAS
SIXTEENTH STREET BAPTIST CHURCH (BIRMINGHAM, ALABAMA)
SOUTHERN REGIONAL COUNCIL
TWELVE KNIGHTS OF TABOR
YOUNG, ROBERT ALEXANDER

Portia P. James
Smithsonian Institution
INDUSTRIAL ARTS
INVENTORS AND INVENTIONS
MURRAY, GEORGE WASHINGTON

Kenneth Robert Janken
University of North Carolina, Chapel Hill
LOGAN, RAYFORD WHITTINGHAM

Gerald D. Jaynes
Yale University
ECONOMICS

Margaret J. Jerrido
Temple University
SPURLOCK, JEANNE

Audreye E. Johnson
University of North Carolina, Chapel Hill
SOCIAL WORK

Jacqueline Jones
Brandeis University
INDUSTRIALIZATION

James H. Jones
Houston, Texas
TUSKEGEE SYPHILIS EXPERIMENT

Lawrence N. Jones
Silver Spring, Maryland
THEOLOGICAL EDUCATION
UNITED CHURCH OF CHRIST

Rhett S. Jones
Brown University
RHODE ISLAND

Shirley Jones
State University of New York, Albany
ARTIS, WILLIAM ELLISWORTH

Erica Judge
Amman, Jordan
AMBASSADORS AND DIPLOMATS

Eileen Julien
Indiana University
NÉGRITUDE

K

Lynn Kane
Columbia, South Carolina
JENKINS, LEROY
SMITH, STUFF
SOUTH, EDWARD "EDDIE"
WHITE, CLARENCE CAMERON

William Loren Katz
New York, New York
AMERICAN INDIANS

Sarah M. Keisling
Providence, Rhode Island
DAVIS, BENJAMIN JEFFERSON, JR.
JONES, ROBERT EARL
McKINNEY, NINA MAE
McNEIL, CLAUDIA
MILES, WILLIAM

Robin D. G. Kelley
University of Michigan, Ann Arbor
COMMUNIST PARTY OF THE UNITED STATES

Randall Kennedy
Harvard Law School
MARSHALL, THURGOOD

Nathan Kernan
Robert Miller Gallery, New York
BASQUIAT, JEAN-MICHEL

Joseph D. Ketner
St. Louis, Missouri
DUNCANSON, ROBERT S.

Cheryl L. Keyes
University of California, Los Angeles
RAP

Martin Kilson
Harvard University
CLASS AND SOCIETY

Jo H. Kim
Columbia University
BROWN, JOHN MIFFLIN
JOHNSON, CHARLES SPURGEON
LOVE, EMANUEL KING
RAY, CHARLOTTE E.
RIVERS, CLARENCE JOSEPH
ROCK, JOHN SWEAT
WALKER, GEORGE THEOPHILUS

Nicole R. King
Philadelphia, Pennsylvania
LORDE, AUDRE GERALDINE

William King
University of Colorado, Boulder
COLORADO
WYOMING

April Kingsley
New York, New York
LOVING, ALVIN

Kenneth Kinnamon
University of Arkansas, Fayetteville
GAINES, ERNEST J.

Jeffrey L. Klein
Columbia University
BELL, PHILIP ALEXANDER
BIBB, HENRY WALTON
GIBBS, MIFFLIN WISTER
JACK, HULAN EDWIN

Bud Kliment
Columbia University
CHECKER, CHUBBY (EVANS, ERNEST)
FITZGERALD, ELLA
FLACK, ROBERTA
FOUR TOPS, THE
FRANKLIN, ARETHA LOUISE
HOLIDAY, BILLIE
McRAE, CARMEN
PULITZER PRIZES (APPENDIX)
RAWLS, LOUIS ALLEN "LOU"
RAZAF, ANDY (RAZAFKERIEFO, ANDREAMENTANIA PAUL)
REDDING, OTIS
REGGAE
SMITH, MAMIE
VAUGHAN, SARAH
WASHINGTON, DINAH (JONES, RUTH LEE)
WILSON, NANCY SUE

Benjamin Kline
University of Alaska, Fairbanks
ALASKA

Vera M. Kutzinski
University of Virginia
WRIGHT, JAY

L

Othal Hawthorne Lakey
Cincinnati, Ohio
CHRISTIAN METHODIST EPISCOPAL CHURCH

Bart Landry
University of Maryland, College Park
RACE, CASTE, AND CLASS

Alycee Jeannette Lane
University of California, Los Angeles
LESBIANS

Ann J. Lane
University of Virginia
BROWNSVILLE, TEXAS, INCIDENT

Roger Lane
Haverford College
CRIME

Richard E. Lapchick
Northeastern University
ARTISTS AND ATHLETES AGAINST APARTHEID

Steven F. Lawson
University of North Carolina, Greensboro
SUFFRAGE, TWENTIETH-CENTURY

Chana Kai Lee
University of Florida
CLARK, SEPTIMA POINSETTE
HAMER, FANNIE LOU (TOWNSEND, FANNIE LOU)

Theresa Leininger-Miller
Cincinnati, Ohio
CINCINNATI, OHIO
DOUGLAS, AARON
FARROW, WILLIAM McKNIGHT
FULLER, META VAUX WARRICK
HARPER, WILLIAM A.
HAYDEN, PALMER C.
SAVAGE, AUGUSTA CHRISTINE FELLS
SMITH, ALBERT ALEXANDER

Kevin Allen Leonard
Albuquerque, New Mexico
CALIFORNIA
LOS ANGELES, CALIFORNIA

Steven J. Leslie
Columbia University
BEASLEY, DELILAH ISONTIUM
BRAWLEY, BENJAMIN GRIFFITH
BROOKE, EDWARD W., III
COOK, MERCER
DePRIEST, OSCAR STANTON
DIGGS, CHARLES COLES, JR.
FARMER, JAMES
MEREDITH, JAMES H.
REDDING, JAY SAUNDERS
WILLIAMS, HOSEA LORENZO

Daniel Letwin
Pennsylvainia State University
NATIONAL NEGRO LABOR COUNCIL

Sholomo Ben Levy
Saint Albans, New York
JUDAISM

David Levering Lewis
Rutgers University, New Brunswick
HARLEM RENAISSANCE

Earl Lewis
University of Michigan, Ann Arbor
VIRGINIA

Petra E. Lewis
Brooklyn, New York
GREAVES, WILLIAM
HARLEM COMMONWEALTH COUNCIL

JOHNSON PUBLISHING COMPANY
NEGRO ELECTIONS DAY
SLAVE TRADE

Samella Lewis
Museum of African-American Art, Los Angeles
BARTHÉ, RICHMOND

Julinda Lewis-Ferguson
Brooklyn, New York
ADAMS, CAROLYN
BENJAMIN, FRED
BETHEL, ALFRED "PEPSI"
DAVIS, CHARLES RUDOLPH "CHUCK"
FAGAN, GARTH
JONES, BILL T.
MILLER, JOAN

C. Eric Lincoln
Duke University
NATION OF ISLAM

Nashormeh N. R. Lindo
*Schomburg Center for Research in Black Culture,
 New York Public Library*
BARBOZA, ANTHONY
SLIGH, CLARISSA
WILLIAMS, PAT WARD

Rick Lipsey
New York, New York
RHODES, THEODORE, JR.

Daniel C. Littlefield
University of Illinois
MAROONAGE
SLAVE TRADE

Leon F. Litwack
University of California, Berkeley
FRANKLIN, JOHN HOPE
JIM CROW

Kofi Lomotey
Louisiana State University
AFROCENTRICITY

Lawrence Londino
Montclair State College
BROWN, PETE
GOLF
PEETE, CALVIN
SIFFORD, CHARLES L.
UNITED GOLFERS ASSOCIATION

Michael A. Lord
Williamsburg, Virginia
BALTIMORE AFRO-AMERICAN
DODDS, JOHN M. "JOHNNY"
JOHNSON, MORDECAI WYATT
SMITH, WILLIE MAE FORD

Kip Lornell
Washington, D.C.
GOSPEL QUARTETS
TERRY, SONNY (TERRELL, SAUNDERS)
TURNER, JOSEPH VERNON "BIG JOE"
WILLIAMSON, JOHN LEE "SONNY BOY"

Eric Lott
University of Virginia
UNCLE TOM'S CABIN

Joseph W. Lowndes
Columbia University
BOUSFIELD, MIDIAN OTHELLO
BRIDGE
BRISTOW, LONNIE R.
CAIN, RICHARD HARVEY
CLEMENT, RUFUS EARLY
FEDERAL ELECTIONS BILL OF 1890
GREEN, AL
INTERRACIAL COUNCIL FOR BUSINESS OPPORTUNITY
 (ICBO)
KEARSE, AMALYA LYLE
LOGAN, ARTHUR COURTNEY
MARTIAL ARTS
PARSONS, LUCY
PICKETT, WILSON
SLOWE, LUCY DIGGS
TYSON, CICELY
WHITE, BILL

John W. Loy
University of Illinois, Urbana-Champaign
BULLOCK, MATTHEW WASHINGTON

Wahneema Lubiano
Princeton, New Jersey
MORRISON, TONI

Marion B. Lucas
Western Kentucky University
KENTUCKY
LOUISVILLE, KENTUCKY

Ralph E. Luker
Antioch College
SOCIAL GOSPEL

Christine A. Lunardini
New York, New York
BAILEY, BILL
BEARDEN, BESSYE JEAN
BRADLEY, EDWARD R.
BROWN, RONALD H.
BROWN, RUTH
CAESAR, ADOLPH
CARROLL, VINNETTE
CHINN, MAY EDWARD
CLARK, KENNETH BANCROFT
CONYERS, JOHN F., JR.
DAVIS, ANGELA YVONNE

DEFRANTZ, ANITA
DU BOIS, SHIRLEY GRAHAM
FAIR EMPLOYMENT PRACTICES COMMITTEE (FEPC)
HIGHLANDER CITIZENSHIP SCHOOL
JORDAN, BARBARA CHARLINE
ROOSEVELT'S BLACK CABINET
SPELMAN COLLEGE
STAUPERS, MABEL KEATON
YOUNG, ANDREW

Paul David Luongo
Philadelphia, Pennsylvania
ALEXANDER, RAYMOND PACE

Jane Lusaka
Washington, D.C.
BROWN, SAMUEL JOSEPH, JR.
DELANEY, JOSEPH
GORELEIGH, REX
HERRING, JAMES VERNON
NEW YORK SLAVE REVOLT OF 1712
THOMAS, ALMA
THRASH, DOX
WASHINGTON, DENZEL

Lois Lyles
San Francisco State University
EVERS, JAMES CHARLES
TUSKEGEE CIVIC ASSOCIATION

M

Paul S. Machlin
Colby College
JOHNSON, JAMES PRICE
ROBERTS, CHARLES LUCKEYETH "LUCKEY"
SMITH, "WILLIE THE LION" (BERTHOLOFF, WILLIAM
 HENRY JOSEPH BONAPARTE)
WALLER, THOMAS WRIGHT "FATS"

David R. Maginnes
Chevy Chase, Maryland
BURNS, ANTHONY

Brendan Maguire
Western Illinois University
WRESTLING

Neil Maher
New York University
WEIR, REGINALD
WILLIAMS, DOUGLAS LEE

Jackie Malone
New York, New York
ATKINS, CHOLLY
BERRY BROTHERS
JAMES, LEON EDGEHILL, AND MINNS, ALBERT DAVID
MANNING, FRANKIE
MILLER, NORMA
POMARE, ELEO

THEATRICAL DANCE
ZOLLAR, JAWOLE WILLA JO

Lawrence H. Mamiya
Vassar College
FARRAKHAN, LOUIS ABDUL
ISLAM
MUHAMMAD, ELIJAH
NATION OF ISLAM

Kenneth R. Manning
Massachusetts Institute of Technology
CHASE, HYMAN YATES
CLAYTOR, WILLIAM WALDRON SCHIEFFELIN
COBB, WILLIAM MONTAGUE
COX, ELBERT FRANK
CREED, COURTLANDT VAN RENSSELAER
DISEASES AND EPIDEMICS
FOLK MEDICINE
HEALTH AND HEALTH CARE PROVIDERS
JUST, ERNEST EVERETT
LLOYD, RUTH SMITH
MATHEMATICIANS
McKINNEY, ROSCOE LEWIS
PUBLIC HEALTH
SCIENCE
THOMAS, VIVIEN THEODORE
TURNER, THOMAS WYATT
WILLIAMS, JAMES HENRY, JR.

Edward Margolies
New York, New York
EQUIANO, OLAUDAH
HIMES, CHESTER

Karal Ann Marling
University of Minnesota
FEDERAL ART PROJECTS

Charles H. Martin
University of Texas, El Paso
TRACK AND FIELD

Gordon A. Martin, Jr.
Newton Center, Massachusetts
PROPOSITIONS 48 AND 42: NCAA BYLAW 14.3

Reginald Martin
Memphis State University
NEAL, LARRY

Sandy Dwayne Martin
University of Georgia
AFRICAN METHODIST EPISCOPAL ZION CHURCH
MISSIONARY MOVEMENTS

Waldo E. Martin, Jr.
University of California, Berkeley
DOUGLASS, FREDERICK
KARENGA, MAULANA (EVERETT, RONALD McKINLEY)

Portia K. Maultsby
Indiana University
MUSIC

Louise P. Maxwell
Columbia University
ALLEN, MACON BOLLING
AMERICAN MORAL REFORM SOCIETY
BORDERS, WILLIAM HOLMES
DURHAM MANIFESTO
GULLAH
FREEDMAN'S BANK
HANCOCK, GORDON BLAINE
HOOKS, BENJAMIN LAWRENCE
HOUSING DISCRIMINATION
HUDLIN, REGINALD
HUDLIN, WARRINGTON
HURLEY, RUBY
JACKSON, PETER
JONES, EDWARD
KEITH, DAMON JEROME
KELLY, LEONTINE TURPEAU CURRENT
KING, CORETTA SCOTT
McCRUMMILL, JAMES
MITCHELL, JOHN R., JR.
MONROE, GEORGE A. "ALFRED"
PICKETT, BILL
PRISON LABOR
RICHMOND, WILLIAM "BILL"
SAUNDERS, PRINCE
TUBMAN, HARRIET ROSS
WATERS, MAXINE MOORE
WHIPPER, WILLIAM
WHITE CITIZENS' COUNCILS

David McBride
State University of New York, Binghamton
MEDICAL COMMITTEE FOR HUMAN RIGHTS
MINTON, HENRY McKEE
PURVIS, CHARLES BURLEIGH

Michael J. McDonald
University of Tennessee
TENNESSEE

Deborah McDowell
University of Virginia
PETRY, ANN LANE
WEST, DOROTHY

Doris Evans McGinty
Howard University
DAWSON, MARY CARDWELL
FISK JUBILEE SINGERS
MARSHALL, HARRIET GIBBS
NATIONAL ASSOCIATION OF NEGRO MUSICIANS

Susan McIntosh
Columbia University
BROWN, CLARA
BROWN, DOROTHY LAVANIA

CLEMENT, RUFUS EARLY
COOPER, RALPH
DAILEY, ULYSSES GRANT
DAVIS, OSSIE
DEE, RUBY (WALLACE, RUBY ANN)
FOXX, REDD
GOLDBERG, WHOOPI
GLOVER, DANNY
HOLLY, JAMES THEODORE
JONES, EDWARD
KITT, EARTHA MAE
KNIGHT, GWENDOLYN
MURPHY, EDDIE
POINTER SISTERS, THE
RICHARDSON, GLORIA ST. CLAIR HAYES
SMITH, ADA BEATRICE QUEEN VICTORIA LOUISE
 VIRGINIA "BRICKTOP"
STEPIN FETCHIT
TEER, BARBARA ANN

Nellie Y. McKay
University of Wisconsin, Madison
HURSTON, ZORA NEALE

James B. McKee
East Lansing, Michigan
SOCIOLOGY

Genette McLaurin
University of North Carolina, Wilmington
COX, IDA PRATHER
GUNN, WILLIAM HARRISON "BILL"
SAM AND DAVE
SCOTT-HERON, GIL

Melton A. McLaurin
University of North Carolina, Wilmington
CELIA

Neil R. McMillen
University of Southern Mississippi
MISSISSIPPI

Linda O. McMurry
North Carolina State University
CARVER, GEORGE WASHINGTON
WORK, MONROE NATHAN

Genna Rae McNeil
University of North Carolina, Chapel Hill
HOUSTON, CHARLES HAMILTON

Lydia McNeill
Columbia University
ALABAMA CHRISTIAN MOVEMENT FOR HUMAN RIGHTS
AUGUSTA, ALEXANDER THOMAS
BARBADOES, JAMES G.
BARNETT, CLAUDE ALBERT
BATEMAN, MILDRED MITCHELL
BEMAN, JEHIEL C.

BISHOP, HUTCHENS CHEW
BLUFORD, GUION STEWART, JR. "GUY"
BOYD, ROBERT FULTON
BROWN, CECIL MORRIS
BROWN, JAMES NATHANIEL "JIM"
BROWN, WILLIAM ANTHONY "TONY"
CAIN, RICHARD HARVEY
CLARK, PETER HUMPHRIES
DICKSON, MOSES
DWIGHT, EDWARD JOSEPH, JR.
ENCYCLOPEDIA OF THE NEGRO, THE
FERRILL, LONDON
FRANKLIN, MARTHA MINERVA
FREEDMEN'S HOSPITAL
GEORGE, DAVID
GREENER, RICHARD THEODORE
GREGORY, FREDERICK DREW
GRIMES, LEONARD ANDREW
HALE, CLARA MCBRIDE "MOTHER"
HALL, GEORGE CLEVELAND
HAMILTON, WILLIAM
HANCOCK, GORDON BLAINE
HARPER, SOLOMON
HOOD, JAMES WALKER
ICE HOCKEY
JEFFERSON, MILDRED FAY
JEMISON, MAE CAROL
JERNAGIN, WILLIAM HENRY
JOHNSON-BROWN, HAZEL WINIFRED
JONES, CHARLES PRICE
LAWRENCE, MARGARET CORNELIA MORGAN
LAWRENCE, ROBERT HENRY, JR.
LEE, REBECCA
LEWIS, REGINALD F.
LOGAN, ARTHUR COURTNEY
MAJORS, MONROE ALPHEUS
MARTIN, JOHN SELLA
MASON, CHARLES HARRISON
MCCARROLL, ERNEST MAE
MCCRUMMILL, JAMES
MILLER, CHERYL DEANNE
MILNER, RONALD
MINTON, HENRY MCKEE
MONROE, GEORGE A. "ALFRED"
MOORE, RICHARD BENJAMIN
NASH, DIANE BEVEL
NAYLOR, GLORIA
ORGAN, CLAUDE H., JR.
PATTERSON, CHARLES R.
POINDEXTER, JAMES PRESTON
POWELL, WILLIAM FRANK
QUINLAND, WILLIAM SAMUEL
RUSSELL, NIPSEY
SEYMOUR, WILLIAM JOSEPH
SIMKINS, MARY MODJESKA MONTEITH
SOCIETY FOR THE PROPAGATION OF THE GOSPEL IN
 FOREIGN PARTS (SPG)
SPENCER, ANNE (SCALES, ANNIE BETHEL)
SPENCER, PETER
STRINGER, CHARLENE VIVIAN
THOMS, ADAH BELLE SAMUELS

UNCLES, CHARLES RANDOLPH
UPSHAW, EUGENE THURMAN "GENE"
WALDRON, JOHN MILTON
WALKER, WYATT TEE
WASHINGTON, VALORES J. "VAL"
WILLIAMS, LACEY KIRK
WILLIAMS, SHERLEY ANNE (SHIRLEY)
WILLIAMS, WILLIAM THOMAS
WRIGHT, CHARLES STEVENSON

Eddie S. Meadows
University of California, Los Angeles
ADDERLEY, JULIAN EDWIN "CANNONBALL"
BROWN, CLIFFORD "BROWNIE"
CARNEY, HARRY HOWELL
CARTER, BETTY
DOLPHY, ERIC ALLAN
ECKSTINE, WILLIAM CLARENCE "BILLY"
HAWKINS, COLEMAN RANDOLPH
MARSALIS, WYNTON
MCFERRIN, ROBERT, JR. "BOBBY"
MINGUS, CHARLES, JR.
ROLLINS, THEODORE WALTER "SONNY"
SHORTER, WAYNE
SILVER, HORACE (TAVARES, WARD MARTIN)
TAYLOR, WILLIAM, JR., "BILLY"

D. H. Melhem
New York, New York
BROOKS, GWENDOLYN ELIZABETH

Michael Meyers
New York, New York
WILKINS, ROY OTTOWAY

Ronald E. Mickens
Clark Atlanta University
IMES, ELMER SAMUEL
PHYSICS

Dennis Mihelich
Creighton University
NEBRASKA

Elizabeth Wright Millard
St. Louis, Missouri
JACKSON, OLIVER LEE

Albert G. Miller
Oberlin College
NATIONAL BLACK EVANGELICAL ASSOCIATION

Allison X. Miller
Columbia University
ARNETT, BENJAMIN WILLIAM, JR.
BEATTY, TALLEY
BOURNE, ST. CLAIR CECIL
CARNEY, WILLIAM H.
DAILEY, ULYSSES GRANT
EDWARDS, LENA FRANCIS
ELAW, ZILPHA

FULLER, SOLOMON CARTER
GREGORY, GEORGE, JR.
JACKSON, LILLIE MAE CARROLL
JONES, CHARLES PRICE
LATIMER, LEWIS HOWARD
MASON, CHARLES HARRISON
MCCOY, ELIJAH J.
O'HARA, JAMES EDWARD
ROBINSON, ROSCOE, JR.
SEYMOUR, WILLIAM JOSEPH
TAYLOR, GARDNER CALVIN
WHITE, GEORGE HENRY
WILSON, ARTHUR ERIC "DOOLEY"

James A. Miller
Trinity College, Hartford, Connecticut
ATTAWAY, WILLIAM ALEXANDER
BIRTH OF A NATION, THE
BLACK WORLD / NEGRO DIGEST
CONNECTICUT
GREGORY, RICHARD CLAXTON "DICK"

Jeanne-Marie A. Miller
Howard University
BRANCH, WILLIAM BLACKWELL
BULLINS, ED
WARD, DOUGLAS TURNER

John Miller
South Dakota State University
SOUTH DAKOTA

Randall M. Miller
St. Joseph's University
SLAVERY

Darrell Milo Millner
Portland State University
OREGON

Thomas K. Minter
Lehman College, City University of New York
EDUCATION

Lisa Marie Moore
Columbia University
MOLINEAUX, TOM
PAGE, ALAN CEDRIC
TUSKEGEE UNIVERSITY

Calvin S. Morris
Howard University
RANSOM, REVERDY CASSIUS

Mark D. Morrison-Reed
West Toronto, Ontario
UNITARIAN UNIVERSALIST ASSOCIATION

William J. Moses
New Haven, Connecticut
NEW YORK AFRICAN SOCIETY FOR MUTUAL RELIEF
NEW YORK MANUMISSION SOCIETY
TOUSSAINT, PIERRE

Wilson J. Moses
Pennsylvania State University
CRUMMELL, ALEXANDER
PAN-AFRICANISM

Alfred A. Moss, Jr.
University of Maryland, College Park
AMERICAN NEGRO ACADEMY (ANA)

Derryn E. Moten
Iowa City, Iowa
IOWA

Esther Hall Mumford
Seattle, Washington
WASHINGTON

James E. Mumford
University of Indiana
BELAFONTE, HAROLD GEORGE "HARRY"
HORNE, LENA
LINCOLN, ABBEY
MATHIS, JOHNNY (MATHIAS, JOHN ROYCE)
MILLS, FLORENCE
WATERS, ETHEL

Gregory J. Murphy
Palo Alto, California
HAMPTON INSTITUTE

Elizabeth Muther
Brunswick, Maine
ARMSTRONG, LILLIAN HARDIN "LIL"
KARAMU HOUSE
MCCLENDON, ROSE
OPPORTUNITY: JOURNAL OF NEGRO LIFE
OWEN, CHANDLER
SPIVEY, VICTORIA REGINA
WALLACE, SIPPIE (THOMAS, BEULAH BELLE)

N

Pam Nadasen
Columbia University
ALEXANDER, SADIE TANNER MOSSELL
BARBER, JESSE MAX
BEASLEY, DELILAH ISONTIUM
BLACK ACADEMY OF ARTS AND LETTERS
BLACK WOMEN'S CLUB MOVEMENT
BRAWLEY, EDWARD MCKNIGHT
BURROUGHS, NANNIE HELEN
CIVIL RIGHTS CONGRESS
CONGRESS OF NATIONAL BLACK CHURCHES, INC.
COOPER, ANNA JULIA HAYWOOD
DAVIDSON, OLIVIA AMERICA
HALE, CLARA MCBRIDE "MOTHER"
HORNE, FRANK SMITH
MATTHEWS, VICTORIA EARLE (SMITH)
NATIONAL ASSOCIATION OF COLORED WOMEN
NATIONAL WELFARE RIGHTS ORGANIZATION
NEW ERA CLUB
OPERATION BREADBASKET

PARKS, ROSA LOUISE MCCAULEY
PATTERSON, WILLIAM
REVOLUTIONARY ACTION MOVEMENT
ROBINSON, JO ANN GIBSON
ROBINSON, MAXIE CLEVELAND
ROBINSON, RANDALL
RUDOLPH, WILMA GLODEAN
SISTERS OF THE HOLY FAMILY
TEMPLE, LEWIS
THOMPSON, LOUISE
WALKER, MAGGIE LENA
WILLIAMS, ROBERT FRANKLIN

Bernard C. Nalty
Hyattsville, Maryland
KOREAN WAR
MILITARY
VIETNAM WAR
WORLD WAR II

Gary B. Nash
University of California, Los Angeles
ALLEN, RICHARD
JONES, ABSALOM

Jim Naughton
Washington, D.C.
JORDAN, MICHAEL JEFFREY

Renee Newman
Cambridge, Massachusetts
BIGGERS, JOHN
BLACKBURN, ROBERT HAMILTON
CHICAGO ART LEAGUE
COLESCOTT, ROBERT H.
CRICHLOW, ERNEST
CRUZ, EMILIO
FAX, ELTON C.
HARMON FOUNDATION
HENDRICKS, BARKLEY
HIGGINS, CHESTER
KNIGHT, GWENDOLYN
MOORHEAD, SCIPIO
PORTER, JAMES AMOS
SCOTT, WILLIAM EDOUARD
WEEMS, CARRIE MAE

Richard Newman
Cambridge, Massachusetts
AFRICAN ORTHODOX CHURCH
BOLES, ROBERT
BOOK COLLECTORS AND COLLECTIONS
CARR, WYNONA
DRANES, ARIZONA JUANITA
GRACE, CHARLES EMMANUEL "SWEET DADDY"
GRAY, WILLIAM HERBERT, III
GREEN, CORA
HAMPTON, JAMES
HAYNES, LEMUEL
LINCOLN THEATRE

MARSHALL, ALBERT P.
MCGUIRE, GEORGE ALEXANDER
MEMPHIS MINNIE (DOUGLAS, LIZZIE "KID")
SCHOMBURG, ARTHUR ALFONSO
STOREFRONT CHURCHES
WALKER, AIDA OVERTON
WESLEY, DOROTHY BURNETT PORTER

Charles H. Nichols
Brown University
BONTEMPS, ARNA

Albert Nickerson
Staten Island, New York
ANTI-APARTHEID MOVEMENT (DIVESTMENT
MOVEMENT)

Donald G. Nieman
Clemson, South Carolina
CIVIL RIGHTS AND THE LAW

Linda Nieman
Clemson, South Carolina
DOUGLAS, AARON
MURALISTS

Robert J. Norrell
University of Alabama
BIRMINGHAM, ALABAMA

Mansur M. Nuruddin
Columbia University
AMSTERDAM NEWS
BLACK SCHOLAR
BROWN, HUBERT G. "H. RAP"
CHAVIS, BENJAMIN FRANKLIN, JR.
DEACONS FOR DEFENSE AND JUSTICE
DU SABLE, JEAN BAPTISTE POINTE
HARLEM BOYCOTTS
KAWAIDA

Levi A. Nwachuku
Lincoln University
LINCOLN UNIVERSITY
SEALE, ROBERT GEORGE "BOBBY"

O

Bill Olsen
Columbia University
JOINT CENTER FOR POLITICAL AND ECONOMIC
STUDIES—PUBLIC POLICY INSTITUTE
MORROW, EVERETT FREDERICK

Robert G. O'Meally
Barnard College
ELLISON, RALPH
HODGES, JOHNNY (HODGE, JOHN CORNELIUS)

Kenneth O'Reilly
University of Alaska
FEDERAL BUREAU OF INVESTIGATION (FBI)

Claude H. Organ, Jr.
University of California, Davis
CURTIS, AUSTIN MAURICE
SURGERY

P

Nell Irvin Painter
Princeton University
DELANY, MARTIN ROBISON
EXODUSTERS
HUDSON, HOSEA

Michael Paller
Columbia Unversity
AMENIA CONFERENCE OF 1916
AMENIA CONFERENCE OF 1933
AMERICAN NEGRO THEATRE
BARRETT, JANIE PORTER
DENT, THOMAS
DEVEAUX, ALEXIS
ELDER, LONNE, III
FOXX, REDD
FULLER, CHARLES HENRY, JR.
GIOVANNI, YOLANDA CORNELIA "NIKKI"
HARRISON, PAUL CARTER
JACKSON, JIMMY LEE
JASPER, JOHN
JOHNSON, NOBLE M., AND JOHNSON,
 GEORGE PERRY
LENOIRE, ROSETTA OLIVE BURTON
LOGUEN, JERMAIN WESLEY
MACKEY, WILLIAM WELLINGTON
MARVIN X
NEGRO ENSEMBLE COMPANY, THE
NEGRO SANHEDRIN
POLITE, CARLENE HATCHER
POWELL, GEORGETTE SEABROOKE
RANDALL, DUDLEY FELKER
SALAAM, KALAMU YA
SULLIVAN, LEON HOWARD
VOTING RIGHTS ACT OF 1965
WALKER, JOSEPH A.
WESLEY, RICHARD
WHITE, EDGAR NKOSE
WILLIAMS, SAMM-ART
WOLFE, GEORGE C.

Louis J. Parascandola
Kew Gardens, New York
CORTEZ, JAYNE
SHANGE, NTOZAKE

Kevin Parker
Columbia University
ARNETT, BENJAMIN WILLIAM, JR.
FULLER, SOLOMON CARTER
GARVEY, AMY ASHWOOD

JORDAN, LEWIS GARNET
LATIMER, LEWIS HOWARD
MURRAY, PETER MARSHALL

Willie J. Pearson, Jr.
Wake Forest University
BRADY, ST. ELMO
CHEMISTRY
JULIAN, PERCY LAVON
MORTALITY AND MORBIDITY

Gayle Pemberton
Princeton University
THOMAS, DEBRA J. "DEBI"

Jeffrey B. Perry
Westwood, New Jersey
HARRISON, HUBERT HENRY

Lewis Perry
Vanderbilt University
ABOLITION

Regenia A. Perry
Virginia Commonwealth University
EVANS, MINNIE JONES
FOLK ARTS AND CRAFTS
HUNTER, CLEMENTINE CLEMENCE RUBIN
MORGAN, SISTER GERTRUDE
QUILT MAKING

Paula F. Pfeffer
Loyola University of Chicago
BROTHERHOOD OF SLEEPING CAR PORTERS
CROSSWAITH, FRANK RUDOLPH

Lily Phillips
Columbia University
CLIFTON, THELMA LUCILLE
HANSBERRY, LORRAINE
KNIGHT, ETHERIDGE
LOGUEN, JERMAIN WESLEY
NAYLOR, GLORIA

Dianne M. Pinderhughes
University of Illinois, Urbana-Champaign
WASHINGTON, HAROLD

Thomas Pitoniak
Columbia University
JACK AND JILL OF AMERICA
WILLIAMS, DOUGLAS LEE

Kimberly Pittman
New York, New York
DESTINÉ, JEAN-LEON
MCINTYRE, DIANE
MCKAYLE, DONALD
THOMPSON, CLIVE
YARBOROUGH, SARA

Anthony M. Platt
California State University, Sacramento
FRAZIER, EDWARD FRANKLIN

Robert A. Poarch
Alexandria, Virginia
STEVENS, NELSON
WHITTEN, JACK
WILSON, JOHN WOODROW

Marcus D. Pohlmann
Rhodes College
FORD, HAROLD EUGENE
MEMPHIS, TENNESSEE

Horace Porter
Stanford University
BALDWIN, JAMES

Alvin F. Poussaint
Boston, Massachusetts
PSYCHOLOGY AND PSYCHIATRY
SEXUALITY

Richard J. Powell
Duke University
GRAPHIC ARTS
JOHNSON, WILLIAM HENRY
WELLS, JAMES LESESNE

Alfred E. Prettyman
New York, New York
EDUCATION

Quandra Prettyman
Barnard College
BRAITHWAITE, WILLIAM STANLEY BEAUMONT
CARY, MARY ANN SHADD
HAMMON, JUPITER
HORTON, GEORGE MOSES
PLATO, ANN
PRINCE, NANCY GARDNER
SMITH, WILLIAM GARDNER
TERRELL, MARY ELIZA CHURCH
WARD, SAMUEL RINGGOLD

R

Melissa Rachleff
New York, New York
SENGSTACKE, ROBERT ABBOTT
SIMPSON, COREEN

Peter J. Rachleff
Macalester College
RICHMOND, VIRGINIA

Arnold Rampersad
Princeton University
DU BOIS, WILLIAM EDWARD BURGHARDT
HUGHES, LANGSTON
LITERATURE
ROBESON, PAUL

Guthrie P. Ramsey, Jr.
Ann Arbor, Michigan
AMMONS, EUGENE "GENE"
CROUCH, ANDRAE EDWARD
DAMERON, TADLEY EWING PEAKE "TADD"
GORDON, DEXTER KEITH
HAMPTON, LIONEL LEO
HAWKINS, EDWIN R.
JACKSON, MILTON "BAGS"
POWELL, EARL "BUD"

Valena Randolph
Wilberforce University
WILBERFORCE UNIVERSITY

Elaine Reardon
University of Chicago
MINORITY BUSINESS SET-ASIDES

Karen E. Reardon
Columbia University
ARNELLE & HASTIE
INVESTMENT BANKING
MAYNARD, ROBERT CLYDE
MITCHELL, ARTHUR WERGS
NIX, ROBERT NELSON CORNELIUS
RIDDICK, GEORGE

Christopher R. Reed
Roosevelt University
DAWSON, WILLIAM LEVI [CONGRESSMAN]
DICKERSON, EARL BURRIS

Harry A. Reed
Michigan State University
DIASPORA

Shipherd Reed
Columbia University
BOURNE, ST. CLAIR CECIL
BROWN, JOE "OLD BONES"
DICKERSON, GLENDA
GARRISON, ZINA
GREAVES, WILLIAM
MACKEY, JOHN
MARSHALL, WILLIAM HORACE
SCHULTZ, MICHAEL

Charlene Regester
University of North Carolina, Chapel Hill
MICHEAUX, OSCAR

Deborah M. Rehn
Columbia University
WARING, LAURA WHEELER

Robert Reid-Pharr
City University of New York
GAY MEN

Marsha J. Reisser
Columbia College, Chicago
SWANSON, HOWARD

Susan M. Reverby
Wellesley College
LAURIE, EUNICE VERDELL RIVERS

Jesse Rhines
New York, New York
DAVIS, SAMMY, JR.

Wilbur C. Rich
Wellesley College
DETROIT, MICHIGAN
YOUNG, COLEMAN ALEXANDER

Sandra L. Richards
Northwestern University
DRAMA

Deborra A. Richardson
Smithsonian Institution
KAY, ULYSSES SIMPSON

Marilyn Richardson
Watertown, Massachusetts
LEWIS, EDMONIA
STEWART, MARIA MILLER

Steven A. Riess
Northeastern Illinois University
ARMSTRONG, HENRY (JACKSON, HENRY, JR.)
BASEBALL
JOHNSON, JOHN ARTHUR "JACK"
LISTON, CHARLES "SONNY"
PATTERSON, FLOYD
ROBINSON, SUGAR RAY (SMITH, WALKER, JR.)

Thomas L. Riis
College of Music, Boulder
MUSICAL THEATER

Kim Robbins
Columbia Univeristy
POWELL, GEORGETTE SEABROOKE
REMOND, SARAH PARKER

John W. Roberts
University of Pennsylvania
FOLKLORE

Samuel K. Roberts
Virginia Union University
HAYNES, GEORGE EDMUND

Greg Robinson
Columbia University
AMERICAN AND FOREIGN ANTI-SLAVERY SOCIETY
ANGLO-AFRICAN, THE
ARKANSAS

ATLANTA RIOT OF 1906
BALDWIN, MARIA LOUISE
BECKWOURTH, JAMES PIERSON
BENNETT, LERONE, JR.
BLACK SWAN RECORDS
BLACKWELL, UNITA
BOND, JULIAN
BUTTS, CALVIN O., III
CAYTON, HORACE ROSCOE, JR.
CHAMBERLAIN, WILTON NORMAN "WILT"
CHESWILL, WENTWORTH
CHURCH, ROBERT REED, JR.
CHURCH, ROBERT REED, SR.
CLAY, WILLIAM LACY
CLEVELAND, OHIO
CORNISH, SAMUEL ELI
COX, OLIVER CROMWELL
CRUSE, HAROLD WRIGHT
DAVIS, OSSIE
DAVIS, WILLIAM ALLISON
DILL, AUGUSTUS GRANVILLE
DISMUKES, WILLIAM "DIZZY"
DOBY, LAWRENCE EUGENE "LARRY"
DOMINGO, WILFRED ADOLPHUS
DUNNIGAN, ALICE ALLISON
DU SABLE, JEAN BAPTISTE POINTE
EBONY
ELAINE, ARKANSAS, RACE RIOT OF 1919
ELDERS, M. JOYCELYN JONES
FAUSET, CRYSTAL DREDA BIRD
FORTUNE, AMOS
FOSTER, ANDREW "RUBE"
FRAZIER, JOSEPH WILLIAM
GAY MEN
GRAVES, EARL GILBERT, JR.
HARLEM BOYCOTTS
HARLEM GLOBETROTTERS
HILL, LESLIE PICKNEY
HILL-THOMAS HEARINGS
JACKSON, JOSEPH HARRISON
JOHN HENRY
JOHNSON, FENTON
JOHNSON PRODUCTS
KANSAS CITY
KNIGHT, ETHERIDGE
LANE, ISAAC
LEADERSHIP CONFERENCE ON CIVIL RIGHTS
LEE, CANADA
LEIDESDORFF, WILLIAM ALEXANDER
LYNK, MILES VANDAHURST
MAYORS
MEACHUM, JOHN BERRY
MIAMI RIOT OF 1980
MILLER, DORIE
MITCHELL, CLARENCE MAURICE, JR.
MORRIS, ELIAS CAMP
MOTON, ROBERT RUSSA
MYERS, ISAAC
NAACP LEGAL DEFENSE AND EDUCATIONAL
 FUND

NAT TURNER CONTROVERSY
NEWARK, NEW JERSEY
NEW ORLEANS RIOT OF 1900
NIAGARA MOVEMENT
NORTON, ELEANOR HOLMES
OKLAHOMA
PACE, HARRY HERBERT
PAGE, INMAN EDWARD
PATTERSON, FREDERICK DOUGLASS
PAUL, THOMAS
PENNINGTON, JAMES WILLIAM CHARLES
POOR, SALEM
RENAISSANCE BIG FIVE (HARLEM RENS)
RIGGS, MARLON TROY
ROBINSON, EDWARD GAY
ROSS-BARNETT, MARGUERITE
ROWAN, CARL THOMAS
ST. LOUIS, MISSOURI
SAN FRANCISCO AND OAKLAND, CALIFORNIA
SHARPTON, ALFRED, JR.
SLAVE TRADE
SMITH, VENTURE
SOLOMON, JOB BEN (JALLO)
SPINGARN MEDAL
SPRINGFIELD, ILLINOIS, RIOT OF 1908
STEWART, PEARL
THOMPSON, HOLLAND
TUCKER, LORENZO
TULSA RIOT OF 1921
TURNER, LORENZO DOW
TWILIGHT, ALEXANDER LUCIUS
UNITED NEGRO COLLEGE FUND
URBANIZATION
VANN, ROBERT LEE
WALCOTT, JERSEY JOE (CREAM, ARNOLD
 RAYMOND)
WALKER, LEROY TASHREAU
WHITFIELD, JAMES MONROE
WILMINGTON, NORTH CAROLINA, RIOT OF
 1898
YERGAN, MAX
YOUNG, CHARLES
YOUNG, CLAUDE HENRY "BUDDY"

Jontyle Theresa Robinson
Atlanta, Georgia
MOTLEY, ARCHIBALD JOHN, JR.

Pearl T. Robinson
Tufts University
TRANSAFRICA

Donn Rogosin
Schenectady, New York
BASEBALL

Keith Rooney
New York, New York
ERVING, JULIUS WINFIELD, II
HALL, ARSENIO

Joel N. Rosen
Oxford, Mississippi
MONTGOMERY, ISAIAH THORNTON
MOUND BAYOU, MISSISSIPPI

David J. Rosenblatt
Auburn University
JACKSON, VINCENT EDWARD "BO"

Frances A. Rosenfeld
Columbia University
BIGGERS, JOHN
JOHNSON, MALVIN GRAY
PITTMAN, PORTIA MARSHALL WASHINGTON
PRIMUS, NELSON A.

Nan A. Rothschild
Barnard College
ARCHEOLOGY, HISTORICAL

Elizabeth Rubin
Columbia University
BUSH, ANITA
DERRICOTTE, JULIETTE ALINE

Rob Ruck
Pittsburgh, Pennsylvania
CAMPANELLA, ROY
CHARLESTON, OSCAR MCKINLEY
CLEMENTE, ROBERTO
COOPER, CHARLES "CHUCK"
GIBSON, JOSHUA "JOSH"
JOHNSON, WILLIAM JULIUS "JUDY"
LEONARD, WALTER FENNER "BUCK"
PAIGE, LEROY ROBERT "SATCHEL"

Frederik L. Rusch
John Jay College
TOOMER, JEAN

Elmer R. Rusco
University of Nevada, Reno
NEVADA

Thaddeus Russell
Columbia University
BING, DAVID "DAVE"
BLACK EMERGENCY CULTURAL COALITION (BECC)
BOND, HORACE MANN
BOWE, RIDDICK
BOWLING
BROWN, WILLIE LEWIS, JR.
CAMBRIDGE, GODFREY MACARTHUR
COINCOIN
COTTON CLUB
DAVIS, JOHN PRESTON
DELLUMS, RONALD V. "RON"
EATON, HUBERT ARTHUR
FIELD HOCKEY
FORD, JAMES W.
FOSTER, ROBERT WAYNE "BOB"
GAINES, CLARENCE EDWARD "BIGHOUSE"

GAITHER, ALONZO SMITH "JAKE"
GIBSON, ROBERT "BOB"
GYMNASTICS
HAGLER, MARVELOUS MARVIN
HAYES, ROBERT LEE "BOB"
HAYWOOD, HARRY
HEARNS, THOMAS
HENDERSON, RICKEY HENLEY
HENSON, MATTHEW ALEXANDER
HOLMES, LARRY
HOLYFIELD, EVANDER
HORSE RACING
JOHNS, VERNON
JONES, CLAUDIA
KECKLEY, ELIZABETH
KING, DON
KITT, EARTHA MAE
KNIGHT, GLADYS
LACROSSE
LEONARD, RAY CHARLES "SUGAR RAY"
LOCAL 1199: DRUG, HOSPITAL, AND HEALTH CARE
 EMPLOYEES UNION
LOWERY, JOSEPH ECHOLS
MAHONEY, MARY ELIZA
MAYFIELD, CURTIS
MAYS, WILLIE HOWARD
MICHAUX, ELDER LIGHTFOOT SOLOMON
MOON, HENRY LEE
MOORLAND, JESSE EDWARD
MOSELEY-BRAUN, CAROL
MOTOR RACING
MURPHY, ISAAC
NEGRO AMERICAN LABOR COUNCIL
NEW YORK SLAVE CONSPIRACY OF 1741
NORTHRUP, SOLOMON
PAYTON, PHILIP A., JR.
PAYTON, WALTER JERRY
PORT CHICAGO MUTINY
POWELL, ADAM CLAYTON, SR.
RANGEL, CHARLES BERNARD
REPUBLIC OF NEW AFRICA
RILES, WILSON CAMANZA
SALEM, PETER
SCOTT, WENDELL OLIVER
SIMPSON, ORENTHAL JAMES "O.J."
SINGLETON, BENJAMIN "PAP"
SMITH, WENDELL
SOCCER
SOFTBALL
SOUTHERN POVERTY LAW CENTER
STEWART, THOMAS MCCANTS
STILL, WILLIAM
STOKES, CARL BURTON
SWIMMING AND AQUATIC SPORTS
VOLLEYBALL
WALKER, GEORGE WILLIAM
WASHINGTON, FREDERICKA CAROLYN "FREDI"
WILKERSON, DOXEY ALPHONSO
WINTER SPORTS
YOUNG, PRESTON BERNARD

Georgia A. Ryder
Norfolk, Virginia
HACKLEY, EMMA AZALIA SMITH
MOORE, UNDINE SMITH
RYDER, NOAH FRANCIS

S

Layn Saint-Louis
Silver Spring, Maryland
AMERICAN COLONIZATION SOCIETY
BLYDEN, EDWARD WILMOT

James M. Salem
University of Alabama
ACE, JOHNNY (ALEXANDER, JOHN MARSHALL, JR.)
THORNTON, WILLIE MAE "BIG MAMA"
WITHERS, ERNEST C.

Jack Salzman
Columbia University
BROWN, ROSCOE CONKLING, JR.

Linda Salzman
Columbia University
ALEXANDER, CLIFFORD L., JR.
ASHFORD, EMMETT L.
BAYLOR, ELGIN GAY
BELL, JAMES THOMAS "COOL PAPA"
BROCK, LOUIS CLARK "LOU"
BROWN, HALLIE QUINN
CHARLES, EZZARD
HARRISON, RICHARD BERRY
IRVIN, MONTE
MURPHY, ISAAC
REED, WILLIS
WILLS, MAURICE MORNING "MAURY"

Vivian Ovelton Sammons
Library of Congress, Washington, D.C.
PARKER, CHARLES STEWART
PECK, DAVID JOHN
STUBBS, FREDERICK DOUGLASS

Rosita M. Sands
Nashua, New Jersey
GUILLORY, IDA LEWIS "QUEEN IDA"
MAKEBA, MIRIAM ZENZI
ODETTA (GORDON, ODETTA HOLMES FELIOUS)
SIMONE, NINA (WAYMON, EUNICE KATHLEEN)

Todd L. Savitt
East Carolina State University
MEDICAL EDUCATION

Marcia R. Sawyer
Del Mar, California
MICHIGAN
STOREFRONT CHURCHES

Mary R. Sawyer
Iowa State University
ECUMENISM

Vasanti Saxena
Columbia University
CARROLL, DIAHANN

Meg Henson Scales
New York, New York
SCALES, JEFFREY HENSON

Derek Scheips
Columbia University
BRATHWAITE, EDWARD KAMAU
BROWN, ROSCOE CONKLING, SR.
DERRICOTTE, JULIETTE ALINE
GUY, ROSA CUTHBERT
KILLENS, JOHN OLIVER
MERIWETHER, LOUISE
SANCHEZ, SONIA
TANDY, VERTNER WOODSON

Peter Schilling
Columbia University
ASHFORD, EVELYN
BODYBUILDING
BONNER, MARITA
BORICAN, JOHN
BOYD, HENRY ALLEN
CAREY, ARCHIBALD J., JR.
COOKE, LLOYD M.
DAVIDSON, SHELBY JAMES
DAVIS, JOHN HENRY
DERRICK, WILLIAM BENJAMIN
DICKINSON, JOSEPH HUNTER
FORTEN, ROBERT BRIDGES
FRATERNAL ORDERS AND MUTUAL AID ASSOCIATIONS
FREE AFRICAN SOCIETY
HALL, PRINCE
HOLSEY, LUCIUS HENRY
HOSIER, HARRY "BLACK HARRY"
JEHOVAH'S WITNESSES
JORDAN, VERNON EULION, JR.
LACY, SAM
MARSHALL, WILLIAM HORACE
MAYFIELD, JULIAN H.
METCALFE, RALPH HORACE
RIBBS, WILLIAM THEODORE, JR.
RUDD, DANIEL A.
SCHULTZ, MICHAEL
SHINE, TED
STRINGER, CHARLENE VIVIAN
THOMPSON, JOHN ROBERT, JR.
THOMPSON, SOLOMON HENRY
TYUS, WYOMIA
WARD, THEODORE
WASHINGTON, ORA MAE
WILLS, HARRY
WILSON, HARRIET E. ADAMS
WRIGHT, RICHARD ROBERT, JR.
WRIGHT, RICHARD ROBERT, SR.

Benjamin K. Scott
Columbia University
BOWLING
EMBRY, WAYNE
FENCING
FIELD HOCKEY
FLIPPER, HENRY OSSIAN
FLOOD, CURTIS CHARLES "CURT"
GYMNASTICS
HOLMAN, MOSES CARL
HUBBARD, WILLIAM DEHART
HYMAN, FLORA "FLO"
JONES, K. C.
JOYNER-KERSEE, JACQUELINE
LACROSSE
LIELE, GEORGE
MARSHALL, ANDREW COX
MCCONE COMMISSION
MOORE, ARCHIBALD LEE "ARCHIE"
MOSES, EDWIN CORLEY
MOTOR RACING
PETERSEN, FRANKLIN E.
RODEO
SAYERS, GALE EUGENE
SHELL, ARTHUR "ART"
SOCCER
SOFTBALL
SWIMMING AND AQUATIC SPORTS
VAILS, NELSON "THE CHEETAH"
VOLLEYBALL
WILKENS, LEONARD RANDOLPH
 "LENNY"
WINTER SPORTS

Deirdre A. Scott
Cooper Hewitt Museum
CHONG, ALBERT
SIMPSON, LORNA

Michael D. Scott
St. Paul, Minnesota
BASIE, WILLIAM JAMES "COUNT"
CALLOWAY, CABELL "CAB"
GAYE, MARVIN (GAY, MARVIN
 PENTZ)
GREEN, FREDERICK WILLIAM "FREDDIE"
JARREAU, ALWYN LOPEZ "AL"

Seret Scott
Upper Nyack, New York
CONWELL, KATHLEEN

Otey M. Scruggs
Syracuse University
GARNET, HENRY HIGHLAND

Ann Sears
Wheaton College
BOONE, "BLIND" (JOHN WILLIAM)
BURLEIGH, HENRY THACKER "HARRY"

William Seraile
New York, New York
PRESIDENTS OF THE UNITED STATES
STEWARD, THEOPHILUS GOULD

Milton C. Sernett
Cazenovia, New York
RELIGION

Helen M. Shannon
New York, New York
CRITE, ALLAN ROHAN
HUNT, RICHARD
JONES, LOIS MAILOU
PIERCE, ELIJAH
PORTER, CHARLES ETHAN C.
WHITE, CHARLES
WILSON, ELLIS
WOODRUFF, HALE ASPACIO

Janet Harrison Shannon
Davidson College
PHILADELPHIA, PENNSYLVANIA

Sandra G. Shannon
Howard University
RICHARDS, LLOYD GEORGE
WILSON, AUGUST

Joan R. Sherman
Rutgers University, New Brunswick
RAY, HENRIETTA CORDELIA

Richard B. Sherman
College of William and Mary
ODELL WALLER CASE

William C. Sherman
Grand Forks, Maryland
NORTH DAKOTA

John C. Shields
Normal, Illinois
WHEATLEY, PHILLIS

Ann Allen Shockley
Fisk University
FISK UNIVERSITY

Grant S. Shockley
Duke University
METHODIST CHURCH

Evan A. Shore
Columbia University
BOND, JULIAN
FORTEN, JAMES
HERNDON, ANGELO BRAXTON
LENOIRE, ROSETTA OLIVE BURTON
MCQUEEN, THELMA "BUTTERFLY"
NORTON, ELEANOR HOLMES

Mwalimu J. Shujas
State University of New York, Buffalo
AFROCENTRICITY

Linda Crocker Simmons
Washington, D.C.
JOHNSON, JOSHUA

Lowery Stokes Sims
Metropolitan Museum of Art
ANDREWS, BENNY
EDWARDS, MELVIN
LEE-SMITH, HUGHIE
PINDELL, HOWARDENA

Amritjit Singh
Lincoln, Rhode Island
CLEAVER, ELDRIDGE LEROY
LESTER, JULIUS
MCMILLAN, TERRY

Theresa A. Singleton
Smithsonian Institution
ANTHROPOLOGY

Harvard Sitkoff
University of New Hampshire
WEAVER, ROBERT CLIFTON

Rene Skelton
Perth Amboy, New Jersey
KERNER REPORT

Joseph T. Skerrett, Jr.
University of Massachusetts, Amherst
MARSHALL, PAULE

Elliott P. Skinner
Columbia University
AFRICA

Patricia E. Sloan
Hampton University
OSBORNE, ESTELLE

David Lionel Smith
Williams College
BARAKA, AMIRI (JONES, LEROI)
BLACK ARTS MOVEMENT
BROWN, STERLING ALLEN
COMEDIANS
COMIC BOOKS
CRITICISM, LITERARY
JACKSON, ANGELA
OBAC WRITERS' WORKSHOP
RODGERS, CAROLYN

Eric Ledell Smith
Harrisburg, Pennsylvania
PENNSYLVANIA

E. Valerie Smith
University of California, Los Angeles
CANADA

J. Clay Smith, Jr.
Howard University
LAWYERS

John David Smith
North Carolina State University
THOMAS, WILLIAM HANNIBAL

Theophus H. Smith
Emory University
SPIRITUALITY

Thomas G. Smith
Nichols College
FOOTBALL

Raymond W. Smock
United States House of Representatives
WASHINGTON, BOOKER TALIAFERRO

Jean Snyder
Pittsburgh, Pennsylvania
BURLEIGH, HENRY THACKER "HARRY"

Werner Sollors
Harvard University
JOHNSON, CHARLES RICHARD
PASSING

Shirley Solomon
Silver Spring, Maryland
HARDRICK, JOHN WESLEY
LINDSEY, RICHARD WILLIAM
SAUNDERS, RAYMOND
SEBREE, CHARLES

Sally Sommer
New York, New York
DUNHAM, KATHERINE
SOCIAL DANCE
TAP DANCE

James M. SoRelle
Baylor University
AARON, HENRY LOUIS "HANK"
ATLANTA COMPROMISE
BROWN FELLOWSHIP SOCIETY

Geneva H. Southall
Minneapolis, Minnesota
BETHUNE, THOMAS GREENE WIGGINS "BLIND TOM"

Daniel Soyer
Columbia University
BRUCE, BLANCHE KELSO
CROWDY, WILLIAM SAUNDERS
DICKSON, MOSES

FOREMAN, GEORGE EDWARD
FRATERNAL ORDERS AND MUTUAL AID
 ASSOCIATIONS
FRATERNITIES AND SORORITIES
FRAZIER, WALTER, II
INSTITUTE OF THE BLACK WORLD
PROFESSIONAL ORGANIZATIONS
TYSON, MICHAEL GERALD "MIKE"

Robert C. Spellman
Scotch Plains, New Jersey
APOSTOLIC MOVEMENT

Robyn Spencer
Columbia University
BLACK SCHOLAR
BROWN, DOROTHY LAVANIA
BROWN, HUBERT G. "H. RAP"
CHANEY, JAMES EARL
COUNCIL OF FEDERATED ORGANIZATIONS
DEACONS FOR DEFENSE
FREEDOM SUMMER
HAIR AND BEAUTY CULTURE
INNIS, ROY
JACKSON, GEORGE LESTER
KAWAIDA
KWANZA
MCKISSICK, FLOYD B.
NASH, DIANE BEVEL
NEWTON, HUEY P.
SHAKUR, ASSATA (CHESIMARD, JOANNE DEBORAH
 BRYON)
TILL, EMMETT LOUIS
WILLIAMS, HOSEA LORENZO

Randolph Stakeman
Bowdoin College
MAINE

Cassandra A. Stancil
Virginia Beach, Virginia
BLACK ENGLISH VERNACULAR
DOZENS, THE

James Standifer
University of Michigan
BARNETT, ETTA MOTEN
BROWN, ANNE WIGGINS
DUNCAN, ROBERT TODD
HAIRSTON, JESTIE "JESTER"
JESSYE, EVA ALBERTA
MITCHELL, ABBIE

Maren Stange
Cooper Union
DECARAVA, ROY

Judith E. Stein
Pennsylvania Academy of Fine Arts
PIPPIN, HORACE

Robert W. Stephens
Montclair State College
CHARLES, RAY (ROBINSON, RAY CHARLES)
COLE, NAT "KING" (COLE, NATHANIEL ADAMS)
COOKE, SAMUEL "SAM"
DOMINO, ANTOINE, JR., "FATS"
JAMES, ETTA
MILLS BROTHERS
PLATTERS, THE

John C. Stoner
Columbia University
BROADSIDE PRESS
CHERRY, FRANK S.
DAVIS, JOHN WARREN
FAUSET, ARTHUR HUFF
HUNT, HENRY ALEXANDER
HUNTON, WILLIAM ALPHAEUS, JR.
HUNTON, WILLIAM ALPHAEUS, SR.
LEWIS, WILLIAM HENRY
MINORITY BUSINESS DEVELOPMENT AGENCY
MOORE, HARRY TYSON
MOREHOUSE COLLEGE
MURPHY, CARL
OPERATION PUSH (PEOPLE UNITED TO SERVE
 HUMANITY)
OVERTON, ANTHONY
POWELL, COLIN LUTHER
RANSIER, ALONZO JACOB
REVEREND IKE (EIKERENKOETTER, FREDERICK J.)
WALLS, JOSIAH THOMAS
WILLIAMS, BILLY DEE (DECEMBER, WILLIAM)
WILLIAMS, WILLIAM TAYLOR BURWELL

Willie Strong
Los Angeles, California
DEPREIST, JAMES ANDERSON
DIXON, DEAN CHARLES
FREEMAN, HARRY LAWRENCE
NEGRO NATIONAL ANTHEM

Niara Sudarkasa
Lincoln University
FAMILY: AFRICAN ROOTS

Derry Swan
New York, New York
DELAVALLADE, CARMEN
HILL, THELMA
MOORE, CHARLES
MOORE, ELLA THOMPSON

T

Kathryn Waddell Takara
University of Hawaii, Mona
HAWAII

Kathryn Talalay
New York, New York
SCHUYLER, PHILIPPA DUKE

Gayle T. Tate
Rutgers University, New Brunswick
CHARLESTON, SOUTH CAROLINA, RIOT OF 1919
CHICAGO RIOT OF 1919
DETROIT RIOT OF 1943
DETROIT RIOT OF 1967
EAST ST. LOUIS, ILLINOIS, RIOT OF 1917
HARLEM RIOTS OF 1935 AND 1943
HARLEM RIOT OF 1964
LONGVIEW, TEXAS, RIOT OF 1919
LOS ANGELES WATTS RIOT OF 1965
URBAN RIOTS AND REBELLIONS
WASHINGTON, D.C., RIOT OF 1919

David V. Taylor
University of Minnesota
MINNESOTA

Durahn Taylor
Columbia University
ABELE, JULIAN FRANCIS
ANDERSON, CHARLES
BRUCE, JOHN EDWARD
CALIFORNIA COLORED CONVENTION
CHEATHAM, HENRY PLUMMER
CONGRESSIONAL BLACK CAUCUS
GANTT, HARVEY BERNARD
HANSEN, AUSTIN
HATCHER, RICHARD GORDON
HAWKINS, AUGUSTUS FREEMAN
JONES, JOHN RAYMOND
LAMPKIN, DAISY ELIZABETH ADAMS
LANKFORD, JOHN ANDERSON
MILLER, THOMAS EZEKIAL
MITCHELL, ARTHUR WERGS
NATIONAL AFRO-AMERICAN LEAGUE / AFRO-AMERICAN
 COUNCIL
NIX, ROBERT NELSON CORNELIUS
PITTMAN, WILLIAM SIDNEY
RIDDICK, GEORGE
STOKES, LOUIS
SULLIVAN, LOUIS
SUTTON, PERCY ELLIS
UNITED COLORED DEMOCRACY

Henry Louis Taylor, Jr.
State University of New York, Buffalo
OHIO

Jeffrey Taylor
Ann Arbor, Michigan
AMMONS, ALBERT
HINES, EARL KENNETH "FATHA"
LEWIS, MEADE "LUX"
YANCEY, JAMES EDWARD "JIMMY"

Quintard Taylor
University of Oregon
BLACK TOWNS
IDAHO
MONTANA
SEATTLE, WASHINGTON
WEST, BLACKS IN THE

Ula Y. Taylor
University of California, Berkeley
GARVEY, AMY EUPHEMIA JACQUES

Jeanne Theoharis
University of Michigan
ATTICA UPRISING
BEVEL, JAMES
BLACK MANIFESTO
FORMAN, JAMES
GARY CONVENTION
JACKSON STATE INCIDENT
JENKINS, ESAU
SHERROD, CHARLES

Daniel Thom
Long Beach, California
BENSON, GEORGE
BROONZY, WILLIAM LEE CONLEY "BIG BILL"
CHRISTIAN, CHARLES "CHARLIE"
HOOKER, JOHN LEE
HOUSE, SON (JAMES, EDDIE, JR.)
HOWLIN' WOLF (BURNETT, CHESTER ARTHUR)
JAMES, RICK (JOHNSON, JAMES AMBROSE)
JORDAN, STANLEY
KING, RILEY B. "B. B."
LITTLE RICHARD (PENNIMAN, RICHARD)
MONTGOMERY, JOHN LESLIE "WES"
MUDDY WATERS (MORGANFIELD, MCKINLEY)

Lamont D. Thomas
Tolland, Connecticut
CUFFE, PAUL
MARITIME TRADES

Lorenzo Thomas
University of Houston, Downtown
UMBRA WRITERS WORKSHOP

Johnnie Lockett Thomas
Paterson, New Jersey
POSTAL SERVICE

Sasha Thomas
Columbia University
BAGNALL, ROBERT WELLINGTON, JR.
HOLLAND, JEROME HEARTWELL
HOPE, JOHN
JORDAN, LEWIS GARNET
KITTRELL, FLEMMIE PANSY
NABRIT, JAMES MADISON
NATIONAL BANKERS ASSOCIATION
SCOTT, EMMETT J.
TANNER, BENJAMIN TUCKER
THIRD WORLD PRESS
VARICK, JAMES
WALTERS, ALEXANDER
WASHINGTON, ORA MAE

Gordon Thompson
City University of New York
CHESNUTT, CHARLES WADDELL
TOLSON, MELVIN BEAUNORUS

Winston Thompson
New York, New York
RASTAFARIANS

J. Mills Thornton III
University of Michigan
MONTGOMERY, ALA., BUS BOYCOTT
MONTGOMERY IMPROVEMENT ASSOCIATION
NIXON, EDGAR DANIEL

John Thornton
Millersville University of Pennsylvania
AFRICAN-AMERICAN ORIGINS

Jeff Todd Titon
Brown University
BLUES, THE
FRANKLIN, CLARENCE LAVAUGHN

Robert C. Toll
Oakland, California
MINSTRELS / MINSTRELSY
WILLIAMS, EGBERT AUSTIN "BERT"

A. Louise Toppin
Greenville, North Carolina
BATTLE, KATHLEEN
BUMBRY, GRACE ANN MELZIA
HARRIS, HILDA
MAYNOR, DOROTHY LEIGH
MCFERRIN, ROBERT, SR.
SHIRLEY, GEORGE IRVING
VERRETT, SHIRLEY

Ann Trapasso
University of North Carolina, Chapel Hill
JOHNSON, GEORGIA DOUGLAS

C. James Trotman
West Chester University
ANDERSON, MATTHEW

Joe W. Trotter, Jr.
Carnegie-Mellon University
MIGRATION / POPULATION
WEST VIRGINIA

Marshall True
East Fairfield, Vermont
VERMONT

Harold Dean Trulear
New York Theological Seminary
HORN, ROSA ARTIMUS
ROBINSON, IDA BELL

Bruce Tucker
Highland Park, New Jersey
BROWN, JAMES JOE, JR.

Renee Tursi
Columbia University
GUARDIAN, THE
MCELROY, COLLEEN J.
MESSENGER, THE

William M. Tuttle, Jr.
University of Kansas
KANSAS

Jules Tygiel
San Francisco State College
ROBINSON, JACK ROOSEVELT "JACKIE"

U

Frank Untermyer
Roosevelt University
DRAKE, ST. CLAIR

V

Richard M. Valelly
Swarthmore College
SUFFRAGE, NINETEENTH-CENTURY

William L. Van Deburg
University of Wisconsin
BLACK POWER CONFERENCE OF NEWARK, 1967
CARMICHAEL, STOKELY

Julia Van Haaften
New York Public Library
PARKS, GORDON, SR.
SLEET, MONETA J., JR.

Charles Vincent
Southern University
LOUISIANA
NEW ORLEANS, LOUISIANA

John Michael Vlach
George Washington University
ARCHITECTURE, VERNACULAR
CEMETERIES AND BURIALS
FOLK ARTS AND CRAFTS

W

Alexis Walker
Columbia University
CHAVIS, BENJAMIN FRANKLIN, JR.
DODSON, OWEN VINCENT
GILPIN, CHARLES SIDNEY
HALEY, ALEXANDER PALMER "ALEX"
NORTON, KENNETH HOWARD "KEN"
REDDING, JAY SAUNDERS

Charles E. Walker
Alexandria, Virginia
ENGINEERING

Clarence E. Walker
University of California, Davis
CARDOZO, FRANCIS LOUIS
REVELS, HIRAM RHOADES
THOMAS, CLARENCE

Juliet E. K. Walker
University of Illinois, Urbana-Champaign
BANKING
ENTREPRENEURS

Randolph Meade Walker
Lemoyne-Owen College
ABERNATHY, RALPH DAVID

Samuel J. Walker
University of Nebraska
AMERICAN CIVIL LIBERTIES UNION

Cheryl A. Wall
Rutgers University, New Brunswick
FAUSET, JESSIE REDMON

William D. Wallace
University of Illinois Medical School
AMOS, HAROLD
ANDERSON, EVERETT
ANDERSON, WINSTON A.
POINDEXTER, HILDRUS A.

Peter Wallenstein
Virginia Polytechnic Institute
GEORGIA

John C. Walter
University of Washington
SPORTS

Hanes Walton, Jr.
University of Michigan
DEMOCRATIC PARTY
POLITICS AND POLITICIANS
PRESIDENTS OF THE UNITED STATES

Rueben C. Warren
Atlanta, Georgia
DENTISTRY

Margaret Washington
Cornell University
TRUTH, SOJOURNER

Clifford E. Watkins
North Carolina A&T State University
MARCHING BANDS

Denton L. Watson
Freeport, New York
NATIONAL ASSOCIATION FOR THE ADVANCEMENT OF
 COLORED PEOPLE (NAACP)
WHITE, WALTER FRANCIS

Jill M. Watts
California State University, San Marcos
FATHER DIVINE
SEMINOLE WARS

Robert Weisbrot
Colby College
CIVIL RIGHTS MOVEMENT

Judith Weisenfeld
Barnard College
ATLANTA NEIGHBORHOOD UNION
BATES, DAISY GASTON
BETHUNE, MARY MCLEOD
BOWLES, EVA D.
BROWN, CHARLOTTE HAWKINS
CHISHOLM, SHIRLEY
FIELDS, MARY
FOOTE, JULIA
HARPER, FRANCES ELLEN WATKINS
HAYNES, ELIZABETH ROSS
HEIGHT, DOROTHY
HOPE, LUGENIA BURNS
HUNTER, JANE EDNA
HUNTER-GAULT, CHARLAYNE
HUNTON, ADDIE WAITES
JACKSON, MAY HOWARD
LANEY, LUCY CRAFT
LAVEAU, MARIE
LEE, JARENA
MOORE, AUDLEY "QUEEN MOTHER"
NATIONAL COUNCIL OF NEGRO WOMEN
NATIONAL LEAGUE FOR THE PROTECTION OF COLORED
 WOMEN
OBLATE SISTERS OF PROVIDENCE
PROSSER, NANCY
WATTLETON, FAYE
WHITE ROSE MISSION AND INDUSTRIAL ASSOCIATION
WILLIAMS, FANNIE BARRIER
WOMAN'S ERA
WOMEN WAGE-EARNERS' ASSOCIATION
YOUNG MEN'S CHRISTIAN ASSOCIATION
YOUNG WOMEN'S CHRISTIAN ASSOCIATION

Nancy J. Weiss
Princeton University
NATIONAL URBAN LEAGUE
REPUBLICAN PARTY

Ron Welburn
University of Massachusetts
JOHNSON, JAMES LOUIS "J.J."
LISTON, MELBA DORETTA
MCLEAN, JOHN LENWOOD, JR., "JACKIE"

PETTIFORD, OSCAR
SHEPP, ARCHIBALD VERNON "ARCHIE"

Cornel West
Harvard University
BLACK IDENTITY

Ellen Harkins Wheat
Indianola, Washington
LAWRENCE, JACOB ARMSTEAD

Maurice B. Wheeler
Pittsburgh, Pennsylvania
HAYES, ROLAND WILLSIE

Krista Whetstone
Columbia University
BAILEY, PEARL

Marvin Y. Whiting
Birmingham Public Library
BIRMINGHAM, ALABAMA

Andrew Wiese
New York, New York
SUBURBANIZATION

Pamela Wilkinson
Columbia University
ARROYO, MARTINA
CHASE-RIBOUD, BARBARA DEWAYNE
DANDRIDGE, DOROTHY
GEORGE, ZELMA WATSON
KENNEDY, ADRIENNE
KOMUNYAKAA, YUSEF
LaBELLE, PATTI (HOLT, PATRICIA LOUISE)
MABLEY, JACKIE "MOMS"
MOSLEY, WALTER

Brackette F. Williams
University of Arizona
ARIZONA

John A. Williams
Teaneck, New Jersey
PRYOR, RICHARD FRANKLIN LENOX THOMAS
SCHUYLER, GEORGE S.

Lillian Serece Williams
State University of New York, Albany
GUMBEL, BRYANT CHARLES
TALBERT, MARY MORRIS BURNETT

Martin Williams
Deceased
ANDERSON, WILLIAM ALONZO "CAT"
ARMSTRONG, LOUIS "SATCHMO"
BLANTON, JAMES "JIMMY"
ELLINGTON, EDWARD KENNEDY "DUKE"
HENDERSON, FLETCHER HAMILTON, JR.
MILEY, JAMES WESLEY "BUBBER"
STRAYHORN, WILLIAM THOMAS "BILLY"
WILLIAMS, CHARLES MELVIN "COOTIE"

Melvin R. Williams
Flanders, New York
PRESIDENTS OF THE UNITED STATES

Patrick G. Williams
Springdale, Arkansas
CUNEY, NORRIS WRIGHT
HOUSTON, TEXAS
RAYNER, JOHN B.
SWEATT V. PAINTER
TEXAS

William H. Williams
University of Delaware
DELAWARE

Deborah Willis-Thomas
Washington, D.C.
BALL, JAMES PRESLEY
BATTEY, CORNELIUS M.
LION, JULES
PHOTOGRAPHY
POLK, PRENTICE HERMAN
SMITH, MARVIN PENTZ, AND SMITH, MORGAN SPARKS

Gayraud S. Wilmore
Atlanta, Georgia
GLOUCESTER, JOHN
HAWKINS, EDLER GARNETT
PRESBYTERIANS

Clint C. Wilson II
Silver Spring, Maryland
CRISIS, THE
JOHNSON, JOHN HAROLD
PITTSBURGH COURIER

Francille Rusan Wilson
Silver Spring, Maryland
WESLEY, CHARLES HARRIS

Judith Wilson
University of Virginia
THOMPSON, ROBERT LOUIS

Olly W. Wilson
University of California, Berkeley
AFRICAN MUSIC, INFLUENCE ON AFRICAN-AMERICAN
 MUSIC OF

Wayne Wilson
Los Angeles, California
JACK, BEAU

Vincent L. Wimbush
Union Theological Seminary
BIBLE AND AFRICAN-AMERICAN CULTURE, THE

Julie Winch
Everett, Massachusetts
MANUMISSION SOCIETIES
PURVIS, ROBERT

Peter H. Wood
Duke University
DENMARK VESEY CONSPIRACY
GABRIEL PROSSER CONSPIRACY
NAT TURNER'S REBELLION
STONO REBELLION

Jon Woodson
Howard University
JOANS, TED
KAUFMAN, BOB

John F. Wozniak
Western Illinois University
WRESTLING

Giles R. Wright
New Jersey Historical Commission
NEW JERSEY

John S. Wright
University of Minnesota
INTELLECTUAL LIFE
LOCKE, ALAIN LEROY

Josephine Wright
College of Wooster
ADAMS, ALTON AUGUSTUS
BLAND, JAMES A.
GREENFIELD, ELIZABETH TAYLOR
JONES, M. SISSIERETTA "BLACK PATTI"

Richard L. Wright
Alexandria, Virginia
ORATORY

Lucius R. Wyatt
Prairie View A&M University
DAWSON, WILLIAM LEVI [COMPOSER]
STILL, WILLIAM GRANT

Y

Donald Yacovone
Arlington, Massachusetts
AMERICAN ANTI-SLAVERY SOCIETY
FIFTY-FOURTH REGIMENT OF MASSACHUSETTS VOLUNTEER
 INFANTRY
FIRST SOUTH CAROLINA VOLUNTEER REGIMENT

FORT PILLOW, TENNESSEE
FORT WAGNER, SOUTH CAROLINA
GENIUS OF UNIVERSAL EMANCIPATION
JOHN BROWN'S RAID AT HARPERS FERRY,
 VIRGINIA
UNDERGROUND RAILROAD

Richard Yarborough
University of California, Los Angeles
BROWN, WILLIAM WELLS

Jean Fagan Yellin
Golden's Bridge, New York
JACOBS, HARRIET ANN

Nancy Yousef
Columbia University
AMERICAN MISSIONARY ASSOCIATION
BLACKWELL, UNITA
BURROUGHS, MARGARET TAYLOR
CAMPBELL, ELMER SIMMS
CHICAGO ART LEAGUE
KWANZA
LEONARD, RAY CHARLES "SUGAR RAY"
LOVE, NAT "DEADWOOD DICK"
MIRROR OF THE TIMES
MOORHEAD, SCIPIO
PORTER, JAMES AMOS
REVOLUTIONARY ACTION MOVEMENT
SOCIETY FOR THE PROPAGATION OF THE GOSPEL IN
 FOREIGN PARTS (SPG)
SPINKS, LEON
SPINKS, MICHAEL

Z

Jeanne Zeidler
Hampton University Museum
CATLETT, ELIZABETH

AACM. *See* Association for the Advancement of Creative Musicians.

Aaron, Henry Louis "Hank" (February 5, 1934–), baseball player. Henry Aaron grew up in relative poverty in Mobile, Ala. The third of eight children born to Herbert and Estella Aaron, he developed an early love for BASEBALL, playing whenever possible on vacant lots and, later, at municipally owned, though racially restricted, diamonds in his neighborhood. He played semipro ball for the Mobile Black Bears before signing a contract in 1952 with the Indianapolis Clowns of the American Negro League. Aaron quickly attracted the attention of major league scouts, and in May 1952, he signed with the Boston Braves of the National League. The Braves sent him to their Northern League farm club in Eau Claire, Wis., where he won Rookie of the Year honors. In 1953, Aaron and two other black ball players were selected to integrate the South Atlantic League by playing for the Braves' Class A farm team in Jacksonville, Fla. In 1954 he was elevated to the Braves' major league club, which had moved to Milwaukee the previous year. Aaron rapidly became one of the mainstays for the Braves, both in Milwaukee and, from 1966 to 1974, in Atlanta, leading the Milwaukee club to World Series appearances in 1957 and 1958 and a world championship in 1957, and Atlanta to the National League championship series in 1969.

In 1957, he was named the National League's most valuable player. In 1975, after twenty-one seasons with the Braves, Aaron was traded to the American League's Milwaukee Brewers, where he completed his playing career in 1976.

The most celebrated highlights of Aaron's major league career came on April 8, 1974, when he eclipsed the career home run record of Babe Ruth by connecting off the Los Angeles Dodgers' Al Downing at Fulton County Stadium in Atlanta. The home run, his 715th in the major leagues, climaxed a very difficult period in Aaron's life as he confronted various forms of abuse, including racial insults and death threats, from those who did not want an African American to surpass Ruth's mark. "It should have been the happiest time of my life, the best year," Aaron has said. "But it was the worst year. It was hell. So many bad things happened. . . . Things I'm still trying to get over, and maybe never will. Things I know I'll never forget" (Capuzzo 1992).

Aaron's lifetime record of 3,771 base hits ranks behind only those of Pete Rose and Ty Cobb, and he is the all-time leader in home runs (755), runs batted in (2,297), extra-base hits (1,477), and total bases (6,856). His 2,174 runs scored tie him for second place (with Ruth) behind Cobb. These credentials, established over a twenty-three-year career, easily earned "Hammerin' Hank" induction into the Major League Baseball Hall of Fame at Cooperstown, N.Y., in his first year of eligibility, in 1982.

Following his retirement as a player, Aaron returned to the Braves' organization as director of

1

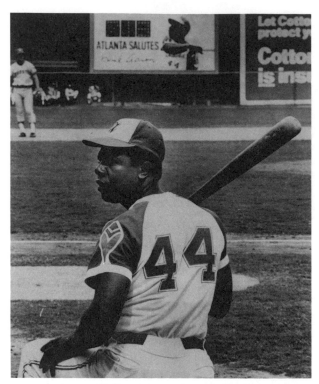

Henry Aaron of the Atlanta Braves in the on-deck circle in 1973, the year before he became the career leader in home runs. (AP/Wide World Photos)

player development and later was promoted to a vice presidency. In this capacity, he has been one of the most outspoken critics of major-league baseball's sparse record of bringing minorities into executive leadership positions both on and off the playing field. In addition, he is a vice president of Turner Broadcasting Company and maintains a number of business and charitable interests in the Atlanta area.

REFERENCES

AARON, HANK, with Lonnie Wheeler. *I Had a Hammer: The Hank Aaron Story*. New York, 1991.
CAPUZZO, MIKE. "A Prisoner of Memory." *Sports Illustrated* (December 7, 1992): 80–92.
TYGIEL, JULES. *Baseball's Great Experiment: Jackie Robinson and His Legacy*. New York, 1983.

JAMES M. SORELLE

Abbott, Anderson Ruffin (1837–December 29, 1913), physician and surgeon. Anderson Abbott was born in Toronto, the son of Wilson R. and Ellen (Toyer) Abbott, free blacks who had migrated from Mobile, Ala., to Canada in 1835. His early schooling took place in Toronto and, from 1856 to 1858, at the Oberlin College Preparatory Department. He stud-

ied at the Toronto School of Medicine and was licensed to practice by the medical board of Upper Canada (Ontario) on December 12, 1862. His mentor was Alexander T. AUGUSTA, a black medical graduate of Trinity College, Toronto (1856).

Abbott began his career as one of only eight black physicians in U.S. Army during the Civil War. His commission as acting assistant surgeon (with rank of captain) ran from September 1863 to April 1866. After helping to establish FREEDMEN'S HOSPITAL in Washington, D.C., he served as its chief executive officer in 1864. He founded and managed the Abbott Hospital in Freedmen's Village, Va. (1864–1866).

Returning to Ontario in 1866, Abbott practiced in Toronto (1866–1872), Chatham (1872–1880), Greensville (1880), Dundas (1881–1889), Oakville (1889–1890), and again in Toronto (1890–1894). He was appointed coroner of Kent County, Ontario, in 1874, and president of the Kent County Medical Society in 1878—probably the first black to hold either position. A community activist, he was a board member of various educational institutions in Chatham and Dundas. He also wrote for magazines and newspapers, served on editorial staffs, and lectured publicly on topics in science and the humanities.

From 1894 to 1897, Abbott acted as surgeon-in-chief of PROVIDENT HOSPITAL, in Chicago, replacing Daniel Hale WILLIAMS, who had moved to a similar post in Freedmen's Hospital in Washington, D.C. Abbott appears to have retired from the practice of medicine by 1900 and returned to Toronto, where he died on December 29, 1913. He and his wife, Mary Ann (Casey), whom he married in 1871, had five children.

REFERENCES

ABBOTT, ANDERSON RUFFIN. " 'Neath the Crown and Maple Leaf (An Afro-Canadian Elegy)." *Colored American Magazine* 2 (March 1901): 336.
ROBINSON, HENRY S. "Anderson Ruffin Abbott, M.D., 1837–1913." *Journal of the National Medical Association* 72 (July 1980): 713–716.

PHILIP N. ALEXANDER

Abbott, Robert Sengstacke (November 28, 1868–February 22, 1940), editor and publisher. Robert S. Abbott was born in the town of Frederica on St. Simon's Island, Ga., to former slaves Thomas and Flora (Butler) Abbott. He developed an interest in African-American rights at a young age, and, after learning the trade of printer at the HAMPTON INSTITUTE between 1892 and 1896, earned an LL.B. from

Chicago's Kent College of Law in 1898. Abbott practiced law for a few years but soon gave up this profession, for reasons that are unclear, and decided on a career in journalism.

On May 6, 1905, he founded the CHICAGO DEFENDER, a weekly newspaper that, over the next three and a half decades, evolved into the most widely circulated African-American weekly ever published. Abbott's newspaper, as its title suggests, was conceived as a weapon against all manifestations of racism, including segregation, discrimination, and disfranchisement.

The *Defender* gave voice to a black point of view at a time when white newspapers and other sources would not, and Abbott was responsible for setting its provocative, aggressive tone. Among the paper's most controversial positions were its opposition to the formation of a segregated Colored Officers Training Camp in Fort Des Moines, Iowa, in 1917; its condemnation in 1919 of Marcus GARVEY's UNIVERSAL NEGRO IMPROVEMENT ASSOCIATION; and its efforts to assist in the defeat of U.S. Supreme Court

Robert Sengstacke Abbott. (Photographs and Prints Division, Schomburg Center for Research in Black Culture, The New York Public Library, Astor, Lenox and Tilden Foundations)

nominee John J. Parker in 1930. The *Defender* frequently reported on violence against blacks, police brutality, and the struggles of black workers, and the paper received national attention in 1915 for its anti-lynching slogan, "If you must die, take at least one with you."

In addition to exerting community leadership through the newspaper, Abbott was active in numerous civic and art organizations in Chicago. He was a member of the Chicago Commission of Race Relations, which in 1922 published the well-known study *The Negro in Chicago*. In 1932, Abbott contracted tuberculosis, and he died in Chicago of Bright's disease on February 29, 1940. His newspaper continues to be published. Its archives, in addition to housing complete files of the *Defender,* contain the Robert S. Abbott Papers.

REFERENCES

Obituary. *Current Biography* (March 1940): 2.
Obituary. *New York Times,* March 1, 1940, p. 21.
SAUNDERS, DORIS E. "Robert Sengstacke Abbott." In Rayford W. Logan and Michael Winston, eds. *Dictionary of American Negro Biography*. New York, 1982, p. 1.
YENSER, THOMAS, ed. *Who's Who in Colored America 1941–1944*. New York, 1944, p. 15.

JOSHUA BOTKIN

Abdul-Jabbar, Kareem (April 16, 1947–), basketball player. Kareem Abdul-Jabbar was born Lewis Ferdinand Alcindor, the only child of Ferdinand Lewis and Cora Alcindor, in the Harlem district of New York City. His father took a degree in musicology from the Juilliard School of Music on the G.I. bill, but worked most of his life as a prison corrections officer and as a policeman for the New York Transit Authority. In 1950 the family moved to the Dyckman Street projects, city-owned middle-class housing in the Inwood section of Manhattan. Surrounded by books and jazz in his home, young Alcindor attended a parochial elementary school, Saint Jude's, and in 1961 he enrolled at another Roman Catholic school in Manhattan, Power Memorial Academy.

Alcindor began playing BASKETBALL competitively at age nine. Standing six feet, eight inches tall at fourteen years of age, he proceeded to lead Power Memorial High School to two New York City interscholastic basketball championships and to two national crowns; he made All-City and All-American

three times each. Widely recruited by colleges, in 1965 he chose the University of California at Los Angeles (UCLA), whose basketball program thrived under coach John Wooden. Freshmen were then ineligible for varsity competition, but in all three of his varsity years Alcindor led the Bruins to National Collegiate Athletic Association (NCAA) championships. By now he was more than seven feet tall, making it virtually impossible for opponents to block his trademark shot, the skyhook. But another of his tactics proved to be more controversial. After his sophomore season, his awesome dunk shot (jamming the ball in the basket) provoked NCAA officials to establish a rule against dunking. The "Alcindor Rule" lasted for just ten years.

During his three varsity seasons, Alcindor scored 2,325 points, averaged 26.4 points per game, and achieved the rare distinction of making first-team All-American for all three years. Yet as a collegian he is probably best remembered for a single game he played in 1968, one of the most famous games in the history of college basketball. In the Houston Astrodome, a live audience of more than fifty thousand and a television audience of millions watched Elvin HAYES and the unbeaten Houston Cougars challenge

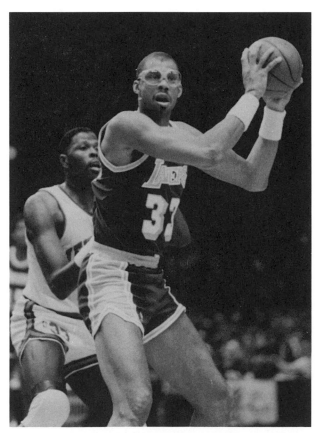

Kareem Abdul-Jabbar, playing for the Los Angeles Lakers in 1986, guarded by Patrick Ewing of the New York Knicks. (AP/Wide World Photos)

Alcindor and unbeaten UCLA. Suffering double vision from an eye bruised in an earlier game, Alcindor still performed well, but Hayes's thirty-nine points led the Cougars to a two-point victory. Later, in the NCAA semifinals, UCLA with a healthy Alcindor demolished Houston, 101–69.

Never a mere athlete, Alcindor emerged in 1968 as a person of political and religious principles. In high school in the early 1960s, his racial consciousness had been raised by the civil rights movement, Birmingham church bombings, Harlem riots, and a racially insensitive coach. He wore his hair Afro-style, participated in the verbal and visible "revolt of the black athlete" led by California sociology professor Harry EDWARDS, and in 1968 effectively boycotted the Mexico City Olympics by refusing to compete for an assured place on the United States Olympic basketball team. For some time he had been studying IS-LAM, and in 1968 he dispensed with his Catholic religion to become a Muslim. His Muslim mentor gave him a new name, Kareem Abdul-Jabbar, "generous and powerful servant of Allah"; three years later he legally changed his name.

In 1969 he launched his professional career with the Milwaukee Bucks, winning the Rookie of the Year award. In 1971, following the acquisition of veteran Oscar ROBERTSON, the Bucks seized the National Basketball Association (NBA) championship. For six seasons with the Bucks, Abdul-Jabbar averaged more than thirty points per game and won three Most Valuable Player (MVP) trophies. Yet he was never really happy at Milwaukee, whose culture and climate were vastly different from anything he had ever known. Marriage and a child provided little solace. Burrowing deeper into his Islamic faith, in 1972 he studied Arabic at a Harvard summer school, and bought a house for the extended family of his Muslim teacher, Hamaas. Tragedy struck in January 1973, when rival Muslims massacred several members of that family; two years later, Hamaas and several comrades were sent to prison for their illegal activities in opposition to a public showing of a film that negatively portrayed Muhammad.

In that same year, 1975, Abdul-Jabbar went to the Los Angeles Lakers in a six-player exchange. Within his first five years with the Lakers, he won three MVP awards. After a frustrating first year, he led the Lakers to the NBA playoffs thirteen consecutive times, and (teamed with Earvin "Magic" JOHNSON in the golden Laker decade of the 1980s) to three NBA championships. For a man seemingly always in search of inward peace, however, sad moments continued to intrude upon Abdul-Jabbar's personal life. In 1983, fire destroyed an expensive California home and an irreplaceable collection of jazz recordings; in 1987, Abdul-Jabbar lost $9 million in bad business

deals. All the while, two sons and two daughters bounced back and forth from their mother, Habiba, to their father in an on-and-off marriage.

After thirty-three years of competitive basketball, Abdul-Jabbar retired in 1989, at the age of forty-two. His numerous NBA records included the most seasons, games, and minutes played; the most field goals attempted, the most made, and the most points scored; and the most personal fouls and blocked shots. In a total of 1,560 NBA outings, he averaged 24.6 points per game. Into retirement he carried six MVP awards, six championship rings, and memories from nineteen NBA All-Star games.

REFERENCES

ABDUL-JABBAR, KAREEM, with Peter Knobler. *Giant Steps: The Autobiography of Kareem Abdul-Jabbar.* New York, 1983.

ABDUL-JABBAR, KAREEM, with Mignon McCarthy. *Kareem.* New York, 1990.

SMITH, GARY. "Now, More than Ever, a Winner." *Sports Illustrated* (December 23–30, 1985): 78–94.

WILLIAM J. BAKER

Abele, Julian Francis (April 30, 1881–April 23, 1950), architect. Julian F. Abele (pronounced "able") was born in South Philadelphia and received his secondary education at Philadelphia's Institute for Colored Youth. Enrolling in the University of Pennsylvania in 1898, Abele became president of the university's Architecture Society. He graduated from the Pennsylvania School of Fine Arts and Architecture in 1904—the first African American to do so. That same year Horace Trumbauer asked Abele to work for the hitherto entirely white firm of Horace Trumbauer & Associates of Philadelphia. Trumbauer sent Abele to L'Ecole des Beaux Arts in Paris, then one of the leading architecture schools in the world, from which Abele received his architectural diploma in 1906. Abele subsequently returned to the firm and became its chief designer in 1908. By 1912, he was drawing an annual salary of $12,000. As chief designer, Abele designed Philadelphia's Free Library and Museum of Art, as well as the Widener Library (the largest building on Harvard Square). He also designed the chapel and much of the campus of Trinity College in Durham, N.C., which would later become Duke University.

Abele was known for modernizing classical forms when designing structures; the Philadelphia Museum of Art, for example, with its striking colonnaded portico and Parthenon-style pediment, was a beaux arts version of a classical Greek temple. In a 1982 tribute to Abele for designing the museum, the *Philadelphia Inquirer* credited him with being "the first black American architect to have an impact on the design of large buildings."

Abele sought little personal fame for himself in return for his accomplishments. Despite his position as Horace Trumbauer's trusted friend and confidant (and Trumbauer's successor as head of the firm from 1938 to 1950), Abele's name did not appear on any of the buildings he designed, although the name of the firm was included. While the exclusion of an individual architect's name in favor of that of the firm was a professional convention of the era, it is also likely that Abele, and the Trumbauer firm as a whole, did not wish to draw attention to the fact that he was an African American. Perhaps for similar reasons, Abele did not personally visit the Duke University campus he designed or become a member of the American Institute of Architects until 1942. Whether by temperament or necessity, or perhaps a combination of the two, the light-skinned Abele was circumspect about the personal publicity he received outside of the Trumbauer firm.

Abele designed one of his last major buildings, the Allen administration building at Duke University, in 1950. He died in April of that year, a week before his sixty-ninth birthday.

See also the overview articles on ARCHITECTURE.

REFERENCES

BRINSON, LINDA. "The Man Who Designed Duke." *Winston-Salem Journal,* August 11, 1991, Sec. A, pp. 13, 16–17.

DOZIER, RICHARD K. "Black Architects and Craftsmen." *Black World* (May 1974): 13.

DURAHN TAYLOR

Abernathy, Ralph David (March 11, 1926–April 17, 1990), clergyman, civil rights leader. Born in Linden, Ala., initially among family members he was called only "David"; later, through the inspiration a teacher gave one of his sisters, the appellation "Ralph" was added. After serving in the U.S. Army during World War II, Abernathy seized the opportunity offered by the G.I. Bill and earned a B.S. degree in 1950 from Alabama State College (now Alabama State University). In 1951 he earned an M.A. in sociology from Atlanta University.

In his formative years Abernathy was deeply influenced by his hardworking father, William L. Abernathy, who was a Baptist deacon and a farmer who owned 500 acres of choice real estate. The son's admiration for his father was a major factor in his work in public life.

In 1948 Abernathy was ordained a Baptist minister. He served as pastor of the following congregations: Eastern Star Baptist Church, Demopolis, Ala., 1950–1951; First Baptist Church, Montgomery, Ala., 1951–1961; West Hunter Street Baptist Church, Atlanta, Ga., 1961–1990.

While a student at Alabama State, Abernathy had two experiences that would prepare him for his later role as a civil rights leader: He was urged to contribute to the freedom struggle of African Americans by such professors as J. E. Pierce and Emma Payne Howard; and, as president of the student council, he led two campus protests, for improved cafeteria services and dormitory conditions. Due to his dignified protests, Abernathy won the respect of the institution's administration. As a result, in 1951 he returned to his alma mater to become dean of men.

While pastor of First Baptist, he became a close friend of Dexter Avenue Baptist Church's courageous pastor Vernon JOHNS. Johns as an older, seasoned pulpiteer displayed extraordinary boldness in his personal defiance of Montgomery's oppressive JIM CROW climate.

When Johns's ties with Dexter were severed, Abernathy developed an even closer friendship with his successor, Martin Luther KING, Jr. The two young pastors' families became intertwined in a fast friendship that prompted alternating dinners between the two households. At these social meetings numerous conversations were held that frequently centered around civil rights.

In 1955 the two friends' ideas were propelled into action by the arrest of Rosa PARKS, a black seamstress. After a long day of toil, Parks refused to yield her seat on a public bus for a white passenger who boarded after her. This refusal by Parks was in violation of the city's segregationist laws. Her action was not the first of its kind by African Americans in Montgomery. However, when Parks was arrested, her quiet, admirable demeanor coupled with her service as secretary of the local NAACP branch helped to stir the black community to protest.

King and Abernathy became leaders of what came to be known as the MONTGOMERY IMPROVEMENT ASSOCIATION (MIA). Through meetings in churches, the two men spearheaded a mass boycott of Montgomery's buses. While King served as head of the MIA, Abernathy functioned as program chief. Nonviolence was the method with which the protest was implemented. Despite having been a soldier, Abernathy like King was convinced that nonviolence was the only acceptable means of dissent. Both had read and accepted the philosophies of Henry David Thoreau and Mahatma Gandhi.

The boycott persisted for more than a year. Despite the inordinate length of the struggle, the black community was consolidated in its refusal to ride segregated buses. Finally, in June 1956 a federal court upheld an injunction against the bus company's Jim Crow policy.

This successful boycott inspired the two young clergymen to expand their efforts to win civil rights for American's black citizens. As a result, in January 1957 the SOUTHERN CHRISTIAN LEADERSHIP CONFERENCE (SCLC) was born in Atlanta. King was elected president of the new organization, and Abernathy became its secretary-treasurer. While he attended this meeting, Abernathy's home and church were bombed in Montgomery. Although it was a close call, Abernathy's family were spared any physical harm.

King moved to Atlanta in 1960, and a year later persuaded Abernathy to follow him and take on the pastorate of West Hunter Street Baptist Church. In the years that followed, the two men under the auspices of SCLC led nonviolent protests in cities such as Birmingham and Selma, Ala.; Albany, Ga.; Greensboro, N.C.; and St. Augustine, Fla. As a consequence, both were arrested many times, and experienced violence and threats of violence. In 1965 Abernathy became vice president at large of SCLC. When King was assassinated in Memphis, Tenn., in 1968, Abernathy was unanimously elected his successor. Soon after, Abernathy launched King's planned Poor People's Campaign. He led other protests until he resigned as head of SCLC in 1977.

After Abernathy assumed the leadership of SCLC, many compared him to King. Unfortunately, he was often perceived as lacking the charisma and poise of his friend. Some even accused Abernathy of being cross or crude in his leadership style. Perhaps the best historical defense of Abernathy's reputation came from himself in the publishing of his autobiography, *And the Walls Came Tumbling Down* (1989). However, its content and literary style were unappreciated by many because of the book's revelations about King's extramarital affairs. The critics accused Abernathy of betraying his long-deceased friend.

REFERENCES

ABERNATHY, RALPH DAVID. *And the Walls Came Tumbling Down: An Autobiography*. New York, 1989.
BRANCH, TAYLOR. *Parting the Waters: America in the King Years, 1954–1963*. New York, 1988.

RANDOLPH MEADE WALKER

Abolition. Scholars often distinguish "abolitionism" from "antislavery," with the latter designating all movements aiming to curtail slavery, no matter

how slowly or cautiously, and "abolitionism" reserved for the most immoderate opposition. This distinction echoes the usage of radical abolitionists, who described their goal as "immediate abolition" and disparaged other reformers' gradualism. The gradualists, for their part, labeled the radicals "ultraists," a term some immediatists embraced despite its intended derogatory connotations. As this war of labels suggests, controversies over methods and goals were recurrent in the history of organized opposition to slavery. In addition, rifts between black abolitionists and white abolitionists in the United States were at times so wide that some scholars speak of two abolitionisms.

If they cling to the radicals' narrow definitions, scholars may get a skewed perspective on the movement's progress: immediatism emerged only in the early 1830s and was submerged in broadscale political movements in the 1840s and 1850s. To stress sectarian disagreements is to obscure the success of slavery's foes in winning allies and eliminating a mammoth institution during a remarkably brief period of history.

In a series of sardonic letters, "To Our Old Masters," published in Canada West (now Ontario) in 1851, Henry Walton BIBB, an ex-slave speaking for all the "self-emancipated"—those who had escaped from the American South's peculiar institution—placed abolitionism in a broader context. Improving the opportunities that freedom provided for the study of history, Bibb had learned "that ever since mankind formed themselves into communities, slavery, in various modifications, has had an existency." The master class's own ancestors had experienced subjugation in eras when Romans and Normans invaded England. History proved other lessons, too: "the individuals held in bondage never submitted to their yoke with cheerfulness," and in slavery's entire history no moral argument had ever been "adduced in its favor; it has invariably been the strong against the weak." Modern masters were crueler than any before, in Bibb's view, but they also were broadly despised—"you elicit the contempt of the whole civilized world." It was inevitable that they would have to "adopt one of the many proposed schemes which the benevolent have put forth for our emancipation," or they would reap the whirlwind. Bibb may have been wrong about past justifications for bondage, but his sense that slavery had lost legitimacy and was approaching its termination turned out to be accurate.

The economic historian Robert William Fogel points out, for example, "how rapidly, by historical standards, the institution of slavery gave way before the abolitionist onslaught." A small group of English reformers formed a society to abolish the slave trade in 1787; by 1807 they had won that fight, by 1833 the

slave system in the British empire was toppled, and slavery was abolished in its last stronghold, Brazil, in 1888. "And so, within the span of little more than a century, a system that had stood above criticism for 3,000 years was outlawed everywhere in the Western world" (Fogel 1989, pp. 204–205). In the United States, where slavery was a deeply entrenched institution and antislavery coalitions looked comparatively weak, the period required to outlaw slavery was even shorter. Thus, discussion of abolitionist factionalism must be balanced by recognition of its triumph.

Early English and American Endeavors

In England, the Quakers (see SOCIETY OF FRIENDS), a small sect with little political influence, took most of the early steps against slavery. Alliances with other dissenting sects broadened support for antislavery in a political system increasingly responsive to popular agitation. When antislavery gained the support of William Wilberforce, Granville Sharp, and other Anglican evangelicals, it acquired respectable voices in Parliament. While advancing the view that slavery was obsolete and immoral, English leaders ensured that no fundamental threat to property rights was associated with abolition. Slave owners retained their human property during a six-year transitional "apprenticeship," and they received compensation for their losses. Having abolished its own immoral institution, England assumed responsibility for campaigns against the slave trade on the high seas, in the Islamic world, and in India. These campaigns had the effect of spreading British imperial influence and promoting British views of civilization.

As British antislavery approached its great triumphs, it began to send speakers, books and pamphlets, and some financial support to its American counterparts. Some Americans viewed British encouragement of American antislavery efforts as unwelcome meddling that endangered American independence and welfare. Both black and white abolitionists venerated names like Wilberforce and applauded the British example, but there was little resemblance between slavery in the two economies and political systems. American antislavery was compelled to address issues affecting a growing black population, a prosperous domestic economic institution, and sectional animosities in a federal political system for which England's experience offered little precedent. On the other hand, there was no existing English equivalent to the network of organizations among northern free blacks, who sought to embolden white reformers to pursue the cause of abolition more aggressively and to combat racial discrimination wherever it occurred.

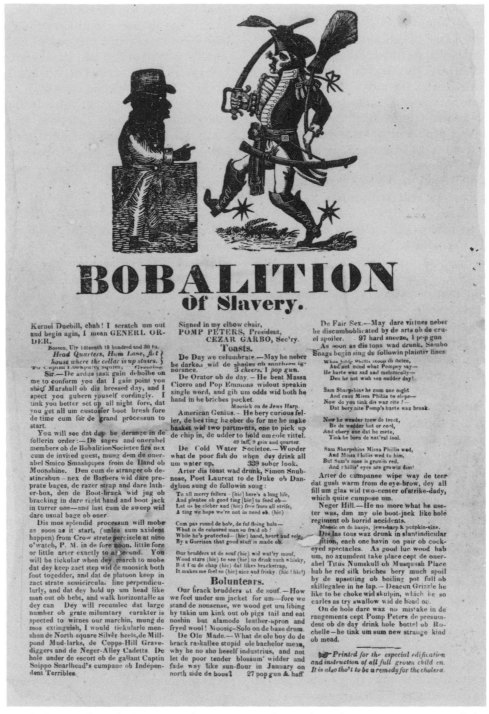

"Bobalition" broadside, one of a series marking the July 14 anniversary of the abolition of the slave trade. (Prints and Photographs Division, Library of Congress)

As they had in England, Quakers took early leadership in American antislavery activities; and they were joined, sometimes, by insurgent evangelical movements to whom old institutions no longer seemed sacred and unchanging. Unlike England, the United States experienced a revolution that supplemented religious reform motivations with strong new reasons for opposing traditional inequalities. Slavery not only violated the law of God, but in an age of liberation and enlightenment, it contradicted the rights of man. Neither religious nor secular arguments necessarily obliged whites to combat racial prejudice or extend humanitarian aid to free blacks. Though black abolitionists would often accuse whites of coldhearted bigotry it may be the case that the Revolution "doomed" slavery.

In the 1780s, abolitionist societies were formed in most states (including the upper South). A national abolitionist "convention" met annually from 1794 to 1806 and periodically thereafter. In the decades after the Revolution, northern states abolished slavery, often after organized antislavery campaigns. In 1808, Congress, which had previously prohibited slavery in the Northwest Territory, ended the foreign slave trade. This was assumed to be a blow to North American slavery (though some slave owners supported the measure, and later experience showed that the slave population grew rapidly without imports). Appeals to the great principles of republican government seemed ready to transform American society.

Those who believed in an optimistic scenario of revolutionary liberation underestimated the ways in which persistent white hostility to blacks would impede antislavery activity. They also overlooked obstacles imposed by the Constitution. Most abolitionists accepted the prevailing consensus that the federal government lacked any constitutional power over slavery in the states. While antislavery coalitions prevailed in states like New York and Pennsylvania, residents of a northern state had no way of influencing legislatures in South Carolina or Tennessee. When controversies over slavery arose in the U.S. Congress, as in debates over fugitive slave acts from 1793 to 1817, proslavery forces won repeated victories. With the elimination of slavery in northern states, abolition societies lost membership and purpose.

The Colonizationist New Departure

Only a change of direction, one that attracted support among southern slaveholders as well as black and white Northerners, revitalized antislavery commitments in the 1820s. Some Southerners had for years entertained hopes of deporting freed slaves (a solution to racial problems somewhat analogous to Indian removal). If ex-slaves could be relocated in the West, perhaps, or Africa, or Central America, slaveholders might be less reluctant to free them, nonslaveholding whites might be less anxious about competition for work, and northern and southern townspeople might show less fear of social consequences of emancipation. Some northern reformers believed that American society would never accept blacks as equals. Appealing simultaneously to those who hated or feared free blacks and those who deplored or regretted American racism, removal schemes raised hopes of forging an irresistible coalition that might, once and for all, end slavery.

The premier organization advancing these schemes was the AMERICAN COLONIZATION SOCIETY (ACS), founded in 1816, which rapidly won the approval of prominent leaders of church and government in both the North and South. It sent only a few thousand

blacks to its colony Liberia before 1830, however, and it failed to get federal funding for its efforts. Enthusiasm for the movement began to subside (though the ACS survived into the twentieth century) as doubts of its practicality grew. Modern scholars frequently dismiss its efforts as futile and its objectives as racist—both irrefutable charges. Less often pointed out are that slavery's most implacable champions hated the ACS; that with its decline, hopes for a national antislavery movement virtually disappeared; and that its predictions of enduring racism and misery for free blacks were realistic. If it included in its numbers slaveholders like Henry Clay, it also included many Northerners who would hold fast to abolitionist purposes for decades to come. It attracted the support of some northern blacks, including John B. RUSSWURM, a Bowdoin College graduate who spent much of his life in Liberia, and free southern blacks like those who appealed to Baltimore's white community in 1826 for help in leaving a republic where their inequality was "irremediable." Not only did they seek for themselves rights and respect that America seemed permanently to withhold, but they also upheld an antislavery vision: "Our absence will accelerate the liberation of such of our brethren as are in bondage."

Black support for colonization was undeniable. It was also extremely limited, while rejection of such schemes by prominent black abolitionists intensified during the 1820s. As early as 1817, a Philadelphia meeting had protested against the ACS's characterizations of blacks as a "dangerous and useless" class; linking manumission to colonization, the meeting continued, would only strengthen slavery. Even black leaders like James FORTEN, who privately favored emigration and believed African Americans would "never become a people until they come out from amongst the white people," joined in the protest. By 1829, militant documents like David Walker's Appeal denounced "the Colonizing Plan" as evidence of the pervasive racism that caused "Our Wretchedness."

The Immediatist New Direction

Anticolonizationist societies were launched in free black communities throughout the North, and several efforts were made to establish national newspapers to coordinate the movement. (Russwurm edited one before his conversion to colonizationism.) It was clear, however, that blacks could never sink the ACS without enlisting white allies. This meant, in practice, that blacks would have to speak in a less militant voice than Walker and other leaders might have preferred: they could not stress the virulence of racism or doubt the responsiveness of whites to conciliatory tactics. They could not advocate violent resistance to slavery or discrimination. They might also have to

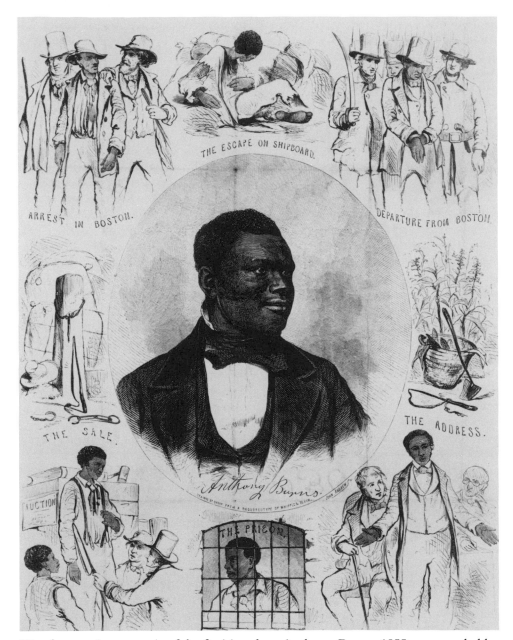

ARREST IN BOSTON.

THE ESCAPE ON SHIPBOARD.

DEPARTURE FROM BOSTON.

THE SALE.

THE ADDRESS.

THE PRISON.

Anthony Burns

Wood engraving portrait of the fugitive slave Anthony Burns, 1855, surrounded by scenes from his life. Copyrighting works such as this print under the name of the subject, Anthony Burns, was a common abolitionist practice. (Prints and Photographs Division, Library of Congress)

accept subsidiary roles in a coalition movement led by whites. These risks seemed tolerable, however, in light of the emergence in the early 1830s of a new, radical, and interracial antislavery movement that defined itself in opposition to the ACS. What for whites was a bold new departure was for blacks an episode in prudent compromise and coalition building.

Black abolitionists discovered a white champion in William Lloyd Garrison. It is likely that James Forten and other blacks influenced Garrison, at that time a colonizationist editor in Philadelphia and Baltimore,

to embrace the idea of human equality. Black readers enabled Garrison in 1831 to launch his Boston-based newspaper, the LIBERATOR, and they made up the great majority of subscribers to this weekly organ of immediate abolitionism throughout its early years. David WALKER was one of several blacks who named children after Garrison; others gave him financial support or protected him as he walked home at night. Many viewed the *Liberator* as their voice in American public life. Maria STEWART was one of many blacks who contributed articles condemning slavery, preju-

dice, and colonizationism. Garrison adopted a style of denunciation thrilling to his friends and infuriating to those whom he opposed: "I will be as harsh as truth, and as uncompromising as justice. . . . I will not equivocate—I will not excuse—I will not retreat a single inch—AND I WILL BE HEARD," proclaimed his first issue. He took up the view of the ACS that blacks had urged in the previous decade and gave it powerful and influential expression. In its first year, the *Liberator* published ten times as many articles denouncing the ACS as explaining immediate abolition. Garrison's *Thoughts on African Colonization* (1832), a withering critique of racist and proslavery quotations from colonization leaders, was widely distributed and persuaded many young reformers to change loyalties and follow a new course.

The attack on the ACS was a means of redefining antislavery strategy that appealed to a new generation of reformers in the early 1830s. Besides Garrison, the most influential of these was Theodore Dwight Weld, a restless and charismatic leader from upstate New York who had traveled extensively and worked for causes ranging from religious revivals to educational reform. As a student at Cincinnati's Lane Seminary in the early 1830s, he worked with blacks in the student body and local community, precipitating a crisis by forcing discussion of slavery and racial prejudice. He had no peer at a style of earnest, emotional antislavery lecturing, facing down mobs and winning converts to the cause, that he taught to other abolitionist speakers. Though Garrison and Weld were (in a not fully acknowledged sense) rivals, the former's uncompromising editorial stance and the latter's confrontational lecture style joined in shaping an exciting new era for abolitionism. Other important abolitionist leaders included the brothers Lewis and Arthur Tappan, merchants in New York City, well connected with prominent evangelical reform movements, who furnished a sober counterpoint to Weld's and Garrison's romantic outbursts. John Greenleaf Whittier, early in a career that led to great fame as a poet, was a valued new convert.

Despite condemnation by Andrew Jackson and other public figures, anticolonizationism spread with remarkable velocity. In 1832 eleven persons formed the New England Anti-Slavery Society, "the first society of this kind created on this side of the Atlantic," as the South Carolina political leader James Henry Hammond later recalled. Though slaveholders initially mocked this news, by 1837, Massachusetts had 145 societies, and New York and Ohio, where the Tappans and Weld held influence, had 274 and 213, respectively. In December 1833, sixty-three men (three of them black) formed the American Anti-Slavery Society (AASS). Earlier that year, interracial female antislavery societies were formed in Boston and Philadelphia, and in 1837 there occurred the first "national" (northern) women's antislavery convention. By 1838, the AASS claimed 1,350 affiliated societies, with membership approaching a quarter million. Important new voices, including those of ex-Southerners James G. Birney and Angelina and Sarah Moore GRIMKÉ, added to the excitement of the mid-1830s.

The positive meaning of the immediatist, anticolonizationist doctrines that stirred up so much commotion was never a simple matter to establish. For decades scholars have argued over which of two strategies—political coercion or nonviolent persuasion—was more consistent with the immediatist commitment of the early 1830s. The truth is that immediatism had more than two potential meanings, as it blended rather unrealistic expectations of religious transformation with cautious recognition of obstacles to reform. On the one hand, some abolitionists wished to persuade slaveholders to let their slaves go free, or they hoped, at least, to encourage antislavery majorities to form in southern states. Conceding the lack of federal authority to interfere with state institutions, founders of the AASS were obliged to adopt a conciliatory stance toward the South. In particular, they denied any intention to use coercion; slavery must end by "moral suasion." On the other hand, the harsh, categorical denunciations of slavery that distinguished the new movement from the ACS were hardly conciliatory. In letters of instruction and training sessions for antislavery lecturers, Weld (who injured his own voice and retired from the field) insisted that they should not get bogged down in political or economic issues: "the business of abolitionists is with the heart of the nation, rather than with its purse strings." Slavery was, he taught, "a *moral* question," and the conviction to drive home was simply that "*slavery is a sin.*" Once convinced of that, clergymen and other opinion leaders would exert pressure on slaveholders to give up their sin. The slaveholders, similarly convinced, would be impelled to change their lives. If they did not, morally awakened democratic majorities had to compel them.

Schism and Variation

By decade's end, it was obvious that slavery was not going to succumb to northern condemnation, no matter how conciliatory or intemperate. Disagreements among abolitionists, subdued during years of enthusiasm, took on new seriousness. The AASS split in two at its 1840 convention when the Tappans and other prominent reformers walked out after a woman, Abby Kelley, was elected to a committee. They protested that under Garrison's leadership the movement was too defiant of social conventions, thus offending the clergy and other respectable leaders of

society, and too enthusiastic about new radical causes, especially a new form of nonviolent anarchism called "nonresistance." The departing abolitionists believed the cause could gain popular support by shunning "extraneous," controversial positions. Many on this side were moving toward more active participation in politics. For Garrison's loyal cadres in the AASS, including radical pacifists like Henry C. Wright, abolitionist commitments led toward broad condemnation of coercive behavior and institutions. The AASS survived as a separate organization, open to all who chose to join, while in the *Liberator* and in speeches and writings, Garrisonians gave increasing attention to nonviolence, utopian communities, women's rights, and other enthusiasms of the 1840s. (They showed less sympathy with working-class reforms.) They remained adamant in opposing political ventures, some out of anarchistic convictions, others out of dismayed assessment of the receptiveness of American politicians to antislavery principles.

Many black abolitionists continued to admire Garrison, but they, too, often criticized the lengths to which he carried the logic of moral suasion. Some agreed with the charge that he depleted antislavery energy by his romantic penchant for adopting new causes. But he, at least, was unwilling to compromise the principle of equality in order to appease northern majorities. Though blacks tended to favor political action, they appreciated Garrison's scorn when political abolitionism bowed to necessity by accepting slavery where it existed in the South and segregation as it worsened in the North. They complained repeatedly that all factions of white abolitionists relegated blacks to subsidiary roles, at best, in their organizations. Such inability to accept blacks in visible leadership positions showed that white abolitionists had not really understood the links between bigotry and slavery. It was difficult, moreover, to interest whites in combating Jim Crow in northern streetcars with the zeal aroused by movements to keep slavery (and African Americans) out of the territories. After the schism of 1840, black abolitionists met more frequently in their own organizations, held their own conventions, and supported their own newspapers, like Samuel E. CORNISH's *Colored American* and FREDERICK DOUGLASS'S PAPER (*see also* Frederick DOUGLASS).

In a powerful 1843 address to slaves, Henry Highland GARNET urged, *"Resistance! Resistance! Resistance!"* His controversial text was suppressed until 1848, but in the following years, similar militancy among other black leaders became increasingly noticeable. Talk of moral suasion gave way to insistence on the universal right of revolution. If whites did not concede to blacks the right to self-defense, some leaders asked, and if blacks never showed their willingness to fight, then how could southern slavery and northern injustice ever be ended? Blacks (with limited white support) engaged in civil disobedience against segregated schools and streetcars, and they used all available means to assist fugitives from slavery. But such militancy coincided with renewed interest in emigration, either to Canada, where tens of thousands of blacks, many of them fugitives, lived in constant rebuke to conditions in the northern and southern United States, or perhaps to Liberia (despite continuing black denunciation of the ACS), or Haiti, favored by Garnet as late as 1861. Douglass, James McCune SMITH, and other black leaders deplored any possible abandonment of the cause of civil rights for free blacks and emancipation of the slaves.

After the war with Mexico from 1846 to 1848, a series of political events and court decisions—particularly events and decisions returning fugitives to bondage—struck abolitionists as calamities. Not only were some black leaders resigned to emigration, but many white Garrisonians denounced the political system dominated by proslavery leaders. Theodore Parker, Thomas Wentworth Higginson, and some others began to contemplate acts of violent resistance to proslavery legislation. Wendell Phillips advocated disunion: the northern states must sunder connections with southern sinfulness. At one public meeting in 1854, Garrison denounced the Fugitive Slave Act and burned the Constitution as "a covenant with Death and an agreement with Hell." Southern extremists portrayed Garrisonians as men and women of enormous influence in the North. They had no such influence, but in taking positions of uncompromising moral purity, these skilled agitators created an atmosphere of escalating moral concern. While eschewing politics, they guaranteed that southern political victories brought the fate of slavery closer and closer to the center of national political debate.

Political abolitionists, meanwhile, tried various courses of action. Some, including many blacks, supported the Whigs; others experimented with third parties. During a period of confusing political realignment, skilled publicists like the journalist Horace Greeley and clergyman Henry Ward Beecher used newspapers, lecture platforms, and other popular institutions to disseminate selected elements of the abolitionist message—that the slave power jeopardized the liberty and prosperity of all workers and farmers—across the North and much of the West. In this endeavor they gained the cooperation of antislavery politicians, who were usually reluctant to confront racial prejudice or clarify the meanings of equality. An antislavery majority probably could not have been assembled without ambiguous appeals to expediency and prejudice as well as to principle. It is important to note, nevertheless, that as political aboli-

tionism augmented its small shares of the electorate (the Liberty party garnered about 6,000 votes in the 1840 presidential election and 60,000 in 1844, and the Free Soil party polled about 290,000 in 1848), the clarity of its attacks on slavery blurred. Both Weld and Garrison had counseled abolitionists to stick to the moral high ground, to denounce the iniquity of slavery and racism. Antislavery opinion grew in the North and West, however, as slavery was seen as threatening to the economic welfare of whites. More often than not, antislavery public opinion of the kind that sustained the Republican party's slim majority in 1860 was saturated by racial prejudice. It would have been content to tolerate slavery where it already existed, if proslavery politicians had not repeatedly fueled northern fears and resentments.

The Triumph of Antislavery

Abolitionism existed in a tense love-hate relation with Abraham Lincoln and the Republicans in the 1860s. Abolitionists took credit for preparing the ground for the new party's success, but some sought to oust Lincoln in 1864. If anything, Garrisonians were more willing than other factions to excuse the Republicans' slow advance toward the goal of abolishing slavery, a goal promoted by all abolitionists throughout the war. Abolitionists did what they could to pressure the Union army to mobilize black soldiers and treat them fairly once in uniform. Black abolitionists worked at recruitment, and some, like Martin R. DELANEY, as well as whites like Thomas Wentworth Higginson, served as officers. Pacifistic abolitionists volunteered for medical duties in hospitals and on the battlefield. Before slavery was abolished, abolitionist men and women went south to work among freedmen in areas occupied by Union armies, thus setting a pattern for educational and related endeavors during Reconstruction and afterward.

At the end of the Civil War, and with enactment of the Thirteenth Amendment, abolitionists were jubilant. The *Liberator* ceased publication, and the AASS disbanded. But abolitionists, especially younger ones who had entered the movement in the 1850s, continued to promote education for African Americans and condemn violations of their civil rights long after the war. As the century approached its end, such endeavors increasingly seemed futile, and many victories of Civil War and Reconstruction days were overturned. At the same time, ironically, some Northerners lauded abolitionists as an example of a principled minority who had led the nation to higher moral conceptions and practices.

Some of this glorification can be discounted as an expression of sectional pride and Republican partisanship. It was offset, for many decades, by scholarly condemnation of abolitionists as fanatics responsible, along with southern fire-eaters, for disrupting the union. Nevertheless, the merging of abolitionist principles, espoused by a zealous minority, with the concerns and interests of a majority of citizens, led to the destruction of slavery, for so long an accepted social institution, and this triumph has gained a prominent place in the history of American democracy. Abolitionists tested the openness of democratic politics to reform, and they agitated successfully for the extension of the nation's founding principles to groups who had formerly been left out. Their triumph has served as an inspiring model for subsequent movements, on both the left and right, from woman's suffrage before 1920 to the student movements of the 1960s and, most recently, to Operation Rescue and antiabortion activities.

REFERENCES

APTHEKER, HERBERT. *Abolitionism: A Revolutionary Movement*. Boston, 1989.

BLACKETT, R. J. M. *Building an Antislavery Wall: Black Americans in the Atlantic Abolitionist Movement, 1830–1860*. Ithaca, N.Y., 1989.

BRACEY, JOHN H., JR., AUGUST MEIER, and ELLIOTT RUDWICK, eds. *Blacks in the Abolitionist Movement*. Belmont, Calif., 1971.

DAVIS, DAVID BRION. *The Problem of Slavery in the Age of Revolution, 1770–1823*. Ithaca, N.Y., 1975.

——. *The Problem of Slavery in Western Culture*. Ithaca, N.Y., 1966.

——. "Reconsidering the Colonization Movement." *Intellectual History Newsletter* 14 (1992): 3–16.

FOGEL, ROBERT WILLIAM. *Without Consent or Contract: The Rise and Fall of American Slavery*. New York, 1989.

PEASE, JANE H., and WILLIAM H. PEASE. *They Who Would Be Free: Blacks' Search for Freedom, 1830–1861*. Urbana, Ill., 1974.

PERRY, LEWIS. *Radical Abolitionism: Anarchy and the Government of God in Antislavery Thought*. Ithaca, N.Y., 1973.

PERRY, LEWIS, and MICHAEL FELLMAN, eds. *Antislavery Reconsidered: New Perspectives on the Abolitionists*. Baton Rouge, La., 1979.

QUARLES, BENJAMIN. *Black Abolitionists*. New York, 1969.

RIPLEY, C. PETER, et al. *The Black Abolitionist Papers*. 5 vols. Chapel Hill, N.C., 1985–1992.

STEWART, JAMES BREWER. *Holy Warriors: The Abolitionists and American Slavery*. New York, 1976.

YEE, SHIRLEY J. *Black Women Abolitionists: A Study in Activism, 1828–1860*. Knoxville, Tenn., 1992.

YELLIN, JEAN FAGAN. *Women and Sisters: The Antislavery Feminists in American Culture*. New Haven, Conn., 1989.

LEWIS PERRY

Abrams, Muhal Richard (September 19, 1930–), pianist and composer. Born in Chicago, Abrams began playing piano at seventeen, and studied at Chicago Musical College, quickly gaining proficiency in a bebop style influenced by Art TATUM and Thelonious MONK. Abrams first played professionally in 1948, and starting in 1950 worked as an arranger for King Fleming's band. He played a sideman in Chicago in the early 1950s, eventually working with Miles DAVIS, Max ROACH, Sonny ROLLINS, and Johnny Griffin, and from 1955 to 1959 he led his own group, the Modern Jazz Two Plus Three, with tenor saxophonist Nicky Hill, bassist Bob Cranshaw, and drummer Walter Perkins. In 1961, with bassist Donald Garrett, he formed the Experimental Band, a rehearsal ensemble that prefigured virtually every aspect of Chicago avant garde jazz to come, both in its membership, which included saxophonists Anthony BRAXTON, Joseph Jarman, Roscoe Mitchell, and Henry THREADGILL, and its updating of traditional jazz materials. During this time Abrams, who had taken Muhal as his first name, also developed into a formidable pianist, at times bluesy and lyrical, at times angry and roiling, in the style of Cecil TAYLOR.

In 1965 Abrams helped found the Association for the Advancement of Creative Musicians (AACM), and he served as the Chicago arts and education cooperative's first president. Abrams led his own ensembles on *Levels and Degrees of Light* (1967) and *Young at Heart/Wise in Time* (1969), albums that contrasted quiet passages with violent moments of furious, noisy, free improvisation. During the better part of the 1970s Abrams remained active in Chicago, leading weekly concerts by the AACM big band as well as performing with his own sextet, and with his colleagues in the AACM. In 1973 he performed with the ART ENSEMBLE OF CHICAGO on *Fanfare for the Warriors,* and also played duets with bassist Malachi Favors (*Sightsong,* 1975), Anthony Braxton (1976), and Leroy JENKINS (1977).

In 1977, Abrams moved to New York and experienced a burst of activity with his own small ensembles (*I-OQA + 19,* 1977; *Lifea Blinec,* 1978), in duets (with pianist Amina Claudine Myers, 1981), and solo (*Voice Song,* 1978). In the 1980s, Abrams concentrated on his big band, using both traditional and experimental jazz styles and instrumentation, on *Blues Forever* (1981), *Rejoicing with the Light* (with "Bloodline," dedicated to Fletcher HENDERSON, Don Redman, and Benny CARTER, 1983), *View From Within,* 1984, and *The Hearinga Suite,* 1989. In the 1990s, Abrams continued to compose for large ensembles (*Blu Blu Blu,* dedicated to MUDDY WATERS, 1990), but performed in the United States infrequently.

REFERENCES

LITWEILER, JOHN. *The Freedom Principle: Jazz After 1958.* New York, 1984.
MARTIN, T. "The Chicago Avant-Garde." *Jazz Monthly* 157 (1968): 12.
TOWNLEY, R. "Profile: Muhal Richard Abrams." *Downbeat* 41, 14 (1974): 34.
WILMER, VALERIE. *As Serious As Your Life.* London, 1972.

JONATHAN GILL

Abyssinian Baptist Church. The Abyssinian Baptist Church in New York City, which is one of the oldest African-American Baptist churches in the northern states, was founded in 1808 when a white-led church, the First Baptist Church, restricted black worshippers to a segregated area of the sanctuary. The Rev. Thomas Paul, a white minister from Boston, and 18 black Baptists left and founded their own congregation on Anthony Street (now Worth Street). The name of the church allegedly derives from a group of seamen and merchants from Ethiopia (then known as Abyssinia), a historically Christian African country, who helped found the new church. The church soon moved to larger quarters on Waverly Place in Greenwich Village. By 1840, the church's membership numbered more than 400, and was the largest African-American Baptist congregation outside the South.

After the Civil War, the church's membership grew slowly, reaching about 1,000 by the turn of the century. Since New York's black population had moved uptown, the Rev. Robert D. Wynn repeatedly urged that the church be relocated in the rising African-American center of Harlem. In 1902, under the leadership of the Rev. Charles S. Morris, the church moved into a new building on West 40th Street.

In 1908, the hundredth anniversary of the church, a dynamic leader, the Rev. Adam Clayton POWELL, SR., was installed as pastor. Powell campaigned successfully to raise money for a church building in Harlem. In 1923, the new building opened at 132 West 138th Street. The new church cost $350,000 to build, and had lush carpets, a recreational center, and an imported marble pulpit.

Despite the cost, the Abyssinian Baptist Church was considered the "church of the people." Its membership, which grew to 14,000 by 1937, the year the Rev. Powell, Sr., retired, reflected the social and economic composition of the surrounding black community; most of the church's members were poor or

From the pulpit of the Abyssinian Baptist Church in Harlem, the Rev. Adam Clayton Powell, Jr., built a power base that eventually made him one of the most powerful members of the U.S. Congress. (UPI/Bettmann)

lower middle class, and there were few professionals among them.

Once settled in Harlem, the church immediately became active in social programs. The Rev. Powell continued the antiprostitution efforts he had begun on 40th Street, and in 1926 he founded a senior citizens' home at 732 St. Nicholas Avenue, which was named in his honor. Under the leadership of his son, the Rev. Adam Clayton POWELL, JR., the church opened a federal credit union and the Friendly Society, a benevolent organization.

Church activities increased with the coming of the depression. In 1930, a soup kitchen opened, followed by a day nursery, an employment bureau, and most significantly, an adult education school, which had some 2,000 students by 1935. After succeeding his father as pastor in 1937, the younger Powell led boycotts and picketing to obtain jobs for blacks in Harlem. Even after he became a New York City Councilman in 1941, and then a U.S. Congressman in 1945, Powell retained his pulpit at the Abyssinian

Baptist Church, where he was renowned for his oratory.

After the death of Adam Clayton Powell, Jr., in 1972, the church selected the Rev. Samuel D. Proctor, a former president of both North Carolina A & T College and Virginia Union University in Richmond, to become its next pastor. Proctor continued the social activism for which the church was known. Under his leadership, the church created the Abyssinian Housing Development Program, which provides over fifty units of housing to needy families in Harlem. Proctor also invited the New York Philharmonic to give annual concerts in the church.

In 1990, the Rev. Calvin BUTTS, who had been the executive minister under Proctor, assumed the pastorate of the church. The Rev. Butts expanded the church's role in housing development, child care, and adult education. A powerful, often controversial leader, Butts has carried out highly publicized campaigns against alcoholism and against alcohol and tobacco companies that target black and Latino consumers for their products. In 1993, Butts began a heated campaign to boycott rap songs whose lyrics denigrate black men and women. Though the membership of the church has dropped over the years to about 5,000, the Abyssinian Baptist Church is still one of the largest and most powerful black churches in America.

REFERENCE

POWELL, ADAM CLAYTON, SR. *Upon This Rock*. New York, 1949.

TIMOTHY E. FULOP

Accommodationism. Accommodationism refers to the asserted systematic acceptance of the inegalitarian racial status quo by African Americans who assume that white-dominated society will then grant concessions in return for that acquiescence. Accommodationism is usually associated with the career and ideology of Booker T. WASHINGTON. As it is commonly used, Washington's accommodationism is seen in his emphasis on African-American economic self-help and development, his dismissal of the importance of electoral political action, and his relationship with influential whites. For many scholars of African-American history, Washington's career provides a near-ideal type of a conservative racial ideology that urges acceptance of, rather than resistance to, the existing sociopolitical order (Meir 1973). This view of Washington as a quintessenital accommodationist is commonly highlighted by contrasting him

with activists such as W. E. B. DU BOIS and the socialist A. Philip RANDOLPH who argued that a direct challenge to overall society rather than the economic development proposed by Washington was necessary for African Americans.

The term accommodationism has had many, often contradictory, applications; almost invariably used negatively, it is perhaps too "loaded" for serious analytical value. Insofar as "accommodationism" suggests a collaborationist "sell-out" stance, few, if any, to whom the term is applied have been willing to be so labeled, even if the elements of their political practice and thought are those normally associated with the term. Washington did not consider himself to be an accommodationist. Indeed, Washington viewed his strategy of laying an economic foundation for the autonomous development of African Americans as being part of the powerful wave of modernizing capitalism that was uprooting, not sustaining, old modes of society (Childs 1989). In essence Washington and his supporters believed that their program would have radical consequences—not conservative accommodationist ones—for fundamental change. Arguments can be presented for and against this outlook, but if accommodationism is to be applied to Washington, it has to be done against his self-asserted transformative objectives and hopes.

Booker T. Washington (front and center) was skilled in winning the support of white philanthropists for the Tuskegee Institute and other projects. He is photographed in about 1913 with a group that includes Andrew Carnegie (on Washington's left). (Prints and Photographs Division, Library of Congress)

The treacherous analytical currents flowing around accommodationism are also apparent when one examines how the term has been used in contradictory ways. For example, Marcus GARVEY, considered a dangerous radical by U.S., French, and British authorities in the 1920s, was an avowed admirer of Washington. More important, Garvey's UNIVERSAL NEGRO IMPROVEMENT ASSOCIATION (UNIA) incorporated the essence of Washington's self-help agenda into its own "radical" outlook of creating a self-sufficient black international community.

The complexity of accommodationism is further illustrated when considering Du Bois's criticism of Washington for his purported compromise with the status quo, along with the African-American socialist attack on *both* Washington and Du Bois as accommodationist "Old Crowd Negroes" whose approaches should be superseded by progressive socialism. At the height of radical socialism around 1920, A. Philip Randolph and his colleagues in the MESSENGER magazine criticized Du Bois's hoped-for creation of a humanistic, classically trained vanguard—the so-called Talented Tenth—as a no less dangerous form of acquiescence to the dominant system than Washington's, insofar as the former encouraged an individualistic and elitist retreat to an intellectual ivory tower with a concomitant disengagement from the real economic-political struggle looming before African Americans. "I would rather be a crack shot," wrote one *Messenger* socialist, in a thinly veiled reference to Du Bois, "than the most finished Homeric scholar in the land." The African-American need was not for Du Bois's "vague theological metaphysics" but for a fully engaged "scientific philosophy," said the socialists. So, while Du Bois could attack Washington as an accommodationist who pulled back from the struggle, Du Bois himself was attacked by African-American socialists. A similar simultaneity of radical and accommodationist labeling can be seen in responses to the NATION OF ISLAM, itself a lineal descendant of Garvey's UNIA. The Nation continued Garvey's emphasis on separate community development. Like Garvey and the UNIA, the Nation was viewed by many, including the authorities, as radical, while it was criticized by African-American socialist-lending activists, such as those in the BLACK PANTHER PARTY, being conservative. Black Panthers viewed the Nation's dream of autonomy as a retreat. They believed that this was dangerous because it would lead to disengagement from the task of struggling directly against domination.

If a group or an individual can be considered accommodationist from one perspective while simultaneously viewed as radical, from another perspective, the limitations of the term itself became apparent. Consequently, it is probably more useful

to draw out the essential elements in accommodationism that have tangible meaning. Clearly a core theme running through the strategies and practices associated with "accommodationism" is the question of autonomy. Are strategies for African-American autonomy a form of escapist withdrawal or a significant means of resisting the domination of white society? From this perspective, our analysis should be less focused on labeling who is, or is not "accommodationist," and more on a comparative social-historical examination of African-American strategies positing group autonomy and disengagement from larger structures of the dominant society. By shifting to the empirical analysis of autonomist-oriented organizations and strategies such as the Tuskegee Institute (*see* TUSKEGEE UNIVERSITY), the UNIA, the Nation of Islam, "community control," and "third-party politics" we can escape the ambiguities surrounding the term "accommodationism."

REFERENCES

CHILDS, JOHN BROWN. *Leadership, Conflict, and Cooperation in Afro-American Social Thought.* Philadelphia, 1989.

MEIER, AUGUST. *Negro Thought in America 1880–1915: Racial Ideologies in the Age of Booker T. Washington.* Ann Arbor, Mich., 1973.

The Messenger, September, 1919.

JOHN BROWN CHILDS

Accreditation. *See* Licensing and Accreditation.

Ace, Johnny (Alexander, John Marshall, Jr.) (1929–December 25, 1954), musician and songwriter. Born John Marshall Alexander, Jr., in Memphis, the son of a Baptist minister and the sixth child of a family of ten, he displayed talent in voice, piano, composition, and painting as a young boy. He left school in the eleventh grade to join the Navy and travel, but his service was brief, resulting in an undesirable discharge in 1947.

By 1949 Alexander was playing piano in B. B. KING's band, the Beale Street Blues Boys (later the Beale Streeters). In 1952 Duke Records of Memphis renamed Alexander "Johnny Ace" and released his ballad "My Song," which Ace cowrote and sang in a Nat "King" COLE–Charles Brown crooning style. It attracted the attention of African-American entrepreneur Don D. Robey (founder of Peacock Records and Buffalo Booking of Houston), who then acquired controlling interest in the label and aggressively promoted Ace's record to the top of the

RHYTHM AND BLUES charts, grooming him as a national R&B headliner.

Ace's career, lasting less than two and a half years, produced eight R&B Top Ten records, including two additional number one hits: "The Clock" (1953) and "Pledging My Love" (1954). The latter ballad, representing neither rhythm nor blues, became the most-played R&B record of 1955 and a pop hit as well—establishing a pattern of white teenage assimilation of black musical sounds and cultural styles that revolutionized American popular music. Ace died on Christmas night 1954, playing Russian roulette during intermission backstage at Houston's City Auditorium.

REFERENCES

GART, GALEN, and ROY AMES. *Duke/Peacock Records: An Illustrative History with Discography.* Milford, N.H., 1990.

SALEM, JAMES M. "Johnny Ace: A Case Study in the Diffusion and Transformation of Minority Culture." *Prospects: An Annual of American Cultural Scholarship* 17 (1992): 209–239.

JAMES M. SALEM

ACL (African Community League). *See* Universal Negro Improvement Association.

ACLU. *See* American Civil Liberties Union.

Adams, Alton Augustus (November 4, 1889–1987), military bandmaster. A native of St. Thomas, Alton Adams received formal music instruction privately and through correspondence courses, and earned a bachelor of music degree from the University Extension Conservatory of Music in Chicago. In 1910 he founded the St. Thomas Juvenile Band, and he later enlisted with the entire band in the U.S. Navy in 1917, after the United States purchased part of the Virgin Islands from Denmark. His unit became the first black band in American naval history. Adams directed the group from 1917 to 1934 and from 1942 to 1947. In 1924, he and the band toured the United States. He also organized and supervised the public-school music program in St. Thomas from 1918 to 1931. He wrote several musical compositions, including "Virgin Islands March" (1917), "Governor's Own" (1921), and "Spirit of the U.S. Navy" (1924), and contributed articles to journals and newspapers.

REFERENCES

FLOYD, SAMUEL A., JR. "Alton Augustus Adams." *Black Perspective in Music* 5, no. 2 (Fall 1977): 173–187.

SOUTHERN, EILEEN. *Biographical Dictionary of Afro-American and African Musicians.* Westport, Conn., 1982.

JOSEPHINE WRIGHT

Adams, Carolyn (1944–), modern dancer and instructor. Carolyn Adams was born in New York City and raised in Harlem. Her father was managing editor of the AMSTERDAM NEWS, and her mother pursued a career as a writer, pianist, and composer.

Adams studied at the Martha Graham School and attended Sarah Lawrence College. When she joined the Paul Taylor Dance Company in 1965, she was the company's only black member. Adams distinguished herself during her years with Taylor. Her particular qualities as a dancer enhanced Taylor's eclectic style of choreography, which emphasized momentum and each dancer's individual talent. The petite Adams demonstrated a gift for lightness and speed.

Adams gained worldwide recognition as a dancer and taught dance composition in London and Denmark. In 1969, while still active as a performer, Adams, with her sister Julie Adams Strandberg, also a dancer, founded the Harlem Dance Foundation. The multipurpose school and center for community preservation and restoration was originally located in the family's historic brownstone residence and eventually expanded into a second Harlem brownstone. Adams divided her time between developing the school and pursuing her interest in brownstone preservation and landmark designation.

REFERENCES

ANDERSON, JACK. *New York Times,* April 22, 1979.
GOLD, SYLVIANE. *New York Post,* June 7, 1976.
SHEPARD, JOAN. *New York Daily News,* December 9, 1982.

JULINDA LEWIS-FERGUSON

Adams, Numa Pompilius Garfield (February 26, 1885–August 29, 1940), physician and educator. Adams was born in Delaplane, Va. After attending schools in his native town and in Steelton, Pa., he taught for two years in Carlisle, Pa. (1905–1907). He entered Howard College in 1907, earning his B.A. in 1911 and proceeding to Columbia University, where he earned a master's degree in chemistry (1912). Appointed to the faculty at Howard, he taught chemistry there until 1919, after which he enrolled for the medical course at Rush Medical College, Chicago. Early in life, he had become interested in health work under the influence of his grandmother Amanda Adams, a midwife in rural Virginia, whom he helped gather herbs and concoct medicinals. He was awarded the M.D. in 1924, following completion of an internship at St. Louis City Hospital No. 2 (later Homer G. Phillips Hospital).

Adams began his medical career in Chicago, where he worked in private practice (1925–1929). He also served as assistant medical director of the Victory Life Insurance Company (of which another African-American physician, Julian H. LEWIS, was medical director) and as instructor in neurology and psychiatry of the PROVIDENT HOSPITAL School of Nursing. On June 4, 1929, he became the first black dean of HOWARD UNIVERSITY Medical School. The appointment, arranged by Mordecai JOHNSON, Howard's first black president, was part of a calculated effort on the part of the administration to place qualified blacks in positions of authority and thus to phase out a long-standing pattern wherein Howard's black faculty worked under the almost exclusive leadership of whites.

In his capacity as dean, Adams reorganized the medical school curriculum and raised standards of admission, recruited talented faculty, and forged a closer link to FREEDMEN'S HOSPITAL. The demands of the work took a toll on his health, however, and he died of pneumonia at the age of fifty-five. Adams was married to Osceola Macarthy, an actress and drama teacher, with whom he had one son, Charles.

REFERENCES

ADAMS, NUMA P. G. "Recent Developments in Medical Education at Howard University." *Howard University Bulletin* 15 (1935): 1–18.
COBB, W. MONTAGUE. "Numa P. G. Adams, M.D., 1885–1940." *Journal of the National Medical Association* 43 (January 1951): 43–52.

PHILIP N. ALEXANDER

Adderley, Julian Edwin "Cannonball" (September 15, 1928–August 8, 1975), jazz alto saxophonist and bandleader. Cannonball Adderley's early musical training included high-school band in Tampa, Fla. He attended Florida A & M University, and from 1948 to 1950 he directed a high-school band in Fort Lauderdale. He played in U.S. Army bands from 1950 to 1953, and then resumed his teaching career in Florida until 1955.

Alto saxophonist Julian "Cannonball" Adderley first achieved wide recognition as a member of the Miles Davis sextet in the late 1950s. He went on to greater fame as a leader of his own ensemble in the 1960s. (UPI/Bettmann)

In 1955, Adderley moved to New York, intending to perform with his brother Nat (Nathaniel) and to pursue graduate studies at New York University. Instead, soon after his arrival, he joined Oscar PETTIFORD's band. Adderley and his brother formed a short-lived quintet in 1956. He joined the famed Miles DAVIS sextet (1957–1959), with John COLTRANE, and later formed a second, very successful quintet with Nat Adderley (1959). Not adhering to the bebop and modal repertory of Pettiford and Davis, the Adderley Quintet espoused both bebop and a jazz-soul fusion repertory. From 1959 to 1975, the quintet featured George Duke, Victor Feldman, Joe Zawinul (composer of "Mercy, Mercy, Mercy" and "Country Preacher"), and Roy McCurdy. From 1962 to 1965, the group, now expanded to a sextet, featured Yusef LATEEF and, later, Charles Lloyd.

Hailed as the "new Bird" after his arrival in New York (in the year of Charlie PARKER's death), Adderley showed both blues and gospel influences in his saxophone improvisations. Although he sometimes imitated Parker, Adderley's style also featured long improvisational lines that were permeated with chromaticism. In addition, while performing with Miles Davis, his style often featured modal ideas, the bebop dominant scale, and effective use of silence, rather than continuous lines. In the mid-1960s, he also experimented with free jazz concepts; from 1969, he began playing soprano saxophone. Adderley was an articulate spokesman on black music, and gave numerous clinic-lectures at colleges and universities.

REFERENCES

BAKER, DAVID. *The Jazz Style of Cannonball Adderley*. Lebanon, Ind., 1980.

WINTER, J. "Julian 'Cannonball' Adderley." *Coda* 186 (1982): 4–5.

EDDIE S. MEADOWS

Advertising. For more than a century, while black people advertised among their group as much as they could, mainstream American advertisers moved quite slowly and cautiously toward the inclusion of African-American consumers as a targeted market. FREEDOM'S JOURNAL, the first paper published by and for African Americans, carried advertisements. The first issue, published in 1827, had an advertisement for "A School for Colored Children."

Black American consumers were seen as a specific advertising market by the mainstream beginning in 1916, when a gas company in South Carolina, working with a church group and the local government, advertised a cooking school for "Negro" servants. The NATIONAL NEGRO BUSINESS LEAGUE conducted a study of the incomes and living habits of African Americans in the 1930s. This first national approach to a study of black consumers was subsidized by Montgomery Ward, Lever Brothers, and Anheuser-Busch. The report stressed the overall spending power of $1.65 billion of this consumer group (Bauer and Cunningham 1970).

In 1932, Paul K. Edwards, professor of economics at Fisk University, wrote the definitive article "The Negro Commodity Market," which gave systematic attention to black consumers for the first time. Then, in the 1940s, African-American marketing consultants were used for the first time when a few black advisers and salesmen were added to mainstream staffs. Thus began a systematic means of advising manufacturers and advertisers about ways to advertise to the "Negro" market. U.S. government census statistics for 1950 compared black and white spending habits and firmly established similarities and differences between the races (Friend and Kravis 1957; Bauer and Cunningham 1970).

After World War II, numerous market surveys were commissioned by African Americans to assess

the black market. During the late 1950s and early 1960s, African Americans were described as consumers who frequently purchased leading brands because they sought status and prestige. Numerous articles in trade publications stressed the brand-loyalty and brand-consciousness of black consumers. *Printer's Ink* (1958) reported to marketers the first analysis of social class distinctions among African-American consumers.

In the 1950s, the immensely popular singer Nat "King" COLE seemed a good candidate for having his own network variety TELEVISION series. Four of his songs were number-one hits between 1944 and 1957, and thirteen were among America's Top Ten at some point during that period. Cole had records on *Billboard* charts for 274 of the 780 weeks between 1940 and 1955. He was a frequent performer on many TV variety shows, and "his popularity exceeded that of Frank Sinatra, Doris Day, Tommy Dorsey and Dinah Shore" (Gitlin 1987; MacDonald 1983; Cole 1957). Thus, in 1956, when NBC agreed to give Cole a fifteen-minute series of his own, many believed that the show had a good chance of doing well.

Although he had respectable ratings at various points, Cole was unable to continue the series beyond the contracted year, because advertisers were afraid to sponsor an African American on television. Sponsors speciously argued that they feared hostile southern markets and the possibility of a nationwide rejection of their products, which might have been labeled "Negro" products (Gitlin 1987; Cole 1957). Thus, they devalued the importance of African-American consumers, a prime viewing group of "The Nat 'King' Cole Show," and disregarded the large number of mainstream consumers who had already proved their loyalty to Cole through their consistent record purchases.

Until the 1960s, the advertising industry's amoral attitude toward social concerns usually went unquestioned. Before then, the industry was observed as having little motivation to seek the improvement of the individual or to impart qualities of social consciousness. Although it wielded an immense influence, it eschewd social goals and felt no social responsibility (Potter 1954). A *New York Times* article of the period noted that "though advertisers tradionally assumed that they could divorce themselves from the nation's social issues, the 'Negro' situation proved otherwise" (Bart 1964).

During this time, the Congress of Racial Equality, the NAACP, and other civil rights groups held meetings with advertising organizations such as the American Association of Advertising Agencies to argue for fundamental alterations of sponsor and advertising-agency attitudes about black consumers, and toward minority marketing strategies. Advertising researchers of the 1960s conducted studies of African Americans as consumers and practitioners, but little changed in the industry regarding these consumers and toward minority markets, except for the addition

The use of blacks in advertising, especially for products associated with the South, was well established even before the Civil War. This tobacco label image, based on an Eastman Johnson oil painting, dates from 1856. Curiously, this is twenty years before James A. Bland composed the famous minstrel song "Carry Me Back to Ole Virginny." (Prints and Photographs Division, Library of Congress)

of a small number of integrated advertisements (Appelbaum 1962).

Advertisements consistently dealt in the hierarchy of skin color, using black models with Caucasian features, fair complexions, and straight or straightened hair. It was not until the 1960s that even black publications, such as *Ebony* magazine, were able to carry advertisements in which Negroid features and the natural Afro hairstyle were the norm. By the 1990s, moreover, the norm for black models had regressed to pre-1960s styles, particularly in mainstream publications.

By the early 1970s, advertisers learned that African Americans constituted twenty-three million Americans, accounted for 11 percent of the population, and spent about $30 billion a year for consumer goods and services. Purely from an economic perspective, advertisers saw that this market was a prime target for cultivation. However, fearful that the white market might become alienated by integrated advertising campaigns, advertisers resisted appealing to the two distinct markets in one advertisement; yet they also resisted targeting to black consumers alone (Sexton 1972).

Various studies were conducted to examine the credibility and viability of this perceived fear of "white backlash." The studies revealed that whites were indifferent to well-conceived integrated advertisments; that there were no negative effects of the use of blacks as models, either by themselves or integrated with whites; that the presence of African Americans in main roles in advertisements produced only a moderate by significantly lower reaction from highly prejudiced students; and that commercials that used black models had more meaning for African-American viewers than did all-white commercials. Thus, while these ads were clearly favored by African-American viewers, they also made little difference to whites. Still, the policy persisted, and well into the 1980s black advertising practitioners and other businesspeople consistently complained about the small number of advertising dollars used to target black consumer groups.

Most marketers subscribed to one of two broad views about black consumers: Black people are too poor to purchase national brands or black people desire the brands and labels they imagine the best white consumers purchase. Marketers believed black consumers who lived at a subsistence income level made up one segment, and those who lived a middle-class life comprised the other (Sexton 1972).

Feeling the powerful effects of the civil rights movement, in the 1970s some large corporations targeted the black consumer. Some of the most successful marketing campaigns directed to black consumers included the corporate-style ads designed by companies such as American Telephone and Telegraph (AT&T). These advertisements focused on AT&T's record in equal-opportunity employment, using two or three generations of black AT&T employees as central, featured characters. Print ads were placed in African-American print media, while radio spots, run on the National Black Network and the Sheridan Network, employed actor Ossie DAVIS to interview the workers. AT&T also used numerous black entertainers in its "Reach Out and Touch Someone" campaign. Some believed that competition from independent telephone networks had encouraged AT&T to establish a solid foundation of loyalty in the black community by conducting advertising campaigns such as these.

In the 1980s, upscale black consumers presented a distinct challenge to the marketers who had targeted the group. Many were first-generation middle-class consumers who maintained tastes for food, atmosphere, and lifestyle from their early years. The common traits and common vocabulary that marketers used when advertising to middle-class whites often did not apply to middle-class blacks, for the African-American community had a unique culture and a distinct personality. Very often the high-salaried, highly successful black people who worked on Madison Avenue still enjoyed—and often preferred—many of the

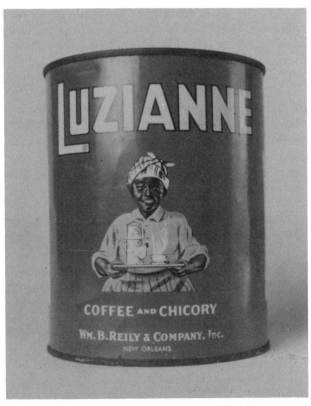

Luzianne coffee can, c. 1930s. (Allford/Trotman Associates)

same foods, recreation, and other products and services that poorer blacks enjoyed (Djata 1987).

While African Americans made up less than 12 percent of the general populace, they consumed higher percentages of products such as instant mashed potatoes (14 percent), floor wax (17 percent), chewing gum (23 percent), malt liquor (32 percent), and hair-conditioning products (36 percent). Black consumers purchased almost double the amount of cornmeal as the general population. The Aunt Jemima brand led in commercial consumption, with 55 percent of its product purchased by black consumers. The parent company of Aunt Jemima products, Quaker Oats, spent only a small portion of its advertising budget in black markets, however. The Wellington Group, a black market-research firm, challenged the marketers of Aunt Jemima: Since Aunt Jemima led in sales in black communities even when few advertising dollars were spent to market the product, if the company spent 55 percent of its advertising budget on the black market, what then would be its share of the black consumer market for cornmeal purchases? ("Black Broadcast" 1983; Allen 1981; Wellington 1983).

The Quaker Oats company was unresponsive to this challenge. Later, however, the company initiated a nationwide campaign designated to recognize and honor black women achievers in the nation's largest cities. It enlisted the aid of the NATIONAL COUNCIL OF NEGRO WOMEN (NCNW) as a cosponsor. Despite criticism of its involvement with the company that had used the Aunt Jemima image for decades, the NCNW was supportive of the Quaker Oats Company. By 1991, Quaker Oats had updated and removed stereotypical patterns from the Aunt Jemima label, and wanted to embrace the African-American community with its new campaign. The NCNW believed it made sense to support the company's new direction.

Black people were easy targets for marketing overtures for two reasons. Black people of all income levels purchased black magazines, listened to black RADIO stations, and watched black people when they appeared on television. All segments of the African-American community were heavy viewers of off-network reruns of former prime-time network programs such as "The Jeffersons," "Sanford & Son," and "What's Happening?"—shows with predominantly African-American casts.

Even in the mid-1980s, however, African-American consumer groups generally were not prime targets for marketers. George Edwards, president in the 1980s of the National Black Network, then the largest African-American radio network in the country (with more than 110 affiliated stations), believed that Wall Street assumed that since African Ameri-

cans spoke English, advertisers should treat them the same as they did any other English-speaking citizens. Thus, advertisers would develop commercials especially for Latinos but not for African-American consumers (Bronson 1983).

Television broadcast programming oriented to African-American viewers on the Public Broadcasting System, and cable's Black Entertainment Network (BET), allowed for more direct access to black consumers in the 1980s. In 1989, when after ten years of operation BET moved into its new studios in Washington, D.C., it declared itself "the information voice of black America" as it continued growing at a rate of two million subscribers per year. In the fall of 1992, it became the first publicly traded black-owned company on the New York Stock Exchange. BET president Bob Johnson noted the viability of black spending power, and encouraged cable system operators to take note of the obvious economic opportunities found among black cable-viewing audiences.

Among the advertising industry's consumer-marketing strategies in the late 1980s, "target marketing" increased in importance, at a point when African-American social and economic viability also had increased. Because of foreign competition and the softening American economy, many in the industry needed new opportunities and new markets. Thus, they often looked toward markets they had once ignored. Many looked to the black and Latino communities, particularly since industry experts realized that between them the African-American and Latino markets controlled almost $300 billion annually. These groups represented the ninth most profitable market in the world, and by most indications, the black and Latino communities would make up one-third of the nation by the year 2000.

Even at this point, however, some marketers questioned the use of black advertising agencies to reach the black consumer market. For example, a vice president of a brewery made the obvious observation that it was possible to communicate with an audience to which one does not demographically belong. He argued further that the target market for beer was the twenty-one to thirty-four-year old segment, but that his company never demanded that its account be serviced by people in that age range. He failed to realize, of course, that all account executives would be, had been, or were twenty-one to thirty-four years old, and knew some things about that age group from experience, whereas they had not been, were not, and would not become members of an ethnic minority group if they were members of the usual white, male decision-making group that controlled American industries (Paskowski 1985; Blake 1985).

Even if reluctantly, however, most marketers increasingly turned to black advertising agencies after

the late 1980s to help them gain better access to the rapidly growing and increasingly powerful black market. At this point, 46 percent of the black population lived in twenty-five cities, where, in many instances, they had reached majority status. Thus, they were easily reachable for marketing overtures (Paskowski 1986).

Black Images in Advertising

As the industry developed advertisements that reflected the society's myths and rituals, which were usually absorbed and accepted as real by the populace, decision makers in advertising were concerned with profit, and not with any side effects that their decisions might produce. They believed that advertising paid the way for Americans to maintain the high standard of living that made them the envy of the rest of the world, and as a solid member of the nation's free-enterprise system, the industry fiercely fought to return profits to stockholders.

In 1962, the New York City branch of the NAACP launched a campaign to desegregate advertising. The organizers examined various print and broadcast media and concluded that from advertisements, visitors "would conclude that there are no Negroes in the USA. Or that if there were Negroes in America, they didn't wear clothes, own automobiles . . . or that advertisers were indifferent to their presence" (Appelbaum 1962). The organizers noted that "if visual advertments of merchandise included the highly visible Negro, along with white people, the American public would get a new and more accurate image of the Negro" (Appelbaum 1962), and they believed that African Americans would then be appreciated for their real worth.

In the early 1970s, the NAACP Legal Defense and Educational Fund appealed to the Federal Communications Commission (FCC) to use its power against discriminatory advertising. The NAACP believed that television was too important an influence for the FCC to ignore the fact that television commercials affected viewers in ways not necessarily intended by their producers and sponsors. The group noted that one of the side effects of commercial advertisement on television was viewer perception that these advertisements reflected images based on truth, reality, and shared values (Christopher 1970).

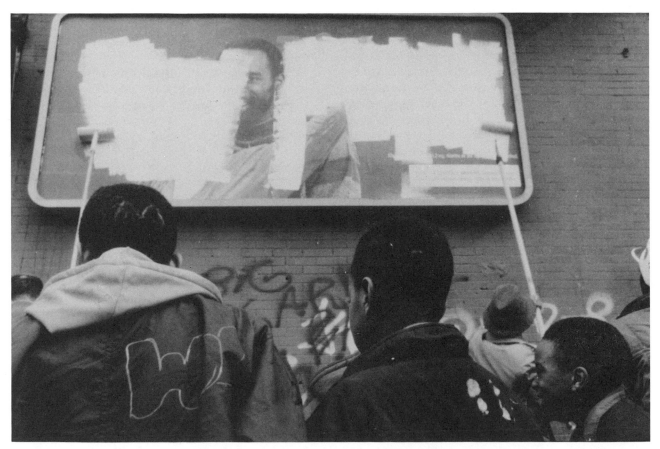

Calvin O. Butts III, pastor of the Abyssinian Baptist Church in Harlem, has used his pulpit to campaign for a number of social and political issues. Here, in 1990, he is leading a protest against cigarette companies that encourage young people, especially African Americans, to smoke. (Allford/Trotman Associates)

By the mid-1970s, African-American actors began to appear with greater frequency in integrated advertisements in the print and electronic media, and they appeared for the first time as star presenters on television and in print ads. African-American entertainer Lola Falana advertised Tigris perfume, while Bill COSBY began to pitch for the Del Monte Corporation. Cosby did an unidentified voice-over, using a gentle, whimsical humor to increase the visibility of the product and to make the commercial palatable. The General Foods Corporation began using Cosby as a spokesman for Jell-O pudding in 1973, and in 1976 Cosby first appeared as star presenter for the Ford Motor Company. Cosby was chosen by Del Monte, Jell-O, and Ford (and subsequently by Ideal Toys, Texas Instruments, Coca-Cola, and Kodak) because research had proved that he exuded an unusual amount of believability and warmth. Thus, he could help each company in its campaign to build a youthful, warm, and modern image as it positioned itself in the market (Gould, Sigband, and Zoerner 1970; Revett 1978; Dub 1985).

Philip H. Dougherty of the *New York Times* noted that "if TV commercials using black actors and actresses have a negative effect on black consumers, while not having a negative effect on white consumers, it would be natural for big national advertisers to use such advertising in heavily black markets. But even if the results in other markets were less positive, wouldn't it be nice if the advertiser would go ahead and use the spot anyhow, just for the sociological impact?" (Dougherty 1982a). Dougherty argued that big national advertisers would need to use network television in addition to spot advertising to achieve this end. He noted that Procter & Gamble, the nation's biggest commercial user of television and the sole sponsor of the 1982 made-for-television miniseries *Marco Polo*, aired 103 commercials for 30 brands during 70 minutes of commercial time for that series, but used very few African-American actors in these commercials. The advertising industry was unresponsive to Dougherty on this matter.

Creative marketers, realizing that music is a universal language, began to use the language of the young and youthful to sell products to that targeted group. In the 1980s, after decades of using "whitened" imitations of black music, advertisers sought the authentic sounds of African Americans: Ray Charles, Diana Ross, B. B. King, the Imperials, and more. Black music, featuring both black and white artists, was used as background for numerous advertisements. Thus, in the 1980s, songs from *Billboard*'s Rhythm & Blues Charts of the 1960s were used to advertise a wide variety of products.

The 1980s advertisements also saw a proliferation of African-American talent in the forefront as star presenters. In addition to Bill Cosby, there were the recording industry's Michael JACKSON and Lionel Ritchie for Pepsi Cola, and Whitney Houston for Diet Coke. There was Bubba Smith, former defensive lineman for the Baltimore Colts, Oakland Raiders, and Houston Oilers, for Miller Lite beer; Will "The Refrigerator" Perry, tackle for the Chicago Bears, for McDonald's hamburgers; Herschel WALKER selling Big Macs and Adidas sneakers; Julius ERVING pitching Crest toothpaste and Converse basketball shoes; and Reggie JACKSON selling Pentax cameras, Panasonic video equipment, and Nabisco cereals (Burwell 1984).

Revlon introduced a new brand of perfume, Unforgettable, in a television commercial in 1989, using the taped image and voice of Nat "King" Cole, interspersed with dissolved shots of white women in alluring poses. Many African-American women expressed annoyance at the subliminal suggestion that Cole would find only white women unforgettable. Surprised by this use of her father's image, Cole's daughter, Natalie Cole, a popular singer in her own right, had just finalized her own creative work that used her father's image and voice with the same song. This song would later earn Natalie Cole almost all of the top music awards in 1992. Revlon modified the commercial to include a fair-skinned black woman with straightened hair and Caucasian features as one of the alluring models.

Aside from the obvious celebrity, advertisers chose to use black music, but few black faces. As black singers sang the jingles, white models flashed across television screens. For example, Chevrolet used a number of 1960s Motown hits sung by Martha and the Vandellas and the Four Tops, while whites drove the cars.

The Pointer Sisters sang "Jump" while whites jumped for Bounce fabric softener commercials. There was "You Are So Beautiful" sung by Brook Benton for Mercury automobiles, again as white models polished, leaned on, or sat in the cars (Djata 1987). In the 1990s, the Lexus automobile sold its "pursuit of excellence" concept on television as Billie Holiday sang the blues, with crystal clarity in her smoldering, pain-filled voice.

In the late 1980s, some television advertisements began targeting black consumers with sensitivity by blending attractive African-American actors and actresses, "catchy music, eye-appealing action and honest representations of black lifestyles" in a manner that was brand-new for television (MacDonald 1984). Minority advertising agencies, the primary force behind the new trend, authenticated these ads by featuring situations that reflected the different tastes, rules for living, codes of conduct, lifestyles, and other motivational factors that differentiated

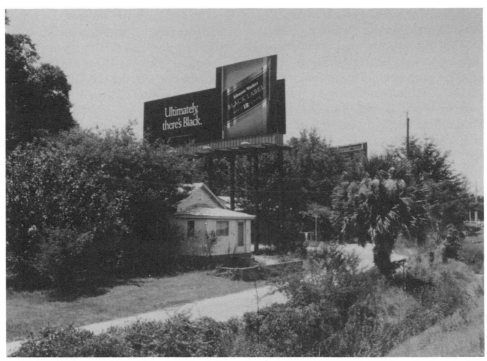

Liquor billboard advertisement, north of Jacksonville, Ky. (Allford/Trotman Associates)

black consumer groups from the general market. At the same time, however, the entertainment programs supported by these new types of advertisements continued to restrict black talent as they had always done.

African-American Advertising Practitioners

Most often, the portrayal of black people in advertising showed an insensitivity to the African-American consumer and lack of understanding of the market. Moreover, white advertising agencies and their clients allocated a few dollars to influence the purchases of black consumers, whom they usually believed were undifferentiated from the general market. In the late 1970s, major advertisers turned to the handful of African Americans working in mainstream advertising for their assistance in reaching the black consumer. Many of these African Americans sensed an opportunity, and black advertising agencies suddenly appeared. Those who set up their own enterprises were often talented but frustrated professionals who had left creative and managerial positions because of the limited opportunities available to them within mainstream advertising (Smikle 1985).

In the 1970s, thirteen advertising agencies were specialists in the black consumer market. The Burrell-McBain Advertising agency in Chicago opened in early 1971 and waited six months to land its first client. By 1972, it had convinced McDonald's that it could help increase McDonald's share of the black consumer market. Burrell Advertising, as it became known after McBain pulled out in 1976, developed more than 100 commercials and advertisements for McDonald's, including the 1979 television commercial "A Family Is," which won a CLIO award for excellence in advertising. Burrell Advertising gradually became a nationally recognized specialist in ethnic market advertising. It filled out its roster of satisfied clients: Blockbuster Entertainment, Brown Forman Beverage Company, First Chicago, Ford Motor Company, Quaker Oats, Coca-Cola, Canadian Mist, Jack Daniels, John Products, and the L'eggs subsidiary of Consolidated Foods Corporation. In the 1980s, Burrell became the Burrell Communications Group, adding the divisions Burrell Public Relations and Burrell Consumer Promotions. Thus by 1992, with a staff of 115, Burrell Communications fielded offices in Chicago and Atlanta, and had annual billings of nearly $80 million.

In 1977, Frank Mingo, a senior vice president at McCann Erickson Advertising, formed a partnership with Caroline Jones, vice president and creative supervisor at BBDO Advertising. The two combined their respective senior-level positions in mainstream agencies and established the New York–based Mingo-Jones Advertising Agency, specified as a general-market advertising agency. By 1984, the firm had acquired 30 percent general billings, 10 percent Hispanic, and 60 percent African American–oriented. The company included among its clients Hueblien's, Seagrams, Miller Brewing Company, Phillip Mor-

ris, Goodyear Tire and Rubber, Liggett & Myers Tobacco, and Westinghouse Electric. One of its general accounts included the New York–region advertising for Kentucky Fried Chicken, with a billing of about $3 million. For the assignment, Mingo-Jones came up with the tag line "We do chicken right." It was later used by the national agency (Smikle 1985). When Frank Mingo died suddenly in 1988, the vice president, Sam Chisholm, succeeded him and the business kept growing.

In 1987, Caroline Jones left Mingo-Jones and set up Caroline Jones Advertising, Inc., becoming the second black woman to head a national advertising agency (see Barbara Proctor, below). The company's clients included Bankers' Trust Company, Western Union, the Bahamas Ministry of Tourism, the Prudential, Anheuser-Busch Companies, and Ryder Systems, Inc. The company included a staff of twenty-five that specialized in advertising promotions and public relations and had annual billings of $20 million in the early 1990s.

Proctor and Gardner was one of the nation's largest black-owned advertising agencies in the mid-1980s, employing twenty-five persons and billing between $12 million and $13 million in annual accounts in the 1980s and 1990s. Most of the company's accounts were from national companies aiming at black consumers. Barbara Proctor—the first African-American woman to head an advertising agency—argued that beginning with Ronald Reagan's presidency the federal government and the American corporate leadership no longer set affirmative-action goals as a priority. Thus, in the late 1980s black advertising agencies like hers had difficulty sustaining their earlier momentum (Klose 1984; Francki 1979; Smikle 1985). By 1992, despite earlier optimism, Proctor became convinced that the American advertising industry's old-boy network could not allow African Americans the same opportunities as whites. She concluded that an uphill battle against racial barriers prevented Proctor and Gardner from emerging as a highly successful company. These barriers did not allow the company to profit from its hard work and expertise as general-market companies were able to do—by accumulating more clients and higher fees and acquiring the greater prestige that would place it on a financial footing with comparable agencies. She no longer believed racial barriers would fall in her lifetime, particularly after events surrounding the Rodney King beating and the disruptions in Los Angeles following the verdict that acquitted the indicted policemen (Ryan 1992).

In the late 1980s, a fierce struggle erupted between black and mainstream advertising agencies. Earlier, it had been routine for the same product to be shared by a black agency and a mainstream agency for ser-

vicing a client's needs, since each firm tapped a different market. The widespread success of black advertising agencies was the root cause of the fight, for in some instances these small agencies' campaigns reached not just the black consumer but the general-market consumer as well. For example, the Mingo-Jones slogan "We do chicken right" for Kentucky Fried Chicken became the tag line for the general campaign as well as for the African-American segmented market. (The company bought the rights to the tag line, but gave the general campaign account to a mainstream company.) Similarly, Burrell Advertising's campaign in the mid-1980s targeted for the black consumer, which simply said, "I assume you drink Martell," obtained a tremendous general-market response. Subsequently, unlike Mingo-Jones with Kentucky Fried Chicken, Burrell obtained the entire mainstream account for Martell, as well as the black segmented market (Smikle 1985).

Although the billings obtained by black ad agencies did not represent huge sums of money in terms of percentages, the general-market competitors did not take such intrusions lightly. Some general-market firms began to test the feasibility of offering their own black consumer marketing services in-house. For example, in 1986, BBDO, one of the largest general-market advertising agencies in the country, formed a separate in-house unit called "Special Markets" to handle everything that was not considered mainstream marketing. They named Doug Alligood, an African American with years of experience in black marketing campaigns and a seasoned BBDO employee, as manager of the division. The general-market agencies had an advantage over minority-owned firms, of course, because of the vast resources at their command. Black advertising agencies' responses to this attack were to note the strong reinforcement such actions gave to the legitimacy of the segmented black market and to go after more of the general-market accounts themselves (Smikle 1985, Paskowski 1986).

The top six African American–owned advertising agencies collectively reported billings of $155 million in 1985, a 70 percent increase over 1984 billings. But, although they billed some of the largest names in corporate America as clients, the billings by the black-owned advertising agencies were small when compared with those of mainstream agencies, and in comparison with African-American consumption of many advertised products.

Black Radio Stations and Advertising

Beginning in the 1970s, minority entrepreneurs began becoming owners of some radio broadcast properties in America. However, their share of the advertising dollar was not what they had dreamed it would

be. The reason: Many advertisers claimed that they could as readily reach black consumers through general-market broadcast advertising, and they claimed that the African-American consumer was not upscale enough to have much expendable income. As a result, advertisers argued that it was not profitable for advertising agencies to target African-American markets through black-formatted and -owned radio properties.

Many black radio entrepreneurs were nearly ruined by this economic constraint. Originally, they had believed that ownership would allow them an opportunity to "get a piece of the pie," as white entrepreneurs had done. The new rules dictated that though they had, individually or in small groups, struggled to leverage money to purchase stations, unlike white investors they would see a return on their investments only in slow dribbles. Black owners responded to this new threat to their economic survival in a number of ways. First, they banded together and formed an organization called the National Association of Black Owners of Broadcasting (NABOB). NABOB believed that there was strength in collective bargaining and that common experiences with peripheral industries and organizations (the National Association of Broadcasters [NAB], advertising agencies, and the like) could be best addressed in a public forum organized to work within the system. At the organization's scheduled meetings they shared information and heard from spokespersons representing the FCC, the NAB, advertising agencies, research organizations, and others. Second, they urged their sales staffs to develop innovative agencies used in determining "media buys" for their clients, the product manufacturers.

Ratings books presented a unique problem for black broadcast owners. Most research organizations, which published rating books, such as Nielsen, Arbitron, and Simmons, had data-collection systems that in the early 1970s bypassed or gave short shrift to black listeners. These major research organizations did not begin to collect data from persons residing in black neighborhoods until 1972. Even after 1972, black entrepreneurs cited instances in which the system worked against their economic viability. For example, a black radio station owner related that the city of Buffalo, N.Y., which had a fairly large black population in the late 1970s, had, according to the data collected by the ratings research organizations, only a negligible number of listeners for Buffalo's only black-formatted radio station. The figure was so small it was not even counted, and therefore did not appear in the ratings book. As one result, advertising agencies, their clients and advertisers paid a disproportionately lower rate for commercials broadcast on the black radio station than they paid for advertisements on general-market stations in the same city. The black-formatted station had strong evidence that the large black population did, in fact, listen faithfully. The station used such evidence as self-administered surveys and community-awareness activities in appealing to advertisers to purchase airtime. The station owners believed data collectors, fearful of venturing into black neighborhoods, interpolated figures from estimates based on other measures.

In 1992, the FCC, made up of Republican appointees and reflecting their business bias, voted to increase sharply the number of AM and FM stations a single licensee could own. This move, many argued, would curtail diversity in programming and ensure that radio ownership would remain in fewer and fewer (white) hands (Williams 1992). The effect would be felt among African Americans who owned, or were attempted to purchase, radio properties. Percy SUTTON, chairman of Inner City Broadcasting, which owned radio stations in New York City and other parts of the country, argued that the African-American community would have fewer opportunities to reach its constituents and to use the marketplace through advertising, to shape images, to program with sensitivity to the community, and to practice entrepreneurial skills.

The advertising industry did not appear to offer equality of opportunity for African Americans as the millennium approached. A vice president at BBDO urged young black people, however, to prepare themselves and be ready to take advantage of those opportunities that were available, scarce though they may have been (Winski 1992).

REFERENCES

ALLEN, HERBERT. "Product Appeal: No Class." *Advertising Age* (May 1, 1981).

APPELBAUM, SYLVIA. "On Desegregating Advertising." *Crisis* (June–July 1962): 313–317.

BARNETT, MARGUERITE ROSS. "Nostalgia as Nightmare: Black and American Popular Culture." *Crisis* (February 1980): 42–45.

BART, PETER. *New York Times,* January 6, 1964, p. 88.

BAUER, RAYMOND A., and SCOTT M. CUNNINGHAM. "The Negro Market." *Journal of Advertising Research* 10 (April 1970): 3–13.

"Black Broadcast: The Market." *TV-Radio Age* (February 1983): A-3.

BLAKE, RICH. "Minorities: Reaching the World's Ninth Largest Market." *Public Relations Journal* 41 (January 1985): 30–31.

BRONSON, GAIL. "No Hurry to Reach the Black Consumer." *U.S. News and World Report* (August 8, 1983): 43.

BROWN, LES. *Television: The Business behind the Box.* New York, 1971.

BURWELL, BRIAN. "Super Deals for Superstars: Top Jocks Put On the Hardsell for Big Bucks." *Black Enterprise* (July 1984): 37–57.

CHRISTOPHER, MAURINE. "NAACP Asks FCC to Eliminate Racism in Ads." *Advertising Age* (October 5, 1970): 29.

COLE, NAT "KING." "Why I Quit." *Ebony* (February 1957): 30.

DJATA. "Madison Avenue Blindly Ignores the Black Consumer." *Business and Society Review* 60 (Winter 1987): 9–13.

DOUGHERTY, PHILIP. "Advertising: Eagle/One Telephone Starts Out." *New York Times,* March 7, 1984, p. D23.

———. "Advertising: Frequency of Blacks in TV Ads." *New York Times,* May 27, 1982, p. D19.

———. "Advertising: Minority Marketing." *New York Times,* June 28, 1982, p. D6.

DUB, GARY. "The Ever-Popular Cosby." *Dallas Morning News,* March 16, 1985.

FRANCKI, RICKI L. "Success Story Good News: Proctor Takes a Gamble and Hits the Jackpot." *Working Woman* (August 1979): 19.

FRIEND, IRWIN, and J. B. KRAVIS. "New Light on the Consumer Market." *Harvard Business Review* (January–February 1957): 112–115.

GITLIN, TODD. "Prime Time Ideology: The Hegemonic Process in Television Entertainment." In Horace Newcomb, ed. *Television: The Critical View,* 4th ed., New York, 1987, pp. 507–532.

GOULD, JOHN W., NORMAN SIGBAND, and CYRIL ZOERNER, JR. "Black Consumers' Reactions to 'Integrated' Advertising: An Exploratory Study." *Journal of Marketing.* 1970.

KLOSE, KEVIN. "In the Spirit of Enterprise." *Washington Post,* January 27, 1984, p. D1.

MACDONALD, J. FRED. *Blacks in White TV: Afro Americans in Television since 1948.* Chicago, 1983, pp. 40, 48–50.

———. "Stereotypes Fall in TV Ad Portrayals." *Advertising Age* (November 19, 1984): 44.

"P & G" Seeks to Build Market among Blacks." *New York Times,* November 12, 1983, p. 8.

PASKOWSKI, MARIANNE. "Cover Story: Shades of Grey." *Marketing and Media Decisions* 21 (March 1986): 30–40.

POTTER, DAVID. *People of Plenty.* Chicago, 1954.

REVETT, JOHN. "Cosby Top Star Presenter of 1978." *Advertising Age* (July 17, 1978): I.

RYAN, NANCY. "Equality Shelved." *Chicago Tribune,* May 10, 1992, sec. 1, p. 17.

SEXTON, DONALD E., JR. "Black Buyer Behavior." *Journal of Marketing* 36 (October 1972): 36–39.

SMIKLE, KEN. "The Image Makers." *Black Enterprise* (December 1985): 44–55.

WELLINGTON, ALPHONSIA. Wellington Group Marketing Packet, 1983.

WILLIAMS, BETTY ANNE. "FCC Deals 'Setback' to Minority Radio." *NABJ Journal* 8, no. 4 (April/May 1992): 1, 6.

WINSKI, JOSEPH M. "The Ad Industry's 'Dirty Little Secret.' " *Advertising Age* (1992).

WINSKI, JOSEPH, and KATHY LAMPHER. "He Said 'No Thanks!' to Handouts." *Advertising Age* (March 1, 1982): M2–3.

JANNETTE L. DATES

Aerospace. The era of aviation began in Kitty Hawk, N.C., with the Wright brothers' flight of December 17, 1903, the first power-driven flight in a heavier-than-air craft. Fourteen years after the Wright brothers, Eugene Bullard, an African American, flew in the Lafayette Flying Corps in the French armed forces on the Western Front in World War I, and is therefore usually identified as the first African-American pilot. The first black woman pilot in the United States was Bessie COLEMAN, who had to go to France to receive training because of racial discrimination in the United States, and who was granted a license by the Fédération Aeronautique Internationale on July 15, 1921.

African-American enthusiasm for aerospace activities and the rise of black participation in the field is due in large measure to Coleman's leadership and the inspiration and motivation she engendered. In 1929, three years after Coleman's death in a plane accident, William J. POWELL organized the Bessie Coleman Aero Club in Los Angeles to promote aviation awareness in the black community. Powell, an African-American pilot, published *Black Wings* in 1934. The volume, dedicated to Coleman, urged African Americans to engage in all aspects of aerospace including aircraft design, maintenance, and piloting. Another African-American aviation pioneer was Hubert JULIAN, a charismatic black barnstorming pilot who dubbed himself the "Black Eagle" and became a star figure of the HARLEM RENAISSANCE. Julian, a former pilot in the Canadian armed forces, attracted attention by a dramatic parachute jump into HARLEM in 1922, later became an agent for Marcus GARVEY's UNIVERSAL NEGRO IMPROVEMENT ASSOCIATION, and started a well-published trip from New York to Africa before his plane came apart and he plunged into Long Island Sound. Julian raised funds for the defense of Ethiopia after the Italian invasion in 1935 and went to Ethiopia to offer his services to Emperor Haile Selassie.

Though African-American participation in aerospace activities during this period was segregated, there was much activity by a large number of black pilots and pilot organizations during the interwar years. John C. Robinson, who in 1931 organized the Challenger Air Pilots Association in Chicago to pro-

mote aviation in the black community, was a strong leader. In 1935 he replaced Julian as Haile Selassie's advisor for the Ethiopian Air Force. Also in 1931, the Curtiss-Wright Aeronautical School in Chicago graduated its first black class certified as pilots and aircraft mechanics. This class included both men and women. Soon after, in 1933, the first airstrip was built in the black town of Robbins, Ill., by the Challenger Air Pilots Association. Janet H. Waterford Bragg, a nurse and a member of the group, bought their first airplane. *Chicago Defender* publisher Robert ABBOTT worked tirelessly to promote interest in aviation in the black community, and lobbied Congress unsuccessfully for black inclusion in federal aviation training programs. Abbott also sponsored tours by African-American aviators to black colleges to foster black interest in airplanes and hired Bragg to write a weekly column on "The Negro in Aviation" for the *Defender*. Another pioneer was John. W. Greene, Jr., who received a limited commercial and transport pilot license in 1937 and was certified as an aircraft and engine mechanic. In later years, he established an aviation mechanics course at Phelps Vocational School in Washington, D.C., and an airport at Croom, Md. Several other African Americans received pilot's licenses during the 1930s, including Harold Hurd (1931), Earl W. Renfroe (1934), and Perry H. Young, Jr. (1939). In 1938, Grover C. Nash became the first black Air Mail carrier, flying an intrastate route through Illinois. A few pilots, such as Willie "Suicide" Jones and Dorothy Darby, made a living as barnstorming daredevils. Chauncey C. Spencer became well known after a parachute jump at a black air show in Chicago in 1939.

Perhaps the most influential African-American pilots and teachers were Cornelius R. Coffey and his wife, Willia B. Brown, who founded the Coffey School of Aeronautics at Harlem Airport in southwest Chicago. Coffey, an African American, was a certified aircraft and engine mechanic and instructor as well as the holder of a limited commercial pilot's license. Brown, a licensed mechanic and pilot, later became a lieutenant, the first African-American officer, in the Civil Air Patrol. She and Janet Bragg became the first African-American women to earn commercial pilot's licenses.

During the 1930s African Americans managed to make a series of long-distance flights. In 1932 pilot James Herman Banning and aircraft mechanic Thomas C. Allen were the first blacks to fly across the continent. Pilots Charles Alfred "Chief" Anderson and Dr. Albert E. Forsythe completed the first round-trip transcontinental flight by African-American pilots: in 1933 they flew between Atlantic City and Los Angeles in a Fairchild 24 named "Pride of Atlantic City." A year later Anderson and For-

sythe made a well-publicized Pan American Goodwill flight in a Lambert Monocouple, the "Spirit of Booker T. Washington," stopping at numerous locations in the Caribbean and South America.

The military buildup of the United States prior to World War II brought about an enormous expansion of the U.S. Army Air Corps. However, the Air Corps remained closed to blacks. In 1940, Coffey, Brown, and Enoch P. Waters started the National Airmen's Association of America to push for the inclusion of blacks in the federal government's Civilian Pilot Training Program (CPTP), which trained reserve pilots who could later be activated for military service. Association pilots Chauncey Spenser and Dale White, supported by the *Chicago Defender,* flew 3,000 miles roundtrip from Chicago to Washington on a whirlwind lobbying trip to meet with members of Congress to request the inclusion of African Americans in the CPTP. In 1941 the CPTP set up an emergency training program at black colleges and the Coffey school, which trained 2,000 black pilots. Four hundred fifty of them eventually saw combat in World War II.

The pressure exerted by blacks and their white allies led to a small initial project. On March 22, 1941 the (newly-renamed) U.S. Army Air Force activated the highly successful and now-famous all-black 99th Pursuit (later Fighter) Squadron, organized by pilots already trained by the CPTP, at Tuskegee Army Air Field under Anderson. The creation of the "Tuskegee Airmen" unit was opposed by many in the Air Corps, the War Department, and Congress. In 1942 the 99th was put under the command of an African-American officer, Col. Benjamin O. DAVIS, Jr. Racism was so pervasive in the training of African-American fighter pilots and officers that riots occurred at several training sites in the South and Midwest. Despite inadequate training and small numbers, the "Tuskegee Airmen" were sent to North Africa. Attached to the white 33rd Fighter Group in the Mediterranean theater, the 99th performed creditably. On July 2, 1943, Charles Hall became the first African-American pilot to shoot down an enemy fighter. Hall later received the Distinguished Flying Cross, as did pilot Wendell Pruitt. Late in 1943, the 99th Squadron merged with three other Fighter squadrons trained at Tuskegee to form the 332nd Fighter Group (the 447th Bombardment Group, which never saw combat, was created the same year). The 332nd was sent to Europe, where its African-American pilots distinguished themselves as bomber escorts.

On July 26, 1948, President Harry S. Truman officially terminated segregation in the armed forces when he signed Executive Order 9981. African-American pilots were slowly integrated into formerly

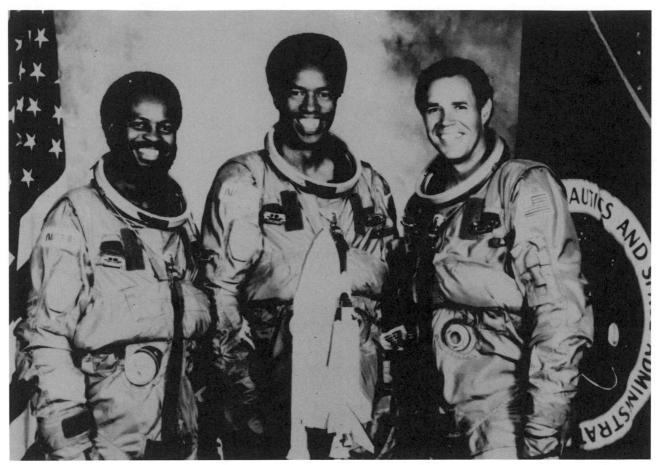

The first three African–American astronauts (from left to right), Dr. Ronald McNair, Maj. Guy Bluford, and Maj. Frederick D. Gregory in 1979. Bluford was the first African American in space, first orbiting Earth in August 1983. He went on three subsequent flights through 1992. Gregory flew on a space shuttle mission in April 1985. McNair had a successful flight in February 1984, before losing his life in the *Challenger* explosion in January 1986. (AP/Wide World Photos)

all-white units. Jessie L. Brown, who became the first naval air pilot, received a posthumous Distinguished Flying Cross and Air Medal for his flying during the Korean War, and his colleague Thomas J. Hudner won the Medal of Honor. By the close of the Korean War, blacks were participating in all activities of the U.S. Air Force and U.S. Army Air Cavalry units. African Americans held officer rank at all levels. Benjamin O. Davis, Jr. was promoted to lieutenant general of the Air Force in 1954. In the years following the Vietnam War, Daniel "Chappy" James was promoted to four-star general, and made head of the North American Defense Command (NORAD).

Following the Korean War, African Americans began to be active in commercial aviation as fixed wing pilots, rotorcraft pilots, flight attendants, aircraft owners, airline operators, and executives. In 1956 New York Airways hired Perry H. Young, Jr., a former civilian flight instructor at Tuskegee Air Field, as a licensed helicopter pilot. Young remained the

only African-American helicopter pilot for many years. More recent helicopter pilots of distinction and achievement have been Julian Council and Jerry R. Curry. In 1958, following years of effort by the New York State Commission Against Discrimination, Mohawk Airlines hired Ruth Carol Taylor of Ithaca, N.Y., as the first African-American flight attendant. In 1965 a notable antidiscrimination lawsuit by Marlon D. Green against Continental Airlines forced airlines to hire black pilots, and Continental, Eastern Airlines, and Trans World Airlines soon hired black commercial pilots, executives, and mechanics and engineers. Shortly thereafter, Capt. David Harris of American Airlines became the first black captain of a major airline. Texas International Airlines hired Jill Brown as the first African-American woman airplane captain in 1971. James O. Plinton, Jr., another Tuskegee Air Field veteran, was vice president of Eastern from 1971 to 1979. Meanwhile, Warren Wheeler, a former pilot for Piedmont Airlines (1967–69), began

Wheeler Flight Services, Inc., the first black-owned airline, in 1969.

U.S. aircraft manufacturers also recognized the value of black aerospace engineers. Beginning in the early 1950s, Douglas Aircraft Company and the Northrop Corporation led the way in hiring. Beginning in the mid-1960s, African Americans became active in all areas of the U.S. aerospace industry, education, and government. Black men and women have been valued performers in all aspects of America's aerospace activities. They include outstanding scientists and technologists such as Drs. George Carruthers, Christine Darden, Wesley L. Harris, Robert L. Norwood, Lonnie Reid, and Woodrow Whitlow. Also active have been Dr. Julian Earls, Isaac Gilliam, IV, John Hines, Wanda A. Sigur, and Earl Washington. Within this group of outstanding African Americans, Wesley L. Harris was the first to obtain the rank of full professor in the Department of Aeronautics and Astronautics at the Massachusetts Institute of Technology (MIT) and the first to be elected Fellow of the American Institute of Aeronautics and Astronautics. Woodrow Whitlow, a student of Harris's, is the first African American to receive a Ph.D. in aeronautics and astronautics from MIT and the first to be a branch chief at the National Aeronautics and Space Administration (NASA) Langley Research Center.

An outstanding group of black astronauts and scientists have supported America's space program. In 1962 Dr. Vance H. Marchbanks, Jr. was a mission control specialist during astronaut John Glenn's orbital flight. Edward DWIGHT, Jr., who in 1963 became the first African American accepted into the United States space program, was eventually passed over by NASA, a move that sparked widespread protest. In 1967 Major Robert Lawrence was selected for the Department of Defense's Manned Orbital Laboratory (MOL) program. He died six months later in a plane crash. Guion S. BLUFORD, Jr., a Vietnam War veteran who has a Ph.D. in aerospace engineering, was the first African American in space (August 30, 1983, on board the space shuttle *Challenger*). Frederick D. GREGORY became the first African American to pilot a space mission on April 29, 1985 at the controls of the space shuttle *Challenger/Spacelab 3*. Ronald E. MCNAIR was the first African American to conduct experiments in space (aboard *Challenger*, February 3, 1984). McNair was killed in the *Challenger* explosion on January 28, 1986. Other African American astronauts with flight experience include Charles F. BOLDEN and Mae C. JEMISON, who in September 1992 became the first African-American woman in space.

In the 1980s and '90s the rich heritage of African-American aviation has received increased attention. In 1982, "Black Wings," an exhibit on black aviation pioneers, appeared at the Smithsonian Institution in Washington, D.C. The Tuskegee Airmen have been recognized in several books and a television documentary.

REFERENCES

GROPMAN, ALAN L. *The Air Force Integrates: 1945–1964*. Washington, D.C., 1978.
HARDESTY, VON and DOMINICK PISANO. *Black Wings: The American Black in Aviation*. Washington, D.C., 1983.
OSUR, ALAN M. *Blacks in the Army Air Forces During World War II: The Problem of Race Relations*. Washington, D.C., 1977.
SANDLER, STANLEY. *Segregated Skies: All-Black Combat Squadrons of World War II*. Washington, D.C., 1992.
STINSON, SONYA. "African Americans in Aerospace and Defense." *Journal of the National Technical Association* 63, no. 2 (Fall 1989): 50–68.

WESLEY L. HARRIS

Affirmative Action. Affirmative action is an act, policy, plan or program designed to remedy the negative effects of wrongful discrimination. "Affirmative action" can remedy the perceived injustice of discrimination on the basis of a person's race, national origin, ethnicity, language, sex, religion, disability, sexual orientation, or affiliation. As a civil rights policy affecting African Americans, "affirmative action" most often denotes race-conscious and result-oriented efforts undertaken by private entities and government officials to correct the unequal distribution of economic opportunity and education that many attribute to slavery, segregation and racism.

What counts as affirmative action varies from one field to the next. Affirmative action in employment has generally meant seeking to hire a racially mixed and balanced workforce that includes a representative number of Americans of African, Latin, Asian-Pacific, or native ancestry, using the distribution of minority groups in the national or local population to gauge adequate representation. Self-described "equal opportunity/affirmative action" employers may voluntarily seek to hire African Americans, sometimes with explicit numerical goals and timetables in mind. For example, an employer whose workforce is 2 percent African American begins to hire additional blacks aiming at a workforce that will eventually include 10 percent African Americans, 3 percent of whom will occupy management positions within three years.

Employers may base affirmative-action programs on the assumption that they can achieve racially balanced workforces through race-conscious hiring and

promotion preferences. Preferential employment strategies involve affirmative action on behalf of a racial minority group when a person's minority race results in employment for which race is not otherwise a significant qualification. A person's race may sometimes be a bona fide job-related qualification (Fullinwider 1980). For instance, undercover police work in black neighborhoods may require black police officers; realistic filmmaking about African-American history may require black actors. In such instances, preferring black workers is not affirmative action.

Not all racial preferences involve affirmative action and not all affirmative action involves racial preferences. For example, to attract more African-American job applicants, an employer with a mainly white workforce begins to advertise job openings in the city's neighborhood newspapers, including newspapers circulated in black neighborhoods. This change in practice is potentially effective affirmative action, but it is not preferential treatment in the sense of according blacks employment advantages over whites or other groups (Greenawalt 1983). However, if the same employer committed itself to hiring blacks over similarly qualified or better qualified whites, or by exempting blacks from the adverse impact of seniority rules, one could describe the employer as according blacks preferential treatment as an affirmative-action measure.

Affirmative action in public and private education has focused on such race-conscious programs as "desegregation," "integration," "diversity," and "multiculturalism." Whether voluntarily or pursuant to court orders, to achieve desegregation in public primary and secondary schools formerly subject to state-imposed racial segregation, school officials have expressly mandated numerical goals, ratios and quotas for faculty hiring and pupil enrollment. At some schools, voluntary affirmative action has meant allocating financial resources to recruiting and retaining minority students with special scholarships, curricula, and social programs. At others, it has also meant admissions procedures that deemphasize standardized test scores and other traditional qualifications. Some colleges and universities have adopted legally controversial minority admissions quotas or diversity criteria aimed at enrolling a representative percentage of nonwhite students each year. In many schools the ideal of a diverse, multicultural student body is thought to require affirmative action to employ teachers and to enroll and retain students of varied racial and ethnic backgrounds.

Beyond employment and education, the distribution of public or private benefits on the basis of race for the remedial purpose of redressing group discrimination fits the definition of affirmative action. Hence, minority "set-aside" requirements that reserve a percentage of public contracts for minority businesses qualify as affirmative action. The concept also reaches special effort made by public and private scientific, humanistic, and arts organizations to disburse a share of their grants, awards, and prizes to members of once-neglected minority groups. The concept even reaches redistricting to aggregate minority voters into district that remedy a history of inadequate political representation. Telling evidence of the link some see between affirmative-action quotas and voting rights was exemplified in 1993 when University of Pennsylvania law professor Lani Guinier's scholarly explorations of cumulative voting and other novel strategies to strengthen minority voting rights earned her the epithet "Quota Queen" among conservatives, who successfully thwarted her presidential appointment to head the Civil Rights Division of the Justice Department.

Viewing affirmative action goals as quotas is often designed to suggest "that they, like yesterday's quotas, serve an immoral end" (Erzorsky 1991). Indeed, the affirmative action practiced in employment, education and other fields has excited intense moral and legal debate. The debate centers on the charges that race-conscious remedies designed to redress invidious discrimination against some groups amount to wrongful "reverse discrimination" against others (Steele 1990). Opponents of affirmative action raise particular concern about any form of affirmative action that involves numerical mandates, especially goals and quotas. Although *goals* often connotes flexible guidelines for group inclusion and *quotas* often connote rigid limits with discriminatory intent, both entail optimal percentages or numbers of persons belonging to specific groups targeted to serve in specific capacities (Fullwinder 1980). The strongest proponents of affirmative action argue that numerical mandates, whether termed "goals" or "quotas," are just and effective remedies for persistent discrimination (Johnson 1992).

History

The idea that special effort is needed to remedy discrimination on the basis of race is as old as President Abraham Lincoln's Emancipation Proclamation and the Thirteenth Amendment to the Constitution ending slavery. However, affirmative action as a distinct race-relations policy did not come about until the crest of the Civil Rights Movement of the 1960s. The term "affirmative action" quietly made its debut in American law in 1935, the year Congress passed the Wagner Act, expressly requiring "affirmative action" of employers guilty of discrimination against workers on the basis of union membership.

In June 1941, President Franklin D. Roosevelt issued Executive Order 8802, a precursor of

affirmative-action policies in the arena of race relations, which called for "special measures" and "certain action" to end "discrimination in the employment of workers in the defense industries or government [occurring] because of race, creed, color, or national origin." Roosevelt's historic move was intended to boost the wartime economy and reduce severe black unemployment, as urged by A. Philip RANDOLPH and other leaders. Executive Order 8802 was not consistently enforced, but in some states sudden black competition for traditionally white jobs prompted hostility and violence against blacks.

Internal White House discussions of employment policy during the presidency of Dwight D. Eisenhower included consideration of mandatory affirmative action. On March 8, 1961, President John F. Kennedy issued Executive Order 10925 establishing a President's Committee on Equal Employment Opportunity to expand and strengthen efforts to promote full equality of employment opportunity across racial lines. Order 10925 also required that all government contractors agree not to "discriminate against any employee or applicant for employment because of race, creed, color or national origin" and to "take affirmative action to ensure that applicants are employed, and that employees are treated during employment, without regard to their race, creed, color, or national origin."

The monumental Civil Rights Act of 1964 outlawed the most blatant forms of racial discrimination in employment, education, housing, public accommodations, and voting. The 1964 Act desegregated restaurants, cinemas, retail stores, hotels, transportation, and beaches. Building on *Brown* v. *Board of Education* (1954), the historic Supreme Court decision that ended legal racial segregation of public primary and secondary schools and pronounced that school desegregation should occur "with all deliberate speed," the Act blocked federal aid to segregated schools. The Act banned unequal application of the requirements of voter registration. The Voting Rights Act of 1965 went even further in protecting the franchise, restricting literacy tests and authorizing federal election supervision in the states. Title VII of the 1964 Act banned discrimination by employers of twenty-five or more, labor unions and employment agencies, and created the Equal Employment Opportunity Commission (EEOC). Title VII empowered the federal courts to order "affirmative action as may be appropriate" to remedy past workplace discrimination.

Finally, on September 28, 1965, in the wake of the Civil Rights Act of 1964, President Lyndon B. Johnson's Executive Order 11246 launched affirmative action as the centerpiece of national employment policy and race relations. Aimed at "the full realization of equal employment opportunity," Executive Order 11246, like Kennedy's earlier order, required that firms conducting business with the federal government and these firms' suppliers "take affirmative action to ensure that applicants are employed, and that employees are treated during employment, without regard to their race, creed, color, or national origin." Order 11246 was amended by Executive Order 11375 and implemented by Labor Department Revised Order No. 4, requiring that government contractors in "good faith" set "goals" and "timetables" for employing previously "underutilized" minority group members available and qualified for hire. The Labor Department's Office of Federal Contract Compliance, awarded responsibility for implementing Order 11246 and its amendments, developed regulations defining a program of "affirmative action" as "a set of specific and result-oriented procedures" undertaken with "every good faith effort" to bring about "equal employment opportunity." Vice President Hubert Humphrey coordinated the Johnson administration's civil rights and affirmative action policies. On August 20, 1965, at a White House conference on equal employment opportunity, Humphrey had revealed a broad understanding of the economic plight of blacks. Humphrey said America had "neglected the Negro too long" and that "government, business and labor must open more jobs to Negroes [and] must go out and affirmatively seek those persons who are qualified and begin to train those who are not."

In 1967, the Department of Health, Education and Welfare (HEW) began requiring colleges and universities receiving federal funds to establish affirmative-action goals for employing female and minority faculty members. In 1972, HEW issued guidelines for higher education requiring both nondiscrimination and efforts to recruit, employ, and promote members of formerly excluded groups "even if that exclusion cannot be traced to particular discriminatory actions on the part of the employer." The HEW guidelines also indicated that colleges and universities were not expected to lower their standards or employ less qualified job candidates. The HEW guidelines distinguished affirmative-action "goals," which its directives required as an indicator of probable compliance, from "quotas" which its directives expressly prohibited. Critics of HEW have argued that a firm distinction is untenable since "a positive 'goal' for one group must be a negative 'quota' for another" (Goldman 1977). Numerous efforts to distinguish goals from quotas have left some analysts unpersuaded: although the purpose of goals may be inclusion and quotas exclusion, "getting people in, where the shape of the 'in' is fixed, will be possible only by keeping others out" (Fullinwider 1980).

By the early 1970s affirmative action in employment became a full-fledged national policy. The EEOC had taken the stand that an obligation of result-oriented affirmative action extended to all employers within its jurisdiction, not just federal contractors or educational institutions receiving federal funds. Political support for the federal government's affirmative action initiatives was initially strong and broad based. Some maintained that affirmative action utilizing numerical goals and timetables was a necessary complement to the 1964 Civil Rights statutes. A century after the formal abolition of slavery, African Americans as a group remained substantially poorer, less well educated, and politically less powerful than whites as a group. Legally enforced segregation had intensified black inequality.

The leadership of the NAACP, the Congress on Racial Equality, the NAACP Legal and Educational Defense Fund, and the National Urban League quickly endorsed affirmative action. Diverse sectors of the economy promptly responded to Washington's affirmative action programs. For example, in 1966, the city of New York, the Roman Catholic Church in Michigan, and the Texas-based retailer Neiman Marcus were among the organizations announcing voluntary plans requiring that their suppliers and other contractors to take affirmative steps toward hiring African Americans.

The political popularity of affirmative action during the Johnson administration subsequently yielded to controversy. An erosion of political support in Congress and the White House for higher education affirmative action programs was evident as early as 1972, seemingly prompted by opposition from faculty members and administrators fearing the demise of traditional standards of scholarly merit. In 1975, the United States Attorney General Edward H. Levi publicly stated that affirmative action constitutes "quotas" and is "not good government." After 1976 both during and after the one-term presidency of the pro-affirmative action Democrat Jimmy Carter, disagreements over the legality, morality, and efficacy of affirmative action strained African-Americans' relationships with labor unions, the Republican Party, and white liberal Democrats, including Jewish liberals who supported the Civil Rights Movement but who were suspicious of government-backed racial quotas that historically had been used to exclude Jews.

Ronald Reagan and George Bush campaigned for the presidency on opposition to affirmative-action "quotas." President Reagan spoke out against affirmative action's numerical goals and quotas, and this opposition became one of the cornerstones of his public policy agenda on issues affecting African Americans. High-profile conservatives defended the ideal of a colorblind society and characterized blacks as overly dependent upon welfare, affirmative action, and other government programs promulgated chiefly by liberal democrats. *Time* and *Newsweek* magazines, as well as other mainstream media, lavished more publicity on affirmative-action controversies than any other topic related to blacks, including unemployment, health, hunger, and homelessness (Daniel and Allen 1988). The NAACP and the National Urban League maintained their support for affirmative action and the civil rights laws. Consistent with the Reagan agenda, however, the federal government lessened its enforcement of federal contracts compliance programs in the 1980s and a number of Supreme Court cases curbed affirmative action in employment and other key fields.

In the 1990s some were prepared to attribute significant gains for blacks to affirmative action, including an increase in black employment and promotion at major corporations, in heavy industry, in police and fire departments, and in higher education (Erzorsky 1991). Yet, persistent critics converted "affirmative action" into a virtual perjorative, along with "preferential treatment," "reverse discrimination," and "quotas." Symbolic of the era, Democrat Bill Clinton, a supporter of affirmative-action policies, after election to the presidency in 1992 abruptly withdrew the nomination of Lani Guinier to the Justice Department after her critics labeled her affirmative-action policies as outside the mainstream.

Moral and Policy Debates

Reflecting ties to the civil rights movement, the stated goals of affirmative action range from the forward-looking goal of improving society by remedying distributive inequities, to the backward-looking goal of righting historic wrongs (Erzorsky 1991; McGary 1977–78). Affirmative action on behalf of African Americans often was, and often is, defended by scholars as compensation or reparation owed to blacks by whites or a white-dominated society (Boxhill 1984; Thomson 1977). In particular, it is argued that after two centuries of legally enforced slavery, racial segregation, and racism, African Americans now deserve the jobs, education, and other benefits made possible through affirmative action. Beyond compensatory or reparative justice, goals ascribed to affirmative action include promoting economic opportunity for minority groups and individuals; eradicating racial subordination; neutralizing the competitive advantages many whites enjoy in education, business, and employment; educating a cadre of minority professionals for service in underserved minority communities; creating minority role models, intellectuals, artists, and civic leaders; and, finally, acknowledging society's cultural diversity (Goldberg 1994; Ezorsky 1991; Boxhill 1984; Greenawalt 1983).

African Americans widely support affirmative action-policies. To be sure, some African-American neoconservatives, such as Glen Loury, Thomas Sowell, and Clarence THOMAS, have rejected affirmative action on the grounds that it is incompatible with a "colorblind" civil rights policy. Other African Americans sometimes have also criticized affirmative action, often on pragmatic grounds (Carter 1991; Steele 1990; Wilson 1987). They have joined those who argue that preferential treatment in education and employment mainly benefits middle-class blacks, leaving the problem of profound rural and urban black poverty untouched (Goldman 1979; Cohen 1980). Critics say affirmative action reinforces pervasive negative stereotypes of blacks as inferior to whites (Jencks, 1983). African Americans have noted this and have argued that racial preferences are demeaning or dispiriting to minorities; that they compromise African-Americans' self-esteem or self-respect (Sowell 1976). Some reject affirmative action because it has proven to be socially divisive, having bred resentment among white Americans (Nagel 1977).

As an antidote to simmering white resentments, William J. Wilson (1987) has proposed promoting race-neutral "universal policies" aimed at the health and employment problems of the poor rather than merely promoting affirmative action for racial minorities. The search for factors beyond race and racism to explain persistent black inequality in the post civil rights era has led some politically conservative opponents of affirmative action to advance the argument that minority economic inequality stems from a pervasive breakdown in work, family, and community values in minority communities.

Supporters of affirmative action offer pertinent replies to all of these arguments (Erzorsky 1991). To the contention that affirmative action does not help the poorest blacks, a reply has been that affirmative action nonetheless enhances the lives of some deserving blacks. To the argument that affirmative action lowers esteem for blacks and blacks' self-esteem, a reply is that blacks are held in very low esteem already and are vulnerable to low self-esteem due to their inferior education and employment. To the argument that affirmative action is racially divisive and breeds resentment, a reply is that blacks should not be deprived of the benefits of affirmative action simply because of white resentment, unless that resentment can be shown to stem from genuine racial injustice. Finally, to the "fingerpointing" argument that blacks' problems result from lapses of individual responsibility, one reply is that communities of poverty, drugs, and violence result from decades of private and public decision making concerning legal, economic, and social policy.

Gertrude Erzorsky (1991), who supports affirmative action, has noted a libertarian argument against affirmative action: employers should be free to choose their own workers as a basic moral freedom, comparable to the freedom to choose one's own spouse. The more common libertarian argument asserts that social and economics benefits should be distributed solely in accordance with colorblind principles of entitlement, merit, and personal. In liberal academic and intellectual circles, opponents of affirmative action have questioned the coherence of the idea that blacks as a group are entitled to, merit or deserve affirmative action as compensation or reparations for past wrongdoing (Sher 1977). Corrective justice, some philosophers say, is both causal and relational. That is, when an injury occurs, the person who caused that injury must personally pay his or her victim. Yet affirmative action makes white males pay for societal injuries to women and minorities that they did not cause (Paul 1991). The ex-slaves wronged by slavery are dead, as are the people who wronged them. It is therefore illogical, the argument continues, to hold all current whites responsible for the evils of slavery that were perpetrated by the remote ancestors of some whites on the remote ancestors of some blacks (Sher 1977). In sum, set-asides and other preferential programs that fall under the rubric of affirmative action "reward an ill-defined class of victims, indiscriminately favor some in that class and leave others totally uncompensated, benefit groups whose members were never the victims of state imposed discrimination, and most importantly, do not concentrate recompense on those whose rights were most flagrantly violated, namely, the black slaves, now long dead" (Simon 1977).

Against the argument that African Americans who stand to benefit by affirmative action were never in bondage to whites and may have led lives free of egregious discrimination, some philosophers defend affirmative action as a moral right of persons belonging to groups that have been uniquely harmed in the past by public law and that are disproportionately poor or otherwise disadvantaged today. Admitting that white citizens are not personally at fault for slavery and may not harbor racist sentiments, these advocates of affirmative action observe that white citizens benefit from the system of racial privilege and institutional racism that continued to pervade American institutions after blacks' emancipation from slavery and segregation (Thomson 1977). Whites have a competitive advantage over blacks that society may fairly seek to erase through affirmative action.

Legal Dimensions
Frequently challenged in the courts of scholarly and public opinion, affirmative action also has been liti-

gated frequently in the nation's federal courts. The question of the legality of racial quotas and other affirmative-action measures has no simple answer. Between 1969 and 1993 alone, the Supreme Court decided more than twenty major cases relating to the legality of diverse race-conscious remedies. In the same period at least five cases considered the legality of affirmative action on behalf of women. While a number of these twenty-five cases validated one or another form of affirmative action, several important cases related to education, employment, minority business opportunity, and voting rejected it as a legal strategy.

Paramount in affirmative-action cases are the implications of Title VII of the Civil Rights Act of 1964 and other civil rights statutes enacted by Congress. Equally important when plaintiffs contest affirmative action by governmental entities are the principles of equal protection embodied in the Fifth and Fourteenth Amendments of the Constitution. The U.S. Supreme Court has established that the Constitution prohibits discrimination on the basis of race by state and federal government, as a denial of equal protection of law. The Court's equal protection jurisprudence presumes that racial classifications are potentially invidious, giving rise to the need for "strict scrutiny" when challenged. Defined as a stringent, virtually impassable, standard of judicial review, strict scrutiny requires that government to justify its law or conduct by appeal to a compelling governmental interest. The constitutional conundrum posed by affirmative action is whether the provisions of the Constitution that presumptively ban state and federal government discrimination on the basis of race and entail the need for strict scrutiny review, nonetheless permit the use of the race-conscious remedies to redress racial discrimination. Whether framed by constitutional or statutory questions, affirmative-action cases commonly involve procedural complexities relating to assigning the burdens of proving or disproving that the absence of minorities or women in an institution is the result of intentional or other unlawful discrimination.

Endorsing Race-Conscious Remedies

The Supreme Court unanimously endorsed quotas and other race-conscious numerical requirements to achieve school desegregation in *United States* v. *Montgomery County Board of Education* (1969) and *Swann* v. *Charlotte-Mecklenburg Board of Education* (1971). In a different context, the Court again endorsed race-conscious remedies in *United Jewish Organizations* v. *Carey* (1977). Over Fourteenth Amendment and other constitutional objections, the Court upheld a New York redistricting plan that explicitly attempted to increase the voting strength of "nonwhite" voters—blacks and Puerto Ricans—seemingly at the expense of a community of Hasidic Jews, viewed as whites under the plan. Four justices agreed that the use of race as a factor in districting and apportionment is constitutionally permissible; that express findings of past discrimination were not required to justify race-conscious policies; and that racial quotas in electoral districting were not by definition unconstitutional. Chief Justice Warren Burger dissented from the judgment of the Court, stressing his discomfort with putting the "imprimatur of the State on the concept that race is a proper consideration in the electoral process."

Seniority Limits on Workplace Preferences

In 1977, the Court established a limitation on affirmative action that it would reiterate in subsequent cases. *International Brotherhood of Teamsters* v. *United States* (1977) held that a disparate impact on minorities alone does not make a seniority system illegal under Title VII. Justice Thurgood Marshall partly dissented from the majority, joined by Justice William Brennan. The Court's lone African-American justice, Marshall cited Federal Court of Appeals opinions, EEOC decisions, scholarly materials, and legislative history to attest to the broadness of the remedial goal of Title VII. Marshall admitted that Congress had expressed reservations about orders of retroactive seniority in a nonremedial context or based solely upon a showing of a policy's disparate impact on minorities without any evidence of discriminatory intent. But Marshall argued that Congress did not clearly intend to preserve seniority systems that perpetuate the effects of discrimination. Seven years after the teamsters came, *Firefighters Local Union No. 1784* v. *Stotts* (1984) overturned a District Court's injunction prohibiting the city of Memphis from following its seniority system's "last hired, first fired" policy during layoffs. In *Wygant* v. *Jackson Board of Education* (1986), Justice Marshall again dissented from a ruling elevating seniority rules over affirmative action principles. Here the Court invalidated the provision of a collective bargaining agreement between a school board and the local teachers' union that would have preserved minority representations in teaching staff in the event of layoffs. Justice Powell applied strict scrutiny to the contested provision arguing for the Court that strict scrutiny applies to any racial classification, even when the classification "operates against a group that historically has not been subject to discrimination." Justices Sandra Day O'Connor and Justice Byron White concurred in the use of strict scrutiny review to assess the impact of affirmative action on whites.

Professional School Admissions: No Strict Quotas

Two cases involving affirmative action in law and medical school admissions evidence the Court's judgment of limited constitutional tolerance for affirmative-action plans involving numerical quotas: *Defunis* v. *Oregaard* (1977) and *Regents of the University of California* v. *Bakke* (1978). In *Defunis,* a law school applicant challenged the race-conscious admissions policies of the state-supported University of Washington Law School as a violation of his right to equal protection under the Fourteenth Amendment. The school had established a separate admissions process for minorities and a fifteen to twenty percent admissions goal for applicants who described their dominant ethnic origin as black, Chicano, American Indian, or Filipino. The Defunis case was not decided on its merits; the Court declared the case moot after Defunis matriculated in law school during the pendency of the suit. However, in a dissenting opinion, Justice William O. Douglas criticized conventional law school admissions criteria and stressed that schools can and should broaden their inquiries beyond test scores and grades. Douglas opined that race could be a factor in admissions, consistent with the constitutional requirement of race neutral evaluation, so long as all persons are judged "on an individual basis, rather than according to racial classifications."

Decided fully on the merits, the highly publicized *Bakke* case struck down the special admissions program of the public Medical School of the University of California at Davis. The program featured a sixteen percent quota for "blacks, Chicanos, Asians, and American Indians." The purpose of the program was to increase minority representation in the medical field, to compensate minorities for past societal discrimination, to increase medical care in underserved communities, and to diversify the student body. Allen Bakke, a twice-rejected white applicant to the medical school, challenged its admissions program both under Title VI of the Civil Rights Act of 1964 and under the Equal Protection Clause of the Fourteenth Amendment.

The court issued a long and complex series of opinions to resolve Bakke's case. In the final analysis, the case declares minority admissions quotas unlawful at schools receiving federal dollars, but upholds the use of race as a factor in selecting a diverse student body. Five members of the Court affirmed the illegality of the Davis program and directed Bakke to be admitted to the school. Justice Powell affirmed the illegality of the school's admissions program, but voted with Justices Brennan, White, Marshall, and Blackmun to approve the use of race as a factor in higher education admissions. Justice Stevens and three others thought it unnecessary to decide the constitutional issues raised by the case, finding that the admissions policy was invalid under Title VI. They ascertained that the plain language of the statute prohibiting discrimination was sufficient justification for nullifying the program.

The dissenting opinion of Justices Brennan, White, Marshall, and Blackmun cautioned that the nation's "colorblind" values were purely aspirational. They argued that a reading of the history and purpose of Title VI did not rule out race-conscious remedies. Taking up the constitutional issues, these justices rejected strict scrutiny review in favor of a lower, "intermediate" level of scrutiny. They reasoned that intermediate scrutiny permits racial classification "substantially related to an important government objective" and concluded that the university's purpose of counteracting an actual or potential disparate racial impact stemming from discrimination was sufficiently important to justify race-conscious admissions. Justice Marshall also separately wrote a dissenting opinion expressing his sense of irony at the Court's reluctance to uphold race-conscious remedies: "[i]t is unnecessary in 20th century America to have individual Negroes demonstrate that they have been victims of racial discrimination; the racism of our society has been so pervasive that none, regardless of wealth or position, has managed to escape its impact."

In 1982 the Supreme Court again took up the subject of affirmative action in professional school admissions in *Mississippi University for Women* v. *Hogan.* The nursing school of the university denied full admission to male students (admitted only as auditors) on the grounds that the education of women was "educational affirmative action" intended to mitigate the adverse effects of discrimination on women. A man denied admission brought suit under the Equal Protection Clause. A five-justice majority that included Justices Marshall and O'Connor invalidated the single-sex policy on his behalf. Justice O'Connor wrote for the Court, applying the intermediate scrutiny standard of review. This same standard is the one the Court normally applies to gender classification cases brought under the Fourteenth Amendment's Equal Protection Clause. It is also the standard that Justice Marshall defended as appropriate for affirmative action cases involving *remedial* racial classifications. The Court required that Mississippi advance an "exceedingly persuasive justification" for its gender distinction in nursing education, that included a claim that the distinction was substantially related to an important government goal. Finding no such relationship or justification, the Court disparaged the

ideal of a single-sex learning environment in nursing as a "self-fulfilling prophecy" based on the stereotype that nursing is "women's work." Dissenting justices Powell, Blackmun, Rehnquist, and Chief Justice Burger denied that the case raised a serious question of gender discrimination. Powell stressed that no woman had complained about the school and that coed nursing education was available elsewhere in the state. Although the majority limited its holding to the nursing school, the dissenters raised concerns about the implication of the case for traditional same-sex higher education in the United States. It appears that affirmative action for women may not be used as a rationale for excluding men from women's traditional provinces.

Title VII Permits Voluntary Quotas

In a significant decision, the Supreme Court reconciled Title VII of the Civil Rights Act of 1964 with voluntary affirmative action programs in *United Steel Workers* v. *Weber* (1979). With a vote of 5 to 2 (two justices did not participate in the decision), the *Weber* case upheld an employer's affirmative-action plan that temporarily required a minimum of 50 percent African-American composition in a skill-training program established to increase African-American representation in skilled positions. The lower courts had ruled that *any* racial preferences violated Title VII, even if they were established in the context of an affirmative action plan. Importantly, the Court held that Title VII's ban on all racial discrimination did not apply to affirmative-action plans. Dissenting justices Burger and Rehnquist disagreed, arguing in separate opinions that the plain language of Title VII and its legislative history banned voluntary racial preferences, even those employed as affirmative-action remedies. *Newsweek* magazine reported the *Weber* decision as a "Victory for Quotas." Eleanor Holmes Norton, the African-American head of the EEOC, declared that "employers and unions no longer need fear that conscientious efforts to open job opportunities will be subjected to legal challenge." Senator Orrin Hatch responded differently, asserting that the purpose of the Civil Rights Act had not been to "guarantee any racial group a fixed proportion of the positions and perquisites available in American society" and that the "American dream" of true liberty was "in real danger."

In *Johnson* v. *Transportation Department* (1987) the court held (6 to 3) that Title VII permits affirmative consideration of employees' gender when awarding promotions. In *Johnson* the Court upheld the promotion of Diane Joyce, made according to the Transportation Agency of Santa Clara County's voluntarily adopted affirmative-action plan. Permitting the use of sex, minority status, and disability as factors

for promotional consideration, the plan survived a challenge under Title VII by a man passed over for a "road dispatcher" position. In another case, *Local No. 93, International Association of Firefighters* v. *Cleveland* (1986), the Court held that parties to a consent decree may agree to relief that might not be within a court's ordering authority under Title VII. An African-American and Latino firefighters' organization, the Vanguards, had filed a complaint against the city of Cleveland for intentional discrimination in "hiring, assignment and promotion." Since the city had previously been unsuccessful in defending other discrimination suits, it sought to settle with the Vanguards. Local 93 (Union) intervened, not bringing any claims for or against either party, but voicing strenuous opposition to a settlement including any race-conscious action. When a consent decree, which provided for the action was agreed upon and entered, the Union filed its unsuccessful formal complaint that the decree exceeded a court's authority under Title VII.

Title VII permits affirmative action that includes numerical goals, and may permit courts to order it. In *Local 28 of the Sheet Metal Workers' International Association* v. *EEOC* (1986), the Supreme Court upheld a court-ordered membership plan for a trade union found guilty of racial discrimination violating Title VII. The plan included a membership goal of 29 percent African American and Latino. The Court was again willing to permit a numerically based affirmative-action remedy in *United States* v. *Paradise* (1987). There the Court validated a temporary affirmative-action plan ordered by a lower court that required a one-for-one promotion ratio of whites to qualified blacks in the Alabama Department of Public Safety. The department had been found guilty of discrimination in 1972, but had failed to adopt promotion procedure that did not have a disparate impact on blacks. Justice William Brennan wrote an opinion arguing that the affirmative-action order was a narrowly tailored means to achieve a compelling government purpose, and it therefore met the requirements of strict scrutiny imposed by Fourteenth Amendment equal protection.

Noncongressional Business Set-Asides Set Aside

A year after the *Weber* case, in *Fullilove* v. *Klutznick* (1980), the Court upheld a provision of the congressional Public Works Employment Act, which mandated that ten percent of $4 billion in federal funds allocated for local public construction projects go to "minority business enterprises," statutorily defined as at least 50 percent owned by citizens who are "Negroes, Spanish-speaking, Oriental, Indians, Eskimos, and Aleuts." The provision had been challenged un-

der equal protection principles. Chief Justice Burger delivered the judgment of the Court, joined by Justices White and Powell. Justice Marshall, concurring in the judgment in *Fullilove* and joined in his opinion by Justices Brennan and Blackmun, argued that "Congress reasonably determined that race-conscious means were necessary to break down the barriers confronting participation by minority enterprises in federally funded public works projects." *Fullilove* survived contest in the Court at a time when critics of federal support for minority business enterprises argued that, in addition to raising questions of fairness raised by all affirmative action, the disbursal of funds under the 1977 Public Works Employment Act by the Commerce Department's Economic Development Administration was subject to abuse (Ross 1979). The Government Accounting Office uncovered hundreds of instances of federal dollars being awarded both to minority brokers serving as go-betweens for nonminority firms and government administrators; and to nonminority firms feigning minority ownership with the help of minority "fronts" installed as phony partners or owners.

Richmond v. *J. A. Croson Co.* (1989) successfully attacked an affirmative-action plan reserving specific numerical percentages of a public benefit for minorities. The invalidated "minority set-aside" plan required prime contractors with the city of Richmond to "subcontract at least 30 percent of the dollar amount of the contract to one or more Minority Business Enterprises." The plan was challenged under 42 U.S.C. §1983, a civil rights statute, by a nonminority firm who lost a contracting opportunity due to noncompliance with the program. The justices widely disagreed about the outcome and the reasoning of the case. Thus, Justice O'Connor delivered the opinion of the Court with respect to three of its parts, joined by Chief Justice Rehnquist and Justices Stevens, White, and Kennedy; Justices Stevens and Kennedy field separate partial concurrences; Justice Scalia field a concurring opinion; Justice Marshall dissented, joined in his opinion by Justices Brennan and Blackmun; finally, Justice Blackmun filed a dissenting opinion, joined by Justice Brennan. A major task for the majority was to explain how they could invalidate the set-aside in *Croson* when the Court had previously validated a similar set-aside in *Fullilove*. Justice O'Connor distinguished the *Fullilove* case on the ground that its set-aside had been created by Congress and involved an exercise of federal congressional power, whereas the set-aside in *Croson* was a creature of municipal government. Justice Thurgood Marshall dissented from the judgment in *Croson*, warning that the Court's ruling threatened all affirmative action plans not specifically enacted by Congress—virtually all plans.

Metro Broadcasting, Inc. v. *FCC* (1990) upheld two race-conscious Federal Communications Commission programs designed to enhance program diversity. The race-conscious set-asides were challenged under equal protection principles by a nonminority broadcasting company that had lost its bid to acquire a broadcasting license to a minority-owned company. The Court argued that programming diversity, a goal both the FCC and Congress linked to ownership diversity, was derived from the public's First Amendment interest in hearing a wide spectrum of ideas and viewpoints. The interest was a sufficiently important one to justify race-conscious allocation policies. Justice O'Connor and three other justices dissented from what they considered excessive deference to Congress and a refusal to apply strict scrutiny to an instance of race-conscious thinking grounded in racial stereotypes.

Future Directions

Decided by the slimmest majority and largely on unusual First Amendment grounds, *Metro Broadcasting* leaves standing the basis for Justice Marshall's concerns about the future of all affirmative action. So, too, does *Shaw* v. *Reno* (1993). This case held that white voters stated a legitimate Fourteenth Amendment equal protection claim against North Carolina for creating a voter redistricting plan described as "so irrational on its face that it c[ould] be understood only as an effort to segregate voters" on the basis of race. Justices White, Souter, and Stevens dissented. In an attempt to comply with the Voting Rights Act, North Carolina had created a redistricting plan with two irregularly shaped "majority-minority" (majority Black and Native American) districts. In reversing the lower court, the Court invoked the ideal of a "colorblind" society and warned of the dangers of "political apartheid." Nonetheless, the constitutionality of the districts was subsequently upheld by a federal judicial panel.

The ideal of a colorblind society continues to vex proponents of race-conscious remedies to discrimination. The greatest consistency in the evolving law of affirmative action is that, at any given time, its precise contour mirrors the mix of perspectives represented on the Court concerning the deepest purposes and meaning of the 1964 Civil Rights Act and the Fourteenth Amendment of the Constitution. The Supreme Court has upheld key affirmative-action measures in the past, and may again in the future, although a series of rulings in the the spring and summer of 1995 have cast considerable doubt on the allowable scope of affirmative action. Notably, in the case of *Adarand Constructors* v. *Peña* (1995) the Court ruled, 5 to 4, that the federal government's affirmative-action programs must be able to meet the same strict

standards for constitutional review as had previously been applied by the Court to state and local programs. Outside the courts, controversy continues.

REFERENCES

Erin Fatica assisted with the legal research for this entry.

BELZ, HERMAN. *Affirmative Action from Kennedy to Reagan: Redefining American Equality*. Washington, D.C., 1984.

BERRY, MARY FRANCIS, and JOHN W. BLASSINGAME. *Long Memory: The Black Experience in America*. New York, 1982.

BOXHILL, BERNARD. *Blacks and Social Justice*. Totowa, N.J., 1984.

CAPALDI, NICHOLAS. *Out of Order: Affirmative Action and the Crisis of Doctrinaire Liberalism*. Buffalo, N.Y., 1985.

CASHMAN, DEAN DENNIS. *African Americans and the Quest for Civil Rights, 1900–1990*. New York, 1990.

DANIEL, JACK, and ANITA ALLEN. "Newsmagazines and the Black Agenda." In Geneva Smitherman-Donaldson and Teun A. van Dijk, eds. *Discrimination and Discourse*. Detroit, 1988, pp. 23–45.

EASTLAND, TERRY, and WILLIAM BENNETT. *Counting by Race: Equality from the Founding Fathers to Bakke and Weber*. New York, 1979.

ERZORSKY, GERTRUDE. *Racism and Justice: The Case for Affirmative Action*. Ithaca, N.Y., 1991.

FINCH, MINNIE. *The NAACP: Its Fight for Justice*. Metuchen, N.J., 1981.

FULLINWIDER, ROBERT K. *The Reverse Discrimination Controversy: A Moral and Legal Analysis*. Totowa, N.J., 1980.

GOLDMAN, ALAN. *Justice and Reverse Discrimination*. Princeton, N.J., 1979.

GROSS, BARRY. *Discrimination in Reverse: Is Turn-about Fair Play?* New York, 1978.

GREEN, KATHANNE. *Affirmative Action and Principles of Justice*. New York, 1989.

GREENAWALT, KENT. *Discrimination and Reverse Discrimination*. New York, 1983.

HORNE, GERALD. *Reverse Discrimination: the Case for Affirmative Action*. New York, 1992.

JOHNSON, ALEX M. "Defending the Use of Quotas in Affirmative Action: Attacking Racism in the Nineties." *University of Illinois Law Review* 1992 (1992): 1043–1073.

KULL, ANDREW. *The Color-Blind Constitution*. Cambridge, Mass., 1992.

LIVINGSTON, JOHN C. *Fair Game? Inequality and Affirmative Action*. San Francisco, 1979.

LOURY, GLENN. "Why Should We Care About Group Inequality?" *Social Philosophy and Policy* 5 (1988): 249–271.

McGARY, HOWARD, JR., "Justice and Reparations." *Philosophical Forum* 9 (1977–78): 250–263.

MOSLEY, ALBERT G. "Affirmative Action and the Urban Underclass." In *The Underclass Question*. Philadelphia, 1992, pp. 140–151.

NEIMAN, DONALD G. *Promises to Keep: African Americans and the Constitutional Order, 1776 to the Present*. New York, 1991.

NEWTON, LISA. "Reverse Discrimination as Unjustified." *Ethics* 83 (1973): 1–4.

ROSENFELD, MICHEL. *Affirmative Action: a Philosophical and Constitutional Inquiry*. New Haven, Conn., 1991.

ROSSUM, RALPH A. *Reverse Discrimination: The Constitutional Debate*. New York, 1980.

SCHWARTZ, BERNARD, *Behind Bakke: Affirmative Action and the Supreme Court*. New York, 1988.

STEELE, SHELBY. "A Negative Vote on Affirmative Action." *New York Times Magazine*, May 13, 1990.

———. *The Content of Our Character: A New Vision of Race in America*. New York, 1990.

"A Stricter Standard for Affirmative Action." *New York Times*, July 21, 1995.

THOMSON, JUDITH J. "Preferential Hiring." In Marshall Cohen, Thomas Nagel, and Thomas Scanlon, eds. *Equality and Preferential Treatment*. Princeton, N.J., 1977, pp. 19–39.

WILSON, WILLIAM JULIUS. *The Truly Disadvantaged*. Chicago, 1987.

ANITA LAFRANCE ALLEN

Africa. This article deals with the African background of African Americans as a means of understanding the ecological aspects of the continent from which the ancestors of this population came, and the history and nature of the major biological, linguistic, and sociocultural processes that produced those Africans. Although many of these processes were continent-wide, specific attention is paid to West and Central Africa, the regions that contributed most of the ancestors of Africans in the New World.

African Americans may have more reasons than other people to ponder the symbolism in the very shape of Africa—a question mark. After pondering the question of their connection to Africa for several centuries, as did Countee CULLEN in his classic poem "Heritage," most African Americans now fully affirm their link with what Cullen described as a land of "Copper sun or scarlet sea/Jungle star or jungle track/Strong black men or regal black/Women from whose loins I sprang/When the birds of Eden sang." Today, African Americans point with pride to their many pan-African links, especially with black South Africans, whose political emancipation they view as ending the long, bitter years of alien domination of the continent. Many proudly wear articles associated with Ghana's "kente-cloth complex" (the royal colors of kings and queens).

Almost as soon as African Americans had mastered elements of European culture, they fought

against the notion that "the superior white man must bear the burden of civilizing colonial peoples of the world, if necessary against the will of those peoples" (Drake and Cayton 1970, p. 47). They especially resented and resisted the assertion that "The very existence of social order [in America] is believed to depend upon 'keep[ing] the Negro in his place' " (ibid., 756). African Americans were determined to disprove the implications of the belief that "it would be a matter of a thousand years before Africans could develop high forms of civilization or become dangerous to the white race" (Beale 1956, p. 44). The issue for African Americans was not to become "dangerous to the white race," but to liberate themselves and Africa from the control of those who questioned their very humanity. African Americans were determined to disprove the common belief that Africa had no history.

African Americans were among the first persons of African origin to insist that the brilliance of the Egyptian past is only one episode in the history of a continent that gave the world so much. Furthermore, while most of the ancestors of African Americans came from the Atlantic coasts of the continent, their cultural background undoubtedly shared many aspects of a widespread and ancient civilization. More than most continents, Africa has always been a veritable museum where kaleidoscopic cultural patterns from various epochs and their syntheses have coexisted. To avoid confusion, it is best to describe many aspects of Africa in the past tense—as part of history, since the African background often resonates as a heritage in the lives of its now far-flung peoples.

The Geography of Africa

A realm of abundant sunshine, Africa bisects the equator; 80 percent of its land mass falls between the Tropics of Cancer and Capricorn. The continent's 11.7 million square miles makes it more than three times the size of the United States, including Alaska. Its northern part borders the Mediterranean. To its east lie the Red Sea and the Indian Ocean; South Africa is surrounded by a confluence of the Indian and the Atlantic oceans. The Atlantic borders all of the western coasts of Africa. Madagascar, the largest of the continent's islands, lies to the southeast, surrounded by the Indian Ocean, and the other African islands—São Tomé, Principe, Bioko, Cape Verde, and the Canaries—are westward in the Atlantic Ocean.

Some geologists believe that Africa was the geomorphological core of an ancient supercontinent known as Gondwanaland. Around 200 million years ago this enormous land mass, averaging about 2,500 feet above sea level, fractured, leaving Africa as a high plateau of ancient Precambrian rocks sloping

toward the north, while the other pieces drifted away to form South America, the Indian subcontinent, Australia, and Antarctica. Although this giant fracture created very few mountain ranges and water basins within Africa, it did create a system of spectacular trenches known as the Great Rift valley in eastern Africa. Starting in Anatolia of northern Turkey, the rift goes south for a distance of some six thousand miles, through what are now the Jordan Valley and the Dead Sea; through the Gulf of Aqaba and the length of the Red Sea; bisecting the Ethiopian Massif and continuing down into East Africa, where it divides into two branches in which are found Lakes Kivu, Edward, Rudolf (Turkana), Albert, Victoria (the source of the Nile River and the second largest of the world's freshwater lakes), Malawi, and Tanganyika, whose bottom is several thousand feet below sea level; and finally ending at the mouth of the Zambezi River.

The majestic glacier-tipped Kilimanjaro, 19,340 feet above sea level and the highest mountain in Africa, was formed, like the other mountain ranges, by tectonic forces after the ancient faulting. The Atlas range in the northwest rises to some 13,000 feet, the Tibesti Massifs in the Sahara are over 13,000 feet, and the Cameroon Highlands in the west are comparable in height. In East Africa there are the Ethiopian Highlands with Mount Ras Dashan (15,158 feet), and further south are the great extinct volcanoes of Mounts Elgon, Kenya, and Ruwenzori (the Mountains of the Moon), which average about 17,000 feet high. The Drakensberg Mountains in southeast Africa rise to more than 11,000 feet.

Large inland basins, which are drained by the continent's spectacular rivers, often extend from the base of these mountain ranges. Characteristically, most African rivers are navigable for great distances across the continent's interior plateau until they plunge over impassable rapids or cataracts as they approach an extraordinarily narrow and relatively straight coastal plain. The advantage here is that the points at which these rivers leave the plateau can be the sites for hydroelectric dams. The disadvantage is that the rivers enter the ocean through deltas and shifting sandbars rather than through estuaries, thereby depriving the African continent of a large number of bays and gulfs that provide natural harbors in other parts of the world.

For example, the Zambezi drops some 343 feet over the spectacular Victoria Falls—more than twice the height of Niagara—before it heads for the sea. The Nile, along whose banks early civilizations bloomed, flows northward out of central Africa and drops over several cataracts before joining the Mediterranean. The Niger River rises in the Liberian Highlands and goes east and then south, picking up

such tributaries as the Benue and Cross rivers before emptying into the Atlantic. The great Congo River with its huge tributaries, the Kasai and the Ubangi, drains thousands of square miles before tumbling over falls to flow into the Atlantic. Many of Africa's smaller river systems, such as the Limpopo, Orange, Senegal, Vaal, and Voltas, exhibit the same pattern. Without outlets to the sea, such internal drainage systems as Lake Chad in the north and the Okavango Swamp in the south end up in shallow, brackish lakes or salt marshes.

Africa has basically seven climatic and vegetation zones. There is a central equatorial zone, and, radiating both north and south, replicating subtropical savanna zones, low-altitude desertlike zones, and Mediterranean zones. All of these are influenced by the contour of the land, and by monsoons and coastal currents. Africa's humid equatorial zone, though often referred to as "jungle," is smaller than those found either in South America or in parts of Asia. It covers central Africa, strips along the Guinea coast, and parts of Gabon, Cameroon, and northern Zaire. Here the temperatures range between 90° F during the day and 70° F during the nights. Rainfall is highest following the equinox (March and September), with an annual amount of about 50–70 inches. In some coastal areas where moisture-laden winds ascend steep slopes, the total can rise to more than 200 inches. The East African Highlands, situated on the equator, have lower temperatures and rainfall than the lowlands. In the lowlands there are tropical rain forests characterized by liana and dense vegetation, as well as species of valuable palm trees, mahogany, ebony, teak, sapele, niangnon, and kolas. The vegetation in the East African Highlands includes deciduous forests and evergreens.

The subtropical savanna ecological zones, which lie both north and south of the equatorial zone, occupy the largest area on the continent and differ only by altitude and proximity to the oceans. The fairly large northern ecological zone, which is also incidentally lower and wider, covers parts of Nigeria, the Sudan, and Chad. The temperatures can range up to 100° F, especially from March to May, just before the rains, but are usually between 70 and 50 degrees; temperatures in December and January are lower, especially during the harmattan, a dry, dusty wind that blows from the Sahara southward. Temperatures are lower in the southern subtropical zone because of the higher elevation and decreased width. The annual rainfall in both zones is 30–60 inches. Both subtropical zones are marked by the preponderant vegetation cover of the continent—grass—and within grasslands are found scattered trees of species such as the baobab and (where rainfall permits) acacia. At particularly high elevations such as the Cameroon Highlands, or the highlands and rolling plateaus of Kenya (Mounts Kilimanjaro and Ruwenzori have permanent ice fields), the upland grasslands are replaced by forests, such as the High Veldt of Transvaal, or by steep mountain slopes. Taken as a whole, this region is the one that supports many of the continent's herbivores, and pastoral activities play an important role in the economies of the indigenous peoples.

Low, dry, hot ecological zones are found both north and south as one moves further away from the equator. The Sahel in West Africa gradually shades into the Sahara, the desert of the Horn, and the Kalahari and Namid deserts are found in the south. The temperatures in the desert areas are quite variable, with great changes in daily temperature, except near the coasts. And while annual precipitation in the northern desert ranges from only 4 inches downward to zero, the popular image of the African deserts as barren rock and sand dunes bereft of vegetation is incorrect. The deserts actually support scrub and, on the margins, even grass for pasturage. The Sahara, in particular, is dotted with oases that support intensive agriculture, and in the east there is the fertile Nile Valley. The Namid Desert, which borders the Atlantic coast of southwestern Africa, is more desolate, receiving less than 10 inches; but the Kalahari, inland from the Namid, is really only a semidesert, receiving as much as 15 inches per year. It comes to quick life with the first sprinkling of rain, and often has stands of grasses and inland pans of water.

Mediterranean subtropical ecological zones are the next latitudinal regions. Characteristic of these are winter rains (from 25 to 32 inches) and summer droughts. The winters are mild, between 50° F and 60° F, and the summers around 70° F. The variable rainfalls and temperatures in these zones permit the growth of forests and brush.

The climate of Madagascar, Africa's largest island, ranges from tropical to largely subtropical. Its coastal lowlands are wet, hot, and covered with tropical forests, while the Central Highlands are drier, fairly cool, and covered with grass and interspersed woodlands. Bioko (the former Fernando Po) and São Tomé possess equatorial ecologies; the Cape Verde Islands share the ecology of the Sahel and are often plagued by droughts.

The distribution of African soils reflects the belts of temperature and especially rainfall. Approximately 36 percent of Africa, especially the equatorial zone of Zaire and the Guinea coast, may be characterized as humid, 22 percent semiarid, 26 percent arid, and 16 percent desert. This means that nearly two-thirds of Africa has a moisture deficiency during all or part of the year. The amount of water available is a function of regional and seasonal swings; it ranges from excess

water, due to persistent rainfall and high humidity, to too little rainfall and high evaporation. The result is that if the soil is suddenly exposed to the elements by either humans or nature, there is severe erosion and a loss of the fertility so necessary for crop cultivation. Nevertheless, most, if not all, African soils are good for short periods, provided that they have a long fallow. The soils in humid and semiarid areas, while initially rich in humus content, lose their fertility and become lateritic if cultivated continuously. The soils of the arid lands are relatively rich in inorganic minerals but low in humus content, and need additional water in order to be usable. Typically, seasonal variation in moisture distribution sets limits on the types and amounts of crops grown. Several parts of Africa have suffered from droughts and "hungry periods" due to shortages of food.

Mineral, Plant, and Animal Resources

Africa is immensely rich in minerals, in flora, and in fauna. The continent has about two-thirds of the world's phosphorites, some 45 percent of the world's bauxite, 20 percent of its copper, 16 percent of its uranium, and substantial reserves of iron ore, manganese, chromium, cobalt, platinum, and titanium. The food crops of Africa include coffee, ensete (a banana-like fruit), varieties of yams and rice, millets, sorghums, varieties of oil palms, the kola nut, and melons, all of which are believed to be indigenous to the continent; wheat, barley, and oats, of Middle Eastern origin; varieties of bananas and plantains, thought to be of Southeast Asian origin; and maize, manioc, peanuts, tomatoes, varieties of potatoes, and some tubers and cocoa beans—all cultigens that arrived in Africa as a result of the post-Columbus great plant migration. Cotton is common in the northern savanna belt and species of trees produced bark used for making cloth. In addition, the hardwoods and lianas of the tropical forests have been utilized by human beings for shelter and for many useful products over generations.

The domestic animals of the continent include varieties of cattle, sheep, goats, horses, donkeys, camels, pigs, dogs, chickens, ducks, and the semidomesticated guinea fowl. Africa is famous for its wide variety of animals representing thousands of species of mammals, reptiles, amphibians, fish, birds, and insects. Huge herds of a variety of antelopes, giraffes, and zebras roam the savannas, providing the prey for cheetahs, leopards, and lions. Herds of elephants still roam parts of eastern and southern Africa, having been largely eliminated in the north and west. The hippopotamus still lives in tropical rivers; varieties of water birds, such as the flamingo, are among the enormous range of African birds. Many of the animals in Africa, such as the rhinoceros, are now under stress for survival as a result of excessive hunting and the growth of the human populations.

Africa and the Origin of Human Beings

A growing number of paleontologists and human geneticists now believe that the origins of the billions of human beings on Earth can be traced to a woman who lived in Africa some 200,000 years ago and left an unmistakable signature on the DNA of all *Homo sapiens*. This was the most important stage in a process that started some 4 million years ago, when the genus *Homo* emerged from the *Australopithecus,* giving rise to *Homo erectus, Homo neanderthalensis,* and other varieties of *Homo*. Then, some 250,000 to 100,000 years ago, modern humans—with lighter skeletons, "their more capacious brains, and their softer brows" and possibly "with language"—radiated out from "their African homeland and overwhelmed or supplanted the many more primitive humans who were then living in Asia and Europe" ("New Debate Over Humankind's Ancestress," *New York Times,* October 1, 1991, sec. C). That such a theory is gaining ground is all the more remarkable since in the past, the prejudice against all things African was pronounced. Charles Darwin suggested that in view of the abundance of animal life there, especially that of the primates, it would be wise to look to Africa as the possible cradle of humankind, but this was rejected by his contemporaries, who were convinced of white supremacy.

Biologists now believe that as human beings moved about within and outside the African continent, they retained the ability to interbreed, but their geno-phenotypes (often referred to as geographical "races") emerged as adaptations to different ecological zones. No one knows what the earliest *Homo sapiens* in Africa looked like, but the so-called Negro-appearing people became the dominant physical type in sub-Saharan Africa (pockets of these Negroid people also lived in the oases of the Sahara). The Negroes in the Nile Valley tend to be taller and darker; eastward, in the Horn of Africa, the people appear to be a mixture of Negroids and the so-called Caucasoids. Caucasoid populations live in northern Africa and in the northern parts of the Sahara and the Nile valley. A short variety of Negroids, popularly known as Pygmies, live scattered among their taller neighbors in the central regions, and in southern Africa live another fairly short population, yellowish in skin color and possessing wiry hair, known as the Khoisan. Also in southern Africa and parts of east-central Africa are found Caucasoid and Caucasoid-like populations of European and Indian provenance; Malayo-Polynesian populations are settled in Madagascar.

Challenges to Human Life

The human populations in Africa have had to cope with a variety of insect-borne and other diseases that flourish in the tropics, and in a few cases they have adapted geno-phenotypically to these. Yellow fever and malaria, carried by mosquitoes, have been widespread, and some populations, especially in West Africa, have acquired a certain immunity to sicklemia (sickle cell anemia), caused by malaria. Trypanosomiasis, or sleeping sickness, whose vector or carrier is the tsetse fly, is found primarily in humid forested or savanna areas and is dangerous to both human beings and animals, especially cattle and horses. Schistosomiasis, by far the most widespread of African diseases, is caused by parasites of the genus *Schistosoma* which live in running water and enter the human body through the skin after a complex life cycle that includes the snail as an intermediate host. Also associated with river valleys is onchocerciasis, or river blindness, which is carried by a species of fly, *Simulium damnosum*. In addition to these, there are varieties of diseases caused by nematodes such as guinea worms, liver flukes, and tapeworms. AIDS is the most recent virulent disease to have appeared. In contrast to many other parts of the world, where it is often associated with homosexuality and intravenous drug use, in Africa AIDS is often associated with heterosexual activities. While no cure has been found for AIDS, such diseases as schistosomiasis, malaria, yellow fever, and trypanosomiasis are less morbid than in the past, and yaws and leprosy have been largely eliminated from African populations.

African Languages

Africa's 750 to 800 different languages not only represent the largest group of languages found on any continent but are spoken by populations differing in physical types and cultures. The debate about the classification, nature, and number of African languages continues, due to the lack of agreement among scholars as to criteria used to determine genetic relationships and differences between languages and their dialects. One major consensus, however, is that all African languages fall into four major families. The languages of the largest family, the Niger-Kordofanian, are spoken in western, central, eastern, and southern Africa. The Bantu languages—one of six subgroups of the Benue-Congo languages—are believed to have recently spread over most of central and southern Africa, since they are closely related to each other. Swahili, spoken in many parts of East Africa, is an Arabized Bantu language. In southern Africa and in parts of Tanganyika are found a small but important group of languages belonging to the *Khoisan* family. This family is believed to be the source of the "clicks" found in the Bantu languages. The *Nilo-Saharan* languages are not only the second largest group of African languages, but members are found widely separated in the Nile Valley and in the Niger basin of West Africa. Also widely distributed are members of the *Afroasiatic* family, which include Semitic languages such as Arabic and Hebrew spoken outside of Africa, Berber, Hausa, and ancient Egyptian, in addition to such Cushitic languages as Amharic, found in Ethiopia. Malayo-Polynesian languages are found in Madagascar; Germanic and Latin languages were brought into Africa by the incoming Europeans.

Peoples and Cultures of Africa

Africa was the site not only of important steps in the evolution of the human species, but of a parallel development; the evolution of culture, a distinctive human characteristic. Some of the earliest traces of human cultural activities—such as stone assemblages—subsequently spread, and the evolution of these artifacts both within the African continent and outside of it, with frequent interchange, attest to the processes by which African cultures subsequently developed. Initially, all African populations lived by foraging, but by 13,000 before the present (B.P.) there is evidence that the Mesolithic (Middle Stone Age) population, which lived in the valley of the Nile around Khartoum, included harvested wild cereals in its diet. By 6000 B.P. the peoples in the Nile Valley shared the practice of crop cultivation and animal domestication with those in other parts of the Fertile Crescent, which extended eastward to the Tigris and Euphrates river valleys. Within the limits of ecological constraints, these food-production techniques involving plants and animals specific to Africa spread to various parts of the continent, replacing but not totally eliminating earlier foraging patterns. The same generalization can be made about the invention and spread of Iron Age technologies and other traits important to early African peoples (Wai Andah 1981, p. 592; Posnansky 1981, pp. 533–534).

Partly as a result of the interchange of indigenous cultural elements within Africa and the addition of those from exogenous regions, it has never been strange to find Africans with differing physical types, speaking different languages, and having different sociocultural systems living contemporaneously in the same or neighboring ecological niches. For example, in central Africa, foraging populations such as the Batwa (Bantu-speaking Pygmies) have lived in contact with the pastoral Hima and agricultural Hutu (both of which are also Bantu speakers). And while these borrowed sociocultural traits from each other, they did not necessarily change their ways of life. In other cases, groups in contact changed their physical

types, languages, and sociocultural traits such as economic, political, and religious systems. In this way, Africa often presented a picture of a veritable museum where the surviving evidence of important stages in the evolution of humans and culture could be witnessed. It is partly because of the interdigitation of African peoples that the classification of their societies has proved difficult—made more so by the cultural, ethnic, and biological chauvinism of Africans themselves and of foreigners who used notions about the level of cultural attainment of Africans as rationalizations for conquest, colonization, and exploitation.

Regional variations of Paleolithic, Mesolithic, and Neolithic cultural assemblages appeared in all parts of Africa, a function of both indigenous development and external influences. From the Neolithic period onward, the cultural assemblages in the Nile Valley had a brilliant florescence as a result of this mingling of indigenous development and external contacts. And while until recently—for racist, historical, and political reasons and because of various strictures peculiar to particular academic disciplines—Egyptian civilization was viewed strictly in terms of its relationship to Asia and the Mediterranean, that view is now changing. One well-known scholar recently remarked that "If the history of early Africa is unthinkable without Egypt, so too is the history of early Egypt inexplicable without Africa. Ancient Egypt was essentially an African civilization" (Davidson 1991, p. 49; Diop 1974). Nevertheless, it is also true that during certain epochs many parts of Africa were firmly linked to external civilizations, and that at other times some external areas were viewed as African. How these links were seen was very much a function of military and political power relations of the world in a given period.

Many early scholars and even contemporary ones have been so impressed by the remarkable similarities of the sociocultural institutions throughout Africa that some have speculated incessantly about whether the migrating "children of the sun" from Egypt diffused such traits as divine kingship, dual monarchies, and matriliny to all parts of the continent, and in some cases to outside areas. One may even postulate the existence of a widespread early "Ur-African" culture, or proto-African cultural elements that constituted a foundation upon which elaborate cultural complexes or centers in such areas as Egypt, the Upper Nile, the Niger, the Congo/Zaire, and the Zambezi were constructed. What follows is a description of African sociocultural institutions, especially those of the western and central regions, which most nearly resemble those of the millions of Africans who were transported to the New World during the terrible transatlantic slave trade.

Economic Organization

Most Africans, including the ancestors of those who came to the New World, were slash-and-burn horticulturists or agriculturists who often used irrigation techniques where warranted. Wheat, barley, and oats were commonly produced in the Nile Valley and North Africa by plow agriculture with irrigation. In other savanna regions, in East, central, and South Africa and the western Sudan, cereals such as the millets, sorghums, and—to a limited extent—varieties of rice and legumes were cultivated by means of the hoe. Root crops, such as yams and other tubers, and varieties of rice and bananas were widely cultivated in the more tropical regions of West Africa and Zaire. Cotton was widely cultivated in the drier regions, and bark for bark cloth processing was produced in the forested regions such as Ashanti.

And while pastoralism based on the herding of cattle, sheep, goats, camels, donkeys, and horses was an important food-producing strategy, it was feasible primarily in the savanna areas that were free from the tsetse fly. Nevertheless, few of the so-called classic pastoralist societies such as the Masai, the Nuer, the Dinka, the Kabbabish Arabs, and the Somali, lived only by the products of their herds. Most of them, including the cattle-keeping people of East, central, and southern Africa and the Fulani of West Africa, lived in symbiotic relations with their cultivator neighbors. Especially in West Africa, many cattle herders often became sedentary cultivators when disease or droughts decimated their herds. This was not so difficult for them, since they moved in transhumance cycles among horticulturists between the forest zones and the desert, as pasturage and rainfall permitted. (Islamic practices appear to have limited the rearing of pigs, even in those areas where climatic factors made this possible.) In many parts of southern and East Africa, there were populations with mixed economies of horticulturists and pastoralists, though in many cases animals were the most valued products.

A minuscule number of African societies, such as the Batwa of Zaire, the Hadtsa and Sandawe of East Africa, and the Kung-San of southern Africa, retained an early adaptation to hunting and general foraging activities, but these economic strategies largely gave way to fishing, pastoralism, and horticulture. Hunting remained only an ancillary economic pursuit among all Africans, including the Mande, Akan, Mossi, Bakongo, and Baluba peoples of West and Central Africa. Fishing, too, declined as the major economic activity, except for a few riverine and coastal populations such as the Ebrie people of coastal West Africa and the Bozo people of the inland Niger River area.

A marked division of labor based on gender existed among all African food producers. Among the cultivators in most West and central African societies, males were primarily responsible for the heavy work of clearing and preparing the land, and growing specific crops. Women generally did most of the actual cultivation, harvesting and processing food. In addition they often cultivated certain crops, often viewed as "women" crops. Families who needed additional food for ceremonial or fiscal reasons obtained labor from voluntary organizations of youths and adults, which they paid or entertained. In the more complex Mande, Bakongo, and Fon societies, free persons and war captives who had become serfs and slaves were obliged to produce foodstuffs for their masters. In certain parts of the Sudan and the Sahel, horticulturists kept animals when conditions permitted, or traded vegetable products for animal products from neighboring pastoralist populations or foragers who hunted wild animals. The pastoralists, such as the Fulani of West Africa and the Kabbabish Arabs of the eastern Sudan, moved their herders in transhumance cycles between the tsetse-infected forest zones and the drier savannas. Males did most of the herding, leaving women to milk animals and to process and trade milk products. Hunting, whether among cultivators, pastoralists, or foragers, was the occupation of males, while women among all of these groups gathered wild products for food. Both males and females kept chickens, ducks, and small domestic animals.

Crafts, Manufactured Products, and Systems of Exchange

Almost all African cultivators used iron implements produced by male blacksmiths whose wives often made pots. These persons were often the only specialists in small-scale subsistence societies. Nevertheless, even these small-scale societies often produced surplus goods and interacted economically with the larger African societies, where specialization gave rise to other smiths who worked such metals as tin, copper, silver, and gold, procured either by mining or by placer washing. This was especially prevalent in West Africa, the Nile Valley, and the Zimbabwe region in southeastern Africa. Weavers, carpenters, glassmakers, and other specialists—especially in North Africa, the Nile Valley, Ethiopia, and West Africa—produced surpluses for high-status persons or for trade in local periodic markets and with long-distance caravaners who supplied complex economies. Many producers of craft goods—for example, smiths, weavers, potters, and leather workers in the western Sudan—were organized into endogamous castelike guilds that posted members along trade routes. And while most of the guilds were egalitar-

ian, others gave unequal access to their economic assets.

Barter persisted in small African communities that were largely self-sufficient, but also continued to play an economic role in some of the larger communities. Silent trade involving barter for gold and other products—as, for instance, between the ancient Malians and Phoenicians—persisted for a long time in many parts of Africa where vast differences in language and culture made face-to-face trade hazardous. Also employed were various types of currencies that ran the gamut from iron implements, lengths of cloth, beads, necklaces, bracelets, anklets, and waist bands to cowrie shells, gold dust, and slaves. In the Niger river areas, merchant guilds took goods on consignment, and used credit to procure goods for sale.

The notion of profit was well developed in various parts of North, East, and West Africa, except where inhibited by Islam. Also in parts of West Africa, destitute persons could pawn themselves or dependents for money. Those pawns who were unredeemed were often married, if female, by the creditors, or became serfs or slaves if male. The urban, or palace- and temple-based, complex economies in Egypt, the western Sudan, and East Africa were often the transit points for international products leaving from or arriving in many African ports of trade. Many west Africans were involved in the economic complex of the Niger river described below:

Lying between the desert and the forest regions of West Africa was a veritable *sahil* (an Arabic word for shore), part of a well-known ecosystem that facilitated the rise of a complex sociocultural system serving as a transit point for persons and products coming from north, south, and east. This region had among its characteristics a large floodplain suitable for cereal agriculture and livestock rearing; many waterways that provided easy transportation for natural resources and manufactured products; and an extensive savanna rich in minerals and in faunal and floral resources. Here arose the core states or empires of Ghana, Mali and Songhay, whose influence radiated throughout western and central Africa.

Leo Africanus described Jenne, one of the most important cities of the Mali empire, as a "place exceedingly aboundeth with barlie, rice, cattel, fishes, and cotton: and their cotton they sell unto the merchants of Barbarie, for cloth of Eirope, for brazen vessels, for armor and other such commodities. Their coine is of gold without any stampe or inscription at all" (Epaulard 1956, p. 468). A number of traditions hold that the gold used to mint the first English coin, the guinea, came from Jenne (Jennie or Guinea). A local scholar, al-Sadi, writing about 1655, described Jenne as "large, flourishing and prosperous; it is rich, blessed and favoured by the Almighty. . . . There

one meets the salt merchants from the mines of Teghazza and merchants carrying gold from the mines of Bitou. . . . The area around Jenne is fertile and well populated; with numerous markets held there on all the days of the week. It is certain that it contains 7077 villages very near to one another" (Al-Sadi 1987, p. 97).

These reports from West Africa could easily be replicated from other parts of the continent with complex economies such as the Congo/Zaire, Zimbabwe, the Swahili coast, and Mogadishu in East Africa, North Africa—which at one time served as the granary of Rome—and, of course, Egypt and the Sudan.

Social Organization

There was a basic notion that the complementary relationship, or what is now being called "complementarity," between females and males lay at the center of the social organization of most African societies. Again, with very few exceptions, the people in African societies always emphasized the "extended family": that is, a group of married and unmarried males, females, and children, living in common or contiguous habitations, normally under the directorship of men. In most cases these men were descended from a common ancestor or ancestress, and the adults tended to interact most frequently with persons of their own gender except for purposes of reproduction. This is contrasted to the so-called nuclear family, where males and females maintained close relations for economic purposes as well as for reproduction and the rearing of children. A common domestic cycle was for a woman (rarely a man) to leave her natal family on marriage, join the extended family of a spouse, and return to her own natal family before death or, in spirit, after death.

The overwhelming majority of African societies emphasized corporate descent groups that were patrilineal: Both females and males traced their descent in the male line to a known apical ancestor, and children belonged to the husband's lineage. The size of the lineages varied in different societies, with subsidiary branches made up of descendants of subordinate known ancestors. In contrast were a small number of matrilineal societies such as the Akan in the Côte d'Ivoire and Ghana, the Lele in Zaire, and the Tonga in east central Africa, where descent was traced to apical female ancestors and children belonged to the lineages of mothers. Where, as among the Akan, both men and women tended to marry others in neighboring areas, they could remain in their natal villages and visit spouses nearby; or either males or females could join the villages of their spouses. In central Africa the men of matrilineages tended to join the villages of their wives, or in some cases men could remain at home and have the husbands of daughters or sisters join them. In a very few societies, such as the Yako of contemporary Nigeria, people recognized both lines, making for what is called "double descent."

Despite the emphasis on either patriliny among the Mande, Mossi, Yoruba, and Igbo or matriliny among the Akan of Ghana and Lele of Zaire, people usually recognized the lineage of their other parent, and sought help and refuge from these relatives when the need arose. Sometimes relationships between such relatives were so close that they risked jeopardizing the rule of corporate lineage affiliation. So important were kin relations in African societies that with few exceptions, the siblings of fathers and mothers (among the Yoruba, for example) were glossed by the same term—that is, "father" and "mother," with terminological distinction based on relative age. It followed then that most of the children of uncles and aunts were considered brothers and sisters, instead of cousins, and the children of these as sons and daughters instead of nephews and nieces. In societies where parental siblings were distinguished from parents, there were terms that were glossed as "aunt" and "uncle" and, of course, the children of these were glossed as "cousins." A variation on this theme occurred when the siblings of only one set of parents, as among the Tuareg, were equated, thereby making their children "brothers" and "sisters," while the children of unequated siblings were "cousins." In some cases these "cousins" were eligible as spouses while the children of other parental siblings were not, and in such situations the normal incest rule against marriage with relatives were strongly invoked. Noted exception to this rule pertained in ancient divine Egyptian families, especially among the Pharaohs, where brother-sister marriages were preferred so as not to dilute their divinity.

With very few exceptions, the families in African societies exchanged or transferred valuables upon the marriage of their children, whether (as among the Lobi) young people chose their own spouses or (as among the Kikuyu) spouses were chosen for them. In what has been called "restricted exchange," families exchanged women among one another (one can say men or grooms were exchanged, but Africans would not agree with that formulation) over an extended period of time. More common was a Hebraic-like "bride service" in which men provided labor for the families of their future spouses. Most common were marriages involving the gift of valuables by the family of the groom to the family of the bride. Glossed variously, as "brideprice," "bride wealth," and "progeny price," these valuables, usually provided by sections of the corporate lineage, legitimized marriages, and especially the parentage of the chil-

dren. Significantly, matrilineal societies such as the Ashanti of Ghana and the Tonga of Zambia made comparably little use of the bride-price even though, as in Ashanti and Baule, ritual drinks confirmed the marriage.

What the bride-price or progeny price entailed was the responsibility of a family to provide additional brides if the one involved was deemed infertile, a practice known as the sororate (marriage of sisters). Women often divorced men who were judged infertile, or if husbands died young, they married their husbands' brothers, another Hebraic-like practice known as the levirate. Like African men, African women deemed it proper to bear children, either for their own lineages, if matrilineal, or for their husbands' lineages, if patrilineal. There were almost no cases of marriages in Africa whereby a woman's family transferred valuables to the family of a potential husband. In almost all African societies, however, women took valuable goods with them, often household items, when they joined their husbands.

The practice of having plural wives, or polygyny, was the ideal marital state for most African men, but actually most marriages were monogamous, that is, a man had only one wife. Nevertheless, most men hoped to become polygynous because, they insisted, polygyny guaranteed progeny. Within the household, however, polygyny was not always viewed as a blessing because there was the recognition that care was necessary to avoid conflict among co-wives. Husbands had to provide wives with separate dwellings and were cautioned to treat them as equitably as possible. In successful polygynous marriages, senior wives often actively sought additional wives for their husbands, not only to ease their own domestic chores, but to increase their own prestige and that of the husband. Apropos to this, in a number of African societies, including such West African cultures as the Fon, Mossi, and Yoruba (all patrilineal societies), women who were able to pay a bride-price were able to procure other women as their own "wives" but not for sexual purposes. Such "wives" performed domestic or commercial duties for their "female husbands," but any children born to them by men were either transferred to the female husband's patrilineage or could be given to the patrilineages of the female husband's patrilineage.

The existence of polygynous marriages and extended families influenced the structure of family life in most African societies. The men of such extended families, whether matrilineal or patrilineal (but especially the latter), tended to bond together, interacting with each other both economically and socially. The wives of men in extended families followed the same pattern, allowing, of course, for conflicts between co-wives. Domestically, however, individual women tended to form a unit with their own children, which sought its interest against the domestic units of co-wives, or of the wives of other men in the extended family. Thus, while the authority of husbands and fathers over their wives and children was fully acknowledged—domestically and, especially, publicly—women were very much in charge of their own hearth and family. Moreover, as African women aged, their status and roles also changed. From timid and prudent brides new to the family of their spouse, they increasingly asserted themselves as they became mothers and senior and respected female relatives in their own households and own lineages. Later, they continued to gain respect as confidants of aging husbands, and finally as the often stern mothers-in-law whose duty it was to watch over the morals of incoming brides.

Since most African women shared many attributes of their domestic units and of their lineages, those women of royal descent and wives of important men often exercised a great deal of power within their domestic units and political systems. They not only had slaves and "wives" but were not above threatening the power of the ruler. From Mali there is an anecdote about a serious dispute between the ruling king and his wife, the daughter of his maternal uncle. She was "his partner in rule according to the custom of the Sudan, and her name was mentioned with his from the throne." Much to the chagrin of his subjects, the ruler suddenly imprisoned his queen and took a commoner as wife. The queen did not reveal the source of the conflict, but sought to shame her husband by placing dust on her head, as a mark of shame and humility, and stood beside the council chamber. The king summoned a servant who told the courtiers that the queen had sent her to the king's cousin with a message supporting him to replace the sovereign, and promising: "I and all the army are at your service." The courtiers agreed that such treachery deserved death, but the queen escaped by seeking sanctuary in a mosque (Levtzion and Hopkins 1981, pp. 294–295).

Africans generally desired children as necessary links in the chain of human life. Throughout the continent there were elaborate naming ceremonies, carried to great lengths by the Wolof, Akan, and Mande groups. In addition to training children at home, most African societies—particularly the ancient Egyptians, the Nuba in the Sudan, and the Somali, Kikuyu, Nyakyusa, Zulu, Bakongo, and Mossi—placed their pubescent children in special schools. There, in addition to undergoing ritual circumcision for boys and clitoridectomy for girls, the young were often enrolled in age-sets and age-grades where they were taught the facts of life, certain social graces, economic activities, political responsibilities, and re

ligious beliefs. Among the Mende of what is now Sierra Leone, the age-set/age-grade systems, called Poro for boys and Sande for girls, provided the basis for their economic, military, social, political, and religious life. Chaka of the Zulu, the Masai, and many martial societies used these units as part of their military establishment. Here friendships and values were formed for life, and prepared people to take their future place in society. In some complex cultures such as the Baganda, requirements of the political system were also taught. In ancient Egypt, the Sudan, and Ethiopia and in Islamic societies, where literacy was important for bureaucracies and for the priesthood, boys alone went to special schools.

Political Organization

African societies differed in scale and had a wide range of mechanisms for preserving order. While such acephalous groups as the Igbo, the Nuer, and the Kikuyu have attracted attention with their ability to preserve order without complex political structures, there is a wide consensus that Africans developed what one scholar once claimed to be "relatively large-scale political societies" that could be studied. It was also suggested that "of all the areas inhabited by nonliterate peoples, Africa exhibits the greatest incidence of complex governmental structures. Not even the kingdoms of Peru and Mexico could mobilize resources and concentrate power more effectively than could some of these African monarchies" (Herskovits 1948, p. 332; Skinner 1963, p. 134).

Those simple African foraging societies such as the San and the Batwa that used kinship, name, and clientelistic ties within their own groups to maintain internal order utilized the same mechanisms to live in peace with their more powerful neighbors. And while many of the pastoral societies, such as the Kipsigis and the Masai, were especially bellicose, having to protect themselves and their herds, they used kinship solidarity for such purposes. The Somali used what was called *dia-paying* groups of kinsmen to pay for damages and seek revenge. The pastoral Fulani and Tuareg of West Africa utilized powerful individuals, sometimes known as sheiks, to maintain order. Among the Nuer and Dinka of the Nilotic Sudan, recourse was also had to ritual specialists such as "leopard-skin chiefs" and "prophets," who restored peace (Evans-Pritchard 1940, pp. 209, 134; Herskovits 1948, p. 32).

Some of the small-scale African horticultural groups organized in village communities, such as the Alur, Lugbara, Tiv, Igbo, Kpelle, and Tallensi, used such institutions as shrines, rain medicines, and medicine men for maintaining peace (Southall 1956, pp. 181–196; Middleton and Tait 1958, pp. 131, 224; Fortes 1945, p. 53). Some of these societies used marriage alliances, common ritual paraphernalia, and myths that they had requested governors from larger and imperialistic African societies in order to live in peace and security. These myths also provided legitimacy for dominant or domineering groups.

The institution of the divine king, who ruled with the legitimacy of heaven and with the support of royal ancestors, appears throughout Africa. Examples are the Pharaohs in Egypt, the Ethiopia negus who had the title "King of Kings and Lion of the Tribe of Judah," the "reth" of the Shilluk in the Sudan, the "kabaka" of the Baganda, the king of the Bakongo in Zaire, the kings of the Ashante, the Alafin of Oyo among the Yoruba, the mais of the Kanuri, and the Mogho Naba of the Mossi of the western Sudan. Often complementing these rulers were royal women who, as in Egypt, the Sudan, and Angola, ruled in their own right but were also royal consorts, queen mothers, queen sisters, or princesses. The Candances and the Cleopatras of the Sudan and Egypt are well known; their counterparts such as Queen Nzinga of Angola, and Amina of the Hausa are less renowned. Both male and female rulers often had shrines, groups of priests, and religious paraphernalia that helped legitimize their rule.

These rulers had elaborate courts or temple complexes, as in the Nile Valley, from which they ruled over provinces, districts, and villages. Quite common was the tendency of rulers to shift their capitals when they assumed power, and in the case of the Egyptians and Sudanese were not above erasing the names of predecessors on the stelae about the kingdom. It was also quite common for monarchs to use royal relatives to rule outlying provinces and districts. But neither was it uncommon to see these personages replaced by administrative officials when the state became more secure. Many were the mechanisms used by African rulers to take censuses and to obtain the revenue to support their thrones and their states. Children were counted during puberty rites; priests reported the number of protective devices given to peasants to save animals from disease; spies reported the riches of subordinate rulers. In this manner, bureaucrats knew the amount of taxes to expect. These taxes included custom receipts from traders and manufacturers, products from fields cultivated for the state, and part of temple tithes and presents destined for local deities and for the rulers themselves. Rulers received wives not only for their bedchambers but to be used as pawns in dynastic marriages or to cultivate fields.

Scholars have been impressed by what is considered to be an African court tradition that was remarkably similar throughout the continent. With respect to West Africa, some of the early court traditions of Ghana, Mali, and Songhay still persist among the

Mossi and Ashanti. The Malian king held court in a domed pavilion in which stood ten horses covered with gold-embroidered materials; behind him stood ten pages holding shields and swords decorated with gold, and on his right were the sons of vassal kings wearing splendid garments, with their hair plaited with gold. Before him sat the governor of the city and his ministers, and guarding the pavilion were pedigreed guard dogs that wore gold and silver collars studded with balls of the same metals. When the beating of a drum announced that the king would receive his visitors, those who professed the king's religion (that is, all except the Muslims) approached him, fell on their knees in greeting, and sprinkled dust on their heads. Visitors reported the Malians to be "the humblest of people before their king and the most submissive towards him. They swear by his name, saying: *Mansa Sulayman ki* (the king has spoken)" (Levtzion and Hopkins 1981, p. 291). The revenue of this king included all gold nuggets found in the country; he received one golden dinar on every load of salt that entered the kingdom, and two dinars when this amount was exported.

African communities and polities used a range of devices to maintain peace internally and to wage war against outsiders. Small village communities such as those in Igbo land used ridicule, various types of ordeals, expulsion, and belief in the efficacy of supernatural entities, often disguised as masked figures, to sanction evildoers. The acceptance of the decision of moot courts in larger societies was often enough to restore social harmony, in the absence of bodies that could enforce the law. State-level societies permitted the use of many informal legal devices at local levels, but all insisted upon judicial review at higher levels, with the monarch sitting as judge. Women often had parallel quasi-judicial and judicial institutions. The death penalty was often meted out for heinous crimes such as rape, murder, and treason. The legal philosophy in most African societies was based on concern for what "reasonable persons" would do if provoked, or expect as punishment for crimes.

Of course, African judges were not infallible, and the complaints of those who believed that they were treated unjustly have come down to us. The legal codes of dwellers in the Nile Valley are well known, and ethnographers have furnished details of legal decisions in other societies. In addition, one reporter from fourteenth-century Mali cited the "lack of oppression," and "the security embracing the whole country, so that neither traveller there nor dweller has anything to fear from thief or usurper." We are told that the ancient Malians "do not interfere with the wealth of any white man who dies among them, even though it be *quintar* [coins] upon *quintar*. They simply leave it in the hands of a trustworthy white man until the one to whom it is due takes it." Persons suspected of wrongdoing were subject to the poison ordeal. The innocent was applauded and the guilty punished (Levtzion and Hopkins 1981, p. 217).

The smaller African polities had no standing armies and waged war only when the men had completely taken in the harvest. In contrast, an aggressive ruler such as Shaka of the Zulus used his society's age-set/age-grade system to build a standing army as a vehicle for conquest. Ancient rulers in Egypt and the Sudan used standing armies not only to unify the valley of the Nile, but to wage war against the ancient Libyans and Assyrians. Hannibal took his elephants across France and the Alps to wage war on Rome, and in revenge the Romans destroyed Carthage in what is now Tunisia. Then when Arab armies conquered Egypt and their converts waged war in the western Sudan, they found that the king of Ghana could put an army of 200,000 soldiers in the field, including 40,000 archers and cavalry. West African soldiers served in the Muslim armies that conquered Spain and governed it until the *Reconquista* ended their rule.

Religion

Beliefs in the supernatural are often the oldest aspects of human cultures. Therefore, it is not surprising that certain African beliefs were continent-wide. And while God and other deities were ready references to most Africans, the conduct and fate of human beings appeared to remain the center of their religious concerns. In this context it is not surprising that for one critic, religion is a language that "allows humans to insert themselves into intimate relationships with the universe" (Mudimbe 1991, p. 9). Myths featuring a creator-god, who lived in the sky and was often personified as the sun, the earth, the moon, and all things that ever lived and will live, were almost universal throughout Africa. The Re/Osiris/Isis/Horus mythic complex of the Nile shares many features with Amma among the Dogon, Mangala among the Mande, Oludarame/Olorum (who came down to earth in an ark) among the Yoruba, Winnam/Naba Zid Winde among the Mossi, and Nyame among the Akan—all creator-gods associated with the sky and the sun. In the larger state societies important rulers such as the Pharaohs, and Yoruba/Nago kings such as Sango, were deified. Also participating in aspects of the divine were deities responsible for death dealing diseases such as smallpox. Other tutelary deities included the serpent and religious referents in *bori, mammy water, orisha,* vodun, and other possession cults through which spirits and humans expressed their will.

The Mande creation story tells how Mangala, the creator, made "the egg of the world" in which were

pairs of seeds and pairs of twins, prototypes of future people. One male twin, Pembe, desiring to dominate creation, erupted from the egg, tearing away a piece of his placenta as he plunged through empty space. That piece of placenta became the dry, barren, and polluted earth, but Pembe could not fructify it, and so returned to the sky for seeds. Meanwhile Mangala, who had created the sun, sacrificed another male twin to account for Pembe's sin. Mangala cut Faro's body into sixty pieces and scattered them through space until they fell to earth, becoming vegetation, symbols of resurrection. Faro was restored to heaven in human form, and Mangala, using part of his placenta, created an ark in which he sent eight ancestral pairs of human beings, plants, and animals down to earth. These human ancestors, like Faro himself, had a common vital force (soul), and complementary male and female spiritual forces. Emerging from the ark, the ancestors watched for the first time the rising of the sun (Dieterlen 1957, pp. 124–138).

As the Mande myth indicates, human beings possessed elements of the divine such as souls, the "breath of life," and "shadows," whose fates and needs could be divined and propitiated when deemed necessary. Belief that one's fate or destiny could be known and influenced was found in the cult of *Fa* among the Yoruba/Nago, and the notion of *chi* (personality characteristics) in Igbo country. There was often the need for people to protect themselves against evildoers (sorcerers), who were believed capable of bringing harm and even death by magical means. There were priests who also knew how to acquire the power to heal—aided, of course, by the more powerful ancestors.

Ancestor veneration was an important feature in most African religions. The ancestors provided a chain across generations, often warning their descendants through dreams or divination that the illnesses, misfortunes, and infertility being experienced were punishments for sins that had to be propitiated. By insisting upon moral rectitude among their descendants, and insisting that only sacrifices to them would bring human happiness, African ancestors could be said to have attempted to cheat death by remaining in the lives of the living. Among the West African Igbo the ancestors were represented as masked figures who came from the land of the dead to preside at court cases of living people. Here, as in many other societies throughout Africa, people believed in forms of reincarnation in which ancestors were reborn. With their emphasis on living human beings, Africans attached less significance to the notion of the land of the dead, or of heaven and hell.

Those external religions that came into Africa—such as early Christianity in ancient Egypt, North Africa, and Ethiopia—usually adapted to local conditions. Monophysite Christianity in Egypt, Ethiopia, and the Sudan successfully resisted pressure from Rome and Byzantium and indeed attempted to impose its doctrines on external Christians. Evangelical and militant Islam failed to dislodge Egyptian Coptic Christianity, but eliminated the churches in North Africa and eventually those in the Sudan. Through the jihad (holy war) and peaceful merchants, Islam gained many adherents in North, West, and East Africa, but not in central or southern regions. Islam, too, adapted to the realities of Africa, and its many practices and beliefs were modified throughout the continent. A number of African rulers in the Sudan used the jihad to enlarge their realm and to challenge local traditional beliefs. In some cases, rulers did not adopt Islam since they needed the legitimacy of traditional religion, but permitted nonruling royals to do so. In East Africa, Islam added another dimension to the Swahili culture, which was an early synthesis of African and Arab cultures.

Sciences and Arts

Ancient Africans probably made the first tools used by human beings, the so-called eoliths or "dawn stones," and these were progressively modified as Africans and their neighbors entered the Copper Age, the Bronze Age, and finally the Iron Age. Along with inventing tools for food production and implements for warfare, early populations in the various river valleys learned about seed selection, and developed complex forms of irrigation that depended upon the invention and use of mathematics for measuring fields and astronomical tables that charted the course of heavenly bodies. Mathematics was important to the architecture used in the building of pyramids, palaces, and cities in the Sudan and Egypt. Some of these inventions remained valid for thousands of years, and undoubtedly diffused and adapted themselves to local cultural traditions throughout Africa and beyond. Mud brick pyramids among the pastoral Nuer people of the Upper Nile come to mind, and the elaboration of an imposing acropolis in Zimbabwe, based on the cattle kraal, is another example of that type of development. Pastoral and agricultural peoples throughout the continent, such as the Fulani and Dogon, had calendars based on the movements of such configurations of stars as the Pleiades Cluster to know when to begin transhumance cycles in search of pastures, and when to plant certain crops. No doubt, the need of evolving states for correct data stimulated the evolution of symbolic writing systems that led to the development of hieroglyphic and its more common version, hieratic. These systems recorded the deeds of royalty on temples and pyramids, as well as hymns of praise to them and to gods in several books of the dead. The need to embalm the

dead led inexorably to the knowledge of anatomy and medicines, and the practice of autopsies to determine the causes of death influenced religious beliefs.

The relationship between these aspects of African cultures can be seen in a description of ancient Ghana. The king's town was said to be a complex of domed buildings, groves, and thickets in which he lived surrounded by priests of the traditional cult, who cared for royal graves decorated with statues. Only the king and his heir could wear sewn clothes (the others dressed in flowing robes), and the monarch wore strands of necklaces and bracelets. He also wore a high cap decorated with gold and wrapped in a turban of fine cotton.

What has been glossed as "art"—in the form of jewelry, statues, carvings, or masks—was well developed, whether used for funerary or other religious purposes, for secular functions, or for both. There is evidence that prehistoric Africans and their descendants transformed their natural bodily characteristics (for example, by creating hairstyles) and used various forms of painting and decoration, as if to move beyond the realm of the "natural" to the domain of the "cultural." The so-called African rock art, consisting of engravings on rocky surfaces both outside and within caves found in the Saharan region of North Africa, the Libyan desert, the Nile Valley, the Sudan, West and central Africa, and East and South Africa, dates to the sixth millennium B.C., and may be related to comparable examples in Spain and southern France. Whether in the Tassili region of the Sahara or in Botswana and Namibia, the art depicts the activities of everyday life, grooming and decorating the body, walking, running, dancing, hunting, feasting, fighting, and worshiping.

Much of African art is symbolic, with those aspects of the body involving fertility or power highlighted, whereas other parts are not. Even in areas with elaborate naturalistic statues, such as Egypt, Ethiopia, the Sudan, and Nigeria, symbolic forms are often included. Egyptian art, with its mixture of anthropomorphic and zoomorphic characteristics, is well known; less well known are the terra-cotta Nok art figures from northern Nigeria, dating from 900 B.C. or earlier, which may have been the prototype for the naturalistic bronze portrait heads of kings and queens of Benin and of the early Portuguese travelers in the region. The art and architectural complex of ancient Zimbabwe suggests not only a heroic period, but also provided an artistic pattern for building work, implements, and decoration throughout southern Africa. The stelae of Egypt, Aksum, and the Sudan provided dynastic histories in artistic form, and recorded totemic relations between humans and the natural and supernatural worlds. Articles used by crafts producers, such as whorls and spindles, were themselves often carved; domestic articles such as calabashes, water bags, pots, and spoons and other utensils were often decorated. Women obtained pot covers on which were carved symbols representing unacceptable behavior; they used these to cover dishes of food brought to their husbands to signal displeasure of their spouses' conduct.

The word—language itself—was the basis of elaborate oral traditions in African societies. Incantations, oaths, warnings, edicts, epics, and praises affected the lives of African peoples. Used for didactic reasons, in theater, legends, myths, poetry (especially among the Swahili), riddles, parables, and proverbs were quite common. Fourteenth-century travelers in the Niger area recorded the presence of "poets" exhorting the monarch to rule well: "This bambi [throne] on which you are sitting was sat upon by such-and-such a king, and his good deeds were so-and-so; so you do good deeds which will be remembered after you." The traveler was specifically informed that this practice "was already old before Islam, and they had continued this to this day" (Levtzion and Hopkins 1981, p. 296).

Africans possessed an impressive number of musical genres, musical instruments, songs, and dances for secular as well as religious purposes. The simple musical bow of the foragers evolved to such chordophones (stringed instruments) as the four-stringed fiddle in Zaire, the chora in Mali, and, of course, the harp in the Nile Valley. The idiophones ranged from simple sticks, rattles, and large varieties of bells to veritable xylophone orchestras among the Chopi in the Zaire/Zimbabwe region, to the West African region. The membranophones, or varieties of drums, such as the "hourglass," pot, gourd, and frame drums, often formed part of orchestras with the xylophones, or were used to send messages. Adding to this musical mélange were aerophones, consisting of trumpets, horns, flutes, whistles, and the like. These instruments were often used together in intricate musical rhythms.

African songs ranged from lullabies, children's didactic songs, initiation chants, love melodies, and work songs to praise songs, religious chants, and funeral dirges. Here again, they were either performed by themselves or accompanied by musical instruments. Many melodies emphasized "call and response"—that is, one person sang and the chorus responded—but Africans often utilized two-, three-, or four-part harmonies. In most cases, however, songs were sung as people danced. The type of dances varied within societies and across regional or cultural areas. Again, dances also varied with the social function involved, from dances of welcome to the stately and slow dances of royalty. And while most African dances were collective, soloists often broke rank to

highlight individual skills, then rejoining the group's intricate choreography. Finally, music and masked dancers often contributed to theatrical festivals and communal rituals.

Given the reasons for which Africans were uprooted and transported to the New World, not all aspects of their cultures were either encouraged or permitted to survive. What is surprising, however, is just how much of this traditional background was reinterpreted and/or syncretized with elements of other cultural systems to act as guides for the behavior of African Americans over the centuries. What is also surprising is the way aspects of the African background often remained quiescent and unrecognized, only to emerge when necessary for survival. Lastly, many contemporary African Americans are going to Africa and seeking forms of culture that they are bringing back to America, and implanting as part of a continuum between the past and the present. This is often quite successful, since for human beings of every time and place, whatever happened before they were born—regardless of how long ago—becomes part of their cultural background to be used as a guide to action.

REFERENCES

AL-SADI. *African Civilizations, Precolonial Cities and States in Tropical Africa: An Archaeological Perspective.* Translated by Graham Connah. Cambridge, U.K., 1987.

BEALE, HOWARD K. *Theodore Roosevelt and the Rise of America to World Power.* New York, 1956.

CULLEN, COUNTEE. *On Thee I Stand: An Anthology of Selected Poems.* New York, 1947.

DAVIDSON, BASIL. *African Civilization Revisited: From Antiquity to Modern Times.* Trenton, N.J., 1991.

DIETERLEN, GERMAINE. "The Mande Creation Myth." *Africa* 17, no. 2 (1957): 124–138.

DIOP, CHEIKH ANTA. *The African Origin of Civilization: Myth or Reality.* Translated by Mercer Cook. New York, 1974.

DRAKE, ST. CLAIR, and HORACE R. CAYTON. *Black Metropolis: A Study of Negro Life in a Northern City.* New York, 1970.

EPAULARD, A. *Description de l'Afrique.* Vol. 2. Paris, 1956.

EVANS-PRITCHARD, E. E. *The Azande: History and Political Institutions.* Oxford, 1971.

———. *The Nuer.* Oxford, 1940.

FORTES, MEYER. *The Dynamics of Kinship Among the Tallensi.* London, 1945.

HERSKOVITS, MELVILLE J. *Man and His Works.* New York, 1948.

LEVTZION, N., and J. F. P. HOPKINS. *Corpus of Early Arabic Sources for West African History.* Translated by J. F. P. Hopkins with annotations by the editors. Cambridge, U.K., 1981.

MIDDLETON, JOHN, and DAVID TAIT, eds. *Tribes Without Rulers.* London, 1958.

MOKHTAR, G., and JOSEPH K. ZERBA, eds. *General History of Africa.* Vols. 1 and 2. London, 1981.

MUDIMBE, V. Y. *Parables and Fables: Exegesis, Textuality, and Politics in Central Africa.* Madison, Wis., 1991.

POSNANSKY, M. "Introduction to the Later Prehistory of Sub-Saharan Africa." In Mokhtar and Zerba, eds. *General History of Africa,* vol. 1. London, 1981, pp. 533–550.

SKINNER, ELLIOTT P. *The Mossi of Upper Volta.* Stanford, Calif., 1963.

SOUTHALL, AIDAN W. *Alur Society.* Cambridge, U.K., 1956.

WAI ANDAH, B. "West Africa Before the Seventh Century." In Mokhtar and Zerba, eds. *General History of Africa,* vol. 2. London, 1981, pp. 593–619.

ELLIOTT P. SKINNER

African-American Origins. Between 1450 and 1850 about twelve million Africans were captured, enslaved, transported across the Atlantic, and sold in the New World. About half of the slaves were destined for Brazil, another 40 percent for the Caribbean, and only about 5 percent came to British North America and the United States. Those who were brought to North America had as their ancestral homelands a wide area of western, central, and eastern Africa. They represented numerous cultures and languages, probably as many as fifty.

In recent decades, in part inspired by Alex HALEY's *Roots* (1976), a fictional account of his heritage, and by scholarship on African retentions, there has been renewed interest in tracing the origins of contemporary African Americans to the specific cultures that fed the slave trade. The extent to which groups of African slaves were influenced by their distinctive heritage, and how the various cultural legacies of Africa were in time combined and submerged have been a subject of intense debate.

In some ways the apparent cultural and linguistic diversity of African Americans can be misleading, for at any one time, either in Africa or in their destinations in the New World, only a few African cultural groups were dominant among those enslaved. However, different regions within this area followed varying rhythms of imports during the period of 1690 to 1810, the major phase of the slave trade. Most of the slaves coming to the Chesapeake region arrived between 1680 and 1770, while the ones imported to South Carolina arrived over a much longer period, from about 1720 to 1810. Louisiana, on the other hand, imported some slaves between 1719 and 1743, and then none until a major burst after 1777 through the early nineteenth century.

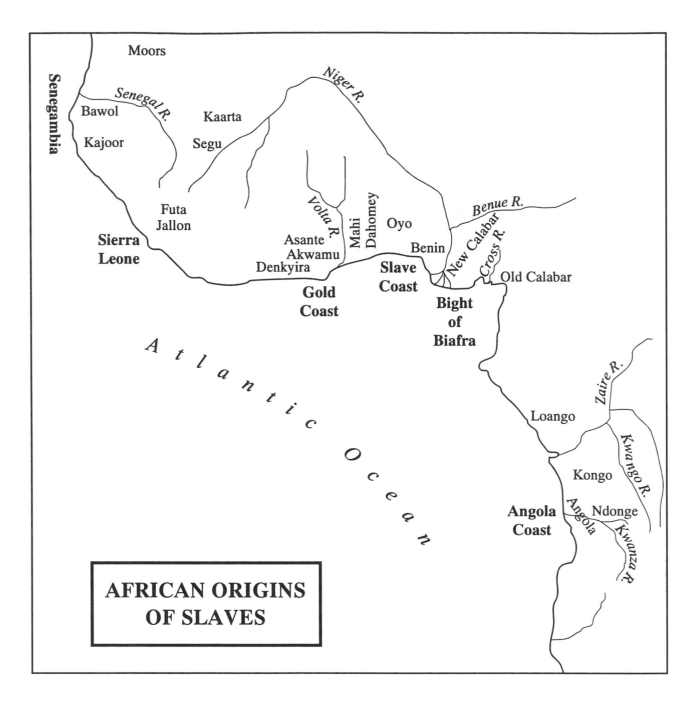

AFRICAN ORIGINS OF SLAVES

The population of African descent in present-day North America derives primarily from these nodes of import. Unlike the African population of other parts of the Americas, the one in North America rapidly became self-reproducing in all but a few areas, thus limiting the need for continual imports. Natural growth of the existing African-American population filled labor needs, and very large internal migrations from one slave-holding region to the other newly settled regions account for the distribution of population in North America today. These factors explain why the period of importation of Africans was relatively brief and why North America imported only about 5 percent of all slaves exported from Africa.

North American importers drew slaves from all parts of west and west central Africa and a few from as far afield as Madagascar off the southeast coast of Africa. In many areas of North America, however, slave imports were dominated by a particular African exporting region. This was because the shippers who supplied slaves to American buyers often had customary relations with a limited group of African sellers, and people from those regions tended to predominate. In addition, North American importers frequently were in competition with importers from the Caribbean who often favored slaves from particular regions and retained them in the Caribbean. Thus, for example, Jamaica retained a large number

of slaves from the Gold Coast, and North America received relatively few people from this region, even though British shipping had good connections and purchased thousands of slaves on the Gold Coast every year.

The African exporting area was traditionally divided by European shippers into three large regions. The first was Upper Guinea which corresponded to the coast from Senegal down to roughly Liberia. Next came Lower Guinea, corresponding to the coast from eastern Ivory Coast to eastern Cameroons. The last was Angola, which commenced in modern Gabon and extended down to the central coast of Angola. These three regions were in turn subdivided into "coasts." Upper Guinea had two major coasts: Senegambia on the north down to the Gambia River, and Sierra Leone from Gambia down to Liberia. Lower Guinea had the Gold Coast from eastern Ivory Coast to the Volta River, the Slave Coast from the Volta to the eastern part of Nigeria, and the Bight of Biafra comprising the complex of rivers and deltas of eastern Nigeria and Cameroon. Terminology varied—Sierra Leone might be called the "Rivers of Guinea" by French or Portuguese shippers, for example—but the general boundaries remained quite stable throughout the long period of the Atlantic trade.

Although these coastal designations were created and maintained by European shippers, they did correspond to African cultural and political realities. Each coast possessed a complex commercial network reaching down to a group of related Atlantic ports, and each network, in turn, was also a zone of frequent communication that included cultural and political interaction. Thus, slave-trading patterns in Africa tended to produce a fairly predictable mixture of people from the hinterland area supplying the coast. By knowing the coast from which a shipload of slaves came, both modern historians and eighteenth-century American slave owners could predict within fairly narrow limits from which cultural groups in Africa the people derived.

It is possible, using shipping records, to calculate approximately from which regions Africans who were brought to North America came. Table 1 presents this data as a percentage of total for each American region.

The distribution of Africans varied in different parts of North America. Angolans and Senegambians predominated, in South Carolina and Louisiana. They were less in the Chesapeake area, while people from the Gold Coast and Bight of Biafra were most numerous in the Chesapeake. People from Sierra Leone constituted a significant proportion of arrivals in South Carolina, but they were virtually absent in the Chesapeake area; people from the Slave Coast were important in Louisiana but not in either South Caro-

TABLE 1. African Origins of North American Slaves by Region

	S.C.	Chesapeake	La.
Senegambia	20	16	30
Sierra Leone	23	—	—
Gold Coast	13	28	10
Slave Coast	2	—	20
Bight of Biafra	2	38	15
Angola	40	17	35

lina or the Chesapeake area. Historians have not yet fully investigated the implications of this regional diversity for the development of African-American culture.

The people who came to America from each of these coasts were known to American slave owners as being divided into a fairly large number of "nations" or "countries" whose membership was determined by cultural criteria such as language or facial and body markings. Comparisons between the detailed surveys of these nations which were conducted by eighteenth-century writers and modern research in African history reveal that there is a trend to identify an African nation using constructs that were not the same as those used by the Africans themselves. Eighteenth-century Africans organized their lives by village, family and grouping, or state, but did not recognize linguistic or cultural criteria as a primary element of their identity. A larger frame of reference for Africans was an adherence to either Islam or Christianity. Many Africans from a broad band of West Africa stretching from Senegal down to Sierra Leone and deep into the interior were Muslims, while most central Africans in Kongo and its southern neighbors in the Portuguese colony of Angola were Christians.

The presence of these various African nations in America was a result of commercial, political, and military events in Africa. Some people were enslaved because of poverty, others through judicial processes, but by far the most important reasons for African enslavement were wars and banditry.

In Senegambia, enslavement in the eighteenth century followed two models. The first of these was wars among the states of the Senegal valley, particularly a cycle of conflict between Bawol and Kajoor that often involved their allies or neighbors. Further inland, a similar rivalry matched the states of Segu (on the Niger River) and Kaarta, farther north. In addition to these wars which were among states indigenous to the area, there were raids conducted from the north by the Moors, who were linked to Morocco, which had ambitions in the Senegal valley region.

A second mode of enslavement came from banditry. Senegambian bandits were often off-duty soldiers. The *ceddo,* royal slaves who governed and staffed the armies of the states, routinely conducted raids on the population of the area. While these raids were illegal, authorities often cooperated with the soldiers in the acquisition and sale of slaves. The *sofa,* professional soldiers of Segu and Kaarta, engaged in the same pattern of unofficial and illegal enslavement with official collusion. Popular resentment against this activity was strong, and on two occasions, in the 1670s and again in the 1770s, popular movements with Islamic leadership revolted against the leadership, although without long-term success.

The many "Bambara" slaves who were imported to Louisiana in the early eighteenth century probably were obtained through these means as were the many Senegambians who appear in the inventories of the last part of the eighteenth century.

In Sierra Leone, small-scale piracy was widespread on the many creeks and rivers of the coast where forests provided hideouts for raiders. This piracy co-existed with petty wars, but the most important source for eighteenth-century enslavement was the "holy war" (jihad) of the Muslim Fulbe cattle herders of Futa Jallon following 1726. While in its initial stages, the jihad was aimed at redressing grievances of the Fulbe and establishing a reformed Islamic polity; in time it became a source of wars, as the new state in Futa Jallon raided its neighbors and sent the fruits of its efforts overseas on the slave ships. The timing of the arrival of Sierra Leonean slaves in South Carolina suggests that the wars of the jihad period played a major role in the burst of exports from the region.

Before the late seventeenth century, the Gold Coast was divided into dozens of small states. Wars were frequent in the area, often occasioned by commercial disputes and unpaid debts. European trading companies, which came to the coast to buy gold, often became involved in the disputes both in an effort to settle their own commercial affairs and also to act as mercenaries hired by African states. It was only in the late seventeenth century, with the rise of larger imperial states in the interior, that the region became a major supplier of slaves to the Atlantic region. The rise of Denkyira, Asante, and Akwamu in the 1670s and later occasioned wars of expansion by these states, which were able to mobilize large armies, and forced the coastal states to operate in conjunction with each other to meet the challenge. Although the petty disputes and wars continued into the eighteenth century, major wars in which tens of thousands of people were captured and exported became more important as the interior kingdoms fought coastal states and each other. By the 1720s Asante had emerged as the most powerful state in the area, but warfare was

still common. Many of the areas that Asante had conquered revolted frequently, and Asante itself was beset with civil wars especially upon the death of a ruler, as occurred in the 1750s.

Slaves from the Gold Coast, who were widely known in English-speaking America as "Coromantees" (from one of the exporting ports), were particularly valued for their strength and spirit in the West Indies, and their relatively limited numbers in America everywhere outside of the Chesapeake area reflected the greater purchasing power of the West Indian planters. On the other hand, their largely military enslavement made Coromantees capable of rebellion, and indeed, they were behind a large number of plots, conspiracies, and rebellions in both the West Indies and North America (such as the NEW YORK SLAVE REVOLT OF 1712).

The pattern of the Gold Coast was primarily repeated on the nearby Slave Coast. Indeed, mercenaries from the Gold Coast were often involved in the politics of the petty states of the coast in the late seventeenth century. However, the rise of the kingdom of Dahomey in the 1680s increased the frequency of large-scale wars in the area. Almost every year Dahomey launched a campaign toward the coast and against the Mahi and the Nagos, loosely structured confederations of states that lay east and west of Dahomey's core. Slaves were taken from the Mahi and the Nagos if the Dahomean armies were successful, or from Dahomey itself if the campaigns failed, as they frequently did. The Empire of Oyo, lying inland from Dahomey, occasionally intervened in the affairs of its coastal neighbors in an attempt to control Dahomey, its nominal vassal since the 1720s, or to act in conjunction with it. Oyo also conducted its own wars, about which few details are known, and many of the people captured or lost in these campaigns were also exported.

Remarkably, few Slave Coast slaves found their way to North America except for those who arrived through French shipping in Louisiana. British shippers maintained posts on the Slave Coast and slaves from these posts and formed a portion of the population in Jamaica and other West Indian islands, but they were not notable in the cargos arriving at any North American port.

Relatively few slaves were taken from the coastal areas of the Bight of Biafra, although piracy along its many rivers and creeks was quite common. Instead, people who were enslaved from the interior were exported from the coastal ports. The river network of the region provided cheap and easy transportation, whilethe population density of the interior regions was probably the greatest of any in Atlantic Africa.

In the early eighteenth century the kingdom of Benin, which dominated the western part of the area,

underwent a lengthy civil war between government factions that lasted into the 1730s. Benin exported many of the victims of these wars through its own port of Ughoton, while many others found their way to other ports such as Warri or New Calabar on the main channel of the Niger River. New Calabar, one of the major exporting ports of the area along with its neighbor Bonny, drew most of its slaves from the Igbo areas that lay up the rivers in the interior. Olouadah EQUIANO, enslaved around 1760, provided a description of the area from which he originated in his autobiography. As he described it, people were enslaved as a result of many intertown wars or were captured by pirates who operated along the rivers and from bases in the thickly wooden regions. In the Cross River region which was served by the port of Old Calabar, a religious association called the Arochukwu often contributed to the supply of slaves. (The Arochukwu was an oracle which settled disputes and had branches over a wide network.) In addition to their religious services, for which they often demanded slaves in payment for adjudication, they also operated a more conventional trading network. Sometimes the oracle or its agents were reputed to kidnap people as well as engage in religious and commercial operations.

The Angola coast was largely supplied in the eighteenth century by the civil war in the kingdom of Kongo. Although there was an active slave trade from the ports of Luanda and Benguela, relatively few slaves exported from these ports or from the hinterland they served in the Kimbundu speaking interior found their way to North America. Instead, they were primarily shipped to Brazil while a few were smuggled to Kongo's ports and taken as slaves by French shippers. A few English crafts worked this coast in the late eighteenth century.

Dynastic disputes of the late seventeenth century lay at the root of Kongo's civil war. Although they were never quite resolved by force, some of these disputes were settled by monarchs in 1715, in the 1760s, the mid-1780s, after 1794, and again in 1805. The violent episodes of royal contest were interspersed with periods of smaller scale violence, because authority was not very centralized. Local wars enforcing shaky authority figures were frequent. This civil unrest and subsequent breakdown of authority led to the rise of bandits who either allied themselves with those in power or else operated on their own.

Just as Muslim reformers in Senegambia sought to mobilize popular support to oppose the oppression of the military bandits and state officials in their area, so the Christian kingdom of Kongo had its own movement of reform. Led by Beatriz Kimpa Vita, who claimed to be possessed by Saint Anthony, the movement sought an end to the civil wars and the enslavement that resulted; they also sought the restoration of Kongo under a new mystical Christian leadership. Although the movement succeeded in occupying the capital, the leader was soon captured and burned at the stake as a heretic in 1706.

After 1750 captives from the civil war in Kongo were joined by increasing numbers of people enslaved from both the north and the east of the kingdom. The slaves from the north seem to have been captured during the petty wars between commercial states, while the slaves from the east were taken as a result of the emergence and raiding of the Lunda empire which extended its authority, or at least its ability to raid, as far as the Kwango River by 1760. All these slaves from Kongo or elsewhere were sold to merchants who served North America largely through ports north of the Zaire River, often under the kingdom of Loango.

Angolans made up a significant portion of the slaves imported into all American regions, but they were particularly numerous in Louisiana and South Carolina. Because so many had served in wars, they, like the Gold Coast Coromantees, were often implicated in revolts and rebellions in America. Angolans led the STONO REBELLION in 1739, and they also played an important role in the other revolts in America such as those in Brazil and in the Haitian Revolution.

Africans who arrived in America came with specific cultural backgrounds that related to their region of origin in Africa. This was particularly true of their linguistic background, for their ability to communicate with other people was limited at first to those of their own ethno-linguistic group. Unlike African social organization, which tended to be based on kinship and locality or citizenship in a state, the social organization of Africans in America was based on common languages. American "nations" or "countries," as they were called in contemporary records, formed social and mutual self-help groups from among people of their own background to bury their dead or to celebrate occasional holidays. They sometimes formed shadow governments with kings and queens, either independently or, in Spanish and Portuguese America, through membership in lay organizations created by the Catholic Church.

The presence of these ethnic social groups, helped to preserve African culture in America. They also provided a cross-state network which could allow coordinated action in larger areas and sometimes played an important role in conspiracies and revolts.

REFERENCES

ELTIS, DAVID. *Economic Growth and the Ending of the Transatlantic Slave Trade*. Cambridge, U.K., 1987.

INIKORI, J.E., ed. *Forced Migration: The Impact of the Export Slave Trade on African Societies.* New York, 1982.

LOVEJOY, PAUL. *Transformations in Slavery: A History of Slavery in Africa.* Cambridge, U.K., 1983.

RODNEY, WALTER. *A History of the Upper Guinea Coast, 1545–1800.* London, 1970.

THORNTON, JOHN. *Africa and Africans in the Making of the Atlantic World, 1400–1680.* Cambridge, U.K., 1992.

———. *The Kingdom of the Congo: Civil War and Transition, 1641–1718.* Madison, Wis., 1983.

JOHN THORNTON

African Americans in the West. *See* West, Blacks in the.

African Benevolent Society. *See* Fraternal Orders and Mutual Aid Associations.

African Blood Brotherhood.

The African Blood Brotherhood (ABB) was the first black organization in the twentieth-century United States to advance the concept of armed black self-defense on behalf of African-American rights. It was founded in September 1919 by the West Indian radical Cyril Valentine BRIGGS.

A semisecret, highly centralized propaganda organization, the ABB was a product of the upsurge of militant racial consciousness enshrined in the NEW NEGRO movement that arose following America's entry in 1917 into World War I. Formally entitled the African Blood Brotherhood for African Liberation and Redemption, it was organized specifically in response to the convulsions spawned by the race riots that swept various cities in the United States during the summer of 1919, which caused it to become known as the RED SUMMER.

Formation of the brotherhood was announced in the October 1919 issue of Briggs's *Crusader* magazine, which thereafter became the official organ of the ABB. With Briggs as its executive head, the group was governed by a supreme executive council that included Theo Burrell (secretary), Otto E. Huiswoud (national organizer), Richard B. MOORE (educational director), Ben E. Burrell (director of historical research), Grace P. Campbell (director of consumers' cooperatives), W. A. Domingo (director of publicity and propaganda), and William H. Jones (physical director).

Combining revolutionary Bolshevik principles with fraternal and benevolent features, the ABB warned in its recruiting propaganda that "Those only need apply who are willing to go to the limit!" (Hill 1987, 2/2:27). From its inception, the brotherhood was aligned with the nascent COMMUNIST PARTY OF THE U.S.A. (CPUSA). Along with fellow West Indians Otto Huiswoud of Suriname and Arthur Hendricks of Guyana, Briggs was among the party's charter members at the time of its founding.

Historically, as the first black auxiliary of the CPUSA, the brotherhood served as a vehicle for Communist recruitment efforts in black communities. It also was the mechanism for the party to attempt to exert its ideological influence upon other black organizations, most notably in the effort directed against Marcus GARVEY's leadership of the UNIVERSAL NEGRO IMPROVEMENT ASSOCIATION (UNIA).

While it derived symbolic inspiration from the "blood brotherhood ceremony performed by many tribes in Black Africa" (Theo. Burrell, "African Blood," in Hill 1987, 5/3:6, 32), the ABB modeled on the Irish Republican Brotherhood, which dated back to 1858 and the founding of the Irish Fenian movement. The group's ritual was said to resemble that of a fraternal order, with the regular trappings of degrees, passwords, signs, initiation ceremony, and brotherhood oath. Organizationally, it comprised a series of "posts," such as the Menelik Post in New York, directed by individual post commanders. (Hill 1987, 4/4:21–23).

Membership in the brotherhood was by enlistment, thus making it difficult to reconstruct even an approximate number of members. It is doubtful, however, that membership ever consisted of more than a few hundred. Commentators such as W. A. Domingo and Claude MCKAY, who were adherents of the brotherhood, even asserted that the ABB was never more than a paper organization.

The only public demonstration known to have been mounted by the ABB occurred in August 1921. The occasion was the second annual international convention of Garvey's UNIA in Harlem, at which the ABB attempted unsuccessfully to lobby convention delegates outside Liberty Hall in support of the link proposed by the ABB with the UNIA. Prior to this, in June 1921, the group was catapulted into national attention, if only briefly, by a race riot in Tulsa, Oklahoma; the media linked the resistance raised by the African-American community of that city with ABB organizers. The ABB was also involved in the All Race Conference of Negroes, better known as the NEGRO SANHEDRIN, which met in Chicago in February 1924, with Briggs as secretary.

Self-described as a workers' organization, the ABB claimed to be "an organization working—openly where possible, secretly where necessary—for the rights and legitimate aspirations of the Negro workers against exploitation on the part of either white or black capitalists." In terms of political program, one of its main distinguishing features, ideologically, was its attempt to marry the principle of racial self-determination to the goal of revolutionary class consciousness. As stated in its program, the ABB sought "a liberated race" while working to achieve "cooperation with other darker races and with class-conscious white workers."

Liquidated in 1924–1925 by decision of the CPUSA (following the changeover of the latter from an underground organization to an aboveground movement), the ABB was replaced by a succession of front organizations subsequently set up by the party, most notably the American Negro Labor Congress and the League of Struggle for Negro Rights.

REFERENCES

FONER, PHILIP S., and JAMES S. ALLEN, eds. *American Communism and Black Americans: A Documentary History, 1919–1929.* Philadelphia, 1986.

HILL, ROBERT A., ed. *The Crusader.* 3 vols. New York, 1987.

ROBERT A. HILL

African Civilization Society (AfCS), Christian missionary and black-emigration organization. After it was founded in September 1858, the society was led by Henry Highland GARNET, the well-known Presbyterian clergyman. From the beginning, the AfCS had close ties with the New York State Colonization Society. Several of the Colonization Society's leaders sat on the eighteen-member AfCS board of directors. Both societies had their offices in Bible House in New York City; both shared an interest in settling free blacks in Africa, although the white-sponsored colonization movement had been vigorously opposed by northern free blacks from its founding in 1817.

The AfCS constitution advocated the "civilization and evangelization of Africa, and the descendants of African ancestors in any portion of the earth, wherever dispersed." Under Garnet's leadership, the AfCS focused this broad directive on establishing a colonial settlement in Yoruba, a region of West Africa. Garnet envisioned the Yoruban settlement as a base from which to extend the supposed benefits of Western civilization—commerce and Christianity—to the entire African continent. The Yoruban settlement also had an antislavery objective. AfCS leaders believed that by encouraging native Africans to grow cotton, they might undermine the profitability of American slavery and the slave trade.

The AfCS generated much interest and gained substantial following, particularly through the endorsement of Henry M. Wilson, Elymas P. ROGERS, and several other noted African-American clergymen. But the society's close association with leaders of the New York State Colonization Society made it suspect in the minds of many black leaders. Frederick DOUGLASS, James McCune SMITH, and J. W. C. PENNINGTON led the antiemigrationist attack and criticized Garnet personally for his involvement in the African emigration movement.

The society's financial resources never matched its ambitious program. One of the AfCS directors, Theodore Bourne, traveled to England early in 1860 to build interest and financial backing for the Yoruban settlement. Even with the support of an English AfCS affiliate, the African Aid Society, Bourne encountered insurmountable difficulties. Martin R. DELANY, organizer of the Niger Valley Exploring Party, was also in Britain promoting his own African settlement proposal. Competition between the two programs created doubt and confusion and dampened enthusiasm among British reformers. Later in 1860, Elymas P. Rogers led an AfCS-sponsored expedition to West Africa to survey possible locations for the Yoruban settlement. The mission was cut short by his death from malaria shortly after his arrival in Liberia. Garnet traveled to England in August 1861 in a final, futile effort to revive flagging interest in African settlement.

In the early 1860s, the AfCS began distancing itself from the controversial subject of African emigration and focusing more on home missions. The Civil War opened new opportunities for missionary activity among former slaves in the South. Under the guidance of a new president, Presbyterian clergyman George W. Levere, the AfCS directed its attention to freedmen's education. From 1863 through 1867, the AfCS sponsored several freedmen's schools in the Washington, D.C., area and other parts of the South.

REFERENCES

BELL, HOWARD H. *Search for a Place: Black Separatism and Africa, 1860.* Ann Arbor, Mich., 1971.

MILLER, FLOYD J. *Search for a Black Nationality.* New York, 1982.

MICHAEL F. HEMBREE

African Community League (ACL). *See* Universal Negro Improvement Association.

African Female Benevolent Society. *See* Early African-American Women's Organizations.

African Free School. The African Free School opened a private home on Cliff Street in New York City in 1787 with forty-seven students supported by the NEW YORK MANUMISSION SOCIETY, a joint effort of Anglicans and Quakers. Over the next fifty years the school was the primary vehicle for black education in New York City. Descended from the Trinity Church School for blacks, first headed by Elias Neau and maintained until 1778, the African Free School had served over 2,300 students by 1814. In 1809 it was the largest single school in the city, with 141 pupils enrolled. Like other charitable schools, it received city assistance, beginning in 1796.

In 1813, a state law provided that the African Free School would receive city and county school funds. Four more such schools had been opened by 1827. The first nonprivate building for the African Free School was at William and Duane streets. Later, schools opened at Mulberry and Grand streets (these were turned into an all-female school in 1831 with additional buildings at Sixth Avenue and Nineteenth Street, 161 Duane Street, and 108 Columbia Street). The Free School taught a basic curriculum of read-

Almost all African-American education in the early nineteenth century was privately funded. Among the more successful schools of the era were the New-York African Free Schools, in Manhattan, sponsored by the New-York Manumission Society, which educated five hundred pupils annually by 1820. This depiction of New-York African Free School No. 2 is from an 1830 engraving after a drawing made by P. Reason, a thirteen-year-old pupil at the school. (Prints and Photographs Division, Library of Congress)

ing, writing, and arithmetic, and augmented it with poetry, drawing, and public speaking. Navigation skills were emphasized, an indication of the importance of seafaring for black employment. Teachers gave special lessons on Haiti. As scrapbooks of award-winning assignments show, the students performed admirably. School rules were strict. Students were required to attend church and read the Scripture, and were continually warned about minor sins of lying, dishonesty, profanity, and "cruelty to beasts." School commenced at 9 A.M. and 2 P.M., with penalties for lateness. The school used the Lancastrian system of education, employing student monitors to assist in instruction. Despite the racism its graduates encountered, the African Free School was the training ground of a generation of talented African Americans. Among its most illustrious graduates were James McCune SMITH, Ira ALDRIDGE, Peter WILLIAMS, JR., James VARICK, Charles Lewis Reason, Alexander CRUMMELL, and Thomas Sydney.

After a period of declining enrollments, Samuel Eli CORNISH, editor of FREEDOM'S JOURNAL, spearheaded efforts to double the student body by 1830. Four new schools opened in 1832. The Free School survived, despite bitterness among African Americans toward the procolonization attitudes of the longtime head of the school, Charles Andrews. It also faced competition, since other members of the black community opened private schools as early as 1812.

The Free Schools did not go above the lower grades. Efforts by Peter Williams, Jr., and David RUGGLES between 1831 and 1837 failed to establish permanent, black-maintained high schools. African-American students were thus forced to continue to patronize the Free School, without much hope for advancement. In 1834 the Free Schools were transferred to the control of the New York State Public School Society, the major local conduit for state funds. In reality, the schools had already ceased to be philanthropic institutions and had become public schools.

REFERENCES

ANDREWS, CHARLES W. *History of the New-York African Free Schools.* New York, 1830.

BARNETT, ENID VIVIAN. "Educational Activities by and in Behalf of the Negroes in New York, 1800–1830." *Negro History Bulletin* 4 (1951): 102ff.

CURRY, LEONARD P. *The Free Black in Urban America 1800–1850.* Chicago, 1981.

GRAHAM RUSSELL HODGES

Africanisms. The transatlantic slave trade was the main avenue for the transmission of African culture to the New World. This trade established a per-

manent link between Africa and North America as Africans sold into slavery transplanted their culture to the New World. Africanisms survived in the New World by a process of cultural transference; cultural synthesis; and cultural transformations. By definition, an Africanism is any cultural (material or non-material) or linguistic property of African origin surviving in the New World or in the African DIASPORA. The study of Africanisms in the New World has sparked much debate over the survival of African culture in North America. Africans, unlike European immigrants, were deprived of their freedom to transport their kinship structures, courts, guilds, cult groups, market, and military. However, Africans made substantial contributions in agriculture, aesthetics, dance, folklore, food culture, and language.

African cultural retentions are found at different levels of the plantation work force. Some of the first groups to have a major impact on American culture were the first Africans—Mandes and Wolofs from Senegambia—arriving in colonial South Carolina. Between 1650 and 1700, the dominant group of Africans imported to South Carolina were Senegambian in origin. They were the first Africans to have elements from their language and culture retained within the developing language and culture of America. David Dalby has identified early linguistic retention among this group and traced many Americanisms to Wolof, including *OK, bogus, boogie-woogie, bug* (insect), *John, phoney, guy, honkie, dig* (to understand), *jam, jamboree, jitter(bug), jive, juke(box), fuzz* (police), *hippie, mumbo-jumbo, phoney, rooty-toot(y),* and *rap,* to name a few.

Africa culture also survived in the form of folklore. Brer Rabbit, Brer Wolf, Brer Bear, and Sis' Nanny goat were part of the heritage the Wolof shared with other West African peoples such as the Hausa, Fula (Fulani), and the Mandinka. The Hare (Rabbit) stories are also found in parts of Nigeria, Angola, and East Africa. Other animal fables that remained popular in the New World include the Tortoise stories found among the Yoruba, Igbo, and Edo-Bini peoples of Nigeria, and Spider (Anansi) tales, found throughout much of West Africa including Ghana, Liberia, and Sierra Leone. The latter have reappeared in the United States in the form of Aunt Nancy stories. These African tales found their way into American culture through the retelling in Joel Chandler Harris's Uncle Remus stories as well as through more authentic African-American sources.

Many slaves, such as Mande house servants in South Carolina, served a unique position as intermediaries in the acculturation of both the planters and the field slaves. The house servant incorporated African cultural patterns into the culinary, religious, and folkloric patterns of the planters. At the same time,

the slaves learned European cultural standards. So, while house servants drew their European heritage from the planters, the planters drew their African heritage from their black servants.

The acculturation process was mutual, as well as reciprocal: Africans assimilated white culture, and planters adopted some aspects of African customs and practices such as the African cultural methods of race cultivation, African cuisine (which had a profound impact on what became southern cooking), open grazing of cattle, and use of herbal medicines to cure New World diseases. For example, Africans are credited with bringing to America folk treatment for smallpox, and antidotes for snakebite and other poisons. Through the root doctor, Africans brought new health practices to the plantations. The African house servants also learned new domestic skills, including the art of quilting from their mistresses. They took a European quilting technique and Africanized it by combining an appliqué style, reflecting a pattern and form which is still found today in the Akan and Fon textile industries of West Africa.

In South Carolina and Louisiana, the field slaves were mainly Angolan and Congolese, who brought a homogeneous, identifiable culture. They often possessed good metallurgical and woodworking skills, and had a particular skill in ironworking, making the wrought-iron balconies in New Orleans and Charleston. But as field workers, the Angolans were kept away from the developing mainstream of white American culture. This isolation worked to the Angolans' advantage in that it allowed their culture to escape acculturation and maintained their homogeneity.

Angolan contributions to South Carolina and Louisiana include not only wrought-iron balconies but also wood carvings, basketry, weaving, baked clay figurines, and pottery. Cosmograms, grave designs and decorations, funeral practices, and the wake are also Bantu in origin. Bantu musical contributions include banjos, drums, diddley bows, mouthbows, the washtub bass, jugs, gongs, bells, rattles, ideophones, and the lokoimni, a five-stringed harp.

After 1780 the Angolans had a substantial presence in South Carolina and other areas of the southeastern United States including Alabama and Louisiana. In areas such as the Sea Islands of South Carolina, the Angolans were predominantly field hands or were used in capacities that required little or no contact with Euro-Americans, so they were not confronted with the same problems of acculturation as were West African domestic servants and artisans. Living in relative isolation from other groups, they were able to maintain a strong sense of unity and to retain a cultural vitality that laid the foundation for the development of African-American culture.

Much of Mande culture was transmitted to white Americans by way of the "de big house." African cooks introduced deep-fat frying, a cooking technique that originated in Africa. Most southern stews (gumbos) and nut stews are African in origin. Gumbo (*kingombo*), a soup made of okra pods, shrimp, and powdered sassafras leaves, was known to most Southerners by the 1780s. Other southern favorites are jambalaya (*bantu tshimbolebole*) and callaloo, a thick soup similar to gumbo.

Another African culinary dish that was recreated by the descendants of Africans in North America is fufu. In South Carolina, it is called "turn meal and flour." This is a traditional African meal eaten from the Senegambia to Angola. "Cornbread" was mentioned by slavers as one of the African foods provided for their African cargo. From this fufu mixture, slaves made "hoecake" in the fields. Later this hoecake evolved into "pancakes" and "hot water cornbread." As early as 1739, American naturalist Marc Catesby noted that slaves made a mush from the cornmeal called pone bread. He also noted that slaves used Indian corn hominy and made grits (similar to the African dish, eba.) Other African dishes that became part of southern cuisine are hop-n-johns (rice and black-eyed peas cooked together) and jollof rice (red rice).

Important crops brought directly from Africa during the translatlantic slave trade included food gathered for Africans on board slave ships. These crops included okra, tania, black-eyed peas, and kidney beans. Other crops introduced into North America from Africa are coffee, peanuts, millet, sorghum, guinea melon, watermelon, the yam, and sesame seeds.

Soul food goes back to days when plantation owners gave slaves discarded animal parts, such as hog maw (stomach), hog jowl, pig's feet, and ham hocks. To these, African Americans added a touch of African cooking, and a group of African foods, which included collard greens, dandelion greens (first recorded in 1887), poke greens, turnip greens, and black-eyed peas (first brought to Jamaica from Africa in 1674 and to North America by 1738).

The first rice seeds were imported to South Carolina directly from Madagascar in 1685. Africans supplied the labor and the technical expertise. Africans off the coast of Senegal trained Europeans in the method of cultivation. Africans were able to successfully transfer their rice culture to the New World. The methods of rice cultivation used in West Africa and South Carolina were identical.

Africa also contributed to American cattle raising. Fulanis accustomed to cattle raising in the Futa Jallon in Senegambia oversaw the rapid expansion of the British American cattle herds in the middle of the eighteenth century. They were responsible for introducing patterns of "open grazing," now practiced throughout the American cattle industry. This practice is used worldwide in cattle culture today. Open grazing made practical use of an abundance of land and a limited labor force.

In West Africa longhorn and shorthorn cattle were common across much of the western region of Africa, particularly in the River Gambia area. Many Africans entering South Carolina after 1670 were experienced in tending large herds. Eighteenth-century descriptions of local West African animal husbandry bear a striking resemblance to what would appear in Carolina and later in the American dairy and cattle industries. Harvesting of cattle and cattle drives to centers of distribution were also adaptations of African innovations. Africans also introduced the first artificial insemination and the use of cow's milk for human consumption in the British colonies.

Historian Peter Wood has argued that the word *cowboy* originated from this early relationship between cattle and Africans. The term originated in the colonial period when African labor and skills were closely associated with cattle raising. Africans stationed at cow pens with herding responsibilities were referred to as "cowboys," just as Africans who worked in the "big house" were known as "houseboys."

Much of the early language associated with cowboy culture had a strong African flavor. The word *bronco* (probably of Efik/Ibibio and Spanish origins) was used centuries ago to denote Spanish and African slaves who worked with cattle and horses. The word *buckra* is derived from *mbakara,* the Efik/Ibibio word for "white man." A related term of cowboy culture is *buckaroo,* another Efik/Ibibio word also derived from *mbakara.* The word *buckra* (poor white man) was used to describe a class of whites who worked as broncobusters—bucking and breaking horses, perhaps because planters used buckras as broncobusters because slaves were too valuable to risk injuring. Another African word that found its way into popular cowboy songs is *dogie,* as in "get along with little dogies." *Dogie* originated from the Kimbundu, *kidogo,* a little something, and *dodo,* small.

Africanisms are not just exclusive to African-American culture, but contributed to an emerging American culture. One area that has been largely ignored in the debate over African cultural survival in the United States is the survival of African culture among white Americans. Many Africanisms have entered southern culture as a whole, such as the banjo, the elaborate etiquette of the South with respect for elders, its use of terms of endearment and kinship in speaking to neighbors, and its general emphasis on politeness. White Southerners have adopted African

speech patterns and have retained Africanisms from baton twirling and cheerleading to such expressions and words as *bodacious, bozo, cooter* (turtle), *goober* (peanut), *hullabaloo, hully-gully, jazz, moola* (money), *pamper, Polly Wolly-Doodle, wow, uh-huh, unh-unh, daddy, buddy,* and *tote,* to list a few.

These are only some of the ways in which both African and European cultures contributed to what was to become American culture. Culturally Americans share a dual cultural experience—one side European and the other African.

REFERENCES

DALBY, DAVID. "The African Element in Black English." In Thomas Kochman, ed. *Rappin' and Stylin' Out.* Urbana, Ill., 1972.

GAMBLE, D. P. *The Wolof of Senegambia.* London, 1957.

HOLLOWAY, JOSEPH E. *Africanisms in America Culture.* Urbana, Ill., 1990.

HOLLOWAY, JOSEPH E., and WINIFRED K. VASS. *The African Heritage of American English.* Urbana, Ill. 1993.

JOYNER, CHARLES. *Down by the Riverside: A South Carolina Slave Community.* Urbana, Ill., 1984.

LEVINE, LAWRENCE. *Black Culture and Black Consciousness: Afro-American Folk Thought from Slavery to Freedom.* Oxford, U.K., 1977.

VASS, WINIFRED K. *The Bantu Speaking Heritage of the United States.* Los Angeles, 1979.

WOOD, PETER H. *Black Majority: Negroes in Colonial South Carolina from 1670 through the Stono Rebellion.* New York, 1974.

JOSEPH E. HOLLOWAY

African Methodist Episcopal Church.

Richard ALLEN (1760–1831), founder of the African Methodist Episcopal (AME) Church, was born a slave in Philadelphia, Pa., on February 14, 1760. Slaveholder Benjamin Chew sold Allen, his parents, and three siblings to Stokley Sturgis of Kent County, Del. METHODIST CHURCH circuit riders frequently preached in the area, and Allen responded to their evangelism—perhaps also to their antislavery reputation—and joined the Wesleyan movement. His piety deepened because Sturgis permitted him to attend Methodist services regularly and to hold religious gatherings in the slave owner's own home. Sturgis also allowed Allen and his brother to buy their freedom, a task which was accomplished in 1783. For three years, Allen traveled through the Middle Atlantic as an itinerant Methodist preacher, then settled in Philadelphia to preach to blacks at the St. George Methodist Episcopal Church. The founding of the FREE AFRICAN SOCIETY OF PHILADELPHIA in 1787 and a racial altercation caused him to leave St. George, which in turn led to the building of Philadelphia's Bethel African Methodist Episcopal Church in 1794, often known as the Mother Bethel Church. In 1807, efforts by several pastors at St. George to control the congregation moved Allen to gain judicial recognition of Bethel's independence. A final attempt in 1815 by a St. George pastor to assert authority at Bethel Church induced Daniel COKER, the leader of Baltimore's black Methodists, to preach a sermon the following year commending Allen for his successful stand. Not long after, Allen drew Coker and other blacks from Baltimore; Salem, N.J.; and Attleborough, Pa., to meet with his Philadelphia followers to form the AME Church.

At the Philadelphia conference in 1816, Coker was elected bishop but declined the offer, perhaps because of his light SKIN COLOR. Allen was then chosen bishop, and under his leadership the denomination rapidly expanded. African Methodism spread north to New York and New England; south through Maryland, the District of Columbia, and (for a time) South Carolina; and west to the Ohio Valley and the old Northwest Territory. During the antebellum period, the denomination included congregations in the slave states of Kentucky, Missouri, and Louisiana. Missionaries such as William Paul QUINN (1788?–1873), an AME bishop after 1844, founded scores of congregations in the Midwest in the 1830s and 1840s. Along the Pacific Coast, the AME church spread from Sacramento and San Francisco in the early 1850s and to other locations in California and adjoining territories. AME loyalists also had success in Canada and made some inroads into Haiti. In 1864, thirty-three years after Allen's death, the AME church had a membership of 50,000 in 1,600 congregations.

During the antebellum period, while the AME Church was largely restricted to the northern states, numerous clergy and congregations gave direct aid to abolitionism. Morris BROWN, who became the second bishop of the church after Allen's death, had been implicated in Denmark Vesey's abortive slave insurrection in South Carolina in 1822 (*see* DENMARK VESEY'S CONSPIRACY). Vesey himself was an AME preacher who, according to white authorities, planned the slave revolt during AME church services. The abolitionist stances of Allen, Quinn, and Brown were reaffirmed at the 1840 Pittsburgh annual conference. Stating that "slavery pollutes the character of the church of God, and makes the Bible a sealed book to thousands of immortal beings," the delegates resolved that their denomination should use its "influence and energies" to destroy black bondage.

Daniel A. PAYNE, who became a bishop in 1852, greatly influenced the development of the AME

church. Freeborn in 1811 in Charleston, S.C., Payne in his early adult years was a schoolteacher until a South Carolina state law forbade the education of blacks and forced him to close his school. In 1835 he moved north and matriculated at Gettysburg Theological Seminary in Pennsylvania. After his ordination into the AME ministry in 1843, Payne pastored in Baltimore, later serving the denomination as historiographer, and crusaded for an educated clergy. In 1863, Payne convinced reluctant AME leaders to commit to a daring venture in higher education by founding WILBERFORCE UNIVERSITY, the first black college started by African Americans. Wilberforce was only the first of several colleges founded by the AME. Others include Allen University (1880) in South Carolina, Morris Brown College (1881) in Georgia, Paul Quinn College (1881) in Texas, and Kittrell College (1886) in North Carolina.

The period of the CIVIL WAR and RECONSTRUCTION proved pivotal to AME church development. Recruitment of black soldiers occurred on the premises of AME congregations such as Israel Church in Washington, D.C. Four AME ministers—Henry M. TURNER, William H. Hunter, David Stevens, and Garland H. White—served with ten other black chaplains in the Union Army. Additional AME clergy, including some who would become bishops, also fought on the Union side.

As northern victories liberated Confederate strongholds in Virginia and North Carolina, the Baltimore annual conference dispatched AME preachers in 1864 to those states to attract blacks into African Methodism. In 1865, Bishop Daniel A. Payne sailed from New York City to his hometown, Charleston, S.C., to establish the AME mission in the South. The rapid acquisition of members and congregations from Virginia to Texas swelled the denomination in 1880 to 387,566 persons in 2,051 churches.

The development of the AME church in Alabama is illustrative of the denomination's expansion in the postbellum South. Mobile had the first, though short-lived, AME congregation as early as 1820. The denomination revived when two AME ministers preached in the state in 1864. Formal organization of an annual conference occurred in Selma in 1868, a year after missionaries arrived from Georgia; it started with 6 churches, 31 missions, and 5,617 members. Preachers such as Winfield Henri Mixon played a large role in spearheading AME Church growth. Born a slave near Selma in 1859, Mixon in 1882 began a long career as a pastor and presiding elder until his death in 1932. As a presiding elder, he reported that between 1892 and 1895 he launched fourteen new congregations. When he started his ministry, the state comprised three annual conferences: the Alabama, the Central Alabama, and the North Alabama. As a result

of his efforts and those of other church founders, Mixon mapped out three additional jurisdictions, including the East, South, and West Alabama annual conferences. In 1890, AME congregations in the state numbered 247 with 30,781 members; Mixon helped to increase these numbers in 1916 to 525 congregations and 42,658 members.

These evangelistic efforts paralleled the unprecedented political involvement of the AME clergy in Reconstruction state governments and in the U.S. Congress. Approximately fifty-three AME ministers served as officeholders in the legislatures of South Carolina, Florida, Alabama, Georgia, and other states. Henry M. Turner, a Republican, was elected to the Georgia state legislature in 1868, only to be ousted that same year by triumphant Democrats. Richard H. CAIN, then pastor of Emmanuel Church in Charleston, served in the South Carolina state Senate from 1868 through 1870 and then in the U.S. House of Representatives from 1873 through 1875. Turner and Cain became AME bishops in 1880.

Bishop Payne was unhappy about the ascent of Turner and Cain to the AME episcopacy. He and other northern-based bishops were wary of the new generation of denominational leaders whose followers came from the South. Many of these new leaders, among them Turner and Cain, had experiences in elective offices that Payne believed caused an unfortunate politicization of denominational affairs. In the late nineteenth century, regional backgrounds of ministers determined regional alliances and formed the bases of power within the AME church.

There was also increasing political involvement of AME clergy in the northern branch of the denomination. Ezekiel Gillespie, a lay founder of the St. Mark Church in Milwaukee, for example, initiated a state supreme court case that won the suffrage for Wisconsin blacks in 1866. Benjamin W. ARNETT, who became a bishop in 1888, won an election in 1886 to the Ohio legislature, where he became a friend of future President William McKinley. He successfully pushed a repeal of Ohio's discriminatory Black Laws (see BLACK CODES).

In the late nineteenth century, the denomination expanded outside of the United States. In 1884 the British Methodist Episcopal (BME) Church, in existence since 1856, reunited with the AME Church. Thereafter, BME congregations throughout Canada, Bermuda, and South America were part of the AME fold. In 1891, Bishop Turner, who was an influential African emigrationist, established annual conferences in West Africa, Sierra Leone, and Liberia. Five years later, Turner formally received the Ethiopian Church of South Africa into the denomination. This church was established in 1892, when dissident Africans led by M. M. Makone withdrew from the white-

In this post–Civil War engraving, a depiction of Richard Allen, the founder of the AME Church, is surrounded by those of later church bishops. The vignettes in the corners of the engraving depict the educational and missionary endeavors of the church. (Prints and Photographs Division, Library of Congress)

dominated Wesleyan Methodist church after experiencing the same kind of racial discrimination that had brought the AME church into existence in the United States. Turner invited an Ethiopian delegation to the United States, where they accepted membership. (In 1900, Bishop Levi J. Coppin became the first resident bishop in South Africa.)

Bishop Turner's missionary interests were not confined to Africa. Between 1896 and 1908 he presided as bishop of Georgia. He mobilized support and manpower from this jurisdiction for expansion into Cuba and Mexico. He commissioned presiding elders from Georgia to establish congregations among black Latinos in both countries, and several successful AME missions were instituted.

Whenever AME advocates for overseas expansion combined this perspective with black nationalism, ideological fissures surfaced in denominational affairs. Turner's espousal of emigration drew vehement opposition from Benjamin T. TANNER. Tanner, who in 1868 became editor of *The Christian Recorder,* a weekly founded in 1852, started the *AME Church Review* in 1884, and edited it until his election to the

episcopacy in 1888. Concerning Turner's back-to-Africa efforts, Tanner asserted that those who wished to escape the fight for racial equality in the United States counseled "cowardice." He felt that blacks should remain in the United States to secure their full constitutional privileges. While Tanner opposed black emigration to Africa, he and other AME leaders did not fully disagree with all of Turner's nationalist views. Tanner, for example, authored *Is the Negro Cursed?* (1869) and *The Color of Solomon, What?* (1895), both of which challenged racist interpretations of scripture and argued that persons of color figured prominently in Biblical history. In 1893, Benjamin ARNETT, who served as bishop with Turner and Tanner, told the World's Parliament of Religions in his speech "Christianity and the Negro" that St. Luke was black and so were other important figures in the early church.

Between 1890 and 1916 the AME Church grew from 494,777 members in 2,481 congregations to 548,355 members in 6,636 congregations. In 1926 the denomination included 545,814 members in 6,708 congregations. There was significant numerical

strength in Georgia, for example, where 74,149 members worshiped in 1,173 congregations. Florida had 45,541 members in 694 churches. There was some decline in AME strength by 1936, however, when the church reported 4,578 congregations and 493,357 members.

While the AME Church in the South was growing, so was the church in the industrial North. The massive black migration from southern rural communities to industrial centers in the North and South during the two World Wars caused major growth in AME churches in New York, Philadelphia, Chicago, St. Louis, Atlanta, Birmingham, Los Angeles, and other major cities. In these settings, clergy fashioned a version of the SOCIAL GOSPEL which required their involvement with numerous issues in housing, social welfare, unionization, and politics. In the 1920s the Rev. Harrison G. Payne, pastor of Park Place Church in Homestead, a milltown near Pittsburgh, initiated an effort to supply housing to blacks newly arrived from the South; and during World War II, investigators with the federal FAIR EMPLOYMENT PRACTICES COMMITTEE found cooperative AME pastors in numerous cities. Many AME pastors worked with labor unions. Dwight V. Kyle of the Avory Chapel Church in Bluff City, Tenn., for example, sided with the efforts of the Congress of Industrial Organizations (CIO) to unionize black and white mass-production workers in a dangerous antiunion setting.

The burgeoning CIVIL RIGHTS MOVEMENT of the late 1940s and early 1950s found substantive support within the AME clergy. J. A. Delaine, a pastor and school principal in Clarendon County, S.C., and Oliver Brown, the pastor of St. Mark Church in Topeka, Kans., filed suits against public school segregation. Their efforts culminated in the landmark BROWN V. BOARD OF EDUCATION OF TOPEKA, KANSAS (1954) decision in which the U.S. Supreme Court nullified the "separate but equal" doctrine. Threats against Delaine pushed him out of South Carolina to New York City. Activist AME clergy moved the denomination at the 1960 general conference to establish a social action department; Frederick C. James, a South Carolina pastor and future bishop, became its first director.

When Bishop Richard Allen authorized Jarena LEE in 1819 to function as an exhorter in the AME church, he opened the door to women in the ministry. For nearly 150 years unordained female evangelists played important roles as preachers, pastors, and founders of congregations. During the nineteenth and early twentieth centuries, Amanda Berry SMITH, Sarah Hughes, and Lillian Thurman preached in AME pulpits. Smith, for example, evangelized widely in the United States and then preached abroad in the British Isles,

India, and West Africa. Like many, Millie Wolfe, a woman preacher in Waycross, Ga., focused her efforts on the denomination's Women's Home and Foreign Missionary Society. She published a book of sermons that included her thoughts about "Scriptural Authority for Women's Work in the Christian Church." Female evangelists in the Rocky Mountain states in the early 1900s became crucial to AME Church expansion in Colorado, New Mexico, Arizona, Wyoming, and Montana. They established congregations and frequently supplied pulpits throughout this large region. While the gifted preaching of Martha Jayne Keys, Mary Watson Stewart, and others sustained the visibility of female ministers in the first half of the twentieth century, it was not until 1960 that the denomination allowed the full ordination of women. (An earlier attempt by Henry M. Turner to ordain women in 1885 had been promptly overturned by a church conference.)

Ecumenical efforts among African-American Christians also drew upon AME church leadership. In 1933, Bishop Reverdy C. RANSOM called together black denominational leaders to establish in 1934 the Fraternal Council of Negro Churches. Similarly, in 1978 Bishop John Hurst Adams spearheaded the founding of the CONGRESS OF NATIONAL BLACK CHURCHES. Subsequently, Bishop Philip R. Cousin became president of the National Council of Churches

Though it would not be until the middle of the twentieth century that the AME church ordained women, female preachers played an important role from the earliest years of the denomination. Julliann Jane Tilman, the subject of this 1844 engraving, was active in the AME church in Philadelphia. (Prints and Photographs Division, Library of Congress)

in 1983 while Bishop Vinton R. Anderson became president of the World Council of Churches in 1991.

The Black Theology movement from the late 1960s into the 1980s drew AME participation through AME trained theologians Cecil W. Cone and James H. CONE. They respectively authored *The Identity Crisis in Black Theology* (1975) and *Black Theology and Black Power* (1969). Jacqueline Grant, another theologian out of the AME tradition, pioneered the development of feminist theology. Her ideas were explored in *White Women's Christ and Black Woman's Jesus* (1989).

Throughout its history, the AME church embraced congregations that crossed lines of class, culture, and geography. Several elements of Wesleyan worship remained in AME services regardless of location and demography. A standard order of worship, mainly consisting of hymn singing, remained a staple of AME worship. Baptismal practices and the communion service made the AME church virtually indistinguishable from white Methodist congregations. However, other practices rooted in African-American tradition—such as extemporaneous praying, singing of spirituals and gospels, and shouting—were observed depending on the cultural makeup of the congregation.

Since its formal founding in 1816, the AME Church's quadrennial general conference has remained the supreme authority in denominational governance. Annual conferences over which active bishops have presided cover particular geographical areas. During these yearly jurisdictional meetings, ministers receive their pastoral appointments. Within the annual conferences, districts have been established; these are superintended by presiding elders. The AME episcopacy from Richard Allen's election and consecration in 1816 to the present has been a lifetime position. General officers who administer such programs as publishing, pensions, Christian education, and evangelism serve for four years, but they can stand for reelection. Bishops and general officers are chosen at the general conference by elected ministerial and lay delegates. By 1993 the denomination had grown to 2,000,000 members in 7,000 congregations in the United States and 30 other countries in the Americas, Africa, and Europe. The AME has no central headquarters, although its publishing house is located in Nashville, Tenn. In 1993 twenty active bishops and twelve general officers make up the African Methodist Episcopal Church leadership.

REFERENCES

GREGG, HOWARD D. *History of the African Methodist Episcopal Church*. Nashville, Tenn., 1980.
PAYNE, DANIEL A. *History of the African Methodist Episcopal Church*. Nashville, Tenn., 1891.

SMITH, CHARLES S. *History of the African Methodist Episcopal Church*. Philadelphia, 1922.
WALKER, CLARENCE E. *Rock in a Weary Land: The African Methodist Episcopal Church During the Civil War and Reconstruction*. Baton Rouge, La., 1982.
WRIGHT, RICHARD R., JR. *The Bishops of the African Methodist Episcopal Church*. Nashville, Tenn., 1963.

DENNIS C. DICKERSON

African Methodist Episcopal Zion Church.

The African Methodist Episcopal Zion Church (AMEZ) was organized in the early 1820s, but its roots go back to the late eighteenth century. A few black congregations in the New York City area in the 1790s sought greater freedom of worship and some measure of autonomy from white-controlled congregations in the predominantly white Methodist Episcopal denomination. With approximately 5,000 members by 1860, the AMEZ Church by the 1990s had a membership in excess of 1.3 million, with 3,000 clergy, 2,900 congregations, and 100,000 members overseas, principally in Africa and the Caribbean. The group also by 1900 had shifted most of its operations from New York to North Carolina and had become a truly national denomination.

The AMEZ has organized agencies and divisions devoted to such matters as youth, Christian education, domestic and overseas missions, and social concerns. Its highest organizational authority is the General Conference, which includes representatives from both clergy and laity. Two other main operational bodies are the Connectional Council, composed of the thirteen bishops as well as other significant ecclesiastical officers, and the Board of Bishops. The denomination has a publishing house located in Charlotte, N.C., where it publishes, among other works, the church newspaper, the *Star of Zion*. It supports four colleges: Livingstone College in Salisbury, N.C.; Clinton Junior College in Rock Hill, S.C.; Lomax-Hannon Junior College in Greenville, Ala.; and AME Zion Community College in Monrovia, Liberia.

Like the other black denominations, associations, and conventions founded prior to the Civil War, the AMEZ Church was formed primarily for the sake of greater autonomy in church participation and leadership, and to evangelize and serve in other ways the needs of African Americans in the late 1700s and the 1800s. The evangelical American Christianity that came to its earliest fruition during the Great Awakening (1730–1750) and the Second Great Awakening (1790–1825) had a profound impact upon the membership of the Christian churches in the United States. Evangelicalism was most clearly manifested

during the Second Great Awakening in groups such as the Methodists, revivalist elements in the Church of England (Protestant Episcopal church), the Baptists, and some Presbyterian and Congregational churches.

Compared with their nonevangelical counterparts, white evangelicals were more receptive to black membership in their societies and churches and even sometimes open to various roles of black leadership. Thus, by the Revolutionary era, evangelicalism was a racially mixed phenomenon, with whites and blacks acting as missionaries, teachers, and preachers, although the preponderance of these activities were still intraracial. By the 1780s and '90s, evangelical blacks were members of a movement and of churches in which they exercised a considerable degree of freedom of religion, relative to the treatment of blacks in nonevangelical churches.

The Revolutionary age brought with it intense rhetoric about the equality of all men and their inalienable rights. Not surprisingly, therefore, when a number of white-controlled (though not always predominantly white) congregations began to curb religious freedom, to introduce new strictures of racial segregation and discrimination, and to refuse to modify policies and practices of caste, many African Americans, especially those with leadership talents, rebelled.

With these rebellious leaders—Peter SPENCER in Wilmington, Del.; Richard ALLEN in Philadelphia; and William Miller in New York City—lie the origins of the independent black Methodist congregations. In the first quarter of the nineteenth century, they joined forces to form three separate black denominations: the Union Church of Africans, in Delaware, in 1813; the AFRICAN METHODIST EPISCOPAL CHURCH (AME Church), based in Philadelphia, in 1816; and the Zion group, based in New York City, in the 1820–1824 period. For the AMEZ, the focal point seems to have been the John Street Methodist Episcopal Church in New York.

By 1793, the John Street congregation's membership was about 40 percent black. Yet blacks were blocked from the higher orders of the ministry and faced discrimination at the Holy Communion table as well as in seating. In 1796, Peter Williams and William Miller helped start a separate black Methodist congregation. They founded the African Chapel in a shop owned by Miller. By 1800 the group gathered around these two men constructed a church building, and in 1801 their congregation was incorporated. These Methodists emphasized their desire to be free of white domination by restricting trustee membership to those of African descent.

Like their forerunners in the Union Church of Africans and the African Methodist Episcopal denomi-

Peter Williams as depicted in a painting from about 1815. A former slave, Williams was a prominent founder of the original congregation of the AME Zion Church in New York City in 1800. (Photographs and Prints Division, Schomburg Center for Research in Black Culture, The New York Public Library, Astor, Lenox and Tilden Foundations)

nation, these black Methodists were struggling to establish and maintain a significant degree of autonomy in the midst of clear, overt white opposition to their efforts. By ensuring that control of their church was in the hands of African Americans, these Methodists were guaranteeing that they would not again be relegated to the status of second-class membership in their own church, as they had been in John Street and other Methodist Episcopal congregations. With the assistance of a white preacher, John McClaskey, nine men incorporated the African Chapel church in 1801: Francis Jacobs, Peter Williams, David Bias, George E. Moore, George Collins, George White, Thomas Sipkins, Thomas Cook, and William Brown. The church was incorporated as the African Methodist Episcopal Church of the City of New York.

Between the years 1816 and 1824, this small group of black Methodists moved more decisively toward the establishment of a separate denomination. In 1816, the Zion Church (formerly the African Chapel) joined with the Asbury Church to petition the Methodist Episcopal Conference of New York to establish

a separate circuit for African Methodists. In 1820 the beginnings of a split in the white parent body, the Methodist Episcopal church, had ramifications for African Methodists. William Stillwell, a white minister who had been appointed pastor of the Zion Church, withdrew from the larger body in an attempt to introduce more democratic procedures.

This move of Stillwell's occasioned further reflection on the part of the African Methodists concerning their own organizational relationship with the Methodist Episcopal church. In August 1820, the African Methodists became a separate black conference within the larger denomination; by October, they had established a discipline (a set of church policies, beliefs, and rules) for the two congregations, Zion and Asbury. A pivotal move took place on June 21, 1821, when the African Methodists held their first annual conference and rejected affiliation with the AME Church, also deciding against reaffiliation with the white-controlled Methodist Episcopal church. Many scholars date the origins of the AMEZ denomination from this year. It was not until 1824, however, that the African Methodists in New York made it clear they were not under any supervision of the Methodist Episcopal denomination.

The new denomination registered slow but steady growth between 1821 and the advent of the Civil War. At the 1821 conference (their first annual meeting), the Zionites had six churches with fewer than 1,500 members: Zion Church (763) and Asbury Church (150) of New York City, and congregations from Long Island, N.Y. (155); New Haven, Conn. (24); Easton, Pa. (18); and Philadelphia (Wesleyan Church, with 300). In 1822 the group selected James VARICK, the pastor of Zion Church, as its first superintendent. He served until 1828, when he was replaced by Christopher Rush, who had migrated north from eastern North Carolina. Throughout the nineteenth century there was intense controversy, friction, debate, and rivalry between the Zion denomination and the AME denomination—much of it fueled by the fact that both, prior to the New York–based group's addition of "Zion" to its title in 1848, termed themselves the African Methodist Episcopal Church.

Given their competition for new members and the alliances of black Methodist congregations, this similarity in names caused confusion and charges of misrepresentation. There was also a lively debate as to which was actually the first organized group. Each extended the date of its founding back into the eighteenth century to coincide with the rise of the oldest congregation of the connection. Concomitantly, each tended to overlook or downplay the origins of the first congregation of the rival group. The Zion group, moreover, was beset by schism in the 1850s

Christopher Rush, who succeeded James Varick as general superintendent (bishop) of the AME Zion Church, was the first historian of the denomination and was responsible for much of its antebellum growth. (Prints and Photographs Division, Library of Congress)

arising from controversy surrounding the status of one of its bishops.

With the coming of the Civil War, the AMEZ, like other independent black denominations and conventions, embarked upon a new era of opportunity and growth. Whereas the Zionites had only a few more than 1,400 members and 22 ministers in 1821, by 1860 they had grown to 4,600 members with 105 preachers. But this slow growth in membership was outdistanced considerably by the phenomenal rise during and following the Civil War. By 1884 the AMEZ registered 300,000 members; by 1896, the number had increased to 350,000.

Both the AMEZ and the AME experienced rather small growth during the pre–Civil War years because both were mainly confined to the northern portion of the country, especially the Northeast. Understandably, independent black organizations, religious or secular, mainly comprising free persons committed to an antislavery stance, were not welcomed in the slaveholding South. In addition, most African-American Methodists in New York, Pennsylvania, and elsewhere elected for a number of reasons to re-

main with the predominantly white Methodist Episcopal denomination. Much of the black Methodist Episcopal constituency had a degree of autonomy as largely black congregations with black ministers, while maintaining the advantages of continued association with a white organization. With the coming of the Civil War, however, and the emancipation of previously enslaved blacks, the doors for inclusion in northern-based, independent black denominations and conventions were opened much wider.

A substantial number of black southern Christians did remain with the white-controlled Methodist Episcopal Church—South, and the Methodist Episcopal Church (North) gained a considerable number of congregations, ministers, and members from their ranks. The vast majority of black Christians, however, flocked to the independent black ecclesiastical groups that followed Union troops into the old Confederacy. The black Baptist churches secured the most members, followed by the AME. But the AMEZ captured a significant and substantial segment of southern black Christians for its connection.

The Zion denomination has encountered a number of significant challenges. One of the main reasons for

Mother AME Zion Church. (Photographs and Prints Division, Schomburg Center for Research in Black Culture, The New York Public Library, Astor, Lenox and Tilden Foundations)

its debut was the evangelization and religious training of people of African descent. A number of organizations connected with the denomination were formed over the years to deal with these goals. The denomination not only expanded in the South following the Civil War but entered the Midwest, the far West, Canada, and the Caribbean. Nova Scotia and the Caribbean areas figured prominently in the AMEZ's outreach efforts during the postbellum years. During the 1870s and 1880s the AMEZ, like its AME and black Baptist counterparts, joined in the efforts to missionize Africa. Andrew Cartwright, the first Zion missionary in Africa, and Bishop John Bryan Small, who later was the first to have episcopal jurisdiction in Africa, were forerunners in the African mission program. The AMEZ Church, like other black Christian groups, pursued the missionizing of Africa for reasons that connected evangelical interests with practical concerns for the well-being of African people.

The AMEZ has always been intimately involved in efforts to achieve greater citizenship rights for African Americans. Outstanding nineteenth-century AMEZ members such as Sojourner TRUTH, Harriet TUBMAN, Jermain Loguen, Catherine Harris, and Frederick DOUGLASS fought to abolish slavery, gain equal rights and justice for black citizens, and expand the freedom of American women. Jermain Loguen's classic address "I Will Not Live a Slave" testifies to the precarious position of many people of color who had escaped bondage in the South and border states, and points out the connections between free people of the North and their enslaved brothers and sisters.

An issue of internal concern in the Zion denomination was the debate over the role and meaning of the terms "superintendent" and "bishop." Zion, like the predominantly white Methodist Protestant church, envisioned itself originally as a more democratic institution than the mother Methodist Episcopal church. It selected the name "superintendent" for its episcopal overseers and mandated their election every four years rather than for life, as was the case in the Methodist Episcopal and African Methodist Episcopal churches. When their AME rivals cast doubts on the episcopal validity of Zion's superintendents, the AMEZ changed their title to bishop and passed a rule stipulating that each was elected for life. This last rule was later modified to require retirement at a certain age. Bishop James Walker HOOD was instrumental during the 1800s in defending the validity of Zion's episcopacy and undergirding the "high church" tradition of episcopacy within the Zion church.

The Zion church has been at the forefront within American Methodism in advancing democracy within its membership by expanding representation

in its highest councils to laypersons. It also supported the ordination of women to the office of elder, the church's highest ministerial office except for bishop. In 1898, Bishop Charles Calvin Pettey ordained Mary Julia Small, a bishop's wife, as the first woman elder in the Zion church, or any major American Methodist denomination. Julia FOOTE, an author, evangelist, and supporter of the holiness movement, was ordained an elder by Bishop Hood. Although Bishops Pettey and Hood stood by their controversial actions, not until the 1980s and 1990s were a significant number of women ordained to the eldership. None of the major black Methodist groups, including the AMEZ, has appointed a female bishop, unlike the United Methodist church, which has appointed both black and white women to the episcopacy.

Another area of concern to Zionites has been ecumenism, especially within the family of black Methodist churches. The first serious and hopeful efforts at black Methodist unity came during the Civil War, in 1864, when the AME and the AMEZ nearly agreed upon a document cementing the union of the two churches. The measure failed because conferences within the AME Church, where the matter was submitted for ratification, rejected the proposal. Other discussions since then have included dialogues with the AME, the CME, and the Methodist Episcopal denominations. The CME and the AMEZ were close to union at one point during the 1980s, but progress stalled. It appeared that independent black denominations are torn between racial solidarity on one hand and transracial unity on the other—between the ideal of union across racial lines and the reality of continued racial prejudice and discrimination, even in ecclesiastical circles.

The AMEZ Church, like most other black denominations, however, has been involved in ecumenical efforts at cooperation, such as the Federal Council of Churches (later the National Council of Churches) and the World Council of Churches. It has participated with other black Methodists, as well as other Christians, in interfaith efforts to advance the civil, political, and economic progress of African Americans. Its membership in the National Fraternal Council of Negro Churches, founded in 1933, serves as an example of Zion's work in this regard.

There have been other major figures in AMEZ history. Bishop Joseph J. Clinton commissioned James Hood and other missionaries for work in the South during and following the Civil War; his efforts greatly facilitated the geographical and numerical expansion of Zion's ranks. Rev. Joseph C. PRICE, popularly esteemed as an orator, was one of the founders and the first president of Livingstone College. Mary Jane Talbert Jones, Meriah G. Harris, and Annie Walker Blackwell were early leaders in the Woman's

Home and Foreign Missionary Society, established in 1880.

The historical and theological significance of the AMEZ Church rests in the claims that black people, when their humanity was greatly compromised in the eyes of many whites, were capable of managing and directing enterprises without the governance and supervision of whites, and the theological position that the Christian faith condemns racial discrimination as sin and heresy.

REFERENCES

BALDWIN, LEWIS V. *"Invisible" Strands in African Methodism: A History of the African Union Methodist Protestant and Union American Methodist Episcopal Churches, 1805–1980.* Metuchen, N.J., 1983.

BRADLEY, DAVID HENRY, SR. *A History of A. M. E. Zion Church.* 2 vols. Nashville, 1956, 1971.

HOOD, JAMES WALKER. *One Hundred Years of the African Methodist Episcopal Zion Church.* New York, 1895.

McCLAIN, WILLIAM B. *Black People in the Methodist Church: Whither Thou Goest?* Cambridge, Mass., 1984.

RICHARDSON, HARRY V. *Dark Salvation: The Story of Methodism as It Developed Among Blacks in America.* Garden City, N.Y., 1976.

WALLS, WILLIAM J. *The African Methodist Episcopal Zion Church: Reality of the Black Church.* Charlotte, N.C., 1974.

SANDY DWAYNE MARTIN

African Music, Influence on African-American Music of.

African-American music developed as a unique musical tradition reflecting the experiences of peoples of African descent within the western hemisphere; however, this musical tradition has been influenced by African music in profound as well as subtle ways. The African influence has been reflected, historically, in shared and similar conceptions regarding the fundamental nature of the musical experience; specific approaches to musical form, patterns of continuity, and syntax, and performance practices (i.e., the process involved in actively making music).

The term "African music" is much too broad to have real significance, given the size of the African continent and its extraordinary cultural diversity. Most scholars divide the continent into at least two major parts: North Africa, north of the Sahara, where most inhabitants speak Semitic and Afro-Asiatic languages and where cultures manifest the impact of Arab culture and Islamic religion; and sub-Saharan Africa, south of the Sahara, which encompasses the

large Niger-Congo language family (West Sudan, Bantu, and Kordofanian), and is inhabited predominantly by peoples of the Negroid racial group. Studies of the slave trade have demonstrated that the majority of slaves transported to America were taken from sub-Saharan Africa, primarily from the Sudan Coast and Congo Basin regions. The music of Africa that had has the greatest influence on African-American music has been music from these regions.

Historical Background

In addition to the African origin of African Americans, there are several historical factors that contributed to the influence of African music on African-American music. First, during the slave trade, African music and dance were often encouraged on slave ships. This practice existed because slave traders believed their human cargoes would be better able to survive the horrible, inhumane conditions of the Middle Passage if they were permitted to dance aboard the ships. The concomitant effects of this practice were to provide opportunities for slaves of diverse ethnic groups to learn the music of one another, and also, literally, to bring African musical practices to the New World every time a new cargo of slaves arrived. Because the African slave trade existed for over four hundred years and involved an estimated ten to fifteen million people, the developing eighteenth- and early nineteenth-century African-American community was continually exposed to new slaves who brought fresh knowledge of traditional African music.

A second historical factor that contributed to the influence of African music on African-American music was the performance of African music in colonial America. From the seventeenth century through part of the nineteenth, various "African festivals," or mass public gatherings of slave and free African Americans, were held in the Colonies, where traditional African music was performed. Among these were the "Pinkster Day" festival in Albany, Manhattan, and other parts of New York; "Lection Day" in Hartford, Conn; "Jubilees" in Potter's Field in Philadelphia; and the John Connu Christmas festival in North Carolina and Virginia. The most famous of these gatherings, cited by several contemporaneous chroniclers, was in New Orleans, at "Place Congo." Here, every week, from as early as 1786 until well into the nineteenth century, large numbers of African Americans assembled, organized themselves into "nations," and performed music that had all of the characteristics of African music.

The significance of both historical factors cited above is that during the formative period of African-American culture, Africans who thought of themselves as exiles and African Americans at various de-

Traditional African musical performance. (© Martha Cooper/City Lore)

grees of acculturation to the new nation were brought into contact with traditional African music, and thereby increased its possible influence on the new music of African Americans.

Influence of African Concepts of the Nature of Music

African conceptions of the fundamental nature of music are among the most important influences on African-American music. Although there are important differences between musical practices of various sub-Saharan African people, a basic conception that music is an essential, obligatory aspect of life is commonly held. Music is used with almost every human activity and has had a persistent central role in African culture. Moreover, it is generally believed that music has affective power and functions as a force or causal agent. This is reflected most vividly in the role music plays in traditional African views of the cosmos. Essentially, the cosmos is perceived as a dynamic order in which hierarchical forces are constantly interacting with one another. Within the cosmos, it is important for humanity to interact with a pantheon of deities who possess dominion over var-

ious aspects of nature and life. Music is the means by which the deities are called forth to possess and commune with mankind, and, in many African cultures, a specific music repertoire is used for each deity. Given this particular world view, music becomes sacred and indispensable; music fulfills an obligatory human function. The traditional West African aphorism "The Gods will not descend without song" is a reflection of this role.

The status of music in Africa as described above influenced African-American culture in important ways. Although the adoption of Christianity by the African exiles and African Americans indelibly altered their traditional view of the cosmos, the reinterpretation of African concepts of religion to conform with the realities of the American experience resulted in a syncretic view of religion in which fundamental African concepts were retained, but their outer manifestations were significantly altered. Hence, although specific music used to call specific deities was rarely practiced in the continental United States (there are exceptions where this did occur, e.g., in New Orleans and in other parts of the South), the concept of music as an important part of the religious service in which members became possessed by the Christian Holy Ghost became well established. The idea of possession and the role of music in inducing possession is retained, though the specific nature of the possession is new. African-American notion of music as a causal agent that fosters religious ecstasy is a clear influence of a reinterpreted African musical concept.

A second African musical conception that influence African-American music is the view that music is a communal activity. Music is an interactive human activity in which everyone is expected to participate: there are no detached listeners, but rather there is a communion of participants. The social structure of music-making thus involves a hierarchy of participants whose responsibilities are variable over a continuum from the highly complex to the very simple. Nevertheless, the basic conception of music entails the notion of inclusion; of participatory, integrative engagement of the entire community. This ideal is also a fundamental construct of traditional African-American folk music and is reflected in all genres of traditional African-American religious and secular music of the eighteenth and early nineteenth centuries.

A third basic conception underlying the practice of African music is the assumption that music is integrally related to language. As Nketia has demonstrated in his classic study *Drumming in Akan Communities of Ghana* (Nketia 1963, p. 33), much of the repertory of Akan drumming has a verbal basis. Many African drum and metallic bell patterns are musical simulations of verbal proverbs, poems, common exhortations, and other verbal statements. Hence music is inextricably related to language, or put most directly, instrumental musical performances often involve the literal musical statement of specific poetic phrases. Therefore, music often exists as a multileveled form of communication. The common musical stimulation of speech is also the basis for one category of "talking drums" of Africa.

In addition, African musicians characteristically use nonsemantic or "nonsense" verbal syllables to reproduce an aural pattern that is analogous to the pitch contour and rhythm of a drum pattern they wish to convey to another person. This verbalization of drum patterns is commonly used in recalling musical patterns or teaching music to novices. This verbal–musical interaction is doubtless enhanced by the fact that most African languages are tonal languages and use tonal levels as a means of defining specific words.

The underlying basic conception of music as a multidimensional verbal–musical experience is a concept that influences African-American music. This is reflected in the continuum from speech to song that is frequently present in African-American music. The most vivid expressions of this continuum are the "singing-performance sermons" of African-American preaching; the "talking, shouting" blues tradition; the speech and dialogue simulations common in jazz instrumental improvisations (especially by muted brass instruments); the phenomenon of jazz poetry performances of the 1920s, '40s, and '60s; and the hip-hop, rap of African-American popular music of the 1980s and the 1990s.

Influence of African Concepts of Musical Organization and Syntax

Much of the scholarship devoted to a consideration of the relationship of African music to African-American music has focused on the comparative analysis of the formal aspects of the two music traditions. The predilection in African music for cyclical music structures that also employ antiphonal or call-and-response forms on multiple structural levels has been well documented as a common organizational principle by many observers. This basic principle has profoundly influenced African-American music. The earliest documented genres of distinctly African-American music, the spirituals, worksongs, and fiddle and banjo secular music, all demonstrate the pervasiveness of the operating principle. Each genre, however, utilizes this formal principle in a manner that is unique to its musical and social function. The adaptation of similar formal techniques for different musical types is one of the factors that makes various genres of the music sound similar. In addition, each

African music at impromptu jam session, Prospect Park, Brooklyn, N.Y. (© Martha Cooper/City Lore)

musical type evolves its own genre-specific techniques of exploiting common formal devices. For example, the twelve-measure, three-poetic-line blues structure with its intrinsic responsorial structure, determined by the statement relationship of the first two lines to the answering third line of the form, also developed the convention of a call-and-response relationship between the singer and his or her instrument within each of the four-measure stanzas.

The blues developed as a post-Civil War musical genre that evolved in part from the wordless "hollers, cries, and moans" that preceded it, and contained the musical outpourings of an individual expressing his or her reactions to the world. Although it continued to develop as a distinct genre that found its most characteristic and exquisite forms in the twentieth century, its formal principles were reinterpretations of concepts associated with earlier African-American music and influenced by African music.

African conceptions of rhythm have had an important impact on African-American rhythmic ideas. The fundamental principle governing African rhythm cited by Nketia, Merriam, and other researchers is what A. M. Jones has referred to as "the clash of rhythm" (Jones 1959), or what might be referred to as the principle of rhythm contrast. The

basic notion is that music will evince a disagreement of rhythmic accents, cross-rhythm, and/or implied metrical contract as an ideal. Syncopation, off-beat accents, and anticipation and retardation of foreground accents that clash with the prevailing metrical framework are the expected norm. The terms "polyrhythm" and "multimeter" have been used by some ethnomusicologists to describe specific subsets of this rhythmic quality, but others have chosen to use the broader inclusive concept of rhythmic contrast.

African-American music reflects usage of the basic principle of rhythmic contrast in many ways. Although complex examples of extended multilayered textures are not as common as in West African music, rhythmic contrast in some form is found within all genres of African-American music as an intrinsic quality. It is the imposition of techniques of rhythmic contrast on previously existing music of European-American origin that is one of the major factors that transforms the music into styles that are distinctively African-American.

One common means of creating rhythmic contrast in African and African-American music is to establish musical textures in which there is a built-in dichotomy between a repetitive rhythmic pattern that exists on one level, and the simultaneously occurring vari

able rhythmic patterns that exist on other strata. This interaction between fixed and variable rhythmic strata that exists within an interlocked rhythmic–metrical framework is a means of establishing rhythmic contrast. In African music, one finds expression of this practice in ensembles in which a group often consisting of a metal bell, a gourd rattle, hand claps, and, sometimes, high-pitched drums, performs a fixed rhythmic pattern that has a metronomic function. This "time line" is used in contrast to other drums, instruments, and voices that perform variable rhythms.

In African-American music, the same basic rhythmic structure is apparent in instrumental genres from the fiddle and banjo music associated with the eighteenth and nineteenth centuries to the complex instrumental ensembles of jazz and popular music that evolved in the twentieth century. In all of these genres, the organization of instruments into the "rhythm section" that plays recurring fixed rhythmic patterns, and the "front line," or lead instruments that play changing rhythmic patterns, is characteristic.

Within African and African-American music, the dynamic relationship between the fixed and variable rhythmic strata is a process that determines one aspect of the syntax of both musical traditions. The organizational structure of both African and African-American music is shaped on a large scale as well as a foreground level in important ways by the interaction of fixed and variable rhythmic strata in conjunction with the usage of antiphony. This operates in different ways and is affected by other music parameters to varying degrees in the two musical traditions, but the fundamental concept is present in both.

Influence of African Concepts of Performance Practice

Of great importance to the development of African-American music is the retention in some instances, and adaptation in others, of performance practices associated with the African music. Among these practices is the approach to singing or playing any instrument in a percussive manner, a manner in which the greatest volume level occurs at the beginning of a sound, the attack phase, and the subsequent duration of the sound has a rapid decay of volume. The result is music characterized by qualitative stress accents. Performances of African and African-American music frequently use instruments that are percussive in nature, and performance on all instruments is approached in a percussive manner.

Another common performance practice idiomatic of African-American music, clearly derived from African practice, is the incorporation of physical body motion as an integral part of the music-making pro-

cess. In sub-Saharan cultures, physical body motion and music are viewed as interrelated components of the same process. Hence, characteristically, singing or playing musical instruments is associated with elaborate physical body movements. These movements are not extraneous gestures, but are often actions necessary to produce a desired effect in the musical performance; they are an intrinsic part of the music process. The most obvious example of this is the traditional African usage of various arm, waist, and ankle rattles that adorn the bodies of dancers and produce a characteristic buzzy timbre when they move. The sounds produced by this movement are important components of the music. The dance becomes the music, and the music is the dance. A similar situation occurs in the work songs in both cultures when the physical action of work produces a sound that becomes an integral part of the music.

The common usage of body percussion (hand claps and slapping of hands against the body), and the history of African-American dances that produce sounds created by the feet, from the shuffling sounds of the nineteenth-century religious dance called "ring shout" to twentieth-century tap dancing, are examples of the association of physical body motion with music. The approach to performance in African and African-American music assumes that physical body motion will be an integral part of the musical experience.

Another African practice that shaped African-American musical performance practice is the predilection to create various ensembles comprised of contrasting timbres (sound colors). African instrumental ensembles consist of instruments whose individual colors are distinct (bells, drums, rattles, horns, etc.); and vocal ensembles in which the vocal qualities of individual performers may be discerned. African-American music utilizes these same practices. The fact that individual singers are identified by distinct vocal timbres that contrast with others (e.g., Louis ARMSTRONG, Billie HOLIDAY, Aretha FRANKLIN, etc.), and that most performers use a wide range of vocal timbral nuances, is a reflection of this ideal. This common practice is most notable in the performance of blues and gospel music. In ways that are both obvious and subtle, African-American music owes a considerable debt to African performance styles.

REFERENCES

BLASSINGAME, JOHN W. *The Slave Community: Plantation Life in the Antebellum South.* Rev. ed. New York, 1979.
CURTIN, PHILLIP C. *The Atlantic Slave Trade: A Census.* Madison, Wis., 1969.

GREENBERG, JOHN H. *The Languages of Africa*. Rev. ed. Bloomington, Ill., 1966.

HERSKOVITS, MELVILLE J. *The Myth of the Negro Past*. New York, 1941.

JONES, A. M. *Studies in African Music*. London, 1959.

MERRIAM, ALAN P. "African Music." William Bascom and Melville Herskovits, eds. In *Continuity and Change in African Cultures*. Chicago, 1958.

NKETIA, J. H. KWABENA. *Drumming in Akan Communities of Ghana*. Edinburgh, 1963.

———. *The Music of Africa*. New York, 1974.

OLIVER, PAUL. *Savannah Syncopators: African Retentions in the Blues*. New York, 1970.

RABOTEAU, ALBERT J. *Slave Religion: "The Invisible Institution" in the Ante-Bellum South*. New York, 1978.

SOUTHERN, EILEEN. *The Music of Black Americans*. Rev. ed. New York, 1983.

VASSA, GUSTAVAS. *The Interesting Narrative of the Life of Olaudah Equiano or Gustavas Vassa, the African*. London, 1794.

WATERMAN, RICHARD. "African Influence on the Music of the Americas." In Sol Tax, ed. *Acculturation in the Americas*. Chicago, 1952.

WILSON, OLLY. "The Association of Movement and Music as a Manifestation of a Black Conceptual Approach to Music Making." In *International Musicological Society Report of the Twelfth Congress*. Basel, 1981.

———. "The Significance of the Relationship between Afro-American Music and West African Music." In Eileen Southern, ed. *Black Perspectives in Music*. New York, 1974.

OLLY W. WILSON

African Muslims in Antebellum America.

Ten to 15 percent of Africans brought to North America between 1731 and 1867 were Muslims. Like many non-Muslim, nonpeasant Africans accustomed to being leaders in social, political, religious, military, or agricultural matters, their sense of dignity and pride gave problems to their masters. Unlike non-Muslims, however, Muslims—when recognized—piqued interest because of their insistence on covering their bodies, avoiding alcohol and pork, praying to one god, reading and writing Arabic—while being black (*see* ISLAM). The extent of their influence has yet to be calculated, but to those who recorded contacts with them in the antebellum era, many African Muslims were impressive people.

African Muslims came from below the Sahara Desert between Senegal and Lake Chad. They were Fula, Serahule, Manding, Songhai, Kanuri, Kassonke, Hausa; few were Moors or Arabs. About fifty

are known by name or reference, fourteen of these by lengthy accounts, nine by portraits. Further information is in seventeen manuscripts in Arabic and eleven translations from Arabic written in America. The stories of their lives in Africa, of capture, marches to the sea, the Middle Passage, and of adjustments to and by masters, missionaries, and amanuenses in America, are informative and corrective. These are often the only firsthand accounts by African-born people on events, conditions, and attitudes upon which historians and literateurs have provided only surmises.

Abbreviated names and outlines of some African Muslim lives illustrate these points. Job, Ibrahim, Omar, Kebe, Salih Bilali, Mahommah, and Mohammed came from prominent, powerful, or extended families. Job was a trader and religious leader, Ibrahim a cavalry officer, Kebe and Omar teachers; all were fathers before their capture. Job, Ibrahim, Kebe, Bilali, Charno, Omar, a "Moorish slave" found on the Mississippi River, "Capt. Anderson's slave," Mohammed, Sambo, and Salih Bilali learned to read in Arabic in Africa. All but the last wrote it. Manuscripts from Job, Ibrahim, Bilali, Charno, Omar, and Anderson's slave are extant. Others are reported; London used phonetic Arabic characters to write black English. Job, Ibrahim, Omar, Mahommah, Mohammed, Salih Bilali, and a Muslim from Charles Ball's slave narrative told of captures in Africa. Ibrahim, Omar, and Kebe were taken in battle, the others kidnapped. They wrote of marches to the sea, providing descriptions of Africa and Africans found nowhere else, and of their sea voyages.

In America, Job, Ibrahim, and Omar ran away from their first masters but had no place to go; Sambo and Osman may have been more successful. Job and Jay were returned to Africa after fewer than five years of slavery because Job impressed English gentlemen and intelligentsia with his dignity and spirituality. Ibrahim and Kebe were returned after thirty-some years of slavery. Ibrahim, Bilali, and Salih Bilali had American wives and children; Yarrow Mamout, Kebe, and Omar apparently chose not to do so. Ibrahim, King, Bilali, and Salih Bilali became trusted slave managers.

All of those named above remained true to their Muslim faith, with the possible exceptions of London, Omar, and Mahommah. London transcribed the Gospel of John; Omar was often admired in North Carolina papers because he was willingly baptized, wrote the Lord's Prayer, and reportedly wrote anti-Muslim statements. None of the latter, however, has been found, and extant manuscripts and his last pastor cast some doubt on his conversion or at least on its totality. Mahommah proposed a return to Africa to preach Christianity but seems not to have been taken seriously. Ibrahim and Kebe made similar

proposals. Ibrahim reverted in Africa; Christianity was, he said, a "good law" but not followed in America. The Muslim on the Mississippi went further verbally, proudly declaring that Americans were not as polite, hospitable, comfortable, or learned as his own people. Finally, Bilali and Salih Bilali each created Muslim communities in Georgia's Sea Islands that were recalled by descendants as late as the 1930s.

Mentions of African Muslims by American historians have been few. The most noticed were Job, Ibrahim, and Omar, who are called Moors or Arabs. They have been de-Africanized, despite portraits and descriptions indicating otherwise. Literary references are also rare. Herman Melville stripped Islam from the black rebels in "Benito Cereno"; Joel Chandler Harris made his hero Aaron, based on Bilali, an Arab who denigrated black people; Mark Twain opined that Abdul Rahahman was a cannibal. Not until 1976, with Alex Haley's *Roots*, did African Muslims begin to be included in the American story.

REFERENCES

AUSTIN, ALLAN D., ed. *African Muslims in Antebellum America: A Sourcebook.* New York, 1984.
CURTIN, PHILIP D., ed. *Africa Remembered: Narratives by West Africans from the Era of the Slave Trade.* Madison, Wis., 1968.

ALLAN D. AUSTIN

African Orthodox Church.

The African Orthodox Church (AOC) was founded September 2, 1921, by George Alexander MCGUIRE, an Antiguan follower of Marcus GARVEY who had been ordained a priest in the Protestant Episcopal church. The purpose of the new denomination was originally to create a kind of state church for the UNIVERSAL NEGRO IMPROVEMENT ASSOCIATION and to further black nationalist religious symbolism, but when the AOC did not become an official part of the Garvey movement, it concentrated on defending the validity of its claims to apostolic succession through orders from the West Syrian Jacobite Church of Antioch.

The AOC has never grown beyond a few thousand members in this country, primarily along the East Coast. Its clergy and members have been largely West Indian, though it occasionally appeals to dissident Roman Catholics and a few traditional Protestants. The church's liturgy is formal and high, a combination of Anglican and Roman rites with some Orthodox influences and usages. The AOC spread to Africa, where its membership numbers in the millions and where it exists uniquely as an independent church with legitimate ties to historic Christianity as well as involvement in African cultural nationalism.

In the United States, the AOC has been a channel of "valid though irregular" ordinations and consecrations among so-called Old Catholic bodies. McGuire was canonized in 1983, but the church did not participate in or benefit from the post–civil rights movement surge of black nationalism. In California, a communitarian group formerly gathered around the widow of jazz musician John COLTRANE has affiliated with the AOC and appears to give the denomination its best hope for active continuity.

REFERENCES

NEWMAN, RICHARD. "The Origins of the African Orthodox Church." In *The Negro Churchman.* Millwood, N.Y., 1977, pp. iii–xxiv.
PLATT, WARREN C. "The African Orthodox Church: An Analysis of Its First Decade." *Church History* 58, no. 4 (December 1989): 474–488.

RICHARD NEWMAN

African Union Methodism.

African Union Methodism is the common name shared by those churches stemming from the movement founded by the Maryland ex-slave Peter SPENCER in Wilmington, Del., in 1805. In its contemporary usage, it refers to the African Union Methodist Protestant Church (AUMP) and the Union American Methodist Episcopal Church (UAME), the only two remaining bodies with roots in the Spencer tradition.

In June 1805, Spencer and William ANDERSON led some forty African Americans out of the predominantly white Asbury Methodist Episcopal Church in Wilmington. Racial discrimination and the desire for black religious independence figured prominently in the secession. The dissenters immediately formed Ezion Methodist Episcopal Church, designed to function as a black "mission church" under the auspices of Asbury Church and the Methodist Episcopal Conference. A second secession occurred in 1813, mainly because of the arbitrary exercise of power against blacks by white elders and disputes over seating arrangements. On September 18, 1883, Spencer took the lead in organizing the Union Church of Africans, also known variously as the Union Church of African Members, the African Union Church, the African Union Methodist Church, and the Union Methodist Connexion.

The new denomination remained essentially Methodist in its articles of religion, general rules, disci-

pline, and multiple conference system. However, the episcopacy, the itineracy, and the strong connectional system of the Methodists were rejected in favor of a more democratic style involving lay elders, elder ministers, deacons, licensed preachers, local congregational autonomy, and the stationed pastorate.

Beginning in the 1850s, a series of schisms interfered with the growth and development of the Spencer Churches. In 1855–1856, conflict in the Union Church of Africans over the authority of elder ministers resulted in the formation of a rival body known as the UNION AMERICAN METHODIST EPISCOPAL CHURCH. In 1866, the remaining congregations in the Union Church of Africans merged with the First Colored Methodist Protestant Church of Baltimore, Md., resulting in the AFRICAN UNION FIRST COLORED METHODIST PROTESTANT CHURCH or the African Union Methodist Protestant Church. A serious rift occurred in the UAME Church in 1935 when three candidates ran unsuccessfully for the episcopacy. This schism culminated in the organization of the rival Reformed Union American Methodist Episcopal Church, a body that no longer exists.

From their founding, the AUMP and UAME Churches have remained regional due to insufficient resources, poor missionary outreach, the lack of strong connectional systems, numerous schisms, and a dearth of vigorous, educated leadership. In 1990, both the AUMP and the UAME Churches reported fewer than 10,000 members located in congregations in Delaware, Maryland, Pennsylvania, New Jersey, New York, Connecticut, Rhode Island, and Washington, D.C. Since the late 1970s, the UAME Church has also struggled to build congregations in parts of the West Indies.

Both the AUMP and the UAME Churches remain significantly smaller and less socially active than the larger national branches of black Methodism, such as the AFRICAN METHODIST EPISCOPAL CHURCH (AME), the AFRICAN METHODIST EPISCOPAL ZION CHURCH (AMEZ), and the CHRISTIAN METHODIST EPISCOPAL CHURCH (CME).

REFERENCES

BALDWIN, LEWIS V. "Invisible" Strands in African Methodism: A History of the African Union Methodist Protestant and Union American Methodist Episcopal Churches, 1805–1980. Philadelphia, 1983.
———. The Mark of a Man: Peter Spencer and the African Union Methodist Tradition. Lanhan, Md., 1987.
RUSSELL, DANIEL J. History of the African Union Methodist Protestant Church. 1920.
———. Our Heritage: The History of the African Union Methodist Protestant and Union American Methodist Episcopal Churches, 1805–1980. 1973.

LEWIS V. BALDWIN

AfriCobra, visual art collective. The African Commune of Bad Relevant Artists (AfriCobra) was organized in 1968 in Chicago to create a black political art that would rouse viewers and mobilize them into revolutionary action. Painter Jeff Donaldson organized the Visual Arts Workshop of the Organization of Black American Culture (OBAC) and, along with painter Wadsworth Jarrell and printmaker Barbara Jones-Hogu, helped to create the *Wall of Respect* (1967), a 30-foot-by-60-foot mural painted on a building of an absentee owner at 43rd and Langley on Chicago's South Side. The *Wall,* which commemorated important figures in African-American history such as MALCOLM X and Frederick DOUGLASS, received wide media coverage and was an inspiration for the more than 1,500 outdoor urban murals from 1968 to 1972 in cities in the United States with substantial black populations. AfriCobra artists also had strong ties with the ASSOCIATION FOR THE ADVANCEMENT OF CREATIVE MUSICIANS (AACM).

After OBAC dissolved in late 1967, Donaldson, Jarrell and Jones-Hogu formed AfriCobra, dedicated to social responsibility and technical excellence. By 1969, this group expanded to include OBAC artist Carolyn Lawrence and painters Gerald Williams and Nelson Stevens, fashion designer Jae Jarrell, fiber artist Napoleon Jones-Henderson and illustrators Sherman Beck and Omar Lama. In biweekly meetings, the AfriCobra artists formulated an aesthetic that emphasized the relationship between African artistic traditions and the work of black artists in the United States. By incorporating colors, symbols, and fabrics prevalent in African art, AfriCobra aimed to instill a sense of nationhood in artists throughout the African DIASPORA. AfriCobra's works often featured African-American political leaders, such as Jarrell's image of Angela DAVIS (*Revolutionary,* 1971), which built Davis' hands and face from the words of her political slogans.

In 1970, half of AfriCobra's members moved from Chicago to northeastern cities such as Washington, D.C., Boston, and Amherst, Mass., and by 1974, the AfriCobra core was located in Washington, D.C. During the 1970s, AfriCobra's work became more visible through exhibits at the Studio Museum in Harlem (1970), the National Center for Afro-American Artists in Boston (1970), the Museo La Tertulia in Cali, Columbia (1971), and the Second World Black African Festival of Art and Culture (FESTAC) in Lagos, Nigeria (1977).

Toward the end of the 1970s, AfriCobra's work was concerned with liberation in South Africa. Following the 1976 student-led insurrection in Soweto, AfriCobra created works on the theme "Soweto—So We Too." AfriCobra exhibited work at the United Nations Commemoration of the Soweto uprising in

1979. During the 1980s, the group developed posters commemorating African Liberation Day using colors of South African minerals to argue that the key political question in South Africa revolved around the economy rather than apartheid.

While AfriCobra artists shared a philosophy and held common aesthetic practices, the members developed independent careers. Artists such as Michael Harris, Frank Smith, and Nelson Stevens, work as professors or administrators of art in American universities, and Murry DePillars and Jeff Donaldson served as deans of Colleges of Fine Arts (Virginia Commonwealth University in Richmond, Va., and Howard University in Washington) into the 1990s. AfriCobra members Wadsworth Jarrell, Napoleon Jones-Henderson, James Phillips, Adger W. Cowans, and Akili Ron Anderson work as independent artists.

AfriCobra was the first artists' group in the United States to espouse a synthesis of African and African-American stylistic elements in the service of sociopolitical style of painting and design in which composition, color, symmetry, luminosity, and pattern extend the most striking features of African art into relevant statements for the contemporary world. The group continued to meet semiannually through the 1990s to discuss their approach to trans-African aesthetics. AfriCobra joined with the collective of Martinique artists to produce a joint exhibit, "AfriCobra: Fwomaje: Universal Aesthetics," at Howard University (1989), and its work toured the northeastern seaboard and midwestern United States in a twenty-year retrospective organized by the Nexus Contemporary Art Gallery in Atlanta (1990–1992).

REFERENCES

GAITHER, EDMUND. *Black Art Ancestral Legacy*. Dallas, 1989.
KAI, NUBIA. *AfriCobra: The First Twenty Years*. Atlanta, 1990.
RICHARD, PAUL. "Evolution of a Revolution: At Howard, A Retrospective of the African Commune of Bad Relevant Artists," *Washington Post*, December 10, 1989, p. G-1.
THORSON, ALICE. "AfriCobra Then and Now: An Interview With Jeff Donaldson." *New Art Examiner* 17, no. 7 (March 1990): 26–31.

JEFF R. DONALDSON

Afro-American (Newspaper). *See* Baltimore Afro-American.

Afrocentricity.
Afrocentricity is a state of being in which consciousness is centered by and within the processes that maintain and perpetuate the historical continuity of African life and culture and establish the perspectives from which reality is interpreted or reinterpreted. Afrocentricity is an essential corollary to the African worldview (Asante 1980, 1987, 1990; Carruthers 1980; Azibo 1992; Ekwe-Ekwe and Nzegwu, 1994) and is worthy of serious consideration by all who study African-American culture and history. Senegalese multidisciplinary scholar Cheikh Anta Diop's (1959, 1978) theory of African cultural unity is regarded as fundamental to both concepts.

Diop's work emerged during the 1950s and '60s, when continental and diasporan African intellectuals were constructing paradigms based on theories of racial unity to guide their resistance to white supremacy (Spady 1978). These attempts to imbue "blackness" with the dynamic qualities required to serve as a theory of African commonality were capable of refuting white supremacy but inadequate to explain the uniqueness of the African way of life. Diop's work, in general, is credited with beginning a movement that extended the thinking of African intellectuals worldwide beyond the limitations of racial analyses by demonstrating the existence of particular qualities of African history, linguistics, and psychology that have endured as aspects of African culture since antiquity (Spady 1978; Ekwe-Ekwe and Nzegwu 1994).

While the Afrocentric worldview has existed from antiquity (*see* AFRICA; ANTIQUITY), Afrocentrism as a construct has not. In an essay entitled "Reflections on the History of the Afrocentric World View," Carruthers (1980) defines the concept of a worldview and distinguishes it from ideology. Unlike ideology, which he associates with class interests, a worldview "includes the way a people conceive of the fundamental questions of existence and organization of the universe" (p. 4). The Afrocentric world view, according to Carruthers, rests on two "basic truths": (1) It is distinct to and universal among African people throughout the world, and (2) its restoration is the only viable foundation for the liberation of all Africans worldwide. Conceptions of Afrocentric worldview consistent with that put forth by Carruthers have been articulated by Nobles (1974), Ani and Richards (1980, 1990, 1994), Azibo (1992), and others. Afrocentrism is a concept constructed to enable Africans to use the strengths of enduring cultural unity as weapons for liberation and as tools for building new social realities in which Africans understand themselves as subjects of their own experiences (Asante 1980). The need for such a concept was created by African experiences with invasion, conquest, enslavement, colonization, and neocolonization, and concomitant processes of cultural alienation.

Restoration of Afrocentric worldview exists as a project because African culture has been the target

of systematic acts of destruction by proponents of Western (European) cultural imperialism and white nationalist supremacy (Williams 1974, Ani and Richards 1994). Frantz Fanon (1967), for instance, noted that racism's object is not the individual "but a certain form of existing" (p. 32). Ani argues that "the most effective weapon" against cultural destruction "is a strong national consciousness" (1994, p. 294). Clarke (1991) and Akoto (1993) as well as Ani and Richards (1994) emphasize nation building as the objective of African worldview restoration. We will conclude with three illustrations of the methodology of African worldview restoration.

In *Afrocentricity: The Theory of Social Change* (1980), Asante avers that Afrocentricity is a "transforming agent" for the restoration of the Afrocentric worldview. The process by which this transformation is to be effected is guided by "Afrology," a term coined by Asante to refer to a comprehensive Afrocentric "philosophical statement with attendant possibilities for a new logic, science, and rhetoric" (p. 65). He formally defines Astrology as "the science or study of all modalities related to people of African descent from an Afrocentric perspective" (p. 117). However, Asante in this book also offers an analysis of the personal transformation process that enables an individual to transcend a consciousness born out of "otherness" and to realize Afrocentricity. It is precisely this possibility of individual transformation that makes an Afrocentric collective consciousness viable.

Azibo (1992) argues that restoring the African worldview requires an understanding of and use of three approaches that may be described as (1) deconstructionist, (2) reconstructionist, and (3) constructionist. Non-African concepts, variables, and formulations must be deconstructed and reconstructed. The *deconstructionist* approach employs critical analysis in a fashion that corresponds to Ani's (1994) notion of "de-Europeanization." It isolates Eurocentric concepts from the mix of ideas and seeks to eliminate their influence. The *reconstructionist* approach "revises, revamps, and otherwise alters alien-centered formulations to better fit or jibe with African reality" (Azibo 1992, p. 86). It takes Eurocentric or other foreign concepts and "Africanizes" them. Lastly, the *constructionist* approach "proceeds with formulations and concepts derived from the African cultural deep-structure" (p. 86). It would seem that deconstruction and reconstruction must occur in tandem, although Azibo does not explicitly state this. The employment of constructionist approaches is necessarily preceded by simultaneous deconstruction and reconstruction.

Finally, Marimba Ani focuses on personal transformation facilitated by the de-Europeanization of the culture concept. In her book *Yurugu: An African-Centered Critique of European Cultural Thought and Behavior* (1994), she argues that the ideological function of culture can be understood through the systematic analysis of European culture's deep structure and the uses of its logic. This essentially means learning how to demystify the universalist claims of Western cultural imperialism by treating them as manifestations of a particular ideology. When culture is made "visible" in this way, it is possible for Africans to transcend the Europeanization of thought and to redefine their thinking in African-centered terms.

See BLACK STUDIES for a brief discussion of how Afrocentricity relates to black studies in general. *See also* the entries on BLACK IDENTITY, NEGRITUDE, PAN-AFRICANISM.

REFERENCES

AKOTO, K. A. *Nationbuilding: Theory and Practice in Afrikan-Centered Education.* Washington, D.C., 1992.

ANI, M., and D. M. RICHARDS. The Implications of African Spirituality. In M. K. Asante and K. W. Asante, eds. *African Culture: The Rhythms of Unit.* Trenton, N.J., 1990.

———. *Let the Circle Be Unbroken: African Spirituality in the Diaspora.* 1980. Reprint. Trenton, N.J., 1989.

———. *Yurugu: An African-Centered Critique of European Cultural Thought and Behavior.* Trenton, N.J., 1994.

ASANTE, M. K. *The Afrocentric Idea.* Philadelphia, 1987.

———. *Afrocentricity.* Buffalo, N.Y., 1980.

———. *Kemet, Afrocentricity, and Knowledge.* Trenton, N.J., 1990.

AZIBO, D. A. "Articulating the Distinction Between Black Studies and the Study of Blacks: The Fundamental Role of Culture and the African-Centered Worldview." *Afrocentric Scholar* 1, no. 1 (1992): 64–97.

CARRUTHERS, J. H. "Reflections on the History of the Afrocentric Worldview." *Black Books Bulletin* 7, no. 1 (1980): 4–7, 13, 25.

CLARKE, J. H. *African World Revolution: Africans at the Crossroads.* Trenton, N.J., 1991.

DIOP, C. A. *The Cultural Unity of Black Africa. The domains of Patriarchy and of Matriarchy in Classical Antiquity.* Chicago, 1978. Published originally in French in 1959 as *L'Unité Culturelle de l'Afrique Noire.*

EKWE-EKWE, H., and F. NZEGWU. *Operationalising Afrocentrism.* Reading, U.K., 1994.

FANON, F. *Toward the African Revolution.* 1964. Reprint. New York, 1967.

KARENGA, M. *Kawaida Theory: An Introductory Outline.* Inglewood, Calif., 1980.

NOBLES, W. W. "Africanity: Its Role in Black Families." *Black Scholar* 5, no. 9 (1974): 10–17.

SPADY, J. "Afterword." In C. A. Diop. *The Cultural Unity of Black Africa: The Domains of Patriarchy*

and of Matriarchy in Classical Antiquity. Chicago, 1978.

WILLIAMS, C. *The Destruction of Black Civilization: Great Issues of a Race from 4000 B.C. to 2000 A.D.* Chicago, 1974.

MWALIMU J. SHUJAS
KOFI LOMOTEY

Ai (Ai Ogawa, Florence) (October 21, 1947–), poet. Ai was born Florence Anthony in Albany, Tex. She was given the surname of her mother's husband, although her real father was a Japanese-American with whom her mother had had a brief extramarital affair. Ai's maternal grandfather was African-American, and her maternal grandmother had African, Choctaw, Irish, and Dutch blood. After a childhood in which she felt unable to assimilate with any particular ethnic group, Ai insisted upon her multiethnicity. At the age of twenty-two, Florence chose "Ai," which means "love" in Japanese, as her pseudonym. When she was twenty-six, after her mother revealed her real father's name, Ai legally changed her name to Florence Ai Ogawa.

Ai grew up poor in a Mexican barrio in Tucson, Ariz., and attended an integrated Catholic high school. She received a B.A. in Oriental studies from the University of Arizona in 1969, and an M.F.A. in creative writing from the University of California at Irvine in 1971. Her first volume of poetry, *Cruelty,* was published in 1973. It is a collection of short first-person monologues in which disfranchised tenant farmers, prostitutes, and murderers dispassionately recount such acts as child abuse, patricide, and necrophilia. Ai draws no moral conclusions regarding her characters, saying, "Whoever wants to speak in my poems is allowed to speak, regardless of sex, race, creed, or color."

Her next volume, *Killing Floor* (1979), won the 1978 Lamont Poetry Prize awarded by the Academy of American Poets. The poems in this collection also feature murderous acts, but they are told from the viewpoint of such historical figures as Leon Trotsky, Yukio Mishima, Lope de Aguirre, and Ira Hayes. In *Sin* (1985) Ai gives voice to Joe McCarthy, the Atlanta serial child murderer, John F. Kennedy, and J. Robert Oppenheimer, as well as to the victims of Hitler, Stalin, the Vietnam War, and Hiroshima. *Fate* (1991) concerns such cultural icons as James Dean, Lenny Bruce, and Gen. George Armstrong Custer, whose identities have been fixed and falsified by society. Through the violence that dominates her work, Ai hopes to achieve transcendence for her characters.

Ai taught creative writing at the State University of New York at Binghamton (1973–1974), the University of Massachusetts, Amherst (1976–1977), Wayne State University (1977–1978), George Mason (spring 1981, 1987, and 1988), Arizona State University (1988–1989), and the University of Louisville (fall 1990). Her honors include a 1975 Guggenheim Fellowship, first prize in the 1978 Pushcart Prize, two National Endowment for the Arts Fellowships (1979, 1985), and a 1987 American Book Award for *Sin.*

REFERENCES

GWYNN, R. S., ed. *Dictionary of Literary Biography.* Vol. 120. *American Poets Since World War II: Third Series.* Detroit, 1992.

METZGER, LINDA, ed. *Black Writers: A Selection of Sketches from Contemporary Authors.* Detroit, 1989.

SIRAJ AHMED

AIDS. *See* Diseases and Epidemics.

Ailey, Alvin (January 5, 1931–December 1, 1989), African-American dancer and choreographer. Born in Rogers, Tex., the only child of working-class parents who separated when he was two, Ailey moved to Los Angeles with his mother in 1942. Shy from his itinerant Texas life, Ailey reluctantly turned to dance when a high-school classmate introduced him to Lester Horton's Hollywood studio in 1949. He poured himself into study and developed a weighty, smoldering performance style that suited his athletic body. Ailey moved to New York in 1954 to dance with partner Carmen DeLavallade in the Broadway production of *House of Flowers.* Performing success and study with leading modern dance and ballet teachers Martha Graham, Doris Humphrey, Charles Weidman, and Karel Shook led Ailey to found his own dance theater company in 1958. The Alvin Ailey American Dance Theater (AAADT) began as a repertory company of seven dancers devoted to both modern dance classics and new works created by Ailey and other young artists. The critically successful first concerts in 1958 and 1960 marked the beginning of a new era of dance performance devoted to African-American theme. *Blues Suite* (1958), set in and around a barrelhouse, depicts the desperation and joys of life on the edge of poverty in the South. Highly theatrical and immediately accessible, the dance contains sections of early twentieth-century social dances, Horton dance technique, Jack Cole-inspired jazz dance, and ballet partnering. Early per-

formances of *Revelations* (1960) established Ailey's company as the foremost dance interpreter of African-American experience. The dance quickly became the company's signature ballet, eclipsing previous concert attempts at dancing to sacred black music. Set to a series of SPIRITUALS and GOSPEL selections arranged by Brother John Sellers, *Revelations* depicts a spectrum of black religious worship, including richly sculpted group prayer ("I've Been Buked"), a ceremony of ritual baptism ("Wade in the Water"), a moment of introverted, private communion ("I Wanna Be Ready"), a duet of trust and support for a minister and devotee ("Fix Me, Jesus"), and a final, celebratory gospel exclamation, "Rocka My Soul in the Bosom of Abraham."

Several Ailey dances established precedents for American dance. *Feast of Ashes* (1962), created for the Harkness Ballet, is acknowledged as the first successful *pointe* ballet choreographed by a modern dancer.

Alvin Ailey in 1955, at the beginning of his dancing career. In 1959, with the founding of the Alvin Ailey American Dance Theater, Ailey emerged as one of the leading choreographers of his generation. (Prints and Photographs Division, Library of Congress)

In 1966 Ailey contributed dances for the New York Metropolitan Opera's inaugural production at Lincoln Center, Samuel Barber's *Antony and Cleopatra*. In 1970 he created *The River* for American Ballet Theatre. Set to an original score commissioned from Duke ELLINGTON, this ballet convincingly fused theatrical jazz dancing and ballet technique. In 1971 Ailey created the staging for Leonard Bernstein's rock-influenced *Mass*, which opened the newly built Kennedy Center in Washington, D.C.

Major distinctions and honors followed Ailey throughout his choreographic career, which spanned the creation of more than fifty dances for his own company, American Ballet Theater, the Joffrey Ballet, the Paris Opera Ballet, the London Festival Ballet, and the Royal Danish Ballet. Among his many awards were honorary doctorates in fine arts from Princeton University, Bard College, Adelphi University, and Cedar Crest College; a United Nations Peace Medal, and an NAACP SPINGARN MEDAL, in 1976. In 1988 he was celebrated by the president of the United States for a lifetime of achievement in the arts at the Kennedy Center Honors.

Company and Repertory

In its earliest years, the AAADT spent much time on the road, touring and bringing dance to a large audience of people who had never heard of concert performance. This largely African-American audience has provided the wellspring of support essential to the Ailey enterprise. The AAADT established its vast international reputation through a series of tours begun in 1962 by a five-month engagement in Southeast Asia and Australia. Sponsored by the International Exchange Program under the Kennedy administration, this tour established a pattern of performance in foreign countries that continued with a trip to Rio de Janeiro (1963); a European tour including London, Hamburg, and Paris (1964); an engagement at the World Festival of Negro Arts in Dakar, Senegal (1966); a sixteen-week European tour, including the Holland Festival in Amsterdam (1967); a visit to Israel (August 1967); a U.S. State Department–sponsored nine-nation tour of Africa (1967); and a performance at the Edinburgh Festival in Scotland (1968). In 1970 the AAADT became the first American modern dance company to perform in the postwar Soviet Union. The company has retained peerless stature as a touring ambassador of goodwill since the 1970s; high points have included a prize-winning performance at the International Dance Festival in Paris (1970); a second Far East tour (1977); a Brazil tour (1978); and several command performances for heads of state and royalty. By 1989, the AAADT had been seen by some fifteen million people worldwide.

Active in the pursuit of dance history, the varied repertory of the AAADT has, in Ailey's words, sustained an "impulse to preserve modern dance to know where it's been in order to know where it's going, and to encourage the participation of the audience" in that process. The eclectic repertory has been provided by choreographers working in a variety of dance modes, including ballet, jazz dance, Graham modern, Horton, and Dunham technique. Important pieces danced by the company have included Donald MCKAYLE's *Rainbow Round My Shoulder* (1959), Talley BEATTY's *The Road of the Phoebe Snow* (1959), Anna Sokolow's *Rooms* (1965), Louis JOHNSON's *Lament* (1965), Geoffrey HOLDER's *Prodigal Prince* (1967), Ulysses DOVE's *Vespers* (1986), Judith JAMISON's *Forgotten Time* (1989), and Donald Byrd's *Dance at the Gym* (1991), as well as dances by venerable American choreographers Ted Shawn, Pearl PRIMUS, Katherine DUNHAM, Joyce Trisler, and Lester Horton. In 1976 the AAADT celebrated composer Duke ELLINGTON with a festival featuring fifteen new ballets set to his music, a project that highlighted Ellington's musical achievement.

Company Members

Ailey encouraged his dancers to present individualized and highly emotional performances, a strategy that created the first series of star personalities in American modern dance. Judith Jamison's electrifying performance of *Cry* presented a coherent relationship between the dancing body and the experience of living as a black woman in America. Created in 1971 as a birthday present for Ailey's mother, Lula Cooper, *Cry* has been successfully assumed by several dancers, most notably Donna WOOD, Renee Robinson, Sara YARBOROUGH, and Nasha Thomas. In 1972, Ailey created the elegiac solo *Love Songs* for dancer Dudley WILLIAMS, revived in 1993 by dancer Michael Joy. Dancer Gary DeLoatch, a longtime principal with the company, brought an eloquent intensity to his roles, especially as the pusher in Talley BEATTY's *The Stack-Up* (1983) and as Charlie PARKER in Ailey's *For "Bird"—With Love* (1984). Innumerable significant dance personalities have passed through the AAADT, including Marilyn Banks, Hope Clarke, Carmen DeLavallade, George Faison, Miguel Godreau, Dana Hash, Linda Kent, Desmond Richardson, Kelvin Rotardier, Elizabeth Roxas, Clive Thompson, James Truitte, Andre Tyson, and Sylvia WATERS.

School and Outreach

In 1969 Ailey founded the Alvin Ailey American Dance Center School to educate dance students in the history and art of ballet and modern dance. Courses have been offered in dance technique and history,

music for dancers, dance composition, and theatrical design. In 1974 the Alvin Ailey Repertory Ensemble, a professional performance ensemble, was formed under the direction of Sylvia Waters as a bridge between study and membership in professional dance companies. In 1984 the Alvin Ailey Student Performance Group was created under the direction of Kelvin Rotardier. The Student Performance Group has offered lecture-demonstrations to communities traditionally underserved by the arts. In 1989 Dance Foundation Inc., the umbrella organizations for the AAADT and the Ailey School, initiated the Ailey Camps program, an outreach program designed to "enhance the self-esteem, creative expression, and critical thinking skills of inner-city youth through dance." Success of the initial venture in Kansas City, Mo., led to similar programs begun in New York City (1990) and Baltimore, Md. (1992).

Ailey created the AAADT to feature the talents of his African-American colleagues, though the company was never exclusively black. Ailey integrated his company to counter the "reverse chauvinism in being an all-black anything." He told the *New York Times,* "I am trying to show the world that we are all human beings and that color is not important. What is important is the quality of our work." In the last interview conducted before his death, he commented that the essence of the Ailey enterprise was that "the dancers be fed, kept alive, interested" in the work. "We're trying to create a whole spectrum of experience for the dancer as well as the audience," he said, dramatically understating the realities of his achievements.

Ailey stopped dancing in 1965 and slowed his choreographic assignments in the 1970s to attend to the administrative and fund-raising operations associated with his ever expanding company. Upon Ailey's death, Judith Jamison was appointed artistic director of the company, to work closely with rehearsal director and longtime company member Masazumi Chaya. The AAADT finally emerged from financial difficulties in 1992, when *Dance Magazine* proclaimed it "recession-proof" due to powerful development efforts on the part of the Dance Foundation Inc.'s board of directors.

Although Ailey gave numerous interviews throughout his career, he was decidedly private about his personal life. He described himself as "a bachelor and a loner" to writer John Gruen and hardly ever allowed outsiders into his most private thoughts. In 1980 Ailey was briefly hospitalized for stress-related conditions. His death followed a long, solitary struggle that had taken him out of the limelight for some time. Ailey's legacy to the dance world was to foster a freedom of choice—from ballet, modern, and social dance performance—to best

express humanity in movement terms suited to the theatrical moment.

REFERENCES

EMERY, LYNNE FAULEY. *Black Dance in the United States from 1619 to 1970.* Palo Alto, Calif., 1972.

GOODMAN, SAUL. "Brief Biographies: Alvin Ailey." *Dance Magazine* (December 1958): 70.

GRUEN, JOHN. "Interview with Alvin Ailey." Transcript of interview, collection of New York Public Library, 1972.

LATHAM, JACQUELINE QUINN. A Biographical Study of the Lives and Contributions of Two Selected Contemporary Black Male Dance Artists—Arthur Mitchell and Alvin Ailey. Texas Women's University diss., 1973.

LONG, RICHARD. *The Black Tradition in American Dance.* New York, 1989.

MAZO, JOSEPH H., and SUSAN COOK. *The Alvin Ailey American Dance Theater.* New York, 1978.

MOORE, WILLIAM. "Alvin Ailey (1931–1989)." *Ballet Review* 17, no. 4 (1990): 12–17.

THOMAS F. DEFRANTZ

Alabama. African Americans have lived in the land comprising present-day Alabama since the eighteenth century. The port of Mobile was founded in 1702 as part of France's Louisiana Colony, and in 1719 the first enslaved blacks were brought in to work as laborers and domestics. They were regulated under the French *code noir.* Though the Mobile settlement grew under the successive control of France, England, and Spain, slavery remained an economically insignificant institution in the area throughout the century. Meanwhile, the rest of Alabama, claimed by England and occupied by the English-allied Creek Indians, became part of the territory of the new United States in 1783. During the following years, settlers from the Georgia piedmont migrated to the area. Still, the population remained small, as the Creeks resisted encroachment. Some Creeks, particularly those closest to white allies, bought enslaved Africans. The 1800 census of the American part of Alabama (established as Washington County in the Mississippi Territory) listed only 494 African Americans.

The invention of the cotton gin and the attendant development of cotton cultivation turned Alabama into a favorable spot for mass settlement. The Creeks were forced to abandon most of their land in Alabama, and during the 1830s they and their slaves were moved out altogether, along the Trail of Tears to present-day Oklahoma. Many new immigrants were slaveholders, and Alabama's black slave population skyrocketed. During the War of 1812, U.S. Army troops conquered the rich port of Mobile, which America had claimed under the Louisiana Purchase treaty. Its inhabitants, including a large free black creole community, were given full civil rights by the federal government according to the treaty. By 1817, when the Territory of Alabama was created, there were 10,000 enslaved blacks in the region. In 1820, the year after Alabama achieved statehood, the census counted 41,879. By 1860 the slave population reached 435,080—nearly half the state's population.

Cotton was the center of Alabama's slave economy in the antebellum years, and the state produced one fourth of the nation's cotton by 1860. Plantations were most frequent in the south of the state, dubbed the "Black Belt" for its fertile black soil, and in the north along rivers such as the Tennessee River. While very large plantations were relatively rare—only 5 percent of slaveholders owned fifty or more slaves —up to 25 percent of white Alabamians owned slaves. Some slaves lived in urban areas such as Montgomery, Tuscaloosa, and Huntsville, where they worked as skilled laborers and tradespeople, sometimes hiring out their own time. Mobile developed into a large port, second in size only to New Orleans in the cotton trade, and a major slave market.

Alabama's slave code, modeled after that of South Carolina, was extremely harsh, though enforcement was lax. Whites were required to be present at any sizable gathering of slaves. The only independent institutions among the slaves were religious. Slave Baptist and Methodist preachers conducted revival meetings and led clandestine services on plantations. In urban areas, congregations were formed, and buildings such as Mobile's African Baptist Church, finished in 1839, were erected.

Antebellum Alabama had a small free black population. While legal manumission became increasingly difficult after 1830 (and was outlawed altogether in 1860), some slave masters freed their slaves. Other blacks purchased their own freedom. About half of Alabama's free people of color lived in rural areas, where they had small farms. A few held black slave laborers themselves. There were also tiny communities in cities such as Florence and Montgomery.

Mobile, the state's largest city, differed in many ways from the rest of Alabama. The city contained most of Alabama's urban free blacks, as well as those black creole families, such as the wealthy Chastang family, who enjoyed special status under American law. While education was legally forbidden blacks in the rest of the state, there were special creole schools in Mobile, with 114 black students in 1860. In 1859 a group of Guinean Africans was brought illegally to

Mobile on the slave ship *Clothilde,* one of the last recorded slave ship voyages to the United States. Unable to sell their captives, the ship's owners freed them, and the Africans formed a separate community, Africa Town, in the city's northern suburb of Plateau. Alabama, with its dominant slave economy and proslavery ideology, was drawn early into the sectional crisis over slavery, and when sectional tensions peaked following the election of Abraham Lincoln as U.S. president in 1860, Alabama seceded from the Union, despite a large minority of moderates and unionists, particularly in the state's nonslave north. Montgomery, the state capital, was the site of the convention of secessionist states at which the Confederate States of America was created, and was made the first capital of the Confederacy. Many of Mobile's small population of free blacks and creoles, who were relatively integrated economically and socially with their white neighbors, supported the Confederacy.

The CIVIL WAR heavily damaged the state's economy. The Union blockade largely shut down the port of Mobile, and conscription of black slave laborers and white soldiers by the army sparked a labor shortage. Some plantations were placed in the care of trusted slaves or of quasi-free black sharecroppers by departing masters. While no major land battles were fought in Alabama, Union troops entered parts of the state as early as 1862, laid waste to land, and confiscated supplies and property. Black slaves took advantage of the presence of the Northern army to flee to freedom behind Union lines or to sell supplies to the invaders. When Congress authorized black soldiers, Alabama's freedmen rushed to enlist. Eventually some 10,000 blacks served as soldiers in the Union army.

The end of the Civil War brought freedom to Alabama's enslaved black population. Many blacks left the plantation to travel, seek out relatives, or settle in other states. Those who stayed founded independent religious groups such as the Primitive Baptists of the Huntsville African Baptist Church, and formed congregations such as Montgomery's First Baptist Church and Dexter Avenue Baptist Church (originally the Second Baptist Church). They also organized fraternal societies, literary groups, and charitable societies. Many longstanding couples sought to be legally wed. Alabama's urban population quickly expanded, despite efforts by white leaders to staunch the flow, as blacks gravitated to such cities as Montgomery and Mobile in search of educational and economic opportunity.

With aid from the Freedmen's Bureau and the charitable AMERICAN MISSIONARY ASSOCIATION (AMA), thirty-five black schools were set up in 1865 alone, and more followed in the next years, along with several high schools and Talladega Normal School (later Talladega University), founded by the AMA in northern Alabama in 1868. Although large numbers of blacks never attended school, and most remained illiterate, the schools did an excellent job of preparing black teachers for efforts in later years. In 1870 the AMA schools were largely replaced by a black public school system.

While a few blacks were able to secure land, many African Americans—both native Alabamians and newcomers—were forced to seek agricultural employment, mostly in the old counties of the Black Belt. Labor relations between white landowners accustomed to slave obedience and African Americans were uneasy. Although wage labor of various sorts was instituted in the early postbellum years, blacks preferred the autonomy the sharecropping system offered, even at lower pay, and that system won out. Blacks bargained effectively for their labor, in the face of an agricultural labor shortage. While officers of the Freedmen's Bureau attempted to supervise the signing and enforcement of labor contracts, many planters were unscrupulous or angry at black self-assertion, and cheated their laborers of wages or shares. Ultimately many blacks were reduced to debt peonage.

Blacks entered the political arena for the first time during RECONSTRUCTION. The state's provisional government, formed in 1865, abolished slavery but instituted a black code with stringent police supervision of African Americans. Extralegal groups such as the KU KLUX KLAN were formed to terrorize African Americans and prevent them from asserting their rights. Nevertheless, black political leaders such as Montgomery's Holland THOMPSON organized a Negro Convention in Mobile, where they petitioned for civil rights and suffrage. The new Alabama legislature, elected in 1866, refused to ratify the FOURTEENTH AMENDMENT, and passed a law providing for the "apprenticeship," usually by the former slave-owner, of any black minors whose parents were judged unable to effectively provide for them. Despite black community opposition and pleas to the Freedmen's Bureau for assistance, hundreds of children were bound.

In 1867, following passage of the First Reconstruction Act, Congress dissolved Alabama's government, enfranchised blacks, and called for a new constitutional convention. Among the 100 delegates chosen were seventeen blacks. The constitution provided for equal rights, and passed despite a boycott by conservatives. Republican Party rule lasted only a few years in Alabama. The state government, despite early leadership by CARPETBAGGERS, was dominated by

native Unionist SCALAWAGS, mostly from the north of the state. They provided aid to railroads and public schools, but did not undertake radical reforms. While blacks were the electoral backbone of the Republican Party, most were anxious not to challenge white allies. As a result, black leaders generally were not offered leading political roles. Still, during Reconstruction, seventy-six freedmen sat in the state legislature, and three—James T. RAPIER, Benjamin TURNER, and Jeremiah HARALSON—were elected to Congress from Alabama.

In 1874 the Democrats regained control of the state government, and dismantled the Reconstruction constitution. Despite the efforts of leaders such as William Stevens, the Republican Party was soon crippled, and no further black state representatives were elected for decades. Laws segregating schools and other facilities were passed, and civil rights laws went unenforced. Blacks retained the franchise, but conservative Democrats, through fraud and economic pressure, were able to manipulate the black vote in their favor.

Deprived of other avenues of self-improvement, Alabama black leaders turned to education. Alabama State University, founded in Marion in 1874, was established in Montgomery in 1887. In 1890, William H. COUNCILL lobbied successfully for state funding to set up the Alabama State Agricultural and Mechanical College for Negroes at Huntsville (founded in 1873 as the Normal and Industrial School for Negroes). In 1881 African Americans in Macon County lobbied successfully for funds for the creation of the Tuskegee Normal and Industrial School for Negroes (later TUSKEGEE UNIVERSITY). The school was originally designed to be headed by a white man, but the position of principal went to Booker T. WASHINGTON. With help from local white leaders and northern philanthropists, Washington built Tuskegee into a thriving black institution, complete with a school brickworks, farm, and dairy. Tuskegee attracted several notable black scholars, including George Washington CARVER and Monroe WORK. Washington's public acquiescence in segregation and reliance on black self-help brought him the support of elite whites throughout the country, and ultimately extraordinary political power in Alabama and the entire South.

The postbellum agricultural depression grew worse during the 1880s, and by 1890 sparked the creation of a massive Farmer's Alliance, an agrarian protest movement. The separate Negro Farmer's Alliance attracted over 50,000 farm workers in support of reform. Together with the white alliance, it supported allied Populist Party candidates in state elections on a platform of black voting rights and aid for

Robert R. Moton (left), successor to Booker T. Washington as president of Tuskegee Institute, with civil rights leader James Weldon Johnson (right). (Photographs and Prints Division, Schomburg Center for Research in Black Culture, The New York Public Library, Astor, Lenox and Tilden Foundations)

farmers. Conservative Democrats countered with appeals to white supremacy. In 1891 the legislature passed a railroad segregation bill, the first of a number of such laws during the next years, supplemented by laws in various municipalities. Through fraud in counting African-Americans' voting returns, Democrats manipulated the 1892 and 1894 elections to assure victory. Yet, even after the Populist challenge was beaten back, elite whites were fearful of the specter of interracial challenge to their rule. In 1901 they called a constitutional convention. The new state constitution included a poll tax plus residence and property requirements. These effectively disfranchised almost all of Alabama's African Americans, as well as many poor whites.

Fraud by white landowners and the periodic devastation of the cotton crop by the boll weevil impoverished many African Americans at the turn of the century. Some blacks created industrial towns, the most famous of which was William E. Benson's Kowaliga Industrial Community, an all-black sawmill and industrial school created in 1896. Many blacks moved north, most during the GREAT MIGRATION which started around 1915. Throughout the twentieth century, Alabama African Americans have succeeded elsewhere in a variety of fields. These have included musicians W. C. HANDY, Nat "King" COLE, Cootie WILLIAMS, Dinah WASHINGTON, and Erskine HAWKINS; athletes Jesse OWENS, Joe LOUIS, Satchel PAIGE, Henry AARON, Willie MAYS, and Willie McCovey; writers Margaret WALKER and Sonia SANCHEZ; and black radicals from James FORD to Angela DAVIS.

Many African Americans who left rural areas went to work in cities. Mobile, Selma, and Montgomery grew slowly, and in 1900 the fast-growing industrial center of Birmingham became the main center of black Alabama population and life. The city boasted black theaters, baseball teams, clubs, newspapers, and other institutions. African Americans were hired as cheap labor in steel mills, railroads, and mines in Birmingham and in other new industrial towns such as Bessemer in the north of the state. Although traditionally excluded from organized labor, African Americans assisted in the organization of the United Mine Workers (UMW), which successfully appealed to both black and white workers, and served as an early example of the struggle for black equality in the workplace. In Alabama, African Americans served as chapter presidents, vice presidents, and executive board members, on grievance committees, as checkweighmen, and as delegates to district and national conventions. Silas Brooks served as vice president of the UMW and of the Alabama Federation of Labor. William Downey and J. H. Bean, an African-American carpenter, were UMW organizers.

Black union activities continued throughout the century. Alabama black leaders helped organize the Southern Tenant Farmer's Union in the 1930s. White officials responded to organizing efforts with violence and harassment, notably the Camp Hill massacre of 1931, in which a posse led by a local sheriff invaded a union meeting, shooting and wounding thirty members before burning down the house. The Alabama Sharecropper's Union, built up by Communists, was the only major locus of interracial association in the 1930s, and a center of civil rights activism and labor organization. Party members such as African-American Hosea HUDSON also formed Worker's Alliances in industrial towns and organized

to register voters. Later, Asbury Howard and Marion Reynolds spearheaded the International Union of Mine, Mill and Smelter Workers. Howard became an International Representative and vice president of the union, and led it in support of civil rights efforts.

Throughout the first half of the twentieth century, despite pockets of racial liberalism, Alabama remained an oppressive and dangerous place for African Americans. Segregation and legal harassment were all but universal. The classic incident of Alabama injustice was the case of the SCOTTSBORO Boys. In 1931 a group of nine African-American youths traveling in a railroad freight train were charged with raping two white women. Despite the lack of credible evidence, the nine were convicted by all-white juries and sentenced to death. The case soon became a cause célèbre. The U.S. Supreme Court twice reversed the death penalty convictions, but five of the nine were convicted and sentenced to long prison terms.

African-American Alabamians made the first cracks in the wall of discrimination in the 1940s. During World War II, the FAIR EMPLOYMENT PRACTICES COMMITTEE (FEPC) won several victories against employment discrimination in Alabama, such as in the Tennessee Valley Authority projects in the north of the state. After Tuskegee Institute President Frederick Douglass PATTERSON lobbied for the creation of the Tuskegee Air Field (where the Tuskegee fighter pilots were trained), a new influx of educated, economically independent blacks entered Macon County. During these years, the seeds of the modern CIVIL RIGHTS MOVEMENT were planted. The Tuskegee Civic Association, created by Charles Gomillion in 1941, organized voter registration drives which put pressure on white officials. When the legislature responded to the influx by passing the Boswell Amendment in 1946, which required prospective voters to be able to "interpret" sections of the state constitution, blacks challenged it in court, and in 1949 the U.S. Supreme Court declared it unconstitutional. In Montgomery, Jo Ann ROBINSON founded the Women's Political Council (WPC) in 1946, and fought for voting rights and equality. Meanwhile, in the teeth of a conservative "Dixiecrat" legislature, liberal governor Jim Folsom campaigned against the state poll tax and appointed registrars who approved the applications of qualified blacks. African-American voters remained rare, but the black vote was able to affect the outcome of local races. Meanwhile, Robinson, E. D. NIXON, and Rosa PARKS, Secretary of the NATIONAL ASSOCIATION FOR THE ADVANCEMENT OF COLORED PEOPLE (NAACP), laid the groundwork for the MONTGOMERY BUS BOYCOTT of 1955–56, which galvanized the nation and

made the Rev. Dr. Martin Luther KING, Jr. a national figure. Several native Alabamians became important civil rights leaders, notably Ralph ABERNATHY, Fred SHUTTLESWORTH, Joseph LOWERY, and Coretta Scott KING.

In the face of the movement, Alabama remained a citadel of reaction. When the U.S. Supreme Court struck down school segregation in the 1954 BROWN v. BOARD OF EDUCATION decision, the legislature "nullified" the ruling, though governor Folsom pledged compliance. In 1956, when Autherine Lucy obtained a court order admitting her to the University of Alabama, local whites rioted and university officials used the violence as a pretext for expelling her. In 1956 Alabama outlawed the NAACP. However, black leaders quickly organized the ALABAMA CHRISTIAN MOVEMENT FOR HUMAN RIGHTS to take its place, and it served as the center of civil rights campaigns. After the reinstatement of the NAACP in 1961, legal efforts to harass and intimidate civil rights activists continued. In 1960, for example, an Alabama official sued black civil rights workers for libel after they published a newspaper advertisement denouncing police actions. The case culminated in the U.S. Supreme Court's landmark libel ruling, *New York Times* v. *Sullivan* (1964), which held that a public figure could only recover for damages if the defamatory statement was made with "reckless disregard" for the truth. In 1957 the legislature capped years of local interference with black voter registration by gerrymandering the town of Tuskegee to eliminate the black vote. The U.S. Supreme Court's *Gomillion* v. *Lightfoot* (1960) ruling eliminated the gerrymander. Soon after, the interracial Alabama Democratic Conference (ADC) was formed. In 1964 the ADC sponsored the election of two Tuskegee city councilmen, Alabama's first black elected officials since Reconstruction.

Throughout the 1960s, Alabama served as the frontline of the civil rights movement, and the various campaigns changed the state forever. The Montgomery Bus Boycott was followed by a mass movement in Birmingham, and a lesser movement in Florence. The sit-in movement hit Birmingham in 1960, but was quickly broken by mass arrests. In 1961 the CONGRESS OF RACIAL EQUALITY (CORE) sponsored an interracial Freedom Ride on interstate buses in Alabama, which demonstrated the enormity of the brutality in Alabama. When a bus arrived in Anniston, the riders were brutally beaten by white mobs as police looked on, and the bus was blown up. After another bus traveled from Anniston to Montgomery, white mobs again assaulted passengers. Throughout the period, members of CORE and the STUDENT NONVIOLENT COORDINATING COMMITTEE (SNCC)

worked in voter registration and teaching freedom schools.

In 1963 Birmingham because the center of organized civil rights protests. Police Commissioner Eugene "Bull" Connor turned police dogs and fire hoses on nonviolent demonstrators, many of them children. Television images of the brutality sparked national protest. In May, downtown Birmingham desegregated. The movement won an important victory, marred by a terror bombing at the Sixteenth Street Baptist Church in September, which killed four little girls.

Another crucial victory came in June of the same year, when black students again sought to enter the University of Alabama. Segregationist governor George Wallace blocked their entry, but the students succeeded in matriculating with the aid of Alabama

Man sits on a bench outside SNCC headquarters in Selma, Ala., with hand lettered sign announcing positions available on primary ballots, May 3, 1966. (© Charmian Reading)

National Guard troops. Alabama civil rights efforts were crucial to the passage of the 1964 Civil Rights Act.

Once the Civil Rights Act passed, the movement turned its attention to voter discrimination. Selma, Ala., was a large, heavily black city with almost no black voters and a reputation for brutal police harassment. During the Selma Voting Rights campaign of 1964–65, demonstrators daily stood in line at the Dallas County courthouse to be registered. White officials adopted numerous stratagems to deny them the opportunity to register. In March 1965, when local demonstrators began a march from Selma to Montgomery, local police led by Sheriff Jim Clark attacked them with whips and cattle prods. The incident focused national attention on Selma. The reconstituted Selma-to-Montgomery March, led by King, attracted widespread support and led to the VOTING RIGHTS ACT of 1965.

With voting rights secured, African Americans rushed to register to vote. The Lowndes County Freedom Organization, founded by Stokely CARMICHAEL and other SNCC members in the aftermath

The Rev. Fred Shuttlesworth escorting children to register at a Birmingham, Ala., elementary school in 1963. Despite a federal court order mandating integration of the schools, the students were barred by Alabama National Guard troops under the direction of Gov. George Wallace. (AP/Wide World Photos)

of the Montgomery March, pushed for black political power in black majority areas. One of the original groups of the Black Power movement, its black panther emblem was later adopted by the BLACK PANTHER PARTY. In 1967 black activists from Lowndes County and elsewhere coalesced into the National Democratic Party of Alabama, a unique black Democratic organization, which for several years sponsored black candidates in primaries and pushed Alabama's regular Democrats into a more progressive posture.

Since the 1960s the political and economic condition of Alabama blacks has improved enormously. Antidiscrimination suits have opened up public accommodations throughout the state. AFFIRMATIVE ACTION policies have begun to remedy the state's long history of employment discrimination. Black candidates have been elected to office in large numbers. In 1993, the year after Earl F. Hilliard became the first black U.S. Congressman from Alabama since Reconstruction, there were nineteen black men and women in the state's House of Representatives and five in the Senate. Also, former segregationist politicians such as George Wallace have been forced to reach out to black voters, and African Americans have been named to numerous state posts.

Still, much of the state's black population remains in a difficult socioeconomic state. The U.S. Civil Rights Commission, studying six counties in the Black Belt in 1984, determined that economic opportunity was still limited, and education segregated and poorly funded. In 1988 Alabama had only 6.6 black-owned businesses per 1,000 residents, the lowest percentage in the South. It remains among the poorest states in funds for education and social welfare policies. Racial issues continue to divide Alabamians. In the early 1990s black and white legislators clashed over the presence of the Confederate flag atop the state Capitol.

REFERENCES

BAILEY, RICHARD. *Neither Carpetbaggers nor Scalawags.* Montgomery, Ala., 1993.

CARTER, DAN T. *Scottsboro: a Tragedy of the American South.* 2nd ed. Baton Rouge, La., 1976.

CHESTNUT, J. L., JR., and JULIA CASS. *Black in Selma: The Uncommon Life of J. L. Chestnut, Jr.* New York, 1990.

FITZGERALD, MICHAEL W. " 'To Give Our Votes to the Party,' Black Political Agitation and Agricultural Change in Alabama, 1865–1870." *Journal of American History* (September 1985).

HUDSON, HOSEA. *The Narrative of Hosea Hudson: His Life as a Negro Communist in the South.* Cambridge, Mass., 1979.

KELLY, ROBIN. *Hammer and Hoe: Alabama Communists During the Great Depression.* Chapel Hill, N.C., 1990.

KOLCHIN, PETER. *First Freedom: The Responses of Alabama's Blacks to Emancipation and Reconstruction.* Westport, Conn., 1972.

MARTIN, DAVID. "The Birth of Jim Crow in Alabama, 1865–1896." *National Black Law Journal* 13, nos. 1–2 (September 1983).

NORRELL, ROBERT J. *Reaping the Whirlwind: The Civil Rights Movement in Tuskegee.* New York, 1985.

ROBINSON, JO ANN. *The Montgomery Bus Boycott and the Women Who Started It: The Memoir of Jo Ann Robinson.* Knoxville, Tenn., 1987.

ROSENGARTEN, THEODORE, ed. *All God's Dangers: The Life of Nate Shaw.* New York, 1974.

THORNTON, J. MILLS, III. *Politics and Power in a Slave Society: Alabama, 1800–1860.* New York, 1978.

HORACE HUNTLEY

Alabama Christian Movement for Human Rights.

The Alabama Christian Movement for Human Rights (ACMHR) was founded in BIRMINGHAM, Ala., in June 1956, after the NAACP was effectively banned in Alabama. The Rev. Fred L. SHUTTLESWORTH, former membership chairman of the Birmingham chapter of the NAACP, led several ministers in founding the organization. Following the tradition of the NAACP, the ACMHR initiated a series of lawsuits to fight segregation in the city. Frustrated with the slowness and inefficiency of the legal process, however, the leaders of the ACMHR decided to combine a program of direct action protest with their legal tactics. When the U.S. Supreme Court ruled in December 1956 that bus segregation was illegal in Montgomery, the ACMHR scheduled a demonstration to be held on December 26 in favor of bus integration in Birmingham.

On Christmas evening Shuttlesworth's house was bombed and his bed blown apart by the explosion, but he was unharmed. He took a neighbor who had been injured to the hospital, and returning home, rode in the front of a segregated bus. Shuttlesworth's bravery strengthened the resolve of his fellow activists, and the next day 250 protestors took part in the demonstration.

Throughout the late 1950s and early '60s, the ACMHR continued to fight legal segregation in Birmingham, targeting the city's schools, housing, parks, and buses. The organization's tactics included staging protest demonstrations and bringing test cases to court to challenge the city's discriminatory laws.

In 1962 the ACMHR joined with local black college students in a boycott against downtown Birmingham stores which were practicing segregation. The boycott reduced business by 40 percent. When the Rev. Dr. Martin Luther KING, Jr., announced that the annual SOUTHERN CHRISTIAN LEADERSHIP CONFERENCE (SCLC) convention would be held that year in Birmingham, local merchants, fearing the adverse effects of increased protests, negotiated with Shuttlesworth to end the boycott, promising to take down their JIM CROW signs and work towards integration.

After the convention, however, the merchants reneged on their promises. King, who called Birmingham "the most segregated city in America," agreed with Shuttlesworth's proposal that the SCLC join with the ACMHR in a massive direct action campaign, called "Project C," against the notorious Birmingham Public Safety Commissioner Eugene "Bull" Connor and the other segregationist city leaders. The protests continued until May 10, 1963, when leaders of the SCLC and the ACMHR, concerned by the mounting violence among the city's blacks, negotiated a truce with members of the city's white business community.

According to the Birmingham Truce Agreement, the city's merchants agreed to fulfill four of the black leaders' basic demands within a specified time frame: the desegregation of downtown stores; improved employment opportunities for blacks in retail stores; the release of jailed demonstrators on low bail; and the establishment of a permanent interracial committee to monitor the situation in Birmingham. While some members of the city's black working class condemned the agreement as a sell-out arranged by the black leaders for the benefit of the city's black elite, the truce did have far-reaching implications. "Project C," during which the Rev. Dr. Martin Luther King, Jr. penned his famous "Letter from Birmingham Jail," and its resolution heightened national awareness of the South's racial problems.

Following the campaign, the ACMHR continued to work with the SCLC, sponsoring workshops on nonviolent protest tactics and challenging the city's discriminatory laws. The organization has continued to function since the 1960s, holding weekly meetings and advising members of the black community on their civil rights. The ACMHR also worked with Birmingham's Civil Rights Institute, which opened in 1992, in organizing and planning programs and exhibits.

REFERENCES

CARSON, CLAYBORNE, et al. *The Eyes on the Prize: Civil Rights Reader.* New York, 1991.

COLAICO, JAMES A. *Martin Luther King, Jr.: Apostle of Militant Nonviolence.* New York, 1988.

LYDIA MCNEILL

Al-Amin, Jamil Abdullah. *See* Brown, Hubert G. "H. Rap."

Alaska. African Americans have been contributing to the development of Alaska since Russia sold its American possessions to the United States for $7.2 million in 1867. Official records seldom accounted for the "Negroes" during the earliest years, but their presence could not be completely ignored. Memoirs, diaries, and documents attest to their active participation in settling the Alaskan frontier. According to the census records, from 1890 to 1940 Alaska experienced a population increase of 125 percent (from 32,052 to 72,524), and of that population, permanent African Americans made up one-half of 1 percent (from 112 to 141). However, as shop owners, miners, whalers, fishermen, laborers, and trappers they overcame social prejudice, building homes and raising families. African Americans joined the stampede of prospectors in the 1890s and, as Ninety-eighters, sought riches in the Klondike Gold Rush.

One of the more striking examples of the contributions made by African Americans to Alaska's

State representative Blanche Smith. (Alaska State Library)

history occurred in 1943. In that year the U.S. government decided to build the Alcan Highway. Over the protests of the U.S. commander for Alaska, who warned against "leaving a trail of new racial mixtures," it was decided that the all-black Ninety-seventh Division of the Corps of Engineers would be chosen to build the Alaskan section. There were many official doubts about the decision, including the argument that blacks were not intelligent enough to handle heavy equipment. However, after assurances were made that black troops would not be allowed near settlements or integrated with whites, the Ninety-seventh began its task.

Ostracized, forced to live in tents while white troops enjoyed the warmth of the newly built air base, and suffering in the worst winter in recorded Alaskan history (temperatures often reached −65°F), the Ninety-seventh finished the road ahead of schedule. At the formal dedication, Brig. Gen. James A. O'Connor, head of the Northwest Service Command, hailed the achievement and predicted that it would "occupy a major place in the lore of the north country." After fifty years, the sole land link between Alaska and the Lower Forty-eight remained the only tribute to the accomplishments of the Ninety-seventh Division. It nonetheless symbolizes the debt owed by Alaska to African Americans.

Since 1940, the permanent African-American population in Alaska has increased considerably. By 1990 it had reached 22,451 out of a total population of 550,043, and had become the largest minority in Alaska's two largest cities, Anchorage and Fairbanks. Since 1959, when Alaska became the forty-ninth state, the influences of African Americans have overshadowed the fact that they have seldom made up more than 6 percent of the population. In 1960, Blanche Smith became the first African American to serve in the state legislature. Others have followed as members of the state legislature, school boards, city councils, and borough assemblies. Willard Bowman served as the first executive director of the State Commission for Human Rights. In 1987, State Representative Walt Furnace was recognized as one of the nation's most promising legislators.

As business leaders, African Americans have shown initiative and longevity. Black-owned companies, such as E & S Diversified Services, a government service contractor, have consistently been top employers in the state. In 1990, 1 of every 9 African-American families earned in excess of $50,000 (the ratio among the white population was about 1 in 5), in comparison to the national average of 2 in every 100. In the professional ranks African Americans are prominent as attorneys, architects, teachers, engineers, medical doctors, and dentists.

Despite such achievements, African Americans in

State representative Walt Furnace. (Alaska State Library)

Alaska have been plagued by the problem of racism and the obstacles to political and economic equality it establishes. Together with the indigenous populations of Eskimos and Indians, blacks have striven to ensure racial equality. It was as a result of their actions that the Civil Rights Laws of 1945 and the Fair Employment Act of 1953 were passed, and that the State Commission for Human Rights was created in 1963. Among the many African Americans who fought for these rights were Pete Aiken, elected to the Fairbanks North Star Borough Assembly in 1956, the first African American in the state to be elected to public office; J. P. Jones, who fought for equal employment opportunities and was an active member of the NATIONAL ASSOCIATION FOR THE ADVANCEMENT OF COLORED PEOPLE (NAACP); and Ernest Griffin, who worked for minority representation in government and fair treatment for wage earners. Organizations made up primarily of African-American members include the NAACP, the Alaska Black Caucus, the Alaska Black Leadership Conference, and the Black Business Council.

However, since 1959 fewer than twenty African Americans have served in elective capacities. Only five have served in the State House of Representatives, and none in the Senate. By 1986 less than three-quarters of 1 percent of the two thousand state em-

ployees earning in excess of $50,000 were African Americans. During the building of the Trans Alaska Oil Pipeline (1986), only two significant contracts out of the thousands issued went to African-American firms. On October 6, 1987, the voters of Anchorage, by a margin of 3 to 1, chose to rescind legislation that would have named a center for performing arts after the Rev. Dr. Martin Luther King, Jr. Clearly, African Americans have suffered from racial bias, but it is also evident that they will continue to be a vital and industrious element of Alaska's future.

REFERENCES

CHASE, WILL H. *The Reminiscences of Captain Billy Moore.* Kansas City, Mo., 1947.
HALLOCK, CHARLES. *Our New Alaska, or Seward Purchase Vindicated.* New York, 1886.
OVERSTREET, EVERETT LOUIS. *Black on a Background of White: A Chronicle of Afro-Americans' Involvement in America's Last Frontier, Alaska.* Fairbanks, Alaska, 1988.
SPURR, J. E. *Through the Yukon Gold Diggings.* Boston, 1900.

BENJAMIN KLINE

Alcindor, Lew. *See* Abdul-Jabbar, Kareem.

Aldridge, Ira (July 24, 1807–August 7, 1867), actor. Born a free black in New York City, Ira Aldridge traveled to London at the age of seventeen to pursue a theatrical career. When he died fifty years later, he was known throughout Britain, Europe, and Russia as the greatest actor of his time.

Aldridge attended the African Free School in New York and possibly performed with the African Theatre of lower Manhattan before he left for England as a steward to the actor James Wallack. His first London stage appearance took place in 1825 at the Coburg Theatre, primarily a house for melodrama, where in a six-week season he performed five leading parts, including the title role of Oroonoko in Thomas Southerne's play and Gambia in *The Slave,* a musical drama by Thomas Norton.

Six years of touring followed in the English provinces, in Scotland, and Ireland. The title role in Shakespeare's *Othello* and Zanga the Moor in Edward Young's *The Revenge* were added to his repertoire. Aldridge also excelled as Mungo, the comic slave in Isaac Bickerstaffe's musical farce *The Padlock,* which was often billed as an afterpiece to *Othello.* In consequence, Aldridge was later compared to the

great English eighteenth-century actor David Garrick, who was equally renowned in both tragedy and comedy.

Having exhausted the number of acceptable black characters in dramatic literature, Aldridge began to perform traditionally white roles such as Macbeth, Shylock, Rob Roy from Walter Scott's novel, and Bertram in the Rev. R. C. Maturin's *Bertram, or, The Castle of Aldobrand*. He received high praise in the provincial press, being referred to as "an actor of genius" and "the perfection of acting." By this point he was only twenty-four, and he set his heart on performing at a major London theater. His opportunity came in 1833, when the leading English actor Edmund Kean collapsed while playing Othello at the Covent Garden theater. Despite resentment from several London papers, Aldridge accepted the role, which he played to public, though not critical, acclaim.

Ira Aldridge as Othello. (Photographs and Prints Division, Schomburg Center for Research in Black Culture, The New York Public Library, Astor, Lenox and Tilden Foundations)

After further provincial traveling, Aldridge at forty-five began touring in Europe, concentrating on performing Shakespeare. To his repertory of *Othello, Macbeth,* and *The Merchant of Venice* he had added *King Lear, Hamlet, Richard III,* and Aaron the Moor in an edited version of *Titus Andronicus.* He played in bilingual productions, speaking English himself while the rest of the cast spoke their native language. These tours were largely successful and brought him considerable fame; many honors were conferred on him by ruling houses. "If he were Hamlet as he is Othello, then the Negro Ira Aldridge would [be] the greatest of all actors," wrote a German critic. The Moscow correspondent for the French publication *Le Nord* praised Aldridge's "simple, natural and dignified declamation . . . a hero of tragedy speaking and walking like a common mortal."

Aldridge was invited to perform *Othello* in 1858 at the Lyceum Theater in London, and in 1865 at the Haymarket, winning a favorable press on both occasions. He was thinking of returning to the United States when he died in 1867 of lung trouble while on tour; he was buried in Lodz, Poland.

Aldridge was twice married and raised four children, three of whom were professional musicians. In addition, his daughter Amanda taught voice production and diction.

REFERENCE

MARSHALL, HERBERT, and MILDRED STOCK. *Ira Aldridge: The Negro Tragedian.* 1958. Reprints. Carbondale, Ill., 1968; Washington, D.C. 1993.

ERROL G. HILL

Alexander, Clifford L., Jr. (September 3, 1933–), lawyer. Clifford Alexander, Jr., was born in New York City. His parents, Clifford L., Sr., and Edith Alexander, strongly influenced his decision to pursue a political career. Alexander graduated from Harvard University in 1955, where he was the first black president of the student council. In 1958, he received a degree from Yale Law School, and then worked as an assistant district attorney for New York County for two years. In 1961, he became the executive director of the Manhattanville–Hamilton Grange Neighborhood Conservation Project, where he worked to get landlords to meet housing code standards. He then became the Program and Executive Director of Harlem Youth Opportunities Unlimited (HARYOU) Inc. (1962–1963), an antipoverty program that attempted to improve the public schools and delinquency problems in Harlem.

Clifford Alexander, Jr. (Photographs and Prints Division, Schomburg Center for Research in Black Culture, The New York Public Library, Astor, Lenox and Tilden Foundations)

In 1963 President John F. Kennedy asked Alexander to serve as foreign affairs officer of the National Security Council. From 1964 to 1967, President Lyndon B. Johnson appointed him deputy special assistant to the president, associate special counsel, and deputy special counsel to the president. Johnson sought his advice on civil rights issues, and in 1967, he made Alexander chairman of the Equal Employment Opportunities Commission (EEOC), an agency that focused on uncovering evidence of discrimination. Alexander left the EEOC when the Nixon administration took office in 1969 and accepted a partnership in the law firm of Arnold and Porter in Washington, D.C., where he remained until 1975, when he briefly joined the firm of Verner, Lipfert, Bernhard, McPherson & Alexander.

From 1971 to 1974, he was host and coproducer of the television show *Cliff Alexander: Black on White;* in addition, he held part-time teaching positions at Georgetown Law School and at Howard University. In 1974, he ran for mayor of Washington, D.C., but he lost to Walter Washington. In 1977, President Jimmy Carter named him Secretary of the Army, a position he held until January 1981. Later that same year, Alexander established Alexander & Associates, a corporate consulting firm in Washington, D.C., which provides advice on workforce inclusiveness for corporate directors and executives. Alexander has received numerous honors and awards, including the Department of the Army's Outstanding Civilian Service Medal and the Department of Defense Distinguished Public Service award, the highest such award given to a civilian.

REFERENCES

ELLIOT, JEFFREY M. *Black Voices in American Politics.* New York, 1986.

MORTIZ, CHARLES, ed. *Current Biography.* New York, 1977.

LINDA SALZMAN

Alexander, John M. *See* Ace, Johnny.

Alexander, Raymond Pace (October 13, 1898–November 23, 1974), lawyer, politician, and judge. Born to parents of humble means, Raymond Pace Alexander worked his way through high school as a paper boy and college as a Pullman porter. He graduated from Philadephia's Central High School in 1917, where he became the first African American to deliver the commencement address. He received his B.A. from the University of Pennsylvania in 1920 and his law degree from Harvard Law School in 1923. That same year he returned to Philadelphia, established a private law practice, and married Sadie Tanner Mossell, who held a Ph.D. in economics and later graduated from the University of Pennsylvania Law School.

Alexander quickly earned a reputation as a talented and accomplished trial lawyer and worked to overcome racism by working through the legal system. Although he is credited with ending discrimination in many Philadelphia hotels and restaurants, two of his most famous successful early desegregation litigations were the Berwyn Schools (1923) and the Aldine Theater (1925) cases; the latter ended discrimination in Philadelphia movie theaters.

In 1935 his law practice had become so profitable that he was able to buy land and construct a building to house his law firm in the heart of the almost exclusively white Center City of Philadelphia. Alexander served two years as president of the largely African-American National Bar Association (1933–1935) and was a cofounder of the National Bar Journal (1925). He gained national recognition in 1951 when he replaced Thurgood MARSHALL as one of the NAACP counsels in the Trenton Six Trial, defending two of the six black men wrongly accused of murdering a white shopowner and his wife in Trenton, N.J. Alexander also prosecuted the Girard College desegregation case on behalf of the city of Philadelphia from 1953 to 1958. (Although the desegregation ruling Alexander obtained was confirmed by the U.S. Supreme Court, it was rendered moot by a technical decision of the Philadelphia Orphans Court.)

Alexander also had a career in politics. In the 1930s he made many attempts to secure a local judgeship but was thwarted by the racism of the local political parties. During the 1940s he sought various types of

appointments at the federal level, but the appointment of William H. HASTIE to the U.S. Circuit Court of Appeals effectively closed the doors to a similar appointment for Alexander. He had been named honorary consul to the republic of Haiti in 1938, and in 1951 was nominated by President Truman (but not confirmed) for the ambassadorship to Ethiopia. Alexander made a successful foray into elective politics in 1951 when he was elected to the city council as a member of the Democratic reform platform, a position to which he was reelected in 1955.

In 1958, he was appointed by Pennsylvania Gov. George Leader to the Common Pleas Court of Philadelphia, becoming the first African American to hold a position on that court. He entered semiretirement as a president judge of the Common Pleas Court in 1970 and died of a heart attack working late in his office in 1974.

REFERENCE

The Alexander Papers Collection, University of Pennsylvania Archives. Philadelphia.

PAUL DAVID LUONGO

Alexander, Sadie Tanner Mossell (January 2, 1898–November 1, 1989), lawyer and activist. Sadie T. M. Alexander was a pioneer among African-American women in law and education and a committed civil rights activist. She was born Sadie Tanner Mossell in Philadelphia, to an accomplished family: Bishop Benjamin Tucker Tanner, among the most prominent of nineteenth-century black clergymen, was her grandfather, and the painter Henry Ossawa Tanner was her uncle. Educated in Philadelphia and in Washington, D.C., she graduated from the M Street High School (now Dunbar High School) in Washington. She entered the University of Pennsylvania's School of Education in 1915, receiving a B.S. in education with honors in 1918. (That year, she helped found the Gamma Chapter of the Delta Theta Sorority.) She earned an M.A. (1919) and a Ph.D. in economics (1921) from the University of Pennsylvania, and was one of the first two African-American women to earn a Ph.D. in the United States and the first African American to receive a doctorate in economics.

From 1921 to 1923, Alexander was an assistant actuary for the North Carolina Mutual Life Insurance Company, a black-owned company in Durham, N.C. On November 29, 1923, she married Raymond Pace Alexander, a graduate of Harvard Law School, who thereafter worked with his wife in numerous

A life of pathbreaking achievement reached its culmination when Sadie Tanner Mossell Alexander served on the presidential commission that produced *To Secure These Rights* (1948). The strongest federal condemnation of segregation issued up to that time, the report called for an immediate end to all forms of segregation and contributed directly to the integration of the armed forces the following year. (Photographs and Prints Division, Schomburg Center for Research in Black Culture, The New York Public Library, Astor, Lenox and Tilden Foundations)

Philadelphia-area civil rights cases. Sadie Alexander continued to be a trailblazer for African-American women in the fields of law and education: she entered the University of Pennsylvania Law School in 1924 (where her father, Aaron Albert Mossell, had graduated in 1888, becoming the first African American to graduate from the law school), worked on the Law Review, and was admitted to the Pennsylvania bar after graduating in 1927. During the late 1920s and 1930s she served as the assistant city solicitor of Philadelphia and as a partner in her husband's law firm. In November 1943, Alexander became the first woman to be elected secretary (or to hold any office) in the National Bar Association, a position which she held until 1947.

In addition to her personal achievements and triumphs in overcoming racial barriers, for over a half a century Sadie Alexander was at the forefront of the

movement for civil rights for African Americans. In the 1920s and 1930s she and her husband successfully challenged discrimination in public accommodations in Pennsylvania. She also worked to integrate the University of Pennsylvania and the U.S. Armed Forces. On December 5, 1946, President Harry S. Truman appointed her to the President's Commission on Civil Rights. She helped prepare its report "To Secure These Rights" (1948), which was influential in the formulation of civil rights policy in the years that followed.

Alexander worked with her husband until 1959, when he was appointed judge in the Philadelphia Court of Common Pleas and she began her own law practice. In 1976, she joined the law firm of Atkinson, Myers, Archie & Wallace as counsel, advising the firm on a part-time basis in estate and family law. Alzheimer's disease forced her retirement in 1982. She died in Philadelphia seven years later.

REFERENCES

DAMMETT, SYLVIA G. L. *Profiles of Negro Womanhood, Vol. III: 20th Century*. New York, 1966.

MALVEAUX, JULIANNE. "Missed Opportunity: Sadie Tanner Mossell Alexander and the Economic Profession." *American Economic Review* 81, no. 2 (March 1991): 307–310.

SIRAJ AHMED
PAM NADASEN

Ali, Muhammad (January 17, 1942–), boxer. Muhammad Ali was born Cassius Marcellus Clay, Jr. in Louisville, Ky. He began BOXING at the age of twelve under the tutelage of Joe Martin, a Louisville policeman. Having little interest in school and little affinity for intellectual endeavors, young Clay devoted himself wholeheartedly to boxing. He showed great promise early on and soon developed into one of the most impressive amateurs in the country. He became the National Amateur Athletic Union (AAU) champion in 1959 and in 1960, and also won a gold medal in the light-heavyweight division at the 1960 Olympics in Rome. As a result of his boyish good looks and his outgoing personality—his poetry recitations, his good-natured bragging, and his undeniable abilities—Clay because famous after the Olympics. Shortly after returning from Rome, he turned professional and was managed by a consortium of white Louisville businessmen. Carefully nurtured by veteran trainer Angelo Dundee, he accumulated a string of victories against relatively mediocre opponents and achieved a national following

with his constant patter, his poetry, and his boyish antics. At 6'3" and a fighting weight of around 200 pounds, he astonished sportswriters with his blazing hand and foot speed, his unorthodox style of keeping his hands low, and his ability to avoid punches by moving his head back. No heavyweight in history possessed Clay's grace or speed.

On February 25, 1964, Clay fought as the underdog for the heavyweight title against Sonny LISTON. Liston, an ex-convict, was thought by many to be virtually invincible because of his devastating one-round victories against former champion Floyd PATTERSON. An air of both the theater of the absurd and of ominousness surrounded the bout in Miami. Publicly, Clay taunted and comically berated Liston. He called him "the Bear," harassed him at his home, and almost turned the weigh-in ceremony into a shambles as he seemingly tried to attack Liston and appeared on the verge of being utterly out of control. Privately, however, Clay was seen with MALCOLM X and members of the NATION OF ISLAM (NOI). Rumors started that he had joined the militant, mysterious sect. Soon after, it was discovered that he had been secretly visiting NOI mosques for nearly three

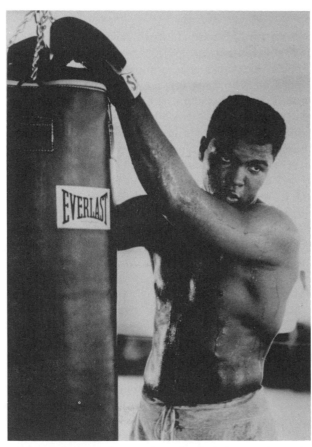

Muhammad Ali (b. Cassius Clay), Miami, Fla., July 1966. (© James Pineda/Black Star)

years and that he had indeed become a friend of Malcolm X, who sat ringside at the Liston fight.

Clay beat Liston fairly easily in seven rounds, shocking the world by becoming heavyweight champion. Immediately after the fight, he announced that he was a member of the NOI and that his name was no longer Cassius Clay but Muhammad Ali. The response from the white press, white America, and the boxing establishment generally was swift and intensely hostile. The NOI was seen, largely through the rhetoric of Malcolm X, its most stylish spokesman, as an antiwhite hate group. (When Malcolm X broke with the NOI, shortly after the Liston fight, Ali remained loyal to Elijah MUHAMMAD and ended his friendship with Malcolm X.) Following his public conversion to Islam, Ali was publicly pilloried. Most publications and sports journalists refused to call him by his new name. Former champion Floyd Patterson nearly went on a personal and national crusade against the NOI in his fight against Ali on November 22, 1965, but Patterson later became one of the few fighters to defend Ali publicly during his years of exile. Indeed, not since the reign of Jack JOHNSON was the white public and a segment of the black population so enraged by the opinions and life of a black athlete.

After winning his rematch with Liston in Lewiston, Me., on May 25, 1965, in a bizarre fight that ended with Liston apparently being knocked out in the first round, Ali spent most of the next year fighting abroad, primarily because of his unpopularity in this country. Among his most important matches during this period were a fifteen-round decision over George Chuvalo in Toronto, a sixth-round knockout of Henry Cooper in London, and a fifteen-round decision over Ernest Terrell in Houston. While Ali was abroad American officials changed his draft status from 1-Y (unfit for Army services because of his low score on Army intelligence tests) to 1-A (qualified for induction). Many saw this change as a direct response to the negative public opinion concerning Ali's political views and the mounting war in Vietnam. Ali refused to serve in the Army on the grounds that it was a violation of his religious beliefs. (Elijah Muhammad, leader of the NOI, had served time in prison during World War II for refusing to serve in the armed services.) In 1967, Ali was convicted in federal court of violation of the Selective Service Act, sentenced to five years in prison, and immediately stripped of both his boxing title and his boxing license. For the next three and one-half years, Ali, free on bond while appealing his case (which he eventually won on appeal to the U.S. Supreme Court), was prohibited from boxing. Still, Ali had inspired black athletes to become more militant and more politically committed. Medal-

winning track stars John Carlos and Tommie Smith gave a clenched-fist salute during the playing of the National Anthem at the Olympic Games in Mexico City in 1968, and Harry Edwards became one of the more outspoken leaders of a new cadre of young black athletes who saw Ali as a hero.

By 1970, with public opinion decidedly against the Vietnam War, and a growing black influence in several southern state governments, Ali was given a license to fight in Georgia. He returned to the ring on October 26 to knock out Jerry Quarry in the third round. Although he was still a brilliant fighter, the nearly four year lay-off had diminished some of Ali's abilities. He took far more punishment in the ring during the years of his return than he had taken before. This was to have dire consequences for him as he grew older.

In the early 1970s Ali fought several of his most memorable matches. On March 8, 1971, he faced the undefeated Philadelphian Joe FRAZIER in New York City. Frazier had become champion during Ali's exile. The fifteen-round fight, which Frazier won in a close decision, was so fierce that both boxers were hospitalized after it. Many have speculated that this fight initiated Ali's neurological deterioration. In July of that year Ali won the North American Boxing Federation (NABF) heavyweight title by knocking out Jimmy Ellis in twelve rounds. His next major boxing challenge came in March 1973, when Ken NORTON captured the NABF title from Ali in a twelve-round decision. Ali regained the title six months later with a twelve-round decision over Norton. In January of the following year, Ali and Frazier staged their first rematch. This nontitle bout at Madison Square Garden ended with Ali victorious after twelve hard-fought rounds. Ali finally regained the World Heavyweight title in Kinshasa, Zaire, on October 30, 1974, when he knocked out a seemingly indestructible George FOREMAN in eight rounds. To counter Foreman's awesome punching power, Ali used what he called his "rope-a-dope" strategy, by which he leaned back against the ropes and covered his head, allowing Foreman to punch himself out. The next year, Ali and Frazier faced off one last time in what Ali dubbed "The Thrilla in Manila." Both boxers received tremendous punishment during this bludgeoning ordeal. Ali prevailed, however, when Frazier's trainer refused to let the boxer come out for the fifteenth round.

During the 1970s Ali was lionized. No longer seen as a race demon, he virtually became a national icon. He appeared in movies—including the film *The Greatest* (1977), based on his autobiography of the same name (1975). Like Jackie ROBINSON and JOE LOUIS before him, Ali played himself in the film—he also appeared in television programs and in commer-

cials. He was one of the most photographed and interviewed men in the world. Indeed, Ali even beat Superman in the ring in a special issue of the comic devoted to him. Part of Ali's newfound popularity was a result of a shift in attitude by the white public and white sportswriters, but part of it was also a reflection of Ali's tempered approach to politics. Ali became a great deal less doctrinaire in the political aspects of his Islamic beliefs and he eventually embraced Wallace D. Muhammad's more ecumenical form of Islam when the NOI factionalized after the death of Elijah Muhammad in 1975. Finally, as befitting a major celebrity, Ali had one of the largest entourages of any sports personality in history, resembling that of a head of state.

On February 15, 1978, Ali again lost the title. His opponent this time was Leon SPINKS, an ex-Marine and native of a north St. Louis housing project. Spinks fought in only eight professional bouts before he met Ali. Ali, however, became the first heavyweight in history to regain the title for a third time when he defeated Spinks on September 15 of the same year.

In 1979, Ali was aged and weary; his legs were shot, his reflexes had slowed, and his appetite for competition was waning as a result of the good life that he was enjoying. Ali retired from the ring at that time, only to do what so many other great champions have so unwisely done, namely, return to battle. His return to the ring included a savage ten-round beating on October 2, 1980, at the hands of Larry HOLMES, a former sparring partner who had become champion after Ali's retirement. His next fight was a ten-round decision lost to Trevor Berbick on December 11 of the following year. After the Berbick fight, Ali retired for good. His professional record stands at: 56 wins, 37 of which were by knockout, and 5 losses. He was elected to the Boxing Hall of Fame in 1987.

During Ali's later years, his speech became noticeably more slurred, and after his retirement he became more aged: moving slowly, speaking with such a thick tongue that he was almost incomprehensible, and suffering from attacks of palsy. There is some question as to whether he has Parkinson's disease or a Parkinson's-like deterioration of the neurological system. Many believe that the deterioration of his neurological system is directly connected to the punishment he took in the ring. By the early 1990s, although his mind was still sound, Ali gave the appearance of being a good deal older and more infirm than he actually was. He found it difficult to write or talk, and often walked slowly. Despite this, he is living a full life, travels constantly, and seems to be at peace with himself.

His personal life has been turbulent. He has been married four times and has had several children as well as numerous affairs, especially during his heyday as a fighter. His oldest daughter, Maryum, is a RAP artist, following in her father's footsteps as a poet—Ali made a poetry recording for Columbia Records in 1963 called *The Greatest*—Maryum has recorded a popular rap dedicated to her father.

It would be difficult to overestimate Ali's impact on boxing and on the United States as both a cultural and political figure. He became one of the most recognized men in the world, an enduring, if not always appropriate, stylistic influence on young boxers, and a man who showed the world that it was possible for a black to speak his mind publicly and live to tell the tale.

REFERENCES

GILMORE, AL-TONY. *Bad Nigger! The National Impact of Jack Johnson*. Port Washington, N.Y., 1975.

HAUSER, THOMAS. *Muhammad Ali: His Life and Time*. New York, 1991.

MAILER, NORMAN. *The Fight*. New York, 1975.

MCCALLUM, JOHN D. *The World Heavyweight Boxing Championship: A History*. Radnor, Pa., 1974.

OLSEN, JACK. *Black Is Best: The Riddle of Cassius Clay*. New York, 1967.

PLIMPTON, GEORGE. *Shadow Box*. New York, 1977.

ROBERTS, RANDY. *Papa Jack: Jack Johnson and the Era of White Hopes*. New York, 1983.

SAMMONS, JEFFREY T. *Beyond the Ring: The Role of Boxing in American Society*. Urbana, Ill., 1988.

SHEEN, WILFRED. *Muhammad Ali*. New York, 1975.

TORRES, JOSE. *Sting Like a Bee: The Muhammad Ali Story*. New York, 1971.

GERALD EARLY

Ali, Noble Drew. See Noble Drew Ali.

Allain, Théophile T. (October 1, 1846–February 2, 1917), politician. The son of a Louisiana planter of West Baton Rouge and his slave mistress, Théophile Allain was taken by his white father on trips to the North and to Europe before he completed his education in New Orleans and New Jersey. A grocer-businessman, he owned a large sugar cane plantation in Iberville, but reportedly ran into debt and lost it. His political career began in 1872 and lasted some twenty years. A member of the Louisiana House of Representatives in 1874, he supported the Funding Act. A member of the state senate (1876–1880), he

served again as a state representative until 1890. In April 1882, he made a speech to the U.S. House Committee on Commerce as a spokesperson sent to urge the federal government to improve the levees along the Mississippi River.

A forceful and effective speaker, Allain was broadly educated. He spoke French and was knowledgeable in diverse areas. Persuaded of the importance of education for African-American advancement, he sent his Catholic children to nondenominational schools. As a member of the Louisiana Constitutional Convention of 1879, he introduced legislation for the establishment of schools for blacks and was responsible for the state's appropriation of funds to establish Southern University. He later proposed a resolution founding an industrial school for blacks in the style of Tuskegee Institute (*see* TUSKEGEE UNIVERSITY). Allain moved to Chicago toward the end of his life.

REFERENCE

SIMMONS, WILLIAM J. *Men of Mark.* Cleveland, 1887.

MICHEL FABRE

Allen, Debbie (January 16, 1950–), dancer and television producer. Debbie Allen was born in Houston, Tex., where her father, Andrew Allen, was a dentist and her mother, Vivian Ayers Allen, was a Pulitzer Prize-nominated writer. Her sister, Phylicia Rashad, became well known for her role as Claire Huxtable on the television series *The Cosby Show.*

As a child, Allen tried to take ballet classes at the Houston Foundation for Ballet, but she was rejected for reasons her mother thought were discriminatory. Allen began learning dance by studying privately with a former dancer from the Ballet Russes and later by moving with her family to Mexico City where she danced with the Ballet Nacional de Mexico. Allen reauditioned for the Houston Foundation for Ballet in 1964, and this time was admitted on a full scholarship and became the company's first black dancer.

After high school, Allen hoped to attend North Carolina School of Arts, but when she was rejected she decided to pursue a B.A. at Howard University (1971) with a concentration in classical Greek literature, speech, and theater. During her college years, she continued to dance with students at the university and with choreographer Michael Malone's dance troupe. After graduating in 1971, Allen relocated to New York City where she would develop her talents as a dancer, actress, and singer in her appearances on Broadway, and eventually in television shows and movies.

Allen's Broadway experience began in 1971 when she became a member of the chorus in *Purlie,* the musical version of Ossie Davis's *Purlie Victorious.* The following year, when chorus member George Faison left the show to form the Universal Dance Experience, Allen became his principal dancer and assistant. By 1973 Allen returned to Broadway and for two years she played the role of Beneatha Younger in *Raisin,* a musical adaptation of Lorraine Hansberry's *A Raisin in the Sun.*

Allen began receiving critical attention in 1980, when she appeared in the role of Anita in the Broadway revival of *West Side Story,* which earned her a Tony Award nomination and a Drama Desk Award. The next year she made her movie debut in the film version of E.L. Doctorow's novel *Ragtime,* and then appeared in the hit movie *Fame,* with a small part as the dance teacher Lydia Grant. When the movie was turned into a television series of the same name, Allen returned as Lydia Grant and developed the role which brought her recognition by international audiences. She remained on the show until it went off the air in 1987, serving as a choreographer, and eventually as a director and producer.

During the 1980s Allen also acted in the television movie *Women of San Quentin* (1983), appeared in Richard Pryor's movie *Jo Jo Dancer, Your Life Is Calling* (1985), and played Charity in the Broadway revival of *Sweet Charity* (1986). In 1988 she became director of *A Different World,* and helped turn it into a Top Twenty television hit. The next year Allen hosted her first television special on ABC, *The Debbie Allen Show,* and later that year she directed the television musical *Polly,* which was followed in 1990 by *Polly: One More Time.* During the 1990–1991 season Allen directed episodes of NBC's *Fresh Prince of Bel Air* and *Quantum Leap.* Allen was a choreographer for the Academy Awards show from 1991 to 1994, and in 1992 she produced and directed the television movie *Stompin' at the Savoy.*

REFERENCES

BURDEN, MARTIN. "'Fame' Comes to Debbie Allen." *New York Post,* August 18, 1982.
"Debbie Allen: On Power, Pain, Passion, and Prime Time." *Ebony* (March 1991): 24–32.
DUNNING, JENNIFER. "Debbie Allen Chips Away At the Glass Ceiling." *New York Times,* March 29, 1992.
GALLO, HANK. "Performing Powerhouse: Debbie Allen May Be Small But Then So Is Dynamite." *Daily News,* March 2, 1989.
HINE, DARLENE CLARK, ed. *Black Women in America: An Historical Encyclopedia.* New York, 1993, pp. 20–21.

ZITA ALLEN

Allen, Macon Bolling (1816–October 15, 1894), lawyer. A. Macon Bolling was born in Indiana. Little is known about Bolling's early life, but by the 1840s he had established himself as a businessman in Portland, Me. In January 1844, Bolling had his name changed to Macon Bolling Allen by an act of the legislature in Massachusetts, where he presumably was also a resident. With the assistance of white abolitionists, Allen first tried to gain admittance to the Maine bar in 1844, but was rejected on the grounds that he was not a United States citizen. However, the following year, he passed the requisite exam and was admitted to the bar, becoming the first licensed African-American attorney in the United States (see also LAWYERS).

Discouraged by the small black population in Maine, Allen chose to practice law in Boston. He was admitted to the Suffolk County bar on May 3, 1845, the first African American to become a member of the bar in Massachusetts. Although Allen opposed slavery, he clashed with New England abolitionists in 1846 when he refused to sign a pledge not to support the government in its war effort in Mexico. In 1847 Allen was appointed justice of the peace by Massachusetts Gov. George N. Briggs. He was the first African American after Wentworth CHESWILL of New Hampshire to hold a judicial post. Allen's appointment was renewed in 1854, and he continued to practice law in Massachusetts until the advent of RECONSTRUCTION. In the late 1860s, Allen moved to Charleston, S.C., to practice law and enter politics.

In 1868, Allen joined William J. WHIPPER and Robert Brown ELLIOT in establishing Whipper, Elliot and Allen, the country's first black law firm. Like his colleagues, who were both members of the South Carolina legislature (Elliot also served in the U.S. Congress), Allen also sought political office. His race for secretary of state for South Carolina in 1872, however, was unsuccessful.

In February 1873, Allen was elected to fill out the term of the deceased George Lee, an African American elected to the judgeship of the Inferior Court of South Carolina in 1872. Allen subsequently was elected to the probate court, on which he served from 1876 to 1878. At the end of his term, Allen returned to his law practice in Charleston, although little is known about his career after the late 1870s. Allen died in Washington, D.C.

REFERENCES

BROWN, CHARLES SUMNER. "The Genesis of the Negro Lawyer in New England." *The Negro History Bulletin* (April 1959): 147–152.

SMITH, J. CLAY, JR. *Emancipation: The Making of the Black Lawyer, 1844–1944.* Philadelphia, 1993.

LOUISE P. MAXWELL

Allen, Richard (February 14, 1760–March 26, 1831), minister and community leader. As a reformer and institution builder in the post-Revolutionary period, Richard Allen was matched in achievements by few of his white contemporaries. At age twenty, only a few months after buying his freedom in Kent County, Del., Allen was preaching to mostly white audiences and converting many of his hearers to Methodism (*see* METHODISTS). At twenty-seven, he was a cofounder of the FREE AFRICAN SOCIETY OF PHILADELPHIA, probably the first autonomous organization of free blacks in the United States. Before he was thirty-five, he had become the minister of what would be PHILADELPHIA's largest black congregation—Bethel African Methodist Episcopal Church. Over a long lifetime, he founded, presided over, or served as officer in a large number of other organizations designed to improve the condition of life and expand the sphere of liberty for African Americans. Although he received no formal education, he became an accomplished writer, penning and publishing sermons, tracts, addresses, and remonstrances; compiling a hymnal for black Methodists; and drafting articles of organization and governance for various organizations.

Enslaved at birth in the family of the prominent Philadelphia lawyer and officeholder Benjamin Chew, Allen was sold with his family to Stokely Sturgis, a small farmer near Dover, Del., in about 1768. It was here, in 1777, that Allen experienced a religious conversion, shortly after most of his family had been sold away from Dover, at the hands of the itinerant Methodist Freeborn Garretson. Three years later he and his brother contracted with their master to purchase their freedom.

For a short time, Allen drove a wagon carrying salt for the Revolutionary army. He also supported himself as a woodchopper, brickyard laborer, and shoemaker as he carried out a six-year religious sojourn as an itinerant Methodist preacher. In something akin to a biblical journey into the wilderness, Allen tested his mettle and proved his faith, traveling by foot over thousands of miles, from North Carolina to New York, and preaching the word to black and white audiences in dozens of villages, crossroads, and forest clearings. During this period of his life, it seems, Allen developed the essential attributes that would serve him the rest of his career: resilience, toughness, cosmopolitanism, an ability to confront rapidly changing circumstances, and skill in dealing with a wide variety of people and temperaments.

Allen's itinerant preaching brought him to the attention of white Methodist leaders, who in 1786 called him to Philadelphia to preach to black members of the Methodist flock that worshiped at Saint George's Methodist Church, a rude, dirt-floored

The Rev. Richard Allen, founder and first bishop of the African Methodist Episcopal church. (Photographs and Prints Division, Schomburg Center for Research in Black Culture, The New York Public Library, Astor, Lenox and Tilden Foundations)

building in the German part of the city. Allen would spend the rest of his life there.

In Philadelphia, Allen's career was marked by his founding of Mother Bethel, the black Methodist church that opened its doors in 1794, and by the subsequent creation, in 1816, of the independent AFRICAN METHODIST EPISCOPAL CHURCH (AME Church). Soon after his arrival in 1786, he began pressing for an independent black church. His fervent Methodism brought him into contention with other emerging black leaders who wished for a nondenominational or "union" church, and thus within a few years two black churches took form. Both were guided by the idea that African Americans needed "to worship God under our own vine and fig tree," as Allen put it in his autobiographical memoir. This was, in essence, a desire to stand apart from white society, avoiding both the paternalistic benevolence of its racially liberal members and the animosity of its racially intolerant members. Allen's Bethel church, after opening its doors in a converted blacksmith's shop in 1794, grew into a congregation of more than five hundred members by 1800.

Bethel's rise to the status of Philadelphia's largest black church was accomplished amid a twenty-year

struggle with white Methodist leaders. White Methodists were determined to make the popular Allen knuckle under to their authority, and this ran directly counter to Allen's determination to lead a church in which black Methodists, while subscribing to the general doctrines of Methodism, were free to pursue their churchly affairs autonomously. The struggle even involved the ownership of the church building itself. The attempts of white Methodists to rein in Allen and his black parishioners reached a climax in 1815 that was resolved when the Pennsylvania Supreme Court ruled on January 1, 1816, that Bethel was legally an independent church. Just a few months later, African-American ministers from across the mid-Atlantic region gathered in Philadelphia to confederate their congregations into the African Methodist Episcopal Church, which was to spread across the United States and abroad in the nineteenth and twentieth centuries.

Allen's epic twenty-year battle with white Methodist authorities represents a vital phase of the African-American struggle in the North to get out from under the controlling hand of white religionists. The AME Church, with Allen as its first bishop, quickly became the most important of the autonomous institutions created by black Americans that allowed former slaves to forge an Afro-Christianity that spoke in the language and answered the needs of a growing number of northern—and, later, southern—blacks. For decades, the AME helped to heal the disabling scars of slavery and facilitated the adjustment of black southern migrants to life as citizens in the North. Allen's success at Bethel had much to do with the warmth, simplicity, and evangelical fervor of Methodism, which resonated with a special vibrancy among the manumitted and fugitive southern slaves reaching Philadelphia in the early nineteenth century.

Between the founding of Bethel in 1794 and the organization of the AME Church, Allen founded schools for black youths and mutual aid societies that would allow black Philadelphians to quash the idea that they were dependent upon white charity. A successful businessman and a considerable property owner, Allen also wrote pamphlets and sermons attacking the slave trade, slavery, and white racism. The most notable of them, coauthored with Absalom Jones in 1794, was *A Narrative of the Proceedings of the Black People, During the Late Awful Calamity in Philadelphia, in the year 1793*. In this pamphlet, Allen and Jones defended the work of black citizens who aided the sick and dying during the horrendous yellow fever epidemic of 1793, but they went on to condemn the oppression of African Americans, both enslaved and free. In the first quarter of the nineteenth century, almost every African-American institution

formed in Philadelphia included Allen's name and benefited from his energy and vision.

In the later years of his life, Allen was drawn to the idea of colonization—to Africa, Haiti, and Canada —as an answer to the needs of African Americans who as freedpersons faced discrimination and exploitation. His son, John Allen, was one of the leaders of the Haitian immigrants in 1824. The capstone of Allen's career came six years later, when he presided over the first meeting of the NATIONAL NEGRO CONVENTION MOVEMENT—an umbrella organization that launched a coordinated reform movement among black Americans and provided an institutional structure for black abolitionism. When death came to Allen shortly thereafter, his funeral was attended by a vast concourse of black and white Philadelphians.

REFERENCES

GEORGE, CAROL V. R. *Segregated Sabbaths: Richard Allen and the Rise of Independent Black Churches.* New York, 1972.

WESLEY, CHARLES H. *Richard Allen, Apostle of Freedom.* Washington, D.C., 1935.

GARY B. NASH

Allen, William G. (1820–?), abolitionist and educator. William G. Allen was born free in Virginia to a mulatto mother and a Welsh father. He received his early education at a black school in Norfolk, and first became involved in antislavery activity while attending the Oneida Institute in Whitesboro, N.Y., in the early 1840s. He settled in Troy, N.Y., participated in Liberty party politics, and served as a delegate at the 1847 National Convention of Colored People.

Allen resettled in Boston in 1847. He clerked in Ellis Gray Loring's law office, and joined in local efforts to protect FUGITIVE SLAVES and end racial discrimination. He also lectured on African-American history and literature, and composed a pamphlet, *Wheatley, Banneker, and Horton,* as a compendium to his presentations. Allen's professional career culminated in December 1850 with an appointment to the faculty of New York Central College in McGrawville. While teaching at the interracial school, he courted a white student, Mary King. Threatened by mob violence, they went New York City for their marriage ceremony, and departed for England in the spring of 1853.

The Allens faced a precarious existence as exiles in London and Dublin, but, embittered by American racism, they refused to return home. Allen worked as tutor and lecturer, and supplemented his meager income by publishing two accounts of his personal

struggle against northern racism. His involvement in British antislavery activities brought him into contact with several altruistic abolitionists (*see* ABOLITION). One, Harper Twelvetrees, provided the resources for him to open the Caledonian Training School in Islington in 1863. The school closed five years later, and by 1878, the Allens had returned to London. His death date is unknown.

REFERENCES

BLACKETT, R. J. M. "William G. Allen: The Forgotten Professor." *Civil War History* 26 (1980): 39–52.

RIPLEY, C. PETER, et al., eds. *The Black Abolitionist Papers, Volume 1: The British Isles, 1830–1865.* Chapel Hill, N.C., 1985.

MICHAEL F. HEMBREE

Allensworth, Allen (April 7, 1842–September 14, 1914), minister, educator. Allen Allensworth was born in Louisville, Ky., to slave parents, Phyllis and Levi Allensworth. He escaped from slavery in 1862 during the Civil War and became a civilian nurse in the 44th Illinois Infantry's hospital corps, which served in the 1862 Nashville campaign. Allensworth joined the Navy later that year and served on gunboats on the Ohio River. By 1865, he became a chief petty officer.

In 1865, Allensworth returned to Louisville, where he converted to the Baptist faith in the Fifth Street Church. He was educated at the Ely Normal School in Louisville and at the Nashville Institute (now Roger Williams University). In 1868, Allensworth began teaching at the Freedmen's Bureau School in Christmasville, Ky., and was ordained a Baptist minister in 1871. He became pastor of the church at Elizabethtown and was appointed financial agent of the General Association of Colored Baptists in Kentucky. He was also a Sunday school worker in Franklin, Louisville, and Bowling Green, and was named superintendent of Sunday schools of the state Baptist convention. Around 1875 he was appointed a missionary by the American Baptists Publication Society in Philadelphia.

A political activist, Allensworth was a Republican elector from Kentucky in 1880 and a delegate to the Republican National Conventions of 1880 and 1884. In 1884, he served temporarily as minister of the Joy Street Baptist Church, Boston, and then assumed a position at the Baptist Church in Cincinnati, where he enjoyed great popularity. In 1886, President Grover Cleveland appointed him chaplain of the 24th Infantry. Allensworth served military posts in New Mexico, Arizona, Utah, and Montana, where he es-

tablished an education program for enlisted men that was imitated around the country. He served as senior chaplain of the 24th Infantry in the Philippines during the Spanish-American War from 1903 to 1906. In 1906 he was promoted to lieutenant-colonel, the highest rank held by an African American at the time.

In 1908 Allensworth moved to Los Angeles, where he organized a company to help blacks migrate to California. Over the next six years, the town of Allensworth in Tulare County grew as a mercantile center for farming and dairying, but the town declined with the depletion of the soil. Allensworth died in a motorcycle accident on September 14, 1914. The site of the former town was designated Allensworth State Historical Park.

REFERENCES

LOGAN, RAYFORD W., and MICHAEL R. WINSTON, eds. *Dictionary of American Negro Biography*. New York, 1982.
SIMMONS, WILLIAM J. *Men of Mark*. New York, 1968.

SABRINA FUCHS

Alpha Suffrage Club,

Alpha Suffrage Club, political organization. Ida B. WELLS-BARNETT, along with Belle Squire, a white colleague, founded the Alpha Suffrage Club (ASC) in Chicago in January 1913, to agitate for women's suffrage, raise political awareness among African-American women, and, after June, encourage black women in Chicago to use their newly won right to vote. The club offered an alternative to the attitudes of the National American Woman Suffrage Association, which put women's suffrage over African-American suffrage and supported restrictions on African-American voting rights. Wells-Barnett, the club's president, was an incessant campaigner for women's suffrage and had long protested segregation in the suffrage movement.

The ASC developed a system of door-to-door canvassing and held weekly seminars to educate black women about their rights and responsibilities as voters. At its height, the club had around two hundred members. Its finest hour was probably the part it played in the election of Chicago's first black alderman, Oscar DEPRIEST. In the Second Ward's 1914 primary, the club was responsible for high registration by women voters, convincing skeptical black male politicians that the resources of the ASC were indispensable. The club's headquarters served as a forum during the 1915 Republican primary, and their efforts paid off when DePriest, endorsed in the *Alpha Suffrage Record,* was elected alderman in February 1915. The efforts of the club gave black women an influential voice in the political arena and a measure of leverage over black and white Republican politicians. Accepted as an integral part of black politics in the city, the ASC continued to play an important role in Chicago for several decades.

REFERENCES

HINE, DARLENE CLARK, ed. *Black Women in America: An Historical Encyclopedia.* Brooklyn, N.Y., 1993.
STERLING, DOROTHY. *Black Foremothers: Three Lives.* Old Westbury, N.Y., 1979.

ALANA J. ERICKSON

Alston, Charles Henry (November 28, 1907–April 27, 1977), artist and teacher. Charles Alston was born in Charlotte, N.C., to Rev. Primus Priss Alston and Anna Miller Alston. His father died when he was three, and three years later his mother married Harry P. Bearden (Romare BEARDEN's uncle) and they moved to New York. Alston attended De Witt Clinton High School, where he was art editor for the annual magazine, and he graduated from Columbia University in 1929. In 1931 he received a master's degree from Columbia's Teachers College. Alston directed art programs at community centers (Jacob LAWRENCE was his student at Utopia House and the Harlem Art Workshop) and continued his studies. He directed the thirty-five artists who worked on the Harlem Hospital murals for the FEDERAL ARTS PROJECT in 1935–1936, painting two of the murals himself. In 1948 he collaborated with Hale WOODRUFF on murals for the Golden State Insurance Company in Los Angeles. Before this commission, Alston's illustrations appeared in the *New Yorker, Fortune,* and *Collier's,* and his drawings of blacks participating in the war effort had appeared in the black press, commissioned by the Office of War Information.

In 1950, Alston sold a painting to the Metropolitan Museum of Art and also became the first African-American instructor at the Art Students League. He later taught at the Museum of Modern Art and City College of New York and received many awards. The best known of his paintings (*Family,* at the Whitney Museum, and *Walking,* in a private collection) are figurative, sculptural in form, and notable for their brilliant color. Alston also painted abstractions and used soft textures in some of his work. In 1963 he was one of the founders of Spiral, a group of black artists formed to explore art and the civil rights struggle. In 1975 he was the first recipient of Columbia University's Distinguished Alumni Award. Alston and his wife, Myra A. Logan, a surgeon involved in

Charles Alston's *Mystery in Magic,* a mural painted for Harlem Hospital, N.Y., oil on canvas, 1937. (The Studio Museum in Harlem)

antibiotics research, died of cancer within months of each other in 1977.

REFERENCE

HENDERSON, HARRY, and GYLBERT GARVIN COKER. *Charles Alston: Artist and Teacher.* New York, 1990.

BETTY KAPLAN GUBERT

Ambassadors and Diplomats. Until quite recently, few African Americans have been given the opportunity to participate in foreign affairs. Although some (including Ebenezer Don Carlos Bassett, Milton J. Turner, John Mercer LANGSTON, Frederick DOUGLASS, Lester Walton, Raphael O'Hara Lanier, and Fred R. Moore) had served as ministers or envoys to black nations in Africa and the Caribbean, the first strictly nonpolitical appointments of African Americans to diplomatic service came only in 1906, when, after taking a perfunctory exam, James Garneth Carter, William Yerby, and James Weldon JOHNSON were named by president The-

odore Roosevelt to consular posts in Madagascar, Sierra Leone, and Venezuela, respectively.

Despite this step, African-American diplomats consistently found themselves appointed to consulates in small, tropical countries, posts unattractive to most white consular officers. In addition, black diplomats found that their support staffs were also black and that they were transferred mainly to posts held by other African Americans. Indeed, of the fifty-one different ambassadorial posts held by African Americans up to 1992, thirty-five were either in Africa or in nations with black-majority populations.

In 1924 the Rogers Act was passed, establishing the modern Foreign Service and instituting a standard recruitment examination. The first African American to pass the new exam was Clifton R. Wharton, Sr. His first post was as third secretary at Monrovia, Liberia. Wharton would twice more make history: In 1958 he was named minister to Romania, and in 1961 he became ambassador to Norway. In each case, he was the first African American to head a U.S. mission to a European nation.

In 1949 Edward Dudley became the first African American to attain the rank of ambassador when the

Ebenezer Bassett, the principal of the Institute for Colored Youth in Philadelphia after 1857, was named minister to Haiti in 1869, the first African American to head a diplomatic mission. (Photographs and Prints Division, Schomburg Center for Research in Black Culture, The New York Public Library, Astor, Lenox and Tilden Foundations)

U.S. ligation in Monrovia, where Dudley was minister, was raised to embassy rank.

Beginning in the 1960s, special efforts were made to appoint African Americans as ambassadors and senior diplomats and encourage their entry into the Foreign Service. Prior to that time, the U.S. Department of State had consistently discriminated against blacks; however, several factors contributed toward bringing about change. First, the racial ferment of the civil rights movement led a few farsighted policymakers to recognize that African Americans were concerned about U.S. foreign policy toward Africa. Second, with the proliferation of former colonial territories in Africa and Asia as new member states at the United Nations, officials realized that darker-skinned Americans would make valuable additions to the diplomatic corps. There was also pressure from groups like the American Society of African Culture (AMSAC) and the American Negro Leadership Conference on Africa (ANLC) to increase black membership in the diplomatic and consular corps. In 1961 only seventeen of approximately 3,700 Foreign Service officers were black. Political appointments of African Americans to ambassadorial and other high-level posts in the State Department increased, with eight African Americans appointed ambassador during the Kennedy and Johnson administrations.

Political appointees as well as Foreign Service officers selected as ambassadors require nomination by the president and confirmation by the Senate. Those who serve as chiefs of mission, as representatives to foreign nations, or as heads of delegations to international organizations hold the highest rank—ambassador extraordinary and plenipotentiary. Between 1948 and 1992, fifty-seven African Americans have served in this capacity. Included among diplomatic corps pioneers are Patricia Roberts HARRIS, the first black woman ambassador; Terence Todman, the first African American assigned to a class I post (Spain) and the first elevated to the rank of career ambassador; Andrew Young and his successor Donald F. McHenry, the first two African Americans to represent the United States at the United Nations; and Edward J. Perkins, the first African American appointed as ambassador to the Union of South Africa and the first African-American director general of the Foreign Service. (Perkins has since become the third African American to be U.S. ambassador to the United Nations.)

One of the most prominent African Americans to work in international diplomacy was Ralph Bunche, who in 1945 was appointed to the Division of Dependent Area Affairs in the State Department, making him the first African American in charge of a State Department desk. He later went on to a distinguished career in diplomacy at the United Nations.

From time to time, notable black Americans have been named to the staff of the U.S. delegation to the U.N. as diplomats without portfolios. The celebrated contralto Marian ANDERSON and singer-comedienne Pearl Bailey have served in this capacity.

The Association of African American Ambassadors, headquartered in Washington, D.C., provides information to African Americans interested in foreign service careers. The organization's first president was Franklin H. Williams, former ambassador to Ghana. In 1992 Horace G. Dawson, former ambassador to Botswana, began his term as president.

Richard T. Greener, diplomat to Russia. (Photographs and Prints Division, Schomburg Center for Research in Black Culture, The New York Public Library, Astor, Lenox and Tilden Foundations)

REFERENCES

FLEMING, G. JAMES. "The Black Role in American Politics: Part 2, The Past." In Mabel Smythe, ed. *The Black American Reference Book.* New York, 1976.

LOGAN, RAYFORD. *The Diplomatic Relations of the United States with Haiti, 1776–1891.* 1943. Reprint. New York, 1969.

"New Search for Diplomats." *Ebony* (October 1962): 65.

SMYTHE, HUGH M., and ELLIOT P. SKINNES. "Black Participation in U.S. Foreign Relations." In Mabel

Smythe, ed. *The Black American Reference Book.* New York, 1976.

ENID GORT
ERICA JUDGE

Amendments to U.S. Constitution. *See* Fifteenth Amendment; Fourteenth Amendment; Thirteenth Amendment.

Amenia Conference of 1916. In 1916, following the death of Booker T. WASHINGTON, leaders of the NATIONAL ASSOCIATION FOR THE ADVANCEMENT OF COLORED PEOPLE (NAACP) canceled the organization's annual meeting as a sign of respect, although Washington had regarded W. E. B. DU BOIS as a threat and had worked privately to undermine the NAACP during his lifetime. Anxious to reconcile Washington's accommodationist supporters (*see* ACCOMMODATIONISM) and the NAACP's activist constituency, and to unify the two sides behind a common program, NAACP leaders W. E. B. Du

Bois and Joel E. Spingarn called for an "independent" conference. They set the meeting for August 24–26, 1916, and chose Troutbeck, Spingarn's two-hundred-acre summer home outside Amenia, N.Y., as the conference location. They invited about two hundred African American and white activists. About fifty men and women, all African Americans, ranging in ideology from Du Bois to the conservative Emmett SCOTT, Washington's former lieutenant, eventually gathered for the conference.

On August 26, the Committee on Resolutions presented a report, written by Du Bois, which the conferees agreed upon. This "Unity Platform" concluded that all forms of education for blacks should be encouraged; that blacks could not advance without complete political freedom; that political freedom could not be achieved without cooperation among black leaders and organizations; that old factional alignments be forgotten; and that methods to achieve education and political freedom in the South must necessarily differ from those in the North. No plan to implement the Unity Platform was ever agreed on, however.

The bitterness and mistrust that divided the two main factions of the black movement did not disappear. Still, the conference was considered a success,

From August 24 to 26, 1916, Joel Spingarn's Amenia, N.Y., estate was the site of a major conference of African-American leaders. The conference enhanced the status of the NAACP as the preeminent civil rights organization. A second conference, held there in 1933, dealt primarily with the impact of the Great Depression on the civil rights movements. (Prints and Photographs Division, Library of Congress)

especially by Du Bois and the NAACP, whose basic program was approved by all factions. The conference marked the true beginning of the NAACP's pre-eminence in the black movement.

REFERENCES

BRODERICK, FRANCIS L., and AUGUST MEIER. *Black Protest Thought in the Twentieth Century.* 2nd ed. Indianapolis, Ind., 1971.

DU BOIS, WILLIAM EDWARD BURGHARDT. *The Amenia Conference: An Historic Negro Gathering.* Amenia N.Y., 1925.

MICHAEL PALLER

Amenia Conference of 1933.

The Amenia Conference of 1933 was promoted by Joel Spingarn, the president of the NATIONAL ASSOCIATION FOR THE ADVANCEMENT OF COLORED PEOPLE (NAACP) with the support of W. E. B. DU BOIS, then editor of the NAACP magazine, CRISIS. Their purpose was to revitalize the organization, whose agenda for social advancement had been severely disrupted by the Great Depression. The NAACP had lost members and had been under fire from Du Bois and the younger black intellectuals he sponsored, such as Abram HARRIS, Louis Redding, and Ira Reid, for ignoring the critical economic difficulties of black America. Du Bois was deeply dissatisfied with the NAACP and the idea of integration and was calling for a separate black economy.

In 1932 Spingarn proposed that the NAACP call an Amenia Conference on the model of its successful 1916 meeting (*see* AMENIA CONFERENCE OF 1916). He asserted that the organization needed ideas from younger "new colored intellectuals" outside the organization. Spingarn discouraged NAACP staff members from participating, and Du Bois recused himself from attendance. Also, though white, Spingarn recognized the need for black leadership of civil rights efforts, and he recommended there be no white participants, although white NAACP leaders and allies could be spectators. NAACP leaders were reluctant to alter the organization's historic program and to do the required organizing; only after Spingarn threatened to resign did they agree to call the conference.

On August 18, 1933, thirty-three people with a wide range of viewpoints assembled for the conference at Troutbeck, Spingarn's estate near Amenia, N.Y. Most were lawyers, professors, and other white-collar professionals. Included were several African Americans from Howard University who later achieved fame: Abram L. Harris, Ralph J. BUNCHE,

Rayford W. LOGAN, E. Franklin FRAZIER, and Charles H. HOUSTON.

The conference lasted three days, and discussions focused primarily on economic matters. The final resolutions were somewhat inconsistent. The conferees concluded that traditional civil rights leadership was inadequate since it did not address economic issues, such as low black purchasing power, as the primary problem. Many of the conferees attacked the capitalist system as fundamentally flawed and felt the early New Deal reforms were inadequate palliatives that did not treat blacks equally. Nonetheless, they agreed that a suitably "reformed democracy" was a more practicable remedy for the depression than either fascism or communism. The conferees agreed that much of the economic difficulties faced by African Americans were the result of their historical lack of solidarity with white unions. While they acknowledged there was little place for blacks in the existing labor movement, they called for black and white workers to join together into industrial unions of skilled and unskilled workers. It should be the NAACP's task, they claimed, to unite blacks and white unions and create a new labor alliance.

While they agreed on the importance of a unified black community and of overcoming "artificial class differences" to build a powerful voting bloc, their position on interracial action was contradictory. Conferees supported cultural nationalism and the fostering of racial pride and consciousness as an important goal, yet they underlined the importance of joint action with whites. They denounced black separatism, much to Du Bois's disappointment.

Many of the conference attendees, such as Ralph Bunche, later termed the meeting a failure, noting the lack of real leadership and vision in the proposals. Like the attendees of the first Amenia Conference in 1916, the leaders who met at the second produced no plan for carrying out the conference recommendations. Abram Harris chaired a committee to make specific suggestions, but while the Harris Committee's report, written in 1935, was endorsed by the NAACP, the organization did little to carry out its recommendations. Du Bois had finally broken with the NAACP in 1934. Many of the conferees became involved in labor organizing during the 1930s, and some joined communist or leftist groups. Despite its lack of influence on NAACP policy, the Amenia Conference of 1933 represented an important attempt by young black intellectuals of the depression era to cope with the enormous social and economic problems faced by African Americans.

REFERENCES

ROSS, B. JOYCE. *J. E. Spingarn and the Rise of the NAACP, 1911–1939.* New York, 1972.

RUDWICK, ELLIOTT. *W. E. B. Du Bois, Propagandist of the Negro Protest.* New York, 1969.

MICHAEL PALLER

American Anti-Slavery Society, the largest and most radical organization opposing SLAVERY and racial oppression in the nineteenth century. The AASS unified activists from diverse social, economic, and religious backgrounds around the idea that slavery was a sin and therefore must be immediately ended. Members viewed slavery as a national sin, not merely a southern one, implicating all Americans in an atrocious crime. The society published millions of copies of pamphlets, books, and newspapers—most important, the *Emancipator* (1833–1850) and the *National Anti-Slavery Standard* (1840–1872)—and sponsored scores of speakers, many of them former slaves such as Frederick DOUGLASS, in a heroic effort to expose the horrors of slavery and persuade northern whites to recognize the essential humanity of all African Americans.

Sixty-two abolitionists from eleven states met in Philadelphia on December 4, 1833, to organize the AASS. New Englanders, led by William Lloyd Garrison, Samuel Joseph May, and John Greenleaf Whittier, joined forces with Arthur and Lewis Tappan of New York; black Pennsylvanians under the leadership of James FORTEN, Robert PURVIS, James MC-CRUMMELL, and James G. BARBADOES; and other reformers from a variety of religious sects. The delegates condemned the colonization movement, designed to remove the nation's free black population to Liberia, and renounced all gradual antislavery schemes as fraudulent. The new society adopted Garrison's "Declaration of Sentiments," which rejected violence as an abolitionist tactic, condemned the Founding Fathers for perpetuating slavery, and repudiated the "peculiar institution" as "an audacious usurpation of the Divine prerogative, a base overthrow of the very foundations of the social compact . . . and a presumptuous transgression of all holy commandments." While not specifically calling for complete social equality, the declaration proclaimed that "all persons of color" ought to be granted the same "privileges" as whites.

Although the AASS spawned hundreds of auxiliary societies across the North, most Americans feared and loathed abolitionists as dangerous agitators. Some denounced the organization as an agent of racial amalgamation, eagerly breaking up abolitionist meetings and assaulting AASS speakers in the name of social order. The intense public hostility unified AASS members, but long-suppressed personal and ideological conflicts eventually broke down the group's solidarity. Individuals like Arthur and Lewis Tappan and Amos A. Phelps of Massachusetts objected to the broad social agenda of William Lloyd Garrison and his colleagues, who promoted nonresistance (a form of radical pacifism), advanced women's rights, and often espoused dissenting religious views. Conflicts among liberal and orthodox Christians, discord over strategy and tactics, and, most destructive of all, dissension over women's rights tore the AASS apart in 1840. Embittered controversy over the antislavery character of the U.S. Constitution and disunionism during the late 1840s and the 1850s between individuals like Gerrit Smith, Lysander Spooner, and the Tappans, on one side, and the allies of Garrison, on the other, precluded unity even in the face of the Fugitive Slave Act of 1850 (*see* FUGITIVE SLAVE LAWS). Black abolitionists deplored the conduct of those white allies who fought furiously over nonresistance and other arcane antislavery theories and virtually ignored the slave. Moreover, black leaders were shut out of leadership roles in the organization, despite their enormous talent and energy. In response, many blacks joined rival societies, labored independently, or worked for black-sponsored associations.

Despite the internecine battles and relentless public hostility, the AASS persisted through the Civil War, keeping the issue of slavery constantly before the public. With the legal end of slavery in 1865, Garrison and many of his supporters maintained that the organization no longer served a useful purpose and sought to disband it. Rival members under the leadership of Wendell Phillips disagreed and saw the end of slavery as only the beginning of their task to democratize the nation and help ensure black freedom. They seized control of the society to push for a just Reconstruction of the southern states, maintaining it until 1870, when the Fifteenth Amendment, guaranteeing black suffrage, was adopted.

REFERENCES

FRIEDMAN, LAWRENCE J. *Gregarious Saints: Self and Community in American Abolitionism, 1830–1870.* New York, 1982.

KRADITOR, AILEEN S. *Means and Ends in American Abolitionism, 1834–1850.* New York, 1969.

RIPLEY, C. PETER, et al., eds. *The Black Abolitionist Papers.* Vol. 3, *The United States, 1830–1846.* Chapel Hill, N.C., 1991.

DONALD YACOVONE

American Civil Liberties Union. A nonprofit organization devoted to the defense of individual liberties under the Bill of Rights, the ACLU was

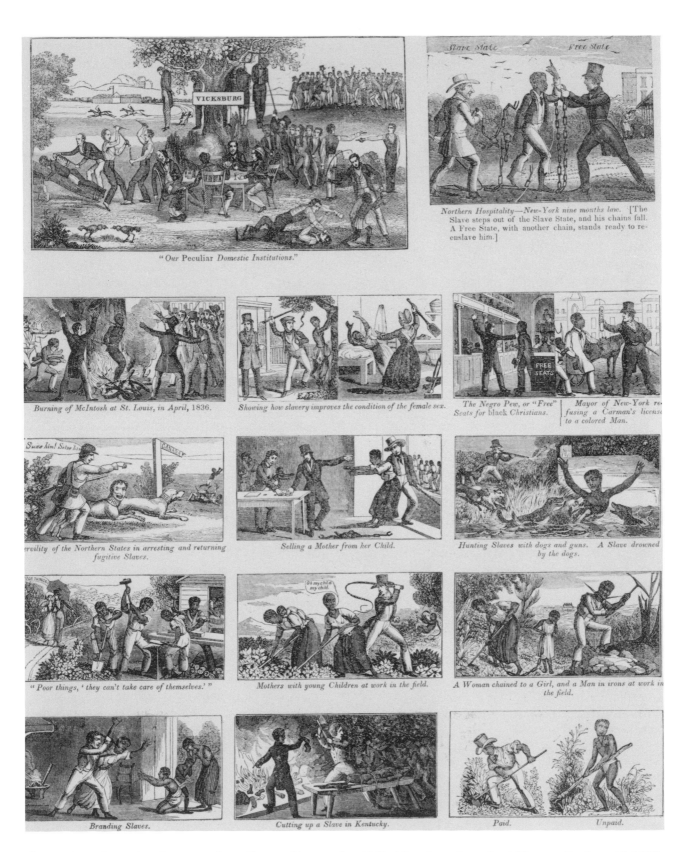

Illustrations from the *American Anti-Slavery Almanac* for 1840. The American Anti-Slavery Society (AASS), which was founded in 1833, was skilled at making use of a wide variety of methods to publicize its cause. In addition to employing newspapers and journals and an active lecture program, the society adapted one of the most common publications of the time, the almanac, for abolitionist ends. (Prints and Photographs Division, Library of Congress)

founded in January 1920 as the successor to the National Civil Liberties Bureau, established in 1917 to fight the suppression of civil liberties during WORLD WAR I. The ACLU has a membership of nearly 300,000 and maintains a national office in New York City, a legislative office in Washington, D.C., and affiliates or chapters in all fifty states. It is supported through membership dues, tax-deductible contributions, and private foundation grants to support special projects.

The ACLU's program consists of litigation, lobbying, and public education. The organization offers free legal assistance to persons whose rights have been violated. It defines civil liberties in terms of four broad areas: First Amendment rights; equal protection of the law; due process of law; and the right to privacy.

The ACLU handles an estimated four thousand to five thousand legal cases a year, and since the 1970s has appeared before the Supreme Court more often each year than any organization except the U.S. government. The vast majority of its cases are handled by cooperating attorneys retained by various ACLU affiliates.

Since its founding, the ACLU has been involved in many of the most famous controversies in American history; it has played some role in an estimated 80 percent of the landmark Supreme Court cases related to individual rights. In 1925, it defended John T. Scopes in the famous "monkey trial," challenging a Tennessee law that prohibited the teaching of evolution in the public schools. During World War II, it challenged the evacuation and internment of Japanese Americans. During the cold war, the ACLU challenged many state and federal laws restricting freedom of political speech and association. ACLU lawyers represented the plaintiffs in the 1962 case *Engle* v. *Vitale,* in which the Supreme Court ruled that religious prayers in public schools were unconstitutional. In the 1960s and early 1970s, the organization defended the rights of persons protesting the Vietnam War. In 1977 and 1978 it defended the right of the Nazi party to hold a demonstration in the predominantly Jewish town of Skokie, Ill.

At the very outset, the ACLU made the issue of racial justice a major part of its program. It immediately established a close working relationship with the NATIONAL ASSOCIATION FOR THE ADVANCEMENT OF COLORED PEOPLE (NAACP). An NAACP leader was always a member of the ACLU Executive Committee (later renamed the Board of Directors) from the 1920s through the 1960s. James Weldon JOHNSON, Thurgood MARSHALL, and Robert Carter, among others, served in this capacity. Under an informal working arrangement, the ACLU generally referred all civil rights cases to the NAACP.

The immediate civil rights crisis, when the organization was founded in 1920, was a wave of vigilante violence against African Americans. The weekly summary of civil-liberties events prepared for the ACLU Executive Committee included numerous incidents of KU KLUX KLAN–led violence. In response, the ACLU concentrated—as it did with other civil-liberties issues—on influencing public opinion. Co–executive director Albert Desilver published several articles in liberal magazines describing Klan violence and calling for racial tolerance. Given the political climate of the period, however, the ACLU saw little hope for civil rights legislation or judicial protection of minorities.

On a number of issues, however, the ACLU and the NAACP disagreed. On First Amendment grounds, the ACLU opposed measures designed to restrict the activities of the Ku Klux Klan and other racist groups. It opposed efforts by the NAACP to have the racist film BIRTH OF A NATION banned in a number of cities. In one highly publicized 1923 incident, it defended the right of Ku Klux Klan members to hold a meeting in Boston after Mayor James Curley had denied them permits. At the same time, the ACLU was fighting similar bans against labor-union organizers, communists, and birth-control advocate Margaret Sanger. Its position was that the First Amendment guaranteed freedom of assembly to all groups and that authorities could not make distinctions between groups based on their personal beliefs.

The ACLU did support one limited restriction on the KKK in the 1920s: it supported laws prohibiting Klan members from parading in public wearing masks. The ACLU accepted this limit to the right of freedom of assembly on the grounds that parading in masks represented intimidation rather than political speech.

In the late 1920s, the ACLU decided to expand its efforts in behalf of civil rights. The immediate result was a 1931 report, *Black Justice,* a comprehensive survey of the denial of civil rights to African Americans across the country. At the same time, several ACLU leaders were instrumental in developing a proposal by the American Fund for Public Service (known popularly as the Garland Fund) for a broad legal attack on institutionalized segregation. The Margold Report, as it was known, eventually became the basis for the legal attack on segregation led by Thurgood Marshall of the NAACP Legal Defense Fund.

ACLU lawyers played important roles in the litigation arising from the SCOTTSBORO CASE: ACLU attorney Walter Pollak successfully argued both the Powell (1932) and the Patterson (1934) segments of the case before the Supreme Court. Both were landmark cases in the development of due-process law and marked the Court's rising concern about racial justice. Also in the 1930s, ACLU co–general council

Arthur Garfield Hays unsuccessfully argued a case in the Supreme Court challenging the poll tax, which was used to disfranchise African-American voters in the South.

The ACLU's civil rights activities increased significantly during World War II. Following racial disturbances in 1943, it created a Committee Against Racial Discrimination (CARD), led by the author Pearl S. Buck. In cooperation with other civil rights groups, it published materials on how to end racial discrimination and prevent further racial disturbances. In one notable case, the organization represented Winfred Lynn in his challenge to racial segregation in the Selective Service. Initially, the NAACP refused to accept Lynn's case, but Thurgood MARSHALL later filed an *amicus* brief. Although unsuccessful, the case was a dramatic challenge to racial segregation in the military.

In the post–World War II years, the ACLU worked closely with the NAACP Legal Defense Fund, filing *amicus* briefs (supplementary, "friend of the court" briefs filed on behalf of one of the parties to a legal action) in virtually all the landmark civil rights cases before the Supreme Court, including BROWN V. BOARD OF EDUCATION. ACLU lawyers also provided assistance in a series of cases involving restrictions on the NAACP in southern states. These cases, beginning with *NAACP* v. *Alabama* (1958), established the legal concept of freedom of association.

The CIVIL RIGHTS MOVEMENT of the 1960s had a profound impact on the ACLU. The Lawyers Constitutional Defense Committee, which it sponsored, provided free lawyers for civil rights workers in Mississippi and, later, other southern states. Involvement in the southern civil rights movement heightened the consciousness of many ACLU leaders about new civil-liberties issues. These included the rights of poor people, the constitutional aspects of prison conditions, discrimination in the application of the death penalty, and restrictions on voting rights. The result was a major expansion of the ACLU's program of activity. In 1964 it opened a southern regional office in Atlanta, which concentrated primarily on voting rights, challenging at-large election districts and other practices that discriminate against or dilute the vote of African Americans.

The most controversial civil rights issue of the 1970s and 1980s was AFFIRMATIVE ACTION. While a number of other members of the national civil rights coalition opposed this concept, the ACLU supported race-based remedies for past discrimination in employment. It also adopted its own affirmative-action plan, establishing goals for employment of racial minorities on its staff and as members of the national board of directors.

Conflict between the ACLU and African-American groups continued into the 1990s. As it had in the past, the ACLU defended the First Amendment rights of Ku Klux Klan members and other racists. In Kansas City, Mo., it defended the right of the KKK to have a program broadcast on the local cable television public-access channel. In 1991, it successfully challenged the creation of a special public school in Detroit for black males.

REFERENCES

LAMSON, PEGGY. *Roger Baldwin: Founder of the American Civil Liberties Union.* Boston, 1976.
MARKMANN, CHARLES LAMM. *The Noblest Cry: A History of the American Civil Liberties Union.* New York, 1965.
MURPHY, PAUL L. *World War I and the Origin of Civil Liberties in the United States.* New York, 1979.
WALKER, SAMUEL. *In Defense of American Liberties: A History of the ACLU.* New York, 1990.

SAMUEL J. WALKER

American Colonization Society. The idea of colonizing black men and women in America outside the territorial limits of the United States existed throughout the antebellum period and beyond. The American Society for Colonizing the Free People of Color in the United States was formed to spearhead this movement. Founded in December 1816 by Presbyterian ministers in the District of Columbia, the American Society soon became known as the American Colonization Society (ACS). The ACS, with considerable support in the upper South, officially embraced colonization as a means to deal with the growing numbers of "free blacks and manumitted slaves" that many southern planters felt were the cause of rebelliousness and even insurrection.

The ACS considered a number of locations for the colonization of peoples of African descent, and agents were sent to explore territories for the settlement of emigrants. Initial colonization attempts failed in Haiti and Sherbro Island, located near the British colony of Sierre Leone. However, on December 15, 1821, agents of the ACS purchased Cape Mesurado, located about 225 miles south of Sierra Leone and surrounding coastal land. In exchange for the land, the ACS agents offered a number of items with little value. After considerable negotiation, the five African kings who controlled the area agreed to sell the land to ACS agents and accepted their baubles as payment.

In January 1822, the first colony settled at Cape Mesurado. Internal disputes within the ACS led to the formation of a number of self-supporting state

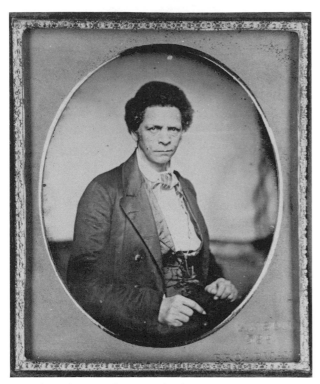

Joseph Jenkins Roberts, a freeborn Virginian, immigrated to Liberia in 1829. Roberts was appointed governor of Liberia by the American Colonization Society in 1842. In 1848 he became the first president of the Liberian Republic, serving until 1856. (Prints and Photographs Division, Library of Congress)

colonization societies that also organized settlements near Cape Mesurado. As a result of the colonization efforts of the ACS and the independent state colonization societies, Liberia was created. Liberia was governed by the ACS until it became a republic in 1847. The capital, Monrovia, was named in honor of the fifth president of the United States, James Monroe, who, along with Congress, gave the society close to $100,000 for the removal plan. But not until 1862 did the U.S. government officially recognize Liberia.

Among the members and supporters of the ACS were men of stature and wealth from both the northern free states and the slave-holding South. But the major office-holders were Southerners, with John C. Calhoun and James Monroe, among other prominent Southerners, having served on the board of directors. And while the organization enjoyed the sanction of the federal government (including the approval of most American presidents), the ACS was often a first stage for future abolitionists who would later join William Lloyd Garrison's Anti-Slavery Society (ASS) and denounce both the government and the ACS for its colonization policy and its refusal to embrace the immediate emancipation of slaves.

In fact, the two organizations were intimately linked, although with opposing purposes, principles, and membership. Formed in 1832 to counteract what it saw as the slow, reform politics of the Colonization Society, the ASS found supporters in men such as Frederick DOUGLASS and many other free African Americans. They fought vigorously against colonization. Frederick Douglass denounced the ACS for encouraging the idea that Africa and not America was the home of black Americans. Furthermore, he insisted, the organization was not militant enough on the question of abolition and wasted its energies far from home. Other black leaders relied on the records of the ACS to argue that colonization had not and could not work. Most notably, they argued that they were now Americans and not Africans. Black leaders also used the high death rate among the settlers of Liberia to argue against emigration.

The ACS, on the other hand, enjoyed the support of most mainstream philanthropic, religious, and private organizations. Abraham Lincoln, who believed for most of his life that white and black men could not live together equally, was a one-time member. Henry Clay was president of the ACS during the late 1840s, and Bushrod Washington, an associate justice of the United States Supreme Court, served as the first president of the ACS.

Members of the ACS encouraged and supported the emigration of African Americans to Liberia for a variety of reasons. Some argued that black Americans should be provided with some education and return to Africa so they could help bring Christianity to their "heathen brethrens." Others saw emigration as a means to rid America of the ever-growing "free black" population that threatened the system of slavery. Still others believed that "whites and blacks could never live together" and that black men and women had to be sent to a separate territory if the race problem was ever to be solved.

There were a few prominent free African Americans who promoted black-sponsored emigration, but with different ends in mind. Martin R. DELANY and Paul CUFFE, for example, wanted to see a black state in exile that would prove to be a model to the world and a beacon for black Americans. The African Civilization Society, founded in 1858, which aided Martin R. Delany in his venture, supported colonization but emphasized the "Christianization of Africa, and of the descendants of African ancestors in any portion of the earth wherever dispersed." Claiming to be a totally black-controlled organization, the African Civilization Society actually had an overlapping membership with some white members of ACS. And the ACS used the services of prominent African Americans to convey its message. Jamaican-born

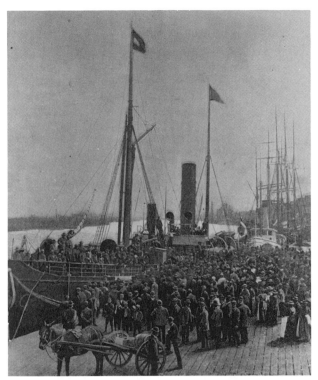

Though the heyday of the American Colonization Society (ACS) was before the Civil War, it continued to sponsor immigration to Liberia in the latter decades of the nineteenth century, as in this voyage of March 19, 1895, leaving Savannah, Ga., bound for Liberia with 200 African Americans aboard. (Prints and Photographs Division, Library of Congress)

John B. RUSSWURM in the 1830s, Alexander CRUMMELL and Edward Wilmot BLYDEN, a St. Thomas native, in the 1850s, and Henry McNeal TURNER in the 1870s are a few of the notable proponents the ACS used to transmit the message of colonization. But the majority of black American leaders opposed the ACS's invitation to relocate to Liberia.

The ACS, however, had developed a sophisticated network of both written and oral communications to convey its message of colonization. The ACS published the *African Repository* (1825–1909) as its official journal. By publishing letters from emigrants who had settled in Liberia and who supported the society's objectives, the *African Repository* served as a propaganda sheet, painting a positive picture of Liberia for black Americans. Some were encouraged by the reports and immigrated, with passage in most cases paid for by the ACS. The ACS also promised to provide those who left for Liberia with land and economic support for six months. This promise was not always kept, and emigrants were at times left stranded on the Cape. By 1885, the ACS had transported approximately 15,700 black men and women to Liberia.

Despite the attempts of the ACS to bring African Americans to Liberia, the organization lost its momentum as a result of the abolition of slavery and the enactment of the THIRTEENTH, FOURTEENTH, and FIFTEENTH AMENDMENTS to the United States Constitution. As the industrial revolution gained momentum, the increasing need for a source of cheap labor also hastened the ACS's decline. In the face of these changes, the ACS lost much of the economic support it needed to continue emigration to Liberia. There were a few settlements after 1860, but the ACS functioned primarily as the "caretaker" of the settlement in Liberia in the post–Civil War period.

By the turn of the century, the work of the ACS had, for the most part, ended. However, in 1929 the ACS did manage to provide support for the Booker T. Washington Agriculture and Industrial Institute in Liberia. The ACS continued to exist until March 22, 1963, when it was dissolved and its assets given to the PHELPS-STOKES FUND in 1964.

Colonization schemes, in general, were an attempt to reconcile the harsh realities of slavery and racism and the ideals of a democratic republic. With a commitment to the high principles contained in the Declaration of Independence and the Bill of Rights, many individuals, with both noble and base motives, saw colonization as a solution to what they saw as an "irrepressible" conflict between the races. For many black and white Americans the idea of separation, a chance to remove others or oneself from the difficult challenge of building a multiracial society, has been a major theme running throughout American history and remains so to this day. The theoretical attractiveness of self-removal to another country notwithstanding, however, most black men and women continue to see their lives as intimately connected with the fate of America.

REFERENCES

DUNBAR, ERNEST. *The Black Expatriates: A Study of American Negroes in Exile.*
MOSES, WILSON J. *The Golden Age of Black Nationalism, 1850–1925.* New York, 1988.

LAYN SAINT-LOUIS

American and Foreign Anti-Slavery Society. The American and Foreign Anti-Slavery Society grew out of a schism in the main antebellum abolitionist group, the AMERICAN ANTI-SLAVERY SOCIETY. When antislavery leader WILLIAM LLOYD GARRISON attempted to introduce secular reform

measures such as women's rights and pacifism, conservative and evangelical leaders rebelled. On May 11, 1840, at the American Anti-Slavery Society's annual convention, Arthur (1786–1865) and Lewis Tappan (1788–1873), New York businessmen and Congregationalist revivalists, led a walkout of thirty clergy and lay abolitionists.

Following the walkout, Lewis Tappan presented a constitution, and the American and Foreign Anti-Slavery Society was formed, with Arthur Tappan as president. The society was cool toward female participation. Women were permitted to attend meetings but were denied voting and office privileges. Society leaders favored political action such as the formation of a third party to fight slavery, but relied primarily on religious and moral suasion. The society published a newsletter, *The American and Foreign Anti-Slavery Reporter,* through which it tried to win the support of churches and missionary societies. Eventually Tappan allied the society with James G. Birney's Liberty party and supported Birney's 1844 presidential candidacy.

The Tappanites placed great emphasis on internationalizing the movement, and sent representatives to the International Anti-Slavery Conventions in London in 1840 and 1843 in order to forge links with the powerful British and Foreign Anti-Slavery Society. Lewis Tappan and African-American minister J. W. C. PENNINGTON became the society's major liaisons with British leaders, with whom they discussed joint strategy on matters such as the annexation of Texas and the treatment of blacks in the United States and Canada.

Despite Lewis Tappan's efforts, the society was never very effective and became virtually defunct after 1844. The organization was a "museum of abolitionists," in one critic's words, tired of the movement and more interested in evangelizing than in politician action. Meanwhile, Garrisonians bitterly fought the society, and their influence drove away membership and funding.

The society's most important action was putting together the AMERICAN MISSIONARY ASSOCIATION (AMA), which grew out of a committee formed to aid refugees from the slave ship (*see* AMISTAD MUTINY). While originally an antislavery coalition of missionaries and evangelists, the AMA later became an important educational organization.

In 1855, following the Kansas-Nebraska Act of 1854, which provided that the populations of territories could vote to allow or prohibit slavery, Tappan decided slavery was in fact unconstitutional (a radical idea at the time). This meant the government could do away with slavery, and political action would replace moral suasion as the main abolitionist weapon. Tappan dissolved the American and Foreign

Anti-Slavery Society, and replaced it with the political American Abolition Society, which disintegrated shortly after its founding over the issue of whether to support armed antislavery efforts.

REFERENCE

WYATT-BROWN, BERTRAM. *Lewis Tappan and the Evangelical War Against Slavery.* Cleveland, 1969.

GREG ROBINSON

American Friends (Quakers). *See* Society of Friends.

American Indians. Though the relationships in America between Europeans and Indians and between Africans and Europeans have been fully explored, in 1920 Carter G. WOODSON called the relationship between Africans and Native Americans "one of the longest unwritten chapters in the history of the United States." It still remains largely unresearched and untold, in part because it had its beginnings in the controversial issue of slave resistance.

The first mention of contact between the two races appears in a letter by Hispaniola's governor Nicolas de Ovando, circa 1503, stating that his African slaves "fled among the Indians . . . and could not be recaptured." America's slave system, originally based on Indian labor, began to add captured Africans, making it a biracial institution. Richard Price's study of Dutch Guiana described a result: "The Indians escaped [slavery] first and then, since they knew the forest, they came back and liberated the Africans."

From the Portuguese and Spanish colonies of Latin America to the British and French colonies of North America, testimony shows that whites dreaded a coalition of enslaved Africans and free Indians that might end slavery and Europe's grip on America. The earliest American slave rebellion (in 1522 on Hispaniola) and the first on what became U.S. soil (in 1526 in North Carolina) had Africans and Native Americans acting in concert. In 1527, Viceroy Mendoza of Mexico reported a major revolt in which Africans and Indians had united. By 1650, contacts between the two peoples of color in Mexico alone had produced an African-Indian population estimated at 100,000.

As Indians and Africans reached out to each other, European powers developed divisive racial policies that hired and bribed Native Americans to hunt Af-

ricans and armed Africans to fight Indians. In 1523 Hernando Cortés enforced a Spanish Royal Decree on Mexico that segregated Africans from Natives.

Europeans were particularly threatened when African slaves fled Native villages or formed their own Maroon or rebel communities, called *quilombos,* in dense, remote frontier areas. French scholars called MAROONS "the gangrene of colonial society." The largest Maroon community was the "Republic of Palmares" in northeastern Brazil. Started in the early 1600s, it grew to 11,000 people, largely Africans and some Indians; it contained three villages, churches, shops, a legal system, and a powerful army. After repeated European failures to breach its defenses, Palmares was overrun in 1694 by an army that included 6,000 Paulistas, who were Christianized Indians recruited by the Portuguese.

Little is known of Maroon culture except that it was adapted from African, Indian, and European traditions and the slave experience. Women were rare, though some became prized members of settlements and sometimes played key roles in village life. In Brazil, the African Filippa Maria Aranha led a Maroon army with such skill that the Portuguese agreed to negotiate a peace that granted her people liberty and sovereignty. After 1700, Maroon leaders were largely mixed offspring of Africans and Native Americans, men likely to be knowledgeable in warfare, negotiations, and European ways.

Contact between Africans and Indians stirred fears among North America's white rulers. Except in Florida, however, African-Indian liaisons did not constitute a serious military threat to either the slave system or white hegemony in the Americas.

Black-red relationships nevertheless had their impact on bondage and the frontier. South Carolina law warned that bringing "Negroes among the Indians has all along been thought detrimental, as an intimacy ought to be avoided." In 1758, South Carolina governor James Glen stated, "It has always been the policy of this government to create an aversion in them [Indians] to Negroes." For the staggering rewards of thirty-five deerskins (in Virginia) or three blankets and a musket (in the Carolinas), British officials hired Native Americans to hunt slave escapees. Col. Stephen Bull sought to "establish a hatred" between races and trained Indians to hunt slaves.

To prevent the formation of biracial coalitions, whites introduced African slavery to the Five Civilized Nations, and by the time of Revolution had ended the enslavement of Native Americans. In 1830 Congress passed a "Removal Bill," which empowered the president to move Native American nations in the East to unoccupied land west of the Mississippi. Indian Removal took place in the era of Nat Turner's rebellion, and might have been partially re-

lated to white fears of an Indian-African concordance of interests.

European-Native treaties from colonial times to the Civil War provided for the return of fugitive slaves living in Indian villages. Such provisions were signed by the Five Civilized Nations (1721), the Iroquois Confederacy (1726), the Hurons (1746), and the Delawares (1747). But historian Kenneth W. Porter states that though each of these groups harbored slaves, none surrendered any.

The most formidable alliance between the two races in North America was born in Florida before the Revolution. Enslaved Africans from Georgia arrived in the peninsula first and welcomed Seminoles who later fled the Creek federation. They taught the Seminoles West African rice-cultivation methods learned in Senegambia and Sierra Leone, and the two peoples united in an agricultural and military alliance. In 1816 a U.S. officer reported prosperous African-Seminole plantations extending for fifty miles along the banks of the Appalachicola River.

In Florida, African-Seminole military forces repeatedly repulsed U.S. slaveholder posses and troops. Porter estimates that the Second Seminole War cost the United States 1,600 dead and $40 million, and at times tied up half of the U.S. Army. The purchase of Florida was in part a U.S. effort to close down a haven for runaways, and one that belied slaveholder claims of innate black inferiority. U.S. negotiators were able to arrange Seminole removal to the Indian Territory only after accepting the crucial African role in Seminole councils.

In the decades before the Civil War, Native American nations along the Atlantic coast became biracial communities. In response, white Southerners tried to end Indian tax exemptions and close down reservations. Artist George Catlin said the race mixture created "the finest built and most powerful men I have ever yet seen."

Thousands of Black Indians took part in the Trail of Tears, and by 1860 they accounted for 18 percent of the Five Civilized Nations in the Indian Territory. When the Confederacy pressured Indian nations to become allies in 1861, hundreds of Black Seminoles, Creeks, and Cherokees, trying to reach safety in Kansas, fought some of the earliest engagements of the American Civil War.

The United States, which had imposed slavery on Native Americans, next imposed emancipation. Seminoles elected six Black Seminoles to their governing council, but other Native societies were slower to grant members with African ancestry equal justice and representation. However, by 1900, people of African ancestry among Native American nations enjoyed more liberty, opportunity, and equality than their brothers and sisters in white society, south or

north. Ironically, African Americans in the U.S. Cavalry, the famed "Buffalo Soldiers," helped end Indian resistance, enforce reservation policy, and control the "hostiles."

The most significant African–Native American leader was Seminole John Horse, a master marksman and diplomat in Florida and Oklahoma and, by the time of the Civil War, the Black Seminole chief in Mexico and Texas. In 1870 he signed a treaty with the United States that brought his people from Mexico to Texas so that his skilled desert soldiers could serve as army scouts. On July 4, 1870, when his Seminole nation crossed into Texas, it was a historic moment: As a result of treaty negotiations with the United States an African people had arrived intact as a nation on this soil, and under the command of their ruling monarch, Chief John Horse.

As African Americans have explored their roots, they have also found Indian ancestors. Today, as a result of further mixture and marriage, virtually every African-American family in the United States—from those of Frederick DOUGLASS, Langston HUGHES, and Alex HALEY to those of the Rev Dr. Martin Luther KING, Jr., Jesse JACKSON, and Alice WALKER—can claim an Indian branch in its family tree.

REFERENCES

FORBES, JACK D. *Black Africans and Native Americans.* London, 1988.

KATZ, WILLIAM LOREN. *Black Indians: A Hidden Heritage.* New York, 1986.

OPALA, JOSEPH A. "Seminole-African Relations on the Florida Frontier." *Papers in Anthropology* 22, no. 1 (Spring 1981): 11–51.

PORTER, KENNETH WIGGINS. *The Negro on the American Frontier.* New York, 1971.

PRICE, RICHARD. *First-Time: The Historical Vision of an Afro-American People.* Baltimore, 1983.

———, ed. *Maroon Societies: Rebel Slave Communities in the Americas.* Baltimore, 1979.

WOODSON, CARTER G. "The Relations of Negroes and Indians in Massachusetts." *Journal of Negro History* 1 (January 1920): 40–57.

WILLIAM LOREN KATZ

American Missionary Association. The American Missionary Association (AMA) was founded in New York on September 3, 1846, as the result of the merger of the Western Evangelical Missionary Society (which sent missionaries to American Indian communities) and the Committee for West Indian Missions, with the Union Missionary Society. The latter, a predominantly African-American missionary organization, had previously absorbed the Amistad Committee (an interracial group founded in 1839 to help the Africans who had mutinied aboard the slave ship *Amistad*—see AMISTAD MUTINY). The American Missionary Association was created to protest the silence of the American Board of Commissioners for Foreign Missions on slavery, and to preach the gospel "free from all complicity with slavery and caste." Officially unaffiliated, it was closely connected with the Congregational Church. Its first board of twelve members included four black abolitionists: Theodore S. WRIGHT, Samuel Ringgold WARD, Charles Bennett RAY, and J. W. C. PENNINGTON, as well as Lewis Tappan and other prominent white antislavery activists. Other early officers included African Americans Samuel CORNISH, Henry Highland GARNET, and Amos Freeman, and white abolitionists Simeon Jocelyn, Gerrit Smith, and Joshua Leavitt.

By 1847 the AMA had begun its work, setting up missions for people of color in Africa, Jamaica, Hawaii, Egypt, and Siam. The AMA also opened schools and provided clothing for black refugees in Canada. Some home missionaries also travelled south in an attempt to convince white Southerners of the evil of slavery. During the early years, about five percent of the AMA's workers, including missionaries such as Mary Ann Shadd CARY, were African Americans.

During and after the CIVIL WAR, the AMA turned its attention to the provision of economic aid and education for newly freed slaves. The first AMA school, in Hampton, Va., was established in September 1861, with African American Mary S. PEAKE as teacher. It later became HAMPTON INSTITUTE. By 1864 the AMA had 250 teachers in Southern states. The next year, the AMA received $250,000 for its activities from the Congregational Church, and it expanded its efforts. By 1868 there were 532 AMA teachers in the South. The so-called Yankee schoolmarms (about two-thirds of whom were women, many of whom came from outside New England) soon became well known. They worked for little pay, usually with poor or nonexistent educational facilities. Ignored or threatened by white southerners, many AMA teachers lived in the black communities where they taught. During the 1870s and '80s, the AMA provided the only secondary schools for African Americans in the rural South. AMA representatives provided relief for poor blacks, lobbied for public education, and worked to obtain land and political/civil rights for blacks. As public school systems were set up in the South, the AMA cut back its primary schools.

After the end of the Civil War, the AMA also became involved in setting up colleges in conjunction

with the Freedmen's Bureau. The most notable were Atlanta University, Tougaloo College in Tougaloo, Miss., Hampton Institute in Hampton, Va., and FISK UNIVERSITY in Nashville, Tenn., all created in the period from 1865 to 1869. While the AMA opposed segregation, the only interracial college it operated was Berea College in Kentucky, which had been founded in 1859 by the Rev. John Fee with AMA aid. The school was soon suspended after rioting by antiabolitionist mobs. The AMA inherited it in 1865 (it remained integrated until 1904, when Kentucky's legislature imposed segregation). The AMA also funded the theology department of HOWARD UNIVERSITY, which was operated by the federal government. By the turn of the century, the AMA released most of its colleges to the control of independent boards of trustees.

The AMA was run by whites committed to establishing institutions offering a full academic education to African Americans in an era when such opportunities were extremely rare. African Americans were active in AMA education, and a few participated in management work—for example, Edmonia Highgate persuaded the board to appoint her collecting agent in the 1860s. As time went on, blacks increasingly demanded the hiring of black teachers. Slowly the AMA complied, and by the late 1880s many of the new students in AMA institutions were being taught by black graduates. The AMA's strong commitment to racial egalitarianism won it praise even from African Americans such as Frederick DOUGLASS and W. E. B. DU BOIS, who scorned the efforts of most white-led benevolent organizations. While the AMA never abandoned its goal of integration, and retained integrated faculties, its leaders often acquiesced in segregation and black disenfranchisement after RECONSTRUCTION. Many white teachers, and some black teachers associated with the AMA as well, were contemptuous of rural black customs and tried to assimilate blacks to their middle-class notions of propriety.

In the latter years of the nineteenth century, the AMA expanded to set up schools for poor whites in Appalachia and for Chinese immigrants in California. In 1893 it sponsored the World Congress on Africa, which introduced African Americans, many for the first time, to whites who knew and respected African culture, and stimulated black American self-help efforts. It continued these efforts into the twentieth century. However, the AMA's educational work declined after 1890. The organization lacked funds and committed teachers to carry out its goals. Member colleges were increasingly forced to seek government funds and other sources of philanthropy to operate. By 1933 the AMA operated just five colleges (plus Fisk University, which was semi-

independent) and twelve high schools in the South, as well as four hospitals and infirmaries, and a few churches.

In 1913 the AMA officially associated with the Congregational Church. While the takeover improved the AMA's financial picture, it restricted its organizational freedom. In 1937 it became a "corporate entity" within the Church's Board of Home Missions (which became the United Church Board for Homeland Ministries following the formation of the United Church of Christ—incorporating the Congregational Church—in 1957). During the early twentieth century, African Americans took greater control of AMA operations. Various African Americans, such as George Edmund HAYNES and G. W. Moore, occupied leadership positions in the organization. Meanwhile, the AMA started to organize commissions and conferences to focus on pressing problems of race relations. In 1942 the AMA sponsored a study by Fisk University's Department of Race Relations, the first of many ongoing studies, which declared segregation "incompatible with American democratic ideals."

In the 1990s the AMA, as part of the United Church Board for Homeland Ministries, was based in New York, where it continued to work for black progress through its six affiliated colleges: LeMoyne-Owen College, Hutson-Tillotson College, Dillard University, Talladega College, Tougaloo College, and Fisk University. It also worked closely with the Board's Race Relations Department (headed from 1986 through 1993 by the Rev. Benjamin Chavis) which operated such programs as the Amistad Foundation and the Amistad Awards, and the annual Institutes on Race Relations at Fisk University.

REFERENCES

DE BOER, CLARA MERRITT. "Blacks and the American Missionary Association." In Barbara Brown Zikmund, ed. *Hidden Histories in the United Church of Christ*, Vol. 1. New York, 1984, pp. 81–95.

HOLMES, DWIGHT OLIVER WENDELL. *Straight Ahead.* New York, 1934.

MCPHERSON, JAMES M. *The Struggle for Equality: Abolitionists and the Negro in the Civil War and Reconstruction.* Princeton, N.J., 1964.

STANLEY, A. KNIGHTON. *The Children Is Crying: Congregationalism Among Black People.* New York, 1979.

NANCY YOUSEF

American Moral Reform Society. Organized in 1836 by a group of elite black leaders in Philadelphia, the American Moral Reform Society (AMRS)

sought to promote morality among both white and black Americans through the influence of temperance, education, economy, and universal liberty.

The AMRS grew directly out of the National Convention Movement, which had first met in Philadelphia in 1830, and it embraced many of the conventions' programs for reform. At the fifth annual convention in 1835, the delegates adopted a proposal, devised by black abolitionist attorney William WHIPPER, for the formation of the AMRS. Black Philadelphians dominated the proceedings and comprised the majority of the officers chosen to the society. Among those appointed were Bishop Morris BROWN of the AFRICAN METHODIST EPISCOPAL CHURCH, and James FORTEN, Sr., who served as the first president of the AMRS. Although plans were made for a convention to meet in New York the following year, it was never held, and the AMRS replaced the convention movement until the AMRS disbanded.

Even at the society's first convention on August 8, 1836, there was factionalism among the leaders from Philadelphia as well as an intercity rivalry between the delegates from that city and those from New York. Opponents of the AMRS accused its leaders of being too visionary and unrealistic. Two AMRS policies proved particularly divisive: the commitment of the AMRS to morally reforming the entire American population, regardless of race, and Whipper's insistence on banning the use of such terms as "colored" and "African." The society's critics argued that there was nothing objectionable in terms of racial identification and asserted that the AMRS should limit its sphere of action to free blacks.

Following the first annual meeting of the AMRS in 1837, there was a clear split among northern black leaders over these issues, with Whipper, Forten, and Robert PURVIS emerging as the primary supporters of the AMRS. Whipper, the chief promoter of the AMRS, redoubled his promotional efforts and helped the AMRS establish its own journal, the *National Reformer,* which failed after only one year. Opponents of the AMRS, meanwhile, became more unified and more insistent in their calls for the revival of the National Convention Movement.

In an attempt to broaden its base of support, the AMRS admitted its first female delegates to the convention of 1839. But its Garrisonian anticlericalism and the revival of the National Convention Movement worked against the AMRS. It ceased to be an effective organization after its sixth convention in 1841.

REFERENCES

BELL, HOWARD H. "The American Moral Reform Society." *Journal of Negro Education* 27 (Winter 1958): 34–40.

WINCH, JULIE. *Philadelphia's Black Elite: Activism, Accommodation, and the Struggle for Autonomy, 1787–1848.* Philadelphia, 1988.

LOUISE P. MAXWELL

American Negro Academy (ANA), first national African-American learned society. Although American blacks had established numerous local literary and scholarly societies from the late 1820s on, the goals and membership of the American Negro Academy, founded on March 5, 1897, in Washington, D.C., made it a distinct and original endeavor. The academy's constitution defined it as "an organization of authors, scholars, artists, and those distinguished in other walks of life, men of African descent, for the promotion of Letters, Science, and Art." The decision to exclude women was based on the belief that "literary . . . and social matters do not mix."

Although the chief concerns of the men who founded the ANA were to strengthen the intellectual life of their racial community, improve the quality of black leadership, and ensure that henceforth arguments advanced by "cultured despisers" of their race were refuted, it was equally significant that the organization was established at a time when European Americans were creating hundreds of learned, professional, and ethnic historical societies. The academy's birth was an expression of this general movement among educated members of the American middle class.

From its establishment until its demise in 1928, the academy claimed as members some of the most important male leaders in the African-American community. Alexander CRUMMELL, its first president, was an Episcopal clergyman who held an A.B. from Queen's College, Cambridge University. Other founders included Francis J. GRIMKÉ, a Presbyterian clergyman trained at Lincoln University and Princeton Theological Seminary; W. E. B. DU BOIS, professor of economics and history at Atlanta University and later a founder of the NAACP; William H. Crogman, professor of classics at Clark University in Atlanta; William S. Scarborough, a scholarly classicist who was on the faculty of Wilberforce University; and John W. Cromwell, a lawyer, politician, and former editor of the *People's Advocate,* a black newspaper published in Washington, D.C., from 1878 to 1884. Throughout its existence, the academy continued to attract a number of the most intellectually creative black men in the United States. Some of those associated with the organization who achieved their greatest prominence after the turn of the cen-

tury were John HOPE, president of Morehouse College and later of Atlanta University; Alain LOCKE, writer, critic, and key figure in the HARLEM RENAISSANCE; Carter G. WOODSON, historian; and James Weldon JOHNSON, poet, writer, and civil rights leader.

Relatively speaking, only a handful of educated black men were ever members of the academy. There were several reasons for this: the ANA was a selective organization to which entrance was controlled by the membership; its activities and goals appealed mainly to a small group of black men who sought to function as intellectuals and who believed that the results of their efforts were crucial to the development and defense of their racial group; it experienced continuous difficulties in realizing its goals; and it never enjoyed the support of Booker T. WASHINGTON, the powerful principal of Tuskegee Institute, who, for over half the life of the organization, was the dominant figure in the African-American community. Washington was invited to become a founding member of the ANA and to attend the inaugural meeting in 1897, but he declined, pleading a busy schedule and prior commitments. The real reason for his absence and lack of involvement was his recognition that the major founders and early leaders of the academy—especially Crummell—were sharply critical of his educational theories, particularly his stress on industrial training as the best education for the majority of his race, and of the Tuskegee educator's willingness to compromise with prominent white racists in the South and North.

Between 1897 and 1924, the ANA published twenty-two "Occasional Papers" on subjects related to the culture, history, religion, civil and social rights, and social institutions of African Americans. The process of choosing the persons invited to present papers at academy meetings and selecting which of the talks delivered would be printed as Occasional Papers was managed by the executive committee of the organization, a body composed of the president, first vice president, corresponding secretary, recording secretary, and treasurer. While the quality of the papers varied, all of them help to illuminate the many ways in which, during the first quarter of the twentieth century, an important segment of the small community of educated American blacks attempted intellectually to defend their people, justify their own existence, and challenge ideas, habits, attitudes, and legal proscriptions that seemed to be locking their race permanently into an "inferior caste."

Throughout its existence, the ANA was preoccupied with survival. As a result, its officers and members were forced to put as much energy into keeping the organization alive as they did into conducting its programs. And yet the society survived for thirty-one years, functioning as a setting in which members and friends shared their intellectual and scholarly work with each other and engaged in critical reflection on it. Through annual meetings, Occasional Papers, exhibits, and the public interest they generated, the ANA was able to initiate dialogues in both the black and white communities that were important contributions to a growing discussion in the United States, Africa, and Europe about race and the relationship between blacks and whites; to introduce the concerns and opinions of educated blacks into quarters where previously they had been ignored or gone unnoticed; and to encourage the growing pride among African Americans in their culture and history.

The American Negro Academy was both a sustainer and a perpetuator of the black protest tradition in an age of accommodation and proscription. By functioning as a source of affirmation and encouragement for an important segment of the black intelligentsia and as a setting in which they could seek to understand the meaning of the African-American experience, it was a model for other and sometimes more successful black organizations founded after 1897 that engaged in similar work or attempted to realize goals that the ANA found unattainable. Perhaps most important, for those men who were active members, the academy's various programs and activities and the interactions they promoted formed a dynamic process in which participants began to free themselves from the entanglements and confusions of ideas and theories that made them feel insecure about their own worth, ashamed of the history and condition of blacks, and doubtful of their race's future possibilities. By strengthening and adding to the intellectual autonomy and insight of its members, the academy helped to prepare them for more informed, honest dialogue with each other, with blacks in the United States and other parts of the world, and, when they would listen, with whites.

REFERENCES

MEIER, AUGUST. *Negro Thought in America, 1880–1915.* Ann Arbor, Mich., 1968.
MOSS, ALFRED A., JR. *The American Negro Academy: Voice of the Talented Tenth.* Baton Rouge, La., 1981.

ALFRED A. MOSS, JR.

American Negro Theatre. The American Negro Theatre (ANT) was founded in Harlem in New York City in 1940 by Abram Hill, a writer, and

Frederick O'Neal, an actor. Their goal was to establish a community-based theater to provide opportunities for black theater artists as the Negro Units of the Federal Theatre Project had done before they were discontinued by Congress in 1939.

The theater was incorporated as a cooperative, and all members shared in expenses and profits, reflecting the theater's policy of emphasizing an ensemble style of acting rather than individual stars. Some officers were paid part-time salaries for their work through a Rockefeller Foundation grant, but most workers donated their time. Those who also performed outside the company paid 2 percent of their earnings to help keep ANT solvent. In 1942, Hill and O'Neal established the ANT Studio Theatre (the first black theater institution sanctioned by the New York State Board of Education) to train a new generation of black theater artists.

From 1940 through 1949, ANT produced nineteen plays, twelve of which were new. ANT's biggest success was *Anna Lucasta* (1944), but the production also sowed the seeds of the company's eventual failure. Based on a play by Philip Yordan about a Polish-American family, Hill and director Harry Gribble Wagstaff adapted it for a black cast. After a five-week run at ANT's theater in the 135th Street library, it moved to Broadway, where it played for two years, becoming the longest-running black drama in Broadway history. A national tour and a film followed, but ANT received no royalties from these, and only a small one from the Broadway production. The fact that only a few actors from the Harlem production were used on Broadway caused discord within the company, some of whose members became more interested in performing on Broadway than in Harlem. *Anna Lucasta* brought many critics to Harlem to see subsequent ANT productions, but their critical judgments were based on Broadway standards. The ANT seemed to change its standards as well, and strayed further and further from its original mission as a community-based theater. After 1945, it produced plays by theater playwrights only, such as *Juno and the Paycock* (1945–1946), *You Can't Take It With You* (1945–1946), and *Riders to the Sea* (1948–1949). Although ANT transferred three more plays to Broadway, none was financially successful.

With growing financial problems in the late 1940s, the ANT lacked the finances to mount complete productions. They turned, instead, to producing inexpensive variety shows and by 1949 had ceased production entirely.

A number of prominent black actors and writers began their careers in ANT productions or in the Studio school. They include Ruby DEE, Lofton MITCHELL, Alice CHILDRESS, Earl Hyman, Sidney POITIER, and Harry BELAFONTE.

REFERENCES

DURHAM, WELDON, ed. *American Theatre Companies, 1931–1986*. New York, 1989.
WALKER, ETHEL PITTS. "The American Negro Theatre." In *The Theater of Black Americans*. New York, 1987.

MICHAEL PALLER

American Revolution. The American Revolution, in which the colonies that became the United States cast off dependence on the mother country, was an important event not only in the history of America but of the world. The Americans' successful struggle for independence was an important development in the formation of the modern social and political conception of humanity. America's liberation was made possible by large-scale support from African-American soldiers, sailors, and laborers, who nevertheless faced racial discrimination within the military and society.

In 1770, shortly before the outbreak of the American Revolution, about one-fifth of the population of the thirteen colonies was African American, of which two-thirds was native-born, one-third African-born. About 5 percent of the African-American population—much of which was in part white or Native American—was free and had varying but limited rights as citizens. All the rest were property of their white masters. SLAVERY existed, all but unchallenged, in every colony. Approximately 90 percent of the slave population lived in the South, where their labor was essential to the economy. Slaves cultivated tobacco, indigo, rice, and sugar—major sources of profit in internal and external trade. They were also used in the South and the mid-Atlantic colonies as personal servants and artisans producing a wide range of clothes and equipment. They were less numerous in New England than elsewhere, but there too, they worked as servants and laborers, or as boatmen and longshoremen in the seaport towns of the region. Slavery not only meant that the body, labor, clothes, and housing of the slave belonged to the master, but that the slaves had no role in the political process and no independent social existence.

All this changed with the coming of war. The emergency situation created by the conflict meant that African Americans, both individually and as a class, gained levels of respectful attention and importance not reached again except in subsequent wars. The labors and loyalties of blacks were crucial to the comfort, security, and military success of several colonies; they had to be officially recognized.

Killed in the Boston Massacre of 1770, Crispus Attucks, of mixed African-American and American Indian descent, has long been honored as a patriotic hero. On this commemorative column, Attucks's name heads the list of massacre victims. (Photographs and Prints Division, Schomburg Center for Research in Black Culture, The New York Public Library, Astor, Lenox and Tilden Foundations)

Furthermore, the existence of slavery met widespread challenge for the first time. The rhetoric of the patriots was suffused with comparisons to slavery, and frequent allegations that the King of England was trying to reduce them, through the Stamp Act (1765), the Townshend Acts (1767), and the quartering of garrisoned British troops, to a condition of slavery and abject bondage. The Boston Massacre in March 1770, in which five Bostonians were killed in a fracas with British troops, marked the first deaths in the conflict. Among those killed was Crispus ATTUCKS, a mulatto. Committees of Correspondence in Massachusetts led to similar confrontations in other colonies. Following the famous "Boston Tea Party" of December 16, 1773, harsh British repression led to the convening in June 1774 of the Continental Congress. Sensitive to the apparent contradiction of calls for liberty in the midst of slavery, Virginia delegates moved successfully to suspend the SLAVE TRADE, whose continued existence the Americans blamed on England. The trade resumed following the end of the war.

In April 1775, war broke out in Massachusetts. The colony's blacks had presented five antislavery petitions to the General Court (the colonial legislature) between 1773 and 1775, but the lawmakers had failed to act on them. Nevertheless, freemen and slaves fought with other patriots at Lexington and Concord and at Bunker Hill. Twelve, including Peter SALEM, Salem POOR, and Lemuel HAYNES, went on to fight in further battles and made names for themselves by their exploits. When Gen. George Washington arrived in Massachusetts to lead the first Continental Army, the slaveholding Virginian convinced the Continental Congress to bar enlistment by blacks in the Army and to dismiss slave soldiers, though he allowed free blacks already serving to finish their enlistments. Many states barred blacks from militia service. Black soldiers strongly protested.

In November 1775, Lord Dunmore, the royal governor of Virginia, issued a proclamation promising freedom for enslaved blacks in Virginia who joined the British armed forces to put down the revolt. Patriot forces throughout the colonies reacted strongly to the "infamous proclamation," and many slaveholders now saw revolution as the only way of avoiding slave insurrection. Virginia and Maryland tightened slave patrols and searched for runaways. News of the proclamation traveled swiftly. Three hundred slaves joined Dunmore's forces within a month and were designated "Lord Dunmore's Ethiopian Regiment." By mid-December, however, after an unsuccessful attack on Norfolk, Va., Dunmore fled to an offshore ship, and blacks who wished to join him were forced to steal boats and travel to asylum offshore. Still, some 2,000 were able to make

their way to the British ships. Once on board, though, many of the black recruits were stricken by fever and died, and the Ethiopian Regiment disbanded.

In January 1776, in the wake of Dunmore's Proclamation, Washington changed his mind. Fearing that blacks once discharged would join the British, he permitted the "faithful" free black soldiers already in the Army to reenlist, and African-American soldiers fought that year in battles in such places as Fort Ticonderoga in New York and around New York City.

The Americans' struggle for liberty and equality, as well as the military service of African-American soldiers, brought about a significant change in the image of slavery and the condition of African Americans. Many patriots, even slaveholders, began viewing the institution as evil. When one of James Madison's slaves was caught trying to flee behind British lines, Madison refused to punish him "for coveting that liberty" that white Americans proclaimed the "right & worthy pursuit of every human being." In 1775, the same year the war broke out, the first antislavery society in America was formed in Philadelphia. Thomas Jefferson's original draft of the Declaration of Independence in 1776 charged that the King of England had "waged cruel war" on humanity by taking an unoffending people from their native land and selling them into slavery in the colonies. No section of the Declaration caused more debate than this. The passage was struck out to appease the delegates of Georgia and South Carolina. In essence, the United States was created amid a fundamental contradiction: A government based on Enlightenment principles of universal liberty and equality was established by people who denied the same freedoms to enslaved African Americans.

General Washington opposed allowing further blacks to join the Army. While Washington was impressed by the black soldiers' military prowess, he refused to allow slaves to enlist out of a combination of republican principle and concern for slaveholder sensibilities. However, this policy also changed in the face of the Continental Army's desperate need for soldiers, and on January 2, 1777, he issued an order allowing all freemen to enlist. While individual states had laws against black military service, opposition to free blacks in the army, even in Virginia, soon dissolved as the personnel shortage grew. By 1777, new enlistments were few, and conscription was largely ineffective. States were forced to hire and pay bounties to meet their enlistment quotas. Many whites refused service and hired free blacks as substitutes. In October 1777 Connecticut allowed slavemasters to manumit slaves who substituted for reluctant whites. In February 1778, Rhode Island, hard-pressed to find

soldiers, passed a Slave Enlistment Act, by which the state freed slave recruits and compensated masters. The state's black regiment eventually served with distinction. By 1781 all the New England states, New York, and Maryland had authorized slave enlistments.

In spring 1779, as the war turned southward, Congress recommended enlisting southern slaves, and sent a representative, John Laurens, to convince South Carolina and Georgia to recruit slaves. Slaves were too valuable as agricultural laborers, however, and slaveholders feared arming any blacks and stirring thoughts of freedom among enslaved African Americans. Laurens's mission was unsuccessful, although both states used proceeds from sales of Loyalist-owned slaves to support military operations. The only black troops to fight in the Deep South were some five hundred black and mulatto soldiers from St. Domingue (later Haiti), including future Haitian king Henri Christophe, who joined the French forces at the siege of Savannah, Ga., in 1779.

Many blacks, James FORTEN being probably the most famous, joined the crews of sailing ships, either in the fledgling American Navy or in merchant ships, and in privateers granted letters of marque. Many African Americans were experienced sailors who navigated ships through treacherous coastal passages. Some were veterans of the Royal Navy. Most were better prepared than whites to face the harsh and restrictive conditions of maritime life. Southerners who refused to arm black soldiers had no objection to free blacks and even slaves fighting under white control on ships in the mid-Atlantic. A few blacks escaped to freedom on the high seas.

Eventually, five thousand or more blacks enlisted in the American armed forces. They fought at Trenton, Brandywine, Saratoga, and in other important battles. Several blacks won special notice in the military: Cornelius Lenox Remond, Barzillai Lew, Cuff Whitmore, Tack Sisson, Prince Whipple (later immortalized in Emanuel Leutze's famous painting *Washington Crossing the Delaware*), Abner Dabney, and others. Other blacks served the cause as military laborers, cooks, guides, spies, drivers, and roadbuilders. The largest contingents came from the northern states that had the smallest black populations, but substantial numbers of free blacks. Together, they made a decisive contribution to the American cause.

Some African Americans served on the British side, even after the fiasco of Lord Dunmore's Ethiopian Regiment. At first, a few joined the Loyalist brigades in the North. However, white Loyalists, many of them slaveholders, decried the use of black troops. Both they and British regulars looked down on blacks and were anxious to crush rebel forces on

their own. Even in the war's southern campaigns, only a few blacks enlistees were active in the British Army. The British considered blacks hard to control and undependable, and feared slave revolts. Blacks, conversely, had no confidence that joining the British Army would improve their situation. Several dozen served, however, in the Royal Navy, as pilots and seamen. After the war ended, the "Black Loyalists" who had served the British were evacuated to Nova Scotia. However, many found conditions unsuitable there and emigrated to the African colony of Sierra Leone.

While the British armed few African Americans, they made full use of the labor of slave "property," which they captured from Americans. They also put to work African Americans who ran behind their lines to freedom. When the British took New York and Philadelphia, a large percentage of those cities' enslaved blacks were liberated. After the war turned south in 1779, tens of thousands of slaves ran from plantations despite strict laws and whites' efforts to hinder runaways. Other slaves were conscripted into the king's service, constructing military fortifications in Savannah and Charleston. Slaves worked as cooks, spies (some were double agents for the Americans), and military servants. The most shocking use of blacks was for biological warfare at Yorktown. Blacks stricken with smallpox were sent to plantations in order to infect rebels. Dunmore and a few others drew up plans to arm slaves in order to augment shorthanded British forces, but nothing ever came of them.

With the end of the American Revolution in 1783, African Americans left the Army. Many veterans, particularly in the North, were emancipated by legislative enactment. Some veterans had only verbal promises of manumission from their masters. Many of these agreements were kept; some were not. Occasionally courts and state legislatures were forced to secure the emancipation of individual veterans to prevent masters from attempting to reenslave ex-soldiers because some did not wait to see whether their masters would keep their promises. Slaves bought up by states for wartime public works projects were resold. Enslaved blacks who had fled to the British were taken by them out of the country, but not necessarily to freedom. Some were claimed as compensation by Loyalist slaveholders or sold in the British West Indies. Others, abandoned, went to the West Indies, Florida, Nova Scotia, England, or Africa. A few migrated to the northern states.

As the treatment of black individuals was mixed, so was the institution of slavery, brought into question for the first time in the Revolutionary era. The territory of Vermont outlawed it in 1777, but for the balance of the war most northern states avoided an-

tislavery action that would alienate Southerners. In 1783, a Massachusetts judge declared that slavery violated the state's constitution. The Northwest Ordinances of 1784 and 1787 banned it, and Congress came within one vote of banning it in the southern territories as well. All northern states banned slave trading, but none of the thirteen original states' legislatures banned slavery outright during the Articles of Confederation period. By the end of the war, however, slavery was discredited, and all the northern states eventually adopted gradual emancipation plans. Even Southerners, whose economy depended on it and who imported large numbers of new slaves to replenish depleted stocks, made manumission easier and allowed the formation of abolitionist societies. However, revolutionary abolitionism was a weak force, and many northern slavemasters simply sold their slaves south to the Cotton Belt.

The African-American role in the American Revolution, though ignored by most whites, then and now, became not only a major abolitionist political weapon, but a sign of historical legitimacy. Beginning with William Cooper NELL in the 1850s, African-American historians have often focused on blacks in the American Revolution. Later contributions by William Wells BROWN in the 1860s, George Washington WILLIAMS in the 1880s, Benjamin BRAWLEY in the 1920s, Luther P. JACKSON in the 1940s, and Benjamin QUARLES in the 1960s added to the body of knowledge, but still, it has taken almost two centuries for full-scale consideration and discussion to take place. Today, documents, facts, analyses, and other data on the war for independence have begun to appear in large quantities.

The most important effect of the war on African Americans was the creation of a large self-conscious class of free blacks who began to organize their own communities. Under leaders such as Richard ALLEN, they formed independent religious denominations. Around their churches grew fraternities, social and literary organizations, and abolitionist societies. Martin R. DELANEY, Frederick DOUGLASS, and others used the efforts of their patriot predecessors and the egalitarian language of the revolution as weapons against slavery, as well as against segregation and discrimination. Still, most blacks had to wait for the second American revolution of the Civil War to see even temporary recognition as citizens of the land in which they were born and for which they fought.

REFERENCES

BERLIN, IRA, and RONALD HOFFMAN, eds. *Slavery and Freedom in the Age of the American Revolution.* Charlottesville, Va., 1983.
FONER, PHILIP S. *Blacks in the American Revolution.* Westport, Conn., 1976.

FREY, SILVIA R. *Water From the Rock: Black Resistance in a Revolutionary Age.* Princeton, N.J., 1991.

KAPLAN, SIDNEY, and EMMA NOGRADY KAPLAN. *The Black Presence in the Era of the American Revolution.* Rev. ed. Amherst, Mass., 1989.

NASH, GARY B. *Race and Revolution.* Madison, Wisc., 1990.

QUARLES, BENJAMIN. *The Negro in the American Revolution.* Chapel Hill, N.C., 1961.

WILSON, ELLEN GIBSON. *The Loyal Blacks.* New York, 1976.

ALLAN D. AUSTIN

American Tennis Association. The American Tennis Association (ATA) is the oldest continuously operated noncollegiate black sports organization in the United States. Formed in the spring of 1916 by prominent African Americans in Washington, D.C., and Baltimore, the ATA has provided encouragement, information, and tournaments for black TENNIS players. The attendees at the organizational meeting were Henry Freeman, John F. N. Wilkinson, Talley Holmes, H. Stanton McCard, William H. Wright, B. M. Rhetta, and Ralph Cook. Cook's brother, Charles, was one of the first coaches at Howard University.

The ATA listed four goals that are still followed today: to develop the sport among blacks, to spur the formation of clubs and the building of courts, to encourage and develop junior players, and to foster the formation of local associations. The ATA's first national championships were held at Druid Hill Park in Baltimore in August 1917; twenty-three clubs sent thirty-nine entries for the men's singles, won by Talley Holmes. Women's singles were added the following year, when Lucy Diggs SLOWE became the first titleholder and the first black female national champion in any sport.

In the 1920s and 1930s, the ATA concentrated on enlarging its summer tournament schedule to provide competitive opportunities for its members. Black college stars at white universities came out of the ATA-inspired programs: Henry Graham at Michigan, Richard Hudlin at the University of Chicago, Reginald WEIR at the City College of New York, and Douglas Turner at the University of Illinois. In 1929, the ATA and the sport's white governing body, the United States Tennis Association (USTA), had a confrontation over the rejection of two players, Reginald Weir and Gerald Norman, from the USTA Junior Indoors tournament. The USTA had an unwritten rule that blacks could not participate in tournaments, and when Weir and Norman were barred, the NAACP made a formal complaint to the USTA. While the NAACP had rarely taken a stand on discrimination in sports during the period, it played a role in the USTA dispute because tennis was a middle-class sport with an avid following in the NAACP's professional constituency.

Black women's tennis during the 1920s and '30s was not dominated by a single player. In the first twenty years of the ATA's existence, however, there were only five different female winners: Lucy Slowe, M. Rae, Isadore Channels, Lulu Ballard, and Ora WASHINGTON. Channels and Washington dominated the tournaments, with Channels winning four ATA national titles (1922, 1923, 1924, 1926) and Washington winning a record eight (each year from 1929 to 1935 and 1937). Washington was unorthodox in her approach to the game; she held the racquet high up on the handle, hardly ever took a full swing, and had unsurpassed foot speed. She maintained her championship standing until 1936, when Lulu Ballard defeated her. Into the 1940s and '50s, other outstanding players included singles champion Flora Lomax (titleholder in 1938, 1939, 1941, and 1942) and the team of Margaret and Roumania Peters, who won the ATA women's doubles crown a record fourteen times (each year from 1938 to 1941 and from 1944 to 1953).

The depression of the 1930s posed many advantages and many challenges for tennis players. The decade saw an expansion of tennis facilities under President Franklin D. Roosevelt's WORKS PROJECT ADMINISTRATION (WPA), including the addition of park courts in black neighborhoods. However, the economic hardships of the 1930s left many people without the resources to spend time playing or watching tennis.

One stronghold of tennis activity during the period was in black colleges, which always had a close relationship with the ATA. Many ATA members were college professors or administrators, and tennis was the most popular participant sport among black female professionals. One early ATA member was R. Walter Johnson, who played football at Lincoln University. He directed the organization's junior development program, which began in the early 1940s and produced tennis champion Althea GIBSON. Cleveland Abbott, Tuskegee University's famed athletic director, was an ATA president. In 1937 the ATA arranged an exhibition tour by its best players at eight high schools and twenty-one colleges.

When racial integration of professional sports began between 1946 and 1950, the ATA adjusted quickly, since acceptance into USTA events was slow for blacks. The ATA and the USTA had an arrangement beginning in 1951 whereby the ATA nominated the black players to compete in the USTA nationals. Sixteen-year-old Arthur ASHE was a nominated player in 1959. The ATA provided indispens-

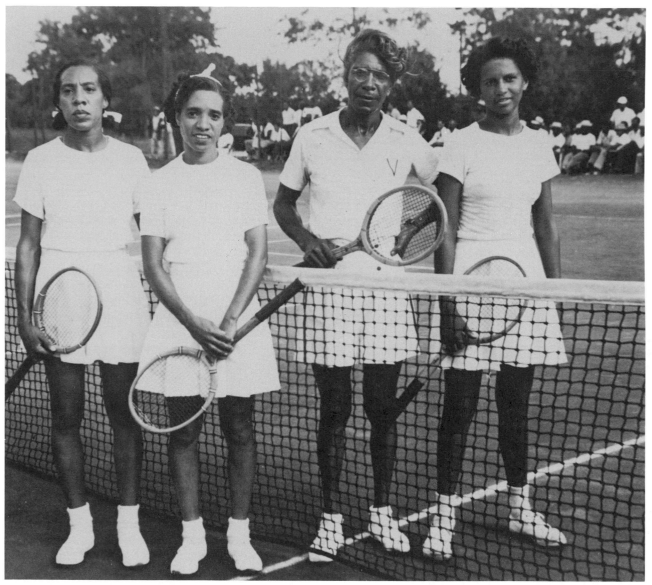

Finalists in the Women's Doubles Championship, American Tennis Association, Tuskegee Institute, Ala., August 18 to 23, 1947. (From left to right) Margaret Peters, Roumania Peters, Ora Washington, Doris Miles. (Photographs and Prints Division, Schomburg Center for Research in Black Culture, The New York Public Library, Astor, Lenox and Tilden Foundations)

able competition for the best black players until the early 1970s, when all racial restrictions were lifted. Blacks nurtured through ATA events captured nearly seventy USTA national junior and senior titles.

The ATA, headquartered in Silver Spring, Md., continues to sponsor training programs for young players and to conduct regional championships. Its National Championships remains a highlight of the African–American summer sports schedule.

REFERENCE

ASHE, ARTHUR. *A Hard Road to Glory: A History of the African-American Athlete, 1919–1945.* New York, 1988.

ARTHUR R. ASHE, JR.

Amistad Mutiny. The *Amistad* mutiny was a rebellion of African captives that occurred off the northern coast of Cuba in July 1839. The mutineers had been seized in Africa, herded onto a Portuguese slave ship along with hundreds of others, and then transported illegally from the African island of Lombokor to Cuba (then a Spanish colony). Upon reaching Havana, the Africans were smuggled ashore under cover of night, in violation of an 1817 treaty between England and Spain that prohibited the slave trade. There, fifty-three captives—forty-nine adult males, three girls, and a boy—were sold to two Spaniards, José Ruiz and Pedro Montes; they were then shipped along the Cuban coast to Puerto Príncipe aboard the Spanish schooner *La Amistad*.

On July 1–2, 1839, just a few days after the *Amistad* set sail, the captured Africans rose up in revolt. Led by Sengbe Pieh (or Joseph Cinqué), they freed themselves from their irons and launched an armed assault against their captors, killing the ship's captain and cook. Several crew members disappeared, and one African was killed in the fray. The mutineers spared Ruiz and Montes, ordering them to sail back to Africa. The Spaniards, however, maintained a meandering northerly course that, by late August, brought the ship to New York state waters.

On August 25, the Africans, desperate from hunger and thirst, anchored the now-bedraggled *Amistad* off the coast of Long Island in New York to search for provisions. But they had been spotted by the crew of the U.S.S. *Washington;* after a show of resistance, they surrendered to the ship's commanders and were towed to New London, Conn. They were shortly afterward taken to New Haven, where they languished in jail while awaiting a hearing on their case. So began an ordeal for the "Mendians" (many of the Africans had come from Mende) that lasted for more than two years.

The *Amistad* case attracted widespread attention along the Atlantic seaboard and even on an international scale. Ruiz and Montes insisted that the Africans had already been slaves in Cuba at the time of purchase and were therefore legal property; as such, they could be tried on charges of piracy and murder. Cuban and Spanish authorities demanded the return of the ship and its surviving human "cargo"—thirty-nine adults and the four children. But abolitionists mobilized in defense of the mutineers, hoping to prove that they had been unlawfully enslaved and must be set free. Some antislavery advocates sought to use the case to demonstrate that the principle of natural rights applied to black people.

The *Amistad* Committee, composed of such prominent abolitonists as Lewis Tappan, Joshua Leavitt, and Simeon Jocelyn, launched a vigorous campaign to raise funds for the defense. They also succeeded in generating substantial public sympathy for the defendants, even among many who did not oppose the institution of slavery itself. Activists located two African-born seamen, James Covey and Charles Pratt, who were able to communicate with the prisoners, including the undisputed leader Cinqué. The Africans were sketched by artists and displayed on speaking tours; models of them were made and sent along to sites where they could not personally appear. They were taught English and instructed in Christianity. Throughout the prolonged period of litigation that followed their arrest, the case was hotly debated in the press.

Thousands of onlookers converged on Hartford, Conn., when the U.S. Circuit Court convened in September 1839. The court refused to release the captives and remanded the case to the U.S. District Court. It was not until January 1840 that a ruling was issued. Judge Andrew T. Judson determined that the Africans had indeed been illegally kidnapped and sold, and that they had legitimately rebelled to win back their freedom. At the same time, he upheld the institution of slavery by ordering the return to Cuba of Antonio, who actually had been a slave of the slain *Amistad* captain. Judson also ordered the return of the mutineers to Africa.

The U.S. government, under the administration of President Martin Van Buren, had been expecting a verdict that would uphold its own position: that the Africans should be returned to Spain under Pinckney's Treaty of 1795. A naval vessel, the U.S.S. *Grampus,* was anchored in New London harbor, waiting to spirit the Africans out of the country and back to Cuba before the abolitionist forces could appeal the ruling. But now, it was the government that filed an appeal. After Judson's decision was upheld in May 1840, the *Amistad* case sent to the U.S. Supreme Court.

A majority of the Court were Southerners who had been slave owners at one time, including Chief Justice Roger B. Taney. The *Amistad* Committee was able to secure the services of John Quincy Adams, former president of the United States, who argued the case before the Court. In March 1841, the Court delivered its opinion, affirming the original ruling by an eight-to-one margin. The *Amistad* mutineers were free. Antonio, at risk of being sent back to Cuba, was transported secretly to Canada via the UNDERGROUND RAILROAD. The *Amistad* Committee set about raising private funds to return the remaining Africans to their homeland.

On November 17, 1841, thirty-five Africans (the others had died while imprisoned in Connecticut), along with translator James Covey and five white missionaries, left New York for Sierra Leone. Traveling with protection from the British, they reached Africa in mid-January 1842. Little is known of Cinqué after his repatriation—according to some accounts, he died some time around 1879—but he remains one of the leading symbols of resistance to the Atlantic SLAVE TRADE. Although the Spanish government demanded reparations, their effort was hampered by sectional divisions within the U.S. Congress and was eventually abandoned with the coming of the U.S. CIVIL WAR.

REFERENCES

BARBER, JOHN WARNER. *A History of the Amistad Captives.* New Haven, Conn. 1840.
CABLE, MARY. *Black Odyssey: The Case of the Slave Ship Amistad.* New York, 1971.

JONES, HOWARD. *Mutiny on the Amistad: The Saga of a Slave Revolt and Its Impact on American Abolition, Law, and Diplomacy*. New York, 1987.

MCCLENDON, R. EARL. "The *Amistad* Claims: Inconsistencies of Policy." *Political Science Quarterly* 48 (1933): 386–412.

ROBERT L. HALL

Ammons, Albert (September 23, 1907–December 2, 1949), pianist. Born in Chicago, Ill., Albert Ammons, along with Meade "Lux" LEWIS and Pete Johnson, was a major figure in the development of the boogie-woogie style of blues playing, which featured percussive and hard-driving left-hand ostinatos and became a national craze in the 1930s and '40s (*see* BLUES). Ammons, who recorded both as a solo artist and with ensembles of varying sizes, was known for the immense strength of his left hand as well as the infectious energy with which he performed. His first exposure to blues playing came from his father, himself a pianist, and Lewis, a fellow Chicagoan who was Ammons's senior by two years. Although Ammons never learned to read music, he showed a natural talent for his instrument, and by the late 1920s and early '30s was finding regular work in local Chicago clubs as both soloist and band pianist. In 1938 Ammons moved to New York, where he frequently appeared with Pete Johnson at the Café Society (*see* NIGHTCLUBS) and performed in John Hammond's "Spirituals to Swing" concerts at Carnegie Hall. Ammons spent the last years of his life mainly in Chicago, where he performed at the Beehive Club and the Tailspin. He died in his home city. Albert Ammons was the father of tenor saxophonist Eugene "Jug" AMMONS (1925–1974).

REFERENCES

RUSSELL, WILLIAM. "Boogie Woogie." In Frederick Ramsey, Jr. and Charles Edward Smith, eds. *Jazzmen*. New York, 1939.

SILVESTER, PETER J. *A Left Hand Like God: A Study of Boogie-Woogie*. London and New York, 1988.

JEFFREY TAYLOR

Ammons, Eugene "Gene" (April 14, 1925–August 6, 1974), jazz saxophonist. Born and raised in Chicago, Gene Ammons, or "Jug" as he was sometimes known, was the son of boogie-woogie pianist Albert AMMONS. He began playing saxophone at the age of ten and studied music with Walter Dyett at DuSable High School. Ammons began playing professionally in 1943 and gained prominence when he joined Billy ECKSTINE's orchestra in 1944, becoming one of Eckstine's leading BEBOP soloists. After leaving Eckstine in 1947, he led his own groups, except for a brief period when he replaced Stan Getz in the Woody Herman band. In the early 1950s, he led a group with Sonny Stitt, with whom he had good-natured tenor-saxophone battles. Throughout the 1950s and early 1960s, Ammons made a series of recordings that featured the warm, relaxed style for which he was noted. Ammons combined the language of bebop with a RHYTHM AND BLUES feel; he was an especially gifted player of ballads. His career was interrupted from 1964 to 1969 when he was convicted on narcotics charges. He continued, however, to perform with a prison orchestra. Ammons resumed his career upon his release, and toured with small groups until his death.

REFERENCE

Downbeat 41, no. 16 (1974): 11.

GUTHRIE P. RAMSEY, JR.

Amos, Harold (September 7, 1919–), microbiologist. Harold Amos was born in Pennsauken, N.J. He earned a B.S. in biochemistry from Springfield College in Springfield, Mass., in 1941 and an M.A. in 1947 and a Ph.D. in 1952 in bacteriology and immunology from Harvard University. He was a U.S. Public Health predoctoral researcher at Harvard in 1950–1951. A Fulbright Scholarship enabled him to study at the Pasteur Institute in Paris in 1951–1952, and he was a postdoctoral fellow at Harvard Medical School for two years (1952–1954).

Amos's academic career began as an associate in bacteriology at Harvard Medical School in 1957. He became a full professor in the Department of Bacteriology and Immunology in 1969, and served as chairman of the department for three years (1968–1971). He also was chairman of the Department of Microbiology and Molecular Biology from 1968 to 1971 (its name was changed from bacteriology and immunology in 1970), and again from 1975 to 1988. He chaired the Division of Medical Sciences in the Harvard Graduate School of Arts and Sciences from 1978 to 1984, while assuming the Maude and Lillian Professorship of Microbiology and Molecular Genetics in 1975. In 1988, he became Presley Professor of Microbiology Emeritus. His research has dealt with hexose metabolism in mammalian cells.

Amos was a recipient of a Career Development award from the National Institutes of Health from

1957 to 1969. In 1986 he was awarded an honorary doctorate from Springfield College, and in 1989 he was the recipient of the Dr. Charles Drew Medical Prize. Two years later, in 1991, he was elected a fellow of the American Association for the Advancement of Science.

REFERENCES

PELLETIER, P. *Prominent Scientist*. New York, 1985.
SAMMONS, V. *Blacks in Science and Medicine*. New York, 1990.

WILLIAM D. WALLACE

Amos 'n' Andy, radio and television series. As a radio series that ran from 1928 until 1960, *Amos 'n' Andy* gave twentieth-century America its most popular and longest-lived comic depiction of black characters.

Freeman Gosden (1899–1982) and Charles Correll (1890–1972), two white men who had met as itinerant directors of amateur minstrel shows, wrote and broadcast *Amos 'n' Andy*. Their daily radio serial, introduced as *Sam 'n' Henry* in Chicago in 1926, featured two black characters who—like many real African Americans of the time—had left the rural South to seek a better life in the northern city. In 1929, the National Broadcasting Company (NBC) Blue network picked up the show, whose title characters had been renamed Amos and Andy the previous year. The series set off a national craze. *Amos 'n' Andy* was played nightly in restaurants, hotel lobbies, and cinemas; sales of radio sets soared, and radio's "golden age" was launched.

Amos 'n' Andy abounded with comic racial stereotypes. Lazy, pretentious Andy and meek, earnest Amos were ignorant, often bumbling figures; the show's dialogue, though truer than that of most other white performers, caricatured black vernacular English and bristled with malapropisms. The series gave no hint that race affected one's fortunes in life. Yet Gosden and Correll skillfully used the daily serial format to build suspense and to flesh out relatively complex characters who aroused empathy in many listeners. The team also pioneered by presenting secondary and incidental black characters who were bright and accomplished, most notably Ruby Taylor, a young Chicago woman who eventually married Amos.

The multifaceted *Amos 'n' Andy* won fans ranging from white racists to outspoken white liberals and African Americans of all social classes. Other blacks, however, complained that *Amos 'n' Andy*—whose maladroit title characters operated a "taxicab company" consisting of a single jalopy—mocked the struggle of African Americans to build a dignified life in a modern capitalistic society. In 1931 the *Pittsburgh Courier,* a black weekly newspaper, claimed to have gathered nearly 750,000 signatures on a petition demanding *Amos 'n' Andy*'s cancellation. Gosden and Correll drew heavily from the work of African-American comedians; the black debate over *Amos 'n' Andy* thus partook of a broader controversy over which aspects of black culture—including JAZZ, the BLUES, and ethnic comedy—should be exhibited to whites, which were better kept within the group, and which ought to be disowned altogether.

In 1943 Gosden and Correll converted their show from a daily serial story into a weekly half-hour comedy revolving more than ever around outlandish situations and verbal gags. The Kingfish, larcenous leader of Amos 'n' Andy's fraternal lodge, had long since become a central character of the show. The Columbia Broadcasting System (CBS) brought this version of *Amos 'n' Andy* to television in 1951. Veteran African-American performers—including Tim MOORE, a former vaudevillian, as the Kingfish; Alvin Childress, a classically trained actor, as Amos; and Spencer Williams, Jr., a retired film director, writer, and actor, as Andy—took over the lead roles.

The new show dashed the hopes of Walter WHITE, leader of the NAACP, that television would avoid the racial caricaturing that had pervaded radio and movies. A strenuous protest by the NAACP's leadership in 1951 resurrected the *Amos 'n' Andy* controversy of 1930–1931 and helped dissuade sponsors for some years afterward from supporting TV comedies featuring blacks.

Nonetheless, many black viewers joined whites to make *Amos 'n' Andy* a hit in its first season on television. Declining ratings led to the show's network cancellation after a second year, but *Amos 'n' Andy* thrived in syndication to local TV stations until 1966. Meanwhile, Gosden and Correll continued to broadcast new material on the radio until *Amos 'n' Andy* finally left the air in 1960. With the show died the American tradition, well over a century old, of white men playing black comic characters.

REFERENCE

ELY, MELVIN PATRICK. *The Adventures of Amos 'n' Andy: A Social History of an American Phenomenon*. New York, 1991.

MELVIN PATRICK ELY

Amsterdam News. The *New York Amsterdam News,* the leading black paper in New York City for most of the twentieth century, was founded by James H. Anderson in 1909 with an initial investment of

only $10. The paper was originally edited out of Anderson's home and is named after the avenue on which he lived in what was then San Juan Hill, the largest black community in the city, now the Lincoln Center area. Anderson and his associates produced a modest six-page weekly that sold for two cents.

Since 1910 the offices of the *Amsterdam News* have been located in Harlem. Its editors in the early decades included George W. Harris, J. E. Robinson, and William M. Kelly. The paper also had a number of renowned journalists on its staff during the early decades. T. Thomas Fortune, previously editor of the *New York Age,* wrote intermittently for the *Amsterdam News* in the 1910s and early 1920s; Cyril V. Briggs, West Indian immigrant and editor of Harlem's black business newspaper, the *Colored American Review,* worked on the paper from 1912 until 1919, when he was fired because of his radical editorials.

In 1926, Anderson sold his interest in the newspaper to Sadie Warren, wife of the paper's first publisher, who formed what eventually became the Amsterdam News Publishing Company. After a six-week strike in 1935 and severe financial troubles, the paper was sold the next year to two West Indian-born physicians, C. B. Powell and P. M. H. Savory. As a result of the strike, which was one of the first open labor disputes between black workers and a black employer, the new owners signed a union contract and consequently the *Amsterdam News* became the first black paper with all of its departments unionized. Powell and Savory served respectively as editor-publisher and secretary-treasurer. In 1941 they renamed the paper the *New York Amsterdam Star-News* but returned to the original name two years later.

The *Amsterdam News* combined sensational headlines with good political journalism to appeal to the mass of black people and was successfully able to compete with the better-established papers in the city. The paper covered stories of crime and scandal, which included police corruption was well as gambling and prostitution rings. But it also covered more-explicitly political issues of concern to the African-American community. The *Amsterdam News* supported the REPUBLICAN PARTY until the New Deal, when it switched its endorsements to the DEMOCRATIC PARTY. The paper rose in prominence in the 1930s when it hired some left-wing writers and advocated New Deal reforms and opposition to Italy's invasion of Ethiopia. It carried columns by such prominent people as Adam Clayton POWELL, JR., W. E. B. DU BOIS, and Roy WILKINS.

The *Amsterdam News* served as a forum for political debate. In the early 1940s it began to explore the relationship between African Americans and Jews. It denounced racism within the Jewish community, but also argued in 1942 that genocide in Nazi Germany should encourage Jewish people to "seek an immediate alliance with colored Americans." Both groups should "rid themselves of adopted prejudices and band together on a common front." During World War II, the *Amsterdam News* supported the struggle for civil rights and equal opportunity in the armed forces and war industries. African-American loyalty to the United States' war effort will be assured, they argued, when racial equality is attained. During its heyday in the postwar period, the *Amsterdam News* became the dominant African-American newspaper in the city, published a second weekly edition, and reached a circulation of more than 100,000. In 1964 the paper had a weekly circulation of 75,500 and had a staff of over one hundred people.

In 1971 the newspaper was sold for $2.3 million to a group of prominent businessmen and politicians which included Percy SUTTON, M. Carl McCall, and Clarence Jones. In the mid-1970s the paper came under attack for the militance of its political positions. In response, the tone was moderated and the paper began to focus on social events and political promotion. In 1979, the paper changed its format from a standard or broadsheet size to a tabloid.

After a series of financial and managerial problems, and a second strike in 1983, the paper came under the control of Wilbert Tatum, who has been the publisher, editor, and principal stockholder since 1984. Tatum has taken positions on a number of racially charged issues in New York that have brought him under criticism from many sectors of the white community and some sectors of the black community. He supported the claims made by Tawana Brawley, denounced the legal system as racist, and has spoken out on police misconduct. Under Tatum the *Amsterdam News* waged a campaign against the administration of New York City mayor Ed Koch, calling for his resignation.

In 1993, when the paper's circulation dropped to 32,701 and had a staff of less than 50 people, Wilbert Tatum unsuccessfully attempted to merge the *Amsterdam News* with the *New York Post*. On its own still, the paper maintains a loyal readership by devoting itself to political, social, and cultural issues related to the black community that are not widely covered by the larger white-owned papers. The paper's political endorsements have given it considerable influence in many racially divided elections in New York City and it remains a successful paper, despite stiff competition from other local and national publications.

REFERENCE

WOLSELY, RODLAND E. *The Black Press, U.S.A.* Ames, Iowa, 1971.

MANSUR M. NURUDDIN

Anatomy. North American scientists have tried over a period of two centuries to find definitive anatomical differences between blacks and whites. At one point or another, their efforts have targeted everything from SKIN COLOR, hair texture, lip thickness, skeletal and muscle structure, and genital and brain size and shape. Most frequently, researchers aimed their interest at black men, placing them in relationship to white women and children—all of whom they declared to be biologically inferior to white, and especially middle-class, men of European origin. The hierarchies that scientists believed their anatomical findings established often left African-American women out of the picture altogether (Stanton 1960; Russett 1989).

Social debates generated much of the scientific concern with anatomical difference. The voluminous scientific outpourings of the nineteenth and earth twentieth centuries paralleled the great debates about slavery and its aftermath. Even in the 1990s, lingering suggestions of fundamental anatomical difference emerge only from particular public concerns. For example, the preponderance of African Americans in certain highly paid sports led to the suggestion that blacks have a different muscle structure than whites. Biological explanations for social phenomena often eclipse sociological ones (for example, that in the United States excelling in sports is one of the only paths out of poverty open to black males).

A number of historians have shown how the prior belief systems of scientists concerned with race prejudiced their findings. One of the best-known examples concerns Philadelphia scientist and physician Samuel George Morton. He collected large numbers of skulls from people of different races, used skull volume as a measure of brain size, and thus established what he believed to be a racial hierarchy of intelligence. In work published in the early to mid–nineteenth century, Morton produced scientific evidence to place whites on top, Native Americans in the middle, and African Americans at the bottom of his hierarchy. In 1978, Stephen Jay Gould reanalyzed Morton's findings, showing how he forced his data to fit with views he already held about the races, views very much supporting the notion that slavery was morally acceptable. Gould (1981) discusses numerous other examples.

Although basic scientists often preferred to study males as the prototype of the race, medical scientists made use of African-American women in the development of new techniques and treatments. Among the most notorious case is that of J. Marion Sims, sometimes described as the father of gynecology. In the decade before the Civil War, he tried out new techniques of vaginal surgery using several slave women as guinea pigs. In some cases he performed the same operation up to thirty times on one woman, failing again and again before he finally got it right. (After the war, he did the same with indigent Irish women in big-city hospitals.) The knowledge Sims acquired of vaginal and other reproductive structures catapulted him from a poor Alabama physician to one of international renown. Today, women of all colors benefit from medical techniques he so brutally elaborated on slave women (Barker-Benfield 1976).

In the 1990s, few scientists believe that anatomical differences between people of different races have social significance. Variations in external features such as skin color and hair texture remain poorly understood, primarily because their biological bases are quite complex and there are extensive gradations within the so-called races. It has never been, nor is it now, possible to identify a person's race on the basis of a single anatomical characteristic. Modern scientists recognize race more as a social and historical category than as a biological one.

REFERENCES

BARKER-BENFIELD, G. J. *The Horrors of the Half-Known Life*. New York, 1976.
GOULD, STEPHEN JAY. *The Mismeasure of Man*. New York, 1981.
———. "Morton's Ranking of Races by Cranial Capacity." *Science* 200 (1978): 503–509.
RUSSETT, CYNTHIA EAGLE. *Sexual Science: The Victorian Construction of Womanhood*. Cambridge, Mass., 1989.
STANTON, W. *The Leopard's Spots: Scientific Attitudes towards Race in America, 1815–1859*. Chicago, 1960.

ANNE FAUSTO-STERLING

Anderson, Charles (April 28, 1866–June 28, 1938), politician. Charles Anderson was born in Oxford, Ohio, to Charles W. and Serena Anderson. He was educated in the Oxford and Middleton public schools, the Spencerian Business College in Cleveland, and the Berlitz School of Languages in Worcester, Mass. He moved to New York City in 1886, where he began to campaign for the REPUBLICAN PARTY in local New York wards. In 1890 he was made president of the Young Men's Colored Republican Club of New York County, and a gauger in a district office of the Internal Revenue Service. Through continued service to the local Republican Party, Anderson's career advanced rapidly. In 1893 he became private secretary to the New York State treasurer; in 1895 he became chief clerk in the state treasury, and in 1898 he rose to supervisor of accounts for the New York State Racing Commission. In 1904 Anderson organized New York City's Colored Republican Club, in order to help reelect The-

odore Roosevelt to the presidency. In 1905 Roosevelt had Anderson appointed collector of internal revenue for the Second New York District, which included Wall Street. In this important position Anderson administered the provisions of the 1913 Income Tax Code (the first income tax code enacted under the Sixteenth Amendment) as they applied to local New York businesses.

Anderson was one of the most powerful supporters of Booker T. WASHINGTON, who was his close friend. He defended Washington from attacks from Hubert H. HARRISON, W. E. B. DU BOIS and his followers (even spying on the 1909 founding conference of the NAACP), and arranged the appointments of black deputy collectors, customhouse inspectors, election examiners, attorneys and district attorneys, and deputy United States marshals.

Anderson lead Washington's unsuccessful efforts in support of Republican President William Howard Taft's reelection campaign in 1912. When Democrat Woodrow Wilson became President in 1913, however, Anderson and many other black federal officeholders were dismissed. Appointed supervisory agent of the state agriculture department in New York City in 1915, Anderson assumed control of New York State marketing and inspecting bureaucracies working within New York City itself. He served as chairman of the Colored Advisory Committee for the Republican party in 1916, and conducted the Republican party's successful campaign for northeastern black votes in 1920.

When a Third Internal Revenue District was created in Harlem in 1923, Anderson became its collector. From this post he again secured the appointments of black wardheelers and election district captains, as well as a deputy collector. In 1927 Anderson fell ill and let his work as collector fall largely to his own lieutenants. He retired from the post in 1934 and died four years later.

Anderson's well-honed skills in patronage distribution made him the preeminent black politician in early twentieth-century America. His efforts enabled African Americans to enter government bureaucracies in unprecedented numbers, and to gain the experience necessary to influence electoral politics in the decades following his death.

REFERENCES

HARLAN, LOUIS R. *Booker T. Washington: The Wizard of Tuskegee, 1901–1915.* New York, 1983.

MEIER, AUGUST. *Black Political Thought in America, 1880–1915: Racial Ideologies in the Age of Booker T. Washington.* Ann Arbor, Mich., 1963.

OSOFSKY, GILBERT. *Harlem: The Making of a Ghetto; Negro New York, 1890–1930.* New York, 1971.

DURAHN TAYLOR

Anderson, Eddie "Rochester" (Edmund Lincoln) (September 18, 1905–February 28, 1977), actor. Eddie Anderson, the actor who played "Rochester" for more than twenty years on Jack Benny's radio and television shows, was born in Oakland, Calif. The son of vaudevillians, Anderson started his career in show business at age fourteen in an all-black revue and later toured with his brother Cornelius in a song-and-dance act. Anderson's film career began in black "race" movies, but in the early 1930s he crossed over to the white studios, playing bit parts in Hollywood movies.

In 1936 Anderson was cast as Noah in the film *Green Pastures*, his first important comic role in a studio production. This led to a part on the Jack Benny radio show. Anderson's appearance as the Pullman porter Rochester was so successful that he was signed on as a full-time member of the cast. Eventually Rochester became the most popular character on the show, aside from Benny. With masterful sarcasm, characterized by his famous line "What's that, boss?" Anderson regularly punctured Benny's inflated ego. The camaraderie between them surpassed the standard portrayal of interracial master-servant relationships. Together they constituted an unusual domestic partnership that entertained audiences for over two decades.

This rapport carried over into films they appeared in together, including *Man About Town* (1939), *Buck Benny Rides Again* (1940), and *Love Thy Neighbor* (1940). Anderson made other films during the 1930s and 1940s, including *Jezebel* (1938), *Gone With the Wind* (1939), *Birth of the Blues* (1941), and the black Hollywood musicals *Cabin in the Sky* (1943) and *Stormy Weather* (1943), starring in *Cabin*. In 1945 his film *Brewster's Millions* was banned in Memphis because it portrayed "too much social equality and racial mixture," typified by Anderson's easy familiarity with the white characters.

From 1950 to 1965 Anderson appeared on *The Jack Benny Show* on television. In 1962 he was listed by *Ebony* magazine as one of the one hundred wealthiest African Americans in the United States. He returned to film with *It's a Mad, Mad, Mad, Mad World* in 1963. On television he appeared in *Bachelor Father* (1962), *Dick Powell's Theatre* (1963), and *Love American Style* (1969). Anderson died in Los Angeles, at the Motion Picture Country Home and Hospital.

REFERENCE

BOGLE, DONALD. *Blacks in American Film and Television: An Illustrated Encyclopedia.* Westport, Conn., 1988.

ELIZABETH V. FOLEY

Anderson, Everett (August 12, 1928–), biologist. Born in Houston, Tex., Everett Anderson received a B.A. in zoology in 1949 and an M.A. in zoology in 1951 from Fisk University in Nashville, Tenn. In 1955 he received a Ph.D. in zoology from the University of Iowa, where he did postdoctoral research in histology-cytology from 1955 to 1956. In 1956–1957, he pursued postdoctoral study in gross anatomy at the University of Colorado School of Medicine in Denver. His major research and teaching interests have been in anatomy, cytology, and reproductive biology (oogenesis, fertilization, and early embryogenesis).

Following his postdoctoral study, Anderson went to Howard University as an instructor in anatomy. After a year there, he moved to Iowa and became an assistant professor of zoology at the University of Iowa. In 1972, he went to Harvard University School of Medicine, where he was appointed professor of anatomy. In 1974 he was appointed associate director of Harvard's Laboratory of Human Reproduction and Reproductive Biology, and in 1990 he became the James Stillman Professor of Comparative Anatomy there.

Anderson has been a recipient of the Harvard University Faculty Prize for Excellence in Teaching. He has over 120 publications to his credit, and more than 85 abstracts. Among his honors are listings in *American Men in Science*. His society memberships include the American Association of Anatomists, the American Society of Zoologists, and the American Society for Cell Biology.

WILLIAM D. WALLACE

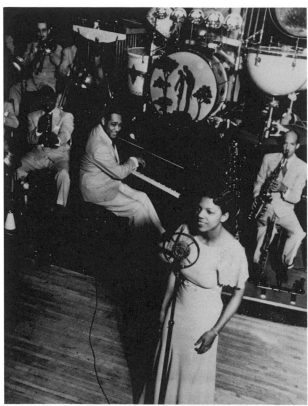

Ivie Anderson, the most popular of all of Duke Ellington's vocalists, sang with his band from 1931 to 1942, introducing such standard songs as "It Don't Mean a Thing (If It Ain't Got That Swing)" and "I Got It Bad (and That Ain't Good)." Behind Anderson (from left to right) are Juan Tizol, trombone; Cootie Williams, trumpet; Duke Ellington at the piano; Otto Hardwick, tenor saxophone. (Photographs and Prints Division, Schomburg Center for Research in Black Culture, The New York Public Library, Astor, Lenox and Tilden Foundations)

Anderson, Ivie Marie (1905–1949), singer. Born in Gilroy, Calif., orphaned, and raised in convents, Ivie Anderson studied voice from the ages of nine to fifteen, and sang in the school glee club and choral society. She joined Harlem's COTTON CLUB as a chorus girl and sang for a time with Earl HINES. Then, in 1931 Duke ELLINGTON hired her as his first featured singer, one of the first female singers to be regularly featured with a band. Her recorded debut with Ellington, "It Don't Mean a Thing (If It Ain't Got That Swing)" (1932) achieved fame. She remained longer with Ellington than any other singer, and ranks as his most distinguished vocalist. Trim, beautiful, and vivacious, Anderson sang with sensitivity, relaxed rhythm, a smoky tone, excellent pitch and diction, and considerable respect for lyrics. She also developed a strong rapport with audiences. Anderson and drummer Sonny GREER built a special relationship: Onstage, he would "talk" to her with his drums; she would answer back. Her foremost recordings include: "Raising the Rent," "Stormy Weather," "I'm Satisfied" (all 1933); "Rose of the Rio Grande," "A Lonely Coed" (both 1938); "Solitude," "Mood Indigo" (both 1940); "Rocks in My Bed" (1941); "I Don't Mind" (1942); and her most enduring song of all, "I Got It Bad and That Ain't Good" (1941). After performing in Ellington's musical *Jump for Joy* (1942), she retired because of serious asthma, and lived in the Los Angeles area for the remainder of her life.

REFERENCE

MILLER, PAUL EDUARD. "Ivie Joined the Duke for Four Weeks, Stays with Band for Twelve Years." *Downbeat* (July 15, 1942): p. 31.

JOHN EDWARD HASSE

Anderson, Marian (February 17, 1897–May 19, 1993), opera and concert singer. Marian Anderson, a contralto of international repute, may be best remembered as the first African American to sing at the Metropolitan Opera Company. She grew up in Philadelphia, where her family members were active as musicians at the Union Baptist Church. An interest in singing was stimulated by her participation in the church choirs, and she began local solo performances by the age of ten, singing professionally while still in high school. Initial venues, in addition to her church, included the Philadelphia Choral Society, New York's Martin-Smith School of Music, the NATIONAL ASSOCIATION OF NEGRO MUSICIANS (which in 1921 awarded her its first scholarship), the NAACP, the National Baptist Convention, schools, and various regional organizations.

Anderson's formal recital debut, at Town Hall in New York in 1922, was not a success, obligating further study. In 1925 she won a vocal competition that granted her a successful performance with the New York Philharmonic at Lewisohn Stadium, but the major appearances that followed were initially in Scandinavia. Her Parisian debut, in 1935, was at-

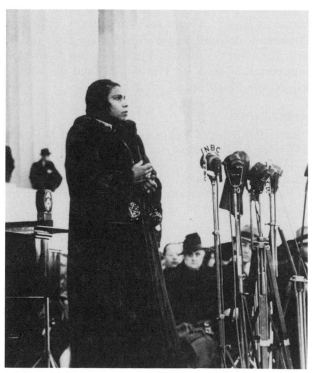

Marian Anderson at an outdoor recital at the Lincoln Memorial before an audience of 75,000, Easter Sunday, 1939. The furor surrounding the refusal of the Daughters of the American Revolution to rent an auditorium to Anderson gave the practice of discrimination against black performers unprecedented publicity. (AP/Wide World Photos)

tended by Sol Hurok, who then became her manager. That summer she won the notice of a distinguished audience at a private recital in Salzburg; in December, she presented a Town Hall recital, this one well received.

Anderson's international acclaim encouraged Howard University in 1939 to seek a recital for her in Washington, D.C. When she was denied access for racial reasons to Constitution Hall by the Daughters of the American Revolution, the public protest approached that of a scandal. Eleanor Roosevelt resigned her DAR membership and criticism came from opera singer Lawrence Tibbett, New York Mayor Fiorello La Guardia, conductor Leopold Stokowski, and other major figures. Secretary of the Interior Harold Ickes granted Anderson use of the Lincoln Memorial for an Easter Sunday concert as an alternative. Seventy-five thousand people heard her program, which began in subtle irony with "My Country 'Tis of Thee" and ended with "Nobody Knows the Trouble I've Seen." The location for this performance was not forgotten nearly a quarter of a century later by the Rev. Dr. Martin Luther KING, Jr., who arranged for her to sing there again during the 1963 March on Washington.

Anderson's tour schedule intensified, and Metropolitan Opera manager Rudolph Bing determined that she would appear as Ulrica in Verdi's *Un Ballo in Maschera.* She sang the role eight times, starting on January 7, 1955, although she was no longer in her prime. (In 1958, RCA Victor issued a recording of highlights from the opera with Dimitri Mitropoulos conducting and Anderson in the role of Ulrica.) She retired from the stage at Carnegie Hall on Easter 1965, after presenting fifty-one farewell concerts across the country. Her repertory was centered on sacred arias by J. S. Bach and Handel, spirituals (especially Harry BURLEIGH's "Deep River"), lieder (Schubert's "Ave Maria" was a favorite), and some opera arias—notably "O Mio Fernando" from Donizetti's *La Favorita,* in which she demonstrated that she could have excelled in bel canto roles, given the chance. When granted the Bok Award in 1940, Anderson established a scholarship fund for vocalists whose awards have been granted to McHenry Boatwright, Grace BUMBRY, Gloria Davy, Reri Grist, Bonia Hyman, Louise Parker, Rawn Spearman, Camellia Williams, and others.

Her primary voice teacher was Giuseppe Boghetti, although she worked in London with Amanda Aldridge, a daughter of the actor Ira ALDRIDGE. Early in her career, she was accompanied by minstrel pianist William King, then by Kosti Vehanen from Finland, and later by Franz Rupp of Germany. Anderson was appointed in 1958 to the U.S. delegation to the

United Nations, where she spoke on behalf of the independence of African nations. Although she denied playing an overt role in the civil rights movement, Anderson's dignity and artistry brought about social change and opened the door for the many concert singers who followed her. In tribute on her seventy-fifth birthday in Carnegie Hall, Leontyne PRICE paid her respects succinctly: "Dear Marian Anderson, because of you, I am."

REFERENCES

ANDERSON, MARIAN. *My Lord, What a Morning: An Autobiography*. New York, 1956.
NEWMAN, SHIRLEE PETKIN. *Marian Anderson, Lady from Philadelphia*. Philadelphia, 1965.
SIMS, JANET L. *Marian Anderson: An Annotated Bibliography and Discography*. Westport, Conn., 1981.

DOMINIQUE-RENÉ DE LERMA

Anderson, Matthew (1845–January 11, 1928), pastor, educator, and social reformer. Matthew Anderson was born in Greencastle, Pa., to Timothy and Mary Croog Anderson, into the comforts of a rural, middle-class family that owned a lumber mill and real estate not far from Gettysburg. Despite his material comforts, Anderson was oriented to a life of service and civic responsibility, guided by Christian principles and the practices of the Presbyterian church.

At home Anderson would hear Bible stories and the dramatic tales of runaway slaves. Religious piety and the pursuit of racial freedom were dominant themes in his life. The cumulative effects of these early experiences, however, prepared and inspired Anderson so deeply that by the time he left Greencastle in 1863, he had decided on the ministry as his vocation. Oberlin College was the first step towards serving his religious faith, his racial group, and pursuing social justice. These themes form an indispensable record in his book, *Presbyterianism: Its Relation to the Negro.*

After graduation from Oberlin in 1874, Anderson entered Princeton Theological Seminary that same year. He became the first African American to live in-residence while pursuing his divinity degree by refusing to live off-campus, which at that time was the custom for black students. Anderson completed his theological studies in 1877, and spent two years in part-time pastoral assignments in New Haven, Conn., where he took courses at Yale Seminary, marking the end of his formal academic training.

While traveling to the South to do missionary work in October, 1879, Anderson stopped in Philadelphia to visit friends. It was, however, to be a permanent stop. He was persuaded to stay and establish a Presbyterian church that would continue developments within the black community in the city. Anderson became renowned in his own time for the "Berean Enterprise," his general name for the institutions he established. (The name was derived from the biblical city of Berea and from Berea, Ohio, the setting for a parable-like narrative Anderson records in *Presbyterianism,* pp. 147–154.) Anderson was also known for his civic and intellectual leadership in, for example, the Universal Peace Movement, a Quaker organization opposed to slavery and war, and in the Afro-American Presbyterian Council, an organization for fellowship and inspiration.

In 1880 Anderson started the Berean Presbyterian Church, in 1884 the Berean Building and Loan Association, and in 1899 the Berean Manual Training and Industrial School. Each institution grew out of a need to provide services, skills and support systems for the black community of Philadelphia during the intensity of RECONSTRUCTION, when the nation was transforming itself from a slave-holding nation to a pluralistic one. Each institution still thrives today on its historical commitment to offer services and opportunities to any who need them. Through these religious, banking, and educational institutions that created a legacy of hope and opportunity, Matthew Anderson, defender of his Presbyterian faith and an articulate witness for social justice, left a permanent and enduring mark on Philadelphia and the nation. He died in Philadelphia.

REFERENCES

"Race, Reform and Religion in the Life of Matthew Anderson." *The Princeton Seminary Bulletin* 9, no. 2 (1988): 145–155.
TROTMAN, C. JAMES. "Matthew Anderson: Black Pastor, Churchman and Social Reformer." *American Presbyterians* 66, no. 1 (1988): 11–21.

C. JAMES TROTMAN

Anderson, Osborne Perry (c. 1830–1872), abolitionist. A participant in JOHN BROWN'S RAID at Harpers Ferry, Va. (now W.Va.), Osborne Anderson was born in West Fallowfield, Pa. He studied at Oberlin College and received training as a printer. In 1850 he settled in Chatham, Canada West (now Ontario), where he established a print shop. Anderson worked closely with Mary Ann Shadd CARY and the small circle of black intellectuals who published the *Provincial Freeman*. He began as a subscription agent and eventually became the printer and an assistant editor for the weekly newspaper. Anderson gained a reputation as an outspoken critic of colonization and

as an advocate for the fugitive slaves who sought sanctuary in Canada.

At John Brown's Chatham Convention in May 1858, Anderson committed himself to the plan to foment a slave uprising in Virginia. He was one of five blacks who participated in the Harpers Ferry raid. Although Brown and most of his followers were either killed or captured at the federal arsenal, Anderson successfully eluded his captors and returned to Canada West. He published a personal account of the dramatic raid, *A Voice from Harpers Ferry,* in 1861. During the Civil War, Anderson served in the Union Army as a noncommissioned officer. He suffered from tuberculosis in his last years and died in Washington, D.C.

REFERENCES

QUARLES, BENJAMIN. *Allies for Freedom: Blacks and John Brown.* New York, 1974.

RIPLEY, C. PETER, ET AL., eds. *The Black Abolitionist Papers, Vol. 2, Canada, 1830–1865.* Chapel Hill, N.C., 1986.

MICHAEL F. HEMBREE

Anderson, Thomas Jefferson "T. J."

Anderson, Thomas Jefferson "T. J." (August 7, 1928–), composer. T. J. Anderson was born in Coatesville, Pa. He earned a bachelor of music degree from West Virginia State College in 1950, a master's in music education from Pennsylvania State University in 1951, and a Ph.D. from the University of Iowa in 1958. In the summer of 1964, he studied with Darius Milhaud at the Aspen School of Music in Colorado. He held teaching positions at West Virginia State College, Tennessee State University, Morehouse College, and Tufts University (from which he retired in 1989). From 1969 to 1971 he was composer in residence with the Atlanta Symphony. Anderson's stylistic and technical range demonstrates thorough knowledge of and broad experience in twentieth-century musical languages. His compositions reflect a synthesis of many types of music, both African-American and European, from black folk music to serial technique to jazz, though each work has a clear, strong, individual personality.

Throughout his career he has been attracted by the power of the human voice. His vocal works include *Personals* (a cantata, 1966), *Spirituals* (1979), and the two-act opera *Solder Boy, Soldier,* depicting the effects of the Vietnam War on inner-city blacks (libretto by Leon FORREST, 1982). Anderson's orchestration of Scott JOPLIN's opera *Treemonisha* was influential in the revival of interest in Joplin's work with its highly successful 1972 world premiere in At-

lanta. *Squares, An Essay for Orchestra* (1965), *Chamber Symphony* (1968), and *Concerto for Two Violins and Chamber Orchestra* (1987–1988) are among his most important commissioned works. In 1989 Anderson retired from his teaching position at Tufts University and moved to North Carolina.

REFERENCES

OLIVER, C. Selected Orchestral Works of Thomas J. Anderson, Arthur Cunningham, Talib Rasul Hakim, and Olly Wilson. Diss., Florida State University, 1978.

SADIE, STANLEY, ed. *New Grove Dictionary of American Music.* New York, 1986.

SOUTHERN, EILEEN. *Biographical Dictionary of Afro-American and African Musicians.* Westport, Conn., 1982.

THOMPSON, B. A. Musical Style and Compositional Techniques in Selected Works of T. J. Anderson. Diss., Indiana University, 1978.

CALVERT BEAN

Anderson, William Alonzo "Cat"

Anderson, William Alonzo "Cat" (September 12, 1916–April 29, 1981), jazz trumpeter. Born in Greenville, S.C., William Anderson was orphaned at the age of four and raised at the Jenkins Orphanage in Charleston, which was well-known for its student orchestras. While there, Anderson played trumpet and toured with school bands, and also formed his own ensemble, the Carolina Cotton Pickers, which performed professionally from 1930 to 1935. In 1936 Anderson came to New York, where he played with the Sunset Royals Orchestra, the Special Services Orchestra, and Lucky Millinder, before joining Lionel HAMPTON's band. While with Hampton, Anderson became famous for his phenomenal ability to reach the trumpet's highest notes.

Anderson's most important work came with Duke ELLINGTON, who hired him in 1944 and featured him on many hit records, including "Trumpets No End" (1946). Anderson left Ellington briefly in 1947 to lead his own group ("Swingin' the Cat," 1947), but returned two years later. He stayed with Ellington for a decade, featured prominently in concert on "Coloratura" and "Happy-Go-Lucky Local," in which he imitated a train whistle. During this time he also recorded "Such Sweet Thunder" (1957) with Ellington. Anderson left Ellington again from 1959 to 1961 in order to lead his own groups ("Cat on a Hot Tin Roof," 1958), and returned from 1961 to 1971 (*Afro-Bossa,* 1962–3, *Concert in the Virgin Isles,* 1965). Anderson left Ellington again in 1971 and moved to California, where he free-lanced in the Los Angeles area. He also toured Europe several times. In 1973

Anderson wrote a treatise on his trumpet technique, *The Cat Anderson Trumpet Method: Dealing with Playing in the Upper Register* (1973). Anderson died in Norwalk, Conn.

REFERENCES

CHILTON, JOHN. *A Jazz Nursery: The Story of the Jenkins Orphanage Bands of Charleston, South Carolina.* London, 1980.

LAMBERT, E. "Cat Anderson: A Resume of His Recorded Work." *Jazz Journal International* 35, no. 6 (1982): 16; 35, no. 7 (1982): 10.

MARTIN WILLIAMS

Anderson, Winston A. (1940–), cellular and development biologist. Winston Anderson was born in Jamaica, West Indies. He received his B.Sc. and M.Sc. in 1963 from Howard University. He earned a Ph.D. in biology from Brown University in 1966 and did post-doctoral work at the Faculté des Sciences, Université de Paris and at Harvard Medical School. After a year (1969–1970) as an instructor in medicine at Harvard Medical School, Anderson was appointed assistant professor of anatomy at the University of Chicago (1970), and an associate professor in 1973. In 1975 he was appointed to the chairmanship of the Department of Zoology at Howard University and was named professor of zoology in the College of Liberal Arts.

Anderson served as professor of biology at Hunter College, New York City, from 1984 to 1986, returning to the zoology department at Howard in 1986 to serve as a professor. He received the following awards for research and teaching: Anne Lange Award for Cancer Research (1975); Basic Science Teaching Award, Pritzker School of Medicine, University of Chicago (1975); Outstanding Research Award, Howard University (1983); Outstanding Research and Service Award, G. E. Mapp Symposium, Department of Biology, Morehouse College (1988); King–Chavez–Rosa Parks Scholar at Oakland University, Rochester, Minn.; and Council Membership, University of Lesotho. He is a member of Sigma Xi Graduate Science Society, the Société Française et Belge de Microscope Électronique, the American Association of Anatomists, the American Society of Cell Biology, the Society for Developmental Biology, and the Society of Histochemistry and Cytochemistry. Anderson's research deals with biochemical and cytological characteristics of spermatozoa in a number of different species, reproductive endocrinology, and fatty-acid analysis.

REFERENCE

ANDERSON, W. A., and W. SALDER. *Perspectives in Differentiation and Hypertrophy.* New York, 1982.

WILLIAM D. WALLACE

Andrews, Benny (November 13, 1930–), artist. Benny Andrews was born into a family of sharecroppers and grew up in Madison, Ga. Andrews drew cartoons as a child, and he began his formal art education at the Art Institute of Chicago in 1954, after returning from four years with the Air Force. He received his B.F.A. from the Art Institute in 1958 and relocated to New York City.

Andrews has worked in collage, painting, and pen-and-ink drawings in a figurative style because he wanted to "reflect what I knew and where I came from." Andrews's compositions represented scenes of black life in America, from his personal experience. One of his best-known early works, *Janitors at Rest* (1957), for example, depicts several custodians at the Art Institute who reminded him of characters from his childhood. The work is a collage that was made from paper towels and toilet paper in the school's bathrooms to render the men through the material they worked with on a daily basis.

During the 1960s, Andrews had difficulty exhibiting works with African-American subjects. Even though he was one of the first artists to display at the Forum Gallery when it opened in 1962 in New York City, he struggled to persuade the gallery to show his *Autobiographical Series* (1966), which depicted the lives of black Georgians in pen-and-ink drawings inspired by Andrews's childhood.

In 1969, Andrews cofounded the Black Emergency Cultural Coalition with Henry Ghent and John Sadler. The Coalition aimed to make museums more responsive to the output of black artists in the United States. Andrews remained co-chair of the organization until 1982, when he became director of the Visual Arts Program of the National Endowment for the Arts (1982–1984). Andrews does not characterize his own art as political, but acknowledges that since he depicted contemporary themes, his work occasionally took a political turn. *Did the Bear Sit Under the Tree?* (1969) depicted a black man with raised fists confronting the American flag, a national symbol which Andrews described as "the very thing that is supposed to be protecting" the embattled man in the painting.

During the 1970s, Andrews incorporated Xerox into his work, and he used spray paint through stencils and folded paper to enrich the textural character of his compositions. Works from the 1970s included

Bicentennial Series (1976) and *Women I've Known.* In 1981 he completed *Flight,* a mural for Hartman International Airport in Atlanta, Ga. Andrews has also illustrated many works, including *I Am the Darker Brother: An Anthology of Modern Poems by Negro Americans* (1968).

Andrews has exhibited at the Forum Gallery (1962, 1964, 1966), at Acts of Art, a black-owned gallery in Greenwich Village (late 1960s), at the Lerner-Heller Gallery (1970, 1971), at the Studio Museum in Harlem (1971), at ACA Gallery (1972), at the High Museum of Atlanta (1975), at the Sid Deutsch Gallery (1983), and at the Armstrong Gallery (1985). He has been active in organizing art education programs in the New York City prison system, has lectured widely on art history, and has taught art at Queens College since the 1970s.

REFERENCES

ANDREWS, BENNY. *Between the Lines: 70 Drawings and 7 Essays.* New York, 1978.

Benny Andrews: Retrospective, essay by Lowery Sims. Los Angeles: California Museum of Afro-American History and Culture 1982.

————. Center Gallery of Bucknell University. *Since the Harlem Renaissance: Fifty Years of Afro-American Art.* Lewisburg, Pa., 1985.

LOWERY STOKES SIMS

Angelou, Maya (1928–), writer. Born Marguerite Annie Johnson on April 4, 1928, to Vivian Baxter and Bailey Johnson in St. Louis, Mo., Angelou was raised in Stamps, Ark., by her grandmother, Anne Henderson. She related her experience of growing up in her popular autobiography *I Know Why the Caged Bird Sings* (1970), a title taken from the poetry of Paul Laurence DUNBAR. It was nominated for a National Book Award. Like many African-American autobiographers, Angelou saw herself not only as an individual but as a representative of black people.

What *Caged Bird* contributed to the tradition of African-American autobiography was its emphasis on the effects of growing up black and female in the South. Angelou writes of the rape of the protagonist by her mother's boyfriend. Until recently, intra-group rape and incest were taboo subjects in African-American literature; *Caged Bird* helped to break that silence. Her second biography, *Gather Together In My Name* (1974), a title taken from the Bible, focuses on the vulnerable Angelou's entry into the harsh urban world of Los Angeles, while her third autobiography, *Singin' & Swinging & Getting Merry Like Christmas* (1976), relates the experience of her first marriage

and of raising her son while pursuing her singing, dancing, and acting career.

The fourth autobiography, *The Heart of A Woman* (1981), a title taken from a poem by Georgia Douglas JOHNSON, the HARLEM RENAISSANCE poet, presents a mature Angelou who works with the Rev. Dr. Martin Luther KING, JR. and MALCOLM X. Active in the CIVIL RIGHTS MOVEMENT, she served as northern coordinator for the SOUTHERN CHRISTIAN LEADERSHIP CONFERENCE in 1959–1960. In her fifth autobiography, *All God's Children Need Traveling Shoes* (1986), Angelou goes to Ghana, where she experiences the complexity of being an African American in Africa.

Angelou has also published many volumes of poetry: *Just Give Me a Cool Drink of Water 'fore I Diiie* (1971), which was nominated for a Pulitzer Prize; *Oh Pray My Wings Are Gonna Fit Me Well* (1975); *And Still I Rise* (1978); *Shaker Why Don't You Sing?* (1983); *Now Sheba Sings the Song* (1987); and *I Shall Not Be Moved* (1990). As these titles indicate, Angelou's poetry is deeply rooted in the African-American oral tradition and is uplifting in tone. Angelou says, "All my work is meant to say 'You may encounter many defeats but you *must* not be defeated.' "

A versatile writer, Angelou has written for television: the PBS ten-part series *Black, Blues, Blacks* (1968); a teleplay of *Caged Bird;* and for the screen; *Georgia Georgia* (1971) and *Sister, Sister* (1979). As well as being a prolific writer, Angelou has been a successful actress and received a Tony nomination for best supporting actress in the TV miniseries *Roots.* Angelou says of her creative diversity, "I believe all things are possible for a human being and I don't think there's anything in the world I can't do." On January 20, 1993, at the request of President Bill Clinton, Angelou concluded the president's inaugu-

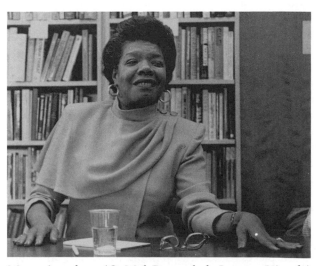

Maya Angelou. (© Mel Rosenthal, Impact Visuals)

ration by reading a poem composed for the occasion, "On the Pulse of Morning," which celebrates a new era of national unity.

REFERENCES

CUDJOE, SELWYN R. "Maya Angelou and the Autobiographical Statement." In Mari Evans, ed. *Black Women Writers (1950–1980)*. New York, 1983.

Interview. In Claudia Tage, ed. *Black Women Writers at Work*. New York, 1983.

BARBARA T. CHRISTIAN

Anglo-African, The. The *Weekly Anglo-African* newspaper and the *Anglo-African Magazine* were perhaps the most influential African-American journals of the late 1850s and the CIVIL WAR era. They were unique in that they served as forums for debate rather than simply reflecting the views of the publisher. They were owned by journalist Thomas Hamilton (1823–1865), the son of New York City community leader William HAMILTON. He and his brother Robert were the editors.

The *Weekly Anglo-African,* whose first issue was dated July 23, 1859, was a four-page weekly, with seven columns of large type to a page. It was four cents per copy, with a yearly subscription price of two dollars. Its motto was "Man must be free; if not through the law, then above the law." Unlike most black newspapers of the time, which only published a few issues before folding, the paper was an almost immediate success. It became respected for its sophisticated analysis of issues such as violent resistance to slavery, the ramifications of the DRED SCOTT DECISION, and JOHN BROWN'S RAID.

The *Anglo-African Magazine,* a thirty-two-page monthly with a yearly subscription price of $1.00, began January 1, 1859. It was one of the first illustrated African-American publications. Its prospectus proclaimed that the magazine was devoted to the cause of literature, science, statistics, and the advancement of the cause of freedom. Among its other features were biographies of outstanding figures such as actor Ira ALDRIDGE, evaluations of the abolitionist cause, comic prose, and fiction.

Many leading black writers and abolitionists, including Martin R. DELANY, Frances Ellen Watkins HARPER, J. W. C. PENNINGTON, and James Theodore HOLLY, were frequent contributors to the journals. Other luminaries, such as Frederick DOUGLASS, William Cooper NELL, Mary Ann Shadd CARY, Daniel PAYNE, and John Mercer LANGSTON, wrote occasional pieces. The *Anglo-African Magazine,* and later the *Weekly Anglo-African,* serialized Delaney's novel

Blake, or, the Huts of America, one of the first African-American novels (it was not printed in book form until 1970). Hamilton also was a book publisher. His publishing list included such books as Robert Campbell's *A Pilgrimage to My Motherland: An Account of a Journey Among the Egbas and Yorubas of Central Africa, 1859–1860* (1961) and William Wells BROWN's *The Black Man: His Antecedents, His Genius, and His Achievements* (1863).

By early 1860, despite their critical success, the Hamiltons developed severe financial problems. The *Anglo-African* magazine ceased publication, and they sold the *Weekly Anglo-African* to James Redpath, a prominent white abolitionist and emigrationist. By fall 1861, they had regained control. Robert Hamilton handled business affairs. The radical abolitionist Henry Highland Garnet, named "Editor of the Southern Department," reported on events in Washington. During the Civil War, the paper covered war news and carried messages from black soldiers. Hamilton became a fervent supporter of the REPUBLICAN PARTY, although he remained critical of northern discrimination. On March 29, 1862, he warned that northern prejudice was a "strong impediment" to black advancement. Hamilton and Garnet called for citizenship and proper education for freedmen. On September 9, 1865, in one of the paper's last issues, Hamilton praised and defended black northern teachers going south, claiming such work was blacks' chief responsibility and greatest service. The newspaper folded in December 1865.

REFERENCES

BULLOCK, PENELOPE. *The Afro-American Periodical Press, 1838–1909.* Baton Rouge, La., 1981.

HUTTON, FRANKIE. *The Early Black Press in America, 1827–1860.* Westport, Conn., 1993.

PENN, IRVING GARLAND. *The Afro American Press and Its Editors.* 1891. Reprint. Salem, N.H., 1988.

GREG ROBINSON

Antebellum Convention Movement. The antebellum convention movement consisted of a series of national, regional, and state conventions held by blacks in North America on an irregular basis from 1830 to 1861. The national convention movement began in the 1830s and revealed the growing consensus among northern free blacks on the importance of moral reform. Six annual conventions, held from 1830 to 1835, were the first attempts by African Americans to address their concerns on a national level. Samuel E. CORNISH, editor of FREEDOM'S JOURNAL, and others had called for a national

gathering on several occasions, but it was the threatened enforcement of the Ohio black laws in 1829 and the revival of the African colonization movement that provoked the first national convention.

Several state laws restricted black civil rights in Ohio, including a requirement that all blacks register and post a $500 security bond or leave the state. When Cincinnati officials called for rigorous enforcement of this provision in 1829 and the city experienced an antiblack riot the following year, blacks in Ohio and other northern states feared a new wave of legal and extralegal racial oppression. Northern free blacks were also alarmed by the rapid growth of the AMERICAN COLONIZATION SOCIETY and its state auxiliaries in the late 1820s. The white-sponsored society, founded in 1816, sought to colonize free black Americans in Africa, and vigorously lobbied federal and state governments for financial support.

In response to the Ohio crisis and colonizationist activities, forty blacks from nine states—including Virginia, Maryland, and Delaware—met at Philadelphia in September 1830. Fearful of local white hostility to the assembly, the delegates held the first five days of sessions in secret. The delegates focused on Canadian emigration as a possible solution to the tandem threat posed by state black laws and forced resettlement in Africa. At the 1831 convention, after the crisis in Ohio had abated and the need to organize a black exodus to Canada seemed less urgent, moral reform emerged as the predominant issue. White abolitionists who attended the conventions encouraged the delegates to direct their attention to moral reform. William Lloyd Garrison, Arthur Tappan, and Simeon S. Jocelyn addressed the 1831 convention. Following their recommendations, the convention accepted a proposal for a manual-labor school in New Haven. The national conventions recognized temperance as a principal component of moral reform, and at the 1833 convention, a committee on temperance recommended the establishment of a national auxiliary—the Coloured American Temperance Society.

From the beginning, the convention movement was marred by personal and intercity rivalries. New York and Philadelphia delegates quarreled over procedural questions as well as issues of substance. Much time at the conventions was given over to formulating admission policies, certifying delegates, and appointing committees. These procedural disagreements revealed not just an intercity rivalry but, more profoundly, the problem of national leadership. Many who attended the conventions had questionable credentials, representing themselves and little else.

The conventions of the 1830s were reserved, even circumspect, in their official pronouncements. To protest the injustice of slavery and racial prejudice,

the 1831 convention recommended "a day of fasting and prayer." The following year the convention agreed to establish provisional state committees, but cautiously added "where the same may be safely done." The 1834 convention condemned public demonstrations by blacks as "vain expenditures" of time and resources, serving only to incite racial prejudice.

Philadelphia delegates had the resources, organization, and leadership to dominate the 1830s convention movement (five of the six conventions were held in their city), and their interest in moral reform eventually prevailed. Led by William Whipper, the Philadelphia delegation turned the 1835 convention into a founding meeting of the American Moral Reform Society, an interracial organization committed to the principles of moral reform.

The antebellum convention movement underwent a profound transition in the 1840s, expanding to include numerous state and regional gatherings. Several conventions focused on single issues: temperance, Christian missions, and emigration. The national convention sites—including Buffalo (1843); Troy, N.Y. (1847); Cleveland (1848); and Rochester, N.Y. (1853)—marked the geographical shift away from the Atlantic coastal cities. A new generation of black leaders—many of them former slaves—came forward to claim positions of leadership in the convention movement. Frederick DOUGLASS, Henry Highland GARNET, James McCune SMITH, and others sought to imbue the movement with a more practical outlook and a militant, independent spirit. Racial progress through moral reform, the staple of the conventions of the previous decade, was subsumed by the call for more forceful tactics and political action.

Not all black leaders welcomed a renewal of the convention movement. Those who held to strict integrationist principles counseled against convening separate black assemblies or establishing racially separate organizations. Others considered it wasteful of time and scarce resources to revisit the well-worn, intractable issues debated at past conventions. But most blacks favored continuing the convention process. The disagreements, often intense, centered mainly on form, agenda, and leadership.

David RUGGLES's revival of the national convention movement at New Haven in 1840 and New York City in 1841 attracted only a few delegates. Poor organization, vague objectives, and editorial opposition from the *Colored American* contributed to the dismal outcome. Henry Highland Garnet had more success in promoting the 1843 national convention. The Buffalo convention set the new tenor for the movement with Garnet's controversial call for slave insurrection (disapproved by a narrow majority of the assembly) and the heated discussion of a resolu-

tion endorsing the Liberty party. The 1847 and 1848 national conventions in Troy and Cleveland highlighted the theme of black independence. James McCune Smith and Frederick Douglass addressed the delegates on the symbolic and practical need for self-reliance and independent black initiatives. These insightful speeches on independence and racial identity, affirmed their reputation as two of the leading black intellectuals of the antebellum period.

Just as in the 1830s, these later national conventions served primarily as a forum for competing ideas and leadership. The delegates approved plans for a national black press, an industrial-arts college, and other proposals of a practical nature. But without adequate resources, none of these objectives could be achieved. The conventions also sought continuity through the establishment of a permanent national organization. In the early 1840s, Ruggles anticipated the need for a national body with the short-lived American Reform Board of Disfranchised Commissioners. A more elaborate proposal—the National Council of the Colored People—emerged a decade later. By the 1850s, even racial assimilationists like Douglass and Smith had come to accept the idea of a separate black national organization. Douglass promoted this as part of an ambitious agenda for the 1853 national convention in Rochester.

The Rochester convention marked the high point of the antebellum convention movement. Over 160 representatives from ten northern states attended. The convention established the National Council of the Colored People, a major advance in black organization, even if it suffered from a contentious leadership and lack of popular support. The National Council faded quietly after the 1855 convention at Philadelphia—the last national convocation before the Civil War. The Philadelphia convention appeared lackluster and unproductive in comparison with the previous meeting in Rochester. Dominated by the seventy-member Pennsylvania delegation, the convention deferred substantial issues and engaged in a lively debate on procedural questions, particularly the propriety of seating a woman delegate, Mary Ann Shadd CARY.

Several conventions in the 1850s reflected the growing pessimism among African-Americans. As hopes faded for racial progress in the United States, a black emigration movement gained increasing support. The North American Convention (1851) reflected the growth and growing influence of black communities in Canada West (see CANADA). Canadian and American delegates meeting in Toronto considered the recent enactment of the FUGITIVE SLAVE ACT OF 1850 and its ramifications. They recognized that the law threatened all African Americans, not just former slaves, with arbitrary arrest and enslavement. The convention highlighted the advantages of Canadian and Jamaican emigration, and urged blacks living in the United States to come under the fair and equitable rule of British law. At the national emigration conventions of 1854 and 1856 in Cleveland, delegates weighed proposals for settlement in Haiti, Central America, and Africa. The interest in emigration continued well into the early 1860s.

In shaping a more practical agenda, blacks brought the convention movement to the state level in the 1840s and 1850s. The state meetings were better suited to address specific civil rights issues. Much of the struggle against racial discrimination involved state laws and municipal ordinances. The black vote, where permitted, weighed more heavily in state and local elections. State conventions made protection and expansion of black voting rights their primary concern. New York blacks held the first state convention at Albany in 1840 to launch a petition campaign against a property requirement that severely limited their franchise. Blacks in Pennsylvania, Michigan, New Jersey, and Connecticut followed with a similar agenda at state conventions during the 1840s.

Emerging black communities in the western states—Ohio, Indiana, Illinois, and California—also challenged voting rights restrictions and proscriptive black laws at state conventions in the 1850s. California blacks focused on restrictions against black testimony in court as well as the suffrage issue. Maryland blacks held the only convention permitted in a slave state before the Civil War. The 1852 Maryland convention, closely scrutinized by the Baltimore press, discussed colonization, the enslavement of free blacks, and petitioning the state legislature on civil rights issues. The convention's careful deliberations and guarded resolutions reflected the delegates' anxiety over white response to their gathering.

Despite the energetic and determined efforts made by the many state and national conventions, blacks achieved few of their avowed goals. But in the process, the conventions provided a sounding board for new ideas, strategies, and tactics. Many blacks established their credibility and their leadership through participation in these conventions. And ultimately the convention movement enhanced the sense of racial unity, identity, and purpose among black communities across the North American continent.

REFERENCES

BELL, HOWARD H. *Proceedings of the National Negro Conventions, 1830–1864.* New York, 1969.

FONER, PHILIP S., and GEORGE E. WALKER, eds. *Proceedings of the Black State Conventions, 1830–1865.* 2 vols. Philadelphia, 1979–1980.

MICHAEL F. HEMBREE

Antelope Case. Congress prohibited the African SLAVE TRADE starting in 1808. In the *Antelope* case, 10 Wheat. 23 U.S. 66 (1825), Chief Justice John Marshall offered the Supreme Court's most important interpretation of this law. The *Antelope* was a Spanish vessel seized on the high seas by pirates. When an American revenue cutter finally captured the vessel and took it to Savannah, Ga., it contained over 280 slaves taken from numerous ships owned by citizens of various countries, including Spain and the United States. The Court ruled that some of the slaves on this ship were to be returned to the Spanish government because they were lawfully owned by a Spanish subject at the time the ship was captured in American waters. The remaining Africans were turned over to the United States government as the fruit of the illegal trade.

Chief Justice Marshall asserted that the African slave trade was "contrary to the law of nature" but that it was "consistent with the law of nations" and "cannot in itself be piracy." This analysis led the Court to recognize the right of foreigners to engage in the slave trade if their own nations allowed them to do so. Thus Marshall wrote: "If it be neither repugnant to the law of nations, nor piracy, it is almost superfluous to say in this Court, that the right of bringing in for adjudication in time of peace, even where the vessel belongs to a nation which has prohibited the trade, cannot exist." This analysis allowed the Court to uphold prosecutions against American traders because they violated the United States' prohibition on the African trade, while also protecting the property rights in enslaved Africans owned by nationals where the trade was legal. Approximately 120 slaves, designated as American, were given over to the American Colonization Society, and approximately 30 were sent to slavery in Spanish Florida.

REFERENCES

DU BOIS, W. E. B. *The Suppression of the African Slave Trade to the United States, 1638–1870.* Cambridge, Mass., 1898.
FINKELMAN, PAUL, ed. *Articles on American Slavery.* Vol. 2, *The Slave Trade and Migration.* New York, 1989.
RAWLEY, JAMES A. *The Transatlantic Slave Trade: A History.* New York, 1981.

PAUL FINKELMAN

Anthony, Florence. *See* Ai.

Anthropologists. At the close of World War II, only ten African Americans had ever earned advanced degrees in the field of anthropology. While five of these were college professors, the others were working outside of a university setting. There was a significant increase in the number of African Americans entering this field in the 1960s. Currently, the Association of Black Anthropologists—which includes some non–American black members—has a membership of 140.

One of the factors accounting for the small number of African Americans in the field of anthropology was its espousal of the nineteenth-century pseudoscience of racial distinction. There was little interest by white anthropologists in teaching African Americans and a corresponding disinclination on the part of blacks to study a science that promoted black inferiority. This in turn led to a lack of qualified African Americans in the field and the absence of an anthropology curriculum at most historically black colleges and universities.

Prior to the twentieth century, there was a single African-American anthropologist in this country. John Wesley Gilbert, a trained archaeologist, specialized in the study of ancient Greek civilization. In the 1880s he conducted fieldwork in Greece and later became a college administrator at a historically black college in Georgia.

In the early decades of this century, anthropologists specialized in the study of foreign cultures in distant lands. Only Native American cultures were considered foreign enough to warrant scholarly attention. Other than Melville Herskovits (1941) and W. Lloyd Warner (1941), few American anthropologists took any scholarly interest in the cultures of other American ethnic groups. Yet most of the African Americans entering anthropology conducted research either in this country or the Caribbean. In the late 1920s, the African-American anthropologist Zora Neale HURSTON, a student of Franz Boas, the Columbia University professor who challenged the prevailing notions of inferiority within the anthropological profession, collected and later published a collection of southern black folklore in *Mules and Men* (1935). A decade later, after completing research on a white New England community, W. Lloyd Warner directed a similar research project on a small southern Mississippi town. The fieldworkers for this research project consisted of one African American, Allison Davis, and a white husband-and-wife team, Burleigh and Mary Gardner. While untrained in anthropology, Davis's wife contributed significantly to the team's research efforts, which lasted for a year and a half and resulted in the pathbreaking study of African-American ethnography *Deep South* (1940).

Despite these early pioneers, of the ten credentialed anthropologists of African descent at the close of World War II, most had earned their undergraduate degrees at white colleges, among them John

Wesley Gilbert, Allison Davis, Katherine DUNHAM, Arthur FAUSET, and Eslanda ROBESON. St. Clair DRAKE, Laurence Foster, and Zora Neal Hurston attended historically black colleges. Drake graduated from Hampton; Foster was an alumni of Lincoln; and Hurston graduated from Howard, though she obtained her master's degree at Barnard College in New York. Since most African Americans prior to the 1950s received their formal education at black institutions, which rarely offered courses in anthropology, few were exposed to the discipline.

It was difficult for African Americans with advanced training in anthropology to obtain employment outside black universities, and even in that setting suitable positions were often lacking. While Irene Diggs, Lawrence Foster, and Montague COBB spent their careers as faculty at black colleges, this was not the case for most of the others. For instance, Eslanda Robeson became a correspondent at the United Nations and business manager for her husband, Paul ROBESON. Unable to secure grant monies to support new research, Zora Neale Hurston turned her intellectual energy to prose and for a brief period was head of the drama department at a historically black college in North Carolina. Arthur Fauset, author of *Black Gods of the Metropolis* (1944), earned his living as a teacher in the Philadelphia public school system and wrote for various black newspapers and magazines. Katherine Dunham utilized her research on Haitian dance and ritual to launch a career in the field of ethnic dance. In 1967, Dunham became the director of the Performing Arts Training Center at Southern Illinois University.

At the close of World War II, of the ten African-American anthropologists only Drake and Davis were employed at white institutions of higher education. In the 1930s both had taught at Dillard, a black college in New Orleans. However, in the 1940s, after earning a doctorate in psychology at the University of Chicago, Davis joined the faculty in the education department at the same institution, where he did vitally important work, disposing once and for all the notion of black intellectual inferiority.

In the same decade, Drake joined the social science faculty at Roosevelt University in Chicago. During this time he coauthored *The Black Metropolis* (1945), an ethnographic account of southern migrant communities of Chicago. During the 1950s, Drake taught at the University of Ghana and served as a special adviser to that country's first president, Kwame Nkrumah. In 1963, he joined the anthropology faculty at Stanford University and later retired as professor emeritus.

Beginning with Elliott Skinner's research on a traditional African political system, *The Mossi of Upper Volta* in 1964, a growing number of African Americans conducted significant studies. While Vera Green conducted research in India and John Gwaltney conducted research in Mexico, most African Americans went to Africa to carry out fieldwork. A few of the notable studies of this period include Gibbs's study of the Kpelle moot system; Bond's examination of political change in Zambia; and Shack's research on the relationship between agricultural production and social organization of an Ethiopian society. While Eslanda Robeson had been the first African-American anthropologist to conduct research in Africa, the ethnographic value of her work was limited because she had not conducted an extended period of fieldwork in any one society. African-American anthropologists of the 1960s conducted fieldwork for periods of twelve months and longer. This research conducted by African-American anthropologists helped to erode some of the myths and misconceptions regarding African societies and cultures.

By the 1970s, African-American anthropologists began to turn their attention to African-American culture. Carol Stack's research on kin networks among lower-class extended families demonstrates the viability of certain "dysfunctional" elements of these families. Equally insightful is Melvin Williams's study of the rites, symbols, and strictures of an urban Pentecostal community. John Gwaltney began collecting the oral narratives for *Drylongso* (1980), a volume which gave African Americans an opportunity to present their worldview without the "imposition" of the researcher's interpretations. Gwaltney has come closest to achieving what his fellow African-American colleague, Delmos Jones, suggests is missing in anthropological studies: the native's voice and knowledge of culture.

Also during the 1970s there was renewed interest in African retentions in the culture of the African diaspora. Sheila Walker studied African-based religions in Brazil; Van Sertima presented controversial evidence to support the contention that there was pre-Columbian contact between Africans and Native Americans; and Sudarkasa tried to demonstrate African origins of certain customs and values associated with African-American family life.

African Americans have also contributed to gender studies within anthropology. Two widely cited works are Leith Mullings's research on the role of African women in the precolonial and colonial societies and Johnnetta Cole's research on Cuban women.

Most African Americans in the discipline are concentrated in social and cultural anthropology. However, Montague Cobb specialized in physical anthropology and published over a hundred scholarly articles while a member of Howard's medical and anthropology faculties. In 1969, he was elected president of the Society of Physical Anthropology.

Throughout his career, Cobb was often a visiting professor at major research institutions.

During the 1980s there was an unfortunate decline in the number of African Americans enrolling not only in graduate anthropology but in graduate programs of any type. This is directly linked to the reduction in federal and state funds for higher education. In addition to the cutback in government funds, the shortage in the number of available teaching positions in anthropology has also influenced the career choices of African Americans. In order to continue to attract students, anthropology departments have begun to teach more courses in applied anthropology. The hope is that anthropologists, as has been the case with other social scientists, will seek positions with government and social agencies, or even in business. Those anthropologists who remain in the academy are increasingly found on the faculty of interdisciplinary programs such as ethnic or gender studies, or are affiliated with medical schools or education departments. In 1988 the American Anthropology Association founded a committee to promote the teaching of the subject in historically black colleges. Johnnetta Cole, president of SPELMAN COLLEGE, was its first president.

The Association of Black Anthropologists recognizes and works to preserve the tradition that African-American anthropologists pioneered—the combining of scholarship and activism. Prior to the founding of this learned society in 1970, there existed a strong commitment among African-American anthropologists to challenge oppression; to dispel stereotypes and myths regarding Africans and other people of color; to utilize anthropology to improve the quality of society; and to foster appreciation for non-Western cultures. In *African Journey* (1946), Robeson condemned colonial rule in Africa and wrote of the oppression it created. Foster, in *The Functions of a Graduate School in a Democratic Society* (1936), outlined how education could be employed in the struggle against racism in a democracy. Both Hurston and Dunham understood the importance of studying the artistic expressions of Africans in the DIASPORA and their work helped to foster respect and appreciation for the cultural genius of people who were generally perceived as backward. Cobb was a champion of improved health care for African Americans and understood the importance of the relationship between culture and affliction long before the existence of the subfield of medical anthropology. This tradition of combining scholarship and activism has made many African Americans pioneers in the field of applied anthropology as well as significant contributors to the efforts of a cadre of scholars who strive to place humanitarian concerns at the forefront of the discipline.

See also ANTHROPOLOGY for a discussion of the field of anthropology as it relates to the study of African-American culture and history.

REFERENCES

BOND, GEORGE C. *Politics of Change in a Zambian Community*. Chicago, 1976.
COLE, JOHNNETTA B. "Women in Cuba: The Revolution Within a Revolution." In Beverly Lindsay, ed. *Comparative Perspectives of Third World Women*. New York, 1980.
DAVIS, ALLISON. *Deep South: A Social Anthropological Study of Caste and Class*. Chicago, 1941.
———. *Social Class Influences Upon Learning*. Chicago, 1947.
DRAKE, ST. CLAIR, and HORACE CAYTON. *Black Metropolis*. New York, 1945.
DUNHAM, KATHERINE. *Dances of Haiti*. Los Angeles, 1983.
FAUSET, ARTHUR H. *Black Gods of the Metropolis*. Philadelphia, 1944.
FOSTER, LAURENCE. *The Functions of a Graduate School in a Democratic Society*. New York, 1936.
GIBBS, JAMES L. *Peoples of Africa*. New York, 1965.
GWALTNEY, JOHN LANGSTON. *Drylongso: A Self-Portrait of Black America*. New York, 1980.
HERSKOVITS, MELVILLE. *The Myth of the Negro Past*. New York, 1941.
HURSTON, ZORA NEALE. *Mules and Men*. Philadelphia, 1935.
MULLINGS, LEITH. "Women and Economic Change in Africa." In Nancy J. Hafkin and Edna G. Bay, eds. *Women in Africa*. Stanford, Calif., 1976.
ROBESON, ESLANDA. *African Journey*. New York, 1946.
SHACK, WILLIAM. *The Gurage*. London, 1966.
SKINNER, ELLIOTT. *The Mossi of Upper Volta*. Stanford, Calif., 1964.
VAN SERTIMA, IVAN. *They Came Before Columbus*. New York, 1977.
WILLIAMS, MELVIN D. *Community in a Black Penecostal Community*, Carbondale, Ill., 1974.

NANCY J. FAIRLEY

Anthropology. Anthropology is the discipline that studies human biological and cultural similarities and differences throughout time and space. Culture, an essential concept to the work of anthropologists, refers to a system of shared beliefs, values, customs, behaviors, and all other products of the human world and thought typical of a population or community that are transmitted from one generation to the next through learning. Anthropology has numerous specializations and research interests subdivided into four major subdisciplines: (1) sociocultural anthropology, which includes both the descriptive study of

a particular culture (ethnography) and a generalizing, theoretical study of cultural patterns in several cultures (ethnology); (2) biological or physical anthropology, which studies the evolution of the human species and the physical variations that exist from population to population within the human species; (3) archaeology, which studies human activities and behavior through the examination of material remains most often recovered from site excavations; and (4) linguistics, which studies the origin and evolution of language, the structure of languages, and the relationship between language and social relations.

Anthropologists studying African Americans are generally concerned with three questions: Are there cultural differences between black and white Americans? If so, what are these differences? Which factors account for the differences? Anthropologists have addressed these questions in various ways: The first anthropologists accepted racist dogma and explained differences between blacks and whites as part of innate biological process. In the first half of the twentieth century, Franz Boas, founder of the Columbia University anthropology department in 1899 and an early champion of antiracism in anthropology, led his students away from racist theories by asserting the separation of race and culture and dismissing notions that black people were inherently inferior. Later anthropologists debated whether or not African-American ways of life resulted from a historically and culturally distinct heritage or from a historical process of economic, social, and political disfranchisement—or a combination of both processes.

Despite the pioneering efforts of Boas and others in dispelling racism within the social sciences, anthropologists conducted few cultural studies of black communities in the United States prior to the BLACK STUDIES movement in the 1960s, for several related reasons: First, American anthropology has, since its beginnings, focused on the study of Native Americans, seeking to collect, record, and preserve information on their rapidly vanishing cultures while assisting the U.S. government in administrating an Indian policy. Second, anthropological thought developed from a preoccupation with understanding "primitives"—non-Western, nonindustrial societies—that were conceived of and interpreted as bounded, isolated, self-contained entities. Although a few anthropologists studied industrialized societies, including the United States, mainstream American culture or American ethnics (other than Native Americans) offered little to interest most anthropologists. Not until the rise of conceptual frameworks capable of analyzing complex, plural societies in the mid-1950s did anthropologists investigate modern American culture with increasing frequency. Third,

the integrationist belief that black Americans had fully assimilated into mainstream American culture made African Americans unlikely subjects for the discipline's focus upon non-Western society.

Since the 1960s, the anthropological study of African Americans in the United States has started to receive the attention that it deserves. Today each subdiscipline of anthropology has a research specialization that examines African-American life.

From Scientific Racism to Antiracism

During the 1890s, when anthropology emerged as an academic discipline and profession, most of its practitioners supported racist ideologies that characterized Africans and people of African descent as inherently inferior to Europeans. Armed with Darwinian principles of evolution and later with Mendelian genetics, the forebears of American anthropology—Lewis Henry Morgan (1818–1881) and Maj. John Wesley Powell (1834–1902) in ethnology, Alex Hrdlicka (1869–1943) in biological anthropology, and William Henry Holmes (1846–1933) in archaeology—believed race and culture constituted a single unit and proposed evolutionary schema that ranked cultures according to physical type. Within this racial hierarchy, Nordic Europeans (Anglo-Saxons) and their descendants in the United States occupied the highest levels while black people occupied the lowest levels, suggesting that a single, progressive line toward an ideal European type existed. Proponents of these race theories, known as unilinear evolutionists, accepted white supremacy and justified the social, political, and economic inequities in American society as the consequence of biologically determined phenomena. Such racist ideas made African Americans very suspicious of the new field and its intentions.

Franz Boas (1858–1942) posed the only formidable challenge to the unilinear evolutionists inside the discipline. The Boasian, or historical particularist, school in anthropology maintained that, as historical, accidental accretions, cultures should only be evaluated within their own terms rather than from an outside perspective. This antiracist approach to anthropology, applauded by black intellectuals, including W. E. B. DU BOIS, met with tremendous opposition from evolutionary anthropologists, who sought to discredit Boas and successfully limited his impact and that of his students on professional organizations, government-sponsored science programs, and philanthropic foundations through the 1920s.

However, in part because of political developments in Europe, sentiments began to shift toward antievolutionary, antiracist anthropology in the 1930s with growing antifascist, labor, and civil rights movements. The racist supremacist ideology of Nazi

Group portrait taken in front of the Institute on Contemporary Africa, Northwestern University, 1951. (Photographs and Prints Division, Schomburg Center for Research in Black Culture, The New York Public Library, Astor, Lenox and Tilden Foundations)

Germany brought public opposition against the scientific premise upon which that ideology was based. As a consequence, Boasian anthropology gained wide acceptance, and the American Anthropological Association adopted a resolution against scientific racism in 1938. Ruth Benedict (1887–1948), a Boasian who played a major role in spreading his views on anthropology, won the respect of black Americans with her publications *Race: Science and Politics* (1940) and *The Races of Mankind* (1943) that dispelled scientific race theories. Antiracist anthropology became an important weapon in the court cases culminating in the 1954 U.S. Supreme Court decision BROWN V. BOARD OF EDUCATION, outlawing segregation on the basis of race in public schools.

Although Boasian anthropologists led the fight against racism within the discipline and influenced others outside the discipline, they placed greater emphasis on cultural studies of American Indians than African Americans. Some Boasian folklorists, such as Zora Neale HURSTON and Elsie Clews Parsons, anthropologists trained under Boas, collected folklore from black communities, but they neither examined black life as a whole nor were interested in the social organization of any of these communities. With the exception of Melville Herskovits, the Boasians apparently did not concern themselves with the study of African-American life because in their struggle

against the evolutionists, they held that the culture of black Americans was essentially the same as that of white Americans. At the time, most black and white liberal scholars of other disciplines shared this view and subscribed to the catastrophist position in African-American history—the belief that all vestiges of African culture were destroyed during the SLAVE TRADE and subsequent enslavement. The idea that black Americans were culturally deprived and did not participate in a historically distinct ethnic culture dominated the scholarship of African-American life until studies emerged that could argue persuasively against it.

The Culturalists and the Social Structuralists

Two divergent approaches to the anthropological study of African-American life arose in the 1930s and still persist today in modified forms: The culturalists emphasized the analysis of African elements to explain the origin and development of African-American cultural traditions; the social structuralists emphasized the analysis of socioeconomic factors to explain the structure of African-American life.

Melville Herskovits is generally considered the pioneer of the culturalist school. Like other Boasians, he initially accepted the catastrophist stance and the belief that black and white Americans shared an identical culture. His ideas changed when he observed

striking similarities in the customs and practices of Africans and African Americans while conducting fieldwork in the Americas (Haiti, Brazil, Suriname, Trinidad) and in West Africa. In *The Myth of the Negro Past* (1941), Herskovits set out to prove the existence of a distinct African-American cultural tradition that had resulted from an African heritage. Scholars both inside and outside anthropology attacked the book shortly after it was published as a misguided exaggeration. The criticism received from black sociologist E. Franklin FRAZIER has generated a great deal of scholarly attention, but the attacks directed toward Herskovits from within the ranks of anthropology greatly inhibited the anthropological study of African Americans for close to three decades.

The most severe criticism among anthropologists came from social anthropologists trained in the British functionalist tradition. Bronislaw Malinowski (1884–1942) and A. R. Radcliffe-Brown (1881–1955) led the functionalist school, and through their prominent disciples—E. E. Evans-Pritchard, Raymond Firth, Meyer Fortes, and others—functionalism dominated anthropological thought from the late 1930s to the mid-1960s. The functionalist school—including the social structuralists, who were also known as the structural-functionalists—rejected the historical particularism of the Boasians in favor of the synchronic problem-oriented research that permitted comparison between cultures and the formulation of general laws. They examined how social structures—kinship, economic, political, religious, or other systems—work to maintain the whole of the culture under study. Functionalists with field training in African ethnology challenged Herskovits not only on conceptual and methodological grounds, but also because of his field methods and the particulars of African ethnography as well.

One of the most important functionalist critiques of Herskovits came from M. G. Smith, who first conducted fieldwork in AFRICA and later in the Caribbean. In his *Plural Society of the British West Indies* (1965), Smith identified three major weaknesses in Herskovits' analysis: the use of imprecise and often ambiguous concepts like "Africanism" that could be equally applied to the pure retention of African traits as well as to the reinterpretation of African culture; the lack of specific evidence for the provenance of many cultural traits; the failure to consider the impact of social conditions occurring since emancipation on the survival or modification of African culture in America.

These valid criticisms contributed to the controversial nature of Herskovits' work and rendered the study of African Americans unpopular among anthropologists. The few who chose to study African

(Left) Willie L. Baber, assistant professor of anthropology, Purdue University, and (right) St. Clair Drake, keynote speaker at a symposium held at Purdue University, March 1985. (Photographs and Prints Division, Schomburg Center for Research in Black Culture, The New York Public Library, Astor, Lenox and Tilden Foundations)

Americans did so under questions or topics where race relations, plantation America, or cultural pluralism formed the organizing principles of the study, and such studies almost always focused on Latin America or the Caribbean. Others continuing in the culturalist tradition also selected African-American communities in the Caribbean or Latin America, where African influences were more obvious and their cultural provenance was better documented than in North America. These followers of Herskovits discarded and refined aspects of his methodology, but kept alive his postulate that an African heritage played a critical role in the development of African-American culture. In the United States, anthropologists more or less abandoned the study of African-American culture until the 1960s.

Around the same time Herskovits was developing his ideas on African survival based upon his fieldwork in Brazil, Haiti, and Suriname, a handful of social structuralists chose to study black communities in the southern United States. These studies constitute some of the first ethnographies that examined modern communities in the United States and include John Dollard's *Caste and Class in a Southern Town* (1937), Hortense Powdermaker's *After Freedom: A Cultural Study in the Deep South* (1939), and W. Allison DAVIS, Burleigh Gardner, and Mary Gardner's *Deep South: A Social Anthropological Study of Caste and Class* (1941). Of these, *Deep South* contained theoretical concepts that influenced later stu-

dents of southern life, particularly leaders of the civil rights movements in the 1950s and '60s.

Allison Davis, the senior author of *Deep South* and one of the few black anthropologists at the time, developed the analytical framework for the study with his major professor W. Lloyd Warner, a white anthropologist based at Harvard. They proposed the use of a caste-class concept for studying southern life in which race formed the basis for two castes—one black and the other white. Within each caste a class structure existed that formed a subculture whereby everyone learned the behavior appropriate to his or her class at an early age. In *Deep South*, the caste-class analysis was applied to understand the social relations in Natchez, Miss. The significance of this study was twofold: First, it showed how the economic and social systems were interconnected and worked to the disadvantage of blacks; and second, by demonstrating the relationship of learned behavior to race relations, it dismissed widespread beliefs that race prejudice was either an inherited or a merely psychological condition.

St. Clair DRAKE, a black student of Davis and a research assistant on the *Deep South* project, conducted the first anthropological study in a large metropolitan area in the United States. In a collaboration with sociologist Horace Clayton, *Black Metropolis: A Study of Negro Life in a Northern City* (1945), Drake refined the caste-class model of Warner and Davis by unraveling the complex social stratification in CHICAGO, both within and outside the predominantly black ghetto. This pioneer study of urban African Americans became one of the most frequently cited books on U.S. race relations for at least two decades after its publication.

The caste-class paradigm (as was the case of Allison's and Drake's work in general) had a greater impact in sociology than in anthropology, but the concept lost its popularity when sociological studies of race relations became more oriented toward policymaking in the 1950s. Similarly, anthropologists began to discredit functionalism by the mid-1960s because its ahistorical framework often produced a faulty construct that ignored other factors in the formation of social relations. Additionally, functionalism failed to address a major methodological question: How can one prove that a certain pattern of behavior serves to maintain a system of which it is a part? Sociocultural anthropologists eventually supplanted functionalism with new modes of analysis—political-economy, structuralism, and critical theory. Despite the limitations of the functionalist analysis that characterized the work of Warner, Davis, and Drake, anthropologists rediscovered them in the 1970s and 1980s, and many considered them to be pioneers of urban anthropology.

The Emergence of African-American Anthropology

The civil rights movement of the 1960s and the establishment of black studies programs revitalized anthropological interest in African Americans in several ways: First, anthropologists increasingly directed their attention toward the study of black communities in the United States. Second, in addition to sociocultural anthropology, the other subfields of anthropology initiated research on African-American life, having previously conducted little or no study in this area. Third, a significant number of black students entered the field of anthropology, creating for the first time a voice that could potentially influence the direction of this research. By the mid-1970s, anthropological research on black Americans was often referred to as "Afro-American anthropology."

The new generation of African Americanists reformulated the culturalist and social structuralist frameworks advanced in the 1930s with fresh ideas that were applied to newly collected data. The culturalist school broadened Herskovits' exclusive focus on African continuities to examine more closely the formation of African-American culture within diverse contexts. African-American culture was seen not just as the result of an African heritage, but the shared experience of enslavement, emancipation, poverty, and racism. The culturalist argument—that African Americans formed a culturally distinct group with its own heritage—finally received wide acceptance, particularly as a growing number of scholars outside of anthropology presented historical evidence that documented many aspects of this cultural tradition.

The social structuralist school continued to explain how social and economic variables affected the organization of African-American communities, but more consideration was given to understanding the historical processes that affected that structure. Borrowing upon the work of St. Clair Drake and others, Norman Whitten and John F. Szwed, in 1970, proposed three concepts for understanding the social organization of African Americans: exclusion from direct access to capital resources, subsequent economic marginality, and an adaptation to marginality.

Black life in the urban ghettos of the United States provided the testing ground for both 1960s approaches. Ghetto ethnographies within the culturalist tradition, such as Roger Abrahams' *Deep Down in the Jungle* (1963) and Charles Keil's *Urban Blues* (1966), interpreted black language, folklore, music, and performance, while ethnographies using socioeconomic models—for example, Elliot Liebow's *Talley's Corner* (1967), Ulf Hannerz's *Soulside* (1969), or David

Schulz's *Coming Up Black* (1969)—examined black family organization, community networks, and street life. Although all of these are important contributions to the urban ethnography of black Americans, critics like Vera Green, a black anthropologist, attacked ghetto ethnographies for concentrating solely upon the poorest and most dependent segments of black communities while ignoring middle and working class segments who also lived in those neighborhoods. In *All Our Kin: Strategies for Survival in a Black Community* (1974), Carol Stack, a ghetto ethnographer, criticized many studies of black urban life for reinforcing popular stereotypes of lower class blacks, and for failing to recognize black people's interpretations of their own behavior and culture.

In an effort to counteract the negative images these studies generated, anthropologists seeking a "native anthropology"—cultural studies that reflect the perspectives of those being studied—engaged members of the respective community in the research project by incorporating their input within both the analytical and writing phases of the research. Works such as Bettlou Valentine's *Hustling and Other Hard Work: Life Styles in the Ghetto* (1978) and John Gwaltney's *Drylongso: A Self-Portrait of Black America* (1980) utilized this approach. This more egalitarian framework for conducting ethnographic research, however, has been slow to gain wide acceptance.

Linguistics research in black English was second to ghetto ethnology in emerging from the political developments of the 1960s. Prior to that time, Lorenzo D. Turner's *Africanisms in the Gullah Dialect* (1949) was the only major work on black English in the United States to challenge the pervasive belief that all forms of black English were deviant and substandard. Turner established the African origins of the Gullah dialect, an English CREOLE language spoken by some black communities along the coastal areas of SOUTH CAROLINA and GEORGIA. Since Turner's pioneering work, studies of black English have proliferated and fall within two major categories: historical investigations of black English and studies of contemporary black speech. Studies of both types support the existence of black vernacular English in the United States; however, research in this field has been controversial.

The primary historical argument concerned the two hypotheses for the foundation of BLACK ENGLISH VERNACULAR: The *creolist* position stressed the African roots of black English and the *dialectologist* position stressed the dominance of English. This debate became highly politicized, with the creolist position gaining popular acceptance during the 1960s and early 1970s. More recent findings suggest that both arguments are overstated, but aspects of both theories

more likely represent the realistic linguistic origins and evolution of black vernacular English.

The controversies surrounding contemporary studies of black English address several questions: Should children whose first language is black English be taught standard English? How should standard English be taught to speakers of black English? With an oral language, is it possible to produce accurate written grammars of black English? Should studies of black English also include black speakers of standard English? These questions reflect ongoing debates in linguistic studies that have had a significant impact on educational policies.

Perhaps the most significant contribution directly attributed to anthropological studies of black English has been the examination of various speech acts that are unique to African Americans. Often as a part of ghetto ethnographies, these studies analyze the social context of verbal confrontations primarily among young black males. Works in this category include: Roger Abrahams' *Deep Down in the Jungle* (1963), Edith Folb's *Running Down Some Lines* (1980), William Labov's *Language in the Inner City* (1972), and Geneva Smitherman's *Talkin and Testifyin* (1977). Most studies have focused upon poor communities, but a few have also examined middle-class communities such as Michael Bell's *The World From Brown's Lounge: An Ethnography of Black Middle-Class Play* (1983). Though controversial, research in African-American English has produced considerable information on the origin, structure, and social context of the language that was virtually unexplored before the advent of black studies.

Of all the subdisciplines, biological anthropology has maintained a continuous research interest in African Americans dating from the nineteenth century. As the discipline evolved, its focus on race and race differences shifted to a focus on human biological and ecological adaptation. Biological anthropological studies of African Americans examine the effect of biological, environmental, and sociocultural conditions upon the health, fertility, morbidity, and mortality of black populations.

The explosion in the 1970s and 1980s of historical studies on slave health and nutrition heightened interest in the biological anthropology of African Americans. This renewed interest in African Americans contributed to the shaping of African-American biohistory—the cross-disciplinary study of health assessments in African-American populations within a historical context. Through the analysis of skeletal remains recovered from archaeological investigations, biological anthropology provides more direct evidence than historical studies utilizing written records on the biological factors affecting a population's health. Nutrition intake, metabolism, genetics,

aging, hormonal interactions, biomechanical stress, diet, type and levels of activity, as well as a subject's reproductive history, all affect the human skeleton. Analysis of African-American skeletal populations has produced information on specific health conditions in a population, as well as information on the broad interpretation of diet, physical stress, and disease (Rankin-Hill 1990).

The highly publicized investigations of the African Burial Ground in lower Manhattan—the largest investigation of a slave cemetery dating from the eighteenth century and yielding more than 400 individuals in 1991–1993—brought national attention to the controversial issues surrounding the excavation of burials and conducting skeletal biological analysis on a minority community other than Native Americans. (Native-American communities protested such studies for decades and succeeded in getting legislation passed in 1990 that protects their grave sites from archaeological study.) Archaeologists generally avoid, whenever possible, excavating burials, because of legal, religious, and moral considerations, but unmarked cemeteries are sometimes inadvertently uncovered or intentionally excavated when subject to land redevelopment, as was the case at the African Burial Ground. The public reaction against the investigations of the African Burial Ground may well impact the availability of human remains for future biohistorical studies of African Americans.

Archaeology was the last subfield to establish a specialization geared toward the study of African-American life, but once established it grew rapidly. As with the other subfields, the political movements of the 1960s served as a momentum for initiating this research; however, its growth is primarily related to the passage of historic preservation laws in the mid-1960s and early 1970s that ensured the investigation of many endangered sites. Few African-American sites have been studied as part of academic research programs; most sites—abandoned slave quarters, tenant farms, black towns, and neighborhoods—were excavated only when land redevelopment projects that were supported by public funds threatened to destroy them.

African-American archaeology examines through the study of tangible materials the ethnic culture of African Americans and addresses questions concerning cultural interaction, racism, social inequality, or power relations. Most of this research has been undertaken on former plantations at the sites once occupied by enslaved or freed laborers. Plantation archaeology has produced a sizable literature that laid the foundation for African-American archaeology and continues to set the direction for most of it. Studies specifically applicable to the examination of African-American life can be grouped into three categories: first, studies focusing upon the material lives of enslaved people—for example, William Kelso's *Kingsmill Plantations, 1619–1800: Archaeology and Country Life* (1984) and Theresa Singleton's edited collection, *The Archaeology of Slavery and Plantation Life* (1985); second, studies of plantation social structure and class relationships—John Otto's *Cannon's Point Plantation, 1794–1860: Living Conditions and Status Patterns in the Old South* (1984) and Charles Orser, Jr.'s *The Material Basis of the Postbellum Tenant Plantation*; third, studies that attempt to elucidate how

A skeleton exhumed from the African Burial Ground in lower Manhattan. The discovery of the burial ground in 1991 has brought unprecedented attention to bear on the presence of blacks in early New York City. (© Chester Higgins Jr.)

Africans and their descendants created a distinctive culture in response to enslavement—Douglas Armstrong's *The Old Village and the Great House* (1990) and Leland Ferguson's *Uncommon Ground: The Archaeology of Early African America 1650–1800* (1992).

Numerous sites not associated with plantations have also been investigated, and these vary widely. They range from communities of unknown black settlers to the former homes of well-known individuals including Benjamin BANNEKER, Frederick DOUGLASS, and W. E. B. Du Bois. In the United States, these sites date from the eighteenth-century Spanish frontier outpost of Gracia Real Santa Teresa de Mose just north of Saint Augustine, Fla., to the twentieth-century planned towns of Allensworth, Calif., and Buxtown, Iowa. Unfortunately, much of this research is still in the preliminary stages and has not been subject to reviews and syntheses such as plantation archaeology. However, such sites provide important insights into understanding African-American life beyond the plantation.

By far the greatest boost to the anthropology of African Americans that resulted from the black studies movement was a substantial increase in the number of African Americans who entered the field. Throughout its history, anthropology has attracted few black students, and fewer than two dozen African Americans completed graduate degrees in anthropology prior to 1970. By the early 1990s, the number of black anthropologists was estimated to be more than 300, slightly over 2 percent of the 15,000 anthropologists in the United States. The overwhelming majority are specialists in sociocultural anthropology, followed by experts in linguistics, biological anthropology, and archaeology. Archaeology and biological anthropology have the fewest African-American practitioners (between fifteen and twenty in the two subfields combined).

Most black anthropologists have undertaken research on either African or African-American communities, and because of this, their work has contributed to the shaping of African-American anthropology. The establishment of the Association of Black Anthropologists (ABA) in 1970 provided a vehicle for black anthropologists to critique Eurocentric approaches in anthropology and to offer alternative perspectives for explaining conditions resulting in social inequalities based on race, ethnicity, class, and gender. The ABA was founded to encourage a more critical anthropology of black people worldwide. It actively supports the development of research that involves the people studied and local scholars in all stages of research.

The anthropological study of African Americans as a cultural group began in the 1930s and has made considerable gains in the past several decades, but a great deal remains to be done to develop a rigorous

African-American anthropology that can potentially make a difference both in the scholarship of African-American life and in its application to contemporary problems. Only when anthropology is effectively restructured and develops analytical frameworks informed by those being studied and that seeks to empower them can an African-American anthropology emerge that is socially and politically responsible.

See also ANTHROPOLOGISTS for a discussion of the role played by African-American anthropologists in the history and development of the discipline.

REFERENCES

BAUGH, JOHN. "A Survey of Afro-American English." *Annual Review of Anthropology* 12 (1983): 335–354.

BLAKEY, MICHAEL L. "Skull Doctors: Intrinsic Social and Political Bias in the History of American Physical Anthropology with Special Reference to the Work of Alex Hrdlicka." *Critique of Anthropology* 7 (1987): 7–35.

CERRONI-LONG, E. L. "Benign Neglect? Anthropology and the Study of Blacks in the United States." *Journal of Black Studies* 17 (1987): 238–249.

DRAKE, ST. CLAIR. "Anthropology and the Black Experience." *Black Scholar* (September–October 1980): 2–31.

———. "In the Mirror of Black Scholarship: W. Allison Davis and *Deep South*." In *Harvard Educational Review* Monograph No. 2 ("Education and Black Struggle: Notes from the Colonized World") (1974): 42–54.

EISENSTADT, SHMUEL N. "Functional Analysis in Anthropology and Sociology: An Interpretative Essay." *Annual Review of Anthropology* 19 (1990): 243–260.

GREEN, VERA. "The Confrontation of Diversity Within the Black Community." *Human Organization* 29 (1970): 267–272.

HANNERZ, ULF. "Research in the Black Ghetto: A Review of the Sixties." *Journal of Asian and African Studies* 9 (April and June 1974): 139–159 (Special issue "Discovering Afro-America," ed. Roger D. Abrahams and John Szwed).

HARRISON, FAYE V. "Anthropology as an Agent of Transformation: Introductory Comments and Queries." In Faye V. Harrison, ed. *Decolonizing Anthropology: Moving Further Toward an Anthropology of Liberation*. Washington, D.C., n.d., pp. 1–14.

———. "Introduction to an African Diaspora Perspective for Urban Anthropology." *Urban Anthropology* 17 (1988): 111–141 (Special issue "Black Folks in Cities Here and There: Changing Patterns of Domination and Response," ed. F. Harrison).

HINSLEY, CURTIS M. *Scientists and Savages*. Washington, D.C., 1981.

JOYNER, CHARLES. *Introduction to Drums and Shadows: Survival Studies Among the Georgia Coastal Negroes*. 1940. Reprint. Athens, Ga., 1986.

MINTZ, SIDNEY. "Introduction." In Melville Herskovits, *Myth of the Negro Past*. 1941. Reprint. Boston, 1990.

RANKIN-HILL, LESLEY. *Afro-American Biohistory: Theoretical and Methodological Consideration*. Ann Arbor, Mich., 1990.

SANJEK, ROGER. "Urban Anthropology in the 1980s: A World View." *Annual Review of Anthropology* 19 (1990): 151–186.

SINGLETON, THERESA. "The Archaeology of Slave Life." In Edward D. C. Campbell with Kym Rice, eds. *Before Freedom Came: African-American Life in the Antebellum South*. Charlottesville, Va., 1991, pp. 155–175.

SPINDLER, GEORGE D., and LOUISE SPINDLER. "Anthropologists View American Culture." *Annual Review of Anthropology* 12 (1983): 49–78.

STOCKING, GEORGE W. *Race, Culture, and Evolution: Essays in the History of Anthropology*. New York, 1968.

WHITTEN, NORMAL E., and JOHN F. SZWED, eds. *Afro-American Anthropology*. New York, 1970.

THERESA A. SINGLETON

Anti-Abolitionism. Investigation has shown there were more incidents of rioting and mob violence in America during the 1830s than any other decade prior to the Civil War, most of these occurring between 1834 and 1836. Nearly half these mob actions involved attacks on abolitionists at a time when northern abolitionism was making its first concerted effort to win converts to its cause.

Several factors explain this dramatic increase in anti-abolition activity. One clear influence was the failure of the AMERICAN COLONIZATION SOCIETY's effort to free slaves and send them back to Africa. This, combined with a rising tide of "negrophobia," caused growing concern among many who had come to the conclusion that the colonization plan offered the best way to rid the nation of its entire black population. At the same time, many in the North were becoming opposed to what they viewed as a massive effort by abolitionists to bring about the assimilation of free blacks into northern society.

Attempts such as that made by Prudence Crandall in Canterbury, Conn., in 1834 to establish a school for both black and white young women, increased concern that children's minds were being poisoned by the abolitionists and led to mob action that resulted in the Quaker woman being forced to give up her school. Also, such efforts conjured up fears of "amalgamation" which, according to many minds, meant intermarriage and a sexual blending of the races, a thought that infuriated whites all across the North.

Another concern dealt with issues related to social control, resulting in a growing fear that the abolitionists were attempting to turn society upside down, leading to a loss of both the power and status held by the established leaders in the community. Jacksonian democracy contributed to these fears by convincing many that the age of the common man had come and that now the unwashed, untutored masses were on the verge of taking control away from those who viewed themselves, particularly in old Federalist strongholds of the Northeast, as the ones most capable of governing.

Ironically, the Jacksonians and the abolitionists had little in common, but both aroused like-minded fears among the leadership class that as a group they were about to be cast out. Added to this were the unrealistic assumptions regarding the growing size and power of the abolitionist movement, notions fed by dramatic technological advances that decreased significantly the cost of printing antislavery newspapers and pamphlets. This, together with a drop in postal charges, suddenly allowed the various abolitionist groups to print and distribute thousands more pieces of antislavery propaganda than ever before, leading to the inaccurate conclusion that there had been a rapid and dangerous increase in their numbers.

As a result, fears intensified, particularly among the leadership class whom Boston abolitionist William Lloyd Garrison labeled the "gentlemen of property and standing." Here the editor of *The Liberator* was referring to the angry group that in October 1835, in one of the most famous of the many anti-abolition mob actions of the time, had seized him, dragged him through the streets of Boston with a rope around his waist and, according to Garrison, planned to hang him. Actually, the Garrison incident possessed ingredients common to much of the anti-abolition mob activity of the 1830s. Such actions were not only often carefully planned in advance, but also their most violent aspects were personally carried out by so-called pillars of the community who saw abolitionism as a threat against their power which had to be destroyed.

Another aspect of the Garrison incident also had broad repercussions. Garrison happened to be attending a meeting of female abolitionists where the scheduled speaker was George Thompson, one of the best known of the English abolitionists who traveled about the United States preaching on behalf of antislavery. Although most Americans no longer possessed the hatred of England common during the era of the revolution, it was easy to rekindle among the many who despised abolitionism and saw people like Thompson as dangerous incendiaries bent on destroying the American nation.

Also needing to be considered among the causes of anti-abolition mob violence were continuing north-

ern and southern differences over the tariff which many in both regions wanted to see resolved amicably. But the slavery controversy made the situation all the more explosive. As a result, the numerous acts of violence aimed at the abolitionists become easier to explain, if not condone, and are a negative part of what, while often perceived as being powerful, was actually a weak and often unsuccessful effort to end slavery in the United States based on arguments related to the institution's immorality.

REFERENCE

RICHARDS, LEONARD L. *"Gentlemen of Property and Standing": Anti-Abolition Mobs in Jacksonian America.* New York, 1970.

DONALD M. JACOBS

Anti-Apartheid Movement (Divestment Movement).

The African-American struggle against segregation and apartheid in South Africa has a long history. In 1912 the NAACP played a role in the formation of the African National Congress (ANC), which opposed violence and sought to end racial discrimination through a legal strategy. In the 1920s, Marcus GARVEY expressed his solidarity with black South Africans and assured them that an army of black Americans would arrive on the shores of Africa to liberate them. The American Committee on Africa (ACOA) was formed in 1953 to coordinate United States activities with the South African liberation movement, which was challenging the oppressive 1948 apartheid laws.

After the Sharpeville Massacre in 1960, when South African police killed sixty-seven people who were opposing laws designed to enforce residential segregation and control the movement of black people, the solidarity movement in the United States gained national recognition and popular support. In the mid-1960s, students, religious leaders, and civil rights activists condemned the brutal policies of the South African government and demanded an end to United States bank loans to South Africa. The CONGRESS OF RACIAL EQUALITY, STUDENT NONVIOLENT COORDINATING COMMITTEE, NAACP, and Students for a Democratic Society led demonstrations and sit-ins, and passed resolutions demanding that the United States cut all ties to South Africa. The Rev. Dr. Martin Luther KING, Jr., linked racism to the foreign policy of the United States when he argued that "the racist government of South Africa is virtually made possible by the economic policies of the United States and Great Britain."

Protests at Princeton University and the University of Wisconsin in 1968 and Cornell University in 1969 brought out hundreds of students who demanded that their universities divest from Chase Manhattan Bank and other corporations doing business in South Africa. Church groups around the country presented stockholder resolutions calling for divestment and voted to close accounts with banks doing business with South Africa. In 1972 the National Council of Churches examined the social impact of corporate behavior on black South Africans. Although these protests raised public awareness about apartheid, they were less successful at forcing companies to withdraw support from South Africa. In 1963 the United States Congress also responded to the repressive policies of the South African government and complied with a United Nations resolution for a voluntary ban on arms sales and related equipment to South Africa.

In 1976 student members of the Black Consciousness Movement in South Africa, which was inspired partly by the BLACK POWER MOVEMENT in the United States, took to the streets of Soweto to protest their segregated educational system. Protestors were met by police fire and the following year Steve Biko, a political leader, was murdered while in police custody. In response, hundreds of protests occurred across the United States, and over 700 students were arrested. TransAfrica, an African and Caribbean lobbying organization, was formed in 1977; Randall ROBINSON, an anti-apartheid activist, was chosen as its head. The organization grew out of a meeting of the CONGRESSIONAL BLACK CAUCUS, where concern was expressed about the lack of African-American influence in United States foreign policy.

Divestment was the central tactic adopted by anti-apartheid protestors, who sought an end to United States governmental and corporate support for South Africa. Critics of divestment contended that American firms must continue to do business in South Africa in order to use their economic muscle to force a change in apartheid policies. They argued that withdrawing would only hurt black South Africans by depriving them of jobs and other benefits.

In 1977, the Rev. Leon SULLIVAN, a prominent African-American activist, developed a voluntary code of conduct for firms operating in South Africa. The Sullivan Principles, as the code of conduct was popularly known, included measures to train and promote black South Africans, increase wages and fringe benefits, and recognize black labor unions. By the mid-1980s, 135 companies had signed onto the Sullivan Principles, and used them to defend their presence in South Africa. It was becoming increasingly clear, however, that the new policy was having minimal influence on moderating apartheid.

Press conference held near the South African Embassy, November 29, 1984, prior to arrests. (© Rick Reinhard/ Black Star)

In 1984 another South African uprising and the ongoing repressive policies of the white government reinvigorated the solidarity movement in the United States, and this time the movement won some concrete concessions. On Thanksgiving Eve in 1984, Randall Robinson and other prominent activists began a daily vigil in front of the South African embassy in Washington, D.C. The vigil, which lasted over fifty-three weeks, raised awareness about the evils of apartheid and expressed opposition to Ronald Reagan's policy of constructive engagement. This policy pursued friendly relations with South Africa as a means of inducing the government to relax apartheid restrictions. The protest sparked similar actions across the country and Great Britain and led to the arrest of over six thousand people, including twenty-three elected representatives.

On college campuses, students formed multiracial anti-apartheid organizations and demanded an end to their universities' involvement with companies doing business in South Africa. In 1985 at the University of California at Berkeley over 7,000 students attended a public hearing on divestment and were supported by union members and faculty. Students elsewhere held teach-ins, blockaded buildings, and built shanties to pressure universities to divest. At Yale University in 1986, 1,500 students demonstrated after the university destroyed a shanty built by anti-apartheid activists. Through their tenacious and militant protests, students were able to win some important victories. Five months after a three-week sit-in at Columbia University in 1985, the university trustees divested. In 1986 Harvard University voted for total divestment and the University of California voted to divest $3.1 billion of its stock in companies doing business with South Africa. In the same year, Congress passed the Comprehensive Anti-Apartheid Act over Ronald Reagan's veto, which banned new public and private loans and investments, the importation of certain South Africa products, including steel and uranium, and the export of certain U.S. products to South Africa, including petroleum and computers. In 1987 Sullivan rejected his own principles and joined the call for a complete corporate pullout.

Because of intensified protests, including national boycotts, corporations began to respond to calls for divestment. In 1984, 406 United States companies operated in South Africa. By 1989, only 130 remained. Corporations played a clever public relations game by announcing their withdrawal and giving few

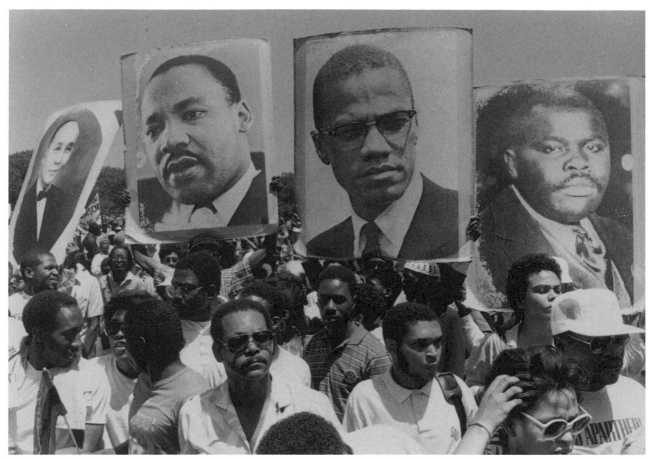

Anti-apartheid rally in Central Park, New York City, June 14, 1986. Depicted on the posters (from left to right) are Elijah Muhammad, Martin Luther King, Jr., Malcolm X, and Marcus Garvey. (© Mel Rosenthal, Impact Visuals)

details about how it would occur. In most cases withdrawal was not complete or straightforward. Companies created subsidiaries, continued to market their products and still provided management and technical skills. The anti-apartheid movement, which had focused so much of its attention on divestment, found it difficult to sustain mass protests in the face of verbal compliance by multinationals. A media blackout of events in South Africa further hindered anti-apartheid organizing and contributed to a decline of the movement in the United States.

Nevertheless, the international movement had helped create a climate that made political and economic support for apartheid less acceptable, and this, in conjunction with continued protests by South Africans, led to the release of Nelson Mandela in 1990 and the beginning of South African President F. W. de Klerk's effort to dismantle the legal apparatus of apartheid the next year. In 1991, George Bush lifted most federal sanctions against South Africa, even though many activists opposed this move until more progress had been made toward achieving a free and democratic state. Most local sanctions remained until

Mandela called for their removal two years later. In 1994, after several years of negotiation and compromise by the white government and the African National Congress, South Africa held its first nonracial elections and Nelson Mandela was elected the first black president.

REFERENCES

HAUCK, DAVID. *Two Decades of Debate: The Controversy Over U.S. Companies in South Africa.* Washington, D.C., 1983.

KIBBE, JENNIFER. *Leaving South Africa: The Impact of U.S. Corporate Disinvestment.* Washington, D.C., 1988.

WIENER, JON. "Students, Stocks, and Shanties." *Nation* (October 11, 1986): 337–40.

ALBERT NICKERSON

Antiquity. It is impossible, in a relatively short space, to cover the vast and controversial prehistory of humanity since its origins in Africa hundreds of

thousands of years ago. Therefore this article will start with the beginnings of agriculture there within the past 20,000 years.

Origins of Agriculture in Africa

Experts agree that agriculture—the cultivation of crops and the domestication of animals—began independently in many different places. There were two major centers or "hearths" in America, one in Southeast Asia, and others. Two important hearths were in AFRICA. The first of these was in the savanna south of the Sahara, where a number of different sorghums and millets were domesticated. Specimens of these have been found dating to around 7000 B.C.E., and domestication may well have begun earlier (Wendorf et al. 1992).

The other acknowledged African hearth is Ethiopia. There other sorghums—as well as grains such as teff and noog, still grown there—were first cultivated. Most scholars maintain that nontropical crops like wheat, barley, and chickpeas were first domesticated in Southwest Asia around 9000 B.C.E. and spread from there to Egypt and the rest of North Africa some twenty-five hundred years later. However, two new discoveries have led a number of specialists to reconsider this hypothesis. the first of these is that during the Ice Age, between fourteen thousand and twelve thousand years before the present, when the climate of southern Egypt was similar to that we now call "Mediterranean," there was a sharp increase in the amount of barley and other grains being harvested and consumed. This does not necessarily mean that they were also being planted, but it seems very likely (Hassan 1980, pp. 437–438). The second discovery is that of the extraordinary variety of types of barley found in Ethiopia, indicating that it has been cultivated there for an extremely long time.

The two new pieces of evidence suggest three possibilities: that barley and wheat were domesticated independently in Ethiopia and Syria; that the cultivation began in Ethiopia and diffused to Southwest Asia; the third and most likely scenario, that toward the end of the Ice Age, inhabitants of the Nile Valley were in fact cultivating barley and other nontropical grains above the first cataract (cataracts are series of rapids and waterfalls that are impossible to traverse by boat). As the climate became hotter and wetter, this cultivation moved north along the Nile to Southwest Asia and up the mountains into Ethiopia (Doggett 1989, p. 33). After two thousand or three thousand years, when the climate of the lower Nile Valley became drier and more temperate, the cereals were reintroduced from Southwest Asia to Egypt and northern Sudan, where they competed successfully with the tropical crops developed in the savanna south of the Sahara.

Although domesticated sheep or goats have been found in southern Egypt from the sixth millennium B.C.E., it seems likely that they were first domesticated in Southwest Asia. Cattle, on the other hand, appear to have been domesticated in both Africa and Southwest Asia (Grigson 1991). Thus, most if not all of the early bases of African agriculture were indigenous.

The Nile Valley 3500–500 B.C.E.

African history, as opposed to African prehistory, begins with the Egyptian records after the upper Egyptian unification of Egypt around 3400 B.C. (Bernal 1991, pp. 207–211). For two hundred years before then, however, there is evidence of a sophisticated state in Nubia—between the second and first cataracts of the Nile. Royal tombs found along the riverbank, now under Lake Nasser, indicate the existence of a rich stratified society and the fact that symbols of royalty such as the hawk on a *serech,* or palace facade, and the white crown later used by Egyptian pharaohs were already in use there. The local pottery shows that the culture was Nubian, not Egyptian, but pots and other objects found in the tombs indicate a pattern of trade stretching from the Kordofan Mountains in what is now south central Sudan to the Levant (now Syria) and Palestine (Williams 1980). The Nubian wealth appears to have come from cultivation along the river banks and herding and hunting in the Acacia desert scrub that existed then, where there is now desert. It is also possible that Nubians were already trading in gold, which was abundant in the region.

Sometime later, another state emerged in Upper Egypt: along the Nile from the first cataract to the mouth of the delta. The physical type of this population was similar to that of Nubia, then and today, and is classified as belonging to the "Saharo-tropical" variant range, which includes both "elongated African," of the type identified with the present Fulani or "Nilotic Negro" seen today in the southern Sudan, and broad or "Negro" physiognomies (Keita 1990).

It is probable that the Nubian language of the time was related to that of Upper Egypt. This belonged to the Afro-Asiatic linguistic super-family, which includes the Semitic and Berber language families, the Cushitic languages of East Africa, and the Chaddic languages to the west, including Hausa. One possible territory in which the super-family could have arisen is in the Upper Nile in what is now southern Sudan, where languages of another African family are now spoken. A more likely original home is in southern Ethiopia, where there is the densest concentration of Afro-Asiatic families and individual languages and from which the African members of the family could have fanned out. It is conventionally

supposed that the Semitic languages now spoken in Ethiopia arrived there from southern Arabia. However, an increasing number of linguists now see the Semitic family as having arisen in Ethiopia and spread from there to Southwest Asia (Murtonen 1967).

Like Nubia, Upper Egypt was a society in which the ruler played a pivotal part, not only as a leader in war but as a producer of agricultural wealth, magically by ensuring good floods of the river and practically by organizing irrigation. He also played a central role in the distribution of bread and beer, the staples of Egyptian life. The greater size and economic potential of Upper Egypt not only gave it the edge in competition with Nubia but enabled its king Menes to conquer Lower Egypt in the Nile Delta and unify the whole country around 3400 B.C.E.

Although Egyptian rulers were always symbolically and actually aware of the distinction between the two halves of Egypt and of the tensions between them, for most of the next three thousand years they were able to maintain unity for the whole country and achieve a record of stability, prosperity, and cultural creativity that—with the possible exception of China—is unsurpassed in human history.

Lower Egypt was inhabited by northern Africans of the "Mediterranean" type found in the coastal Maghreb, but with unification of Egypt there was an immediate mixing of population types among the elites and a slower one among the people as a whole. Even today there is a definite cline or slope from south to north, with the appearance of the population tending toward that of Southwest Asia. This tendency has intensified with the many infiltrations and invasions from Southwest Asia that have taken place over the past five thousand years. These seem to have begun even before the unification of 3400 B.C.E., and traces of settlements from Syria at this time have been found in the Delta. As stated above, there was trading contact between the Levant and Nubia and presumably Upper Egypt in the first half of the fourth millennium.

Cultural influences from Syria and Mesopotamia increased after unification, as exemplified by some of the artistic styles of the first two dynasties. It is also possible that the concept of writing was introduced to the Nile Delta from Southwest Asia at this time. However, the fundamental differences between Mesopotamian cuneiform and Egyptian hieroglyphs and the fact that many ancient symbols from Nubia and Predynastic Egypt were incorporated in later Egyptian script indicates that even if the idea of a visual representation of speech came from outside, the form of Egyptian writing was entirely local. Similarly, the centralized kingdoms of the middle Nile Valley are totally unlike the city states found in Mesopotamia and Syria at the same time, and the pharaonic system would seem to be a completely indigenous development.

Egyptian culture was consolidated at the beginning of the Third Dynasty, around 3000 B.C.E. The following five hundred years of the Old Kingdom were those in which nearly all of the pyramids were built and Egyptian architecture, mathematics, and art were raised to a high level. From the beginning, Egyptian culture was extremely analytical. Butchery of animals and the dissection and separation of organs necessary for mummification—a tradition of Saharan origin not found in Southwest Asia—is paralleled by the central myth of the murder, dismemberment, and reassembly of Osiris, the god of fertility, rebirth, and immorality. In hieroglyphics, fractions could be written as the different strokes that made up the sign for the "eye of Horus," said to have been torn apart by the wicked god Seth and restored by Thoth, god of wisdom and calculation. This analytical tradition of distinguishing the different parts and functions of the whole remained important in Egyptian culture and played a significant role in the development of Greek medicine and science (see Bernal 1992).

Although the political unity and prosperity of the Old Kingdom was destroyed by the anarchy of the First Intermediate Period after 2500 B.C.E., its high culture survived and continued to develop during the Middle Kingdom (2100–1800 B.C.E.) and New Kingdom (1570–1070 B.C.E.). During these peaks of wealth and centralized authority, Egypt frequently extended its military power to the north over Syria and its political influence much further, to include parts of what are now Turkey and Greece. To the south, Egyptian control sometimes reached up the Nile as far as the fourth cataract, just 150 miles north of modern Khartoum.

Nevertheless, Nubian culture did not disappear. In the Old Kingdom, Egypt conquered lower Nubia to the second cataract, but when it collapsed around 2500 B.C.E., a new form of Nubian culture emerged. During the Middle Kingdom, Egyptians established a series of forts at the second cataract unparalleled in the ancient and medieval worlds (Adams 1984, pp. 175–188). Their enormous scale testifies not only to Egyptian wealth and power at the time but also to the importance with which Egypt considered Nubia. Scholars debate as to whether the forts were mere assertions of grandeur or had practical defensive value. If the latter were the case, it would demonstrate that the Nubians of the time were extremely powerful and well organized. Another possibility is that the forts—none of which is far from the river—were built to protect trade from the south. These suggestions are not mutually exclusive, but the last would seem to be the most important. The signifi-

cance of this trade is shown graphically by Egyptian tomb paintings of the import of tropical goods and gold from the south.

Trade also seems to have been an important factor in the growth of a kingdom at Kerma, just above the third cataract. This kingdom may also have been part of the threat against which the Egyptian forts were constructed. Kerma became still more powerful after the collapse of the Middle Kingdom and the invasion of Egypt from Syria by the barbaric Hyksos. Royal tombs at Kerman contain the largest number of human sacrifices around the deceased ruler found by archaeologists anywhere in the world. This indicates the existence of a powerful central authority. Excavations in the 1980s showed that there was also a large fortified city containing houses built of stone, mud brick, or wood, dating from before 2000 B.C.E. and lasting for several centuries (Connah 1987, pp. 39–40). There is no doubt that there were Egyptian influences in the architecture and material culture of Kerma. Nevertheless, it was clearly an indigenous civilization, which collapsed only with the conquests up to the fourth cataract, of the Egyptian New Kingdom in the sixteenth century, B.C.E.

With the climatic deterioration between 4000 and 1500 B.C.E., lower Nubia eventually became almost uninhabitable below the second cataract. However, by the ninth century B.C.E. a new form of Nubian culture had arisen at Napata above the third cataract. This state dominated the Nile Valley as far south as the modern Khartoum. Although completely independent politically, Napata was heavily Egyptianized. Its rulers saw themselves as pharaohs, used Egyptian hieroglyphs for inscriptions, and worshipped Egyptian gods, especially Amon, who was generally associated with the south in Egyptian religion. In the decade following 730 B.C.E., Pi'ankhy, the ruler of Napata, sailed and marched down the Nile into Egypt, which was in chaos with local disorder compounded by increasing Assyrian interference from the north. Pi'ankhy died after several battles but his brother Shabaka went on to conquer the whole country in 715 B.C.E. The Nubian pharaohs were outstanding for their generosity and their piety to the Egyptian gods. After seventy years, they were driven out of Egypt and retired to Napata, where the state survived in Upper Nubia, until the fifth century B.C.E., when it was replaced by that of Meroë, still further up the Nile.

Other Regions of Africa Before 500 B.C.E.

The Nile Valley has been far more extensively excavated than other parts of the continent. Thus, it is much less easy to tell the extent of urbanization and state formation elsewhere. Traces of agriculture and pottery from before 8000 B.C.E. have been found in the Sahara. By 2000 B.C.E. the cultivation of tropical African crops had spread across the savanna south of the Sahara and beyond, possibly as far as South Africa (Davies 1975). By this time, sorghum had also been taken overseas to become—with rice—the staple of South Indian agriculture (Doggett 1989, pp. 43–45). The spread of agriculture in Africa does not mean that hunters and gatherers disappeared; in fact, they continued to occupy large territories in the continent until the last few centuries.

The beautiful rock paintings of the central Sahara illustrate the life of pastoralists or "Bovidians" of the Southern Saharan-Sudanese tradition for thousands of years as it moved up toward the wetter mountains to escape climatic deterioration. The paintings illustrate a mixed population consisting of some North African types but predominantly of black peoples of the Fulani or elongated African type. The extremely dark, tall, thin Haratîn are still found in some Saharan oases. In the middle of the second millennium B.C.E. the style of paintings changed and became stiffer and more concerned with horses and chariots than with cattle. The new chariot riders appear to have been the ancestors of the nomadic Berber-speaking Tuaregs, who came to dominate the native agriculturists. However, as we shall see, Saharan blacks came to play a significant role in chariot warfare.

Further west, in what is now inland Mauritania, the Saharan-Sudanese Neolithic tradition, based on agriculture, has left traces of many stone-built villages and towns from between 1500 and 1100 B.C.E. (Munson 1976). After 1100 B.C.E. the villages were fortified and in more defensible positions. After 850 B.C.E. there was a definite deterioration of the culture, which has been interpreted as the result of attacks by Berber speakers from the north, who possessed both chariots and bronze. Since then, until today, this zone has been contested between the predominantly black and Negroid local population and the newcomers. It was from this region that much later, in the fourth century C.E., the Soninke (Niger Kordofanian) -speaking kingdom of Ghana arose.

There is no archaeological evidence of urban life in the forests of West Africa before 500 B.C.E. However, given the availability of wood, fibers, and leaves for construction and tools and the heavy rainfall, the chances for preservation of remnants are very low. The possibility of urbanization and technical sophistication, as well as cultural influences from the Nile around 1000 B.C.E., is suggested by the significant though controversial evidence of West Africans in prominent positions and by Nilotic cultural features in the Olmec civilization of Central Mexico (Van Sertima 1992).

There are two other nonarchaeological indicators of very early cultural sophistication in Africa. These

are the Tifineh alphabet, still used by Tuaregs in the Southern Sahara, and the Ethiopic alphabet, the basis of the Amharic alphabet used in Ethiopia and Eritrea today. Both of these derive from an alphabet in use in the Levant in the Late Bronze Age and contain archaic features indicating arrival in Africa before 1200 B.C.E. (Bernal 1990, p. 51). Thus, during the second half of the second millennium B.C.E., both the northern African societies invading and infiltrating the Sahara and the Ethiopian agriculturists contained literate individuals.

African Contacts with Southwest Asia and Europe, 3500–500 B.C.E.

Contacts between the Nile Valley and the Levant in the fourth millennium B.C.E. were referred to above. With the Egyptian unification, the relationship became unequal, with Egypt as the dominant partner. Contacts were made not only by land, over the Sinai peninsula, but also and more often by sea. Byblos, the oldest and greatest city on the Levantine coast, during the Bronze Age had a particularly close relationship with Egypt. During the Middle and New Kingdoms, Egypt controlled much of the Levant directly and had strong political influence over the rest. During these centuries, Egyptian culture and language had a substantial influence on the Semitic languages of the region, notably the West Semitic Canaanite, of which Hebrew and Phoenician were dialects. (The Semitic and Egyptian languages were already related as members of the Afro-Asiatic language family.) It is because of the heavy influence of Egypt on the Canaanites that Canaan was seen as a son of Ham (Egypt) and a brother of Cush (Nubia) in the Table of Nations in Genesis, chapter 10.

During the intermediate periods of disunity between the great Egyptian kingdoms, there were peaceful migrations and invasions by Semitic speakers and others from Syro-Palestine. The most famous of the latter were the Hyksos, who ruled Egypt from about 1730 to 1570 B.C.E. These led to later Egyptian culture being influenced by that of the Levant. Despite such interactions, fundamental differences remained between the African Egyptian irrigation farmers along the Nile and the nomads, rainfall farmers, and traders of Syro-Palestine.

Egypt, and to a lesser extent Libya, had a lengthy influence around the Aegean in what is now largely Greece. Predynastic Egyptian objects have been found in Crete, as well as objects and material indications of Egyptian influence dating from before the building of the great Cretan palaces around 2000 B.C.E. The architectural and bureaucratic structures of Crete were largely based on Southwest Asia and a Semitic language may well have been dominant there until the Greek conquest of the island around 1450

B.C.E. However, much of Cretan religion and art developed locally, while a great deal clearly derived from Egypt.

During the period of Hyksos domination of Syria and Lower Egypt, there appear to have been particularly close relationships around the eastern Mediterranean. It is possible that these were the result of conquests and settlements in the south Aegean by the Hyksos, who brought more Semitic and Egyptian culture to the region (Stubbings 1973; Bernal 1991, pp. 361–408). Strong indications of such influence have been found on pictures from this period (the seventeenth century B.C.E.) on the Aegean island of Thera, and Cretan influences have been found on murals in the Hyksos capital in the Nile Delta and in the Galilee.

Around 1570 B.C.E., Egyptian rulers from the south expelled the Hyksos and set up the Eighteenth Dynasty and the New Kingdom. With national unity, Egyptian power not only expanded south to the fourth cataract, but also to the north. Direct rule was established over much of Syro-Palestine and a sphere of diplomatic and political influence extended far beyond that. By 1400 B.C.E., Egypt's only serious rival was the Hittite Empire, based in what is now central Turkey. Contact was established with the enemies of the Hittites to their west in order to outflank them and to gain the products of the Aegean region, which, after the middle of the fifteenth century B.C.E., came under the overall domination of the Greek rulers of Mycenae in the northeast of the Peloponnese.

Tomb paintings from the Egyptian capital at Thebes show Aegean envoys and their servants bringing Cretan products and offering their submission to the pharaoh. Diplomatic correspondence from western Turkey to the pharaoh and religious reformer Akhenaten (1367–1350 B.C.E.) has been found. Furthermore, as the Egyptologist Donald Redford wrote recently: "There is no reason to doubt that the Egyptian court was at all times during the Mycenaean Age in correspondence with the court at Mycenae, although the letters have not as yet been recovered" (Redford 1992, pp. 242–243). Archaeological finds from this period provide the same picture. Many Egyptian and Levantine objects have been found around the Aegean and Mycenaean pottery in the Levant as well as in Egypt and Nubia (Cline 1987). Still more startling have been two shipwrecks from this period, excavated off the Turkish coast. Their cargoes, one of which is extremely rich, show considerable trade among Egypt, the Levant, and Cyprus and the Aegean (Bass 1987).

There is no doubt that the kingdoms of the Aegean were important players in the international system between 1450 and 1200 B.C.E. They exported metals,

pottery, finished metalwork, and probably cloth, wine, olive oil, honey, and slaves. We also know that Mycenaean mercenaries served in the Egyptian armies. Nevertheless, it is clear that Egypt was the dominant partner. Economically, it had a huge grain surplus and was a producer of linen and papyrus; it was also a conduit for gold and tropical products such as ebony and ivory. Politically, it had a strong centralized state extending far into Syria. Culturally, it was far in advance of Mycenaean Greece, with two thousand years of almost continuous religious and technical development behind it. Although there was clearly substantial Egyptian influence on Greece—directly or through Crete—before this time and for many centuries after, 1450 to 1200 B.C.E. was probably the period of Egypt's greatest direct impact on Greece (Bernal 1991, pp. 408–484).

There are a number of indications of the presence of Africans in Bronze Age Greece from 1650 to 1200 B.C.E. Among the paintings at Thera was one identified by the excavator as two African boys boxing. This interpretation has been challenged, but there is no doubt about other paintings of black Africans from the Bronze Age Aegean or about the six representations of Negroid Africans found from Bronze Age Cyprus (Karageorghis 1988, pp. 8–15). Documents found in Greece from the thirteenth century B.C.E. contain a significant number of West Semitic names, but also others, such as Aikuptiyo (the later Greek Aigyptios) and Misarayo (from the West Semitic Misry), both meaning "Egyptian." The names Kamayo and Kemeu may come from the Egyptian *km* or *kame* ("black") and Kmt or Kēme ("the black land or people," i.e., "Egypt"). It is generally acknowledged that the name Aitioq/po found on these tablets is the later Greek Aithiops, "Ethiopian" (Snowden 1970, p. 102).

"Aithiops" had a wide range of meanings. It was sometimes used to denote any people substantially darker than Greeks or Romans themselves. Homer, for instance, refers to two sets of "Ethiopians," one to the south and one to the east. The latter clearly indicates the dark Asian populations of Elam (in what is now Iran) and India. At the other end of the scale, the meaning of Aithiops was restricted to black Africans with Negroid features. In Roman times, the name Aegyptius became a synonym of Aithiops. Before then, it meant an inhabitant of Egypt, hence people of either dark Mediterranean or upper Egyptian Nilotic appearance. Thus, from the beginning there was an overlap between the Aithiops and Aigyptios, although the former generally denoted darker and more Negroid types.

One of the earliest Greek poems—now lost—was called *Aithiopis*. It was concerned with Memnon, king of the Ethiopians. Its date is uncertain, but the story of the "most beautiful," noble, and brave Ethiopian prince, who marched to Troy's rescue and died there heroically, was known by the earliest Greek poets whose works survive: Hesiod and Homer, who lived in the tenth or ninth centuries B.C.E. (Bernal 1987, pp. 86–88). There is some confusion as to whether Memnon was an Asian "Ethiopian" or an African one (Snowden 1970, pp. 151–152; Bernal 1991, pp. 258–260). The predominant tradition, however, linked him to Egypt and Nubia and the most plausible origin of his name is from Imn m ḥt, or Ammenemes II, the Twelfth Dynasty pharaoh, who campaigned far to the north of Egypt in the nineteenth century B.C.E. (Bernal 1991, pp. 267–268).

Memnon was not the only Ethiopian to play a prominent role in the Homeric epics. In the first book of the *Iliad*, Zeus goes with the other gods to feast with "the blameless Ethiopians" (I. 423–424). The *Odyssey* opens with Poseidon visiting them (I. 22–24). Thus, for Homer, and presumably other Greeks of his time, the Ethiopians were a particularly virtuous people with close associations with the gods. This, and Homer's knowledge of Pygmies (who lived in the land where cranes migrated in winter), shows that he had some sense of African geography (*Iliad* III. 5–7).

Homer had a great admiration for Egypt. He considered its capital Thebes the richest city imaginable; its medicines and magic were the most effective and its rulers the most just and generous in the world (*Iliad* IX. 382–386; XIX. 37–39; and *Odyssey* IV. 123–126; XIV. 282–286). The poet also saw Africans in Greece. Odysseus' herald Eurybates, who accompanied him on important missions, was described as having "black skin and woolly hair" (Snowden 1970, p. 102; Drake 1990, pp. 318–319). There was also a lord called *Aigyptios* on Odysseus' island, Ithaca. The modern scholar Frank Snowden has suggested that there may have been a special connection between Ithaca and Egypt (Snowden 1970, p. 102). This would seem unlikely, however, given the use of the name in Bronze Age texts. It is much more probable that Egyptians and other Africans were living in many places around the Aegean, both during the Bronze Age, which Homer depicted, and in his own time several centuries later. However, the poet's use of the name and description of Eurybates' physiognomy as remarkable indicate both that Egyptians and other Africans were familiar in Greece and that they were unusual there.

Africa 500 B.C.E.–500 C.E.

Around 400 B.C.E., the Napatan state declined and was replaced by one still further up the Nile at Meroë, just seventy miles north of Khartoum. Archae-

ologists have excavated a large city there with monuments and official buildings of stone and ordinary houses of brick. There are many inscriptions in hieroglyphics and in a special cursive alphabet developed from Egyptian writing for the Meroitic language. This has been deciphered, and historians have been able to establish a list of the kings and queens for the state's seven hundred years of history after the shift of the capital from Napata. Unfortunately, the Meroitic language is still undeciphered and the texts cannot be read (Adams 1984, pp. 294–332). Nevertheless, from Egyptian inscriptions, friezes illustrating royal triumphs, descriptions by Greek and Roman travelers, and archaeological finds it is possible to reconstruct aspects of Meroitic politics and society.

Royal power was based on pharaonic principles, and pyramids, of a distinctive type, and collossi were constructed. However, Meroitic queens, the "Candaces" of the Bible and Greek sources, were clearly more powerful than in Egypt. (It should be noted that in the first millennium B.C.E. the status of women in Egypt was itself far higher than in contemporary Syro-Palestine or Greece.) The Meroitic state extended well to the south of Khartoum and to the north as far as the Egyptian frontier under Greek or Roman rule. In the first century C.E., technological improvements allowed water to be raised for irrigation and lower Nubia to be cultivated once again. The state controlled over twelve hundred kilometers of the Nile Valley from above the sixth to well below the second cataract, some stretches of which were extremely fertile and productive. Thus, the economy of the Meroitic state had a firm agricultural basis. Cotton fabrics were produced in Nubia earlier than in Egypt. From these textiles and some of the art styles, it is clear that Meroë was in contact—presumably via the Red Sea—with India.

Most scholars believe that Nubia at this time was a "corridor" and gained great wealth from trade between Egypt and the Mediterranean and central Africa, and some have gone on to suggest that Nile Valley culture was diffused elsewhere in Africa from Napata and Meroë (Arkell 1961, p. 177). This has been denied in the recent academic trend towards isolationism (Connah 1987, pp. 64–66). However, some striking similarities require explanation. Amazing parallels between the rituals and objects of Egyptian and Nubian pharaohs and those of royalty from elsewhere in Africa have been noted by many scholars (Hoffman 1979, pp. 258–260). There are two explanations for this: that Nubia and Egypt drew from a wider African tradition, and that Nile Valley styles of kingship diffused elsewhere in the continent. The two explanations are not mutually exclusive. Indeed, it would seem likely that both processes took place. Nevertheless, some of the specifics are too close to be

explained simply as part of a general tradition and, given other cultural similarities between Nubia and distant parts of the continent, it is very likely that there was cultural diffusion from Napata and Meroë across the savanna at least as far as Nigeria during the first millennium B.C.E.

Merë was a major producer of iron. One scholar has even proposed that smelting iron "formed [its] economic basis" (Phillipson 1977, p. 88). The slag heaps outside the capital led another to describe it as "the Birmingham of ancient Africa" (Adams 1984, p. 301). It is generally believed that the process of forging iron was first developed in Anatolia, modern Turkey, in the second millennium B.C.E. However, it is likely that Egyptians were using terrestrial (nonmeteoric) iron by the period of the Old Kingdom, and there is no doubt that it was in use there in the New Kingdom, though never on such a large scale as in Nubia (Dunham and Young 1942). Nubian sandstone contains easily accessible iron ore, and given the shortage of tin, which is needed for bronze, the development of iron there is not surprising. Iron was being smelted not only at Meroë. By the ninth century B.C.E., it was being worked far to the south in Rwanda and Burundi. By Meroitic times, the metal was being smelted to the southwest of Lake Nyanza in Tanzania (Sinclair 1991, p. 200). The Nok culture of the Nigerian savanna that was later to produce such wonderful naturalistic sculpture was already working iron by 500 B.C.E. It is difficult to say whether this widespread occurrence in such a relatively short period was the result of independent invention or diffusion, and, if the latter, what the point of origin was. Despite the early working in Rwanda, before the emergence of the Napatan kingdom, the most likely candidate for origin is the Nile Valley. Given the major ironworks of Meroë, this state certainly had a significant influence in the spread of the metal's use.

The huge and rapid expansion of the Bantu language family appears to have begun by about 400 B.C.E. Linguistic evidence leaves no doubt that the family originated in the savanna of what is now Cameroon, and both linguistics and archaeology indicate that its success was the result of a superior iron technology. There is, however, so far no evidence for this in Cameroon. Thus, scholars postulate that Bantu-speaking agriculturists spread around the north of the rain forest of the Congo basin, to the Great Lakes region, where they encountered and learned new herding techniques and metallurgy from the Sudanic- and Cushitic-speakers there. Some of them migrated south and southwest, and began the process that eventually led to the occupation of virtually the whole of central and southern Africa. The patterns of Bantu migration and absorption of other peoples were undoubtedly extremely complex, and it

is unlikely that historians, linguists, and archaeologists will ever completely unravel them (Phillipson 1977, pp. 210–230). In any event, the Bantu expansion led to the later establishment of many large and successful states.

Meroë was destroyed in the fourteenth century C.E. by one or more of its neighbors, the tribes to the east and west and the Kingdom of Aksum, whose king Ezana boasted of having raided Meroë in the early fourth century. The Kingdom of Aksum, based in the Northern Highlands of Ethiopia, is claimed as the ancestor of the Ethiopian monarchy, which was abolished only in 1975. As mentioned above, the Ethiopian highlands had been one of the major African agricultural hearths and a very early recipient of barley and wheat. The introduction of the alphabet suggests that a society of some stratification and sophistication existed there before the emergence, early in the first millennium B.C.E., of the powerful and cultivated states across the Red Sea in South Arabia (present-day Yemen). It is also interesting to note that this early introduction fits with the strong Ethiopian tradition of relations between Ethiopia and Israel during the reign of King Solomon in the tenth century B.C.E., although many of the details of the tradition would seem to be mythical. There is also no doubt that there was a strong Jewish influence in Ethiopia well before the country became Christian in the fourth century C.E.

Archaeological discoveries have confirmed the traditional belief that there was a close relationship between Ethiopia and the South Arabian kingdoms. This does not mean, however, that the Semitic languages in Ethiopia came from Arabia. Nor were conquests always from Asia to Africa: In the sixth century C.E., for instance, Ethiopians conquered South Arabia. Almost a thousand years earlier, in the fifth and fourth centuries B.C.E., however, there is evidence of cultural influence from South Arabia to Ethiopia of such intensity as to suggest a conquest. Nevertheless, the culture always remained distinctively Ethiopian. Impressive temples were constructed, and bronze and iron were smelted. After the third century B.C.E., the civilization continued to develop more independently, and in the first century C.E. Aksum was established as a strong kingdom. It was referred to with respect in Greek and Roman sources, and there is archaeological evidence of grand monuments and huge fortified stone palaces (Connah 1987, pp. 74–83). Ezana, the best-known king of Aksum, left inscriptions recording his triumphs in the first quarter of the fourth century C.E. He raided the Nile Valley and declared Christianity the state religion of Aksum. Thus, Ethiopia was the second country to become officially Christian (Armenia had converted some twenty years earlier). Ezana also reformed the Ethiopian alphabet by introducing the use of diacritical marks, which are placed above consonantal letters to indicate the vowel that follows them. This principle was adopted from India and shows the extent of trade across the Indian Ocean at the time. As a literate, urbanized, and Christian state, Aksum survived for many centuries and provided a cultural basis for later Ethiopian religious and social structures, even after the capital moved to more productive climatic zones further south.

As the Sahara became drier, the coast and mountains of northwestern Africa were increasingly cut off from the rest of the continent. Their relationship with the Mediterranean world was enhanced by the establishment, after 1100 B.C.E., of a number of colonies from Phoenicia; these became integrated into a trading network that formed the first basis of the "slave society" that later became typical of the Greek and Roman worlds. Nevertheless, the Phoenicians of Carthage and the other cities of the northern coast of Africa had significant links with the native Berber-speaking peoples of the mountains and the Berbers and others who inhabited the Sahara and the savanna to its south.

A significant part of the population of Carthage at this time is described by physical anthropologists as Negroid, including members of the upper classes (Keita 1990, pp. 36–37). Thus, around 500 B.C.E. there was in Carthage, as in Egypt, Upper Nubia, and Ethiopia, a distinctive literate, urbanized civilization on the African continent.

Africans, Asians, and Europeans from 500 B.C.E. to 500 C.E.

Dislike or suspicion of peoples who look different from the physical norm or ideal type of population occurs in many societies. However, before 500 B.C.E. there is no evidence that Asians or Europeans disliked Africans for their skin color or physiognomy. On the contrary, there seems to have been a general admiration not merely for the cultural and moral achievements of Egyptians and Ethiopians, but also for their appearance. This favorable impression did not disappear immediately. Herodotus, the earliest Greek historian whose work is extant, wrote in the fifth century B.C.E. that the Ethiopians (by which he meant the Nubians of the Upper Nile) were "said to be the tallest and best-looking people in the world" (III. 20). By this time, however, a prejudice against both darkness of skin and Negroid physiognomy was growing around the Mediterranean World. In Egypt, black was the color of fertility, life, and immortality, in contrast to the sterile red of the desert. This contrasted with Greece, where there is no doubt that, at least as far back as Homer, blackness was associated with night and death as well as with the terrors that

these inspire. This is not a human universal. In many cultures white or pallor—the color of corpses—is the symbol of death. In early Greece, black also had some positive aspects. It was seen as the color of bravery and manliness, while white was that of effeminacy and lily-livered cowardice. The predominant association of blackness with evil began in Greece only in the fifth century B.C.E.

A similar shift took place in the Hebrew tradition. It is clear that there were people of African appearance in Ancient Israel. The name Pinchas comes from the Egyptian Pȝ Nḥs "The Nubian," and Simʿôn (Sim[e]on) may well come from Šmʾw "Upper Egyptian." This does not necessarily mean that the individuals so named were themselves black, but the names do indicate both that there had been people of this type in Israel and that they differed from the norm. In the Old Testament, the predominant color of sin is scarlet, a tradition preserved today in the color of the devil. In Israel, too, black had unfortunate associations. It was used to portray psychological as well as natural gloom, but black—and night as a relief from the heat of the day—also had positive connotations. Black was the color of the clouds that brought the precious rain, and the beautiful and erotic lover in the Song of Songs is called in both the Hebrew and Greek texts "black *and* beautiful" (Drake 1990, p. 307). White, too, had both negative and positive connotations. It was sometimes the color of purity, but also that of leprosy. In the labeling of people, the ambivalence at the level of abstraction was made more acute by the uncertainties involved in transposing an abstract color to human complexions.

By the time of the New Testament, at the beginning of our era, black had become the color and complexion of evil, and white that of purity and goodness (Drake 1990, pp. 4–5). The shift is symbolized by the fact that the Latin "Vulgate" translation of the Song of Songs changes the description of its heroine to "black *but* beautiful." It was in the last centuries B.C.E. that the long and unfortunate tradition began of people with dark skins being patronized by others, or excusing themselves with the argument that their souls are white.

The Biblical story of Noah's punishment of his son Ham by a curse on Ham's son Canaan had originally been used to justify the Israelites' extermination and enslavement of the Canaanites. In biblical interpretations written in the new atmosphere, the curse was transferred to Ham, the African, and took the form of "ugly" blackness and perpetual slavery (Drake 1990, pp. 15–23).

What caused this change of attitude? The standard explanation—that it was the first encounter between Mediterranean peoples and black Africans—does not hold, because of the evidence of substantial contact between the two groups during the Bronze Age and the period up to 500 B.C.E. There are two other explanations for the diminution of the positive connotations of blackness and the exaggeration of the negative ones at this time. The first is that Greeks began to dominate darker peoples of Southwest Asia and Egypt during these centuries and began to find complexion a useful marker and justification of rule; the second explanation is influence from Persia.

During the second millennium B.C.E. Indo-European-speaking invaders, calling themselves "Arya," invaded the older civilizations of Elam (in what is now Iran) and the Indus Valley. The "Aryans" were generally lighter in color than the natives, who seem to have resembled the south Indians of today. During these struggles, a cult of lightness, associated with the sun and the sky, grew up. The Hindu Vedas, or scriptures, contain violent images of the destruction of natives described as "darker," and are clear-cut in their preference for the invaders' own lighter skins, though black has continued to be valued in some respects in Indian culture (Drake 1990, p. 309). In Iran, these struggles became integrated into the Zoroastrian religion, which, like its later branch Manicheanism, sees the universe as in perpetual conflict between the forces of good and evil, or light and darkness.

In the sixth century B.C.E., Persia irrupted into the Mediterranean, conquering the Levant and Egypt as well as many Greek city-states. In Egypt, the emphasis on the value and moral superiority of lightness was useful both to the conquerors and to Greeks, who played an increasingly important role there even before the conquest by Alexander the Great and the establishment of the Macedonian or Greek Ptolemaic dynasty there around 300 B.C.E. This preference for the invaders and paler Lower Egyptians introduced a new sense of "race" to Egypt; resistance to the Persians and, later, to the Greeks involved a cultural "return" to the art of the great southern dynasties in Upper Egypt and an image of Nubia as a refuge (Drake 1990, pp. 259–265).

These new "racial" attitudes spread into Greece. Nevertheless, the prejudice against people of evident African descent that grew up at this time was qualitatively different from the "caste racism" found in the modern world as a direct result of European needs to justify the horrors of race-based slavery. In the modern form, the best black is seen as inferior to the worst white. This was never the case in classical Greece and imperial Rome. The presence of many Africans in these two societies is indicated by the large numbers of blacks in Greek and Roman art (Snowden 1970). Some were slaves, although most slaves of the period were Mediterranean or northern European. Some Africans were important free craftsmen. The best-known and most admired potter in

fifth-century Athens had the Egyptian name Amasis and was portrayed by a rival as a black African (Snowden 1970, pp. 16–17). Blacks were also admired and feared as warriors. The bulk of Hannibal's Carthaginian army that crossed the Alps and invaded Italy was African, and some were Negroid. The coin struck to pay the troops and symbolizing this army had a Negro head on one side and an elephant on the other (Snowden 1970, pp. 70–71).

This leads us to consider Greek and Roman relations with Africa beyond Egypt. The name "Africa" probably comes from the Afar people, who lived (and live) at the southern end of the Red Sea. In Roman times, however, "Africa" was used as a euphemism for the hated Carthage, in the territory we now call Tunisia. These northern Africans continued to play an important role in Roman history. The early Roman playwright Terence, a central figure in the formation of Latin drama, was surnamed Afer and was born in North Africa. The Roman imperial dynasty of the Severans, who ruled the Empire from 193 to 235 C.E., were originally Punic or Phoenician in culture and came from the coast of what is now Libya. A number of the most important Christian fathers of the church came from Northwestern Africa, the most important being St. Augustine of Hippo, the theological and philosophical founder of much of Roman Catholic church teaching.

The Roman provinces of northwestern Africa were conquered not only by the Carthaginians but by Berber tribes and the urbanized Berber kingdoms of the mountains to the south, who put up a ferocious resistance to the Roman legions, which were never able to establish themselves in the desert.

For the Romans and Greeks, there were three types of blacks. There were those who lived within the empire, who were generally, though not always, in the lower classes. Then there were the admired civilized and philosophical "Ethiopians," who were generally located in the Nubian state of Meroë. (The name "Ethiopia" has maintained this high status into the modern period.) The third type, the fierce nomadic "Ethiopians" of the desert from Egypt to the Atlantic, resisted Roman attacks and raided cities within the empire. From these and from black forces in the Roman legions, Africans gained a reputation for soldierly qualities. In Christian times, the patron saint of soldiers became St. Maurice, a soldier from Upper Egypt of the third century C.E., who was always portrayed as a Negro (Drake 1990, pp. 214–220).

Ptolemy, the mathematician and astronomer of the second century C.E., was also an Upper Egyptian, and known to Arab writers as a black (Bernal 1992, p. 606). Christian writers did not refer to his appear-

ance. Thus, despite the widespread fear and suspicion of blacks among western Europeans of the Middle Ages, the dominant figures or authorities in their theology, warfare, and science—St. Augustine, St. Maurice, and the learned Ptolemy—were Africans, and the last two were sometimes or often seen as blacks. The name "Maurice" was itself linked to blackness, as it appears to come from the Roman province of Mauritania, the present Morocco and Western Sahara, from which the later Latin Maurus, the English "Moor" and the Modern Greek mavros, "black," all come.

Another word with a somewhat similar history is "nigger." The Canaanite verb ngr means "to gush forth, flow, or vanish." In Hebrew, one finds the words niggarim and niggarôt as "torrents" or "streams." Throughout the Arabian and Saharan deserts there are ancient place-names of the Gerrha, Nagara, and Negra type. These derive from the Phoenician dialect of Canaanite and mean "oasis" or "river that flows into the desert." It is from the last that the name of the river Niger seems to have derived. Classical writers refer to a people called Nigretai, Nigretes or Negritai, who were Western Ethiopians or lived to the west of the Ethiopians. Together with their neighbors the Pharusai, they were described as having ridden across the desert on horses and chariots to raid and destroy three hundred Phoenician cities on the coast. The Roman writer Pliny (23–79 C.E.) believed they came from the Niger, but it seems more plausible to suggest that they came from the Saharan oases (Pliny, V. 43.). There is no doubt that they appeared black to the peoples of the coast.

It is not a coincidence that the best-known Latin word for "black" is niger. There is no common Indo-European root for "black," although niger has descendants in all the Romance languages—negro, nero, noir, etc.—there are no cognates to it in other Indo-European languages and its origin is unknown to orthodox lexicographers. In early Latin there were many words for the color, the commonest of these being ater, used for the dull black of shade or night, and niger. The meaning of niger was originally restricted to the brilliant black, with a violet tinge found in southern products such as ebony and opals. Although not used to describe people in the early period, this color fits exactly with the complexions of the Haratîn in the oases of the Sahara, and the Latin word niger would seem likely to derive from them as the Nigretai, Nigretes, or Negritai. Later niger displaced ater and the other terms to become the standard Latin term for "black." The fact that the Portuguese used their word for "black," negro, to describe the people they raided and enslaved on the African coast seems to be simply a coincidence. The negative connotations of "negro" and its deriva-

tive "nigger" in the era of race-based SLAVERY more than justify the distaste with which they are held today. Nevertheless, the terms have an honorable prehistory, showing once again the intricacy and intimacy of relations between Africa and Europe in antiquity.

REFERENCES

ADAMS, WILLIAM Y. *Nubia: Corridor to Africa.* Princeton, N. J., 1984.

ARKELL, ARTHUR, J. *A History of the Sudan from the Earliest Times to 1821.* 2nd ed. London, 1961.

BASS, GEORGE. "Oldest Known Shipwreck Reveals Splendors of the Bronze Age." *National Geographic* 172, no. 6 (1987): 693–733.

BERNAL, MARTIN G. "Animadversions on the Origins of Western Science." *Isis* 83, no. 4 (1992): 596–607.

———. *Black Athena: The Afroasiatic Roots of Classical Civilization. The Fabrication of Ancient Greece, 1785–1985.* New Brunswick, N.J., 1987.

———. *Black Athena: The Afroasiatic Roots of Classical Civilization. Vol. 2. The Archaeological and Documentary Evidence.* New Brunswick, N.J., 1991.

———. *Cadmean Letters: The Transmission of the Alphabet to the Aegean and Further West Before 1400 B.C.* Winona Lake, Wis., 1990.

CLINE, ERIC. "Amenhotep III and the Aegean: A Reassessment of Egypto-Aegean Relations in the 14th Century B.C." *Orientalia* 56 (1987): 1–36.

CONNAH, GRAHAM. *African Civilisations: Precolonial Cities and States in Tropical Africa: An Archaeological Perspective.* Cambridge, U.K., 1987.

DAVIES, OLIVER. "Excavations at Shongweni South Cave: The Oldest Evidence to Date of Cultigens in Southern Africa." *Annals of the Natal Museums* 22 (1975): 627–662.

DOGGETT, HUGH. "A Suggested History for Crops Common to Ethiopia and India." In L. Krzyaniak and M. Kobusiewicz, eds. *Late Prehistory of the Nile Valley and the Sahara.* Poznan, Poland, 1989, pp. 27–48.

DRAKE, ST. CLAIR. *Black Folk Here and There.* 2 vols. Los Angeles, 1987–1990.

DUNHAM, D., and W. J. YOUNG. "An Occurrence of Iron in the Fourth Dynasty." *Journal of Egyptian Archaeology* 28 (1942): 57–59.

GRIGSON, CAROLINE. "An African Origin for African Cattle?—Some Archaeological Evidence." *African Archaeological Review* 9 (1991): 119–144.

HASSAN, FEKRI, A. "Prehistoric settlements Along the Main Nile." In Martin A. J. Williams and Hugues Faure, eds. *The Sahara and the Nile: Quaternary Environments and Prehistoric Occupation in Northern Africa.* Rotterdam, 1980.

HOFFMAN, MICHAEL A. *Egypt Before the Pharaohs: The Prehistoric Foundations of Egyptian Civilization.* New York, 1979.

KARAGEORGHIS, V. *Blacks in Ancient Cypriot Art.* Houston, 1988, pp. 8–15.

KEITA, SHOMARKA. "Studies of Ancient Crania From Northern Africa." *American Journal of Physical Anthropology* 83 (1990): 35–48.

MUNSON, PATRICK J. "Archaeological Data on the Origins of Agriculture in the Southwestern Sahara and Their Implications for West Africa." In J. R. Harlan; J. M. J. de Wet, and A. D. B. Stemler, eds. *The Origins of African Plant Domestication.* The Hague, 1976, pp. 187–210.

MURTONEN, A. *Early Semitic: A Diachronical Inquiry into the Relationship of Ethiopic to the Other So-Called South-East Semitic Languages.* Leiden, 1967.

PHILLIPSON, D. W. *The Later Prehistory of Eastern and Southern Africa.* London, 1977.

POLLINGER-FOSTER, KAREN. "Snakes and Lions: A New Reading of the Frescoes from Thera." *Expedition* 30 (1987): 10–30.

REDFORD, DONALD, B. *Egypt, Canaan, and Israel in Ancient Times.* Princeton, N.J., 1992.

SINCLAIR, P. J. "Archaeology in Eastern Africa: An Overview of Current Chronological Issues." *Journal of African History* 32 (1991): 79–219.

SNOWDEN, FRANK M. *Blacks in Antiquity: Ethiopians in the Greco-Roman Experience.* Cambridge, Mass., 1970.

STUBBINGS, FRANK H. "The Rise of Mycenaean Civilisation." In *Cambridge Ancient History.* 3rd ed. Vol. 2. Pt. 1. 1973, pp. 627–658.

VAN SERTIMA, IVAN. "Evidence for an African Presence in Pre-Columbian America: An Address to the Smithsonian." In *African Presence in Early America.* Special issue of the *Journal of African Civilizations.* 1992, pp. 29–81.

WENDORF, F., A. CLOSE, R. SCHILD, K. WASYLIKOWA, R. A. HOUSLEY, J. A. HARLAN, and H. KROLIK. "Saharan Exploitation of Plants 8,000 B. P. *Nature* 359.6397 (October 22, 1992): 721–724.

WILLIAMS, BRUCE. "The Last Pharaohs of Nubia." *Archaeology* (1980): 12–19. Reprint. *Journal of African Civilizations* 4, no. 2 (1985): 38–52.

MARTIN G. BERNAL

Antoine, Caesar Carpetier (1836–1921), politician and publisher. A free Creole born and educated in New Orleans, Antoine was the son of a veteran of the War of 1812 and a West Indian–born daughter of an African chief. He attended private schools in New Orleans and then was employed as a barber, one of the few occupations open to African Americans in the antebellum South. When federal troops captured Louisiana in 1862, he organized an African-American outfit in the Union Army, the 7th Louisiana Colored Regiment, known as the Corps d'Afrique. After the war, Antoine moved to Caddo Parish, near Shreveport, Louisiana, but he remained active in New Orleans politics throughout his life. A delegate to the

Louisiana Constitutional Convention of 1867, he advocated an extensive bill of rights, tax reforms, and extension of the Freedmen's Bureau. As a state senator representing Caddo Parish from 1868 to 1872, Antoine led the fight for state support of African-American and integrated education, which Louisiana adopted during Reconstruction. In 1872, Antoine became one of the most powerful African-American politicians during Reconstruction when he was elected lieutenant governor of Louisiana. He held that office until 1877, when federal troops were withdrawn from Louisiana and the Republican state government toppled.

Antoine was also a successful businessman and one of the wealthiest African Americans in nineteenth-century Louisiana. From 1870 to 1872 Antoine was copublisher of the *New Orleans Louisianian,* a semiweekly newspaper. He invested in railroads, lotteries, and racehorses, and in 1880 served as president of the Cosmopolitan Life Insurance Company. Antoine also served as vice president of the *Comité des Citoyens* in New Orleans, a Creole antidiscrimination organization founded in 1890 which financed and organized the challenge to Jim Crow transportation laws in the 1896 *Plessy* v. *Ferguson* case. The committee's efforts failed when the Supreme Court upheld the legality of segregated public facilities. In his later years Antoine owned a small plantation in Caddo Parish and invested in urban real estate.

REFERENCES

BLASSINGAME, JOHN W. *Black New Orleans, 1860–1880.* Chicago, 1973.

LOGAN, RAYFORD W., and MICHAEL R. WINSTON, eds. *Dictionary of American Negro Biography.* New York, 1982.

SIMMONS, WILLIAM J. *Men of Mark: Eminent, Progressive, and Rising.* Cleveland, 1887.

MICHEL FABRE

Apollo Theater. The Apollo Theater has stood in the heart of Harlem, N.Y., as the single most important African-American theater for more than half a century, presenting major stars and launching the careers of previously unknown amateur musicians, dancers, and comics.

Located at 253 West 125th Street, the Apollo opened in 1913 as Hurtig and Seamon's Music Hall, presenting white vaudeville and burlesque theater to white audiences. As burlesque routines lost popularity and became incorporated into the downtown musical comedy revues, the theater was rechristened

the Apollo by Sidney Cohen, who bought it in 1933. The inaugural show, billed as "Jazz à la Carte" and held on January 26, 1934, featured a film and several types of acts, including the Benny CARTER Orchestra.

Under the direction of Frank Schiffman, the Apollo soon became famous for presenting top performers in lavish costumes on often exotic stage settings hosted by Ralph Cooper. The 1,600-seat auditorium hosted thirty shows each week, and was the site of regular live broadcasts on twenty-one radio stations across the country. The greatest jazz musicians of the era performed at the Apollo, including the Duke ELLINGTON Orchestra, Lionel HAMPTON's band, and Louis JORDAN. Perhaps the most famous of the Apollo's offerings was its Amateur Hour, held every Wednesday night from 11 P.M. until midnight, when the performances of seven or eight contestants would be judged by audience response. Those who failed to earn the audience's approval were booed off stage in mid-performance, but winners, including Ella FITZGERALD, Sarah VAUGHAN, and Pearl BAILEY, were sometimes rewarded with recording and performance contracts. The thrilling experience of concerts at the Apollo during this period is captured on a recording of jazz broadcasts made at the Apollo in the mid-1940s, *Live at the Apollo* (1985), including performances by the Count BASIE Orchestra, the Jimmie LUNCEFORD Orchestra, and Marjorie Cooper, a singer who failed to gain the amateur hour audience's approval.

With the demise of the Swing Era, many of New York's grand black theaters and nightclubs closed, but the Apollo remained popular by embracing the new sounds of rhythm and blues. By the mid-1950s, the Apollo regularly featured rhythm and blues revues, as well as gospel stars, and comedians such as Moms MABLEY and Pigmeat MARKHAM. With the ascendance of soul music in the 1960s, the theater presented sold-out runs by soul singers such as James BROWN, Sam COOKE, Jackie WILSON, and popular shows by Dionne WARWICK, the Jackson 5, Gladys KNIGHT, and Funkadelic. Brown's album *Live at the Apollo* (1963) captured not only one of the greatest performances by the "Godfather of Soul," but the extraordinary fervor that the discerning Apollo audience was capable of.

By the mid-1970s, black entertainers had gained access to better-paying stadium and arena venues, and the theater could no longer afford to draw top acts. The Apollo fell on hard times, presenting only a few dozen shows per year, and closed its doors in 1977. In 1981 an investment group headed by Percy SUTTON bought the theater out of bankruptcy for $225,000. Despite being declared a national historic landmark in 1983, the reinstatement of amateur hour

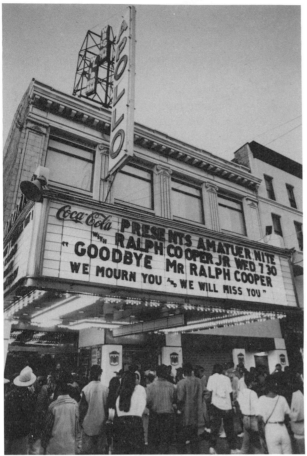

The marquee of the Apollo Theater in Harlem, N.Y., in 1992, acknowledging the passing of emcee Ralph Cooper, who had presided over the Apollo's amateur night competitions since their start in 1935. (AP/ Wide World Photos)

in 1985, and a guarantee of its mortgage by New York state, the theater failed to succeed. In 1988, the theater underwent a $20 million renovation, but it continued to lose money—$2 million a year until 1991, when it was taken over by a non-profit organization led by Leon Denmark and Congressman Charles Rangel. Since that time, the Apollo has led the revitalization of 125th Street by once again presenting both the stars and unknowns of black popular music, from B. B. KING to Luther Vandross, hip-hop, and rap shows.

REFERENCES

COOPER, RALPH, with Steve Dougherty. *Amateur Night at the Apollo.* New York, 1990.

FOX, TED. *Showtime at the Apollo.* New York, 1983.

SCHIFFMAN, JACK. *Uptown: The Story of Harlem's Apollo Theater.* New York, 1971.

IRA BERGER

Apostolic Movement. From its origins only seventy-five years ago, the Apostolic Pentecostal churches now number more than 1,500,000 members and, from a minor role on the fringe, are now emerging as a major force in world religion. With roots in the HOLINESS MOVEMENT and PENTECOSTALISM, Apostolics hold a unique "Oneness" doctrine, dating from 1914, which rejects the traditional Christian Trinitarian formula of God in three persons in favor of a belief in "Jesus Only." Apostolics hold that Jesus Christ is God: Father in creation, Son in redemption, and Holy Spirit operating the church as his mystical body.

Apostolics trace their beginnings to the Azusa Street Revival of 1906–1909 in Los Angeles under the leadership of William J. SEYMOUR, in which participants experienced glossolalia (speaking in tongues), which they believed to be the baptism of the Holy Ghost as recorded in the Book of Acts. The necessity for this baptism is held by all Apostolics. Also descended from Wesleyan Holiness groups, Apostolics nevertheless reject the Arminian doctrine of the "three works of grace," which holds that sanctification is a gradual process not requiring the Holy Ghost. To Apostolics, in contrast, justification and sanctification occur at once when a believer receives the gift and power of the spirit.

The Apostolic Movement appealed from the beginning to working-class people, who contributed generously to building and maintaining churches. The majorities of most congregations consist of women members, although ministerial leadership positions are generally held by men. The movement is often referred to as "leader centered" because the minister's charisma and personality, displayed especially through dynamic preaching, are the most important criteria for establishing recognition and determining success in congregations with little denominational structure.

One of the early Apostolic leaders was Garfield T. Haywood (1880–1931), who reported receiving the gift of the Spirit in 1908 in the Indianapolis church of Henry Prentess, who had been at Azusa Street. Originally a Trinitarian, Haywood accepted the Oneness (or "New Issue") doctrine in 1915 under the preaching of evangelist Glen Cook, and he began to baptize in "Jesus' Name." He served as secretary of the Pentecostal Assemblies of the World, from which many white members withdrew in 1924, and in 1925 he became presiding bishop.

At Haywood's death, Robert Clarence Lawson (1883–1961) became the most notable African-American advocate for Oneness Apostolicism. Lawson stated that he was miraculously healed of tuberculosis and that he experienced the Spirit in 1914 under Haywood's ministry. Lawson became a gen-

eral elder in the Pentecostal Assemblies of the World but resigned in 1919 in a dispute with Haywood over women preachers and divorce, both of which he opposed. He founded the Refuge Churches of Our Lord, later known as the Church of Our Lord Jesus Church of the Apostolic Faith, Inc., a denomination now of nearly 500 congregations in the United States, Africa, Europe, the West Indies, and Canada.

Out of Lawson's branch of the movement came the Church of the Lord Jesus Christ Apostolic, established in 1930 by Sherrod Johnson (1897–1961) of Philadelphia. Johnson became famous by publicly debating doctrinal issues on the radio; many Apostolics were pioneers in early radio ministries. Johnson's disagreement with Lawson centered on women's dress; Johnson advocated cotton stockings and ankle-length dresses and opposed hair plaiting and straightening; Lawson maintained it was not clothes that made for righteousness but whether one's life is sanctified.

Other leaders who emerged from the Lawson movement include Henry C. Brooks (c. 1895–1968), founder in 1927 of the Way of the Cross Churches of Christ, Inc.; J. P. Shields, who founded the Zion Assembly Churches in 1938; and Lymus Johnson, who established the Evangelistic Churches of Christ. From these groups have come further splits and divisions, notably the United Churches of Jesus Apostolic (1970) of James C. Richardson, Sr.; the United Way of the Cross Churches of Christ of the Apostolic Faith (1974) of Joseph H. Adams; and United Church of Jesus Christ (Apostolic) (1965) of Monroe Saunders.

Perhaps the most important person to split from Lawson was Smallwood E. Williams (1907–1991), who in 1957 founded the Bible Way Church of Our Lord Jesus Christ World Wide. Williams was a participant in the CIVIL RIGHTS MOVEMENT, served as head of the Washington, D.C., SOUTHERN CHRISTIAN LEADERSHIP CONFERENCE, and on the board of the NAACP, and was a sponsor of low- and middle-income housing projects, all despite criticism from many African-American Apostolics for his secular political involvement. At Williams's death in 1991, the Bible Way organization numbered over 350 churches. Williams was succeeded as presiding bishop by Laurence D. Campbell of Danville, Va.

William L. Bonner (c. 1929–) was, after Hubert J. Spencer, the actual successor to Lawson, supervising the denomination's 450 congregations. Beginning as Lawson's chauffeur, Bonner became assistant pastor of Refuge Temple in New York and later built "Solomon's Temple," a 3,000-member congregation in Detroit. A gifted radio and television producer, Bonner has established large congregations across the country and is himself pastor of four, including the 4,000-member Greater Refuge Temple in New York.

These numerous schisms are sometimes over personal power and the bishopric, but many are the result of controversies over doctrinal positions. Serious disagreements have divided Apostolics over such issues as clothes, jewelry and beauty products; the question of whether women's heads should be covered during worship; marriage and divorce; the question of women ministers, methods of water baptism; governance by one leader or several; and the role of Apostolic Pentecostals in social reform.

Although many Apostolic debates have concerned the role and position of women in the church, women have served as many of the movement's members and workers, and some have achieved leadership positions. Mattie Poole (1903–1968) conducted a healing ministry in Chicago and via radio. Carrie F. Lawson (1891–1946), R. C. Lawson's first wife, was known as the "Praying Mother of the Air." Delphia Perry (c. 1901–c. 1984) founded the International Women's Council of the Church of Our Lord Jesus Christ. Pearl Williams Jones (1931–1991) was a prominent academic and musician.

Music has played an important part in the movement, inspiring songs, anthems, and songbooks. Garfield Haywood composed many Pentecostal hymns in his book *Bridegroom Songs,* and R. C. Lawson wrote many lyrics and melodies that were compiled in *The Songs of Christ.* Full and enthusiastic congregational participation in singing is a major characteristic of Apostolic worship, and the entire church may stand, sing, and clap hands simultaneously with the choir or song leader. In the movement's early period, washboards, tambourines, and guitars were used as percussion instruments, but with greater prosperity pianos and organs and now multi-tiranged amplification systems and computer-controlled music systems have become more prevalent.

REFERENCES

DuPREE, SHERRY S. *Biographical Dictionary of African-American Pentecostals, 1880–1990.* Washington, D.C., 1990.
JONES, CHARLES E. *Black Holiness: A Guide to the Study of Black Participation in Wesleyan Perfectionist and Glossolalic Pentecostal Movements.* Metuchen, N.J., 1987.
RICHARDSON, JAMES C. *With Water and Spirit.* Washington, D.C., 1980.

ROBERT C. SPELLMAN

Aquatic Sports. *See* Swimming and Aquatic Sports.

Archaeology, Historical. Historical archaeology is a relatively recent branch of archaeology. It developed in North America, where its focus has been on the fifteenth to twentieth centuries, or the period of European and African contact and settlement, when written records began to be kept in the western hemisphere. It draws on two or three separate types of data (archaeological deposits, documents, and oral history) as independent sources for the understanding of the past. Using several kinds of information, each with its own biases, allows the construction of a more complete and accurate picture of a former society than would otherwise be possible.

The first use of the term dates to the 1930s; the first major historic site excavation occurred at Jamestown, Va., with Civilian Conservation Corps labor. The formal recognition of a subdiscipline was manifested by the creation of the Society for Historical Archaeology in 1967. It has gradually evolved from a field whose focus was antiquities and artifacts to a more theoretically-oriented science with a goal of understanding the lifeways of those who have lived in North America during the historic period, whether they left written records or not. Its interests overlap to some degree with those of history and anthropology, and it draws on both fields for background and interpretation as well as for information. There are two areas in particular in which historical archaeology can contribute to our understanding of the past and in which the discipline of history often has gaps. One is the collection of data on the lives of those people for whom documentary records may not exist, because they are missing from the tax rolls and extensive records of property holders, because they were denied access to education and thus could not leave written accounts of their own, or because they were not thought important enough to record. Women, the poor, African Americans, and many other groups fall into this category. The other contribution is an insight into aspects of life which were not (or were only minimally) recorded on paper, such as foodways, frontier situations, illicit activities, or behaviors that were taken for granted, were thought too unimportant to mention, or were not socially approved.

Early publications in the field stressed dating techniques, using such items as ceramics, glass beads, or pipes with known dates of manufacture to identify when an archaeological deposit (either European-American or Native-American) was created. They also focused on narrow historical questions (for example: When was a certain house built? How was it modified? Where was the original kitchen?). The major orientation was toward white male–dominated colonial culture, looking at sites from Spanish missions and English settlements and forts of the six-

teenth to eighteenth centuries; some historic aboriginal sites were examined as well.

However, beginning in the late 1970s, publications began to reflect a wider variety of theoretical models, such as structuralism in sociocultural anthropology, and the quantitative methodology and focus on process rather than events that were part of the "new" prehistoric archaeology. Since then, historical archaeology has flourished, and has expanded to include both new research topics and new methodological approaches. It has also extended its period of interest to the twentieth century. Historical archaeologists have begun to consider a wide variety of issues, including those of unequal power relations, seen in class, gender, ethnicity, and "race."

Environmental protection laws, in existence since the 1970s, have produced a number of excavations in places that archaeologists would not previously have been interested in exploring, mainly because it was assumed that the sites would have been too disturbed to yield significant deposits. Urban archaeology is the outgrowth of this circumstance, and it has been one of the most fascinating and revealing kinds of archaeology, and one of the most inclusive in terms of its potential for revealing the lifeways of all members of society.

An interest in the archaeology of African Americans has been developing since the 1970s. It has had several components: the study of plantation life, the analysis of communities of free blacks in both northern and southern rural and urban contexts, and the excavation of several important cemetery sites, the largest and most significant of which is the "African burial ground" discovered in lower Manhattan in 1991, during an archaeological examination prior to construction of a federal office building.

The largest body of information within this subfield derives from the analysis of plantations, both in the southeastern United States and in the Caribbean. Plantation archaeology has focused on the material remains from slave, overseer, and planter groups, and how they reflect meaningful differences in ways of life. For example, the analysis of foodways using both ceramic forms (proportions of bowls to plates) and food bone indicates the dietary variation in enslaved family households (Fairbanks 1984; Otto 1984). It clarifies the role that individuals played in supplementing their allotted food, and contradicts the belief that a plantation kitchen prepared meals for all. Archaeological excavations have also revealed that certain objects supposedly denied slaves—notably guns—were present in their households (Fairbanks 1984). Some examinations have demonstrated the essential role played by African Americans in plantation production. Finally, there has been considerable interest in documenting the presence of African cul-

tural and material traits, from house plans (Deetz 1977; Singleton 1985, 1988) to ceramics (Deetz 1977; Ferguson 1992) and showing the ways in which enslaved peoples retained an African identity, even though they came from many parts of Africa. This approach is part of a group of studies in archaeology showing the use of material culture as a means of resistance to domination.

The study of free black communities such as Weeksville in Brooklyn, N.Y. (Salwen and Bridges 1974); Sandy Ground on Staten Island, N.Y. (Schuyler 1974); Parting Ways in Plymouth, Mass. (Deetz 1977); and residents of Alexandria, Va. (Shephard 1987; Blomberg 1990); and postbellum southern farms has shown a number of important things. It demonstrates the great variety of strategies employed by people in these settings; the existence and importance of a separate African-American culture, reflected in distinctive material traits; and the early presence of racism and the consequent poverty associated with it, reflecting the frequent interrelationship between class and race. The analysis of cemetery populations has the potential to reveal some of the most basic kinds of information about past lives. This becomes particularly important among people for whom the written record is scanty. Some of this information demonstrates religious beliefs, as seen in orientation of the bodies (at the African burial ground in Manhattan they were placed with their heads to the west, presumably in order to sit up and see the rising sun on Judgment Day), or the placement of objects in the grave (at the African burial ground there were few objects; most of these were buttons and shroud pins, but at least one individual had pennies over the eyes). Other data derived from human skeletons can identify the composition of the population (56 percent adult and 44 percent children at the African burial ground, with more males than females observed in preliminary analysis); the age at death; in some cases, the cause of death (trauma or disease); the health of the population; and the level of nutrition. Sometimes DNA analysis of hair or other material can provide evidence of place of birth.

There have been a number of archaeological sites excavated within New York City in the 1980s and 1990s. One of the more important projects had two components, both associated with federal construction. The archaeological examination (in July 1991) on the site of a new courthouse in lower Manhattan is providing considerable evidence on Five Points, a racially mixed notorious slum occupied from the late eighteenth century on. The other part of the project, the construction of a new thirty-four-story office building at Broadway and Reade St., revealed the African burial ground, one of the oldest and, so far, the largest black cemetery known in the United States. The cemetery was placed on land that was outside the settled area of New York City (then south of the present City Hall) and was used as a place of burial for black people between about 1710 and 1790. Well over 10,000 people were probably buried there, about 400 of whom were removed by archaeologists. About 96 percent of the cemetery population, according to recent estimates, were enslaved or free blacks. Archaeologists and African-American leaders called for excavation to cease, for the office building to be relocated and the site left as a monument. On July 30, 1992, the government permanently halted digging and in 1993 the African burial ground and Commons historic district were declared a New York City Historic District, and the burial ground was named a National Historic Landmark.

REFERENCES

BLOMBERG, BELINDA. Free Black Adaptive Responses to the Antebellum Urban Environment: Neighborhood Formation and Socioeconomic Stratification in Alexandria, Virginia, 1790–1850. Ph.D. diss., George Washington University, 1990.

DEETZ, JAMES. In Small Things Forgotten: The Archaeology of Early American Life. Garden City, N.Y., 1977.

FAIRBANKS, CHARLES H. "The Plantation Archaeology of the Southeastern Coast." Historical Archaeology 18 (1984): 1–14.

FERGUSON, LELAND. Uncommon Ground: Archaeology and Early African America, 1650–1800. Washington, D.C., 1992.

LEONE, MARK P. "Archaeology as the Science of Technology: Mormon Town Plans and Fences." In Charles L. Redman, ed. Research and Theory in Current Archaeology. New York, 1973, pp. 125–50.

OTTO, JOHN S. Cannon's Point Plantation, 1794–1860: Living Conditions and Status Patterns in the Old South. Orlando, Fla., 1984.

SALWEN, BERT, and SARAH BRIDGES. "The Ceramics from the Weeksville Excavations, Brooklyn, N.Y." Northeast Historical Archaeology 3 (1974): 4–29.

SCHUYLER, ROBERT L. "Sandy Ground: Archaeological Sampling in a Black Community in Metropolitan New York." In Papers of the Conference on Historic Site Archaeology 7 (1974): 13–51.

SHEPHARD, STEVEN JUDD. "Status Variation in Antebellum Alexandria: An Archaeological Study of Ceramic Tableware." In Suzanne Spencer-Wood, ed., Consumer Choice in Historical Archaeology. New York, 1987, pp. 163–198.

SINGLETON, THERESA A. "An Archaeological Framework for Slavery and Emancipation, 1740–1880." In Mark P. Leone and Parker B. Potter, Jr., eds. The Recovery of Meaning. Washington, D.C., 1988, pp. 345–370.

———, ed. The Archaeology of Slavery and Plantation Life. Orlando, Fla., 1985.

SOUTH, STANLEY. *Method and Theory in Historical Archaeology*. New York, 1977.

NAN A. ROTHSCHILD

Architecture. African Americans have been involved in building and architecture since the colonial era. The colonial plantation system relied heavily on slave craftsmen imported from Africa, who brought with them skills in ironworking, woodcarving, and the use of earth and stone to produce buildings, furniture, and tools. Written records and physical examination of building technologies indicate slave involvement in most early plantation construction throughout Louisiana, such as Magnolia in Plaquemines Parish in 1795, Oakland in Bermuda, and the mansion in Cloutierville that became the home of the nineteenth-century novelist Kate Chopin. Gippy Plantation, in South Carolina, and Winsor Hall, in Greenville, Ga., were also built by slave artisans. Some of these slave artisans were hired out to other owners as well, such as James Bell of Virginia, who was sent to Alabama to construct three spiral staircases for the Watkins-Moore-Grayson mansion.

A number of free blacks also designed and built in the antebellum South. Charles, a free black carpenter, woodworker, and mason, contracted with Robin de Logny in 1787 to build Destrehan Plantation in St. Charles Parish, La. Free black planters in Louisiana built plantation houses that include Mignon Carlin's Arlington (1850), Pierre Cazelar's Cazelar House, and Andrew Drumford's Parrish Plantation. Louis Metoyer, one of fourteen children of a former slave, studied architecture in Paris and designed the Melrose house and several other later buildings in Isle Breville, a settlement of "free people of color." Central African influences are noticeable in most of his work, especially the African House (c. 1800), recently designated a landmark as the only structure of its type standing in the United States.

This period of African-American activity in building and construction came to an abrupt end after the CIVIL WAR. Increasing industrialization, developing trade unions in the cities of the North that excluded blacks, and the economic depression that accompanied RECONSTRUCTION largely eliminated the free black planter class and with it the independent artisan and craftsman. Many free black landowners, such as the Metoyers, either lost or had their property holdings significantly reduced.

During the second half of the nineteenth century, EDUCATION throughout the United States became increasingly formalized in all disciplines; it became progressively more difficult for a craftsman to construct a building independently. However, the majority of the states did not establish formal requirements for licensing or professional identification until well into the twentieth century.

The Massachusetts Institute of Technology (MIT), founded in 1861, inaugurated the first formal architecture program in the United States in 1867. In 1868 the Freedman's Bureau founded HAMPTON INSTITUTE in Virginia to train black men and women, many of them former slaves, to "go out and teach and lead their people." From the start, Hampton offered a full building-skills program, and a number of campus buildings were designed and built by faculty and students.

Booker T. WASHINGTON modeled Tuskegee Institute (now TUSKEGEE UNIVERSITY) in Alabama on Hampton, his alma mater, and expanded his normal school to include training in architecture and the building trades. By 1893 the school had been renamed Tuskegee Normal & Industrial Institute and, under the direction of Robert R. Taylor, offered a complete architectural drawing program in its Department of Mechanical Industries. Tuskegee's early buildings were designed by department faculty members and built under their supervision by students with student-made bricks. School records indicate that the department was established to make a profit—though this proved elusive—and that it took on design and construction jobs outside the school.

The Tuskegee program differed significantly from Hampton's in two ways; it employed a black faculty and it promoted a strong service ethic. Washington linked his architecture program to the school's primary mission to uplift a people. His program also sought to reinstate the role of the black artisan in the skilled trades. Speaking in 1901, Washington stated, "We must have not only carpenters, but also architects; we must not only have people who do the work with the hand but persons who at the same time plan the work with the brain." Aside from the work done at Hampton and Tuskegee, he continued, there were few African Americans trained in the basic principles of architecture. Indeed, in Washington's time (and to this day), the number of practicing black architects in the United States was (and is) disproportionately low. In the 1890 census, which was the first to provide a separate tabulation for architects of color, there were only forty-three black architects, a number that would rise slowly over the succeeding decades.

A number of the earliest recognized black architects began their careers at Tuskegee as students or as faculty. Washington recruited Robert R. Taylor in 1892 to develop the Department of Mechanical Industries. Taylor had been among the first blacks to graduate from the architecture program at MIT. During his forty-one-year tenure at Tuskegee he became

(Above) Melrose plantation house, Isle Breville, La., designed in the antebellum era by Louis Metoyer. (Below) African House, built in Louisiana around 1800, also designed by Metoyer. (R. K. Dozier Collection)

Robert R. Taylor supervised a program of architectural drawing in the 1890s at Tuskegee Normal and Industrial Institute. (R. K. Dozier Collection)

a vice president and confidant of Washington, designed many of Tuskegee's major buildings, and supervised overall campus planning. Other Tuskegee architecture faculty included Wallace A. Rayfield, William Sidney PITTMAN, Walter T. Bailey, and William Augustus Hazel.

Wallace A. Rayfield taught at Tuskegee from the 1890s until 1907. Like Taylor, he designed several campus buildings but eventually left to establish the first known black architectural office in Birmingham, whose successful practice was focused on church design, one of the major areas of the field then open to blacks. He became the national architect for the AFRICAN METHODIST EPISCOPAL (AME) ZION CHURCH. Other Rayfield church designs include the Ebenezer Baptist Church in Chicago and Birmingham's SIXTEENTH STREET BAPTIST CHURCH, a landmark of the CIVIL RIGHTS MOVEMENT of the 1960s.

John A. LANKFORD, one of Taylor's first pupils, established one of the first black architectural offices in Washington, D.C., in 1897. In 1898 he designed and supervised the construction of the $100,000 Coleman Cotton Mill in Concord, N.C. He later worked as an instructor in architecture at several black colleges and served as superintendent of the Department of Mechanical Industries at Shaw University. He served as the national supervising architect for the AFRICAN METHODIST EPISCOPAL CHURCH, for which he designed Big Bethel, a landmark of Atlanta's Auburn Avenue. He also designed churches in West and South Africa. The Grand Fountain United Order of the True Reformers, organizers of one of the first black-owned banks, commissioned his office to design their national office in Washington. Lankford also participated in the creation of the School of Architecture at HOWARD UNIVERSITY in the 1930s. Both he and Rayfield published their work in leading black journals of the time, including the CRISIS and OPPORTUNITY.

William Sidney Pittman, after earning degrees at Tuskegee and Drexel institutes, was a member of the Tuskegee faculty from 1899 to 1905. In 1905 Pittman moved to Washington, D.C., to establish an architectural office. In 1907 he married Booker T. Washington's daughter Portia. Pittman's output included designs for schools, libraries, lodges, and other public buildings from 1907 to 1913, which established his reputation as one of the nation's most promising black architects. The frequent "Negro Exhibits" held at national expositions following the World's Columbian Exposition at Chicago in 1893 gave Pittman and many other black architects a chance to display their skills. Pittman won the national competition for the design of the Negro Building for the Jamestown Exposition in Virginia in 1907, a building that was erected by an all-black team of contractors and workmen. In 1913 Pittman and his family moved to Dallas, Tex., where he lived until his death in 1958.

George Washington Foster, Jr. (1866–1923), studied at Cooper Union in New York (1888–1889) and worked as a draftsman in Henry J. Hardenberg's firm; it is generally believed that he later worked on the Flatiron Building (1903) in New York City as a member of Daniel Burnham's firm. In 1902 he became the first black architect licensed to practice in New Jersey. After meeting Vertner Woodson TANDY through the Elks' "colored branch," the two established a partnership in 1909 that lasted until 1915. One of the highest achievements from the latter period of Foster's life was the commission to build the Mother African Methodist Episcopal Zion Church on 137th Street in Harlem.

Vertner Woodson TANDY became the first African-American architect licensed in New York State. A Tuskegee alumnus (1905), Tandy was also the first black graduate of Cornell University's School of Architecture (1907), where he helped found Alpha Phi, the first fraternity for African Americans. The most significant commissions of Tandy and Foster's practice in New York include St. Philip's Episcopal

(Above) brick yard and (below) dormitory under construction at Tuskegee Institute. (R. K. Dozier Collection)

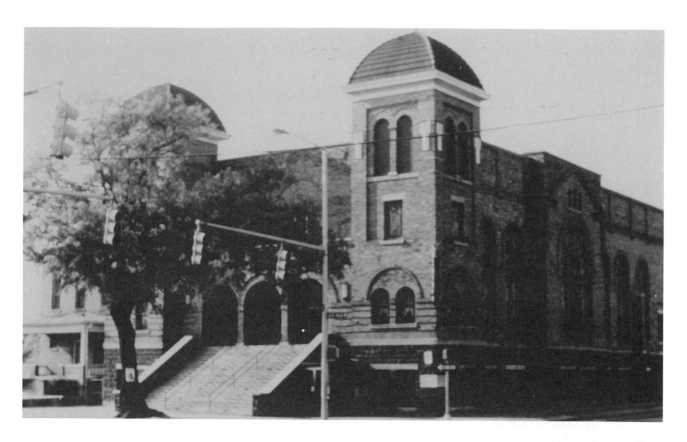

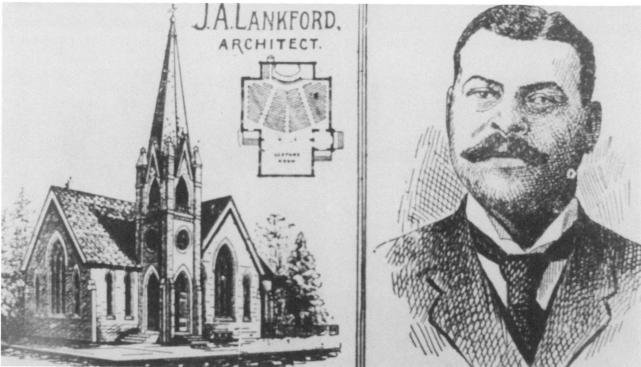

(Above) the Sixteenth Street Baptist Church, Birmingham, Ala., designed by Wallace A. Rayfield. (Below) model church designed by John A. Lankford, a successful architect based in Washington, D.C., who participated in the founding of Howard University's School of Architecture. (R. K. Dozier Collection)

Church and its Queen Anne–style Parish House (1910–1911) and the Harlem townhouse of Madame C. J. WALKER. After their partnership dissolved, Tandy designed Madame Walker's country house, the Villa Lewaro in Irvington-on-Hudson, New York (1917–1918); the Harlem Elks Lodge; Smalls' Paradise; and the Abraham Lincoln Houses in the Bronx, N.Y., a joint venture with Skidmore, Owings & Merrill in the 1940s.

John Lewis Wilson (1898–1989), who worked for Tandy, came from a prominent Mississippi family. He was inspired to study architecture by Wallace Rayfield, who designed a church for his father, a well-known minister. In 1923 Wilson became the first black student to attend the School of Architecture at Columbia University, N.Y., but after graduating, he was unable to find work at any of the white firms to which he applied. After the HARLEM RIOTS OF 1935, Wilson was the single African American appointed to a team of seven architects to design the Harlem River Houses, one of the first federal housing projects. His appointment came after protests from the black community.

Julian Francis ABELE came from a privileged family and graduated from the University of Pennsylvania School of Fine Arts and Architecture in 1904. Following graduation, he worked for Horace Trumbauer & Associates in Philadelphia. It was Trumbauer who sent Abele to the École des Beaux Arts in Paris, where he received his diploma in 1906. Abele worked for Trumbauer for the next thirty-one years, becoming the firm's chief designer. Abele was responsible for the Gothic design of Duke University. Following the death of Trumbauer, Abele established his own office and became one of the few black members of the American Institute of Architects (AIA) in 1941.

Paul Revere WILLIAMS was discouraged by his teacher at Los Angeles Polytechnic High School from pursuing a career in architecture because of his race. Ignoring this advice, he worked his way through the University of Southern California's School of Architecture and went on to achieve considerable fame. He is best known for his designs for the houses of such Hollywood celebrities as Tyrone Power, Betty Grable, Julie London, Frank Sinatra, Cary Grant, Bill "Bojangles" ROBINSON, Barbara Stanwyck, Bert Lahr, and William Holden. For middle-class homeowners, he published Small Homes of Tomorrow (1945) and New Homes for Tomorrow (1946). In addition, Williams designed the Los Angeles International Airport restaurant building and the Freedmen's Hospital at Howard University. In 1926 he became the first black member of the AIA and was also named by President Calvin Coolidge to the National Monument Commission. In 1956 Williams became the first black to be elected to the AIA College of Fellows. Over the years, Williams received numerous awards for his residential designs, as well as honorary degrees from Atlanta, Howard, and Tuskegee universities.

WORLD WAR II had a profound effect on the progress of African Americans in the architectural profession. In a milestone decision for black architects, the War Department awarded a $4.2 million contract in 1941 to McKissack & McKissack, a black architecture, engineering, and construction firm, founded in 1909, for the construction of Tuskegee Air Force Base. Hilyard Robinson, an architect practicing in Washington, D.C., won the architectural-design portion of the job. In 1943 Allied Engineers, Inc., a California firm organized by Paul Williams, received a $39 million contract for the design and construction of the U.S. Navy base in Long Beach, Calif. Williams also contributed to the establishment of the Standard Demountable Homes Company of California, which focused on providing housing for war workers.

With funds newly available through the GI Bill of 1944, returning African-American veterans from World War II were eligible for educational opportunities far exceeding those open to previous generations. Racial segregation still limited their choices, however, creating unprecedented enrollments at Howard, Hampton, and Tuskegee. In 1949 Howard University's School of Architecture became the first predominantly black architecture school to be accredited. However, a series of U.S. Supreme Court cases culminating in the 1954 BROWN V. BOARD OF EDUCATION OF TOPEKA, KANS., opened the doors of white architectural schools to black students.

Whitney M. YOUNG, Jr., the civil rights leader and executive director of the NATIONAL URBAN LEAGUE, forced the architectural profession to reconsider its wider social responsibilities when he delivered his famous keynote address "Man and His Social Conscience" at the annual national convention of the American Institute of Architects in 1968. Young told his audience:

> You are not a profession that has distinguished itself by your social and civic contributions to the cause of civil rights, and I am sure that does not come to you as a shock. . . . You are most distinguished by your thunderous silence and your complete irrelevance. . . . You are employers, you are key people in the planning of our cities today. You share the responsibility for the mess we are in, in terms of the white noose around the central city. We didn't just suddenly get this situation. It was carefully planned.

Soon after Young's speech, the Ford Foundation established scholarships for black architecture stu-

(Above) Duke University chapel, designed by Julian Francis Abele. (Below) Los Angeles Airport restaurant building, designed by Paul Revere Williams. (R. K. Dozier Collection)

Architecture and design student, Tuskegee University. (R. K. Dozier Collection)

dents as part of a far-reaching program that included grants to schools for the upgrading of facilities. The AIA itself created a Task Force on Equal Opportunity and formed a joint venture with the Ford Foundation to establish the Minority/Disadvantaged Scholarship Program (this replaced the Ford Foundation program when the latter was discontinued in 1973). In 1982 an endowment was created to support that program. In 1983 a program report stated that more than three hundred students in fifty schools had been assisted, with a considerable success rate.

In 1968 Howard University still had the only predominantly black, accredited architecture school, prompting the AIA and the Association of Collegiate Schools of Architecture (ACSA) to join forces to accredit other programs. In the mid-1990s eight institutions identified as historically black colleges and universities (HBCUs) offered accredited, professional architecture degrees, and two offered degrees in architectural engineering. Those eight schools were Howard University, Washington, D.C.; Hampton University, Hampton, Va.; Southern University, Baton Rogue, La.; Tuskegee University, Tuskegee, Ala.; Florida A&M University, Tallahassee, Fla.; Morgan State University, Baltimore, Md.; Prairie View A&M University, Prairie View, Tex.; and the University of the District of Columbia.

The Whitney M. Young, Jr., Citation Award was established in 1970 by the AIA's Social Concern Task Force. It is awarded to an architect or an architecturally focused organization in recognition of a significant contribution to social responsibility. Robert Nash was the first recipient of the citation, and he became the AIA's first African-American vice president in 1970.

In 1971 the National Organization of Minority Architects (NOMA) was founded in Chicago when a caucus of twelve black architects met at the AIA Convention in Detroit and resolved to "specifically address the concerns of black and other minority architects [in order to] add a needed dimension to the scope of the minority architects' sphere of influence." The organization strives to promote the design and development of a living, working, and recreational environment of the highest quality, as well as to increase the numbers of black architects by supporting the recruitment and education of new architects. In 1994 NOMA's membership reached approximately five hundred. Its forerunner was the National Technical Association, founded in 1926 in Chicago by Charles S. Duke.

Another resource group for black architects, founded since the 1970s, is the AIA's Minority Resources Committee (MRC), known until 1985 as the Minority Affairs Task Group (MATG). The MRC collects and disseminates information and oversees policies at the national level, as well as acting as a clearinghouse for the AIA, ACSA, and NOMA.

The tradition of African-American involvement in community-based and public building that began with the public housing and military projects of the 1930s and 1940s expanded in the 1960s and 1970s with the advent of the free clinic for architectural and urban design problems. The first prototype of the free clinic was the Architecture Renewal Committee in Harlem, or ARCH, founded by two white archi-

Architecture and design student, Florida Agricultural and Mechanical University, Tallahassee. (R. K. Dozier Collection)

tects, Richard Hatch and John Bailey, in 1965 to address issues of "advocacy planning" (a phrase coined by urban planner Paul Davidoff); Max Bond was ARCH's first black director. The free-clinic concept was eventually adopted by the federal government as Community Design Centers, or CDCs. In President Lyndon Johnson's War on Poverty, CDCs provided services for the disadvantaged, primarily in urban areas. By the end of the 1960s it was clear that a substantial market for nonprofit services of this kind existed, extending beyond minority groups to many segments of society.

The recession of the mid-1970s severely affected the entire architectural profession, as did President Nixon's moratorium on construction of low- and moderate-income housing, one of the mainstays of black architectural practices. During this fallow period, architects were forced to search elsewhere for projects. However, William COLEMAN, a black lawyer from Philadelphia who was the Nixon administration's secretary of transportation, established a landmark affirmative action program in public works, which mandated that 15 percent of federal funds for mass transit projects must be allocated to minority firms. However, the withdrawal of much federal support for urban social programs and for low- and moderate-income housing under Presidents Reagan and Bush had a negative impact on the black architectural community.

In 1991 the DIRECTORY OF AFRICAN-AMERICAN REGISTERED ARCHITECTS identified some 877 black architects in forty-three states. Of these, only 49 are women. In 1993 black architects made up only 7.5 percent of the AIA; in the profession as a whole, their numbers are estimated at only 1 percent. Furthermore, the majority of black architects work in the public sector on government projects, since institutional and professional biases continue to restrict their ability to obtain private commissions. Two recent reports commissioned by the AIA and the ACSA reiterate the fact of low numbers in the profession and focus on the problems faced by minorities in the architectural profession. Major obstacles that were identified for both students and practicing professionals included racism, depressed social communities, lack of role models, the high cost of education, isolation from resources, a decrease in minority set-asides, poor representation in the AIA, the absence of publicity of accomplishments in the field, tokenism in joint ventures to pursue commissions, and a high attrition rate among black students.

In addition, the century-old vocational/professional split still plagues blacks in the architecture profession. Related to the entrenched division between design and production maintained in the schools of architecture, there is even now a noticeable division in large majority firms, where larger numbers of African-American architects work on the production or technical side of building rather than in the design studios.

Black architects are also currently engaged in a fierce debate on the merits of assimilation versus a more explicitly Afrocentric architecture, with a third group focused on the professional and artistic concerns of the profession itself. A resurgence of interest in HBCUs, designs that incorporate traditional African elements, and interest in working almost exclusively within the black community characterize the Afrocentrist position, as opposed to the integrationists, who wish to be perceived as architects first and African Americans second.

The third group in the debate focuses on the role of African Americans in the architectural profession as a whole. This group deals less with political concerns and more with issues of social responsibility and community orientation. Their approach is based on the complex cultural and artistic history of black architects in the context of modern American society. In a situation in some ways analogous to the history of jazz, the proponents of this third position tend to draw upon African elements in their work, but they filter them through the lens of contemporary American culture.

One of the most visible contemporary black architects is Jack Travis, editor of the widely acclaimed book *African-American Architects in Current Practice* (1991). Travis earned his B. Arch. from Arizona State University in 1977. After working for Skidmore, Owings & Merrill, he established his own firm in New York in 1985. Travis served as a professional adviser on director Spike LEE's *Jungle Fever* (1991), a film that featured Wesley Snipes as a black architect trying to succeed in a white professional world. Travis frequently brings African-inspired elements into his sleek, modernist designs. His work includes Spike Lee's office headquarters in Brooklyn, N.Y.; many corporate projects, including retail showrooms for designer Giorgio Armani; and various private residences. He is currently an adjunct professor at the Fashion Institute of Technology, New York.

Lou Switzer is the founder and chairman of the Switzer Group, a corporate space-planning and design firm located in New York, whose clients include IBM, Con Edison, and Citibank. After working as an office messenger and then a draftsman for various design firms, Switzer attended night architecture courses at Pratt Institute, New York. Switzer worked at E. F. Hutton as assistant director of facilities planning worldwide, then began his own firm in 1975 with a minimum of capital and employees. Since the 1980s it has become a major mainstream design firm, not bound to any particular design philosophy. The firm is developing a $1.5 billion multiuse complex near the United Nations.

Harvey B. GANTT, a founding partner of Gantt Huberman Architects in Charlotte, N.C. (1971), harbored an ambition to become an architect since the ninth grade. He went on to earn his B. Arch. from Clemson University in 1965 (he was the architecture department's first black graduate) and his M. Arch. in city planning from MIT in 1970. Major works include the First Baptist Church in Charlotte, N.C. (1977) and the C. G. O'Kelly Library at Winston-Salem State University, N.C. (1990). Since the 1980s Gantt has become active in politics. He was mayor of Charlotte from 1983 to 1987 and ran for the U.S. Senate in 1990 but was narrowly defeated by incumbent Jesse Helms.

J. Max Bond, Jr., a partner in Davis Brody & Associates Architects of New York, has distinguished himself as both a teacher and practitioner in the architectural profession. Bond earned his M. Arch. from Harvard University in 1958 and spent several years during the 1960s teaching and designing buildings in Ghana, West Africa. From 1969 to 1984 Bond was professor in and then chairman of Columbia University's Division of Architecture. Since 1985

J. Max Bond has written extensively on the problems facing black architects and black architecture in the contemporary world. He is the architect of the Civil Rights Institute in Birmingham, Ala., among other commissions. (Photographs and Prints Division, Schomburg Center for Research in Black Culture, The New York Public Library, Astor, Lenox and Tilden Foundations)

he has been dean of the School of Architecture and Environmental Studies at City College of New York. A recipient of the Whitney M. Young, Jr., Citation Award in 1987, Bond has long been active in urban renewal efforts in New York City, serving as a member of the City Planning Commission from 1980 to 1986 and as executive director of the Division of Architects Renewal Committee of Harlem. Well-known projects include the Martin Luther King, Jr., Center for Nonviolent Social Change in Atlanta (1981) and the Studio Museum in Harlem (1982).

Harry L. Overstreet decided he wanted to be an architect in high school and then gained practical building experience in the U.S. Army Corps of Engineers. Overstreet worked as a self-employed designer in San Francisco and later became a licensed architect. He was appointed to the planning commission of the city of Berkeley, Calif., and served as the national president of NOMA from 1988 to 1990. Currently a principal in Gerson/Overstreet, Overstreet's work includes the Williard Junior High School in Berkeley (1980) and the Veterans Administration Medical Center in San Francisco (1991).

Roberta Washington is known for her work in Harlem salvaging neglected buildings and turning them into social-service and health-care facilities. Her twelve-person practice, Roberta Washington Architects, has taken on numerous renovation projects since its founding in 1983, including Astor Row, Hotel Cecil, Hale House Homeward Bound Residence, and Sarah P. Huntington House. Washington attended Howard University, then earned her M. Arch. from Columbia University. She worked in Mozambique from 1977 to 1981, designing a prototype for a medical center for women and children.

Shortly after the landmark U.S. Supreme Court decision SWEATT V. PAINTER (1950), which integrated graduate programs, John S. Chase entered the University of Texas Graduate School of Architecture in Austin in 1950 as that institution's first black student. Weathering intense racial prejudice and isolation at the university, Chase earned his M. Arch. in 1952. After graduation, no Houston architecture firms were willing to hire him, so Chase opened his own practice, becoming the first African American licensed to practice architecture in Texas, the first accepted into the Texas Society of Architects, and the first accepted into the Houston chapter of the AIA. Today Chase is the chairman and president of his own firm, with offices in Washington, D.C. and Houston, Dallas, and Austin, Tex. Appointed by President Carter as the first African American to serve on the U.S. Commission of the Fine Arts (1980), he received the Whitney M. Young, Jr., Citation Award in 1982 and has also received the NOMA Design Excellence Award four years consecutively. Chase's striking modernist designs include

Birmingham Civil Rights Institute, a Max Bond project. (Davis, Brody & Associates)

the School of Education Building at Texas Southern University, Houston (1977), and the Federal Reserve Bank of Dallas (associate architect; 1992).

Norma Merrick Sklarek earned her B. Arch. from Columbia University in 1950. Thirty years later she became the first black female fellow of the AIA (1980). She was also the first black female licensed to practice architecture in California. She is currently a principal in the Jerde Partnership, Inc., Los Angeles. Her work includes Downtown Plaza, Sacramento, Calif. (1993), the all-glass Pacific Design Center in Los Angeles (1978), the Queens Fashion Mall in Queens, N.Y. (1978), and the U.S. Embassy in Tokyo, Japan (1976). An architectural scholarship award has been founded in her name at Howard University.

Robert Traynham Coles has been the president and CEO of his own firm since 1963, with offices in Buffalo, N.Y., and New York City. He received his B. Arch. from the University of Minnesota (1953) and his M. Arch. from MIT (1955). Coles has taught architecture at the University of Kansas (1989) and at Carnegie Mellon University in Pittsburgh, Pa. (1990–1995). The recipient of a Whitney M. Young, Jr., Citation Award (1981), he has worked to increase the representation of blacks in the architectural pro-

fession, serving as the AIA's deputy vice president for minority affairs (1974–1976), then becoming a founding member of NOMA. His work includes the Providence Railroad Station in Providence, R.I. (1986), the Frank D. Reeves Municipal Center in Washington, D.C. (1987), and the Human Services Office Building in Canandaigua, N.Y. (1988).

Notable African-American architectural partnerships include Donald L. Stull and M. David Lee of Stull and Lee, Inc., Architects & Planners in Boston, Mass. Stull and Lee founded their firm in 1966, shortly after obtaining their M. Arch.'s from Harvard University. Their work includes the Ruggles Street Station in Boston (1986) with its giant glass arched entry; Roxbury Community College, Mass. (1987); and Harriet Tubman House, Boston (1974). Their design for a Middle Passage Memorial (1990) consists of several giant, tangential, and abstract geometric forms, whose ominous shapes evoke a slave ship (see SLAVE TRADE). Stull has served as president of the FAIA in addition to teaching design at Harvard University (1974–1981) and winning numerous awards from the AIA. Lee has served as vice president of the AIA and has taught urban design and architecture at Harvard and at MIT (1974–1983).

Three generations of the Fry family comprise Fry & Welch Associates, P.C., Architects & Planners. The firm was founded in 1954 and maintains offices in Washington, D.C., Atlanta, Richmond, Va., and Baltimore. The Frys—Louis E. Fry, Sr., Jr., and III— have completed such projects as the Tuskegee Chapel, Tuskegee University, Ala. (1960), and the Coppin State Athletic Center at Coppin State College, Baltimore (1986).

Wendell J. Campbell and Susan M. Campbell are the husband-and-wife team that make up Wendell Campbell Associates, Inc., of Chicago, Ill., and Gary, Ind. Wendell Campbell, the firm's president, was a founding member and the first president of NOMA (1972) and a recipient of the Whitney M. Young, Jr., Citation Award in 1976. Susan M. Campbell, the firm's vice president, received her M. Arch. from the Illinois Institute of Technology in 1992. The Campbells have designed St. Mark's Zion Church in East Chicago, Ind. (1973), the Genesis Convention Center in Gary, Ind. (1982), and the Dr. John Price House in Downers Grove, Ill. (1990), among other projects.

There has been an increasing professional self-awareness among black architects. Robert Coles's speech "Black Architects: An Endangered Species," Richard Dozier's research and lectures, Jack Travis's pioneering book *African-American Architects in Current Practice,* Harry Robinson's implementation of archives at Howard University, Sharon E. Sutton's seminal work on architectural theory, and Harry Overstreet's energizing term as president of the NOMA have been critical elements in creating a climate that supports discussions of blacks in architecture.

For three hundred years, the black experience in architecture has been inseparable from the social history, political involvements, and educational opportunities of African Americans. Black architects share not only the disadvantages but also the rich cultural heritage of African Americans. As the American population grows increasingly "minority," the architecture profession has the opportunity to enrich itself by becoming more representative of the nation as a whole.

REFERENCES

ADAMS, MICHAEL. "A Legacy of Shadows." *Progressive Architecture* (February 1991): 85–87.

BOND, J. MAX, JR. "The Black Architect's Experience." *Architectural Record* (June 1992): 60–61.

COLES, ROBERT TRAYNHAM. "Black Architects: An Endangered Species." *Journal of Architectural Education* (Fall 1989): 60–62.

CRAIG, LOIS, ed. *The Federal Presence: Architecture, Politics, and Symbols in United States Government Building.* Cambridge, Mass., 1981.

CROSBIE, MICHAEL J. "Howard University School of Architecture." *Architecture* (April 1991): 52–53.

DEAN, ANDREA OPPENHEIMER. "A Values-Added Practice: Equal Measures of Conviction and City Smarts Underlie the Success of Harlem-Based Roberta Washington Architects." *Progressive Architecture* (October 1993): 54–57.

DOZIER, RICHARD K. "The Black Architectural Experience in America." In Jack Travis, ed. *African-American Architects in Current Practice.* Princeton, N.J., 1991, pp. 8–9.

ENGLE, CLAUDE. "Minorities in Practice." *Progressive Architecture* (June 1991): 59–62.

GORMAN, JEAN. "Southern Savvy: The Switzer Group Plays a Defining Role in the Corporate Big League." *Interiors* (July 1993): 54–56.

GRANT, B. C., and D. A. MANN. *Directory of African-American Registered Architects.* Cincinnati, Ohio, 1991.

KAY, JANE HOLTZ. "Invisible Architects." *Architecture* (April 1991): 106–113.

PATTERSON, TERRY. "Education: The Reconcilable Duality." *Progressive Architecture* (September 1990): 69.

RUSSELL, BEVERLY. "Diversity in the Big Apple: With His Outspoken Personality, Jack Travis Is a Much Sought-After Architect." *Interiors* (July 1993): 50–53.

RYDER, DONALD P. "Diverse School with a Special Mission." *Architecture* (August 1987): 48–51.

SUTTON, SHARON E. "The Progress of Architecture." *Progressive Architecture* (October 1993): 76–79.

TRAVIS, JACK, ed. *African-American Architects in Current Practice.* Princeton, N.J., 1991.

RICHARD DOZIER
GRETCHEN G. BANK

Architecture, Vernacular.

Defined as the ordinary buildings and spaces constructed, shaped, or inhabited by a particular group of people, vernacular architecture characterizes a place by giving it a specific social identity. Consequently, vernacular architecture is more than a segment of the man-made environment; it also entails an overall perception, a sense of place. Vernacular buildings and landscapes are thus especially important in the study of African-American history and culture, since as a group, African Americans left very little in the way of written documentation about the intimate day-to-day features of their domestic experiences. Encoded within any artifact is its design—its cultural base—as well as evidence of manufacture and use—its social narrative. Vernacular architecture, while a diffuse sort of data demanding cautious interpretation, affords scholars entry into the spatial realms established by certain groups of African Americans.

The Africans brought to the United States during the seventeenth century were, contrary to dismissive prejudicial stereotypes, fully equipped with the conceptual and technological skills required to build their own houses. Forced to labor on plantations along the shores of the Chesapeake and in the Carolina low country, they responded to the need for reasonable shelter by constructing small mud-walled dwellings. Archaeological remains indicate that these houses were generally rectangular in shape, and from various written accounts one can further surmise that they had roofs covered with a thatch made from tree branches or long grasses. Looking like houses straight out of Africa, these buildings did not pose, at first, the threat to a slaveholder's sense of command that one might suppose. Similar rectangular buildings with earthen walls and thatched roofs were commonplace as well in the British Isles, where they were usually identified as cottages suitable for the peasant classes who performed the bulk of the agricultural labor. The African houses with clay walls were thus allowed to stand for at least a generation.

The colonial period was characterized by a syncretic encounter between African and British cultures that fostered what the Africans would likely have interpreted as an opportunity to carry out their own ideas about house and home. What remained hidden within these buildings was an African feeling for appropriate space; the dimensions of the rooms were set according to the codes that their builders carried deep within their cultural personalities. In much of West and Central Africa, houses are built with small square rooms averaging 10' x 10'. These same dimensions discovered in the earliest slave quarters, whether they were built with earthen walls or constructed out of hewn logs, are perhaps an African signature that signals a significant degree of cultural continuity. Where Europeans saw only a small house built by people of little consequence, the enslaved Africans saw a good house constructed according to an appropriate plan. That its rooms were the right size for their style of social interaction should be seen as a subtle, but important, means of cultural preservation.

Overt African expressions of all sorts were met with increasing hostility over the course of the eighteenth century as planters initiated thoroughgoing campaigns to "improve" their properties. Even slave quarters were upgraded as slaveholders had new houses constructed with wooden frames covered with milled boards. Mud-walled houses, however, were still encouraged by some planters both for quarters and other service buildings. Robert Carter of Virginia, for example, asked his slave dealer to find him an artisan who "understood building mud walls . . . an Artist, not a Common Laborer." But the

appreciation of such skills was clearly on the decline by the middle of the nineteenth century. When James Couper, owner of Hopeton Plantation in Georgia, discovered that his African slave Okra had built an African hut plastered with mud and thatched with palmetto leaves, he had the building torn down immediately.

Nevertheless, mud continued to be used in the building of chimneys on into the early twentieth century, when bricks could not be obtained and small outbuildings intended as animal shelters, particularly in the Sea Island areas of South Carolina, were still covered with a thatching of palmetto branches. While this can be seen simply as the methodology of poor people who had to make do with the materials that were easily available, African memories should not be discounted.

By 1860, 2.6 million blacks were living on plantations all across the South, and close to two-thirds of them were held on the larger estates in groups of fifty or more. Thus the plantation was not only a familiar place in the black experience; it also provided a primary context in which a distinctive African-American identity would take place. An extensive repertoire of African-American cultural traits was nurtured in the quarters communities where blacks lived largely in the exclusive company of one another. The testimony of former slaves who lived at such places describes their quarters as "little towns."

These were black places that were not merely left to the slaves, but were also, as repeated testimony confirms, places claimed by black people. Similar to the hidden African values found in the early slave houses was the sense of territorial imperative expressed by African Americans living on plantations. Out in the quarters, the fields, the work spaces, and in the woods at the margins of the plantation, too, some slaves reappropriated themselves. One Mississippi planter reported with a discernible measure of dismay that his slaves took pride in crops and livestock produced on his estate as *theirs*. With such possessive territorial gestures, slaves defined space for themselves.

In addition to distinctive expressions of music, oral literature, dance, folk art and craft, religion, and kinship that evolved within the plantation context, slave communities also developed sets of house types. While their designs were determined chiefly by the slave owners, the various clusters of slave cabins ultimately were understood by their occupants as home places. Historian Leslie Howard Owens has recognized that the vigorous culture created by enslaved African Americans was contingent, in large measure, on a secure sense of place. "The Quarters," writes Owens, "sometimes partially, sometimes entirely, and often mysteriously, encompassed and breathed

The Historic American Buildings Survey of the 1930s photographed many former slave cabins. Slave cabins at Savannah, Ga. (above), and Greenhill Plantation, Va. (below), exhibit a combination of African and European influences. (Prints and Photographs Division, Library of Congress)

its own special vitality into these [social] experiences, frequently assuring that bondage did not snuff out the many-sided existence slaves created for themselves."

Under the watchful eyes of planters and overseers, quarters communities were fashioned that contained a variety of housing options. All these house types were derived from the basic square room also known as a "pen." A single pen could stand alone as a one-room cabin or could be combined with other pen units to form larger houses. Single- and double-pen cabins were the most frequently used, but also common was the so-called "dogtrot cabin" (two pens with a wide passage between them). Occasionally, two-story houses were provided; these buildings were basically double-pen cabins stacked one on top of another. These houses, meant to provide shelter for four slave families, resembled a building type known as the I-house, the dwelling form used as residences by the majority of planters. Larger quarters buildings were sometimes created by linking smaller cabins into a single structure; four- and six-pen barracks were built in this way. In the French areas of southern Louisiana, slaves were housed in distinctive buildings with relatively exotic features that one might expect to see in Quebec or even Normandy. During the 1820s on the larger rice plantations along the coasts of South Carolina and Georgia, a specialized quarters house was developed that had an asymmetrical three-room plan consisting of one narrow but deep general-purpose room that was flanked to one side by two smaller bedrooms. The loft, which could be entered by a ladder from the larger room, was intended as a sleeping area for children. Referred to as "tenement houses," dwellings of this sort were built in either single or double configurations.

By 1860 most slave housing was constructed with wooden frames that were covered with siding. Nevertheless, many were also being built with tiers of corner-notched logs, in brick and stone masonry, and, in coastal Georgia and Florida, with tabby concrete. In addition to this variety of building techniques, slave quarters, particularly those within sight of the planter's residence, might be finished in one of several fashionable styles. Touches of Grecian, Gothic, or Italianate decoration might be added to the windows, doors, and eaves. One sees in slave housing the extensive efforts by slave owners to impose their will—indeed, their cultural values—upon their human property. These persistent attempts at discipline and control resulted in the architectural assimilation of African Americans, at least with respect to building repertoire.

By the mid-nineteenth century, blacks were thoroughly familiarized with Euro-American building forms and construction techniques. Significantly, the cabins used as quarters on plantations were not exclusively plantation structures; the same buildings were used by white yeoman farmers for the residences on their modest holdings. As slaves became accustomed to living in and building these houses, they transformed themselves essentially into black Southerners. When some of them were able to acquire their own land after 1865, they usually chose a standard plantation building like double-pen or dogtrot houses as the models for their new homes. What was different was that now they occupied both halves of the house, whereas previously a whole family had been confined to only one room. Further, they appended all manner of sheds and porches to their dwellings—personalizing touches that expressed a sense of self-empowerment and a degree of autonomy plainly suppressed in the slave cabins that were, on the outside at least, merely unadorned boxes with roofs. On the plantation, a slave quarter was an outbuilding in which property was sheltered. With the end of the plantation era, black builders transformed quarters into homes, a significant social achievement.

Throughout the nineteenth century, white and black vernacular traditions merged into a single regional entity so that differences along racial lines were manifested more as a function of relative wealth than as a matter of design choice. One instance will serve as an example of the merger of cultures in the saga of African-American vernacular architecture. Sometime about 1910 an unknown black farmer living near Darien, Ga., built what appeared to be nothing more than a slightly larger-than-usual single-pen house with a mud-and-stick chimney at one end. But in plan the house was actually a miniature version of a planter's house, consisting of four rooms divided by central passageway. Black notions of appropriate form and the highbrow southern ideal had become thoroughly integrated.

There remained, however, one African-American house form that signaled an alternate tradition: the shotgun house, a building one-room wide and three or more deep, oriented with its gable end to the front, stood apart from dwellings derived from the Anglo-dominated plantation system. This house owes its origins to the free black people of New Orleans, a population shaped by a massive infusion of Haitian refugees in 1809. With the arrival that year of more than 4,000 Haitian blacks, 2,060 of them free people of color, the city developed a decided black majority. In such a context free black citizens were almost equal in number to whites and thus there was ample opportunity for them to exercise a greater degree of cultural autonomy than might be found in other places. When they commissioned contractors to build houses, it is not too surprising that the Haitians re-

quested buildings most familiar to them. The shotgun house was such a house. It had a history on the island nation of Sainte Domingue (known today as Haiti) reaching back to the early sixteenth century and had been used as a mode of housing for both slaves and free blacks. Occasionally referred to as a *maison basse,* or "low house," examples were built in all sections of New Orleans, but most of them were concentrated in the Creole districts downriver and north of the French quarter.

Since almost all houses that come from European-derived traditions have their doorways on the long side, the shotgun, with its primary entrance located on the narrow gable end, was an immediately distinguishable building form. It was recognizable as both different and African-American, and the name "shotgun" (locally explained as deriving from the possibility of shooting a shotgun through the house without hitting anything) may derive ultimately from the African word *to-gun,* meaning in the Fon language of Benin "place of assembly." These black cultural associations had become totally obscured by the turn of the twentieth century as more and more shotguns were constructed as homes for white people. Even the name was lost when the house was relabeled a "Victorian cottage."

However, hundreds of shotgun houses are still to be found in the black sections of southern towns and cities from New Orleans to Louisville, from Jacksonville to Houston. Indeed, one of the distinctive markers of the black side of town in the South is often the presence of rows of shotgun houses. This continuity, however, seems to stem mainly from the lack of economic power among contemporary blacks. Since more thin, narrow shotgun houses can be crammed into the confines of a piece of property than other house forms with wider frontage, they are the most profitable choice for rental speculators. Lower-income black people find themselves being exploited, then, by means of an artifact that once stood out as a sign of cultural difference.

Today, as a result of the great migration of rural southern blacks to northern cities during the first half of the twentieth century, three-fourths of the African-American population in the United States is now found in urban settings. Contemporary black vernacular architecture thus consists mainly of buildings occupied by black people rather than buildings that they have constructed for themselves. Like most Americans, they have become consumers of domestic structures rather than creators of them. Nevertheless, through various means, principally with flowering plants and decorative painting schemes, some blacks are able to give their otherwise bland and conformist architectural settings some distinctive flourishes—often touches reminiscent of southern experi-

ence, of life "back in the country." To some extent, this type of behavior recalls the reappropriation of space first practiced in the plantation context. This is an efficient strategy, for it allows one to make rather bold claims of ownership without actually having to invest the resources required for construction. It is a marking strategy rather than a design strategy, and one that achieves important psychological benefits while husbanding one's limited economic assets.

REFERENCES

FERGUSON, LELAND. *Uncommon Ground: The Archaeology of African-America.* Washington, D.C., 1991.
ISAAC, RHYS. *The Transformation of Virginia, 1740–1790.* Chapel Hill, S.C., 1982.
McDANIEL, GEORGE W. *Hearth and Home: Preserving a People's Culture.* Philadelphia, 1982.
UPTON, DELL. "White and Black Landscapes in Eighteenth-Century Virginia." *Places* 2:2 (1985): 52–68.
VLACH, JOHN MICHAEL. *Back of the Big House: The Architecture of Plantation Slavery.* Chapel Hill, S.C., 1993.
———. "The Shotgun House: An African Architectural Legacy." Reprinted in Dell Upton and John Michael Vlach, eds. *Common Places: Readings in American Vernacular Architecture.* Athens, Ga., 1976, pp. 58–78.
———. " 'Us Quarters Fixed Fine:' Finding Black Builders in Southern History." Reprinted in John Michael Vlach. *By the Work of Their Hands: Studies in Afro-American Folklife.* Charlottesville, Va., 1985, pp. 161–178.
WESTMACOTT, RICHARD. *African-American Gardens and Yards in the Rural South.* Knoxville, Tenn., 1992.

JOHN MICHAEL VLACH

Archy Lee Incident. The Archy Lee Incident of 1858 was the most famous fugitive-slave case in California's first decade after statehood. It dramatized the tenuous legal status of California's African-American population, which was subject to treatment by contradictory and often ridiculous interpretations of law. But the Archy Lee Incident also illustrates the growing strength of California's free black community in Sacramento and, particularly, San Francisco.

Archy Lee, an eighteen-year-old slave, had been brought from Mississippi to Sacramento in 1857 by Charles Stovall, the son of Lee's owner. Lee was initially hired out for wages, but, fearing he would run away, Stovall decided to send him back to Mississippi. Lee fled, and was soon found (by Stovall) in Sacramento's Hotel Hackett, owned by J. Hackett, a free black from Pennsylvania. (Stovall had Lee arrested by local authorities.) Over the next few

months, a series of court decisions attempted to establish the legal status of Archy Lee.

In a contradictory ruling, the district court in Sacramento stated that Stovall should be allowed to return Lee to slavery, while simultaneously ruling that persons who came to California with the intention to stay could not own slaves. This ruling united San Francisco's African-American community behind Lee's cause, and on March 5, 1858, he was "arrested" on board the *Orizaba* as it attempted to leave San Francisco Bay for Panama. From Panama, Stovall planned to return Lee to Mississippi.

In a San Francisco district court, Republican attorney Edward D. Baker, hired by Lee's supporters, successfully argued that the earlier ruling was contradictory and unconstitutional. District Court Judge Freelon declared Lee a free man. In the subsequent appeal by Stovall's attorney, Lee's case was put before United States Commissioner William Penn Johnston. On April 14, Johnston ruled in favor of Lee, upholding the district court ruling. Lee quickly left California for Victoria, British Columbia, leaving behind a San Francisco African-American community emboldened by its successful fight for legal rights. Little is known of Lee's later life until he died in Sacramento of pneumonia in 1873.

REFERENCES

FRANKLIN, WILLIAM E. "The Archy Lee Case: The California Supreme Court Refuses to Free a Slave." *Pacific Historical Review* (May 1963): 137–154.
LAPP, RUDOLPH M. *Archy Lee: A California Fugitive Slave Case.* San Francisco, 1969.

DAVID B. IGLER

Arizona. The first African to visit the land that later became Arizona was Estevanico [Dorantes], a Spanish Moor who took part in an expedition to the territory in 1539. Under Spanish rule, some blacks entered the territory, and some married Native Americans. Still, the first African Americans did not migrate to the territory until the 1860s. The first African American to settle in the village of Phoenix was Mary Green, the servant of an Arkansas family that headed West. Soon thereafter, Isiah Bell, his family, and Charles COOPER traveled in a covered wagon to the settlement of Tucson. The 1870 census listed 26 blacks in Arizona. In the following twenty years, the territory's black population rose to 1,357, despite widespread discrimination by the area's whites, many of whom were ex-Southerners. One of the most important sources of the African-American Arizonian population were individuals associated with the army. Following the CIVIL WAR, black troops were sent West. The 9th and 10th infantry, created in 1866, and the 24th and 26th Cavalry, created in 1869, were stationed at Fort Huachuca in the 1880s. The "Buffalo Soldiers" fought Native Americans and engaged in law enforcement. They included several Medal of Honor winners, such as Sgt. Isiah Mays. Lt. Henry O. FLIPPER, the first African American to graduate from West Point, came to Arizona after his expulsion from the military and prospered as an engineer and writer.

Another group of African Americans that settled in Arizona was cowboys. Blacks eventually represented a significant part of the territory's ranch labor force. Some of the most famous were Isom Dart (aka "Cherokee Bill"); Tombstone's John Slaughter Swain, known as "Nigger Jim"; and Nat LOVE, famous as "Deadwood Dick." Some set up farms and cattle ranches of their own.

Other African Americans came following the failure of a colonization scheme intended to relocate freedpeople in an area of Mexico south of Yuma, Ariz. The affair turned out to be a confidence game. Numerous participants found themselves in Arizona with no land and their investment lost. Many acquired land and founded settlements—black towns named after the founders' town of origin. However, the land was often too dry or prone to flooding, and white banks refused to lend capital for improvements, leaving the inhabitants in harsh circumstances. As the settlements failed, the population moved into urban areas or to other rural areas, where they sought wage labor in Arizona's agricultural industry.

During territorial days, racial discrimination and segregation posed problems for African-American settlers. Whites moved to establish formal segregation and to institutionalize informal Jim Crow arrangements. For example, in 1909 the legislature passed an amendment which segregated elementary schools and allowed 15 percent of a district's residents to call an election to decide whether to segregate African Americans in "separate but equal" high schools. Blacks led by businessmen William Powhatan Crump and Samuel Bayless unsuccessfully challenged the law in the courts the following year, although Bayless received permission to send his children to a white school. In most rural areas and small towns, small numbers made separate facilities financially unfeasible, and the law was generally ignored. Even in Phoenix and Tucson, numbers were insufficient to warrant a separate high school for blacks until 1926, when Booker T. Washington High School was established in Phoenix. Instead, African-American students were provided teachers and space, separate rooms or "cottages," on the grounds at a distance from other students. The University of Ar-

izona was located in a black neighborhood and did not bar African-American students. It graduated its first African American in 1922. A handful of other blacks followed during the next twenty years.

By the time Arizona achieved statehood, in 1912, it had an established African-American population. Most lived in urban areas, such as Phoenix, Tucson, Flagstaff, and Sufford. Black settlers took advantage of business opportunities available in a developing economy and bought property or opened businesses such as barbershops, stagecoach lines, restaurants, and hotels. J. W. Miller's mining business, the Afro Mining Company, began in 1912 and lasted until 1923. George Rodgers founded the Western Mutual Benefit Association, a successful insurance company. Churches such as Phoenix's First Colored Baptist, founded in the 1890s, and Tucson's Prince Chapel African Methodist Episcopal (1906) and Mt. Calvary Baptist (1907) served as community centers. The Phoenix black community, located in the Washington-Jefferson St. area, also socialized in Eastlake Park. Phoenix African-American leader Robert L. Fortune, a former U.S. Deputy Marshal, ran unsuccessfully for the state legislature in 1916.

Nevertheless, statehood brought increased legal difficulties. The first state Constitution legalized seg-

Cowboy John Slaughter Swain. (Arizona Historical Society/Tucson)

regation and imposed a harsh law against intermarriage. By 1916, a KU KLUX KLAN unit had been organized in the state, and in Phoenix, an all-white Pioneers Association grew up to protect "native-born" Arizonians. African Americans responded by creating parallel institutions such as the Colored Pioneers Association (1917). In 1919, Samuel Bayless founded the Phoenix Advancement League, ancestor of the state's NAACP chapter. Churches took a large role in community support, and blacks founded newspapers such as the *Gleam* and the *Arizona Tribune* to convey their perspective on social and political issues.

During the 1920s, the state's African-American population expanded to such cities as Prescott, Douglass, Clinton, and Yuma. The cotton industry's search for migrant labor between 1920 and the mid-1950s spawned new African-American settlements like Randolph, sixty-five miles south of Phoenix.

In 1924 the Cady Lumber Company of McNary, La., transported several hundred African-American laborers and their families to Cooley, Ariz., located on the Apache White Mountain reservation. The town was renamed McNary, and housing was built for blacks in an area of the town that was subsequently known as "the Negro Quarters." (The lumber mill closed in 1979. The town reverted to Apache control in 1991, and its black residents were expelled.)

The struggle for black equality in Arizona continued during the Depression, under the leadership of the Colored Businessman's Council and the Phoenix Protection League, which organized mass meetings and demonstrations by unemployed blacks. Not until WORLD WAR II, however, did large-scale change begin. Black military personnel, including fifty-two black doctors, were stationed at Fort Huachuca, at the Litchfield Naval Station, and at the state's two air bases. Under pressure from the FAIR EMPLOYMENT PRACTICES COMMITTEE, military contractors were forced to hire large numbers of black employees. In 1942, the *Arizona Sun* newspaper was begun. It was a powerful force for equality during its twenty-year existence. In 1945, Tucson's Father Emmett McGlaughlin founded the Arizona Urban League and obtained funding for a black housing project, the Matthew Henson Houses. In 1950, Phoenix businessman Carl Sims and lawyer H. B. Daniels (Arizona's sole black attorney) became the first African Americans elected to the state legislature.

In 1952 Daniels and a group of white lawyers (one of whom was Stewart Udall, future U.S. Secretary of the Interior) successfully brought suit against segregated schools. The court's ruling in February 1953 was a precedent for the Supreme Court's BROWN V. BOARD OF EDUCATION OF TOPEKA, KANSAS decision

a year later. In the late 1950s, the state Supreme Court declared the law against intermarriage unconstitutional. Despite this decision, however, segregation remained largely entrenched. In 1960, students from the Phoenix NAACP Youth Council sat in at a local lunch counter. The owner removed the counter seats and protested. When NAACP leaders censured the demonstrators, they formed a chapter of the CONGRESS OF RACIAL EQUALITY (CORE). CORE also formed a chapter in Tucson. After a series of demonstrations, CORE won a desegregation pledge from the two cities' merchants in December 1960. Phoenix passed an "open door" ordinance in 1963, although the Tucson City Council refused to pass civil rights legislation. Despite internal friction, CORE and the NAACP joined forces, and in 1964, 300 people marched on the state capitol.

In 1965, Arizona finally passed a statewide Civil Rights and Fair Employment law. However, housing remained heavily segregated, and discrimination and police harassment continued. In July 1967, blacks rioted in both Tucson and Phoenix, throwing stones and challenging police. Phoenix's mayor imposed a tight curfew and surrounded the black area of South Phoenix with police, and the rioting wound down.

In the twenty-seven years since 1967, African Americans have been elected to the state legislature, to city councils, and to school boards. Clovis Campbell, the first black state senator, was elected in 1970, and Ethel Maynard, the first black woman representative, took office in 1972. Several well-known African Americans, including track star Jesse OWENS, Lt. Gen. Emmett Paige Jr., and poet Jayne CORTEZ have made their home in Arizona. However, blacks have remained underrepresented in the professions and overrepresented in low-wage and unemployment statistics. Police harassment has remained a chronic complaint. In 1982, Phoenix attracted national attention after two black members of a religious sect were shot in a confrontation with police over traffic tickets. Tucson delayed into the 1990s implementing a school antidiscrimination plan approved in 1976. In 1992, after a nationally publicized twenty-year struggle, Arizona voters approved adding a new holiday, Martin Luther King Jr. Day/Civil Rights Day, to the state's calendar. Though the absolute number of African Americans in Arizona was substantially increased in recent decades, from 43,400 in 1960 to 111,000 in 1990, this was part of a huge general population influx to the state, and the percentage of black Americans has remained at about 3 percent of the total population throughout the century.

REFERENCES

HARRIS, RICHARD E. *The First 100 Years: A History of Arizona Blacks;* Apache Junction, Ariz., 1983.

LAWSON, HARRY, ed. *African Americans in Aviation in Arizona.* Tucson, Ariz., 1989.

LECKIE, WILLIAM. *The Buffalo Soldiers: A Narrative of the Negro Cavalry in the West.* Norman, Okla., 1967.

NIMMONS, KIM. *Arizona's Forgotten Past: The Negro in Arizona, 1539–1965.* M.A. thesis, Northern Arizona University, 1971.

SMITH, GLORIA L. *Arizona's Slice of Black Americana.* Tucson, Ariz., 1976.

———. *Black Americana in Arizona;* Tucson, Ariz., 1976.

BRACKETTE F. WILLIAMS

Arkansas. Arkansas, sandwiched between Missouri, Oklahoma, and Louisiana on the west bank of the Mississippi River, has traditionally displayed both border state and Deep South characteristics, and the history of its black residents has been marked by an unusual mixture of oppression and tolerance. African Americans have played a crucial role in Arkansas history. The labor of enslaved blacks built up the new state's economy in the antebellum period; the political power of the state's African Americans shaped the state's lasting institutions during the RECONSTRUCTION period and after; and throughout the twentieth century, black Arkansans struggled in the face of determined white opposition to bring interracial democracy to the state.

The land within the borders of present-day Arkansas was originally claimed by France as part of the territory of Louisiana, and in 1719 King Louis XV granted financier John Law a huge tract of land in Arkansas. In 1719 Law colonized the Post of Arkansas with some 2000 white immigrants from Germany and 300 enslaved Africans. Most soon left, however, following the failure of Law's speculations. In 1771 the Post of Arkansas had only sixty-eight whites and sixteen blacks. During and after the American Revolution, however, American hunters, trappers, and farmers entered the area, and in 1803, when the United States acquired Arkansas as part of the Louisiana Purchase, the Post had 874 residents, including 107 black slaves and two free blacks.

In 1819 residents of Arkansas, then part of the Missouri Territory, petitioned Congress to establish the area as an independent territory. The petition sparked debate in congress over slavery, and an antislavery provision barely failed in a vote. The Arkansas Territory was established in 1819. The agitation in Congress over Arkansas slavery prefigured the furor that broke out the following year over slavery in Missouri and led to the Missouri Compromise of 1820.

Slavery grew slowly in Arkansas. At first the farmers of the eastern uplands, who came with their slaves

from slave states, were the dominant group. Eventually, however, two opposing regions, roughly divided by the Arkansas River, formed in the territory. The southern and eastern section, consisting of a fertile alluvial plain, was the main slaveholding area, while the Ozark plateau of the north and west contained few slaves, and was the center of a growing antislavery movement led by Methodists.

Slavery resurfaced as an important issue in the mid-1830s, when Arkansas applied for statehood. Territorial leaders such as Congressional delegate Ambrose Huntley Sevier argued that Arkansas needed to lure established planters to spur the state's economy, and warned that abolitionist "fanatics" would exclude Arkansas from the union unless the territory's residents took immediate action. In 1836 a constitutional convention called by the legislature began work on a state constitution. The finished document firmly established slavery. However, it provided a majority of seats in the state's House of Representatives for legislators from the nonslaveholding North and West, and permitted slaves to sue in court and to receive equal punishment with whites if convicted of crimes. Despite efforts by antislavery forces in Congress to block a vote on statehood, Arkansas became the twenty-fifth state in June 1836.

Even after achieving statehood, Arkansas remained a frontier area, crisscrossed by rivers and swamps which made farming and transport difficult. There were few native-born residents, and Arkansas never developed a large plantation system. By 1840 there were 19,935 slaves in Arkansas. Most enslaved blacks worked on small farms or cleared frontier land for the planting of cotton. In the more settled southeastern counties were a few large sugar plantations. The insecurities of the frontier environment led to relatively high slave mortality and to harsh laws on slave discipline. They also facilitated slave escapes, the most notable being that of Nelson Hacket, a butler who fled the state on a stolen racehorse before being caught in Canada and extradited. With laborers at a premium, the price of slaves constantly rose. Many whites were active in slave trading, despite a technical prohibition on "speculation" in the 1836 constitution. Little Rock and other towns developed "auction marts."

Over the years, Arkansas lawmakers moved to solidify slavery in the state. Laws restricted manumission of slaves, and required free blacks and mulattoes to pay a $500 bond. After 1843, free black immigration was banned. Despite these obstacles, a small antebellum free black community grew up in the area. Nathan Warren was a respected carriage driver and pastry cook in Little Rock, then a small town. In 1834, Elizah Williams, a free black, was identified in a court record as a "true and lawful attorney." In Marion County there were several black property owners.

Improvements in banking and railroads brought about the introduction of cotton cultivation and agricultural growth after 1840, and by 1860 Arkansas' slave population numbered 111,115, one fourth of the state's total population. Economic self-interest bound Arkansas with the South during the 1850s, as the national debate over slavery heightened. Rumors of slave insurrections provoked hysteria over abolitionist activities, and in 1859, following the DRED SCOTT DECISION, Arkansas expelled its free black population. The law threatened all free blacks with reenslavement, and most fled. A new state constitution (1861), prohibited manumission.

In March 1861, a statewide convention rejected SECESSION, but the outbreak of the CIVIL WAR gave Arkansas secessionists a majority, and the state left the Union soon after. Meanwhile, northern Arkansans organized loyalist militia, and Union troops began taking over parts of the state. Arkansas had a significantly smaller slave population than any other Confederate state except sparsely settled Florida, and its slave system was crushed in the chaos of the Civil War. After the Confederate government authorized the conscription of slaves into labor brigades in 1862, many masters tried to hide or transport their slaves out of the state, usually unsuccessfully. Enslaved blacks liberated themselves by going behind Union lines. The army employed them as cooks and laborers. Ultimately, in an unsuccessful experiment to judge the feasibility of wage labor among African Americans, many escaped slaves were put to work growing scarce cotton on abandoned plantations which had been leased by Northern speculators. In 1864 the Army began forming brigades of Arkansas blacks, and some 5,000 joined up.

That same year, white Unionists established a government in Little Rock under federal protection. They adopted a new state constitution that forbade slavery and banned discrimination in public education, but rejected black suffrage and forbade black immigration without federal government authorization. The end of the Civil War in Arkansas brought no end to racial discrimination. The legislature elected in 1866 was composed almost exclusively of ex-Confederates reenfranchised by the state's Supreme Court. This legislature allowed blacks to sue in court and hold property, but it rejected the FOURTEENTH AMENDMENT and denied blacks the right to sit on juries or serve in the militia. While the state constitution provided for equal education, the legislature adopted school segregation, and then refused to vote funds for black schools.

In 1867 the U.S. Congress dissolved the legislature and called for a new constitutional convention. This

time, blacks were enfranchised, and there were eight black delegates in the convention. The black delegates, led by William Grey, an antebellum free black from Virginia and a powerful orator, lobbied successfully for suffrage and free public schools and against a constitutional provision forbidding intermarriage. Following a Democratic and conservative boycott of elections, the constitution was ratified in 1868, and the state of Arkansas was readmitted to the Union.

Under RECONSTRUCTION, blacks were able to vote and to attend school for the first time. They were too small a fraction of the voting population to elect black federal representatives or statewide officials. Still, there were up to twenty black state representatives at any one time, and two blacks, William Grey and Joseph Corbin, held positions in the governor's cabinet in the early 1870s. The black legislators united to push successfully for civil rights acts in 1868 and 1873, prohibiting discrimination in public accommodations. They also obtained funding for black schools on a segregated basis. In 1874 the legislature established the Branch Normal College for Negroes at Pine Bluff in order to train black teachers. On other issues, blacks divided on class and ideological lines, and leaders established contacts across the political spectrum. Black voters supported both Republican and Democratic candidates.

Despite these gains, the mass of Arkansas' African-American population remained poor. Some blacks, such as millionaire planter Scott Bond, were able to secure title to land, but most were forced to work as wage laborers or sharecroppers. Black laborers were assigned to pick cotton, now the primary crop of much of the state's fertile black belt. They were without legal and economic protection, and were vulnerable to cheating by unscrupulous planters. Before long, many were trapped in debt peonage, despite crop lien laws favoring laborers. Those who were arrested and convicted, even on minor or trumped-up charges, were put to work as convict labor, and leased to private contractors in a slavery-like arrangement which lasted as late as 1912. The KU KLUX KLAN terrorized blacks in Arkansas, and its victims numbered in the hundreds. In 1869 Republican Gov. Powell Clayton declared martial law and sent militia troops, some black, to protect citizens.

In 1874, following a legal struggle between two claimants for the governorship, the Democrat-backed candidate prevailed, and his supporters selected delegates for a new constitutional convention. Only eight black delegates were selected to the convention. While the new constitution dismantled much of the state government built up during Reconstruction, the prevailing spirit of racial conciliation remained, and black voting and citizenship rights

were protected. Arkansas governors during the "Redemption" period continued to promote black schools and civil rights and to provide leaders with patronage. White leaders were not threatened by black voting and were anxious not to provoke federal authorities or alienate black labor through harsh racial policies. They were also interested in using the state's moderate image to attract new black laborers and EXODUSTERS to the Arkansas Delta.

Arkansas at the end of the nineteenth century boasted several distinguished black residents, including the Rev. Elias MORRIS of Helena, founder and president of the NATIONAL BAPTIST CONVENTION; John E. Bush, founder of a large FRATERNAL ORDER, the Mosaic Templars of America; dentist and novelist John Henry Smith; and John THOMPSON and Scipio Jones, talented lawyers who later practiced before the U.S. Supreme Court. Perhaps the era's most prestigious black Arkansan was Mifflin W. GIBBS, who had been a wealthy gold miner and elected official in Canada before moving to Arkansas and establishing himself as a lawyer and the nation's first African-American municipal judge.

Economic opportunity remained open for Arkansas' cadre of middle-class blacks. The state capital, Little Rock, developed into a center of black business and was the home of three black colleges: Philander Smith College (originally Walden Seminary), founded by the Methodist Episcopal Church North in 1877; Arkansas Baptist College, founded in 1884; and Shorter University (originally Bethel University), an African Methodist Episcopal Church institution founded in 1886. Around the churches and schools grew fraternal organizations—at least forty-three by 1900—clubs, charitable groups, and literary societies, most notably the Lotus Club and the Bay View Reading Club.

In the last decade of the nineteenth century, the political and social status of blacks in Arkansas dropped sharply, in the face of white anger over economic competition. Also, the agrarian populist Union Labor party became popular following agricultural depression. Elite Democrats feared a challenge to their rule by a class-based coalition of agrarians and black Republicans. They used appeals to white supremacist sentiment to divide the opposition. In 1891, following a Democratic victory in a disputed election marked by fraud, the state assembly passed a law changing the electoral system. Ostensibly a reform measure, it had the effect of reducing a large part of the state's voting population, a disproportionate number of whom were African American. The same year, despite powerful speeches by George BELL, Arkansas' lone black state senator, and William Lucas, one of seven black state assemblymen, the legislature passed a law segregating railroads, the first

of many segregation statutes to come. In 1893 the legislature passed an amended poll tax law, which disfranchised half the voting population, black and white (in 1912 the State Suffrage League, led by Scipio Jones, successfully blocked a proposed "grandfather clause" exempting the white population from the tax). After 1894, no further black legislators were elected in Arkansas until the mid-1960s. In 1906, Gov. Jeff Davis, a racist demagogue, instituted a "white primary" that struck out the last vestiges of black voting power in Arkansas.

In the first part of the twentieth century, Arkansas resembled other southern states in race relations. Segregation was widespread and blacks, particularly in the agricultural counties of the Delta "black belt," were restricted to sharecropping, low-wage factory labor, and domestic service work. A few native black Arkansans, such as composers Florence PRICE and William Grant STILL, jazz musician Louis JORDAN, blues artist Little Willie John, gospel singer "Sister" Rosetta THARPE, and publisher John JOHNSON, achieved renown. The black population remained largely static after 1910, and declined relative to the white population as native-born African Americans emigrated in search of greater opportunity.

In 1919, following the end of World War I, a group of African-American farmers in rural Phillips County, led by Robert L. Hill, organized the Progressive Farmers and Householders Union, a cooperative and self-help organization designed to raise agricultural prices and assure fair treatment. During a union meeting at a local church, a white deputy sheriff fired shots into the building to disperse the attendees. Union members returned the fire, wounding the deputy. The local white population, plus squads of armed whites from surrounding areas shipped in by

Scipio Jones. (Arkansas History Commission)

railroad, broke out into a furious riot. Hundreds of blacks were killed or wounded, and the county's black district was heavily damaged. While no whites were arrested for rioting, a dozen blacks were convicted of murder and lesser offenses in a mob-dominated trial. Following an appeal by the NAACP, their sentences were overturned by the U.S. Supreme Court in the landmark case *Moore v. Dempsey* (1923).

The GREAT DEPRESSION brought widespread misery to Arkansas blacks. In 1933, following the institution of cotton production quotas by the Federal Agricultural Adjustment Administration, thousands of sharecroppers—black and white—were removed from the land they worked. In order to fight for their rights and to improve wages and educational opportunity, Arkansas sharecroppers formed the interracial Southern Tenant Farmers' Union (STFU) in rural Tyronza, in 1934. Despite terror campaigns and daily harassment from Arkansas officials and planters, the STFU publicized the plight of farm workers. It won some signal victories, gaining price raises through strikes, and forcing the creation of the Arkansas Tenancy Commission and then the federal Farm Security Administration to work on resettling and improving conditions among farm workers. In 1936, following statements by Arkansas planters and Gov. J. Marion Furrell that there was no debt peonage in the state, an FBI investigation prompted by STFU complaints culminated in the arrest and conviction of Paul Preacher, a deputy sheriff, on charges of holding thirteen union members in slavery. The STFU continued to be a power in Arkansas until 1939, when its membership split over the issue of Communist involvement in union activities.

Civil rights activism continued during the era of WORLD WAR II. Little Rock's weekly black newspaper, the *State Gazette,* was founded in 1941 by L. C. and Daisy BATES. The *State Gazette* courageously reported details of police brutality towards black soldiers training at nearby Camp Robinson, and forced city authorities to hire black police and take steps to halt the harassment. In the decades following World War II, large numbers of African Americans left Arkansas. Some of them, notably baseball player Lou BROCK, musician Henry DUMAS, writer Maya ANGELOU, and black radical Eldridge CLEAVER, went on to fame elsewhere.

Even as the state's black population fell, a spirit of racial moderation prevailed in Arkansas, and African Americans achieved a few symbolic civil rights victories. Liberal governor Sid McMath (1948–1952) spoke in favor of antilynching legislation and against poll taxes, and made token appointments of blacks to state commissions. In 1948 the University of Arkansas voluntarily opened its law school to blacks, the first southern state university to do so, and in 1954

the state's college system desegregated. After the U.S. Supreme Court's 1954 BROWN V. BOARD OF EDUCATION OF TOPEKA, KANSAS school desegregation ruling, Arkansas officials pledged compliance, and five schools were peacefully integrated in 1955–56. Gov. Orval Faubus, elected in 1954, increased aid to schools and pensions. In 1956 he easily defeated a rigid segregationist opponent who charged him with being overly liberal on racial issues. Arkansas seemed a bastion of moderation.

In 1957, in response to lobbying from Daisy Bates, by then chair of the Arkansas NAACP, Little Rock school board officials worked out a plan for the token desegregation of the city's Central High School. Soon after, a segregationist local Citizen's Council tried unsuccessfully to block the move in the courts. Conservatives put pressure on Gov. Faubus, and on September 2, 1957, Faubus sent in Arkansas National Guard troops to prevent violence, and they blocked the entry of the nine teenage black students (later

dubbed "the Little Rock Nine"). Following a court injunction, Faubus removed the troops, but students attempting to enter the school were met by jeering mobs who threatened violence. The mob scenes, distressing symbols of white intransigence, were displayed on national television. Ultimately, on September 25, President Dwight D. Eisenhower was forced to call in troops of the 101st Airborne Division to assure the safe enrollment of the students. Arkansas Guard troops remained at the school for the whole year to guarantee the students' safety. The nine black students' calm determination won them and Bates the NAACP's coveted SPINGARN MEDAL, and made them heroes to African Americans throughout the United States. All managed to stay in school the entire year.

Segregationist sentiment remained dominant. In 1958 the state legislature closed Central High, and Faubus ordered it shut for an entire year. Arkansas authorities banned the state's NAACP for several

(Left to right) Garfield Parker, the Rev. Jesse Jackson, Daisy Bates, and L. C. Bates at the National Black Convention, March 16, 1974. (Arkansas History Commission)

years after it refused to surrender its membership list. Economic reprisals forced the *State Press* to end publication in 1959, and Daisy Bates left the state. Over the following decade, schools integrated at a snail's pace. Little Rock school officials who had supported integration were dismissed or transferred. After a mammoth struggle between the mass campaign Committee to Retain Our Segregated Schools (CROSS) and the pro-integration group Stop This Outrageous Purge (STOP), limited desegregation proceeded in the mid-1960s. However, Central High School did not reopen until 1975.

Despite its tenure as a civil rights battleground, Arkansas remained relatively quiet during the 1960s. New investment in the state dropped by 80 percent after the Little Rock affair, and state authorities were anxious to avoid controversy. Gov. Faubus, backed by a solid segregationist vote, firmly controlled Arkansas, but he complied with federal civil rights orders. Throughout the early 1960s, the STUDENT NON-VIOLENT COORDINATING COMMITTEE's (SNCC) Arkansas Project, led by the Rev. Ben Grinage, registered thousands of voters. In 1966 Faubus left office, and Winthrop Rockefeller, a liberal Republican, was elected governor with the aid of a solid black vote. He hired black state troopers and appointed blacks to state and municipal offices.

Rockefeller and his successors helped reestablish Arkansas' moderate reputation, and presided over the state's shift from a predominantly agricultural system to a more diverse Sunbelt economy built with the aid of industry and retiree immigration. Little Rock was the showpiece of this trend. With the aid of new industry, the city's economy expanded, and residents cultivated a liberal image. In 1981 Charles Bussey was elected Little Rock's first African-American mayor, although blacks made up only about one-third of the city's population. Large communities have also grown in Pine Bluff, Helena, Fayetteville, and other places, though many blacks reside in rural areas throughout the state.

Most Arkansas African Americans have not shared in the state's new wealth, and they represent a disproportionate share of its poor and unemployed citizens. Still, they have made enormous progress in the political arena since the 1960s. While no African Americans have been elected to Congress from Arkansas, more than a dozen African Americans have served as state representatives or state senators, although blacks represent only sixteen percent of the state's population. In 1977 George Howard, Jr., became the first African American to sit on the state's Supreme Court. During the 1980s, liberal Gov. Bill Clinton appointed some 300 African Americans to state offices, half of them women. In 1990 Kenneth Harris won the Republican party primary race for

lieutenant governor. In 1991, in a historic victory, African American Lottie Shackleford was elected the first woman mayor of Little Rock. Educational standards have also improved. In 1972 the Branch Normal College for Negroes became the University of Arkansas at Pine Bluff and was upgraded to equal status with other colleges in the state system. In the 1980s Clinton campaigned for increased funds for education programs, although Arkansas still ranked forty-fifth among states in educational expenditures per pupil in 1990.

Clinton's popularity among black voters in Arkansas and elsewhere was a decisive factor in his successful run for the office of president of the United States in 1992. Once in office, he selected a highly visible and successful member of his team, Health Commissioner Dr. Joycelyn ELDERS, as U.S. Surgeon General, a cabinet-level position. Elders's controversial tenure and achievements in that crucial and difficult post not only made her probably the best-known Arkansas African American but are symbolic of both the problems and successes of Arkansas blacks.

REFERENCES

BASKETT, TOM, JR., ed. *Persistence of the Spirit: The Black Experience in Arkansas.* Little Rock, Ark., 1986.

BATES, DAISY. *The Long Shadow of Little Rock.* New York, 1962.

CORTNER, RICHARD C. *A Mob Intent on Death: The NAACP and the Arkansas Riot Cases.* Middletown, Conn. 1988.

GRAVES, JOHN WILLIAM. *Town and Country: Race Relations in an Urban-Rural Context, Arkansas 1865–1905.* Fayetteville, Ark., 1990.

MITCHELL, H. L. *Mean Things Happening in This Land.* Montclair, N.J., 1979.

PATTERSON, RUTH POLK. *The Seed of Sally Good'n: A Black Family of Arkansas, 1833–1953.* Lexington, Ky., 1985.

TAYLOR, ORVILLE W. *Negro Slavery in Arkansas.* Durham, N.C., 1958.

TUCKER, DAVID A. *Arkansas: A People and Their Reputation.* Memphis, Tenn., 1985.

WILLIAMSON, LLEWELLYN W. *Black Footprints Around Arkansas.* Hope, Ark., 1979.

GREG ROBINSON

Armstrong, Henry (Jackson, Henry, Jr.)

(December 12, 1912–October 22, 1988), boxer. Born in Columbus, Miss., he was the eleventh of fifteen children of farmer-butcher Henry Jackson, Sr., and his wife, America (Armstrong). The family moved to St. Louis, where he graduated from high school.

Henry adopted his mother's maiden name when he began to box. He achieved a BOXING record of 58–4 as an amateur, and turned pro in 1931. The 5'5½" fighter won the world featherweight championship on October 29, 1937, with a sixth-round knockout of Pete Sarron. Then he dethroned welterweight champion Barney Ross on May 31, 1938, and lightweight champion Lou Ambers on August 17, 1938, both by fifteen-round decisions. He is the only boxer ever to hold three world championships simultaneously. Armstrong resigned his featherweight crown in November 1938, having never defended it. He lost a rematch with Ambers on August 22, 1939, and thereafter mainly fought as a welterweight, although he lost a ten-round decision to middleweight champion Ceferino Garcia in 1940. Armstrong at one time won forty-six straight bouts, including twenty-seven consecutive knockouts, which earned him the nickname "Homicide Hank." He lost his welterweight crown on October 4, 1940, decisioned in fifteen by Fritzie Zivic. Zivic knocked him out in their Madison Square Garden rematch on January 17, 1941, drawing a record indoor crowd of 23,190.

Armstrong retired in 1945, with a record of 144–21–8–1 (including 97 KOs among the 144 victories) with over $1 million in purses. Thereafter he was involved in a Los Angeles nightclub, and in 1951 he became an ordained Baptist minister, working as an evangelist and running the Henry Armstrong Youth Foundation to fight juvenile delinquency. The movie *King Punching* was based on his life. An autobiography, *Gloves, Glory and God,* appeared in 1956. He became director of the Herbert Hoover Boys Club in St. Louis in 1972. Armstrong was elected to the Boxing Hall of Fame in 1954.

REFERENCE

Obituary. *New York Times,* October 25, 1988, Sec. 2, p. 7.

STEVEN A. RIESS

Armstrong, Lillian Hardin "Lil" (February 3, 1898–August 27, 1971), jazz pianist. Born in Memphis, Tenn., Lil Hardin studied classical piano and organ as a child. She attended Fisk University in Nashville until around 1917, when her family moved to Chicago. There she studied at the Chicago College of Music and began working as a song demonstrator at Jones's Music Shop. By the early 1920s, Hardin had accompanied the singer Alberta HUNTER, played with the Original Creole Jazz Band, and led her own ensemble at the Dreamland club. She joined King OLIVER's Creole Jazz band in 1921. Oliver's famous band, the first to bring "hot" New Orleans jazz to Chicago, became even more popular after Louis ARMSTRONG joined as second cornet a few months later. The ensemble's recordings, among the first great examples of a jazz ensemble, include "Riverside Blues" (1923), "Dippermouth Blues" (1923), and "Weather Bird Blues" (1923).

In 1924, Hardin and Armstrong were married. That year, at the urging of his wife, Louis Armstrong left Oliver and joined Fletcher HENDERSON's orchestra, which led to his emergence as the major trumpeter of his era. Starting in 1925, Lil Hardin Armstrong and her husband joined in two ensembles: a quintet known as the Hot Five and a septet called the Hot Seven. Recordings by these groups, including the jazz classics "Cornet Chop Suey" (1926), "Muskrat Ramble" (1926), and "Potato Head Blues" (1927), are usually credited to Louis Armstrong, but Lil Armstrong was the initial force behind organizing the ensembles. Lil Hardin Armstrong gathered the same performers in 1926 to record as Lil's Hot Shots on "Georgia Bo Bo" and "Drop That Sack." She also composed the famous "Struttin' with Some Barbecue" (1927).

Although Louis Armstrong took the spotlight onstage, offstage it was clear that his wife had managed his career and even schooled him in musical matters, a situation that led to their separation in 1931 and divorce in 1938. After the late 1920s, Louis Armstrong's career eclipsed that of his wife, but she was nonetheless an accomplished soloist and composer who played a crucial role in the development of the standard jazz ensemble. During the mid to late 1920s, she also performed with the New Orleans Wanderers ("Gate Mouth," 1926) and Johnny Dodds ("San," 1927). In the late 1920s she went back to school, earning a teacher's diploma at the Chicago College of Music in 1928 and a graduate diploma at the New York College of Music in 1929.

In the late 1920s and early '30s, Lil Hardin Armstrong appeared with Ralph COOPER, King Oliver, Freddie Keppard, and an all-female group called the Harlem Harlicans. She recorded "Virginia" (1932), "Just for the Thrill" (1936), "Born to Swing" (1937), "Lindy Hop" (1937), and "You Shall Reap What You Sow" (1938). She also performed in *Hot Chocolates* (1929) and *Shuffle Along* (1933). After a big band tour of the Midwest in 1935–1936, she settled in New York, working as a pianist for Decca Records.

Lil Hardin Armstrong moved to Chicago permanently in 1940. Among her later recordings are "I Did All I Could" (with Lonnie Johnson, 1941), "East Town Boogie" (1947), "Lil's Boogie" (recorded in 1953 in Paris), and "Red Arrow Blues" (1961). She also recorded an album of reminiscences, *Satchmo and Me* (1958–1959). Lil Armstrong died in August 1971

after collapsing at a Chicago memorial concert for Louis Armstrong, who had died the month before.

REFERENCES

COLLIER, JAMES LINCOLN. *Louis Armstrong.* New York, 1983.

DAHL, LINDA. *Stormy Weather: The Music and Lives of a Century of Jazzwomen.* London, 1984.

ELIZABETH MUTHER

Armstrong, Louis "Satchmo" (August 4, 1901–July 6, 1971), jazz trumpeter and singer. Although it is certain that Louis Armstrong was born in New Orleans in poverty, there has long been confusion concerning his exact birth date. During his lifetime, he claimed he was born on July 4, 1900, but a baptismal certificate discovered in the 1980s now establishes his real date of birth as August 4, 1901. He was raised in terrible poverty by his mother and grandmother, and he contributed to the family income from his earliest years. His first musical experience was singing in a barbershop quartet. In 1912 or 1913, according to legend, he celebrated the Fourth of July by firing a pistol; he was arrested and sent to the Colored Waifs' Home, where he remained for about two years.

There an already evident interest in music was encouraged, and he was given instruction on cornet and made a member of the band. Armstrong came to adulthood just as jazz was emerging as a distinct musical style in New Orleans, and the new music and Armstrong matured together (*see* JAZZ). He played in local clubs called "tonks" and apprenticed in local bands, where he met most of New Orleans's early jazz musicians, and found a mentor in Joseph "King" OLIVER. He soon developed a reputation as one of the best young brass musicians in the city. In 1919 he joined Fate Marable's band, playing on Mississippi riverboats, where he learned to read music. He returned to his hometown in 1921.

In 1923 King Oliver invited Armstrong to join his successful Creole Jazz Band in Chicago as second cornetist, and it was with Oliver that Armstrong made his first recordings. These records provide an invaluable document of early New Orleans jazz, and, while they contain much ensemble playing and collective improvisation, they also show that Armstrong was already a formidable soloist. The following year, encouraged by his second wife, Lil Hardin, Armstrong joined the jazz orchestra of Fletcher HENDERSON in New York City. Recordings such as Don Redman's arrangement of the 1924 "Copenhagen" reveal an inventive melodist and improvisor. His big-band experience helped Armstrong fashion a new type of jazz

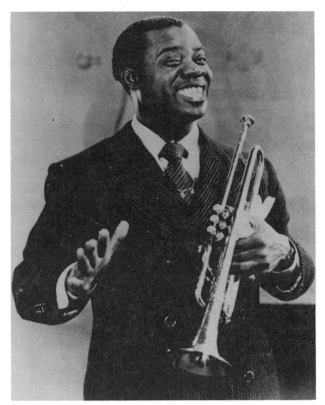

Louis Armstrong, c. 1929. (AP/Wide World Photos)

playing, featuring extended improvised solos. In New York he also recorded as an accompanist to blues singers Bessie SMITH, "Ma" RAINEY, and Bertha "Chippie" Hill.

This new style was featured in the extraordinarily influential series of recordings made under Armstrong's leadership from 1925 to 1929 with ensembles called the Hot Fives and Hot Sevens. His collaborators on the early dates include Johnny DODDS on clarinet, Kid ORY on trombone, and pianist Lil Hardin, whom he married. Hardin played an important role at this time in furthering and supervising her husband's career.

His solos on "Big Butter and Egg Man" (1926), "Struttin' with Some Barbecue" (1927), "Potato Head Blues" (1927), and "Hotter Than That" (1927) are superb improvised melodies, and they showed that jazz was becoming a soloist's art. Every night on the bandstand, Armstrong found in pianist Earl "Fatha" HINES a musician who could not only function on his level but with whom he could exchange musical ideas. That collaboration did not produce recordings until 1928, but then it produced such masterpieces as "West End Blues," "Skip the Gutter," and the duet "Weather Bird."

In 1929 Armstrong returned to New York, which remained his home for much of the remainder of his life. That year he appeared in the Fats Waller/Andy

Razaf Broadway Show *Hot Chocolates*. He was also the leader of his own orchestra, which featured popular tunes rather than the original blues and New Orleans songs he had previously favored. Increasingly prominent in his performances at this time was his singing, which in its use of scat (wordless syllables) and creative rhythmic reworking of a song's lyrics and melodies influenced all subsequent jazz singers. His recordings "Body and Soul," "Memories of You," "Sweethearts on Parade" (all 1930), and "Stardust" (1931), among many others, helped establish both the repertory and playing style of big-band jazz. In 1932, and again in 1933–1935, he toured Europe. On the first tour he acquired the nickname "Satchmo," short for "Satchelmouth," though his fellow musicians favored the sobriquet "Pops."

There were no real innovations in Armstrong's work after the early 1930s, but there were over three decades of this powerful trumpeter and grand and compelling entertainer's life still ahead. Extending the range of his instrument to F above high C, Armstrong recorded "Swing That Music" (1936) and two years later revisited "Struttin' with Some Barbecue," offering another classic solo on that piece. In addition to his purely musical accomplishments, Armstrong in the 1930s became an entertainment celebrity, the first African American to appear regularly on network radio programs and to be widely featured in motion pictures such as *Pennies from Heaven* (1936) and *Going Places* (1938).

By the early 1940s, Armstrong's popularity had waned somewhat. In 1947 his career was reinvigorated by his return to a small-group format under the name of Louis Armstrong and the All-Stars, which he continued to lead with varying personnel for the remainder of his life. In its early years, his fellow band members included pianist Earl Hines, trombonist Jack Teagarden, and clarinetist Barney BIGARD. In his later years Armstrong made numerous tours of Europe, Asia, and Africa; in 1960 the United States government appointed him a special "ambassador of goodwill" for the positive feelings his travels abroad engendered.

Armstrong's genial and nonconfrontational personality, and his inclusion of some "coon" and plantation songs in his repertory (including his theme song "When It's Sleepy Time Down South"), were sometimes criticized by a younger, more militant generation of black entertainers. Though Armstrong was a product of the segregated South who learned early in his career not to discuss racial matters in performance, he cared deeply about racial injustice. In 1957 his uncharacteristically blunt comments about the inaction of the Eisenhower administration in the Little Rock incident ("The way they are treating my people in the South, the government can go to hell") created something of a furor, though such public statements by Armstrong were rare.

Armstrong was perhaps best known to the general public in the last years through popular recordings featuring his singing, including "Blueberry Hill" (1949), "Mack the Knife" (1955), and "Hello, Dolly" (1967). In 1988 his 1968 recording of "It's a Wonderful World" appeared on the popular charts after it was used in the film *Good Morning, Vietnam*.

As Albert Murray has remarked, Louis Armstrong had the innate ability to make people feel good simply by his presence. But that feeling was not a simple matter of cheering up his audiences. His music could encompass melancholy and sadness while at the same time expressing a compensating and equally profound joy. Armstrong was the first great improvisor in jazz, and his work not only changed that music but all subsequent popular music, vocal and instrumental. He expanded the range of his instrument and all its brass cousins in ways that have affected composers and players in all forms of music. In his progression from simple beginnings to international celebrity he became, arguably, both the most beloved and the most influential American musician of the twentieth century. Armstrong, whose career had slowed after a 1959 heart attack, died in Corona, Queens, where he had lived since 1942 with his fourth wife, Lucille Wilson.

REFERENCES

ARMSTRONG, LOUIS. *Satchmo: My Life in New Orleans.* New York, 1954.
GIDDINGS, GARY. *Satchmo.* New York, 1988.
SCHULLER, GUNTHER. "The First Great Soloist." In *Early Jazz.* New York, 1968, pp. 89–132.
WILLIAMS, MARTIN. "Louis Armstrong: Style beyond Style." In *The Jazz Tradition.* New York, 1983, pp. 52–64.

MARTIN WILLIAMS

Arnelle & Hastie, corporate law firm. In 1985 H. Jesse Arnelle and William H. Hastie cofounded Arnelle & Hastie, one of the first minority-owned and -operated corporate law firms in the nation. The firm began with only two lawyers in a small space in San Francisco. By 1994, the firm had expanded to include offices in Los Angeles, Sacramento, New York, Philadelphia, and Cherry Hill, N.J., with six partners and thirty associates, many of whom had a background in civil rights litigation.

H. Jesse Arnelle was born in New Rochelle, N.Y., and received his B.A. from Pennsylvania State University in 1955. Having participated in collegiate

sports, Arnelle played professional basketball from 1955 to 1956 and professional football from 1957 to 1958. Following his brief career in professional sports, Arnelle entered law school, graduating from Dickinson School of Law in Carlisle, Pa., in 1962. In 1963, he was named associate director of the Peace Corps in Turkey. Two years later, he was appointed regional director in India, and in 1967, he became the deputy in charge of special recruiting. Before entering private practice, he served as the associate general counsel at the Federal Power Commission (1968) and as a public defender in the Ninth Circuit (California) of the U.S. District Court (1973–1975). From 1975 to 1985, Arnelle worked as a sole practitioner.

William Hastie, who specializes in employment law, was born in Charlotte Amalie, St. Thomas, in the U.S. Virgin Islands, where his father, William H. HASTIE, Sr., was serving as governor. Shortly after the younger Hastie's birth, the family moved to Philadelphia, and he attended high school there. Hastie received a B.A. from Amherst College in 1968 and a J.D. from Boalt Hall School of Law, University of California, Berkeley, in 1971. That same year, Hastie cofounded and worked as a lawyer at Public Advocates, California's first public law firm. In 1976, he accepted a position as executive officer and general counsel for the California Fair Employment Practice Commission. He left public service in 1978 to cofound Hastie-Lawrence Associates, a management and legal consulting company, but returned to state employment in 1979 as the undersecretary and general counsel for state and consumer services and as chairman of the California State Building Standards Commission. From 1983 to 1985, he taught law as a visiting professor at the University of California at Berkeley and practiced law part-time.

Together, Arnelle and Hastie have built a multimillion-dollar establishment with a strong national reputation. In 1993, the firm ranked among the top ten bond counsels (verifying and approving the underwriting of municipal and corporate bonds) in the state of California.

REFERENCES

DE WITT, KAREN. "Two Black Lawyers' 'Crazy Idea' That Worked." *New York Times,* January 28, 1994, pp. 138–139.

VON HOFFMAN, NICHOLAS. "Crossing the White-Shoe Line." *New Yorker* 69 (May 10, 1993): 54–58.

KAREN E. REARDON

Arnett, Benjamin William, Jr.

Arnett, Benjamin William, Jr. (March 6, 1838– October 9, 1906), religious and political leader. Benjamin Arnett was born in Brownsville, Pa. As a young man he labored as a dockworker along the Ohio and Mississippi rivers. He also worked as a hotel waiter. He became a member of the AFRICAN METHODIST EPISCOPAL CHURCH (AME) in 1856, shortly before his eighteenth birthday. A tumor on his leg necessitated its amputation in 1858. He married a few months later. A self-educated man, Arnett was granted a teacher's certificate by Fayette County, Pa., in 1863 and taught school in Brownsville. He moved to Washington, D.C., in 1864 and decided to become a minister. The Baltimore Conference of the AME licensed Arnett to preach in 1865 and in 1867 assigned him his first pastorate in Walnut Hills, Ohio, near Cincinnati, where he also taught school, there beginning a long tenure of service to the AME in Ohio.

A rising star among AME ministers, Arnett was ordained a deacon in 1868 and made an elder in 1870. He established ties with WILBERFORCE UNIVERSITY and the related Payne Theological Seminary, both institutions serving as the intellectual center of the AME. In 1872 he was elected to the AME General Conference and was made its secretary four years later. The conference elected Arnett its financial secretary in 1880. From that year until 1904 he edited the AME *Budget,* which contained not only financial information but documentation of African-American Methodist culture and religious practices as well.

Arnett had become an active REPUBLICAN and equal rights activist during the Civil War. In 1864 he traveled to Syracuse, N.Y., to join the National Equal Rights League, led by Frederick DOUGLASS. After the war, he campaigned vigorously on behalf of Ohio Republican candidates. He acted as chaplain for the Ohio legislature in 1879, for the Republican State Convention of Ohio in 1880, and for the National Republican Convention in St. Louis, Mo., in 1896. In addition to serving as the vice president of the Anti-Saloon League of America, a prohibition group, he was also active in the YOUNG MEN'S CHRISTIAN ASSOCIATION (YMCA). Throughout his life, Arnett collected a large library of African-American literature, which was sold upon his death.

Because of the strength of his ties to Wilberforce, which was near bankruptcy, its regents in 1885 urged Arnett to run for the Ohio legislature in order to secure state aid for the school. With assurances to white voters that he would not press for civil rights legislation, Arnett was elected representative from Greene County, one of the first African Americans selected from a predominantly white constituency. He secured funds in the form of a teacher training and vocational school. Although Ohio granted only $2,000 in aid in 1887, its commitment had increased to $16,000 per year by 1893. Arnett introduced a bill to abolish the state's "Black Laws," which had main-

tained segregation in Ohio. Passed in 1887, the law also desegregated state schools and repealed laws banning interracial marriage. Because of his advocacy of these controversial laws, he was not reelected in 1887.

While in the Ohio House, Arnett met and befriended fellow legislator William McKinley. When McKinley ran for president of the United States in 1896, Arnett rallied blacks in the South and North to vote for him. In return, McKinley's administration gave Arnett access to numerous patronage jobs for family and AME members during McKinley's presidency (1897–1901), while Arnett himself was considered the country's most influential African American.

Arnett was elected a bishop of the AME church in 1888 and was assigned to the Seventh Episcopal District (South Carolina and Florida). He also served districts covering the West, Midwest, and much of Pennsylvania. In 1890 Arnett's biography, *Poor Ben: A Story of Real Life,* written by Lucretia H. Newman Coleman, was published in Nashville by the AME Sunday-School Union. He established a permanent home at Wilberforce in 1900, where he died six years later.

REFERENCES

GERBER, DAVID A. *Black Ohio and the Color Line, 1860–1915.* Urbana, Ill., 1976.
JORDAN, CASPER LeROY. *The Benjamin William Arnett Papers.* Wilberforce, Ohio, 1958.

KEVIN PARKER
ALLISON X. MILLER

Arroyo, Martina (February 2, 1936–), soprano. Martina Arroyo was born in New York City and raised in Harlem. She studied voice with Joseph Turnau at Hunter College and earned her living as a social worker before making her professional debut as First Chorister in Ildebrando Pizzetti's *L'Assassinio nella Cattedrale* (based on T.S. Eliot's play *Murder in the Cathedral*) at New York's Carnegie Hall in 1958. The following year, she made her debut at the Metropolitan Opera as the Celestial Voice in Verdi's *Don Carlo.* After performing small parts at the Met, Arroyo went on to sing major roles in the opera houses of Vienna, Frankfurt, Berlin, and Zürich. In 1965, she returned to the Met in the title role of *Aida.*

With her rich, powerful voice and dignified stage presence, Arroyo was particularly admired as an interpreter of Verdi. In addition to singing his spinto roles—Aida, Amelia in *Un Ballo in Maschera,* Leonora in *La Forza del Destino,* and Hélène in *Les Vêpres Siciliennes*—she won acclaim for her renditions of Madama Butterfly and La Gioconda, as well as for

her portrayals of Elsa in Wagner's *Lohengrin,* Liù in Puccini's *Turandot,* Donna Anna in Mozart's *Don Giovanni,* and Santuzza in Mascagni's *Cavalleria Rusticana.* In 1968, she made her Covent Garden debut as Valentine in Meyerbeer's *Les Huguenots.*

In addition to singing in the great opera houses in the United States and abroad, Arroyo appeared as a guest soloist with many of the world's major orchestras throughout the 1970s and '80s. Her immense versatility as a performer is further demonstrated by recordings she made in the 1960s of twentieth-century repertory as diverse as Samuel Barber's dramatic "scena" *Andromanche's Farewell* and Karlheinz Stockhausen's avant-garde *Momente.* She also taught voice at Louisiana State University and Bowling Green University in Ohio. Although she officially retired from performing in 1989, Arroyo continued to make guest appearances, and in 1991 sang the role of the slave Miranda in *Blake,* a new opera by African-American composer Leslie Adams.

REFERENCES

HAMILTON, DAVID, ed. *Metropolitan Opera Encyclopedia.* New York, 1987.
SADIE, STANLEY, ed. *The New Grove Dictionary of Opera.* New York, 1992.

PAMELA WILKINSON

Art Collections. There are numerous collections of African-American art throughout the United States in institutional, corporate, and private possession. Some of the major collections are more than fifty years old, but many have been formed only within the last several decades. One reason that most African-American art collections have only been developed recently is the lack of importance given art in post-Reconstruction African-American education. A major thrust of education, from Reconstruction onward, has been training for manual labor. The study of literature and art was considered superfluous. African-American artists were few, for they had no support groups, patrons, or buyers. (This situation caused George Washington CARVER to change his major from art to science.)

When blacks from rural areas began moving to cities after World War I they took advantage of the greater scope of activities urban centers had to offer. In his *Modern Negro Art* (1943), James A. Porter notes these landmarks in the progress of black artists; the exhibitions held at the 135th Street Branch of the New York Public Library in 1921; the Dunbar High School in Washington, D.C., in 1922 (sponsored by

Tanner Art League); the Chicago Women's Club in 1927; and also those of the HARMON FOUNDATION from 1927 to 1933. Because of the exposure and prizes offered at the exhibitions and by the magazines CRISIS and OPPORTUNITY, there was hope that the work of black artists would be recognized and valued. That happened, but slowly, because the collectors themselves were black and also subject to the economic restraints imposed by racism.

Many of the collections described below also include extensive holdings of African, Haitian, or Caribbean art.

Collections in Universities and Libraries

HAMPTON University in Virginia (founded in 1868 as Hampton Normal and Agricultural Institute) had early museum experience. Samuel Armstrong established an ethnographic museum at the same time he founded Hampton. He wrote, "I wish to make and have here the finest collection in the U.S. I think that by taking pains I can beat the other collections in this country." The collection of African-American art began in 1894 with gifts of Henry O. TANNER's "Lion's Head" (1892) and "The Banjo Lesson" (1893). Now comprising 1,500 paintings, graphics, and sculpture, the African-American art collection is second only to that of the National Museum of American Art of the Smithsonian Institution. Because of the 1967 gift of the Harmon Foundation (nearly half the collection) and the gift and purchase in 1986 of works owned by Countee CULLEN, the major artists of the HARLEM RENAISSANCE are exceptionally well represented: Richmond BARTHÉ, Aaron DOUGLAS, Malvin G. JOHNSON, and Hale WOODRUFF. Eight more works by Tanner are included, as are the works of Romare BEARDEN, John BIGGERS, Elizabeth CATLETT, Allan CRITE, Paul Goodnight, Palmer HAYDEN, Jacob LAWRENCE, Norman LEWIS, Richard Mayhew, Augusta SAVAGE, James WELLS, Charles WHITE, Benjamin Wigfall, and Ellis WILSON.

The HOWARD UNIVERSITY Gallery of Art was opened on April 7, 1930, two years after the board of trustees established it. The first exhibition was a traveling exhibition from the College Art Association. Under its first two directors, James V. HERRING and James A. PORTER, a program was developed to acquire a permanent collection. Henry O. Tanner's *Return from the Crucifixion* was possibly the first painting in the collection and the last one Tanner did before his death in 1937. The collection is now representative of a wide range of artists, from Robert DUNCANSON, Edward BANNISTER, and Edmonia LEWIS of the nineteenth century to such contemporary artists as Richard HUNT and Sam GILLIAM. The collection was further enriched by Alain LOCKE's bequest in 1955 of his collection of paintings and African sculptures.

In the early thirties, FISK UNIVERSITY in Nashville, Tenn., began amassing an art collection through gifts. Art by African Americans now comprises about 900 paintings, prints, and sculpture. Murals and other works by Aaron Douglas, who taught at Fisk from 1937 to 1966, are in the library, as are works by Malvin Gray Johnson, William H. JOHNSON, David DRISKELL, and Sam Middleton.

The ATLANTA UNIVERSITY Collection of Afro-American Art had an unusual genesis. In 1942 Hale Woodruff, who had been in the university's art department for a decade, instituted an annual exhibition. He wanted young and older artists to be able to exhibit their work on a national, juried basis, free of racism. He also wanted to bring art to the community. The winning entries were purchased to form the collection. Charles ALSTON and Lois Mailou JONES were among the winners in 1942. The annual, which continued until 1970, accounts for 300 of the acquisitions. This core collection has been increased by gifts from private individuals and institutions, as well as by purchase (such as three Tanners in 1967). Gifts include works by Romare Bearden, Palmer Hayden, Malvin Gray Johnson, William H. Johnson, Jacob Lawrence, and Archibald MOTLEY. In 1950, Hale Woodruff was commissioned to paint a six-part mural, *Art of the Negro*. The annuals not only created a major institutional art collection, but for twenty-eight years they provided an exhibit space and an atmosphere of artistic competition, free of racism, that engaged artists and stimulated the general public.

A large part of the Arts and Artifacts Collection of the Schomburg Center for Research in Black Culture, New York Public Library, consists of works by African-American artists. Prominent white artists such as Alice Neel and William Zorach are also included. By 1926, when Arthur A. SCHOMBURG's collection of books, manuscripts, prints and other art works became part of the 135th Street Branch, the branch had been hosting the Harmon Foundation's annual art exhibitions for five years. All of this accounts for this public library's beginnings as a repository for a major collection. As early as 1911, Schomburg commissioned a portrait of his wife from William E. Braxton, now in the collection with other works by Braxton. Most of the acquisitions, until the late seventies, were gifts of friends, patrons, and artists. The collection is strong in works from the WORKS PROJECT ADMINISTRATION (WPA), its paintings having been given to branch libraries when the WPA was dissolved in the 1940s. Works by Palmer Hayden, Malvin Gray Johnson, and Jacob Lawrence arrived this way. Works by all important artists who have been noted throughout the article are part of the collection, as are those by E. Simms CAMPBELL, Bar-

bara CHASE-RIBOUD, Claude Clark, Beauford DELANEY, Rex GORLEIGH, Sam Middleton, Sister Gertrude MORGAN, Horace PIPPIN, Augusta Savage, William E. Scott, Charles SEBREE, and Bill Traylor.

The Amistad Research Center, created by the AMERICAN MISSIONARY ASSOCIATION in 1966, is now on the campus of Tulane University in New Orleans. Among its holdings is the Aaron Douglas Collection of nearly 300 paintings and sculptures by African-American artists. This collection was assembled by David Driskell and Grant Spaulding for the United Church Board for Homeland Ministries, which then donated it in 1983. Rich in work from the Harlem Renaissance, the collection contains twelve paintings by Aaron Douglas and seventeen by Malvin Gray Johnson. There are also seventeen paintings by the nineteenth-century artist, Edward M. Bannister. Both Bearden and Lawrence are strongly represented, and among other artists there are works by Wilmer JENNINGS, Alma THOMAS, William E. SCOTT, Ellis Wilson, Sam Middleton, Keith Morrison, Vincent SMITH, David Driskell, Mildred Thompson, and Walter Williams.

South Carolina State College in Orangeburg opened its I. P. Stanback Museum and Planetarium in 1980. By 1991, it valued its collection of African-American art, acquired through gifts, at nearly one million dollars. African art, photography, and works by students are included. Prominent artists such as Romare Bearden and Jacob Lawrence are part of the collection.

Museums

The National Museum of American Art, Smithsonian Institution, in Washington, D.C., has works of art by 105 African Americans. Although founded in 1829, the museum, reflecting American aesthetics and prejudices, did not own any of these works before 1964. Their first acquisition was James HAMPTON's room-sized 180-piece assemblage, *The Throne of the Third Heaven of the Nations Millennium General Assembly*. In 1966, IBM donated works by Sargent JOHNSON, Romare Bearden, and Charles Sebree. At the same time, the Harmon Foundation, a repository of black art for forty years, had to disburse its collection. Unable to find a taker in New York, it turned to the Smithsonian. This vast donation, plus purchases by the museum, paved the way for other donors: a bequest of twenty-five paintings from Alma Thomas and a donation by Warren Robbins of many nineteenth-century works by black artists.

The Studio Museum in Harlem opened in 1968 in rented quarters above a liquor store and without a permanent collection. Its aims were to provide studio space for black artists to work and to be a venue for exhibitions of black art. In 1979 the New York Bank for Savings donated a vacant building, which opened in 1982. With its own building, the Studio Museum could acquire a permanent collection and present lectures, performances, workshops, concerts, and seminars as well as continue its exhibitions and provide space for artists in residence. The collection includes about 10,000 items in all formats. It is particularly strong in the politically conscious art of the sixties. The Studio Museum was accredited by the American Association of Museums in 1988.

Affiliated with the Elma Lewis School in Boston, the National Center for Afro-American Artists was established in 1978. Its museum was developed at that time in cooperation with the Museum of Fine Arts. The permanent collection began with a donation of over 200 works by Allan Crite, Richard Yarde, and John WILSON, among others. Prints and photographs by African Americans are also held.

The Amistad Foundation at the Wadsworth Atheneum in Hartford, Conn., was formed in 1986 to acquire the Simpson Collection, now known as the Amistad Foundation's African-American Collection. Randolph Linsly Simpson collected more than 6,000 objects over twenty-five years, which graphically document the history of blacks in America. Although the collection contains a sculpture by Richmond Barthé and a painting by David Bowser, it is not exclusively a collection of works by African Americans. It is rather a collection of works and artifacts about them, and the holdings include paintings, prints, photographs, sculpture, slave chains, sheet music, chairs made by slaves, documents, dolls, and a carpet bag.

The Museum of African American Art opened in Tampa, Fla., in April 1991. It houses the Barnett-Aden Collection of 171 paintings, sculpture, and lithographs, representing eighty-one artists, reaching back to the nineteenth century. The Barnett-Aden Gallery was started in 1943 by James V. Herring and Alonzo J. Aden of Howard University. It was open to white artists, although an objective was to collect and preserve black art. Adolphus Ealy, to whom the collection was bequeathed, sold it to the Florida Endowment Fund for Higher Education in 1989 for six million dollars. Many major artists—Tanner, Bearden, Woodruff, Bannister, Catlett—are included in this collection, which spans almost a century of African-American creation (1860 to 1955).

Other museums of African-American art are the DuSable Museum in Chicago (1961) and the Museum of African American Art in Los Angeles (1975). The former has a permanent collection of 800 works from the WPA period and the BLACK ARTS MOVEMENT of the 1960s. The second is home to the Palmer C. Hayden Collection and Archives, as well as the works of many contemporary artists.

Corporate Collections

There are several significant collections of black art among the holdings of large black-owned companies. An early example is the Golden State Mutual Life Insurance Company. Founded in Los Angeles in 1925, it began its art collection in 1949 to celebrate the dedication of a new building. The artists Charles Alston and Hale Woodruff were commissioned to paint two murals depicting the history of blacks in California. Alston's panel *Exploration and Colonization* covered the years from 1527 to 1850; Woodruff's *Settlement and Development* showed historic events from 1850 to 1949. Golden State's Afro-American Art Collection has become a showplace for the works of, among others, Charles White, John Biggers, Hughie LEE-SMITH, Richard Hunt, Beulah Woodard, Betye SAAR, Henry O. Tanner, and Richmond Barthé.

The ATLANTA LIFE INSURANCE COMPANY of Atlanta, Ga., celebrated its seventy-fifth anniversary in 1980 by dedicating new corporate headquarters. Believing the community should have cultural enrichment as well as economic stability, president Jesse Hill, Jr., established the Atlanta Life First National Annual African-American Art Competition and Exhibition. Winning works of the competition, for which $15,000 was provided, became part of the collection. Modeled on the annual juried exhibitions that formed the basis of Atlanta University's art collection, it differs in a fundamental way: Atlanta Life wished to give exposure and encouragement to up-and-coming artists, rather than to those already established. The first planners and advisers included Margaret Burroughs, founder of the Du Sable Museum, professors of art, and collectors. Jurors over the years have included E. Barry Gaither, Samella Lewis, Richard Long, Lowery Sims, and Robert BLACKBURN. The company now owns over 300 pieces in many media, including photography. On display in the vast lobby is an impressive body of work by young or local artists, as well as historical figures such as Romare Bearden, Elizabeth Catlett, Ed DWIGHT, Jacob Lawrence, and Hale Woodruff.

The JOHNSON PUBLISHING COMPANY of Chicago—the publisher of EBONY and JET—has amassed one of the most important collections of African-American art. According to articles in *Ebony* (September 1972, December 1973), "It is the world's largest and most representative corporate collection of black artists' work . . . what we intend is that the building and art collection combine as a really bold positive statement about the company's commitment to the black people it serves." By 1980 the collection consisted of about 250 pieces, displayed in the public spaces and the editorial offices of the building. The building, which opened in 1971, was designed by John Moutoussamy. Some of the artists represented were born either in Chicago or have a connection to the city. The art works include paintings, sculpture, drawings, and lithographs in all media. Richard Hunt was commissioned to create the bronze, *Expansive Construction*. Romare Bearden, Jacob Lawrence, Charles Alston, Hughie Lee-Smith, and Hale Woodruff are some of the well-known artists in the collection. Others include Eldzier CORTOR, Charles White, Robin Hunter, Geraldine McCullough, Valerie Maynard, Frank Hayden, and Jeff Donaldson. African and Haitian art also appears in the collection.

Private Collections

It is impossible to provide a comprehensive list of private collections of African-American art. In 1980, Richard V. Clarke, a former chairman of the Studio Museum in Harlem said, "I find it rare, now, to go into someone's home and not see black art" (*Black Enterprise*, December 1980). Clarke started his own collection in 1958. It is strongest in works by Romare Bearden, Hughie Lee-Smith, Jacob Lawrence, Eldzier Cortor, Norman Lewis, Henry Tanner, and Hale Woodruff, who consulted in the development of the collection. James Audubon, Betye Saar, Wilfredo Lam, Edward Bannister, and Howardena PINDELL are some artists represented, as are sculptors Richmond Barthé, Elizabeth Catlett, and Sargent Johnson. Haitian paintings, African masks and figures, and photographs are included in Clarke's collection of black art.

Another important private collection is held by Walter and Dr. June Jackson Christmas. Although each was collecting in the 1940s, their purchasing increased after their marriage. Their first purchase after marrying was Ellis Wilson's *Three Kings*. The collection spans the twentieth century and includes works by Bearden, Lawrence, Tanner, Ellis Wilson, Norman Lewis, Ernest Crichlow, and Selma Burke. Also represented are Vivian Browne, Calvin Burnett, Frank Wimberly, Virginia Smit, Robert Blackburn, and Ronald JOSEPH. There is a portrait of Walter Christmas, himself an artist, painted by Georgette Seabrook POWELL. Modern South African artists, such as Hargreaves Entuckwana, are included, as are artists from Haiti, Brazil, and Jamaica. The collection includes two watercolor designs for costumes painted by Derek WALCOTT, the Nobel laureate for Literature, for one of his plays. Contemporary sculpture by Gordon Christmas, Clarence Queen, and from Burkina Faso add an extra dimension to the Christmas collection.

The John H. and Vivian D. Hewitt Collection of the twentieth-century paintings, drawings, and etchings began in 1949. It is particularly strong in works by Ernest Crichlow, Eugene Grigsby, Henry O. Tanner, and Hale Woodruff, although other artists,

such as Charles Alston, are included. Paintings by Haitian artists are a large part of the collection. The Hewitts are interested in promoting African-American art through public exhibitions, and often lend works from their collection. They also host discussions and private showings for church and school groups.

Leon and Rosemarie Banks of Los Angeles began collecting art in the 1950s, when Banks was a U.S. Air Force surgeon in England and was able to visit the museums and galleries of Europe. Banks describes his collection as "mainly contemporary and American and while it doesn't reflect any specific trend, it does lean to more abstract styles." Both black and white artists are in the collection: Richard Hunt, Mel EDWARDS, Sam Gilliam, Henry O. Tanner, and Bob Thompson are some of the black artists; the white artists include Alberto Giacometti, Willem deKooning, David Hockney, and Robert Motherwell. Most of the purchases, however, have been of the works of younger, less established artists.

The Walter O. Evans Collection of African American Art was started in the late 1970s. Evans, who lived in Detroit, met Romare Bearden and was inspired to collect art. At that time he purchased only paintings that portrayed black people, because he almost never saw any in the museums he visited. Evans also commissioned Bearden and Richard Hunt to create album covers for his own record label. Since then he has broadened the collection to include the major black artists of the nineteenth century, although their landscapes have no human figures. Artists such as Robert Duncanson, Edward Bannister, Charles Porter, and Henry O. Tanner are well represented in the collection. About half the works in the Evans Collection were painted for the WPA during the thirties. Haitian painters and sculptors are included in this collection which is often exhibited. In 1991 it traveled to Savannah, Ga., and it is scheduled to appear in seven other states through March 1996.

Other private collectors in the 1990s include Arthur ASHE and his wife Jeanne Moutoussany-Ashe, Harry BELAFONTE, Camille Billops, Jacqueline Bontemps, Kenneth CLARK, Bill COSBY, Wes Cochran, Robert H. Derden, David Driskell, Laura Hynes Felrath, Warren Goins, Russell Goings, Danny Glover, Edmund Gordon, Earl GRAVES, William Harvey, Jacqueline J. Holland, Lois M. Jones, Spike LEE, James W. Lewis, Reginald LEWIS, Regenia Perry, Joseph Pierce, Sidney POITIER, Beny Primm, Meredith Sirmans, Dorothy Porter WESLEY, E. T. Williams, and Reba and Dave Williams.

REFERENCES

DEACON, DEBORAH A. "The Art & Artifacts Collection of the Schomburg Center for Research in Black Culture." *Bulletin of Research in the Humanities* (Summer 1981): 145–261.

"Dr. and Mrs. Leon Banks: Collectors Living with Art." *Black Enterprise* (December 1975): 46–47.

DUPLESSIS, LAUREL T. *Hampton's Collections and Connections: Part I–Returning Home to Hampton.* Hampton, Va., 1987.

PERRY, REGENIA A. *Free Within Ourselves: African-American Artists in the Collection of the National Museum of American Art.* Washington, D.C., 1992.

Walter O. Evans Collection of African American Art. Savannah, Ga., 1991.

WILSON, JUDITH. "The Bullish Market for Black Art." *Black Enterprise* (December 1980): 34–41.

ZEILDER, JEANNE. "1993–Anniversary Year for Three Renowned Paintings." *International Review of African American Art* 10/3 (1993): 20–22, 60–63.

BETTY KAPLAN GUBERT

Art Ensemble of Chicago.

The Art Ensemble of Chicago is perhaps the longest-standing and most versatile "free jazz" group to emerge from the 1960s. Its motto, "Great Black Music: Ancient to the Future," is indicative of their eclectic style. Its repertory comprises nearly the entire spectrum of the African-American musical tradition including music from Africa (drum choirs) and Europe.

The Art Ensemble of Chicago evolved out of Roscoe Mitchell's Art Ensemble of 1967, a group that never recorded. Four of the group's members—saxophonists Roscoe Mitchell and Joseph Jarman, bassist Malachi Favors, and trumpeter Lester Bowie—went to Paris in 1969, where the ensemble was formalized. In Paris they were an instant success, recording six albums within two months. While there, they were joined by drummer Don Moye, who completed the lineup they have maintained ever since. All the members of the quintet sing and all play percussion instruments from around the world, including drums, cymbals, gongs, bicycle horns, whistles, and sirens.

Because each member plays several instruments and because they often integrate the spoken word (poetry, dialogue) as well as dance into their works, Art Ensemble performances can be sonically diverse as well as visually appealing. Some members appear on stage in traditional African clothing, and Bowie often wears a lab coat. Although each member has his own solo career, the group continues to record and perform throughout the world, spending lengthy periods in Europe and Japan. Many of their recordings, long unavailable, began to be reissued in the late 1980s; in addition, much of their unreleased 1980s output is being released through an agreement signed with Sony Records in 1992.

REFERENCES

GIDDINS, GARY. *Rhythm-a-ning: Jazz Tradition and Innovation in the '80s.* New York, 1985.
LITWEILER, JOHN. *The Freedom Principle: Jazz after 1958.* New York, 1984.

TRAVIS JACKSON

Artis, William Ellisworth (February 2, 1914–1977), sculptor, potter, and teacher. William Ellisworth Artis was born in Washington, N.C. The son of Elizabeth Davis and Thomas Miggett, Artis and his half-brother Warren were raised by their great-grandmother Liza Lane, a religious woman who came from a family of freed slaves. In 1926 the boys joined their mother and her husband George, in New York City, and Artis took his stepfather's surname.

Artis won the John Hope Prize for creative sculpture and the Metropolitan Scholarship Award for creative sculpture, from the Art Student's League, New York City, in 1933. The league's award enabled him to study sculpture in the evenings while attending high school. He graduated from Haaren High School, New York City, in 1936. He became the protégé of Augusta SAVAGE, a leading sculptor in the HARLEM RENAISSANCE and the first director of the WORKS PROJECT ADMINISTRATION's Harlem Community Art Center. This association also brought him into contact with other prominent artists such as Charles ALSTON, Romare BEARDEN and Jacob LAWRENCE. The Harmon Foundation later helped Artis gain representation in both black- and white-juried shows nationwide and to serve as an artist-in-residence at historically black colleges.

Drafted into the Army in 1941, Artis served through 1945 in the Mediterranean. While in the service, he received several outstanding awards, such as the Special Sculpture Award from Grace Horn Galleries, Boston (1942), for two heads entitled *Negro Children* (terra cotta), and the second prize at the exhibit for enlisted men held by the Red Cross in Bari, Italy (1944), for *Portraits of a Brother and Sister* (terra cotta). He received the Edward B. Alford Purchase Award at the Third Annual Exhibition at Atlanta University for *Negro Boy* (terra cotta) in 1944 and won other annual awards from Atlanta University (1947, 1952, 1959, 1962, and 1965).

Artis received bachelor's (1950) and master's (1951) degrees from Syracuse University, and a bachelor's degree in education in 1955 from Nebraska State Teacher's College. The last twenty years of his life were dedicated to teaching and researching at Nebraska State (1956–1966) and Makato State College

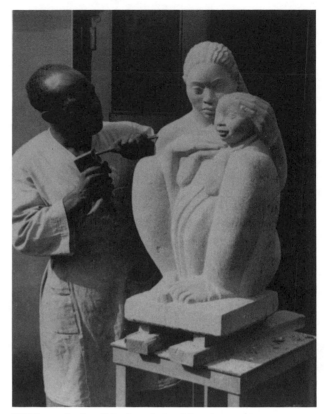

William Artis. (National Archives)

(1966–1977). In May 1977 he was posthumously awarded a doctorate in fine arts from North Carolina Central State University in Durham, N.C., which, along with Atlanta and Howard Universities, feature his work in their permanent collections.

Artis is represented in national exhibitions catalogs such as: *The Negro Artist Comes of Age* (Albany, N.Y., 1945), *The Evolution of Afro-American Artists: 1800–1950* (New York City, 1967), and *Against the Odds: African-American Artists and the Harmon Foundation* (New Jersey, 1989). Critics describe him as a "genius in his element" (Willard Moore Interview, August 6, 1992). His art will be remembered for its "sense of the divine in human character . . ." (Porter 1943), and as "a statement of pride and beauty of subject, a fitting tribute to his people and to the world of art . . ." (Pendergraft 1977).

REFERENCES

GREENE, C., JR. *The Evolution of Afro-American Artists: 1800–1950.* New York, 1967.
IGOE, L. *Artis, Bearden, and Burke: A Bibliography and Illustration List.* Durham, N.C., 1977.
PENDERGRAFT, N. E. *Heralds of Life: Artis, Bearden and Burke,* Durham, N.C., 1977.
PORTER, J. A. (1943). *Modern Negro Art,* New York, N.Y., pp. 139, 140.

REYNOLDS, G. In *Against the Odds: African-American Artists and the Harmon Foundation*. Newark, N.J., 1989, pp. 10–11.

SHIRLEY JONES

Artists and Athletes Against Apartheid.

Artists and Athletes Against Apartheid (AAAA) is an African-American–led interracial organization composed primarily of personalities in the entertainment and sports industries. It was formed in September 1983 to promote a cultural and sports boycott of South Africa and to protest its strict policies of racial segregation, called apartheid.

Under the joint leadership of tennis player Arthur ASHE and entertainer Harry BELAFONTE, AAAA sought to educate the arts, sports, and entertainment communities about apartheid, persuade entertainers and athletes not to perform or play in South Africa, and organize demonstrations against those who ignored the boycott. AAAA has close ties to TRANS-AFRICA, a Washington, D.C.–based African-American lobbying group on African and Caribbean issues, which has helped to coordinate the campaign as well as shape foreign policy and/or provide political perspectives on the group's programs and policies.

The organization is also endorsed by thirty national and international organizations, including the American Committee on Africa and ACCESS, the American Co-ordinating Committee for Equality in Sports and Society, which were largely responsible for initiating the boycott in the 1970s. AAAA's executive committee is composed of internationally acclaimed celebrities such as Bill COSBY, Jane Fonda, Paul Newman, Quincy JONES, Sidney POITIER, Michael Moriarty, Judy Collins, Tony Randall, Dick GREGORY, Kareem ABDUL-JABBAR, Anita DE-FRANTZ, and Larry HOLMES.

A special focus of AAAA's boycott was on a massive sports and entertainment resort: Sun City, in Bophuthatswana, one of six unconnected territories northwest of Johannesburg declared in 1977 as an independent national state, separate and distinct from South Africa, with its own president and legislature. Bophuthatswana, the official "homeland" for the more than two million Tswana people, purported to give blacks self-rule and give visitors the impression of integration. However, it remained economically tied to South Africa and most of the indigenes resided elsewhere. Apart from South Africa, no country recognized Bophuthatswana as an independent nation. Sun City was viewed as a decoy created by the South African government to lure American and international entertainers and athletes with exorbitant fees to

Entertainers Gregory Hines (left) and Tony Randall (center) join with tennis star Arthur Ashe (right) at the United Nations in 1983 to announce the formation of Artists and Athletes Against Apartheid. (AP/Wide World Photos)

perform in Bophuthatswana, in opposition to the United Nations–sponsored international boycott of South Africa. The presence of the high-powered artists and performers so lured was used as a symbol of international acceptance.

To counteract misleading public-relations propaganda by the apartheid regime, AAAA embarked on an American anti-apartheid networking campaign by forging strong links with numerous community-based organizations. With this symbiotic alliance, the groups were uniquely positioned to generate national media attention on the issue of apartheid and significantly boost the cultural isolation of South Africa. Other initiatives of the groups included attempts to extend the growing divestiture and disinvestment movement to sports and entertainment unions; establish a system whereby royalties earned in South Africa in the past would be invested in the fight against apartheid; make U.S. universities' intramural recreational facilities off-limits to South African sports teams; and secure a clause in actors' contracts prohibiting the showing of their work on South African television.

REFERENCES

Statement of TransAfrica on the U.S. Effort in Support of the Cultural Boycott of South Africa.
United Nations Center Against Apartheid Notes and Documents. *Artists and Entertainers Against Apartheid: An Update.* 1991.
———. *Register of Entertainers, Actors and Others Who Have Performed in Apartheid South Africa.* 1988.

RICHARD E. LAPCHICK

Ashe, Arthur Robert, Jr. (July 10, 1943– February 6, 1993), tennis player and political activist. Born in Richmond, Va., Arthur Ashe traced his lineage back ten generations on his father's side to a woman who in 1735 was brought from West Africa to Yorktown, Va., by the slave ship *Doddington*. Ashe's mother, Mattie Cunningham, also of Richmond, taught him to read by the time he was four. She died when Arthur was six, one year after giving birth to her second son and last child, Johnnie.

Ashe, who was frail in his youth, was forbidden by his father, a police officer in Richmond's Department of Recreation and Parks, to play football on the segregated Brookfield playground adjacent to the Ashes' home. Instead, young Ashe took to playing tennis on the four hard courts of the playground. By the time he was ten, Ashe had attracted the keen eye of Dr. Walter Johnson, a Lynchburg, Va., physician and tennis enthusiast who had previously discovered

and coached Althea GIBSON, the first black woman to win Wimbledon.

Ashe's father and Dr. Johnson were both stern disciplinarians who insisted that Ashe cultivate self-discipline, good manners, forbearance, and self-effacing stoicism. These qualities would characterize Ashe throughout his entire life and, even in the midst of the most turbulent social conditions, would define him as a man of reason, conscience, integrity, and moral authority. His cool disposition enabled him not only to survive, but to distinguish himself in an overwhelmingly white tennis environment.

In 1960, Ashe was awarded a tennis scholarship to UCLA, where he earned All-American status. Two years after Ashe graduated with a business degree, he became the first black man to win one of the preeminent Grand Slam titles, accomplishing that as an amateur and U.S. Army representative at the U.S. Open of 1968. Numerous titles would follow, highlighted by Ashe's place on three victorious Davis Cup squads

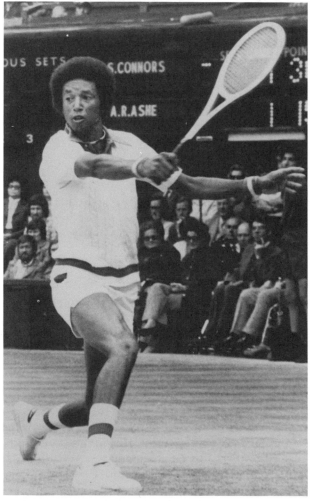

Arthur Ashe playing at Wimbledon against Jimmy Connors in the men's singles final, July 5, 1975. (AP/ Wide World Photos)

and the addition of two more Grand Slam titles, one at the Australian Open in 1970, and the other, his *pièce de résistance,* at Wimbledon in 1975.

Throughout those years, Ashe devoted considerable time and energy to civil rights issues. In 1973, after three years of trying, he secured an invitation to play in the all-white South African Open. Although his participation was controversial, it personified Ashe's lifelong belief in constructive engagement—an attitude that he abandoned only on one noteworthy occasion in 1976, when he joined in the call for an international embargo of all sporting contact with South Africa.

In 1979, at age thirty-six, Ashe suffered a myocardial infarction, which forced him to have bypass surgery and retire from tennis. Nevertheless, over the ensuing years he served as the U.S. Davis Cup captain (1981–1985), he worked as a journalist and television commentator, and he served or helped create various foundations, ranging from the American Heart Association to the UNITED NEGRO COLLEGE FUND to his own Safe Passage Foundation.

Eighteen months after undergoing a second heart operation in 1983, Ashe learned that he had contracted the AIDS virus through blood transfusions. He immediately set to work on his definitive three-volume history of black athletes in America, *A Hard Road to Glory* (1988). Forced by the national newspaper *USA Today* to reveal that he was suffering from AIDS in April 1992, Ashe worked as an activist for the defeat of AIDS until he died of the disease in February 1993.

REFERENCES

ASHE, ARTHUR R., JR., with Frank Deford. *Arthur Ashe: Portrait in Motion.* Boston, 1975.
ASHE, ARTHUR, JR., with Neil Amdur. *Off the Court.* New York, 1981.
ASHE, ARTHUR, and ARNOLD RAMPERSAD. *Days of Grace: A Memoir.* New York, 1993.

PETER BODO

Ashford, Emmett L. (November 23, 1914– March 1, 1980), baseball umpire. Ashford was the first African-American umpire in major league baseball. He began umpiring in the college circuit for the University of Southern California and the University of California at Los Angeles, and was given his first professional tryout in Mexico in 1951, where the other umpires initially refused to work with him because of his race. In 1952, Ashford was given a contract for a full season, which led him to resign from his fifteen-year job with the post office and devote

Emmett Ashford became the first African-American umpire in the major leagues in 1966. (AP/Wide World Photos)

himself full-time to baseball. He umpired in the Arizona-Texas League in 1952 and the Western International League from 1954 to 1965, the last three years as an umpire-in-chief. In 1966, at the age of fifty-one, Ashford began his first year in the major leagues, officiating at the opening-day game in Washington, D.C., when the Senators played the New York Yankees. He worked in the American League from 1966 to 1970, including the 1967 All-Star Game and the 1970 World Series.

REFERENCES

RUST, ART, JR. *"Get That Nigger Off My Field!": A Sparkling, Informal History of the Black Man in Baseball.* New York, 1976.
———. *Art Rust's Illustrated History of the Black Athlete.* Garden City, N.Y., 1985.

LINDA SALZMAN

Ashford, Evelyn (April 19, 1957–), track and field athlete. Born in Shreveport, La., Evelyn Ashford did not run competitively until her senior year

of high school, when she ran on the boys' track team because the school had no team for girls. Ashford won a track scholarship to the University of California at Los Angeles in 1975. The following year she finished fifth in the 100-meter dash at the Montreal Olympics, and her 400-meter relay team finished seventh. Although she dropped out of UCLA in 1979, UCLA women's track coach Pat Connolly continued to train her, and Ashford won the 100-meter dash at the 1979 World Cup, becoming the top woman sprinter. Her dream of winning a gold medal in the 1980 Olympics was thwarted, however, when the United States decided to boycott the 1980 Olympics in Moscow.

After this disappointment, Ashford considered dropping out of track and field. But with her husband Ray Washington as her coach, she won the women's 100-meter dash at the 1981 World Cup. In the 1984 Los Angeles Olympics, Ashford won the 100-meter dash and anchored the winning 400-meter relay team. The result of the recognition she finally gained with her Olympic gold medals was promotional work for such large international corporations as American Express and Mazda.

In 1986, Ashford won the 100-meter dash in the 1986 World Cup, ran the fastest 100 meters of the year, and was ranked number one for the year. In 1988 she competed in her third Olympics, and won a silver medal in the 100-meter competition and a gold medal as part of the winning 400-meter relay team. In 1992, at the age of thirty-five, Ashford competed in the Barcelona Olympics, where she won her fourth Olympic gold medal as the lead-off runner in the 400-meter relay. In June 1993 she retired from competition.

REFERENCES

ASHE, ARTHUR R., JR. *A Hard Road to Glory: A History of the African-American Athlete Since 1946.* New York, 1988, p. 205.

BONDY, FILIP. "Ashford Hands Off and Then Signs Off." *New York Times*, August 8, 1992, section 8, p. 3.

DAVIS, MICHAEL D. *Black American Women in Olympic Track and Field: A Complete Illustrated Reference.* Jefferson, N.C., 1992, pp. 9–15.

PETER SCHILLING

Associated Publishers.

Historian Carter G. WOODSON founded the Associated Publishers in 1922 in Washington, D.C. Frustrated by his inability to get his own work published by white publishers, Woodson decided to form his own publishing company. He not only helped black scholars find a publisher for their work, he also hoped to make money to support research programs initiated through the ASSOCIATION FOR THE STUDY OF AFRO-AMERICAN [originally *Negro*] LIFE AND HISTORY. Although he tried to interest black scholars in becoming financial partners in his new firm, only a few close associates invested. Among them were Louis Mehlinger, who served as secretary, and John W. DAVIS, who was treasurer.

While they did publish scores of books by black authors, as well as works by whites who wrote on black subjects, they did not make money for Woodson's association and actually drained the organization financially. By the late 1930s authors needed to pay a subvention, but Associated Publishers continued to issue scholarly works as well as those directed to a mass audience. Although published in smaller runs than books issued during the 1920s and 1930s, more than a dozen volumes were published in the 1940s, many directed at schoolchildren and a mass audience. Volumes that otherwise would not have been published came out under their auspices. Even English translations of books by foreign authors were published, including Arthur Ramos's *The Negro in Brazil*. Associated Publishers continues to publish books every year under director Willie Lee MILES.

REFERENCE

GOGGIN, JACQUELINE. *Carter G. Woodson: A Life in Black History.* Baton Rouge, La. 1993.

JACQUELINE GOGGIN

Association for the Advancement of Creative Musicians (AACM).

Originally an informal rehearsal band led by pianist Muhal Richard ABRAMS and bassist Donald Garrett in Chicago in 1961, the Association for the Advancement of Creative Musicians (AACM) went on to become one of the dominant influences in avant-garde JAZZ. Along with Abrams and Garrett, several students studying at Wilson Junior College, including saxophonists Anthony BRAXTON, Henry THREADGILL, Joseph Jarman, and Roscoe Mitchell and bassist Malachi Favors, were among the significant participants in weekly jam sessions at various nightclubs, small theaters, settlement houses, and churches on Chicago's South Side. Also involved as performers and composers were drummers Jack DeJohnette, Steve McCall, and Thurman Barker, saxophonists Maurice McIntrye and Troy Robinson, trumpeter Leo Smith, and pianists Phil Cohran, Amina Claudine Myers, and Jodie Christian. Inspired by SUN RA, Cecil TAYLOR, Ornette COLEMAN, and John COLTRANE, they theatrically juxtaposed explosive free jazz with deli-

cate, whimsical tinkling on hubcaps and frying pans.

The AACM was chartered as a nonprofit organization in 1965, with Abrams as president, and began to sponsor art exhibits, plays, living arrangements, and a school. At first, the music world greeted the AACM with hostility, and as a result the cooperative's early work was poorly documented. Nonetheless, several albums alerted the New York–based avant garde that a new movement was afoot in Chicago. These albums include Mitchell's *Sound* (1966), Jarman's *Song For* (1967), trumpeter Lester Bowie's *Numbers 1 and 2* (1967), Abrams's *Levels and Degrees of Light* (1968), and Braxton's *Three Compositions of New Jazz* (1968). These works proceed not by improvising on melodic theme or harmonic chord changes, but by variations in instrumental texture, particularly unorthodox sounds on standard instruments. Along with such blips, squeaks, and overtones are sounds made by "little instruments," mostly common household or industrial objects.

In 1969, tragedy struck the organization with the death of two key members, bassist Charles Clark and pianist Christopher Gaddy. Many AACM musicians then moved to Paris, where they were soon engaged in celebrated concerts and recordings. However, they returned to the states within a few years, claiming, in a famous statement, that they missed "the inspiration of the ghetto." Most settled in New York and participated in the cooperative "Loft Jazz" movement of the mid-to-late 1970s (*Wildflowers,* Volumes 1–6, 1976).

The ensembles formed by members of the AACM have proved among the most significant in jazz. The ART ENSEMBLE OF CHICAGO, whose motto is "Great Black Music, Ancient to Future," was formed in 1969 by Bowie, Jarman, Mitchell, and Favors. Drummer Famoudou Don Moye joined them in Paris in 1970. Their recordings include *Message to Our Folks* (1969), *Nice Guys* (1978), and *Dreaming of the Masters* (1987). Concerts by the Art Ensemble are famous for the engergetic wit they bring to the avant garde. Mitchell plays straight man to Bowie, who often wears a chef's hat and white medical coat, while the flamboyantly greasepainted Jarman waves flags and sounds sirens.

In Paris, Braxton, violinist Leroy JENKINS, Smith, and McCall had great success under the name Creative Construction Company, but aside from one concert financed and recorded by Coleman (1970), they were unable to keep the group together in America. Braxton went on to lead his own ensembles (*Five Compositions (Quartet)*, 1986), as did Smith (*Go in Numbers,* 1980). Jenkins worked with the Revolutionary Ensemble (*Manhattan Cycles,* 1972), and then as a leader (*For Players Only,* 1975). McCall worked in the group Air (*Air Lore* 1975) with bassist Fred

Hoplins and Threadgill, who leads his own ensembles (*Just the Facts and Pass the Bucket,* 1983). Abrams continues to work with his large ensembles (*Blu Blu Blu,* 1990).

Most of the members of the AACM overcame an initial obscurity, but some have remained undiscovered. These include pianist Jodie Christian, trombonist Lester Lashley, and saxophonists Fred Anderson, John Stubblefield, and Kalaparusha Maurice McIntyre. In the 1970s and 1980s, a new generation of AACM members came to prominence, including trombonist George Lewis and saxophonists Chico Freeman, Edward Wilkerson, and Douglas Ewart. Most of the original members of the AACM live in New York, and few remain in close contact with the organization. The AACM itself, however, has grown and prospered as a Chicago arts collective over the past three decades, continuing to sponsor classes, workshops, and performances.

REFERENCES

LITWEILER, JOHN. *The Freedom Principle: Jazz After 1958.* New York, 1984.
MUNI, K. "AACM: "Continuing Tradition." *Bebop and Beyond* 4, no. 2. (1986).
WILMER, VALERIE. *As Serious As Your Life: The Story of the New Jazz.* London, 1980.

JONATHAN GILL

Association for the Study of Afro-American Life and History.

Historian Carter G. WOODSON founded the Association for the Study of Negro Life and History (ASNLH) in Washington, D.C. on September 9, 1915. Woodson may have been stimulated to found a new organization, albeit indirectly, by D. W. Griffith's *The Birth of a Nation,* released in 1915. To counter Griffith's racist depiction of blacks, Woodson began an organization devoted to the preservation and dissemination of historical and sociological information on African Americans. When the ASNLH was initially founded, Woodson became the first director; George Cleveland HALL (personal physician to Booker T. WASHINGTON and surgeon at PROVIDENT HOSPITAL in Chicago) became the first president; and Alexander L. Jackson, executive secretary of the black YMCA organization in Washington, and James E. Stamps, a Yale economics graduate student who assisted Jackson, helped to launch the association.

Prior to Woodson's establishment of the ASNLH, black historians had no professional organization that welcomed them as members. Racially exclusive, the historical profession fostered policies that promoted academic segregation, which closely mirrored the

racism and segregation of society as a whole. This racism was reflected in the practices of the American Historical Association, which was founded in 1884. Through the ASNLH Woodson and the handful of black historians with whom he collaborated used their scholarship to influence white public opinion in general, and the white historical establishment in particular. With the founding of the ASNLH, Woodson not only challenged the scholarly authority of the white historical establishment, but also provided black historians with a forum for the presentation and publication of their research.

Annual meetings of the association offered black historians an opportunity to deliver scholarly papers before their peers and encouraged further scholarly production. The association functioned as a clearinghouse and information bureau, providing research assistance in black history to scholars and to the general public. Woodson sponsored numerous research projects that involved a broad segment of the black community; both scholars and interested amateurs participated in association research projects. To ensure the publication of the research undertaken by these scholars, Woodson founded a publishing company in 1922 called the ASSOCIATED PUBLISHERS. Woodson collected historical documents and edited them for publication. He also edited and published the JOURNAL OF NEGRO HISTORY, which began in 1916, and the Negro History Bulletin, which began in 1937 and was directed at school children. Through the auspices of the association, Woodson brought black history to a mass audience when he began the annual celebration of Negro History Week in 1926. Negro History Week was celebrated annually in February in the closest possible proximity to the birthday of Abraham Lincoln (February 12) and the presumed birthday of Frederick DOUGLASS (February 14).

After Woodson's death in 1950, the organization underwent some financial difficulties and several administrative reorganizations. The historian Charles Harris WESLEY became president in 1951 and assumed many of Woodson's former administrative roles. (Under Mary McLeod BETHUNE, who served as the association's first female president from 1936 to 1951, the presidency had been primarily a ceremonial position.) By 1965, the association had largely completed its reorganization, and in that year Wesley became its first executive director since Woodson. Wesley guided the ASNLH through the tumultuous civil rights era and retired in 1972. That same year, recognizing the increasing cultural and race consciousness among African Americans, the association's members voted to change its name to the Association for the Study of Afro-American Life and History (ASALH). The headquarters of the organization remained in Washington, D.C., with offices in Woodson's original townhouse. In 1976, due in part to the efforts of executive director J. Rupert Picott, the association expanded Negro History Week into BLACK HISTORY MONTH, which is now celebrated for the entire month of February. Woodson's townhouse was declared a national historical landmark in 1976, and in February 1988 it became part of the Washington, D.C. Black History National Recreation Trail, which was also dedicated in Woodson's honor.

Woodson was succeeded as editor of the Journal of Negro History by the historian Rayford W. Logan, who served from 1950 to 1951. William Miles Brewer was editor from 1951 to 1970. W. Augustus Low, best known for coediting the Encyclopedia of Black America with Virgil A. Clift, was editor from 1970 to 1974. Low was succeeded by Lorraine A. Williams, who established the Carter G. Woodson Award for article contributions and worked to attract a wider spectrum of contributors to the publication. Alton Hornsby, Jr., professor of history at Morehouse College, succeeded Williams in 1976.

In 1983, financial difficulties forced the association to briefly suspend the publication of the Journal of Negro History and the Negro History Bulletin; both publications were revived within a year. Financial difficulties also led the association to remove Dr. Samuel L. Banks from the position of national president in 1985, two years after his election to the post. Dr. Janette H. Harris became the association's second female president in 1993 faced with these pressing economic conditions. Under Hornsby and Harris however, the Journal of Negro History attracted more black scholars from historically black colleges and universities. The Journal also brought more women and first-time historians into its ranks of article contributors. At the same time, the Association continued to sponsor an annual essay contest for college students, a scholar-in-residence program, and an October convention on current historical research.

REFERENCES

GOGGIN, JACQUELINE. Carter G. Woodson: A Life in Black History. Baton Rogue, La., 1993.
MEIER, AUGUST, and ELLIOTT RUDWICK. Black History and the Historical Profession. Urbana, Ill., 1986.

JACQUELINE GOGGIN

Associations, Medical. See Medical Associations.

Associations, Scientific. See Scientific Associations.

Astronauts, Black. *See* Aerospace.

Atkins, Cholly (1913–), choreographer, dancer, director, teacher. Born in Birmingham, Ala., Cholly Atkins relocated with his family to Buffalo, N.Y. at the age of four. When he was ten years old, Atkins won a Charleston contest at a local theater and by the time he was in high school, he was alternating basketball practice with rehearsals for musicals.

In 1929 Atkins began working as a singer waiter at a club near Buffalo where he met William Porter, a dancing waiter. By 1933, they were known as the Rhythm Pals, a vaudeville-style song-and-dance team. That partnership ended in 1939, but Atkins's skills landed him a job dancing and helping to choreograph acts for the renowned Cotton Club Boys, who were appearing with Bill ROBINSON in the *Hot Mikado* at the World's Fair in New York City in 1939. During 1941 and 1942, Atkins performed as part of a duo with his future wife, the dancer and singer Dottie Saulter. Their credits at this time included appearances with the MILLS BROTHERS, the Earl HINES Orchestra, the Louis ARMSTRONG Orchestra and the Cab CALLOWAY Revue.

After three years in the Army during World War II, Atkins formed a "class act" team featuring precision dancing with tap-dancer Charles "Honi" COLES. This led to a series of tours from 1946 to 1949, including a very successful European tour in 1948. During these years, they continued to appear with big bands, such as those led by Count BASIE and Billy ECKSTINE. In 1949, Coles and Atkins were featured in the Broadway musical *Gentlemen Prefer Blondes.* However, when the musical closed in 1952, the popularity of tap was declining, and opportunities to perform were becoming scarce. Unwilling to give up dance completely, Atkins accepted a job as head of the tap department at the Katherine Dunham School of Arts and Research in New York City. Coles and Atkins performed again in 1955, working in Las Vegas, and later with Pearl BAILEY, but as interest in tap-dancing continued to fade, the duo parted in 1961.

Atkins then built a new dance career as a coach for vocal groups who were replacing variety shows at theaters around the country. He was staff choreographer for MOTOWN Records from 1965 to 1971. Among the groups for which he choreographed between 1953 and 1992 were: the Cadillacs, Frankie Lymon & the Teenagers, the SUPREMES, the TEMPTATIONS, Gladys KNIGHT & The Pips, and the O'Jays. Atkins has also choreographed for Broadway and in 1989 he shared a Tony Award for the choreography in *Black and Blue.*

Tap dancing duo Honi Coles and Cholly Atkins. (Photographs and Prints Division, Schomburg Center for Research in Black Culture, The New York Public Library, Astor, Lenox and Tilden Foundations)

REFERENCES

MALONE, JACKIE. "'Let the Punishment Fit the Crime: The Vocal Choreography of Cholly Atkins." *Dance Research Journal* 20, no. 1 (Summer 1988): 11–18.
STEARNS, MARSHALL and JEAN. *Jazz Dance.* New York, 1968.

JACKIE MALONE

Atlanta, Georgia. The origins and early growth of Atlanta can be directly traced to the railroads. In 1837, surveyors for the Western and Atlantic Railroad selected as a southern terminus for their line a spot seven miles southeast of the Chattahoochee River on a plateau formed by the eastern slope of the Allegheny Mountains. Here, a small settlement, aptly named Terminus, arose. While work was progressing on the Western and Atlantic, Terminus grew, changed its name twice (to Marthasville in 1843 and finally to Atlanta two years later), and linked up with two other Georgia railroads. The junction of these three railroads made Atlanta the center of a growing transportation network and hastened the city's devel-

opment as a commercial center of the Southeast. By the eve of the Civil War, Atlanta, with a population of more than 9,000, was the fourth largest city in Georgia.

Fewer African Americans, either free or enslaved, were present in Atlanta during the antebellum period than in the older, more-established cities of the South. One Atlanta resident noted in 1847 that "there are not 100 Negroes in the place, and white men black their own shoes, and dust their own clothes, as independently as in the north." Between 1850 and 1860 the number of slaves in Atlanta increased from 493 to 1,914, and "free persons of color" grew slightly in number from 19 to 25. Slaves in both census years, however, made up only about one-fifth of the city's population. (By way of contrast, Savannah's 1850 slave population of 6,231 was about 40 percent of that city's population, and 686 free blacks resided in the city.) The relatively small number of slaves and free blacks in Atlanta and their dispersal throughout the city precluded the formation of any large black enclaves during the antebellum period.

Whatever biracial residential patterns had been established in Atlanta were disrupted by the siege and destruction of the city during the CIVIL WAR and the tremendous influx of blacks and whites following the war. Between 1865 and 1867 almost 9,000 African

Americans and 10,000 whites migrated to the city. Three years later, blacks in Atlanta numbered over 12,000 and made up almost one half of the city's total population.

In the intense competition for living space that ensued, race and class were the prime determinants of residential location. The resulting patterns resembled those found in many preindustrial cities, with the upper class living near the center of the city and the poor (both black and white) on the urban periphery. Emerging black settlements in Atlanta, as in many other southern cities, were further relegated to the most undesirable areas of the city: back alleys; low-lying, flood-prone ground; industrial sites; and tracts of land adjacent to railroads, cemeteries, city dumps, and slaughter houses. These locations not only tended to separate black settlements from surrounding white neighborhoods, but also contributed in some cases to very high black-mortality rates.

By 1880, several large and distinctive black communities had emerged within the city limits—most notably, Jenningstown on the west side of Atlanta, Summer Hill to the south, Shermantown on the east side, and Mechanicsville in the southwestern quadrant of the city. Other smaller black communities were scattered throughout the city, and in some areas whites and blacks continued to live in close proxim-

Scene from the 1988 Democratic convention held in Atlanta, Ga. (Allford/Trotman Associates)

ity. Nonetheless, the emerging pattern in the late nineteenth century was one of separation and increasing racial division as black settlements became more concentrated and well defined. W. E. B. DU BOIS said that Atlanta's black population by the turn of the century "stretched like a great dumbbell across the city, with one great center in the east and a smaller one in the west, connected by a narrow belt."

For African Americans in Atlanta after the Civil War, employment opportunities were largely confined to unskilled labor, domestic service, or to jobs that whites did not want. Rural blacks migrating to the city tended to swell the ranks of unskilled workers, and even those freedmen who enjoyed positions as craftsmen or artisans before the war were often denied the opportunity to use those skills by prevailing white prejudice and an increasingly specialized urban job market. As a result, the vast majority of the city's unskilled labor positions (over 76 percent in 1870 and almost 90 percent in 1890) were filled by African Americans.

The economic insecurity facing back Atlantans during this period was further reflected in the relative scarcity of African Americans who owned property and the number of black women employed in personal and domestic service. In 1870 only 311 black men and 27 black women (about 3 percent of the adult population) were property owners. Ten years later, the number of black property owners had almost doubled but still lagged far behind the total for whites. Because of the low average earning power of black males, black women worked in much larger numbers than their white counterparts. The vast majority of black working women (92 percent in 1890) were confined to low-paying domestic service positions.

On the few occasions in the nineteenth century that black workers in Atlanta organized to negotiate for more pay, better working conditions, or increased job security, their efforts were usually unsuccessful. In 1881 an estimated 3,000 of Atlanta's black washerwomen joined forces to strike for higher wages and the establishment of a citywide charge of $1 per dozen pounds of wash. The city government and enraged white employers responded to these demands with arrests, fines, and threats of economic reprisals and incarceration. Under the weight of this government hostility and economic pressure, the strike eventually collapsed. Nine years later, protest by black firemen at the Georgia Pacific Railroad collapsed when the striking workers were replaced by white applicants.

Despite the considerable obstacles facing them, some black Atlantans did succeed during this period in establishing thriving businesses and accumulating wealth and property. Among these were undertaker David T. Howard, barbers Moses H. Bentley and

Alonzo F. Herndon (who was also the founder of ATLANTA LIFE INSURANCE COMPANY), grocer James Tate, and hotel owner and grocer Moses Calhoun. These businessmen made their mark in a hostile economic environment in part by catering to black clients or by providing services to whites that were not in direct competition with white businesses.

White Atlantans and the city government were equally unwilling to address the social and educational needs of the city's growing black population. It was not until 1908 that the city established its first social service agencies and programs for African Americans. In the interim, black community needs were met instead through the actions of individuals or the programs of a growing array of black self-help, fraternal, and religious organizations. Carrie Steele Logan founded the city's first black orphanage. Self-help agencies such as the mutual aid societies organized to provide medical and death benefits for their members. The Neighborhood Union (founded by Lugenia HOPE, wife of a Morehouse College president) established health centers, boys' and girls' clubs, and vocational classes for children; it also lobbied for improved public facilities for blacks. Fraternal organizations such as the Odd Fellows and the Good Samaritans raised thousands of dollars for the poor and infirm of the city.

The black churches of Atlanta likewise organized programs to meet the pressing social and economic needs of their communities. The First Congregational Church of Atlanta under the leadership of the Reverend HENRY HUGH PROCTOR, for example, sponsored a home for black working women, business and cooking schools, a kindergarten, and an employment bureau. Similar community services and programs were provided by the city's other prominent black churches such as Big Bethel A.M.E. Church and Wheat Street Baptist.

In the area of education, black churches and religious organizations also played a prominent role. Atlanta University, the first black institution of higher learning in the city, was founded by the AMERICAN MISSIONARY ASSOCIATION in 1865. Atlanta Baptist College for men (MOREHOUSE COLLEGE) followed two years later, and CLARK UNIVERSITY, supported by the Freedmen's Aid Society of the Methodist Episcopal Church, was established in 1870. The final two schools of what would later become the ATLANTA UNIVERSITY CENTER—Morris Brown College, affiliated with the AFRICAN METHODIST EPISCOPAL CHURCH (A.M.E.), and Spelman Seminary (SPELMAN COLLEGE) for women, a Baptist school—opened in 1881. Although many of these schools were, at first, little more than advanced grammar or secondary schools, this nucleus of black higher education, unmatched in any other city in the United

States, provided important educational and training opportunities for Atlanta's black students and contributed to the growth of what would become a sizable and well-educated black middle class.

Black Atlantans were less successful in the nineteenth century in establishing public elementary and secondary schools for their children, partly because of a sudden decline in the political strength of the city's African-American population following a signal achievement. In 1870, Republicans in the Georgia state legislature succeeded in changing the election system in the state's cities from an at-large selection process to a ward system. In the elections that followed in Atlanta that year, two African Americans— William Finch and George Graham—won seats on the city council. Finch used this opportunity to push for the establishment of black public schools; despite strong Democratic opposition and obstruction, he succeeded in incorporating into the city's school system two schools for black children organized and run by the American Missionary Association.

The following year, however, Democrats regained control of the state legislature, repealed the election law, and swept Finch and other Republican leaders out of office. The city continued to maintain separate public schools for its black students until the 1960s, but these schools remained few in number, and were overcrowded and understaffed. For many years, blacks were limited to grammar schools; not until the 1920s did Atlanta construct its first black public high school.

Efforts in Atlanta to segregate African Americans and restrict their political rights intensified in the period from 1890 to 1920 as the city's black population more than doubled. In 1892, local Democratic officials enacted a "white primary" law, effectively limiting voting in primary elections to white males. That same year, the city passed its first segregation ordinance, which authorized and mandated the separation of black and white passengers on streetcars. In 1913, Atlanta became the first city in Georgia to try to extend segregation to housing patterns through use of a residential segregation ordinance. Although this law was struck down by the state supreme court two years later, the city council passed a similar statute in 1917 and in 1922 tried to institute and formalize segregated housing through use of a comprehensive zoning ordinance.

Violence or threats of violence often accompanied attempts in the South during this period to disfranchise and segregate African Americans. A dramatic example of the ever-present potential for racial violence occurred in the ATLANTA RIOT OF 1906. Racial tensions that year were intensified by a long and bitter campaign for governor in which both candidates called for the complete exclusion of blacks from the political process. Following a series of unsubstantiated reports in the local newspapers of wanton black attacks on white females, a race riot erupted in the city. Spurred on by lurid newspaper accounts of black rapists and rumors of black insurrection, roving gangs of white males attacked African Americans wherever they could find them in the downtown area and in nearby black neighborhoods.

Estimations of the number of blacks and whites killed and wounded in this riot vary widely among contemporary accounts, but the impact of this disturbance on black housing and business patterns was more clear. The riot hastened the city's move toward the economic exclusion and residential segregation of African Americans. Following the riot, African Americans were more likely to settle in established black communities, particularly those located on the eastern fringe of downtown or on the west side of the city near Atlanta University. And black businesses, which had once been interspersed among white commercial concerns on Peachtree Street, were now increasingly located to the east on Auburn Avenue, where a thriving but separate black business district soon developed.

Modest efforts to promote biracial understanding followed in the wake of the riot, culminating in the formation of the Commission on Interracial Cooperation in 1919. Overtures such as this, however, remained the exception in the 1920s and 1930s, as white supremacist organizations made their presence felt in the city. The KU KLUX KLAN, reborn on nearby Stone Mountain in 1915, designated Atlanta as its headquarters (renaming it the "Imperial City of the Invisible Empire"). By 1923 the city's Nathan Bedford Forrest Klan No. 1 had a membership of over 15,000, including many notable local businessmen, educators, clergy, and politicians. In 1930, in the midst of growing unemployment, another white supremacist organization—the "Order of the Black Shirts"—surfaced in the city and pushed for the replacement of all black workers with unemployed whites. Although the Black Shirts' influence was short-lived, the organization nonetheless helped contribute to a restriction of the opportunities for African Americans during the years of the GREAT DEPRESSION.

Amazingly, in the midst of this repressive JIM CROW system, Atlanta's African Americans still managed to register some impressive gains. In 1921, for example, blacks used their ability to vote in city bond referendums and negotiations with the Commission on Interracial Cooperation to gain a commitment from the board of education to build the city's first black high school. The school was eventually constructed on the west side of town, where pioneer black businessman, banker, realtor, and builder He-

man Perry was already developing new homes for Atlanta's blacks. Though Perry's overextended business empire collapsed later in the decade, his efforts on the west side helped pave the way for subsequent residential expansion in that area.

Ironically, the economic exclusion of Atlanta's African Americans from white business transactions also contributed to the growth of the city's middle class and the development of a black business and cultural mecca on Auburn Avenue that *Fortune* magazine would later describe as "the richest black street in the world." By 1920, Auburn Avenue was already home to a wide range of black-owned and -operated businesses, such as insurance companies, banks, a newspaper, barber and beauty shops, restaurants, grocery stores, photo studios, and funeral homes that provided African Americans the services denied them in the larger urban community. Freed from competition with white businessmen and assured the patronage of Atlanta's black community, many black entrepreneurs and their businesses prospered under Jim Crow.

By 1930, Jim Crow and the color line had been firmly established in the city. In the period from 1940 to 1960, however, black leaders began negotiating with city hall and white business leaders to weaken Jim Crow's hold. That city hall and the white business elite were even willing to discuss the issue with black leaders was a reflection of two important post–World War II developments: increased black voting strength and a rapidly deteriorating housing situation.

The repeal of the poll tax by the Georgia legislature in 1945 and the invalidation of the white primary by the state supreme court the following year removed two important barriers to black political participation, and Atlanta's black community responded in 1946 with a voter registration drive that added almost 18,000 new black voters to the city's rolls in only fifty-one days. Three years later, in an effort to coordinate and concentrate their newfound political strength, black Republicans and Democrats joined together to form the Atlanta Negro Voters League—a body which was soon openly courted by the mayor and by white candidates for office.

This increased black voting power and the severe housing shortage facing black Atlantans brought city hall, black leaders, and the white business elite together in behind-the-scenes meetings to negotiate such issues as the range and location of black residential expansion, redevelopment of the central business district, and city plans for annexation and growth. Each side succeeded in taking something away from the table. Mayor William Hartsfield gained important black electoral support for the city's 1951 annexation of northside suburbs (which added an estimated 100,000 residents, most of them white, to the city's population). White business leaders solicited general support for urban renewal plans that would remove low-income blacks and whites from the fringe of the central business district. They also received assurances that black residential expansion would not proceed into northside Atlanta. Black leaders got land for expansion and the construction of new housing and commitments from the city to build additional low-income housing. They also got promises from Mayor Hartsfield for a gradual phase-out of Jim Crow and increased protection against white violence.

The concessions gained on black housing were important for African Americans of all income levels, as dwelling units in most of the city's black neighborhoods were overcrowded and in poor condition. As late as 1959, blacks made up over one-third of the city's total population, yet occupied only about 16 percent of the developed residential land. Not surprisingly, almost three-fourths of the dilapidated housing in the city was found in black communities.

Yet as important as these negotiated agreements were, they did little to break the rigid color line in Atlanta. Interstate highway construction and urban renewal programs in the 1950s and 1960s, for example, wiped out many inner city neighborhoods, displacing thousands of black residents who then relocated in nearby, already overcrowded, black communities. Similarly, while low-income public housing in Atlanta was increased during these decades, facilities remained strictly segregated and most new public housing was located in existing black residential areas. As a result, public housing tended not to disperse the black population throughout the metropolitan area but instead to confine it to existing areas of black residential concentration. Finally, although the 1951 annexation held certain benefits for Atlanta's black population, it also initially diluted black voting strength by adding thousands of white voters.

The peaceful biracial negotiations of this era contributed to Atlanta's emerging image as the most racially progressive city in the South. In 1961, this national reputation was further enhanced by the peaceful desegregation of four of the city's white high schools. Atlanta, ever mindful of the value of a good image, promoted itself during this decade as "the city too busy to hate."

Signs were already emerging, however, that suggested that the era of backstage biracial negotiations and gentlemen's agreements was fast coming to a close. SIT-INS in 1961 by black students to desegregate Atlanta's downtown restaurants threatened to upset relationships and alliances forged between black leaders and the white business elite and exposed gen-

erational cleavages within the black community. Martin Luther KING, Jr., who had personally led one of the sit-in demonstrations, soon found himself in the unenviable position of mediating between the more radical college students and older black leaders like his father, "Daddy" King.

One year later, changes in black leadership and tactics became even more apparent in the response of African Americans to the so-called "Peyton Road barricades." In that year, as blacks moved into the new white-only subdivision in southwest Atlanta, the city responded much as it had in the past by erecting barriers to slow and contain further black expansion (in this instance, by putting up street barricades). The resulting uproar in the black community and the accompanying national press coverage embarrassed the city and forced city hall to recognize that the days of a tightly segregated housing market in Atlanta, kept in place by overt discrimination and racial barriers, was over. While segregation practices would continue in more discreet forms—through the use of real estate tactics like blockbusting, racial steering, and discriminatory loan and mortgage policies—the right of African Americans to housing on an equal opportunity basis was now officially acknowledged.

This acknowledgment and the accelerated movement of African Americans into formerly all-white communities in south and east Atlanta contributed to a dramatic outmigration of white Atlantans in the 1960s. During this decade, the city's white population declined by 60,000 while its black population increased by 70,000. The result, as documented in the 1970 census, was that Atlanta had a black majority for the first time in its history.

This dramatic population change was reflected in black political gains in the city's 1973 elections. Not only was the city council evenly divided between whites and blacks for the first time, but the school board now had a slim African-American majority and Maynard JACKSON was elected the city's first black mayor. One hundred and twenty-five years of white rule in Atlanta had come to an end.

In the years following Jackson's 1973 victory, significant gains have been made in minority participation in city government and business. Andrew YOUNG and, most recently, Bill Campbell have continued Atlanta's black mayoral presence, and efforts have been instituted to encourage the city's black and white business elite's involvement in city planning and development.

Atlanta's population base has also changed dramatically in the last few decades with the infusion of a growing cultural and ethnic diversity in what has traditionally been a biracial society. Both the city and the larger metropolitan area, however, retain a high degree of racial segregation as the city remains over two-thirds black while the surrounding suburbs are over two-thirds white. The increasing suburbanization of new jobs and business growth (particularly on the north side) has also left Atlanta, like many other cities, with a declining economic base and decreased job opportunities for those other than white-collar workers.

The growing multicultural nature of Atlanta's population, the presence of internationally recognized business concerns (e.g., CNN and Coca-Cola) and the city's selection as the site for the 1996 Olympics underlie Atlanta's current claims to being "the next great international city." How well the city succeeds at this task may be determined by Atlanta's success in overcoming the racial divisions, both social and geographical, that have historically divided the city.

REFERENCES

DITTMER, JOHN. *Black Georgia in the Progressive Era.* Chicago, 1977.

RABINOWITZ, HOWARD N. *Race Relations in the Urban South, 1865–1890.* Chicago, 1980.

RUSSELL, JAMES MICHAEL. *Atlanta, 1847–1890: City Building in the Old South and the New.* Baton Rouge, La., 1988.

STONE, CLARENCE N. *Regime Politics: Governing Atlanta, 1946–1988.* Lawrence, Kans., 1988.

WHITE, DANA F. "The Black Sides of Atlanta: A Geography of Containment and Expansion, 1870–1970." *Atlanta Historical Journal* 26 (Summer/Fall 1982): 199–215.

JOSEPHINE ALLEN

Atlanta Compromise. On September 18, 1895, Booker T. WASHINGTON, the president of Tuskegee Institute (*see* TUSKEGEE UNIVERSITY) in Alabama, delivered an address at the Cotton States and International Exposition in Atlanta, Ga., that gained him recognition as the leading spokesman for African Americans.

Speaking to a predominantly white audience, Washington called upon black Southerners to subordinate their demands for equal civil and political rights, at least temporarily, in order to focus upon efforts to achieve an economic base in the New South. The speech climaxed with Washington's apparent acquiescence to southern white desires for racial segregation when he proclaimed: "In all things that are purely social we can be as separate as the fingers, yet one as the hand in all things essential to mutual progress." This "compromise" epitomized the accommodationist ideology of racial self-help that

came to be associated with Booker T. Washington's leadership in the late nineteenth and early twentieth centuries.

REFERENCES

HARLAN, LOUIS R. *Booker T. Washington: The Making of a Black Leader, 1856–1901.* New York, 1972.
MEIER, AUGUST. *Negro Thought in America, 1880–1915: Racial Ideologies in the Age of Booker T. Washington.* Ann Arbor, Mich., 1963.

JAMES M. SORELLE

Atlanta Life Insurance Company. In 1905, Alonzo Herndon bought three black INSURANCE COMPANIES—the Atlanta Benevolent Protective Association, the Royal Mutual Insurance Association, and the National Laborers' Protective Union—and reorganized them into the Atlanta Mutual Insurance Association. Like John Merrick, founder of NORTH CAROLINA MUTUAL LIFE, Herndon (1858–1927) had made a fortune through the ownership of barbershops. A friend of both Booker T. WASHINGTON and W. E. B. DU BOIS, Herndon saw business development as an important aspect of racial progress.

Like other African-American insurance companies, Atlanta Life faced a number of difficulties unknown to white-owned companies. Due to the relative poverty of its policyholders, Atlanta Life was forced to offer only industrial insurance—a type of insurance in which insurees paid a weekly premium of only a few cents and received a small return. Industrial insurance incurred high operating costs, because agents made weekly trips to the homes of policyholders. The collection of debts was made more difficult for African-American agents who encountered segregated railway cars and hotels. Nonetheless, in the company's first year, Atlanta Life had $389,327 insurance in force. By 1921, when that figure had grown to $9,464,493, Atlanta Mutual was reorganized into a stock corporation and renamed the Atlanta Life Insurance Company.

Between 1922 and 1924, Atlanta Life undertook swift expansion, entering a half dozen new states, most in the lower South. Herndon also began to acquire smaller African-American-owned insurance companies on the verge of failure. In running the company, Herndon was aided by a number of long-term assistants, such as Lemuel Harry Haywood, who served as the first agency director from 1922 to 1955. Haywood helped create a strong agency force for Atlanta Life by sending agents throughout the state to open offices and hire solicitors to sell directly to homes and churches. Sales agents made an appeal to black pride, urging the support of African-American-owned institutions. Despite this, the vast majority of blacks continued to buy policies from the larger, nationally operating, white-owned insurance companies. Atlanta Life's expansion slowed by the late 1920s. Faith in black-owned insurance companies had been undermined by the failures of the Standard Life Insurance Company (1925) and National Benefit Life Insurance Company (1932). At the same time, the GREAT DEPRESSION forced a number of insurees to let their policies lapse.

After the death of Alonzo Herndon in 1927, his son Norris Herndon (1897–1977) took over the presidency of Atlanta Life. He remained at the helm of the company for more than four decades. Norris Herndon expanded the territory covered by Atlanta Life from nine to eleven states. For most of Herndon's tenure, Atlanta Life was the second-largest African-American-owned insurance enterprise in the United States in terms of total assets—behind the North Carolina Mutual Life Insurance Company. It was second also in terms of insurance in force through the 1950s, when it was eclipsed by Golden State Mutual of Los Angeles, which specialized in group insurance. At the time of Norris Herndon's retirement in 1973, Atlanta Life had $346 million insurance in force.

In 1973, Jesse Hill, Jr., became president of Atlanta Life. Hill had served on the Georgia Board of Regents and had been an active member of the Atlanta Committee for Cooperative Action (ACCA) and the NAACP. Under his lead, Atlanta Life began to make significant inroads into ordinary insurance (first offered by the company in 1922) and group policies. By 1982, only about 40 percent of the total volume of Atlanta Life's business came from industrial insurance. In 1993, Atlanta Life had $2.5 billion of insurance in force and $158 million in total assets.

REFERENCE

HENDERSON, ALEXA BENSON. *Atlanta Life Insurance Company: Guardian of Black Economic Dignity.* Tuscaloosa, Ala., 1990.

SIRAJ AHMED

Atlanta Neighborhood Union, African-American women's organization. The Atlanta Neighborhood Union was part of a network of groups in the late nineteenth and early twentieth centuries through which African-American women addressed a wide variety of community needs. It was founded in 1908 by Lugenia Burns HOPE and a small

group of black activists in Atlanta. Responding to a lack of organized community work to improve conditions for Atlanta's black population, Hope gathered a number of neighborhood residents and Atlanta University students and sent them out to survey the community's needs. They found that black residents of Atlanta were in need of services ranging from day care, education, and playgrounds to sanitation and health care.

Building on a long tradition of African-American women's organizing in churches and clubs, the Neighborhood Union addressed the community's needs through a number of departments: moral and educational, literary, music, and arts. The union offered vocational classes, provided health information and access to clinics, and assisted in creating housing opportunities. The organization's primary concern was with the welfare of children, and, as such, it focused much of its attention on the public schools. Under Hope's leadership, the Women's Civic and Social Improvement Committee investigated schools, lobbied the board of education, and was successful in moving the city to provide better facilities and the city's first black public high school.

Like many African-American organizations in this period, the Neighborhood Union's leadership was composed primarily of educated middle-class black women. The organization intentionally involved a broad range of community members in its work, however. Neighborhood Union women and men were committed to cooperative work, emphasizing that cooperation would benefit the entire African-American community. While the union's period of peak influence was during the 1920s and 1930s, its legacy remains strong in the Neighborhood Union Health Center in Atlanta today.

REFERENCES

ROUSE, JACQUELINE A. "The Legacy of Community Organizing: Lugenia Burns Hope and the Neighborhood Union." *Journal of Negro History* 69 (Summer/Fall 1984): 114–133.
——. *Lugenia Burns Hope: A Black Southern Reformer.* Athens, Ga., 1989.

JUDITH WEISENFELD

Atlanta Riot of 1906. The Atlanta Riot was an expression of southern white hysteria over rape and the social and political implications of race. On September 22, 1906, following a race-baiting gubernatorial campaign by Hoke Smith and a lengthy newspaper series about a purported wave of black rape of white women, the city of Atlanta, Ga., a center of the black middle class, was taken over by a white mob.

On the evening of September 22, whites, aroused by false and exaggerated reports of arguments between blacks and whites, massed on Decatur Street. Word spread, and whites attacked streetcars and destroyed black shops and businesses on Auburn Street, then invaded black neighborhoods—with halfhearted resistance by or the support of city police and local militia. Black homes were pillaged, and five blacks were murdered. Blacks put up some resistance but were overwhelmed and outnumbered in pitched battles with armed whites. On the following night, state militia troops arrived, but many joined the white mob, which headed toward Brownsville, the city's middle-class black college suburb, and attacked its black residents. Police arrested and disarmed blacks who attempted to defend themselves. The next morning, police and militia entered Brownsville homes, supposedly to hunt for guns and arrest rioters; they beat and arrested affluent blacks. White rioting continued every night until September 26, when order was finally restored. Twenty-five blacks were killed (as well as one white), and hundreds were injured or had their property destroyed. More than a thousand blacks left Atlanta during and after the riots.

The rioting in Atlanta demonstrated the helplessness of black populations in urban settings and the emptiness of rhetoric about the "new South." The white savagery caused many blacks to question the effectiveness of Booker T. WASHINGTON's accommodationist philosophy (*see* ACCOMMODATIONISM). Washington himself was energized by the riots into calling the Carnegie Hall Conference of 1906, which prompted the formation of the Committee of Twelve, a short-lived attempt at unified black leadership. Elite whites disclaimed participation in the riot, which they blamed on blacks and on poor, immigrant whites. However, elite whites joined in promoting the rebuilding of black Atlanta. They sought to avoid further rioting by joining with "respectable" black moderates such as John HOPE and Henry Hugh PROCTOR to reduce racial tensions. Out of the movement came annual meetings on race relations in the Southern Sociological Congress, beginning in 1912, which led to the formation of the Commission on Interracial Cooperation in 1919.

See also URBAN RIOTS AND REBELLIONS.

REFERENCES

BROWN, RICHARD MAXWELL. *Strain of Violence.* New York, 1975.
WILLIAMSON, JOEL. *The Crucible of Race: Black-White Relations in the American South Since Emancipation.* New York, 1984.

GREG ROBINSON

Atlanta University Center. The Atlanta University Center was founded as a consortium of six historic black colleges and universities, located less than a mile from downtown Atlanta. The six contiguous campuses include CLARK–ATLANTA UNIVERSITY, MOREHOUSE COLLEGE, SPELMAN COLLEGE, Morris Brown College, Morehouse School of Medicine, and the Interdenominational Theological Center. The affiliation has enabled the six independent institutions to divide the cost of shared resources so that each can develop its own academic specialty.

Though the histories of the individual colleges date back to the early days of RECONSTRUCTION, the origin of the center itself dates from the third decade of the twentieth century. After WORLD WAR I, economic difficulties necessitated a closer degree of cooperation among the colleges and universities in Atlanta. Financial sources had become scarce and there were some on the board of the General Education Board who believed that there were more black institutions of higher learning in Atlanta than should be sustained. Rather than wait for a recommendation that one of them be shut down or merged into another, Atlanta University (founded 1865), Spelman University (a four-year female institution, founded 1881), and Morehouse College (a four-year male institution,

founded 1867), signed a contract of affiliation in 1929. As a result of this agreement Atlanta University became exclusively a graduate school, and several student services were consolidated for all three schools.

The affiliation proved to be very successful, and in 1953 the three other institutions adjacent to Atlanta University were invited to join. They were Morris Brown College (founded 1881), the Gammon Theological Seminary (founded 1869), and Clark University (founded 1869). Negotiations for formal participation were completed, and in 1957 the Atlanta University Center (AUC) was born. Each of the six institutions held membership as coequals. The Interdenominational Center (which absorbed the Gammon Theological Seminary), became a member in 1958 and Morehouse School of Medicine joined in 1982. Financial pressures forced a reorganization in 1972, and the center incorporated.

Through careful planning and the coordination of resources, the center offers its students much more than any one of the members could provide on its own. Two of the most noteworthy joint projects are the Robert W. Woodruff Library and the Science Research Institute. The Robert W. Woodruff Library, founded in 1982, was designed to hold over one million volumes. It is home to one of the largest collec-

Atlanta University football team. (Photographs and Prints Division, Schomburg Center for Research in Black Culture, The New York Public Library, Astor, Lenox and Tilden Foundations)

tions of documents in the country related to the black experience. The Dolphus E. Milligan Science Research Institute (SRI), named for the black Atlanta University graduate and scientist, also opened in 1982. The institute receives federal research grants, plays a large role in the training of future black scientists, and maintains an internship program which gives students experience in laboratories across the nation.

Since 1948, the AUC also has hosted interracial meetings and civil rights conferences. These have included meetings of the board of directors of the UNITED NEGRO COLLEGE FUND, the Southern Regional Council, the Southeastern Regional YMCA and YWCA, a Conference on Discrimination in Higher Education active throughout the South, the National Association of Biblical Instructors, the Georgia Committee on Interracial Cooperation, and the American Association for the Advancement of Science. In addition, several African-American groups also have held meetings there. They include the Association for the Study of Negro Life and History, the Association of Social Science Teachers, the National Negro Business Conference, the Conference of Supply on Negro Physicians. An annual art exhibit (begun in 1942), was founded to develop art appreciation in the center and the region.

REFERENCES

BACOTE, CLARENCE A. *The Story of Atlanta University*. Atlanta, 1969.

LEWIS, DAVID LEVERING. *W. E. B. Du Bois: Biography of a Race 1868–1919*. New York, 1993.

MCPHERSON, JAMES M. *The Abolitionist Legacy*. Princeton, N.J., 1975.

ROEBUCK, JULIAN B. and KOMANDURI S. MURTY. *Historically Black Colleges and Universities*. Westport, Conn., 1993.

DEBI BROOME

Attaway, William Alexander

Attaway, William Alexander (November 19, 1911–June 17, 1986), novelist. Born in Greenville, Miss., to William Alexander Attaway, a physician, and Florence Parry Attaway, a schoolteacher, William Alexander Attaway was raised in Chicago.

He attended local public schools and the University of Illinois, where he pursued literary interests. His father died during his second year in college and Attaway left school to hobo his way west, working along the way as a cabin boy, stevedore, and migrant laborer. He returned to Chicago and the university in 1933; there he published his first literary efforts. During this period Attaway became involved with the Illinois branch of the FEDERAL WRITERS' PROJECT and first met Richard WRIGHT.

After graduating from the University of Illinois in 1936, Attaway moved to New York City, determined to earn his living as a writer. With the assistance of his younger sister, Ruth, an actress, he won a role in the road company of *You Can't Take It with You*. He was on tour with the play when he learned that his first novel, *Let Me Breathe Thunder* (1939), a naturalistic novel about the experiences of two white migrant farm workers, had been accepted for publication.

Blood on the Forge (1941), Attaway's second and most significant novel, encapsulates the mass migration of southern blacks to northern cities as it traces the experiences of three half-brothers in the steel mills of Pennsylvania. Although *Blood on the Forge* received favorable critical reviews, the novel was not a success in the literary marketplace—overshadowed, perhaps, by the triumph of Richard Wright, whose novel *Native Son* had become a bestseller the previous year. *Blood on the Forge* was the high point of Attaway's literary career. In his later years, he wrote for radio, film, and television; developed a deep interest in Caribbean and U.S. folk music; and published two works, *The Calypso Song Book* (1957) and *Hear America Singing* (1967). He spent the last years of his life in Los Angeles, dying in relative obscurity.

REFERENCES

BELL, BERNARD W. *The Afro-American Novel and Its Tradition*. Amherst, Mass., 1987, pp. 167–171.

YARBOROUGH, RICHARD. Afterword to *Blood on the Forge*. New York, 1987.

JAMES A. MILLER

Attica Uprising

Attica Uprising. On September 13, 1971, after more than 1,200 black and Latino inmates seized control of Attica Correctional Facility, a state prison in Attica, N.Y., 211 state troopers and corrections officers retook the prison, killing ten hostages and twenty-nine prisoners. Four days earlier, the inmates had taken over the prison, held thirty-nine hostages, and issued a series of demands, including a minimum wage for prison labor, more educational opportunities, religious freedom, better medical treatment, balanced diets, and complete amnesty for those involved in the uprising.

Since the 1950s, Attica's prison population had included a large number of black and Latino inmates. With the intensification of radical protest in the 1960s, there were also a substantial number of political prisoners, some of whom were members of the BLACK

PANTHER PARTY and others adherents of the NATION OF ISLAM. In addition, many black prisoners had been radicalized by the killing of Black Panther leader Fred Hampton by Chicago police in December 1969 and the death two years later in a California prison of George JACKSON, a black activist who spent much of his life fighting injustice in the prison system.

At the same time, prison conditions had deteriorated substantially, and overcrowding was a chronic problem. Since the summer of 1971, prisoners at Attica had organized and demanded changes in prison conditions. In July the inmates sent a list of their grievances to the warden. When little came of their efforts to effect changes within the facility, tension rose. On September 9, after a minor scuffle the previous day between inmates and guards, Attica prisoners rebelled. The riot spread quickly as guards were taken hostage and the inmates gathered together in one yard.

Inmates asked for and received an outside committee of politicians, journalists, and activists to help negotiate their cause. The committee drafted a proposal that included most of the inmates' demands, but New York State Corrections Commissioner Russell C. Oswald refused to consider amnesty for the protesting prisoners. One of the corrective officers who had been injured during the takeover died during the negotiations; the inmates could have been charged with murder. The inmates, aware of the potential consequences they faced, did not want to accept a compromise without amnesty. After four days of negotiations, Gov. Nelson Rockefeller, who had refused to go to the prison or speak with the inmates, authorized a raid.

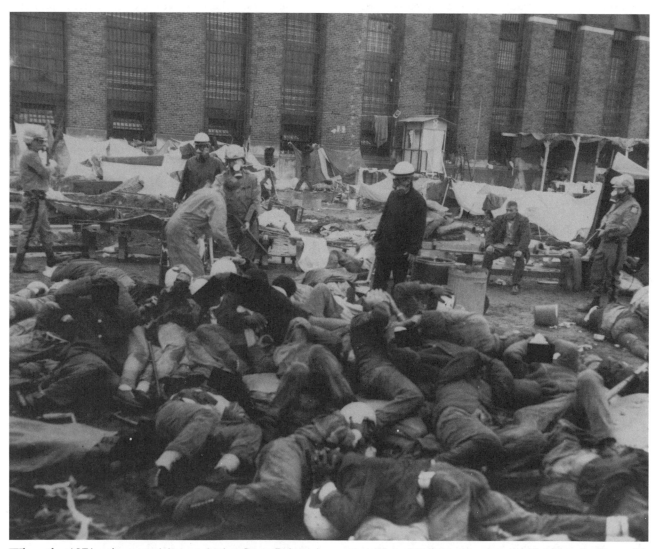

When the 1971 prison uprising at Attica State Prison in upstate New York was suppressed by state police with massive use of force, many raised questions about the racial tensions that contributed to the initial rebellion and the severity of its suppression. In this photograph, taken just after the recapture of the prison yard, some prisoners are undergoing strip searches, while others lie on the ground under guard. (AP/Wide World Photos)

During the raid on September 13, tear gas was dropped by helicopter into the prison yard and members of the National Guard fired indiscriminately into the smoke-filled area. When the smoke cleared, thirty-nine people had been shot—including ten hostages. Once the prisoners were in custody, corrective officers and National Guard members continued the pattern of brutal behavior. Inmates were verbally abused, threatened, and mercilessly beaten. Their watches, wedding rings, and glasses were smashed, and other personal belongings were burned. In one instance, prisoners were forced to run through a tunnel lined with rows of state troopers who beat them with nightsticks.

Shortly after the raid, state and prison officials disclaimed responsibility and blamed the prisoners, who had no firearms, for the deaths of the hostages. Yet within a few days it was apparent that all the hostages had been killed by the police during the assault. The district attorney launched an investigation of the rebellion and retaking of the prison, but state police refused to cooperate and intentionally covered up their actions by withholding or destroying evidence such as photographs, videotapes, and testimony. Subsequent inquiries charged that the district attorney's investigation, which resulted in indictments of 62 inmates and one officer, was one-sided. By 1976 most of the inmates had been acquitted, pardoned, or had their charges dismissed. Charges against the one trooper were also dismissed. Although officials were never brought to trial by the state, all official investigations concurred that there was undoubtedly an excessive use of force on the part of the troopers.

In 1974, 1,281 prisoners who participated in the rebellion filed a lawsuit to hold the troopers accountable for their use of excessive force, but the case was stalled with the mass pardonings and dismissals in 1976. After years of appeals and delays, inmates who sought to hold four supervisory officials liable for the use of unnecessary force and abuse by state troopers were granted another trial in 1991. The court decided the next year that the inmates had suffered "cruel and unusual punishment" and that the state had failed to provide adequate medical care. However, only a deputy warden was found liable in the final resolution of the suit. Subsequently, inmates appealed under federal civil rights law for monetary compensation for personal damages in a case that was still pending at the end of 1993.

Attica is indelibly etched into the collective memory of the African-American community and is a symbol for all Americans of the potential for brutality by state and law-enforcement authorities. The state response showed the willingness of officials to sacrifice the lives of their employees for the sake of political posturing in a conflict that could have ended peacefully. In addition, Attica exhibited the ways in which governments can rely on force to quell dissent or opposition and demonstrated the difficulty of seeing justice served when the victims are poor black and Latino prisoners.

REFERENCES

BELL, MALCOLM. *The Turkey Shoot: Tracking the Attica Cover-Up*. 1985.
HAMPTON, HENRY, and STEVE FAYER. *Voices of Freedom*. New York, 1990.
WEISS, ROBERT. "Attica: The Bitter Lessons Forgotten?" *Social Justice* 18, no. 3, 1991.
WICKER, TOM. *A Time to Die,* New York, 1975.

JEANNE THEOHARIS

Attucks, Crispus (c. 1723–March 5, 1770), patriot. Crispus Attucks is acclaimed as the first martyr of the American Revolution. Although not much is known about Attucks's early life, he was a tall, muscular mulatto of African and Natick Indian ancestry, and a slave of William Brown of Framingham, Mass., before he ran away in November 1750. Attucks worked on whaling ships operating out of various New England ports over the next two decades. On the night of March 5, 1770, he was a leader of a crowd of twenty to thirty laborers and sailors who confronted a group of British soldiers, whose presence in Boston was deeply resented. Brandishing a club, Attucks allegedly struck one of the grenadiers, prompting several soldiers to fire into the crowd. Attucks fell instantly, becoming the first of five to die in the so-called Boston Massacre. His body was carried in its coffin to Faneuil Hall, where it lay for three days before he and the other victims of the massacre were given a public funeral. Ten thousand people marched in their funeral cortege. During the officers' trial, John Adams, acting as their defense attorney, ascribed to Attucks, whom Adams claimed had "undertaken to be the hero of the night," chief blame for instigating the massacre. The soldiers were acquitted.

The Boston Massacre was used by Revolutionary-era patriots to heighten opposition to the British, and March 5 was commemorated in Boston until the 1840s. In 1858, as a reaction to the Supreme Court's DRED SCOTT DECISION, African-American historian William Cooper NELL revived Crispus Attucks Day, and Boston's blacks celebrated it until 1870. By the middle of the nineteenth century, Attucks's name graced numerous African-American schools and other institutions. In 1888, Boston authorities erected a monument to him on Boston Common.

Throughout the twentieth century, black leaders called for a national holiday on March 5. In 1965,

blacks in Newark, N.J., revived Crispus Attucks Day with annual parades, and in 1967 the Newark school system began school closings to observe the holiday. By the 1970s, a few cities were celebrating Crispus Attucks Day. However, the interest in Crispus Attucks Day waned as agitation grew for the creation of a holiday for the Rev. Dr. Martin Luther King, Jr.

REFERENCES

FONER, PHILIP. *Blacks in the American Revolution.* Westport, Conn., 1976.
ZOBEL, MILLER B. *The Boston Massacre.* New York, 1970.

ROY E. FINKENBINE

Augusta, Alexander Thomas (March 8, 1825–December 21, 1890), physician and professor. Born in Norfolk, Va., Alexander Augusta worked as a barber while he studied medicine with private tutors in Baltimore, Md. He next moved to Philadelphia, but was thwarted in his wish to gain admittance to the University of Pennsylvania School of Medicine. However, he favorably impressed Professor William Gibson, who gave him private lessons. Augusta was never allowed to enter any medical school in the United States, but he did matriculate in 1850 at Trinity Medical College in Toronto, Canada, and graduated in 1856 with a Bachelor of Medicine degree.

After several years of private practice in Toronto, in 1862 Augusta moved to Washington, D.C. The following year he became the first black surgeon in the U.S. Army, with a commission as a major in the Seventh U.S. Colored Troops. When his two white assistant surgeons complained to President Lincoln about the indignity of serving under a black man, Augusta was transferred out of the unit and served for a time as head of Freedmen's Hospital in Washington, D.C. In 1864, when he was the medical examiner of black recruits in Baltimore, Augusta was forced to complain to Senator Henry Wilson because the Army paymaster in Baltimore would allow him only seven dollars a month, the salary of a black enlisted man. The senator intervened on his account, and Augusta began to be paid according to his rank. In March 1865, he attained another milestone when, in reward for his meritorious and faithful service, he was promoted to lieutenant colonel. He was the first African American to gain that rank.

In October 1866, Augusta was discharged from the Army, and resumed private practice in Washington. In 1868, he accepted a teaching post in the medical department of Howard University, thereby becoming the first black with a position in the faculty of any American medical school. He retired from that position in 1877 and conducted his private practice until his death. He is buried in Arlington National Cemetery.

REFERENCES

GREENE, ROBERT EWELL. *Black Defenders of America, 1775–1973.* Chicago, 1974.
LOGAN, RAYFORD W., and MICHAEL R. WINSTON, eds. *Dictionary of American Negro Biography.* New York, 1982.

LYDIA MCNEILL

Aunt Jemima. *See* Stereotypes.

Autobiography. Autobiography holds a position of priority—indeed, many would say preeminence—among the narrative traditions of black America. African Americans had been dictating and writing first-person accounts of their lives for almost a century before the first black American novel appeared, in 1853. Between 1850 and 1950 the autobiographies of Frederick DOUGLASS, Booker T. WASHINGTON, and Richard WRIGHT made a more lasting impression on the American readership than did any African-American novel or school novelists of the same era. The number of late-twentieth-century African-American novels that read as or are presented as autobiographies confirms the judgment, made by more than one critic, that black writing in the United States incorporates an extraordinarily self-reflexive tradition.

African-American autobiography has consistently testified to the commitment of people of color to realize the promise of their American birthright and to articulate their achievements as individuals and as persons of African descent. Perhaps more than any other form in black American letters, autobiography has been recognized since its inception as a powerful means of addressing and altering sociopolitical as well as cultural realities in the United States.

Nineteenth-century abolitionists sponsored the publication of the narratives of escaped slaves out of a conviction that first-person accounts of those victimized by and yet triumphant over slavery would mobilize white readers more profoundly than any other kind of antislavery discourse. A similar belief in modern black American autobiography's potential to

liberate white readers from racial prejudice, igno-rance, and fear has prompted an unusually large and generally supportive response on the part of publish-ers and critics to African-American autobiographers of the twentieth century, particularly since the 1960s.

As a form of discourse, African-American auto-biography can best be characterized in terms of the three constituent elements of the word itself: *autos* (self), *bios* (life), and *graphe* (writing). Undoubtedly, the window that autobiography opens onto African-American life, especially aspects of that life which have made black experience distinctive, has been cru-cial to the success of the genre with the popular reader in the United States and abroad. But one should not overlook the social import of the black autobiogra-pher's concern with claiming a psychological as well as an experiential distinctiveness for himself or her-self. Such writers have traditionally felt an obligation to speak for and to people of color, rather than just on behalf of the individual self.

Yet autobiographers from Frederick Douglass to MALCOLM X have realized that by identifying the as-pirations of a people with the ambitions of a self, gen-uine impetus to the cause of freedom could be gener-ated. A key manifestation of *autos* since the beginning of the African-American autobiographical enterprise has been the struggle to attain the autonomy of au-thorship, the right to express oneself independent of the direction or approval of white sponsors and edi-tors. Increasingly in the twentieth century, the act of writing, the representation of selfhood through a per-sonalized storytelling style, has become a sign of the African-American autobiographer's assertion of inde-pendence of mind and individuality of vision.

During its first century or so from 1760 to 1865, the form was dominated by autobiographical narra-tives of ex-slaves. The best-known slave narratives were authored by fugitives who used their personal histories to illustrate the horrors of America's "pecu-liar institution." Classics of the genre by Frederick Douglass, William Wells BROWN, and Harriet JA-COBS center on the former slave's rite of passage from bondage in the South to freedom in the North. Ad-vertised in the abolitionist press and sold at anti-slavery meetings throughout the English-speaking world, at least a dozen of the more than seventy slave narratives published in the antebellum era went through multiple editions. A few, such as *The inter-esting Narrative of the Life of Olaudah Equiano, or Gusta-vus Vassa, the African* (1789; *see* Olaudah EQUIANO) and the *Narrative of the Life of Frederick Douglass* (1845), sold in the tens of thousands.

From the end of the Civil War to the onset of the Great Depression, the ex-slave narrative remained the preponderant subgenre of African-American auto-biography. At least fifty former slaves wrote or dic-tated book-length accounts of their lives, in which slavery is depicted as a kind of crucible in which the resilience, industry, and ingenuity of the slave were tested and ultimately validated. The bestselling African-American autobiography of the early twen-tieth century was Booker T. Washington's *Up from Slavery* (1901), a former slave's contribution to the American success story.

As African Americans learned the bitter lessons of the post-Reconstruction era, black autobiography be-came less focused on the individual's quest for per-sonal power and more concerned with the realization of communal power and prestige in African-American institutions, particularly the school and the church. Educators, headed by Washington and his many protégés who wrote autobiographies, and min-isters, whose influential memoirs range from Bishop Daniel PAYNE's *Recollections of Seventy Years* (1888) to Bishop Alexander WALTERS's *My Life and Work* (1917), argued that black survival, not to mention fulfillment, depended largely on building institu-tional bulwarks against the divide-and-conquer strat-egy of American white supremacy. By sublimating his personal desires and ambitions in a larger frame-work, the institutional man of African-American au-tobiography asked the world to judge him primarily according to his "usefulness," his ability to work within the existing socioeconomic order to accom-plish good for his people.

Although the NEW NEGRO era was a time of com-paratively few noteworthy autobiographies, William Pickens and Ida B. WELLS—each of them southern-born, middle class, and dedicated to civil rights activ-ism—made signal contributions to African-American autobiography in the 1920s. Pickens's *Bursting Bonds* (1923) chronicles the evolution of a latter-day Booker T. Washington into a militant proponent of the ideas of W. E. B. Du Bois. Wells's posthumously pub-lished *Crusade for Justice* (1970) tells an equally com-pelling story of its author's dauntless commitment to a life of agitation and protest on behalf of African Americans. The pioneering efforts of Pickens and Wells in the 1920s, and James Weldon JOHNSON's *Along This Way* in 1933, helped to reorient African-American autobiography to its roots in the slave nar-rative ideal of the black leader as articulate hero who uses words as weapons in the fight for individual and communal freedom.

The decade and a half after the New Negro Re-naissance saw the publication of several important autobiographies by literary figures such as Claude MCKAY (*A Long Way from Home*, 1937), Langston HUGHES (*The Big Sea*, 1940), Zora Neale HURSTON (*Dust Tracks on a Road*, 1942), and Richard Wright (*Black Boy*, 1945). The unprecedented emphasis in these texts on the search for an authentic selfhood,

predicated on the writers' skepticism about institutions and epitomized in their heightened sensitivity to literary style as self-presentation, marks a turning point in the history of African-American autobiography. *Black Boy* became the most widely read and discussed such text of the post–World War II period, primarily because of its quintessentially modernist portrait of the black writer as alienated rebel, dedicated uncompromisingly to the expression of truth as individually perceived.

This sense of the autobiographer's foremost responsibility to absolute authenticity of self-expression largely precluded Wright's participation in what had become by the mid–twentieth century a traditional role for the African-American autobiographer—that of spokesman for the African-American community. To a new generation of self-styled "revolutionary" black autobiographers of the 1960s, however, Wright's ideal of personal authenticity could be achieved only by identifying with the oppressed masses of black America and then "telling it like it is" to white America on their behalf. The exemplar of this mode of testimony, powerfully energized by the civil rights and Black Power movements, was *The Autobiography of Malcolm X* (1965), which turned a street-corner organizer for a splinter group of black separatists into a culture hero for young, disaffected middle-class whites and their black counterparts in search of a standard-bearer for a new racial consciousness. Malcolm's successors produced a chorus of denunciation of American racism and hypocrisy unmatched since the era of the fugitive-slave narrative.

The appearance in 1970 of Maya ANGELOU's *I Know Why the Caged Bird Sings* signaled one of the most remarkable developments in recent African-American autobiography: the unprecedented outpouring of personal, sometimes very intimate, narratives by black women. Although women were longtime contributors to such bedrock African-American traditions as the spiritual autobiography, recent women autobiographers, led by Angelou, Audre LORDE, Marita Golden, and Itabari Njeri, have re-envisioned the idea of the spirit and salvation, discovering them anew in the secular experience of black female artists and activists. Through such reinvigorations of traditional forms and themes, African-American autobiography continues to bear profound witness to its cultural heritage and to its ongoing responsibility to represent the personal and communal voices of black Americans.

REFERENCES

ANDREWS, WILLIAM L. *African-American Autobiography: A Collection of Critical Essays.* Englewood Cliffs, N.J., 1993.

———. *To Tell a Free Story: The First Century of African-American Autobiography, 1760–1865.* Urbana, Ill., 1986.

ANDREWS, WILLIAM L., and NELLIE Y. MCKAY, eds. "Twentieth-Century African-American Autobiography." *Black American Literature Forum* 24 (1990): 195–415.

BRAXTON, JOANNE M. *Black Women Writing Autobiography.* Philadelphia, 1989.

WILLIAM L. ANDREWS

Autoimmune Deficiency Syndrome (AIDS). *See* Diseases and Epidemics.

Avery Normal Institute.

Avery Normal Institute was a private college preparatory and normal school organized for African Americans by the American Missionary Association (AMA), a branch of the Congregationalist Church, in Charleston, S.C., in 1865. During the first two years of its existence, the school was forced to relocate twice because local white authorities opposed the AMA's efforts to educate African Americans. In its first years, the school was known by several names, including the Tappan School and the Saxton School. In 1868, northern philanthropist Charles Avery donated money for a permanent location and the school was renamed Avery Institute on May 7, 1868.

Avery was organized as part of AMA's Congregationalist-influenced goal to make southern schools resemble those of New England and to educate black leaders to head their own schools. Under its first principal, Francis L. CARDOZO, a leading black Reconstruction politician, Avery began offering a classical curriculum, including Latin, geometry, literature, and philosophy, as well as teacher-training courses.

After 1870, when South Carolina began requiring all its children to attend school for a minimum of two years, Avery became a main supplier of black teachers for black students, particularly in rural areas of the state, and by 1880 a majority of Avery students were training to become teachers. Avery's college preparatory program also continued to serve a vital role in Charleston as the only accredited black high school through the 1930s.

Avery Institute had financial difficulties in the 1930s and '40s, and there were a number of plans to save the school. Many parents and alumni hoped Avery would become a college for blacks unable to leave South Carolina for their education, but in 1947,

financial difficulties forced Avery to become a public school. In 1954, unable to avoid financial ruin, the school was closed.

Avery faculty and graduates were known for their commitment to political and social equality. While the school's administration was criticized for paternalistic attitudes favoring lighter skinned blacks and fostering class distinctions, its students and teachers were consistently at the forefront of Charleston's civil rights movement. In 1917 Avery Institute was the center of NAACP activity in Charleston, and the local organization, which was made up of many Avery alumni, led the 1919 campaign that forced the Charleston Public School System to hire African-American teachers. Later, during the 1950s, many Avery graduates attended the Highlander Folk School in Monteagle, Tenn., and helped establish pioneering citizenship schools in South Carolina. Some of Avery's most prestigious graduates include painter Edwin A. HARLESTON, who led Charleston's NAACP during the 1919 public school campaign; sociologist G. Franklin Edwards; and civil rights leader Septima Poinsette CLARK.

In 1978, a group of Avery alumni and supporters organized the Avery Institute of Afro-American History and Culture and purchased the Avery building to house the Center. In 1985, the Avery Research Center for African-American History and Culture became part of The College of Charleston.

REFERENCES

DRAGO, EDMUND, and EUGENE C. HUNT. *Initiative, Paternalism, and Race Relations: Charleston's Avery Normal Institute.* Athens, Ga., 1990.

RICHARDSON, JOE M. *Christian Reconstruction: The American Missionary Association and Southern Blacks, 1861–1890.* Athens, Ga., 1986.

JOCELYN BRYANT HARDEN

B

Bagnall, Robert Wellington, Jr. (October 14, 1883–August 20, 1943), priest and NAACP official. Born in Norfolk, Va., Robert Bagnall was the son of an Episcopal priest. Following the vocation of his father, the younger Bagnall attended Bishop Payne Divinity School in Petersburg, Va., an institution organized for the purpose of training African Americans for the Episcopal ministry. Bagnall graduated in 1903 and was ordained as an Episcopal priest the same year. In 1906, he married Lillian Anderson of Baltimore. Between 1903 and 1910, he led Episcopal congregations in Pennsylvania, Maryland, and Ohio, and ultimately became rector of St. Matthew's Church in Detroit, in 1911. Bagnall helped organize the Detroit branch of the NATIONAL ASSOCIATION FOR THE ADVANCEMENT OF COLORED PEOPLE (NAACP) and served as the principal speaker for its first session in 1914. Between 1914 and 1918 Bagnall successfully fought school segregation in Ypsilanti, Mich., campaigned against police maltreatment, and persuaded the Ford Motor Company in Dearborn, Mich., to hire more African-American workers. He was appointed NAACP district organizer for the Michigan area in 1918, and in the next two years he campaigned unsuccessfully for the passage of civil rights bills in Michigan and Ohio.

In 1921 Bagnall moved to New York City, where he succeeded James Weldon JOHNSON as national director of NAACP branches. In this capacity he traveled to NAACP branches nationwide to raise funds for the central organization; he also streamlined the branch system so that it contained fewer but stronger units. Throughout the 1920s Bagnall contributed articles to such periodicals as the *Crisis* and the *Messenger*. From 1923 to 1926 he worked to deport Pan-Africanist leader Marcus GARVEY. Bagnall attacked Garvey's UNIVERSAL NEGRO IMPROVEMENT ASSOCIATION as impractical, and denounced Garvey as a racial traitor for his association with the KU KLUX KLAN. In 1923, Bagnall cosponsored an open letter to Attorney General Harry Daugherty, urging Garvey's prosecution for mail fraud.

As the NAACP faced fiscal retrenchment in 1930, newly appointed national secretary Walter WHITE urged Bagnall's removal on the grounds that Bagnall was not raising sufficient revenue. Under increasing pressure from the NAACP board, Bagnall resigned in 1931. The following year he moved to Philadelphia and became pastor of St. Thomas's Episcopal Church, which he led until his death in 1943. He was remembered by associates in both the Episcopal church and in the NAACP particularly as an outstanding orator and community organizer.

REFERENCES

FINCH, MINNIE. *The NAACP: Its Fight for Justice.* Metuchen, N.J., 1981.

"R. W. Bagnall Dies." *Crisis* (September 1943): 286.

SHELTON, BERNICE DUTRIEUILLE. "Robert Wellington Bagnall." *Crisis* (November 1943): 334, 347.

THOMAS, RICHARD W. *Life for Us Is What We Make It: Building Black Community in Detroit, 1915–1945.* Bloomington, Ind., 1992.

SASHA THOMAS

Bailey, Bill (1912–December 17, 1978), entertainer. Born Willie Eugene Bailey in Washington, D.C., in 1912, Bill Bailey, like his younger and better-known sister, Pearl BAILEY, was drawn to entertainment at an early age. As a youngster, Bailey danced for pennies on Washington street corners, often joined by his minister father, who would pass the hat while his son performed. This humble beginning led to a successful professional career in tap dancing.

Bill "Bojangles" ROBINSON was Bailey's mentor and longtime friend, and Bailey was often favorably compared to Robinson. Throughout his thirty-year career, Bailey performed with such stars as Cab CALLOWAY, Count BASIE, Duke ELLINGTON, Billie HOLIDAY, and Miles DAVIS, as well as his sister. Bailey was plagued for the better part of his career by a recurring problem with drug addiction. He was forced to retire from entertaining in 1946.

Supported by his wife, Pernell, and by his four sons and seven daughters, Bailey resolved after his retirement to change his life. He studied religion and eventually opened his own church over a poolroom in Harlem. The congregation included performers from the nearby APOLLO THEATER. Bailey came out of retirement briefly in 1951 to appear at the Apollo with his long-time friend, Count Basie. He died in Philadelphia on December 17, 1978.

REFERENCE

Obituary. *New York Times,* December 18, 1978.

CHRISTINE A. LUNARDINI

Bailey, DeFord (December 14, 1899–July 2, 1982), country musician. Born near Carthage, Tenn., DeFord Bailey was exposed to music through family members who played the violin and banjo. Bailey, who suffered from polio, took up the harmonica at age three. He played in a style he called black hillbilly, which had strong affinities with both white country music and the BLUES. He also played the guitar, mandolin, banjo, and fiddle. After living near Franklin, Tenn., where his family had moved, Bailey moved to Nashville in 1918. He worked at various odd jobs and also sought work as a professional musician. When Nashville's first radio station, WDAD, started broadcasting in 1925, Bailey was invited to appear. The same year, Bailey was hired for regular performances on the WSM Barn Dance by George D. Hay, also known as Judge Hay. Bailey continued his performances when the WSM Barn Dance was renamed the Grand Ole Opry in 1927.

Bailey, the first African American to appear on the Grand Ole Opry, was one of the show's most popular performers in the 1920s. Known as "the Harmonica Wizard," Bailey was often allowed to perform for almost a half hour of the three-hour show and appeared more frequently than any other performer. In 1927–1928 Bailey made his only commercial recordings, including "Pan-American Blues," "Alcoholic Blues," "John Henry," and "Ice Water Blues."

Being the only African American in an all-white industry in the segregated South had its drawbacks. Although he was one of the few Opry performers to receive a regular salary, the five dollars per show he received was far below the percentage of ticket revenues that the rest of the performers received. He also encountered constant difficulties with hotels, restaurants, and bathrooms when the Opry traveled for performances in the South. Finally Bailey's short stature as the result of his childhood polio led some performers and audience members to treat him as something of a mascot for the Opry.

In the 1930s his popularity declined, and in 1941 he was removed from the Opry's roster. It is not clear whether, as Hay claimed, Bailey was fired because he refused to learn new songs. Bailey claimed he was fired for racial reasons. Bailey never made his living as a musician again and rarely performed publicly. He lived in relative obscurity in Nashville working as a boot black. He was honored by the Grand Ole Opry on his seventy-fifth birthday in 1974 and died in Nashville eight years later.

REFERENCES

JONES, JESSICA JANICE. "DeFord Bailey." *Black Music Research Newsletter* 4, no. 1 (Spring 1980): 3.
MORTON, DAVID C., and CHARLES K. WOLF. *DeFord Bailey—A Black Star in Early Country Music.* Knoxville, Tenn., 1991.

JONATHAN GILL

Bailey, Pearl (March 29, 1918–August 17, 1990), singer and actress. Popularly known as Pearlie Mae, Pearl Bailey was born in Newport News, Va., to Joseph James Bailey, a revivalist minister, and Ella Mae Bailey. At the age of four, she moved with her family to Washington, D.C., and after her parents divorced she moved to Philadelphia with her mother and her stepfather, Walter Robinson. There Bailey attended school until the age of fifteen, when she began her career as an entertainer after winning an amateur contest at the Pearl Theater. For a while she worked in coal-mining towns in Pennsylvania, then in small clubs in Washington, D.C. Beginning in 1941 she toured with the United Service Organiza-

tion (USO), and in 1943–1944 she performed with bands led by Charles "Cootie" WILLIAMS, William "Count" BASIE, and Noble SISSLE. It was during this period that she began to develop her distinctive trademark, described by one critic as "a warm, lusty singing voice accompanied by an easy smile and elegant gestures that charmed audiences and translated smoothly from the nightclub stage and Broadway to film and television." In the early forties she made solo appearances at the Village Vanguard and the Blue Angel, before making her Broadway debut in 1946 in the musical comedy *St. Louis Woman,* for which she won the Donaldson Award as the most promising new performer of the year. The following year she appeared in the motion picture *Variety Girl,* in which she sang one of her most popular songs, "Tired." Thereafter, she made numerous stage, screen, and television appearances, including the 1954 Broadway musical *House of Flowers* and such films as *Carmen Jones* (1954), *St. Louis Blues* (1958), and *Porgy and Bess* (1959). Her most acclaimed performance came in 1967, when she appeared with Cab Calloway in the all-black production of *Hello, Dolly!* This brought her a special Tony Award in 1968 for distinguished achievement in the New York theater.

In 1969, Bailey received the USO's Woman of the Year award. The following year President Richard Nixon appointed her "Ambassador of Love," and in 1975 she was appointed special representative to the United Nations. (Despite her popularity, Bailey's association with the Nixon administration was criticized by some African Americans; Harlem congressman Charles Rangel in particular stated that her appointment was an insult to better-qualified blacks.) During this period she returned to school, studying theology at Georgetown University in Washington, D.C., from which she received both an honorary degree in 1978 and a bachelor's degree in 1985, at the age of sixty-seven. An inveterate traveler, frequently accompanied by her husband, jazz drummer Louis Bellson (whom she married in 1952), Bailey also authored several books, including the autobiographical *The Raw Pearl* (1968) and *Talking to Myself* (1971). *Between You and Me: A Heartfelt Memoir on Learning, Loving, and Living* was published in 1989, shortly before she died of heart disease on August 17, 1990. Two years before her death, Bailey was presented with the Medal of Freedom by President Ronald Reagan.

REFERENCES

BOGLE, DONALD. *Blacks in American Film and Television.* New York, 1988.

SMITH, JESSIE CARNEY. *Notable Black American Women.* Detroit, 1992.

WILSON, JOHN. Obituary. *New York Times,* August 19, 1990.

KRISTA WHETSTONE

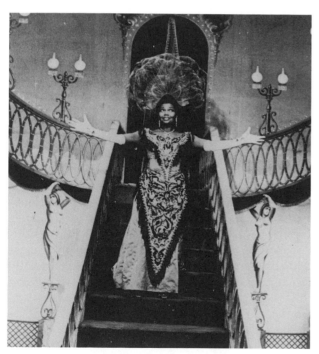

In 1967, in the all-black cast of *Hello, Dolly!* Pearl Bailey had the greatest of her many successes in Broadway musicals. Bailey's performance was acknowledged by a special Tony Award the following year. (AP/Wide World Photos)

Baker, Ella J. (December 13, 1903–December 13, 1986), activist. Ella J. Baker was a leading figure in the struggle of African Americans for equality. In the 1960s she was regarded as the godmother of the CIVIL RIGHTS MOVEMENT, or, as one activist put it, "a Shining Black Beacon." Though she was not accorded recognition by the media, Baker was affiliated with all the major civil rights organizations of her time, and she worked closely with all the better-known leaders of the movement.

Ella Baker was the daughter of a waiter on the Norfolk–Washington ferry, and was a grade-school teacher and the granddaughter of slaves. From the extended family of aunts, uncles, and cousins who lived on land her grandfather had purchased from owners of the plantation on which they had worked as slaves, Baker acquired a sense of community, a profound sense of the need for sharing, and a sense of history and of the continuity of struggle. She also gained a fierce sense of independence and a belief in the necessity of rebellion, which guided her work for the rest of her life.

After leaving Shaw University in Raleigh, N.C., from which she graduated as valedictorian, Baker immersed herself in the cause of social justice. She moved to New York, where she continued her education on the streets of the city, attending all kinds of political meetings to absorb the intellectual atmosphere. In the 1930s, while earning her living working in restaurants and as a correspondent for several black newspapers, Baker helped to found the Young Negroes Cooperative League, of which she became executive director. She worked for the WORKS PROJECT (originally Works Progress) ADMINISTRATION (WPA), teaching consumer and labor education. During the depression, Baker learned that, in her words, "a society could break down, a social order could break down, and the individual is the victim of the breakdown, rather than the cause of it."

In 1940, Baker accepted a position as field secretary at the NATIONAL ASSOCIATION FOR THE ADVANCEMENT OF COLORED PEOPLE (NAACP). She soon established regional leadership-training conferences with the slogan "Give light and the people will find a way." While a national officer, Baker traveled for several months a year throughout the country (concentrating on the segregated South), building NAACP membership and working with the local people who would become the sustaining forces of the civil rights movement. Her organizing strategy was to stress local issues rather than national ones and to take the NAACP to people, wherever they were. She ventured into beer gardens and nightclubs where she would address crowds and secure memberships and campaign workers. Baker was named director of branches in 1943, but, frustrated by the top-down approach of the NAACP leadership, resigned in 1946. In this period she married a former classmate, Thomas Roberts, and took on the responsibility of raising her sister's daughter, Jacqueline.

From 1946 to 1957, while working in New York City for the New York Cancer Society and the New York Urban League, Baker participated in campaigns to desegregate New York City schools. She was a founder of In Friendship, a group organized to support school desegregation in the South; a member of the zoning subcommittee of the New York City Board of Education's committee on integration; and president and later education director of the New York City branch of the NAACP.

In 1957 Bayard RUSTIN and Stanley Levison, advisers to the Rev. Dr. Martin Luther KING, Jr., asked her to return south to set up the office of the newly organized SOUTHERN CHRISTIAN LEADERSHIP CONFERENCE (SCLC), headed by King, and to organize the Crusade for Citizenship, a voter-registration drive. Intending to stay six weeks, she remained with the SCLC for two years, serving variously as acting director, associate director, and executive director.

In 1960 Baker mobilized SCLC support for a meeting to bring together the student sit-in protest groups that had sprung up across the South. A battle for control of the sit-in movement ensued. Older civil rights organizations, particularly the SCLC, sought to make the new movement a youth arm of their own operations. Baker, however, advocated an independent role for the student activists.

Baker resigned from the SCLC in 1960 to accept a part-time position as human-relations consultant to the YOUNG WOMEN'S CHRISTIAN ASSOCIATION (YWCA), working with colleges across the South to further integration. In 1963 she joined the staff of the Southern Conference Educational Fund (SCEF), a regionwide interracial organization that put special emphasis on developing white support for racial justice. While affiliated with the YWCA and SCEF, Baker devoted much of her time to the fledgling STUDENT NONVIOLENT COORDINATING COMMITTEE (SNCC), in which she found the embodiment of her belief in a "group-centered leadership, rather than a leadership-centered group."

SNCC was for Baker the "new community" she had sought. Her work was an inspiration for other activist movements of the 1960s and '70s: the anti–Vietnam War movement and the feminist movement. But Baker's greatest contribution was her counseling of SNCC. During one crisis she pointed out that both direct action and voter registration would lead to the same result—confrontation and resolution. Her support of confrontation was at variance with the Kennedy administration's policy, which advocated a "cooling-off" period. Baker also counseled the young mavericks of SNCC to work with the more conservative southern ministers, who, she advised, had resources that could help them.

In 1964, SNCC was instrumental in organizing the MISSISSIPPI FREEDOM DEMOCRATIC PARTY (MFDP), which sent its own delegation to Atlantic City to challenge the seating of the segregationist Mississippi delegation at the Democratic National Convention. Baker, in the new party's Washington headquarters and later in Atlantic City, orchestrated the MFDP's fight for the support of other state delegations in its claim to Mississippi's seats. This challenge eventually resulted in the adoption of new Democratic party rules that guaranteed the inclusion of blacks and women in future delegations.

After the convention, Baker moved back to New York, where she remained active in human-rights affairs. Throughout her life she had been a speaker at hundreds of Women's Day church meetings across the country, a participant in tenants' associations, a consultant to the wartime Office of Price Administration, an adviser to the Harlem Youth Council, a

founder and administrator of the Fund for Education and Legal Defense. In her later years she worked with such varied groups as the Puerto Rican Solidarity Committee, the Episcopal Church Center, and the Third World Women's Coordinating Committee.

While never professing a political ideology, Baker consistently held views far to the left of the established civil rights leadership. She was never a member of a political party, but she did run for the New York City Council on the Liberal party ticket in 1951. She acted within the constraints of a radical critique of society and was drawn toward "radical" rather than "safe" solutions to societal problems. Her credo was "a life that is important is a life of service."

REFERENCES

BRANCH, TAYLOR. *Parting the Waters*. New York, 1988.

CANTAROW, ELLEN. *Moving the Mountain*. New York, 1980.

FAIRCLOUGH, ADAM. *To Redeem the Soul of America*. Athens, Ga., 1987.

FORMAN, JAMES. *The Making of Black Revolutionaries*. New York, 1972.

GARROW, DAVID. *Bearing the Cross*. New York, 1986.

GRANT, JOANNE. "Mississippi Politics: A Day in the Life of Ella J. Baker." In *The Black Woman*. New York, 1970, pp. 56–62.

LERNER, GERDA. *Black Women in White America*. New York, 1972.

MORRIS, ALDON. *The Origins of the Civil Rights Movement*. New York, 1984.

JOANNE GRANT

Baker, George. *See* Father Divine.

Baker, Josephine (June 6, 1906–April 14, 1975), entertainer. Josephine Baker was born in St. Louis, Mo., the daughter of Carrie McDonald, an unmarried domestic worker, and Eddie Carson, a jazz drummer. At age eight she was working as a domestic. At age eleven she survived the East St. Louis race riots in which thirty-nine blacks were killed. Before she was fourteen, Baker had run away from a sadistic employer, and married and discarded a husband, Willie Wells. "I was cold, and I danced to keep warm, that's my childhood," she said. After entertaining locally, she joined a traveling show called the Dixie Steppers, where she developed as a dancer and mime.

In 1920 she married a jockey named Willie Baker, but quickly left him to try out for the new black musical, Noble SISSLE and composer Eubie BLAKE's path-breaking *Shuffle Along*. She was turned down as too young, too thin, and too dark. At sixteen she was hired as end girl in a *Shuffle Along* road show chorus line, where she captivated audiences with her mugging. Sissle and Blake wrote her into their next show, *Chocolate Dandies* (1924), and the next year, Caroline Dudley invited her to join a troupe of "authentic" Negro performers she was taking to Paris in *La Revue Nègre*.

Baker was an overnight sensation and became the rage of Paris, a phenomenon whose style and presence outweighed her talents, and a black exotic jungle Venus. Everyone danced her version of the Charleston and Black Bottom. Women copied her hairdo. Couturiers saw a new ideal in her body. She took a series of lovers, including Paul Colin, who immortalized her on posters, and Georges Simenon, who worked as her secretary. In 1927 "La Bakair" opened at the *Folies Bergère* in her famous costume of a few rhinestoned bananas.

That same year she met the café-society habitué "Count" Pepito de Abatino (actually a Sicilian stonemason). He became her lover and manager, taught her how to dress and act, trained her voice and body, and sculpted a highly sophisticated and marketable star. They toured Europe and South America. In Vienna, Baker was preached against for being the "impure incarnation of sex." She provoked hostility fueled by economic frustration, moral indignation, xenophobia, and racism.

When she returned to France, Abatino had done what he had promised: turned the diamond-in-the-rough of 1925 into the polished gem of 1930. There followed a ten-year reign of Baker in the music halls of Paris. Henri Varna of the Casino de Paris added to her image a baby leopard in a $20,000 diamond necklace and the song which would become her signature "J'ai deux amours, mon pays et Paris." Her name was linked with several Frenchmen, including singer Jacques Pills, and in 1934 she made her best motion picture, *Zouzou*, costarring Jean Gabin, followed by *Princess Tam Tam* in 1935.

Baker returned to New York to play in the 1936 *Ziegfield Follies*, but the show was a fiasco. She learned America would neither welcome her nor look on her with color-blind eyes as France did. Abatino died of cancer before she returned to Paris. Baker married Jean Lion, a wealthy sugar broker, in 1937, and divorced him fourteen months later. By 1939, Baker had become a French citizen. When the Nazis occupied France during World War II, Baker joined the Resistance, recruited by the head of French intelligence. For her activities in counterintelligence, Baker received the Croix de Guerre and the Légion d'Honneur. After operating between Marseilles and Lisbon under cover of a revival of her operetta *La*

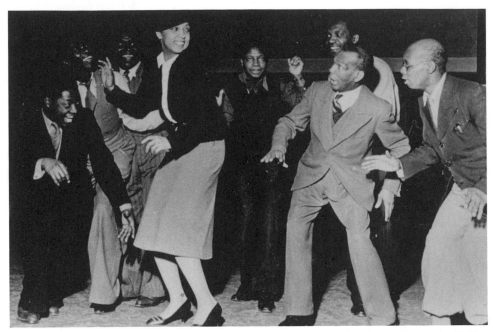

Though a popular performer in black musicals in New York City in the early 1920s, Josephine Baker had her greatest acclaim in Paris, where she achieved legendary success as a dancer after her Paris debut in 1925. (© Lidoff/Rapho/Black Star)

Creole, she was sent to Casablanca in January of 1940 to continue intelligence activities.

In 1941 Baker delivered a stillborn child, the father unknown. Complications from this birth endangered her life for more than nineteen months, and at one point her obituary was published. She recovered and spent the last years of the war driving an ambulance and entertaining Allied troops in North Africa. After the war, she married orchestra leader Jo Bouillon and adopted four children of different races that she called her "Rainbow Tribe." She turned her château, Les Milandes, into her idea of a multiracial community. In 1951, she attracted wide attention in the United States, and was honored by the NAACP, which organized a Josephine Baker Day in Harlem.

She continued to be an outspoken civil rights advocate, refusing to perform before segregated audiences in Las Vegas and Miami, and instigating a notorious *cause célèbre* by accusing the Stork Club of New York of discrimination. Her controversial image hurt her career, and the U.S. State Department hinted they might cancel her visa. Baker continued to tour outside America as her Rainbow Tribe grew to twelve. Between 1953 and 1963, she spent more than $1.5 million on Les Milandes, her financial affairs degenerated into chaos, her fees diminished, and she and Bouillon separated.

In 1963, Baker appeared at the March on Washington, and after performing in Denmark, had her first heart attack. In the spring of 1969, she declared bankruptcy and Les Milandes was seized. Baker accepted a villa in Monaco from Princess Grace, began a long series of farewell performances, and begged in the streets when she couldn't work. In 1975, she summoned all her resources and professionalism for a last farewell performance at the Olympia Theatre in Paris. Baker died two days into her performance run on April 14. Her televised state funeral at the Madeleine Church drew thousands of people and included a twenty-one-gun salute.

REFERENCES

CHASE-RIBOUD, BARBARA. "Josephine Baker: Beyond Sequins." *Essence* (February 1975).
HAMMOND, BRYAN. *Josephine Baker.* London, 1988.
HANEY, LYNN. *Naked at the Feast.* New York, 1981.

BARBARA CHASE-RIBOUD

Baldwin, James (August 2, 1924–November 30, 1987), author and civil rights activist. Born in New York City's Harlem in 1924, James Baldwin, who started out as a writer during the late 1940s rose to international fame after the publication of his most famous essay, *The Fire Next Time,* in 1963. However, nearly two decades before its publication, he had already captured the attention of an assortment of writers, literary critics, and intellectuals in the United States and abroad. Writing to Langston HUGHES in 1948, Arna BONTEMPS commented on Baldwin's "The Harlem Ghetto," which was pub-

lished in the February 1948 issue of *Commentary* magazine. Referring to "that remarkable piece by that 24-year-old colored kid," Bontemps wrote, "What a kid! He has zoomed high among our writers with his first effort." Thus, from the beginning of his professional career, Baldwin was highly regarded and began publishing in magazines and journals such as the *Nation,* the *New Leader, Commentary,* and *Partisan Review.*

Much of Baldwin's writing, both fiction and nonfiction, has been autobiographical. The story of John Grimes, the traumatized son of a tyrannical, fundamentalist father in *Go Tell It on the Mountain,* closely resembles Baldwin's own childhood. His celebrated essay "Notes of a Native Son" describes the writer's painful relationship with his stepfather. Born out of wedlock before his mother met and married David Baldwin, young Jimmy never fully gained his stern patriarch's approval. Raised in a strict Pentecostal household, Jimmy became a preacher at age fourteen, and his sermons drew larger crowds than his father's. When Jimmy left the church three years later, the tension with his father was exacerbated, and, as "Notes of a Native Son" reveals, even the impending death of David Baldwin in 1943 did not reconcile their mutual disaffection. In various forms, the problems of father-son conflict, with all of its Old Testament connotations, became a central preoccupation of Baldwin's writing.

Baldwin's career, which can be divided into two phases—up to *The Fire Next Time* (1963) and after—gained momentum after the publication of what were

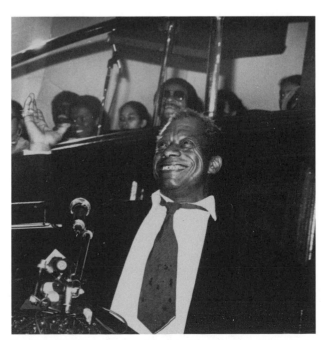

James Baldwin at the Abyssinian Baptist Church in Harlem, N.Y. (© Coreen Simpson)

to become two of his more controversial essays. In 1948 and 1949, respectively, he wrote "Everybody's Protest Novel" and "Many Thousands Gone," which were published in *Partisan Review.* These two essays served as a forum from which he made pronouncements about the limitations of the protest tradition in American literature. He scathingly criticized Harriet Beecher Stowe's UNCLE TOM'S CABIN and Richard WRIGHT'S *Native Son* for being firmly rooted in the protest tradition. Each writer failed, in Baldwin's judgment, because the "power of revelation . . . is the business of the novelist, that journey toward a more vast reality which must take precedence over all other claims." He abhorred the idea of the writer as a kind of "congressman," embracing Jamesian ideas about the art of fiction. The writer, as Baldwin envisioned himself during this early period, should self-consciously seek a distance between himself and his subject.

Baldwin's criticisms of *Native Son* and the protest novel tradition precipitated a rift with his mentor, Richard Wright. Ironically, Wright had supported Baldwin's candidacy for the Rosenwald Fellowship in 1948, which allowed Baldwin to move to Paris, where he completed his first novel, *Go Tell It on the Mountain* (1953). Baldwin explored his conflicted relationship with Wright in a series of moving essays, including "Alas, Poor Richard," published in *Nobody Knows My Name.*

Baldwin left Harlem for Paris when he was twenty-four. Although he spoke little French at the time, he purchased a one-way ticket and later achieved success and fame as an expatriate. Writing about race and sexuality (including homosexuality), he published twenty-two books, among them six novels, a collection of short stories, two plays, several collections of essays, a children's book, a movie scenario, and *Jimmy's Blues* (1985), a chapbook of poems. Starting with his controversial *Another Country* (1962), many of his books, including *The Fire Next Time* (1963), *If Beale Street Could Talk* (1974), and *Just Above My Head* (1979), were best-sellers. His play *Blues for Mr. Charlie* (1964) was produced on Broadway. And his scenario *One Day When I Was Lost: A Scenario Based on Alex Haley's "The Autobiography of Malcolm X"* was used by the movie director Spike LEE in the production of his feature film on MALCOLM X.

Baldwin credits Bessie SMITH as the source of inspiration for the completion of his first novel *Go Tell It on the Mountain* (1953). In "The Discovery of What It Means to Be an American," he writes about his experience of living and writing in Switzerland: "There, in that alabaster landscape, armed with two Bessie Smith records and a typewriter, I began to re-create the life that I had first known as a child and

from which I had spent so many years in flight . . . Bessie Smith, through her tone and cadence . . . helped me dig back to the way I myself must have spoken when I was a pickaninny, and to remember the things I had heard and seen and felt. I had buried them very deep."

Go Tell It on the Mountain recaptures in some definitive ways the spirit and circumstances of Baldwin's own boyhood and adolescence. John Grimes, the shy and intelligent protagonist of the novel, is remarkably reminiscent of Baldwin. Moreover, Baldwin succeeds at creating a web of relationships that reveals how a particular character has arrived at his or her situation. He had, after all, harshly criticized Stowe and Wright for what he considered their rather stereotypical depiction of characters and their circumstances. His belief that "revelation" was the novelist's ultimate goal persisted throughout his career. In his second and third novels—Giovanni's Room (1956) and Another Country (1962)—he explores the theme of a varying, if consistent, American search for identity.

In Giovanni's Room the theme is complicated by international and sexual dimensions. The main character is forced to learn a harsh lesson about another culture and country as he wrestles with his ambivalent sexuality. Similarly, in Another Country Baldwin sensationally calls into question many American taboos about race, sexuality, marriage, and infidelity. By presenting a stunning series of relationships—heterosexual, homosexual, interracial, bisexual—he creates a tableau vivant of American mores. In his remaining novels, Tell Me How Long the Train's Been Gone (1968), If Beale Street Could Talk (1974), and Just Above My Head (1979), he also focuses on issues related to race and sexuality. Furthermore, he tries to reveal how racism and sexism are inextricably linked to deep-seated American assumptions. In Baldwin's view, race and sex are hopelessly entangled in America's collective psyche.

Around the time of The Fire Next Time's publication and after the Broadway production of Blues for Mr. Charlie, Baldwin became known as a spokesperson for civil rights and a celebrity noted for championing the cause of black Americans. He was a prominent participant in the March on Washington at which the Rev. Dr. Martin Luther KING, Jr., gave his famous "I Have a Dream" speech. He frequently appeared on television and delivered speeches on college campuses. Baldwin actually published two excellent collections of essays—Notes of a Native Son (1955) and Nobody Knows My Name (1961)—before The Fire Next Time. In fact, various critics and reviewers already considered him in a class of his own. However, it was his exhortative rhetoric in the latter essay, published on the one hundredth anniversary of

the Emancipation Proclamation, an essay that anticipated the urban riots of the 1960s, which landed him on the cover of Time magazine. He concluded: "If we—and now I mean the relatively conscious whites and the relatively conscious blacks who must, like lovers, insist on or create the consciousness of the others—do not falter in our duty now, we may be able . . . to end the racial nightmare, and achieve our country, and change the history of the world."

After the publication of The Fire Next Time, several black nationalists criticized Baldwin for his conciliatory attitude. They questioned whether his message of love and understanding would do much to change race relations in America. Eldridge CLEAVER, in his book Soul on Ice, was one of Baldwin's more outspoken critics. But Baldwin continued writing, becoming increasingly more dependent on his early life as a source of inspiration, accepting eagerly the role of the writer as "poet" whose "assignment" was to accept the "energy" of the folk and transform it into art. It is as though he was following the wisdom of his own words in his story "Sonny's Blues." Like Sonny and his band, Baldwin saw clearly as he matured that he was telling a tale based on the blues of his own life as a writer and a man in America and abroad: "Creole began to tell us what the blues were all about. They were not about anything very new. He and his boys up there were keeping it new at the risk of ruin, destruction, madness, and death, in order to find new ways to make us listen. For, while the tale of how we suffer, and how we are delighted, and how we may triumph is never new, it always must be heard. There isn't any other tale to tell, it's the only light we've got in all this darkness."

Several of his essays and interviews of the 1980s discuss homosexuality and homophobia with fervor and forthrightness, most notably "Here Be Dragons." Thus, just as he had been the leading literary voice of the civil rights movement, he became an inspirational figure for the emerging gay rights movement. Baldwin's nonfiction was collected in The Price of the Ticket (1985).

During the final decade of his life, Baldwin taught at a number of American colleges and universities—including the University of Massachusetts at Amherst and Hampshire College—frequently commuting back and forth between the United States and his home in St. Paul de Vence in the south of France. After his death in France on November 30, 1987, the New York Times reported on its front page for the following day: "James Baldwin, Eloquent Essayist in Behalf of Civil Rights, Is Dead."

REFERENCES

CAMPBELL, JAMES. Talking at the Gates: A Life of James Baldwin. New York, 1991.

LEEMING, DAVID. *James Baldwin: A Biography*. New York, 1994.
PORTER, HORACE. *Stealing the Fire: The Art of Protest and James Baldwin*. Middletown, Conn., 1989.

HORACE PORTER

REFERENCE

PORTER, DOROTHY B. "Maria Baldwin." *Journal of Negro History* (Winter 1952): 94–96.

GREG ROBINSON

Baldwin, Maria Louise (September 13, 1856–January 9, 1922), teacher, activist. Maria Baldwin was born in Cambridge, Mass., the daughter of a Haitian immigrant who worked as a letter carrier. She was educated in the Cambridge public schools, and in 1875 graduated from the Cambridge training school for teachers. After a brief teaching assignment in Chestertown, Md., Baldwin returned to Cambridge.

In 1881 Baldwin was hired as a teacher at the Agassiz Grammar School, a predominantly white public school near Harvard University. She remained there until her death. Baldwin was such an impressive teacher (Harvard University President Charles W. Eliot later referred to her as the first teacher in New England) that in 1889 she was appointed the principal of the Agassiz School. She was one of the first African-American women to head a mostly white school. During the next several years she expanded her educational activities. She taught summer teachers' courses at HAMPTON INSTITUTE and at the Institute for Colored Youth in Cheyney, Pa. She attended classes at Harvard University and other colleges, and held reading classes for black Harvard students in her home.

Baldwin was also active as a lecturer and clubwoman. At the turn of the century she made several tours of the country, lecturing on women's suffrage, black poetry, and other subjects. In 1897 she became the first black woman invited to give the annual Washington's Birthday address before the Brooklyn Institute of Arts and Sciences. Baldwin was heavily involved with the Women's Era Club and countless other organizations, and served a term as Secretary of the Boston Banneker Club. Baldwin's house became an important salon for Boston's black intelligentsia.

In 1916 the Agassiz School moved into a new building and expanded its enrollment to include the higher grades. Baldwin's position was raised to master of the school, with authority over twelve teachers and five hundred students. In January 1922, while she was speaking at a fund-raising function to benefit the Robert Gould Shaw House, a Boston settlement house, Baldwin had a heart attack, collapsed, and died. She is memorialized by the Maria Baldwin Auditorium at the Agassiz School and by Maria Baldwin Hall at HOWARD UNIVERSITY in Washington, D.C.

Ball, James Presley (1825–1905), photographer. J. P. Ball was free-born in Virginia. In 1845 he became interested in photography after meeting John B. Bailey, a black daguerreotypist, in White Sulphur Springs, Va. That year, Ball opened a daguerreotype studio in Cincinnati. After three months, he closed the unsuccessful studio and in 1846 settled in Richmond, Va. Ball worked in a hotel in Richmond and saved money to rent a furnished room, where he made portraits of local residents from all economic classes, both black and white, enslaved and free.

Ball returned to Ohio in 1847 and worked as an itinerant photographer until 1849, when he opened the first of his several studios in Cincinnati. Ball became active in Cincinnati's abolitionist movement, and in 1855 he created his most famous work, the 2,400-square-foot antislavery photo panorama and accompanying pamphlet known as *Ball's Splendid Mammoth Pictorial Tour of the United States Comprising Views of the African Slave Trade; of Northern and Southern Cities; of Cotton and Sugar Plantations; of the Mississippi, Ohio and Susquehanna Rivers, Niagara Falls, & C.* With the help of landscape painter Robert S. DUNCANSON, who served as a daguerreotypist, Ball charted the slave experience through images of life in Africa, the horrors of the middle passage, and daily routines in America. The panorama included portraits, cityscapes, and significant events in the history of American slavery, and it was seen by thousands of viewers at Ball's studio and in an 1855 exhibit at Boston's Armory Hall.

In 1860 the Ball & Thomas Photographic Art Gallery, which Ball owned in Cincinnati with his brother-in-law Alexander Thomas, was destroyed in a hurricane and rebuilt with the help of local white families. Ball & Thomas was a popular studio, earning $100 a day, and it attracted such renowned sitters as Frederick DOUGLASS, Henry H. GARNET, Jenny Lind, and Ulysses S. Grant.

Ball worked steadily as a photographer in Cincinnati from the late 1860s into the 1900s, when he relocated to Minneapolis. In September, 1887, he became the official photographer of the twenty-fifth anniversary celebration of the EMANCIPATION PROCLAMATION. The following month Ball moved to Helena, Mont., where his son was an editor of a local newspaper, the *Colored Citizen*. In Helena, Ball owned a studio with his son and he photographed the construction of the Montana state capital, newly ar-

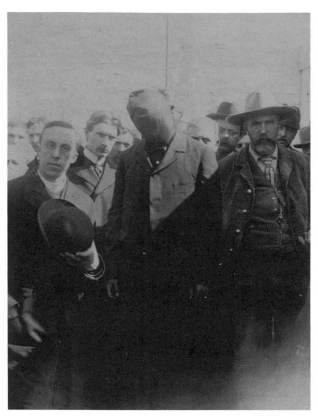

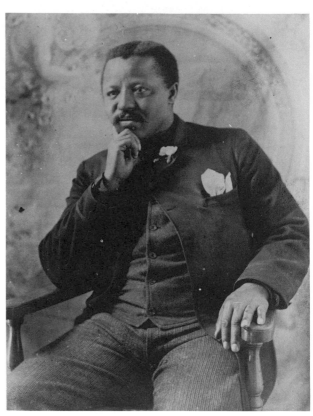

As part of the documentation concerning the murder case against William Biggerstaff, J. P. Ball was commissioned to photograph Biggerstaff prior to and at his public hanging. The Rev. Victor Day and Sheriff J. Henry Jurgens stand with the hanged man, Helena, Mont., 1896. (Montana Historical Society, Helena)

rived immigrants, civic and emancipation day celebrations, individuals in the town's small African-American community, and local public hangings. Ball also began a political career in Helena, serving as a local delegate to a civil rights convention in 1887 and a delegate to the REPUBLICAN PARTY convention in 1894, and in the same year became president of the state's Afro-American Club.

Ball moved to Seattle around 1900 and opened Globe Photo Studios, which he maintained until 1904. After a struggle with rheumatism, which inspired him to seek a warmer climate, Ball moved to Hawaii in 1904, where he lived until his death the following year.

REFERENCE

WILLIS, DEBORAH, ed. *J. P. Ball, Daguerrean and Studio Photographer.* New York, 1993.

DEBORAH WILLIS-THOMAS

Ballet. The African-American presence in classical ballet, triumphantly confirmed by the founding of the DANCE THEATER OF HARLEM in 1969, grew

slowly alongside general American interest in the European form of theatrical stage dancing. Classical ballet developed from dancing styles of sixteenth-century European courts. Refined in France, especially under the monarchy of Louis XIV, ballet became the preferred form of dance expression in Europe and Russia by the nineteenth century. Ballet captured the interest of an American public only after tours of Daighilev's Ballets Russes proved undeniably entertaining in the early part of the twentieth century. The assumption that the European outlook, history, and technical theory of ballet were alien to the black dancer culturally, temperamentally, and anatomically plagued African-American interest in the form for generations. Dance aesthetes wrote about the unsuitability of the black dancer's "tight joints, a natural turn-in rather than the desired ballet turn-out, hyperextension of the knee, [and] weak feet," and most black dancers, barred from all-white ballet schools, turned to performing careers in modern and jazz dance. Ballet training, however, remained the basis of many stage-dance techniques, and individual teachers had profound effects on pioneer African-American dance artists. In Chicago in the 1920s, Katherine DUNHAM studied ballet with Ludmilla Speranzeva before creating her own Dunham dance

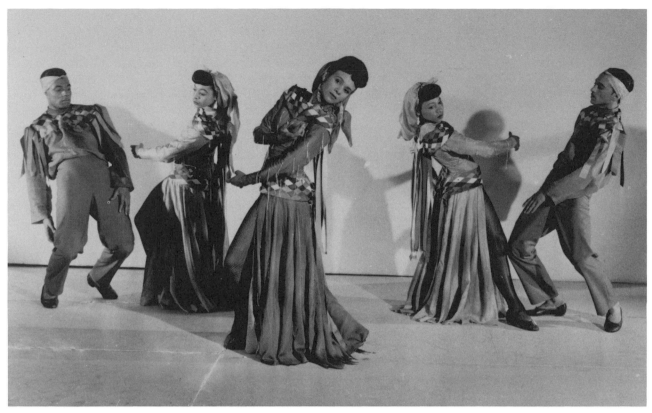

Katherine Dunham performing with the Stormy Weather dancers. (UPI/Bettmann)

technique. The Jones-Haywood School of Dance, founded in Washington, D.C., in 1940, trained several significant ballet personalities, including Sylvester Campbell and Louis JOHNSON. Philadelphia's Judimar School, created in 1948, offered ballet classes led by Essie Marie Dorsey and produced several outstanding ballet artists, including Delores Brown, Tamara Guillebeaux, John Jones, and Billy Wilson.

The racial division of Americans led to the formation of several separatist, "all-black" dance companies to offer performing opportunities for growing numbers of classically trained dancers. Hemsley Winfield's New Negro Art Theater Dance Group brought concert dance to the New York Roxy Theater in 1932, effectively proving that black dancers would be accepted by largely white audiences. John Martin of the *New York Times* noted the dancers' refusal to be "darkskinned reproductions of famous white prototypes" and termed the concert "an effort well worth the making." Winfield's company performed with the Hall Johnson Choir in dances of his own making.

Eugene Von Grona's American Negro Ballet debuted on November 21, 1937, at Harlem's Lafayette Theater. The son of a white American mother and a German father, Von Grona trained with modern dance choreographer Mary Wigman before moving to the United States in 1925. To form his company,

he ran a newspaper advertisement in the AMSTERDAM NEWS offering free dance lessons at the Harlem YMCA. Von Grona chose thirty trainees out of 150 respondents, and after three years of training in ballet and modern dance relaxation techniques, the company offered a program designed to address "the deeper and more intellectual resources of the Negro race." The original program, choreographed by Von Grona to ELLINGTON, Stravinsky, W. C. HANDY, and J. S. Bach, was received by critics as "more of the nature of a pupil's recital than an epoch-making new ballet organization." The program included a version of Stravinsky's *Firebird,* though critics worried that "a Negro interpretation of a classical ballet would . . . be too unrestrained" to appeal to a ballet audience. Lukewarm critical reception and the absence of a committed audience shuttered the company's concert engagements after only five months. In 1939 the company appeared in Lew Leslie's *Blackbirds* and at the APOLLO THEATER, and was renamed Von Grona's American Swing Ballet. By the end of that year Von Grona was bankrupt and disbanded the company. Dancers in the company included Lavinia WILLIAMS, Jon Edwards, and Al Bledger.

Wilson Williams's Negro Dance Company, founded in 1940 to "discipline talent, give it creative direction, [and] to train artists capable of expression through means of a technique," struggled for five

years to garner dancers and patronage. Williams, an accomplished black modern dancer, intended to provide a three-year course at his School of Negro Ballet, with classes in folk forms as well as modern and classical ballet. The Negro Dance Company's first performances in 1943 were received as modern dance.

The First Negro Classic Ballet, also briefly known as the Hollywood Negro Ballet, was founded in 1948 by Joseph Rickhard. Rickhard, a German émigré and former dancer with the Ballets Russes, taught ballet to black students in Los Angeles. The company had a first concert in 1949. This was truly a classical company, with ballerinas performing on point. They performed *Variations Classiques,* a suite of dances to Bach, as well as a reworking of *Cinderella* with African-American materials. Critically successful, the company lasted seven seasons touring the West coast, with an annual performance at Los Angeles' Philharmonic Auditorium. In 1956 Rickhard brought his dancers to New York, and this company combined with the New York Negro Ballet.

Aubrey Hitchens's Negro Dance Theater, created in 1953, was an all-male repertory company. Hitchens was born in England and had danced with the Russian Opera Company in Paris before he opened his own New York school in 1947. Hitchens, who "ardently believed in the special dance talents of the Negro race," managed to book his group to perform at Jacob's Pillow Dance Festival in August 1954. Its repertory included *Gotham Suite* by Tony Charmoli, with "modern idioms based on classical forms being suggested by the five boroughs of New York City," and Hitchens's own *Italian Concerto* to music of Bach. Among the dancers associated with the Negro Dance Theater were Anthony Basse, Frank Glass, Nat Horne, Bernard Johnson, Charles Martin, Charles MOORE, Joe Nash, Charles Queenan, Edward Walrond, and Arthur Wright. The company remained together only through 1955.

Edward Flemyng's New York Negro Ballet Company, founded as Les Ballets Nègres in 1955, began as a small group that took daily technique classes with Maria Nevelska, a former member of the Bolshoi Ballet. Flemyng, a charismatic and driven African-American dancer born in Detroit, organized private sponsorship of the company, which led to a landmark in 1957 tour of England, Scotland, and Wales. Among the dancers on that tour were Anthony Basse, Dolores Brown, Candace Caldwell, Sylvester Campbell, Georgia Collins, Theodore Crum, Roland Fraser, Thelma HILL, Michaelyn Jackson, Frances Jiminez, Bernard Johnson, Charles Neal, Cleo Quitman, Gene Sagan, Helen Taitt, Betty Ann Thompson, and Barbara Wright. The company's repertory included Ernest Parham's *Mardi Gras;* two Louis Johnson ballets—*Waltze,* a classical ballet for twelve dancers, and *Folk Impressions,* an American ballet set to music by Morton Gould; and a purely classical *pas de deux* from *Sleeping Beauty* danced by Dolores Brown and Bernard Johnson. Reviews of the company were flattering and encouraging, and the London-based *Dance and Dancers* wrote: ". . . New York Negro ballet amounts to a sincere attempt at establishing the Negro as an important contributor to the art of ballet as a whole." Soon after the two month tour, Flemyng's principal patron died and the company began to unravel. A 1958 performance in New York under the name Ballet Americana was noted by writer Doris Hering as having a "zest and high energy . . . yet to be cast in the careful mould of ballet," but the company could not find sufficient patronage and was completely disbanded by 1960.

Dances and Dancers

Documentation of African-American interest in the ballet exists well before the establishment of any of the all-black companies. Helena Justa-De Arms performed toe dances in vaudeville in the 1910s; Mary Richards danced on toe in the 1923 Broadway production of *Struttin' Along;* and Josephine BAKER performed on toe for at least one number in her Paris Opera days. In 1940 Agnes De Mille created *Black Ritual* for the New York Ballet Theater, the precursor of the present-day American Ballet Theatre. Performed by a cast of sixteen women to a score by Darius Milhaud, the piece was intended to "project the psychological atmosphere of a primitive community during the performance of austere and vital ceremonies." Though this was not a classically shaped ballet, its cast had received dance training in a specially established "Negro Wing" of the Ballet Theater school. Critical reaction to the piece was muted but inspired dance writer Walter Terry's call for "a Negro vocabulary of movement . . . composed of modern dance movements, ballet steps, tap and others . . . [which] should enable the Negro to express himself artistically and not merely display his muscular prowess."

The post–WORLD WAR II era brought the beginnings of integrated classical dance in the United States. Talley BEATTY, Arthur Bell, and Betty Nichols were briefly associated with New York's Ballet Society, where Beatty appeared in Lew Christiansen's *Blackface* (1947) and Bell in Frederick Ashton's *Illuminations* (1950). In 1952 Louis Johnson, a student of the School of American Ballet (SAB), created a role in Jerome Robbins's *Ballade* for the New York City Ballet. Johnson began his significant choreographic career with *Lament* (1953), a story ballet set to music of Heitor Villa-Lobos and first presented

with an integrated cast at the third New York Ballet Club Annual Choreographers' Night.

Janet Collins, the most famous African-American classical dancer of this era, began her career in vaudeville and was a member of the original Katherine Dunham troupe. Born in New Orleans and raised in Los Angeles, Collins danced with Lester Horton before moving to New York in 1948, where she won a prestigious Rosenwald Fellowship to tour the East and Midwest in her own dances. Her 1949 New York performance debut was greeted with exceptional enthusiasm by John Martin of the *New York Times,* who called her a "rich talent and a striking theatrical personality at the beginning of a promising career. Her style is basically eclectic; its direction is modern and its technical foundation chiefly ballet. The fusing element is a markedly personal approach. . . ." Collins won a Donaldson Award for her Broadway performance in Cole Porter's *Out of This World* (1951). According to the *Daily Compass,* "Janet Collins dances with something of the speed of light, seeming to touch the floor only occasionally with affectionate feet. . . ." Collins achieved her greatest fame as prima ballerina at the Metropolitan Opera from 1951 to 1954, where she danced in *Aida* (1951), *La Gioconda* (1952), and *Samson and Delilah* (1953).

Many African-American ballet artists found an acceptance in Europe unknown in the United States. Sylvester Campbell remained in Europe after the New York Negro Ballet tour and eventually became a principal with the Netherlands National Ballet, dancing leading roles in *Swan Lake, Romeo and Juliet,* and *Le Corsaire.* Gene Sagan and Roland Fraser, also of the New York Negro Ballet, joined the Marseilles Ballet and the Cologne Ballet, respectively. Brooklyn-born Jamie Bower danced with Roland Petit's Ballets de Paris and appeared with the company in the MGM film *The Glass Slipper* (1953). In 1954 Raven Wilkenson was admitted to the Ballets Russes de Monte Carlo as that company's sole black female ballerina. Wilkenson stayed with the company for six years, though she was occasionally barred from performing in some southern theaters because of her race. Arthur MITCHELL, who joined the New York City Ballet as its first permanent black dancer in 1955, experienced similar racial discrimination when U.S. television broadcasters refused to air programs in which he danced with white ballerinas.

The affiliation of African-American dancers with mostly white companies accelerated throughout the 1960s. The Harkness Ballet of New York ran an aggressive recruitment and educational program in consultation with New York Negro Ballet alumna Thelma Hill that, by 1968, had successfully placed five black members in that company. Choreographer Alvin AILEY, who created *Feast of Ashes* for the Joffrey Ballet in 1962, also made *Ariadne* (1965), *El Amor Brujo* (1966), and *Macumba* (1966) for the Harkness Ballet. Keith Lee joined the American Ballet Theatre in 1969, and in 1970 he created the popular ballet *Times Past* to music by Cole Porter. Lee achieved the rank of soloist in 1971 and left in 1974 to form his own company. Significant post–civil rights era dancers affiliated with major American ballet companies include John Jones, who danced with Jerome Robbins's, Ballets: U.S.A., the Dance Theater of Harlem, the Joffrey Ballet, and the Harkness Ballet; Christian Holder of the Joffrey Ballet; Debra Austin of the New York City Ballet and the Pennsylvania Ballet; and Mel TOMLINSON of the Dance Theater of Harlem and the New York City Ballet.

The Dance Theater of Harlem Legacy

The founding of the Dance Theater of Harlem (DTH) in 1969 conclusively ended speculation about the suitability of African-American interest in ballet. Arthur Mitchell's company and its affiliated school provided training and performing opportunity for black dancers and choreographers from all parts of the world. Heralded as a major company of international stature within its first fifteen years, the DTH fostered an unsurpassed standard of black classicism revealed in the versatile technique of principal dancers Stephanie Dabney, Lorraine Graves, Christina Johnson, Virginia JOHNSON, Ronald Perry, Judith Rotardier, Eddie J. Shellman, Lowell Smith, and Donald Williams.

As DTH performances set a standard of black classicism, discernible African-American influences on ballet began to be understood and documented. Choreographer George Balanchine, who served on the original DTH board of directors, succesfully articulated a neoclassical style of ballet that emphasized thrust hips and rhythmic syncopations commonly found in African-American social dance styles. Prominent in his masterpieces *The Four Temperaments* (1946) and the "Rubies" section of *Jewels* (1967) are references to the Charleston, the cakewalk, the lindy hop, and tap dancing.

The critical success of the DTH hinged upon its dancers' ability to embody these social movement styles within classical technique. The company excelled in its resilient performances of the Balanchine repertory. It also turned to African-American folk materials that underscored affinities between ballet and ritual dance, as in Louis Johnson's *Forces of Rhythm* (1972), which comically juxtaposed several styles, including generic "African" dance, vaudeville, Dunham-based modern, disco, and ballet; Geoffrey HOLDER's *Dougla* (1974), a stylized wedding ceremony synthesis of African and Hindu motifs; and

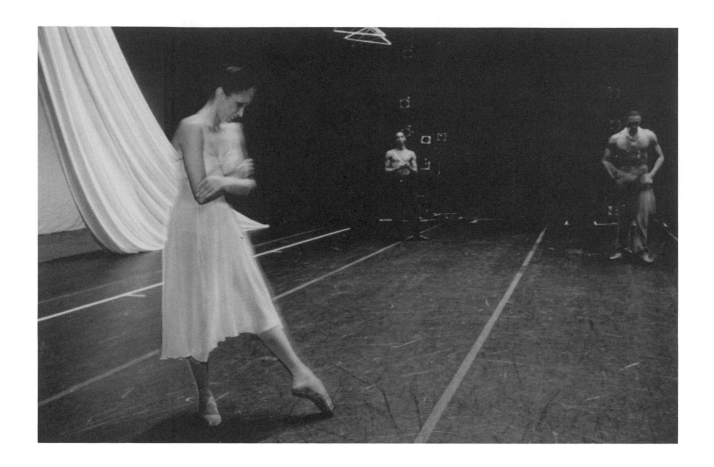

(Top) Virginia Johnson, principal dancer with the Dance Theater of Harlem. (Bottom) Students of the Dance Theater of Harlem. (Allford/Trotman Associates)

Billy Wilson's *Ginastera* (1991), a combination of Spanish postures and point dancing.

Black musicians inspired several important ballet collaborations, including Alvin Ailey and Duke Ellington's *The River* (1970), which was choreographed for the American Ballet Theatre and included both parody and distillation of social African dance styles in several sections; Wynton MARSALIS and Peter Martins's *Jazz* (*Six Syncopated Movements*) (1993), created for the New York City Ballet and featuring African-American dance soloist Albert Evans; and the Joffrey Ballet production of *Billboards,* set to music by PRINCE (1993). Other choreographers who have worked in the classical idiom include Paul Russell, once a leading dancer with the DTH, who became artistic director of the American Festival Ballet of Boise, Idaho, in 1988; former DTH principal Homer Bryant, who formed the Chicago-based Bryant Ballet in 1991; Barbados-born John Alleyne, who

Bill T. Jones, cofounder and artistic director of the Bill T. Jones/Arnie Zane Dance Company, in rehearsal in Chicago in 1992. (AP/Wide World Photos)

Among the most versatile dancers of their generation, Carmen De Lavallade and Geoffrey Holder are accomplished in both theatrical dance and ballet, and have also been successful as choreographers, actors, directors, and authors. They are shown here in 1955, the year of their marriage. (Prints and Photographs Division, Library of Congress)

trained at the National Ballet School of Canada and in 1993 was appointed artistic director of Ballet British Columbia in Vancouver, Canada; and Ulysses DOVE, former principal of the Alvin Ailey company. Dove's searingly physical point ballets predicate a heightened awareness of African-American performance practice in their reliance on asymmetry, prolonged balance, and cool stance tempered by explosive power.

The profound artistic achievement of the DTH, innumerable individual African-American artists in companies around the world, and Balanchine's neoclassic fusion of ballet and African dance style created a contemporary ballet repertory that was undisputably African-based, vividly realized in works by American choreographers Gerald Arpino, William Forsythe, Jerome Robbins, and Twyla Tharp. Ironically, core African-American dance styles, which value subversive invention, participatory interaction, and an overwhelming sense of bodily presence, diverge neatly from ballet's traditional conception of strictly codified body line, a silenced and motionless audience, and movement as metaphoric abstraction. The process of building an African-American audience base responsive to ballet, an action begun by the DTH, is necessary to expand the legacy of black classicism for generations to come.

REFERENCES

ACOCELLA, JOAN ROSS. "Van Grona and his First American Negro Ballet." *Dance* magazine, (March 1982): 22–24, 30–32.

BANES, SALLY. "Balanchine and Black Dance." *Choreography and Dance* 3, part 3 (1993).

BARNES, CLIVE. "Barnes on . . . the Position of the Black Classic Dancer in American Ballet." *Ballet News* 3, no. 9 (March 1982): 46.

EMERY, LYNNE FAULEY. *Black Dance in the United States from 1619 to 1970*. Palo Alto, Calif., 1972.

"Harlem Under Control, Negro Ballet Gives 'Fire Bird' and Park Ave. Approves." *Newsweek* (November 29, 1937): 28.

JACKSON, HARRIET. "American Dancer, Negro." *Dance* (September 1966): 35–42.

KISSELGOFF, ANNA. "Limning the Role of the Black Dancer in America." *New York Times*, May 16, 1982, pp. 10, 32.

LONG, RICHARD. *The Black Tradition in American Dance*. New York, 1989.

McDONAGH, DON. "Negroes in Ballet." *New Republic* 159 (1968): 41–44.

MARTIN, JOHN. "The Dance: A Negro Art Group." *New York Times*, February 14, 1932, sec. 8, p. 11.

———. "The Dance: Newcomer." *New York Times*, February 27, 1949, sec. 2, p. 9.

"Negroes in Ballet." *Dance and Dancers* (October 1957): 9.

"Newest Ballet Star." *Ebony* (November 1954): 36–40.

STAHL, NORMA GENGAL. "Janet Collins: The First Lady of the Metropolitan Opera Ballet." *Dance* (February 1954): 27–29.

TERRY, WALTER. "To the Negro Dance." *New York Herald Tribune*, January 22, 1940.

WEST, MARTHA ULLMAN. "On the Brink: DTH Men in Crisis." *Dance* (October 1990): 43–45.

WILLIAMS, WILSON. "Prelude to a Negro Ballet." *Dance* (*American Dancer*) (March 1940): 14, 39.

YOUNG, STARK. "Slightly Ghosts." *New Republic* (December 8, 1937).

THOMAS F. DeFRANTZ

Baltimore, Maryland. When Baltimore was established as a town in 1729, many African Americans already lived in the area which, like most of Maryland, was rural. As the town grew during the eighteenth century, its African-American population increased gradually. Both slaves and free blacks worked as house servants, laborers, and craftsmen. Trades such as barbering, blacksmithing, and coach driving came to be almost exclusively black.

In Baltimore, as elsewhere, African Americans fought on both sides of the AMERICAN REVOLUTION. Before free blacks were allowed to enlist in the Maryland militia, 250 black men helped build the batteries and mount the guns around Whetstone Point, where Fort McHenry is now located, at the entrance to the port of Baltimore. Many enslaved blacks manumitted during the Revolutionary era settled in Baltimore. In 1789 a group of prominent Baltimoreans formed the Society for the Abolition of Slavery and the Relief of Poor Negroes and Others Unlawfully Held in Bondage. Although these abolitionists did not win a legal end to slavery, by 1810 free blacks, their numbers augmented by free black and mulatto refugees from Haiti, outnumbered slaves in the city 3,973 to 3,713. The city's most notable abolitionist in the nineteenth century was Benjamin Lundy, editor of the journal the *Genius of Universal Emancipation*. The famous abolitionist leader William Lloyd Garrison began his antislavery career in Baltimore as one of Lundy's assistants.

The African-American experience in Baltimore during the antebellum era was unique. Although Maryland was a slave state, slavery declined rapidly in urban areas. By 1820 Baltimore had the largest free black population of any city in the antebellum United States. The first independent black institutions in Baltimore were churches. In the 1780s African-American religious congregations began to separate from white-controlled churches. As early as 1787, blacks left white Methodist congregations and formed the Baltimore African Church on Sharp Street. In 1793 an African School opened on Sharp Street with financial help from local Quakers. A few years later, operation of the school was taken over by the African-American congregation of the Sharp Street African Methodist Church. An outstanding preacher from Sharp Street, Daniel Coker, formed the African Bethel Church (later Bethel African Methodist Episcopal Church), became its first ordained Methodist preacher in 1811, and helped form the AFRICAN METHODIST EPISCOPAL (AME) Conference in 1816.

Other congregations, Sunday schools, and day schools were set up during the ensuing years. In 1824 a group of free and enslaved blacks led by William Levington, an Episcopal priest from New York City, founded St. James Episcopal Church. The church building, finished in 1827, is a landmark which still stands in Lafayette Square in West Baltimore, though it was damaged in a major fire in 1994. In 1829, a group of black Catholics led by Elizabeth Lange, an educated Haitian mulatto who had opened a school for black children, founded the OBLATE SISTERS OF PROVIDENCE, the first black women's Catholic order, with the assistance of Sulpician priest Father Jacques Hector Nicholas Joubert. That same year, the Oblate nuns established on Richmond Street the first black girls' school in the United States, Saint Frances of Rome Academy. Another school, the William

Watkins Academy for Negro Youth, operated until 1850, and boasted Baltimore native Francis E. Watkins HARPER as its most distinguished graduate. In 1860 the Madison Avenue Presbyterian Church had Hiram REVELS, later a senator, as its pastor, and Henry McNeal TURNER, later an AME bishop, was a deacon at Bethel AME Church.

Slavery continued in Baltimore, though on a small scale, throughout the antebellum period. By 1860 there were 25,680 free blacks, and only 2,218 slaves. Most slave owners owned one or two slaves, who served as domestic servants. Other slaves, notably Frederick DOUGLASS, who came to Baltimore in the late 1820s and worked as a caulker in the city's shipyards, were hired out or charged to find skilled or unskilled labor by their masters.

There was a clear social difference between slaves and free blacks, although free blacks suffered the same discrimination the slaves did. Blacks were excluded from the interior of streetcars (until 1871 they could only ride on the outside platforms), theaters, and schools in the city, and most housing was segregated. Their always precarious social position was increasingly attacked in the years before the CIVIL WAR. Maryland slave owners disliked the example of freedom Baltimore's black community offered their slaves. Also, the city's economy underwent several convulsions. Many white immigrants settled in Baltimore, so that despite African-American population growth, the percentage of blacks in the city fell from 22 percent in 1810 to 13 percent in 1860. Job competition between black laborers and immigrant white laborers was intense, and violent conflicts often ensued. Pro-Confederate sentiment ran high in the city. In March 1861, a white mob stoned Union troops.

Following the end of slavery in 1864, African-American progress was dramatic, despite continued discrimination. In 1865 the Frederick Douglass Institute, a cultural center created to "promote the intellectual advancement of the colored portion of the community," opened in a former war hospital on Lexington Avenue near Monument Square. The building contained a concert/meeting hall, dining room, and offices of an African-American newspaper, the *Communicator*. The institute, white-owned but black-managed, remained open until 1888. In 1867 Centenary Biblical Institute (later Morgan State University) opened, and in 1871 "colored" public schools opened for the first time. In 1900 a Colored Training School for teachers, later named in honor of Fannie Jackson COPPIN, was established. In 1894 African-American doctors William T. Carr and John Marcus Cargill opened Provident Hospital. The city's small black aristocracy, led by such figures as Francis CARDOZO, settled on Druid Hall in the city's northwest section. There they built charitable organizations, fraternities such as the Baltimore Assembly, and literary societies such as the Monumental Literary and Scientific Association, founded in 1885. The great lasting legacy of late nineteenth-century black Baltimore is the BALTIMORE AFRO-AMERICAN newspaper, founded in 1892, the oldest major black journal still in publication. The era's most famous black Baltimorean was explorer Matthew HENSON, codiscoverer of the North Pole.

In 1866, following a strike by white caulkers attempting to exclude blacks, black workers led by Isaac MYERS organized a successful cooperative shipyard and labor union. Myers later helped establish entrepreneurial associations such as the Colored Business Men's Association of Baltimore and the Colored Building and Loan Association of Baltimore. In 1890 a black Republican lawyer, Harry Sythe Cummings, was elected to the city council, and five more blacks served on the council over the following fifty years.

Black political influence in the city waned after 1900, and conditions for blacks worsened. In 1904 railroads and ships (but not trolley cars) were segregated. Soon, further ordinances followed, as Baltimore's caste lines hardened and the city belatedly sought to imitate its southern counterparts. For a short time after 1912, the city mandated separate black and white city blocks. During the 1920s, epidemic tuberculosis was rampant in the black community.

However bleak the political situation, the cultural picture was impressive. Baltimore natives such as Eubie BLAKE had long played a part in black theater and music. During the 1920s and '30s, Pennsylvania Avenue in West Baltimore emerged as the center of local African-American business and social life. Baltimore native Cab CALLOWAY and other important musicians were featured in clubs, while the city gave birth to performers such as Billie HOLIDAY, Chick WEBB, John Kirby, and Joe TURNER.

In 1935 the Baltimore NAACP, largely dormant since its founding in 1913, was revived by Lillie Mae Carroll JACKSON, who built it into the largest NAACP chapter outside New York City (see also NATIONAL ASSOCIATION FOR THE ADVANCEMENT OF COLORED PEOPLE). During the 1930s the NAACP organized a "Don't Buy Where You Can't Work" campaign that opened up job opportunities for blacks throughout Baltimore; arranged the hiring of black police officers, though initially without uniforms or arrest powers; registered large numbers of new voters; and, with the aid of Baltimore-born NAACP counsel Thurgood MARSHALL, pushed successfully for equalization of black and white teachers' salaries. Jackson's daughter, Juanita Jackson MITCHELL, became the NAACP's national youth director, and went on to gain a law degree, becoming a prominent civil rights lawyer.

World War II brought 33,000 new black migrants to Baltimore in two years, sparking racial tension. In April 1942, after a white policeman shot an African American in the back, thousands marched on Baltimore in protest, and intensified political action. The city's bureau of the Fair Employment Practices Commission, administered by Baltimore native Clarence MITCHELL, succeeded in ending discriminatory policies in many firms.

In 1943, with the aid of heavy support in black areas, liberal Republican Theodore McKeldin was elected mayor of Baltimore. During his two terms, McKeldin named blacks to health, education, and recreation boards, and hired large numbers of black police and nurses. The first victory over black exclusion from public facilities occurred in 1946, when Willie Adams, a millionaire gambler and liquor industry tycoon, led a successful protest over segregated city golf courses. However, while Ford's Theater and downtown department stores began admitting blacks in the early 1950s, most of the city remained segregated until 1954, when the Supreme Court's BROWN V. BOARD OF EDUCATION OF TOPEKA, KANSAS ruling led to the integration of public schools (Catholic schools also became integrated). Further integration was slow. In 1956 the city passed an equal employment ordinance but without enforcement powers. In early 1960, students from Morgan State began lunch counter sit-ins aimed at desegregating city facilities. However, city authorities did not pass a civil rights statute until 1962.

Baltimore's economy worsened during the 1960s. Police brutality was a chronic problem, and job and union discrimination remained rampant. In February 1966, black women staff of the city's Lincoln Nursing Home staged a walkout. With help from organizers from the CONGRESS OF RACIAL EQUALITY (CORE), they formed the Maryland Freedom Union (MFU) to bring civil rights tactics and consciousness to unions. The MFU, whose leaders and membership were largely black and female, organized low-wage nursing home, retail, and service workers. The MFU organized boycotts of retail stores in black neighborhoods and won contracts from three large retailers. Leaders also attempted, with less success, to organize food stores and hospitals. Eventually, faced by financial restraints and the hostility of mainstream organized labor, the MFU dissolved.

On April 6, 1968, following the assassination of the Rev. Dr. Martin Luther KING, Jr., rioting erupted in Baltimore. Looting broke out on Gay Street, then spread as blacks started fires and broke windows. The next day, as rioting grew more intense, Maryland Governor Spiro Agnew declared the riot an insurrection and called in National Guard troops. Violence continued for two more days. Altogether there were six deaths, dozens of injuries, 5,512 arrests, and 1,208 major fires. On Wednesday, April 10, Agnew met with a hundred moderate black leaders, but instead of promising to deal with conditions causing the riot, he blamed the disturbance on black radicals and denounced the moderates as "cowards" for not opposing them. Most of the group walked out, and Agnew refused to listen to the remaining leaders. (Later invited to tour black ghetto areas, he replied, "if you've seen one slum, you've seem them all"). Agnew's uncompromising stance soon led to his nomination and subsequent election as vice president of the United States.

Since 1968 Baltimore has followed the pattern of many urban areas in the United States. During the mid-1970s, Baltimore became a black majority city. The city's economy has declined in the face of deindustrialization and middle-class migration to nearby suburbs. Unemployment and crime have been recurring problems. In 1992 a Maryland Commission report found that over half of Baltimore's black men between eighteen and thirty-five were in trouble with the law.

At the same time, blacks have established political control of the city. In 1970 in a close election, Parren Mitchell became Baltimore's first African-American congressman from a district that had a white majority at the time. After retiring in 1986, he was succeeded by Kweisi Mfume. In 1987 Kurt Schmoke, a former Rhodes scholar and state's attorney, became the city's first black mayor. Schmoke has adopted various reforms to deal with the housing, health and safety problems of the city's African Americans and has focused his attention on improving education. He increased school funding in the city's budget, and in cooperation with city businesses, he set up the Commonwealth Agreement and the College Bound Foundation, which guaranteed jobs or college educations to qualifying high school graduates. His slogan is "Baltimore: the city that reads." In 1990 he approved the creation of three experimental all-black, all-male public schools as a way of promoting racial consciousness and self-esteem. He has also gained national attention through his controversial advocacy of drug legalization.

In 1991 Baltimore became the home of the Great Blacks in Wax museum, the nation's first wax museum devoted to African Americans, a fitting tribute to the important place blacks have occupied in the city's history.

REFERENCES

BRUGGER, ROBERT J. *Maryland: A Middle Temperament, 1634–1980.* Baltimore, 1988.

FIELDS, BARBARA JEANNE. *Slavery and Freedom on the Middle Ground: Maryland During the Nineteenth Century.* New Haven, Conn., 1985.

GREENE, SUZANNE ELLERY. *Baltimore: An Illustrated History*. Woodland Hills, Calif., 1980.

OLSON, SHERRY H. *Baltimore: The Building of an American City*. Baltimore, 1980.

WADE, RICHARD S. *Slavery in the Cities: The South 1820–1860*. New York, 1964.

SUZANNE ELLERY GREENE CHAPELLE

Baltimore Afro-American,

Baltimore Afro-American, newspaper. The *Baltimore Afro-American,* first published in 1892 and now in its second century of continuous publication, is the oldest family-owned black newspaper in America. During its peak years, between the two world wars, the newspaper printed thirteen separate editions from New Jersey to South Carolina and competed with both the CHICAGO DEFENDER and the PITTSBURGH COURIER to be the nation's largest African-American paper.

Founded by ex-slave John Henry Murphy, the *Afro-American* grew from a small, church-based newsletter to the largest black paper on the eastern seaboard, with a circulation of over 225,000. After John Murphy died, his son Carl became senior editor and publisher. For nearly forty years, Carl MURPHY and the *Afro-American* never shied from reporting the truths of life in a segregated America.

As early as 1912, the *Afro-American* addressed the discriminatory practices of the U.S. military. In the late 1930s, the paper reported on the early signs of apartheid in South Africa and was soon supporting Thurgood MARSHALL and the NAACP's legal battles to end school segregation. Throughout these years, numerous articles were devoted to black leaders such as Marcus GARVEY, W. E. B. DU BOIS, Ralph BUNCHE, and the Rev. Dr. Martin Luther KING, Jr.

In addition to providing the news of the day, the *Afro-American* performed a community service by publishing the births, marriages, and deaths of local African Americans, since these listings were rarely found in the white-owned newspapers of the time. Ironically, the newspaper's decline in circulation in the 1960s and '70s was due in part to its success in pressuring the white news media to hire black journalists.

REFERENCES

DOMINGUEZ, ALEX. "Afro-American Paper Marking Century of News." *Baton Rouge Advocate,* August 13, 1992, p. 4C.

"100 Year Old Black Paper Is Struggling." *New York Times,* August 23, 1992, p. 28L.

MICHAEL A. LORD

Bambara, Toni Cade (March 25, 1939–), writer. Born Toni Cade in New York City to Helen Brent Henderson Cade, Bambara adopted her last name in 1970. Bambara grew up in various sections of New York (Harlem, Bedford-Stuyvesant, and Queens) as well as in Jersey City, N.J. She earned a B.A. in theater arts and English from Queens College in 1959—the year in which she published her first short story, "Sweet Town"—and an M.A. in English from City College of New York in 1965. At the same time, she served as a community organizer and activist as well as occupational therapist for the psychiatric division of Metropolitan Hospital.

Bambara's consciousness was raised early as she watched her mother instruct her grade school teachers about African-American history and culture and as she listened on New York street corners to Garveyites, Father Diviners, Rastafarians, Muslims, Pan-Africanists, and communists. She learned early of the resiliency that would be needed for a poor, black female to survive. Bambara's streetwise sensibility informs two collections of writings by black women that she edited, *The Black Woman* (1970) and *Tales and Stories for Black Folks* (1971). The stories that she contributed to these collections portray young, black women who weather difficult times and who challenge others to join the struggle for equality.

Between 1959 and 1970 Bambara wrote a series of short stories that were published in 1972 as *Gorilla, My Love*. A collection of fifteen stories, this book focuses on relationships that rejuvenate, family, community, and self-love. Her second collection of stories, *The Sea Birds Are Still Alive* (1977), revolves around the theme of community healing. Her characters do not despair; instead, they nurture each other back to spiritual and physical health. The theme of healing is further explored in Bambara's novel *Salt Eaters* (1980), which received the American Book Award that year.

Bambara has taught at several universities, including City College of the City University of New York, Rutgers University, Livingstone College, Duke University, and Spelman College. Her commitment as a writer is to inspire others to continue to fight for improved conditions for the community.

REFERENCES

DECK, ALICE A. "Toni Cade Bambara." In Thadious Davis and Trudier Harris, eds. *Afro-American Writers After 1955: Dramatists and Prose Writers, Dictionary of Literary Biography*. Vol. 38. Detroit, 1985.

"Toni Cade Bambara." *Contemporary Authors,* vols. 29–32.

ELIZABETH BROWN-GUILLORY

Banking. Black banks developed in the RECONSTRUCTION era as a response to the needs of black entrepreneurs and other members of the black community. There were several reasons behind the founding of these banks. African Americans were generally denied access to capital markets and white-controlled financial intermediaries. It was also believed that African-American banks could direct their investments to other black businesses and thereby improve the financial structure of black communities.

Banking, 1619–1865

African secret burial societies in America reflected the predisposition for saving in the first African slaves in colonial America. These societies pooled the resources of its members to ensure the costs of funeral expenses. Founded by free blacks, early mutual aid self-help organizations provided similar services (see FRATERNAL ORDERS AND MUTUAL AID ASSOCIATIONS) and on occasion made small loans to members. These informal activities expanded during the post–Revolutionary War era. From monthly deposits made by its members, mutual aid societies provided cash benefits for sickness and unemployment and for widows and orphans of members. By 1861, antebellum blacks had founded several hundred mutual aid and benevolent societies in both the North and the South.

This early national era also saw the emergence of commercial banks. The bank of North America, chartered in Pennsylvania in 1781, was the nation's first commercial bank. The federal government chartered the First (1791–1811) and Second (1816–1836) Banks of the United States (BUS), which served as de facto central banks. However, after the failure of the rechartering of the second BUS, there was a rapid expansion of the number of commercial banks. From 1837 to the Civil War, in many states the free banking system was in operation; anyone could establish a bank, take deposits, and, when backed with securities on deposit with the state banking authority, issue banknotes. However, the "freedom" of free banking was often limited where blacks were concerned. In the antebellum South, Abram L. Harris wrote: "Special statutes and acts incorporating state banks prohibited Negroes from becoming stock-holders and depositors." However, there were always exceptions.

Before the Civil War, there were two instances of blacks who sat as members of bank boards. Pennsylvanian Stephen Smith, one of the wealthiest northern antebellum blacks, who was a lumber merchant, coal dealer, and real estate investor, sat on the board of the Columbia Bank in Columbia, Pa., in the 1830s, where it was reported that Smith "was the largest stock-holder of his day in the Columbia Bank; and, according to its rules, would have been

president had it not been for his complexion. Being thus barred, he was given the privilege of naming the white man who became president in his stead." Also in Pennsylvania, wealthy Robert PURVIS was a member of the largest money corporation in Philadelphia.

African Americans in the North, both individuals and organizations, often used white banks. Yet it was also common for wealthy blacks before the Civil War, including Smith, to act as private bankers holding funds for fellow blacks while making loans with interest and discounting banknotes to blacks who did not want their finances a matter of public attention. Northern antebellum blacks who served in the capacity of private bankers included Peter Vandyke of New York, as well as James FORTEN and Joseph Cassey of Philadelphia. In the South, wealthy black slaveholders John C. Stanley of North Carolina and William Johnson of Mississippi also acted in this role. In Louisiana, black large-plantation owners and slaveholders Cyprian Ricaud, the Metoyer family, and the New Orleans merchant and slaveholder Madame CeCee McCarty also acted in the capacity of private bankers. The informal banking activities of wealthy real estate investor and merchant Tomy Lafon survived the Civil War. Until his death in 1894, Lafon was a successful moneylender.

Before the Civil War, under the auspices of the Negro convention movement, several failed attempts were made by blacks in New York City and Philadelphia to establish black banks. Black deposits in New York white banks in 1856 were reported at $60,000; in Philadelphia the figure was $28,366.

Banking, 1865–1874

During the Civil War, free labor banks and military banks were established by the Union Army in the South. The labor banks accepted the savings of both civilian and military blacks, while the military savings banks initially accepted only the deposits of black soldiers. By 1865, African-American soldiers in the Union Army had deposited $200,000 in the military bank in Beaufort, S.C., alone.

In March 1865, Congress incorporated the Freedman's Savings Bank and Trust Company, a privately owned bank, founded by John Alvord and other white investors, most of whom had been abolitionists (see also FREEDMAN'S BANK). Their bank charter outlined the purpose of the Freedman's Bank as "to receive on deposit such sums of money as may, from time to time, be offered therefore by or on behalf of persons heretofore held in slavery in the United States, or their descendants, and the investing the same in the stocks, bonds, treasury notes or other securities of the United States." Eventually, there were thirty-four branches of the Freedman's Savings

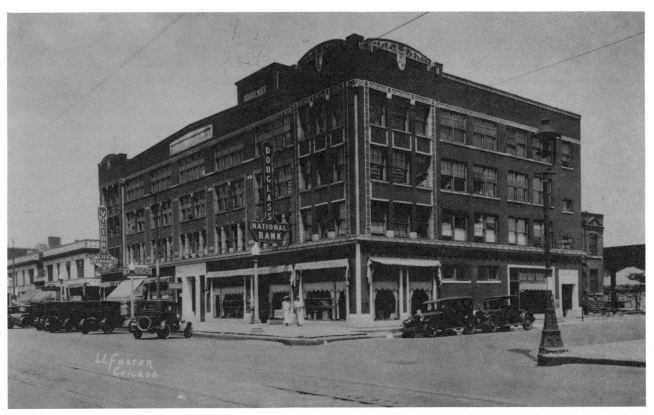

Douglass National Bank building in Chicago, the home of Overton Hygiene Manufacturing Co., founded by Anthony Overton. (Photographs and Prints Division, Schomburg Center for Research in Black Culture, The New York Public Library, Astor, Lenox and Tilden Foundations)

Bank. With the exception of New York, Philadelphia, and St. Louis, all were primarily located in southern cities. From the perspective of blacks, there were problems with the Freedman's Bank from the outset. African-American involvement in the running of the bank was minimal. Furthermore, there were few loans made to black businesses. Despite this, freed slaves supported the bank enthusiastically. Total deposits in the Freedman's Bank amounted to $57 million in the nine-year period of its existence. The Freedman's Bank failed in 1874, largely because of poor management, corrupt banking practices, and defaults on unsecured loans. Shortly before the bank's failure, in a desperate move to shore up confidence among black depositors, Frederick DOUGLASS was named president. At that time, there were 61,131 depositors who were owed $3,013,699. Efforts to secure full restitution for investors proved futile. In 1900, final payments were made to the depositors in the amount of $1,638,259. The failure of the bank led to a loss of confidence by many blacks in white banking institutions.

Banking, 1888–1963

From 1888 to the era of the civil rights movement, black banks were usually short-lived, from five to fif-

teen years. When *Black Enterprise,* a magazine which reports on black entrepreneurial efforts, first listed the top black business and financial institutions, it showed that, in 1972, thirty-seven "black controlled" banks were in operation. Only six had been founded before 1945. Richmond's Consolidated Bank & Trust Company, established in 1903, was the oldest. There were also forty-four black savings-and-loan associations in operation and forty-two black-managed insurance companies. Until the 1960s, the South had the largest number of black financial institutions. Virginia, with eighteen banks, ranked first in the number of black banks founded in any state.

The first African-American commercial bank was the Capital Savings Bank of Washington, D.C., which opened in October 1888. The Savings Bank of the Grand Fountain United Order of True Reformers in Richmond, Va., although chartered earlier (March 2, 1888), opened in April 1889. It was founded by the ex-slave William Washington Browne (1849–1897), one of several businesses he established for the fraternal order. The late nineteenth century also marked the founding of black savings-and-loan associations: the Berean Savings Bank in Philadelphia, 1888; the People's Savings & Loan Association in Hampton, 1889; the Dwelling House Savings & Loan Associa-

tion in Pittsburgh, 1890, and the Tuskegee Federal Savings and Loan Association, 1894.

The first American woman—black or white—to found a bank and hold the position of bank president was African-American Maggie Lena WALKER, the founder of the St. Luke's Penny and Savings Association, established in 1904. She served as president until her death in 1935. The first black banking organization, the National Negro Bankers Association, affiliated with the NATIONAL NEGRO BUSINESS LEAGUE or Booker T. WASHINGTON, was founded in 1900.

The origins of the twenty-eight black-owned banks founded before 1905 can be attributed primarily to the initiative taken by African-American fraternal insurance orders and black churches. These banks were founded to provide financial institutions that could serve as repositories for the money, dues, insurance premiums, and donations collected from their members; they were also used to promote black business.

The True Reformers Bank, a subsidiary of the Grand Fountain United Order of True Reformers, a fraternal organization, was founded by a minister, as was the Alabama Penny Savings Bank in Birmingham, which eventually established two branches. The St. Luke's Penny Savings Bank, headed by Maggie Walker, was affiliated with the Independent Order of St. Luke in Richmond, Va., and African-American women's mutual aid organization founded in 1867. Banks established by fraternal organizations invariably used their name.

During the first major era of black bank founding—1888 to 1934—some 134 banks were founded. Only one black bank was founded during the Great Depression, the Industrial Bank of Washington. By 1943, of the nation's 14,621 banks, there were only eleven black banks. Except for Philadelphia's Citizens' & Southern Bank and Trust Company, all were located in the South. By 1950, there were fourteen

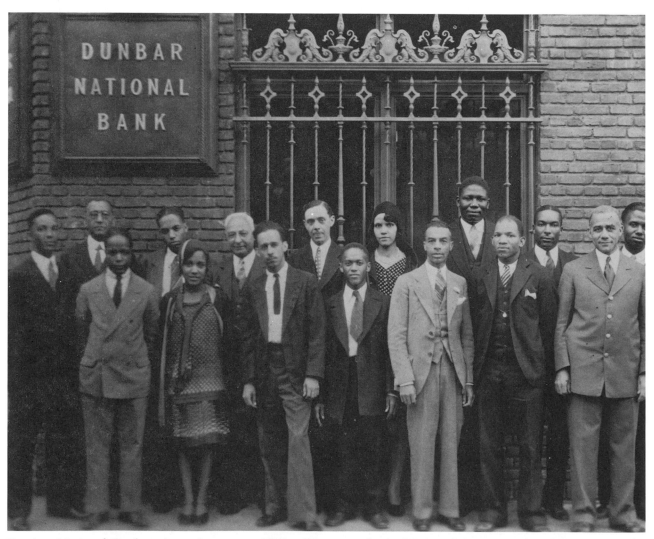

Dunbar National Bank and employees, c. 1920s. (Photographs and Prints Division, Schomburg Center for Research in Black Culture, The New York Public Library, Astor, Lenox and Tilden Foundations)

black banks; in 1960, there were only twelve black banks.

Black-owned banks were also founded in BLACK TOWNS, such as in Boley, Okla., which had the first black national bank, as well as the Bank of MOUND BAYOU in Mississippi in the town of the same name. In 1908, C. C. SPAULDING, an officer of the North Carolina Mutual Insurance Company (who became its president in 1923), founded the Mechanics and Farmers Bank in Durham, with a branch in Raleigh. The Mechanics Bank stands among the leading black banks today.

The 1912 *Negro Year Book,* reported that there were sixty-four black banks, capitalized at about $1.6 million, with annual business activity in the area of $20 million. In 1920, the Memphis Solvent Savings Bank and Trust Company, founded in 1906 by black millionaire businessman Robert R. CHURCH, SR. became the first black bank to hold $1 million in deposits. In the North, the first black commercial banks were the First Northern Colored Cooperative Banking Association of Philadelphia, chartered in July 1901, and which failed in 1902. The Peoples Savings Bank in Philadelphia was founded in 1907. The Binga Bank, established in Chicago in 1908, was one of eight banks founded in Illinois before World War I.

Early twentieth-century black banking history also includes the founding of black-organized industrial banks, as well as building-and-loan associations. The Industrial Savings Bank of Washington, D.C., founded in 1913, survived until 1932 and was reorganized as the Industrial Bank of Washington two years later. One of the reasons for its failure was its acquisition of the Prudential Bank, founded in 1920, which served as a depository of the African Methodist Episcopal (AME) Church. Prudential's president, John R. Hawkins, was also financial secretary for the denomination. The People's Finance Corporation in St. Louis, founded in 1922, was also an industrial savings bank. Atlanta's Citizens Trust, founded by Herman Edward Perry in 1921, provides a model of the first full-service commercial bank operated by African Americans. Its diverse services included farm and business loans as well as a women's department.

In 1920, in the North, Pennsylvania had five black banks, while Illinois, Massachusetts, Michigan, and Ohio each had two black banks located in the major cities of those states. The Harlem-based Dunbar Bank was founded in 1928. With the stock market crash of 1929, Abram Harris notes that the Chicago-based Binga Bank and the Douglass National Bank were the largest black banks in the nation, holding 36 percent of the $11 million held by the twenty-one black banks still existing. Both banks were founded by wealthy black entrepreneurs: Jesse Binga, former Pullman porter, peddler, and wealthy real estate spec-

ulator; and Anthony OVERTON, founder and president of Overton Cosmetic Company. Neither survived the GREAT DEPRESSION.

Banking 1964–1994

The immediate postwar period was a fallow period for black bank formation. A new phase in the history of black banking began with the civil rights era and the renewed emphasis on black capitalism. While only four black banks were founded from 1945 to 1962, twenty-six "black controlled" banks were established from 1963 to 1972. Eight had national charters; four were chartered by state authorities. The incorporators were usually private investors. The geographic location of these new banks—primarily located in northern states—reflected demographic shifts in the black population. In 1972, only six of the twenty-six black banks were located in the South.

There has been a shakeout among the new black-owned financial institutions. Some ten years later, in 1982, there were forty-four black banks, a decrease from the forty-six in 1981; whereas in 1992, there were only thirty-six "black controlled" banks. The decline of black banks can be attributed to banks either being sold a majority interest to white investors, such as the National Bank of Commerce in Miami, or merging with white-controlled banks, as did the Community Bank of Omaha.

Black savings-and-loan associations/building-and-loan associations also experienced a decline in both numbers and profits. In 1929, there were eighty black savings-and-loan associations, fifty in 1938, and twenty-two in 1947. Although twenty institutions were established from 1945 to 1962, only ten were founded after 1962. In 1972, there were forty-four black savings-and-loans, thirty-seven in 1982, and eighteen in 1992.

In 1993, Carver Federal Savings Bank in New York City, headed by Richard T. Greene, ranked first in *Black Enterprise*'s 1993 listing of financial companies, with over $300 million in assets. Chicago-based Seaway National, which controls two other large banks, Independence and Drexel (ranked sixth and seventh, respectively, on *Black Enterprise*'s 1993 list) is, by other estimates, the largest assemblage of black banks under a single ownership group.

The Future of Black Banking

Since the late 1960s, there has been a debate on whether black banks were "ornaments"—symbols of racial pride—or whether, acting in the role of brokers or market makers, black banks have successfully assisted the development of the black community and the expansion of black businesses. In 1969, a leading African-American economist, Andrew Brimmer, a former governor of the Federal Reserve Board said:

"If you want to focus on the improvement of economic conditions on a large scale in the black community, and if you look toward black banks as an instrument of economic development, you will be disappointed." The lack of capitalization, Brimmer argued, made it difficult for black-owned banks to be as efficient as larger banks.

In 1992, the thirty-six black banks had total assets of $2 billion dollars—out of all American assets of $3.5 trillion dollars. It is obvious that certain financial limitations persist for black banks in the United States. The main concerns of most minority banks since the 1800s involved small accounts (i.e., low deposits and high withdrawal rates) high operating costs, capital adequacy (the ratio of loans and securities to assets), heavy loan losses, and comparatively low profitability rates. Maintaining adequate capital levels proves difficult for black commercial banks. This must be balanced against the financial services they can provide to black business and the fact that they are more forthcoming in providing capital credit to black consumers and businesses than white financial institutions.

Continued growth of black commercial banks requires access to white corporate America for deposits and loan grants. Black commercial banks also need diversified portfolios beyond their traditional investments in government securities and the federal funds market. Indirectly, these investments channel funds out of the black community, encouraging credit rationing, which reduces the number of loans to black businesses, often already lacking alternative access to financial institutions for capital.

Historically, African Americans have been denied equitable access to funds from white financial institutions, especially in securing loans for home ownership and venture capital for business development. Whether or not the increasing accumulation of capital in black banks can provide a source of commercial credit for the economic development of the black community and black business expansion in this new phase of black banking history in the late twentieth century remains inconclusive. Will black banks survive? Profits are increasing. The shift in financial policies of black commercial banks and the establishment of black investment banks, marking greater participation in mainstream American banking practices, opens a new phase in the history of African-American banking.

REFERENCES

BATES, TIMOTHY, and WILLIAM BRADFORD. *Financing Black Economic Development.* New York, 1979.

BRADFORD, WILLIAM. "Merge or Purge." *Black Enterprise* (June 1986): 143–144.

———. "Minority Financial Institutions, Inner City Economic Development, and the Hunt Commission Report." *Review of Black Political Economy* 4, no. 3 (1974): 47–62.

BRIMMER, ANDREW. "Black Banks: An Assessment of Performance and Prospects." *Journal of Finance* (May 1972): 379–405, 465–471.

———. "The Negro in the National Economy." In *The American Negro Reference Book.* New York, 1966, chapter 5.

DEMOND, ALBERT LAWRENCE. *Certain Aspects of the Economic Development of the American Negro, 1865–1900.* Washington, D.C., 1945.

DU BOIS, W. E. B. *Economic Co-Operation Among Negro Americans.* Atlanta, 1907.

———. *The Negro in Business.* Atlanta, 1899.

FLEMING, WALTER L. *The Freedman's Savings Bank: A Chapter in the History of the Negro Race.* Chapel Hill, N.C., 1927.

GILBERT, ABBY. "Black Banks: A Bibliographic Survey." *Bulletin of Bibliography* 28 (April–June 1971).

GREEN, SHELLEY, and PAUL PRYDE. *Black Entrepreneurship in America.* New Brunswick, N.J., 1990.

HARMON, J. H., JR., ARNETT G. LINDSAY, and CARTER G. WOODSON. *The Negro as Businessman.* Washington, D.C., 1929. Reprint. New York, 1969.

HARRIS, ABRAM, L. *The Negro Capitalist: A Study of Banking and Business Among Negroes.* Philadelphia, 1936. Reprint. New York, 1968.

HINES, GEORGE W. *Negro Banking Institutions in the United States.* Washington, D.C., 1924.

IRONS, EDWARD D. "A Positive View of Black Capitalism." *Bankers Magazine* 153 (Spring 1970): 43–47.

KINZER, ROBERT, and EDWARD SAGARIN. *The Negro in American Business: Conflict Between Separatism and Integration.* New York, 1950.

LINDSAY, ARNETT G. "The Negro in Banking." *Journal of Negro History* (April 1929): 156–201.

McCOY, FRANK. "Investment Firms Show What They Can Do." *Black Enterprise* (June 1993): 173–174, 176–179.

National Bankers Association. *Annual Report of Banking Institutions Owned and Operated by Negroes.* Washington, D.C., 1963.

OSTHAUS, CARL R. *Freedmen, Philanthropy, and Fraud: A History of the Freedman's Savings Bank.* Urbana, Ill., 1976.

PATTERSON, PAT. "An Interview with Andrew Brimmer." *Black Enterprise* (October 1972): 43, 45–47.

PIERCE, JOSEPH A. *Negro Business and Negro Business Education: Their Present and Prospective Development.* New York, 1947.

"Report on Black Financial Institutions: Banks and Savings & Loans Associations." *Black Enterprise* (June 1973).

THIEBLOT, ARMAND J., JR. *The Negro in the Banking Industry.* Philadelphia, 1970.

WALKER, JULIET E. K. "Racism, Slavery, and Free Enterprise: Black Entrepreneurship in the United States Before the Civil War." *Business History Review* 60 (1986): 343–382.

JULIET E. K. WALKER

Banks, Ernest "Ernie" (January 31, 1931–), professional baseball player. Born in Dallas, Tex., Ernie Banks began his professional BASEBALL career in the Negro Leagues in 1950 with the Kansas City Monarchs, batting .255 in fifty-six official league games. After two years in the Army, he was signed by the Chicago Cubs in 1953, the second African-American player to join the team. He stayed with the Cubs his entire career and retired from baseball in 1971.

In his nineteen years in Chicago, Banks was known primarily as a shortstop, though after 1961 he played mostly at first base. He appeared in thirteen All-Star games and in 1958 and 1959 won the Most Valuable Player award. In 1958 Banks hit 47 home runs, a record for shortstops that still stands, and finished his career with 512 home runs.

Baseball fans know Banks as "Mr. Cub," as much for his open enthusiasm as for his skill as a player, as exemplified in his well-known catchphrase "Let's play two" (that is, a doubleheader) on sunny afternoons. Banks was inducted into the Baseball Hall of Fame in 1977, and his number (14) was the first ever retired by the Cubs. In recent years, Ernie Banks has been a motivational lecturer, as well as a board member of such organizations as the Chicago YMCA and the Chicago Transit Authority.

REFERENCES

ASHE, ARTHUR R. JR. *Hard Road to Glory: A History of the African-American Athlete Since 1946.* New York, 1988.
BANKS, ERNEST, and JIM ENRIGHT. *Mr. Cub.* Chicago, 1971.

PETER EISENSTADT

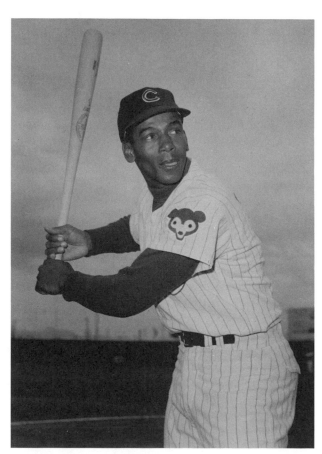

Ernie Banks, a member of the last generation of black ballplayers to have experience in the Negro Leagues, played for the Kansas City Monarchs before joining the Chicago Cubs in 1953, where he stayed for nineteen standout seasons. (AP/Wide World Photos)

Banneker, Benjamin (November 9, 1731–October 9, 1806), amateur astronomer. Banneker was the first African-American man of science. He was born free in Baltimore County, Md., the son of a freed slave from Guinea named Robert, and of Mary Banneky, the daughter of a formerly indentured English servant named Molly Welsh and her husband Bannka, a freed slave who claimed to be the son of a Gold Coast tribal chieftain.

Raised with three sisters in a log house built by his father on his 100-acre farm near the banks of the Patapsco River, Banneker received no formal schooling except for several weeks' attendance at a nearby Quaker one-room schoolhouse. Taught to read and write from a Bible by his white grandmother, he became a voracious reader, borrowing books when he could. He was skillful in mathematics and enjoyed creating mathematical puzzles and solving others presented to him. At about the age of twenty-two, he successfully constructed a wooden striking clock without ever having seen one. He approached the project as a mathematical problem, working out relationships between toothed wheels and gears, painstakingly carving each from seasoned wood with a pocketknife. The clock continued telling and striking the hours until his death. Banneker cultivated tobacco, first with his parents and then alone until about the age of fifty-nine, when rheumatism forced his retirement. He was virtually self-sufficient, growing vegetables and cultivating orchards and bees.

It was during his retirement that Banneker became interested in astronomy after witnessing a neighbor observing the stars with a telescope. With borrowed instruments and texts and without any assistance from others, Banneker taught himself sufficient mathematics and astronomy to make observations and to be able to calculate an ephemeris for an almanac. His efforts to sell his calculations for 1791 to a printer were not successful, but he continued his celestial studies nonetheless.

Benjamin Bannaker's
PENNSYLVANIA, DELAWARE, MARY-
LAND, AND VIRGINIA
A L M A N A C,
FOR THE
YEAR of our LORD 1795;
Being the Third after Leap-Year.

PHILADELPHIA:

Printed for WILLIAM GIBBONS, Cherry Street

Benjamin Banneker's (here spelled "Bannaker's") annual almanacs, which appeared from 1792 to 1797, were intended as a challenge to those, such as Thomas Jefferson, who underestimated the intellectual abilities of blacks. (UPI/Bettmann)

Banneker's opportunity to apply what he had learned came in February 1791, when President Washington commissioned the survey of an area ten miles square in Virginia and Maryland in which to establish the national capital. Unable on such short notice to find an assistant capable of using the sophisticated instruments required, the surveyor Andrew Ellicott selected Banneker to assist him until others became available. During the first three months of the survey, Banneker occupied the field observatory tent, maintaining and correcting the regulator clock each day, and each night making observations of the transit of stars with the zenith sector, recording his nightly observations for Ellicott's use on the next day's surveying. During his leisure, he completed calculations for an ephemeris for 1792. Banneker was employed on the survey site from early February until late April 1791, then returned to his home in Baltimore County. Recently discovered records of the survey state that he was paid $60 for his participation and the costs of his travel.

Shortly after his return home, Banneker sent a handwritten copy of his ephemeris for 1792 to Secretary of State Thomas Jefferson, because, he wrote, Jefferson was considered "measurably friendly and well disposed towards us," the African-American race, "who have long laboured under the abuse and censure of the world . . . have long been looked upon with an eye of contempt, and . . . have long been considered rather as brutish than human, and scarcely capable of mental endowments." He submitted his calculations as evidence to the contrary, and urged that Jefferson work toward bringing an end to slavery. Jefferson responded promptly: "No body wished more than I do to see such proofs as you exhibit, that nature has given to our black brethren, talents equal to those of other colors of men, and that the appearance of a want of them is owing merely to the degraded condition of their existence, both in Africa & America. . . . no body wishes more ardently to see a good system commenced for raising the condition of both their body & mind to what it ought to be, as fast as the imbecility of their present existence, and other circumstances which cannot be neglected, will admit." Jefferson sent Banneker's calculations to the Marquis de Condorcet, secretary of the French Academy of Sciences, with an enthusiastic cover letter. There was no reply from Condorcet because at the time of the letter's arrival he was in hiding for having opposed the monarchy and having supported a republican form of government. The two letters, that from Banneker to Jefferson and the statesman's reply, were published in a widely distributed pamphlet and in at least one periodical during the following year.

Banneker's ephemeris for 1792 was published by the Baltimore printer Goddard & Angell with the title *Benjamin Banneker's Pennsylvania, Delaware, Maryland and Virginia Almanack and Ephemeris for the Year of Our Lord 1792.* It was also sold by printers in Philadelphia and Alexandria, Va. He continued to calculate ephemerides that were published in almanacs bearing his name for the next five years. Promoted by the abolitionist societies of Pennsylvania and Maryland, Banneker's almanacs were published by several printers and sold widely in the United States and England. Twenty-eight separate editions of his almanacs are known. A recent computerized analysis of Banneker's published ephemerides and

those calculated by several contemporaries for the same years, including those by William Waring and Andrew Ellicott, has revealed that Banneker's calculations consistently reflect a high degree of comparative accuracy. Although he continued calculating ephemerides through the year 1802, they remained unpublished.

Banneker died in his sleep following a morning walk on October 9, 1806, one month short of his seventy-fifth birthday. He was buried several days later in the family graveyard within sight of his house. As his body was being lowered into the grave, his house burst into flames, the cause unknown, and all of its contents were destroyed. Fortunately, the books and table he had borrowed, his commonplace book, and the astronomical journal in which he had copied all of his ephemerides had been given to his neighbor immediately following his death, and have been preserved. Although he espoused no particular religion or creed, Banneker was a very religious man, attending services and meetings of various denominations held in the region, preferring those of the Society of Friends.

REFERENCES

BEDINI, SILVIO A. "Benjamin Banneker and the Survey of the District of Columbia." *Records of the Columbia Historical Society* 69–70 (1971): 120–127.

———. *The Life of Benjamin Banneker.* New York, 1972.

LATROBE, JOHN H. B. "Memoir of Benjamin Banneker." *Maryland Colonization Journal,* n.s., 2, no. 23 (May 1845): 353–364.

TYSON, MARTHA E. *Banneker, the Afric-American Astronomer. From the Posthumous Papers of Martha E. Tyson. Edited by Her Daughter.* Philadelphia, 1884.

SILVIO A. BEDINI

Bannister, Edward Mitchell (c. 1826–January 9, 1901), painter. Edward Mitchell Bannister was born sometime between 1826 and 1828 in St. Andrews, a small seaport in New Brunswick, Canada. His father Edward Bannister, probably a native of Barbados, died in 1832, and Edward and his younger brother William were raised by their mother, Hannah Alexander Bannister, a native of St. Andrews. Bannister's artistic talent was encouraged by his mother, and he won a local reputation for clever crayon portraits of family and schoolmates.

By 1850, Bannister had moved to Boston with the intention of becoming a painter, but because of his race he was unable to find an established artist who would accept him as a student. He worked at a variety of jobs to support himself, and by 1853 was a barber in the salon of the successful African-American businesswoman Madame Christiana Carteaux, whom he married in 1857.

Bannister continued to study and paint, and began winning recognition and patronage in the African-American community. In 1854 he received his first commission for an oil painting, from African-American physician John V. DeGrasse, entitled *The Ship Outward Bound* (present whereabouts unknown). By 1863 Bannister was featured in William Wells BROWN's book celebrating the accomplishments of prominent African-Americans (Brown, 1863). His earliest extant portrait, *Prudence Nelson Bell* (1864), was commissioned by an African-American Boston family.

Bannister was active in the social and political life of BOSTON's African-American community. He belonged to the Crispus Attucks Choir and the Histrionic Club. His colleagues included such leading black abolitionists as William Cooper NELL, Charles Lenox REMOND, Lewis Hayden, and John Sweat ROCK. He was an officer in two African-American abolitionist organizations (the Colored Citizens of Boston and the Union Progressive Association), added his name to antislavery petitions, and served as a delegate to the New England Colored Citizens Conventions, in 1859 and 1865. In 1864, Bannister donated his portrait of the late Col. Robert Gould Shaw (whereabouts unknown) to be raffled at the Solders' Relief fair organized by his wife to assist the families of soldiers from the Massachusetts Fifty-fourth Colored Regiment.

Bannister is said to have spent a year in New York City in the early 1860s apprenticed to a Broadway photographer; he advertised himself as a photographer from 1863 to 1866. An 1864 photograph of Bannister's early patron Dr. DeGrasse survives from that period. Bannister continued to paint and win commissions, and although he listed himself in city directories as a portrait painter until 1874, works like his *Untitled* [Rhode Island Seascape] and *Dorchester, Massachusetts,* both painted c. 1856, document his beginning interest in interpreting the New England landscape.

In the mid-1860s Bannister began to receive greater recognition in the Boston arts community. Sometime between 1863 and 1865 he received his only formal training, studying in the life-drawing classes given by physician and artist William Rimmer at the Lowell Institute. Bannister took a studio in the Studio Building from 1863 to 1866, where he was exposed to William Morris Hunt's promotion of the French Barbizon painters, and his paintings began receiving favorable notices from Boston critics. His growing confidence as an artist is indicated in two tightly painted monumental treatments of farmers

and animals in the landscape, *Herdsman with Cows* and *Untitled* [Man with Two Oxen], both completed in 1869.

Bannister was part of a community of African-American artists in Boston in the 1860s. Sculptor Edmonia LEWIS had a studio just two doors from him in the Studio Building; portraitist William H. SIMPSON was a neighbor and fellow member of the Attucks Choir and the Histrionic Club; and the young painter Nelson PRIMUS sought out Bannister when he moved to Boston in the mid-1860s.

In 1869, the Bannisters moved to Providence, R.I., where Bannister was immediately recognized by its growing art community. His first exhibit included *Newspaper Boy* (1869), one of the earliest depictions of working-class African Americans by an African-American artist, and a portrait of abolitionist William Lloyd Garrison (whereabouts unknown).

Bannister came to national attention in 1876, when his four-by-five-foot painting *Under the Oaks* (whereabouts unknown) won a first prize medal at the Philadelphia Centennial Exposition. This bucolic view of sheep and cows under a stand of oaks received widespread critical acclaim. But Bannister later remembered how, when he stepped forward to confirm his award, he was "just another inquisitive colored man" to the hostile awards committee.

Recognition for *Under the Oaks* brought Bannister increasing stature and success. By 1878 he sat on the board of the newly created Rhode Island School of Design, and he and fellow artists Charles Walter Stetson and George Whitaker founded the influential Providence Art Club. From 1877 to 1898, Bannister's studio was in the Woods Building, along with artists John Arnold, James Lincoln, George Whitaker, Sidney Burleigh, and Charles Walter Stetson. His Saturday art classes were well attended, and he won silver medals at exhibitions of the Boston Charitable Mechanics Association in 1881 and 1884. He exhibited throughout his career at the Boston and Providence Art Clubs, and also in Hartford, Conn.; New York City; New Orleans; and Detroit. His work was much in demand by New England galleries and collectors, and in 1891 the Providence Art Club featured thirty-three of his works in a retrospective exhibition, to favorable reviews.

A number of Bannister's paintings (including *Woman Walking Down a Path,* 1882; *Pastoral Landscape,* 1881; *Road to a House with a Red Roof,* 1889; *Seaweed Gatherers,*1898) reflect his strong affinity for the style and philosophy of Barbizon artists like Jean-François Millet and Camille Corot. But Bannister drew from numerous sources throughout his career, producing work in a variety of styles and moods, from serene vistas like his *Palmer River* (1885), to the Turner-influenced dramatic skies of *Sunset* (c. 1875–

1880) and *Untitled* [Landscape with Man on Horse] (1884), to free and lushly rendered views of woodland scenery like *Untitled* [Trees and Shrubbery] (1877), in order to express what he described as "the infinite, subtle qualities of the spiritual idea, centering in all created things."

Remembered primarily as a landscape painter, Bannister's subjects also included classical literature (*Leucothea Rescuing Ulysses,* 1891), still life (*Untitled* [Floral Still Life], n.d.), and religion (*Portrait of Saint Luke,* n.d.). His prolific output as a marine painter is represented by numerous drawings and watercolors, and paintings like *Ocean Cliffs* (1884), *Sabin Point, Narragansett Bay* (1885), and *Untitled* [Rhode Island Seascape] (1893).

As in Boston, Bannister associated with, and his work was collected by, leaders of Rhode Island's African-American community. Bannister and his wife continued their involvement in the concerns of their church and community. In 1890 Christiana Carteaux Bannister led the efforts of African Americans to establish a Home for Aged Colored Women in Providence, which is today known as the Bannister Nursing Care Center.

Although he had been experiencing heart trouble in his later years, Bannister continued to paint. Indeed, his late works (*Street Scene,* c. 1895; *The Old Home,* 1899; *Untitled* [Plow in the Field], 1897) reveal an openness to experimentation and growth, with an increasingly abstract consideration of form and color on canvas.

On January 9, 1901, Bannister collapsed at an evening prayer meeting at the Elmwood Street Baptist Church and died shortly thereafter. Held in great esteem by Providence artists and patrons, he was the subject of lengthy tributes and eulogies. In May 1901, his friends in the Art Club organized a memorial exhibition of over one hundred Bannister paintings loaned by local collectors. Later that year, Providence artists erected a stone monument on his grave in North Burial Ground. Christiana Carteaux Bannister died two years later.

REFERENCES

BROWN, WILLIAM WELLS. "Edward M. Bannister." In *The Black Man: His Antecedents, His Genius, and His Achievements.* 1863. Reprint. New York, 1968, pp. 216–217.

HARTIGAN, LYNDA ROSCOE. "Edward Mitchell Bannister." In *Five Black Artists in Nineteenth-Century America.* Exhibition catalog. Washington, D.C., 1985, pp. 69–84.

HOLLAND, JUANITA MARIE. *The Life and Work of Edward Mitchell Bannister: A Research Chronology and Exhibition Record.* New York, 1992.

———. "Reaching Through the Veil: African-American Artist Edward Mitchell Bannister." In

Edward Mitchell Bannister, 1828–1901. Exhibition catalog. New York, 1992, pp. 17–60.

JUANITA MARIE HOLLAND

Baptists. African-American Baptists are Christians who trace their common descent to Africa and share similar Biblical doctrines and congregational policy. They share these values with the broader American Baptist religious tradition. African-American Baptists represent the largest and most diverse group of the many African-American denominations in the United States. They are known for their emphasis on emotional preaching and worship, educational institutions, economic leadership in the community, and sociopolitical activism.

The origin of African-American Baptists must be understood in the context of the interracial religious experiences of colonial American history and the African roots of the spirituality of slaves. White Baptists were initially slow in their evangelistic efforts among African slaves. Language barriers and economic considerations militated against the rapid evangelization of transplanted Africans. However, by the second half of the eighteenth century, a few persistent Baptist evangelists eluded these barriers and converted growing numbers of slaves.

Antebellum Baptists

The movement began largely on plantations in the South where the vast majority of African slaves resided, and it spread to urban areas. Generally, the conversion of slaves tended to follow the denominational lines of white masters. Hence, the numbers of African-American Baptists tended to grow along with the remarkable expansion of Baptists in the South between 1750 and 1850. On occasion, Baptist evangelists were invited by masters belonging to local Baptist congregations to preach to their plantation slaves. On other occasions, masters would allow slaves to accompany them to church or hold devotional services in their own "big houses."

There were scattered instances of African Americans holding membership in biracial churches during the late colonial period. As early as 1772, Robert Stevens and eighteen other African Americans held membership in the First Baptist Church of Providence, R.I. By 1772, the First Baptist Church of Boston was also receiving blacks into its membership. Very likely, the Baptist churches of the South had received some into their membership prior to the 1770s. As a result of interracial evangelizing between 1773 and 1775, David GEORGE organized the first black Baptist church in North America, at Silver Bluff, S.C., near Savannah, Ga. At any rate, this increasing tendency to receive slaves into the Baptist churches created the interracial Baptist church experience in colonial American society.

By the early national period, the presence of slaves exceeded the numbers of whites in a few churches in the South. Whether they were the majority or minority presence in these churches, African-American Baptists were still limited in their membership privileges and responsibilities. Slavery and racism prevented the existence of authentic fellowship based on Christian principles within these early churches. These social pressures later resulted in the demise of racially mixed churches and the emergence of Baptist churches organized along racial lines.

Slave preachers were the first to verbalize the need of churches separate from the white Baptists. Some of them had been previously exposed to leadership roles, having served as religious leaders in Africa. They wanted a style of Baptist life and witness that would permit the free expression of spirituality and the involvement of African-American preachers in pastoral leadership. The first movement toward separate black Baptist churches took place when African Americans stole off to the woods, canebrakes, and remote cabins to have preaching and prayer meetings of their own. These meetings were usually held early in the morning when the patrols over the slaves would retire from night duty to sleep during the day. Hence, early morning prayer meetings were created out of necessity.

Among the early African-American Baptist preachers who pioneered the plantation missions and the movement toward separate churches were "Uncle Jack," who went from plantation to plantation in Virginia in the last quarter of the eighteenth century, preaching to whites as well as African Americans; "Uncle Harry" Cowan, who labored extensively in North Carolina; and George LIELE, who preached on the plantations of South Carolina and Georgia and actually paved the way for the planting of the first separate churches among African-American Christians. Liele's evangelistic ministry inspired the founding of the Silver Bluff Baptist Church in Aikens County, S.C., by David George in the late 1700s and of the First Colored Baptist Church of Savannah, Ga., by Andrew BRYAN in the 1780s. There were other African-American preachers who labored on plantations for the evangelization of slaves and the subsequent separate Baptist church movement, but most of their names are now lost.

Within a decade after the founding of African-American Baptist churches in South Carolina and Georgia, slaves and free blacks in other parts of the country began similar movements away from white-dominated churches and toward the creation of their

own churches. During the AMERICAN REVOLUTION, the African-American Baptists of Petersburg, Va., organized the Gilfield Baptist Church and the Harrison Street Baptist Church in Petersburg, and the first Baptist churches in both Williamsburg and Richmond, Va.

African-American Baptist churches were soon organized in the north. The Joy Street Baptist Church, originally called the African Meeting House, was constituted in Boston in 1805. The ABYSSINIAN BAPTIST CHURCH of New York City was organized in 1808, presumably by a group of traders who came to New York City from Ethiopia. These were followed by Concord Baptist Church of Brooklyn, N.Y. (May 18, 1847); the First African Baptist Church, Philadelphia, Pa. (June 19, 1809); the First African Baptist Church, Trenton, N.J. (1812); the Middlerun Baptist Church, Xenia, Ohio (1822); and the First Colored Peoples' Baptist Church of Baltimore (1836). This lists only some of the more important churches.

The roots of the Baptist cooperative movement go back to the antebellum period. In the early 1830s, organizational consciousness emerged among black Baptists in Ohio with the evolution of the associational movement. Baptists began to see the need for united Christian ministries among churches in near proximity. Hence, local churches began the formation of associations to advance such causes as education, home missions, and foreign missions. In 1834, they organized the Providence Baptist Association in Berlin Cross Roads, Ohio. This was followed by the founding of a politically oriented movement called the Union Anti-Slavery Baptist Association, also organized in Ohio in 1843. Slowly, the associational movement spread to other states. The organization of Baptist state conventions began in North Carolina with the founding of the General State Convention in 1866.

The cooperative efforts of African-American Baptists were prompted by a growing consciousness of an interest in doing missionary work in Africa. Lott CAREY and other pioneer African-American missionaries inspired early church leaders to seek even greater cooperation among their separate churches. As early as 1840, black Baptists of New England and the Middle Atlantic states met in New York's Abyssinian Baptist Church to organize the American Baptist Missionary Convention, their first cooperative movement beyond state lines.

Civil War and the Era of Church Growth

The CIVIL WAR era and RECONSTRUCTION gave impetus to the organization of several cooperative movement bodies. The Baptists of the West and Southwest met in St. Louis in 1864 and organized the Northwestern and Southern Baptist Conventions. In 1866, these two regional conventions met in a special session in Richmond, Va., and organized the Consolidated American Baptist Convention, representing 100,000 black baptists and two hundred ministers. The new convention was an attempt to promote unity and discourage sectionalism, and to create a national spirit of cooperation. The work of the Consolidated Convention was fostered by the formation of district auxiliary conventions, state conventions, and associations.

In 1873 the African-American Baptists of the West organized the General Association of the Western States and Territories; and in 1874 those in the East organized the New England Baptist Missionary Convention. These two bodies soon overshadowed the spirit of unity expressed in the Consolidated American Baptist Convention. A persistent spirit of independence and sectionalism on the part of both eastern and western Baptists caused the decline of the Consolidated Baptist Convention, and resulted in its termination at the last meeting in Lexington, Ky., in 1878. A vacuum in the cooperative missionary movement resulted.

In response, William W. Colley, a missionary to Africa appointed by the Foreign Mission Board of the Southern Baptist Convention, returned to the United States with a determination to revive a cooperative spirit among African-American Baptists. He led the way for the organization of the Baptist Foreign Mission Convention on November 24, 1880, in Montgomery, Ala. This convention effectively revived an expanding interest in the evangelization of Africa. (*See also* MISSIONARY MOVEMENTS.)

The next steps toward separate denominational development were with the organization of the American National Baptist Convention (1893) and the Tripartite Union (1894). These organizations merged to form the first real denomination among African-American Baptists with the founding of the National Baptist Convention (NBC) U.S.A. on September 28, 1895. For the first time, the combined ministries of the churches throughout the nation were fostered by a separate national organization of African-American Baptists.

Primitive Baptists

A number of African-American baptists were opposed to the organization of missionary associations, in part because the Arminianism of the mid-nineteenth century revivals was in conflict with traditional notions of predestination. The major outgrowth of the anti-mission movement was the rise of the African-American Primitive Baptists. Initially, Primitive Baptists inherited their anti-mission spirit from white Baptists. As early as 1820, the St. Barley

Primitive Baptist Church of Huntsville, Ala. (originally organized as the Huntsville African Baptist Church), evolved as one of the earliest separate Primitive Baptist churches. Subsequently, a number of churches joined with them.

By 1907 these churches had gained sufficient strength to organize themselves into the National Primitive Baptist Convention. However, their rate of growth was far below that of the National Baptists. Still smaller in numbers and influence are the United American Freewill Baptists. Both the Primitive and Freewill Baptists constitute a minority presence among African-American Baptists.

The question of missions also played a major role in a split at the National Baptist Convention, U.S.A. In 1897 a controversy erupted in the annual session of the convention convening in Boston. The major issues in dispute were the financial administration of foreign mission programs and cooperation with white Baptists. The majority opinion favored the fiscal policy of the convention and the exclusive operation of the denomination independent of white Baptist influence.

However, a minority of delegates from Virginia, North Carolina, and several other Atlantic seaboard states, as well as Washington, D.C., decided to organize a separate missionary society that, with white support, was designed exclusively to advance a foreign mission enterprise. They met at the Baptist Church, in Washington, D.C., and organized the Lott Carey Baptist Foreign Mission Convention. These leaders adopted a constitutional provision requiring at least 75 percent of all funds collected by the convention to be sent to foreign missions.

The great cleavage within the National Baptist Convention, U.S.A., during its formative years came in 1915. All effort to maintain unity and harmony within the convention had previously posed vexing challenges to the officials. Unlike the crisis which led to the Lott Carey Convention movement, the crisis of 1915 was primarily a legal problem regarding the ownership and management of the National Baptist Publishing Board, headquartered in Nashville. Signs of dissent within the leadership of the convention were apparent for almost a decade before the actual separation of 1915.

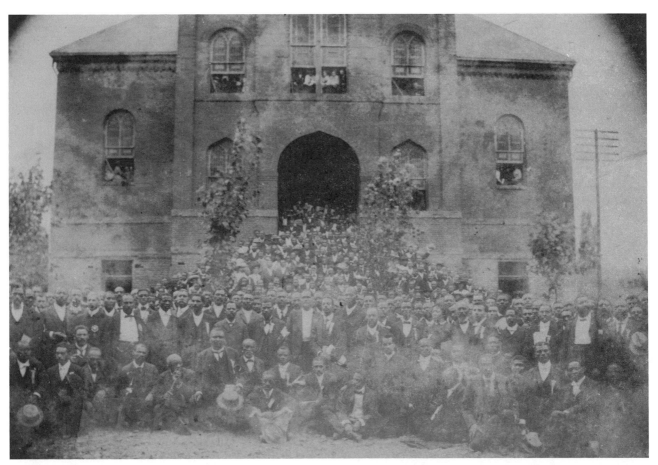

National Baptist Convention, Birmingham, Ala., September 1903. (Photographs and Prints Division, Schomburg Center for Research in Black Culture, The New York Public Library, Astor, Lenox and Tilden Foundations)

The crisis came to a head during the annual session in Chicago. It took the form of a legal struggle between two groups: the majority, who supported convention control of the publishing board, and those who favored the independence of the publishing board as a separate corporate entity. The court decided in favor of the majority, and unity between the factions could not be restored. The result was the organization of a new denomination. The majority faction incorporated as the NATIONAL BAPTIST CONVENTION U.S.A., Inc; the minority group met at the Salem Baptist Church and organized the National Baptist Convention of America, on September 9, 1915. It is now called the National Baptist Convention of America. Members of the publishing board played the key role in the development of the new denomination. Its policies are similar to those of the National Baptist Convention, U.S.A., Inc.

Progressive National Baptist Convention

The Progressive National Baptist Convention of America, Inc., organized in 1961, grew out of a major crisis within the National Baptist Convention, U.S.A., relating to the issues of tenure and civil rights strategies. Joseph H. JACKSON, the president of the National Baptist Convention, was opposed to the civil rights agenda of the SOUTHERN CHRISTIAN LEADERSHIP COUNCIL (SCLC) and related organizations. He was opposed by Gardner C. Taylor, pastor of Concord Baptist Church, Brooklyn, N.Y., and the Rev. Martin Luther KING, Jr., president of the SCLC.

The initial struggle erupted in 1961 when Taylor challenged Jackson's bid for reelection to the presidency on the grounds that Jackson had exceeded the tenure requirement. The challenge was marked by violence, controversy, and a legal battle. The "Taylor team" was determined to defeat Jackson and plan a new course for the convention. However, Jackson's popularity prevailed in the vote on the floor of the convention and was upheld in the civil court. The Taylor team did not accept this defeat since they were determined to lead African-American Baptists in a new and progressive direction, especially in the area of civil rights.

On September 11, 1961, a national news release invited progressive-minded leaders to join forces with the Taylor team and organize a new denomination named the Progressive National Baptist Convention of America, Inc. The new denomination promoted the civil rights program of Martin Luther King, Jr., and launched a program of cooperation with the largely white American Baptist Churches, U.S.A. The new program was called the Fund of Renewal, designed to promote specialized mission projects. Moreover, this program also engendered a new spirit of cooperation between African-American and white Baptists.

Black Baptism was one of the anchors of the CIVIL RIGHTS MOVEMENT, with Baptist ministers such as Vernon JOHNS, Benjamin MAYS, Adam Clayton POWELL, JR., Martin Luther King, Jr., David ABERNATHY, and Gardner Taylor in the forefront of the struggle for black equality. The contribution of black Baptists to the civil rights movement, and the inspiration that it has provided to both Americans and oppressed people elsewhere, will no doubt prove to be one of the greatest legacies of twentieth-century African-American Baptists.

The vast majority of African-American Baptists have been strong supporters of foreign missions. Early pioneers of the missionary enterprise, besides Lott Carey and George Liele, were Prince Williams and W. W. Colley. These men set the stage for an aggressive missionary program in India, Africa, Central America, and the West Indies. With the rise of foreign missions boards among the denominations, African-American Baptists developed a sophisticated approach to the evangelization of non-Christians. They developed schools, hospitals, clinics, and agricultural projects, and they planted new churches in various parts of the world. The Lott Carey Baptist Foreign Mission Convention pioneered the movement to utilize indigenous people in leadership positions on the foreign fields, a movement that facilitated the philosophy of self-help and independence among peoples in developing nations. Many of the leaders within these nations came out of the missionary agencies.

One of the important changes in the black Baptist church in recent decades has been the changing status of women. Nannie Helen BURROUGHS (1883–1961), through her longtime leadership of the Women's Convention Auxiliary of the National Baptist Convention, was a dominant figure in twentieth-century African-American Baptist life. For the most part, however, women were not allowed until recently to be preachers or take active roles in church leadership. The Baptists were slow to ordain women for the ministry; black women were not ordained until the 1970s and even then in small numbers. Nor have women been allowed until recently other positions of leadership within the church, such as deacon. The bias against promoting women to positions of prominence in the Baptist church is changing, although too slowly for many.

Education

The ministry of education of African-American Baptists has been in the forefront of the cooperative programs of associations, state conventions, and national conventions. The Civil War marked the beginning of strong cooperative strides among local churches to

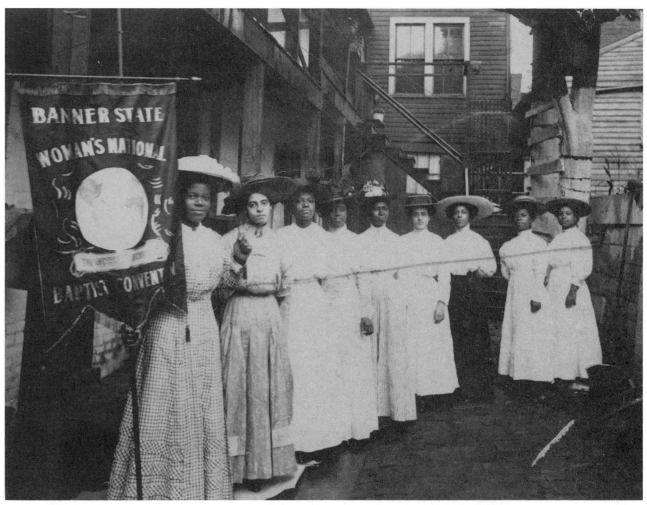

Nannie Burroughs, holding the banner, founded the Women's Convention, an auxiliary of the National Baptist Convention, U.S.A., in 1900 and led it for several years, ensuring that women would have a significant role in the governance of the National Baptist Convention. (Prints and Photographs Division, Library of Congress)

advance the intellectual development of blacks. Many churches served as schools during the week and houses of worship on Sundays. Moreover, local associations organized schools in many of the rural areas and small towns of the South. With the rise of public education, most of the associational secondary schools closed.

The development of higher education for African Americans, however, has been among the lasting contributions of African-American Baptists. The magnitude of the task prompted African-American Baptists to cooperate with whites in the development of schools of higher learning. This evolution may be classified into two groups: cooperative schools with whites and independent African-American schools. There are a number of Historically Black Colleges and Universities (HBCU) that were founded with Baptist support. These colleges, most of which were created in the South in the postbellum years, had two main purposes. Some of these schools were seminaries and

helped train young men for the ministry. An even more pressing task in the minds of many of the college founders was to create a cadre of teachers that in turn could educate freedmen in primary schools. However, due to funding problems, many of the Baptist HBCUs functioned as little more than secondary schools in their early decades.

Many Baptist HBCUs were founded by whites, one of the driving forces being the American Baptist Home Mission Society (ABHMS). Wayland Seminary, the first seminary for black Baptists, later incorporated into Virginia Union University, opened in Washington, D.C., in 1865. Another root of the Virginia Union University was the Richmond Theological Center, founded in Richmond, Va., also in 1865. Other HBCUs founded by white Baptists include Shaw University (originally Raleigh Institute, 1865) in Raleigh, N.C.; MOREHOUSE COLLEGE (originally Augusta Institute, 1867) in Atlanta, Ga.; SPELMAN COLLEGE (originally Atlanta Baptist Female Semi-

nary, 1881) in Atlanta; Benedict College in Columbia, S.C. (1870); Jackson State University (originally Natchez Seminary, 1877) in Jackson, Miss.; and Florida Memorial College (originally Florida Baptist Institute, 1879) in Miami, Fla.

Many of these schools represent substantial efforts by white Baptists in the intellectual development of African Americans. They financed, administered, and staffed most of these schools. Only gradually did African-American Baptists assume responsibility for directing the schools. A number of schools also were founded by African-American Baptists, but because of problems with funding, they had severe operating difficulties and had to close. The first independent African Baptist school of higher learning founded by black Baptists was Guadelupe College in Seguin, Tex. Others appeared in rapid succession: Houston College at Houston, Tex. (1885); Walker Baptist Institute, Augusta, Ga. (1888); and Friendship Baptist College in Rock Hill, S.C. (1891). Only Morris College in Sumter, S.C. (1908) remained open in the 1990s.

In the early twentieth century, Baltimore became a center of Baptist seminaries. The Colored Baptist Convention of Maryland organized Clayton-

Williams Academy and Biblical Institute in 1901; the Maryland Baptist Missionary Convention organized Lee and Hayes University in 1914; the Independent Colored Baptist Convention organized Williams and Jones University in 1928; and the United Baptist Missionary Convention organized Maryland Baptist Center and School of Religion in 1942. These Baltimore schools were largely the result of convention rivalry and survived only a few years. In 1921 two other schools were organized: Central Baptist Theological Seminary at Topeka, Kan., and Northern Baptist University, Rahway, N.J. Both schools provided educated leadership for blacks, and many of the graduates have helped to advance the social, political, economic, and religious progress of African Americans. The Interdenominational Theological Center in Atlanta, Ga., was formed in 1958 by a merger of a number of African-American seminaries, including the former Morehouse School of Religion.

Music and Liturgy

From the beginning of separate religious services, African-American Baptists utilized music in their worship. This music was an expression of the deep sentiment of the people as they reacted to the severe

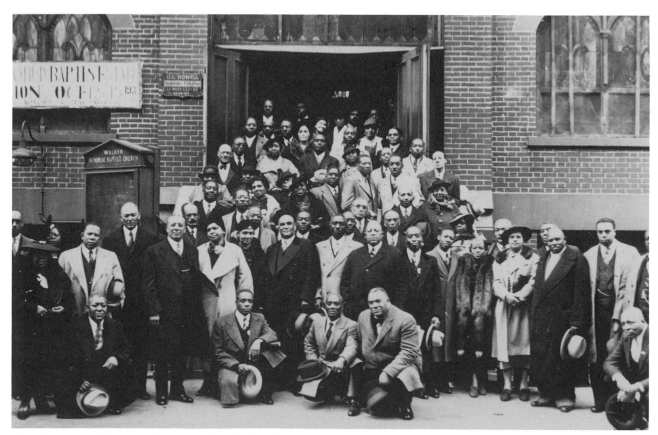

Members attending the State National Baptist Convention, Harlem, N.Y., 1939. (Photographs and Prints Division, Schomburg Center for Research in Black Culture, The New York Public Library, Astor, Lenox and Tilden Foundations)

oppression of life in America. It grew out of the secular songs of plantation slave-labor gangs. As slaves were converted to Christianity, they incorporated their new religious beliefs into the songs of the plantations. The result was Negro SPIRITUALS. These songs played a major role in church life until the postbellum era, when Protestant hymns from the white religious experience began to become more important in church services. Groups such as the FISK JUBILEE SINGERS (1871) sustained the spiritual tradition in the late nineteenth century. Their concert tours of Europe and America introduced concert spirituals to a new and highly receptive audience.

Gospel music has been one of the most important innovations in church services in the twentieth century. Thomas A. DORSEY, a pioneer GOSPEL MUSIC composer, exponent, and instructor, was largely responsible for the introduction of gospel music in the worship of these churches. In 1932, the National Convention of Gospel Choirs was organized to promote the work of Dorsey in the churches. This organization encouraged the introduction of contests of choirs, quartets, and soloists in local churches. Two other major individuals contributed to the development of music in the religious experience of African Americans; James A. Cleveland, through his National Workshop Choir, and Glenn T. Settle, originator of WINGS OVER JORDAN, a nationally acclaimed chorus. Subsequently, most of the performing artists in the broader culture received training, inspiration, and exposure from serving in local church choirs and choruses. Currently, many African-American Baptist churches are influenced by recording artists on popular gospel music radio stations.

Similarly, drama has played a role in the development of African-American Baptist churches. African-American preaching itself emerged as a unique art form. The dramatic presentation of the sermon was characteristic of these churches; preachers literally acted out the contents of their messages to their congregations. Moreover, these churches served as the central stage for dramatic presentations of other performing artists in talent shows, plays, and pageants. The recitation of religious poetry became a component of the artistic expression of church programs.

Painting has been less influential in African-American Baptist churches, which have tended to accept white expressions of religious art. However, the Black Power and Black Theology movements (see THEOLOGY, BLACK) altered the art works in the churches. Currently, some churches, like New Shiloh Baptist Church of Baltimore, are developing Afrocentric murals of the Last Supper, the Crucifixion, and scenes from African-American life and culture.

Because of the inherent autonomy of African-American Baptists, there remains much variety in size, political involvement, and religious practice of independent congregations. Some of the larger urban churches, such as Shiloh Baptist Church in Washington, D.C., Mount Olivet in Chicago, Concord Baptist Church in Brooklyn, and the Abyssinian Baptist Church in Harlem, have long been centers of community activity and have also served as political bases for their pastors. On the other hand, small rural Baptist churches, while their numbers have declined somewhat in recent years, remain the backbone of numerous communities.

Since the 1930s, and with even more emphasis since the '60s, many black Baptist pastors have emphasized the social aspects of their ministry, and have stressed social outreach, working with disaffected teenagers and prison populations and discouraging drug use. Baptism remains the largest denominational group among African Americans and continues to shape black cultural, political, and spiritual life in countless ways. In 1990 there were approximately twelve million African-American Baptists. Black Baptists will likely continue to endure and change in response to the myriad challenges of contemporary African-American life.

REFERENCES

BOYD, JESSE L. *A Popular History of the Baptists in Mississippi.* Jackson, Miss., 1930.
HIGGINBOTHAM, EVELYN BROOKS. *Righteous Discontent: The Women's Movement in the Black Baptist Church, 1880–1920.* Cambridge, Mass., 1993.
LINCOLN, C. ERIC, and LAWRENCE H. MAMIYA. *The Black Church in the African-American Experience.* Durham, N.C., 1990.
LUMPKIN, WILLIAM L. *Baptist Confessions of Faith.* Philadelphia, Pa., 1959.
PIEPKORN, ARTHUR CARL. "The Primitive Baptists of North America." *Concordia Theological Monthly* (May 1971): 297–313.
SOBEL, MECHAL. *Trabelin' On: The Slave Journey to an Afro-Baptist Faith.* Westport, Conn., 1979.
———. *The World They Made Together: Black and White Values in Eighteenth-Century Virginia.* Princeton, N.J., 1987.
WASHINGTON, JAMES M. *Frustrated Fellowship: The Black Baptist Quest for Social Power.* Macon, Ga., 1986.

LEROY FITTS

Baraka, Amiri (Jones, LeRoi) (October 7, 1934–), poet, playwright. Amiri Baraka, born Everett LeRoi Jones in 1934, first gained fame as a poet and playwright in New York's Greenwich Village and subsequently became the most prominent and

influential writer of the BLACK ARTS MOVEMENT. Throughout his career, Baraka has been a controversial figure, noted for his caustic wit and fiery polemics. In his poems, plays, and essays, Baraka has addressed painful issues, turning his frank commentary upon himself and the world regarding personal, social, and political relations. As a stylist, Baraka has been a major influence on African-American poetry and drama since 1960; and as a public figure, he has epitomized the politically engaged black writer.

Raised in Newark, N.J., Baraka attended Howard University and served briefly in the U.S. Air Force: an episode that his autobiography describes as "Error/Farce." As Baraka explains, his subscriptions to *Partisan Review* and other literary magazines led authorities to suspect him of communist affiliations, and he was "undesirably discharged." He subsequently moved to Greenwich Village, where he met and married another young writer, Hettie Cohen. They had two daughters, Kellie and Lisa. Baraka, known as LeRoi Jones in this period, gained notoriety in the Village literary scene, frequently publishing, reading, and socializing alongside Diane di Prima, Allen Ginsberg, Jack Kerouac, and other Beat movement figures. He and Cohen edited *Yugen,* an avant-garde literary magazine, and his book *Preface to a Twenty Volume Suicide Note* (1961) established him as a major voice among the new poets.

During this period he published his celebrated essay "Cuba Libre," a New Journalistic travelogue about visiting Cuba shortly after the revolution. This essay marked the beginning of his movement toward radical politics and away from his bohemian associates. His early political essays were eventually collected in *Home* (1966). Similarly, his book *Blues People* (1963) introduced his continuing interest in jazz as a key to African-American culture. Baraka's plays of this period, emotionally intense and quasi-autobiographical, culminate with *Dutchman* (1964), an Obie winner that remains his most famous and admired work. *Dutchman* explores the manic tension and doomed attraction between a black man and a white woman riding in the New York subway. Like *The Slave* (1965) and his second volume of poems, *The Dead Lecturer* (1965), this work reflects the racial anxieties that would soon estrange him from his white wife and Village friends.

After the assassination of MALCOLM X on February 21, 1965, LeRoi Jones abandoned his family, moved to Harlem, and changed his name to Imamu Amiri Baraka (Blessed Priest and Warrior). Entering a period of intense black cultural nationalism, he directed the Black Arts Repertory Theater and School in Harlem while continuing to publish prolifically throughout the late 1960s. His important books of this period include *Black Magic Poetry* (1969), *Four Black Revolutionary Plays* (1969), *Raise Race Rays Raze* (1971), and *Black Music* (1968). Many of these works attack whites and assail Negro false consciousness, advocating an authentic black identity as the prerequisite to political liberation.

In the 1970s, Baraka renounced cultural nationalism, dropped "Imamu" from his name, and embraced what he called "Marxism/Leninism/Mao Tse Tung Thought." His subsequent writing has remained in a Marxist mode, but with a strong African-American and Third World orientation. Some of these later works lapse into schematically pedantic social commentaries and crude, unimaginative polemics. At his best, however, in long poems such as "In the Tradition" and "Wailers," Baraka demonstrates his continuing brilliance, combining music, sports, and political struggle into a densely realized vision of African-American culture as a triumphant, complexly expressive tradition.

The most comprehensive collection of Baraka's work is *The LeRoi Jones/Amiri Baraka Reader,* edited by William J. Harris. Baraka lives in Newark with his wife and collaborator, Amina, and is a professor of African Studies at SUNY–Stony Brook.

Amiri Baraka combined cultural nationalism and community and political organizing with a scalding rhetorical voice. His example provided a model and inspiration to many in the Black Arts movement. (Shawn Walker)

REFERENCES

BARAKA, AMIRI. *The Autobiography of LeRoi Jones.* New York, 1984.
BENSTON, KIMBERLY. *Baraka: The Renegade and the Mask.* New Haven, 1976.
HUDSON, THEODORE. *From LeRoi Jones to Amiri Baraka.* Washington, D.C., 1971.

SOLLORS, WERNER. *Amiri Baraka/LeRoi Jones: The Quest for a "Populist Modernism."* New York, 1978.

DAVID LIONEL SMITH

Barbadoes, James G. (c. 1796–January 22, 1841), abolitionist. Little is known about the birth or early life of James Barbadoes. By 1830, he was living in Boston and had emerged as a leader of the Boston African-American community, supporting himself as a clothes dealer and barber.

Barbadoes was a leader with David WALKER in the Massachusetts General Colored Association, founded in 1826, and served as its secretary. In 1831, he was delegate to the Convention of the People of Color, in Philadelphia.

Barbadoes was an associate and admirer of the abolitionist William Lloyd Garrison (*see* ABOLITION), and named a son after him. He was one of three blacks among the founders of Garrison's AMERICAN ANTI-SLAVERY SOCIETY, established in Philadelphia in 1833, and served on its board of managers from 1833 to 1836. In 1834, he helped organize the annual meeting of the New England Anti-Slavery Society, where he spoke of his recent efforts to free his brother from prison. Robert Barbadoes, a free man born in Boston, had been kidnapped in New Orleans, jailed, and threatened with slavery. It took five months of agitation by Barbadoes, and letters from the governor of Massachusetts, for him to be released.

Barbadoes was opposed to black American colonization of Africa, and publicly supported Garrison against conservative abolitionists within the Anti-Slavery Society on this as well as other issues, including women's rights. However, after his involvement in a project in 1840 to recruit free black settlers to British Guiana, Barbadoes became interested in leaving the United States. Shortly afterward, he emigrated with his family and a group of other blacks to Jamaica, intending to farm silkworms. However, two of his children died of malaria soon after they arrived. Barbadoes himself perished of the same disease the following year.

REFERENCES

APTHEKER, HOWARD. *A Documentary History of the Negro People in the United States.* New York, 1951.
HORTON, JAMES, and LOIS HORTON. *Black Bostonians.* New York, 1979.
QUARLES, BENJAMIN. *Black Abolitionists.* New York, 1969.

LYDIA MCNEILL

Barber, Jesse Max (July 5, 1878–September 20, 1949), journalist and dentist. J. Max Barber, the child of ex-slaves, was born in Blackstock, S.C. He attended secondary school at the Friendship Institute in Rock Hill, S.C., and was trained as a teacher at Benedict College in Columbia, S.C. Barber earned a bachelor's degree from Virginia Union University in Richmond in 1903, where he was president of the Literary Society and student editor of the *University Journal.*

Shortly after leaving Virginia Union, Barber met Austin Jenkins, a white publisher who wanted to establish a new black journal, *Voice of the Negro,* in Atlanta. Barber was recruited as managing editor and John Wesley Edward Bowen, a professor at Gammon Theological Seminary, became general editor. Under Barber's leadership, *Voice of the Negro,* which was founded in January 1904, became the foremost black journal of its time, reaching fifteen thousand subscribers at its peak in 1906. This monthly periodical contained poetry, stories, news, reviews, and hard-hitting editorials. Contributors came from varying political perspectives and included W. E. B. DU BOIS, T. Thomas FORTUNE, Mary Church TERRELL, and Pauline HOPKINS.

Barber was forthright on many issues and an unrelenting opponent of racial injustice. He examined race relations in foreign countries, condemned disfranchisement in the United States, and defended the rights of women. In 1905, he responded to Du Bois's call to establish the NIAGARA MOVEMENT to challenge the accommodationism of Booker T. WASHINGTON. Barber became an outspoken critic of Washington, questioning the value of industrial education and denouncing conciliatory politics.

Barber took his boldest position after the ATLANTA RIOT in 1906. He countered prevalent assumptions that the riot was the fault of blacks in Atlanta and redirected responsibility to unscrupulous white politicians and sensationalist newspaper reporting. Barber's position outraged conservative blacks and whites in Atlanta, including the police commissioner, who warned Barber to leave town. Barber immediately relocated his journal to Chicago and was consequently called a coward by his critics.

Booker T. Washington, a powerful figure in black politics, conspired to control the editorial policies of *Voice of the Negro.* When that failed, he contacted the white publishers and convinced them to pressure Barber to mute his criticism of Washington. In the spring of 1907, the publishers negotiated to sell the magazine to Washington, who ultimately decided against the purchase. By the fall of 1907, the magazine was heavily in debt and was forced to close.

Washington's enormous influence on the African-American press continued to harm Barber's career

and forced him to leave journalism altogether. Barber moved to Philadelphia and entered dental school at Temple University. After graduating in 1912 he opened an office and developed a successful dental practice. But he remained committed to social and political change. He was president of the Negro Professional Club of Philadelphia and was on the executive committee of the national NAACP from 1919 to 1921 and on the local executive committee from 1921 to 1924. Barber was also the president of the John Brown Memorial Association, which after many years of effort, succeeded in 1935 in erecting a statue of the abolitionist leader (*see* JOHN BROWN'S RAID) at his gravesite in North Elba, N.Y. Thereafter, Barber's active public life diminished. He died in Philadelphia in 1949.

REFERENCES

BULLOCK, PENELOPE L. *The Afro-American Periodical Press, 1838–1909.* Baton Rouge, 1981.

HARLAN, LOUIS. "Booker T. Washington and the *Voice of the Negro, 1904–1907.*" *Journal of Southern History* 45, no. 1 (February 1979).

JOHNSON, ABBY ARTHUR, and RONALD M. JOHNSON. *Propaganda and Aesthetics: The Literary Politics of African-American Magazines in the Twentieth Century.* Amherst, Mass., 1991.

JOSHUA BOTKIN
PAM NADASEN

Barboza, Anthony (1944–), photographer. Born in New Bedford, Mass., Anthony Barboza moved in 1963 to New York City to study photography. While attending school, he met fashion photographer Hugh Bell, with whom he studied printing. Concurrently he joined a group of African-American photographers called the Kamoinge Workshop, who met periodically to discuss and critique each other's work.

Self-portrait of Anthony Barboza titled *Introspect,* 1982 (original in color). (© Anthony Barboza)

Barboza joined the Navy in 1965 and worked part-time as a base photographer. After his discharge in 1970, he opened his own studio and began what became a lucrative business in fashion photography. In 1975, he started experimenting with portraiture. These pictures are of close friends, well-known artists, athletes, and models. He received a grant from the National Endowment for the Arts in 1980 that enabled him to publish these portraits in his first book, *Black Borders*.

Barboza's subjects are often in motion and the photographs are sometimes blurred, giving these pictures an accidental, almost mystical quality. He uses off-beat compositional formats, such as tilted horizons and dramatic strobe lighting. Sometimes he creates backgrounds with metallic spray paints and other objects. Of his portraiture, Barboza says, "When I shoot a portrait, I meet another person's space. I interpret it and define it."

Barboza writes poetry and short stories. A founder of the International Black Photographers, an organization dedicated to recognizing the works of living black photographers, he also collects images produced by nineteenth-century black photographers. Barboza's work has been exhibited widely and is in several important collections. His work has also appeared in numerous publications such as EBONY, *Essence, Esquire, Camera, Vogue,* and American photographic magazines.

REFERENCES

BARBOZA, ANTHONY. *Black Borders,* with poetry by Ntozake Shange and Steven Barboza. Self-published. New York, 1980.
EDELSON, MICHAEL. "The Four Faces of Barboza." *35mm Photography* (Spring 1977).

NASHORMEH N. R. LINDO

Barnes, Robert Percy (February 26, 1898–March 18, 1990), chemist and educator. Barnes was born in Washington, D.C., the son of William and Mary Jane (Thomas) Barnes. A graduate of Dunbar High School in Washington, he attended Amherst College (B.A., 1921) and served there as a research assistant in chemistry (1921–1922) before joining the faculty at HOWARD UNIVERSITY. He earned graduate degrees in chemistry at Harvard University (A.M., 1930; Ph.D., 1933), where his doctoral thesis was entitled "The Reactions and Keto-Enol Equilibria of an Alpha Diketone."

Barnes published forty papers, mostly in *Journal of the American Chemical Society,* but also in *Organic Syntheses, Journal of Organic Chemistry, Industrial and Engineering Chemistry,* and *Journal of Chemical and Engineering Data*. He often cowrote with graduate students whom he mentored at Howard. Among these were George W. Reed, who became senior scientist at the Argonne National Laboratory in 1968, and Wendell M. Lucas, professor of surgery and chief of the urology division at Howard University.

In addition to his teaching and research, Barnes served on the first National Science Board of the National Science Foundation, established in 1950, with twenty-three other prominent scientists appointed by President Harry S. Truman. Their mission was to develop a national policy for the promotion of basic research and education in the sciences. In 1952, Barnes's reappointment to a six-year term on the board was confirmed by the U.S. Senate. He served until 1958.

A lifelong resident of Washington, D.C., Barnes retired in 1967 and died on March 18, 1990. He was twice married, first to Ethel Hasbrock (1922), then to Florence Abrams (1933).

REFERENCE

WADE, HAROLD, JR. *Black Men at Amherst.* Amherst, Mass., 1976, pp. 25–26, 42.

PHILIP N. ALEXANDER

Barnes, William Harry (April 4, 1887–January 15, 1945), physician, surgeon, otolaryngologist, and inventor. Barnes was born in Philadelphia, the son of George W. and Eliza Webb Barnes. His family was poor, and he worked his way through high school. In 1908, he became the first African American awarded a four-year scholarship to the University of Pennsylvania Medical School. After graduating with an M.D. in 1912, he did a one-year internship at Douglass Hospital and Mercy Hospital, Philadelphia.

Barnes practiced all his life in Philadelphia. Early in his career, he had a general practice and served as assistant otolaryngologist at Douglass Hospital. In the early 1920s, he decided to limit his practice to ear, nose, and throat treatment—making him one of the first blacks to follow this route at a time of growing specialization in medicine. After taking a postgraduate course at the University of Pennsylvania in 1921, he was appointed chief otolaryngologist at Douglass Hospital and consulting otolaryngologist at Mercy Hospital. He also attended courses at the Universities of Paris and Bordeaux. When the American Board of Otolaryngology awarded him his diploma in 1927, he became the first board-certified black specialist. Commuting from Philadelphia, he served as lecturer

on bronchoscopy at Howard University Medical School (1931–1945).

Barnes invented a hypophyscope for visualizing the pituitary gland. Active in a number of medical societies, he was elected the thirty-seventh president of the National Medical Association in 1936. He cofounded (1931) and served as executive secretary of the Society for the Promotion of Negro Specialists in Medicine, the objective of which was "to stimulate, encourage, assist and promote the development of specialists among the Negro medical profession." Barnes was married to Mattie E. Thomas, with whom he had five sons. Two of his sons, Lloyd T. Barnes and Leroy T. Barnes, also pursued careers in medicine.

REFERENCE

COBB, W. MONTAGUE. "William Harry Barnes, 1887–1945." *Journal of the National Medical Association* 47 (January 1955): 64–66, 69.

PHILIP N. ALEXANDER

Barnett, Claude Albert (1889–August 2, 1967), journalist and entrepreneur. Claude Barnett was born in Sanford, Fla., but he moved to Illinois when he was very young to live with relatives. He received an engineering degree from Tuskegee Institute in 1906. From 1906 to 1915 he worked as a postal clerk in Chicago, and then as an advertising salesman for the *Chicago Defender*. In 1913 he created a mail-order business to market reproduced photographs of famous African Americans, and in 1918 he and several other businessmen established the Kashmir Chemical Company, a cosmetics firm.

As advertising manager for Kashmir, Barnett traveled to newspaper offices across the United States. On these sales trips he became aware of the need for a news service geared to black newspapers, which was concerned with news items specifically relevant to the African-American community. In 1919, he founded the Associated Negro Press (ANP). By 1935, the ANP was serving over 200 subscribers in the United States, and after World War II its membership grew to include more than 100 African newspapers, as well. During World War II, Barnett joined other black newsmen in pressuring the U.S. government to accredit black journalists as war correspondents. He traveled a great deal gathering information and wrote many articles himself on the adverse effects of segregation in the armed forces.

Barnett was also concerned about the terrible living conditions of black tenant farmers. Accordingly, from 1942 to 1953 he served as a consultant to the Secretary of Agriculture in an effort to improve these conditions. He was a member of Tuskegee's board of directors until 1965, and was also on the board of governors of the American Red Cross. Barnett served for more than twenty years on the board of directors of Chicago's Supreme Liberty Life Insurance Company, and was for a time president of the board of directors of Provident Hospital in Chicago. The ANP ceased operating after Barnett died of a cerebral hemorrhage in 1967.

REFERENCES

LOGAN, RAYFORD W., and MICHAEL R. WINSTON, eds. *Dictionary of American Negro Biography*. New York, 1982.

Obituary. *New York Times,* August 3, 1967.

LYDIA MCNEILL

Barnett, Etta Moten (November 24, 1902–), concert singer. Etta Moten Barnett was born probably in 1901 or 1902, in a small town near San Antonio, Tex., to Rev. Freeman Moten, a minister in the African Methodist Episcopal Church, and his wife. She moved frequently during childhood, attending elementary and secondary schools in Waco, Tex., Los Angeles, and Kansas City, Kan. Moten married at age seventeen, had three daughters, and was divorced soon after. She received a bachelor of fine arts degree from the University of Kansas in Lawrence, majoring in voice, and did graduate work in speech and psychology at Northwestern University. Moten performed in concerts and church choirs and on radio programs, as both soloist and choir member. Her senior recital at the University of Kansas in 1931 earned her an invitation to perform solo work with the Eva JESSYE Choir in New York City.

During the 1930s Moten appeared in the Broadway musicals *Fast and Furious* (1931), *Sugar Hill* (1931), *Zombie* (1932), and *Lysistrata* (1933), a drama with Rex Ingram and Leigh Whipper. In Hollywood she introduced the song "Carioca" in the film *Flying Down to Rio* (1933), and she sang the featured song, "My Forgotten Man," in *Gold Diggers of 1933*.

In 1934, the year in which she married Claude BARNETT, founder of the Associated Negro Press, Moten auditioned for the role of Bess in the original Broadway production of George Gershwin's *Porgy and Bess,* but it was given to Anne Wiggins BROWN. When Brown left the company in 1942, however, the part was arranged for Moten's voice and she sang the role for three years. Thereafter, she continued to present concerts around the world.

REFERENCE

ALPERT, HOLLIS. *The Life and Times of Porgy and Bess.* New York, 1990.

JAMES STANDIFER

Barrett, Janie Porter (August 9, 1865–August 27, 1948), social reformer and educator. Janie Porter Barrett was born in Athens, Ga., and raised in the home of a wealthy patrician family, the Skinners. Her mother, Julia Porter, worked in the Skinner house as a housekeeper and seamstress. Little is known about her father, who may have been white.

Porter was light-skinned, and Mrs. Skinner, who had moved to Georgia from New York, encouraged her to pass for white and obtain an education in the North. Julia Porter, however, insisted that her daughter be educated among blacks, and sent her to the Hampton Institute of Virginia, which she attended from 1880 to 1884.

Janie Porter taught briefly in Dawson, Ga., and then at the Haines Normal Industrial Institute in Augusta, Ga. From 1886 to 1889 she taught night school at the Hampton Institute, where she met and married Harris Barrett, who was the institute's bookkeeper and cashier.

In 1890, Janie Barrett founded the Locust Street Social Settlement in Hampton, Va. The settlement, for local women, children, and the elderly, was the first in Virginia, and one of the first for African Americans in the United States. In 1907, Barrett cofounded the Virginia Federation of Colored Women's Clubs, and in 1908 she became its first president. During this era, women's clubs became a powerful force for social reform, and black women's clubs were no exception. In 1915, realizing that young black women who had troubles with the law needed a place to obtain both job and social skills, the federation established the Virginia Industrial School for Colored Girls in Peake (now Hanover), Va., north of Richmond. Barrett served as the first secretary of the board of trustees and a year later became its resident superintendent, refusing an offer from the Tuskegee Institute to become its dean of women. The school became a leader in the development of humane social work. By the mid-1920s, the Russell Sage Foundation ranked the school as one of the five best of its kind in the nation.

Barrett was awarded the William E. Harmon Award for Distinguished Achievement Among Negroes in 1929. In 1930, she participated in the White House Conference on Child Health and Protection.

After Barrett's death in 1948, the Virginia Industrial School for Colored Girls was renamed the Janie Porter Barrett School for Girls. In 1975 it was renamed the Barrett Learning Center.

REFERENCES

CARNEY, JESSIE SMITH, ed. *Notable Black American Women.* Detroit, 1992.
WHITMAN, ARDEN, ed. *American Reformers.* New York, 1985.

SABRINA FUCHS
MICHAEL PALLER

Barron, William, Jr. "Bill" (March 27, 1927–September 21, 1989), jazz saxophonist. Born in Philadelphia, Bill Baron studied piano as a child. He later switched to tenor and soprano saxophones and performed with Mel Melvin and with the Carolina Cotton Pickers before being drafted into the U.S. Army in 1945. Upon his discharge he returned to Philadelphia and played with Red Garland and Jimmy Heath. In the late 1950s Barron settled in New York, where he eventually worked with musicians as diverse as the avant-garde pianist Cecil TAYLOR and the hard-bop drummer Philly Joe JONES. In the early 1960s he joined with trumpeter Ted Curson to form an ensemble. His recordings from this period include *The Tenor Stylings of Bill Baron* (1961) and *The Legend* (1963).

In the late 1960s Barron's reputation as an educator equaled his popularity as a saxophonist. In addition to leading an ensemble with his younger brother, pianist Kenny Barron, he directed a jazz workshop at Brooklyn's Bedford-Lincoln Neighborhood Museum. In the early 1970s Barron also produced the radio series *Anthology of Black Classical Music*. In addition, he taught at the City University of New York and at Wesleyan University in Middletown, Conn., where he became head of the music department in 1984, all the while continuing to perform at nightclubs and in concerts. He also recorded the album *Variations in Blue* (1984). Barron taught at Wesleyan until his death from cancer in 1989.

REFERENCES

HACKNEY, CARRIE. "Bill Barron." *Black Perspective in Music* 20 (1990): 214.
RUSCH, BOB. "Bill Barron." *Cadence* 13, no. 10 (October 1987): 11.

TRAVIS JACKSON

Barrow, Joseph Louis. *See* Louis, Joe.

Barry, Marion Shepilov, Jr. (March 6, 1936–), civil rights activist, and politician. Marion Barry was born to sharecroppers on a cotton plantation near Itta Bena, Miss. After his father's murder in 1944, Barry's mother moved the family to Memphis, Tenn., and remarried. His family grew up in poverty and often picked cotton in nearby Mississippi to earn money.

After graduating from high school, Barry enrolled at Le Moyne College in Memphis, where he was president of the campus chapter of the NAACP. In 1958 he graduated as a chemistry major and became a graduate student at Fisk University in Nashville, Tenn.

At Fisk Barry led several student SIT-INS against segregated facilities. His leadership in this successful effort led to his election in April 1960 as the first national chair of the STUDENT NONVIOLENT COORDINATING COMMITTEE (SNCC). He earned an M.S. in chemistry from Fisk that August and resigned as the chair of SNCC in November (though remaining a member of the group and participating on its executive and finance committees). He took a teaching assistantship at the University of Kansas (1960–1961) and at the University of Tennessee (1961–1964), while continuing his graduate study in chemistry at Tennessee. He also taught briefly at Knoxville College.

In 1964 Barry was assigned to raise funds for SNCC in New York City; he was transferred to Washington, D.C., in June 1965. Barry led protests against the VIETNAM WAR, led a boycott against proposed fare increases on district bus lines, and helped organize the "Free D.C. Movement" aimed at placing control of the district's government in the hands of its black citizens. In August 1967 he helped establish Youth Pride, Incorporated, a self-help organization that created employee-owned businesses in the inner city and offered job training to poor black youths. Following the assassination of the Rev. Dr. Martin Luther KING, Jr., in April 1968, and the riots in Washington, D.C., that followed, Barry worked to reform the city's economy in a way that would increase African-American control over some local businesses.

Barry's popularity as a political activist helped him get elected to the city's school board in 1971; he became president of the board a year later. In 1974, the first year in which a mayor and city council were elected under district home rule, Barry won a seat in the city council, where he fought against inner city gentrification and wasteful municipal spending. Campaigning for mayor on these same issues in 1978 (and gaining public sympathy after an attempt on his life that March), Barry narrowly defeated incumbent African-American mayor Walter WASHINGTON for the Democratic nomination and won the election

against Republican Arthur Fletcher. Barry was not the district's first African-American mayor; that distinction belonged to Washington, who was appointed mayor from 1967 to 1974 and elected mayor under home rule the following term. Yet for many Washington citizens Barry's election was the culmination of the city's civil rights struggle, the ascension of its activist leadership to control over the district's municipal government.

Barry's three-term mayoral administration (1979–1991) was credited by many with successfully mediating group conflicts, balancing the city's budget, instituting a second financial accounting system, improving the city's bond rating, and enhancing delivery of city services.

At the same time, Barry's success was undercut by charges of fiscal mismanagement and corruption; in addition, there were allegations of widespread cocaine use in his administration. In October 1990, Barry himself was convicted of cocaine possession and served a six-month prison sentence. The conviction sparked a spirited controversy because the videotaped evidence against Barry suggested that he was the possible victim of entrapment. Barry and his followers charged the federal prosecutor, Jay Stephens, with conducting a racially biased prosecution against Barry. Barry's conviction split his constituency between those who remained loyal and those who felt he had outlasted his usefulness to Washington's black community.

As a result of the controversy, Barry did not run for reelection to the mayoralty in November 1990 but sought election to an at-large seat on the city council. His loyal followers returned him to a council seat in 1992, and with their support Barry entered the 1994 campaign to unseat incumbent mayor Sharon Pratt Kelly. Barry's cocaine conviction and questions about corruption in his administrations reduced his support among whites and many middle-class African Americans, but he retained a large enough core of support among African Americans willing to forgive his personal indiscretions to win the election.

REFERENCES

AGRONSKY, JONATHAN I. Z. *Marion Barry: The Politics of Race.* New York, 1991.

JANOFSKY, MICHAEL. "Ex-Mayor Barry Rises from Ashes." *New York Times,* August 1, 1994, p. B7.

PERSONS, GEORGIA, and LENNEAL HENDERSON. "Mayor of the Colony: Effective Mayoral Leadership as a Matter of Public Perception." *National Political Science Review* 2 (1990): 145–153.

ZINN, HOWARD. *SNCC: The New Abolitionists.* Boston, 1965.

MANLEY ELLIOTT BANKS II

Barthé, Richmond (January 28, 1901–March 6, 1989), sculptor. Richmond Barthé was born in Bay Saint Louis, Miss., to Richmond Barthé and Marie Clementine Roboteau. His father died at the age of twenty-two, when Richmond was only one month old. Left with a devoted mother whose influence on his early life and his aesthetic development was significant, Barthé credited her with providing experiences that nurtured his desire to become an artist.

At the age of twelve, Barthé's work was shown at the county fair in Mississippi. He continued to demonstrate his remarkable talent and at age eighteen, having moved to New Orleans, he won his first prize—a blue ribbon for a drawing that he entered in a parish (county) competition.

In New Orleans, Barthé's work attracted the attention of Lyle Saxon of the *Times Picayune*. Saxon tried unsuccessfully to register Barthé in a New Orleans art school. The refusal was based on the young man's color rather than on his artistic ability. This early rejection made Barthé more determined than ever to become an artist of note.

In 1924, with the aid of a Catholic priest, the Rev. Harry Kane S.S.L., Barthé with little formal training and a great deal of ambition and talent, was admitted

Richmond Barthé. (National Archives)

to the school of the Art Institute of Chicago. During his four years there he followed the curriculum designed for majors in painting. However, during his senior year he was introduced to sculpture by his anatomy teacher, Charles Schroeder, who also suggested that a better understanding of the third dimension might improve his knowledge of painting. This, according to Barthé, was the beginning of his long career as a sculptor.

In February 1929, following his graduation from the institute, Barthé moved to New York. The following two decades saw him build a reputation that would be the envy of many of his peers. The 1930s and '40s would see him rise to great prominence and gain high praise for his work from both critics and collectors.

By 1934, Richmond Barthé was granted his first solo show at the Caz Delbo Galleries in New York City. Numerous other exhibitions and important commissions followed thereafter. His works were added to important collections such as the Whitney Museum of American Art (*African Dancer*), the Metropolitan Museum of Art, the Pennsylvania Museum of Art, the Virginia Museum of Fine Arts, and the Museum of the Art Institute of Chicago (*The Boxer*).

Barthé's commissions included a bas relief of Arthur Brisbane for New York's Central Park, and an eight-by-eighty-foot frieze, *Green Pastures: The Walls of Jericho,* for the Harlem River Housing Project. Other commissions included two portrait busts and a garden sculpture for the Edgar Kaufman house (*Falling Water*), designed by architect Frank Lloyd Wright; a Booker T. WASHINGTON portrait bust for the Hall of Fame of New York University; an *Othello* modeled after Paul ROBESON for Actor's Equity; and the General Toussaint Louverture Monument, Port-au-Prince, Haiti.

In 1947 Barthé moved from New York to Jamaica, West Indies, in order to escape the tense environment of big city life, which was taking its toll on his creative energies. By this time he was considered to be one of the leading "moderns" of American art, but he decided to abandon this role at the peak of his career for the calm and peaceful countryside of rural Jamaica, where he lived until 1969. Barthé later traveled to Europe, where he spent several years enjoying the company of old friends and immersing himself in the art and culture of the Italian Renaissance masters Donatello and Michelangelo, whose works he revered and to whom he owed a great debt.

In 1976 Richmond Barthé returned to the United States. Following a brief stay in Queens, N.Y., he moved to Altadena, Calif., where he remained until his death in 1989.

REFERENCES

"Richmond Barthé: Sculptor." *Crisis* (June 1948): 164–165.
"Sculptor." *Ebony* (November 1949).

SAMELLA LEWIS

Baseball. African Americans have been involved in baseball, or "base ball" as it was first known, since its earliest days. Some enslaved blacks on southern plantations played baseball during their time off from work, and there were scattered African-American amateur baseball players in the Northeast in the years before the Civil War. Games were played in Brooklyn between the Colored Union Club and the Unknown Club in 1860 and also between the Unknown Club and the Monitors in 1862. By 1867, the Philadelphia Pythians, a well-known team that included among its members the abolitionist William STILL, a participant in the UNDERGROUND RAILROAD, encountered the first known example of racial exclusion of all-black organized ballclubs. In that year, the Pythians applied to join the National Association of Base Ball Players, whose nominating committee, wishing to avoid "political subjects" and "division of feeling," unanimously voted to exclude "any club which may be composed of one or more colored persons."

The National Association of Professional Baseball Players, formed in 1871, never formally banned black teams and players. However, both it and its successor, the National League, formed in 1876, adhered to a tacit prohibition. Nevertheless, several black teams, which played both each other and white teams, sprang up. As among the white clubs of the time, the membership of these early clubs was overwhelmingly middle class. In 1869, the Pythians played and defeated the white Philadelphia City Items in a series of games. The same year, the Brooklyn Uniques and the Philadelphia Excelsiors were matched up in what was billed as the "Championship of Colored Clubs." The Washington Alerts, a powerful club, had as secretary Charles E. Douglass, son of Frederick DOUGLASS. Even in New Orleans, where thirteen black clubs played a tournament in 1875, there were interracial games. By the late 1870s, various blacks, including Oberlin's Fleet and Weldy Walker, Marietta College's John L. Harrison, and Dartmouth's Julius P. Haynes, joined white college teams. In the 1890s, James Francis Gregory played for Amherst, becoming team captain, and his brother Eugene pitched for Harvard.

Early Professional Baseball

Within organized baseball, the minor leagues did not originally exclude African Americans, and a total of seventy-three blacks competed in various leagues during the nineteenth century. Bud Fowler was probably the first black professional ballplayer. Born John Jackson in upstate New York in 1858, he grew up, like most baseball players of the day, in the North. Some sources say he was paid by a club in Springfield, Mass., in 1872. He pitched in semipro leagues, beating the National League's Boston Red Stockings in one game, then switched to the infield and played in several minor leagues. In 1884 he signed with Stillwater, Minn., of the Northwestern League, and during the following two years, he played for Keokuk and Topeka of the Western League. He was released after pressure from white players led to the exclusion of blacks from the league. According to *Sporting Life*, a magazine of the time, "[Fowler] is one of the best general players in the country, and if he had a white face would be playing with the best of them . . . the poor fellow's color is against him. With his splendid abilities he would long ago have been on some good club had his color been white instead of black. Those who know say there is no better second baseman in the country."

The first professional all-black teams were the Philadelphia Orions, founded in 1882, and the St. Louis Black Stockings, founded soon after, but the best was the Cuban Giants, founded in 1885 by Frank Thompson, headwaiter at Babylon, N.Y.'s Argyle Hotel. The club, composed originally of hotel staff, called itself "Cuban" to alleviate prejudice (which was often less pronounced in the case of dark-skinned foreigners) and "Giants" after New York's National League team. The nickname became a common one among black teams, with ball clubs such as the Philadelphia Giants, the (New York) Lincoln Giants, the Chicago Giants, and the Leland Giants springing up later. The Cuban Giants were owned by Walter Cook, a white man, and managed by an African American, S. K. Govern. Players earned wages of $48 to $72 per month depending on their position (pitchers and catchers made the most, infielders the least). These were good wages in comparison to what other black workers earned. The Cuban Giants played other black "nines," college squads, and even minor and major league clubs, although the American Association champion St. Louis Browns backed out of a scheduled contest in 1887. In 1889, the Cuban Giants and another black team, the New York Gothams, spent a season playing white teams as part of the Middle States League. In 1886, black promoters in Jacksonville, Fla., formed the six-team Southern League of Colored Baseballists, but it only lasted

a few games. The nine-team League of Colored Baseball Clubs was organized one year later, and was recognized by the National Association as an organized baseball league, but it was disbanded after only one week.

In 1883, the Toledo, Ohio, team of the minor Northwestern League hired a catcher, Moses Fleetwood "Fleet" Walker. Walker, who was a minister's son from Steubenville, Ohio, and had attended college at Oberlin and Michigan, played well. Adrian "Cap" Anson, player-manager of the National League's Chicago White Stockings, one of the game's biggest stars, threatened to cancel a planned exhibition game with Toledo if Walker played. Toledo's manager, who had been planning to rest the injured Walker, responded by putting him in the lineup, and the game proceeded without incident. The next year, Toledo joined the American Association, a rival of the National League, and Fleet Walker became the first black major leaguer.

Walker had to face enormous obstacles. Pitcher Tony Mullane later admitted that Walker "was the best catcher I ever worked with, but I disliked a Negro and whenever I had to pitch to him I used anything I wanted without looking at his signals." In Richmond, Va., six fans (using pseudonyms) wrote a letter threatening him with a beating by a mob of seventy-five men if he played. Walker was not on the team by then, and the threat went unchallenged. In fifty-one games, Walker batted .263, and he was praised for his catching. At the end of the season, his brother, Weldy Walker, joined Toledo for five games. The team folded at the end of the season. The two Walkers were the only African-American players to reach the major leagues during the nineteenth century.

In 1885 Fleet Walker played for Cleveland in the Western League and then Waterbury in the Eastern League. In 1887 he joined Newark of the International League (IL), which was then, as it is today, one step below the majors. There were seven African Americans in the IL, playing on six of the league's ten teams. The most notable were pitcher George Stovey of Newark, who set an all-time IL record with 34 wins, and second baseman Frank Grant of Buffalo, considered the best black player of the nineteenth century, who batted .366 and led the league in doubles, triples, and home runs.

However, black players in the IL faced the same widespread abuse Fleet Walker had experienced from white players, both teammates and opposition players, who were racists or who feared the presence of blacks would lower the status of their occupation and lower salary levels. Blacks had balls thrown at them, and spikings on the field from fellow players were common. Grant allegedly developed wooden shin guards to protect his legs from injury by white baserunners. White teammates gave wrong advice to blacks and shunned them off the field. Some white players even refused to pose with black teammates for pictures. The derogatory public image of black players was reinforced by the media. Pictures in *Harper's Weekly* depicted them as lazy and stupid, and *The Official Baseball Record* referred to them as "coons." In July 1887, the league's team owners bowed to pressure from white players, and agreed not to sign additional black players. They limited the seven existing players to two per team. The seven players soon left to join all-black teams. Fleet Walker was the last IL holdout, playing through 1889.

In 1887, the same year the International League restricted blacks, "Cap" Anson refused to schedule a game with the Newark team of the International League if their star African-American pitcher, George Stovey, played. Unlike Toledo four years previously, Newark complied, benching Stovey. The black baseball historian Sol White, himself a former professional baseball player, wrote in his landmark *History of Colored Baseball* (1906) that Anson was primarily responsible for pushing blacks out of organized baseball. However, without minimizing Anson's role, it seems clear that he reflected widespread white opinion. As *Sporting News* commented in 1889, "Race prejudice exists in professional baseball to a marked degree, and the unfortunate son of Africa who makes his living as a member of a team of white professionals has a rocky road to travel."

Only three blacks played on white teams in the 1890s, and after 1898 whites refused to compete against all-black teams. By the end of the nineteenth century blacks were also excluded from most other major sports, including horse racing and bicycling. A few blacks may have "passed" as white during the 1890s, and in 1901 Baltimore Orioles manager John McGraw tried to pass off African-American Charlie Grant as an Indian during preseason games. The ruse was discovered, however, and Grant was released. When the Cincinnati Reds signed two Cuban players in 1911, they pledged that the players were Caucasian and that they would take no blacks. In 1916 Jimmy Claxton, a pitcher of mixed black and Indian ancestry, played two games for the Oakland Oaks of the Pacific Coast League before being released.

Black Baseball in the Jim Crow Era

Baseball prospered among blacks throughout the era of segregation. Countless young African-American boys and girls played. Black leaders, including such disparate figures as activist Ida B. Wells (see WELLS-BARNETT) and poet James Weldon JOHNSON, were

baseball players or fans. Chicago established itself as a leading black baseball center with several fine teams. Numerous black army teams sprouted up, including the team from the all-black 25th Infantry, later famous for its involvement in the Brownsville incident of 1906, which beat all comers in competition in the Philippines. On the amateur level, black college teams had existed at HOWARD UNIVERSITY and elsewhere since the 1860s. In the 1890s, Atlanta became a center of college baseball with competing teams from Atlanta Baptist Seminary (now MOREHOUSE COLLEGE), Atlanta University, Clark University, and Morris Brown College.

Outside organized baseball, there was still interracial competition all during the first half of the twentieth century. Major and minor league teams and various "barnstorming" squads (see below) played black teams—who more than held their own—in exhibition games. Black American players starred in interracial competition in Cuba and Mexico. The success of African Americans against white competition gave the lie to any claim that blacks were not good enough for the major leagues. Also, white colleges featured various black players, such as Paul ROBESON at Rutgers from 1915 to 1918, and northern neighborhoods sometimes featured matches between black and white teams. The most genuinely integrated teams, ironically, may have been prison baseball teams such as those at New York's Sing Sing and at San Quentin in California, both of which had numerous black inmates competing alongside whites.

Once excluded from organized competition with white clubs, black teams made their money by what were called "barnstorming" tours, playing each other, or taking on local or semipro teams. The Cuban Giants were joined by such teams as Philadelphia's Cuban X Giants, the Philadelphia Hilldales, and the Columbia (Page Fence) Giants, which had been started by Bud Fowler and which paraded through towns on bicycles. In 1903, the Cuban X Giants played the Philadelphia Giants in a series dubbed "The Colored Championship of the World."

During the first twenty years of the twentieth century, a few standout baseball players made a reputation for themselves. John Henry Lloyd, shortstop for the Indianapolis ABC's, was dubbed "the Black Honus Wagner," and "Smokey Joe" Williams of the Lincoln Giants compiled a 6–4–2 record against white major leaguers in exhibition games, including a three-hit shutout against the National League champion Philadelphia Phillies in 1915.

During this period, there were two attempts to form leagues. In 1906 the International League of Independent Baseball Clubs, with four black and two white teams, was organized, but played just one season. The National Negro Baseball League, founded

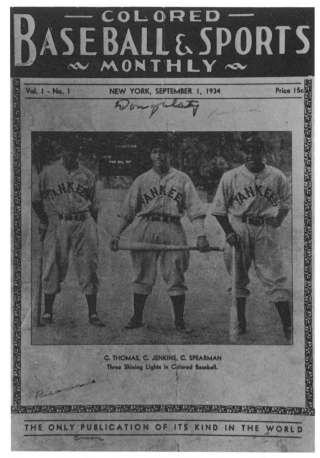

Cover of the first issue of the *Colored Baseball & Sports Monthly*, September 1934. (Photographs and Prints Division, Schomburg Center for Research in Black Culture, The New York Public Library, Astor, Lenox and Tilden Foundations)

in 1910 by Chicago Giants owner Frank Leland, did not last long enough for a single game. In 1911 star pitcher Andrew "Rube" FOSTER, so named for having outpitched the New York Giant pitcher Rube Marquard in unofficial competition, took a white partner, baseball promoter John Schorling, and founded the powerful Chicago American Giants. Three years later, J. K. Wilkinson, a white man, put together a powerful All-Nations team, which included African Americans, whites, Latinos, and Native Americans. In 1920, Wilkinson combined players from the All-Nations team with members of the black 25th Infantry Squad Army team to form the Kansas City Monarchs, one of the most important black teams.

The Negro Leagues

The first NEGRO NATIONAL LEAGUE (NNL), officially named the National Association of Professional Baseball Clubs, was founded in Kansas City in 1920. The guiding force behind it was Rube Foster, who

had built his Chicago American Giants into a strong, financially successful team. Foster's organizational genius and astute understanding of the promotional possibilities inherent in league play, plus his desire to wrest economic power and leadership over black baseball from white booking agents, led him to put together the first lasting Negro league.

The league was composed of six teams located in midwestern cities with significant black populations. It was originally designed to be entirely black-owned, but the popular appeal of Wilkinson's Kansas City Monarchs led Foster, after much thought, to agree to their inclusion. The new league was an almost immediate success, with outfielders like Oscar CHARLESTON of Indianapolis ("the Black Babe Ruth") and John Lloyd, who joined several teams; or pitchers like "Smokey Joe" Williams and Wilbur "Bullet" Rogan of the Kansas City Monarchs.

The Negro National League was challenged in 1923 by the white booking agent Nat Strong, who created the Eastern Colored League with six teams, four white-owned, in eastern cities. After a period of mutual bad feeling and raids on each other's players, the two leagues observed a truce and organized a structure similar to that of white leagues, with champions of the two leagues competing in a black World Series. However, since ballclubs sometimes preferred lucrative barnstorming exhibitions to scheduled league games, teams played uneven numbers of games, so league standings were hard to determine. There was a third league, the short-lived Southern Negro League, created around the same time, but it could not compete financially with the other leagues and it remained independent. A few independent teams, notably Pittsburgh's Homestead Grays, refused to join the Negro Leagues but played exhibition games with league teams. The Eastern Colored League folded in 1928, and some teams were absorbed into the NNL.

The Great Depression took a heavy toll on black baseball. The NNL, already weakened by Rube Foster's 1926 breakdown and his subsequent death in 1930, was unable to meet its debts and folded in 1931. During the following two years, teams disbanded or survived precariously as local semipro or touring barnstorming teams depended on white bookers for survival. Some players went to play in the Caribbean or Mexico.

In 1933, the Negro National League, containing six teams (later eight), was reformed under the guidance of Gus Greenlee. Greenlee was a prosperous "numbers" king in Pittsburgh who sought a legitimate outlet for his money. He organized the Pittsburgh Crawfords. Other black businessmen—including several gangsters—followed suit in putting together teams, and the league was recreated. The new NNL played two half-seasons. The winners of each portion met in the World Series. The Pittsburgh Crawfords were the dominant team in the early to mid 1930s, as the free-spending Gus Greenlee recruited LeRoy "Satchel" PAIGE, Josh GIBSON, Oscar CHARLESTON, James "Cool Papa" BELL, and Judy JOHNSON, all future Hall-of-Famers, to play on his team, but other clubs eventually evened the balance of power within the leagues. In 1937, the six-team Negro American League (NAL) was organized. This league was mainly white-owned and included the Kansas City Monarchs, who had previously declined to join the revamped NNL. The NNL now concentrated on eastern teams, while the NAL held western franchises. The two league champions met each other in the Colored World Series, either in September or October. However, the biggest event in black baseball was not the World Series but the East-West game, played in Chicago. Greenlee introduced the idea. In 1933 (the same year the first Major League All-Star Game was played, also in Chicago), a squad of the best players from the eastern teams met their western counterparts. The games, played yearly until 1950, routinely attracted crowds of 30,000 to 40,000. This showcase event was covered nationally in the increasingly important black press and became a national social event of significance in black America. Indeed, newspapers such as the the CHICAGO DEFENDER and the PITTSBURGH COURIER had large national circulations in part because they were the only source of regular black baseball information.

The Negro League season began in the southern states in February with spring training. After a few days the teams began barnstorming, working their way north. The exhibition games not only furthered team development and strategy, but were also a necessary source of revenue, and helped cement the relationship between players and the local black populations. In April or May the teams arrived in their home cities and commenced league play, although they continued to play exhibitions throughout the season, sometimes playing three or four games per day. When the season ended in September, or after the Colored World Series, the better players went on to play in winter leagues in Mexico, Cuba, the Dominican Republic, and California.

As with the first NNL, the constant exhibition games played havoc with League schedules and standings. Because the big city black population could not sustain a major league schedule of 154 games, and because the white stadiums most teams rented when major or minor league teams were away were unavailable at times, the teams traveled much more than comparable white teams. Players normally traveled by bus, or in several cars, over bad rural roads. A few black teams had their own ballparks.

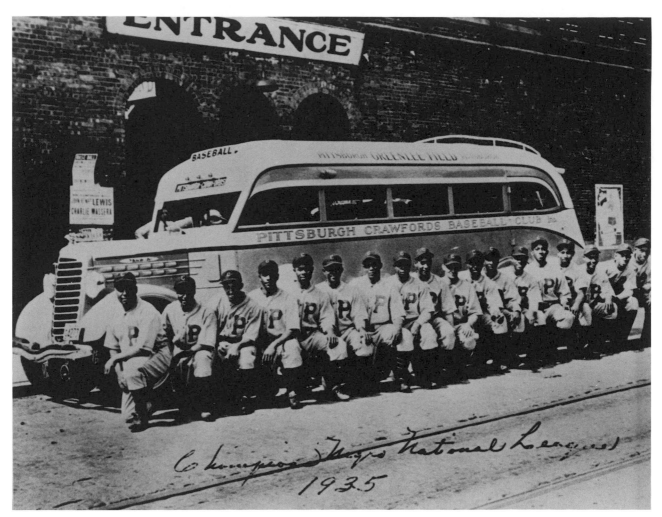

The 1935 Pittsburgh Crawfords, including five (future) Hall of Fame members: Oscar Charleston, Judy Johnson, James "Cool Papa" Bell, Josh Gibson, and Leroy "Satchel" Paige. (Photographs and Prints Division, Schomburg Center for Research in Black Culture, The New York Public Library, Astor, Lenox and Tilden Foundations)

Around 1932, the Kansas City Monarchs became one of the first teams to use portable lights for night baseball. Night games eased schedule conflicts with white teams, few of which had lights in their ballparks, and had a larger potential black worker audience than day games.

League play was exciting. While there were power hitters, the greatest being Josh Gibson of the Pittsburgh Crawfords and Homestead Grays, runs were scored slowly and games depended, more than in white leagues, on pitching, defense, and speed. Pitchers, the most famous being LeRoy "Satchel" Paige of the Kansas City Monarchs and other teams, worked frequently and were reliant not only on speed but on trick pitches to beat opposing teams. There was little money for equipment, so scuffed and loaded balls remained in play. The spitball and similar pitches, which had been banned in the major leagues in 1920, remained legal in the Negro Leagues. Running was

also emphasized in Negro League play, and bunts, stolen bases, and hit-and-run plays were common strategies.

Another difference between white and black baseball was the amount of showmanship involved. Black baseball players were particularly conscious of their role as entertainers. Batters might begin their at-bat with their back to home plate, and then turn around to hit the ball. Pitchers such as Satchel Paige would call in the outfielders, and proceed to strike out the other side. Paige, in fact, was so popular and renowned for his exploits that his home club, the Kansas City Monarchs, raised revenue by loaning Paige out to minor league or semipro teams. The Indianapolis Clowns (previously the Ethiopian Clowns), an independent black team whose players clowned and pulled trick plays in the manner of basketball's HARLEM GLOBETROTTERS, were such a financial attraction that despite their unserious reputation, they

were invited to join the Negro American League in 1938.

Negro League baseball, in economic terms, was one of the most successful black businesses of the JIM CROW era. Not only were the leagues themselves profitable, but they also boosted related black-owned enterprises. As a cultural institution, Negro League baseball was ubiquitous throughout black America. The games provided an important source of recreation and local pride, and were choice social events. The barnstorming tradition meant that teams played wherever there was a sizeable black population, and indeed in many places, such as in the Dakotas or the Canadian prairie provinces, the local populace's only contact with blacks was via the black teams that came to town every summer.

Despite the hard life and the rigorous travel and play schedules players underwent, the leagues had a certain glamour. The players themselves were popular heroes of the first magnitude in the black communities of the North. They were acknowledged stars, of particular importance because of their victories over white players in exhibition games. They were also a particularly cosmopolitan group, akin to other black entertainers of the period. They were equally at home in the small-town rural world of the Deep South, staying in homes of local community members when they visited southern towns, and in the big cities of the North with their vibrant social and cultural life. Also, the many darker-skinned Latinos, such as Martin Dihigo and Luis Tiant, Sr., who played in the leagues gave them an international flavor, buttressed by the sojourns of Negro League stars in Latin America, where they mingled freely with the political and economic leadership of the countries like other celebrities.

The integration of organized baseball, beginning with Jackie ROBINSON in 1946, plus the coming of televised games, spelled the end of the Negro Leagues. Black fans made it clear that they preferred seeing their heroes compete in the newly integrated major leagues rather than in all-black leagues. As early as 1947, the Negro League teams on the eastern seaboard ("Jackie Robinson country") suffered severe financial losses as black fans deserted the Negro National League. The last East-West classic was played in 1950, and the NNL folded after the next season. The Negro American League, whose franchises tended to be in midwestern states, further from major league franchises, continued to play on a reduced level. In a move to increase attention, in 1953 the NAL's Indianapolis Clowns signed a woman, Toni Stone, who played 50 games at second base and hit .253. During the 1950s, major league teams moved west and NAL teams could not compete financially for talented players. The NAL folded in 1960, and the Indianapolis Clowns returned to their independent status, touring small towns and playing semipro teams through the 1980s.

During the 1970s, African American and white interest in the Negro Leagues was awakened, partly by the book and documentary film *Only the Ball Was White* (1969). The Baseball Hall of Fame created a Negro League Committee, and 11 players out of an estimated 2,600 who played in the Negro Leagues were inducted at this time for their league efforts: Rube Foster, Satchel Paige, Josh Gibson, Cool Papa Bell, Judy Johnson, Buck LEONARD, Oscar Charleston, Monte IRVIN, Martin Dihigo, Ray Dandridge, and John Henry Lloyd. In 1990, the Negro League Baseball Museum was created in Kansas City, Mo., and the Negro Leagues Players Association was established in New York.

Integration

Little serious effort was made to integrate the major leagues until the postwar 1940s, despite the acknowledged skill of blacks in the Negro Leagues who performed at a high level against touring major leaguers. Baseball Commissioner Judge Kenesaw Mountain Landis, a midwesterner who served from 1920 to 1944, was a firm opponent of integration, although he disingenuously maintained that there was no rule against blacks in organized baseball. In 1943, at the annual baseball meetings, African Americans led by Paul ROBESON were granted the opportunity to speak to owners about integration, but Landis was unmoved. The same year, entrepreneur Bill Veeck sought to purchase the Philadelphia Phillies, but Landis blocked the sale when he learned of Veeck's plans to stock the club with black players.

Baseball's owners accepted and rationalized the situation. Critics of integration claimed that fans would lose interest in the game, that black players would be opposed by their colleagues (while some players were racists, a poll of major leaguers in the late 1930s indicated that 80 percent did not object to integration), and that severe social problems would emerge, especially during spring training in the South. Larry MacPhail, president of the Brooklyn Dodgers, claimed in 1943 that integration would kill off the Negro Leagues. This assertion was challenged by white Newark Eagles owner Effa Manley, the only female owner in the Negro Leagues, but many Negro League owners opposed integration, fearing rightly that it would destroy their business.

The movement for integration was promoted in the 1930s by white journalists Westbrook Pegler, Jimmy Powers, and Shirley Povich, who recognized black talent in baseball and the accomplishments of other black sportsmen such as Joe LOUIS and Jesse OWENS. Their black colleagues, including Wendell

SMITH of the *Pittsburgh Courier,* Sam LACY of the BALTIMORE AFRO-AMERICAN, and Joe Bostic of the *People's Voice* (Harlem) campaigned for integration. Communists such as Lester Rodney, the white sports editor of the *Daily Worker,* also played a role in publicizing the issue. They demanded tryouts for Negro Leaguers, collected petitions, and picketed ballparks. On opening day in 1945, one banner outside Yankee Stadium read, "If We Can Stop Bullets, Why Not Balls?" The demonstrations led to several tryouts for black players but no jobs.

Ultimately, World War II tipped the balance, causing Americans to reevaluate the meaning of democracy. It was difficult to fight for freedom overseas while neglecting it at home. Furthermore, when the major leagues, faced by a shortage of players, admitted players who would not normally be given a chance to compete, such as teenagers and handicapped players like one-armed Pete Gray, the exclusion of blacks seemed more glaring. Judge Landis's death in December 1944 removed an important obstacle to integration. The new commissioner, former Kentucky governor and senator Albert "Happy" Chandler, was subjected to pressure for integration from labor unions, civil rights leaders, and politicians.

In the summer of 1945, the crucial first step was taken by Branch Rickey, president of the Brooklyn Dodgers. He secretly investigated Negro League talent under the guise of scouting for a new Brooklyn Brown Dodgers Negro League team. Rickey knew that the first African American in the majors had to be an excellent all-around athlete who could maintain a high level of performance despite certain abuse and pressure, and decided that the best candidate was Jackie Robinson of the Kansas City Monarchs, a good player though hardly the best in the league. Robinson had grown up in an interracial community in California, had been an outstanding all-around athlete and a good student at UCLA, had been a noncommissioned officer in the Army, and was married. After a stressful interview with Rickey, in which he promised not to challenge racist attacks, Robinson was signed on October 33, 1945. Rickey's action was unanimously opposed by other club owners.

In 1946, Robinson played for the Montreal Royals, the Dodgers' top farm team. Spring training in Florida proved a trying experience, as Robinson had difficulty finding meals and accommodation and was once even ordered off the field by a local sheriff, but when the club moved north conditions eased. For a time, he was joined by John Wright and Roy Partlow, Negro League veterans, but they were eventually demoted to Trois Rivières, Quebec (Class C). Robinson was enormously successful, leading the Class AAA International League with a .349 batting average and in runs scored with 119. That year, the Dodgers also had two other African-American minor leaguers, catcher Roy CAMPANELLA and pitcher Don Newcombe, who played for Nashua, N.H. (Class B).

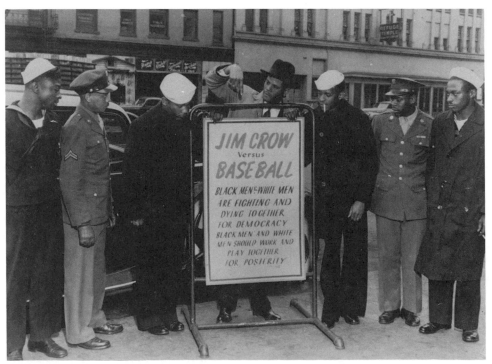

Protesting discrimination in sports during the World War II era. (Moorland-Spingarn Research Center, Howard University)

In 1947, Jackie Robinson joined the Brooklyn Dodgers following spring training in Cuba, where race relations were less hostile than in Florida. He encountered discrimination from teammates, who originally petitioned to keep him out. Rickey offered to trade any player who did not wish to play alongside Robinson. Opponents, particularly members of the Philadelphia Phillies and St. Louis Cardinals, threatened to strike, but were warned by Commissioner Chandler that any player who struck would be suspended. Robinson turned out to be a great gate attraction, and had a superb first year, despite being moved to an unfamiliar position, first base. He led the Dodgers to the National League pennant and won the first Rookie of the Year Award. A handful of other blacks also played that year, including pitcher Dan Bankhead for the Dodgers. Larry DOBY, one of the Negro Leagues' top prospects, became the first African American in the American League when Cleveland Indians' owner Bill Veeck bought him for $10,000 from the Newark Eagles in mid 1947. This purchase was an exception to the general pattern of uncompensated raids that major league clubs were beginning to make on Negro League teams, whose players had no reserve clause binding them to their teams. Later in the season, Henry Thompson and Willard Brown were briefly brought up by the St. Louis Browns to increase attendance, but neither did well and they were demoted after a month.

In 1948, the Dodgers brought up Roy Campanella. The same year, at the age of at least forty-two, Satchel Paige, legendary among both white and black fans, joined the Indians after twenty-two years as a professional. He had been the highest paid Negro Leaguer, and like most other black players took a substantial salary cut to compete in the major leagues. His contribution, however, was less significant than that of Larry Doby, who batted .301 and helped lead the Indians to the World Championship.

The following year, Don Newcombe of the Dodgers was named Rookie of the Year, Jackie Robinson was named NL Most Valuable Player, and he, Doby, and Campanella made the All-Star teams. However, the major leagues had room only for stars and were not interested in older players, with the exception of Paige. There were blacks in every Class AAA and A league that year. Many, such as Ray Dandridge, an all-time Negro League star who hit .364 for Minneapolis (of the Class AAA American Association), started in leagues beneath their ability.

Within the next few years, lower minor leagues and other areas of organized baseball outside the South also integrated. Even the All-American Girls Baseball League discussed integrating its teams in the years before its demise in 1954. Recruitment was too difficult to make gender integration successful, however. The integration of southern teams in the minors (there were no teams in the major leagues south of the border states until the 1960s) began in 1952 in Florida, the Upper South, and the Southwest, because of blacks' superior play and their ability to attract crowds. A major breakthrough occurred in 1953 when the Class A South Atlantic (Sally) League, which had teams in Florida, Georgia, and Alabama, integrated with three blacks, including Henry "Hank" AARON with Jacksonville. The Cotton States League integrated in 1954, with blacks playing for Hot Springs, Ark., and Meridian, Miss. After the BROWN V. BOARD OF EDUCATION OF TOPEKA, KANSAS decision in 1954, race relations became more hostile in the South, and integrated baseball became a threat to white supremacy. Integration continued, however, though at a slowed pace. By 1955, the only high-level minor league without blacks was the Southern Association (AA). Nat Peeples, who appeared in two games for Atlanta, was the only African American to play in the league, which disbanded in 1961. In 1957 Texas League nines were barred by Louisiana law from playing their black players in Shreveport. African-American fans responded by boycotting the league, with the result that the league dropped the Louisiana franchise.

The pace of integration in the major leagues was slow, and as late as September 1953, only six teams had black players. Many whites undoubtedly felt like St. Louis Cardinals owner Sam Breadon, who in the late 1940s expressed his belief that only a handful of black players could be talented enough to make the major leagues. Teams avoided older blacks and sought only players with star potential and a clean image. Players who were considered too proud or "uppity," like Vic Power of the Cleveland Indians, faced great difficulties. Between September 1953 and early 1954, six more teams integrated, but the champion New York Yankees refused to integrate until 1955 when catcher Elston Howard joined the team, and it was not until July 21, 1959, that the last holdout, the Boston Red Sox, brought up Elijah "Pumpsie" Green to the majors. Teams did not go out of their way to assure blacks service at restaurants and hotels. Players of different races were rarely roommates, and teams with more than one African-American player always roomed them together.

African Americans in Contemporary Baseball

In the years since integration, African Americans have starred in major league baseball. In the National League, the first to integrate, African Americans soon won five straight Rookie of the Year Awards (1949–1953) and seven straight Most Valuable Player (MVP) Awards (1953–1959). Blacks and Latinos, most of whom had been too dark-skinned for the

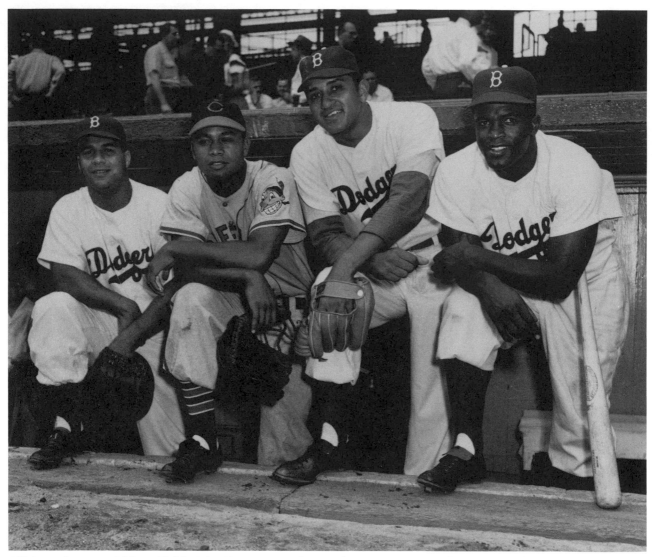

All-Star players at Ebbets Field, July 12, 1949. (Left to right) Roy Campanella, Larry Doby, Don Newcombe, and Jackie Robinson. (AP/Wide World Photos)

major leagues before integration, soon revolutionized the game, introducing an emphasis on speed and baserunning in addition to power hitting. Between 1947 and 1993, white players led the NL in stolen bases just twice, and in the AL only on two occasions from 1951–1993. Maury WILLS broke Ty Cobb's forty-seven-year-old record by stealing 104 bases in 1962, before his total was exceeded by Lou BROCK, who stole 118 in 1974 and a record 938 during his career which included 3,023 hits. Brock's record was exceeded in turn by Rickey HENDERSON's 130 in 1982 and 1,117 total stolen bases (through 1994).

Through 1993 blacks and Latinos have won forty-six batting titles, thirty-five home run championships, and forty-three MVP awards. They have included three of the top four lifetime home run leaders, including such greats as Henry Aaron, the all-time leader in home runs (755), runs batted in (2,297), and

extra-base hits (1,477); Willie MAYS (third in career home runs); and Roberto CLEMENTE. Frank ROBINSON (fourth in lifetime home runs) was a Triple Crown Winner (1966) and the first player to win the Most Valuable Player award in both leagues. Among pitchers, in 1968 Bob GIBSON attained a 1.12 ERA, by far the lowest since World War I, and is second in World Series wins and strikeouts (with the single-game record of 17). Ferguson Jenkins won 284 games and had 3,192 strikeouts. There are twenty-eight blacks and Latinos in the Hall of Fame, eleven chosen primarily for their performance in the Negro Leagues.

Among North American blacks, representation in the major leagues reached its proportionate share of the national population in the late 1950s (12 percent). The first all-black starting team played for the Pittsburgh Pirates in 1967. The percentage of black Amer-

icans in the major leagues peaked at 26 percent in 1974. In the early 1990s, blacks represented between 16 and 20 percent of all major leaguers. The current declining African-American presence in baseball mirrors reduced black interest in the sport. A 1986 survey found that blacks made up just 6.8 percent of baseball spectators, less than either football (7.5 percent) or basketball (17.0 percent), both of which are professional sports with higher average ticket prices, but sports whose players are predominantly African American.

Baseball, like other sports, has been an avenue of African-American social mobility. A study made during the late 1980s of major leaguers born since 1940 found that five-sixths of blacks (83.3 percent) had blue-collar backgrounds while three-fourths of white players came from white-collar backgrounds. Until the 1970s, black players generally earned less than white players of equal ability. By the mid-1980s, African-American players made more money per capita than white players, and race was no longer considered a factor in their wages.

However, discrimination has continued in many areas. Blacks have long complained of informal team quotas and the fact that mediocre black players were removed from teams, while white nonstarters were retained. Blacks have also been slotted by position. Black pitchers and catchers (positions which are often considered centers of leadership and intellectual challenge) have been relatively rare. Conversely, in 1960, one-third of major league outfielders were black; by 1989, 58 percent of blacks were outfielders, while only 18 percent of black players (versus 45 percent of whites) were at the central positions of catcher, shortstop, and second base.

Many blacks still consider racism prevalent in the baseball world. In the early 1970s, when Henry Aaron was challenging Babe Ruth's home run record, he received hate mail and racial threats. In the 1980s, the Equal Employment Opportunity Commission found that Boston Red Sox coach Tommy Harper was fired after he complained that the Florida country club which served as the team's spring training headquarters excluded blacks. In 1993 Cincinnati Reds owner Marge Schott was suspended for racial slurs.

Off-the-field opportunities in baseball have remained limited. In 1966, Emmet ASHFORD became the first black umpire in the major leagues. The first black manager was Frank Robinson of Cleveland in 1975. Robinson later managed in Baltimore and San Francisco. There have been five other black managers, and in 1993, four out of twenty-eight teams had black managers. Also, few blacks—only 21 percent in 1993—had positions as coaches, especially at third base, the position that most often leads to a manag-

er's spot. The issue of black underrepresentation in management got considerable attention in 1987 from an interview with Al Campanis, Los Angeles Dodgers vice president for player personnel, on the ABC-TV show *Nightline,* in which he questioned whether blacks had the character "necessities" to be managers. Only 9 percent of all front office employees of baseball clubs are black, including just 3 percent of vice presidents and general managers. In 1990, Ellen Weddington of the Boston Red Sox became the first black female assistant general manager; there are no black CEOs or owners. Bill WHITE, an African American, became president of the National League in 1989, but he complained bitterly of the slowness of minority hiring in baseball. In the early 1990s, the Rainbow Commission for Fairness, led by Jesse JACKSON, attempted to use demonstrations and boycotts of games to call attention to the problem of black employment in baseball. Meanwhile, the World Series victories of the Toronto Blue Jays in 1992 and 1993, led by African-American manager Cito Gaston, have served as an inspiring reminder of the possibilities for black leaders in baseball.

REFERENCES

ASHE, ARTHUR R., JR. *A Hard Road to Glory: A History of the African-American Athlete Since 1946.* New York, 1988.

BANKES, JAMES. *The Pittsburgh Crawfords: The Lives and Times of Black Baseball's Most Exciting Team.* Dubuque, Iowa, 1991.

The Baseball Encyclopedia. 9th ed. New York, 1993.

BRUCE, JANET. *The Kansas City Monarchs: Champions of Black Baseball.* Lawrence, Kans., 1985.

DIXON, PHIL. *The Negro Leagues, 1867–1955: A Photographic History.* Mattituck, N.Y., 1992.

HOLWAY, JOHN. *Black Diamonds: Life in the Negro Leagues from the Men Who Lived It.* Westport, Conn., 1989.

———. *Voices from the Great Black Baseball Leagues.* New York, 1975.

LAPCHICK, RICHARD. "Richard Report Card." *Sporting News* (August 2, 1993): 97.

MALLOY, JERRY. "Out at Home." *National Pastime* 2 (Fall 1982): 14–28.

PARROTT, HAROLD. *The Lords of Baseball.* New York, 1976.

PETERSON, ROBERT. *Only the Ball Was White.* Englewood Cliffs, N.J., 1969.

RIESS, STEVEN A. *Touching Base: Professional Baseball and American Culture in the Progressive Era.* Westport, Conn., 1980.

RILEY, JAMES A. *The Biographical Encyclopedia of the Negro Baseball Leagues.* New York, 1994.

ROGOSIN, DONN. *Invisible Men: Life in Baseball's Negro Leagues.* New York, 1983.

SCULLY, GERALD W. "Discrimination: The Case of Baseball." In Roger Noll, ed. *Government and the*

Sports Business. Washington, D.C., 1974, pp. 221–273.

———. "Race Discrimination in Baseball." In *The Business of Major League Baseball.* Chicago, 1989, pp. 171–181.

SEYMOUR, HAROLD. *Baseball: The People's Game.* Vol. 3. New York, 1990.

TROUPPE, QUINCY. *Twenty Years Too Soon.* Los Angeles, 1977.

TYGIEL, JULES. *Baseball's Great Experiment: Jackie Robinson and His Legacy.* New York, 1983.

VOIGT, DAVID Q. *American Baseball.* 3 vols. University Park, Pa., 1983.

WHITE, SOLOMON. *Sol White's Official Baseball Guide.* 1907. Reprint. Philadelphia, Pa. 1984.

STEVEN A. RIESS
DONN ROGOSIN

Basie, William James "Count"

Basie, William James "Count" (August 21, 1904–April 26, 1984), jazz pianist, bandleader. Born in Red Bank, N.J., Basie took up drums as a child, performing at informal neighborhood gatherings. He began to play piano before his teens, and in high school he formed a band with drummer Sonny GREER. In 1924 Basie moved to New York, where he was befriended by two of the greatest stride piano players of the day, Fats WALLER and James P. JOHNSON. Basie himself became a fine stride pianist, as well as a proficient organist, learning that instrument while observing Waller's performances at the Lincoln Theater in Harlem. Basie left New York in the mid-1920s to work as a touring musician for bands led by June Clark and Elmer Snowden, and as accompanist to variety acts such as those led by Kate Crippen and Gonzelle White. When White's group broke up in Kansas City in 1927, Basie found himself stranded. He supported himself as a theater organist, but more important, also began performing with many of the Southwest "territory" bands. In 1928 he joined bassist Walter Page's Blue Devils, and the next year he joined Bennie MOTEN's band in Kansas City.

After Moten's death in 1935, Basie took over the group, now reorganized as Count Basie and the Barons of Rhythm. Producer John Hammond heard the band on a 1935 radio broadcast from the Reno Club in Kansas City, and the next year brought the band to New York City. During this time the Basie band became one of the country's best-known swing bands, performing at the SAVOY BALLROOM, at the Famous Door on 52nd Street, and at the Woodside Hotel in Harlem, a stay immortalized in "Jumpin' at the Woodside" (1938). The band's recordings from this time represent the best of the hard-driving, riff-based Kansas City style of big-band swing. Many of

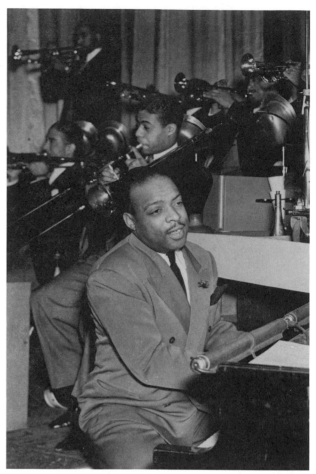

When Count Basie's band moved from Missouri to New York City in 1936, it soon demonstrated the power and driving intensity of Kansas City swing to a national audience. In this photograph from Harlem's Apollo Theater in 1939, Basie (foreground) is seen with members of the band's brass section. (Frank Driggs Collection)

these recordings are "head" arrangements, in which the horns spontaneously set up a repeating motif behind the melody and solos. Memorable recordings from this period include "Good Morning Blues" (1937), "One O'Clock Jump" (1937), "Sent for You Yesterday" (1937), "Swinging the Blues" (1938), "Every Tub" (1938), and "Taxi War Dance" (1939). In 1941 the Basie band recorded "King Joe," a tribute to boxer Joe LOUIS, which had lyrics by Richard WRIGHT and vocals by Paul ROBESON. In 1943 the band appeared in two films, *Stage Door Canteen* and *Hit Parade of 1943.*

In the late 1930s and early '40s, the Basie group was primarily a band of soloists. The leading members included tenor saxophonists Herschel Evans and Lester YOUNG, alto saxophonists Buster Smith and Earle Warren, trumpeters Harry "Sweets" Edison and Wilbur "Buck" Clayton, and trombonists Eddie

Durham and William "Dicky" Wells. Jimmy RUSH-ING, Helen HUMES, and Billie HOLIDAY provided vocals. In the 1940s Basie also added saxophonists Buddy Tate and Don BYAS, trumpeters Clark TERRY and Joe Newman, and trombonists Vic Dickenson and J. J. JOHNSON. Throughout, the band's "all-American rhythm section" consisted of Basie, drummer Jo JONES, bassist Walter Page, and guitarist Freddie GREEN, who remained with the band for more than fifty years. Together, they provided the sparse and precise, but also relaxed and understated, accompaniment. Basie himself was one of the first jazz pianists to "comp" behind soloists, providing accompaniment that was both supportive and prodding. His thoughtful solos, which became highly influential, were simple and rarefied, eschewing the extroverted runs of stride piano, but retaining a powerful swing. That style is on display on Basie's 1938–1939 trio recordings ("How Long, How Long Blues," "Oh! Red"). He also recorded on the organ in 1939.

With the rise of the bebop era, Basie had difficulty finding work for his big band, which he dissolved in 1949. However, after touring for a year with a bebop-oriented octet, Basie formed another big band, which lasted until his death. The "second" Basie band was very different from its predecessor. The first was famed for its simple and spontaneous "head" arrangements. In contrast, arrangers Neal Hefti, Johnny Mandel, and Ernie Wilkins, with their carefully notated arrangements and rhythmic precision, were the featured musicians of the second Basie band. The latter also had many fine instrumentalists, including saxophonists Eddie "Lockjaw" Davis and Paul Quinichette, Frank Wess and Frank FOSTER playing saxophone and flute, trombonist Al Grey, trumpeter Thad Jones, and vocalist Joe WILLIAMS.

Basie's second band toured extensively worldwide from the 1950s through the '70s. Basie had his first national hit in 1955 with "Every Day I Have the Blues." Other popular recordings from this time include *April in Paris* (1955, including "Corner Pocket" and "Shiny Stockings"), *The Atomic Basie* (1957, including "Whirly Bird" and "Lil' Darlin"), *Basie at Birdland* (1961), *Kansas City Seven* (1962), and *Basie Jam* (1973). During this period the Basie band's popularity eclipsed even that of Duke ELLINGTON, with whom they made a record, *First Time,* in 1961. The Basie band became a household name, playing at the inaugural balls of both John F. Kennedy and Lyndon B. Johnson, and appearing in such films as *Cinderfella* (1959), *Sex and the Single Girl* (1964), and *Blazing Saddles* (1974).

In the 1980s, Basie continued to record, in solo, small-group, and big-band settings (*Farmer's Market Barbecue,* 1982; *88 Basie Street,* 1984). He lived for many years in the St. Albans section of Queens, N.Y., with Catherine Morgan, a former dancer he had married in 1942. Health problems induced him to move to the Bahamas in his later years. He died in 1984 in Hollywood, Fla. His autobiography, *Good Morning Blues,* appeared the next year. Basie's band has continued performing, led by Thad Jones until 1986 and since then by Frank Foster.

REFERENCES

BASIE, COUNT, and ALBERT MURRAY. *Good Morning Blues: The Autobiography of Count Basie.* New York, 1985.
DANCE, STANLEY. *The World of Count Basie.* New York, 1980.
SHERIDAN, C. *Count Basie: A Bio-Discography.* Westport, Conn., 1986.

MICHAEL D. SCOTT

Basketball. Although basketball in the United States is now dominated by African Americans, their role in the sport was relatively unimportant in the early years of the game. Created in 1891 by James Naismith at a Springfield Mass., YMCA, basketball was originally played primarily at YMCAs. Black YMCAs produced the earliest African-American teams.

By the outbreak of World War I, a handful of blacks competed on white varsity basketball teams, mostly in small, remote midwestern colleges. Ironically a man who did not play varsity basketball, Edwin B. Henderson, opened the door for many others to compete at both the interscholastic and intercollegiate levels. In 1905, after a summer at Harvard, Henderson, who was a physical education instructor, returned home to Washington, DC to become a founding father of African-American basketball. As physical education director for black schools in Washington, Henderson led in the organization and promotion of high school, club, and YMCA sports programs for African-American youths. In 1909 he became an instructor at HOWARD UNIVERSITY, where he introduced basketball. Two years later he launched a varsity program, recruiting most of his players from the black YMCA in Washington.

A number of black colleges joined Howard in adopting basketball for intramural and intercollegiate purposes. During World War I, these colleges began forming conferences "in a common effort for athletic elevation," as a Howard professor put it, and "to train students in self-reliance and stimulate race-pride through athletic attainment." In 1916 Howard, LINCOLN, Shaw, and Virginia Union universities joined HAMPTON INSTITUTE in forming the Central Inter-

scholastic Athletic Association. Four years later, educators and coaches from several Deep South colleges convened at MOREHOUSE COLLEGE in Atlanta to form the Southeastern Athletic Conference. By 1928, four regional conferences covered most of the black institutions below the Mason-Dixon line. By codifying rules and clarifying terms of athletic eligibility, these new conferences benefited the game of basketball.

Historians have made much of the massive black migration northward in the 1920s, but there also was a reverse migration of black athletes from the North to such southern schools as Tuskegee Institute (later TUSKEGEE UNIVERSITY) in Alabama and Tugaloo College in Mississippi. Basketball especially flourished at Morgan State University in Baltimore, which went undefeated in 1927; at Xavier University in New Orleans, whose entire starting team in the late 1930s came from a championship high school team in Chicago; and Virginia Union University, whose 42–2 record in 1939–1940 included two victories over the National Invitation Tournament (NIT) champions Long Island University.

During the period between World War I and World War II, some black students played basketball at integrated colleges. John Howard JOHNSON, the first black basketball player at Columbia University, graduated from there in 1921. Basketball players who later achieved fame in other endeavors included Ralph BUNCHE, a Nobel Peace Prize recipient who starred at UCLA in the mid-1920s, and Jackie ROBINSON, who, also playing for UCLA (1939–1941), led his conference in scoring two years in a row before he went on to become the first African American to play baseball in the modern major leagues.

Since basketball is less expensive than football and more centrally positioned in the academic year than baseball, it became popular in black high schools in the 1920s. The black state high school athletic associations of West Virginia were the first of many to begin sponsoring state basketball tournaments in 1924. By 1930 eight tournaments were established; by 1948 every racially segregated southern and midwestern state had African-American statewide athletic organizations that emphasized basketball. In May 1929, Charles H. Williams, the director of physical education at Hampton Institute, inaugurated the National Interscholastic Basketball Tournament, which was held annually until 1942.

Of the several professional basketball leagues that rose and fell during the interwar period, all excluded blacks, though given the weak and disorganized nature of professional basketball at this time, this ban had less impact than for other professional sports. Independent all-black teams such as the Smart Set in Brooklyn, St. Christopher's, Alphas, and the Spartans in New York City, and Loendi in Pittsburgh struggled to survive despite inadequate facilities, small turnouts, and uncertain schedules. The most successful teams hit the road, barnstorming from city to city on a trail blazed by the best all-white team of the interwar era, the Original Celtics. The two best African-American squads, the New York-based RENAISSANCE BIG FIVE ("Harlem Rens") and the Chicago-based HARLEM GLOBETROTTERS, frequently played against the Original Celtics and other all-white touring teams, thus making basketball the only interwar professional team sport to allow interracial competition.

The Rens began in 1923, the creation of the St. Kitts native Robert L. Douglas, who immigrated as a child to the United States in 1888. For several years Douglas played with the New York Spartans, then decided to form his own team. He rented the Renaissance Casino ballroom in Harlem. The team took their name from that home site, but played most of their games on the road against any team—black or white, city or small town—that would take them on. Over a twenty-year span, the Rens averaged more than 100 victories annually. In their greatest season, 1932–1933, they won 88 consecutive games and finished with a 120–8 record. At Chicago in 1939 they won the first "world tournament" of professional basketball. Little wonder that all seven players who formed the core of the team during the 1930s— Charles T. "Tarzan" COOPER, John "Casey" Holt, Clarence "Fats" Jenkins, James "Pappy" Ricks, Eyre "Bruiser" Satch, William "Wee Willie" Smith, William J. "Bill" YANCEY—are in the Basketball Hall of Fame.

The Rens were already well established when the Harlem Globetrotters played their first game in January 1927. Initially called the Savoy Big Five because they played in the SAVOY BALLROOM in Chicago, the Globetrotters were the brainchild of a Jewish immigrant, Abraham Saperstein. The somewhat misleading Harlem tag was a public relations ploy, which provided a racial rather than a geographical reference. As a team of barnstorming professionals, they traveled far longer, more widely, and to consistently larger crowds than any sports team in history. In 1951 they appeared before 75,000 spectators in Berlin's Olympic Stadium. They have performed for literally millions of live spectators around the world, as well as to huge television and movie audiences.

Although best known in recent decades for their basketball comedy, the original Globetrotters were serious, highly skilled athletes. In 1940 they succeeded the Rens as "world champions" in the fiercely fought Chicago tournament. Earlier, during the GREAT DEPRESSION, they averaged nearly 200 games per year, winning more than 90 percent of them.

Youth basketball team, New York City, 1926. (Photographs and Prints Division, Schomburg Center for Research in Black Culture, The New York Public Library, Astor, Lenox and Tilden Foundations)

Constant travel produced fatigue; large margins of victory made for boredom. For rest and relief from tedium, the Globetrotters began clowning, especially on those frequent occasions when they dramatically outmatched their opponents. Comedy proved contractually lucrative, so the Globetrotters developed funny skits and routines. Staged silliness swamped competitive play in the 1940s. Still, Reece "Goose" Tatum, Marques Haynes, Meadow George "Meadowlark" Lemon, Nat "Sweetwater" Clifton, Connie Hawkins, and Wilt CHAMBERLAIN are among the most famous of the many superb athletes who have worn the colorful Globetrotter uniform.

It was just as well that the Globetrotters shifted from serious basketball to comedy routines, because the racial integration of the National Basketball Association (NBA) in 1950 meant that the Globetrotters could no longer attract the best college athletes. (A forerunner of the NBA, the Basketball Association of America, signed black players as early as 1948.) For the 1950–1951 season, the Boston Celtics recruited Charles "Chuck" Cooper from Duquesne University, the Washington Capitals tapped Early Lloyd from West Virginia State College, and the New York Knicks bought Sweetwater Clifton from the Globetrotters.

Prior to World War II the abolition of the center jump, the introduction of an innovative one-handed shot, and the use of the fast break, served to streamline Naismith's slow and deliberate original game. In the early 1950s, the NBA responded to the market's demand for a faster, more attractive game by banning zone defenses, doubling the width of the foul lane (to twelve feet), and introducing a twenty-four-

Perhaps the most famous confrontation in all of basketball: Wilt Chamberlain going for shot, Bill Russell defending. At the time of this 1969 playoff game, Chamberlain was playing for the Los Angeles Lakers, while Russell was in the last season of his remarkable career with the Boston Celtics. (AP/Wide World Photos)

second shot clock. All these changes were completed by 1954 and worked to the great advantage of African-American newcomers who had mastered a more spontaneous, personalized style of play on the asphalt courts of urban playgrounds.

The first African American to become a dominant player in the NBA was William "Bill" RUSSELL. Russell came from an extremely successful undergraduate career at the University of San Francisco where he and another gifted African American, K. C. JONES, led the San Francisco Dons to 55 straight victories and two National Collegiate Athletic Association (NCAA) championships. Rather than go into the NBA immediately, however, both men participated in the 1956 Summer Olympics in Melbourne, Australia, leading the United States basketball team to an easy gold medal. Then, while Jones fulfilled a two-year military obligation, Russell joined the Celtics at mid-season. The defensive, shot-blocking, and rebounding skills of Russell complemented those of several high-scoring Celtics. Together they produced their first NBA championship in Russell's first pro season.

Jones joined the Celtics in 1958–1959, and he and Russell helped the Celtics to an all-time record nine consecutive NBA crowns. In 1964 Boston fielded the first all-black starting lineup in the NBA: Russell, Jones, Sam Jones, Tom "Satch" Sanders, and Willie Naulls; John THOMPSON, the future coach of Georgetown University, backed up Russell. Russell's NBA nemesis was a high-scoring giant of a man, Wilton Norman "Wilt" Chamberlain. Over seven feet tall and weighing 265 pounds in his prime, Chamberlain earlier led Overbrook High School in Philadelphia to two city championships, once scoring 90 points in a single game. In his varsity debut at the University of Kansas in 1957, his 52 points set the Jayhawks on the path to the NCAA finals, where they narrowly lost in triple overtime to top-ranked North Carolina. After two All-American seasons at Kansas, Chamberlain toured for a year with the Harlem Globetrotters, then joined the Philadelphia Warriors in the NBA in 1959. In a fourteen-year NBA career, he played with four different teams and was selected for thirteen All-Star games, seven first-team All-NBA squads, and four Most Valuable Player awards. In a total of 1,045 NBA games, he averaged more than 30 points per game, and in 1962, he scored 100 points in a single game against the New York Knickerbockers. At his retirement in 1973, he held or shared forty-three NBA records.

In addition to Chamberlain and Russell, black athletes such as Elgin BAYLOR and Oscar ROBERTSON achieved basketball renown in the late 1950s and '60s. Though they had their differences in talent and style, it is perhaps possible to see in their play elements of a shared athletic aesthetic that would dominate NBA basketball in the 1970s. Baylor, Chamberlain, Robertson, and Russell exhibited skills developed in playground competition best represented in the Rucker tournament (New York) and the Baker League (Philadelphia), both created in the postwar era. All four of these early NBA stars grew up in urban, not rural, America, and they developed their game in East Coast, industrial Midwest, and West Coast inner-city playgrounds. All four also attended white rather than traditionally black colleges. Other players from the early and mid 1960s who exemplified the playground style were Earl "the Pearl" Monroe, who attended Winston-Salem College in North Carolina, before beginning a successful career with the Baltimore Bullets and New York Knicks. Connie Hawkins, a consummate playground basketball player from New York City, had his promising career derailed by his ambiguous involvement in a point-shaving scandal in 1960. After some years in basketball purgatory, he joined the Phoenix Suns in 1969.

In the period after World War II, blacks became prominent in college basketball. Two black players started for the City College of New York (CCNY)

squad of 1950, the only team ever to win the NCAA and NIT tournaments in the same year. When the first significant cracks appeared in the armor of racially segregated universities in the 1950s, basketball coaches rushed to recruit blue-chip African-American athletes for traditionally all-white teams. Even the smallest of colleges sought to enhance their status through the basketball prowess of new black talent. With fewer than 1000 students, little St. Francis College of Loretto, Pa., wooed Maurice Stokes. He carried them from the obscure National Catholic Tournament to the more prestigious and lucrative National Invitational Tournament in 1955.

As integration undercut black college athletics, coach John B. McLendon's program at Tennessee A&I enjoyed a kind of last hurrah of basketball excellence. After successful stints at North Carolina College and Hampton Institute, McLendon in 1954 went to Tennessee A&I in Nashville. Employing a fast-break press-and-run game that he claimed to have learned years earlier from the aged Dr. Naismith at the University of Kansas, within five years McLendon won four league championships and three national titles in the newly integrated National Association for Intercollegiate Athletics (NAIA). The Most Valuable Player of the 1959 NAIA Tournament was Tennessee A&I's Richard "Dick" Barnett, a future New York Knickerbocker stalwart.

Strong racially integrated teams won NCAA titles for the University of Cincinnati and Loyola University of Chicago in the early 1960s. Building on a tradition of integration that dated back to the 1920s, UCLA attracted a number of African-American athletes during the eleven-year span (1964–1975) in which they won ten national titles. The person most identified with UCLA's reign was Lew Alcindor, later known was Kareem ABDUL-JABBAR, a 7'2" dominating center with a deft scoring touch, who later went on to a twenty-year career in the NBA with the Milwaukee Bucks and the Los Angeles Lakers.

The passing of the old era of segregated basketball was symbolized in the NCAA finals of 1966, in which an all-black squad from Texas Western University (now the University of Texas at El Paso) defeated a highly favored all-white team from the University of Kentucky. Shortly thereafter, the color bar began crumbling in the segregated schools of the Southwest Conference, when James Cash became Texas Christian University's first black basketball player in 1966. In Maryland, Billy Jones became the first African-American basketball recruit in the Atlantic Coast Conference. Finally, Perry Wallace of Vanderbilt University broke the racial barrier in the Southeastern Conference in 1967, the same year the University of Alabama's new basketball coach, C. M. Newton, began recruiting African Americans. In 1974 Alabama became the first SEC team to field five black starters.

The growing dominance of African Americans in college basketball has not been without its share of problems, however. Many colleges recruit black players as athletes, with little regard for or interest in providing them with an education. For example, shortly after winning the 1966 NCAA title, members of the Texas Western team began dropping out of college. They had all been recruited from the New York City area, and the overwhelmingly white, southern campus environment provided a combination of academic and social pressure. Even today, dropout rates remain at unacceptably high levels. Between 1985 and 1991, the average graduation rate among black college athletes was 26.6 percent, as opposed to the rate of 45.7 percent for white athletes (the rate for each group was slightly higher for basketball players). Another problem that has ruined or seriously detoured many promising careers is drug addiction. Len Bias, a number one NBA draft choice from the University of Maryland, allegedly died of a drug overdose in 1988. Other talented black basketball players, such as the playground legends Earl "the Goat" Manigault or Herman "Helicopter" Knowings of New York City, or William "Chicken Breast" Lee, or Terry "Sweets" Matchett, from Washington, D.C., did not have the social skills to enable them to move beyond the milieu of their hometown neighborhoods.

The African-American player has simply transformed basketball at all levels, especially bringing extraordinary excitement, media exposure, and financial success to the NBA. The seamless web of connection between high school, college, and professional basketball is best seen in Baltimore's Dunbar High School squad of 1982–1983. Finishing with a 31–0 record, Dunbar was top-ranked among all high school teams by *USA Today*. Virtually the entire team went to college on basketball scholarships. In 1987, three of them were selected in the first round of the NBA draft: Tyrone "Mugsey" Bogues of Wake Forest, by the Washington Bullets; Reggie LEWIS of Northeastern, by the Boston Celtics; and Reggie Williams of Georgetown, by the Los Angeles Lakers. As of 1992 three-quarters of all NBA players were black.

African Americans also play a prominent role in women's basketball. The 1984 Olympic women's basketball team included Cheryl MILLER, who led her University of Southern California team to two NCAA championships, Pam McGee, and Lynette WOODARD, who later became the first female player for the Harlem Globetrotters. C. Vivian STRINGER, who became coach of the women's basketball team at Cheyney State College in 1972, led the team to a

second-place victory in the NCAA Women's National Basketball Championship ten years later. When Stringer became coach of the University of Iowa's women's team in 1983, she became the first black female coach to lead a women's basketball team of national rank. Under her leadership, the Iowa team qualified to play in the NCAA national tournament for seven straight years, from 1986 to 1992. In 1992, Stringer became the NCAA delegate for the committee organizing the Barcelona Olympic Games.

Although African Americans are vastly underrepresented in the management and coaching ranks of the NBA, they are considerably more visible there than in major league baseball or in the National Football League. At the outset of the 1992–1993 season, the NBA had only two black head coaches, although three had been let go during the previous year; but fully one-third of the assistant coaches, five general managers, and one co-owner (of the Denver Nuggets) were African American.

In the collegiate ranks, African-American head coaches John Thompson of Georgetown, John CHANEY of Temple, George Raveling of the University of Southern California, and Nolan Richardson of the University of Arkansas are the exceptions, not the rule, for NCAA Division I teams. Division II coach Clarence "Big House" GAINES is less well known, but he is by far the most successful of all African-American coaches. At the end of the 1992–1993 season, he retired after forty-seven years as coach of Winston-Salem State University. Gaines coached his teams to a record of 828–440, making him second only to Kentucky coach Adolph Rupp in career victories.

Georgetown's John Thompson is probably the most visible, and certainly the most controversial, African-American coach. After a brief, successful stint at St. Anthony's Catholic High School in Washington, D.C., Thompson moved to Georgetown in 1972. Emphasizing the tenacious defense and team play he had learned during his brief time as a Celtic, he steered the Georgetown Hoyas to three consecutive NCAA finals, from 1983 to 1985, and to the national championship in 1984. Four years later he coached the United States Olympic team to a bronze medal in Seoul. Always emphasizing the primacy of academics, he ably recruited African-American athletes for Georgetown. Patrick Ewing and Alonzo Mourning are two of the most famous among many players to whom Thompson directed his homilies of racial pride and achievement.

In the 1980s basketball soared to new heights of international popularity, as did African-American basketball players. Two players who stood out in particular are Earvin "Magic" JOHNSON and Michael JORDAN. Johnson, an unusually tall guard at 6'8", led

John Thompson (right), coach of Georgetown University's basketball team, NCAA champions in 1984, was one of the leading basketball coaches of the 1980s and '90s. He coached the U.S. Olympic basketball team in 1988. (Photographs and Prints Division, Schomburg Center for Research in Black Culture, The New York Public Library, Astor, Lenox and Tilden Foundations)

Michigan State University to an NCAA championship in his sophomore year in 1979, before turning pro and joining the Los Angeles Lakers. He helped the Lakers to an NBA championship in his rookie season and subsequently led his team to five championships during his career. In addition to his basketball skills, his effervescent and winning personality propelled him to media celebrity. His many admirers were shocked to learn of his early retirement in the fall of 1991 after he announced that he had contracted the HIV virus. In the second half of the 1980s and early 1990s the dominant basketball player was Michael Jordan. Jordan played for the University of North Carolina before joining the Chicago Bulls in 1984, where, as a shot maker of astounding versatility, he quickly became one of the most powerful players in league history. Jordan also became a media spokesman for a number of products and advertising campaigns. His widespread acceptance and popularity has been as remarkable as his outstanding on-court skills. The role of African Americans in basketball was underlined by the success of the so-called "Dream Team," an NBA All-Star team that romped

against the best of the rest of the world in the 1992 Summer Olympics in Barcelona. Eight of the twelve players on the team were black, including Magic Johnson in his final competitive appearance before his retirement. Michael Jordan would himself retire in October 1993 but returned in spring 1995. New aspirants also began to rise. Seven-foot-tall Shaquille O'Neal of the Orlando Magic, who in February 1993 became the first rookie since 1985 to lead the NBA All-Star Game starting lineup, would become one of the most closely watched stars of professional basketball.

Yet, despite the increasing successes of individual black basketball players, the nature of collegiate basketball itself continues to be an issue of controversy in the African-American community. In late 1993 and early 1994 the NCAA considered the adoption of new rules for prospective players, setting minimum academic standards for team admittance (a grade of "C" or better) and limiting the number of college scholarships offered for basketball. The rules revived tensions between a number of interests: the need to attract more promising minority athletes, the need to maintain a quality team in order to attract alumni donations, the need for schools to maintain consis-

tent academic standards, and the decrease in available scholarship funds. For prospective African-American student athletes, the proposed new rules meant the intensification of an already keen competition for a chance at professional status. The controversy highlighted the debate within the black community on whether basketball unduly dominated the activities of black teenagers, and the role of basketball as a means of upward mobility for inner-city youth.

REFERENCES

ASHE, ARTHUR R., JR. *A Hard Road to Glory: The History of the African-American Athlete Since 1946.* New York, 1988.

GEORGE, NELSON. *Elevating the Game: Black Men and Basketball.* New York, 1992.

PETERSON, ROBERT W. *Cages to Jump Shots: Pro Basketball's Early Years.* New York, 1990.

PORTER, DAVID L., ed. *Biographical Dictionary of American Sports: Basketball and Other Indoor Sports.* Westport, Conn., 1989.

WILLIAM J. BAKER

Julius Erving, playing for the Philadelphia 76ers in 1981, in a typically acrobatic move to the basket. (AP/Wide World Photos)

Basquiat, Jean-Michel (December 22, 1960–August 12, 1988), artist. Jean-Michel Basquiat was one of the most prominent artists to gain worldwide recognition in the 1980s. He was born in Brooklyn, N.Y., of Haitian and Puerto Rican–American parentage. His parents were separated in 1968, and Basquiat and his two sisters grew up with their father in Brooklyn, except for a period from 1974 to 1976, when the family lived in Puerto Rico. At the age of seven, Basquiat was badly hurt when he was hit by a car. He spent a month in the hospital, where his spleen was removed. While he was recuperating, his mother gave him *Gray's Anatomy,* a reference work that led to a lifelong interest in images of human anatomy.

Basquiat dropped out of high school and left home at the age of seventeen, determined to become a star in the downtown art and club scene of the late 1970s, where his aphoristic graffiti writings and drawings signed "SAMO©" soon earned wide underground recognition. In 1980 his art was exhibited for the first time and to critical acclaim in the Times Square Show in New York City. Other group shows followed, and in 1981 he had his first solo exhibition in Modena, Italy.

In New York, Basquiat began showing at the Annina Nosei Gallery in SoHo, using the gallery basement as his studio. His first one-man show there took place in 1982, and soon his work was being exhibited at prominent galleries worldwide. In 1982, Basquiat was the youngest artist to participate in

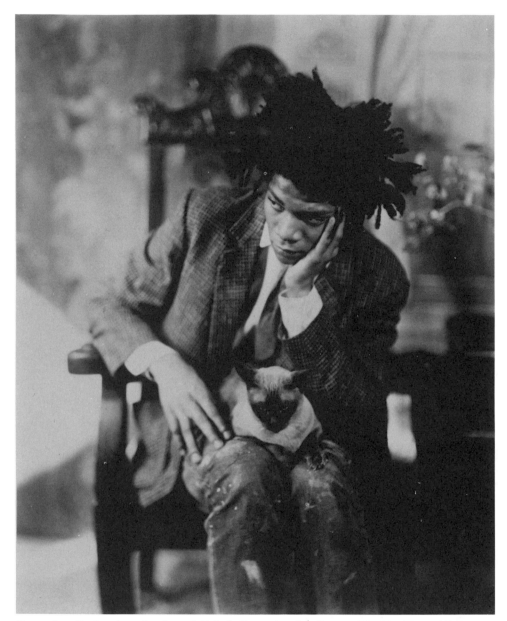

Portrait of visual artist Jean-Michel Basquiat by James VanDerZee. (Courtesy Donna VanDerZee)

Documenta 7 in Kassel, Germany, and one of the youngest ever to be included the following year in the Whitney Biennial. A close friendship with Andy Warhol was a significant force in his life until Warhol's death in 1987.

Within the space of a few years, Basquiat rose from an anonymous street graffitist to become a world-famous artist, a feat that—as much as his art itself—came to define his popular image and to epitomize the fast-paced art world of the 1980s. As a young black male, however, he was viewed with suspicion by people blind to the significance of his work. In addition, a growing drug problem exacerbated his difficult relations with dealers, family, and the people closest to him. Basquiat died of a heroine overdose in August 1988 at the age of twenty-seven.

Since his death, the importance of Basquiat's work has come to be still more widely recognized. In only eight years his work evolved from a direct, highly energized, expressionistic vocabulary to a complex synthesis of African-American and European cultural traditions, incorporating elements of black history, music, and popular culture in an advanced visual language of painting, collage, photo-mechanical reproduction, and sculpture. In his hands a sometimes raucous world of boxing, jazz, TV, and political reality was expressed in the language of Picasso, Rauschenberg, Warhol, Twombly, Dubuffet, and Leonardo da

Vinci. His syncopated and haunting juxtaposition of words with images created a kind of visual poetry that is one of his most distinctive contributions to twentieth-century painting.

The first full museum retrospective of Basquiat's work, organized by the Whitney Museum of American Art, opened in New York City in 1992.

REFERENCES

MARSHALL, RICHARD, ET AL. *Jean-Michel Basquiat.* New York, 1992.

THOMPSON, ROBERT FARRIS. *Jean-Michel Basquiat.* New York, 1985.

NATHAN KERNAN

Bass, Kingsley, B. *See* Bullins, Ed.

Bassett, Ebenezer Don Carlos (October 16, 1833–1908), educator and diplomat. Born in Litchfield, Conn., the son of Tobias Bassett, a light-skinned black, and Susan Bassett, a Shagticoke-Pequot Indian, Bassett received his early education at the Wesleyan Academy at Wilbraham, Mass., and at the Connecticut State Normal School. Bassett continued his education at Yale College in New Haven, where he simultaneously served as the principal of a local high school.

In 1857 Bassett was hired as principal of the Institute for Colored Youth in Philadelphia. He would head the school for the next twelve years, and according to Philadelphia's mayor, the institute became "unquestionably the foremost institution of its kind in the country." Bassett left the institute in 1869, when President Grant appointed him U.S. minister to Haiti and the Dominican Republic, making him the first African-American diplomat. For the next eight years, Bassett would perform his job admirably, despite the constant internal conflicts of these Caribbean nations. Frederick DOUGLASS, a lifelong friend, later wrote that Secretary of State Hamilton Fish had told him "he wished one-half of his ministers abroad performed their duties as well as Mr. Bassett."

After Bassett returned to the United States in 1877, he served as consul-general for Haiti in New York until 1888. When Frederick Douglass was appointed American minister to Haiti and the Dominican Republic in 1889, Bassett served as his interpreter and adviser. Later, in a private correspondence to Bassett, Douglass alleged that Bassett had accepted $6,000 from the Haitian government to influence Douglass's

decisions as minister. There exists no proof of this charge. Bassett returned to service for the Haitian consul-general office in the early 1900s, and it was during this time that he wrote *A Handbook on Haiti* (1902) for the Pan American Union, though he is not credited with its authorship in the volume. The last years of his life were spent with his family in Philadelphia, where he died in 1908.

REFERENCES

DOUGLASS, FREDERICK. *The Life and Times of Frederick Douglass.* New York, 1962.

HEINL, NANCY GORDON. "America's First Black Diplomat." *Foreign Service Journal,* August, 1973, pp. 20–22.

LOGAN, RAYFORD W. *The Diplomatic Relations of the United States with Haiti, 1776–1891.* Chapel Hill, N.C., 1941.

DAVID B. IGLER

Bateman, Mildred Mitchell (March 22, 1922–), psychiatrist and administrator. Born in Cordele, Ga., Mildred Bateman received her B.S. in 1941 from Johnson C. Smith University, Charlotte, N.C. She earned an M.D. from the Women's Medical College of Pennsylvania in 1946 and did her residency at the Menninger School of Psychiatry in Topeka. After serving as a physician and then clinic director at the Lakin State Hospital of West Virginia, Bateman became Director of the West Virginia Department of Mental Health. She was the first female mental health officer in the United States, as well as the first black to head an executive department in West Virginia. Under her leadership, federal aid to the state increased significantly, as did the number of West Virginia communities offering mental health services. Bateman received numerous honors over the years, including an honorary doctorate of science degree from Johnson C. Smith University, and the Woman of the Year Award from the *Gazette-Mail* in 1962.

REFERENCES

LOW, W. AUGUSTUS, and VIRGIL A. CLIFT, eds. *Encyclopedia of Black America.* New York, 1981.

PLOSKI, HARRY A., and JAMES WILLIAMS, eds. *The Negro Almanac.* Detroit, 1989.

LYDIA MCNEILL

Bates, Clayton "Peg Leg" (October 11, 1907–), tap dancer. Born in Fountain Inn, S.C., Bates began dancing when he was five, then lost his

leg in a cotton-seed mill accident at age twelve. Determined to continue dancing, Bates left home at age fifteen, shortly after his uncle made him a wooden leg, to embark on a professional career as a dancer. Quickly working his way upward from minstrel shows and carnivals to the vaudeville circuits, he joined Lew Leslie's Paris revue *Blackbirds* in 1929.

Returning to the United States in the 1930s, Bates became a featured tapper at such top NIGHTCLUBS in HARLEM as the COTTON CLUB, Connie's Inn, and Club Zanzibar. He was one of the few black tap dancers able to cross the color barrier and performed in the prestigious white vaudeville circuits, where he appeared with Bill "Bojangles" ROBINSON, Fred Astaire, and Gene Kelly. From the 1930s to the '50s,

Clayton "Peg Leg" Bates. (Photographs and Prints Division, Schomburg Center for Research in Black Culture, The New York Public Library, Astor, Lenox and Tilden Foundations)

Bates was a frequent guest on the *Ed Sullivan Show*.

Bates invested his earnings in a large resort, the Peg Leg Bates Country Club, located in the Catskill Mountains near Kerhonkson, N.Y. Opened in 1952, the club catered to a black clientele and flourished as the largest black-owned and -operated resort in the country. It remained popular through the 1960s and '70s. Bates continued to perform there, along with other jazz musicians and dancers, until he sold the property in the late 1980s. He was the subject of an hour-long documentary, *The Dancing Man: Peg Leg Bates,* released in 1992.

Bates's dancing was melodically and rhythmically enhanced by the combined sounds of his deep-toned peg, made of leather and tipped with rubber, and the higher-pitched metallic tap on his right foot. Bates had to reinvent each tap step, adding individual interpretations to such classic steps as the "Shim Sham Shimmy," "Half Break," "Suzie-Q," and "Trucking." Accomplished in acrobatics, legomania (dancing as if with "rubber legs"), flash (spectacularly difficult steps usually involving aerial maneuvers), and novelty dancing (dancing with the use of special props), Bates surmounted his physical challenge to achieve technical virtuosity, and consistently proved himself among the finest of all rhythm tap dancers.

REFERENCES

FRANK, RUSTY. *Tap! The Greatest Tap Dance Stars and Their Stories, 1900–1955.* New York, 1990.
WINERIP, MICHAEL. "A Legend and His Catskills Resort for Blacks." *New York Times,* July 15, 1985.

CONSTANCE VALIS HILL

Bates, Daisy Gaston (1920–), activist. Daisy Bates is best known for her leadership in the struggle to integrate Central High School in Little Rock, Ark., in 1957. A native of Arkansas, she knew well the realities of education under segregation. The black schools in her local school system, like others under segregation, suffered from inadequate facilities and lack of access to textbooks and supplies. This experience had a profound effect on her, and it moved her to action, as it did so many others in the civil rights era. In 1941 Daisy Gaston married L. C. Bates, a journalist from Mississippi, and the two published the weekly *Arkansas State Press.* Through the paper, they addressed major issues facing African Americans, making it a popular and effective community instrument.

As president of the state conference of the NATIONAL ASSOCIATION FOR THE ADVANCEMENT OF COLORED PEOPLE (NAACP), Bates, with other ac-

Book jacket for *The Long Shadow of Little Rock* by Daisy Bates. (Photographs and Prints Division, Schomburg Center for Research in Black Culture, The New York Public Library, Astor, Lenox and Tilden Foundations)

tivists, sought to move the school systems to comply with the 1954 BROWN V. BOARD OF EDUCATION Supreme Court decision. Although Little Rock had designed a program for integrating the schools, it had failed to act on the plan. One of the tactics Bates employed to draw attention to this was photographing African-American children attempting to gain admission to white public schools. This tactic was bolstered by an NAACP lawsuit against the school board for failure to implement a desegregation plan. Finally, the school board agreed to integrate Central High School in the fall of 1957.

Bates spearheaded the movement to organize students to register for Central. While almost eighty students were willing to register, the school board placed obstacles in the way and dissuaded parents, bringing the final number to nine. None of these was among the group of students involved in the NAACP court case against the Little Rock board. It was clear that there would be violence surrounding the open-

ing of school when, two weeks before the semester began, a rock was thrown through the window of Bates's home. A note attached to the rock read, "Stone this time. Dynamite next."

Bates took responsibility for transporting the nine students to Central High. However, under the pretense of maintaining order, Gov. Orval Faubus used the Arkansas National Guard to prevent the nine from entering the school. The immediate situation was resolved when President Eisenhower brought the Arkansas National Guard under federal control to protect the students and their right to attend Central High School. The "Little Rock Nine" finally began the school year on September 25, 1957. It was the beginning of what would prove to be a very difficult year.

Bates and other state NAACP officials were arrested the following month for violating a statute that required organizations to furnish the county with membership and financial information. The statute was designed to hinder the operations of civil rights organizations. Bates was convicted and fined one hundred dollars, but her conviction was overturned by the Supreme Court.

Following the integration of Central High, Daisy Bates went on to be active in DEMOCRATIC PARTY politics, voter registration, and community projects. She continues to be a voice in the ongoing struggle for civil rights.

REFERENCES

BATES, DAISY. *The Long Shadow of Little Rock*. New York, 1962.

HUCKABY, ELIZABETH. *Crisis at Central High School: Little Rock, 1957–1958*. Baton Rouge, La., 1980.

WILLIAMS, JUAN. *Eyes on the Prize: America's Civil Rights Years, 1954–1965*. New York, 1987.

JUDITH WEISENFELD

Battey, Cornelius M. (August 26, 1873–March 15, 1927), photographer. Born in Augusta, Ga., in 1873, C. M. Battey learned the rudiments of photography in the mid-1890s. He trained with Underwood and Underwood in New York City, and by 1900 he had established a substantial reputation in the portrait studios of Cleveland and New York. He owned and operated one of the most popular portrait studios on Mott Street in New York, where he photographed numerous American and European figures, including Frederick DOUGLASS, Booker T. WASHINGTON, Bob COLE, J. Rosamond JOHNSON, President Calvin Coolidge, Sir Thomas Lipton, and Prince Henry of

Prussia. He also produced genre scenes—photographic tableaux that described life in the African-American communities of the North and South.

In 1914 Battey was invited by Booker T. Washington, president and founder of Tuskegee Institute (*see* TUSKEGEE UNIVERSITY) in Alabama, to set up the photography department there. Battey was head of the Photographic Division of the Mechanical Department from 1914 until his death in 1927. In addition to teaching, Battey documented the daily life at Tuskegee by photographing in the classrooms and on campus and by creating images of parades and leisure activities. He also began to make picture postcards and large-format photogravures of major African-American political and literary figures such as John Mercer LANGSTON, Blanche BRUCE, Frederick Douglass, Paul Laurence DUNBAR, W. E. B. DU BOIS, and Booker T. Washington. During this period, he entitled the series "Our Heroes of Destiny," and in 1918 retitled it "Our Master Minds." The series was sold throughout the country and was received with great praise. Between 1915 and 1927, Battey's photographs were featured on the covers of the CRISIS, the MESSENGER, and OPPORTUNITY magazines. The collective visual message of his work was that of racial pride and dignity. Shortly after Battey's death, an editorial in *Opportunity* eulogized, "Battey unveiled to us through the unique union of camera and artistic interpretation our marvelous variety of character and profile, as well as the humor, dignity, and pathos of our life."

REFERENCES

Obituary. *Crisis* (May 1927): 91.
Obituary. *Opportunity* (May 1927): 126.

DEBORAH WILLIS-THOMAS

Tuskegee Institute students in carpentry class, photographed by C. M. Battey, 1920. (Photographs and Prints Division, Schomburg Center for Research in Black Culture, The New York Public Library, Astor, Lenox and Tilden Foundations)

Battle, Kathleen (August 13, 1948–), opera singer. Born in Portsmouth, Ohio, Kathleen Battle was the daughter of Ollie Battle, a community and church activist, and Grady Battle, a steelworker who also sang in a gospel quartet. She first sang at the Portsmouth African Methodist Episcopal Church. A National Merit Scholar in mathematics, Battle majored in music education at the University of Cincinnati College-Conservatory (B.M. and M.M.). She taught music for two years in Cincinnati elementary schools before embarking on her professional career. A lyric soprano noted for her small, sweet voice, she made her professional singing debut in Brahms's *A German Requiem* with the Cincinnati orchestra at the Spoleto Festival in Italy (1972). Her opera debut came soon after as Rosina in Rossini's *Il Barbiere di Siviglia* with the Michigan Opera Theater. In 1974, she met James Levine, later to become artistic director of the Metropolitan Opera, who became her mentor. The following year, she appeared on Broadway in Scott Joplin's opera *Treemonisha*. In 1976, Battle appeared as Susanna in *The Marriage of Figaro* at the New York City Opera, and made her Metropolitan Opera debut in 1978, singing the shepherd in Wagner's *Tannhäuser*. Since then she has sung several leading roles, among them Mozart's Pamina, Richard Strauss's Sophie in *Der Rosenkavalier*, and Handel's Cleopatra in *Giulio Cesare*. Subsequent to her European debut as Despina in Mozart's *Così Fan Tutte* in Salzburg in

1982, Battle performed there several times as Despina, as Susanna, and as Zerlina in *Don Giovanni*—the last for American national television—as well as in many other places. In 1993, she attracted sellout audiences during a Metropolitan Opera tour of Japan.

Battle, whom *Time* magazine in 1985 called "the best lyric coloratura in the world," has shifted effortlessly between the opera stage and the concert hall, where she performs with symphony orchestras and gives several recitals per year. She has won three Grammy awards, including one for her recital album *Kathleen Battle at Carnegie Hall* (1992). Other recordings include a selection of Bach arias, the title role in Handel's *Semele*, pieces by George Gershwin, and two albums of Baroque concert pieces and arias with African-American trumpeter Wynton MARSALIS.

In 1991, Battle and soprano Jessye NORMAN gave a concert of SPIRITUALS at Carnegie Hall which was shown on national television and prompted a best-selling recording. In 1993, Battle sang the premiere of a song cycle she had commissioned from African-American writer Toni MORRISON and composer André Previn.

REFERENCES

HOBAN, PHOEBE. "Battlemania." *New York* (July 12, 1992).
STORY, ROSALYN M. *And So I Sing: African-American Divas of Opera and Concert.* New York, 1990, pp. 196–200.

A. LOUISE TOPPIN

Leading soprano Kathleen Battle has sung with most of the world's great opera companies and frequently appears as a recitalist and soloist with symphony orchestras. She sings here in 1992 with the Boston Symphony Orchestra, conducted by Seiji Ozawa, at New York's Carnegie Hall. (AP/Wide World Photos)

Baumfree, Isabella. *See* Truth, Sojourner.

Baylor, Elgin Gay (September 16, 1934–), basketball player. Elgin Baylor was born and grew up in Washington, D.C. Baylor's father, John Baylor, named his son after his treasured Elgin pocketwatch. Baylor did not play basketball until high school. At Spingarn High School, he made the high school All-America team. He then played briefly for the College of Idaho, before moving to Seattle University, where he played two seasons as forward. In 1956 and 1957, he was third in scoring and led the country in rebounding; in 1957 and 1958, he averaged 31.5 points per game and was third in rebounding.

In 1958, Baylor signed with the Minneapolis Lakers of the National Basketball Association (NBA). In his first season, he averaged 15 rebounds and 24.9

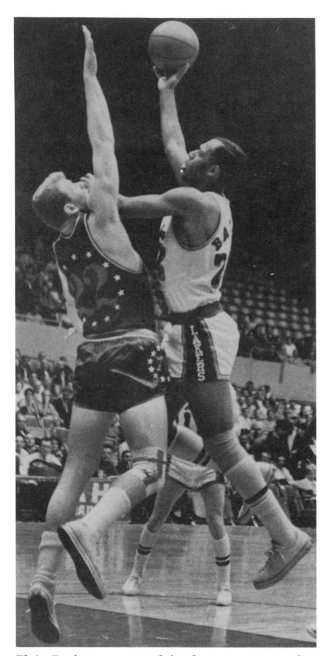

Elgin Baylor was one of the first great power forwards in the NBA. In this photograph from 1964, Baylor tries to shoot over Lee Shaffer of the Philadelphia 76ers. (AP/Wide World Photos)

points per game, winning Rookie of the Year and All-NBA honors. In a game against the New York Knickerbockers in 1960, he scored 71 points, then a single-game high. Team owner Robert Short credited Baylor's exciting play with saving the franchise from bankruptcy through rising ticket sales. The franchise moved to Los Angeles, where it became extremely profitable, and Baylor became one of the most durable players of his era.

Although only 6' 5", Baylor possessed an amazing jumping ability that made him a top scorer and re-bounder. His shooting and driving ability made him one of the game's first star "power forwards." Baylor continued with the Lakers until 1972, when knee injuries forced him to retire. He ended his career with 23,149 points, an average per game of 24.9 points. He made the All-NBA team ten times, and was elected to the NBA Hall of Fame in 1976. In 1978, he became head coach of the expansion basketball team the New Orleans Jazz. He held the position for three seasons, compiling an 86–134 record. In 1979, he was hired by another expansion team, the Los Angeles Clippers, as general manager, and in 1986 he became the Clippers' executive vice president for basketball operations.

REFERENCES

ASHE, ARTHUR R., JR. *A Hard Road to Glory: The History of the African-American Athlete Since 1946.* New York, 1988.
PEPE, PHIL. *Greatest Stars of the NBA.* Englewood Cliffs, N.J., 1970.

LINDA SALZMAN

Beard, Andrew Jackson (1849–1921), inventor. Born a slave in Eastlake, Ala., Andew Jackson Beard spent his teenage years as a farmer in Birmingham, Ala. Although he had little education and could not read or write (he signed his patent applications with an *X*), he possessed talent as an inventor. In 1884, Beard sold patent rights to a plough he had invented for $4,000. Three years later, he sold a second plow patent for $5,200. He then began inventing more complicated machinery, including a rotary steam engine (patented 1892) that was cheaper to operate than other steam engines in use at the time. In November 1897, Beard received a patent for his most important invention—a car coupler for automatically hooking railroad cars together. His invention was the forerunner of the modern automatic coupler. Beard, who had worked for a railroad in Alabama, invented the device after losing his leg in a car-coupling accident. In the early days of railroading, the coupling of cars was done manually—a railroad worker would brace himself between two cars and drop a heavy metal connecting pin into place at the exact moment the cars came together. This was a dangerous operation, causing many workers to lose fingers, hands, or arms. Beard's coupler consisted of a set of "horizontal jaws," as he noted on his patent application, which linked two cars together automatically when one bumped the other. His coupler and others that were developed were improved upon and refined into a single standard coupler adopted nationally in 1916.

Beard received $50,000 for his patent from a New York manufacturing firm. Little is known about Beard's life between 1897 and his death in 1921.

REFERENCE

WILLIAMS, JAMES C. *Recognition at Last: The Story of Black Inventors in America.* Chicago, 1978.

ROBERT C. HAYDEN

Bearden, Bessye Jean (October 1888–September 25, 1943), journalist. Although she was born in Goldsboro, N.C., Bessye Bearden often referred to Atlantic City, N.J., as her hometown. Her mother, Carrie, and her stepfather, George T. Banks, moved the family to Atlantic City while Bessye was still a young child. She attended Hartshorn Memorial College in Richmond, Va., and graduated from Virginia Normal and Industrial School in Petersburg. Later, she did postgraduate work at the University of Western Pennsylvania and took journalism classes at Columbia University. She married Richard Howard Bearden; following the birth of their only child, Romare BEARDEN, in 1911, the family moved several times before finally settling in Harlem.

One of Bearden's first jobs, in the box office at the Lafayette Theater, brought her in contact with a wide variety of African-American artists, entertainers, and community leaders. The Bearden home quickly became a stopping-off place for people like Duke ELLINGTON, Fats WALLER, Arna BONTEMPS, and Marcus GARVEY. In 1922, Bearden was elected to the school board for District 15. When District 15 became District 12, she was elected chairwoman, the first black woman to serve in that capacity. The *Chicago Defender* asked her, in 1927, to write a weekly column for the paper. She accepted and continued writing the column until her death.

In the 1930s, Bearden became active in the Democratic party and was one of the founders of the Colored Women's Democratic League in New York. Rewarding her commitment, the Roosevelt administration appointed her deputy collector and tax auditor in 1935. She was also active in the National Colored Women's Club. Mary McLeod BETHUNE called on her frequently for consultation and advice.

REFERENCES

CAMPBELL, MARY SCHMIDT. "Bessye Bearden." In Jessie Carney Smith, ed. *Notable Black American Women.* Detroit, 1992, pp. 70–72.
SCHWARTZMAN, MYRON. *Romare Bearden: His Life and Art.* New York, 1990.

CHRISTINE A. LUNARDINI

Bearden, Romare (September 2, 1912–March 12, 1988), artist. In the last twenty-five years of Romare Bearden's life, collage was his principle medium. Through that medium, relying on memory, he recorded the rites of African-American life in all their historical and ceremonial complexity. In so doing, he joined the ranks of Picasso, Matisse, and Miró, artists who transformed collage into a quintessentially twentieth-century language. Working with a medium which by its very nature is fragmented and heterogeneous, where reality and illusion hang in a precarious balance, Bearden, as his friend the writer Ralph ELLISON once noted in *Projections,* captures

> the sharp breaks, leaps in consciousness, distortions, paradoxes, reversals, telescoping of time and surreal blending of styles, values, hopes and dreams which characterize much of Negro American history.

Fred Howard Romare Bearden was a child of privilege. He was born in Charlotte, N.C., in the home of his great-grandparents, Rosa and Henry Kennedy. Former slaves, the Kennedys had become prosperous landowners, and Bearden spent the early years of his life in a spacious Victorian-style frame house surrounded by doting great-grandparents and grandparents. In spite of their comfortable life, however, Bearden's college-educated parents, Bessye and Howard, were dissatisfied with the limitations of the JIM CROW South. On the eve of World War I, like hundreds of thousands of black Americans throughout the South, they migrated north.

After traveling to Canada, Bessye and Howard finally settled in Harlem. Harlem, in the years following World War I, was the black cultural capital of the world, the home of the NEW NEGRO movement, the site of the HARLEM RENAISSANCE. A flowering of poetry, painting, and music that marked the African American's first efforts to define himself as a distinctive cultural entity within the larger American culture, the Harlem Renaissance proved to be a rich crucible for Bearden.

Bessye, Bearden's beautiful and dynamic mother who was a New York editor for the CHICAGO DEFENDER and a political organizer, was at the center of this cultural activity. Her Harlem apartments were always filled with writers and intellectuals such as W. E. B. DU BOIS, Paul ROBESON, Langston HUGHES, and Zora Neale HURSTON, as well as painters Aaron DOUGLAS and Charles ALSTON. Musicians, too, were part of Bearden's circle, and young Romy, as he was called, was surrounded by such exciting jazz musicians and composers as Fats WALLER, Andy Razaf, and Duke ELLINGTON. Together, Bessye and Howard, who worked for the Department of Health, provided their only child with a remarkable upbringing.

During the summers Bearden often visited his great-grandparents and grandparents in Mecklenberg, a place which became a veritable paradise in his mind. During his high school years he lived in Pittsburgh with his maternal grandmother, Carrie Banks, who ran a boardinghouse for steelworkers. Like Charlotte and Harlem, Pittsburgh became part of a rich inventory of images for Bearden's mature art.

Bearden came of age as an artist during the depression. While in high school, he met the successful black cartoonist E. Simms CAMPBELL. Campbell's success inspired Bearden to try his hand at cartooning. From 1931 to 1935 he did editorial cartoons for the *Baltimore Afro-American* and drawings for *Collier's* and the *Saturday Evening Post*. After short stays at Lincoln University and Boston University, Bearden enrolled at New York University where in 1935 he received a B.S. in education. He continued cartooning at NYU, contributing to the university's humor magazine, *The Medley*.

After he graduated, Bearden became interested in inserting a social message into his cartoons, which led him, as he said, "to the works of Daumier, Forain, and Käthe Kollwitz, to the Art Students League and to George Grosz." Grosz, a German satirist whose visual commentary on post–World War I society was unforgiving, instilled in Bearden the lifelong habit of studying the artists of the past even as he was trying to make contemporary social commentary. Bearden's stay at the Art Students League was his only formal art school training.

Formal training, however, was amply augmented for Bearden by the Harlem art scene of the 1930s and 40s. In spite of the depression, Harlem boasted a thriving community of visual artists. Many, supported by the NEW DEAL's federally funded WORKS PROJECT ADMINISTRATION (WPA), worked on public art projects, taught, or worked on WPA easel projects. They were supported by a network of exhibition spaces and art centers: the federally supported art center at West 125th Street, sculptor Augusta Savage's art garage, Ad Bates's exhibiting space at 306 West 141st Street, local libraries, the YMCA, and upscale living rooms and salons. Though Bearden did not qualify for the WPA because his well-to-do parents supported him, he was active nonetheless in artistic activities uptown. He was one of the artists who organized uptown artists into the Harlem Artists Guild, and he wrote articles for OPPORTUNITY, the magazine of the Urban League, on black American art and social issues.

More important, Bearden and his artist friends—Norman LEWIS, Roy DECARAVA, and Ernest CRICHLOW—were devotees of jazz. They regularly made the rounds of nightclubs and cabarets where they heard firsthand the compositionally complex innovative music. Though it was many years before Bearden was able to recognize the esthetic importance of jazz to his painting—inspired by his mentor, Stuart Davis—the music became as important to him as the painting of the masters he studied with George Grosz.

During this time, 1937 to 1940, Bearden produced his first paintings, gouaches on brown paper, eighteen of which were exhibited along with some drawings at his first solo show held at Ad Bates's place on West 141st Street. Scenes of black life in Charlotte, and on the streets of Pittsburgh and Harlem, these early paintings, with their terra-cotta colors, bulky figures, and narrative, almost illustrational quality, were painted in the then fashionable social realist style.

Bearden's uptown art community disintegrated with the coming of World War II and the dismantling of the WPA. Bearden enlisted in the army, continued to exhibit, and came to the attention of Caresse Crosby, the flamboyant founder and publisher with her husband of Black Sun Press. Crosby exhibited Bearden's works at the G Place Gallery in Washington and introduced him to gallery dealer Samuel M. Kootz. Kootz invited Bearden to exhibit, and from 1945 until 1948, Bearden showed there along with such other leading avant-garde painters as Robert Motherwell, Adolph Gottlieb, William Baziotes, Carl Holty, and Byron Browne. During this period Bearden painted oils filled with abstract figures. His works were largely derived from epic literary sources—the Bible, Rabelais, Homer, García Lorca. The style, boldly drawn contours filled with vibrant stained-glass color, was derivative as well, reminiscent of analytical cubism.

During his time at the Kootz gallery, Bearden grew intellectually restless. He found the direction of his colleagues—who came to be known as abstract expressionists—unsatisfying, and he left the country in 1950 to study in Paris on the GI bill. Though he enrolled at the Sorbonne, Bearden spent most of his time enjoying the city. When he returned in 1951, he found that he had lost interest in painting and he took up songwriting. Without painting, however, he was disconnected. He had a nervous breakdown and recovered with the help of Nanette Rohan, whom he married in 1954.

With Bearden's recovery came a return to painting. To spur his return, he systematically copied the old masters, actually making large photostatic copies and tracing them. Starting with Duccio and Masaccio, he worked his way into the present, tracing Vermeer, Rembrandt, Delacroix, Matisse, and Picasso. Bearden's copying taught him well, and with Carl Holty he wrote a book on space, color, and composition entitled *The Painter's Mind: A Study of the Re-*

lations of Structure and Space in Painting (1969). Once he had relearned painting, Bearden began to paint large abstract expressionist oils with mythopoeic titles such as "Blue Is the Smoke of War, White the Bones of Men" (1960).

Bearden's most noteworthy work did not come until he was over fifty years old. Galvanized by the CIVIL RIGHTS MOVEMENT, Bearden, as he had done in the 1930s, organized a group of black artists. They took the name Spiral. The group wanted to do something to celebrate the movement, and Bearden thought that perhaps a group work, a collage, might be a vehicle. The group, however, was not interested, but he found himself engaged by the medium. As Bearden worked on these collages, allowing images of Charlotte, Pittsburgh, and Harlem to flood his memory, he captured the turbulence of the time with spacial distortions, abrupt juxtapositions, and vivid imagery.

Bearden's collages made use of a visual language seldom seen in American painting. His collages were populated by conjure women, trains, guitar players, birds, masked figures, winged creatures, and intense ritualistic activities: baptism, women bathing, families eating together at their dinner tables, funerals, parades, nightclub scenes. His representative works contain scenes of enduring ceremonies underscoring the beauty and densely complex cultural lineage of African-American life. Notable works include Watching the Good Trains Go By (1964); At Connie's Inn (1974), one of his many collages on the theme of jazz; Maudell Sleet's Magic Garden (1978) from his autobiographical series; Calypso's Sacred Grove (1977) from his series based on Homer's Odyssey; and lushly colored, late works like In a Green Shade (1984). Ralph Ellison referred to Bearden's images as "abiding rituals and ceremonies of affirmation." Bearden invented his own phrase—the "Prevalence of Ritual"—to underscore the continuity of a culture's ceremonies, marking the traditions and values that connect one generation to another.

In his earliest works Bearden painted genre scenes, but in his mature work he pierced the skin of those scenes to explore the interior lives of black people. Bearden's first collages were photomontages, that is, they were photographic blow-ups of collages. After a year he abandoned that technique and, as his collages matured, began to use color more sensuously, creating lush landscapes with layers upon layers of cut paper, photographs, and paint. By the time of his death in 1988, Bearden had won virtually every prize and accolade imaginable, including the Medal of Honor, countless honorary doctorates, cover stories in the leading art magazines, and several retrospectives of his work, including one at the Museum of Modern Art in 1971.

REFERENCES

BEARDEN, ROMARE. The Painter's Mind: A Study of the Relations of Structure and Space in Painting. New York, 1969.

———. "Rectangular Structure in My Montage." Leonardo 2 (1969): 11–19.

CAMPBELL, MARY SCHMIDT. "Romare Bearden: Rites and Riffs." Art in America (December 1981): 134–142.

ELLISON, RALPH. Romare Bearden: Paintings and Projections. Albany, N.Y., 1968.

SCHWARTZMAN, MYRON. Romare Bearden: His Life and Art. New York, 1990.

MARY SCHMIDT CAMPBELL

Beasley, Delilah Isontium (September 9, 1872–August 18, 1934), journalist and historian. Delilah Isontium Beasley was born in Cincinnati, Ohio. She started writing at the age of twelve for the Cleveland Gazette and three years later began a regular column in the Cincinnati Enquirer. Her journalism career was cut short, however, because of the death of her parents. For the next twenty-three years, although Beasley held a number of jobs—maid, masseuse, and physical therapist—she never lost her interest in research and education.

In 1910 Beasley moved to California where she informally studied history at the University of California in Berkeley and became a contributor to the Oakland Tribune. For the next two decades, through her column "Activities Among Negroes," she agitated for an unbiased portrayal of African Americans in journalism and academia. Beasley rebutted racist stereotypes, challenged popular misconceptions, and successfully demanded that the local white press stop using the words "darky" and "nigger." She developed a reputation as an outspoken activist who challenged discrimination and worked for equality between blacks and whites.

In 1919, after years of meticulous research, Beasley published The Negro Trail-Blazers of California, which chronicled the role of African Americans in the far West. She traced the lives of black merchants, soldiers, poets, educators, and the communities they created and argued that property accumulation was the key to improving the overall position of African Americans. This comprehensive and highly acclaimed book paved the way for a more inclusive and accurate history of California that recognized the role of African Americans within that history. Beasley died of heart disease in 1934 in San Leandro, Calif.

REFERENCES

CROUCHETT, LORRAINE J. Delilah Isontium Beasley—Oakland's Crusading Journalist. San Francisco, 1990.

DAVIS, ELIZABETH. "Miss Delilah I. Beasley, Historian and Newspaper Writer." In *Lifting As They Climb.* 1933.

STEVEN J. LESLIE
PAM NADASEN

Beatty, Talley (1923–), choreographer and dancer. Talley Beatty grew up in Chicago, Ill. While he was very young, he accompanied his father, a decorator, on many trips through the Midwest and Northwest. Interested in dance from a young age, he originally dreamed of becoming a tap dancer and took a few lessons in cakewalking from pianist Eubie BLAKE. From age fourteen, Beatty studied with African-American dancer and choreographer Katherine DUNHAM and was a member of her troupe from 1937 to 1943. Beatty made his debut with Dunham's group in 1937 at the 92nd Street Young Men's Hebrew Association (YMHA) in New York City. He performed in Dunham's concert *Tropics and Le Jazz Hot* in 1940. Critics found Beatty's style somewhat more balletic than other company members. Beatty left the company in 1943, following the completion of the film *Stormy Weather.* He then toured California nightclubs with fellow ex-Dunham company dancer Janet Collins. The pair assumed Spanish-sounding stage names to deflect suspicion that they were black.

Throughout the 1940s, Beatty continued to experiment with a variety of roles and dance styles. In 1945, he followed an appearance in Maya Deren's experimental film *A Study in Choreography for Camera* with a role on Broadway's *Cabin in the Sky* with Dunham and Ethel Waters. He was cast the next year as a lead dancer in a Broadway revival of *Showboat* opposite Pearl PRIMUS. Beatty also danced in a minstrel ballet, *Blackface,* in 1946 before deciding to concentrate on concert dance and choreography.

Talley Beatty formed his own dance company to tour the United States and Europe in 1952, with a program entitled *Tropicana,* a suite that featured dances in a variety of styles derived from African and Latin American culture. As the 1950s and '60s progressed, he explored themes of African-American life that served as a counterpoint to the CIVIL RIGHTS MOVEMENT. In 1959, he choreographed *The Route of the Phoebe Snow* (also known as *The Road of the Phoebe Snow*), which centered on life around the Lackawanna Railroad, accompanied by the music of Duke ELLINGTON and Billy STRAYHORN. Beatty took the title of the piece from freight trains with the name "Phoebe Snow" painted on their sides, which he observed as a boy on the road with his father. The piece, one of Beatty's greatest achievements, became

part of the Alvin Ailey company repertory in 1964. Beatty also created *Come and Get the Beauty of It Hot* (1960), *Montgomery Variations* (1967), and *Black Belt* in 1969.

Beatty had a long and fruitful collaboration with Duke Ellington that began in the 1950s and '60s. The two would often meet at one o'clock in the morning and work through the night. Beatty provided choreography for several of Ellington's extended works, such as *A Drum Is a Woman* (1957) and *My People* (1963). Beatty also choreographed for other companies, including Stockholm's Birgit Cullberg Ballet, the Boston Ballet, the Inner City Dance Company of Los Angeles, Ballet Hispanica of New York City, and the Bat-Sheva Company of Israel. Since the late 1960s, Beatty has primarily been a teacher of dance, serving as artist-in-residence at the Elma Lewis School of Fine Arts in Roxbury, Massachusetts. Throughout the 1970s, he composed many theatrical works for directors, including Vinnette CARROLL, among them *Your Arms Too Short to Box with God* (1977) and *But Never Jam Today* (1978), an African-American adaptation of Lewis Carroll's *Alice in Wonderland.* Other major works have included *The Stack Up* (1983) and *Blues Shift* (1984). His choreography was featured in *Homage to Mary Lou,* performed by the Nanette Beardon Contemporary Dance Theatre in 1988 in tribute to jazz pianist-composer Mary Lou WILLIAMS. Another Beatty work inspired by Duke Ellington, *Ellingtonia,* had its premiere at the 1994 American Dance Festival in Durham, N.C. The work was performed by the Cleo Parker Dance Ensemble.

REFERENCE

LONG, RICHARD A. *The Black Tradition in American Dance.* New York, 1989.

ALLISON X. MILLER

Beavers, Louise (March 18, 1902–October 26, 1962), actress. Beavers was born in Cincinnati, Ohio, and raised in Los Angeles. She began her acting career in vaudeville in the 1920s at Loewes State Theatre and sang in the Ladies Minstrel Troupe in 1926. Her first screen role was in the 1927 silent screen version of *Uncle Tom's Cabin.* Beavers subsequently had bit parts in such films as *Annabelle's Affairs* (1931), *Girls Around Town* (1931), and *The Big House* (1932). Due to her size and her southern accent (which was to some extent affected), she became typecast as the "mammy" or "Aunt Jemima" kitchen maid. She played Jean Harlow's maid in *Bombshell* (1933) and Mae West's maid in *She Done Him Wrong*

(1933). Beavers received her first substantive role as a mother in *The Imitation of Life* (1934), which many critics considered worthy of an Oscar. She then returned to more traditional roles: as a former slave in *Rainbow on the River* (1936), as a Harlem numbers racket queen in *Bullets or Ballots* (1936), and as Carole Lombard's housekeeper in *Made for Each Other* (1939). Beavers accepted many mediocre roles in the years that followed. Her most notable performances were as Cary Grant's maid in *Mr. Blandings Builds His Dream House* (1948) and as Jackie ROBINSON's mother in *The Jackie Robinson Story* (1950). Beavers replaced Hattie MCDANIEL, the other notable "mammy" in show business, in the 1952–1953 season of the radio and television series *Beulah*. Beavers died in 1962 of diabetes and heart disease. She was inducted into the Black Filmmakers Hall of Fame in 1976.

REFERENCES

BOGLE, DONALD. *Blacks in American Film and Television*. New York, 1988.

———. *Toms, Coons, Mulattoes, Mammies, and Bucks*. New York, 1974.

MAPP, EDWARD, ed. *Directory of Blacks in the Performing Arts*. Metuchen, N.J., 1990.

SABRINA FUCHS

Bebop, Betty. *See* Carter, Betty.

Bechet, Sidney Joseph (May 14, 1897–May 14, 1959), jazz musician, saxophonist. Sidney Bechet was born in New Orleans. He first borrowed his brother's clarinet at age six and within a few years was performing with the city's most established musicians. In 1914 he began a lifetime of touring, settling in Chicago in 1917. There he purchased a soprano saxophone, which would become his favorite instrument. In 1919 he joined Will Marion COOK's Southern Syncopated Orchestra, with whom he toured Europe. In the fall of 1919, Swiss conductor Ernest Ansermet's glowing review of the orchestra, and Bechet in particular, marked the first time that a jazz artist was given serious consideration by an established classical musician. Bechet returned to New York in 1921 and made his first recording in 1923, establishing himself as one of jazz's premier soloists. Bechet went back to Europe in 1925 with Josephine Baker's *La Revue Nègre* and in 1928 began a ten-year association with Noble SISSLE's orchestra. By the end of the 1930s Bechet was based in New York, where he performed and recorded regularly for the next de-

cade. His 1939 interpretation of "Summertime" became his best known work. After three European tours Bechet permanently settled in France in 1951 and achieved a measure of celebrity reached by few jazz musicians. He died of cancer in 1959.

Bechet's playing was characterized by a wide vibrato and a passionate, commanding spirit. He was a unique stylist and was instrumental both in changing jazz from ensemble music to a soloist's art and spreading New Orleans jazz throughout America and the world. His autobiography, *Treat It Gentle* (1960), is a vivid portrait of his Louisiana Creole background and the formative period of New Orleans jazz.

REFERENCES

BECHET, SIDNEY. *Treat It Gentle*. New York, 1960.

CHILTON, JOHN. *Sidney Bechet: The Wizard of Jazz*. London, 1987.

MARVA GRIFFIN CARTER

Beckwourth, James Pierson (April 6, 1798–1866), frontiersman and explorer. Jim Beckwourth's real life is hard to disentangle from legend. His autobiography (dictated to Thomas D. Bonner), *The Life and Adventures of James P. Beckwourth, Mountaineer, Scout, and Pioneer, and Chief of the Crow Nation of Indians, with Illustrations* (1856), is filled with inaccuracies and exaggerations. What is known is that Beckwourth was born in Petersburgh, Va., the son of a white Revolutionary War veteran and a black (possibly slave) mother. The family soon moved to the Missouri Territory, where Beckwourth was apprenticed to a blacksmith. He ultimately ran away from home and signed up as a scout for the Rocky Mountain Fur Company. Over the following years, he served as a trapper and guide in the Rocky Mountain area. Beckwourth was the first African American, if not the first non–American Indian, to visit many areas in present-day Colorado, Wyoming, Arizona, and other places. He also accumulated large amounts of information on the topography, soil, and climate of the western regions he visited, and made contacts with Blackfoot and Crow Indians. Beckwourth later claimed the Crow made him a chief and that he had Indian wives and children.

In 1837, tiring of the grueling pioneer existence, Beckwourth settled in St. Louis, Mo., for a few years. The Second Seminole War in the early 1840s convinced him to return to scouting. After serving with American forces in Florida, he established trading posts on the Arkansas and North Platte Rivers, then moved to California and established further trading posts there. He fought in the 1846 California

James P. Beckwourth. (Photographs and Prints Division, Schomburg Center for Research in Black Culture, The New York Public Library, Astor, Lenox and Tilden Foundations)

revolt against Mexico, and then in the Mexican War, serving as a dispatch carrier for Gen. Stephen Kearny. In 1848, after the end of the war, Beckwourth joined Gen. John C. Frémont's exploration expedition to California. A pass in the Sierra Nevadas, which he may or may not have discovered and which was used by many future pioneers to enter California, was named the Beckwourth Pass in his honor.

Accounts of Beckwourth's later life are sketchy. In 1866, the federal government asked him to lead a delegation to the Crow Indian tribe in the Dakota territory, asking them to retain peaceful relations with the federal government during its war with other tribes. Beckwourth seems to have died among them that year. According to one account, he was poisoned by Crow Indians. In 1994 Beckwourth appeared on a U.S. postage stamp as part of a series honoring America's western heritage.

REFERENCE

WILSON, ELINOR. *Jim Beckwourth: Black Mountain Man and War Chief of the Crows.* Norman, Okla., 1972.

GREG ROBINSON

Belafonte, Harold George "Harry" (March 1, 1927–), singer, actor, and activist. The son of a Jamaican mother and a father from Martinique, Harry Belafonte was born in New York City and received his early education in the public schools in Jamaica. In 1940 he returned to the United States and attended high school in New York. After Navy service during World War II, he enrolled in Irwin Piscator's Dramatic Workshop in New York City and in 1948 became a member of the acting group of the American Negro Theater in New York. In September and October 1949 he appeared as a regular on CBS's black variety show, *Sugar Hill Times.*

Racial stereotyping greatly limited Belafonte's acting possibilities, and so he turned to singing. He made his debut in 1949, singing pop songs at New York's Royal Roost nightclub. He signed a record contract with RCA in 1952; however, it was not until 1957 that he achieved major commercial success as a singer. In the meantime he turned again to acting, and his muscular body, good looks, and rich, husky voice made him one of the first interracial male sex symbols. He appeared in the Broadway show *Almanac,* for which he won a Tony Award (1952), and he shared billing with Marge and Gower Champion in the musical *Three for Tonight* (1954). Belafonte's first film role was in *Bright Road* (1953), and he drew critical acclaim for his performance the next year in *Carmen Jones,* a black version of George Bizet's opera *Carmen.* He also appeared in the films *Island in the Sun* (1957) and *The World, the Flesh, and the Devil* (1959).

In the mid-1950s Belafonte began singing calypso, a folk-song style popular in Trinidad and other Caribbean islands. His passionate, witty and suave renditions of such songs as "Matilda," "Jamaica Farewell," "Island in the Sun," "Brown Skin Girl," "Come Back Liza," and his signature tune, "The Banana Boat Song," ignited a calypso fad in the United States. Belafonte's album *Calypso* (1956) became the first solo album in history to sell a million copies. Over the next decade he recorded eleven more albums, including *Belafonte Sings of the Caribbean* (1957), *Belafonte at Carnegie Hall* (1957), *Porgy and Bess* (with Lena Horne, 1959), *Jump Up Calypso* (1961), *The Midnight Special* (1962), and *Belafonte on Campus* (1967).

In 1960 Belafonte became the first African American to star in a television special, which won him an Emmy Award. Belafonte also began a long association with African culture and politics at this time. In 1959 he brought to the United States two protégés, the South African musicians Miriam Makeba and Hugh Masekela.

Like his idol, Paul ROBESON, Belafonte combined singing with civil rights activism. In part because of his friendship with Robeson, Belafonte was partially

blacklisted during the early fifties and was refused television and other engagements. He, in turn, refused to appear in the South from 1954 to 1961. In 1956 Belafonte helped raise money to support the Montgomery bus boycott and met the Rev. Dr. Martin Luther KING, Jr. The two became close friends, and by 1960 Belafonte was a major fund-raiser and strategist in the CIVIL RIGHTS MOVEMENT. He helped raise funds to support freedom riders and voter-registration efforts and in 1963 helped establish the Southern Free Theater in Jackson, Miss., which was dedicated to the development of a black political leader. Belafonte also served as an unofficial liaison between the Kennedy administration and black leaders. In 1961 he was named to the advisory committee of the Peace Corps.

He was an active film and television producer, and his company, Harbel, formed in 1959, was responsible for the first major television show produced by a black, *Strolling Twenties,* which featured such well-known black artists and performers as Duke ELLINGTON, Sidney POITIER, Nipsey RUSSELL, and Joe WILLIAMS. In 1959 the company also produced the film *Odds Against Tomorrow,* in which Belafonte appeared with Ed Begley and Robert Ryan. In the 1970s, following the death of Martin Luther King and the ebbing of the civil rights movement, Belafonte resumed making films, appearing with Sidney Poitier in *Buck and the Preacher* (1971) and *Uptown Saturday Night* (1974). Toward the end of the 1970s, Belafonte, who had sung in nightclubs only sporadically in the past decade, resumed singing. He made major tours in 1976 and 1979. In 1984 Belafonte co-produced the hip-hop film *Beat Street.*

Through the 1980s and early 1990s Belafonte achieved a new renown for his intentional political activities. Most notable was his commitment to humanitarian efforts in Ethiopia. In 1985 he conceived the project that resulted in the recording "We Are the World," written by Lionel Richie and Michael Jackson and conducted by Quincy Jones, which raised over $70 million to aid victims of famine in Africa. For his humanitarian work he was awarded the position of goodwill ambassador for UNICEF in 1986. In 1988 he recorded an album of South African music, *Paradise in Gazankulu.* In 1990, Belafonte, a long-time opponent of apartheid, served as chair of the committee that welcomed African National Congress leader Nelson Mandela to America. The same year, New York Governor Mario Cuomo appointed Belafonte to lead the Martin Luther King, Jr., Commission to promote knowledge of nonviolence.

REFERENCES

BRANCH, TAYLOR. *Parting the Waters: America in the Civil Rights Years.* New York, 1987.

SHAW, ARNOLD. *Belafonte: An Unauthorized Biography.* New York, 1960.

JAMES E. MUMFORD

Bell, George (1761–1843), educator. George Bell was born a slave in Virginia. His wife, Sophia Browning, purchased his freedom for $400 by secretly selling produce from her garden. Later, Bell was able to buy her and two of his three children from their owner. The family settled in Washington, D.C., where he worked as a carpenter. Bell is significant for his contribution to the education of free African Americans. In 1807 he, Moses Liverpool, and Nicholas Franklin, none of whom was able to read or write, built the first schoolhouse for African-American children in Washington, D.C. Although the Bell School, as it was called, closed shortly afterward for lack of funds, it set an important example.

In another attempt to educate African Americans, Bell, along with others, founded the Resolute Beneficial Society. On August 29, 1818, the society announced in the *National Intelligencer* the opening of a new school housed in the building of the old Bell School. The society offered the use of the building to Sunday and evening schools. The first teacher was a Mr. Pierpont of Massachusetts, who was followed by John Adams, the first male African-American teacher in the District of Columbia. The school was successful for several years.

REFERENCE

LOGAN, RAYFORD, and MICHAEL R. WINSTON, eds. *Dictionary of American Negro Biography.* New York and London, 1982.

DORIS DZIWAS

Bell, James Madison (April 3, 1826–1902), poet and social activist. James Madison Bell, "the Bard of the Maumee," was born in Gallipolis, Ohio. He moved to Cincinnati in 1842 and worked until 1853 as a plasterer. While in Cincinnati, Bell attended high school and became a committed abolitionist. In 1854 he moved with his family to Chatham, Canada West (now the province of Ontario), a refuge for fleeing slaves and a center of abolitionist activity at the time.

In Canada, Bell developed a close political and personal association with John Brown. During Brown's "Provisional Constitutional Convention," convened in Chatham in April 1858, the abolitionist leader stayed with Bell. The next year, Bell helped organize the momentous attack on the federal arsenal at Har-

James Madison Bell. (Photographs and Prints Division, Schomburg Center for Research in Black Culture, The New York Public Library, Astor, Lenox and Tilden Foundations)

per's Ferry, Va. (now in West Virginia), by aiding Brown in obtaining men and money. (*See* JOHN BROWN'S RAID) Following the congressional investigation of the Harper's Ferry raid, Bell fled to San Francisco in 1860.

It was here that Bell, while continuing to work as a plasterer, first published and made public recitations of his poetry. In 1864, to celebrate the first anniversary of the Emancipation Proclamation, he wrote "The Day and the War," a 750-line poem on the African–American experience from slavery to freedom, and dedicated it to John Brown. In 1870 Bell commemorated the FIFTEENTH AMENDMENT by reading his ode "The Triumph of Liberty" at the Detroit Opera House. Overall, his fairly conventional poetry is marked by a forthright dedication to African–American liberty. While it often seems clichéd to modern readers, Bell's listeners were inspired by his recitations. The literary scholar Joan Sherman has called Bell, "*the* verse propagandist for Afro-Americans in his century."

In San Francisco, Bell also became active in politics, agitating for black educational and legal rights. In 1865 he was a member of the Fourth California Colored Convention, which fought for suffrage rights. In 1866 Bell returned briefly to Canada, gath-

ered his family, and then moved to Toledo, Ohio. He was a dedicated Republican and in 1872 a delegate to the Republican National Convention. In these years, he spent much time lecturing and reading from his poetry, both within Ohio and in large cities across the city.

Bell abandoned his recital tours around 1890. In 1891 he published his collected poems in a single volume, *Poetical Works*. Bell died in Toledo in 1902.

REFERENCES

BELL, JAMES MADISON. *Poetical Works*. New York, 1973.
COYLE, WILLIAM, ed. *Ohio Authors and Their Books*. Cleveland, 1962.
SHERMAN, JOAN. *Invisible Poets: Afro-Americans of the Nineteenth Century*. Chicago, 1989.

QADRI ISMAIL

Bell, James Thomas "Cool Papa" (May 17, 1903–March 17, 1991), baseball player. Born in Starkville, Miss., James Thomas Bell broke into the Negro National League as a pitcher for the St. Louis

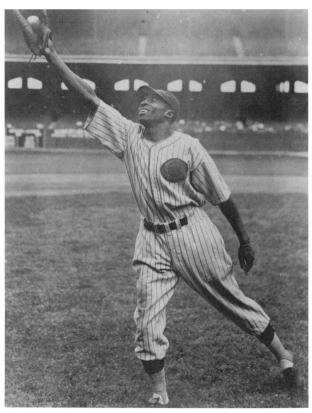

James "Cool Papa" Bell. (Photographs and Prints Division, Schomburg Center for Research in Black Culture, The New York Public Library, Astor, Lenox and Tilden Foundations)

Stars in 1922. Nicknamed "Cool Papa" by other players for his calm disposition, Bell was an effective pitcher, with a 10–7 record, according to surviving statistics. Nevertheless, he was transferred to center field in 1924 so that the team might take advantage of his hitting and speed. He soon gained a reputation as a base stealer, reportedly stealing 175 bases in approximately 200 games in 1933. Bell routinely scored from second base on ground balls. He was so fleet-footed that it was said he could turn off the light switch in his room and be under the covers before the lights went out.

Bell played for several teams in the Negro National League, including the Stars, the Kansas City Monarchs, and the Pittsburgh Crawfords. From 1937 to 1941, Bell played in the Dominican Republic and in Mexico, then returned to play with the Chicago American Giants, Homestead Grays, and Detroit Senators. For his career, according to partial statistics, Bell hit .337 with 1,241 hits in 940 games, and had 143 stolen bases.

From 1948 to 1950, Bell managed the Kansas City Stars, the Monarchs' farm club. He later worked as a custodian and night watchman in St. Louis's city hall, retiring in 1970. Bell was elected to the National Baseball Hall of Fame in 1974. In 1990, his name again came before the public when part of his priceless memorabilia collection was stolen. He died in St. Louis the following year.

REFERENCE

PETERSON, ROBERT W. *Only the Ball Was White*. Englewood Cliffs, N.J., 1970.

LINDA SALZMAN

Bell, Philip Alexander (1808–April 24, 1889), journalist. Philip Alexander Bell was a crusading journalist, editor, and community leader who founded newspapers both in the East and the West. Nothing, save the year of his birth, is known of Bell's early life, but by 1831 he had become active in organizations for the promotion of black rights in NEW YORK CITY, and was secretary of a black citizen's group which opposed the creation of a Colonization Society in New York. By 1833 he was a director of the Phoenix Society of New York, which promoted "the improvement of the colored people in Morals, Literature, and the Mechanic Arts." He regularly attended National Negro Conventions, and actively opposed segregation of churches and schools. In January 1837, Bell founded a newspaper, the WEEKLY ADVOCATE, in New York City, and in March changed its name to the *Colored American*. For two

years, Bell managed the paper while Samuel E. CORNISH served as editor. In 1839 Cornish left and Bell became the paper's coeditor, along with James McCune SMITH. He spent two years as editor, then left the *Colored American* in 1841.

Little is known about Bell's life in the 1840s and '50s. Some time after 1857, he went west to San Francisco. In 1862 Bell was appointed editor of the black newspaper *Pacific Appeal*. He turned the *Appeal* into the main voice of black opinion on the West Coast. A leading member of the CALIFORNIA COLORED CONVENTION movement, he pressed for civil and political rights for African Americans.

In 1865, after leaving the *Pacific Appeal*, Bell founded a new newspaper, the *Elevator*, in conjunction with a civil rights group, the Executive Committee of San Francisco. The newspaper's title reflected Bell's desire to "elevate" the status of African Americans. As associate editor, he continued to call for suffrage and equal rights, and he also promoted education and economic self-help for blacks who wished to prove their worth as citizens. Bell was also a prominent opponent of Chinese immigration, claiming that Chinese workers lowered wage scales and threatened the advancement of black labor.

In July 1872, Bell sold the *Elevator* to Alexander Ferguson, another African American. However, he soon assembled stronger financial backing, and he bought back the paper in November. Bell continued as the paper's owner, publisher, and editor until 1879, when the *Elevator* was absorbed by another paper. In 1880 Bell was named doorkeeper for the California Senate. He continued at this post until his retirement in 1885. He died destitute four years later.

REFERENCES

PORTER, DOROTHY, ed. *Early Negro Writing, 1760–1837*. New York, 1971.

SNORGRASS, J. WILLIAM. "The Philosophy of a Black Editor: Philip A. Bell, 1808–1889." *Negro History Bulletin* 44 (April–May 1981): 32–33.

JEFFREY L. KLEIN

Beman, Amos Gerry (1812–1874), clergyman. Amos Beman was born in Colchester, Conn., the son of African Methodist Episcopal Zion clergyman Jehiel C. BEMAN. His attempt to enroll at Wesleyan College in Middletown, Conn., was blocked by racist threats from white students, but he received private tutoring and eventually attended several schools, including Oneida Institute in 1835. He worked as a teacher in Hartford and completed his studies for the ministry, then moved to New Haven in June 1838,

acquiring a position with the Temple Street Colored Congregational Church.

Like his father, Beman integrated moral reform principles into his ministry, and he made temperance the cornerstone of his message. He participated in a variety of black organizations dedicated to mental and moral improvement, and he organized the New Haven Literary and Debating Society. In the early 1830s, Beman worked with his father to establish a temperance organization in Middletown, and in 1836 he cofounded the state's first total-abstinence society—the Connecticut State Temperance Society of Colored People. Beman's essays on temperance, moral reform issues, and religious matters appeared in the *Colored American* and in a short-lived journal that he edited in 1842, *Zion's Wesleyan*. Later in the 1840s and '50s, he contributed similar writings to several black newspapers, including the *North Star*, FREDERICK DOUGLASS'S PAPER, *Voice of the Fugitive*, and *Weekly Anglo-African*.

Although a member of the AMERICAN ANTI-SLAVERY SOCIETY, he was never comfortable with some of the radical social tenets advocated by the Garrisonians. When the society experienced a schism in 1840, he joined with several other black Congregational and Presbyterian clergymen and helped organize the American and Foreign Anti-Slavery Society. He presided at the 1843 black national convention in Buffalo, N.Y. (*see* ANTEBELLUM CONVENTION MOVEMENT), and used his influence to defeat Henry Highland GARNET's convention resolution calling for slave violence. He served as a delegate to the National Council of the Colored People, the first national black organization, founded in 1853.

Beman gained a national reputation as a spokesperson for the Connecticut black community, which exceeded 8,600 by 1860. His interest in moral reform never hindered his commitment to political action, and he became the leader of the black suffrage movement in Connecticut. He advocated resistance to the Fugitive Slave Act of 1850, and turned his church into a way station for escaped slaves on the Underground Railroad.

Beman suffered a family tragedy in 1856, when his wife, eldest son, and daughter succumbed to typhoid fever. His two surviving children were sent to relatives, leaving him alone and destitute. His career in the ministry required frequent relocations. After remarrying in 1858, he received an appointment as pastor of the Fourth Colored Congregational Church in Portland, Maine. Beginning in July 1859, he served for a year as a lecturing agent for the American Missionary Association. Afterward, Beman supported himself and his family by filling several short-term ministerial posts, including mission work among the freedpeople in Tennessee.

Beman was a lifelong critic of colonization. He also opposed African and Haitian emigration programs in the 1850s, but he endorsed the AFRICAN CIVILIZATION SOCIETY when it turned away from African emigration and directed its efforts to freedpeople's education in the early 1860s. He served the society as an adviser for its freedpeople's school program in Washington, D.C. The Connecticut legislature recognized his life's accomplishments by appointing him chaplain in 1872.

REFERENCE

WARNER, ROBERT A. "Amos Gerry Beman, 1812–1874: A Memoir on a Forgotten Leader." *Journal of Negro History* 22 (1937): 200–221.

MICHAEL F. HEMBREE

Beman, Jehiel C. (nineteenth century), preacher and abolitionist. Although information on his birth and death dates is lacking, Jehiel Beman was born in Connecticut, the son of an escaped slave (who celebrated his freedom and humanity by taking the name Beman). Jehiel Beman was the first pastor of the African Methodist Episcopal Zion Church in Boston, Mass., and was also at one time pastor of the African Church in Middletown, Conn. He was a participant in the National Conventions of Free People of Color and in 1831 acted as an agent in Middletown collecting funds for a black college that had been proposed at one of the conventions.

As associate of William Lloyd Garrison, Beman broke with him in 1839 to establish the New England Abolition Society. He also established an employment agency to help needy blacks find work. Beman was the father of Amos Gerry BEMAN, who became well known as a preacher and civil rights activist.

REFERENCE

HORTON, JAMES OLIVER, and LOIS E. HORTON. *Black Bostonians.* New York, 1979.

LYDIA McNEILL

Benjamin, Fred (September 8, 1944–), dancer, choreographer, and instructor. Born in Boston, Mass., Fred Benjamin began dancing at age four at Elma Lewis's School of Fine Arts in Roxbury.

Benjamin danced with Talley BEATTY from 1963 until 1966, when the company folded. Two years later, he started his own New York–based Fred Benjamin Dance Company, which existed, largely without funding, for twenty years.

Like most African-American choreographers of the time, Benjamin's work was compared to that of Alvin AILEY, but Benjamin modeled himself after his idol, Beatty. The group movement in *Parallel Lines,* the emphasis on entrances in a work such as *Our Thing,* the signature sassiness of many other works—all reflected Beatty's influence.

Benjamin added ballet to Beatty's contemporary, energized style and helped popularize the genre known as ballet-jazz. He introduced many inner-city youth to dance via the Harlem Cultural Council's annual DanceMobile series, but his greatest gift may have been in teaching. At New York's Clark Center for the Performing Arts and Steps studios, Benjamin influenced many young dancers.

Benjamin has also worked extensively in theatrical dance. He has taught in the Netherlands, worked in summer stock, and danced with the June Taylor Dancers. On Broadway he worked with Gower Champion and Michael Bennett and performed in such hits as *Hello, Dolly!* and *Promises, Promises.*

REFERENCE

EMERY, LYNNE FAULEY. "Concert Dance: 1950–Today." In *Black Dance from 1619 to Today*. Princeton, N.J., 1988, p. 305.

JULINDA LEWIS-FERGUSON

Bennett, George Harold "Hal" (April 21, 1930–) novelist and journalist. Born in Buckingham, Va., Bennett was raised in Newark, N.J., and spent summers in Virginia. In high school he was a feature writer for the *Newark Herald News,* and he served later in the U.S. Air Force as a newspaper editor for American forces in Korea. He started a newspaper in Westbury, Long Island, with little success and decided to enter Mexico City college, where he began his first novel. In 1966 Bennett won a fiction fellowship from the Bread Loaf Writers' Conference for his first novel, *A Wilderness of Vines.* In 1970 he was chosen by *Playboy* as most promising young writer of the year for his short story "Dotson Gerber Resurrected." He also received the Faulkner Award for fiction in 1973.

Bennett's first novel, *A Wilderness of Vines* (1966), set in the fictive southern community of Burnside, Va., is concerned with black self-hatred as well as racial prejudice in a stratified society of light-skinned blacks, dark-skinned blacks, and whites. His next novel, *The Black Wine* (1969), plots the migration of a black youth, David Hunter, and his family from Burnside to Newark in the 1950s.

Bennett reached novelistic maturity in *Lord of Dark Places* (1970), a satire using explicit language and such experimental techniques as time shifts. The protagonist Joe Market sees himself as the "lord of dark places," symbolized by his male potency. Market inverts Christian goodness by inciting others to murder and suicide and by killing himself in holy martyrdom.

Bennett's next two novels, *Wait Until the Evening* (1974) and *Seventh Heaven* (1976), are set in the fictive ghetto town of Cousinville, N.J. *Wait Until the Evening* is a grotesque murder story with a post–World War II setting. The protagonist, Kevin Brittain, is influenced by his evil grandmother to seek power and liberation through murder. *Seventh Heaven* is set in the 1960s; the title ironically refers to the ghetto town of Cousinville. The protagonist, Bill Kelsey, attempts to escape the racial prejudice of the North by returning to his southern origins, only to discover the universality of discrimination. As in many of Bennett's novels, Kelsey seeks liberation from ghetto life through "servitude in love," or sexual bondage. Bennett also published a collection of stories, *Insanity Runs in Our Family* (1977).

REFERENCES

DAVIS, THADIOUS M., and TRUDIER HARRIS, eds. *Dictionary of Literary Biography*. Vol. 38. Detroit, 1984.
METZGER, LINDA, ed. *Black Writers*. Detroit, 1989.

SABRINA FUCHS

Bennett, Gwendolyn Bennetta (July 8, 1902–May 30, 1981), writer and artist. Although cited among those whom Ronald Primeau designates as the "second echelon poets" of the HARLEM RENAISSANCE, seen simply as a minor author of the period when she has not been omitted from literary histories altogether, Gwendolyn Bennett occupied a significant place in the arts. As a member of the 1920s Writers' Guild and later the 1930s Harlem Artists' Guild, and as a poet, fiction writer, journalist, illustrator, graphic artist, arts teacher, and administrator on the FEDERAL ARTS PROJECT, Bennett played an active role in the African-American arts community for over twenty years.

Artistic and multitalented as a child, Bennett continually felt the pull of two career dreams—to be a writer, to be an artist. Bennett's literary abilities and artistic talent had first won her recognition at Brooklyn's Girls' High, which she attended from 1918 to 1921. She was the first African American invited to join the school's literary society, she participated in the drama society, and she won first place in an art

contest with a poster design. Following graduation, Bennett attended Columbia University (1921) and then Pratt Institute (1922–1924), preparing herself for a career in the arts. While obtaining her credentials in art education and the fine arts, she simultaneously began submitting her poetry for publication. First to accept a submission was OPPORTUNITY, which bought her poem "Heritage" in December 1923. The CRISIS carried a cover illustration of Bennett's the same month.

From 1923 to 1931, twenty-two Bennett poems appeared in journals of the period: *Crisis, Opportunity, Palms,* and *Gypsy.* Other poems of hers were collected in William Stanley BRAITHWAITE's *Anthology of Magazine Verse for 1927 and Yearbook of American Poetry* (1927), Countee CULLEN's *Caroling Dusk* (1927), and James Weldon JOHNSON's *The Book of American Negro Poetry* (1931). During this period, Bennett's poetry reflected either the shared themes and motifs of the NEW NEGRO era—racial pride, rediscovery of Africa, celebration of blackness—or the tradition of the poetry of personal statement, the romantic lyric. In 1926, the short-lived *Fire!!* (on whose editorial board Bennett served) carried "Wedding Day," her first published short story. "Tokens," her second story, was published in Charles S. JOHNSON's *Ebony and Topaz: A Collectanea* (1927).

Although she never produced a volume of verse, the 1920s proved fruitful for Bennett. She published poetry, prose, and illustrations; mounted art exhibits; taught at HOWARD UNIVERSITY; won a fellowship to study art in Paris; edited "The Ebony Flute," a literary column for *Opportunity* (1926–1928); and earned a scholarship to the Barnes Foundation to study in Albert C. Barnes's private art collection. In 1928, she married Dr. Alfred Jackson and the young couple moved to Florida, where Jackson began a medical practice.

The thirties and forties took Bennett down a different path. The Jacksons returned to New York, but Bennett virtually ceased creative writing for publication; Alfred "Jack" Jackson died in 1936. Concentrating less on polishing her own work and more on facilitating the artistic development of others, she joined the Harlem Artists Guild; directed the HARLEM COMMUNITY ART CENTER, largest of the Federal Arts Project endeavors; worked with the Negro Playwright's Guild, where she served on the board of directors; and directed the development of the George Washington Carver Community School. In all these capacities Bennett nurtured and fostered the talents of young African-American artists.

In the late 1940s, weary of the Red-baiting political attacks often mounted on her or the organizations she was associated with, Gwendolyn Bennett essentially retreated from public life. From the late forties to the late sixties, she worked for Consumers Union, primarily as a correspondent. When she retired, she and her second husband, Richard "Dick" Crosscup (whom she had married in 1941), moved to Kutztown, Pa., and opened an antiques shop. Richard Crosscup died in January 1979; two years later, alone and embittered by his untimely death, Gwendolyn Bennett Crosscup died in a Reading, Pa., hospital.

REFERENCES

GOVAN, SANDRA Y. Gwendolyn Bennett: Portrait of an Artist Lost. Ph. D. diss., Emory University, 1980.
PRIMEAU RONALD. "Frank Horne and the Second Echelon Poets of the Harlem Renaissance." In Arna Bontemps, ed. *The Harlem Renaissance Remembered.* New York, 1972, pp. 247–267.

SANDRA Y. GOVAN

Bennett, Lerone, Jr. (October 28, 1928–), writer and journalist. Lerone Bennett was born in Clarksdale, Miss. He attended public schools in Jackson, and attended Morehouse College in Atlanta, Ga., receiving a bachelor's degree in 1949. Following his graduation, Bennett was hired by the *Atlanta Daily World* newspaper and became city editor in 1952. The following year he was named associate editor of the fledgling black newsmagazine JET, thus beginning a career-long association with the Johnson Publishing Company. In 1954 he switched to the company's senior publication, EBONY, assuming the post of associate editor, and in 1957 was named senior editor. Although he served as visiting professor of history at Northwestern University and as fellow at the INSTITUTE OF THE BLACK WORLD, both in 1968, his *Ebony* post remained his primary occupation for thirty years. In 1987 Bennett assumed the position of executive editor.

During Bennett's tenure as editor, *Ebony* became known for its coverage and support of the CIVIL RIGHTS MOVEMENT and for its numerous articles on black history subjects. Bennett has become equally known for his popular black history books, written out of his strong belief that the black struggle for equality gains strength and insight from an awareness of history. His first book, *Before the Mayflower: A History of Black America, 1619–1962* (1962), which provided a comprehensive summary of the history of African Americans, has been reissued several times. Bennett's other historical works include *Black Power, U.S.A.: The Human Side of Reconstruction, 1867–1877; The Shaping of Black America: The Struggles and Tri-*

Longtime *Ebony* editor Lerone Bennett has been popularizing black history to a large audience for several decades. His history of African Americans, *Before the Mayflower,* is one of the more successful works of its kind. (© Leandre Jackson)

umphs of African Americans, 1619–1990s (1975, 1993); and *Wade in the Water* (1979) (reprinted as *Great Moments in Black American History*). He supplemented his historical works with *What Matter of Man,* a 1964 biography of the Rev. Dr. Martin Luther KING, Jr., and collaborated on publisher John H. JOHNSON's memoirs, *Succeeding Against the Odds* (1989).

During the 1960s and early 1970s, Bennett also wrote several works on race relations and the Black Power movement, notably *The Negro Mood* (1964); *Confrontation: Black and White* (1965); and *The Challenge of Blackness* (1972). Bennett called for whites to recognize the contributions of blacks to American history and society and called for increased black-white communication but warned black leaders not to divorce themselves from their base. Bennett combined his historical and polemical interests in an article in the John Henrik Clarke anthology *William Styron's Nat Turner: Ten Black Writers Respond* (1968), excoriating Styron for his stereotypical, insufficiently "virile" novelistic depiction of one of the heroes of black history.

Bennett has been the recipient of honorary degrees from several institutions, notably Boston University (1987), Dillard University (1980), and Marquette University (1979). In 1993 he was appointed by President Clinton to the National Panel on the Arts and Humanities.

REFERENCES

BENNETT, LERONE, JR. *Before the Mayflower: A History of Black America, 1619–1962.* Chicago, 1962.
JOHNSON, JOHN H., and LERONE BENNETT, JR. *Succeeding Against the Odds.* New York, 1989.

GREG ROBINSON

Benson, George (March 22, 1943–), guitarist and singer. Born in Pittsburgh, Pa., George Benson began his career as a singer, recording for RCA Victor at age ten. He started playing guitar in his midteens, playing with local rock and roll groups. His jazz career began when he worked as a sideman for organist Brother Jack McDuff's quartet (1962–1965). Following his tenure with McDuff, Benson was a sideman for Miles DAVIS, Herbie HANCOCK, Hank Mobley, and Freddie Hubbard. He also began performing and recording under his own name. By the early 1970s Benson was recording in a more commercial, vocal-oriented style, which presented him to a much broader audience while he continued to work in traditional jazz settings. The change in style yielded several hits, including "On Broadway" (1977) and "Give Me the Night" (1980). In the late 1980s Benson once again began recording jazz, collaborating with McCoy Tyner and the Count Basie Orchestra on successive albums.

Although best known for his smooth, appealing voice, Benson has remained a force as a guitar player. His exceptional technique and lyrical approach to soloing have remained constant throughout his career. The most recognizable aspect of his sound, however, is his practice of scat singing in unison with his improvisations.

REFERENCES

BOURNE, MICHAEL. "Back to Basics, Back to Basie." *Down Beat* (January 1991): 16–19.
SIEVERT, JON. "George Benson: Platinum Jazz." *Guitar Player* 13, no. 7 (July 1979): 86.

DANIEL THOM

Bentley, Charles Edwin (February 21, 1859–October 12, 1929), dentist and educator. Bentley was born in Cincinnati, Ohio, the son of Charles E. and Sarah Watson Bentley. A graduate of Gaines High School in Cincinnati, he considered a musical career before entering the Chicago College of Dental Surgery in 1885, the only African American in his class. He graduated with a D.D.S. in 1887.

Bentley's career was spent entirely in Chicago. He served first as oral surgeon to the outpatient dispensary of Rush Medical College, resigning in 1891 to take the post of oral surgeon at PROVIDENT HOSPITAL. During the evenings, he taught oral surgery at Harvey Medical College until its closure in 1905. Bentley also built one of the largest and most successful private practices in the city. A cofounder (1888) and first president of the Odontographic Society, he initiated an investigation into the condition of the mouths and teeth of schoolchildren. The resulting report, published in 1900, became a model for future surveys and earned him the title "father of the public schools' oral hygiene movement."

A vocal opponent of racial segregation, Bentley was among the group of black Americans who met in Niagara Falls, N.Y., at the turn of the century to organize a civil rights struggle. The NIAGARA MOVEMENT, as it was called, grew into the NATIONAL ASSOCIATION FOR THE ADVANCEMENT OF COLORED PEOPLE, which Bentley served as a member of the board of directors from its establishment in 1909 until his death. Bentley was married first to Traviata Anderson, an accomplished pianist, and then to Florence Augusta Lewis, a writer and editor. He died on Columbus Day 1929.

REFERENCES

BENTLEY, CHARLES E. "Report of Committee Appointed to Investigate What Work Had Been Done in the Public Schools in the Civilized World by Dentists." *Dental Review* 14 (1900): 945–949, 983–991.

DUMMETT, CLIFTON O., and LOIS DOYLE DUMMETT. *Charles Edwin Bentley: A Model for All Times.* St. Paul, Minn., 1982.

PHILIP N. ALEXANDER

Berry, Charles Edward Anderson "Chuck"

(October 18, 1926–), rock-and-roll singer. Berry was born in St. Louis, Mo., the third of four children. His parents were deeply religious Baptists, but Berry became interested in secular music as a teenager. He was inspired to become a performer and guitarist after an enthusiastic reception of his rendition of "Confessin' the Blues" at Sumner High School, where he was a student. He attended Poro School of Beauty Culture in St. Louis during the 1940s and used his skills as a hairdresser and cosmetologist to support himself in the late 1940s and early '50s. Berry also performed at clubs around St. Louis with several groups in the early 1950s and became popular with both white and black audiences because he sang country songs and blues with equal zest.

Charles Edward Anderson "Chuck" Berry, 1956. (Frank Driggs Collection)

In 1955, Berry relocated to Chicago, where MUDDY WATERS recommended him to Chess Records, which signed him to a recording contract. Berry's first recording, and his first hit tune, was "Maybelline" (1955), a reinterpretation of the traditional country song "Ida Red" named for the Maybelline line of hair creams. He performed the song with crisp rapid-fire delivery and introduced new lyrics on the subjects of teenage love and car racing.

Berry was a pioneer in rock and roll and helped transform the new music into a commercially successful genre. His greatest success was in the late 1950s with songs that were definitive expressions of the themes of teenage angst, rebelliousness, and the celebration of youthful vitality. His best-known recordings include "Roll Over, Beethoven" (1956), "School Days" (1957), "Rock-and-Roll Music" (1957), "Sweet Little Sixteen" (1958), "Memphis" (1958), and "Johnny B. Goode" (1958). His only number-one record was the crass and forgettable "My Ding-a-Ling" (1972), a salute to male teenage masturbation.

After 1959 Berry's career was interrupted when he was arrested for transporting a minor across state lines. Though the events are still contested, Berry

allegedly took a fourteen-year-old prostitute from Texas to St. Louis to check hats for a nightclub where he was performing. When he fired her, she reported his actions to local police. Berry served a two-year prison sentence at the federal penitentiary at Terre Haute, Ind. from 1961 to 1963. While Berry never reached his former level of popularity, he became active in the rock and roll revival circle of the 1980s and early 1990s and performed widely.

Berry was arguably the central figure in the creation of the sound and style of rock and roll in the mid-1950s. He had a tremendous influence on rock performers who came after him, including Buddy Holly, the Beatles, the Beach Boys, the Rolling Stones, and Linda Ronstadt, who emulated both his guitar style and his highly energized stage presence. Berry's tune "Johnny B. Goode" was included in the payload of the Neptune-bound *Voyager 1*, a testimony to the original and representative nature of his work.

REFERENCES

BERRY, CHUCK. *Chuck Berry: The Autobiography*. New York, 1987.
DEWITT, H. *Chuck Berry: Rock 'n' Roll Music*. New York, 1981.
HARDY, PHIL, and DAVIE LAING. *Encyclopedia of Rock*. London, 1987.
PARELES, JON, and PATRICIA ROMANOWSKI. *The Rolling Stone Encyclopedia of Rock 'n' Roll*. New York, 1983.
REESE, K. *Chuck Berry: Mr. Rock 'n' Roll*. New York, 1982.

DAVID HENDERSON

Berry, Leon Brown "Chu" (September 13, 1908–October 30, 1941), tenor saxophonist. Born in Wheeling, W.Va., Leon Berry was taught piano as a child by family members and later studied alto saxophone in high school. In 1929, after studying for three years at West Virginia State College, he was hired by Edwards' Collegians in Bluefield, W.Va., and then Sammy Stewart's orchestra in Columbus, Ohio. At that time Berry began to wear a goatee, lending him an Asiatic appearance that led his bandmate alto saxophonist Billy Stewart to call him Chu-Chin-Chow, a nickname later shortened to Chu.

Berry came to New York in 1930 with the Stewart Orchestra for engagements at the Savoy and Arcadia ballrooms. From 1930 to 1932, he worked with Cecil Scott, Otto Hardwick, Kaiser Marshall, Walter Pichon, and Earl Jackson. He was hired in 1932 by Benny CARTER, with whose orchestra he made his first recordings. It was also with the members of

Carter's orchestra that Berry participated in Spike Hughes's well-regarded 1933 recordings. In 1932 Berry worked for Charlie Johnson, and in 1933 he performed on Bessie SMITH's final recording session. From 1933 to 1935, Berry played with Teddy Hill's orchestra; at this time he met Roy ELDRIDGE, who would become his close friend and musical collaborator. In 1935 Berry was hired to play in the Fletcher HENDERSON orchestra's lead tenor chair, a role once occupied by Berry's hero and model, Coleman HAWKINS. Berry was hired by Cab CALLOWAY in 1937 and became the orchestra's star soloist on, for example, its recording of "Ghost of a Chance" (1940). During this time he also began to record as a leader in his own small group swing sessions, often heading a group called Chu Berry and His Stompy Stevedores, and with leading soloists and singers of the swing era, notably with Count BASIE. Some of his best-known recordings are "Indiana" (1937), "46 West 52nd Street" (1938), "Oh! Lady Be Good!" (1939), and "Blowin' Up a Breeze" (1941).

Berry, who eventually performed with Lionel HAMPTON, Billie HOLIDAY, Benny Goodman, Mildred Bailey, Gene Krupa, and Wingy Manone, was prized as one of the top swing tenor soloists, as influential during his lifetime as Coleman Hawkins, Ben WEBSTER, Lester YOUNG, and Herschel Evans. Noted for his large, warm tone and vigorous, buoyant sense of swing, Berry died at the peak of his career from head injuries received in an automobile accident near Conneaut, Ohio.

REFERENCES

EVENSMO, JAN. *The Tenor Saxophone of Leon Chu Berry*. Oslo, 1976.
IOAKIMIDIS, DEMETRE. "Chu Berry." *Jazz Monthly* (March 1964).

IRA BERGER

Berry Brothers, theatrical dance act. Ananias J. (c. 1912–1951) and James J. (c. 1915–1969) Berry were born in New Orleans, and Warren J. Berry (c. 1918–) was born in Denver, but they were raised in Hollywood, Calif., where their dancing talents soon became apparent. By 1925 Ananias and James were competing in amateur Hollywood dance contests. Four years later, they began appearing at Harlem's Cotton Club with the Duke ELLINGTON Band. When Ananias Berry married dancer, singer, and trumpeter Valaida Snow, he left the act, and his younger brother Warren was recruited for his place. At the time, Warren was a piano student, but he also had formal training in acrobatics and tap.

Warren and James worked primarily in theaters and clubs until the mid-1930s, when Ananias returned and a trio was formed.

The Berry Brothers' classic four-and-a-half-minute act was built around acrobatics blended with tap steps (without metal plates), the soft shoe, and a cane and strut dance derived from the classic cake-walk. Ananias Berry's strut step was exceptional; his brother Warren recalls: "He brought it out [and had an] ability to kick above his head with ease and pointed toes."

Dynamism, tempo, and precision were the hall-marks of the trio's act. The Berry Brothers toured with the bands of Ella FITZGERALD, Count BASIE, Cab CALLOWAY, and Jimmy Dorsey. For ten years the trio worked together successfully in theaters and nightclubs and developed an international reputation. They appeared in films such as *Lady, Be Good* (1941), *Panama Hattie* (1942), and *Boarding House Blues* (1948).

When Ananias died suddenly in 1951, the act dissolved. Warren Berry left show business to became a film editor and author. James Berry had a role with the *Our Gang* comedies, and his continued interest in jazz and tap led to a fifteen-year collaboration with Russian-born Mura Dehn, a former modern dancer. Together they founded the Traditional Jazz Dance Company, a vehicle for documenting and preserving classic jazz dance. Ananias, James, and Warren Berry created one of the most brilliant "flash" acts in the history of the American stage.

REFERENCES

COHEN-STRATYNER, BARBARA. *Biographical Dictionary of Dance.* New York, 1982.
DEHN, MURA. "Jazz Profound: James Berry with Mura Dehn." *Dance Scope* 11/1 (Fall/Winter 1976/1977): 18–27.
FRANK RUSTY. *Tap! The Greatest Tap Dance Stars and Their Stories 1900–1955.* New York, 1990.

JACKIE MALONE

Bethel, Alfred "Pepsi" (1923–), dancer, choreographer, instructor. Born and raised in Greensboro, N.C., Pepsi Bethel's first ensemble, the Southland 400, was formed while he was in high school and performed during intermission at big band shows near Greensboro. In the late 1940s and early 1950s Bethel studied with Herbert White, a pioneer of the Lindy Hop. He received extensive training in jazz dance forms with Al Minns and Leon James, Norma Miller, and the Mura Dehn Jazz Ballet Company. In 1954 he began studying modern dance and ballet at Adelphi University in Hempstead, N.Y., under Hanya Holm, Alfred Brooks, and Maxine Munts.

Bethel joined the teaching staff of the Clark Center for the Performing Arts in 1963. In 1968 he formed, with Avon Long, the Authentic Jazz Dance Theatre. After touring Africa with Avon Long and other dancers in 1969, Bethel incorporated the company in 1972.

Both in his teaching and in his choreography, Bethel was dedicated to the preservation of authentic jazz dance forms such as the swing, the lindy, the cakewalk, and other blues and ballroom steps such as the shim sham, big apple, mooche, shorty George, slow drag, and the tuck Annie.

Bethel was a popular teacher at the ALVIN AILEY AMERICAN DANCE THEATER as well as the Clark Center for the Performing Arts and performed, choreographed, and staged works for festivals, film, and stage in the United States and Europe.

REFERENCES

EMERY, LYNNE FAULEY. *Black Dance from 1619 to Today.* 2nd rev. ed. Princeton, N.J., 1988, pp. 330–332.
MUNGER, GUY. "A 200-Pound Man with Lots of Dancing in His Roots." *Raleigh (N.C.) News and Observer,* November 20, 1988.

JULINDA LEWIS-FERGUSON

Bethune, Mary McLeod (July 10, 1875–May 18, 1955), rights activist. "If I have a legacy to leave my people, it is my philosophy of living and serving. As I face tomorrow, I am content, for I think I have spent my life well. I pray now that my philosophy may be helpful to those who share my vision of a world of peace, progress, brotherhood, and love." With these words, Mary McLeod Bethune concluded her last will and testament outlining her legacy to African Americans. Bethune lived up to her stated philosophy throughout her long career as a gifted institution builder who focused on securing rights and opportunities for African American women and youth. Her stunning successes as a leader made her one of the most influential women of her day and, for many years, a premier African-American leader.

Mary McLeod was born in 1875, the thirteenth of fifteen children of Sam and Patsy (McIntosh) McLeod. The McLeod family, many of whom had been slaves before the Civil War, owned a farm near Mayesville, S.C., when Mary was growing up. Mary McLeod attended the Trinity Presbyterian Mission School near her home from 1885 until 1888, and with the help of her mentor, Emma Jane Wilson, moved on

Dr. Mary McLeod Bethune at the time of her retirement as president of Bethune-Cookman College in Daytona Beach, Fla., in 1943. In 1941, nearly forty years after the school's founding by Bethune as an all-female industrial training school, it initiated a four-year academic curriculum. (Prints and Photographs Division, Library of Congress)

to Scotia Seminary (later Barber-Scotia College), a Presbyterian school in Concord, N.C.

McLeod set her sights on serving as a missionary in Africa and so entered the Bible Institute for Home and Foreign Missions (later known as the Moody Bible Institute) in Chicago. She was devastated when she was informed that the Presbyterian Church would not support African-American missionaries to Africa. Instead, McLeod turned her attentions and talents to the field of education at home.

From 1896 through 1897, McLeod taught at the Haines Institute, a Presbyterian-sponsored school in Augusta, Ga., an experience that proved meaningful for her future. At Haines, McLeod worked with Lucy Craft LANEY, the school's founder and a pioneering African-American educator. McLeod took away examples and skills she would put into action throughout her life.

From Haines, McLeod moved on to another Presbyterian school, the Kendall Institute in Sumter, S.C., where she met and married Albertus Bethune in 1898. The couple moved to Savannah, Ga., and in 1899 their only child, Albert Bethune, was born. Al-

though Albertus and Mary McLeod Bethune remained married until Albertus's death in 1918, they were no longer together by 1907. In 1900 Bethune moved to Palatka, Fla., where she founded a Presbyterian school and later an independent school that also offered social services to the community.

In 1904 Bethune settled in Daytona, Fla., in order to establish a school for African-American girls. She opened her Daytona Educational and Industrial Institute in a rented house with little furniture and a tiny group of students. Students at the school learned basic academic subjects, worked on homemaking skills, engaged in religious activities, and worked with Bethune in the fields of a farm she bought in 1910. Through the farm, Bethune and her students were able to feed the members of the school community, as well as sell the surplus to benefit the school. The Daytona Institute also emphasized connections with the community, offering summer school, a playground for children, and other activities. All of this made Bethune an important voice in her local community.

The school's reputation began to grow at the national level through a visit by Booker T. WASHINGTON in 1912 and the addition of Frances Reynolds Keyser to the staff in the same year. Keyser had served as superintendent of the White Rose Mission in New York and was a well-known activist. After World War I, the school grew to include a high school and a nurses' training division. In 1923 the school merged with the failing Cookman Institute of Jacksonville, Fla., and embarked on a coeducational program. In 1929 it took the name BETHUNE–COOKMAN COLLEGE. By 1935 Bethune's school, founded on a tiny budget, had become an accredited junior college and, by 1943, a fully accredited college, awarding bachelor's degrees. This success gained Bethune a national reputation and won her the NAACP's prestigious SPINGARN MEDAL in 1935.

In addition to her success as an educator, Bethune also made a major mark on the black women's club movement in America. In 1917 she was elected president of the Florida Association of Colored Women, a post she retained until 1924. Under her leadership, the organization established a home for young women in Ocala. In 1920 Bethune organized the Southeastern Federation of Colored Women and guided this group through 1925. From 1924 to 1928, she served as president of the NATIONAL ASSOCIATION OF COLORED WOMEN (NACW), the most powerful organization of African-American women's clubs in the country. During this period, she toured Europe as the NACW's president and established the organization's headquarters in Washington, D.C., in 1928. Bethune's crowning achievement in the club movement was the 1935 founding of the NATIONAL COUNCIL OF

A Works Project Administration teacher instructs National Youth Administration resident students on experimental gardening at the Fort Valley Normal & Industrial School. Mary McLeod Bethune helped to found the NYA and served from 1936 to 1943 as its first director. (Photographs and Prints Division, Schomburg Center for Research in Black Culture, The New York Public Library, Astor, Lenox and Tilden Foundations)

NEGRO WOMEN (NCNW). This organization served to coordinate and streamline the cooperative work of a wide variety of black women's organizations. During Bethune's fourteen years as president, the NCNW achieved this goal, began to work closely with the federal government on issues facing African Americans, and developed an international perspective on women's lives.

Bethune's influence with the Franklin D. Roosevelt administration led her to activities that made her an even greater public figure on behalf of African Americans. In 1936 she organized the Federal Council on Negro Affairs, popularly known as the Black Cabinet, a group of black advisers who helped coordinate government programs for African Americans. In this same period, she became deeply involved in the work of the National Youth Administration (NYA), serving on the advisory committee from its founding in 1935. In 1936 Bethune began functioning as director of the NYA's Division of Negro Affairs, a position which became official in 1939 and which she held until 1943. This appointment made her the highest ranking black woman in government up to that point. Bethune's goals in the NYA were to increase the representation of qualified African Americans in

leadership in local and state programs and to ensure that NYA benefits distributed to whites and to blacks achieved parity.

In addition to Bethune's many other achievements, she served as the president of the ASSOCIATION FOR THE STUDY OF NEGRO LIFE AND HISTORY from 1936 to 1951, established the Mary McLeod Bethune Foundation, and wrote a column for the PITTSBURGH COURIER. Bethune's career is testimony to her leadership skills, her commitment to justice and equality for African Americans, her unfailing dedication to the ideals of American democracy, and her philosophy of service.

REFERENCES

BETHUNE, MARY MCLEOD. "My Last Will and Testament." Ebony, August 1955.

HOLT, RACKHAM. Mary McLeod Bethune: A Biography. New York, 1964.

SMITH, ELAINE. "Mary McLeod Bethune and the National Youth Administration." In Mabel E. Deutrich and Virginia C. Purdy, eds. Clio Was a Woman: Studies in the History of American Women. Washington, D.C., 1980.

JUDITH WEISENFELD

Bethune, Thomas Greene Wiggins "Blind Tom" (May 25, 1849–June 13, 1908), pianist and composer. Blind from birth, Thomas Bethune was bought as a slave with his parents in 1850 by Col. James N. Bethune, a Columbus, Ga., journalist, lawyer, and politician. Tom demonstrated musical aptitude and exceptional retentive skills by his fourth birthday and was given informal instruction from Bethune's daughter and traveling musicians. In 1857, Tom was hired out to Perry Oliver, a tobacco planter from Savannah, for three years and exhibited as a slave prodigy. Oliver continued to exploit his talents, exhibiting him throughout Georgia and other slave-holding states. His concerts included a command performance in Washington, D.C., for Japanese dignitaries. With the outbreak of the Civil War, Tom was returned to Colonel Bethune, who exhibited him throughout the South, raising money for the Confederacy. Tom's first tour abroad took place in 1866. He was accompanied by W. P. Howard of Atlanta, his musical tutor. After returning from Europe, he moved to Warrenton, Va., with the Bethunes in 1868 (Bethune had gained legal guardianship of Tom in 1865) and continued his concert career, which was to last almost forty years more. By the end of the nineteenth century, advertised as an "untaught idiot savant," Tom was well known throughout the United States. His programs included works by European masters, improvisations on operatic tunes, popular ballads, and original compositions. He allegedly could perform difficult pieces after one hearing, sing and recite poetry or prose in several languages, duplicate lengthy orations, and imitate sounds of nature, machinery, and musical instruments. His more than one hundred compositions were representative of the pianistic and theoretical practices of nineteenth-century romantic salon pieces. In 1887, Bethune's son's widow managed to gain legal control over Tom and continued the exploitation of his talent until his final concert appearances in 1904–1905 on the vaudeville circuit.

GENEVA H. SOUTHALL

Bethune-Cookman College. On October 3, 1904, African-American educator and activist Mary McLeod BETHUNE founded a normal and industrial school for African-American girls in Daytona Beach, Fla. Though she began with only five students in a small rented house, in less than two years Bethune attracted 250 pupils and founded the Daytona School for Girls in a building she erected on top of a garbage dump. By 1916, the school had grown into the Daytona Normal and Industrial Institute, and was affili-

ated with the United Methodist Church. After absorbing the Cookman Institute for Boys, previously located in Jacksonville, the school, newly christened Bethune-Cookman College, was established as a high school with junior college courses in 1924. Bethune, who continued as president of the college until 1947, raised funds for the school from middle-class blacks and liberal white philanthropists. Committed to integration and interracial cooperation, Bethune sought out a mixed-race board of directors, but she opposed white directors who favored a vocational curriculum. Bethune pushed for the inclusion of a full liberal arts program, and the school continuously upgraded its standards and facilities. Despite a heavy financial squeeze during the Great Depression, Bethune-Cookman became a two-year junior college in 1939 and a four-year institution shortly after, receiving a Grade A accreditation in 1947, the last year of Bethune's presidency. In 1990 Bethune-Cookman, the only historically black college founded by a woman, had a student body of approximately 2,200 and had thirty-two buildings on fifty-two acres, and offered degrees in subject areas as diverse as biology, business, and communications.

REFERENCES

BETHUNE, MARY MCLEOD. "A College on a Garbage Dump." In Gerda Lerner, ed. *Black Women in White America: A Documentary History*, pp. 134–143. New York, 1972.
HOLT, RACKHAM. *Mary McLeod Bethune: A Biography*. New York, 1964.

MARGARET D. JACOBS

Bevel, James (October 19, 1936–) civil rights activist. James Bevel was born in Itta Bena, Miss. In his early teens he experienced a religious conversion and became well known throughout his town as an inspiring preacher. He was ordained as a Baptist minister in 1959 and received a B.A. from American Baptist Theological Seminary in Nashville, Tenn., two years later.

Bevel's childhood experiences had familiarized him with wrenching rural poverty and left him with a commitment to work for the end of racial injustice. In 1958 Bevel attended the Highlander Folk school, an interracial adult-education center in Tennessee that focused on promoting social activism. At Highlander, Bevel had his first in-depth exposure to nonviolent theories of social change and was deeply influenced by the commitment to interracialism of Myles Horton, the director of the Highlander School. One year later, Bevel attended a Vanderbilt Univer-

sity training workshop for student activists in Nashville sponsored by the Fellowship of Reconciliation (FOR), a nonviolent direct action group. Through his involvement with FOR, he became a leader in the Nashville student movement and played a central role in organizing and staging SIT-INS to force Nashville businesses to desegregate.

In 1960, Bevel became one of the founding members of the STUDENT NONVIOLENT COORDINATING COMMITTEE (SNCC), a grass-roots civil rights organization. The following year, he married Diane Nash, a SNCC activist, and in 1962 they moved to Albany, Ga., where he became a prominent leader in the Albany Movement to fight racism and segregation and became involved in the SOUTHERN CHRISTIAN LEADERSHIP CONFERENCE (SCLC).

In SCLC Bevel coordinated direct action protests and trained student activists. In 1963 he was appointed director of direct action and nonviolent education. He traveled to Birmingham, Ala., to coordinate SCLC's activities and led a protest march of black children from the Sixteenth Street Baptist church that played a pivotal role in galvanizing Birmingham's black community. He worked closely with his wife and the couple's ideas were influential in the planning for the March on Washington later that year. Bevel played an integral role in SCLC's attempt to apply nonviolent civil rights techniques in the North, and in 1966 he traveled to Chicago to organize direct-action workshops and tenant strikes.

Over time Bevel became involved in a broader range of social and political issues. In the summer of 1966, he worked with the Nonviolent Human and Community Development Institute, and in 1967 he took a leave of absence from SCLC to become executive director of the Spring Mobilization Committee to End the War in Vietnam.

Despite his relative obscurity, Bevel was a dynamic and dedicated civil rights leader. He composed several freedom songs—"Dod-Dog" (1959), "Why Was a Darky Born" (1961), and "I Know We'll Meet Again" (1969)—that inspired many in the civil rights movement. He worked closely with the Rev. Dr. Martin Luther KING, Jr., and was at his side when he was assassinated in Memphis, Tenn., on April 4, 1968. Assessing Bevel's pivotal role in the civil rights movement, Ralph ABERNATHY stated, "I guess Bevel was the number three man in the movement [alongside King and himself] because he didn't want the glory or the praise, he just wanted to do the work."

Following King's death, Bevel left SCLC after unsuccessful attempts to focus the organization's agenda on education, international arms reduction, and a fair trial for King's accused assassin, James Earl Ray. By the 1980s, when Bevel reentered the public arena, his politics had shifted to the right. In 1980 he campaigned for Ronald Reagan, and four years later he ran unsuccessfully for the House of Representatives from Chicago on the Republican ticket.

In the late 1980s Bevel centered his attention on education—founding Students for Education and Economic Development (SEED) in Chicago—and international issues, such as human-rights abuses in former Soviet bloc countries. In 1989 he formed the National Committee Against Religious Bigotry and Racism (NCARBAR), and in the early 1990s he gained prominence as an opponent of capital punishment.

REFERENCES

BRANCH, TAYLOR. *Parting the Waters: America in the King Years, 1954–63.* New York, 1988.

GARROW, DAVID J. *Bearing the Cross.* New York, 1986.

KRYN, RANDALL. "James L. Bevel: The Strategist of the 1960 Civil Rights Movement." In David J. Garrow, ed. *We Shall Overcome: The Civil Rights Movement in the United States in the 1950s and 1960s,* Vol. 2. Brooklyn, N.Y., 1989.

JEANNE THEOHARIS

Bibb, Henry Walton (May 10, 1815–1854), author, editor, and emigrationist. Born a slave on a Kentucky plantation, Henry Bibb was the oldest son of a slave, Milldred Jackson. Like many slaves, he never knew his father and was even unsure of his father's identity; he was told, however, that he was the son of James Bibb, a Kentucky state senator. His six brothers, all slaves, were sold one by one, until the entire family was scattered. In 1833, he met and married a mulatto slave named Malinda, with whom he had one daughter, Mary Frances. Bibb's fierce desire to obtain freedom and reclaim his wife and daughter motivated his repeated attempts to escape from slavery. In 1842, he successfully fled to Detroit, where he began work as an abolitionist. He continued to search for Malinda and his daughter, but after learning that Malinda had been sold as the mistress of a white slave owner, Bibb gave up his longtime dream and resolved to advance the antislavery cause.

In 1850 he published his autobiography, *Narrative of the Life and Adventures of Henry Bibb, an American Slave.* One of the best-known slave narratives, the book contains an extensive, personal account of Bibb's life as a slave and runaway. Soon after it appeared, Congress passed the Fugitive Slave Act of 1850, which gave slave owners the right to reclaim runaways and obligated Northerners to help them to do so. Bibb, like many others, openly stated that he preferred death to reenslavement, and fled with his

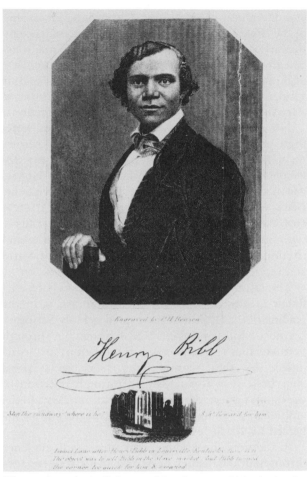

The emigration of almost fifty thousand blacks in the antebellum period created many opportunities for developing self-governing community institutions. One of the most zealous advocates of black autonomy was Henry Walton Bibb, editor of *Voice of the Fugitive.* Like many Canadian blacks of the time, Bibb was an escaped slave; this poster offers a reward for his return to Kentucky. (Prints and Photographs Division, Library of Congress)

second wife, Mary Miles Bibb of Boston, to CAN-ADA. In Ontario, the Bibbs soon became leaders of the large African-Canadian community.

In 1851, Bibb established the *Voice of the Fugitive,* the first black newspaper in Canada. Through the *Voice,* he expressed his essential ideas as an emigrationist by urging slaves and free blacks to move to Canada. The newspaper became a central tool of emigration advocates. In addition to the *voice,* Bibb's civic and political accomplishments in the Ontario communities were substantial.

Two years before his death, and as a direct result of his work as a writer and orator, Bibb was reunited with three of his brothers, who had escaped from bondage and emigrated to Canada. He interviewed them and published their stories in the *Voice of the*

Fugitive. Bibb died in the summer of 1854, at the age of thirty-nine.

REFERENCES

BIBB, HENRY WALTON. *Narrative of the Life and Adventures of an American Slave.* New York, 1850.

BLASSINGAME, JOHN W. "Henry Walton Bibb." In Rayford W. Logan and Michael R. Winston, eds. *Dictionary of American Negro Biography.* New York, 1982.

JEFFREY L. KLEIN

Bible and African-American Culture, The.

The history of the influence, uses, and functions of the Bible among African Americans is dramatic and complex, and reflects the different, sometimes conflicting, sociopolitical and religious self-understandings, orientations, and aspirations of a dominant segment, if not the great majority, of African Americans.

The earliest large-scale cultural encounter with the Bible can be traced to the late eighteenth century, as evidenced by the formation of independent African-American congregations in the North and South, both visible and "invisible," and in different cultural interpretive expressions, such as slave songs, poetry, sermons, and journals. Finding themselves enslaved by those who seemed to find in the Bible a source of power and knowledge, Africans in the New World embraced the Bible for themselves as a source of psychic-spiritual emotional power and hope, as inspiration for learning, and as a language of veiled criticism.

The dramatic narratives of the Hebrew Bible, especially the Exodus story and the moral and sociopolitical excoriations of the prophets, the display of the thaumaturgical powers of Jesus, and his pathos and ultimate vindication in the New Testament, captured the collective popular imagination of enslaved Africans from the beginning of their encounter with the Bible.

Thus, in the initial hearings and adoption of the stories of the Bible, African Americans essentially transformed the Bible from the Book of Slaveholders and of Slaveholding Religion into the Book of the World and Religion of Slaves. It was thereby engaged as a window onto another world, a language world full of personalities and drama with which the slaves could identify, notwithstanding the historical and spatial gulf which the hearing and the reading made obvious. It was precisely the hearing and reading of dramatic biblical stories about times and exploits long ago in faraway lands that seemed most arresting: Such engagement provided not only occasional psychic respite from the harshness of slavery, but also a powerful rhetorical and conceptual reper-

toire for resistance, and positive constructions of the African-American religious self.

The Bible continued to serve multiple functions among African Americans through the end of the period of slavery and the decades of Reconstruction and Jim Crowism and into the civil rights movements of the 1950s and '60s. But a dominant pattern of reading can be discerned during the period. From the founding of the independent black churches and denominations in the late eighteenth century to the clamor against segregation in the mid-twentieth century, a great number of African Americans saw in the Bible the language and concepts of social and prophetic critique, the blueprint for racial uplift, social integration, political peace, and economic equality. A few leaders (Alexander Waters, Martin R. DELANY, Edward W. BLYDEN, among others) advanced more radical pan-Africanist views, citing biblical injunctions for black separatism, including a back-to-Africa program (see PAN-AFRICANISM). But for the majority, including nineteenth-century mainline learned and not-so-learned clergy and their communities and twentieth-century educators and politicians, the Bible was the primary blueprint for a type of social reform. The biblical principle of the universal kinship of all humanity under the sovereignty of God was embraced by the majority of African Americans as a mandate for social integration and political equality, and as a critique of the America that claimed to be God-fearing. New Testament passages illustrative of the principle (Gal. 3:26–128; Acts 2, 10:34–36) were often quoted, paraphrased, or alluded to in orations, sermons, and tracts.

In this dominant African-American reading, the Bible continues to be primary in terms of the construction of the religious self. And it also continues to provide a language of critique. But the critique is not radical. This reading, of both the Bible and American culture, is canonical. It more or less respects both the dominant traditional white Protestant parameters of principles of interpretation, as well as the range of texts considered worthy of consideration. Biblical images and teachings provided the impetus and ideological foundations for the founding of separate African-American churches and educational and other institutions. But these separate institutions do not represent comprehensive alternative pedagogies, philosophies, or politics. They represent both accommodationist and integrationist interests and limited, racialist social critique. And both responses are supported by biblical example and injunction.

The growth and dominance of the religion-inspired separate but accommodationist African-American institutions and ideologies of the nineteenth and early twentieth centuries notwithstanding, they could not and did not embrace, or reflect the sensibilities of, every individual or community. A very different reading of the Bible among African Africans is in evidence by the early decades of the twentieth century in major urban areas in the United States. This reading is critical of both the dominant white American culture and its secular and religious aspects and the dominant African-American religious and cultural orientations.

No single unified group can be identified here; there are a number of groups—the Garvey Movement (see Marcus GARVEY; UNIVERSAL NEGRO IMPROVEMENT ASSOCIATION), the NATION OF ISLAM, FATHER DIVINE and the Peace Mission Movement, Black Jews (see JUDAISM), the SPIRITUAL CHURCH MOVEMENT, and other so-called sects and cults—without formal ties, but with shared sensibilities and rhythms, and a shared critique of the dominant world and the African-American mainline churches.

The critique is registered in different ways by different groups. One of the most dramatic is in the reading of the Bible that is accepted as Holy Scripture by most whites and African Americans, but through hermeneutics (principles of interpretation) not legitimized by these communities (such as spiritual churches). It is also registered through rejection of the canon respected by mainline communities and the embracing of esoteric sacred texts (such as those embraced by Black Jews).

In addition, the readings of women are in evidence throughout the history of African-American engagement with the Bible—from Phillis WHEATLEY to Maria STEWART and Jarena LEE and their countless unnamed counterparts to late twentieth-century critical womanist interpreters. Although women's readings of the Bible are a constitutive part of each cultural reading outlined above, women's readings bring special nuances or intensity, especially regarding the articulation of exclusion and suffering or their opposites, inclusion and joy.

REFERENCES

FELDER, CAIN H. *Troubling Biblical Waters: Race, Class, and Family.* Maryknoll, N.Y., 1989.
———, ed. *Stony the Road We Trod: African-American Biblical Interpretation.* Minneapolis, 1990.
REID, STEPHEN BRECK. *Experience and Tradition: A Primer in Black Biblical Hermeneutics.* Nashville, 1990.
THOMAS, LATTA. *Biblical Faith and the Black American.* Valley Forge, Pa., 1986.
WEEMS, RENITA. *Just a Sister Away: A Womanist Vision of Women's Relationships in the Bible.* San Diego, 1988.
WIMBUSH, VINCENT L. "Biblical-Historical Study as Liberation: Toward an Afro-Christian Hermeneutic." *Journal of Religious Thought* 42, no. 2 (Fall/Winter, 1985/1986): 9–21.

VINCENT L. WIMBUSH

Bigard, Leon Albany "Barney" (1906–1980), clarinetist and composer. Born in New Orleans, Barney Bigard was a light-skinned, French-speaking Creole of color. He studied with the Mexican-American clarinetist Lorenzo Tio, Jr., and in the mid-1920s played with King OLIVER and Luis Russell. After settling in New York in 1927, he joined Duke ELLINGTON's orchestra, where he brought in to prominence the woody clarinet tone favored by New Orleans players. He read difficult parts easily; played precisely in tune; had a beautiful sound, with a clear, warm tone; phrased elegantly; injected agile obbligatos; improvised inventively; soared and swooped above the brass without screeching; and swept nimbly from one end of the register to the other, as in his characteristic long and smooth upward glissandi. His celebrated recordings with Ellington include "Black Beauty" (1928), "Ducky Wucky" (1932), "New Black and Tan Fantasy" (1938), "Jack the Bear," "Harlem Air Shaft," "Across the Track Blues" (all 1940), "Main Stem" (1942), and his liquid solo on "Clarinet Lament (Barney's Concerto)" (1936). Bigard was cocomposer with Ellington of "Mood Indigo" (1930) and "Rockin' in Rhythm" (1931). From 1936 to 1941, he recorded with Ellington in small ensembles under his own name, including the relaxed "Barney Goin' Easy" (1939). Bigard left Ellington in June 1942. From 1947 to 1961, he played on and off with Louis ARMSTRONG and His All-Stars, where he exercised his gifts for small-group collective improvisation. His extended stints with two of the greatest masters of jazz were recounted in his posthumous autobiography, *With Louis and the Duke* (1985).

JOHN EDWARD HASSE

Biggers, John (April 13, 1924–), artist. John Biggers was born into a family of seven children in Gastonia, N.C. His father, Paul Biggers, knew Latin and Greek and worked intermittently as a school principal, a preacher, a coal miner, and a basket maker. In 1937, Biggers attended high school at Lincoln Academy near Gastonia, working there part-time as a janitor. In 1941, he enrolled at the Hampton Institute in Virginia with the intention of becoming a plumber, but after studying painting with Victor Lowenfeld and woodworking and ceramics with Joe Gilliard, he decided to become an artist, with a particular interest in murals.

Biggers served in the U.S. Navy from 1943 to 1946, then returned to Hampton in 1946 to study sculpture with Elizabeth Catlett and painting with Catlett's husband, Charles White. At Hampton, some

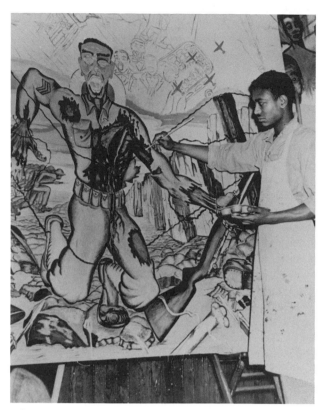

John Biggers, while a student at Hampton Institute, working on his mural *Dying Soldier*. (Hampton University Museum and Archives)

of his first murals included *Dying Soldier,* which depicted the boyhood memories of a black soldier as he lay dying on the battlefield, and *Community Preacher,* which visualizes a minister's sermons about Africa. In 1946, Biggers followed Lowenfeld to Pennsylvania State University, where he earned B.S. and M.S. degrees in art education in 1948 and a Ph.D. in education in 1954.

In 1949, Biggers married and spent the summer teaching at Alabama State Teachers College in Montgomery. He and his wife relocated to Houston in the fall, where Biggers was hired to organize an art department for Texas Southern University (TSU). Biggers aimed to attract young black Texans who had little experience with art in segregated public schools to the newly formed program. The art department soon became well known for sponsoring student murals on campus and for bringing art into black neighborhoods. In the Houston area, Biggers painted murals on black women in America, the history of African-American education, and his reflections upon a trip to Africa (*Birth From the Sea,* 1964).

In 1957, Biggers received a UNESCO fellowship to travel to Ghana and Nigeria. During the next ten years, he illustrated many books, including *I, Momolu* (1966) by Lorenz Graham. In 1962, he published

Ananse: The Web of Life in Africa, an acclaimed collection of images and writings on his experiences in Africa. After teaching at the University of Wisconsin for one year (1965–1966), Biggers returned to TSU, where he became involved in the political demonstrations on campus, heading a university committee to mediate conflicts between students and police. His painting activity was slowed in the 1970s, though in the early 1980s, Biggers resumed painting murals on black life—*The Quilting Party* (1981) at Houston's Music Hall and *The Adair Mural* (1982) at Christa Adair Park in Harris County, Tex.

While Biggers's early murals followed the social-realist style of the Mexican muralists, his mature work displays a simpler, more abstract style. In his best-known drawings, murals, and sculpture, Biggers draws upon black spirituals and folktales to express the inner rhythms and values of African-American rural life. Black women and families constitute the most frequent subjects of his work. Biggers has also developed his own unique iconography of African-American life consisting of such symbols as quilts, webs, and shotguns houses. In a recent colored lithograph, *Family Ark* (1993), Biggers depicts in triptych form a series of ancestral figures using his typical palette of earth tones accented with blues and greens. The image conveys a sense of both personal and collective memory by mixing everyday and domestic symbols of African-American life (pot-bellied stoves, washboards, hair combs, and train tracks) with spiritual and religious objects (the cross, African fetish figures, elephants, and Egyptian hieroglyphics).

Biggers's work has been shown in solo exhibitions at the Houston Museum of Fine Arts (1962, 1968), the Institute of Texan Cultures in San Antonio (1980, 1993), and the California Museum of Afro-American History and Culture (1983), among others. In 1983, he retired from his position at Texas Southern University, but has continued to work as an artist in Texas.

REFERENCES

BARRY, ALWYN, and ROBERT CALVERT, eds. *Black Leaders: Texans for Their Times.* Austin, Tex., 1981.
BEARDEN, ROMARE and HARRY HENDERSON. *A History of African-American Artists.* New York, 1993, pp. 427–436.
BIGGERS, JOHN and CARROLL SIMMS. *Black Art in Houston: The Texas Southern University Experience: Presenting the Art of Biggers, Simms, and Their Students.* College Station, Tex., 1978.
ENGLEY, HOLLIS. "Muralist Preserves the Black Experience." *New Mexican,* April 1, 1984, p. A1.

RENEE NEWMAN
FRANCES A. ROSENFELD

Billy Dee. *See* Williams, Billy Dee (December, William).

Bing, David "Dave" (November 29, 1943–), basketball player and industrialist. Dave Bing was born and raised in Washington, D.C., where he excelled in basketball and baseball at Spingarn High School. After graduating in 1962 Bing was recruited to play basketball at Syracuse University. As a 6'3" guard Bing set the Syracuse career scoring record and was named a first-team All-American in 1966, his senior year.

A first-round draft choice by the Detroit Pistons of the National Basketball Association (NBA), Bing averaged 20.0 points per game his first year and won the 1967 Rookie of the Year Award. The following season Bing led the NBA with 27.1 points per game. He played for the Pistons until 1975, when he was traded to the Washington Bullets. Bing was waived by Washington in 1977 and then signed as a free agent by the Boston Celtics. He retired after the 1978 season with 18,327 career points and a 20.3 points per game average. Bing was named to the NBA All-Star game seven times. In 1990 he was elected to the Basketball Hall of Fame.

Following his basketball career, Bing established Bing Steel Inc., a successful Detroit steelworks, and later the Bing Group, a conglomerate of his steel and other manufacturing enterprises. Through the 1980s and early '90s Bing was active in Detroit politics and became a close ally of former mayor Coleman YOUNG. In 1989 he led a successful fund-raising campaign to save the sports programs for the Detroit public schools. In 1993 the Bing Group reported sales of $83,324,000, making it the twelfth largest black-owned business in the United States.

REFERENCES

PORTER, DAVID L. *Biographical Dictionary of American Sports.* Westport, Conn., 1987.
TELANDER, RICK. "Life Lessons from a Man of Steel." *Sports Illustrated* (August 19, 1991): 48–51.

THADDEUS RUSSELL

Bird. *See* Parker, Charles Christopher "Charlie."

Birmingham, Alabama. Birmingham's African-American community came into existence with the founding of the city in 1871. Its initial growth

was rapid, but in 1873, the outbreak of cholera and a national economic panic substantially reduced both black and white populations. Recovery was slow.

In the early 1880s, with the advent of a viable coal and iron industry, came a revitalized economy and a renewal of population growth. Thousands of African Americans flocked to the Birmingham area to mine coal or work in the iron mills. In both the 1890 and 1900 censuses, African Americans constituted 43 percent of the total population. After a slight decline in the years between 1910 and 1940, the percentage of African Americans in the city's total population began a steady increase, reaching 55 percent in 1980 and 63 percent in 1990.

Most African-American immigrants in Birmingham came from cotton farms in south Alabama and from the virtual enslavement represented by the sharecropper system. The city's lure was the promise of regular wages paid in cash, but what these migrants found available were generally the most menial jobs or those that were lowest paying. For African-American males, who worked in the mines and mills, the jobs they received were invariably the most dangerous. For females, job opportunities meant domestic work as maids or cooks or employment as dishwashers, laundresses, seamstresses, waitresses, or in the kitchens.

Despite the hard work, low pay, and discrimination that African Americans experienced, however, life in Birmingham was generally an improvement over what they had known on the farm. They had more money, a more active social life, more freedom

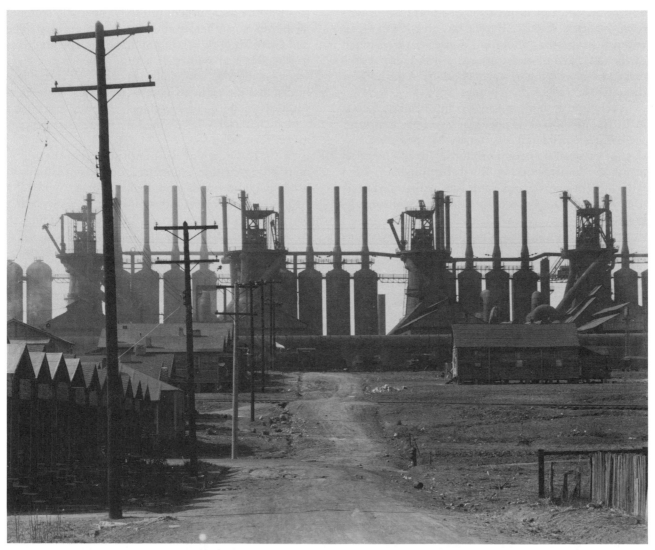

Steel mills and worker housing, Birmingham, Ala., 1936. Unlike many industrial cities in the south, heavy industry in Birmingham actively recruited black labor. This in turn helped to shape a unique tradition of African-American political and union radicalism in the city. (Prints and Photographs Division, Library of Congress)

from white domination, and better education for their children. The best evidence of Birmingham's attractiveness to blacks exists in the census, which shows a reasonably sustained growth of the city's black population.

Most African Americans lived in the areas that were generally, but not strictly, segregated. New arrivals often moved into a "company house": a three- or four-room rental structure owned by a coal or steel company. Usually identical in design, company houses stood in rows; several rows made up a company "village." Blacks and whites were segregated by rows of houses, but a black row and a white row often stood back to back. Thus, company villages respected segregation in principal, but in reality they did not keep the races very far apart.

Until the 1960s the largest single concentration of blacks in one neighborhood was Birmingham's Southside, the area immediately south of the downtown business district. Before the mid-1960s urban renewal program, "shotgun" houses covered much of the area. Domestics, furnace and foundry workers, and a smattering of teachers occupied the houses, though few owned their homes.

Several large, predominantly white neighborhoods in Birmingham had distinct black sections that were sometimes considered—especially by their own residents—as separate neighborhoods. Tuxedo Junction in Ensley, Collegeville in North Birmingham, Zion City in Woodlawn, and Kingston in East Birmingham were all black enclaves in otherwise white neighborhoods.

Among the purely black neighborhoods were several that were middle class in character. Enon Ridge, just northwest of Interstates 59 and 65 near downtown, became the fashionable place for the few black professionals in the city in the 1890s. Shortly after the turn of the century, the neighborhood of Smithfield—southwest of Enon Ridge—was developed; large numbers of black teachers and some other professionals bought homes there. In the 1940s South Titusville, to the west of Southside, began to attract working-class African Americans who could afford to own their own homes.

Once settled in a job and a neighborhood, African Americans usually joined a church. Each black neighborhood had at least one, and usually several churches. By far the most popular denomination among African Americans was the Baptist (*see* BAPTISTS), which had perhaps three times as many members as its nearest rival, the METHODIST. The various Pentecostal sects had the next largest number of members. The Presbyterians, Catholics, Episcopalians, and Congregationalists each had at least one, but not more than four, black congregations in the Birmingham area.

The typical black church in Birmingham at the turn of the century closely resembled the country churches of rural south Alabama. Several larger churches had a somewhat different character from the smaller neighborhood ones, primarily because of the higher economic status of their congregations. The SIXTEENTH STREET BAPTIST CHURCH, the first black church downtown (1873), always had many professionals among its members. Its services, conducted by highly educated ministers, rarely had the emotionalism seen in many other black churches.

The Sixth Avenue Baptist Church on the Southside was for decades the largest working-class church in Birmingham. In recent decades, however, it has added many professional members, and in the early 1990s, was the largest black congregation in the state.

Birmingham's African Americans encountered both prejudice and discrimination from the time the city was first established, but they especially suffered in the years just before the turn of the century. The rapid growth of the black population in Birmingham frightened local whites at a time when racist fears were on the rise nationally. In 1901, all but a few blacks lost the right to vote when a new state constitution established a poll tax, literacy tests, and "good character"—as defined by whites—as prerequisites for voting.

In 1911, the city of Birmingham began the enactment of segregation ordinances, outlawing saloons in black neighborhoods and making ones owned by whites separate black and white customers by using partitions. Other ordinances followed, including an encompassing JIM CROW statute in the 1920s.

In the early years of Birmingham's African-American community, educational concerns centered less on professional degrees than on establishing grammar schools. The first black public grammar school in Birmingham was Lane School, founded in 1886 on the Southside. Carrie A. Tuggle built Tuggle Institute, a popular private school and orphanage, on Enon Ridge in 1903.

There was no black high school in Jefferson County before 1900. Parents who wanted to educate their children beyond grammar school sent them to TUSKEGEE INSTITUTE or Talladega College, which had high schools at the time. In 1899, however, a group led by William R. Pettiford, a local minister and businessman, requested that the city establish a public high school for blacks. The next year the board of education appointed Arthur Harold Parker as the first principal of "Industrial High School."

The local black community took great pride in the school for which Parker had responsibility, and justifiably so. In the 1930s, for example, Industrial was recognized as the largest black high school in the world. Nowhere, however, was discrimination

against African Americans more evident than in education. In 1911 Birmingham spent $18.86 for each white child of school age but only $1.81 for each black child. White teachers had an average of thirty-six students per class. Black teachers, who earned much less than their white counterparts, had fifty-eight. Moreover, the school buildings provided for African Americans were grossly inferior to those for whites. Until 1925, for instance, the Industrial High School building was nothing more than two rows of shotgun houses connected by ramps.

Discrimination kept many African Americans from attempting business enterprises. Among those that did, a number located their businesses along Fourth Avenue North between Sixteenth and Eighteenth Streets, an area that became Birmingham's central black commercial district.

Most African-American businesses provided services to other black Americans not provided by white businessmen. For example, A. G. Gaston, Birmingham's wealthiest black businessman, began his career with the Smith and Gaston Funeral Homes in 1923; he then added the Booker T. Washington Insurance Company and, subsequently, a business college, a drug store, a motel, a radio station, and a bank—Citizen's Federal Savings and Loan. All of these businesses originally filled the needs of the black community in a way that whites either refused to do or did inadequately.

Fraternal organizations also originally performed for blacks some of the services that insurance companies did for whites. The Masons (see MASONIC ORDER), the Knights of Pythias, the Elks, and the Oddfellows were all burial societies in addition to providing social activities for their male members.

African-American women formed social clubs for the same reasons that their male counterparts joined fraternal organizations. Membership in women's clubs like Sojourner Truth, founded in 1895, or Semper Fidelis, organized in 1900, carried with it status and opportunities for social activities.

Certain recreational activities have been particularly popular among Birmingham's African Americans. Through the first half of this century, baseball attracted many talented athletes and thousands of avid fans. Many blacks played in industrial leagues, and a few made it to professional teams. The Birmingham Black Barons, whose roster from 1948 to 1950 included baseball Hall of Famer Willie MAYS, drew large crowds of both African Americans and whites to Rickwood Field, though white attendance fell when the city commissioned enforced segregated seating in the 1940s.

Birmingham was also a center for jazz in the 1920s and 1930s. The growth of jazz in Birmingham must be traced to John T. "Fess" Whatley, band director at Industrial High School. A stern taskmaster, Whatley schooled his many students on the fundamentals of reading and performing music. One of Whatley's most famous students, Erskine Hawkins, brought fame to Birmingham jazz and its black neighborhoods in 1939 when he wrote a song entitled "Tuxedo Junction," which became a national hit.

The happy lyrics of "Tuxedo Junction" should not hide the misery felt by Birmingham's blacks in the 1930s. The depression hit Birmingham early and hard. Tens of thousands of black miners and steel workers were thrown out of work as the big steel companies virtually ceased operations. Getting food and fuel became a major problem for most black families in the city's industrial neighborhoods. The hard times brought a radical political response from some of Birmingham's African Americans, who joined the American Communist party. Unions, however, attracted far more blacks unhappy with their economic situation than the Communist party did. In the 1890s, they had responded enthusiastically to the United Mine Workers' organizing efforts among African-American miners. They remained loyal to the UMW despite several concerted efforts on the part of coal companies to break up the union by creating racial animosity between black and white workers.

Biracial organizing was used in the 1930s against the Mine, Mill, and Smelter Workers, an organization of iron ore miners that some whites called "the nigger union." In an effort to destroy the union, its opponents accused some Mine, Mill officials of being Communists and harassed white members about their close association with blacks. In the late 1940s Mine, Mill was absorbed by the Steelworkers Union, against the will of many black members.

Civil rights activism began to appear in the 1930s, especially in the area of voting discrimination. It was not, however, until the end of World War II that a confrontation between the races became pointed. Tension between blacks and whites increased markedly after World War II, as whites sensed that blacks intended to challenge segregation and other forms of discrimination. In addition to voting, residential patterns became a point of conflict. The need for more and better housing led blacks to build in sections of neighborhoods that had previously been all white.

In 1947 a local black man successfully challenged Birmingham's residential segregation law when the city attempted to prevent him from occupying his new home in North Smithfield, a neighborhood the city had designated as white. Two weeks later his home was blown apart by a dynamite bomb. Other blacks followed him to North Smithfield, but so did more trouble. Several new black homes were bombed in the late 1940s and early 1950s, apparently the work of local Klansmen angry at black encroach-

ment into white neighborhoods. The violence happened with such regularity that this section of town became known as "Dynamite Hill."

In the late 1950s blacks began to challenge the segregation of public schools, but it was not until 1963 when, under federal court order, several all-white schools were desegregated despite bitter opposition from local whites.

In the 1960s the national CIVIL RIGHTS MOVEMENT accelerated change in Birmingham. The sit-in movement (see SIT-INS) in 1960 and the freedom-riders in 1961 challenged "Jim Crow" restaurants and waiting rooms and heightened the anxieties of segregationist whites. In the spring of 1963 the Rev. Dr. Martin Luther KING, Jr., Birmingham minister Fred SHUTTLESWORTH, and the SOUTHERN CHRISTIAN LEADERSHIP CONFERENCE initiated a series of protests against all forms of discrimination in Birmingham.

Daily marches in downtown Birmingham exposed the protesters to the violent tactics of Birmingham Police Commissioner Eugene "Bull" Connor. When thousands of black school children joined the protest, Connor met the challenge with police dogs and firehoses. After King was arrested during the demonstrations, he wrote his "Letter from Birmingham Jail," one of the central statements of his political and spiritual convictions. After several weeks of conflict, business and civil rights leaders arranged a truce, and a settlement that broke down some of the segregation barriers soon followed.

The worst moment of racial turmoil in Birmingham, however, came a few months later, on Sunday morning, September 15, when a bomb exploded in the Sixteenth Street Baptist Church. It killed four young girls—Cynthia Wesley, Addie Mae Collins, Carole Robertson, and Denise McNair.

After the spring demonstrations and the Sixteenth Street bombing, race relations in Birmingham improved. Many new doors were opened, literally and figuratively, to blacks. No achievement was more important than the gaining of the right to vote. Arthur Shores, a local black attorney, was elected to the Birmingham City Council in 1969, and blacks subsequently won other public offices. The election of Richard Arrington, Jr., a black educator and city council member, to the mayor's office in 1979 was the best evidence of black progress in politics.

The years since World War II have brought many changes in the black community not directly related to civil rights. Fewer African Americans work in the steel industry, but more have white-collar occupations. Fewer African Americans live on the Southside, but many more live in the western section of the city in what were all-white neighborhoods. Older neighborhoods like Ensley, Woodlawn, West End, and North Birmingham have gained black population and lost whites at a rapid rate since the mid-1960s.

In 1963 Birmingham was accurately characterized as the "most segregated city" in the United States. By the early 1990s, however, schools, playgrounds, parks, and other public facilities had been desegregated. All of the segregation ordinances have been repealed. Although vestiges of racial segregation remain, communication and cooperation between blacks and whites have greatly improved in an effort to make Birmingham "the Magic City."

REFERENCES

ATKINS, LEAH RAWLS. *The Valley and the Hills: an Illustrated History of Birmingham & Jefferson County.* Woodland Hills, Calif., 1981.

DISMUKES, OTIS, and ROBERT J. NORRELL. *The Other Side: The Story of Birmingham's Black Community.* Birmingham, Ala., 1981.

GASTON, A. G. *Green Power: the Successful Way of A. G. Gaston.* Birmingham, Ala., 1968.

HARRIS, CARL V. *Political Power in Birmingham, 1871–1921.* Knoxville, Tenn., 1977.

MARVIN Y. WHITING
OTIS DISMUKES
ROBERT J. NORRELL

Birth Control. The debate surrounding birth control for African Americans has historically been inextricable from other issues at the forefront of black consciousness, including the sexual exploitation of black women under SLAVERY, the practice of involuntary sterilization, conditions of economic impoverishment, and race pride and sustainability. Since the 1920s, black leaders have publicly debated the issue of birth control in light of these issues and the growing demand by women for control of their own fertility. Marcus GARVEY saw the use of birth control and the accompanying decline in population as a threat of racial extinction, and condemned its use at the 1934 UNIVERSAL NEGRO IMPROVEMENT ASSOCIATION convention. W. E. B. DU BOIS argued in "Birth," published in 1922 in the CRISIS, for access to birth control as a means for African-American women to achieve independence.

The emergence of an organized African-American women's movement for equality during the late nineteenth and early twentieth century gave an organized political foundation for the demand for birth control clinics. Traditional methods had included withdrawal, douching, alum water, the placement of Vaseline and quinine over the uterus; in the 1920s such products as vaginal powders and jellies were

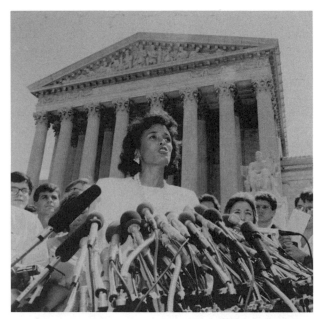

For fourteen years, from 1978 to 1992, Faye Wattleton was president of Planned Parenthood and chief spokeswoman for the contentious and bitterly fought effort to maintain the legal right to abortion. Wattleton here speaks to reporters from the steps of the U.S. Supreme Court building in June 1989. (AP/ Wide World Photos)

also available. The number of illegal abortions expedited a campaign in Harlem for health clinics which would include contraceptive services. The first successful clinic opened in Harlem in 1929, with the backing of the NATIONAL URBAN LEAGUE and the Birth Control Clinical Research Bureau. Shortly after, the Birth Control Federation created a Division of Negro Service. During the next decade over eight hundred clinics for African Americans opened in the United States, many administered by African Americans.

But the issue was not as simple as access, and the debate around birth control has raged on into the late twentieth century. Many African-Americans saw birth control as "unnatural" and were suspicious of its promotion in the black community by whites; indeed, many proponents of eugenics did see birth control as a means of diminishing the black population. In addition, the abuse of sterilization practiced upon communities of color in the United States gave rise to suspicion of racist motivations behind family-planning programs. By definition, the strategy of "Strength in Numbers" was antithetical to birth control. Thus the BLACK PANTHER PARTY in the 1960s and '70s opposed access to both birth control and abortion, and the national BLACK POWER CONFERENCE OF NEWARK in 1967 passed a resolution repudiating birth control as genocidal. The NATION OF

ISLAM under Elijah MUHAMMAD also opposed birth control access, citing the fact that funds were directed to birth control programs in African-American sectors while social and economic inequities were left unchallenged. MALCOLM X was less rigid in his stance, but was critical of "population control" measures.

African-American feminists such as Toni Cade, Linda La Rue, and Frances M. Beal saw no contradiction in the struggle for black empowerment and the right of women to control their own fertility. An important part of these women's advocacy was the exposure of sterilization abuses practiced on the African American community. Many of the more mainstream African-American organizations, such as the Urban League and the NATIONAL ASSOCIATION FOR THE ADVANCEMENT OF COLORED PEOPLE also gave support to Planned Parenthood.

REFERENCES

RODRIQUE, JESSIE. "Birth Control Movement." In Darlene Clark Hine, ed. *Black Women in America: An Historical Encyclopedia.* Brooklyn, N.Y., 1993.
WEISBORD, ROBERT G. *Genocide? Birth Control and the Black American.* Westport, Conn., 1975.

MARIAN AGUIAR

Birth of a Nation, The. Hailed by many film critics and historians as a major aesthetic achievement and a milestone in the history of American cinema, *The Birth of a Nation,* directed by D.W. Griffith, remains as controversial as it was when it premiered in Los Angeles on February 8, 1915. Inspired by *The Leopard's Spots* (1902) and *The Clansman* (1905), bestselling, overtly racist novels by Thomas Dixon, Griffith linked sophisticated cinematic techniques with mass appeal, creating in the process the first Hollywood film spectacular—a film whose appeal cut across lines of class, ethnicity, and region, and which was viewed by millions of people (*see* FILM AND MOVIES).

From the opening shot of the film, which argues that the seeds of national disunion were sown by the Africans brought to America, to its sustained climax—the revenge exacted by the white community for the attempted rapes of two white women by black men—Griffith's three-hour epic offers its own distinct version of American history from the defeat of the South in the Civil War through the Reconstruction era to the triumph of the KU KLUX KLAN and the rebirth of southern society from the supposed chaos of black Reconstruction governments. A shrewd entrepreneur, Griffith arranged a private screening of

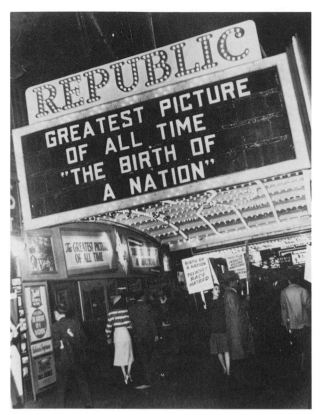

At its initial release in 1915 and in subsequent reissues, D. W. Griffith's notoriously racist film *The Birth of a Nation* provoked widespread protests by African Americans throughout the United States. (Prints and Photographs Division, Library of Congress)

the film for President Woodrow Wilson at the White House. He did the same for the chief justice and other members of the Supreme Court, members of the Senate, the House of Representatives, and the U.S. Diplomatic Corps, and other high officials.

The newly founded NATIONAL ASSOCIATION FOR THE ADVANCEMENT OF COLORED PEOPLE and other organizations, quick to recognize the racially incendiary themes of the film, fought endless battles against the screening of *The Birth of a Nation,* but the voices of protest against the film were drowned out by the accolades it received. It undoubtedly established film as a legitimate art form in the United States at the same time that it helped to shape the images that would govern Hollywood's conception of black life for some years to come.

REFERENCES

FRANKLIN, JOHN HOPE. " 'Birth of a Nation'—Propaganda as History." *Massachusetts Review* 20 (1979): 417–433.

ROGIN, MICHAEL. "The Sword Became a Flashing Vision: D. W. Griffith's *The Birth of a Nation.*" *Representations* 9 (1985): 150–195.

JAMES A. MILLER

Bishop, Hutchens Chew (October 26, 1858–May 17, 1937), minister. A native of Baltimore, Md., Hutchens Chew Bishop was baptized in St. James First African Church, the Episcopalian church in Baltimore which his parents, William Hutchens Bishop and Elizabeth Chew, helped to found. He attended the General Theological Seminary in New York City from 1878 to 1881, and was its first African-American graduate. After the Episcopal Diocese of Maryland refused him ordination because he was black, Bishop established residency in Albany, N.Y., where he was ordained a priest on May 24, 1883. He then returned to Baltimore as assistant priest at the Chapel of St. Mary the Virgin, of which his older brothers and sisters were charter members. A few months later he was named rector of St. Mark's Church in Charleston, S.C. In 1886 he was called to be the fourth rector of St. Philip's Episcopal Church in New York City, where he served for 47 years.

Bishop's first undertaking as St. Philip's rector was to move the church on May 30, 1886, from Mulberry Street to 161 West 25th Street. After years of battling unfair housing practices and discrimination in that area of New York, the church made a historic second move to Harlem in 1911. Between 1906 and 1910, Bishop had sold church property in midtown and bought a row of new apartment buildings in Harlem in his own name. He was able to pass as white and deal with property owners who normally refused to sell to blacks. Bishop turned the property over to the church, which was thus able to provide housing for African Americans. Bishop's business acumen made St. Philip's the richest African-American church at that time, wealthy enough to build a $220,000 church on West 134th Street, and to serve as the cornerstone of the immigration of blacks to Harlem.

In July 1911, Bishop was named the NAACP's "Man of the Month," and in 1913, he was elected to the NAACP's National Board of Directors. In 1917, he served as chairman of the committee which organized the "Silent Protest Parade," a march down Fifth Avenue to the sound of muffled drums, calling attention to the murders of blacks in East St. Louis, Mo. In 1922, Bishop formed the Fair Play League, which inspected police station houses to ensure proper treatment of black prisoners. He retired in 1933, at the age of 74, and was succeeded as rector of St. Philip's by his son, Shelton Hale Bishop. Hutchens Chew Bishop continued his involvement with St. Philip's as Rector Emeritus until his death in 1937.

REFERENCES

BRAGG, GEORGE FREEMAN, JR. *History of the Afro-American Group of the Episcopal Church.* Baltimore, 1922.

Reaching Out: An Epic of the People of St. Philip's Church. New York, 1986.

LYDIA MCNEILL

Black Academy of Arts and Letters. The Black Academy of Arts and Letters was founded in Boston in 1969 in the tradition of the American Negro Academy (1897–1916) to "define, reserve, cultivate, promote, foster and develop the arts and letters of black people." At the founding meeting C. Eric Lincoln, a noted historian of black religion, was elected president; novelist John O. KILLENS, vice president; psychiatrist Alvin POUSSAINT, treasurer; and author Doris Saunders, secretary. The fifty founding members included African Americans from a wide spectrum of the artistic and scholarly world, such as Alvin AILEY, Margaret Walker Alexander, Lerone Bennett, Arna BONTEMPS, Oliver Cromwell COX, Alex HALEY, Vincent Harding, Vivian Henderson, Henry Lewis, Carl ROWAN, and Nina SIMONE.

One goal of the Black Academy of Arts and Letters was to recognize those who have made a notable contribution to black America. The First Annual Awards Banquet in 1970 drew a crowd of over 600 members and friends. With Harry BELAFONTE as master of ceremonies, a hall of fame was established and Carter G. WOODSON, Henry O. TANNER, W. E. B. DU BOIS, Lena HORNE, C. L. R. James, Diana Sands, Imamu Amiri BARAKA, and Paul ROBESON were inducted.

The academy honored George JACKSON with an award for his book, *Soledad Brothers,* after its publication in 1970. In 1972 it sought to bring W. E. B. Du Bois's remains from Ghana for burial in the United States in hopes of bringing greater recognition of his achievements and contributions to the African-American struggle for freedom. The academy also attempted to purchase Langston HUGHES's house in Harlem. After restoration, they hoped to use one wing of the house as their hall of fame. However, the controversy surrounding some political positions of the academy, such as their support of George Jackson, made fund raising extremely difficult. By the early 1970s the academy had ceased functioning.

REFERENCES

Editorial. *Negro History Bulletin* 33 (November 1970): 156–157.
MOSS, ALFRED A., JR. *The American Negro Academy: Voice of the Talented Tenth.* Baton Rouge, La., 1981.

PAM NADASEN

Black Arts Movement. The Black Arts movement (BAM), which could be dated roughly 1965–1976, has often been called the "Second Black Renaissance," suggesting a comparison to the HARLEM RENAISSANCE of the 1920s and '30s. The two are alike in encompassing literature, music, visual arts, and theater. Both movements emphasized racial pride, an appreciation of African heritage, and a commitment to produce works that reflected the culture and experiences of black people. The BAM however, was larger and longer lasting, and its dominant spirit was politically militant and often racially separatist.

To specify the exact dates of cultural movements is difficult and, given the amorphous nature of complex cultural phenomena, may appear arbitrary. In 1965, however, several events occurred that gave direct impetus to the movement: the assassination of MALCOLM X, which prompted many African-Americans to take a more militantly nationalist political stance; the conversion of the literary prodigy LeRoi Jones into Imamu Amiri BARAKA, the movement's leading writer; the formation of the musically revolutionary ASSOCIATION FOR THE ADVANCEMENT OF CREATIVE MUSICIANS (AACM) in Chicago; and the founding of BROADSIDE PRESS, which became a leading publisher of BAM poets, in Detroit. Each of these events galvanized black artists.

While the movement had no specific end point, certain events and works decisively marked shifts in the cultural climate. For example, the decision in 1976 by JOHNSON PUBLISHING to discontinue BLACK WORLD effectively silenced the most important mass-circulation periodical voice of the movement. Furthermore, works published in 1976, such as Ntozake SHANGE's *for colored girls . . . ,* Ishmael REED's *Flight to Canada,* and Alice WALKER's *Meridian,* spoke critically and retrospectively of the movement. The major figures of the movement became less prominent in the late 1970s as new, different African-American voices began to emerge. Thus, while no one can specify when the movement ended, there was a consensus in the late 1970s that the movement was indeed over.

The BAM was fundamentally concerned with the construction of a "black" identity as opposed to a "Negro" identity, which the participants sought to escape. Those involved placed a great emphasis on rhetorical and stylistic gestures that in some sense announced their "blackness." Afro haircuts, daishikis, African pendants and other jewelry, militant attitudes, and a general sternness of demeanor were among the familiar personal gestures by which this blackness was expressed. In many cases these activists dropped their given "slave names" and adopted instead Arab, African, or African-sounding names, which were meant to represent their rejection

The creative outpouring in the 1960s and '70s known as the Black Arts movement involved almost every genre of artist, including painters, poets, novelists, essayists, and critics. This group portrait includes (back row, left to right) unidentified, Ishmael Reed, Jayne Cortez, Leon-Gontran Damas, Romare Bearden, and Larry Neal. (Front row, left to right) Nikki Giovanni and Evelyn Neal, c. 1970. (Photographs and Prints Division, Schomburg Center for Research in Black Culture, The New York Public Library, Astor, Lenox and Tilden Foundations)

of the white man and their embracing of an African identity. Such gestures, as they became popularized, rapidly degenerated into clichés, which have subsequently become easy targets of satire for the movement's many detractors. Depicted in extreme forms, Afrocentric dress, soul handshakes, and other affectations of blackness appear ludicrous. Facile parodies, however, should not blind us to the serious social, cultural, and political yearnings that common gestures of personal style reflected but could not ade-

quately express. Silly fads as well as profound art derived from this impulse to discover and create black modes of self-expression.

The BAM is often but inadequately conceived of as a poetry and theater movement that articulated in literary terms the militant, separatist, social, and political attitudes of the 1960s Black Power movement. While the BAM had direct links to the Black Power movement, both movements derived from complex historical legacies and cannot be understood simply

in the context of the black community or the 1960s. The BAM, in particular, drew inspiration from numerous sources and manifested itself across the spectrum of aesthetic modes, casting its influence far beyond the black community and the tumultuous 1960s. To understand the BAM adequately, we must consider its manifestations in literature, music, dance, visual arts, theater, and other modes. Ultimately, this movement represented an evolving consensus about the nature and sources of art and the relationship of art to its audience.

The movement is often attacked or dismissed by subsequent artists and critics as having been dogmatically polemical. Since the movement generated a great deal of polemical and theoretical writing, this criticism does have a basis in fact. For example, many poems of the movement contain attacks on white people and "Uncle Tom Negroes"; many plays pontificate about the proper relationship between black men and black women (often asserting male primacy and advocating female submissiveness); musical compositions often incorporate rambling monologues of "relevant" poetry or invoke ancient African kingdoms or Malcolm X; and the images of Malcolm X and the American flag recur incessantly in the visual arts of the movement. To recognize that the movement has its clichés, however, is not to suggest that cliché typifies all or even most of its works.

It is also important to acknowledge that the BAM did not encompass every African-American artist who was active during the 1960s and '70s, nor did all of the artists within the BAM agree with each other on every social and aesthetic issue. The consensus that characterized the movement represented a very broad set of attitudes and principles that participants in the movement understood in varying ways and shared to varying degrees. At the same time, sharing these general principles and attitudes did not necessarily entail the acceptance of the agendas or judgments of those who articulated or advocated these principles. Establishing these distinctions allows us to understand that the movement reflects both strong agreement and acrimonious dissent.

The shared agenda of the movement was commonly described as the quest for a black aesthetic. Despite constant efforts, the term "black aesthetic" never acquired a precise definition, and it is better understood as the symbol of a shared aspiration than as a descriptively accurate label for a fully elaborated mode or theory of art. Nevertheless, "black aestheic" does clearly indicate the attempt to create art with African-American cultural specificity. What this might mean is surprisingly difficult to ascertain.

One aspect of it is obviously social. The most concise statement of this social dimension of the black aesthetic appears in "Black Cultural Nationalism," an influential 1968 essay by Ron KARENGA (who later adopted the name Maulana, meaning "teacher"). Citing Leopold Senghor (see also NÉGRITUDE), Karenga asserts that "all African art has at least three characteristics: that is, it is functional, collective, and committing." By this Karenga means that "black art must expose the enemy, praise the people, and support the revolution." Karenga's influence became pervasive in part because his theories were embraced and promulgated by the influential Imamu Amiri Baraka. This view of art, arguably more Marxist-Leninist than African, became the dominant view of the social function of black art: It should expose the enemy and raise black consciousness.

This narrowly pragmatic conception of black art worked against another major concern of the black aesthetic: to connect with black cultural traditions. Ironically, many of the black aestheticians spurned significant aspects of genuine African-American culture, such as the BLUES. Karenga, for example, complained that the blues enabled an acceptance of existing realities, while Don L. Lee (Haki MADHUBUTI) remarked in his poem "Don't Cry, Scream": "All the blues did was / make me cry." In such instances, black aesthetic ideology severed black art from black traditions. Regarding actual African-American culture, the movement was often divided against itself.

The most important legacy of the Black Arts Movement was its quest for new modes of expression based on African-American traditions. The sentiment of black solidarity provided a fundamental premise of the movement. Practically speaking, this sentiment led to the formation of artists' organizations, schools, and publishing ventures located in and directed to the black community. In order for black art to flourish, these activists believed, black artists must control the means of production. Needless to say, such principles had always been operative in black cultural institutions, and some precursors of the black arts, such as the KARAMU PLAYHOUSE in Cleveland, had been active for decades. One of the earliest 1960s black arts groups was the UMBRA WRITERS WORKSHOP, founded in New York's Greenwich Village in 1963 by Tom DENT, Calvin Hernton, and David Henderson. Although political and aesthetic disagreements soon caused Umbra to implode, it provided an important model for subsequent groups, and several of its members were among the most innovative and influential figures of the BAM. These include Ishmael Reed, Roland Snellings (Askia Touré), Henry DUMAS, Norman Pritchard, and Steve Cannon.

Even before Umbra, the National Conference of Artists (NCA) had been founded in 1959. While a few visual artists, among them Joe Overstreet, and even some musicians, such as SUN RA (who was also a poet), had been involved with Umbra, NCA was

strictly a visual artists' organization. Though conceived as a professional organization rather than a workshop, NCA shared with subsequent black arts organizations the broad objectives of "preserving, promoting, and developing the creative forces and expressions of African-American artists." Its activities included annual conferences, a newsletter, a journal, regional meetings, exhibitions, lectures, workshops, placement services, and scholarships. The national scope and professional orientation of this group, however, distinguish it from most BAM institutions. The differences between NCA and AFRICOBRA, reflect, as we shall see, the particularity of the BAM.

Though much of the Black Arts activity occurred on the East Coast, Chicago incubated two of the most influential and enduring of the movement's institutions: the Organization of Black American Culture (OBAC), founded in 1967, and the ASSOCIATION FOR THE ADVANCEMENT OF CREATIVE MUSICIANS (AACM) founded in 1965. Also notable among Chicago institutions are THIRD WORLD PRESS and the Institute for Positive Education, founded in 1967 by OBAC members Haki Madhubuti and Johari Amini. OBAC was originally conceived as an umbrella group, comprising workshops in literature and visual arts, as well as a politically oriented community workshop. In its original declaration of principles, OBAC stated its intention to encourage work based on the black experience and expressing a black aesthetic. Like NCA, it aspired to develop both artists and critics who could create and appraise black art and to develop various mechanisms for disseminating art and fostering discussions within the community.

Even the acronym OBAC was designed to reflect the high ambitions of the group. Pronounced "oh-bah-see," OBAC echoes the Yoruba word *oba,* which denotes royalty and leadership. OBAC aspired to spearhead the incipient black cultural revolution. Its founders included Hoyt Fuller, the editor of *Negro Digest* (renamed *Black World* in 1970) and Gerald Mc-Worter (Abdul Alkalimat), a graduate student at the University of Chicago. The work of OBAC writers such as Johari Amini, Haki Madhubuti, and Carolyn RODGERS often appeared in *Negro Digest/Black World* along with the editorials and commentaries of Hoyt Fuller and quickly gained a national audience for both the art and the polemics of OBAC.

The most dramatic public statement by OBAC was *The Wall of Respect,* a Black Power mural painted on a building at the corner of 43rd Street and Langley Avenue on Chicago's South Side by Jeff Donaldson, Eugene Wade, Bill Walker, and other members of the visual arts workshop in 1967. The wall depicted various historical and contemporary black heroes such as Muhammad ALI, W. E. B. DU BOIS, Malcolm X, Marcus GARVEY, Nina SIMONE, Amiri Baraka, and Gwendolyn BROOKS. This mural galvanized the imaginations of community people, and based on their comments, the artists made various revisions on the mural. The appeal of public art notwithstanding, this privately owned building was eventually razed, and *The Wall of Respect* passed into legend.

Despite its brief existence, the mural sparked a local and national movement. Numerous cities soon produced their own equivalents, such as *The Wall of Dignity* in Detroit, several murals by artists including Dana Chandler and Gary Rickson in Boston, and similar projects in New York, Philadelphia, and San Francisco, among others. Needless to say, the mural movement had roots going back to the 1930s in the WPA public art projects and especially in the powerful work created by the Mexican artist Diego Rivera. The Black Arts movement also echoed the 1930s in that the vogue of murals was seized upon by state and federal arts agencies. While black artists could see such murals as "committed and committing," government agencies saw them as a fine combination of public art and social control mechanisms for urban youths who could be organized into painting teams during the incendiary summers of the 1960s. Artists such as Bill Walker and Dana Chandler organized mural projects in several cities, but the political impact of these projects diminished as their frequency increased, and when government support evaporated in the arid 1970s, the mural movement withered away.

Nevertheless, the movement launched the careers of many artists. Five of the OBAC artists—Jeff Donaldson, Jae Jarrell, Wadsworth Jarrell, Barbara B. Jones, and Gerald Williams—formed their own organization, COBRA (Coalition of Black Revolutionary Artists) in 1968. The next year they became AfriCobra (African Commune of Bad Relevant Artists), adding Napoleon Henderson and Nelson STEVENS to their ranks. By the time of the first AfriCobra show at Harlem's Studio Museum in July 1970, Sherman Beck, Omar Lama, and Carolyn M. Lawrence had joined the group, bringing the number to ten. For many people, AfriCobra came to epitomize the new black art. Their work used vivid, basic colors. It was representational, usually incorporating the faces of black people, and it was explicitly political. In direct rebellion against the elitist norms of establishment art, these artists endeavored to produce work that was immediately comprehensible and appealing to common people. As Jeff Donaldson put it, "This is 'poster art'—images which deal with concepts that offer positive and feasible solutions to our individual, local, national, international, and cosmic problems. The images are designed with the idea of

mass production." This statement captured the spirit of the black aesthetic as many artists understood it.

The music of the Association for the Advancement of Creative Musicians, was arguably even more dazzling, iconoclastic, and influential than the poetry, fiction, and art of OBAC. AACM resembled OBAC in that it was independent and community based. Both groups consisted mostly of younger artists, in college or recently graduated, but both received leadership from older, established figures. Three band leaders, Muhal Richard ABRAMS, Phil Cohran, and Jodie Christian, for example, conceived AACM and called its founding meeting on May 8, 1965. Abrams, a noted pianist and composer, was elected president of AACM and served in that capacity for over a decade. The initial impetus for AACM was more economic than political. By the mid-1960s most of Chicago's important jazz clubs had closed, and jazz was everywhere in decline. These musicians saw a cooperative as the best way for musicians to take control of their own professional destinies.

AACM soon attracted many of the best young musicians in Chicago. The group established an educational program (in 1967) and an AACM orchestra that met (and continues to meet) weekly to perform new compositions by AACM members. Most importantly, AACM provided a setting in which young musicians could meet, perform together, and exchange ideas. AACM members and groups performed frequent concerts around Chicago's South Side during the late 1960s and early '70s. Ensembles formed, dissolved, and reconfigured around AACM, a few of which soon distinguished themselves: the various groups led by Abrams; the Fred Anderson Quintet; the ART ENSEMBLE OF CHICAGO; the Creative Construction Company; and (in the 1970s) Air.

Each of these groups had its own unique character but they had some traits in common. They were profoundly influenced by the "free jazz" innovations of Cecil TAYLOR and Ornette COLEMAN, by the intense instrumental styles of John COLTRANE and Eric DOLPHY, by the musical eclecticism of Charles MINGUS, and by the theatrical staging and grand vision of Sun Ra. Unlike the populist OBAC, AACM produced difficult, challenging, unabashedly avant-garde work. While these musicians could play blues and conventional jazz, their interests lay in extending the frontiers of musical possibility. They experimented with extended and free-form compositions, and with exotic instruments; they even tried to redefine what constitutes music. Some compositions by the Art Ensemble, for example, incorporate bicycle horns, bird whistles, street noises, poetry, sermons, screams, and nonsense conversation.

The Art Ensemble is the group that most epitomizes AACM as an aspect of the Black Arts movement. The group consists of Roscoe Mitchell and Joseph Jarman, reeds; Lester Bowie, trumpet; Malachi Favors, bass; and Famodou Don Moye, percussion. While performing, Jarman, Favors, and Moye wear facial paint and African-style costumes; Bowie wears a white lab coat; and Mitchell dresses in ordinary street clothes (jeans, turtlenecks, etc.). Usually, the Art Ensemble packs the stage with batteries of standard instruments (sopranino to bass saxophones, soprano to bass clarinets, various flutes, and often bassoons); a standard drum kit, plus congas, gongs, and marimbas; and countless "little instruments" (whistles, bells, tambourines, conch shells, maracas, and various noisemakers). Art Ensemble concerts are visual spectacles and unpredictable musical events, reflecting the group's motto: "Great Black Music: Ancient to the Future." Their compositions, such as *People in Sorrow* (1969), exemplify the devotional parodic, evocative, experimental, lyrical eclecticism of the Art Ensemble.

In contrast to the Art Ensemble, which has flourished for three decades, the Creative Construction Company—Anthony BRAXTON, reeds; Leroy JENKINS, violin; Leo Smith, trumpet; Muhal Richard ABRAMS, piano; Richard Davis, bass; and Steve McCall, drums—persisted only for a few years. However, all of these men became major figures in the new music. Their concerts and albums were celebrated for their dazzling ensemble playing, which emphasized collective improvisation rather than solos. Both these bands developed aesthetics based upon the Black Arts precept of committed collectivity.

Chicago also developed notable and enduring black theater groups, such a KUUMBA and Ebony Talent Theater (ETT), but New York was clearly the more important city for theater and dance, and most of the famous Black Arts plays premiered there. However, the proliferation of black theater groups on campuses and in communities throughout the country guaranteed that plays by established authors, local talents, and emerging stars were quickly disseminated. Although Amiri Baraka, due to his broad range of literary and political activities, was the best known of the Black Arts playwrights, he had many talented peers. Ed BULLINS, Ron MILNER, Lonne ELDER, Charles FULLER, Douglass Turner WARD, Adrienne KENNEDY, Melvin VAN PEEBLES, Loften MITCHELL, and Ben Caldwell all wrote provocative work that challenged audiences and incited lively debate.

These authors worked in a variety of styles, and their political and cultural views differed. Nonetheless, they shared a vision of American society in crisis and a conviction that drama should challenge the complacency of audiences by exposing racism, economic exploitation, social conflict, and false con-

sciousness. Some of these plays were satirical, while others were intensely confrontational; some relied on dialogue, while others bristled with shocking language. Furious assaults on whites were at times matched by blistering arguments between father and son, brother and sister. Black Arts theater was the theater of a people becoming aware of and rebelling against their own oppression. However, it was also a theater that sought solutions, new understandings, and transformed social relations. In keeping with the idea of an art derived from and directed to the black community, nearly all of the Black Arts theaters instituted discussion forums immediately following their productions, involving the director, cast, audience, and sometimes the author. Black art was to be educational, not just entertaining.

Black dance also proliferated during this period. The Alvin AILEY group, though founded in 1960, just before the advent of BAM, exemplified the visual and rhythmical ideals of the black aesthetic. Several other major companies were formed during the movement: among others, Dayton Contemporary Dance Company in Ohio (1968); the Dance Theater of Harlem in New York City (1969); the Philadelphia Dance Company, or Phildanco (1970); Garth FAGAN's Bucket Dance in Rochester, N.Y. (1970); the Cleo Parker Robinson Dance Ensemble in Denver (1971); and the Joel Hall Dancers in Chicago (1974). While all of these troupes specialize in African-American dance, most of them have been multiethnic in composition. This conflict between the nationalist impulse to form all-black companies and the pluralist impulse to include qualified people who, regardless of their background, have the talent and disposition to make a contribution reflects a larger tension in the movement. African-American culture is inherently an amalgam, including European elements as well as African. Most black artists have been trained in institutions with European orientations. How, then, can black artists come honestly to terms with the complex nature of their own cultural heritage? Dance embraced the pluralist reality of American culture more forthrightly than the other black arts generally did.

At the same time, black dance immersed itself deeply in the cultures of Africa, the Caribbean, and black America. Unlike the literary artists and theorists of the BAM, whose acquaintance with Africa was too often only through cursory reading and vigorous fantasy, dancers had a highly developed tradition of African dance technique to draw upon. Since the early 1930s, African dancers such as Asadata DAFORA and Shologa Oloba had taught African dance in New York. Nana Yao Opare Dinizulu had begun teaching African dance and culture in Harlem in 1947

and founded a company in the same year. Subsequently, the companies of Charles MOORE and Chuck DAVIS extended this tradition. African percussion masters such as Babatunde Olatunji also traveled to the United States, imparting their vast knowledge of African music and dance. African traditions as developed in Haiti, Jamaica, and Trinidad had been studied, adapted, and taught since the 1930s by influential dancers such as Katherine DUNHAM, Pearl PRIMUS, and Jean-Léon DESTINE. Even costuming and stage design had transcended mere ethnographic imitation and instead, borrowing the vivid colors and basic styles of African tradition, had evolved—preeminently in the work of Geoffrey HOLDER—into dazzlingly imaginative modes of expression. Thus, when large numbers of dancers began traveling to study in Africa during the late 1960s and '70s, their challenge was not to introduce new forms to American dance but rather to refine and extend a firmly established tradition.

To explain companies like Bucket Dance and the Dance Theater of Harlem as products of BAM would be simplistic and inaccurate. Clearly, however, the desire to create black cultural institutions and the desire to engage artists and audiences in a rediscovery of African and African-American expressive modes links the efforts of choreographers such as Garth Fagan and Arthur MITCHELL to the broader BAM. These dancers also shared the educational commitments of the movement. In addition to training young dancers for their own companies in the traditional manner of independent dance ensembles, choreographers like Fagan, Mitchell, and Davis have always maintained vigorous public outreach programs, including workshops for children. Furthermore, since dance often captured the aesthetics of the movement without its polemics, many of the works created by Ailey, Mitchell, Fagan, Talley BEATTY, Eleo POMARE, and other choreographers of that period have remained fresh and compelling, while by contrast, many popular literary works of the era now seem shrill and dated. The greatest artists of BAM may not be its acknowledged spokespersons.

Similarly, many artists who came of age during the movement have continued to develop, leaving behind many of the themes, modes, and attitudes of their own earlier work. In the visual arts, for example, many artists relied on chains and distorted images of American flags to make overtly political points. The sculptor Melvin EDWARDS, for example, created a series of works in the late 1960s called *Lynch Fragments*. One installation of it appeared at the Whitney in 1970, consisting of strands of barbed wire strung from the ceiling and attached to loops of heavy chain. Such work is pointed but aesthetically limited.

By contrast, Edwards's work of subsequent years is large-scale, welded-steel sculptures, often in abstract forms but sometimes incorporating chain or chain-like figures as well. The growth in imaginative complexity and aesthetic appeal is immediately obvious.

Faith RINGGOLD, a painter with strong political commitments, was actually convicted in 1970, along with two other artists, for desecrating the American flag. Her flag paintings such as "The Flag Is Bleeding" (1967) and "Flag for the Moon: Die Nigger" (1969) are effective polemics about American violence and racism. Nonetheless, outside the angry context of the late 1960s, these works appear strident and facile. Her later works that utilize folk-art forms (as she had begun to do even in the 1960s), textiles, quilting, and various other media embody artistic maturity, not just effective visual rhetoric. David HAMMONS made heavy use of both flags and chains in his works of the late 1960s. Indeed, his body prints such as "Pray for America" (1969) and "Injustice Case" (1970), the latter regarding the Chicago Seven case, are among the most memorable American art images of that era. Like Edwards and Ringgold, however, Hammons discovered profounder aesthetic possibilities and resources when he moved away from the obvious symbolism and unambiguous political sentiments of BAM. Hammon's work of the 1980s and '90s, from his spade sculptures to his basketball installations, is playful, ironic, and much more deeply grounded in African-American culture. Like many other artists of their generation, Edwards, Ringgold, and Hammons were BAM artists, but their artistic growth did not terminate at the boundaries of the movement.

Some critics of the BAM have focused exclusively on a few extremist works, artists, or tendencies of the movement, thereby defining the movement only in terms of its most egregious features. While the extremes of the movement are shocking indeed, its fecundity and diversity have not been sufficiently recognized. Much has been written, for example, about the political assertiveness of BAM works. The humor of the movement, in all of its genres, has not generally been acknowledged. Much of Baraka's work is bitingly satirical. Douglass Turner WARD's *Day of Absence,* a coon show performed in whiteface, is slapstick comedy in the ministrel tradition (*see* MINSTRELS/MINSTRELSY). Cecil BROWN, Sam Greenlee, and Ishmael Reed are all comic novelists. David Hammons, the Art Ensemble, and Garth Fagan have made humor a major element of their works. Haki Madhubuti and Nikki GIOVANNI, even at their most earnest, are playful and witty poets.

Despite the stern dogmatism of some Black Arts theory, the movement always encompassed diverse voices and perspectives. Some critics have dismissed the BAM as a sexist outpouring, dominated by misogynistic men. Actually, many of the iconic BAM figures were women, such as Sonia SANCHEZ, Nikki Giovanni, Carolyn Rodgers, Audre LORDE, Toni Cade BAMBARA, Faith Ringgold, June JORDAN, and Adrienne Kennedy. These and other women within the movement vigorously debated gender issues among themselves and with their male counterparts, in their works, in public forums, and in organizational meetings. The common claim that women's voices were suppressed by the BAM is belied by a reading of the anthologies, periodicals, museum show catalogs, playbills, and other documents of the period.

In fact, one might argue that the most direct literary legacy of the BAM was the explosion of black women's writing in the late 1970s and '80s. For instance, while Ntozake Shange's play *for colored girls who have considered suicide/when the rainbow is enuf* (1976) anticipates in its themes and attitudes the feminism and womanism of the 1980s and '90s, its aesthetic roots—especially its use of vernacular language, color, music, and dance—are clearly in the BAM tradition. Toni Cade BAMBARA's intricate masterpiece *The Salt Eaters* (1980) is certainly the most sophisticated and probing book yet written on how this black nationalist political and aesthetic movement shaped the lives of its participants. Finally, womanist critics of the BAM have rejected many aspects of the movement, including some of its fundamental social values. Nevertheless, their conception of art, especially literature, as a tool of consciousness raising and community building is a direct echo of Black Arts theory.

BAM even had within it a vigorous multiculturalist tendency, which was most forcefully represented by Ishmael Reed and his San Francisco Bay Area cohorts, such as Al YOUNG. In his poems, essays, and novels, Reed advocated a vision of multicultural pluralism, social freedom, and political tolerance. Spurning the dogmatic nationalism of many BAM adherents, Reed declared himself a multicultural artist more than a decade before the idea of multiculturalism became fashionable. Through his editing of periodicals such as *Yardbird Reader, Y'bird,* and *Quilt,* which published writers of numerous ethnic backgrounds and his leadership in multicultural collectives such as the Before Columbus Foundation, Reed acted decisively to implement his pluralist commitments. Furthermore, Reed has written devastating satires on and criticisms of Black Arts dogmas and excesses. Yet as an alumnus of the Umbra Workshop, Reed is himself a foundational figure of the movement. Clearly, the BAM was large enough, in

the best Whitmanesque tradition, to contain contradictions and multitudes.

REFERENCES

BARAKA, AMIRI. *The Autobiography of LeRoi Jones*. New York, 1984.

BROOKS, GWENDOLYN, ed. *A Broadside Treasury: 1965–1970*. Detroit, 1971.

DONALDSON, JEFF. "Ten in Search of a Nation." *Black World* 19, no. 12 (October 1970); 80–89.

FABRE, GENEVIÉVE. *Drumbeats, Masks, and Metaphor: Contemporary Afro-American Theatre*. Cambridge, Mass., 1983.

FINE, ELSA HONIG. *The Afro-American Artist: A Search for Identity*. New York, 1982.

FOWLER, CAROLYN. *Black Arts and Black Aesthetics: A Bibliography*. Published by author, 1981.

GAYLE, ADDISON, ed. *The Black Aesthetic*. Garden City, N.Y., 1971.

JONES, LEROI, and LARRY NEAL, eds. *Black Fire: An Anthology of Afro-American Writing*. New York, 1968.

LEWIS, SAMELLA. *African American Art and Artists*. Berkeley, Calif., 1990.

LONG, RICHARD. *The Black Tradition in American Dance*. New York, 1989.

PARKS, CAROLE, ed. *Nommo: A Literary Legacy of Black Chicago (1967–1987)*. Chicago, 1987.

REDMOND, EUGENE B. *Drumvoices: The Mission of Afro-American Poetry*. Garden City, N.Y., 1976.

SMITH, DAVID LIONEL. "The Black Arts Movement and Its Critics." *American Literary History* 3, no. 1 (Spring 1991): 93–110.

DAVID LIONEL SMITH

Blackburn, Robert Hamilton

Blackburn, Robert Hamilton (December 10, 1920–), lithographer and teacher. Robert Blackburn was born to Jamaican parents in Summit, N.J., in 1920 and moved to Harlem in 1926. He took art classes at P.S. 139 in Harlem under the instruction of WORKS PROJECT ADMINISTRATION (WPA)–sponsored teachers Rex GORLEIGH and Zell Ingram. In 1935 Blackburn studied at the Harlem Community Arts Center and joined the Uptown Community Workshop. In 1941 he received a scholarship at the Art Students League and apprenticed in the studio of printmaker Will Barnet (1941–1943).

In 1948 Blackburn opened his own studio, the Printing Workshop, on 17th Street in New York City, offering evening classes and space for artists to operate printing presses. He created a collaborative relationship between the artist and lithographer so that printing became part of the artistic process. He remained involved with the workshop for over forty years, teaching printmaking and creating his own prints. Artists who used the facility included Romas

Viesulas, Clare Romano, Sue Fuller, and Chaim Koppelman.

While teaching at the workshop, Blackburn was also an instructor at the National Academy of Design (1949), the New School for Social Research (1950–1951), Cooper Union (1965–1971), the School of Visual Arts (1967–1971), and at the Painting and Sculpture Division of Columbia University's School of the Arts (1970–1991). He exhibited at community galleries and in larger venues, including the Brooklyn Museum, the Boston Museum of Fine Arts, and the Columbia Museum of Art in South Carolina.

In 1957 Blackburn became the master printer for Tatyana Grosman's Universal Limited Art Editions, a printing house that operated from Grosman's living room in West Islip, Long Island (N.Y.). While at Universal, Blackburn was the lithographer of choice for many artists of the New York School, including Jasper Johns and Robert Rauschenberg. He also printed works by many black artists, including Romare BEARDEN and Hale WOODRUFF.

In 1971, the Printing Workshop was incorporated as a nonprofit organization and began programs to teach lithography in economically disadvantaged communities. Some of his own prints include *Girl in Red* (1951), *Strange Objects* (1959), and *What Is Apartheid* (1984).

REFERENCES

Art in Print: A Tribute to Robert Blackburn. New York, 1984.

JEMISON, NOAH. *Bob Blackburn's Printmaking Workshop*. New York, 1992.

———. *Robert Blackburn: A Life's Work*. New York, 1988.

RENEE NEWMAN

Black Business Community

Black Business Community. Traditionally, typical firms in the black business community have included the barbershop, the beauty parlor, or the mom-and-pop food store. Such small retailing and personal-service lines of business were concentrated in African-American residential areas and served a neighborhood clientele. This type of traditional black enterprise has been in a state of continuous decline since the 1960s.

The growing lines of black business are dominated today by larger-scale firms that are likely to serve a racially diverse clientele; increasingly these enterprises sell to other businesses, including large corporations, and to units of government. They are commonly run by black entrepreneurs who have attended college. Particularly rapid growth areas in-

clude skill-intensive service industries: finance, business services, and various professional services. Such growth industries are commonly called "emerging" lines of black enterprise. They are emerging in the sense that the presence of African-American owners in these industries has historically been minimal. Furthermore, the mode of operation—the frequent use of paid employees and the emphasis on a nonminority clientele—tends to differentiate firms in the emerging industries from those in the traditional black business community. Opportunities created by government minority business set-asides and corporate procurement programs have contributed to the growth of these emerging lines of black-owned business.

The evolution away from traditional industries and into emerging fields in recent decades has been possible because of a growing interest in self-employment among highly educated African Americans. Prior to the 1960s, black college graduates largely avoided the world of business. This historical pattern was substantially altered in the 1970s and 1980s: a younger, better-educated, higher-income group entered into small business ownership. The larger size of firms commonly created by these entrepreneurs reflected, in part, owner financial investments far larger than the tiny amounts that had funded the creation of traditional black businesses.

Since the 1960s, the black business community has clearly started to diversify and expand, in response to the influx of entrepreneurial talent and financial capital. Aggregate figures on black-owned business understate this progress because they fail to identify two divergent trends: absolute decline in many traditional lines of business and real progress in emerging fields. Why the decline in the traditional strongholds? The large traditional sector of the black business community developed under pervasive racial segregation. Partial desegregation in housing, the workplace, commercial establishments, and public accommodations contributed to the decline of these firms; desegregation widened the range of retail and service markets accessible to black consumers. Desegregation did not, however, lead to significant white patronization of black-owned businesses. Many of the traditional black firms—long denied access to the mainstream economy by discriminatory barriers—were ill equipped to exploit the new opportunities desegregation offered.

The dual trends of growth and decline that typify the current community of black-owned businesses are rooted in the fundamentally different attributes of the traditional and emerging enterprise groups. Beyond catering to a minority clientele, the traditional firms tend to: (a) be small scale, (b) have high failure rates, and (c) generate few jobs, because owners often have low education and skill levels and invest little financial capital into their business ventures. Emerging firms, in contrast, are most commonly started by better-educated owners (many have attended four or more years of college) and financial investments are high relative to those in traditional lines of business. Emerging firms, therefore, tend to: (a) be larger scale, (b) have lower failure rates, and (c) generate more jobs relative to their traditional cohorts.

The trajectory of the black business community is causing a narrowing of the gap in self-employment earnings reported by blacks and whites (Bates 1987). Nonetheless, parity with nonminority businesses is not close at hand. The emerging as well as the traditional sector of the black business community lags behind nonminority small business; firms tend to be smaller, less profitable, and more prone to failure than those operated by nonminorities. The difficulties experienced by self-employed blacks in breaking into larger emerging lines of business are a reflection of constraints that are deeply rooted in U.S. society.

A long-term perspective is vital for understanding the dual trends of decline and growth that typify traditional and emerging sectors of black business. The black business community has historically been shaped by limited access to credit, limitations on educational and training opportunities, and white stereotypes about the roles of minorities in society. In his landmark 1944 work *An American Dilemma,* economist Gunnar Myrdal observed:

> The Negro businessman encounters greater difficulties than whites in securing credit. This is partially due to the marginal position of Negro business. It is also partly due to prejudicial opinions among whites concerning business ability and personal reliability of Negroes. In either case a vicious circle is in operation keeping Negro business down.

The role played by discrimination in shaping black business has been all-encompassing. Labor-market discrimination made it difficult for blacks to accumulate the initial equity investment that business creation requires. Lack of black-owned construction companies in unionized urban areas, for example, was partially caused by the traditional practice of barring blacks from apprentice programs in the building trades. Limited educational opportunities have historically handicapped black entrepreneurs. Even those who attended college were traditionally restricted by social attitudes about occupations that were appropriate for blacks: 73 percent of the black college graduates between 1912 and 1938 became either preachers or teachers (Holsey 1938). Medicine, dentistry, and law were open to a fortunate few, but black college graduates were exceedingly rare in fields

such as engineering, accounting, and general business. These and other constraints produced a community consisting largely of very small firms concentrated in a few lines of business—beauty parlors, barbershops, restaurants, cleaning-and-pressing services, shoeshine operations, or mom-and-pop food stores.

Evolution of Black Enterprise: Historical Perspective

Black business development has certainly been shaped by the limitations on financial capital access and on educational and training opportunities. More fundamentally, however, it was shaped by a specific time period, the nineteenth century, and a specific region, the South. The case of the skilled black artisan illustrates how profoundly discrimination undermined and distorted the emergence of black entrepreneurship. Blacks at one time dominated many skilled trades in the South. Rather than depending on white labor, slavemasters typically relied on their own slaves trained in carpentry, blacksmithing, and other skilled trades. Slave mechanics were often allowed to hire out on their own in return for a fixed sum of money or a percentage of the slave's earnings. In response, skilled white workers appealed to government, demanding that blacks be legally restricted to menial jobs. These efforts were largely unsuccessful, however, because planter-dominated legislatures saw limitations on slave labor use as a threat to the value of their property. At the end of the Civil War, an estimated 100,000 out of a total of 120,000 artisans in southern states were black (Kelsey 1903).

Emancipation and postwar Reconstruction undermined the black artisan class. No longer protected by the slave owners, black artisans now had to compete in a free, unprotected market while whites were often protected by craft unions and Jim Crow institutions. South Carolina, for example, required after 1865 that blacks purchase licenses, costing ten dollars annually, before working as artisans, mechanics, or shopkeepers; whites were not required to pay these license fees (Ransom and Sutch 1977). Craft unionism with its apprenticeship system was particularly effective in diminishing the ranks of black artisans. Craft-union exclusion of blacks was typically more effective in the heavily unionized northern cities than in the South (Bates and Fusfeld 1984).

As late as the 1970s, the most common lines of black enterprise mirrored the black business community before the Civil War. In the antebellum South, free blacks were prominent in several lines of business that utilized the skills and aptitudes they had acquired as slaves. Their social positions were actually conducive to business success in some areas of self-employment; since white entrepreneurs avoided businesses having a servile connotation, blacks had virtually no competition in these fields. Personal-service occupations were freely open to those who could obtain enough capital. In many southern communities blacks had a near-monopoly on cooking, beauty parlor and barbershop operation, cleaning-and-pressing, and shoeshining (Bates 1973).

In no trade was the reputation of blacks more secure than in the field of cooking. In Philadelphia, for example, blacks dominated the catering field for decades. Entering business in 1818, black caterer Peter Augustin developed a reputation for courtesy and efficiency that spread throughout the eastern United States (Du Bois 1967). Augustin and his successors had the loyal patronage of Philadelphia high society for most of the nineteenth century.

While low social status was in this sense an asset to most black entrepreneurs, it was a distinct handicap to the few who ventured into merchandising. Commercial enterprises requiring considerable investments of financial capital were naturally the least common kinds of businesses run by free blacks. By the mid–nineteenth century, most southern states had passed laws forbidding blacks from running firms in fields that required a knowledge of reading and writing. In the North, blacks were denied the right to sue, and black merchants were generally unable to obtain trade credit. Black entrepreneurship endured in those fields that white society felt were consistent with the subservient status of the freed slave.

Varying regional diversity in the activities of black entrepreneurs indicated responses to a complex array of social attitudes and institutional racial constraints. In Louisiana—where a pattern of race relations reflecting Latin American influences persisted well beyond 1803 (see CREOLES)—freed blacks participated in a wide array of business activities. "The Haitian migration of skilled and educated Creoles in the mid-1790s and again in the early 1800s, before the American purchase, assured the entrenchment of free men of color in both skilled and white collar occupations" (Walker 1986). White family connections sometimes contributed to the success of black-owned businesses in Louisiana. In her study of twenty-one wealthy (net worth exceeding $100,000) antebellum black entrepreneurs, Juliet Walker (1986) notes that "only four accumulated their wealth outside the state of Louisiana." The large and successful New Orleans black business community prospered as long as social attitudes were appropriately tolerant. But an increasingly hostile racial climate in the 1850s led to a decline in black business participation in New Orleans.

EMANCIPATION failed to increase significantly the number of black-owned businesses. The postwar South sank into a severe depression, and black entrepreneurs found modest success only in their tradi-

tional fields. Virtually all blacks lived in rural areas, most as tenant farmers or manual laborers, and relied for supplies on their landlord or the company store. If landlords did not run their own commissaries, they would make arrangements with local white merchants to supply the tenant farmers' need. This system effectively isolated black merchants from the bulk of their potential market. The strongholds of black business before the Civil War were the strongholds of black business in the late nineteenth century.

Coupled with their failure to establish themselves in new lines of business, African-American entrepreneurs were actually being undercut in their traditional fields. Founded to serve whites, the early black businesses gradually lost white patronage after Emancipation. "The Negro caterer has slowly been losing ground, probably through loss of personal contact with the fashionable group whose first thought used to be for the Negro when 'service' of any kind was to be done" (Fleming and Sheldon 1938). Having acquired decades of business experience in personal services and food preparation, black enterprises often remained viable only by increasing their black patronage when white patronage declined. Finally, many late-nineteenth-century immigrants were competing with blacks in personal-service enterprises, and white entrepreneurs were quick to exploit business opportunities in embryonic urban black communities. While whites could open businesses in black residential areas, black merchants were usually kept out of white neighborhoods.

Black entrepreneurship showed its first weak signs of post–Civil War progress in the 1880s. The disfranchisement of the southern freedman and the general elimination of blacks from politics after RECONSTRUCTION left the small black leadership class out of work. Leadership sought an outlet, and those who had looked toward government for assistance now sought other strategies for advancement. A small number of widely scattered black-owned enterprises of consequence became successful in such nontraditional industries as manufacturing. By the 1890s, black-owned firms were manufacturing such diverse products as pickles, mattresses, razor straps, and shoe polish.

The development of black-owned INSURANCE COMPANIES represents the greatest business success story of this era. Particularly after the publication of Frederick Hoffman's *Race Traits and Tendencies of the American Negro,* which argued that blacks were poor insurance risks, major life-insurance companies often refused to cover blacks. The black-owned insurance companies were offsprings, typically, of fraternal societies that offered insurance benefits to their members. Available resources were sufficiently meager that many of these early insurers would levy special assessments on all members each time a death claim occurred. From these humble beginnings, a number of black life-insurance companies have grown into multimillion-dollar enterprises.

Founded in 1898, North Carolina Mutual of Durham, N.C., typified the emerging black-owned life-insurance company. The fraternal societies that provided insurance benefits frequently lacked cash reserves, rarely used actuarial methods to set premiums and predict cash flow, and often priced benefits at unrealistically low levels in order to attract new members. At best, insurance benefits offered by these societies were problematic; at worst, the schemes were operated by confidence men (Light 1972). Critics among the black middle class called for true insurance companies, run in a businesslike fashion. The call was reinforced by the writings and speeches of Booker T. WASHINGTON, who advocated the uplifting of the African American through expanded involvement in business enterprises.

The growing intensity of JIM CROW was an important factor in shaping the environment that spawned North Carolina Mutual. In North Carolina, 1898 was perhaps a low point in race relations, with a white supremacist election campaign as well as a race riot. In this milieu, the logic of black solidarity was widely appealing, and economic self-sufficiency was an important part of that strategy. North Carolina Mutual's motto—"A Company with a Soul and a Service"—reflected its message that investment in Mutual was not merely an individual economic decision, but a moral act of solidarity. In fact, the company did become a catalyst for black economic development. It created the Mechanics and Farmers Bank of Durham in 1907; it invested in black-owned businesses and real estate; it played a major role in founding the nation's first black chamber of commerce, the Durham Business and Professional Chain, in 1938.

By the end of the nineteenth century, black leaders led by Booker T. Washington increasingly stressed business ownership as a strategy for improving the condition of the black masses. Aside from a few conspicuous examples of large-scale success, however, enterprise development was constrained by the small supply of entrepreneurial expertise in the black community. Educated blacks had little training in business; they crowded into the teaching and preaching professions.

The NATIONAL NEGRO BUSINESS LEAGUE (NNBL), organized in 1900 by Booker T. Washington, sought to publicize the accomplishments of black entrepreneurs. The NNBL's strategy of economic development through black business ownership appealed to leaders of big business; white industrial benefactors provided financial support for the orga-

(Top) The Coleman Manufacturing Company in Concord, N.C., in 1900, the only black-owned cotton mill in the United States. (Bottom) Board of Directors of the Coleman Manufacturing Co. (Prints and Photographs Division, Library of Congress)

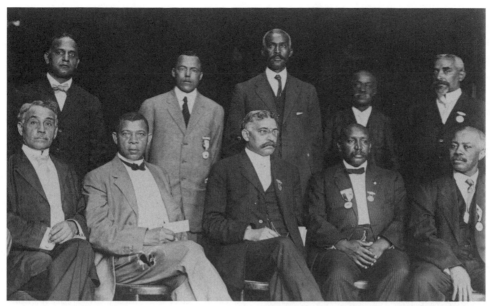

National Negro Business League executive committee. Booker T. Washington is seated second from left. (Prints and Photographs Division, Library of Congress)

nization. Washington's popularity and dynamic leadership, however, did not suffice to increase noticeably the financial capital and credit available to black entrepreneurs. Washington estimated that in 1900, there were 9,838 blacks who owned businesses requiring capital (1907, p. 16).

Development in the Twentieth Century

The aftermath of World War I saw the development of a fundamentally new, dynamic, rapidly growing African-American business community. Abundant wartime industrial jobs swelled urban black populations. The wave of 1919 race riots in Chicago, Washington, and many other cities (see URBAN RIOTS AND REBELLIONS) aroused urban blacks to a high state of racial consciousness. Coming together for mutual help and protection, they quickly grasped the notion of building and supporting their own enterprises. The long-binding financial constraint was eased for many black entrepreneurs by savings accumulated during the prosperous war years. A "buy black" sentiment prevailed, and many businesses were financed by churches and fraternal lodges, whose members would become loyal patrons of the newly formed firms. Church support for individual black firms was so decisive in some areas that the religious denomination of the entrepreneur would determine the clientele patronizing the business.

A conspicuous example of increasing racial consciousness was the widespread development of black community NEWSPAPERS. In turn, a black-owned printing industry arose as a complement to the rapidly growing publications. Capitalizing on racial sen-

timent and on financing from high wartime incomes, black businesses formed in every line of commerce and industry.

Particularly in the northern industrial cities, the events of WORLD WAR I permanently altered the pace and character of life for blacks. The economic expansion resulting from industries gearing up to supply the war effort created an enormous demand for labor. The traditional source of manual labor for manufacturing—European immigrants—was closed off by the war precisely at the time when manufacturers were most in need of blue-collar workers. Deprived of its abundant foreign-labor supply, industry was forced to seek workers from the domestic agricultural hinterlands. Northern mills, foundries, and assembly plants sent recruiting agents to the South, urging blacks and whites alike to come to the great industrial cities. Chicago, for example, experienced a 148 percent increase in black population between 1910 and 1920 (from 44,103 to 109,458), along with a 21 percent increase in white population. Most of this rural-to-urban migration took place between 1916 and 1919. Because large-scale immigration from Europe did not resume after World War I, black workers continued to be a critical component of the industrial labor force during the rapid growth years of the 1920s. The black population increased particularly in the largest northern cities—during the 1920s it rose 115 percent in New York, 194 percent in Detroit, and 114 percent in Chicago (U.S. Bureau of the Census 1935).

The increased population was accompanied by a concentration of blacks in constricted sections of

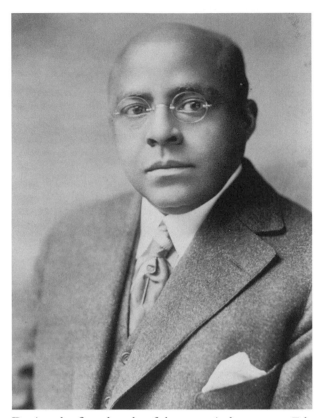

During the first decade of the twentieth century, Edward Payton Phillips was instrumental as a real estate broker in opening up Harlem to African-American residents. (Photographs and Prints Division, Schomburg Center for Research in Black Culture, The New York Public Library, Astor, Lenox and Tilden Foundations)

northern cities. Perhaps like the European migrants before them, blacks from the agrarian deep South initially preferred residential segregation in order to ease the transition from subsistence agriculture to an urban way of life. The clusters of racially mixed neighborhoods where black community life had been concentrated before World War I rapidly lost their white populations. Housing construction had nearly halted during the war years, and afterward the demand remained unfulfilled; existing black sections filled up and rents for all kinds of accommodations skyrocketed. As blacks sought housing in adjoining neighborhoods, whites increasingly spoke of the black "invasion" of their communities. Black-white competition for housing created antagonisms that paralleled those emerging in the labor market right after the war. The return of soldiers seeking jobs in 1919 coincided with the fading of war-induced prosperity; blacks and whites viewed each other as competitors for scarce jobs as well as scarce housing. In this tense milieu, 1919 produced at least twenty-six race riots in U.S. cities. Some of these took place in

the South, but the largest outbreaks of violence occurred in northern cities. In Chicago, periodic bombings and attacks on blacks venturing into white communities were merely a prelude to the great 1919 race riot. Five days of violence caused mainly by white gangs took at least 38 lives, caused over 500 injuries, destroyed much property, and left over 1,000 people homeless.

Once the color line had been drawn around black neighborhoods, the ghetto had been defined and the fight for additional housing was waged block by block. As growing spatial separation reduced contacts between the races, black institutions expanded and flourished. Partly by choice and partly as a means to avoid white rejection and possible conflict, blacks increasingly patronized their own churches, stores, and places of amusement. The decline of normal and spontaneous black-white interactions tended to lessen racial tolerance and mutual understanding, reinforcing the acceptance of ghetto existence in people's minds.

Aspiring African-American leaders in the urban North sought to channel heightened black consciousness in various directions. All could agree with A. Philip RANDOLPH when he warned African-Americans not to "depend on white men and white women to work out the problem. We have too long relied on whites. . . . You have got to get it yourself" (Stein 1986, p. 47). While black socialists such as Randolph judged unions to be the most effective vehicle for attaining racial power, Marcus GARVEY and others stressing a "race first" ideology attempted to tie black community militancy to the development of black business. Garvey's Black Star Line, a proposed transatlantic steamship enterprise, typified the goal of racial independence in business operations.

In the turmoil of 1919, many black professionals, intellectuals, and small businessmen supported the Black Star Line as a strategy to anchor the new racial consciousness in a large-scale business venture. Such enterprises would, according to Garvey, "make it possible for the youth of the race to find suitable employment . . . and remove the need for our high school and college graduates seeking jobs among the whites." In explaining his ambition to create a great enterprise that would produce both commercial opportunity and self-respect for African Americans, Garvey stated, "We had no monetary considerations or reward before us but the good we could do for our race" (Stein 1986, pp. 85, 200). But large-scale businesses, financed and operated by African Americans or any other group, require considerable financial capital and expertise. Garvey's unsuccessful line possessed neither: neither he nor any members of his board of directors had practical experience in the shipping business.

The Black Star Line notwithstanding, the growth of the black business community in the 1920s was most rapid. Black professionals, often moving north along with their clients, saw their practices and incomes rise as segregation increased. After 1920, black businessmen were commonplace in urban black communities. Previously concentrated in a few fields—as barbers, restaurant owners, undertakers—blacks were now participating in many lines of business within black residential areas. By 1930, an estimated 70,000 black-owned businesses were operating in the United States, a 700 percent increase over 1900 (Pierce 1947). Black entrepreneurs had penetrated retailing widely, but successes in manufacturing and wholesaling were still not widespread. In finance, progress was particularly apparent in the life-insurance industry: thirty-two firms employed 6,000 agents and controlled assets of over $18 million in 1928 (Harmon, Lindsay, and Woodson 1929). The 1920s were golden years for urban black business.

That community was vibrant in many southern as well as northern cities. The Hayti district of Durham, N.C., had by the 1920s become home of a substantial and widely diversified black business community. Commercial activities were concentrated on two main streets, ensuring a high level of pedestrian traffic for retailers. Black-owned banks encouraged development by providing business and real-estate loans. In addition to the many types of black-owned retail operations, the district included hotels, restaurants, personal services, repairs, finance, insurance, real estate, professional services, a library, and trade schools—all black-owned and -operated.

The GREAT DEPRESSION destroyed much of the ground gained during the previous decade. Black retailers benefited heavily from the "buy black" campaigns of the 1920s, and they were hit hardest by the depression. White ghetto merchants had always enjoyed greater access to financial capital and trade credit, and this advantage often proved decisive in the trough of the Great Depression. The viability of the black retailer had often been predicated on the loyalty of the black consumer; during hard times, this loyalty weakened. Black merchants, failing in

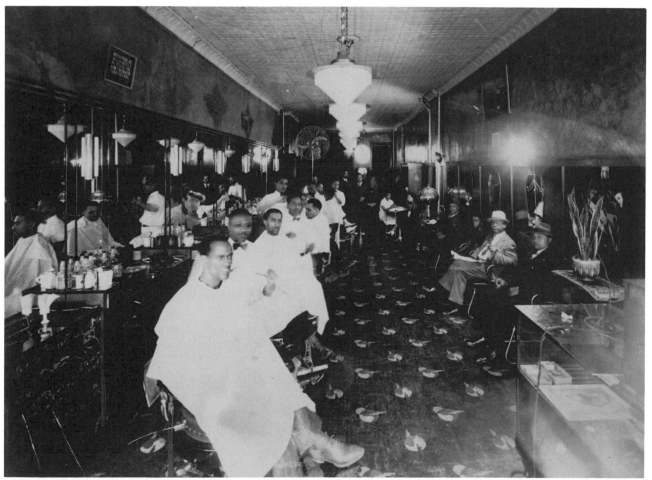

Harlem barbershop, c. 1929. (Photographs and Prints Division, Schomburg Center for Research in Black Culture, The New York Public Library, Astor, Lenox and Tilden Foundations)

droves, cried that they were being abandoned by their race. Black consumers responded that they were being exploited by the self-serving racial appeals of the black merchant. Economist Abram Harris wrote that "what the Negro businessman wants is to monopolize and exploit the market the black population provides" (1936, p. 184).

The Great Depression did create one noteworthy black entrepreneurial success story. In urban black communities, policy syndicates organized and controlled daily lotteries in which participants bet on certain numbers. These syndicates had great influence over economic life in the ghettos of the 1930s, and some of the largest black enterprises in the United States today were financed initially by the profits of policy. In the late 1930s, it was estimated, nearly one-quarter of the biggest black businesses in Chicago were either owned or controlled by the policy syndicate (Drake and Cayton 1962).

Harlem, in the depth of the Great Depression, saw small-business success materialize from a tightly knit religious cult, FATHER DIVINE's Peace Mission Movement. The Peace Mission Movement Cooperatives were started to provide employment for Father Divine's growing membership. Groups of the faithful pooled their capital and their labor to set up businesses and purchase real estate. Recruits to the movement had to abandon their worldly names, promise celibacy and chastity, turn over all of their earnings, and subscribe to the proposition that "Father Divine is God." Father Divine's followers in Harlem operated 25 restaurants, 10 barbershops, 10 dry-cleaning establishments, a coal company, and numerous other firms. His restaurants sold thousands of wholesome ten-cent meals to the unemployed (Light 1972). In addition, the restaurants provided 2,500 free meals a day in Harlem alone. Followers established similar operations in Newark, Bridgeport, Baltimore, and other cities. Father Divine's small-business empire, which he called "God, Incorporated," continued to expand after the end of the Great Depression. It dissolved only after his death in 1965.

In 1944, under the sponsorship of Atlanta University, the first large-scale quantitative study of the black business community was undertaken. Joseph Pierce's survey of 3,866 black firms in twelve cities revealed a clear picture of the state of urban black enterprise. Six lines of personal services and retailing dominated the sample: beauty parlors and barbershops, 1,005; eating places, 741; food stores, 293; cleaning and pressing establishments, 288; shoeshine and repair operations, 183; funeral parlors, 126 (1947, pp. 33–35). Except for funeral parlors and grocery stores, this list could be a survey of the enterprises that dominated the black business community in the antebellum South.

For a subsample of firms operating in nine cities, Pierce collected additional information describing financial capitalization, the age of firms, and the operational problems of business ownership as expressed by the owners themselves. The median value for initial capitalization was an incredibly low $549. This paucity of financial capital was heavily responsible for the very small size that typified the businesses described by Pierce. The median initial capitalization for all sampled retail firms was $544, and the median age was 5.3 years. For firms operating in service industries the median age was 7.1 years, and for the six most common lines of black enterprise, funeral parlors were oldest (22.6 years), while shoeshine and repair shops were youngest (3.2 years). When asked to rank the most significant obstacles to progressive business operation among blacks, the entrepreneurs identified lack of financial capital as their single greatest barrier. Other commonly mentioned obstacles were the lack of African-American patronage and a shortage of trained personnel.

Outstanding among the few large-scale types of black business, black-owned life-insurance companies weathered the Great Depression, and by 1942 they carried nearly $500 million in insurance, an increase of nearly 40 percent since 1928. Black-owned commercial banks had never been particularly successful, and they were devastated during the 1930s. Between 1888 and 1934, 134 black banks had opened; in 1934, only 12 were still operating (Ofari 1970).

The history books have nothing to say about the black business community of the 1950s; this is indicative of the lack of developments. A 1964 survey of black business in Philadelphia revealed a pattern of very small firms concentrated in personal services and retailing: the most common were beauty parlors and barbershops (35 percent) and restaurants (11 percent). Black firms were concentrated in the same lines of business that had been reported by Pierce in 1944, and mean growth in sales had barely outpaced inflation (Foley 1966).

The Late 1960s: Renewed Interest in Black Enterprise

Twentieth-century black urban ghettos have always had an active black entrepreneurial class in their midst, but they have been more often noted for such phenomena as high rates of unemployment and poverty, inadequate school systems, and substandard housing units. Destructive civil disorders in the mid-1960s in South Los Angeles, Detroit, Cleveland, and other cities drew national attention to the socioeconomic status of the black ghetto. It was precisely at this point that leaders from government and business began discussing black entrepreneurship. Heightened awareness of both the plight of blacks and their po-

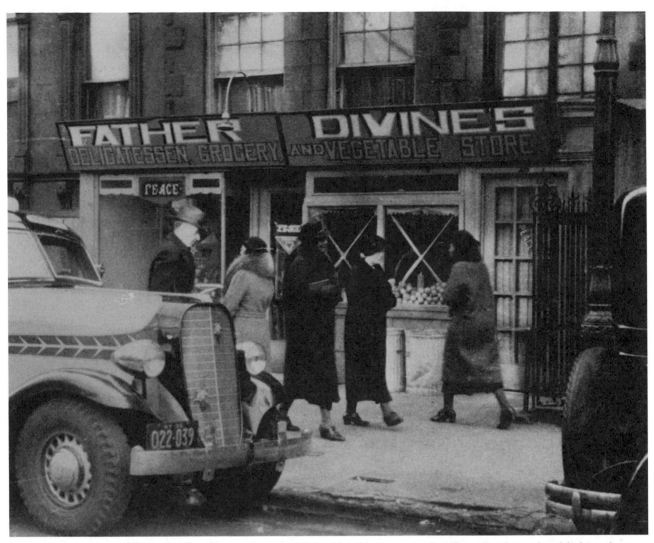

African-American religious leaders have often established businesses, ranging from banks and publishing houses to corner groceries, as adjuncts to their spiritual missions. This Harlem delicatessen was run by followers of Father Divine in the late 1930s. (UPI/Bettmann)

tential for urban disruption led various interest groups to endorse a proliferation of black economic-development programs. Presidential candidate Richard Nixon, in 1968, made government promotion of "black capitalism" the centerpiece of his civil rights platform. First under President Lyndon Johnson and then under the Nixon administration, the Small Business Administration (SBA) was mandated to promote black business development.

Since the mid-1960s, the SBA has initiated two major types of programs to assist minority entrepreneurs: (1) provision of loan assistance and (2) preferential procurement of federal contracts. Despite recurring problems in the SBA's programs, promoting minority-owned business development has wide appeal across the political spectrum, and Republicans and Democrats alike throughout the 1970s expanded

procurement, financial, and managerial assistance programs for minorities (Bates 1981).

The vast publicity given to black capitalism in the 1960s was quite out of proportion to realistic prospects for alleviating ghetto problems via black business development. Black-owned firms as a group had been stagnant since the 1920s. Yet after 1965, federal dollars were increasingly available to assist black enterprise, and efforts to promote minority-owned businesses were taken up in the 1980s by many state and local governments.

A highly influential (and very pessimistic) assessment of the development prospects of the black business community was authored by Andrew BRIMMER in the late 1960s. A member of the board of governors of the Federal Reserve System, Brimmer had a broad impact because he was the highest-ranking

black economist serving in government at that time. According to Brimmer, the typical African-American firm lacked the technical, managerial, and marketing competence needed to compete successfully in the business world (1966). Black businesses existed in niches where whites were reluctant, or unwilling, to compete for black customers. The resultant segregation provided protected markets, which directly benefited black enterprise. "Behind the wall of segregation which cut Negroes off from many public services, there grew up a whole new area of opportunity. Behind this wall of protection emerged the Negro physician, the Negro lawyer, and above all, the Negro businessman" (Brimmer 1968, p. 34).

This segregated market, serving as a protective tariff, was the foundation for a business community of personal services, professional services, and public accommodations. In fields where black customers had relatively free access to retail establishments (such as department stores), black-owned businesses were typically nonviable. Progress toward desegregation, according to Brimmer, would merely undermine black businesses. Specifically, the erosion of segregation and discrimination was giving blacks greater access to public accommodations, and white firms were catering to buyers increasingly without regard to race. As the tariff wall fell, Brimmer suggested that most black firms would face very hard times. Government assistance to the black business community, by implication, was a strategy doomed to failure.

Could blacks expand beyond their few lines of traditional personal-service and retailing enterprise? Caplovitz, in his 1968 study of retail businesses operating in central Harlem, found that white business owners had higher educational levels than black owners. Furthermore, whites were much more likely to have had managerial or sales experience prior to their entry into self-employment. Black business owners operated small establishments, and they were generally less successful than their white Harlem cohorts. A later study by Brimmer suggested that the job-creation potential of black enterprise, even under "optimistic" assumptions, was minimal. These estimates assumed that no jobs would be created by black firms in the construction, manufacturing, and transportation industries. "This omission was not accidental; rather it resulted from the fact that there are few Negro-owned firms competing in these types of businesses" (Brimmer and Terrell 1971, pp. 304–306).

The pessimists, including Andrew Brimmer, were not at all surprised when the SBA's efforts to provide long-term credit access to minority-owned businesses produced very high rates of loan delinquency and default. The major government lending effort targeted to assist self-employed blacks was the Economic Opportunity Loan (EOL) program. Prior to

1968, virtually all SBA loans to minority borrowers were EOL loans, and in the five fiscal years 1969–1973, 24,422 of the 36,782 SBA loans to minorities were EOLs. In 1973, the average SBA loan for minority borrowers came to $19,795 under the EOL program and $61,157 under all other programs; the mean SBA loan for all nonminority borrowers exceeded $100,000 (Bates 1975). The EOL program was designed to help low-income persons who either owned or wanted to establish very small businesses. A high personal income and/or any evidence of past or present aptitude for success in business was grounds for loan denial, since the EOL program was designed to serve minorities who were unlikely candidates for success in business. Hence, the high default rate followed logically from the underlying philosophy of the program. The availability of EOL loans at low interest rates encouraged many blacks to enter businesses that were not viable. The resulting events—failing in business and defaulting on loan obligations—placed severe hardships on many unsuccessful entrepreneurs.

The EOL program, of course, could not be used to judge the potential of black enterprise because it was merely a massive case study of institutionalized failure. Studies contrasting successful with unsuccessful black-owned businesses have provided something of a model portrait, a description that typifies the successful black business owner of the 1970s and 1980s. A college graduate with an above-average income enters business—usually outside such traditional areas as personal services, often in an emerging field such as finance. In terms of firm size (sales volume, total assets), the business is above average. Cash flow is strong relative to debt-repayment obligations. The size of the owner's financial investment at the point of business entry is the strongest single predictor of firm viability (Bates 1989). The model owner is likely to be over thirty-five but under sixty.

The model portrait that typifies black business failure follows logically from the above analysis: A low-income individual who has not graduated from high school enters business—most likely in a small-scale retail operation or a service line of business that is not skill-intensive. Financial investment is low and the firm size is small. The firm is often unable to achieve a scale of operation that is sufficient to provide the entrepreneur with a decent income. With or without a loan, discontinuance of the business is likely.

The world of small business, finally, is rife with highly educated entrepreneurs whose ventures have gone belly-up. There are no guaranteed formulas for success.

Brimmer's pessimistic view of the black business community has not withstood the test of time. One fundamental flaw in his analysis was the assumption

that the emerging black firms of the 1970s would be replicas of the existing species; the possibility of evolution and progress was not considered. Brimmer's observation that segregation and discrimination had protected black business, although not devoid of insight, is a one-sided interpretation of the historical development of black entrepreneurship in America. His "protected markets" thesis failed to explore causal relationships between racism and the stunted state of the black business community. Among the more important causal relationships was the fact that financial capital sources—such as commercial banks—had frequently been closed to black firms. Discrimination in the labor market made it difficult to generate the initial equity investment for business formation, which partially explained the black business community's small size and industry orientation. Constraints limiting educational and training opportunities similarly thwarted many potential lines of enterprise. Indeed, the erosion of discrimination ushered in a new era of opportunity for black entrepreneurs.

A lessening of discrimination reduced key constraints that historically have thwarted black business progress. In the survey by Pierce cited above, for example, black entrepreneurs identified their inability to obtain credit as a serious handicap in the competitive struggle for success. Scarcity of financial capital caused the overwhelming majority of black firms to concentrate in lines of business requiring little capital. When capital markets began to open up, black businesses predictably expanded into fields where they theretofore had been unable to compete on an equal basis. Project OWN, the initial 1968 government effort to encourage commercial-bank lending to black enterprise, achieved a broadening of the black industry base. The industry distribution of black firms receiving bank loans sharply differed from the distribution of all black businesses: few of the borrowers were in traditional fields; most operated in emerging lines of business (Bates 1973).

Easing the Historical Constraints

The constraints that shaped the traditional black business community—limited capital access, barriers to education and training, and so forth—have changed substantially since the 1960s. The availability of government loan guarantees (against default risk) induced thousands of banks to extend business loans, thus eroding a tradition of minimal contact between blacks and commercial-bank lending departments. College enrollments by black students increased dramatically in the 1960s and 1970s; enrollment growth in business-related fields was particularly rapid.

While increased loan availability typified black (and other minority) business promotion efforts in

the 1960s, the use of procurement dollars and "set-asides" targeted to minority firms by corporations and government units did not become a major force until the late 1970s. Large corporations in the consumer-products industries routinely targeted procurement dollars to minority firms, advertised in minority-owned publications, and deposited funds in minority-owned banks. Set-asides and preferential procurement programs targeting minority enterprise, widely utilized by local governments in the 1980s and 1990s, reflect the growing political power of blacks (and Hispanics) in many central cities. Atlanta, Chicago, Los Angeles, Philadelphia, Detroit, New Orleans, Dallas, and Minneapolis are among the large cities that have shown major support for minority business development activities.

While the traditional black business community consisted predominantly of very small firms serving a ghetto clientele, the lure of market opportunity in recent years has induced entrepreneurs to create larger firms that are oriented toward corporate and government clienteles (Bates 1985). The finance, insurance, and real-estate field typifies the above trends in black entrepreneurship. Among all self-employed blacks in this field in 1980, 66 percent had attended college (versus 28 percent of all self-employed blacks) and the majority of these had graduated from four-year colleges or universities (Bates 1987). In the universe of all self-employed individuals, the incidence of college attendance has risen steadily through time; among blacks, however, growth in the reported frequency of college attendance has been relatively more rapid than among nonminorities. A comparison of 1970 and 1980 census data indicates a 120 percent increase in the incidence of college attendance among self-employed blacks, versus a 91.7 percent increase for their nonminority cohorts.

The importance of well-educated, highly skilled blacks in explaining growth in entrepreneurship is emphasized by findings of a study by Handy and Swinton (1983). In explaining growth in the number of black-owned firms between 1972 and 1977, Handy and Swinton found that three closely related variables most accurately predicted growth in a particular metropolitan area: (a) growth in the available pool of black professional and managerial manpower; (b) the initial level of black professional and managerial manpower; and (c) the level of education among blacks within the metropolitan area.

A longer-term perspective on the changing composition of the minority business community is highlighted in Table 1's comparison of 1960 and 1980 U.S. Census data on minority self-employment. Two lines of business—personal services and retailing—accounted for well over half of all minority enterprises in 1960. Lesser concentrations of minorities

TABLE 1. **Percentage of All Minority Self-Employed in Various Industries, 1960–1980***

Industry	1960	1980	% Change since 1960	Industry Growth Rate
Construction	16.7%	16.5%	−1.2%	Stagnant
Manufacturing	4.1	6.0	46.3	Moderate
Transportation, communications, and utilities	3.9	6.0	53.8	Rapid
Wholesale	1.7	3.6	111.8	Rapid
Retail	25.4	25.4	0.0	Stagnant
Finance, insurance, and real estate	1.4	4.0	185.7	Rapid
Business services	2.4	6.6	175.0	Rapid
Repair services	5.2	6.9	32.7	Moderate
Personal services	28.9	14.7	−49.1	Declining
Other services	10.3	10.3	0.0	Stagnant
Total	100.0%	100.0%		

* Excludes agriculture, doctors, and lawyers.

Source: U.S. Bureau of the Census unpublished data.

were working in miscellaneous other services (such as entertainment, lodging, and repair services), and construction. Collectively, these four most common fields—personal services, retail, construction, and miscellaneous other services—accounted for 81.3 percent of self-employed minorities in 1960. Between 1960 and 1980, all of the growth in relative self-employment shares—as measured by the proportions of minority entrepreneurs in various lines of business—took place *outside* these four areas (Bates 1987). Self-employment growth was most rapid in four fields that collectively more than doubled their relative share of the entrepreneur pool: business services; finance, insurance, and real estate; transportation, communication, and utilities; and wholesale. Moreover, within certain broad industry categories, the distribution of black-owned firms has changed markedly. Special trade contractors in areas such as painting and carpentry have decreased in incidence, while general contracting and heavy construction firms have increased substantially. These shifts reflect a movement toward more skill- and capital-intensive lines of business within the broad industrial groupings.

Although marginal operations are undoubtedly numerous within the black business community, data from the U.S. Bureau of the Census reveal a clear trend toward more skill-intensive lines of business. In 1960, nearly 30 percent of self-employed blacks ran personal-services firms and fewer than 10 percent operated in skill-intensive areas such as finance, insurance, and real estate; business services; and professional services. Among black-owned firms that began operations in the 1976–1982 period, 25 percent were in these skill-intensive service industries; only 10.3 percent of startups were in personal services. In 1960, blacks in skill-intensive areas were concentrated in several specialties: medicine, law, insurance. By the 1990s, common lines of business include not only these fields but consulting firms, ad agencies, engineering services, accounting firms, employment agencies, and computer-software operations. The data on black business reflect trends toward diversity that are vitally important for comprehending the trajectory of black entrepreneurship.

Growing numbers of experienced, financially sophisticated black entrepreneurs are manifested in business dealings that are thrusting some enterprises into the mainstream of corporate America. In 1987, Reginald LEWIS completed the largest transaction ever negotiated by an African American when he purchased the International Foods Division of Beatrice, Inc., which had annual sales of $1.8 billion. J. Bruce Llewellyn (with his partner, Julius ERVING) owns the Philadelphia Coca-Cola Bottling Company. The very largest of the black-owned businesses today compete in the open marketplace: they do not typically target a minority clientele. In contrast, the largest black-owned enterprises of the mid–twentieth century—firms selling life insurance and hair-care products—catered almost exclusively to minority clients. These giants of an earlier era, as noted by Brim-

mer, flourished in market niches that were generally overlooked by corporate America. Black-owned businesses reliant on such protected markets have experienced growing competition from mainstream corporate America since the 1960s. Their changing fortunes are a reflection of the same basic social forces that have permitted emerging black-owned firms to compete successfully in the nonminority marketplace.

The black business community is profoundly different today than it was in the 1960s. Its size and scope have expanded; industry diversity has flourished; highly educated entrepreneurs are the norm in many lines of business; bank credit is more widely available. Black emerging businesses are progressing rapidly overall, but they must still contend with a range of problems that typify small business in general, as well as several that disproportionately affect black firms. A key factor responsible for black enterprise growth is the rising incidence of highly educated entrepreneurs in nontraditional lines of business; a key factor that continues to retard growth is the paucity of equity capital available for investment in small firms. Personal-wealth holdings are traditionally a major source of capital for small-business creation and expansion. Disparities in such holdings discourage entry into self-employment and handicap black business startups.

Data describing family-wealth holdings in 1984 indicate that black households had a median net worth of $3,397, versus $39,135 for white households: for every dollar of wealth in the median white family, the median black family had nine cents (Jaynes and Williams 1989, 292). While only 8.6 percent of the white households had zero or negative net worth, 31 percent of the black households held absolutely no wealth. Wealth in the form of business equity was most commonly observed among black households whose income exceeded $24,000. Business equity was held by 3.5 percent of the black upper-middle-income ($24,000-$48,000) households, and by 14.0 percent of the black high-income households. In contrast, the fraction of white households with business equity ownership surpassed that of black households at every income level. At the upper-middle and high income levels, respectively, 11.0 percent and 21.5 percent of the white households held wealth in the form of small business equity. The greatest disparity in business equity holdings, however, derived from the fact that higher-income white households are relatively much more numerous than higher-income blacks. Disparities in personal-wealth holdings, therefore, continue to handicap black business startups today. In the 1990s as in the 1890s, black business creation has been concentrated in industries where

formation requires relatively little financial capital. Lacking assets, and therefore lacking borrowing capacities, blacks are too often ill equipped to exploit economic opportunities.

The financial capital constraint facing black-owned businesses is unlikely to ease anytime soon. The low net-worth holdings that typify most black households will be alleviated, at best, only gradually over a period of many years. Low levels of personal wealth restrict business viability in several ways. Commercial banks lend most freely to those who possess significant amounts of equity capital to invest in their businesses. Beyond banks, the second and third most important sources of debt capital for small business are family and friends, respectively (Bates 1991). The low net-worth holdings of black households in general restrict the availability of debt capital that family and friends can invest in small business operations.

Access to credit has been expanded for black firms in recent decades. Relative to the situation in 1944 described by the Pierce survey, the fact that over 25 percent of African-American businesses beginning operations between 1976 and 1982 received commercial bank loans is noteworthy (Bates 1991). But credit access is certainly not approaching parity with that of white businesses. Black college graduates are least disadvantaged relative to white business owners, but black firms as a group are less likely to get loans, and the loans that are extended are much smaller than those afforded to their white cohorts (Ando 1988; Bates 1991).

An entirely different sort of barrier to continued black business progress has emerged in the federal courts. Challenges to the constitutionality of minority business assistance programs threaten to reverse the process of broadening the range of markets served by black-owned enterprises. Minority business set-asides at the state and local levels are being cut back due to the judicial constraints imposed on these programs by the Supreme Court's 1989 *Richmond* v. *Croson* ruling.

Another constraint on black business viability is location-based. Inner-city black communities are increasingly being left out of the business development process. All the basic elements of black business viability—talented entrepreneurs, financial capital, and markets—are threatened in the inner-city milieu: banks redline, better-educated entrepreneurs are pulling out, and markets are weak (Bates 1989). In light of the reorientation of emerging black enterprises toward racially diverse or largely nonminority clienteles, choice business locations are increasingly found outside of minority neighborhoods.

The nature of the black business community is largely derivative of broad social forces. Slavery and

the social milieu of the antebellum South shaped black entrepreneurship in the nineteenth century. Urbanization, northern migration, and the growing intensity of segregation that followed World War I shaped a black business community in the 1920s that was profoundly different from its nineteenth-century predecessor. Finally, a lessening of segregation and discrimination in recent decades has generated an entirely new growth dynamic in the black business community of the 1990s. The lessening of discriminatory barriers has not been a smooth and steady social process. The future composition of the black business universe may derive from the expanded opportunities offered by a less segregated society, or it may reflect growing constraints imposed by evolving discriminatory barriers.

REFERENCES

ANDO, FAITH. "Capital Issues and Minority-Owned Business." *Review of Black Political Economy* 16 (1988): 77–109.

BATES, TIMOTHY. *Black Capitalism: A Quantitative Analysis.* New York, 1973.

———. "Black Entrepreneurship and Government Programs." *Journal of Contemporary Studies* 4 (1981): 59–70.

———. "Commercial Bank Lending to Black and White-Owned Businesses." *Quarterly Review of Economics and Business* 31 (1991): 64–80.

———. "Government as Financial Intermediary for Minority Entrepreneurs." *Journal of Business* 48 (1975): 541–547.

———. "Impact of Preferential Procurement Policies on Minority-Owned Businesses." *Review of Black Political Economy* 14 (1985): 51–66.

———. "Self-Employed Minorities: Traits and Trends." *Social Sciences Quarterly* 68 (1987): 539–551.

———. "Small Business Viability in the Urban Ghetto." *Journal of Regional Science* 29 (1989): 625–643.

BATES, TIMOTHY and DANIEL FUSFELD. *The Political Economy of the Urban Ghetto.* Carbondale, Ill., 1984.

BRIMMER, ANDREW. "The Negro in the National Economy." In John Davis, ed. *American Negro Reference Book.* Englewood Cliffs, N.J., 1966, pp. 251–336.

———. "Desegregation and Negro Leadership." In *Business Leadership and the Negro Crisis.* New York, 1968.

BRIMMER, ANDREW, and HENRY TERRELL. "The Economic Potential of Black Capitalism." *Public Policy* 19 (1971): 289–308.

CAPLOVITZ, DAVID. *The Merchants of Harlem: A Study of Small Business in the Black Community.* Beverly Hills, Calif., 1973.

DRAKE, ST. CLAIR, and HORACE CAYTON. *Black Metropolis.* New York, 1962.

DU BOIS, W. E. B. *The Philadelphia Negro: A Social Study.* New York, 1967.

FLEMING, G. JAMES, and BERNICE SHELDON. "Fine Food for Philadelphia." *Crisis* 45 (1938): 111–116.

FOLEY, EUGENE. "The Negro Businessman: In Search of a Tradition." Talcott Parsons and Kenneth Clark, eds. In *The Negro American.* Boston, 1966, pp. 555–579.

HANDY, JOHN, and DAVID SWINTON. "The Determinants of the Rate of Growth of Black-Owned Businesses." *Review of Black Political Economy* 12 (1984): 85–110.

HARMON, J., ARNETT LINDSAY, and CARTER WOODSON. *The Negro as Businessman.* College Park, Md., 1929.

HARRIS, ABRAM. *The Negro as Capitalist.* Philadelphia, 1936.

HOLSEY, ALBON. "Seventy-Five Years of Negro Business." *Crisis* 45 (1938): 231–247.

JAYNES, GERALD, and ROBIN WILLIAMS. *A Common Destiny: Blacks and American Society.* Washington, D.C., 1989.

KELSEY, CARL. "The Evolution of Negro Labor." *Annals of the American Academy of Political and Social Science* 21 (1903): 59–74.

LIGHT, IVAN. *Ethnic Enterprise in America.* Berkeley, Ca., 1972.

MYRDAL, GUNNAR. *An American Dilemma.* New York, 1944.

OFARI, EARL. *The Myth of Black Capitalism.* New York, 1970.

PIERCE, JOSEPH. *Negro Business and Business Education.* New York, 1947.

RANSOM, ROGER, and RICHARD SUTCH. *One Kind of Freedom.* New York, 1977.

STEIN, JUDITH. *The World of Marcus Garvey.* Baton Rouge, La., 1986.

U.S. BUREAU OF THE CENSUS. *Negroes in the United States, 1920–1932.* Washington, D.C., 1935.

WALKER, JULIET. "Racism, Slavery and Free Enterprise: Black Entrepreneurship in the United States before the Civil War." *Business History Review* 60 (1986): 343–382.

WASHINGTON, BOOKER T. *The Negro in Business.* Boston, 1907.

TIMOTHY BATES

Black Codes. Black codes were laws passed to regulate the rights of free African Americans in the antebellum and post–Civil War eras. Before the Civil War, a number of midwestern states adopted black codes (or black laws) to inhibit the migration of free blacks and in other ways limit black rights. After the Civil War, most southern states adopted far more severe black codes to prevent former slaves, called freedmen at the time, from having the full rights of citizens and to reimpose, as much as possible, the labor and racial controls of slavery.

In 1804, Ohio passed an act to "regulate black and mulatto persons." This law became the prototype for subsequent laws passed in Ohio, Indiana, Illinois, and the Michigan Territory. It required that blacks migrating to Ohio show proof of their freedom and exacted a fifty-dollar fine from any white hiring a black who did not have such proof. On its face, this law could be seen as a good-faith effort to prevent fugitive slaves from entering the state. In fact, it was primarily designed to discourage black migration. An 1807 law raised the fine to one hundred dollars and required migrating blacks to find two sureties to guarantee their "good behavior" and assure that they would not require public assistance. Subsequent amendments to these laws prevented blacks from serving on juries and testifying against whites and severely limited their access to public schools. Although discriminatory, these laws did not prevent blacks from owning real estate, entering professions—including law and medicine—or exercising freedom of speech, press, assembly, and worship. Moreover, once blacks were legally present in a state, the black codes of the North did not inhibit their geographic mobility.

These laws were generally ineffective in limiting the growth of the free black population. From 1803 to 1860, Ohio's black population actually grew at a slightly faster rate than did its white population. Between 1830 and 1860, Indiana, Illinois, and Ohio all saw growth in their black populations of over 300 percent. There is little evidence that migrating blacks were usually asked to prove their freedom or that anyone enforced the requirement that migrating blacks find sureties to sign bonds for them. There are, in addition, no recorded cases of any whites being fined for hiring blacks who failed to provide proof of their freedom.

In 1849, Ohio repealed most of its black codes, including those provisions discouraging black migrants from coming to the state. The repeal was part of an elaborate legislative compromise that also sent the abolitionist Salmon P. Chase to the U.S. Senate. Indiana and Illinois retained their discriminatory laws until after the Civil War. Iowa, California, and Oregon also adopted some aspects of the northern black codes, but Iowa and California dropped virtually all these rules before or during the Civil War.

By the end of the Civil War, blacks in the North had substantial equality under the law, with the exceptions that in most states they could not vote or serve on juries. These disabilities based on race disappeared after the ratification of the FIFTEENTH AMENDMENT in 1870. After 1870, some northern states still prohibited marriages between blacks and whites, but otherwise most remnants of the black codes were no longer on the books.

In the South, the situation was far different. The loss of the war and the emancipation of four million slaves immediately and dramatically affected southern society. Emancipation upset the system of racial control that had kept blacks subordinate to whites since the seventeenth century, and also destroyed the economic relationship that had allowed planters to count on a pliable and ever-present source of labor. With slavery gone, the legal status of the freedmen and their role in the postwar South were uncertain. Immediately after the war, southern legislatures began to adopt "black codes" to define the status of former slaves and to cope with the emerging problems resulting from Emancipation.

Northerners assumed that after Emancipation ex-slaves would have the same rights as other free people. But southerners did not hold such views. Before the war, the rights of free blacks were severely restricted, and usually enumerated in slave codes, underscoring the antebellum southern view that free blacks were an anomalous and inherently dangerous class of people. Thus, when the war ended the ex-slaves of the former Confederate states lacked most legal rights. The black codes changed this but in a way that rigorously limited the rights of freedmen.

At the personal level, the black codes allowed African Americans to marry each other (but not whites) and furthermore declared that all slaves who had lived as married couples would be considered legally married. Mississippi's laws of 1865—the first adopted in the postwar South—illustrate how the black codes gave former slaves some rights, while at the same time denying them many others that whites had. The end result was to give former slaves most of the responsibilities, but few of the benefits, of freedom.

An 1865 law, with the misleading title "An Act to confer Civil Rights on Freedmen, and for other Purposes," declared that blacks could "sue and be sued, implead and be impleaded" in all state courts, but only allowed them to testify in cases involving other blacks and prohibited them from serving on juries. The law allowed freedmen to acquire and dispose of property "to the same extent that white persons may," but prohibited them from renting any land except in "towns or cities." In other words, free blacks could not rent farmland. In overwhelmingly rural Mississippi, this meant freedmen would become a peasant class, forced to work for white landowners and unable to acquire land on their own. Another provision of this law required that all labor contracts made with freedmen for more than a month had to be in writing, and that any freedman who quit before the end of the term of a contract would "forfeit his wages for the year," including those earned up to the time he quit. In a provision similar to the antebellum slave codes, this law obligated "every civil officer" to

"arrest and carry back to his or her legal employer any freedman, free negro or mulatto, who shall have quit the service of his or her employer before the expiration of his or her term of service." This in effect made the free blacks of Mississippi slaves to their employers, at least for the term of their employment. Anyone attempting to hire a black under contract to someone else was subject to fine, jail terms, and civil damage suits. Another Mississippi statute allowed counties to apprentice African-American children if their parents were declared to be too poor to support them. To many, this appeared to be an attempt to re-enslave the children of the freedmen. Still another statute, also enacted in 1865, declared that any black who did not have a labor contract would be declared a vagrant and would be subject to fines or imprisonment. This law provided punishment for free blacks who were "found unlawfully assembling themselves together either in the day or night time," for whites who assembled with such blacks, and for whites and blacks who married or cohabited.

Other states adopted laws with similar intent but different provisions. Rather than prohibiting blacks from renting land, South Carolina prohibited them from working in nonagricultural jobs without paying special taxes that ranged from ten to one hundred dollars. South Carolina also enacted harsh criminal laws to suppress African Americans. Stealing a hog could lead to a thousand-dollar fine and ten years in jail. Other crimes had punishments of whipping, the stocks, or the treadmill, as well as fines and long imprisonment. Hired farm workers in South Carolina could not even sell farm produce without written authorization from their employers. Other provisions of the law created special taxes and fines for blacks with imprisonment or forced labor for those who lacked the money to pay them. Like Mississippi, South Carolina provided for the apprenticing of black children. These and similar laws created something close to a reimposition of slavery in South Carolina. In 1865, Louisiana and Alabama adopted laws similar to those of South Carolina and Mississippi.

The black codes of 1865 shocked many Northerners. In South Carolina, Gen. Daniel E. Sickles suspended the law, as did Union troops in the Mississippi military. Even some white governors, including William L. Sharkey of Mississippi and Robert Patton of Alabama, opposed some of the more blatantly discriminatory laws. In Congress, Republicans responded by introducing legislation that led to the Civil Rights Act of 1866 and eventually to the FOURTEENTH AMENDMENT.

In 1866 the rest of the former Confederacy adopted black codes. Florida's code was as harsh as those of Mississippi and South Carolina, providing whipping, the pillory, and forced labor for various offenses.

Florida prohibited any blacks from moving into the state, prohibited African Americans from owning firearms, and, though allowing the creation of schools for blacks, prohibited the use of state money to pay for them.

Other states were more discreet in their legislation, trying to avoid giving ammunition to Republicans in Congress who were growing increasingly impatient with the South's attempts to reimpose bondage and oppression on the freedmen. Virginia's vagrancy law carefully avoided any reference to race, but still punished offenders with forced labor, and was clearly directed at the freedmen. Not surprisingly, Gen. Alfred H. Terry suspended its operation, although two other generals, in other parts of Virginia, allowed it to go into force. Tennessee's new criminal code provided the death penalty for breaking and entering with the intent to rob, for robbery itself, and for horse stealing. This law did not use any racial terms, but was clearly aimed at blacks. Similarly, Georgia and North Carolina tried to avoid the use of racial terms that might have jeopardized their chances of readmission to the Union. Nevertheless, none of the former Confederate states was ready to have racially blind statutes, much less racially blind justice. North Carolina's law, arguably the least offensive of the new black codes, nevertheless provided a death penalty for black rapists when the victim was white, but not for white rapists, no matter what the color of the victim.

Like the 1865 laws, those passed in 1866 regulated the movement of blacks, their ability to live where they wished, and their ability to sell their labor on an open market. All of the 1866 laws also tried to create racial controls to keep African Americans in a subordinate role, even as they tried to avoid the appearance of racial discrimination. By 1867, southern legislatures had repealed most of the provisions that designated specific punishments by race. Even without racially specific language, courts continued to apply solely to African Americans provisions of the black codes regulating vagrancy, contracts, and children.

Although these laws remained on the books in one form or another throughout RECONSTRUCTION, their enforcement was sporadic. Congress, the Freedmen's Bureau, and the military opposed them. Nevertheless, the laws remained a symbol of the oppression that the postbellum South offered African Americans. After 1877, the South gradually reimposed those provisions of the black codes that segregated blacks and regulated labor contracts. Such laws led to peonage and a second-class status for southern blacks in the late nineteenth and early twentieth centuries.

REFERENCES

BERWANGER, EUGENE D. *The Frontier Against Slavery*. Urbana, Ill., 1967.

ERICKSON, LEONARD. "Politics and Repeal of Ohio's Black Laws, 1837–1849." *Ohio History* 82 (1973): 154–175.

FINKELMAN, PAUL. "Prelude to the Fourteenth Amendment: Black Legal Rights in the Antebellum North." *Rutgers Law Journal* 17 (1986): 415–482.

———, ed. *Race, Law, and American History, 1700–1990*. Vol. 3, *Emancipation and Reconstruction*. New York, 1992.

NIEMAN, DONALD. *To Set the Law in Motion: The Freedmen's Bureau and the Legal Rights of Blacks, 1865–1868*. Millwood, N.Y., 1979.

WILSON, THEODORE B. *The Black Codes of the South*. University, Ala., 1965.

PAUL FINKELMAN

Black Emergency Cultural Coalition (BECC),

ad hoc protest group. A loosely organized protest organization of African-American and white New York artists, the Black Emergency Cultural Coalition (BECC) helped bring attention to the absence of black artists from the mainstream art world in the late 1960s and early '70s. Its tactics, however, often served to alienate the very constituency it claimed to represent.

Led by African-American artists Benny ANDREWS, Cliff Joseph, Henri Ghent, and Edward Taylor, the BECC was first organized in the fall of 1968 when it picketed an exhibit of American painting and sculpture of the 1930s at New York City's Whitney Museum. The coalition criticized the absence of significant representation of black artists in the exhibit.

The BECC gained notoriety in January 1969 when it protested an already controversial exhibit at the Metropolitan Museum of Art called "Harlem on My Mind," a documentary photographic history of HARLEM organized by a white curator, which they claimed reflected the "white man's distorted, irrelevant and insulting" view of the black experience. Ironically, the exhibit was earlier criticized by New York's Mayor John Lindsay and several Jewish organizations for alleged anti-Semitism in the exhibit's catalog. The BECC avoided the Jewish issue, but denounced what it called a "paternalistic approach to black people—one that demands that whites define and describe the black experience, about which they know nothing." The coalition alleged the exhibit lacked any positive reference to political, institutional, or cultural developments in Harlem since the nineteenth century except for JAZZ in the 1920s.

In April 1971, an exhibit opened at the Whitney Museum, "Contemporary Black Artists in America," which was the result of negotiations between the BECC and the Whitney following the 1969 protest. However, the BECC called for a boycott of the exhibit, claiming that the museum director had reneged on an informal agreement to hire blacks as members of the curatorial staff and that the exhibit should have been shown during the winter, the peak of the art season. The Whitney was also criticized by the BECC for refusing to consult the black art community for curatorial advice and for not including any works by any of the BECC's 150 members, which by then included painters Vivian Browne, Russ Thompson, James Denmark, and Reggie Gammon. The Whitney argued in its defense that it had indeed gone forward with the exhibition, had made permanent purchases of black art, and had presented lobby displays of work by young black artists. The BECC drew criticism from some artists who resented coalition members' asking them to withdraw their work from such a visible forum after the BECC itself had helped initiate the exhibit. Although fifteen artists withdrew their work, the boycott tarnished the reputation of the BECC within the black art community. The coalition presented a protest exhibition, "Rebuttal to Whitney Museum," at the Acts of Arts Galleries in New York at the same time that the Whitney's exhibit was taking place.

In 1976 the coalition, led by Andrews, once again targeted the Whitney, this time the museum's celebration of two hundred years of American art, at which no black artists and only one woman were represented.

During the 1970s the BECC conducted several art workshops for prison convicts. The coalition continued into the 1980s as a cultural watchdog group encouraging the participation and employment of blacks in educational, curatorial, and policymaking areas of art institutions.

REFERENCES

GLUECK, GRACE. "Black Show Under Fire at the Whitney." *New York Times,* January 31, 1971, p. D25.

———. "Fifteen of Seventy-five Black Artists Leave as Whitney Museum Opens." *New York Times,* April 6, 1971, p. 50.

HANDLER, M. S. "Seventy-five Artists Urge Closing of Museum's 'Insulting' Harlem Exhibit." *New York Times*, January 23, 1969, p. 14.

TAPLEY, MELVIN. "Racism Charged Against Museum." *New York Amsterdam News*, April 4, 1971, pp. 1, 47.

THADDEUS RUSSELL

Black English Vernacular.

Black English Vernacular (BEV), also known as Black English, Nonstandard Negro Dialect, or Ebonics, is the term used

to describe the dialect of Standard American English (SAE) spoken by some African Americans. As an English language variation marked by systematic distinctions in grammar and phonetics, BEV is one of many long recognized and well researched dialects. The existence of some form of BEV dates to the arrival of the first Africans on the North American continent and has been historically recorded in court records, travelers' diaries, slave narratives, and literary accounts. While written accounts continue to be important in researching BEV, linguistic research among living communities of BEV speakers reveals that rules and logic are integral to the dialect.

Origins

Early language researchers of the 1920s and '30s claimed that BEV derived from a dialect of English spoken by rural British peasants and yeomen. Anglicist theorists, like John Bennett, George P. Krapp, Guy B. Johnson, and Mason Crum, relied more on stereotypes than actual research to claim that BEV speakers could only master poor approximations of English due to thick lips and the inability of childlike minds to properly mimic the English they heard. Early dialect geographers engaged in mapping language variations across the United States since the 1920s have also attempted to deny the linguistic independence of BEV. According to the cartographers, regional speech distinctions outweighed ethnic ones. Consequently black dialects were perceived to be essentially the same as southern white dialects.

Linguist Lorenzo Dow Turner conducted the groundbreaking research that spelled out the systematic aspects of one BEV dialect spoken by isolated communities of African Americans and linked their language system to African grammar and pronunciation rules. During the 1930s and '40s, Turner conducted research in Africa and among the GULLAH—African Americans from the Sea Islands off the coasts of South Carolina and Georgia. He determined that Gullah was undeniably connected by syntax, sound, and lexicon to several African languages such as Efik, Ewe, Ibo, Kimbundu, Kongo, Mende Twi, Wolof, and Yoruba.

Turner's culminating work, *Africanisms in the Gullah Dialect* (1949), remains relevant as a model for modern Afrocentric research which explores surviving cultural connections between Africans of the Old World and their New World descendants. Moreover, Turner's intimate research project revealed the Gullah people to be bidialectal—quite capable of using an essentially English vocabulary with outsiders while reserving a more African vocabulary for other Gullah speakers. This, and the fact that the bulk of the Africanisms were culled from an elaborate and private naming system similar to African naming systems,

demonstrated that Gullah was communication reserved for in-group use. Turner's findings and his research model focusing on a finite community of BEV speakers are being replicated and substantiated by ongoing linguistic research.

Another notion of the origins of BEV holds that the American slavery experience brought together Africans of many tongues who were then forced to learn to communicate in the language system of their owners. A pidgin language system developed that allowed those of different tongues to communicate by borrowing words and meanings from one another's language. As subsequent generations achieved greater competence in the pidgin over their original tongues, creole languages evolved. Linguists hold that BEV is what remains of the pidgin that was the first communication system between new African imports and their owners.

Dialect Rules

The work of sociolinguists such as Walt Wolfram and William Labov has demonstrated that BEV is not merely an inadequate or substandard English resulting from cultural deprivation. Their research revealed urban black children to be highly vocal and verbally creative when communicating within their peer groups. Fieldwork conducted by Labov and his colleagues among urban BEV speakers in New York, Philadelphia, and Washington, D.C., has specifically targeted the phonetic and grammatical rules of BEV. According to Labov (1972), adherence to these rules caused interference for the BEV speaker attempting to learn SAE. Among the pronunciation rules and examples he delineated:

- The sound /R/ is omitted, producing identical pronunciations for *nor/gnaw; fort/fought; guard/god.*
- The sound /L/ is omitted, producing identical pronunciations for *toll/toe; all/awe; help/hep.*
- Consonant clusters at word ends are simplified, creating identical pronunciations for *past/pass/passed; rift/riff; wind* (verb)*/wine; meant/men/mend.*
- Final consonants are weakened, creating identical pronunciations for *boot/boo; feed/feet; road/row.*
- There is no distinction between /i/ and /e/ before nasals, creating identical pronunciations for *pin/pen.*
- Final fricatives are merged, creating identical pronunciations for *Ruth/roof* and *death/deaf.*

Among the grammatical rules Labov observed in BEV:

- Verb forms of "to be" are frequently omitted. "He is nice" in SAE becomes "He nice" in BEV.
- Plural endings are absent from the third person

singular tense. "She knows" in SAE becomes "She know" in BEV.

- When verbs are negated, the indefinites (*something, anybody, anyone, somebody,* and *some*) are replaced by negatives (*nothing, nobody* and *none*) in BEV. "He doesn't like anybody" in SAE becomes "He don't like nobody" in BEV.
- In future tense forms, the *will* or final /l/ is dropped, making the colloquial future tense identical to the present tense in BEV. "You will make" or "you'll make" in SAE is reduced to simply "You make" in BEV.
- When possession is specified by word order, the possessive *'s* is absent in BEV. "That is John's house" in SAE becomes "That John house" in BEV.

The preceding lists of phonetic and grammatical rules are by no means complete, but they are adequate enough to demonstrate that BEV is structured and systematic. In addition to being distinguished by such specific rules, BEV is also distinctive for its lexicon. As an SAE dialect, BEV does share with standard English lexicon many words that communicate the same meanings in both SAE and BEV. However, BEV also produces an additional lexicon by several processes. First, BEV has historically been the source of African terms which have become part of the English lexicon. A few examples from Turner's Gullah research (1949) include *goober* (peanut), *tote* (to carry), *juke* (juke box), and *heap* (big). Second, BEV slang and colloquialisms have also generated terms adopted into colloquial SAE, such as *jive* (misleading talk), *hip* (aware), and *jazz* (music genre). Third, one creative feature of BEV is the way it appropriates SAE terms and infuses them with new meanings. Some examples are *cat* (male), *rap* (talk), and *signifying* (verbal dueling). Finally, like other living dialects, the BEV lexicon is constantly evolving as it responds to current events, or to individual and group creativity. Consequently, the BEV lexicon is always evolving as speakers adapt, revise, and appropriate new terms that become a part of the BEV language system.

BEV Today

In the 1980s investigators in the South substantiated the logic- and rule-driven features revealed by BEV research conducted in the urban North. This new frontier of research also confirms that "education, age, and social class influence linguistic choices as much as race does" (Montgomery and Bailey 1986, p. 22). Recent research finds little of the uniform language standardization implied by a "Plantation Creole" presumed to have been used by enslaved BEV speakers across the South. Research models honed on BEV speakers demonstrate that BEV use is largely determined by demographic variations, as are dialects of other ethnic and community groups in the United States.

Ongoing research continues to demonstrate BEV's validity as a chosen in-group form of communication that reflects racial and cultural pride, though debates about its proper function persist. Educators still debate the use of BEV in the classroom, with little consensus on what or how to teach children whose BEV skills are reinforced in their homes and communities. Many linguists suggest that teachers at least familiarize themselves with BEV logic to avoid the ethnocentrism of earlier generations. Those upholding an Afrocentric position see no reason to replace one perfectly good language system with another, merely for the sake of change. Those who believe that proficiency in standard English spells access to upward mobility, power, and money firmly support learning SAE.

Theories, research frontiers, and debates aside, BEV remains a viable dialect due to its continued use on several fronts. BEV use is current within communities and subgroups of African Americans. As long as people continue to segregate themselves by choice or by long-standing practice, isolated and distinctive environments will perpetuate distinctive dialects. Even when social contact and blurred class distinctions make the differences between BEV and SAE dialects less obvious, certain subgroups remain more likely to continue BEV use. These groups include teenagers, the less educated, adult males, and segregated rural and urban dwellers.

In the folklore and oral traditions of African descendants in the United States and across the DIASPORA, the spoken context for BEV grammar and phonetics is a well recognized artfulness in verbal expression that is prized by in-group members. Specific qualities identified with the art of BEV include the use of language that is exaggerated, rhythmic, spontaneous, and filled with metaphors and imagery. Such BEV language use is displayed in discursive speech acts like rapping, signifying, joning, marking, playing the dozens, and in narrative forms like sermons, toasts, and monologues. These traditions are spoken by men and women "of words" for a cultural group that has always valued and celebrated verbal artistry.

Writers have long used BEV as a device to convey class distinctions, race, African-American culture, and the African-American experience. Fiction writers like Gertrude Stein, Mark Twain, Chester Himes, Richard WRIGHT, and Alice WALKER have used basic BEV phonetics and grammar to represent specific African-American characters in their stories and novels. Others like Zora Neale HURSTON, Ralph ELLISON, Toni MORRISON, and June JORDAN further

pushed the envelope in BEV literary use, relying on BEV to both narrate their texts and characterize African-American people, settings, and situations.

In popular culture, BEV language and style are markers of past and present popular music idioms such as SPIRITUALS, BLUES, GOSPEL, soul, and RAP. All of these musical forms make extensive use of BEV grammar, phonetics, lexicon, speech acts, and narrative forms. Consumed worldwide by listeners and viewers of mass communications media, African-American popular music in the form of gospel, soul, and rap permeate world culture and increase public familiarity with BEV far more profoundly than decades of considered academic research and literary prose. In the 1990s, words and expressions drawn from BEV have been incorporated into the standard lexicons of the English language.

REFERENCES

BENTLEY, ROBERT H. "Social Dialects." In *The Legacy of Language*. Reno, Nev. 1987, pp. 69–80.
BENTLEY, ROBERT H. and SAMUEL D. CRAWFORD, eds. *Black Language Reader*. 1973.
DILLIARD J. L. *Black English: Its History and Usage in the United States*. New York, 1972.
DUNDES, ALAN, ed. *Mother Wit from the Laughing Barrel*. New York, 1990.
SMITH, ARTHUR L. *Language, Communication and Rhetoric in Black America*. New York, 1972.
SMITHERMAN, GENEVA. *Talkin and Testifyin*. Boston, 1977.
TURNER, LORENZO DOW. *Africanisms in the Gullah Dialect*. New York, 1949.

CASSANDRA A. STANCIL

Black Enterprise. *See* Graves, Earl Gilbert, Jr.

Black History Month/Negro History Week.

The annual celebration of Negro History Week was one of historian Carter G. WOODSON's most successful efforts to popularize the study of black history. Omega Phi, one of the oldest African-American fraternities, first celebrated black achievements on Lincoln's birthday, February 12. Woodson, an honorary member of the fraternity, convinced the Omegas to let the ASSOCIATION FOR THE STUDY OF NEGRO LIFE AND HISTORY sponsor Negro History Week to reach a larger audience. Woodson began the annual celebration in 1926 to increase awareness of and interest in black history among both blacks and whites. Months before the first celebration, he sent out promotional brochures and pamphlets to state boards of education, elementary and secondary schools, colleges, women's clubs, black newspapers and periodicals, and white scholarly journals, suggesting ways to celebrate. Woodson chose the second week of February, to commemorate the birthdays of Frederick DOUGLASS and Abraham Lincoln. Each year the association produced bibliographies, photographs, books, pamphlets, and other promotional literature to assist the black community in the celebration— over 100 photographs of blacks were available for sale, and specialized pamphlets included bibliographies on various aspects of African-American history. Woodson also prepared in 1928 a "Table of 152 Important Events and Dates in Negro History," which he sold for fifty cents. Negro History Week celebrations generally included parades of costumed characters depicting the lives of famous blacks, as well as breakfasts, banquets, lectures, poetry readings, speeches, exhibits, and other special presentations.

During the 1940s, Negro History Week celebrations became increasingly more sophisticated and attracted even larger audiences. Woodson compiled and sold Negro History Week kits, posters, and large photographs that depicted periods of African-American history. Black women's organizations and social-service groups sponsored lectures and rallies for their members. Libraries, museums, and educational institutions held special exhibits. School systems throughout the country sponsored institutes to help teachers prepare. Teachers assigned students essays on topics in black history, helped them write and produce plays, and sponsored oratorical and essay contests. Woodson credited schoolteachers with ensuring the success of the annual celebrations; he regularly reported on their efforts in the *Journal of Negro History* and in the black press, highlighting the most creative and innovative activities. In some school systems the celebration was so successful that teachers established Negro History Study Clubs, which gave attention to the subject throughout the school year. White politicians made annual proclamations in honor of Negro History Week, and whites began to participate in special activities. During Woodson's lifetime the celebration became so far-reaching in its popularity that whites and blacks in Latin America, the West Indies, Africa, and the Philippines participated.

Many of Woodson's contemporaries contended that the annual celebration was his most impressive achievement. Writing in *Dusk of Dawn* in 1940, sociologist W. E. B. DU BOIS claimed that it was the greatest single accomplishment to arise from the HARLEM RENAISSANCE. Similarly, historian Rayford LOGAN maintained that Negro History Week helped

blacks overcome their inferiority complex and instilled racial pride and optimism. After Woodson's death in 1950, the Association for the Study of Negro Life and History continued to sponsor the annual event, selling Negro History Week kits and assisting teachers, women's clubs, and civic associations with their celebrations. By the early 1970s the organization decided to extend the celebration to the entire month of February and use the term *black*. Politicians, the media, and the organization that previously had supported the effort to promote black history during the second week of February began celebrating throughout the month. Now the Association for the Study of Afro-American Life and History, the organization that Woodson founded, continues to press for greater recognition of black history throughout the year, not just during the month of February.

REFERENCES

GOGGIN, JACQUELINE. *Carter G. Woodson, a Life in Black History*. Baton Rouge, La., 1993.
MEIR, AUGUST, and ELLIOTT RUDWICK. *Black History and the Historical Profession*. Urbana, Ill. 1986.

JACQUELINE GOGGIN

Black Identity. Black culture is the creative and complex product of the terrifying African encounter with the absurd *in* America and the absurd *as* America. Like any other group of human beings, black people forged ways of life and ways of struggle under circumstances not of their own choosing. They constructed structures of meaning and structures of feeling in face of the ultimate facts of human existence—death, dread, despair, disease, and disappointment. Yet the specificity of black culture—those features that distinguish black culture from other cultures—consists of both the *African* and the *American* character of how black people sustained mental sanity and spiritual health, social life and political struggle, in the midst of a slaveholding white supremacist civilization that viewed itself as the most enlightened, free, tolerant, and democratic experiment in human history.

Any serious examination of black culture should begin with what W. E. B. DU BOIS dubbed "the spiritual strivings" of black people—the dogged determination to survive and subsist, the tenacious will to persevere, persist, and maybe even prevail. These strivings occur within the multilayered whirlwinds of white supremacy—that is, as responses to the vicious attacks on black beauty, black intelligence,

black moral character, black capacity, and black possibility. To put it bluntly, every major authority in American civilization—churches, universities, courts, academies of science, newspapers, magazines, and others—attempted to exclude black people from the human family in the name of white supremacist ideology. This unrelenting assault on black humanity produced the fundamental problem of black culture—the problematic of black invisibility and namelessness.

This basic problematic functions on at least four levels—existential, social, political, and economic. The existential level is the most important because it has to do with what it means to be a person and live a life under the horrifying conditions of white supremacist assault. To be a black human being under circumstances in which one's humanity is questioned is to engage in not only a difficult challenge but also a demanding discipline.

The sheer absurdity of being a black human being whose mere black body is viewed as an abomination, whose black thoughts and ideas are perceived as debased, and whose black pain and grief are rendered invisible on the human moral scale is the New World context in which black culture emerges. Needless to say, black people are first and foremost an African people in that the cultural baggage they brought with them to the New World was grounded in their earlier adaptations to African conditions. Yet the rich African traditions—including the kinetic orality, passionate physicality, improvisational intellectuality, and combative spirituality—would undergo creative transformation in European languages and instrumentalities under New World circumstances. No JAZZ without New World Africans with European instruments.

On the crucial existential level of the problematic of black invisibility and namelessness, the first difficult challenge and demanding discipline is to ward off madness and discredit suicide as a desirable option. A central preoccupation of black culture is to confront candidly the ontological wounds, psychic scars, and existential bruises of black people while precluding a move to black insanity and black self-annihilation. Black culture consists of black modes of being-in-the-world obsessed with black sadness and sorrow, black agony and anguish, black heartache and heartbreak, without fully succumbing to the numbing effects of such misery. This is why the urtext of black culture is neither a word, nor a book, not an architectural monument, or a legal brief. Instead it is a guttural cry and a wrenching moan—a cry not so much for help as for home, a moan less out of complaint than for recognition. The most profound black cultural products—John COLTRANE's saxophone solos, Billie HOLIDAY's vocal leaps, the Rev. Gardner

TAYLOR's sermonic rhapsodies, James BALDWIN's poignant essays, or Toni MORRISON's dissonant novels—distill in artistic form this cry and moan. The deep black meaning of this cry and moan goes back to the indescribable cries of Africans on the slave ships during the cruel transatlantic voyages to America and the indecipherable moans of enslaved Afro-Americans on Wednesday nights, kneeling on wooden benches at prayer meetings in black churches. This fragile existential weaponry—rooted in silent tears and weary lament—supports black endurance against madness and suicide. The primal black cries and moans lay bare the profoundly tragic character of black life. Ironically, they also embody and enact the life-preserving content of black styles—creative ways of fashioning power and strength through the body and language that yield black joy and ecstasy.

The great W. E. B. Du Bois captures this primal scene of black culture at the beginning of his classic *The Souls of Black Folk* (1903), in chapter 1, "Of Our Spiritual Strivings." He starts with thirteen lines from the poem "The Crying of Water," by Arthur Symons, the noteworthy symbolist critic and poet who went mad a few months after its composition. The hearts of human beings in a heartless civilization that refuses to see their humanity cries out like the sea: "All night long crying without avail/As the water all night long is crying to me."

This metaphorical association of black hearts, black people, and black culture with water, the sea, or a river runs deep in black artistic expression—as in Langston HUGHES's recurring refrain "My soul has grown deep like the rivers" in his classic poem "The Negro Speaks of Rivers." Black striving resides primarily in movement and motion, resilience and resistance against the resoluteness of madness and the stillness of death.

Du Bois continues with the musical bars of the Negro spiritual "Nobody Knows the Trouble I've Seen," known not simply for its plaintive melody but also for its inexplicable lyric reversal.

> Nobody knows the trouble I've seen
> Nobody knows but Jesus
> Nobody knows the trouble I've seen
> Glory hallelujah!

This exemplary shift from a mournful brooding to a joyful praising results from life-enhancing efforts to look life's abyss in the face and keep "keepin' on"—with only the integrity of style, song, and the spirituality of a beloved community (Jesus' proclamation of the Kingdom).

The first of Du Bois' own words in the text completes the primeval scene of black culture—the fully crystallized problematic of black invisibility and namelessness.

> Between me and the other world there is ever an unasked question: unasked by some through feelings of delicacy; by others through the difficulty of rightly framing it. All, nevertheless, flutter round it. They approach me in a half-hesitant sort of way, eye me curiously or compassionately, and then, instead of saying directly, How does it feel to be a problem? They say, I know an excellent colored man in my town; or I fought at Mechanicsville; or, do not these Southern outrages make your blood boil? At these I smile, or am interested, or reduce the boiling to a simmer, as the occasion may require. To the real question, How does it feel to be a problem? I answer seldom a word.
>
> And yet, being a problem is a strange experience—peculiar even for one who has never been anything else, save perhaps in babyhood. . . .

This seminal passage contains the basic components of the problematic of black invisibility and namelessness: black people as a problem people rather than people with problems; black people as abstractions and objects rather than individuals and persons; black and white worlds divided by a thick wall (or a veil) that requires role-playing and mask-wearing rather than genuine humane interaction; black rage, anger, and fury concealed to assuage white fear and anxiety; and black rootlessness and homelessness on a perennial journey to discover who they are in an American civilization content with blacks as the permanent underdog.

To view black people as a problem people is to view them as an undifferentiated blob, a homogenous bloc or monolithic conglomerate. Each black person is interchangeable or substitutable since all black people are believed to have the same views and values, sentiments and sensibilities. Hence, one set of negative stereotypes holds for all of them, regardless of how high certain blacks may ascend in the white world ("savages in a suit or suite"). And the mere presence of one black person in a white context generates white unease or dis-ease, even among whites of goodwill.

This problematizing of black humanity deprives blacks of individuality, diversity, and heterogeneity. It reduces black people to the level of abstractions and objects constructed by white aspirations and insecurities.

The celebrated opening passage of Ralph ELLISON's classic novel *Invisible Man* (1952) highlights this reduction:

> I am an invisible man. No, I am not a spook like those who haunted Edgar Allan Poe; nor am I

one of your Hollywood-movie ectoplasms. I am a man of substance, of flesh and bone, fiber and liquids—and I might even be said to possess a mind. I am invisible, understand, simply because people refuse to see me, like the bodiless heads you see sometimes in circus sideshows, it is as though I have been surrounded by mirrors of hard, distorting glass. When they approach me they see only my surroundings, themselves, or figments of their imaginations—indeed, everything and anything except me.

This distorted perception—or the failure to see the humanity and individuality of black people—results primarily from the historic "veil" that separates the black and white worlds. This veil not only precludes honest communication because blacks and whites, it also propels blacks to live in two worlds in order to survive. Whites need not understand or live in the black world in order to thrive. But blacks must grapple with the painful "double-consciousness" that may result in "an almost morbid sense of personality and a moral hesitancy which is fatal to self-confidence." Du Bois notes,

> The worlds within and without the Veil of Color are changing, and changing rapidly, but not at the same rate, not in the same way; and this must produce a peculiar wrenching of the soul, a peculiar sense of doubt and bewilderment. Such a double life, with double thoughts, double duties, and double social classes, must give rise to double words and double ideals, and tempt the mind to pretence or to revolt, to hypocrisy or to radicalism.

Echoing Paul Laurence DUNBAR's famous poem "We Wear the Mask," Du Bois proclaims that "the price of culture is a Lie." Why? Because black people will not succeed in American civilization if they are fully and freely themselves. Instead they must "endure petty insults with a smile, shut [their] eyes to wrong." They must not be too frank and outspoken or fail to flatter and be pleasant in order to lessen white unease and discomfort. Needless to say, this is not the raw stuff for healthy relations between black and white people.

Yet this suppression of black rage, anger, and fury—the reducing "the boiling to a simmer"—backfires in the end. It reinforces a black obsession with the scars, wounds, and bruises that may easily reduce the tragic to the pathetic. Instead of exercising agency or engaging in action against the odds, one may wallow in self-pity after acknowledging the sheer absurdity of it all. After playing the role and wearing the mask in the white world, one may accept the white world's view of one's self. As Du Bois writes: "It is a peculiar sensation, this double-consciousness, this sense of always looking at one's self through the eyes of others, of measuring one's soul by the tape of a world that looks on in amused contempt and pity."

Toni Morrison portrays a moving example of this dilemma of black culture in the character of Sweet Home in her profound novel *Beloved* (1987): ". . . for sadness was at her center, the desolated center where the self that was no self made its home."

This theme of black rootlessness and homelessness is inseparable from black namelessness. When James Baldwin writes about these issues—*Nobody Knows My Name* (1961) and *No Name in the Street* (1972)—he is trying to explore effective ways to resist the white supremacist imposition of the black subordinate role, place, station, and identity. He is attempting to secure some set of existential strategies against the overwhelming onslaught of white dehumanization, devaluation, and degradation. The search for black space (home), black place (roots), and black face (name) is a flight from the visceral effects of white supremacy. Toni Morrison characterizes these efforts as products of a process of "dirtying you":

> That anybody white could take your whole self for anything that came to mind. Not just work, kill, or maim you, but dirty you. Dirty you so bad you couldn't like yourself anymore. Dirty you so bad you forgot who you were and couldn't think it up.

Toni Morrison's great novel has a privileged place in black culture precisely because she pushes this dilemma to its ultimate consequence—the black flight from white supremacy (a chamber of horrors for black people) may lead to the murder of those who are candidates for the dirtying process. The black mother, Sethe, kills her daughter, Beloved, because she loved her so, "to out-hurt the hurter," as an act of resistance to the dirtying process.

> And though she and others lived through and got over it, she could never let it happen to her own. The best thing she was, was her children. Whites might dirty *her* all right, but not her best thing, her beautiful magical best thing—the part of her that was clean. No undreamable dreams about whether the headless, feetless torso hanging in the tree with a sign on it was her husband Paul A; whether the bubbling-hot girls in the colored-school fire set by patriots included her daughter; whether a gang of whites invaded her daughter's private parts, soiled her daughter's thighs and threw her daughter out of the wagon. *She* might have to work the slaughterhouse yard, but not her daughter.
> And no one, nobody on this earth, would list her daughter's characteristics on the animal side of

the paper. No. Oh no . . . Sethe had refused—and refused still.

. . . what she had done was right because it came from true love.

Is death the only safe black space (home), place (roots), and face (name) from a pervasive white supremacy? Toni Morrison's Sethe echoes Du Bois's own voice upon the painful passing of his firstborn:

> . . . but love sat beside his cradle, and in his ear wisdom waited to speak. Perhaps now he knows the all-love, and needs not to be wise. Sleep, then, child—sleep till I sleep and waken to a baby voice and the ceaseless patter of little feet—above the Veil.

The most effective and enduring black responses to the problematic of black invisibility and namelessness are forms of black resistance predicated on a deep and abiding black love. These responses take the form of prophetic thought and action: bold, fearless, and courageous attempts to bear witness to black suffering and keep faith with a vision of black redemption. Like the urtexts of the guttural cry and wrenching moan—enacted in Charlie PARKER's bebop sound, James BROWN's funk, or Aretha FRANKLIN's GOSPEL sound—the prophetic utterances that focus on black suffering and sustain a hope against hope for black freedom constitute the heights of black culture. The spiritual depths of Martin Luther KING's visionary speeches, Martin PURYEAR's unique sculpture, Jacob LAWRENCE's powerful paintings, Marvin GAYE's risky falsettos, Fannie Lou HAMER's fighting songs, and above all, John Coltrane's *A Love Supreme* constitute such heights. Two of the greatest moments in black literature also exemplify such performances. First, James Baldwin's great self-descriptive visionary passage in *Go Tell It on the Mountain* (1952):

> Yes, their parts were all cut off, they were dishonored, their very names were nothing more than dust blown disdainfully across the field of time—to fall where, to blossom where, bringing forth what fruit hereafter, where?—Their very names were not their own. Behind them was the darkness, nothing but the darkness, and all around them destruction, and before them nothing but the fire—a bastard people, far from God, singing and crying in the wilderness!
>
> Yet, most strangely, and from deeps not before discovered, his faith looked up; before the wickedness that he saw, the wickedness from which he fled, he yet beheld like a flaming standard in the middle of the air, that power of redemption to which he must, till death, bear witness; which, though it crush him utterly, he could not deny; though none among the living might ever behold it, *he* had beheld it, and must keep the faith.

For Baldwin, the seemingly impossible flight from white supremacy takes the form of a Chekhovian effort to endure lovingly and compassionately, guided by a vision of freedom and empowered by a tradition of black love and faith. To be a bastard people—wrenched from Africa and in, but never fully of, America—is to be a people of highly limited options. To bear witness is to make and remake, invent and reinvent oneself as a person and people by keeping faith with the best of such earlier efforts, yet also to acknowledge that the very new selves and peoples to emerge will never fully find a space, place, or face in American civilization—or in Africa. This perennial process of self-making and self-inventing is propelled by a self-loving made possible by the overcoming of a decolonized mind, body, and soul.

This is precisely what Toni Morrison describes in the great litany of black love in Baby Suggs's prayer and sermon of laughter, dance, tears, and silence in "a wide-open place cut deep in the woods nobody knew for what at the end of a path known only to deer and whoever cleared the land in the first place." On those hot Sunday afternoons, Baby Suggs "offered up to them her great big heart":

> She told them that the only grace they could have was the grace they could imagine, that if they could not see it, they would not have it.
>
> "Here," she said, "in this here place, we flesh; flesh that weeps, laughs; flesh that dances on bare feet in grass. Love it. Love it hard. Yonder they do not love your flesh. They despise it. They don't love your eyes; they'd just as soon pick 'em out. No more do they love the skin on your back, yonder they flay it. And O my people they do not love your hands. Those they only use, tie, bind, chop off and leave empty. Love your hands! Love them. Raise them up and kiss them. Touch others with them, pat them together, stroke them on your face 'cause they don't love that either. *You* got to love it, *you!* And no, they ain't in love with your mouth. Yonder, out there, they will see it broken and break it again. What you say out of it they will not heed. What you scream from it they do not hear. What you put into it to nourish your body they will snatch away and give you leavins instead. No, they don't love your mouth. *You* got to love it. This is flesh I'm talking about here. Flesh that needs to be loved. Feet that need to rest and to dance; backs that need support; shoulders that need arms, strong arms, I'm telling you. And O my people, out yonder, hear me, they do not love your neck unnoosed and straight. So love your neck; put a hand on it, grace it, stroke it and hold it up. And all your inside parts that they'd just as soon slop for hogs, you got to love them. The dark, dark liver—love it, love it, and the beat and beating heart, love that too. More than eyes or

feet. More than lungs that have yet to draw free air. More than your life-holding womb and your life-giving private parts, hear me now, love your heart. For this is the prize." Saying no more, she stood up and then danced with her twisted hip the rest of what her heart had to say while the others opened their mouths and gave her the music. Long notes held until the four-part harmony was perfect enough for their deeply loved flesh.

In this powerful passage Toni Morrison depicts in a concrete and graphic way, the enactment and expression of black love, black joy, black community, and black faith that bear witness to black misery and keep alive a vision of black possibility. Black bonds of affection, black networks of support, black ties of empathy, and black harmonies of spiritual camaraderie provide the grounds for the fragile existential weaponry to combat black invisibility and namelessness.

Yet this most effective of strategies in black culture has not successfully come to terms with the problematic of black invisibility and namelessness. The black collective quest for a name that designates black people in the U.S.A. continues—from colored, Negro, black, Afro-American, Abyssinian, Ethiopian, Nubian, Bilalian, American African, American, African, to African American. The black individual quest for names goes on with new, unique ones for children in order to set them apart from all others for the purpose of accenting their individuality and offsetting their invisibility. And most importantly, black rage proliferates—sometimes unabated.

Of all the hidden injuries of blackness in American civilization, black rage is the most deadly, the most lethal. Although black culture is in no way reducible to or identical with black rage, black culture is inseparable from black rage. Du Bois's renowned eulogy for the towering nineteenth-century black intellectual Alexander CRUMMELL is one of the most penetrating analyses of black rage. Du Bois begins his treatment with a virtually generic description of black childhood:

This is the history of a human heart—the tale of a black boy who many long years ago began to struggle with life that he might know the world and know himself. Three temptations he met on those dark dunes that lay gray and dismal before the wonder-eyes of the child: the Temptation of Hate, that stood out against the red dawn; the Temptation of Despair, that darkened noonday; and the Temptation of Doubt, that ever steals along with twilight. Above all, you must hear of the vales he crossed—the Valley of Humiliation and the Valley of the Shadow of Death.

Black self-hatred and hatred of others indeed are continuous with the hatred of all human beings who must gain some sense of themselves and the world. But the tremendous weight of white supremacy makes this human struggle for mature black selfhood even more difficult. As black children come to view themselves more and more as the degraded other, the temptation of hate grows, "gliding steadily into their laughter, fading into their play, and seizing their dreams by day and night with rough, rude turbulence. So [they] ask of sky and sun and flower the never-answered Why? And love, as they grow, neither the world nor the world's rough ways."

The two major options in black culture (or any culture) for those who succumb to the temptation of hate are a self-hatred that leads to self-destruction or a hatred of others—degraded others—that leads to vengeance of some sort. These options often are two sides of the same coin. The case of Bigger Thomas, portrayed by Richard WRIGHT in his great novel *Native Son* (1940), is exemplary in this regard:

Bigger's face was metallically black in the strong sunlight. There was in his eyes a pensive, brooding amusement, as of a man who had been long confronted and tantalized by a riddle whose answer seemed always just on the verge of escaping him, but prodding him irresistibly on to seek its solution. The silence irked Bigger; he was anxious to do something to evade looking so squarely at this problem.

The riddle Bigger seeks an answer for is the riddle of his black existence in America—and he evades it in part because the pain, fear, silence, and hatred cut so deep. Like the "huge black rat" with which the novel begins, Bigger reacts to his circumstances out of instinct. Yet his instinct to survive is intertwined with his perception that white supremacy is out to get him. To make himself and invent himself as a black person in America is to strike out against white supremacy—out of pain, fear, silence, and hatred. The result is psychic terror and physical violence—against Bessie and Mary:

Bigger rose and went to the window. His hands caught the cold steel bars in a hard grip. He knew as he stood there that he could never tell why he had killed. It was not that he did not really want to tell, but the telling of it would have involved an explanation of his entire life. The actual killing of Mary and Bessie was not what concerned him most; it was knowing and feeling that he could never make anybody know what had driven him to it. His crimes were known, but what he had felt before he committed them would never be known. He would have gladly admitted his guilt if he had thought that in doing so he could have also given in the same breath a sense of the deep, choking hate that had been his life, a hate that he had not wanted to have, but could not help hav-

ing. How could he do that? The impulsion to try to tell was as deep as had been the urge to kill.

The temptation to hate is a double-edged sword. Bigger's own self-hatred leads him not only to hate other blacks but also to deny the humanity of whites. Yet he can overcome this self-hatred only when he views himself as a self-determining agent who takes responsibility for his actions and acknowledges his relations with others. Although Wright has often been criticized for casting Bigger as pitiful victim, subhuman monster, and isolated individualist—as in James Baldwin's "Everybody's Protest Novel" and "Many Thousands Gone" in *Notes of a Native Son* (1955)—Wright presents brief moments in which Bigger sees the need for transcending his victim status and rapacious individualism. When his family visits him in jail, Bigger responds to their tears and anger.

> Bigger wanted to comfort them in the presence of the white folks, but did not know how. Desperately, he cast about for something to say. Hate and shame boiled in him against the people behind his back; he tried to think of words that would defy them, words that would let them know that he had a world and life of his own in spite of them.

Wright does not disclose the internal dynamics of this black world of Bigger's own, but Bigger does acknowledge that he is part of this world. For example, his actions had dire consequences on his sister, Vera.

> "Bigger," his mother sobbed, trying to talk through her tears. "Bigger, honey, she won't go to school no more. She says the other girls look at her and make her 'shamed. . . ."
> He had lived and acted on the assumption that he was alone, and now he saw that he had not been. What he had done made others suffer. No matter how much he would long for them to forget him, they would not be able to. His family was a part of him, not only in blood, but in spirit. He sat on the cot and his mother knelt at his feet. Her face was lifted to his; her eyes were empty, eyes that looked upward when the last hope of earth had failed.

Yet even this family connection fails to surmount the layers of hate Bigger feels for himself and them. It is only when Bigger receives unconditional support and affirmation across racial lines that his self-hatred and hatred of others subside—for a moment.

> He looked at Jan and saw a white face, but an honest face. This white man believed in him, and the moment he felt that belief he felt guilty again; but in a different sense now. Suddenly, this white man had come up to him, flung aside the curtain and walked into the room of his life. Jan had spoken a declaration of friendship that would make other white men hate him: a particle of white rock had detached itself from that looming mountain of white hate and had rolled down the slope, stopping still at his feet. The word had become flesh. For the first time in his life a white man became a human being to him; and the reality of Jan's humanity came in a stab of remorse: he had killed what this man loved and had hurt him. He saw Jan as though someone had performed an operation upon his eyes, or as though someone had snatched a deforming mask from Jan's face.

In both instances, Bigger lurches slightly beyond the temptation of hate when he perceives himself against an agent and subject capable of producing consequences for which he is responsible. These consequences consist of a sister and friend victimized owing to his actions. Yet the depths of his self-hatred—his deep-seated colonized mind—permits only a glimpse of self-transformation when the friendship of a white significant other is extended to him.

Similar to Bigger Thomas, Alexander Crummell is inspired by a white significant other: Beriah Green. This sympathetic affirmation makes the temptation of hate grow "fainter and less sinister. It did not wholly fade away, but diffused itself and lingered thick at the edges." Both Bigger and Alexander reveal the tremendous pull of the white world and the tragic need for white inspiration and affirmation among so many black people caught in the dilemma of black invisibility and namelessness.

The temptation of despair is the second element in Du Bois's analysis of black rage. This temptation looms large when black folk conclude that "the way of the world is closed to me." This conclusion yields two options: nihilism and hedonism. Again, two sides of the same coin. This sense of feeling imprisoned, bound, constrained, and circumscribed is a dominant motif in black cultural expressions. Again, Wright captures this predicament well with Bigger Thomas.

> "Goddammit!"
> "What's the matter?"
> "They don't let us do *nothing*."
> "Who?"
> "The *white* folks."
> "You talk like you just now finding that out," Gus said.
> "Naw. But I just can't get used to it," Bigger said. "I swear to God I can't. I know I oughtn't think about it, but I can't help it. Every time I think about it I feel somebody's poking a red-hot iron down my throat. Goddammit, look! We live here and they live there. We black and they white. They got things and we ain't. They do things and we can't. It's just like living in jail.

Half the time I feel like I'm on the outside of the world peeping in through a knot-hole in the fence. . . ."

The temptation of despair is predicated on a world with no room for black space, place, or face. It feeds on a black futurelessness and black hopelessness—a situation in which visions and dreams of possibility have dried up like raisins in the sun. This nihilism yields lives of drift, lives in which any pleasure, especially instant gratification, is the primary source of feeling alive. Aggression usually surfaces in such living. Bigger says: "I hurt folks 'cause I felt I had to; that's all. They was crowding me too close; they wouldn't give me no room. . . . I thought they was hard and I acted hard. . . . I'll be feeling and thinking that they didn't see me and I didn't see them."

The major black cultural response to the temptation of despair is the black Christian tradition—a tradition dominated by music in song, prayer, and sermon. The unique role of this tradition is often noted. Du Bois writes:

> . . . That the Negro church antedates the Negro home, leads to an explanation of much that is paradoxical in this communistic institution and in the morals of its members. But especially it leads us to regard this institution as peculiarly the expression of the inner ethical life of a people in a sense seldom true elsewhere.

Even Bigger Thomas—the most cynical and secular of rebels in the black literary tradition—is captivated by the power of black church music:

> The singing from the church vibrated through him, suffusing him with a mood of sensitive sorrow. He tried not to listen, but it seeped into his feelings, whispering of another way of life and death. . . . The singing filled his ears; it was complete, self-contained, and it mocked his fear and loneliness, his deep yearning for a sense of wholeness. Its fullness contrasted so sharply with his hunger, its richness with his emptiness, that he recoiled from it while answering it.

The black church tradition—along with the rich musical tradition it spawned—generates a sense of movement, motion, and momentum that keeps despair at bay. As with any collective project or performance that puts a premium on change, transformation, conversion, and future possibility, the temptation of despair is not eliminated but attenuated. In this sense, the black church tradition has made a ritual art out of black invisibility and namelessness. Ralph Ellison updates this black endeavor when he writes:

> Perhaps I like Louis Armstrong because he's made poetry out of being invisible. I think it must because he's unaware that he *is* invisible. And my own grasp of invisibility aids me to understand his music. . . . Invisibility, let me explain, gives one a slightly different sense of time, you're never quite on the beat. Sometimes you're ahead and sometimes behind. Instead of the swift and imperceptible flowing of time, you are aware of its nodes, those points where time stands still or from which it leaps ahead. And you slip into the breaks and look around. That's what you hear vaguely in Louis' music.

For a fuller and richer elaboration of this Ellisonian insight, the classic works of Albert Murray, *Stomping the Blues* and *The Hero and the Blues,* are peerless.

The temptation of doubt is the most persistent of the three temptations. White supremacy drums deeply into the hearts, minds, and souls of black people to expect little of one another and one's self. Such sad, self-fulfilling prophecies make the temptation of doubt an especially seductive one—one which fans and fuels the flames of black rage. Du Bois states:

> Of all the three temptations, this one struck the deepest. Hate? He had outgrown so childish a thing. Despair? He had steeled his right arm against it, and fought it with the vigor of determination. But to doubt the worth of his lifework—to doubt the destiny and capability of the race his soul loved because it was his; to find listless squalor instead of eager endeavor; to hear his own lips whispering, "they do not care; they cannot know; they are dumb driven cattle—why cast your pearls before swine?"—This, this seemed more than man could bear; and he closed the door, and sank upon the steps of the chancel, and cast his robe upon the floor and writhed.

The two principal options for action after one yields to the temptation of doubt in black culture are authoritarian imposition from above upon the "ignorant" masses or individual escape from them into the white mainstream. These two options are not two sides of the same coin, though they often flow from a common source: an elitist vision that shuns democratic accountability. And though this elitist vision—that of the exceptional Negro who is "better than those other blacks"—is found more readily among the black educated and middle class, some of the black working poor and very poor subscribe to it, too. Even Bigger Thomas:

> As he rode, looking at the black people on the sidewalks, he felt that one way to end fear and shame was to make all those black people act together, rule them, tell them what to do, and make them do it . . . But he felt that such would never happen to him and his black people, and he hated them and wanted to wave his hand and blot them out. Yet, he still hoped, vaguely. Of

late he had liked to hear tell of men who could rule others, for in actions such as these he felt that there was a way to escape from this tight morass of fear and shame that sapped at the base in his life. He liked to hear of how Japan was conquering China; of how Hitler was running Jews to the ground; of how Mussolini was invading Spain. He was not concerned with whether these acts were right or wrong; they simply appealed to him as possible avenues of escape. He felt that someday there would be a black man who would whip the black people into a tight band and together they would act and end fear and shame. He never thought of this in precise mental images; he felt it; he would feel it for a while and then forget. But hope was always waiting somewhere deep down in home.

This hope for black unity and action was based on a profound doubt regarding black people's ability to think for themselves and act on principles they examined, scrutinized, and chose. Ironically, this same elitist logic is at work among those who uncritically assimilate into the white mainstream and trash other blacks for lacking discipline and determination. Alexander Crummell overcame the difficult challenge of self-doubt and doubt of other black folk by moving to Africa and later returning to America to fight for and "among his own, the low, the grasping, and the wicked, with that unbending righteousness which is the sword of the just."

In the end, Alexander Crummell triumphed over hate, despair, and doubt owing to "that full power within that mighty inspiration" within the veil. He was able to direct his black rage through moral channels sustained by primarily black bonds of affection, black networks of support, and black ties of empathy. Yet few today know his name and work, principally owing to the thick veil of color then and now.

> His name today, in this broad land, means little, and comes to fifty million ears laden with no incense of memory or emulation, and herein lies the tragedy of the age: not that men are poor—all men know something of poverty; not that men are wicked—who is good? Not that men are ignorant—what is Truth? Nay, but that men know so little of men.

For Du Bois, "the problem of the twentieth century is the problem of the color line" primarily because the relative lack of communication across the veil of color precludes a critical and candid examination of the weight and gravity of the problematic of black invisibility and namelessness in the shaping of modernity and American civilization. And since communication is the lifeblood of a democracy—the very measure of the vitality of its public life—we either come to terms with race and hang together or ignore it and hang separately. This is why every examination of black culture is integral to the prevailing crisis of race raging in America; our very future in America may well depend on it.

REFERENCES

BALDWIN, JAMES. *Go Tell It on the Mountain.* New York, 1953.
———. *Nobody Knows My Name.* New York, 1961.
———. *No Name in the Street.* New York, 1972.
———. *Notes of a Native Son.* New York, 1955.
CRUMMELL, ALEXANDER. *The Future of Africa.* 1862. Reprint. New York, 1969.
DU BOIS, W. E. B. *The Souls of Black Folk.* Chicago, 1903.
ELLISON, RALPH. *Invisible Man.* New York, 1952.
———. *Shadow and Act.* New York, 1964.
MORRISON, TONI. *Beloved.* New York, 1987.
MURRAY, ALBERT. *The Hero and the Blues.* Columbia, Mo. 1973.
———. *Stomping the Blues.* New York, 1989.
WEST, CORNEL. *Keeping Faith.* New York, 1993.
———. *Prophesy Deliverance.* Louisville, Ky., 1982.
———. *Prophetic Reflections.* Monroe, Maine, 1993.
———. *Prophetic Thought in Postmodern Times.* Monroe, Maine, 1993.
WRIGHT, RICHARD. *Native Son.* New York, 1940.

CORNEL WEST

Black Manifesto. Prepared by James FORMAN with the assistance of the League of Black Revolutionary Workers and adopted by the National Black Economic Development Conference (NBEDC) in Detroit, Mich., on April 26, 1969, the Black Manifesto called on white churches and synagogues to pay $500 million (about $15 per black person) in reparations for black enslavement and continuing oppression. The money would fund projects to benefit blacks, including the establishment of a southern land bank, four television networks, and a black university. The manifesto indicted white religious organizations for complicity in American racism and called on blacks to bring whatever pressure was necessary to force churches and synagogues to comply.

On May 4, 1969, the date set by the manifesto to start disrupting religious institutions, Forman took the pulpit in the middle of services at New York City's Riverside Church and demanded reparations. Riverside Church was selected because of its connections with the Rockefeller family, viewed by the manifesto's authors as classic white oppressors. Some predominantly white churches expressed some sympathy with the aims of the manifesto but primarily increased aid to existing or new programs of their own rather than providing money for the reparations

fund. Forman's call did raise about half a million dollars, about $200,000 from Riverside Church alone. Many prominent black organizations, including the NAACP and the National Baptist Convention, distanced themselves from the call for reparations and urged that money be given to them for related purposes instead.

By mid-May 1969 both the FBI and the Justice Department had begun investigations into the NBEDC. The money raised by the manifesto was used by the Interreligious Foundation for Community Projects for a number of projects, including the funding of Black Star Publications, a revolutionary black publishing house in Detroit, connected to James Forman.

REFERENCES

FORMAN, JAMES. *The Making of Black Revolutionaries.* Seattle, Wash., 1985.

HAINES, HERBERT H. *Black Radicals and the Civil Rights Mainstream, 1954–1970.* Knoxville, Tenn., 1988.

JEANNE THEOHARIS

Black Panther Party for Self-Defense. Huey P. NEWTON and Bobby SEALE founded the Black Panther Party for Self-Defense in October 1966, and despite periods of imprisonment, they remained leaders as the party expanded from its Oakland, Calif., base to become a national organization. Assuming the posts of defense minister and chairman, respectively, of the new group, Newton and Seale drafted a ten-point program and platform that included a wide range of demands, summarized in the final point: "We want land, bread, housing, education, clothing, justice and peace." Rather than on its program, however, the party's appeal among young African Americans was based mainly on its brash militancy, often expressed in confrontations with police. Initially concentrated in the San Francisco Bay area and Los Angeles, by the end of 1968 the Black Panther party ("for Self-Defense" was dropped from its name) had formed chapters in dozens of cities throughout the United States, with additional support chapters abroad. Although most of its leaders were male, a substantial proportion of its rank-and-file members were female. Influenced by the ideas of Marx and MALCOLM X, the Black Panther Party's ideology was not clearly defined, and the party experienced many internal disputes over its political orientation. The FBI's covert Counterintelligence Program (COINTELPRO) and raids by local police forces exacerbated leadership conflicts, resulted in the imprisonment or death of party members, and hastened the decline of the group after 1968.

After joining the party in 1967, Eldridge CLEAVER, a former convict and author of a book of essays called *Soul on Ice,* became one of the party's main spokespersons and a link with white leftist supporters. Arrested in May 1967 during a protest at the California state capitol in Sacramento against pending legislation to restrict the carrying of weapons, Cleaver remained affiliated with the Panthers despite repeated efforts of authorities to return him to prison for parole violations. His caustic attacks on white authorities combined with media images of armed Panthers wearing black leather jackets attracted notoriety and many recruits during the summer of 1967. Cleaver's prominence in the Black Panther party increased after October 28, 1967, when Newton was arrested after an altercation that resulted in the death of an Oakland police officer. The Panthers immediately mobilized to free Newton, who faced a possible death sentence if convicted. As part of this support effort, Cleaver and Seale contacted Stokely CARMICHAEL, former chairman of the STUDENT NONVIOLENT COORDINATING COMMITTEE (SNCC) and a nationally

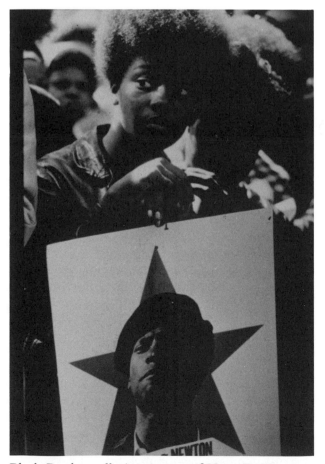

Black Panther rally in support of Huey P. Newton, May 1, 1969. (© Alan Copeland/Black Star)

known proponent of black power. SNCC activists and representatives from other black militant groups participated in "Free Huey" rallies during February 1968, helping to transform the Panthers from a local group into a national organization. When Cleaver was arrested during an April 6 raid that resulted in the killing of party treasurer Bobby Hutton, his parole was revoked, and his legal defense, as well as that of Newton, became a major focus of Panther activities.

Serious conflicts accompanied the party's rapid growth, however, for its leaders divided over ideological and tactical issues. Cleaver and Seale were unsuccessful in their effort to forge an alliance with SNCC, whose members distrusted the Panthers' hierarchical leadership style. When relations between the two groups soured during the summer of 1968, Carmichael decided to remain allied with the Panthers, but his advocacy of black unity and Pan-Africanism put him at odds with other Panther leaders, who advocated class unity and close ties with the white New Left. Although his presence helped the Panthers to establish strong chapters in the eastern United States, Carmichael severed ties with the party after he established residency in Africa in 1969. The party's relations with southern California followers of black nationalist Maulana Karenga also deteriorated, a result both of the FBI's COINTELPRO efforts and the Panthers' harsh criticisms of Karenga's cultural nationalist orientation. In January 1969, two members of Karenga's U.S. organization killed two Panthers during a clash at UCLA.

Although the Black Panther party gradually shifted its emphasis from revolutionary rhetoric and armed confrontations with police to "survival programs," such as free breakfasts for children and educational projects, clashes with police and legal prosecutions decimated the party's leadership. Soon after finishing his 1968 presidential campaign as candidate of the Peace and Freedom party, Cleaver left for exile in Cuba and then Algeria to avoid returning to prison for parole violation. In March 1969, Seale was arrested for conspiracy to incite rioting at the 1968 Democratic convention in Chicago, and in May, Connecticut officials charged Seale and seven other Panthers with murder in the slaying of party member Alex Rackley, who was believed to be a police informant. In New York, twenty-one Panthers were charged with plotting to assassinate policemen and blow up buildings. Though nearly all charges brought against Panther members either did not result in convictions or were overturned on appeal, the prosecutions absorbed much of the party's resources. An effort during 1969 to purge members considered disloyal or unreliable only partly succeeded.

In 1970, when Newton's conviction on a lesser manslaughter charge was reversed on appeal, he re-turned to find the party in disarray. Seale still faced murder charges (they were dropped the following year). Chief of staff David Hilliard awaited trial on charges of threatening the life of President Richard Nixon. Some chapters, particular those in the eastern United States, resisted direction from the Oakland headquarters. In 1971, Newton split with Cleaver, in exile in Algeria, charging that the latter's influence in the party had caused it to place too much emphasis on armed rebellion. In 1973, Seale ran an unsuccessful, though formidable, campaign for mayor of Oakland. The following year Newton, facing new criminal charges and allegations of drug use, fled to Cuba. After Newton's departure, Elaine Brown took over leadership of the ailing organization. The Black Panther party continued to decline, however, and, even after Newton returned in 1977 to resume control, the group never regained its former prominence.

REFERENCES

BROWN, ELAINE. *A Taste of Power: A Black Woman's Story.* New York, 1992.
CLEAVER, ELDRIDGE. *Eldridge Cleaver: Post-Prison Writings and Speeches.* New York, 1969.
HEATH, G. LOUIS, ed. *Off the Pigs! The History and Literature of the Black Panther Party.* Metuchen, N.J., 1976.
HILLIARD, DAVID. *Side of Glory: Autobiography of David Hilliard and the Story of the Black Panthers.* Boston, 1993.
NEWTON, HUEY P. *Revolutionary Suicide.* New York, 1973.

CLAYBORNE CARSON

Black Patti. *See* Jones, M. Sissieretta "Black Patti."

Black Power Conference of Newark, 1967.

Continuing in the tradition of the antebellum Negro convention movement and the early twentieth-century PAN-AFRICAN CONGRESSES, the National Conference on Black Power was an assembly of more than 1,000 delegates representing 286 organizations and institutions from 126 cities in 26 states, Bermuda, and Nigeria. They met in the riot-torn New Jersey city of Newark from July 20 to 23, 1967, for the purpose of discussing the most pressing issues of the day. Headquartered at the Episcopal diocese of Newark, the delegates held workshops, presented papers, and developed more than eighty resolutions calling for specific programs of action in political, economic, and cultural affairs.

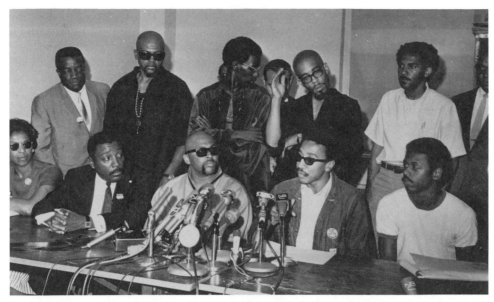

The opening session of a four-day conference on Black Power in Newark, N.J., included (seated, beginning second from left) comedian Dick Gregory; Maulana Ron Karenga, leader of the Black National Cultural Organization of the U.S.; H. Rap Brown, national chairman of the Student Nonviolent Coordinating Committee; and Ralph Featherstone, also of SNCC. The three men standing at the center in back are aides of Karenga's; the others are unidentified; July 20, 1967. (UPI/Bettmann)

Only one resolution, a "Black Power Manifesto," won official approval at the final plenary session, but others were adopted "in spirit" and were meant to be advisory to the continuing bodies established by the conference. These included calls for a dramatic increase in the number of black elected officials, the assignment of black police captains to black neighborhoods, the upgrading of jobs held by black workers, and the empowering of black boards of education and black school administrators in African-American communities.

Other resolutions proclaimed the right to self-defense, sought to initiate debate on the question of partitioning the United States into separate black and white nations, encouraged the study of black history, and urged support for the freedom struggles of non-white peoples. The manifesto condemned "neo-colonialist control" of black populations worldwide and called for the propagation of a "philosophy of Blackness" that would unite and direct the oppressed in common cause. Nathan Wright, Jr., was the conference chairman, and workshop coordinators included Ossie DAVIS, James FARMER, Hoyt Fuller, Nathan Hare, Maulana Ron KARENGA, Cleveland Sellers, and Chuck Stone.

REFERENCE

STONE, CHUCK. "The National Conference on Black Power." In Floyd B. Barbour, ed. *The Black Power Revolt,* pp. 189–198. Boston, 1968.

WILLIAM L. VAN DEBURG

Black Scholar. *Black Scholar* was established in 1969 as the journal of the Black World Foundation. The journal emerged out of the context of social struggle and black self-realization that characterized the Black Power movement and was planned as a medium through which African-American ideologies could be examined, discussed, and evaluated.

The original list of contributors included such black intellectuals and activists as the psychiatrist Prince Cobb; Charles V. Hamilton, professor of political science at Columbia University; Sonia SANCHEZ, poet and political activist; and Maulana Ron KARENGA, cultural nationalist and founder of US. Under the editorial leadership of Robert Chrisman, *Black Scholar* provided a forum for black poets such as Alice WALKER, Maya ANGELOU, and Gwendolyn BROOKS, as well as fiction writers Gayl JONES, Clarence MAJOR, John STEWART, and Woodie KING, Jr.

Black Scholar actively sought to bridge the gap between black academia and the black community through the promotion and support of BLACK STUDIES programs in colleges and universities. In addition, the *Black Scholar* contained community service items, such as "The Blackboard," a listing of news, events, conferences, and rallies; "The Speakers Bureau," through which speakers could be solicited; and the "Prisoner's Fund," which provided free issues of the journal to black prisoners.

Black Scholar was initially published monthly, but since 1982 it has appeared quarterly. It has remained financially self-sufficient, relying on no outside

sources other than subscriptions and selective advertisements. Its zenith of influence was in the mid-seventies; however, it has maintained its visibility into the nineties with a circulation base of 10,000. In 1992, a collection of essays, entitled *Court of Appeal: The Black Community Speaks Out on the Racial and Sexual Politics of Clarence Thomas vs. Anita Hill,* was published under the auspices of the *Black Scholar.*

REFERENCE

DANIEL, WALTER C. *Black Journals of the U.S.* Westport, Conn., 1982.

MANSUR M. NURUDDIN
ROBYN SPENCER

Black Star Line. *See* Universal Negro Improvement Association.

Black Studies. Black studies, also known as African studies, is "the multidisciplinary analysis of the lives and thought of people of African ancestry on the African continent and throughout the world" (Harris 1990, p. 7). Black studies is interdisciplinary; its earliest roots are in history, sociology, literature, and the arts. The field's most important concepts, methods, and findings are still centered within these disciplines.

Black studies consists of research; courses at the high school, college, and university levels; and organizational structures such as programs, centers, and departments. This entry focuses on the historical development of research in black studies in part because the research aspects of the field are much better documented in the literature than course offerings (Lyman 1972; Meier and Rudwick 1986). Also, there were few course offerings outside of historically black institutions prior to 1970 (Ford 1973). Readers can examine other sources for a discussion of organizational issues; they are beyond the scope of this entry (Harris, Hine, and McKay 1990; Hu-DeHart 1995). Because of its limited scope, this entry focuses on historical and sociological research in black studies; scholarship in literature and the arts is not discussed. Readers are referred to the following sources for treatment of these research areas: Baker and Redmond 1989; Campbell et al. 1987; Dallas Museum of Art 1989; Jackson 1989.

The typology of the development of black historical scholarship conceptualized by John Hope FRANKLIN (1986) is used to organize this entry. It is appropriate to use this typology to describe the historical development of black studies because history was the field's birthplace and remains an important center. Franklin describes four generations of scholarship in African-American history. These periods are not clearly distinct but are overlapping and interrelated.

The First Generation of Black Studies

The first period or generation is marked by the publication of what is generally regarded as the first history of African Americans in 1882, *History of the Negro Race in America* by George Washington WILLIAMS, published in two volumes (1882 and 1883). Williams, the first black to serve in the Ohio legislature, was not a professionally trained historian but was a gifted and interesting orator, writer, soldier, minister, journalist, lawyer, and politician. Other significant works published during this period included *The Suppression of the African Slave-Trade to the United States of America* by W. E. B. DU BOIS in 1896 and *Story of the Negro* by Booker T. WASHINGTON in 1909. Du Bois's book, a carefully researched and respected publication, was his Ph.D. thesis at Harvard.

An important goal of the writers during the first generation of African-American scholarship was to counteract the negative images and representations of African Americans that were institutionalized within academic and popular cultures. A key tenet of social science research of the time was that blacks were genetically inferior to whites and that Africa was the "dark continent" that lacked civilizations (Caldwell 1830; Ripley 1989). The AMERICAN NEGRO ACADEMY, founded in 1896, had as one of its major goals "to aid, by publications, the vindication of the race from vicious assaults, in all lines of learning and truth" (Moss 1981, p. 24).

It was also during this first generation that "early black literary associations sought to preserve and to publicize the legacy of African peoples" (Harris, Hine, and McKay 1990, p. 7), and black academics initiated research studies. In 1899, W. E. B. Du Bois published a landmark sociological study, *The Philadelphia Negro.* He implemented, at Atlanta University, a series of important studies from 1898 to 1914 known as the Atlanta University Studies. The series consists of more than sixteen monographs (Harris, Hines, and McKay 1990).

Carter G. Woodson and the Professionalization of Black Studies

The rise of Carter G. WOODSON as an influential scholar and the founding of the ASSOCIATION FOR THE STUDY OF AFRO-AMERICAN [formerly "Negro"] LIFE AND HISTORY (ASNLH) in 1915 signaled the beginning of a new era in black studies. Woodson,

his publications, and the people he mentored and influenced—such as Charles H. WESLEY and Rayford W. LOGAN—were destined to dominate the second generation of black studies.

Woodson probably had more influence on the teaching of African-American history in the nation's schools and colleges from the turn of the century until his death in 1950 than any other scholar. With others, he established the ASNLH. He founded the JOURNAL OF NEGRO HISTORY in 1916 and served as its editor until his death. It is one of Woodson's most significant contributions to the study and teaching of black studies. In 1921 Woodson established ASSOCIATED PUBLISHERS, a division of the ASNLH, to publish scholarly books and textbooks on African Americans. In addition to publishing Woodson's major books, Associated Publishers also published important books by scholars such as Horace Mann BOND and Charles H. Wesley.

Woodson, a former high school teacher, played a major role in popularizing African-American history and in promoting its study in the nation's black schools, colleges, churches, and fraternities. He initiated Negro History Week in 1926 to highlight the role that African Americans played in the development of the nation and to commemorate their contributions. In time, and with the vigorous promotion, efforts by the ASNLH and its branches throughout the nation, Negro History Week—later expanded to Afro-American History Month—became nationally recognized and celebrated (see BLACK HISTORY MONTH/NEGRO HISTORY WEEK). Woodson never intended for Negro History Week to be the only time of the year in which black history was taught. Rather, he viewed it as a time to highlight the ongoing study of black history that was to take place throughout the year.

In 1937 Woodson established the *Negro History Bulletin* to provide information on black history to elementary and secondary school teachers. He also wrote elementary and secondary school textbooks that were widely used in black schools, including *African Myths* (1928a), *Negro Makers of History* (1928b), and *The Story of the Negro Retold* (1935). His widely used and popular text *The Negro in Our History,* first published in 1922, was published in eleven editions.

More White Scholars Participate in Black Studies

The period from about 1945 to the late 1960s marked the third generation of African-American scholarship in history and the social sciences (Franklin 1986). Franklin notes that this period was characterized by an increasing legitimacy of the field and by the entrance of increasing numbers of white scholars. Prior to the 1940s, most of the research done in black studies was conducted by African-American scholars who taught at small, historically black institutions.

Between 1940 and 1960, whites began to publish significant works in black studies. The Swedish economist, Gunnar Myrdal, published *An American Dilemma: The Negro Problem and Modern Democracy* in 1944. Supported by the Carnegie Corporation and begun in 1939, it was the most expensive and comprehensive study of race relations ever undertaken in the United States. It is significant that a European—and not an African American—was chosen to direct the study. However, Myrdal drew heavily on the works of African-American scholars such as Allison Davis, W. E. B. Du Bois, E. Franklin FRAZIER, Ralph BUNCHE, and Charles S. JOHNSON. Some of these scholars wrote original papers for the Carnegie project.

Two European-American scholars who made significant contributions to black studies were Franz Boas, an anthropologist at Columbia University, and Robert E. Park, a sociologist at the University of Chicago. Boas challenged the dominant paradigm about race, which stated that some races were inferior to others and that the environment could have little influence on heredity (Stocking, 1974).

Park taught one of the first black studies courses at a predominantly white university. In the fall quarter of 1913, he taught the course "The Negro in America" at the University of Chicago (Bulmer 1984). Park was a leader in the "Chicago School" of sociology, which became distinguished for its empirical studies on cities and minority groups. Park also trained some of the nation's leading African-American sociologists, such as Charles S. Johnson, E. Franklin Frazier, and Horace CAYTON. Some of the influential books by Park's former students include *Shadow of the Plantation* by Johnson (1934) and *The Negro Family in the United States* by Frazier (1939/1966). St. Claire DRAKE, who also studied at Chicago, coauthored a seminal sociological study with Cayton, *Black Metropolis: A Study of Negro Life in a Northern City,* published in 1945.

Important historical works published by white scholars during this period included *The Peculiar Institution: Slavery in the Ante-Bellum South* by Kenneth M. Stampp (1956), *Slavery: A Problem in American Institutional and Intellectual Life* by Stanley Elkins (1959), and *Negro Thought in America, 1880–1915* by August Meier (1963).

African-American scholars continued to produce significant and landmark publications in black studies, even though their institutions provided them with little scholarly support. Among the influential historical works produced by African Americans during this period were *What the Negro Wants* by Rayford

Logan (1944); *The Negro in the American Revolution* (1961) and *Lincoln and the Negro* (1962) by Benjamin QUARLES; *The Free Negro in North Carolina,* 1790–1860 (1943) and *The Emancipation Proclamation* (1963) by John Hope Franklin. The first edition of John Hope Franklin's influential college textbook *From Slavery to Freedom: A History of Negro Americans* was published in 1947. It is still one of the most popular textbooks in African-American history.

A New Era of Black Studies Begins in the 1970s

Prior to 1970, most African-American students attended historically black colleges and universities in the southern and border states. One consequence of the CIVIL RIGHTS MOVEMENT of the 1960s was that an increasing number of African-American students attended predominantly white institutions, especially in the Midwest, East, and West. Many of these students, a significant percentage of whom were admitted to college through equal opportunity or open admission programs, were from working-class backgrounds. Many were the first children in their families to attend college. Their presence on college campuses was destined to have a significant influence on the curriculum and the ethnic makeup of the faculty.

During the late 1960s and early 1970s African-American students—often in strident voices that reflected their sense of marginalization on predominantly white campuses—made a number of demands on universities. These included demands for black studies programs, black professors, black cultural centers, and in some cases, separate dormitories.

In responding to the demands of African-American students—who were often joined by the black community and later by other students of color who made parallel demands—college and universities established black studies courses, programs, centers, and institutes. In time, a few of these programs and centers became departments. However, black studies programs in most colleges and universities do not enjoy departmental status even today (Hu-DeHart 1995).

In part because of the political climate out of which they emerged, black studies courses, programs, and centers had a rocky beginning in the early seventies. Many university administrators created instance programs and hired professors who did not have standard academic qualifications in order to silence ethnic protest. There was a shortage of individuals trained in black studies. Courses and programs were developing more rapidly than qualified individuals could be trained in doctoral programs. Another problem that haunted early black studies programs was the series of budget cuts that colleges and universities throughout the United States experienced in the 1970s and '80s. Because they were the last hired, many teachers and administrators in black studies programs were highly vulnerable to financial downturns.

Black studies programs and black studies scholarship have experienced a renaissance since the early 1970s. According to a report prepared by Robert L. Harris, Jr., Darlene Clark Hine, and Nellie McKay (1990) for the Ford Foundation on the status of black studies in the United States, most black studies programs have gained legitimacy on their campuses, are valued by campus administrators, and are becoming institutionalized. Because of the growth and increasing legitimization of black studies, more black professors are being hired on predominantly white campuses. Most black studies programs are undergraduate; however, a few are granting master's degrees. One department—the one at Temple University directed by Molefi K. Asante—established a doctoral program in 1988.

Despite their march down the road toward institutionalization, black studies programs still face important challenges as they enter the twenty-first century. These include retaining and acquiring new resources in an era of diminishing resources and aggressive budget cuts; attaining departmental status so they will gain needed control over budgets, tenure, and promotion; and educating and mentoring a new generation of scholars to whom the torch can be passed. Black studies programs must also determine the amount of time and resources to devote to a consistent research agenda and how much time to devote to the new wave of racist social science epitomized by the publication and public reception of *The Bell Curve* (Herrnstein and Murray 1994).

New Scholarship Since the 1970s

The period from 1970 to 1995 has been one of the most richly prolific periods in black studies scholarship. Many well-trained African-American scholars—who are teaching and doing research at some of the nation's most prestigious universities—have entered the field. They have written many significant and landmark publications. David L. Lewis's seminal biography of W. E. B. Du Bois was the recipient of the Pulitzer, Parkman, and Bancroft prizes in 1994 (Lewis 1993).

Important studies produced by black scholars since the 1970s include *The Signifying Monkey: A Theory of African-American Literary Criticism* by Henry Louis Gates, Jr. (1988); *Long Black Song: Essays in Black American Literature and Culture* by Houston A. Baker, Jr. (1972); *The Slave Community* by John W. Blassingame (1972); *Slave Culture: Nationalist Theory and The Foundations of Black America* by Sterling Stuckey (1987); *The Black Church in the African-American Ex-*

perience by C. Eric Lincoln and Lawrence H. Mamiya (1990); and *The Truly Disadvantaged* by William Julius Wilson (1987).

Many white scholars are also producing significant publications in black studies. Notable works written by white scholars since 1970 include *Roll, Jordan, Roll: The World the Slave Made* by Eugene D. Genovese (1972); *The Black Family in Slavery and Freedom, 1750–1925* by Herbert G. Gutman (1976); and *Black Culture and Black Consciousness* by Lawrence W. Levine (1977).

The Afrocentric Paradigm

In the 1980s the Afrocentric movement (*see* AFROCENTRICITY) became important within black studies. It has been influenced most significantly by Molefi K. Asante (1987, 1990) and his colleagues at Temple University. The Afrocentric paradigm is a radical critique of the Eurocentric ideology and research paradigm that, in the view of Afrocentric theorists, "masquerades as a universal view" in the various social science and applied disciplines (Asante 1987, p. 3). Afrocentricity, according to Asante (p. 6), means "placing African ideals at the center of any analysis that involves African culture and behavior." Afrocentrists believe that all knowledge is positional and that Eurocentric knowledge reinforces and legitimizes dominant group hegemony and structural inequality (Ani 1994).

Black Women's Studies

Another important challenge black studies faces is how to incorporate the new field of black women's studies into the discipline. Feminist researchers such as Stanlie E. James and Abena P. A. Busia (1993), Patricia Hill Collins (1990), and Angela Y. DAVIS (1981) have developed concepts, paradigms, and insights that describe the extent to which black women have been marginalized in black studies. They document ways in which black studies has traditionally been and still is primarily black men's studies. The title of one of the earliest edited works in black women's studies exemplifies this marginalization: *All the Women Are White, All the Blacks Are Men, but Some of Us Are Brave* (Gloria T. Hull, Patricia Bell Scott, and Barbara Smith, 1982). Write Betty Schmitz and colleagues (1995, p. 711), "A new field of study, black women's studies, emerged in part because of the failure of both black studies and women's studies to address adequately the experiences of women of African descent in the United States and throughout the world."

Black women's studies is a growing and significant field. Significant and influential scholarly works are published each year. An important early publication is an edited collection by Toni Cade (1970), *The Black Women.* Other notable works in the genre include *The Afro-American Women: Struggles and Images,* edited by Rosalyn Terborg-Penn and S. Harley (1978); and *When and Where I Enter* by Paula Giddings (1984). Major original, scholarly works include *Labor of Love, Labor of Sorrow: Black Women, Work, and the Family, from Slavery to the Present* by J. Jones (1985), a white scholar; and *Righteous Discontent: The Women's Movement in the Black Baptist Church, 1880–1920* by E. B. Higginbotham (1993).

In the early 1990s, a major collection of studies on African-American women and two important biographical volumes were published. *Black Women in United States History,* a sixteen-volume collection of studies and primary resources edited by eminent historian Darlene Clark Hine and colleagues, was published in 1990. This was a major publishing event in black women's studies. In 1992 *Notable Black American Women,* edited by Jessie Carney Smith, was published. *Black Women in America: An Historical Encyclopedia,* a landmark two-volume work, was published in 1993 and edited by Darlene Clark Hine; Elsa Barkley Brown and Rosalyn Terborg-Penn are the associate editors of this work.

The Future of Black Studies

Black studies seem anchored to face successfully its challenges related to its quest for legitimacy, financial constraints, and the need to be transformed so it can incorporate concepts and paradigms related to the experience of black women. If the field meets these challenges, not only will it be revitalized but so will the curricula of the nation's colleges and universities.

REFERENCES

ANI, MARIMBA. *Yurugu: An African-Centered Critique of European Cultural Thought and Behavior.* Trenton, N. J., 1994.

ASANTE, MOLEFI KENTE. *The Afrocentric Idea.* Philadelphia, 1987.

———. *Kemet, Afrocentricity, and Knowledge.* Trenton, N.J., 1990.

BAKER, HOUSTON A., JR. *Long Black Song: Essays in Black American Literature and Culture.* Charlottesville, Va., 1972.

BAKER, HOUSTON A., JR., and PATRICIA REDMOND, eds. *Afro-American Literary Study in the 1990s.* Chicago, 1989.

BLASSINGAME, JOHN W. *The Slave Community: Plantation Life in the Antebellum South.* New York, 1972.

BULMER, MARTIN. *The Chicago School of Sociology: Institutionalization, Diversity, and the Rise of Sociological Research.* Chicago, 1984.

CADE, TONI, ed. *The Black Women.* New York, 1970.

CALDWELL, CHARLES. *Thoughts on the Original Unity of the Human Race.* New York, 1830.

CAMPBELL, MARY S., DAVID DRISKELL, DAVID L. LEWIS, and DAVID W. RYAN. *Harlem Renaissance Art of Black America.* New York, 1987.

COLLINS, PATRICIA HILL. *Black Feminist Thought: Knowledge, Consciousness, and the Politics of Empowerment.* New York, 1990.

Dallas Museum of Art. *Black Art Ancestral Legacy: The African Impulse in African-American Art.* New York, 1989.

DAVIS, ANGELA Y. *Women, Race and Class.* New York, 1981.

DRAKE, ST. CLAIRE, and HORACE R. CAYTON. *Black Metropolis: A Study of Negro Life in a Northern City.* New York, 1945.

DU BOIS, W. E. B. *The Philadelphia Negro.* 1899. Reprint. Millwood, N. Y., 1973.

——— *The Suppression of the African Slave-Trade to the United States of America, 1638–1870.* Cambridge, Mass., 1896.

ELKINS, STANLEY M. *Slavery: A Problem in American Institutional and Intellectual Life.* New York, 1959.

FORD, NICK AARON. *Black Studies: Threat or Challenge?* Port Washington, N.Y., 1973.

FRANKLIN, JOHN HOPE. *The Emancipation Proclamation.* Garden City, N.Y., 1963.

———. *The Free Negro in North Carolina, 1790–1860.* New York, 1943.

———. *From Slavery to Freedom: A History of Negro Americans.* New York, 1947.

———. "On the Evolution of Scholarship in Afro-American History." In Darlene Clark Hine, ed. *The State of Afro-American History: Past, Present, and Future.* Baton Rouge, La., 1986, pp. 13–22.

FRAZIER, E. FRANKLIN. *The Negro Family in the United States.* 1939. Reprint. Chicago, 1966.

GATES, HENRY LOUIS, JR. *The Signifying Monkey: A Theory of African-American Literary Criticism.* New York, 1988.

GENOVESE, EUGENE D. *Roll, Jordan, Roll: The World the Slaves Made.* New York, 1972.

GIDDINGS, PAULA. *When and Where I Enter: The Impact of Black Women on Race and Sex in America.* New York, 1994.

GUTMAN, HERBERT G. *The Black Family in Slavery and Freedom, 1750–1925.* New York, 1976.

HARRIS, ROBERT L., JR., DARLENE CLARK HINE, and NELLIE MCKAY. *Three Essays: Black Studies in the United States.* New York, 1990.

HERRNSTEIN, RICHARD J., and CHARLES MURRAY. *The Bell Curve: Intelligence and Class Structure in American Life.* New York, 1994.

HIGGINBOTHAM, EVELYN BROOKS. *Righteous Discontent: The Women's Movement in the Black Baptist Church, 1880–1920.* Cambridge, Mass., 1993.

HINE, DARLENE CLARK, ELSA BARKLEY BROWN, TIFFANY R. L. PATTERSON, and LILLIAN S. WILLIAMS, eds. *Black Women in United States History.* 16 vols. Brooklyn, N.Y., 1990.

HINE, CARLENE CLARK, ELSA BARKLEY BROWN, and ROSALYN TERBORG-PENN, eds. *Black Women in America: An Historical Encyclopedia.* Brooklyn, N.Y., 1993.

HU-DEHART, EVELYN. "Ethnic Studies in U.S. Higher Education: History, Development, and Goals. In James A. Banks and Cherry A. McGee Banks, eds. *Handbook of Research on Multicultural Education.* New York, 1995, pp. 696–707.

HULL, GLORIA T., PATRICIA BELL SCOTT, and BARBARA SMITH, eds. *All the Women are White, All the Blacks are Men, but Some of Us Are Brave.* New York, 1982.

JACKSON, BLYDEN. *A History of Afro-American Literature.* Vol. 1, *The Long Beginning, 1746–1895.* Baton Rouge, La., 1989.

JAMES, STANLIE M., ABENA P. A. BUSIA, eds. *Theorizing Black Feminisms: The Visionary Pragmatism of Black Women.* New York, 1993.

JOHNSON, CHARLES S. *Shadow of the Plantation.* Chicago, 1934.

JONES, JACQUELINE. *Labor of Love, Labor of Sorrow: Black Women, Work and the Family, from Slavery to the Present.* New York, 1985.

LEVINE, LAWRENCE W. *Black Culture and Black Consciousness: Afro-American Folk Thought from Slavery to Freedom.* New York, 1977.

LEWIS, DAVID LEVERING. *W. E. B. Du Bois: Biography of a Race.* New York, 1993.

LINCOLN, C. ERIC, and LAWRENCE H. MAMIYA. *The Black Church in the African American Experience.* Durham, N.C., 1990.

LOGAN, RAYFORD. *What the Negro Wants.* Chapel Hill, N.C., 1944.

LYMAN, STANFORD M. *The Black American in Sociological Thought: A Failure of Perspective.* New York, 1972.

MEIER, AUGUST. *Negro Thought in America, 1880–1915.* Ann Arbor, Mich., 1963.

MEIR, AUGUST, and ELLIOTT RUDWICK. *Black History and the Historical Profession, 1915–1980.* Urbana, Ill., 1986.

MOSS, ALFRED A., JR. *The American Negro Academy: Voice of the Talented Tenth.* Baton Rouge, La., 1981.

MYRDAL, GUNNAR, with the assistance of Richard Sterner and Arnold Rose. *An American Dilemma: The Negro Problem and Modern Democracy.* New York, 1944.

QUARLES, BENJAMIN. *Lincoln and the Negro.* New York, 1962.

———. *The Negro in the American Revolution.* New York, 1961.

RIPLEY, WILLIAM Z. *The Races of Europe: A Sociological Study.* New York, 1899.

SCHMITZ, BETTY, JOHNNELLA BUTLER, DEBORAH ROSENFELT, and BEVERLY GUY-SHEFTALL. "Women's Studies and Curriculum Transformation." In James A. Banks and Cherry A. McGee Banks, eds. *Handbook of Research on Multicultural Education.* New York, 1995, pp. 708–728.

SMITH, JESSIE CARNEY, ed. *Notable Black American Women*. Detroit, 1992.

STAMPP, KENNETH M. *The Peculiar Institution: Slavery in the Antebellum South*. New York, 1956.

STOCKING, GEORGE W., JR. *A Franz Boas Reader: The Shaping of American Anthropology, 1883–1911*. Chicago, 1974.

STUCKEY, STERLING. *Slave Culture: Nationalist Theory and the Foundations of Black America*. New York, 1987.

TERBORG-PENN, ROSALYN, and SHARON HARLEY, eds. *The Afro-American Women: Struggles and Images*. Port Washington, N.Y., 1978.

WASHINGTON, BOOKER T. *Story of the Negro: The Rise of the Race from Slavery*. New York, 1909.

WILLIAMS, GEORGE WASHINGTON. *History of the Negro Race in America*. Vols. 1 and 2. New York, 1892–1893.

WILSON, WILLIAM JULIUS. *The Truly Disadvantaged: The InnerCity, the Underclass, and Public Policy*. Chicago, 1987.

WOODSON, CARTER G. *African Myths*. Washington, D.C., 1928a.

———. *Negro Makers of History*. Washington, D.C., 1928b.

———. *The Negro in Our History*. Washington, D.C., 1922.

———. *The Story of the Negro Retold*. Washington, D.C., 1935.

JAMES A. BANKS

Black Swan, The. *See* Greenfield, Elizabeth Taylor.

Black Swan Records. In 1921, music publisher/entrepreneur Harry PACE, realizing the potential of sound recordings, founded Pace Phonograph records, the first black-owned record label. He named his recording label Black Swan, after the nineteenth-century opera singer Elizabeth Taylor GREENFIELD, and promised that "[a]ll stockholders are colored, all artists are colored, all employees are colored." Black Swan's first office was on West 138th Street in New York's Harlem, but it soon moved to the Times Square area. Pace hired composer William Grant STILL as arranger/music director. Meanwhile, bandleader Fletcher HENDERSON was hired as recording director, and began his recording career as pianist and conductor for the label. The first record was released in September 1921. The company was renamed the Black Swan Phonograph Co. in March 1923.

Black Swan recorded black performers in many different musical styles, including opera singers, classical soloists, choruses, vaudeville duos, JAZZ bands, and dance orchestras. The label became best known for recording BLUES singers such as Alberta HUNTER, Trixie Smith, and Ethel WATERS. Waters's recording of "Down Home Blues" was a sensation, prompting the founding of a vaudeville group, the Black Swan Troubadours, led by Waters and Henderson.

Black Swan played an important role in developing the market for "race records"—popular music recorded by African Americans for the African-American market. Nevertheless, the label failed within two years. In 1922 Pace purchased the Olympia Disc Record Company, and issued records made by white artists. Many African Americans resented Pace for breaking his promise of an all-black company. Meanwhile, the success of the "race records" led to costly competition and price-cutting by white-owned labels such as Okeh and Paramount. In 1923 Black Swan went bankrupt; its catalogue was leased by Paramount in May 1924. There were no other black-owned record companies until the mid-1940s.

REFERENCES

"Black Swan Catalogue." *Record Research* 1 (1955): no. 5, p. 7; no. 6, p. 21; 2 (1956–1957): no. 1, p. 10; no. 2, p. 13; no. 3, p. 23; no. 5, p. 10; 3 (1957–1958): no. 1, p. 12; no. 2, p. 20; no. 3, p. 24; no. 4, p. 11.

SOUTHERN, EILEEN. *The Music of Black Americans: A History*. New York, 1983.

GREG ROBINSON

Black Towns. African-American town promoters established at least eighty-eight, and perhaps as many as two hundred, black towns throughout the United States during the late nineteenth and early twentieth centuries. Black towns, all-black incorporated communities with autonomous black city governments and shopkeeper economies, were created out of a combination of economic and political motives. The founders of towns such as Boley, Okla., and MOUND BAYOU, Miss., like the entrepreneurs who created Chicago, Denver, and thousands of other municipalities across the nation, hoped their enterprises would be profitable, and appealed to early settlers with the promise of rising real estate values. However, they added special attractions to African Americans: the ability to escape racial oppression, control their economic destinies, and prove black capacity for self-government.

Headquarters of the Mound Bayou foundation, an all-black town in Mississippi, subsidized by the Yazoo Mississippi Valley Railroad, January 1939. (Prints and Photographs Division, Library of Congress)

The first attempts at establishing all-black communities were in Upper Canada (later Ontario), as an offshoot of the abolitionist movement. In 1829 the settlement of Wilberforce was created to resettle black refugees expelled from Cincinnati. Wilberforce, as well as most of the later Canadian settlements such as Dawn and Elgin, were operated largely by white charities, and were designed to give African Americans land and teach them usable skills. However, they were poorly funded and managed, and none survived long. The first black town in the United States was created in 1835, when Free Frank McWhorter, an ex-Kentucky slave, founded the short-lived town of New Philadelphia, Ill. More black towns were settled in the first years after the Civil War. Texas led the way in the late 1860s, with the founding of Shankleville in 1867 and Kendleton in 1870. These arose from the desire of emancipated slaves to own land without interference.

However, the vast majority of black towns emerged following the end of RECONSTRUCTION. Like whites, blacks were lured by the promise of the West, and many towns were planned in western areas. African Americans, largely unable to secure land and economic opportunity in settled areas, looked to the West, with its reserves of land obtainable cheaply, or free through the Homestead Act. Furthermore, the society of the frontier had a reputation for egalitarianism and individual autonomy. To blacks in the ex-Confederate states, who had briefly tasted political power before being overwhelmed by white re-

gimes, the possibility of black-run areas was attractive. Among these dozens of black communities, six representative towns will be discussed in depth.

Nicodemus, Kans., was the first all-black community that gained national attention. Nicodemus was founded by W. R. Hill, a white minister and land speculator, who during the mid-1870s joined three black Kansas residents—W. H. Smith, Simon P. Rountree, and Z. T. Fletcher—in planning a black agricultural community in western Kansas, near the frontier. They founded a land company to create Nicodemus, named after a legendary African slave prince who purchased his freedom, and recruited settlers from the South.

The first group, thirty colonists, arrived from Kentucky in July 1877. Undaunted by the treeless, windswept countryside, another 150 Kentucky settlers reached the site in March 1878, and more newcomers arrived later in the year from Tennessee, Missouri, and Mississippi as part of the "EXODUSTER" migration. By 1880, 258 blacks and 58 whites resided in the town and surrounding township. Both the townspeople and the farmers, who grew corn and wheat, helped Nicodemus emerge as a small, briefly thriving community. The first retail stores opened in 1879. Town founder and postmaster Z. T. Fletcher opened the St. Francis Hotel in 1885. Two white residents established the town's newspapers, the *Nicodemus Western Cyclone* in 1886 and the *Nicodemus Enterprise* one year later. By 1886 Nicodemus had three churches and a new schoolhouse.

The town's success attracted other African Americans, including Edwin P. McCabe, who would soon become the most famous black politician outside the South. A Troy, N.Y., native born in 1850, McCabe arrived in Nicodemus in 1878 and began working as a land agent, locating settlers on their claims. In 1880, when Kansas governor John P. St. John established Graham County (which included Nicodemus), McCabe was appointed acting county clerk, beginning a long career of elective and appointive officeholding. In November 1881, McCabe was elected clerk for Graham County, and the following year, at age thirty-two, he became the highest-ranking African-American elected official outside the South when Kansas voters chose him as state auditor. Nicodemus's fortunes, however, began to decline in the late 1880s. An 1885 blizzard destroyed 40 percent of the wheat crop, prompting the first exodus from the area. By 1888 three railroads had bypassed the town, despite its commitment of $16,000 in bonds to attract a rail line. Moreover, toward the end of the decade Oklahoma began to appeal to prospective black homesteaders.

Oklahoma was the most important center of black town activity. Thirty-two all-black towns, the largest number in the nation, emerged in the Twin Territories, Oklahoma Territory and Indian Territory, that became the state of Oklahoma in 1907. The two most famous towns were Langston City in Oklahoma Territory and Boley in Indian Territory. Though the specific reasons for town founding varied, most grew out of the tradition of autonomy among the black ex-slaves of Indian peoples; anti-black violence in the South, which encouraged migration to the Twin Territories; and the political maneuvers of Edwin McCabe and other black politicians who settled in Oklahoma. The government-owned land in Oklahoma was a primary focus of black leaders, who lobbied for the creation of an all-black territory there in the years before 1889. For African Americans like McCabe, Oklahoma Territory, whose former Native American reservations were opened to non-Indian settlement in 1889, represented not only the last major chance for homesteading but also a singular opportunity to develop communities where black people could achieve their economic potential and exercise their political rights without interference. McCabe, who emerged as the leading advocate of black settlement, would also become a town promoter, combining political and racial objectives with personal profit.

McCabe and his wife, Sarah, moved to Oklahoma in April 1890 and six months later joined Charles Robbins, a white land speculator, and William L. Eagleson, a black newspaper publisher, in founding Langston City, an all-black community about ten miles northeast of Guthrie, the territorial capital. Langston City was named after the Virginia black congressman who supported migration to Oklahoma. The McCabes, who owned most of the town lots, immediately began advertising for prospective purchasers through their newspaper, the Langston City Herald, which was sold in neighboring states. The Herald portrayed the town as an ideal community for African Americans. "Langston City is a Negro City, and we are proud of that fact," proclaimed McCabe in the Herald. "Her city officers are all colored. Her teachers are colored. Her public schools furnish thorough educational advantages to nearly two hundred colored children." The Herald also touted the agricultural potential of the region, claiming the central Oklahoma prairie could produce superior cotton, wheat, and tobacco. "Here is found a genial climate, about like that of . . . Northern Mississippi . . . admirably suited to the wants of the Negro from the Southern states. A land where every staple . . . can be raised with profit." By February 1892 Langston City had six hundred residents from fifteen states including Georgia, Maryland, and California, with the largest numbers from neighboring Texas. The businesses established included a cotton gin, a soap factory, a bank, and two hotels. An opera house, a racetrack, a billiard parlor, three saloons, masonic lodges, and social clubs provided various forms of entertainment.

Like Nicodemus, Langston City residents hoped a railroad would improve their town's fortunes. Between 1892 and 1900 McCabe waged a steady but ultimately unsuccessful campaign to persuade the St. Louis & San Francisco Railroad to extend its tracks through the town. When the rail line bypassed the town, Langston residents believed they lost their main opportunity to grow. Throughout the railroad campaign, however, town promoters urged other reasons for migration to their community. The Herald (no longer owned by the McCabes) continued to emphasize the superior racial climate of the area. McCabe, using his political connections as chief clerk of the territorial legislature in 1896, was able to obtain for Langston City the Colored Agricultural and Normal School (later Langston University). The location of the school, the only publicly supported black educational institution in the territory, in Langston City ensured the town's permanence.

Boley, the largest all-black town in Indian Territory, was founded in the former Creek Nation in 1904 by two white entrepreneurs, William Boley, a roadmaster for the Fort Smith & Western Railroad, and Lake Moore, an attorney and former federal commissioner to the region's Indian tribes. Boley and Moore chose Tom Haynes, an African American, to handle promotion of the town. Unlike Langston

City, Boley was on a rail line and in a timbered, well-watered prairie that easily supported the type of agriculture familiar to most prospective black settlers. The frontier character of the town was evident from its founding. Newcomers, who usually arrived by train, were forced to live in tents until they could clear trees and brush to construct homes and stores. During the town's first year, Creek Indians rode several times through Boley's streets on shooting sprees that killed several people. T. T. Ringo, a peace officer appointed by townsite officials, stopped the violence. However, Boley's reputation for lawlessness continued into 1905, when a second peace officer, William Shavers, was killed while leading a posse after a gang of white horse thieves who terrorized the town.

By 1907 Boley had a thousand residents, as well as more than two thousand farmers in the surrounding countryside, and was beginning to take on a permanent air. Boley's businesses included a hotel, sawmill, and cotton gin. Churches, a school, fraternal lodges, women's clubs, and a literary society attest to the cultural development of the town. A community newspaper, the *Boley Progress,* was founded in 1905 to report on local matters and promote town growth. After a visit in 1905, Booker T. WASHINGTON described Boley as a "rude, bustling, Western town [that nonetheless] represented a dawning race consciousness . . . which shall demonstrate the right of the negro . . . to have a worthy place in the civilization that the American people are creating."

Boley's spectacular growth was over by 1910. When the Twin Territories became the state of Oklahoma in 1907, the Democrats emerged as the dominant political party. They quickly disfranchised black voters and segregated public schools and accommodations. Their actions eliminated the town's major appeal as a political center, part of a territory where African Americans escaped the JIM CROW restrictions they faced in southern states. Although blacks continued to vote in local elections, political control at the local level could not compensate for marginal influence at the courthouse or the state capital, where crucial decisions affecting the town's schools and roads were routinely made by unsympathetic officials. Moreover, after the initial years of prosperity, declining agricultural prices and crop failures gradually reduced the number of black farmers who were the foundation of the town's economy. Although Boley remained the center of a famous black rodeo, it ceased to be an important center of black life.

Mound Bayou, Miss., was the most successful all-black town. Founded by the Louisville, New Orleans & Texas Railroad in 1887, the town was situated along the rail line that extended through the Yazoo-Mississippi delta, an area of thick woods, bayous, and swamps that nonetheless contained some of the

richest cotton-producing lands in the state. When the fear of swampland diseases deterred white settlement, the railroad hired two prominent African-American politicians, James Hill and Isaiah MONTGOMERY, as land promoters. Hill had once been Mississippi's secretary of state, while Montgomery was the patriarch of a family of ex-slaves of Joseph Davis. After the CIVIL WAR, the Montgomery family had acquired the Davis Bend plantations of their former master and of his more famous brother, Confederate president Jefferson Davis. The Davis heirs reclaimed the lands in the 1880s, prompting the Montgomery family to seek other business opportunities.

The railroad, which wanted settlers on the least populated lands along its route, chose a site fifteen miles east of the Mississippi River and ninety miles south of Memphis to establish a town. The four-square-mile area selected included two bayous and several Indian burial mounds, inspiring Montgomery to name the town and colony Mound Bayou. Montgomery, the more active of the two promoters, sold the first town lots to relatives and friends from the Davis Bend plantations. In the fall of 1887 he led the first twelve settlers to Mound Bayou. By 1888 the town had forty residents, and about two hundred people had settled in the surrounding countryside. Twelve years later it had grown to 287 residents, with 1,500 African Americans in the vicinity.

With rail transportation assured and a sizable population of black farmers nearby, Montgomery and other promoters concentrated on efforts to increase business development. Those efforts were helped by his close association with Booker T. Washington. Montgomery and Washington met in 1895 when the Mississippi planter served as a commissioner for the Atlanta Exposition, at which Washington gave the speech that launched his national career. Washington, who saw in Montgomery and Mound Bayou the embodiment of his philosophy of black economic self-help, featured the Mississippian in exhibitions and conferences sponsored by Tuskegee Institute (now TUSKEGEE UNIVERSITY). Montgomery, in turn, used the Tuskegee educator's fame and contacts to attract investors. While Montgomery accepted a federal post in Jackson in 1902 and ceased his direct involvement in Mound Bayou promotional activities, Washington's interest in the town remained strong. He switched his support to merchant-farmer Charles Banks, who settled there in 1904 and founded the Bank of Mound Bayou. In 1908, following a visit to Mound Bayou, the Tuskegee educator prompted a number of flattering articles on the town in national magazines and profiled the community in books he published in 1909 and 1911.

Mound Bayou's population reached eleven hundred in 1911, with nearly eight thousand in the rural

area. The sizable population ensured economic support for the town, which featured the largest number of African-American-owned businesses of any of the all-black towns. Mound Bayou's businesses included its bank, a savings and loan association, two sawmills, three cotton gins, and the only black-owned cottonseed mill in the United States. By 1914, however, some businesses, including the Bank of Mound Bayou, closed, and the town experienced its first population losses. Booker T. Washington's death in 1915 initiated a period of estrangement between Isaiah Montgomery and Charles Banks, the promoters most closely identified with the town's fortunes. By the early 1920s the town lost its vitality and began to resemble other small delta communities.

In 1908 white and black land speculators combined to create the westernmost all-black town, Allensworth, Calif. The town was initiated by the California Colony and Home Promoting Association (CCHPA), a black, Los Angeles-based land development company. CCHPA hoped to encourage black settlement in California's rapidly growing San Joaquin Valley, and it envisioned a town as the commercial center of a thriving agricultural colony. Since CCHPA had no resources to purchase land, it joined with three white firms, the Pacific Farming Company (owners of the site of the prospective town), the Central Land Company, and the Los Angeles Purchasing Company, to create an eighty-acre townsite in Tulare County along the Santa Fe Railroad, about halfway between Fresno and Bakersfield. Allensworth was named for Lt. Col. Allen ALLENSWORTH, chaplain of the all-black Twenty-fourth Infantry Regiment, and the highest-ranking African American in the U.S. Army. After his retirement, Allensworth settled in Los Angeles, and he became president of the association in 1907.

Initial sales were slow, and by 1910 the town had only eighty residents. Most of the adult residents worked on ten-acre farms nearby, which they purchased for $110 per acre on an installment plan. The town's slow growth prompted Allensworth to intensify his promotional efforts. In January 1912 he sent a lengthy letter to the *New York Age,* the nation's largest African-American newspaper, promoting the townsite and linking it to Booker T. Washington's call for black economic self-help. Allensworth also suggested that his town's objectives were similar to those of Mound Bayou. By May Allensworth began to concentrate recruiting efforts on his former soldiers, issuing a promotional newspaper, *The Sentiment Maker,* which specifically targeted black military personnel.

The town of Allensworth had one hundred residents in 1914. Despite their small numbers, they owned dozens of city lots and three thousand acres of nearby farmland. Oscar O. Overr, a migrant from Topeka, Kans., was the community's most prosperous resident native, with a 640-acre farm and four acres of town lots. In 1914 Overr became California's first elected black justice of the peace. Allensworth also had a twenty-acre park named after Booker T. Washington, and a library named for Colonel Allensworth's wife, Josephine, and which received as its first holdings the family's book collection. After the colonel's death on September 14, 1914, Overr and William A. Payne, the town's first schoolteacher, attempted to establish the Allensworth Agricultural and Manual Training School, modeled after Tuskegee, to train California's black youth in practical skills. They failed to obtain state funding, however, because urban black political leaders feared the school would encourage segregation. The school promotion scheme was the last concerted effort to lure settlers to Allensworth. Except for a brief period in the 1920s, the town's population never exceeded one hundred residents.

One all-black Colorado town, Dearfield, emerged in Weld County. Dearfield was conceived by O. T. Jackson, who arrived in the state in 1887 and became a messenger for Colorado governors. Inspired by Booker T. Washington's book *Up from Slavery,* Jackson went into business. He believed successful farm colonies were possible in Colorado and chose as his first site a 40-acre tract 25 miles southeast of Greeley, which he homesteaded. Jackson attracted other black Denver investors who made additional land purchases. Among them was Dr. J. H. P. Westbrook, a physician, who suggested the name Dearfield. The town's population peaked at seven hundred in 1921, with families occupying nearly fifteen thousand acres in the area. Dearfield's farmers grew wheat, corn, and sugar beets, and like their Weld County neighbors, prospered during WORLD WAR I because of the European demand for American foodstuffs. Town founder Jackson was also its most prominent businessman. He owned the grocery store, restaurant, service station, and dance hall. The war years were the apex of the town's prosperity. Declining agricultural prices and the attractiveness of urban employment caused Dearfield to steadily lose population. Only a handful of "pioneers" remained when Jackson died in Dearfield in 1949.

None of the surviving all-black towns are the thriving, prosperous communities envisioned by their promoters. Many, like Nicodemus, Allensworth, and Dearfield, have long been emptied of residents. In the 1990s Boley, Mound Bayou, and Langston City continue, but they are not dynamic centers of economic or cultural activity for their regions. Like thousands of small towns throughout the United States, black communities were subject to the vagar-

ies of transportation access, unpredictable agricultural productivity, detrimental county or state political decisions, and shifting settlement patterns. Moreover, towns such as Nicodemus, Allensworth, and Dearfield, which had few black farmers in their hinterlands to sustain their prosperity, were especially vulnerable to decline.

No town, however, could successfully compete with the attraction of larger cities, which lured millions of Americans from farms and small towns during the twentieth century. Most of these communities began declining in about 1915, the first year of the Great Migration of hundreds of thousands of southern African Americans to northern cities. Moreover, the initial reason for the creation of the towns may have hastened their demise. Blacks could now gain some of the political rights and job opportunities they sought by moving to northern cities rather than small southern or southwestern towns, while the racial insularity of these communities, which seemed attractive to one generation, proved restricting to another. For one brief period in the late nineteenth and early twentieth centuries, a handful of all-black communities throughout the nation symbolized the aspirations of African Americans for political liberty and economic opportunity.

See the Appendix for a list of nineteenth- and twentieth-century black towns in the United States.

REFERENCES

CROCKETT, NORMAN L. *The Black Towns.* Lawrence, Kans., 1979.

FRANKLIN, JIMMIE LEWIS. *Journey Toward Hope: A History of Blacks in Oklahoma.* Norman, Okla., 1982.

HAMILTON, KENNETH MARVIN. *Black Towns and Profit: Promotion and Development in the Trans-Appalachian West, 1877–1915.* Urbana, Ill., 1991.

SMALLWOOD, JAMES M. *Time of Hope, Time of Despair: Black Texans During Reconstruction.* Port Washington, N.Y., 1981.

WAYNE, GEORGE H. "Negro Migration and Colonization in Colorado—1870–1930." *Journal of the West* 15 (1976): 102–120.

QUINTARD TAYLOR

Blackwell, David Harold (1919–), mathematician. Born in Centralia, Ill., David H. Blackwell attended local schools, where he soon demonstrated extraordinary promise as a mathematician. All of his higher education was at the University of Illinois, where he received his doctorate in 1941. After teaching at a number of universities, including Howard (1944–1954), he moved to the University of California at Berkeley in 1954, where he is professor emeritus.

Blackwell has a distinguished record as a scholar and teacher, making major contributions in classical analysis, set theory, game theory, probability, statistics, and dynamic programming. He is coauthor with Meyer A. Girshick of *Theory of Games and Statistical Decisions* (1954). Blackwell was the first of two African Americans elected to the National Academy of Science, and was president of both the Institute of Mathematical Statistics and the Bernoulli Society, and recipient of the John von Neumann Theory Prize (1979) and the R. A. Fisher Award.

JAMES A. DONALDSON

Blackwell, Edward Joseph (October 10, 1929– October 7, 1992), jazz drummer. Born in New Orleans, Blackwell started playing drums as a youth, inspired by the parade bands of his hometown, and particularly influenced by the drummer and bandleader Paul Barbarin. By his late teens, he was performing with Plas Johnson, Roy Brown, and Ellis Marsalis. He moved to Los Angeles in 1951, where he met and worked with Ornette COLEMAN. After returning to New Orleans in 1956, Blackwell toured with Ray CHARLES and recorded with Earl King and Huey "Piano" Smith. In 1960 Blackwell settled in New York, where he rejoined Ornette Coleman's group.

Blackwell's performances on a number of Coleman recordings, including *This Is Our Music* (1960), document how deeply Coleman's ideas about liberating harmony and rhythm had affected jazz drumming. However, on these recordings, Blackwell's percussive approach and meticulous attention to the tuning of his drums also reflects the enduring influence of the music of his hometown, New Orleans. Although Blackwell played on Coleman's epoch-making *Free Jazz* (1960), his drumming never broke away from an identifiable pulse during this time, and at no point did he favor the temporal elasticity and rhythmic abstraction practiced by other avant-garde drummers from this period.

During the 1960s Blackwell worked with many of the leading figures of the jazz avant-garde, including John COLTRANE (*The Avant Garde,* 1960), Eric DOLPHY and Booker Little (*At the Five Spot,* 1961), Don CHERRY (*Complete Communion,* 1965), Archie SHEPP, and Randy Weston. Blackwell lived and worked in Africa from 1965 to 1968, an experience that influenced several of his later ablums. In 1971 Blackwell again worked with Coleman (*Science Fiction*), and in 1975 he became an artist in residence at Wesleyan

University. In 1976 Blackwell helped form Old and New Dreams, a group made up of former Coleman sidemen, dedicated to playing Coleman's music (*Old and New Dreams,* 1976; *Playing,* 1980). Some of Blackwell's most important music in his last decade was made with trumpeter Don Cherry (*El Corazon,* 1982); in his last years he also performed with David Murray. Blackwell, who struggled for many years against complications due to diabetes, died in Hartford, Conn., in 1992.

REFERENCES

HARTIGAN, ROYAL. Blood, Drum, Spirit. Ph.D. diss., Wesleyan University, 1986.
PALMER, ROBERT. "Ed Blackwell: Crescent City Thumper." *Down Beat* 44, no. 12 (1977): 17.

ANTHONY BROWN

Blackwell, Unita (March 18, 1933–) civil rights activist, politician. Born in Lula, Miss., Unita Blackwell grew up during the depression and spent her first thirty years migrating from farm to farm in Mississippi, Arkansas, and Tennessee. Blackwell has been an exemplar of grass-roots activism and organization within rural African-American communities.

Unita Blackwell from the Mississippi Freedom Democratic Party addressing the Poor People's Conference held at the International Inn, Washington, D.C., 1966. (© Charmian Reading)

In 1962 Blackwell and her first husband settled in the then-unincorporated town of Meyersville in Issaquena County, Miss., where she chopped cotton in the fields for three dollars a day. Inspired by visiting civil rights workers, she registered to vote and began to encourage other laborers to register. Fired by her employers for her activism, Blackwell joined the STUDENT NONVIOLENT COORDINATING COMMITTEE full time. In 1964 she helped organize the MISSISSIPPI FREEDOM DEMOCRATIC PARTY and traveled to the Democratic convention in Atlantic City with the party in its failed attempt to be seated. In 1968 she would serve as a state delegate at the Democratic convention in Chicago. In 1965 and 1966, she initiated *Blackwell* v. *Board of Education,* a landmark case that furthered school desegregation in Mississippi.

In 1976, equipped with the political and administrative skills she had developed in the civil rights movement, Blackwell set out to incorporate the 691-acre town of Mayersville, Miss., organizing town meetings, filing petitions, and having the land surveyed. The incorporation became official on December 28, 1976. Blackwell was elected mayor, the first African-American woman mayor in Mississippi, a post she held through the mid-1990s. An expert on rural housing and development, Blackwell has campaigned successfully for state and federal funds for public housing and welfare. She has been selected as chairperson of the National Conference of Black Mayors, and she received a MacArthur Fellowship in 1992.

REFERENCES

HINE, DARLENE CLARK, ed. *Black Women in America.* Brooklyn, N.Y., 1993, pp. 138–139.
KILBORN, KETER. "A Mayor and Town Pulled Up." *New York Times Biographical Service* 23 (June 1992): 760.

NANCY YOUSEF
GREG ROBINSON

Black West, The. *See* West, Blacks in the.

Black Women's Club Movement. The black women's club movement emerged in the late nineteenth century and was comprised of a number of local reform organizations dedicated to racial betterment. These grass-roots organizations were made up primarily of middle-class women who were part of the larger progressive reform effort. Black women formed social organizations to provide services, fi-

nancial assistance, and moral guidance for the poor. Many of the groups grew out of religious and literary societies and were a response to the intensified racism in the late nineteenth century.

Although organizations existed all over the country, they were concentrated in the Northeast. Women involved in the club movement gained knowledge about education, health care, and poverty and developed organizing skills. They also sought to teach the poor how to keep a household, manage a budget, and raise their children. The local groups were usually narrow in focus and supported homes for the aged, schools, and orphanages. In Washington, D.C., the black women's club movement was dominated by teachers who were concerned about children and their problems. Active participants held conventions, conferences, and forums to engage the intellectual elite. In New York City clubwomen honored Ida B. Wells (*see* IDA B. WELLS-BARNETT) for her political activism to publicize the prevalence of lynching.

In 1895 women organizing at the local level made attempts to develop national ties. The New Era Club in Boston began a publication, THE WOMAN'S ERA, which covered local and national news of concern to clubwomen. Two national federations of local clubs were formed in 1895. The next year these two merged and became the NATIONAL ASSOCIATION OF COLORED WOMEN (NACW). Women in the Northeast played a central role in setting the agenda for the NACW, which was more conservative than some of the local clubs. Mary Church TERRELL, a supporter of Booker T. WASHINGTON, was the first president of the NACW.

In the 1930s, during the GREAT DEPRESSION, self-help and social reform came under attack as methods of social change. Increasing emphasis was placed on structural change and electoral politics. In 1935, a faction of the NACW, led by Mary McLeod BETHUNE, which rejected the philosophy of self-help and sought to put pressure on the political system to improve conditions for African Americans, formed the NATIONAL COUNCIL OF NEGRO WOMEN (NCNW). The NCNW quickly came to dominate both the politics of the club movement and the national political agenda of black women. Although both the NACW and the NCNW continued to be central to black women's political activity, the social conditions and context for organizing had changed dramatically in the 1930s. As the reform efforts of African-American women became more explicitly political, both the local and national club movements declined in importance.

REFERENCES

GIDDINGS, PAULA. *When and Where I Enter: The Impact of Sex and Race on Black Women in America.* New York, 1984.

SALEM, DOROTHY. *To Better Our World: Black Women in Organized Reform, 1880–1920.* Brooklyn, N.Y., 1990.

PAM NADASEN

Black World/Negro Digest.

Created in 1942 by Chicago-based publisher John H. JOHNSON, who also produced EBONY, *Tan,* and JET magazines, the original series of *Negro Digest* was issued on a monthly basis from 1942 to 1951. An unabashed imitation of *Reader's Digest,* it published general articles about African-American life, with an emphasis on racial progress. It also reprinted relevant articles from other journals, particularly mainstream white publications. The original *Negro Digest* ceased publication in 1951, but it reappeared after a ten-year hiatus, with Johnson listed on the masthead as editor, Hoyt W. Fuller as managing editor, and Doris E. Saunders as associate editor.

During the first several years of its reincarnation, *Negro Digest* generally followed the path of its predecessor. It continued to reprint articles from other magazines and its outlook was distinctly integrationist, an emphasis underscored by the monthly column "Perspectives," originally coauthored by Fuller and Saunders. At the same time, however, it devoted considerably more attention to African-American literature, history, and culture than the earlier *Negro Digest.* Fuller assumed the sole responsibility for the "Perspectives" column in August 1962, signaling the beginning of his emergence as the most influential editor among the numerous African-American journals that flourished during this period.

In his column and in book reviews, articles, news items, and various notes, Fuller's ideological outlook shifted from civil rights and integration to black power/black arts and Pan-Africanism. These shifts—reflective of wider changes in the mood and outlook of the black community—were inevitably reflected in the pages of *Negro Digest.* Beginning with his essay "Ivory Towerist vs. Activist: The Role of the Negro Writer in an Era of Struggle," published in the June 1964 issue, Fuller began to emphasize his belief in the connection between politics and literature. As his outlook evolved further in the direction of black nationalism, Fuller began to aim sharp verbal attacks at two targets: white literary critics and anthologists, whom he saw as cultural interlopers who could not understand African-American literature, and those African-American writers, most notably Ralph ELLISON, who emphasized literary craft over political commitment.

Fuller pursued his efforts to develop new standards for African-American writing by polling black au-

thors on various questions. The results appeared in two symposia in *Negro Digest:* "The Task of the Negro Writer as Artist," in the April 1965 issue, and "A Survey: Black Writers' Views on Literary Lions and Values," in January 1968. The second symposium in particular spurred the national debate about the black aesthetic. By 1968, Fuller's transformation to black cultural nationalism was virtually complete, and the pages of *Negro Digest* reflected his altered outlook. As of the May 1970 issue, the title of the magazine was changed to *Black World* to reflect its new emphasis.

As the only national black literary magazine with a paid staff and a solvent financial base, *Negro Digest/ Black World* played a prominent role in the debates about African-American literature, culture, and politics that flourished during the 1960s and early '70s. During its heyday, it served as a national forum for emerging as well as established black writers and intellectuals. As the revolutionary mood of the late 1960s and early '70s subsided, however, a complex set of economic, political, and cultural forces led to its demise—and indeed to that of many of the "little" black magazines of the period. The final issue of *Black World* appeared in April 1976. Hoyt Fuller returned to his native Atlanta, where he launched a new journal, *First World,* publishing several issues before his death in 1981.

REFERENCES

JOHNSON, ABBY ARTHUR, and RONALD MABERRY. *Propaganda & Aesthetics: The Literary Politics of Afro-American Magazines in the Twentieth Century.* Amherst, Mass., 1979, pp. 161–167, 187–193.

PARKS, CAROLE A., ed. *Nommo: A Literary Legacy of Black Chicago (1967–1987).* Chicago, 1987, pp. 293–335.

JAMES A. MILLER

Blair Education Bill. Throughout the 1880s and early '90s, Sen. Henry W. Blair, a Republican from New Hampshire, repeatedly introduced in the U.S. Senate a bill (strongly supported by African Americans) known as the Blair Education Bill. The bill provided for the dispensation of surplus federal revenues to state schools in proportion to the prevalence of illiteracy in their districts. For African Americans, who had the highest rates of illiteracy due to slavery and its legacy, the bill, if enacted, would have facilitated their educational efforts.

The North Carolina State Teachers' Association described the bill as a "relief of our educational disabilities," and a "further means of promoting the condition of all the unfortunate classes of our peo-

ple." Although the Senate endorsed the bill in 1886 and appropriated $77 million for its enactment, the House of Representatives defeated it. Despite Sen. Blair's repeated efforts, the bill never passed.

REFERENCE

APTHEKER, HERBERT, ed. *A Documentary History of the Negro People in the United States.* New York, 1951, pp. 648, 693–94.

MARGARET D. JACOBS

Blake, James Hubert "Eubie" (February 7, 1883–February 12, 1983), jazz pianist, composer. Born in Baltimore, Md., the son of former slaves, Eubie Blake began organ lessons at the age of six and was soon syncopating the tunes he heard in his mother's Baptist church. While in his teens he began to play in the RAGTIME style then popular in Baltimore sporting houses and saloons. One of his first professional jobs was as a dancer in a minstrel show, *In Old Kentucky.* During this time Blake also began to compose music, with his first published piece, "Charleston Rag," appearing in 1899. While in his twenties Blake began performing each summer in Atlantic City, where he composed songs ("Tricky Fingers," 1904) and came in contact with such giants of ragtime and stride piano as Willie "The Lion" SMITH, Luckey ROBERTS, and James P. JOHNSON. His melodic style and penchant for waltzes were influenced by the comic operettas of Victor Herbert, Franz Lehar, and Leslie Stuart. During this time Blake began to perform songs in his mature style, which was marked by broken-octave parts and arpeggiated figures, as well as sophisticated chord progressions and altered BLUES chords. In 1910 Blake married Avis Lee, a classical pianist.

In 1916, with the encouragement of bandleader James Reese EUROPE, Blake began performing with Noble SISSLE as "The Dixie Duo," a piano-vocal duet. Sissle and Blake performed together on the B. F. Keith vaudeville circuit, and also began writing songs together. In 1921 Sissle and Blake joined with the well-known comedy team of Flournoy Miller and Aubrey Lyles to write *Shuffle Along,* which became so popular in both its Broadway and touring versions that at one point three separate companies were crisscrossing the country performing it. In 1924 Sissle and Blake teamed up with Lew Payton to present *In Bamville,* which later was known as *The Chocolate Dandies.* After the closing of the show in 1925, Sissle and Blake returned to vaudeville, touring the United States, Great Britain, and France. In 1927 Sissle remained in Europe, and Blake teamed up with Henry

James Hubert "Eubie" Blake. (Photographs and Prints Division, Schomburg Center for Research in Black Culture, The New York Public Library, Astor, Lenox and Tilden Foundations)

Creamer to write cabaret shows. In 1928 Blake joined with Henry "Broadway" Jones and a cast of eleven performers to tour the United States on the Keith-Albee Orpheum circuit with *Shuffle Along Jr.* In that year he also wrote "Tickle the Ivories." Two years later Blake set to music lyrics by Andy Razaf for Lew Leslie's *Blackbirds of 1930,* which included "Memories of You," which became one of the best known of Blake's many songs. In 1932, after the death of Lyles, Sissle and Blake reunited with Miller to present *Shuffle Along of 1933,* but the show closed after only fifteen performances. During the GREAT DEPRESSION, Blake wrote several shows with Milton Reddie. *Swing It,* which included the songs "Ain't We Got Love" and "Blues Why Don't You Leave Me Alone," was produced by the WORKS PROJECT ADMINISTRATION. During the war years Blake performed in U.S.O. shows and wrote *Tan Manhattan* (1943). When "I'm Just Wild About Harry," from *Shuffle Along,* became popular during the 1948 presidential campaign of Harry Truman, Sissle and Blake reunited to update the show. The new version failed to gain popularity, and Blake retired from public life.

In the 1960s there was a renewed public interest in ragtime, and Blake recorded *The Eighty-Six Years of Eubie Blake* (1969), an album that led to a resurgence in his career. Thereafter, Blake performed regularly in concert and on television, and continued to compose ("Eubie's Classic Rag," 1972). He performed at jazz festivals in New Orleans (1969) and Newport R.I. (1971). Even in his last years, he retained his remarkable virtuosity on piano, vigorously improvising melodic embellishments to a syncopated ragtime beat. In 1978 the musical revue *Eubie!* enjoyed a long run on Broadway. Blake also established a music publishing and recording company and received numerous honorary degrees and awards, including the Presidential Medal of Freedom in 1981. Blake, whose more than three hundred compositions brought a sophisticated sense of harmony to the conventions of ragtime-derived popular song, was active until his ninety-ninth year, and his centennial in 1983 was an occasion for many tributes. However, the 1982 death of his wife, Marion, to whom he had been married since 1945—his first marriage had ended with the death of his wife, Avis—led to a decline in his own health. He died on February 12, 1983 in Brooklyn, N.Y., only five days after his hundredth birthday.

REFERENCES

BERLIN, E. *Ragtime: A Musical and Cultural History.* Berkeley, Calif., 1984.

BOLCOM, WILLIAM, and R. KIMBALL. *Reminiscing with Sissle and Blake.* New York, 1973.

GRAZIANO, JOHN. "Black Musical Theater and the Harlem Renaissance Movement." In Samuel A. Floyd, Jr., ed. *Black Music in the Harlem Renaissance.* Westport, Conn., 1980.

ROSE, A. *Eubie Blake.* New York, 1979.

JOHN GRAZIANO

Blakey, Art (Buhaina, Abdullah Ibn) (October 11, 1919–October 16, 1990), drummer and bandleader. Born in Pittsburgh, Pa., and orphaned as an infant, Blakey learned enough piano in his foster home and school to organize a group and play a steady engagement at a local nightclub while in his early teens. He later taught himself to play drums, emulating the styles of Kenny CLARKE, Chick WEBB, and Sid CATLETT. Blakey left Pittsburgh for New York City with Mary Lou WILLIAMS's band in the fall of 1942, leaving her band in 1943 to tour with the Fletcher Henderson Orchestra. After his stint with HENDERSON, he briefly formed his own big band in Boston before heading west to St. Louis to join Billy ECKSTINE's new big bebop band. Blakey remained with the band for its three-year duration, working with other modern jazz musicians including Dizzy

GILLESPIE, Charlie PARKER, Sarah VAUGHAN, Miles DAVIS, Dexter GORDON, and Fats NAVARRO (*see* JAZZ).

After Eckstine disbanded the group in 1947, Blakey organized another big band, the Seventeen Messengers. At the end of the year, he took an octet including Kenny Dorham, Sahib Shihab, and Walter Bishop, Jr., into the studio to record for Blue Note Records as the Jazz Messengers. In the same year Blakey joined Thelonious MONK on his historic first recordings for Blue Note, recordings that document both performers as remarkably original artists. The next year Blakey went to Africa to learn more about Islamic culture and subsequently adopted the Arabic name Abdullah Ibn Buhaina. During the early 1950s Blakey continued to perform and record with the leading innovators of his generation, including Charlie Parker, Miles Davis, and Clifford BROWN. With his kindred musical spirit, Horace SILVER, Blakey in 1955 formed a cooperative group with Kenny Dorham (trumpet) Doug Watkins (bass), and Hank Mobley (tenor saxophone), naming the quintet the Jazz Messengers. When Silver left the group in 1956, Blakey assumed leadership of the seminal hard bop group, renowned for combining solid, swinging jazz with rhythm and blues, gospel, and blues idioms.

Blakey's commitment to preserving the quintessence of the hard bop tradition lasted unflaggingly for over thirty-five years. His group toured widely, serving both as a school for young musicians and the definitive standard for what has become known as "straight-ahead jazz." Blakey's Jazz Messengers graduated from its ranks many of the most influential figures in jazz, including Wayne SHORTER, Freddie Hubbard, Donald Byrd, Jackie McLean, Lee Morgan, Johnny Griffin, Woody Shaw, Keith Jarrett, JoAnn Brackeen, Branford, Delfayo, and Wynton MARSALIS, Donald Harrison, and Terence Blanchard. A drummer famous for his forceful intensity, hard swinging grooves, and an inimitable press roll, Blakey also adopted several African drumming techniques—including rapping the sides of his drums and altering the pitch of the tom-toms with his elbow—which expanded the timbral and tonal vocabulary of jazz drumming. His drumming style as an accompanist is characterized by an unwavering cymbal beat punctuated by cross-rhythmic accents on the drums. A distinctive soloist, Blakey exploited the full dynamic potential of his instrument, often displaying a command of rhythmic modulation and a powerful expressiveness that incorporated polyrhythmic conceptual influences from West Africa and Cuba. In addition to his singular achievements as a drummer and bandleader, Blakey also served as a catalyst in bringing together percussionists from diverse traditions to perform and record in a variety of ensembles. His versatility as a drummer outside of the context of his own group received global recognition during his 1971–1972 tour with the Giants of Jazz, which included Dizzy Gillespie, Sonny Stitt, Thelonious Monk, Kai Winding, and Al McKibbon. Blakey died in New York City in 1990.

Art Blakey. (Photographs and Prints Division, Schomburg Center for Research in Black Culture, The New York Public Library, Astor, Lenox and Tilden Foundations)

REFERENCES

PORTER, LEWIS. "Art Blakey." In Barry Kernfeld, ed. *The New Grove Dictionary of Jazz*. London, 1988, pp. 115–116.
SOUTHERN, EILEEN. "Art Blakey." *Biographical Dictionary of Afro-American and African Musicians*. Westport, Conn., 1982, p. 37.

ANTHONY BROWN

Bland, James A. (October 23, 1854–May 5, 1911), minstrel and songwriter. Born in Flushing, N.Y., James A. Bland was educated in Washington, D.C.

He attended Howard University, but left after two years to pursue a career in music. Largely self-taught, he initially sang and played the banjo for local hotels and private social functions, and composed songs for his own use as an entertainer. Some of his songs came to the attention of white minstrel George Primrose, who used them in his show. Bland joined the Original Black Diamonds in 1875, and toured variously between 1876 and 1880 with the Bohee Brothers Minstrels, Sprague's Georgia Minstrels, and Haverly's Genuine Colored Minstrels. In July 1881 he accompanied Haverly's Minstrels to London, and remained abroad when the company returned to the United States, touring Europe for almost a decade as a star performer. He returned in 1890 at the height of his fame and popularity, and toured briefly with W. S. Cleveland's Colored Minstrels. After 1891 his appearances became less frequent. He apparently last performed in public in 1898 with Black Patti's Troubadours.

Bland was a pioneer in nineteenth-century American show business. He was recognized by his contemporaries as one of the most successful composers of popular songs in the United States during the 1870s and '80s. He reportedly wrote over six hundred songs, among which his most famous are "Carry Me Back to Old Virginny" (1878), "Oh, Dem Golden Slippers" (1879), and "In the Evening by the Moonlight" (1880).

REFERENCES

FLETCHER, TOM. *100 Years of the Negro in Show Business.* 1954. Reprint. New York, 1984.

SOUTHERN, EILEEN. *Biographical Dictionary of Afro-American and African Musicians.* Westport, Conn., 1982.

JOSEPHINE WRIGHT

Blanton, James "Jimmy" (October 1918–July 30, 1942), jazz bassist. Born in Chattanooga, Tenn., on a date that has not been determined, Blanton first learned about music from his mother, a pianist who led her own orchestra. He also studied violin and music theory with an uncle. While enrolled at Tennessee State College in Nashville, he switched to string bass. Blanton's first professional work came in the late 1930s, when he worked with the Fate Marable and Jeter-Pillars bands in St. Louis.

Duke ELLINGTON hired him in 1939, and it was as Ellington's regular bassist for the next two years that Blanton almost singlehandedly changed the role of the instrument in jazz ensembles. In "Jack the Bear" (1940), "Koko" (1940), and "Concerto for Cootie"

(1940), Blanton rejected the overwhelmingly percussive rhythmic approach of his predecessors in favor of an attention to harmony. This development coincided with his refusal to either slap the strings against the neck of the instrument, or pluck them in a classical style. Rather, Blanton pulled the strings with the fleshy part of the side of his forefinger, a sound that is particularly noticeable on his duets with Ellington ("Plucked Again," 1939; "Mr. J.B. Blues," 1940; "Pitter Patter Panther," 1940). In late 1941 Blanton was diagnosed with tuberculosis, which proved fatal. He died the next year in a Los Angeles sanitorium.

REFERENCES

KANTH, I. *A Discography of Jimmy Blanton.* Stockholm, 1970.

SCHULLER, GUNTHER. "What Makes Jazz Jazz?" In *Musings.* New York, 1986.

MARTIN WILLIAMS

Blaxploitation Films. Blaxploitation film is a type of film oriented to black audiences. It developed in the late 1960s and flourished up through the late '70s. According to the Oxford English Dictionary (1989), the term "blaxploitation" was first employed in the June 12, 1972, issue of *New York* magazine to characterize such films, specifically *Superfly* (1972). The word derives from "sexploitation," first used in 1942. The OED defines "blaxploitation" as "the exploitation of blacks, especially as actors in films of historical or other interest to blacks." A variant spelling, "blacksploitation," is provided by *Colliers Year Book,* 1973. Some film critics, such as James Robert Parish and George H. Hill, have preferred the term "black action films," seeing the form as a continuum of black adventure films that began in the 1950s and continues into the present. For film scholar Thomas Cripps, "blaxploitation" is a subgenre of the black film itself. *Sweet Sweetback's Baadasssss Song* (1971), an independent production written, filmed, directed, and produced by Melvin VAN PEEBLES (who also plays the title role), is generally considered the first "blaxploitation" film. Notable successors were *Shaft* (1971), *Superfly* (1972), *Blacula* (1972), *Coffy* (1973), *The Legend of Nigger Charlie* (1972), *Melinda* (1972), *Cleopatra Jones* (1973), and *The Mack* (1973). An estimated 150 blaxploitation films were produced before the vogue faded.

Origins of the Blaxploitation Film Movement

The blaxploitation film movement had six sources of origin: (1) the precedent of integrationist films that

began in the 1940s; (2) the decline of the Hollywood studio system; (3) the Black Power movement; (4) the independent black film movement; (5) the availability of talented black actors and musicians; and (6) the newly discovered profitability of the urban black film audience.

After World War II, pressure from black and white American groups and the Cold War rivalry between the United States and the Soviet Union for favorable world opinion made the integration of America a national priority. For Hollywood, desegregation meant the increased hiring of black actors, the creation of viable black characters instead of replicating stereotypes, and the production of serious films that addressed the issue of sustaining democratic values in a racist society. Films such as *Blackboard Jungle* (1955), *The Defiant Ones* (1958), and *Pressure Point* (1962) portray black men in complex social relationships with whites in which they often assert themselves through moral or physical confrontation of racism—a first step in a new black cinema.

In the 1960s, the feature action film was integrated. A number of such feature films starred former football great Jim BROWN (*Rio Concho*, 1964; *The Dirty Dozen*, 1967; *Ice Station Zebra*, 1968; *The Split*, 1968; *100 Rifles*, 1969; and *Riot*, 1969) with white stars such as Gene Hackman, Julie Harris, Rock Hudson, Lee Marvin, Burt Reynolds, and Raquel Welch. Brown's virile, brooding presence reflected the growing influence of the Black Power movement upon mainstream culture and established the black rebel as a legitimate screen persona. Brown became the prototype of the black male action star.

Another contributing factor was the decline of the Hollywood studio system as a result of the U.S. Supreme Court antitrust ruling of 1948. This ruling required Metro-Goldwyn-Mayer (MGM), Warner Brothers, Paramount, Columbia, Twentieth Century Fox, and other giants to divest themselves of their nationwide theater chains, thus breaking the studios' previous monopoly on all aspects of the film industry. The decline of this monopoly also ended Hollywood's power to define the black presence in American films and control its dissemination to the public. Television further weakened the studios, and in the free fall that followed, major actors became independent contractors, independent film companies developed, and the theater chains were forced into open competition for the movie-goer's dollar. By the mid-1960s, 80 percent of all films released by major distributors were made by independent companies, in contrast to 20 percent in 1949. Independent black filmmakers begin to spring up and production companies emerged that were free to address racial issues. The seminal films *Nothing but a Man* (1964, Ivan DIXON, director), *The Story of a Three-Day Pass*

(1968, Melvin Van Peebles), and *Odds Against To-morrow* (1959), were independent productions. The independent black film movement was furthered by the demands of the CIVIL RIGHTS MOVEMENT and Black Power movement for positive portrayals of black life. Black actors, always minimally employed during the Jim Crow era, provided a ready pool of talent for the new films: Adolph CAESAR, Ossie DAVIS, Ruby DEE, Moses GUNN, Ellen Holly, William MARSHALL, Brock Peters, Beah Richards, among others. New talents emerged, among them John Amos, Rosalind Cash, Godfrey CAMBRIDGE, Pam Grier, Vonetta McGee, Ron O'Neal, Richard PRYOR, and Richard Roundtree. Composers such as Marvin Gaye (*Trouble Man,* 1972), Isaac Hayes (*Shaft*), Quincy JONES (*Melinda*), and Curtis MAY-FIELD (*Superfly*) composed scores for these films, Hayes winning an Oscar in 1971 for best score, for *Shaft*.

Character, Plot, Content, and Thematic Concerns of Blaxploitation Films

The typical blaxploitation protagonist, male or female, is a proud, self-assured, independent person of action who is often a private detective, intelligence agent, or underworld antihero. The protagonist's ethic includes professionalism; loyalty to friends, family, and community; a belief in the efficacy of violence and the necessity of revenge; a distrust of government; and a relentless opposition to white racism. This ethic does not preclude professional and sexual bonding across the color line or open conflict with black antagonists who, typically, have "sold out the black community," betrayed a personal trust, cheated on a business deal, or in some other way violated the protagonist's ethic.

Fast-paced action is the essential feature in a blaxploitation film plot, and it usually supersedes character development. The plot line is simple and direct, often based upon revenge, rescue, or money. At the film's conclusion, the protagonist has usually achieved his or her goal and emerged intact. In one of the most critically esteemed films, *Shaft*, the protagonist, John Shaft (Richard Roundtree) is a private detective hired by a black gangster, Bumpy Jonas (Moses Gunn), to rescue his daughter, who has been kidnapped by the Mafia. The Mafia hopes to extort from Bumpy control of the Harlem rackets. White control of black rackets is viewed as an intrusion by the black community. As is often the case in blaxploitation films, the black community is portrayed as a unified whole, and youths, militants, and hustlers all unite to help Shaft rescue Bumpy's daughter. Blaxploitation films also featured female protagonists. Tamara Dobson portrayed a U.S. government agent, Cleopatra Jones, in *Cleopatra Jones* and *Cleo-*

patra Jones and the Casino of Gold (1975). In the style of the 1970s, Cleopatra Jones is a sexually liberated female and, like her male counterparts, is expert in martial arts and weapons use. In *Coffy,* Pam Grier stars as a black woman who seeks vengeance upon the drug dealer who made her sister a hopeless drug addict at the age of eleven. To achieve this goal she poses as a call girl, seduces the drug czar, and after failing in her first attempt to assassinate him, escapes, destroys his operation, and then kills him.

There are two Americas in the blaxploitation film, a privileged white America and an oppressed black America, separated by racism and economic exploitation. Characteristically the ghettoes of urban black America are its *mise-en-scène,* and their problems of crime, drug traffic, sexual exploitation, police brutality, and government indifference and corruption are grist for the plot. The positing of a separate black America in such films permitted a nationalist and, at times, revolutionary treatment of U.S. race relations. This black perspective engaged the Afro-American community and at times distanced white American viewers, particularly critics who would complain of reverse racism. Often the blaxploitation films provided a parodic treatment of black-white relationships and stereotypes portrayed during the earlier stages of American film.

Black films of this era also reworked earlier white films and genres. John Ford's *The Informer* (1936) becomes *Uptight* (1968); Edward G. Robinson's *Little Caesar* (1931) is refilmed as *Black Caesar* (1972); John Huston's *The Asphalt Jungle* (1950) is remade as *The Cool Breeze* (1972); the Dracula legend is retold as *Blacula,* starring William Marshall; and *Spartacus* is told again as *The Arena,* featuring a revolt of female gladiators led by Pam Grier, who reprises Kirk Douglas's role. *Cotton Comes to Harlem* (1972) and *Come Back, Charleston Blue* (1972), both based upon novels by black author Chester B. HIMES, recast the detective genre in humorous terms.

The Profitability of Blaxploitation Films

The black urban film audience proved a lucrative market and inner-city blacks filled the decaying old-line theaters in Chicago, New York, Los Angeles, Washington, D.C. and other metropolises that had been left empty by whites' migration to the suburbs. Shot on location with low budgets, rapid schedules, and unknown or low-paid black actors, the blaxploitation film's average cost ranged from $150,000 to $700,000. *Shaft,* for example, cost less than $700,000 to make, including a $13,500 salary for star Richard Roundtree, and within its first year it grossed over $16 million. It is credited with saving MGM from bankruptcy. (Roundtree received $50,000 for the sequel, *Shaft's Big Score,* 1972.) *Coffy* (1973), starring Pam Grier, cost an estimated $500,000 and grossed

over $2 million in domestic film rentals. *The Legend of Nigger Charley* (1972), a black Western starring Fred Williamson, another former football star, cost $400,000 to make and grossed $3 million in domestic film rentals. The independent production, *Sweet Sweetback's Baadasssss Song,* cost under $500,000 and grossed $4.1 million in domestic film rentals. With the exception of *Sweet Sweetback's Baadasssss Song* and *Superfly,* both black-financed productions, the majority of blaxploitation profits went to the white studios, producers, and distributors responsible for their production. (The figures cited represent the distributor's gross income after the theaters have been paid; figures do not include videotape rights and rentals.)

The Critical Response to the Blaxploitation Films

These films influenced fashion and styles and had social impact. The chic clothing and accessories worn by the heroes of *Shaft* and *Superfly* were marketed to black youth, as were hairstyles, cosmetics, and jewelry. Their soundtracks often became best-selling records. The blaxploitation film, some critics argued, not only exploited the black moviegoer, but as its images became reified throughout the society, it influenced black consumer and behavior patterns, too.

Black psychiatrist Alvin Poussaint charged, "These movies glorify criminal life and encourage in black youth misguided feelings of machismo that are destructive to the community as a whole. . . . These films, with few exceptions, damage the well-being of all Afro-Americans. Negative black stereotypes are more subtle and neatly camouflaged than they were in the films of yesteryear, but the same insidious message is there: blacks are violent, criminal, sex savages who imitate the white man's ways as best they can from their disadvantaged sanctuary in the .ghetto." Poussaint continued, "Movies of any type are seldom mere entertainment because they teach cultural values and influence behavior" (Poussaint 1974). Added black critic Clayton Riley, "the danger of this fantasy is to reinforce the ordinary black human being's sense of personal helplessness and inadequacy." Observing the hunger of black audiences for films that see the world from a black point of view, *Newsweek* magazine concluded that "the intent of the new black films is not art but the commercial exploitation of the repressed anger of a relatively powerless community" (August 28, 1972). Junius Griffin, former head of the Beverly Hills–Hollywood branch of the NAACP, made similar criticisms and in 1972 launched the Los Angeles–based Coalition Against Blaxploitation (CAB), which included NAACP, CORE, and SCLC.

In responding to the fantasy-versus-reality critique, Gordon PARKS, photographer, auteur, and director of *Shaft,* argued, "It's ridiculous to imply that

blacks don't know the difference between truth and fantasy and therefore will be influenced by these films in an unhealthy way." "People talk about black movies being exploitative," said Hugh Robertson, director of *Melinda,* "and sure a lot of them are spoofy and outrageous, but the black community has been conditioned to want fantasy in films by the movies they've seen just as white people have. The only difference now is that the black fantasy isn't totally negative." In the distinguished black actor James Earl JONES's opinion, "If they're going to put the damper on John Shaft, let them put it on John Wayne too and they'll find out that there are a lot of people who need those fantasies" (*Newsweek,* October 23, 1972).

With reference to the issue of crime and violence, white film producer Larry Cohen (*Black Caesar*) argued that the "white" gangster films of the 1930s that starred Humphrey Bogart, James Cagney, and Edward G. Robinson also featured violence to an approving audience: "The only difference was that the perpetrator had to pay for his crime before the film ended, due to the Code restrictions of that day . . . it really made no difference in the impact on the audience" (*Variety,* March 7, 1973). Further, stated Ron O'Neal, the star of *Superfly,* "The critics of *Superfly* want to support the myth that crime doesn't pay. But we all happen to know that crime is paying off for some people every day." In a review of *The Mack* and *Superfly,* critic Stanley Kauffmann addressed the issue of quality: ". . . why in the world should we expect black film people, now empowered to make movie money, to behave differently or better than 99 percent of white film people behaved in the seventy years that they had full control of the screen . . . only after there is a *body* of black films, as generally rotten as most white films, will there be a chance for the occasional good black film, as there is for the occasional good white one" (*New Republic,* April 28, 1973).

As the movement drew to a close, most blacks involved in the film industry concluded that to assure quality, blacks must finance and control the production of black-oriented films. In Jim Brown's view, the blaxploitation films were a necessary stage: "The Black films were at least developing producers, directors and technical people, and everyone knows that you have to crawl before you can walk. Maybe the Black films weren't of the highest quality, but Black people were getting experience in the industry" (*Ebony,* October 1978).

The Legacy of Blaxploitation Films

Blaxploitation films were part of a general resurgence of black artistic and political activity during the 1960s and early '70s. In tandem with these black action films, a number of black feature films were produced that satisfied the concern of middle-class black and white communities for black positive images and value systems that would vindicate the quest for assimilation into mainstream American society. These films included *Sounder* (1972), *Claudine* (1974), *The Learning Tree* (1969), and *The River Niger* (1976), and featured such black stars as Diahann CARROLL, Louis GOSSETT, James Earl JONES, Sidney POITIER, Richard Pryor, Diana ROSS, Cicely TYSON, and Paul Winfield. In considering the complex relationship between market, film quality, and audience of race-related films in 1963, *Variety* had commented, "it's a hard fact of film life that the race pix which have been most successful at the box office have been out-and-out exploitation dramas of rather dubious artistic and social import." The marketing strategy of race films was to budget the picture so that the producer, if necessary, could recoup its costs in just the black market, even while aiming at as broad a market as possible. Concluded *Variety:* "Ironically, however, as the equal rights fight must continue to succeed, that very hard core 'Negro market' must continue to diminish. Thus, to succeed, these projected films must appeal to the new, 'desegregated market'" (July 17, 1963). The great appeal of the blaxploitation films indicated that much of America's population and imagination was still segregated in the 1970s.

But the blaxploitation films integrated attitudes, expressions, body language, and style of inner-city blacks into the repertory of black and white feature films, thus legitimizing both black culture and these media. Richard Pryor and Eddie MURPHY became major box office attractions in the 1980s through a series of fast-paced action comedies. Often playing fast-talking street hustlers, Pryor and Murphy incorporated into their characters many of the iconoclastic and scatological attitudes of inner-city blacks toward whites that were first developed in the blaxploitation films. Whoopi GOLDBERG has continued this trend in many of her vehicles.

Among the first of the post-blaxploitation action films, Sylvester Stallone's series, *Rocky I–IV* (1976, 1979, 1982, 1985) effected such an integration through the use of black actors Carl Weathers, who plays flamboyant heavyweight champion Apollo Creed, patterned upon Muhammad ALI, and Mr. T., who took the part of ghetto-tough boxer Clubber Lang. However, Stallone's films valorized the Italian-American working-class culture, as roustabout Rocky Balboa, played by Stallone, becomes a champion boxer in a sport dominated by blacks. Increasingly feature films began to include black actors in major roles, but the ideological authority of the film resided within the actions and perspective of the white protagonist.

In summary, among the achievements of blaxploitation films have been: (1) to prove that black audiences would support black films; (2) to revitalize white studios and urban theaters during the late 1960s

to mid '70s; (3) to develop a genre of black action film; (4) to stimulate the integration of mainstream feature films; and (5) to broaden the range of character for black actors and actresses; and (6) to provide an opportunity for new black talent, in front of the camera and behind it.

REFERENCES

CRIPPS, THOMAS. *Black Film as Genre.* Bloomington, Ind., 1979.

GREEN, THEOPHILUS. "The Black Man as Movie Hero: New Films Offer a Different Male Image." *Ebony* (August 1972): 144–148.

KAEL, PAULINE. "Notes on Black Movies." *New Yorker* (December 2, 1972): 159–165.

LEAB, DANIEL J. *From Sambo to Superspade: The Black Experience in Motion Pictures.* Boston, 1975.

MASON, B. J. "The New Films: Culture or Con-Game?" *Ebony* (December 1972): 60–62.

MICHER, CHARLES. "Black Movies." *Newsweek* (October 23, 1972): 74–81.

MURRAY, JAMES P. *To Find an Image: Black Films from Uncle Tom to Superfly.* Indianapolis/New York, 1973.

NESTEBY, JAMES R. *Black Images in American Films: The Interplay Between Civil Rights and Film Culture.* Lanham, Md., 1982.

NOBLE, PETER. *The Negro in Films.* New York, 1970.

PARISH, JAMES ROBERT, and GEORGE H. HILL. *Black Action Films: Plots, Critiques, Casts and Credits for 235 Theatrical and Made-for-Television Releases.* Jefferson, N.C., 1989.

PATTERSON, LINDSAY. *Black Films and Film-Makers: A Comprehensive Anthology from Sterotype to Superhero.* New York, 1975.

POUSSAINT, ALVIN F. "Cheap Thrills That Degrade Blacks." *Psychology Today* 7 (February 1974): 22–32.

WARD, RENEE. "Black Films, White Profits." *Black Scholar* 7 (May 1976): 13–24.

YEARWOOD, GLADSTONE. *Black Cinema Aesthetics: Issues in Independent Black Filmmaking.* Athens, Ohio, 1982.

ROBERT CHRISMAN

Bledsoe, Julius C. "Jules" (December 29, 1898–July 14, 1943), singer. Born in Waco, Tex., Julius Bledsoe began singing and playing the piano in church as a child. He received a bachelor's degree in history, composition, and piano in 1918 at Bishop College in Marshall, Tex. After considering medicine, he chose a career as a professional singer, studying voice with Claude Warford. He later studied in Europe with Luigi Parisolti and Lazar Samoiloff. On April 20, 1924, Bledsoe made his concert debut as a baritone at Aeolian Hall in New York City. Following his first major stage appearance on Broadway, as the Voodoo King in William Harling's *Deep Rive*

(1926), his greatest fame came when he created the role of Joe in Jerome Kern's *Show Boat* in 1927.

In 1927, Bledsoe joined the music staff of the Roxy Theater on Broadway, becoming the first African-American artist to be continually employed by a Broadway theater. During the 1930s he appeared in concerts and operas throughout Europe, singing the roles of Boris Godunov, Rigoletto, Tonio in *I Pagliacci,* and Amonasro in *Aida.* In the United States he appeared in the title role of Louis Gruenberg's *The Emperor Jones* (1933) and as the Voodoo Man in Shirley Graham DuBois's *Tom-Tom* in Cleveland (1933). His compositions include *Ode to America* (1941), dedicated to President Franklin D. Roosevelt; an *African Suite* for violin and orchestra; and various songs in spiritual style. He died in Hollywood.

REFERENCE

GEARY, LYNETTE G. "Jules Bledsoe: The Original 'Ol' Man River.' " *The Black Perspective in Music* 17, nos. 1, 2 (1989): 27–54.

KYRA D. GAUNT

Blind Tom. *See* Bethune, Thomas Greene Wiggins "Blind Tom."

Blount, Herman "Sonny." *See* Sun Ra.

Blues, The. A type of African-American musical art that was first developed in the Mississippi Delta region of Louisiana at the end of the nineteenth century, the blues, like many musical expressions, is difficult to define. Some people think of the blues as an emotion; others regard it primarily as a musical genre characterized by a special blues scale, containing twelve bars and three chords in a particular order. Besides embodying a particular feeling (the "blues") and form, the blues also involves voice and movement: poetry set to dance music. It is vocal not only in the obvious sense that most blues songs have lyrics, but in that even in purely instrumental blues, the lead instrument models its expressivity on the singing voice; and it involves dance because it quite literally moves listeners—even when they are sitting down. Its influence on JAZZ, GOSPEL MUSIC, theater music, rock, and almost every subsequent form of popular music in the twentieth century has been incalculable.

Early blues singers composed their own songs, inventing verses and borrowing from other singers, and they were among the first Americans to express feelings of *anomie* characteristic of modern life and to

rise above it through art. By singing about frustration, mistreatment, and misfortune and often overcoming it with irony, blues singers helped themselves and their listeners to deal with the problems of life, whether frustrated and angered by cheating lovers, ignorant bosses, hypocritical churchgoers, crooked shopkeepers, an unjust legal system, racism and prejudice, police brutality, inadequate pay, unemployment, or the meaninglessness of menial labor. Blues singers fought adversity by asserting human creativity, by turning life into art through ironic signification, by linking themselves through their traditional art to others in the community, and by holding out a future hope for freedom and better times down the road. The blues as music and poetry can convey a tremendous range of emotions succinctly and powerfully. Blues lyrics represent an oral poetry of considerable merit, one of the finest genres of vernacular poetry in the English language.

The blues is a distinct musical type. It is an instrumentally accompanied song-type with identifying features in its verse, melodic, and harmonic structures, composition, and accompaniment. Most blues lyrics are set in three-line or quatrain-refrain verses. In the three-line verse shown below, the second line repeats the first, sometimes with slight variation, while the third completes the thought with a rhyme.

> I'm gonna dig me a hole this morning, dig it
> deep down in the ground;
> I'm gonna dig me a hole this morning, dig it
> deep down in the ground;
> So if it should happen to drop a bomb around
> somewhere, I can't hear the echo when it sound.
> ("Lightnin' " Hopkins, "War News Blues")

In the quatrain-refrain verse shown below a rhymed quatrain is followed by a two-line refrain. Each verse form occupies twelve measures or bars of music; in the quatrain-refrain form the quatrain occupies the first four of the twelve.

> I got a job in a steel mill,
> a-trucking steel like a slave.
> For five long years every Friday
> I went straight home with all my pay.
> If you've ever been mistreated, you know just
> what I'm talking about:
> I worked five long years for one woman; she
> had the nerve to throw me out.
> (Eddie Boyd, "Five Long Years")

The tonal material in the blues scale (illustrated herewith) includes both major and minor thirds and sevenths and perfect and diminished fifths. Blues shares this tonal material with other African-American music such as work songs, lined hymnody, gospel music, and jazz. A sharp rise to the highest pitch followed by a gradual descent characterizes the melodic contour of most vocal lines in each verse. Blues shares this contour with the field holler, a type of work song.

A blues scale in the key of C.

Blues has a distinctive harmonic structure. The first line of the verse (or the quatrain in the quatrain-refrain form) is supported by the tonic chord (and sometimes the subdominant, resolving to the tonic at the end of the line), the second line by the subdominant (resolving to the tonic), and the third line by the dominant seventh and then the subdominant before resolving to the tonic. Urban blues and jazz musicians modify this harmonic structure with altered chords and chord substitutions. The blues also has characteristic contents and performance styles. Most blues lyrics are dramatic monologues sung in the first person; most protest mistreatment by lovers and express a desire for freedom. Early blues singers improvised songs by yoking together lines and verses from a storehouse in their memories; most of today's singers memorize entire songs.

Most early down-home blues singers accompanied themselves on piano or on guitar, on the latter supplying a bass part with the right-hand thumb and a treble part independently with the right-hand fingers. Early vaudeville or classic blues singers were accompanied by pianists and small jazz combos. In the 1930s or after, blues "shouters" were accompanied by jazz and RHYTHM 'N' BLUES bands, and this led in the 1940s to urban blues singers who played electric guitar and led their own bands. After WORLD WAR II, most down-home blues singers played electric guitar, sometimes with a small combination of bass, drums, second guitar, harmonica, or piano.

The beginning of blues cannot be traced to a specific composer or date. The earliest appearance of music recognizable as the blues was the publication of W. C. HANDY's "The Memphis Blues" (1912) and the "St. Louis Blues" (1914), but by his own testimony, Handy first heard the blues along the lower Mississippi River in the 1890s, and many historians agree with Handy that this was the likeliest environment for the origin of the blues. However, just when and where one locates the origin of blues depends upon what is considered sufficient to the genre. Some cultural historians locate the essence of the blues in resignation or in protest against mistreatment, and they believe that since slaves sung about their condition, these songs must have been blues,

In the late nineteenth and early twentieth centuries, marching bands afforded many young black musicians an opportunity to practice and develop their craft. The young W. C. Handy, photographed around 1900, played in the Mahara Minstrels band from 1896 to 1903 before starting his own marching band. (Frank Driggs Collection)

even though there is no evidence that they were called blues or that the verse or musical forms resembled later blues. Folklorists and musicologists, on the other hand, have constructed a narrower definition, essentializing structural aspects of the blues as well as their subject and relying for evidence on a combination of oral history, autobiography, and the first blues music recorded by the oldest generation of African Americans.

W. C. Handy and "Jelly Roll" MORTON, well-known and accomplished African-American musicians who were very much involved in music before the turn of the twentieth century, recalled in their autobiographies that blues began along the Mississippi in the 1890s as a secular dance music, accompanied by guitars and other portable instruments or piano, with more or less improvised verses, among the river roustabouts in the juke joints and barrel-houses and at picnic and other roadside entertainments. About 1900, folklorists first collected this music, but did not realize they were witnessing the formation of a new genre. Verse patterns varied, the only standard feature being the repetition of the first line; sometimes once, sometimes twice, sometimes three times. The verses were aphoristic, and their subjects concerned lovers, traveling, and daily aspects of life. Harmonic support often was confined to the tonic. The collectors did not call those songs blues, and we may suppose that the singers did not, either.

The first recordings of African Americans singing blues were not made until the 1920s, but it is clear that between 1890 and 1920 the blues developed into a named and recognizable musical genre. In this period the blues developed and diffused wherever there were African Americans in the United States, in the rural areas as well as the towns and cities and among the traveling stage shows. Ma RAINEY, the "mother of the blues," claimed to have begun singing blues from the stage in 1902, while "Jelly Roll" Morton identified a blues ballad, "Betty and Dupree," as popular fare in New Orleans during the last years of the nineteenth century. Handy's "Memphis Blues" was used in the 1912 mayoralty campaign, while "St. Louis Blues" was a show tune designed to elevate blues to a higher class. Rural songs at country dance parties gradually consolidated toward three-line verse forms with twelve-measure stanzas and the typical harmonic pattern indicated above, while many of the stage songs featured two sections, an introduction followed by a section in recognizable blues form. The stage songs later became known as "classic" or "vaudeville" blues.

African Americans recorded vaudeville blues beginning with Mamie SMITH in 1920. Women with stage-show backgrounds, accompanied by pianists and small combos, sang blues songs composed by professional tunesmiths. The best of the vaudeville blues singers, Ma Rainey and Bessie SMITH, appealed across racial and class boundaries, and their singing styles revolutionized American popular music. In some of their blues, Rainey and Smith sang about strong, independent women who put an end to mistreatment. Rainey in particular, who sang about such subjects as prostitution, LESBIANISM, and sadomasochistic relationships, may be viewed as a spokesperson for women's rights. Other vaudeville blues singers, such as Mamie Smith, Sippie WALLACE, Ida COX, and Alberta HUNTER, were also very popular in the 1920s, but the era of vaudeville or "classic" blues came to an end during the Great Depression. The down-home or country-flavored blues was recorded beginning in 1926, when record companies took portable recording equipment to southern cities and recorded the local men who sang the blues and accom-

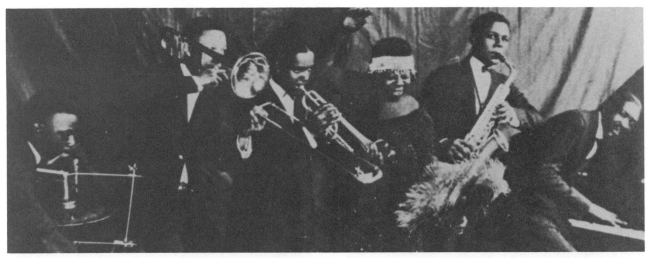

Ma Rainey, one of the greatest blues singers of the 1920s, with her jazz band in 1925. (From left to right), the band includes an unidentified drummer, Al Wynn (trombone), Dave Nelson (trumpet), Ma Rainey, Ed Pollock (alto saxophone), and Thomas A. Dorsey (piano). Dorsey later achieved renown as a gospel composer. (Photographs and Prints Division, Schomburg Center for Research in Black Culture, The New York Public Library, Astor, Lenox and Tilden Foundations)

panied themselves on guitars and pianos in the juke joints and at the country dance parties. Some of the older singers like Charley PATTON and Henry Thomas (1874–c. 1959) sang a variety of traditional songs, not all blues; others, like "Blind" Lemon JEFFERSON, specialized in blues; yet others, like Blind Blake, achieved instrumental virtuosity that has never been surpassed. The variety of traditional music recorded by the older generation reveals the proto-blues as well as the blues and helps to show how the form evolved.

Geographic regions featured their own particular instrumental guitar styles before WORLD WAR II. The down-home blues of Florida, Georgia, and the Carolinas tended toward rapidly finger-picked accompaniments: "ragtime" styles in which the right-hand thumb imitated the stride pianist's left hand, while the right-hand fingers played melody. Blind Blake, Blind Boy Fuller (c. 1909–1941), and Blind Gary Davis (1896–1972) were among the first exponents of this East Coast style. In Mississippi, on the other hand, chord changes were not as pronounced, and accompaniments featured repeated figures, or riffs, rather than the melody of the verse. Charley Patton, "Son" HOUSE (1902–1988), Robert JOHNSON, and MUDDY WATERS (McKinley Morganfield) were outstanding guitarists in the Mississippi Delta style. Piano styles equally reflected regional differences. All embodied genuine innovations, such as bottleneck or slide guitar or imitating the expressiveness of the voice, and an inventiveness and technical accomplishment unparalleled in vernacular American music.

Down-home blues became so popular in the late 1920s that talent scouts arranged for singers to travel north to make recordings in the companies' home studios. Blues music was available on what were called "race records," 78-rpm records for African Americans, and they were advertised heavily in black newspapers like the Chicago *Defender*.

While early recordings offer the best evidence of the sound of blues music in its formative years, they can only begin to capture the feel of an actual performance. Because down-home blues usually was performed in barrelhouses, juke joints, at parties, and picnics where the bootleg whiskey flowed, gambling took place, fighting was not uncommon, and sexual liaisons were formed, the music became associated with those who frequented these places. Churchgoers shunned blues because it was associated with sin, while middle-class blacks kept blues at a distance. Most communities, whether rural or urban, had their local blues musicians and entertainments, however. In the 1920s, blues was the most popular African-American music.

The depression cut heavily into record sales and touring stage shows, and most of the classic blues singers' careers ended. The increasing popularity of jazz music provided an opportunity for their successors to tour and record with jazz bands. The down-home blues continued unabated in the rural South and in the cities. A small number of outstanding down-home singers, including Tommy McClennan (1908–1960) Memphis Minnie (McCoy), and Robert Johnson, made commercial recordings, but the big-band blues of Count BASIE and other jazz bands, featuring blues "shouters" like Walter Brown, Jimmy Rushing, and "Hot Lips" Page, rode radio broadcasts and records to national popularity later in the 1930s. The blues form became a common ground for jazz improvisors, and jazz artists of the highest stature,

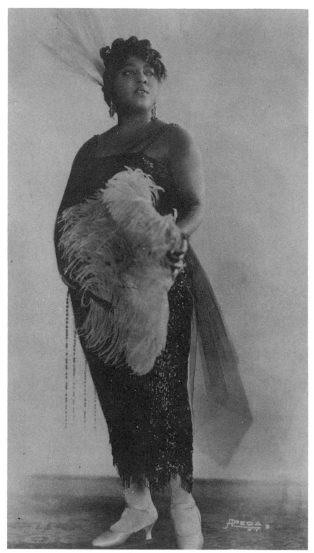

Mamie Smith's 1920 record "Crazy Blues" sparked the blues craze of the 1920s and marked the real beginning of the recording of black popular music. She remained a stage and recording star through the 1930s. (Photographs and Prints Division, Schomburg Center for Research in Black Culture, The New York Public Library, Astor, Lenox and Tilden Foundations)

from Louis ARMSTRONG through Duke ELLINGTON, Billie HOLIDAY, and Charlie PARKER, Sarah VAUGHN, Miles DAVIS, John COLTRANE, and Wynton MARSALIS, composed and improvised a great many blues. For Charles MINGUS, one of the most important jazz innovators of the 1950s and 1960s, blues and church music were the twin African-American cornerstones of jazz, and much of his music successfully integrated these roots into contemporary "soul" music. Indeed, since the 1940s, periodic reinvigorations of jazz have taken blues for their basis, and it appears that they will continue to do so:

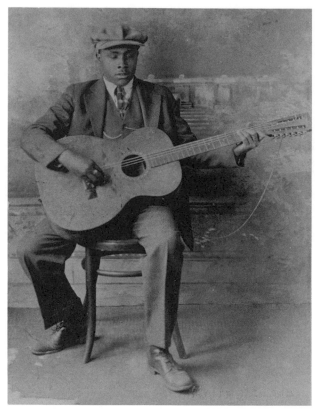

Blind Willie McTell, an extraordinary twelve-string guitarist, was a much-recorded exponent of the southeastern blues style in the 1920s and '30s. (Frank Driggs Collecton)

bop, hard bop, funk, and other jazz movements all looked for inspiration in blues roots.

Besides the jazz bands, blues in the 1940s and '50s was featured in the urban and rhythm 'n' blues bands led by such guitarists-singers as (Aaron) "T-Bone" WALKER and (Riley) B. B. [Blues Boy] KING, whose spectacular instrumental innovations virtually defined the genre and influenced countless blues and rock guitarists. Electronic amplification of the guitar allowed it to be heard above the piano and brass and reed instruments; Walker's pioneering efforts virtually invented the modern blues band, the core of which is an electric guitar accompanied by a rhythm section. King's live performances combined instrumental virtuosity in the service of great feeling with a powerful, expressive voice that transformed daily experience into meaningful art, and he spoke to and for an entire generation. His album *B. B. King Live at the Regal* (1965) is often cited as the finest blues recording ever made.

Down-home blues was well served in the years just after World War II by a host of new recording companies. Among the outstanding singer-guitarists were Sam "Lightnin' " HOPKINS from Houston and John Lee HOOKER from Mississippi (and later De-

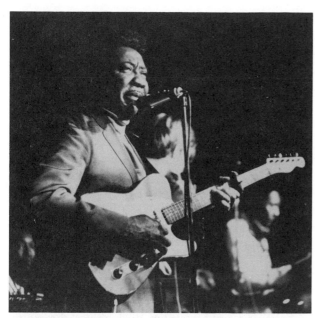

Muddy Waters was one of the supreme masters of the blues. His uniquely scalding version of the blues combined his Mississippi Delta heritage with the electrified ensembles of postwar Chicago sound. (AP/Wide World Photos)

troit) who, along with West Helena and Arkansas harmonica-player "Sonny Boy WILLIAMSON" (Rice Miller), contributed a magnificent body of original blues lyric poetry. The Mississippi Delta connection led to such singers as Muddy Waters and HOWLIN' WOLF (Chester Burnett), who led small combos in Chicago after 1945 that helped create the Chicago blues style, basically a version of the Delta blues played on electrified and amplified instruments. Muddy Waters' band of the early 1950s, featuring "Little" Walter (Jacobs) on amplified harmonica, defined a classic Chicago blues sound that many think was the high point of the genre. With his horn-influenced, amplified harmonica solos, "Little" Walter invented a completely new sound, and his work stands as another influential example in a music with a history of astonishing technological innovation in the service of greater expressivity. A cluster of post–World War II artists including Waters, Wolf, Jimmy Reed (1925–1976), John Lee Hooker, Elmore JAMES, Little Walter, Sonny Boy Williamson (Rice Miller), and others greatly influenced ROCK 'N' ROLL in the 1960s, while a number of similar artists, relying heavily on blues, such as Fats DOMINO and Chuck BERRY, helped to define rock 'n' roll in the 1950s.

In the 1960s, the African-American audience for blues declined, while the white audience increased and the first "blues revival" occurred. Young white musicians and researchers rediscovered older down-home blues singers such as Son House and Missis-

sippi John Hurt, and blues singers and bands became featured acts in coffeehouses, clubs, and festivals that catered to a college-age white audience. Many blues singers' musical careers were extended by this attention. Young white musicians began to play and sing the music, and, along with traditional blues musicians, found a new audience. Earlier recordings were reissued for collectors, research magazines devoted to blues appeared, and cultural historians and scholars began writing about the music. Although black musicians continue to perform blues in traditional venues—bars, juke joints, etc.—particularly in Chicago and in the Mississippi Delta, since the 1960s, newer styles such as MOTOWN, soul music, disco, funk, RAP, and hip-hop eclipsed blues as popular music among African Americans.

In the early 1990s, another blues revival began to take place. As a resurgence of interest in blues occurs, older blues recordings are being reissued on CD, and some recordings, such as those of Robert Johnson, sell extremely well, while younger singers and musicians, black and white, increasingly choose to perform and record blues. Blues radio shows, such as the one hosted on National Public Radio by Ruth BROWN, have increased the music's visibility and popularity. Blues now appears as background music for ads on radio and television. Nightclubs featuring blues can now be found in many American cities, and older artists such as Robert Jr. Lockwood (1915–) and Buddy Guy (1936–) have had new careers, while younger artists such as the Holmes Brothers and Robert Cray have come to prominence. Some southern cities and states, such as Memphis and Mississippi, have set up a significant tourist industry around blues, and there are blues museums and mon-

Bluesman John Lee Hooker's first hit record was "Boogie Chillen'" in 1948. Popular with both black and white audiences, Hooker has enjoyed a long and successful career. (AP/Wide World Photos)

uments as well. Thirty years ago, it was a music in decline, known outside African-American culture only to a small number of aficionados; but today the blues is historicized, an official part of American and African-American culture. Thirty years ago, literary critics and cultural historians saw little use for the blues, viewing it as a music of slave-consciousness and resignation; but today a new generation of African-American writers, such as Henry Louis Gates, Jr., and Houston Baker, see blues as a source of black pride and a root tradition. As such, blues has had a profound effect upon African-American life and, lately, upon popular culture throughout the world where it and its musical offspring have spread.

REFERENCES

BAKER, HOUSTON. *Blues, Ideology and Afro-American Literature: A Vernacular Theory.* Chicago, 1984.

EVANS, DAVID. *Big Road Blues: Tradition and Creativity in the Folk Blues.* Berkeley, Calif., 1982.

GATES, HENRY LOUIS, JR. *The Signifying Monkey: A Theory of African-American Literary Criticism.* New York, 1988.

GEORGE, NELSON. *The Death of Rhythm and Blues.* New York, 1988.

HART, MARY, et al., eds. *The Blues: A Bibliographical Guide.* New York, 1989.

LIEB, SANDRA. *Mother of the Blues: A Study of Ma Rainey.* Amherst, Mass., 1981.

OLIVER, PAUL, ed. *The Blackwell Guide to Blues Recordings.* New York, 1989.

PALMER, ROBERT. *Deep Blues.* New York, 1981.

PEARSON, BARRY LEE. *"Sounds So Good to Me": The Bluesman's Story.* Philadelphia, 1984.

SAWYER, CHARLES. *The Arrival of B. B. King.* London, 1982.

TITON, JEFF TODD. *Early Downhome Blues: A Musical and Cultural Analysis.* Urbana, Ill., 1977.

TITON, JEFF TODD, ed. *Downhome Blues Lyrics: An Anthology from the Post-World War II Era.* 2nd ed. Urbana, Ill., 1990.

JEFF TODD TITON

Bluford, Guion Stewart, Jr. "Guy" (November 22, 1942–), astronaut. Born and raised in Philadelphia, Guion Bluford was an Eagle Scout who was certain of his interest in aerospace engineering by the time he reached junior high school. In 1964 he received a B.S. in aerospace engineering from Pennsylvania State University where he was enrolled in the Air Force's Reserve Officers' Training Corps (ROTC). After graduation, he joined the Air Force as a lieutenant colonel. Bluford received his pilot wings in January 1965 from the pilot training program at Williams Air Force Base (AFB) in Arizona and went to Vietnam, where he flew 144 combat missions as a member of the F-4 fighter squadron. From 1967 to 1972 he taught acrobatic flying at Sheppard AFB in Texas. He then served as Chief of the Aerodynamics and Airframe branch of the Air Force Flight Dynamics Laboratory at Wright-Patterson AFB in Ohio, while he studied at the Air Force Institute of Technology (AFIT). In 1978 AFIT granted him a Ph.D. in aerospace engineering after his completion of a dissertation entitled "A Numerical Solution of Supersonic and Hypersonic Viscous Flow Fields Around Thin Planar Delta Wings."

In 1978 Bluford was accepted into the National Aeronautics and Space Administration's (NASA) astronaut program. After completing training, Bluford became the first African American in space, serving as a mission specialist on the eighth *Challenger* shuttle flight in August 1983. His next space mission was again aboard *Challenger* in a joint venture with West Germany on October 30, 1985. He flew twice more, in April 1991 and December 1992, aboard the orbiter *Discovery*.

While living in Houston, Tex., where NASA is headquartered, Bluford continued his studies, earning an M.B.A. in 1987 from the University of Houston. In June 1993, he resigned from NASA and the Air Force to become vice president and general manager of the Engineering Services Division of NYMA, Inc., an engineering and computer software firm in Greenbelt, Md. Bluford has received numerous awards, including the Vietnam Cross of Gallantry with Palm (1967), the Vietnam Service Medal (1967), the Air Force Commendation Medal (1972), the Air Force Meritorious Service Award (1978), two NASA Group Achievement Awards (1980, 1981), the NAACP Image Award (1983), the Ebony Black Achievement Award (1983), and several honorary doctorates.

REFERENCE

HAWTHORNE, DOUGLAS B. *Men and Women of Space.* San Diego, Calif., 1992.

LYDIA MCNEILL

Blyden, Edward Wilmot (August 3, 1832– February 7, 1912), Liberian nationalist. Born on the Caribbean island of St. Thomas, Edward W. Blyden was the son of free blacks, Romeo, a tailor, and Judith, a schoolteacher. He was the third of seven children. As early as 1842 while in Porto Bello, Venezuela, he began to develop a facility with language. He also became more acutely aware that the majority of people of African descent in the Americas were slaves, and this affected the future course of his life. Upon returning to St. Thomas, Blyden attended

school and completed a five-year apprenticeship as a tailor. He grew interested in becoming a minister after meeting a Dutch Reformed minister, Rev. John P. Knox.

Knox was instrumental in Blyden's decision to come to the United States in 1850 and seek admission at Rutgers Theological College. Blyden was prevented from entering the school, however, because of his race. This experience, coupled with his devotion to further the black struggle, led him to support the African colonization movement. Less than a year after entering the United States, Blyden emigrated to LIBERIA with the support of members of the AMERICAN COLONIZATION SOCIETY (ACS).

Once in Liberia, Blyden entered school and prepared himself for a leadership role. His education was enhanced by travels to Europe, the Middle East, and throughout Africa. By 1858 he had been ordained a Presbyterian minister and accepted the position of principal of a high school in Liberia. He also served as government correspondent and editor of the government newspaper, the *Liberian Herald,* for a year. His most important appointment was from 1880 to 1884 as president of Liberia College, which was overseen by a board of trustees in Boston and New York.

Born on St. Thomas in 1832, Edward Wilmot Blyden devoted most of his life to Liberia and the cause of African nationalism. In the 1870s and '80s Blyden spent several years promoting African issues in the United States. (Photographs and Prints Division, Schomburg Center for Research in Black Culture, The New York Public Library, Astor, Lenox and Tilden Foundations)

While Blyden was unable to receive all the formal educational training he hoped for, his vision for Liberia and for all people of African descent was defined in his writings. He argued that the African race had indeed made significant contributions to human civilization and that African cultural institutions and customs should be preserved. He expressed the view that Islam had served Africa better than Christianity had, but that there was much for Africa to learn from the West. The essence of Blyden's thoughts was contained in his books *Hope for Africa* (1862), *Christianity, Islam and the Negro* (1887), and *Race and African Life and Customs* (1908). A major portion of his writings focused on the colonization of blacks in Liberia. He envisioned that with the emigration of highly educated blacks, Liberia could reach its full potential and become an example of the capabilities of the African race to the world.

Blyden was a major supporter of the ACS, which founded Liberia. This organization was instrumental in his own emergence within Liberia and in the international community. Blyden wrote many articles for the ACS journal, the *African Repository,* and regularly corresponded with the group's officials. He also made numerous visits to the United States on behalf of the ACS to urge educated blacks to emigrate. Throughout his lifetime, Blyden held the view that blacks could never be wholly accepted as equals in America. His emigrationist appeals, however, fell primarily on deaf ears. Blyden and the ACS were on occasion forced to look for emigrants to Liberia in the Caribbean.

Much of Blyden's life was spent in pursuit of political goals. Appointed Liberia's secretary of state in 1864 (he served until 1866), Blyden used this position to encourage the emigration of "genuine blacks," rather than mulattoes, to Liberia. In 1871, he left the country after narrowly escaping being lynched due to political instability caused by warring factions and his opposition to mulatto rule and control within Liberia. He spent this time in Sierra Leone, returning to Liberia in 1873. After his return, Blyden continued traveling to the United States, advocating emigration. He resumed his role as educator and was appointed minister of the interior and secretary of education in 1880. He also made an unsuccessful attempt to become Liberia's president in 1885.

After 1885, Blyden focused much of his attention on the issue of West African unity, which had been initiated while he was in Sierra Leone. He used his diplomatic positions in London and Paris to advance this agenda. However, the unity theme was clouded by his belief that European colonialism in Africa could be positive for development. He believed that the climate would prevent Europeans from settling in Africa on a permanent basis.

Prior to his death in Sierra Leone, Blyden was in poor health and received a moderate pension at the instruction of the colonial secretary from the governors of Sierra Leone, Lagos, and the Gold Coast. While his emigrationist vision for Liberia did not succeed as he had hoped, his racial fervor made him a symbolic figure for future generations of nationalists.

REFERENCES

LYNCH, HOLLS R. *Edward Wilmot Blyden, Pan-Negro Patriot, 1832–1912.* London, 1967.

————, ed. *Selected Letters of Edward Wilmot Blyden.* New York, 1978.

LAYN SAINT-LOUIS

Bodybuilding. African-American men have won important amateur and professional competitions since Sergio Olivia, a black weightlifter who defected to the U.S. from Cuba in 1962, won the Mr. Olympia title three years in a row (1967–1969). Henri Christophe Dickerson finished second in the 1969 Mr. America contest, and when he won the title in 1970, he became the first black Mr. America.

The first Mr. America amateur bodybuilding competition was held in 1939 and the first Mr. Olympia, the championships of men's professional bodybuilding, in 1965. Bodybuilding remained on the fringe of American culture, however, until the 1970s, when Arnold Schwarzenegger capitalized on a heightened interest in physical fitness to bring bodybuilding to a wide audience. At this time there was also a shift toward an ever more muscular physique—and a growing reliance on anabolic steroids—among participants.

In the 1980s and early '90s African-American men dominated professional bodybuilding. In 1982 Chris Dickerson won Mr. Olympia. Lee Haney of South Carolina won the 1979 Mr. Teenage America, finished fourth in the 1980 Mr. U.S.A., won the 1982 Mr. America and Mr. Universe, had a third place finish in the 1983 Mr. Olympia, and then won every Mr. Olympia from 1984 until 1991—setting the record for the most Mr. Olympia titles. Although Haney retired in 1991, there were a number of other African-American standouts. The top finishers in amateur and professional competitions were more often than not African American. For example, Vince Taylor finished third at Mr. Olympia in 1989 and 1991 and came in third at the Schwarzenegger Classic in 1991 and 1993, winning there in 1992. In 1993 Ken "Flex" Wheeler won the Schwarzenegger Classic and came in second at Mr. Olympia. Mike Ashley took first at the 1990 Schwarzenegger Classic. Shawn Ray

Jim Morris, winner of both the Mr. U.S.A. and Mr. America contests, displaying his remarkable physique. (Photographs and Prints Division, Schomburg Center for Research in Black Culture, The New York Public Library, Astor, Lenox and Tilden Foundations)

won it the next year and had a third at both the 1990 and 1993 Mr. Olympia, as well as a fifth in 1991. Kevin Levrone had a second-place finish at Mr. Olympia in 1992 and a fifth in 1993. Dorian Yates of Britain won the 1993 Mr. Olympia, but four of the top six finishers were African American (more than half of the U.S. entrants were black).

African-American women have done well in bodybuilding from the start of female competition in the late 1970s. The Ms. Olympia competition, first held in 1980, has had two African-American champions: in 1983 Carla Dunlap, who was featured in the film, *Pumping Iron II: The Women,* and Lenda Ann Murray, who won four consecutive titles from 1990 to 1993. Among women, competition shifted from an

early preference for a thinner, toned appearance, to a larger, bulkier, more powerful look.

Men's and women's professional competitions carry purses in the $80,000 (Schwarzenegger Classic) to $100,000 (Ms. Olympia) range, and top performers, such as Lenda Murray, can earn $300,000 dollars a year between prize money and promotions. After retiring from competitions, most performers stay in the fitness industry. Haney, for instance, began his own franchise of gyms in the Atlanta region, wrote several fitness books, such as *Lee Haney's Ultimate Bodybuilding Book* (1993), and released bodybuilding videos. He also trained boxer Evander HOLYFIELD. Haney, as well as Carla Dunlap, has hosted exercise programs for ESPN. Dunlap, in addition to her television work, has modeled for Danskin and trains bodybuilding judges.

Besides the elite tournaments, the 1980s and '90s saw a dramatic increase in the number of local, state, and regional competitions, and African-American participants represented a growing percentage of top finishers.

REFERENCE

OLRICH, TRACY WARREN. The Relationship of Male Identity, the Mesomorphic Image, and Anabolic Steroid Use in Bodybuilding. M.A. thesis. University of Michigan, 1990.

PETER SCHILLING

Bojangles. *See* Robinson, Bill "Bojangles."

Bolden, Charles Joseph "Buddy" (September 6, 1877–November 4, 1931), jazz cornetist. Both traditionally received and romanticized jazz history have accorded Charles Joseph "Buddy" Bolden almost legendary stature. He was a gifted and—especially among people of color—extraordinarily popular cornet player and bandleader in competitive and music-saturated turn-of-the-century New Orleans. Mainly self-taught, Bolden was playing professionally in a local band by his teen years and soon successfully led his own band, eventually earning the appellation "King."

While most often noted for a clear and uncommonly powerful tone (reputedly strong enough to be heard by the faithful across the river), he was an important innovator. Before Bolden's era, New Orleans bands consisting of musicians of color generally were trained readers able to handle formally arranged music in "legitimate" style. Bolden, a soloist and a

tune embellisher with a good ear and memory, injected a measure of individuality and spontaneity into ensemble playing, especially for dancing. Thus, he contributed importantly to the development of expressiveness in pre- and early jazz. Jazz authorities characterized him as a seminal influence on upcoming cornet and trumpet players such as King OLIVER, Bunk Johnson, and Louis ARMSTRONG and on subsequent musicians in the jazz continuum. The ensemble playing of his band influenced contemporary and later New Orleans and Dixieland groups.

His career ended shortly before 1907 when he was committed to a mental institution, where he remained until his death in 1931. "King" Buddy Bolden was not recorded, since the first commercial jazz recording sessions occurred almost a decade after the end of his career.

REFERENCES

MARQUIS, DONALD M. *In Search of Buddy Bolden*. Baton Rouge, La., 1978.
SCHAFER, WILLIAM J. *Brass Bands and New Orleans Jazz*. Baton Rouge, La., 1977.
SCHULLER, GUNTHER. *Early Jazz: Its Roots and Musical Development*. 1968. Reprint. New York, 1986.

THEODORE R. HUDSON

Boles, Robert (July 13, 1942–), writer. Robert Boles was born in Chicago, the son of Henry C. Boles and Myrtle Spralley Boles. Henry Boles was an architect, employed at one time by the U.S. State Department, and the family moved often. Robert Boles was a medic with the U.S. Air Force in France from 1963 to 1966, then features editor for the *Register,* a weekly newspaper in Cape Cod, Mass. From 1967 to 1968, Boles was a public-relations writer for the NATIONAL URBAN LEAGUE, ghostwriting speeches for executive director Whitney M. YOUNG, Jr. He taught literature and creative writing at the University of Iowa, Amherst College, and Boston University, and worked as an editor at G. K. Hall in Boston. He received a Guggenheim Fellowship in creative writing for 1970–1971.

Boles has published short stories in various magazines, including the *New Yorker,* several of which have been included in anthologies; "The Engagement Party" is in *The Best Short Stories by Negro Writers* (1967), edited by Langston HUGHES. Boles's major work consists of two novels, *The People One Knows* (1964) and *Curling* (1968), both issued by Houghton Mifflin. Since 1979, he has been a staff writer for the *Cape Cod Times,* writing features and columns as well as news stories. Divorced, he has one son, Mark Adin

Boles, and lives in Provincetown, Mass., where he continues to write fiction.

REFERENCES

BELLAMY, JOE DAVID. "Theme and Structure in Boles' *Curling:* An Interview with the Author." *Black Academy Review* 1, no. 1 (Spring 1970): 29–31.

GIOVANNI, NIKKI. "Books Noted." *Negro Digest* 17, no. 10 (August 1968): 86–88.

RICHARD NEWMAN

Bolin, Jane Mathilda (April 11, 1908–), judge. Jane Bolin was born in Poughkeepsie, N.Y. She attended public schools there, then went to Wellesley College, graduating in 1928 as a Wellesley Scholar, an award given to the top twenty students in the class. She then attended Yale Law School and was its first black female graduate in 1931.

Bolin joined the New York bar in 1932, becoming the first African-American woman to do so. After working for six months at her father's law firm in Poughkeepsie, she looked for employment in New York City law firms but was unable to find a job. She spent the next five years in private practice with her husband, Ralph Mizelle, whom she married in 1933. In 1936 she was an unsuccessful Republican candidate for the state assembly. In April 1937 Bolin was appointed to the Corporation Counsel's office in New York City and assigned to the Domestic Relations Court.

Two years later, Bolin was named justice of the Domestic Relations Court, becoming the first black woman judge in the United States. Mayor Fiorello La Guardia administered the oath of office to her at the 1939 World's Fair in New York. Bolin remained on the court (which was renamed the New York Family Court in 1962) until she reached the mandatory retirement age of seventy in December 1978.

While on the bench, Bolin improved the situation of black children. She worked to increase the number of probation officers assigned to cases in black neighborhoods and made private child-care agencies that receive public funds accept children without regard to their ethnicity.

Bolin also worked in civil rights, serving on the board of the New York Urban League and the national board of the NAACP. She has long been involved with child-care issues, including a stint on the board of the Child Welfare League. After retirement, she returned to private practice as a consultant in family law. In 1993 Bolin received an award for distinguished service from the New York City Corporation Counsel's office.

REFERENCE

STONE, CHUCK. *Black Political Power in America.* Indianapolis, 1968.

QADRI ISMAIL

Bond, Horace Mann (November 8, 1904–December 21, 1972), teacher and administrator. Horace Mann Bond was born in Nashville, Tenn., the youngest of five sons of Jane Bond and James Bond, an educator and Methodist minister. Bond was named for Horace Mann, the nineteenth-century proponent of public education. When Bond was a young boy, the family traveled throughout the South, settling near educational institutions with which James Bond was affiliated, such as Berea College in Kentucky, Talladega College in Alabama, and Atlanta University. A precocious student, Bond was placed in high school when he was nine years old. While in high school, Bond moved with his family back to Kentucky, where his father served as chaplain during World War I at Camp Taylor.

In 1919, at the age of fourteen, Bond enrolled at Lincoln University, an African-American liberal arts college in southeastern Pennsylvania. After graduating from Lincoln in 1923, Bond entered the University of Chicago as a graduate student in education. While pursuing his Ph.D., Bond was a teacher and administrator at several African-American universities: Langston University in Oklahoma, Alabama Agricultural and Mechanical College, and FISK UNIVERSITY in Nashville.

In the early 1930s Bond gained a national reputation by publishing a number of articles in scholarly journals and popular magazines on black education in the South. In 1934 he published a major scholarly work, *The Education of the Negro in the American Social Order,* which argued that the poor quality of education among African Americans was directly linked to their lack of political and economic power. Bond did not recommend the abolition of segregated schools; instead, he called for the equalization of resources given to black and white children. Along the lines of W. E. B. DU BOIS's theory of the "talented tenth," Bond's book also argued that young African Americans showing intellectual promise should be trained as future leaders.

While at Chicago, Bond developed a relationship with the Julius Rosenwald Fund, a philanthropic organization that provided funding for African-American scholars and universities. The fund supported Bond through most of his career, first with research fellowships that allowed him to publish

Horace Mann Bond, the author of several pathbreaking studies of black education in the 1930s, was later president of Fort Valley State College in Georgia and Lincoln University in Pennsylvania. (Photographs and Prints Division, Schomburg Center for Research in Black Culture, The New York Public Library, Astor, Lenox and Tilden Foundations)

widely and later with significant grants to the universities where he served as administrator.

In 1936, the same year he completed his dissertation on the development of public education in Alabama, Bond accepted the deanship of Dillard University, a newly reorganized black college in NEW ORLEANS. Bond remained at Dillard until 1939. That year he published his dissertation, *Negro Education in Alabama: A Study of Cotton and Steel*. The work was considered an important challenge to established scholarship on RECONSTRUCTION. Bond argued that Reconstruction was a significant step forward for black Americans, in particular in the educational institutions established during that period.

Following the publication of *Negro Education in Alabama*, Bond devoted the rest of his career to administration at black colleges, serving as president of Fort Valley State Teachers College in Georgia from 1939 to 1945 and as the first black president of Lincoln University in Pennsylvania from 1945 to 1957. In large part his career was made by successfully lobby-

ing for his institutions, often transforming them from underfunded colleges into comprehensive, well-respected research and teaching universities.

Bond had a variety of social involvements and intellectual interests. While at Lincoln University, he helped to direct research for a historical document supporting the NAACP's challenge to segregation in the BROWN V. BOARD OF EDUCATION OF TOPEKA, KANSAS Supreme Court case. In the 1950s and '60s Bond developed an interest in Africa. Through tours, lectures, and articles he attempted to raise support among African Americans for independence movements in African countries. He was a leader of the American Society for African Culture, an organization funded by the Central Intelligence Agency, which both encouraged interest in African culture and warned against the dangers of communism in the African independence movements.

After Bond left Lincoln in 1957, he spent the rest of his career as an administrator at Atlanta University, first as dean of the School of Education and then as the director of the Bureau of Educational and Social Research. During the summer before his first year at Atlanta, Bond delivered the Alexander Inglis Lectures at Harvard University, published in 1959 under the title *The Search for Talent*, in which he argued that social circumstances determine the outcome of mental testing. In the last half of his career Bond's scholarship focused primarily on social influences, and he often argued that IQ tests were biased against African Americans. He retired in 1971.

Horace Mann Bond, who died in Atlanta in 1972, was the father of Julian BOND, the civil rights activist and politician.

REFERENCES

URBAN, WAYNE J. *Black Scholar: Horace Mann Bond, 1904–1972*. Athens, Ga., 1992.
WILLIAMS, ROGER M. *The Bonds: An American Family*. New York, 1971.

THADDEUS RUSSELL

Bond, Julian (January 14, 1940–), activist, elected official. Julian Bond was born in Nashville, Tenn., of a prominent family of educators and authors. He grew up in the town of Lincoln University, Pa., where his father, Horace Mann Bond, was then president of the university, and later in Atlanta, when his father became president of Atlanta University. While attending Morehouse College in the early 1960s, Julian Bond helped found the Committee on Appeal for Human Rights. He dropped out of Morehouse to join the STUDENT NONVIOLENT COORDINATING

COMMITTEE (SNCC), of which he became communications director in 1962. In 1964 he traveled to Africa and upon his return became a feature writer for the *Atlanta Inquirer*. Later he was named its managing editor. He eventually received his B.A. from Morehouse in 1981.

Bond won election to the Georgia House of Representatives in 1965, triggering controversy. On January 10, 1966, fellow legislators voted to prevent him from taking his seat in the house when he refused to retract his widely publicized support of draft evasion and anti-Vietnam activism. Protest in defense of Bond's right to expression was strong and widespread. Both SNCC and the SOUTHERN CHRISTIAN LEADERSHIP CONFERENCE (SCLC) sought mass support for Bond through community meetings, where discussion and ferment strengthened African-American awareness of the relationship between

Julian Bond in the Georgia state legislature. When originally elected in 1965, he was not allowed to take his seat because of his opposition to the Vietnam War. After the U.S. Supreme Court ordered him to be admitted to the legislature, Bond served until 1975 and has had a distinguished career as a civil rights activist and author. (Photographs and Prints Division, Schomburg Center for Research in Black Culture, The New York Public Library, Astor, Lenox and Tilden Foundations)

peace activism and the civil rights struggle. The Rev. Dr. Martin Luther KING, Jr., rallied to Bond's defense, Vice President Hubert Humphrey publicly supported Bond, and noted cultural figures took out ads for pro-Bond campaigns.

After nearly a year of litigation, the U.S. Supreme Court ruled that Bond's disqualification was unconstitutional. The Georgia house was forced to seat Bond, and he remained in the house until 1975. In 1968 Bond was presented as a possible vice presidential candidate by opposition Democrats at the Democratic Convention in Chicago. He was too young, however, to qualify for the office, and his name was withdrawn. In 1972 he published *A Time to Speak, a Time to Act: The Movement in Politics*, in which he discussed ways of channeling civil rights activism into the electoral system. In 1975 Bond was elected to the Georgia state senate, where he served for twelve years. His activities during this period included the presidency of the Atlanta NAACP, where he served until 1989, and service as the narrator of both parts of the popular PBS documentary series about the CIVIL RIGHTS MOVEMENT, "Eyes on the Prize" (1985–1986, 1988–1989).

In 1986 Bond ran for U.S. Congress from Georgia and narrowly lost in a bitter contest with John LEWIS, his former civil rights colleague. In the early 1990s Bond served as visiting professor and fellow at various colleges, including the University of Pennsylvania, Drexel University, Harvard University, and the University of Virginia, and was a frequent essayist and commentator on political issues. He also was, in the early 1990s, the host of a syndicated television program, *TV's Black Forum*.

REFERENCES

LEWIS, AMY. "Julian Bond." In William McGuire and Leslie Wheeler, eds. *American Social Leaders*. Santa Barbara, Calif., 1993.
NEARY, JOHN. *Julian Bond: Black Rebel*. New York, 1971.

EVAN A. SHORE
GREG ROBINSON

Bonds, Margaret Allison (March 3, 1913–April 27, 1972), composer, pianist. Born in Chicago, Margaret Bonds showed musical promise early, composing and performing as a child. She studied piano and composition with T. Theodore Taylor, Florence PRICE, and William Levi DAWSON. She received her B.M. and M.M. degrees from Northwestern University in 1933 and 1934, respectively. In 1939 she moved to New York and attended the graduate

school of the Juilliard School of Music, where she studied with Djane Herz, Roy Harris, and Robert Starer.

During the 1930s Bonds was active as a concert pianist and accompanist. In 1933 she became the first black soloist to appear with the Chicago Symphony in a performance of Florence Price's *Piano Concerto in One Movement*. During this time she founded the Allied Arts Academy in Chicago for talented black children. In New York she worked as an editor for the Clarence Williams publishing house. In the 1960s she moved to Los Angeles, where she was director for the Inner City Repertory Theatre. She wrote art songs, popular songs, piano music, arrangements of spirituals, orchestral and choral works, and music for the stage. Her best known works include the cantata *Ballad of the Brown King* (1961, text by Langston HUGHES) and the art songs "The Negro Speaks of Rivers" (1946, text by Hughes) and "Three Dream Portraits" (1959, text by Hughes). Representing the second generation of African-American composers, Bonds's music is strongly influenced by modern music, including jazz and blues idioms. She died in Los Angeles in 1972.

REFERENCES

BONDS, MARGARET. "A Reminiscence." In *International Library of Negro Life and History: The Negro in Music and Art*. Compiled and edited by Lindsay Patterson.

BROWN, RAE LINDA. "Florence B. Price and Margaret Bonds: The Chicago Years." *Black Music Research Bulletin* 12/2 (Fall 1990): 11–13.

RAE LINDA BROWN

Bonner, Marita (June 16, 1899–December 6, 1971), writer. Marita Bonner was one of four children born and raised in the area around Boston, Mass., to Mary Anne Noel and Joseph Andrew Bonner. After attending Brookline High School, she was admitted to Radcliffe College in 1918, where she majored in English and comparative literature. While at Radcliffe, Bonner began a career as a high school teacher in nearby Cambridge. After graduating in 1922, she taught high school in Bluefield, W. Va., and then in Washington, D.C. In 1930 she married William Almy Occomy and went with him to Chicago, where she taught in the public schools and spent the rest of her life.

During her eight years in Washington, D.C., Bonner was a part of Georgia Douglas Johnson's literary gatherings at S Street. In 1925 she published her first story, "The Hands," in *Opportunity*, an organ of the

Urban League. This was followed by a number of works published in the NAACP's *Crisis*: an autobiographical essay, "On Being Young—a Woman—and Colored" (1925), and several short stories, including "The Prison-Bound" (1926), "Nothing New" (1926, her first story about Chicago's Black Belt), "One Boy's Story" (1927), and "Drab Rambles" (1927). During this period, Bonner became a member of the Krigwa Players in Washington and in quick order wrote three plays—*The Pot Maker* (1927), *The Purple Flower* (1928), and *Exit—An Illusion* (1929)—apparently all meant to be read rather than performed.

After leaving Washington, D.C., in 1930, Bonner turned her attention exclusively to fiction, publishing under her married name. Many of the stories she wrote while living in Chicago consist of what she called a "black map" of the city's African-American communities, their class distinctions, the ways in which they interacted with other immigrants, and the social and economic hardships under which they lived. Published for the most part in the *Crisis* and *Opportunity*, Bonner's Chicago stories—many set in fictional Frye Street—frequently work together to build single, elaborate tales but are narrated from different perspectives and printed independently of each other. Her stories during this period range from the two-part "Tin Can," which won *Opportunity*'s literary prize for fiction in 1933, to the harrowing account of a mother who kills her own child, "The Whipping" (1939), to her last published story, "One True Love" (1941), which focuses on the obstacles facing black women with professional aspirations.

After 1941 Bonner wrote infrequently and published nothing. She continued to teach, raised her three children, and became involved with the Christian Science movement. She died in 1971 of injuries she received when her apartment caught fire.

REFERENCE

FLYNN, JOYCE, and JOYCE OCCOMY STICKLIN, eds. *Frye Street & Environs: The Collected Works of Marita Bonner*. Boston, 1987.

PETER SCHILLING

Bontemps, Arna (October 13, 1902–June 4, 1973), writer. Arna Bontemps—poet, playwright, novelist, critic, editor, and anthologist—was a leading figure in the HARLEM RENAISSANCE of the 1920s and 1930s. His work is distinguished by a passionate struggle for liberation and a mystical faith in the unseen. The latter may derive from his early religious training, for his parents were Seventh-Day Adventists. Born in Alexandria, La., in 1902, Bontemps grew up in Los An-

geles. The early death of his mother left him in the care of an austere father and his grandparents. Upon his graduation from San Fernando Academy in 1920, he enrolled in Pacific Union College, another Seventh-Day Adventist institution, where he earned an A.B. degree in 1923.

In 1924 Bontemps went to New York, where he met other young writers, including Langston HUGHES, Countee CULLEN, and Claude MCKAY. He was stimulated by the cultural vitality of New York—its theater, its music, its concern with world affairs, and the struggle of its black people for social recognition and cultural realization. Bontemps taught in Adventist schools, such as the Harlem Academy, and began his serious career as a writer. His first novel, *God Sends Sunday,* published in 1931, is the story of Little Augie, a jockey who earns a great deal of money and spends it lavishly on brothels, women, and fancy cars. The character was suggested by a great-uncle of Bontemps. Bontemps and Countee Cullen transformed the story of Little Augie into a musical, *St. Louis Woman,* which played on Broadway in 1946.

Bontemps's historical novel *Black Thunder* (1936), among the first of the genre in African-American literature, was based on a Virginia slave revolt in 1800. *Drums at Dusk* (1939), more superficial and romantic than *Black Thunder,* deals with the Pierre

Arna Bontemps. (Photographs and Prints Division, Schomburg Center for Research in Black Culture, The New York Public Library, Astor, Lenox and Tilden Foundations)

Toussaint-Louverture uprising in Haiti. Other historical works include *We Have Tomorrow* (1945) and the biography *Frederick Douglass: Slave, Fighter, Freeman* (1958). In collaboration with Jack Conroy, Bontemps wrote a history of black migration, *They Seek a City* (1945; updated in 1966 as *Any Place but Here.*)

In 1932 Bontemps coauthored, with Langston Hughes, *Popo and Fifine: Children of Haiti.* He and Conroy also produced a series of original tales for children: *The Fast Sooner Hound* (1942); *Slappy Hooper, the Wonderful Sign Painter* (1946); and *Sam Patch, the High, Wide and Handsome Jumper* (1951). In writing books for children, Bontemps made a major contribution, since juvenile literature written by and for African Americans was virtually nonexistent at the time. In 1956 he received the Jane Addams Children's Book Award for *Story of the Negro* (1948).

Throughout his career, Bontemps produced original poetry, notable for its brooding quality and its suggestive treatment of protest and black pride. "A Black Man Talks of Reaping," which won a *Crisis* magazine first prize in 1926, is one of the strongest of his protest poems. "Golgotha Is a Mountain" and "The Return" won the Alexander Pushkin Award for Poetry offered by *Opportunity* magazine in 1926 and 1927, respectively. *Personals,* a collection of his poems, was published in 1963 by Paul Bremen in London.

In 1943 Bontemps became head librarian at Fisk University in Nashville, Tenn.; in 1965, he became director of university relations. From 1966 to 1969 he was a professor at the Chicago Circle campus of the University of Illinois and in 1969 served as visiting professor and curator of the James Weldon Johnson Collection at Yale University. In 1970 he returned to Fisk as writer-in-residence; he died there in 1973.

REFERENCES

BONTEMPS, ARNA. *The Harlem Renaissance Remembered.* New York, 1972.
———. *The Old South.* New York, 1973.
HUGHES, LANGSTON, and ARNA BONTEMPS. *Book of Negro Folktales.* New York, 1958.

CHARLES H. NICHOLS

Book Collectors and Collections. Book collecting involves an interactive community of bibliophiles, sellers and dealers, librarians, bibliographers, and academics representing all the disciplines. Fortunately, many of the leading collections of African-Americana over the years have found their way into public and private institutions where they can be both preserved and made available and accessible to re-

searchers. Unfortunately, much material has been lost, some irretrievably, through ignorance, indifference, and the belief that the material was not worth saving. This is particularly true of African-American newspapers and serials—vital sources of information—but there are also books of which no known copies exist; this is even more the case with manuscripts.

Perhaps the most remarkable fact about African-American book collecting has always been its political nature. From the outset, collectors have been motivated by the desire to demonstrate black intellectual capacity and capability. A lone copy, after all, of Phillis WHEATLEY's 1773 book of poems renders absurd both the old arguments for slavery, racism, and segregation and more subtle contemporary manifestations of prejudice. Arthur SCHOMBURG informed the white world that history would have to be rewritten because of the truth to be learned from the books he had unearthed by and about people of African descent. And to those inside the black community itself, subject to an inferiority defined by the dominant society, Bert WILLIAMS, the great comedian, was only partly joking when he said his library contained a book about Africa which proved that every Pullman porter was the descendant of a king.

A professor of medicine at the University of Göttingen at the turn of the nineteenth century was probably the first person intentionally to collect a library of books by and about blacks. Johann Friedrich Blumenbach (1752–1840), an anatomist who is considered the father of modern physical anthropology, became convinced through the comparison of skulls that Africans were more like non-African people than they were like apes, a conclusion that openly challenged both the popular and scientific views of the day. Blumenbach gathered other evidence to support his thesis that blacks are human, including a library of books they had written. He had titles by Phillis Wheatley, Benjamin BANNEKER, and Anthony William Amo.

Blumenbach's influence was important, although not wide-ranging, but he had a particular impact on Henri Grégoire (1750–1831), the constitutional bishop of Blois, who organized with Robespierre and Condorcet "The Friends of the Blacks," and sent a copy of Banneker's 1792 almanac to the French Academy. Grégoire built his own library, becoming the first historian of black literature with his 1808 *De la littérature des Nègres*. This book inspired great modern collectors like Arthur SCHOMBURG and Arthur B. Spingarn and provided a bibliography and desiderata list of the earliest black publications, as well.

In the United States the early collections were those of the numerous antebellum literary societies organized by free blacks in Northern cities. Dorothy Porter WESLEY has located forty-five of them, and their influence has not yet been fully appreciated. The Philadelphia Library Company of Colored Persons held six hundred volumes that it kept in the basement of St. Thomas Episcopal Church, and the New York Philomathean Society owned another six hundred.

The earliest large collections in the United States were on the subjects of slavery, antislavery, abolition, and colonization, concentrating particularly on copies of the countless polemical tracts issued in the pamphlet war for and against slavery. It is difficult to judge holdings in institutions where this material is neither separately catalogued nor housed, but there are certainly extensive materials dispersed throughout the library collections of Berea College, Colby College, the John Carter Brown Library at Brown University, the New-York Historical Society, Harvard University, the Boston Public Library, and the New York Public Library. Bowdoin College has identified its primary and manuscript sources and created a finding aid, *Antislavery Materials at Bowdoin College*.

The May Collection at Cornell University is considered the largest and best gathering of slavery and antislavery sources. In 1870 the abolitionist Samuel J. May (1797–1871) of Syracuse, N.Y., donated his large library to Cornell, two years after Cornell's library opened and seven years after May had issued a catalog of his extensive collection. The May Collection is especially strong in controversial literature, slave narratives, and foreign material. The latter was enhanced in 1871 by the gifts of their collections from Elizabeth Pease Nichols of Edinburgh and Richard D. Webb of Dublin. The American material was strengthened by the addition of Jared Sparks's U.S. history collection in 1872 and the books of C. D. Cleveland of Philadelphia in 1877.

Much material was added to the original May library as the result of an appeal for relevant books sent out in 1874 and signed by abolitionist veterans William Lloyd Garrison, Wendell Phillips, and Gerritt Smith, as well as by May himself. In 1931 it was estimated that the May Collection consisted of some 4,500 pamphlets, 1,500 other publications, 729 newspapers, and 2,679 miscellaneous items such as broadsides and letters. The earliest piece is Anthony Benezet's 1760 *Observations on the Inslaving, Importing and Purchasing of Negroes*, and one of the more unusual volumes is the third edition of David Walker's *Appeal*, inscribed to May from Garrison.

Oberlin College was a center of antislavery sentiment and activity from the influence of Theodore Weld and the Lane rebels, so it is not surprising that its library would build what it termed a Collection of Anti-Slavery Propaganda. William Dawes and John Keep visited England in 1839–1840 and brought back

to Oberlin many British antislavery books and pamphlets. Children's antislavery materials are an unusual feature of the collection. In 1885, in conjunction with the opening of the Spear Library, Oberlin appealed for additional materials to strengthen its holdings. As a result, the collections of Oliver Johnson and the Liberty party's William Goodell also came to the college. Goodell's included numerous manuscripts, one of which is the draft of the *Declaration of Sentiments of the American Anti-Slavery Society* in Garrison's hand.

The Harris Collection on the Civil War and Slavery, gathered by C. Fiske Harris (1818–1881) and originally called the Rebellion Collection, was purchased by the Providence, R.I., Public Library around 1884. Harris also brought together the well-known American poetry collection that bears his name, the John Harris Library, now at Brown University. The broad Rebellion Collection numbers about 8,300 items, incorporating music, portraits, and posters, some of which advertise for runaway slaves. The most curious item is reportedly Harrison Berry's 1861 *Slavery and Abolitionism As Viewed by a Georgia Slave*. In 1891 Johns Hopkins University Library received over a thousand books on the history of slavery from Gen. William Birney (1819–1907), most of them collected by his father, James G. Birney (1792–1857), who was the Liberty party candidate for president in 1840 and 1844. There are fifty bound volumes of pamphlets and a virtually complete run of Benjamin Lundy's newspaper *The Genius of Universal Emancipation*.

The first university research library committed to collecting materials by and about people of African descent was the Moorland Foundation at HOWARD UNIVERSITY. Jesse E. Moorland (1863–1940), born to a free black family in Ohio, was a Congregational minister and official of the Colored Men's Department of the Young Men's Christian Association (YMCA) where he was particularly effective in raising funds for the construction of YMCA buildings in African-American Urban Centers. An 1891 graduate of Howard University's Theology Department, Moorland became a trustee of the university in 1907. He supported Dean Kelly MILLER and Prof. Alain LOCKE in their vision of a separate research center for African and African-American studies, what they called a "Negro-Americana Museum and Library."

To this end, in 1914 Moorland donated to Howard University his personal library of some 3,000 books and other materials on African Americans, probably the largest collection then in private hands. It was valued at the time at some two to three thousand dollars. The university created the Moorland Foundation, a Library of Negro Life, and housed it in the new Carnegie library building where the staff worked out an appropriate classification scheme since one did

not exist for black material. Howard's first librarian, Danforth B. Nichols, had begun an abolitionist and CIVIL WAR collection in the university's early days (it was founded in 1867), supported by a gift of books from Oliver O. Howard, "the Christian General," for whom the school was named. The university library also held the important 1873 bequest of antislavery materials of abolitionist Lewis Tappan (1788–1873) of some sixteen hundred items and also had sixty volumes from William Lavalette, plus newspapers and scrapbooks donated by John W. Cromwell.

In 1946 Howard University acquired the extraordinary collection of Arthur B. Spingarn (1878–1971), a New York City attorney and the brother of fellow NAACP officer Joel E. Spingarn. Arthur Spingarn collected for fifty years and concentrated on works by black authors. He ranged across every discipline and language, however, and his awareness of the breadth of the Diaspora was reflected in his strong holdings in Haitian, Afro-Brazilian, and Afro-Cuban materials. In the difficult business of identifying the race of the authors, Spingarn adopted the American view of who a Negro was—that is, anyone with any African blood—and collected accordingly. His original impetus was to be able to demonstrate black achievement to his acquaintances who doubted black intellectual capacity.

An indefatigable collector and wealthy enough to pursue and actualize his aims, Spingarn began with Abbé Grégoire's list of authors and scoured every possible place anywhere in the world for books. He tracked down the work of the individual contributors to the 1845 New Orleans anthology of Creole poets, LES CENELLES, for instance, and found twenty-two published plays by Victor Séjour. Spingarn had, he claimed, one thousand volumes not listed in Monroe WORK's supposedly definitive 1928 *Bibliography of the Negro*. For over thirty years Spingarn compiled an annual bibliography of new works by black authors that was published each year in the *Crisis*, so he was able to keep up with new books. But his collection was equally rich in older materials, and he owned such treasures as J. E. J Capitein's 1742 dissertation on slavery, three editions of David WALKER's *Appeal*, and the works of such little known African-American writers as Albery Whitman and Joseph C. Holly.

Probably the most extensive and comprehensive as well as the best known African-American collection is that of the black bibliophile Arthur A. Schomburg (1874–1938), born in Puerto Rico a year after slavery was abolished there. His lifelong passion for collecting presumably came as a consequence of a grammar school teacher's informing him, in response to his question about the history of black people, that black people in fact had no history. Tellingly, he was later to write, "The African American must remake his

past in order to remake his future," and he devoted his life to assembling the evidence to document the existence of a history that not only was rich and meaningful but had been ignored and distorted.

Schomburg emigrated to the United States, worked first as a messenger for Bankers Trust Co., joined the Porto [sic] Rican Revolutionary Party, and with John Edward "Bruce Grit" Bruce founded in 1911 the Negro Society for Historical Research. By the mid-1920's he had amassed over five thousand books, two thousand etchings, and three thousand manuscripts, including work in the hands of Phillis Wheatley, Lemuel HAYNES, Paul Laurence DUNBAR, and Alexander CRUMMELL. His collection included such rare books as Juan Latino's 1573 Latin verse and works by Olaudah EQUIANO and Jupiter HAMMON.

At the same time, the 135th Street Branch of the New York Public Library (NYPL) was beginning under Ernestine Rose to acquire black materials and to serve as an intellectual and cultural center for the growing black population in HARLEM, by then the home of a significant black literary and artistic ferment. In 1926, at the initiative of the NATIONAL URBAN LEAGUE, the library bought Schomburg's private collection with $10,000 from the Carnegie Corporation. It was soon expanded, notable additions being Harry A. Williamson's eight hundred volumes on Negro freemasonry and, later, Kurt Fisher's Haitian materials.

Catherine Latimer, probably the first black professional staff person in the NYPL system, integrated the Schomburg materials into existing holdings. Schomburg himself became its curator after two years at FISK UNIVERSITY, where he built up black acquisitions. The Schomburg Collection was eventually transferred administratively from the NYPL branch system to the research libraries. These were already rich in African-American materials—although they were not separately catalogued—particularly in history and the performing arts. The Schomburg Center for Research in Black Culture, as it was named, has continued to acquire comprehensively in all fields, in all languages, and from all countries, including those of Africa, the Caribbean, and Latin America. The publication of the Schomburg card catalogue, photographically reproduced and issued in book form by G. K. Hall & Co. in 1962 and later supplemented, made bibliographic access to the collection available to researchers in other libraries and facilitated the emergence of black studies as an academic discipline.

Carl Van Vechten (1880–1964), the leading white patron of the HARLEM RENAISSANCE, was also a compulsive collector who assembled a mass of research materials to document his ill-titled 1926 novel *Nigger Heaven*. In 1941 he offered his expansive archive to Yale University, whose librarian Bernhard Knollenberg accepted it readily because, as he said, "We haven't any Negro books at all." Van Vechten named his substantial gift the James Weldon Johnson Memorial Collection of Negro Arts and Letters to honor his multitalented friend who had recently been killed in an automobile accident. Van Vechten urged others to contribute also, and books and ephemera came from Dorothy Peterson, a founder of the Negro Experimental Theatre, Walter WHITE, Harold Jackman, and others. The most significant additions were the literary effects of James Weldon JOHNSON himself.

The James Weldon Johnson Collection is strongest in twentieth-century, particularly Harlem Renaissance, material, with Zora Neale HURSTON and Claude MCKAY manuscripts and extensive numbers of letters, programs, clippings, realia, and phonograph records, as well as some five hundred photographs of African Americans taken by Van Vechten. There is a particularly strong Langston HUGHES archive, and many of the books in the collection are presentation copies to Van Vechten. His gift made Yale, he claimed, "the first white college in the North . . . to make any effort to secure such material."

The Countee Cullen Memorial Collection at Atlanta University was founded in 1942 as the Harold Jackman Collection of Contemporary Negro Life. Jackman (1901–1961), a New York City public school teacher and bon vivant of the Harlem Renaissance, renamed the collection for his friend Countee CULLEN at Cullen's death in 1946. It is strong in music, theater, and dance materials, particularly programs and sheet music, and there are also some scarce periodicals. In 1947 the Cullen Collection was estimated to contain some 3,250 items. Jackman was initially inspired by Van Vechten's gift to Yale, and some who helped Van Vechten gather books, like Dorothy Peterson, aided Jackman also.

In 1946 Atlanta University purchased for $25,000 the Henry Proctor Slaughter Collection of some ten thousand books, pamphlets, and early Negro periodicals. The collection is strong in slavery and in art books depicting blacks, and there are fifty volumes on the KU KLUX KLAN. The collection also includes some 100,000 newspaper clippings. Slaughter (1871–1950) was a Howard University Law School graduate who worked as a U.S. government typographer and served as president of the Negro Book Collectors, a group of bibliophiles who belonged to the American Negro Academy. He turned his ten-room Washington, D.C., house into a private library, and it was said that his first wife left him because he cared more for his books than for her. Slaughter enriched his own collection by purchasing the library of William Carl Bolivar, the Philadelphia bibliophile. Atlanta University also holds the Clarkson and Tut-

tle slavery collections and the Maud Cuney Hare music collection.

Richard B. MOORE (1893–1978) was a militant Caribbean nationalist (he opposed the use of the term West Indian) and political radical who collected books for forty years. Inspired by Schomburg, the Rev. Charles Martin, and George Young, Moore opened his own book store on 125th Street in Harlem in 1942, but customers were often confused because many volumes on the shelves were part of his own collection and were not for sale. Called the Frederick Douglass Book Center, the shop was a meeting place for Caribbean political activists living in New York. Moore's collection was especially strong in Caribbean authors and reached perhaps fifteen thousand volumes. In 1965 the collection went to the Centre for Multi-Racial Studies, in Cave Hill, Barbados. Moore was also an author and publisher and is probably best known for his polemical 1960 book, *The Name "Negro," Its Origin and Evil Use.*

Edward T. Garrett (1905–1968), a New York City etcher and engraver, began collecting books as an adolescent after his mother took him to the New York Public Library because she had, she felt, too little schooling to teach her children herself. Garrett gathered over his lifetime some fifteen hundred volumes, many of which, bearing his distinctive bookplate, are now in the Schomburg Collection. Most of his purchases occurred during World War II when he was employed in a Bridgeport, Conn., arms factory. Highly race conscious, Garrett only collected books by black authors and once removed an essay by Toussaint Louverture from a volume and had it rebound as a separate publication. He also wrote a *Negro Encyclopedia* of some 4,000 entries and compiled a *Negro Bibliography* of 3,380 citations, neither of which was ever published.

Modern collectors of special note include Charles L. Blockson (1933–), whose books and other items gathered over forty years are now housed as the Blockson Collection at Temple University (which includes an unusual collection of African Bibles and early treasures like William Wells BROWN's 1853 novel *Clotel*). Clarence Holte (1909–1993), an ethnic marketing specialist, brought together a collection of some seven thousand books with a strong African component that he sold to Ahmadu Bello University in Nigeria. Richard L. Hoffman (1930–) gathered a collection rich in modern firsts, many signed and inscribed, and strong in African-American theater, which was sold to the University of Minnesota, where it is known as the Archie Givins Collection. It was supplemented in 1993 with the Paul Breman Collection, also strong in modern literature.

The Ernest R. Alexander Collection of Negroana went to Fisk University. AME Bishop Benjamin

Arnett's library was dispersed among Arthur Schomburg, W. E. B. Du Bois, Fisk University, and WILBERFORCE UNIVERSITY. Henry Baker gathered some two thousand certificates of inventions patented by African Americans; these went to Howard University in 1949. Charles BENTLEY, a member of the NIAGARA MOVEMENT, gave one hundred books in 1929 to the Special Negro Collection at the George Cleveland Hall branch of the Chicago Public Library. P. B. Brooks, a Washington, D.C., physician, had a library of ten thousand volumes, which was purchased for Hampton Institute in 1925 by George Foster Peabody. Hallie Q. BROWN left her own library to Central State University.

Glenn Carrington left Howard University some twenty-two hundred books, recordings, and sheet music in 1975. The Levi Jenkins Coppin Collection is at Wilberforce. The Julia Davis Collection came to the St. Louis Public Library in 1961. Focused on history, it includes books donated by Lulu E. Hawkins, the grandniece of William STILL. William Henry Dorsey of the American Negro Historical Society in Philadelphia collected books, manuscripts, and 388 scrapbooks of clippings, now at Cheney State University. Frederick DOUGLASS's library remains in his house in Anacostia, now a national historic site. Leon Gardiner's books, with those of Jacob C. White, Jr., are at the Historical Society of Pennsylvania.

Around 1950 Alexander Gumby gave over three hundred scrapbooks of clippings and ephemera to Columbia University. One of Harlem's more colorful characters, Gumby rarely missed a theater opening, and his clippings reflect his immersion in popular culture. George Henry of Providence, R.I., built a book collection that went to Livingstone College. In 1990 Bruce Kellner donated his library, named the Carl Van Vechten Memorial Collection of Afro-American Arts and Letters, to Millersville University. Alain Locke's library at his death in 1954 went to Howard University. Locke's personal papers constitute the largest such collection in what is now called the Moorland-Spingarn Research Center. The one thousand books of Tucker A. Malone were bought for Hampton Institute in 1905 by George Foster Peabody. The Rev. Charles Douglass Martin, pastor of Beth Tphillah, the Fourth Moravian Church, in Harlem, collected some thirty-five hundred books, all of which went to North Carolina Central University in 1950.

Victoria Earle Matthews organized a library at the White Rose Home. Daniel A. P. Murray, William Bolivar's cousin, worked from 1871 to 1923 at the Library of Congress, and his own 1,448 books and pamphlets went there. It was Murray who prepared the bibliography for the American Negro Exhibit at the Paris Exhibition of 1900. The Randolph Linsly

Simpson Collection was purchased by the Wadsworth Athenaeum in Hartford, Conn. The Southern YMCA College specialized in books on race relations, a collection which went to Fisk in 1936. The Edward Starr Collection went to Boston University, which dispersed much of it. Willis D. Weatherford's library on the Negro in the South also went to Fisk.

As with Richard B. Moore, the line between collectors and booksellers is not always clear. Robert Adger was a Philadelphia dealer, the organizing president in 1897 of the African American Historical Society, and a member of the Banneker Literary Institute (which had its own library). Adger's earliest extant catalogue (1894) listed sixty-five items and a portrait of Frederick DOUGLASS. His second known catalogue of 320 items (1904) was bought in its entirety by Ella Smith Elbert and her husband of Wilmington, Del., who gave it in 1938 to Wellesley College, of which she was the second black graduate. Another collection of Adger's, called the Adger Repository, was in Philadelphia's Home for Aged and Infirm Colored Persons but is now lost.

David RUGGLES was in the 1830s probably the earliest black bookseller, and Dorothy Porter Wesley identifies him as perhaps the first black book collector. He was also a printer and binder who specialized in abolitionist publications. A former Pullman porter, George Young operated Young's Book Exchange: The Mecca of Literature Relating to Colored People, on 135th Street in Harlem, from 1915 until his death in the mid-1930s, when the business was taken over by his wife. Lewis H. Michaux was probably Harlem's best-known bookseller with his National Memorial African Book Store, which he opened in 1930 on Seventh Avenue in Harlem. The store was a center for nationalists, militants, and intellectuals, including MALCOLM X, and Michaux delighted in displaying a window sign which permanently advertised in very large type a book entitled *The Goddam White Man*.

Charles F. Heartman was a scholar and a bibliographer as well as a dealer, and his 1947 *Americana* catalogue is a master list of African-American titles. The Heartman Collection went to Texas Southern University around 1950, and in 1967 Dorothy Briscoe reported that it consisted of some fifteen hundred items. Walter Goldwater opened the University Place Book Shop in New York in 1932 and came to specialize in African-American titles, at first to supply Arthur Spingarn. Goldwater was also a major supplier of books over the years to the Schomburg Collection. He was succeeded by William P. French, who by 1990 was regarded as the most knowledgable bibliographer of black books. Another sophisticated expert is Philip McBlain of McBlain Books, Hamden, Conn.

Other collectors past and present include William C. Bolivar, Benjamin BRAWLEY, Charles Brown, Blanche K. BRUCE, John E. Bruce, Randall K. Burkett, Joseph W. H. Cathcart, Richard V. Clarke, Thomas Clarkson, W. Montague COBB, George William Cook, Anna COOPER, Wendell P. Dabney, Owen DODSON, Pablo Eisenberg, Carlton Funn, Henry Louis Gates, Jr., Thomas Montgomery Gregory, Archibald GRIMKÉ, Francis GRIMKÉ, M. A. "Spike" Harris, Daniel Johnson, Oliver Jones, Leon Litwack, Mary E. Moore, Richard Newman, William C. Scarborough, Granville Sharp, Charles Seifert, William STILL, Era Bell Thompson, Leigh Whipper, Thomas Wirth, Monroe WORK, Pauline Young, and John S. Zwille.

REFERENCES

BALL, WENDY, and TONY MARTIN. *Rare Afro-Americana: A Reconstruction of the Adger Library*. Boston, 1981.

NEWMAN, RICHARD. "Collectors of African American Books." *AB Bookman's Weekly* 87, no. 20 (May 20, 1991): 2089–2092.

PORTER, DOROTHY. "Fifty Years of Collecting." In Richard Newman, ed. *Black Access: A Bibliography of Afro-American Bibliographies*. Westport, Conn., 1984.

SINNETTE, ELINOR DES VERNEY, et al., eds. *Black Bibliophiles and Collectors: Preservers of Black History*. Washington, D.C., 1990.

RICHARD NEWMAN

Boone, "Blind" (John William) (May 7, 1864–October 4, 1927), pianist and composer. John W. Boone was born in Miami, Mo., to Rachel Boone, a freed slave; his father was a musician in the Union Army. Blind from infancy, he displayed musical gifts early. In 1872 Rachel, after the death of Boone's father, married Harrison Hendrix. Soon after, Boone attended the St. Louis School for the Blind with financial support from the Johnson County Court and Warrensburg townspeople. He had some two and a half years of piano lessons at the school, then left to pursue a music career. After several difficult years he met John Lange, Jr., following a concert at the Second Baptist Church in Columbia, Mo., Lange, a well-established African-American businessman, took an interest in Boone and arranged continued study and concert dates. Under Lange's management, the Blind Boone Concert Company probably performed first on January 18, 1880, at Saint Paul's Methodist Church in Jefferson City. The pro-

gram included piano pieces by Liszt and Beethoven, opera potpourris, Boone's own pieces, his cyclone imitation, imitations of other instruments, and comic and plantation songs.

The company flourished, performing many benefits for black schools, churches, and benevolent societies. In 1889 Boone married Lange's sister Eugenia. By the time of John Lange's death in 1921, the company had toured all of North America. Although operations continued, they never recovered from Lange's loss. Confronted with rising racism, competition from radio, and limited bookings, Boone retired. His last concert was on May 31, 1927, shortly before his death in Warrensburg, Mo.

Boone is chiefly noted for his ragtime medleys and piano rolls. His published works include piano dance and concert pieces and songs. He was influenced by RAGTIME, Franz Liszt's virtuosic music, and "Blind Tom" BETHUNE, after whose programs and compositions Boone modeled his own. Boone is also remembered for his pioneering company, the first to have a black manager, and for his humanitarian support of the black community.

REFERENCES

BATTERSON, JACK ALAN. The Life and Career of Blind Boone. M.A. thesis, 1986.
FUELL, MELISSA. Blind Boone: His Early Life and Achievements. Kansas City, 1915.
SEARS, ANN. "John William 'Blind' Boone, Pianist-Composer: 'Merit, Not Sympathy Wins.'" Black Music Research Journal 9, no. 2 (Fall 1989): 225–247.

ANN SEARS

Borde, Percival Sebastian (December 30, 1922–August 31, 1979), dancer and choreographer. Born in Port of Spain, Trinidad, the son of George Paul Borde, a veterinarian, and Augustine Francis Lambie, Borde began dancing in his twenties and soon became a director of the Little Carib Theatre in Trinidad. In 1953 noted anthropologist and dancer Pearl PRIMUS convinced Borde to emigrate to the United States to teach at her New York school. Shortly thereafter, he and Primus were married. Borde achieved performing success with Primus's modern dance company, on television, and on Broadway. Among his solo concert performances built around ethnographic dance characterizations was the four-part 1958 program *Earth Magician,* which included portrayals of an Aztec warrior, a giant Watusi, a Yoruba chief, and a Shango priest. In 1959 Borde toured Africa and performed in Ethiopia, Ghana, Mali, Kenya, Nigeria, and Liberia. He produced *Talking Drums of Africa,* an education in the schools program, and served as the resident choreographer for the Negro Ensemble Company's 1969 season. Borde taught movement courses at New York University and in 1970 became a professor of theater arts and black studies at the State University of New York at Binghamton. His highly popular courses offered dance-based studies of African-Caribbean culture which emphasized the connections between dance, ritual, and everyday life. Borde's intelligent performance style and masculine stage presence helped to widen interest in concert African-American dance forms. Borde died backstage at the Perry Street Theater in New York City, immediately after performing "Impinyuza," the strutting Watusi solo he had danced for over twenty years.

REFERENCES

LEKIS, LISA. "Choreography in the Caribbeans." Dance Magazine (July 1952): 18–19, 38.
MARTIN, JOHN. "Borde: Artist from Trinidad in Engaging Debut." New York Times, October 5, 1958.

THOMAS F. DEFRANTZ

Borders, William Holmes (February 24, 1905–November 23, 1993), minister. Born in Macon, Ga., William Holmes Borders represented the third generation of preachers in his family. He received a B.A. from MOREHOUSE COLLEGE in Atlanta, Ga., in 1929, a B.D. from Garrett Theological Seminary in 1932, an M.A. from the University of Chicago in 1936, and an L.H.D. from Wilberforce University in 1962. In 1937, after serving as pastor of small Baptist churches in Illinois and Georgia, Borders became pastor of the prominent Wheat Street Baptist Church of Atlanta. Borders believed that the clergy must address the practical as well as the spiritual needs of their people and built the Wheat Street Baptist Church into a powerful institution that provided its neighborhood with crucial social services, including affordable housing, recreation facilities, and a credit union. His desire for leadership of Atlanta's black Baptist community led him into a long-standing rivalry with Martin Luther King, Sr., although the two often set aside their personal differences to work together on civil rights issues.

Until his retirement in 1988, Borders was a leader in the struggle for civil rights in Atlanta. In 1939 he led efforts to integrate the Atlanta Police Department and to increase black voter registration; in 1945 he served as president of the "Triple L," an organization that directed the fight to hire black bus drivers. From 1960 to 1961 Borders chaired the Adult-Student Li-

aison Committee, which negotiated the desegregation of hotels, restaurants, and lunch counters in Atlanta. The committee was controversial within the black community. It was, as its name suggests, an often uneasy alliance between black elders such as Borders and Martin Luther King, Sr., and black college students (such as Julian BOND) whose political tactics were informed more by meetings of the STUDENT NONVIOLENT COORDINATING COMMITTEE (SNCC) than by Sunday morning church sermons.

In March 1961 the adults of the committee negotiated an historic agreement with the Atlanta Chamber of Commerce that promised the desegregation of lunch counters and the desegregation of public schools. At a raucous meeting on March 7, the students initially refused to ratify the agreement, objecting that it contained no dates for desegregation of either lunch counters or schools. Both Borders and King, Sr., were shouted down. It took an impromptu speech by Martin Luther KING, Jr., who made an unscheduled appearance, to reconcile both sides. The agreement was then ratified.

Borders was the author of several books, including *Thunderbolts* (1942), *Seven Minutes at the Mike in the Deep South* (1943), and *Men Must Live as Brothers* (1947). He was the originator of the phrase Jesse JACKSON later made famous, "I'm somebody."

REFERENCES

BRANCH, TAYLOR. *Parting the Waters: America in the King Years, 1954–1963.* New York, 1988.
"William H. Borders, Civil Rights Leader in South, Dies at 88." *New York Times,* November 27, 1993, p. A10.
WORMLEY, STANTON T. *Many Shades of Black.* New York, 1969.

LOUISE P. MAXWELL

Borican, John (1913–December 22, 1942), middle-distance runner. John Borican was born in Bridgeton, N.J. He first came to national attention in 1936 when he began competing in track and field at Temple University. Borican transferred to Virginia State College in Petersburg, where he continued his national domination of the middle distances. After graduating from Virginia and while still competing in track, Borican enrolled in a master's program in fine arts and education at Teachers College, Columbia University (1938–1941). He also began showing some of his critically acclaimed watercolors and oils at art exhibitions.

In 1941 Borican became the first person to win the U.S. national title in both the pentathlon and the decathlon in the same year. At various times he held AAU, American, and world records in the 600 yards, the 800 meters, the 880 yards, the 1,000 yards, and the three-quarter mile in both indoor and outdoor competitions. In 1939 he was named to the all-American track team in the 1,000 meters. In 1942, after becoming the national indoor champion in the 800 meters and 1,000 meters (his third consecutive AAU championship for the 1,000 meters), Borican contracted an unidentified illness and died on December 22 at the age of twenty-nine.

REFERENCES

ASHE, ARTHUR R., JR. *A Hard Road to Glory: A History of the African-American Athlete 1919–1945.* New York, 1988.
Obituary. *New York Times,* December 23, 1942.

PETER SCHILLING

Boston, Massachusetts. For over 350 years African Americans have been an active part of Boston's history, and they have been instrumental in shaping the life of the city. The history of African Americans in Boston dates back to 1638, the year in which Africans were first brought to Noodles Island, or what is now East Boston, as slaves aboard the slave ship *Desire.* Within three years of their arrival, the Massachusetts Bay Colony established the category of "slave" in its Body of Liberties, thus becoming the first of the English colonies to legally recognize slavery. In 1670 the laws were amended to include the children of slaves. By the beginning of the eighteenth century, Boston was one of the main colonial ports in the "triangle trade," and some of the city's residents were active in the shipping industry and the SLAVE TRADE.

Slave laborers in Boston, called "servants," were granted basic "liberties and Christian usages" such as marriage, but could be whipped for striking white citizens, and sold out of the province for "improper intercourse." Like European indentured servants, they were generally employed either as household workers or unskilled laborers. Some were bound for set periods, then freed. By 1752, fifteen hundred blacks lived in Boston, representing 10 percent of the city's population as well as most of the colony's African Americans. Among the more renowned slaves in the city were philanthropist Amos Fortune, poet Phillis WHEATLEY, prose writer Briton HAMMON, and artist Scipio MOOREHEAD. At the same time, a free black community grew up in the city's North End enclave of "New Guinea."

Antislavery efforts in Boston began early in the eighteenth century. In 1700 Samuel Sewall campaigned for the Boston Board of Trade to impose an import duty on slaves in the vain hope of ending the trade. The £4 duty Massachusetts imposed in 1705 was widely evaded. Similarly, in 1701 city officials received a petition demanding term limits on slavery. They responded in 1703 by making manumission more difficult. Sewall's 1712 book *The Selling of Joseph* prompted several manumissions. Another notable work was Elihu Coleman's *Testimony Against That Antichristian Practice of Making Slaves of Men* (1733). Still, the legality of slavery remained unchallenged. Many Puritan clerics, notably Cotton Mather, regarded slavery as divinely sanctioned under the Mosaic Code, although Mather taught his own "servants" to read and write, and accepted them into his congregation.

The revolutionary war era sparked a new outburst of antislavery sentiment. Boston's African Americans, beginning with Crispus ATTUCKS in the Boston Massacre of 1770, took an active part in the struggle for liberty. Beginning in 1773, in one of the very earliest expressions of African-American group political activity, Boston blacks attached their names to petitions asking the Massachusetts legislature to abolish slavery. Slavery did not finally end in the state until after the Quock Walker decision in 1783. Several black residents, including Primus Hall, John T. Hilton and Seymour Burr fought in the American Revolution. Quite a few members of the community distinguished themselves in the creation of organizations that addressed the needs of African-American people. One of the better known is the African Masonic Lodge, founded by Prince HALL in 1787. In 1796 forty-four blacks began the African Society, a mutual aid and antislavery society.

By 1800 Boston's black population was approximately eleven hundred, making it one of the largest free black communities in North America. The community grew up around "Nigger Hill," the slope of Beacon Hill where black servants of wealthy white families built cabins. In 1805 under the leadership of Rev. Thomas Paul, a group of blacks angered by segregated churches formed the African Baptist Church, the first black Baptist congregation in the Northern states, and helped raise funds for the construction of the African Meeting House on Beacon Hill. The Meeting House was finished late in 1806. As the sole black-owned public building in the city, it rapidly became the hub of the community, housing fraternal and literary societies, abolitionist groups, and a school in the basement. In 1834, the state set up the Abiel Smith School, the first black public school in the United States. By 1850 Boston had four black churches as well as the Tremont Temple, an integrated congregation founded as the Free Church in 1846.

By the 1830s Boston had become the center of America's renascent abolitionist movement. Over the following decades it was home to black abolitionists such as Charles Lenox REMOND and Sarah REMOND, Lewis Hayden, William Cooper NELL, John Sweat ROCK, William Wells BROWN, and Maria W. STEWART, as well as whites such as William Lloyd Garrison and Wendell Phillips. Garrison's influential newspaper *The Liberator* was published in the city. As early as 1826 the Massachusetts General Colored Association was organized by African-American abolitionists and backed by white supporters. In 1832 this orgaization reformed as the regional New England Anti-Slavery Society, which combined abolitionist activities with civil rights protest.

Despite employment discrimination, Boston's black community remained relatively educated and affluent. There were several shopkeepers and professionals, and large numbers of skilled workers. Other African Americans worked as servants, sailors, barbers, or dockworkers. A group of black "ol' clothes men," dealers in secondhand clothes, set up shop across the Charles River in Cambridge. The most distinguished of these dealers was David WALKER, author of the militant abolitionist tract *Appeal to the Colored Citizens of the World* (1829). William Cooper Nell, a bookkeeper and law clerk, obtained many jobs for blacks through his column in the *Liberator*.

Beginning in the 1840s, waves of Irish immigrants arrived in Boston. They competed with blacks for jobs and housing. As a result, the city's African-American population began to decline. Blacks faced bigotry from the Irish and from other whites, particularly merchants with southern connections. In 1850 three medical students, including abolitionist editor Martin R. DELANY, entered Harvard University in nearby Cambridge. They were expelled after a term following widespread student and alumni protest. However, in reaction to the passage of the Fugitive Slave Act of 1850, abolitionism and problack sentiment grew increasingly powerful in the city. The interracial Boston Vigilance Committee hid and protected fugitives such as William and Ellen CRAFT from rendition to the South, and challenged the law in the Shadrack and Anthony BURNS cases. In 1855 following a fifteen-year struggle led by Nell, the state legislature passed a bill banning Boston's JIM CROW schools. In 1858 Nell also organized an annual Crispus Attucks Day on March 5 to celebrate the contributions of African Americans to the nation's freedom.

Boston's black community was energized by the outbreak of the CIVIL WAR in 1861. As soon as fighting began, abolitionists began lobbying for the en-

listment of black soldiers. In 1863 the 54th Massachusetts Infantry was formed in Boston under the command of Robert Gould Shaw, the son of noted white abolitionists. Boston abolitionists traveled the state recruiting African Americans, and they pressed for equal pay and treatment for black soldiers. However, tensions between African Americans and Irish Americans were aggravated by the war, especially as freed southern blacks migrated or were sent to Boston by the Freedmen's Bureau. Labor competition grew fierce. Irish workers succeeded in excluding blacks from some trades, while black natives undercut Irish labor prices, with the migrants employed as strike breakers. In July 1863, the same time that New York exploded in a huge draft riot, Boston's Irish population also rioted, though on a much smaller scale. The uprising was quickly put down by city authorities. For some time thereafter, black workers traveling to work were forced to arm themselves.

Following the Civil War, African Americans, mainly urban blacks from the upper South recruited by factory owners or invited by relatives, migrated to Boston. The city's black population doubled within a decade. The rate of migration slowed thereafter, but the black population had again doubled in size by 1900. The new immigrants squeezed into the overcrowded tenements in the city's West End, while more affluent black natives moved to suburban enclaves in Cambridge and Chelsea. Class tensions grew between migrants and natives. Even those who lived in the same areas and attended church together —apart from the migrant-founded Ebenezer Baptist Church (1871), Southerners tended to join established congregations—often socialized separately. Nevertheless, the "black brahmin" elite organized services to aid the newcomers, and successful migrants such as Julius C. Chappelle later organized self-help groups such as the National League of Boston.

Meanwhile, African Americans were slowly integrated into the city's political and public life. In 1866 Harvard University admitted its first black undergraduate, Richard GREENER, and in 1869 George L. Ruffin received an LL.B. from the Harvard Law School. In 1866 Edwin Garrison Walker of Charlestown and Charles Lewis Mitchell of Boston were elected to the General Court (the state legislature), and in 1873 Joshua Smith was elected to the state senate from Cambridge. Several black Bostonians went on to serve in municipal and state elected positions for the rest of the century. Others, such as Ruffin, Nell, and James Monroe TROTTER, held appointed offices or occupied civil service posts.

During the last part of the nineteenth century, Boston's racial ambivalence became increasingly obvious. On the one hand, most of the city's blacks remained impoverished—in 1910 over 70 percent were servants or menial laborers—and discrimination remained a chronic problem despite numerous civil rights laws. For example, banks refused to make business loans to African Americans, and black doctors and nurses were forbidden to train or practice at City Hospital. Boston was among the most segregated of American cities, and relations between blacks and whites, particularly Irish Americans, were often tense. However, the abolitionist legacy of racial liberalism remained strong in Boston. The annual Crispus Attucks Day festivities served as the focus of black civic pride. The erection of a memorial to the 54th Massachusetts Infantry on the Boston Common in 1893 was a further symbol of the city's attachment to African-American history. Boston developed a network of settlement houses with interracial leadership, including the well-known South End House and Robert Gould Shaw House. Furthermore, there were a good number of successful black businesses in Boston. While the majority of these were small, there were several larger businesses, such as the grocery firm of Goode, Dunson and Henry and the stable and livery business of Henry C. Turner. The Eureka Cooperative Bank, the only black-owned bank in the East at the turn of the century, was also located in Boston. In 1900, in tribute to Boston's importance in the black economy, Booker T. WASHINGTON founded the NATIONAL NEGRO BUSINESS LEAGUE in the city.

During this same period, Boston (including Harvard University in nearby Cambridge) was the intellectual center of a small black elite, composed of such figures as William Henry LEWIS, William H. Ferris, Josephine St. Pierre RUFFIN, Angelina Weld GRIMKÉ, and Maria Baldwin, who joined educational and social organizations such as the Boston Literary and Historical association and the Women's Era Club. The black elite, notably William Monroe Trotter and George Washington Forbes, publishers of the militant newspaper *The Guardian,* spoke eloquently in favor of civil rights and better education for African Americans. In 1903 an anti-Bookerite crowd disrupted a speech by Washington in a Boston church. Trotter was held responsible for the "Boston Riot," and spent a month in jail. Trotter subsequently helped organize such groups as the NIAGARA MOVEMENT, the Boston Committee to Advance the Cause of the Negro (which in 1910, after his departure, became the first branch of the NAACP), and the National Equal Rights League.

In the early twentieth century there was a gradual increase in the black community as new arrivals from the West Indies, Cape Verde, and the southern states migrated to Boston. Most of the new immigrants settled in the growing black enclaves of Roxbury and

the South End. During the 1920s, Boston's black population increased at six times the rate of the white, though the wave of migrants who settled in northern cities during the Great Migration largely avoided the city due to its lack of industry and employment opportunity. The city became a black cultural and entertainment center, with nightclubs such as the Savoy Cafe, the Storyville Club, and the Hi Hat Club.

Throughout the period, blacks organized civil rights campaigns, and succeeded in gaining access to a few places that had excluded them. Still, schools were virtually completely segregated, and housing remained poor and difficult to obtain. In 1915 the NAACP led an unsuccessful campaign to ban the film BIRTH OF A NATION in the city, though the film was forbidden elsewhere in Massachusetts. In 1921, however, African Americans and Irish Catholics combined to force a ban on a showing of the film. In 1921–1922, Harvard University President A. Lawrence Lowell segregated undergraduate dormitories, leading to a major lobbying effort by black leaders such as Trotter and college alumni and their white supporters. Trotter also led a successful campaign for the integration of the staff of the city hospitals. During the 1930s, with the support of the activist *Boston Chronicle* newspaper, Lillian Williams organized a campaign to force stores in black areas to hire African Americans, and Edith Washington of the Youth Council of the NAACP led pickets and worked to register voters. The black population, while small, remained a powerful voting bloc wooed by both parties. On the local level, blacks became a part of the city's Irish-led Democratic machine. Roxbury "boss" Shag Taylor and South End "boss" Robert Taylor controlled patronage positions.

World War II changed Boston's black population. As industrial jobs opened up in defense industries, black migrants (including the young MALCOLM X) entered the city from the South and Midwest. While the white population declined after 1950 as industry moved to nearby suburbs, the city's African-American population continued to grow. Many of the black students who attended the city's numerous colleges would go on to distinguish themselves, notably the Rev. Dr. Martin Luther KING, Jr., Coretta Scott KING, and U.S. Senator Edward BROOKE. Despite the success of numerous individual African Americans, however, Boston remained a largely segregated and racially tense city.

In 1946 Lawrence Banks was elected to the state legislature from Roxbury, the first African American in two generations to serve. However, growing black political power was checked by the institution in 1950 of at-large city council elections, which prevented the election of candidates without a large white vote. The antimachine "reform" administration which

took office that year, however, did not challenge entrenched housing segregation, and its "slum clearance" and highway construction programs weakened community links.

During the 1960s, Boston became a civil rights battleground, and the city's racial ambivalence drew national attention. The STUDENT NONVIOLENT CO-ORDINATING COMMITTEE (SNCC) and the CONGRESS OF RACIAL EQUALITY (CORE) opened offices in Boston and were involved with the Massachusetts Freedom Movement coalition fighting housing discrimination. In 1961 the Boston NAACP won a suit against the Boston Housing Authority, and began a slow and highly contested integration process. The Citizens for Boston Public Schools (CBPS), formed in 1960, elected school board candidates and in 1963 sponsored Stay Out, a student boycott in which one fourth of the city's black students participated. However, Louise Day Hicks, a white leader, gained control of the school board and used it as a platform to oppose civil rights efforts. In 1965 the state legislature passed a Racial Imbalance Law mandating school integration but opposing busing. Since no effective formula for integration was established, school boycotts continued. At the same time, many African Americans turned to more radical protest. In the summer of 1967, waves of street fighting broke out in Roxbury. The NATION OF ISLAM, led in Boston by Louis FARRAKHAN (then Louis X), had long had a following in the city, and Boston became a center of BLACK PANTHER activity. In the fall of 1967, largely on the strength of black votes, Tom Atkins, an African American, was elected to the Boston City Council.

In the last third of the twentieth century, Boston remained polarized over race. When court-ordered busing of black students to white schools in South Boston began in 1974, whites rioted outside the schools and attacked black children. Boston became a national symbol of resistance to busing. Mayor Kevin White (who with black support had defeated Louise Day Hicks in the 1967 and 1971 mayoral campaigns) refused to order police to act against rioters. Despite the protests, however, integration was established.

Black efforts were less successful in other areas. In 1979, following massive white resistance, integration of South Boston's housing projects ceased, and was halted for nine years despite black protest. When it resumed in 1988, police escorts were required to protect black tenants. In 1987, after Charles Stuart falsely claimed his wife had been murdered by a young black man, the city's police department randomly searched and intimidated young African-American men. Throughout the period, the city's black population had one of the lowest rates of per capita income and highest cost of living rates of any city in the United States. In 1986 black leaders in Roxbury, which con-

tained 95 percent of Boston's black population, organized an unsuccessful campaign to secede from the city and incorporate as "Mandela."

However, several bright spots also appeared for Boston's black community. In 1977 John O'Bryant became the first African-American school board member in seventy-five years, and in 1985 Laval Wilson became the Superintendent of Schools. (Five years later, however, in a racially charged incident, he was dismissed by the school committee.) In 1979 and 1983, Mel King, an African-American state representative from an integrated district, ran for mayor. With backing from blacks and white liberals, he made a strong showing the first time, and the second time did well enough to qualify for the runoff. While he was defeated, his powerful effort reflected the maturing of black political power.

In the 1990s, Boston remained a center of black life. The city is home to several large black-owned firms, including the Boston Bank of Commerce and BML Associates, Inc., as well as such cultural resources as the W. E. B. Du Bois Institute for Afro-American Research at Harvard University; the William Monroe Trotter Institute at the University of Massachusetts; the Museum of the National Center for Afro-American Artists; and the Museum of Afro-American History located in the old Abiel Smith School building. The city has been the home of large numbers of well-known African Americans throughout the twentieth century, including singer Roland HAYES; jazz musicians Johnny HODGES, Sonny Stitt, Paul Gonsalves, Roy Haynes, and Harry CARNEY; historian Benjamin QUARLES; poet/publisher Joseph Cox; and athletes K. C. JONES, Jim Rice, Robert Parish, and Patrick Ewing.

REFERENCES

CARDEN, LANCE. *Witness: An Oral History of Black Politics in Boston, 1920–1960.* Boston, 1989.

DANIELS, JOHN. *In Freedom's Birthplace.* 1914. Reprint. New York, 1969.

HAYDEN, ROBERT C. *African Americans in Boston: More Than 350 Years.* Boston, 1991.

HORTON, JAMES OLIVER, and LOIS E. HORTON. *Black Bostonians: Family Life and Community Struggle in the Antebellum North.* New York, 1979.

HOWER, BETH ANNE. "Material Culture in Boston: The Black Experience." In McGuire, Randall and Robert Paynter, eds. *The Archeology of Inequality,* Cambridge, Mass., 1991, pp. 55–63.

JACOBS, DONALD M. ed. *Courage and Conscience: Black and White Abolitionists in Boston.* Bloomington, Ind., 1993.

JENNINGS, JAMES and MEL KING, eds. *From Access to Power: Black Politics in Boston.* Rochester, Vt., 1986.

LUKAS, J. ANTHONY. *Common Ground.* New York, 1985.

PLECK, ELIZABETH HAFKIN. *Black Migration and Poverty: Boston 1865–1900.* New York, 1979.

SOLLORS, WERNER, CALDWELL TITCOMB, and THOMAS A. UNDERWOOD. eds. *Blacks at Harvard.* New York, 1993.

ROBERT A. BELLINGER

Bouchet, Edward Alexander (September 15, 1852–October 28, 1918), scientist and educator. Born in New Haven, Conn., Edward Bouchet received his early schooling at Sally Wilson's Artisan Street Colored School, New Haven High School (1866–1868), and Hopkins Grammar School, where he graduated as class valedictorian in 1870. In the fall of the same year, just a few months after the ratification of the Fifteenth Amendment removed racial covenants on voting rights, Bouchet matriculated at Yale University. Four years later, in 1874, he became the first African-American graduate of the institution. Exceptionally motivated, Bouchet achieved high grades during a distinguished undergraduate career that included honors in Latin composition and oratory as well as election to Phi Beta Kappa. Eager to pursue graduate study in New Haven—the city where his father, William Francis Bouchet, had moved in 1824 to work as a servant for John B. Robertson, a Yale student from Charleston, S.C.—he availed himself of Yale's seminars in experimental physics, chemistry, mineralogy, and calculus. With the completion of course work in his major field of physics and the submission of his thesis, "Measuring Refractive Indices," Bouchet emerged from Yale in 1876 as the first black American to be awarded a Ph.D. by an American university.

Between September 1876 and June 1902, Bouchet designed and taught laboratory courses in chemistry and physics at Philadelphia's Institute for Colored Youth (later Cheney State College), a Quaker institution with a highly regarded academic department. In subsequent years, he held appointments at Sumner High School (physics and math teacher, 1902–1903), Provident Hospital (business manager, 1903–1904), and the Louisiana Purchase Exposition (U.S. inspector of customs, 1904–1905), all in St. Louis. He also served at St. Paul's Normal and Industrial School in Gallipolis, Ohio (director of academics, 1906–1908), and Bishop College in Marshall, Tex. (professor, 1913–1916). Bouchet, who never married, remained active in the Episcopal church, the Yale Alumni Association, and the NAACP before his retirement, due to illness, in 1916. He died in New Haven.

REFERENCES

GREENE, HARRY WASHINGTON. *Holders of Doctorates among American Negroes*. Boston, 1946.

PERKINS, LINDA MARIE. *Fanny Jackson Coppin and the Institute for Colored Youth, 1865–1902*. New York, 1987.

GERARD FERGERSON

Bourne, St. Clair Cecil (February 16, 1943–), filmmaker. Born and raised in Crown Heights, Brooklyn, N.Y., St. Clair Bourne acquired his interest in media communications from his father, who was a reporter for the radical *People's Voice* in the 1930s and an editor for the AMSTERDAM NEWS. Bourne, known as Saint to his friends, entered Georgetown University in 1961 with ambitions of becoming a diplomat. Instead, he embraced student activism and was expelled from school for participating in a sit-in. He went to Lima, Peru, with the Peace Corps in 1964 and edited a Spanish-language newspaper. Bourne returned to complete his college degree at Syracuse University in New York in 1967. The next year he began to study film at Columbia University but was again expelled after the campus unrest of 1968.

Two weeks after he left Columbia, Bourne was hired as a producer for BLACK JOURNAL, the first African-American public-affairs television show. Under executive producer William Greaves, Bourne was allowed much latitude in creating images specifically for African Americans. One of Bourne's films for *Black Journal*, "Malcolm X Liberation University" (1969), depicted black students and faculty leaving a predominantly white college in North Carolina to form their own institution.

Bourne established Chamba Productions in 1969, taking the name of the company from a Kiswahili word for "images of the eye." Throughout the 1970s Bourne solidified his position as part of a vanguard of African-American documentary filmmakers, among them Greaves, Madeline Anderson, and Kent Garrett. His first film for Chamba was *Something to Build On* (1971), commissioned by the College Entrance Exam Board for its project to attract black high school students to college. *Nothing but Common Sense, A Piece of the Block,* and *Pusher Man* followed in 1972. In 1973 Bourne produced *Let the Church Say Amen!* which dealt with African-American religion in Mississippi and South Chicago through the eyes of a young seminary graduate. The film garnered many honors on the film-festival circuit and was widely shown in film classes. Throughout the mid- to late-1970s, Bourne produced many hour-long documentaries for public television, often on Boston's experimental station WCBG.

Bourne's style did not adhere strictly to the cinema verité style of "objective" documentary reportage but made political and cultural perspectives explicit and sometimes used actors or a loose narrative structure. In *The Black and the Green* (1982), commissioned by the BBC, Bourne followed a group of black American civil rights activists through a tour of Northern Ireland, illustrating connections between the African-American struggle and the movement to free Ireland from English oppression.

Like many of his colleagues, Bourne also sought to document black history. He examined literary lives with *In Motion: Amiri Baraka* (1982) and *Langston Hughes: Keeper of the Dream* (1987), as well as the development of black urban culture in *Big City Blues* (1986). After a retrospective at New York's Whitney Museum in 1988, Bourne released *Making "Do the Right Thing"* (1989), one of his most successful films, about the production of the Spike LEE film. The project was symbolic of the relationship between two generations of African-American filmmakers. Bourne represented the elder group of documentary directors, while Lee illustrated a new group of independent directors who preferred narrative structures. In 1993 Bourne made *Sea Island Journey*, a National Geographic special about the GULLAHS. He also continued to run Chamba from New York City.

REFERENCES

BOURNE, ST. CLAIR. "St. Clair Bourne: A Pioneer Looks Back at 20 Years in Film." *Black Film Review* 4, no. 3 (Summer 1988): 13–17.

MATTOX, MICHAEL. "Film: St. Clair Bourne: Alternative Visions." *Black Creation* 4, no. 3 (Summer 1973): 32–34.

SHIPHERD REED
ALLISON X. MILLER

Bousfield, Midian Othello (August 22, 1856–February 16, 1948), physician, civic activist. Born in Tipton, Mo., Midian Othello Bousfield received a bachelor's degree from the University of Kansas in 1907. He graduated from the medical school of Northwestern University in 1909 and then interned at Freedman's Hospital in Washington, D.C. In 1911 Bousfield went to Brazil with the intention of settling there to practice; but discouraged by the lack of opportunity, he briefly turned to prospecting before coming back to the United States. Upon his return, he worked on the railroad as a barber and porter for a year before he settled and established a medical practice in Chicago. Along with his practice, he was also a consultant to the U.S. Children's Bureau and to the Chicago Board of Health.

Bousfield was a cofounder of the Liberty Life Insurance Company, and from 1921 to 1929, he served variously as a member of the board of directors, medical director, and president. After Liberty merged in 1921 with another company and became Supreme Liberty and Life, Bousfield was chairman of the executive committee and, until his death, vice president and medical director.

Bousfield was elected president of the National Medical Association for 1934. In 1939 he was appointed director of the Negro Health Division of the Rosenwald Fund. In the latter position, he supported the National Association of Colored Graduate Nurses as well as African-American medical schools. In 1940 he was appointed to the planning committee of the White House Conference on Children in a Democracy, where he served on two subgroups—Children in Racial and Ethnic Minorities, and Public Health and Medical Care. In the course of his career Bousfield was a member of numerous national, state, and local government agencies. He is credited with being responsible for African-American physicians becoming members of state boards of health and was especially active in promoting work against tuberculosis.

During WORLD WAR II, Bousfield organized and served as commanding officer of the station hospital at Fort Huachuca, Ariz., a 1,000-bed facility which was the first military hospital staffed entirely by African-American physicians. Before his retirement from the army in 1945, he became the first African-American colonel in the Army Medical Corps. Bousfield died of a heart attack in his Chicago home in 1948.

REFERENCES

LOGAN, RAYFORD W., and MICHAEL R. WINSTON, eds. *Dictionary of American Negro Biography.* New York, 1982.
MORAIS, HERBERT M. *The History of the Negro in Medicine.* New York, 1967.
Obituary. *Chicago Daily News,* February 17, 1948, p. 20.

SIRAJ AHMED
JOSEPH W. LOWNDES

Bowe, Riddick (1967–), boxer. Riddick Bowe was born and raised in Brooklyn, N.Y. He began boxing at age eleven and won four Golden Gloves championships as a teenager. Bowe joined the 1988 U.S. Olympic boxing team and won the silver medal in the heavyweight division at the Seoul, Korea, Games.

After the Olympics Bowe was signed to a professional contract by promoter Rock Newman. The six-foot, five-inch, 240-pound fighter won his first thirty professional bouts by knockout and in 1992 became the top-ranked heavyweight contender. In November of that year, Bowe captured the heavyweight championship with a twelve-round decision over Evander HOLYFIELD.

Bowe easily dispatched his first two challengers, Michael Dokes and Jesse Ferguson, with early knockouts. A rematch with Holyfield in November 1993 became one of the strangest events in boxing history. The outdoor title fight was stopped during the seventh round when a man flying a paraglider landed on the ring's ropes. During the fight the smaller and quicker Holyfield adopted a successful hit-and-run strategy, and Bowe lost the heavyweight title by a majority decision.

Bowe reentered the ring in August 1994 and knocked out Buster Mathis, Jr., in the fourth round. The fight was ruled a "no contest," however, because Mathis had one knee down when Bowe delivered the final punch.

REFERENCES

SIMPSON, JANICE C. "Float Like a Butterfly, Sting Like . . . Ali." *Time* 142 (1993): 72–74.
SMITH, CHRIS S. "Big Bopper." *New York* 26 (1993): 38–45.

THADDEUS RUSSELL

Bowen, John Wesley Edward (December 3, 1855–July 7, 1933), clergyman and educator. At the 1896, 1900, and 1904 General Conferences of the Methodist church's Epworth League (*see* METHODISTS), John Wesley Edward Bowen was acknowledged as the most distinguished African-American clergyman in the largely white denomination. He was born in New Orleans, and received a bachelor's degree in 1878 as a member of the first graduating class from New Orleans University, a school created for African Americans. From 1878 until 1882, he taught ancient languages at Central Tennessee College, and then returned to school, receiving in 1885 a Bachelor of Sacred Theology degree, and in 1887 a Ph.D., both from Boston University. Gammon Theological Seminary in Atlanta, Ga., later awarded him an honorary Doctor of Divinity degree.

During 1888 and 1889, Bowen was professor of church history at Morgan College in Baltimore, and during 1890 and 1891, professor of Hebrew at HOWARD UNIVERSITY. While a student in Boston and a professor in Baltimore and Washington, he also min-

istered to local congregations. In 1892, he became field secretary for the Methodist Missionary Board, and in 1893, chair of historical theology at Gammon, a position he held until 1932, when he became professor emeritus. From 1906 until 1910 he was president of the seminary, and from 1910 until 1932, vice president. While at Gammon, he was coeditor with J. Max Barber of *Voice of the Negro,* the first magazine edited in the South by blacks. He also edited the addresses and proceedings from two other conferences that he himself organized.

REFERENCE

VAN PELT, J. R. "John Wesley Edward Bowen." *Journal of Negro History* (April 1934): 217–221.

SIRAJ AHMED

Bowles, Eva D. (January 24, 1875–June 14, 1943), YWCA administrator. The majority of Eva Bowles's career was dedicated to making a place for African-American women in the YOUNG WOMEN'S CHRISTIAN ASSOCIATION (YWCA), and to making its work relevant to the lives of young black women. Bowles was born, raised, and educated in Ohio, the granddaughter of a Civil War army chaplain and the daughter of a schoolteacher. She trained as a teacher and taught in a number of southern normal schools before moving to New York City in 1906. Here she became the first salaried African American in the YWCA, serving as the branch secretary of the organization that would eventually become the Harlem YWCA.

After a brief period with Associated Charities in Ohio, Bowles returned to the YWCA in 1913, taking on a position with the organization's national board. With a small staff, she set out to survey YWCA work conducted by African-American women across the country and to bring such work fully into line with national board guidelines.

The First World War proved to be a turning point for black YWCA workers. Bowles guided them through this trying period, and black women in the Y emerged much stronger. In 1917 the national board of the YWCA appointed Bowles director of the Colored Work Committee of its War Work Committee. She was given a large budget to tend to the needs of black soldiers in training camps and their families—a budget that allowed her to increase her staff and to demonstrate to the YWCA the organizational and leadership abilities of its African-American workers. Following the war, African-American YWCA work was organized under a Bureau of Colored Work, which Bowles directed.

Bowles and other black YWCA workers were committed to the organization's potential for bringing about changes in race relations in America through interracial work. During her tenure with the association, however, it operated not as an interracial organization but as a biracial one. Despite Bowles's best efforts, the national board of the YWCA and many local Ys capitulated to segregation and often denied black women decision-making power. Although there were black women in the employ of the national board, no black woman was elected a board member until 1924, almost fifty years after they first participated in YWCA work. Prominent black women, both within and outside the YWCA, criticized the organization and Bowles for their failure to move toward truly integrated work. Lugenia Burns HOPE, Lucy LANEY, and Jane Edna HUNTER were among the vocal critics.

For many years, Eva Bowles was committed to working within the structure of the YWCA and assisting it to reach its potential. In 1932, when the national board reorganized its structure, Bowles argued that the new plan would diminish black women's power in the YWCA. She resigned her position, feeling that she could no longer accomplish her goals through the organization. She held a number of positions after this, including one with the Cincinnati YWCA, until her death in 1943. Through her career with the YWCA, Eva Bowles used her leadership skills to address the needs of the black community and opened up an avenue to train new generations of African-American women for leadership.

REFERENCES

GIDDINGS, PAULA. *When and Where I Enter: The Impact of Black Women on Race and Sex in America.* New York, 1984.

OLCOTT, JANE. *The Work of Colored Women.* New York, 1919.

ROUSE, JACQUELINE A. *Lugenia Burns Hope: A Black Southern Reformer.* Athens, Ga., 1989.

JUDITH WEISENFELD

Bowling. Bowling was one of the few leisure sports to have a separate African-American players' organization. The National Negro Bowling Association (NNBA) was founded in 1939 in Detroit as a response to the white-only policies of the American Bowling Congress (ABC) and the Women's International Bowling Congress (WIBC), which organized amateur tournaments. The NNBA established several clubs throughout the Midwest and organized tournaments of black players. In 1944 the organ-

ization changed its name to the National Bowling Association (NBA). J. Wilbert Sims, Merrit Thomas, G. Walker, and Ben Harding each won multiple men's championships in NNBA and NBA tournaments. The most successful champions in the women's tournaments were Hazel Lyman, Virginia Dolphin, and Doris Largent.

In 1950 several members of the NBA, joined by Minneapolis Mayor Hubert Humphrey, union leader Walter Reuther, and Father Carow, a Catholic priest from Brooklyn, mounted a protest campaign and threatened lawsuits against the white bowlers' associations. Under mounting pressure, the ABC and WIBC finally desegregated in 1951. Despite this victory, the NBA continued to thrive as a black alternative to the predominately white organizations through the early 1990s.

In 1960 Fuller Gordy, a relative of Motown founder Berry GORDY, became the first African American to join the Professional Bowlers Association (PBA) tour. Other notable black PBA members were Bobby Williams and Charlie Venable, who toured in the 1970s.

REFERENCE

ASHE, ARTHUR R., JR. *A Hard Road to Glory: A History of the African-American Athlete.* 3 vols. New York, 1988.

THADDEUS RUSSELL
BENJAMIN K. SCOTT

Boxing. Despite the fact that professional prizefighters and sites for professional boxing matches are found all over the world, the origins of modern boxing can be traced to one country and era: late eighteenth- and early nineteenth-century England.

Although proto-forms of combat or blood sports existed in ancient Greece and Rome, they have little connection with the sport of boxing as practiced and understood today. The antecedent of modern boxing was bare-knuckle prizefighting, which sprang up in England almost simultaneously with that country's emergence as a major capitalist world power.

To be sure, the less restrictive moral atmosphere accompanying the decline of Puritanism in the mid-1600s permitted a revival of the rough sports of antiquity. Early on, boxing had close ties to the city, as it was supported by urban wealth when local squires migrated to the metropolis along with increasing numbers of working-class men. Boxing's rise came in large part from the growth of commercialized leisure and popular recreation.

Before the rules formulated by Jack Broughton, one of the earliest of the new breed of "scientific boxers" who appeared on the English sporting scene in the early 1730s, bare-knuckle fighting largely consisted of butting, scratching, wrestling, and kicking. Under the Broughton Rules, elements of wrestling remained, but there was more emphasis on the fists, on skilled defensive maneuvers, and on different styles of throwing a punch effectively. Broughton, for instance, developed the technique called "milling on the retreat," or moving backward while drawing one's opponent into punches, a technique Muhammad ALI used to great effect during his reign as heavyweight champion over two hundred years later. Broughton also used gloves or "mitts" for training his pupils, many of whom were among England's leading citizens.

Under the Broughton Rules, which were superseded by the London Prize Ring Rules in 1838, boxers fought for indeterminate lengths of time, a fight not being declared ended until one could not come up to the scratch mark in the center of the ring. A round lasted until one fighter was felled; both men then returned to their corners and were given thirty seconds to "make scratch" again. London Prize Ring Rules governed the sport of prizefighting as a bare-knuckle contest until the coming of gloves and the Marquis of Queensberry Rules. The first heavyweight championship fight under Queensberry Rules was held between the aging John L. Sullivan and James J. "Jim" Corbett on September 7, 1892. Not only did the fight usher in the age of Queensberry, it also ushered in the age of American domination of the sport, as both Sullivan and Corbett were Americans.

The golden age of bare-knuckle fighting in England, overlapping with the Regency period, occurred between 1800 and 1824, an era captured by Pierce Egan, one of the earliest boxing journalists, in his classic work *Boxiana*. It is during this era that there is record of the first black boxers of note. Bill RICHMOND was a slave who learned to box by sparring with British seamen. He was taken to England in 1777 by Gen. Earl Percy, a commander of British forces in New York during the American Revolution. Richmond, known as "the Black Terror," became the first American to achieve fame as a prizefighter. He stood about five feet tall and weighed between 155 and 170 pounds. Richmond beat such established British fighters as Paddy Green and Frank Mayers. Among his losses was one in 1805 to the British champion Tom Cribb, who was a title aspirant at the time. Richmond, who died in London, is probably best known not for his fighting but for being a second to the first black fighter to challenge for the championship.

That man, also an American ex-slave, made an even bigger name for himself as a prizefighter. Tom MOLINEAUX apparently came from a boxing family, as it has been claimed that his father was an accomplished plantation scrapper. While there is no record of Molineaux's career before his arrival in England, it is well established that many planters engaged their more athletic slaves in sports. Since most young planters had taken the obligatory European tour and discovered boxing to be the rage among British gentlemen, it is little wonder they imported it to America.

Molineaux, who became known in England as "the Moor," arrived in England in 1809 and quickly defeated Bill Burrows and Tom Blake. Molineaux was matched with Tom Cribb, the champion, for the first time on December 18, 1810, a bitterly cold day (during the bare-knuckle era, most fights took place outdoors). It was one of the most talked-about and eagerly anticipated sports events in British history. Molineaux apparently won the fight, knocking Cribb out in the twenty-eighth round. However, Cribb's

Tom Molineaux, a Virginia slave, boxed his way to freedom in the late eighteenth century. He later made his way to England, where he had several important bare-knuckle matches, including a bout with the English champion, Tom Cribb. (Photographs and Prints Division, Schomburg Center for Research in Black Culture, The New York Public Library, Astor, Lenox and Tilden Foundations)

seconds accused Molineaux of illegal tactics. During the pandemonium that ensued, Cribb was able to recover, finish the fight, and beat Molineaux, largely because the black boxer had become chilled by the damp cold. The two men fought a rematch in 1811, with Cribb the easy winner, as Molineaux had failed to train and had generally succumbed to dissipation. He went downhill rapidly after his second loss to Cribb and died in Ireland in 1818, a shell of the figure he had been in his prime.

Despite the impact of Richmond and Molineaux, blacks did not constitute a significant presence in boxing until the late nineteenth and early twentieth centuries, when the United States became the principal venue for professional matches. This era can be referred to as the pre–Jack JOHNSON age, as the coming of Johnson signified a new epoch not only in boxing but in American sports history. The years 1890 and 1905 are considered among the worst in American race relations, when blacks experienced JIM CROW and American racist practices in their most virulent, oppressive, and blatant forms. Life for black fighters was far from easy: They often were denied fights against whites or, if permitted, found they were expected to throw the fight. They were paid less and fought far more often than did their white counterparts.

Among the important black fighters of this era were Peter JACKSON, George Dixon, Joe Gans, and Jersey Joe WALCOTT. The latter three were all champions in the lighter weight divisions. Boxing under the Queensberry Rules had evolved to the point where there were now firmly established weight divisions, unlike during the bare-knuckle days of Richmond and Molineaux, when boxers fought at "open weight," and there were sometimes great weight disparities between the contestants.

Peter Jackson was arguably the best heavyweight of his generation. Many experts felt he could have taken the measure of the then-champion, John L. Sullivan, had not Sullivan—in keeping with the intense racism of the times—drawn the color line and refused to meet Jackson. The "Black Prince," as Jackson was called, was born in St. Croix, Virgin Islands. His family emigrated to Australia when he was twelve years old and returned to the Virgin Islands three years later. Jackson did not come back with them, opting to seek his fortune as a sailor. During his years as a sailor, Jackson developed his boxing skills. He became the Australian heavyweight champion, but on discovering that America was a place to make one's name, he emigrated in 1888.

At the age of thirty, in 1891, Jackson fought contender Jim Corbett to a sixty-one-round draw, but it was Corbett who fought Sullivan for the title the following year. Although Jackson enjoyed success as

a fighter, he left the ring for the stage, as he was unable to obtain a title match against either Sullivan or Corbett once Corbett defeated Sullivan for the championship. Jackson toured with a stage production of *Uncle Tom's Cabin* for several years. At thirty-seven, out of condition and well past his prime, he tried a comeback against Jim Jeffries, only to be knocked out in three rounds. Despite the frustration Jackson endured, he was widely admired by many white sports enthusiasts for his gentlemanly demeanor, and he was idolized by blacks. The abolitionist Frederick DOUGLASS in his old age hung a portrait of Jackson in his home. Jackson died of consumption in Australia in 1901.

George Dixon, known to the world as "Little Chocolate," was a smooth and cagey boxer who began his professional career on November 1, 1886. He first became bantamweight champion, although there was dispute about the exact weight qualification for this division. He eventually became the world featherweight champion, a title he held from 1892 to 1900. Dixon was a popular fighter, often featured in white sporting publications such as the *National Police Gazette,* as well as being seen in the haunts of the black entertainment world. Life in the sporting world eventually dissipated Dixon, who was knocked out by Terry McGovern in New York in 1900. He lost his last fight to Monk Newsboy in 1906 and died penniless and broken in health in 1909.

Joe Gans, "the Old Master," is considered by many historians of boxing to be one of the greatest lightweights of all time. He was born in Baltimore on November 25, 1874, and launched his professional career in 1891. He reigned as lightweight champion from 1902 to 1908. Gans was plagued by ill health, eventually losing his title to Battling Nelson in a rematch. In 1909, he tried to win his title back in another battle against Nelson, but he was sick and aging and easily beaten. Gans died a year later of tuberculosis. It has been suggested that he became a follower of FATHER DIVINE before his death. Gans died in Baltimore, and Divine was living there at the time, although at this stage in his career, Divine was virtually unknown as a black religious leader. As Divine was known as a healer (it is not clear whether, at this stage, his followers believed he was God, as they later did) and Gans was afflicted with a disease with no known cure that ravaged the black community, he may have been drawn to Divine as a last-ditch effort to seek a cure.

Joe Walcott was born in Barbados on March 13, 1873. Called "the Barbados Demon" because of his whirlwind punching power and ability to endure punishment (a style that can be likened to that of the popular 1970s junior welterweight champion Aaron Pryor), Walcott held the welterweight title from 1898 to 1906. He retired from the ring in 1911 and worked for a time as a janitor, winding up, as many black fighters did, with no money from his ring efforts. He was killed in an automobile accident in 1935.

From 1908 to the present, the history of blacks in boxing can be divided into three periods: the Jack Johnson era (1908–1915), the Joe LOUIS era (1937–1949), and the Muhammad Ali era (1964–1978). There have been many impressive and important black fighters aside from these heavyweight champions: Henry ARMSTRONG, a dominant force in the 1930s, who became champion of the featherweight, lightweight, and welterweight divisions simultaneously, the first fighter to achieve such a feat; Sugar Ray ROBINSON, welterweight champion and winner of the middleweight title on five different occasions, who dominated his weight division in the 1950s and was probably one of the most stylish and influential boxers in history; Archie MOORE, "the Old Mongoose," who was champion of the light heavyweight division from 1952 and 1962; Floyd PATTERSON, Olympic champion in 1952, heavyweight champion from 1956 to 1962, one of the youngest men ever to

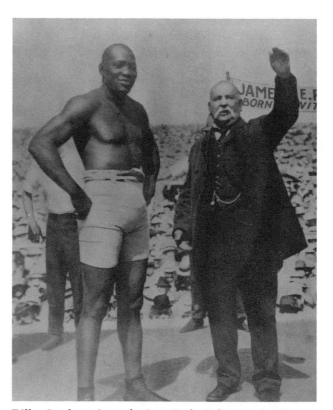

Billy Jordan, introducing Jack Johnson in Reno, Nev., July 4, 1910, prior to his heavyweight title defense against former champion James J. Jeffries. Jeffries, the most accomplished of the "white hopes" put forward to defeat Johnson, was knocked out in the fifteenth round. (Prints and Photographs Division, Library of Congress)

hold that title; Sugar Ray Leonard, Olympic champion in 1976, champion in the welterweight, junior middleweight, middleweight, and super middleweight divisions, one of the most popular fighters in the 1980s; and the controversial Mike TYSON, who was imprisoned for rape, the youngest man ever to win the heavyweight championship when he won the belt in 1986, and one of the most ferocious and unrelenting fighters ever to enter the ring.

These are a few of the notable black fighters of the twentieth century. But none of these men exercised the social and political impact on American society that Johnson, Louis, and Ali did. These three not only changed boxing, but their presences reverberated throughout the world of sport and beyond. People who normally had no interest in either boxing or sport took an interest in the careers of these three.

Jack Johnson learned the craft of boxing as a child in the same manner many black youngsters were forced to: through participating in battles royal, where five, six, or seven black youngsters were blindfolded and fought against one another in a general melee. The toughest survived the ordeal and made the most money. It may be argued that battles royal were not necessarily more brutal than ordinary prizefights, but they were surely far more degrading.

Johnson fought his first professional fight at the age of nineteen, and the defensive skills he learned to survive the battle royal stood him in good stead when he challenged white fighters in the early twentieth century. Black fighters at this time were expected not to win many fights against white opponents; if they did win, they did so on points. Johnson was among three other black heavyweights who fought during this period: Joe Jeanette, Sam McVey, and Sam LANGFORD, also known as "the Boston Tarbaby." Johnson became a leading contender for the title. After much wrangling and many concessions, he fought Tommy Burns for the heavyweight championship in December 1908 in Sydney, Australia.

Although the color line had been drawn against black challengers to the heavyweight title, Johnson succeeded in part because he was in the right place at the right time. Many in the white sporting public felt it was time to give a black a shot at the title, and Johnson was, at that point, well liked by the white sporting fraternity. Publications such as the *National Police Gazette,* not noted for any enlightened racial attitudes, campaigned vigorously for him to get a title fight. When Johnson defeated Burns, he became the first black heavyweight champion, the most prized title in professional sports.

Soon, however, the white sporting public soured on Johnson. His arrogance and his public preference for white women provoked a cry for "a great white hope" to win the title back for whites. In 1910, Jim

Cuban-born bantamweight Eligo Sardinias, better known as "Kid Chocolate," was one of the best-known boxers in New York City during the 1920s. (Photographs and Prints Division, Schomburg Center for Research in Black Culture, The New York Public Library, Astor, Lenox and Tilden Foundations)

Jeffries, a former champion, was lured out of a six-year retirement to take on Johnson in the Nevada desert, a fight that was the most publicized, most heatedly discussed, and most fervently anticipated sporting event in American history at that time. It was the first prizefight to take on significant political overtones, as many whites and blacks saw it as a battle of racial superiority. Johnson was easily the most famous, or the most notorious, black man in America, and the fight occurred at the height of American and Western imperialism, when racial segregation and oppression in this country were fiercely enforced and severely maintained. Johnson easily won the fight, although the victory caused race riots

around the country as angry whites brutalized rejoicing blacks. This was Johnson's last great moment as a professional athlete.

In 1912, Johnson's first white wife, Etta Duryea, committed suicide at the champion's Chicago nightclub. In 1913, on the testimony of a white prostitute with whom Johnson had once been intimate, he was convicted under the Mann Act and sentenced to a year and a day in federal prison. Johnson's personal life was now in shambles, and he had no future as a

During 1937 and 1938 boxer Henry Armstrong was simultaneously the featherweight, lightweight, and welterweight champion. He later became a preacher. (Prints and Photographs Division, Library of Congress)

fighter because he was thoroughly hated by the white public. He left the country for Paris.

Johnson lost the title to Kansan Jess Willard in Cuba in 1915, a fight Johnson claimed he threw in order to regain entry to the United States. In fact, he did not return until 1920, when he served his time in prison with little fanfare or notice. Johnson went on to become a museum raconteur, an autobiographer, a fight trainer, and an occasional participant in exhibitions. He died in an automobile accident in 1946.

When Joe Louis defeated Jim Braddock in June 1937 to win the heavyweight title, he was the second black to become heavyweight champion, the first permitted even to fight for the championship since the end of Johnson's tenure in 1915. During the ensuing twenty-two years, there were only three black champions of any division, and two had brief reigns: West African Battling Siki was light heavyweight champion from September 1922 to March 1923, Tiger FLOWERS was middleweight champion for six months in 1926, and Kid Chocolate was featherweight and junior lightweight champion from 1931 to 1933.

Joe Louis's father was institutionalized for mental illness and his mother remarried. The family relocated from Alabama to Detroit because of job opportunities in the automobile industry. Louis had little interest in school and was attracted to boxing. He had a distinguished amateur career before turning professional in 1934 under the management of John Roxborough and Julian Black, both African Americans. Louis's trainer Jack Blackburn, a former fighter of considerable accomplishment, was also black. With Mike Jacobs, an influential New York promoter, serving as the entrée into big-time fights, Louis's career was carefully guided to the championship in three years.

Image was everything for Louis, or at least for his handlers. In order to be accepted by the white public, he had to be the antithesis of Johnson in every respect. Johnson had bragged and consorted with white women publicly; Louis was taciturn and seen only with black women. Louis went about his business with dispatch, never relishing his victories or belittling his opponents. This latter was an especially sensitive point, as all of Louis's opponents, before he won the championship, were white.

Louis came along at a time when blacks were more assertively pushing for their rights, unlike the era of Johnson. A. Philip RANDOLPH scored a significant victory when he achieved recognition for his union from the Pullman Car Company and achieved further gains when his threatened March on Washington forced President Franklin D. Roosevelt to issue Federal Order 8802 in 1942, integrating defense industry jobs. Louis came of age after the HARLEM RENAIS-

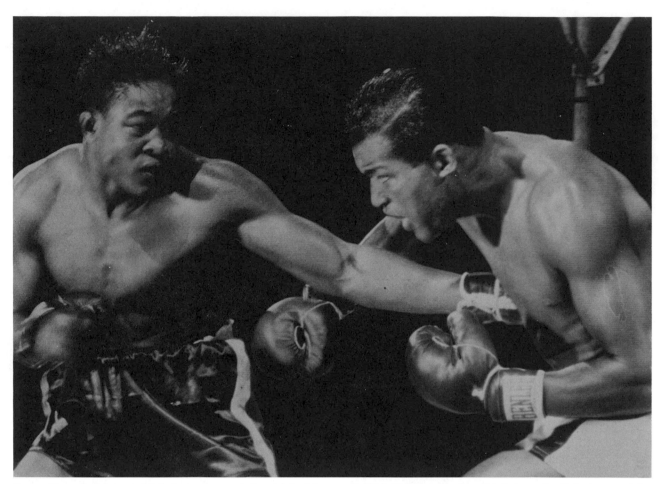

Sugar Ray Robinson (right), welterweight titleholder, and Kid Gavilan in the third round of their nontitle, ten-round fight at Yankee Stadium, New York City, September 23, 1948. (AP/Wide World Photos)

SANCE and after Marcus GARVEY'S UNIVERSAL NE-GRO IMPROVEMENT ASSOCIATION movement, both of which signaled greater militancy and race awareness on the part of blacks.

Louis's most important fight was his rematch against German heavyweight Max Schmeling in 1938. Louis had lost to Schmeling in 1936 and for both personal and professional reasons wanted to fight him again. Because Schmeling was German and probably a Nazi, the fight took on both racial and political overtones. Louis became the representative of American democracy against German arrogance and totalitarianism, as well as of American racial fair play against Schmeling's image of racial superiority and intolerance.

Louis won the fight easily, smashing Schmeling in less than a single round. As a result, he became the first black hero in American popular culture. During World War II, he served in the U.S. Army and donated purses from his fights to the war effort. He retired in 1949, after holding the title longer than any other champion and defending it successfully more times than any other champion. Money problems,

particularly back income taxes, forced him to make a comeback in 1950. He retired permanently after his loss to Rocky Marciano in 1951. In later years, Louis became a greeter in a Las Vegas hotel. He suffered from mental problems as well as a period of cocaine addiction. He died in Las Vegas in 1981, probably the most revered black boxer, arguably the most revered black athlete, in American history.

Muhammad Ali, born Cassius Clay, Jr., had a distinguished career as an amateur, culminating in a gold medal at the 1960 Olympic Games. Always outgoing with a warm but theatrical personality, the photogenic young boxer spouted poetry, threw punches with greater grace and speed than any heavyweight before him, and was generally well received by the public. Although many people disliked his showy, sometimes outrageous ways, others thought him a breath of fresh air in boxing. The young Clay fought an aging but still intimidating Sonny LISTON for the championship in 1964, defeating the older man in a fight in which Clay was the decided underdog.

It was after this fight that Clay announced his conversion to the NATION OF ISLAM. Shortly afterward,

he changed his name to Muhammad Ali, probably one of the most widely and thoroughly discussed and damned name changes in American history. Ali's popularity among whites plummeted as a result of his conversion.

But he was not through provoking the white American public. In 1967 he refused induction into the armed services on religious grounds. His spiritual leader, Elijah MUHAMMAD, had served time in prison during World War II for taking the same stand. Ali was stripped of his title, and his license to fight was revoked. Despite outcries from more liberal sections of the white public, Ali was, in effect, under a kind of house arrest for three and a half years, not permitted to fight in this country and not permitted to leave the country to fight abroad while his case was being appealed.

Ali was finally permitted to fight again in late 1970 in Georgia against journeyman heavyweight Jerry Quarry, whom he dispatched in a few rounds. During the interval of Ali's exile, the sentiments of the white public had changed significantly. Many turned against the VIETNAM WAR. The deaths of Rev. Dr. Martin Luther KING, Jr., and Robert Kennedy only two months apart in 1968, made many think the

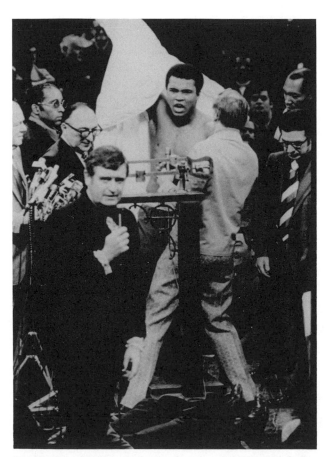

Muhammad Ali weighs in for the Ali-Frazier fight, March 8, 1971. (© Fred Kaplan/Black Star)

country was on the verge of collapse, and as a result there was a greater sense of tolerance and understanding. Ali's religious beliefs did not strike so many as being as bizarre and threatening as they had a few years earlier. Finally, blacks had achieved some political leverage in the South, and this was instrumental in getting Ali a license to box again. Ali eventually won his case in the U.S. Supreme Court when his conviction was overturned as one of a series of decisions that broadened the allowable scope for conscientious objection to war.

Ali lost his claim to the title when he suffered his first professional defeat at the hands of Joe FRAZIER in March 1971, the first of three epic battles between the two great fighters. But Ali eventually regained his title in 1974 when he defeated George FOREMAN in a shocking upset in Zaire. He lost the title again in 1978 to Olympic champion Leon SPINKS, but regained it a few months later in a rematch, becoming the first heavyweight to win the championship three times.

Ali was by far the most popular champion in the history of boxing. His face was, and still is, recognized more readily in various parts of the world than that of virtually any other American. Ali has been particularly important in creating a stronger sense of kinship between American blacks and people of the Third World. He is the most renowned Muslim athlete in history.

Like many before him, Ali fought too long, disastrously trying a comeback in 1981 against champion Larry HOLMES, who badly thrashed him over ten rounds. Ali's health deteriorated throughout the 1980s. It was finally revealed that he suffers from Parkinson's disease, induced by the heavy punishment he took in the ring. Although physically not what he once was, Ali remains a formidable physical presence, a man of great warmth and humor, and an athlete who is still honored around the world for his courage both in and out of the ring.

With Ali's departure from boxing, the heavyweight division was dominated for a considerable period by Holmes, a formidable fighter but a man of little personality, wit, or engagement. Although Holmes enjoyed considerable popularity during his reign, it was fighters from the lighter weight divisions who attracted media attention and huge purses during the late 1970s through the 1980s. Sugar Ray Leonard, Marvelous Marvin HAGLER, Matthew Saad Muhammad, Aaron Pryor, Dwight Muhammad Qawi, Thomas "Hitman" HEARNS, Marvin Johnson, Mike "the Body Snatcher" McCallum, Livingstone Bramble, and Michael SPINKS were among the best and most highly publicized fighters of the day.

Relying on the popularity of several highly skilled Latin American fighters, including the redoubtable

Roberto Duran, Alexis Arguella, Pipino Cuevas, and Victor Galindez, which enabled fight promoters to once again use ethnic and cultural symbolism as a lure for a diverse and fragmented public, these black fighters were able to bring greater attention and larger sums of money to boxing arenas in the 1980s than ever before.

After Holmes, the heavyweight class fell into complete disarray, similar to the 1930s before the coming of Joe Louis. A succession of undistinguished champions paraded before the public. Not until the emergence of Mike TYSON did the category reclaim its position as the glamour division of the sport. Tyson enjoyed greater financial success than any other heavyweight in history. However, he was poorly advised, surrounded by cronies who did not protect his interests or their own. Tyson pursued a self-destructive path of erratic, violent behavior and suspected substance abuse, and was finally imprisoned for an assault on a black beauty contestant.

REFERENCES

FLEISCHER, NAT. *Black Dynamite: The Story of the Negro in the Prize Ring from 1782 to 1838.* 5 vols. New York, 1938.

GORN, ELLIOTT. *The Manly Art: Bare-knuckle Prize Fighting in America.* Ithaca, N.Y., 1986.

McCALLUM, JOHN D. *The World Heavyweight Boxing Championship: A History.* Radnor, Pa., 1974.

MEAD, CHRIS. *Champion—Joe Louis, Black Hero in White America.* New York, 1985.

REID, J. C. *Bucks and Bruisers: Pierce Egan and Regency England.* London, 1971.

ROBERTS, RANDY. *Papa Jack: Jack Johnson and the Era of White Hopes.* New York, 1983.

SAMMONS, JEFFREY. *Beyond the Ring: The Role of Boxing in American Society.* Urbana, Ill., 1988.

YOUNG, A. S. "DOC." *Negro Firsts in Sports.* Chicago, 1963.

GERALD EARLY

Boyd, Henry Allen (April 16, 1876–May 28, 1959), businessman. Henry Allen Boyd was born in Grimes County, Tex. Accounts of his education differ, though it is likely that Boyd studied theology at the Hearn Academy in Texas and at Guadalupe College in Seguia, Tex. After graduating, he worked in San Antonio, Tex., as a headwaiter and then as a postal clerk; but, due to eye problems, Boyd left the post office just before 1900 and moved with his family to Nashville, Tenn., where he lived for the rest of his life. The son and business heir of Richard Henry BOYD, Henry Allen Boyd followed his father into the higher echelons of the NATIONAL BAPTIST CONVEN-

TION, and, particularly, the National Baptist Publishing Board. With the aid of his father, Boyd ran the *Nashville Globe and Independent,* a weekly African-American newspaper established in 1905.

When the National Baptist Convention divided in 1915—in part over the Boyds' domination of the successful publishing firm and the desire by some other members of the convention to incorporate—the Boyds became sole owners of the publishing facilities and leading members of the National Baptist Convention, Unincorporated. Upon the death of his father in 1922, Henry Boyd became publisher and president of the *Globe and Independent,* and took control over the publishing firm as well as his father's bank, the One Cent Savings Bank and Trust Company, now the Citizens Savings Bank and Trust Company of Nashville.

Boyd proved an able businessman. When many African-American banks collapsed during the GREAT DEPRESSION, Boyd guided the One Cent to success. With his capital, as well as his influential position as editor of the *Globe and Independent,* Boyd became the principal advocate for numerous local and statewide black concerns and campaigns, including the founding in Nashville of the Tennessee Agricultural and Normal School (now Tennessee State University).

Boyd had an abiding concern with the success of blacks in the United States, and as a banker, businessman, and publisher, did his utmost to help other African Americans and their business projects. At the time of his death, Boyd was a director of the Supreme Liberty Life Insurance Company, an executive of the Negro YMCA of Nashville, secretary of the National Sunday School Congress of the National Baptist Convention of America, and was on the board of trustees at FISK UNIVERSITY, Meharry Medical College, the NATIONAL NEGRO BUSINESS LEAGUE, the NAACP, and the National Council of Churches.

REFERENCES

LOGAN, RAYFORD W. and MICHAEL R. WINSTON. *Dictionary of American Negro Biography.* New York, 1982.

Obituary. *New York Times,* May 30, 1959.

PETER SCHILLING

Boyd, Richard Henry (March 15, 1843–August 23, 1922), Baptist leader. Richard Boyd was born in Nexubee County, Miss., as a slave named Dick Gray and changed his name after emancipation in 1867. During the Civil War, he accompanied members of the family that held him in slavery to the battlefield.

In 1869, he became a Baptist preacher and entered Bishop College, in Marshall, Tex.

In 1870, Boyd left college to organize, largely with his own funds, Texas's first African-American Baptist association, which comprised six churches. From 1896 to 1914, he was secretary of home missions of the National Baptist Convention, in which capacity he established four churches and one school in Panama during the construction of the Panama Canal. In 1896 he founded the National Baptist Publishing Board, of which he was secretary from the founding until 1922. He conceived the idea of publishing literature for African-American Baptist Sunday Schools and was the first to issue Baptist literature. In a major conflict over the incorporation of the National Baptist Convention (1915), which ended finally in the formation of two conventions, Boyd represented the faction against incorporation.

Boyd was the founder and first president of the Citizen's Savings Bank and Trust Company of Nashville, a bank for African Americans that he served from 1904 until his death. He also founded the National Negro Doll Company, originating the idea of black dolls for African-American children, and was the first president of the Nashville Globe Printing Company, which published the *Nashville Globe*. He wrote or edited fourteen books about the Baptist denomination and donated money to various African-American colleges. Boyd suffered a cerebral hemorrhage and stroke on August 19, 1922, and died four days later.

REFERENCES

LOGAN, RAYFORD W., and MICHAEL R. WINSTON, eds. *Dictionary of American Negro Biography*. New York, 1982.
Obituary. *Chicago Defender*. September 2, 1922, pp. 1–2.
Obituary. *Nashville Banner*. August 24, 1922, p. 1.

SIRAJ AHMED

Boyd, Robert Fulton (July 8, 1858–July 20, 1912), physician and dentist. Robert Boyd was born in Giles County, Tenn., the son of slaves. He was educated at public schools in Pulaski, Tenn., and subsequently taught in those schools from 1875 to 1880 before moving to Nashville, where he earned an M.D. from Meharry Medical College in 1882. He then taught courses in chemistry at Meharry while attending Central Tennessee College, from which he received a B.A. in 1886. Continuing with his studies, Boyd earned a D.D.S. from Meharry in 1887. His busy professional life included private practice in

medicine and dentistry and teaching at Meharry Medical School. In addition, he opened Boyd's Infirmary in 1893, which served as a teaching hospital for Meharry, and he became superintendent and surgeon-in-chief of Nashville's Mercy Hospital in 1900.

Boyd served for a time as president of one of the first black-owned banks in the U.S., the People's Savings Bank and Trust Company in Nashville. One of the founders of the National Medical Association, Boyd was its first president (1895–1897).

REFERENCES

KENNY, JOHN A. *The Negro in Medicine*. Tuskegee, Ala., 1912.
LOW, W. AUGUSTUS, and VIRGIL A. CLIFT. *Encyclopedia of Black America*. New York, 1981.

LYDIA MCNEILL

Boyd, Walter. *See* Ledbetter, Hudson William "Leadbelly."

Bradley, Clarence "Buddy" (1908–July 17, 1972), tap dancer and choreographer. Born in Harrisburg, Pa., Buddy Bradley taught himself to dance the Charleston and popular social dances at an early age. Orphaned at the age of fourteen, Bradley went to live with relatives in Utica, N.Y., where he worked as a hotel busboy. Three months later he ran away to New York City, where he learned to tap in an alley next to Connie's Inn; he was eventually hired as a chorus member at Connie's, where he picked up acrobatic steps and became known as one of HARLEM's most promising young dancers.

In the late 1920s, Bradley coached white clients at Billy Pierce's dance studio in midtown Manhattan, blending easy tap with popular black vernacular dance, and building routines that flowed gracefully and rose to a climax. Inspired by the music of the day, Bradley ignored melody and translated the accents of improvising jazz soloists into dance patterns. Word of his talent for coaching and choreography spread quickly in show business circles and transformed Pierce's one-room studio into the Pierce Studios, where Bradley eventually directed a staff of five, and earned over one thousand dollars a week. He rechoreographed the *Greenwich Village Follies of 1928* (credited to Busby Berkeley) and the sensational "High Yaller" routine from the "Moanin' Low" number in *The Little Show* (1929), but received no program credit. In the late 1920s and early '30s he created routines for Mae West, Eddie Foy, Gilda Gray, Jack Don-

ahue, Paul Draper, Ruby Keeler, Lucille Ball, Eleanor Powell, and Fred and Adele Astaire, among others; he was paid well for his work but received no public acknowledgment for it, and so remained largely unknown outside of show business circles.

In Europe, Bradley served as a kind of American ambassador of jazz and tap dance: he worked there from the 1930s on as a dance director for musical revues, films, and television. He received the first choreographic credit of his career in the all-white London production of *Evergreen* (1930), and his second for *Cochrane's Revue of 1931*, which catapulted him into English musical theater and the emerging film industry. He choreographed the ballet *High Yellow* (1932), which featured Frederick Ashton and Alicia Markova, for the Camargo Society, as well as a number of films, including *Radio Parade* (1935), *It's Love Again* (1936), and *Walking on Air* (1946). In addition, Bradley created cabaret acts for Vera Zorina and Anton Dolin, and collaborated with Leonide Massine, George Balanchine, and Agnes DeMille on several productions. Bradley remained in England as the proprietor of a London dance school until 1968. Afterward he returned to the United States, where he died at the age of sixty-four.

REFERENCES

HILL, CONSTANCE VALIS. "Buddy Bradley: The "Invisible" Man of Broadway Brings Jazz Tap to London." *Proceedings of Society of Dance History Scholars* 14–15 (February 1992): 77–84.

STEARNS, MARSHALL, and JEAN STEARNS. *Jazz Dance: The Story of American Vernacular Dance.* New York, 1968.

VAUGHN, DAVID. *Frederick Ashton and His Dances.* London, 1977.

CONSTANCE VALIS HILL

Bradley, David Henry, Jr. (September 7, 1950–), novelist. Bradley was born and raised in rural Bedford, Pa., the son of David Henry and Harriette (Jackson) Bradley. He attended the University of Pennsylvania, where he studied English and received his B.A. *summa cum laude* in 1972. Afterward he moved on to King's College in London, where he earned his M.A. in United States studies in 1974. After working for two years in publishing, Bradley became a member of the English department at Temple University in Philadelphia.

Bradley wrote his first novel, *South Street* (1975), while still an undergraduate at the University of Pennsylvania: alienated from his peers, whose urban lifestyle and politicized outlook he found artificial, Bradley spent most of his free time with the locals at a bar on Philadelphia's South Street. The novel offers original perspectives on the links within the black community and its relationship to history and memory and powerfully evokes life in the ghetto, with its numbers games, Saturday night drinking parties, and storefront churches.

Bradley's second novel, *The Chaneysville Incident* (1981), won several awards in 1982: the PEN/Faulkner Award, the American Academy and Institute of Arts and Letters award for literature, and a *New York Times Book Review* "Editor's Choice" citation. The core of this more ambitious novel is an incident from Bedford's history. In doing research for the area's bicentennial in 1969, Bradley's mother discovered thirteen unmarked graves on the property of a Bedford County landowner: in doing so, she confirmed a local myth concerning thirteen fugitives on the UNDERGROUND RAILROAD who, on the point of recapture, had preferred death to slavery and asked to be killed.

Bradley's narrative concerns a young black historian, John Washington, who has returned to his hometown in western Pennsylvania for the last few days of his surrogate father's life. His return inspires him to investigate his past; by digging up information from family papers, he manages to tie his natural father's suicide to the death of the thirteen fugitives. In relating his discovery to his girlfriend, a white psychiatrist, the protagonist discovers that history must be rooted in communal memory to be authentic, and that, in order for an individual to create, his emotions must be fed and sustained by the oral traditions of the group. This itinerary informs the narrative, which is gradually transformed from a factual account into a reflection on the meaning of the past.

In addition to two novels, Bradley has written articles and essays for many publications, including *Esquire,* the *New York Times Magazine* and *Book Review, Redbook,* and the *Southern Review.* He was awarded a Guggenheim Fellowship in 1989 and a National Endowment for the Arts Fellowship in 1991.

REFERENCES

BRELIN, CHRISTA, and WILLIAM C. MATNEY, JR., eds. *Who's Who Among Black Americans.* 7th ed. Detroit, 1992.

METZGER, LINDA, ed. *Black Writers: A Selection of Sketches from Contemporary Authors.* Detroit, 1989.

SMITH, VALERIE. "David Bradley." In *Dictionary of Literary Biography,* vol. 33, *Afro-American Fiction Writers After 1955.* Detroit, 1984.

MICHEL FABRE

Bradley, Edward R. (June 21, 1941–), news correspondent. Ed Bradley was born in Philadelphia, the son of Edward R. Bradley and Gladys Bradley. He

received a B.S. degree in education in 1964 from Cheyney State College in Cheyney, Pa.

In 1963, Bradley began work as a news reporter with radio station WDAS in Philadelphia, and in 1967 he moved to WCBS radio, New York. In 1971, he made the transition to television, becoming a stringer in the CBS Paris bureau. In September 1972, he was transferred to the Saigon bureau, where he remained until he was reassigned to the CBS News Washington bureau in June 1974. Shortly after being named a CBS News correspondent in 1973, he was wounded while on assignment in Cambodia. In March 1975, he volunteered to return to Indochina to cover the fall of Cambodia and Vietnam.

Beginning in 1976, Bradley served as a CBS News White House correspondent, becoming a principal correspondent for the news program *CBS Reports* (1978–1981), while maintaining an anchor position on the CBS Sunday-night news (1976–1981). In 1981, Bradley joined the famed *60 Minutes* team of Mike Wallace and Morley Safer as coeditor. His work on the program brought him wide public recognition as well as numerous awards, including three Emmies (two in 1983 and one in 1985). Bradley also received two Alfred I. duPont–Columbia University Awards in 1979 for his documentaries "The Boat People" and "Black in America: With All Deliberate Speed?" That same year he was the recipient of the George Foster Peabody Award, the Ohio State Award, and the Overseas Press Club Award. In addition to his position on *60 Minutes,* in 1992 Bradley became the anchor of CBS News's *Street Stories.*

REFERENCE

CLOYD, IRIS, ed. *Who's Who Among Black Americans, 1990–91.* Detroit, 1990.

CHRISTINE A. LUNARDINI

Bradley, Thomas "Tom" (December 27, 1917–), politician. Tom Bradley was born in Calvert, Tex., a town located between Waco and Houston. Both his mother and father were sharecroppers. When Bradley was four, the family moved to Dallas, and when he was six, to Somerton, Ariz., where they moved in with relatives and where he first attended school. In 1924, the family moved to Los Angeles.

There, Bradley attended Polytechnic High School, where he was one of 113 blacks out of a student population of 1,300. He excelled as a scholar and athlete, and won a scholarship to the University of California at Los Angeles (UCLA).

In 1941, Bradley left UCLA to enter the Police Academy. He remained in the police department un-

Tom Bradley was first elected mayor of Los Angeles in 1973. Though blacks comprise only about 15 percent of the city, Bradley proved popular with a wide cross-section of the population and was reelected four times, serving through 1993. (Photographs and Prints Division, Schomburg Center for Research in Black Culture, The New York Public Library, Astor, Lenox and Tilden Foundations)

til 1961, rising to the rank of lieutenant, the highest position achieved up to then by an African American.

During his years on the police force, Bradley attended Loyola University Law School and Southwestern University Law School at night, and was accepted to the California Bar in 1956. Upon leaving the force in 1961, he joined the law practice of Charles Matthews. In 1963, Bradley ran successfully for the City Council seat for Los Angeles' 10th District, a predominantly white district. He was one of the first blacks outside the East Coast elected to political office by a nonblack majority constituency. He retained his seat until 1973.

In August 1965, when the WATTS riot erupted, Councilman Bradley's criticism of police brutality brought him into conflict with his former comrades in the LAPD and Mayor Sam Yorty. Despite a widespread political "white backlash" against civil unrest and black militancy, Bradley's law enforcement background and moderately liberal politics, along with his dignified, unthreatening bearing, gave him

interracial popularity in a city only 15 percent black. In 1969, Bradley challenged Yorty for the office of mayor. He won the primary, with 46 percent of the vote to Yorty's 26 percent, but in the runoff, after a race-baiting campaign by Yorty, Bradley was narrowly defeated.

In 1973 he ran again, this time defeating Yorty 56 percent to 43 percent, to become Los Angeles' first black mayor, as well as the first African-American mayor of a predominantly white city. He would be reelected four times. A major highlight of Bradley's tenure was the athletically and commercially successful 1984 Summer Olympics. The Bradley administration also spurred downtown development. However, partly as a result of weak municipal government, Bradley was accused of neglecting working-class and inner-city neighborhoods, particularly black areas. Nevertheless, Bradley was sufficiently popular in 1982 to win the Democratic party nomination for governor of the nation's largest state. He was projected to win the race, but narrowly lost to Republican George Deukmejian. In 1985, Bradley won a fourth term as mayor, and the same year won the NAACP's SPINGARN MEDAL. In 1986 he again ran for governor, and once again lost.

While Bradley was reelected mayor in 1989, his final term was marred by the Rodney King incident. In March 1991, the savage beating of King, a black motorist, by four LAPD officers, was secretly videotaped. Repeated showings of the tape on national television caused a countrywide furor. When the officers charged were acquitted in 1992, Los Angeles erupted in a riot that dwarfed the Watts uprising of 1965. Bradley drew heavy criticism from blacks over his ineffective control of the police department, and from whites for his inability to reestablish order in the city. When King's assailants were tried on federal charges in 1993, Bradley prepared an emergency response in case of another riot, but two officers were convicted and no violence occurred. Bradley completed his last term in 1993.

REFERENCES

"Biography of Mayor Tom Bradley." Mayor's Office, City Hall, Los Angeles, 1993.
HORNE, GERALD. *Fire This Time: The Watts Uprising and the Meaning of the 1960s.* Forthcoming.
PAYNE, J. GREGORY, and SCOTT RATSAN. *Tom Bradley: The Impossible Dream.* Santa Monica, 1986.

GERALD HORNE

Brady, St. Elmo (1884–1966), chemist and educator. He was born in Louisville, Ky., and educated at Fisk University, where he received his A.B. in chemistry in 1908. In 1913, Brady began his graduate studies in chemistry at the University of Illinois; he received an M.A. in 1914, and was a fellow in chemistry from 1914 until 1916, when he became the first African American to receive a Ph.D. in chemistry. His dissertation was entitled "The Divalent Oxygen Atom."

Brady held positions at Tuskegee Institute as head of the division of science and at Howard University as chairman and professor of chemistry, before returning to his alma mater as head of the department of chemistry. He published in *Science* and the *Journal of Industrial and Engineering Chemistry*. Brady also presented papers at the annual meetings of the American Chemical Society. He held memberships in Phi Lambda Upsilon, the National Chemical Society, and Sigma Xi.

REFERENCES

MANNING, KENNETH R. *Black Apollo of Science: The Life of Ernest Everett Just.* New York, 1983.
"Men of the Month." *Crisis* 12 (1916): 190–191.
SAMMONS, V. O. *Blacks in Science and Medicine.* New York, 1990.

WILLIE J. PEARSON, JR.

Bragg, George Freeman, Jr. (January 25, 1863– March 12, 1940), Episcopal minister, civil rights leader, editor, and author. George Freeman Bragg was born in Warrentown, N.C. In 1865 his family moved to Petersburg, Va., where they joined his paternal grandmother, who had been the house slave of an Episcopal rector. Bragg entered the Theological School for Negroes in Petersburg, a branch of the Virginia Theological Seminary, but was suspended in 1880, probably because he campaigned for, and held several minor positions in, the Readjustor Party, which advocated increased taxes on corporate wealth. After serving as a page in the Virginia state legislature in 1882, he reentered the Theological School for Negroes in 1885 and was ordained an Episcopal priest in 1887.

In 1888 Bragg became a priest at St. Luke's Church in Norfolk, Va., stimulating the growth of the congregation and improving the facilities of the church. Three years later he was appointed rector of St. James Church in Baltimore, which had been in financial decline, and he eventually made it self-supporting. He remained rector until his death forty-nine years later. He founded an industrial school for African-American girls, two Episcopal missions, and, in 1899, the Maryland Home for Friendless Colored Children.

With his own press, Bragg edited and published a newspaper entitled *The Church Advocate*. He also published *Lancet*, one of the first African-American weekly journals in Virginia. He wrote many pamphlets and, in 1922, he authored a history entitled *The Afro-American Group of the Episcopal Church*, which remains the standard work on the subject.

Bragg led the fight to insure that black teachers were hired in black schools in Baltimore. In 1905, advised and funded by the Committee of Twelve, a group of black leaders including Booker T. WASH-INGTON and W. E. B. DU BOIS, Bragg was among the Maryland leaders who campaigned against the Poe Amendment, which was intended to extend the disenfranchisement of blacks to Maryland. But in his political beliefs, Bragg was closer to Du Bois—whose NIAGARA MOVEMENT he joined before the end of 1905—than to Washington. He believed that the status of blacks would improve if the educated and economically productive members of both races cooperated, and that the Episcopal Church was the national institution where this kind of cooperation took place. Hence he criticized racism within the church, including the exclusion of blacks from the Episcopal episcopacy. Bragg died in Baltimore.

REFERENCE

Obituary. *Journal of Negro History* 24 (July 1940): 399–340.

SIRAJ AHMED

Braithwaite, William Stanley Beaumont

(December 6, 1878–June 8, 1962), author. The son of an immigrant from British Guiana and the daughter of a former slave, William Stanley Braithwaite was born and raised in Boston, Mass. He and three other siblings were educated at home until 1884, when his father's death left the family destitute. For some years afterward, Braithwaite attended public school, but left when he was twelve and went to work full-time to support his family. He worked for several firms before finding employment as an errand boy at the publishing firm of Ginn & Co., where he eventually became apprenticed as a compositor. Braithwaite later claimed that he had been setting the first lines of John Keats's "Ode on a Grecian Urn" when he realized his passion for poetry, and determined to write his own verse. He submitted poems and critical essays to various newspapers and magazines, including the *Atlantic Monthly*, the *North American Review*, and *Scribner's*, before publishing his first book of verse, *Lyrics of Life and Love*, in 1904. Two years later, he

began contributing essays and reviews to the *Boston Evening Transcript*, and published his first anthology, the *Book of Elizabethan Verse*. A second volume of poetry, *House of Falling Leaves*, appeared in 1908.

Braithwaite was appreciated more for his editorial efforts than for his own poems, which emulate the traditional forms, meters, and themes of British nineteenth-century works, and make no reference to racial identity. Two additional anthologies, the *Book of Georgian Verse* and the *Book of Restoration Verse*, were published in 1908 and 1909. In 1913 Braithwaite produced the first *Anthology of Magazine Verse and Yearbook*, the publication for which he is best known. The anthology appeared annually between 1913 and 1939, and included such HARLEM RENAISSANCE authors as Sterling BROWN, Countee CULLEN, Langston HUGHES, James Weldon JOHNSON, Claude MCKAY, and Anne SPENCER, as well as the early work of Carl Sandburg, Vachel Lindsay, Amy Lowell, Wallace Stevens, and Robert Frost. Braithwaite also served as an editor for the *Poetry Journal* (1912–1914) and *Poetry Review* (1916–1917). In recognition of his literary accomplishments, he was awarded the NAACP's SPINGARN MEDAL for outstanding achievement by an African American in 1918; that same year, he received honorary degrees from Taladega College and Atlanta University. In 1922

William Stanley Braithwaite, poet and anthologist, one of the most distinguished African-American men of letters in the opening decades of the twentieth century. (Prints and Photographs Division, Library of Congress)

Braithwaite founded the B. J. Brimmer Publishing Company, and published several works, most notably Georgia Douglas JOHNSON's first volume of poetry, *Bronze* (1922), and James Gould Cozzen's first novel, *Confusion* (1924), before his firm folded in 1925. Braithwaite's famous essay, "The Negro in American Literature," appeared in Alain LOCKE's *The New Negro* that year. Braithwaite continued to support himself and his family through writing and editing before accepting a professorship in creative literature at Atlanta University, where he taught for ten years. During this time, he started to work on his autobiography, *The House Under Arcturus*, which was published in three parts in *Phylon* in 1941.

Braithwaite retired from teaching and moved to Harlem in 1945. He published a volume of his *Selected Poems* (1948), *The Bewitched Parsonage*, a critical work on the Brontës (1950), and the *Anthology of Magazine Verse for 1958* (1959).

REFERENCES

BUTCHER, PHILIP, ed. *The William Stanley Braithwaite Reader*. Ann Arbor, Mich., 1972.

HARRIS, TRUDIER, and THADIOUS DAVIS, eds. *Dictionary of Literary Biography*. Vol. 51, *Afro-American Writers from the Harlem Renaissance to 1940*. Detroit, 1987.

LOGAN, RAYFORD W., and MICHAEL R. WINSTON, eds. *Dictionary of American Biography*. New York, 1982.

QUANDRA PRETTYMAN

Branch, William Blackwell (September 11, 1927–), playwright. William Blackwell Branch was born in New Haven, Conn. In 1949 he received a B.S. in speech from Northwestern University and in 1958, an M.F.A. in dramatic arts from Columbia University. In 1958–1959 he did postgraduate work in film production at Columbia, and in 1965–1966, at the Yale School of Drama, he was a resident fellow in screenwriting. His first ambition was to be an actor, but he turned to writing for the stage, television, radio, and films because of his disillusionment about the truthfulness of the portrayal of the African-American experience by others. An influential playwright, particularly during the 1950s, Branch wrote in a realistic manner about the African-American experience.

In October 1951 Branch's first play, *A Medal for Willie*, which deals with southern white hypocrisy in the honors posthumously given to an African-American war hero, opened at Club Baron in Harlem. The day following the opening, ironically, Branch was drafted into the U.S. Army, where he served from 1951 to 1953. *In Splendid Error*, which he began

writing while in the Army and which focuses on the controversy between Frederick DOUGLASS and John Brown over the best way to abolish slavery, opened at the Greenwich Mews in New York in 1954. Other stage plays include *A Wreath for Udomo* (1960), based on Peter Abrahams's novel about the career of an African prime minister, and *Baccalaureate* (1975), which treats some problems in the life of a young African-American middle-class woman. Branch's *Light in the Southern Sky* (1958), a television drama based on the life of the African-American educator Mary McLeod BETHUNE, won a Robert E. Sherwood Television Award and a citation from the National Conference of Christians and Jews. His *Still a Brother: Inside the Negro Middle Class* (1968), a documentary film, won an American Film Festival Blue Ribbon Award in 1969 and an Emmy nomination, which Branch shared with coproducer William Greaves. Other awards received by Branch include a Guggenheim Fellowship in playwriting in 1959–1960 and a 1992 American Book Award from the Before Columbus Foundation for *Black Thunder,* an anthology of contemporary African-American plays compiled and edited by Branch.

Founder and president of a media consulting and production firm, William Branch Associates, he also has been a visiting playwright and professor at various colleges and universities such as the University of Maryland, Baltimore County; the University of Ghana; and Cornell University.

REFERENCE

ABRAMSON, DORIS E. *Negro Playwrights in the American Theatre*. New York, 1969.

JEANNE-MARIE A. MILLER

Branson, Herman Russell (August 14, 1914–) physicist, college president. Born in Pocahontas, Va., Branson received a B.S. in physics from Virginia State University in 1939 and a Ph.D. in physics from the University of Cincinnati in 1939. As chairman of the Department of Physics at HOWARD UNIVERSITY from 1941 to 1968, he spearheaded research in physics and biophysics that led to new understandings about organic molecules and biological systems. His work in mathematical biology and protein structure was pioneering. As a collaborator with Robert B. Corey and the Nobel Prize–winning Linus Pauling, Branson was one of a three-member team that identified the alpha and gamma helical structures of proteins. His utilizing of research teams at Howard consisting of physicians, engineers, mathematicians, biologists, chemists, and physicists resulted in pro-

lific and productive scientific research output between 1941 and 1968.

After twenty-seven years of trailblazing research that included contributions in four areas—the structures of proteins, the integral equation description of processes in biological systems, information theory in biology, and physiochemical studies of sickle-cell anemia, Branson moved on to the presidency of two historically black colleges—Central State University (Ohio), from 1968 to 1970 and LINCOLN UNIVERSITY (Pennsylvania), from 1970 to 1985.

Following his last college presidency he directed the Pre-College Science and Mathematics Program at Howard University, which provided senior-level high school students with summer research internships under the mentorship of professional scientists. Branson's outstanding work has been recognized by his election to membership in the leading academic and scientific organizations of the country, as well as the numerous honorary degrees he has been awarded.

REFERENCES

American Men and Women of Science, 16th ed. New York, 1971, p. 683.
GREENE, HARRY WASHINGTON. *Holders of Doctorates Among Negroes.* Boston, 1946, p. 146.

ROBERT C. HAYDEN

renderings of black speech and music, particularly JAZZ.

In addition to more than ten volumes of poetry, Brathwaite has worked as a playwright (*Odale's Choice,* 1967), essayist (*Caribbean Man in Space and Time,* 1974), editor (*New Poets from Jamaica,* 1979), and contributor to periodicals.

Roots, a 1986 history of Caribbean literature and culture, won the Casa de las Americas Prize for Literary Criticism. Brathwaite's other honors include Guggenheim (1972) and Fulbright fellowships, and the Institute of Jamaica Musgrave Medal (1983). In 1994 he received the $40,000 Neustadt International Prize for Literature. Sponsored by *World Literature Today* and the University of Oklahoma, the award recognized Brathwaite for being what Ghanian author Kofi Awoonor called "a poet of the total African consciousness."

REFERENCES

BRATHWAITE, EDWARD KAMAU. *The Zea Mexican Diary.* Madison, Wis., 1993.
BREINES, LAURENCE A. "Edward Kamau Brathwaite." In *Dictionary of Literary Biography,* Vol. 125, *Twentieth-Century Caribbean and Black African Writers.* 2nd series. Detroit, Mich., 1993.
SALKEY, ANDREW. "Barbados." *World Literature Today* (Summer 1983): 500.

DEREK SCHEIPS

Brathwaite, Edward Kamau (May 11, 1930–), poet. Edward Kamau Brathwaite was born to Hilton Edward and Beryl (Gill) Brathwaite in Barbados. He attended Harrison College and earned degrees from Cambridge University (B.A., 1953; Diploma of Education, 1954), and the University of Sussex (Ph.D., 1968). From 1955 to 1962 he was an officer in the Ministry of Education of Ghana, and he later balanced his teaching duties at the University of the West Indies (St. Lucia, Jamaica), with travel and work in England and the United States. In 1994 he was a visiting professor at New York University.

Brathwaite's earliest poetry collections—*Rights of Passage* (1967), *Masks* (1968), and *Islands* (1969)—established him as a major talent. This autobiographical trilogy, collected as *The Arrivants* (1973), reflects the poet's contact with white cultures and Africa, and explores the shaping of racial identities. In the volumes that followed, such as *Other Exiles* (1975), *Sun Poem* (1982), *X/Self* (1987), and *Middle Passages* (1992), he highlighted global concerns from a remarkable array of African, European, and Caribbean perspectives. His poetry is characterized by a deft interweaving of voices, innovative fonts, and vivid

Brawley, Benjamin Griffith (1882–February 1, 1939), educator and author. Brawley was born in Columbia, S.C., to Margaret Dickerson Brawley and Edward McKnight Brawley. His father's career as a Baptist preacher and professor required that the family move several times; although Brawley attended a succession of elementary and secondary schools, his early education took place primarily at home. He earned a baccalaureate degree at Atlanta Baptist (later Morehouse) College in 1901; in 1907, he earned a B.A. from the University of Chicago and completed his M.A. at Harvard University in 1908.

Brawley devoted his life to the study of literature; in particular, he concentrated on the lives and works of African-American writers and artists. His teaching career was spent primarily at Atlanta Baptist College (1912–1920); Shaw University (1922–1931), where his father was also a professor; and Howard University (1910–1912 and 1931–1939). While teaching at Howard in 1912, he met and married Hilda Damaris Prowd.

Brawley built a reputation as a prolific scholar, a master teacher, and an occasional poet, and although

his verse is not remembered today, his scholarly works are still highly regarded. Among his seventeen books are: *A Social History of the American Negro* (1921); *The Negro in Literature and Art* (1918), which was republished as *The Negro Genius* (1937); *Early Negro American Writers* (1935); and *Paul Laurence Dunbar: Poet of His People* (1936). He also lectured frequently and published many scholarly articles and textbooks, including *A New Survey of English Literature* (1925).

Brawley's quiet and sensitive approach to literary studies utilizes biography and history, reading artistic works from within the context of the authors' lives. He was keenly aware of the struggles of blacks in American society, and dedicated to making his audience, black and white, aware of the breadth and depth of the contributions of African Americans. As his writings demonstrate, he also sought to illuminate universal themes transcending race. As he concludes in his respected work on Paul Laurence DUNBAR, "Against the bullying forces of industrialism he [Dunbar] resolutely set his face. . . . Above the dross and the strife of the day, he asserted the right to live and love and be happy."

Brawley died on February 1, 1939. On February 6, classes and other activities at Howard University were suspended for the day to mark his funeral and interment.

REFERENCES

BRAWLEY, BENJAMIN GRIFFITH. *Paul Laurence Dunbar: Poet of His People.* Chapel Hill, N.C., 1936.

PARKER, JOHN W. "Benjamin Brawley—Teacher and Scholar." *Phylon: Review of Race and Culture* 10, no. 1 (1949).

———. "A Bibliography of the Published Writings of Benjamin Griffith Brawley." *North Carolina Historical Review* 34, no. 2 (1957).

REDDING, SAUNDERS. "Benjamin Brawley." In Rayford W. Logan and Michael R. Winston, eds. *Dictionary of American Negro Biography.* New York, 1982.

STEVEN J. LESLIE

Brawley, Edward McKnight (March 18, 1851–January 13, 1923), minister. Edward McKnight Brawley was born free in Charleston, S.C., to James M. and Ann L. Brawley. In 1861 he was sent to Philadelphia, where he attended grammar school for three years and graduated from the Institute for Colored Youth in 1866. From 1866 to 1869 he worked as an apprentice to a shoemaker in Charleston. Brawley was baptized in the Shiloh Baptist Church in Phila-

delphia in 1865, and thus began a life of religious involvement.

In 1870, he entered Howard University in Washington, D.C., to study theology. The following year he transferred to Bucknell University in Lewisburg, Pa., and in 1875, he became the first African American to receive a bachelor's degree from that school. Three years later, Brawley received a master's degree from Bucknell. In 1885, he received an honorary Doctor of Divinity degree from the State University of Louisville.

Brawley was an active educator and administrator. In 1875, he was ordained as minister of the white Baptist church in Lewisburg, Pa., and was commissioned by the predominantly white American Baptist Publication Society (ABPS) to work as a missionary in South Carolina. Under these auspices, Brawley organized Sunday schools into a state convention over which he presided as secretary and financial agent. He remained in South Carolina until 1883, when he became president of the Alabama Baptist Normal Theological School, later renamed Selma University. At Alabama Baptist, he overhauled the curriculum and brought it up to college status. Brawley also helped found Morris College in Sumter, S.C., and assumed the position of president in 1885.

Throughout his career, Brawley was committed to integration, and his involvement in the ABPS was indicative of his desire to bring black and white Christians together. He believed black Baptists "should merge race feeling in the broader spirit of an American Christianity." In 1890, in an effort to give greater public recognition to black Baptists, black ministers within the ABPS invited black Baptists to be writers and agents for the organization. The all-white Southern Baptist Convention responded with outrage and protest and threatened to withdraw support from the ABPS. Most black Baptists condemned the ABPS for succumbing to Southern white racism, and many advocated greater separation from white Baptists. Brawley's was one of the few conciliatory voices. Rather than dealing with the crisis at hand, he reviewed what the ABPS had accomplished for black people and urged reconciliation. This incident widened the chasm between Brawley and many other black Baptists. After this conflict the ABPS tried to appease black ministers and in 1890 recruited Brawley to edit the *Negro Baptist Pulpit,* the first collection of theological and denominational articles ever written and edited by black Baptists.

In January 1877 Brawley married Mary Warrick. By the end of the year his wife and child had died. In December 1879 he married Margaret Dickerson, with whom he had four children. Their eldest son, Benjamin Brawley, author and historian, was born in 1882. From 1912 until 1920, Brawley served as min-

ister of White Rock Baptist Church in Durham, N.C. He also taught biblical history at Shaw University in Raleigh, N.C. Brawley wrote several religious texts, including a book on evangelism entitled *Sin and Salvation,* and edited the *Baptist Tribune* and *The Evangel.* Brawley died on January 13, 1923, ending a long career in the ministry, education, publishing, and writing.

REFERENCES

JACKSON, J. H. *A Story of Christian Activism: The History of the National Baptist Convention, USA, Inc.* Nashville, Tenn., 1980.

SIMMONS, WILLIAM J. *Men of Mark.* 1887. Reprint. New York, 1968.

WASHINGTON, JAMES MELVIN. *Frustrated Fellowship: The Black Baptist Quest for Social Power.* Macon, Ga., 1986.

SABRINA FUCHS
PAM NADASEN

Braxton, Anthony (June 4, 1945–), saxophonist, composer. Born in Chicago, Ill., Anthony Braxton formed a RHYTHM AND BLUES "doo-wop" vocal group while still in grammar school. He studied alto saxophone and composition from 1959 to 1964 at the Chicago School of Music and at Wilson Junior College. From 1964 to 1966 Braxton served in Army bands in Korea. After returning to Chicago, he studied philosophy and music at Roosevelt University and played in the Regal Theatre's house band, backing SAM AND DAVE, and the Del-Vikings. At the same time Braxton was influenced by musicians as diverse as John Philip Sousa, Arnold Schoenberg, John Cage, Karlheinz Stockhausen, and SUN RA. In 1966 he joined the Association for the Advancement of Creative Musicians, the Chicago free jazz cooperative.

On Braxton's first recording, *Three Compositions of New Jazz* (1968), his mature style is already evident, with composition titles that resemble mathematical formulas. Braxton plays various wind instruments in an icy tone, and his ambitious compositions are inspired by both serial music and conceptual performance art. Braxton's music has been attacked as humorless and nonswinging, but his relentless and swaggering improvisations, particularly on jazz standards (*In the Tradition,* 1974; *Seven Standards,* 1985; *Six Thelonious Monk Compositions,* 1987), are in the saxophone tradition of Frank Trumbauer, Lester YOUNG, Paul Desmond, and Eric DOLPHY.

In 1969, Braxton, along with many members of the AACM, moved to Paris, where he played with the Creative Construction Company. In the early 1970s, he settled in New York, where for a brief time he made a living as a chess hustler. Under the sponsorship of Ornette COLEMAN, Braxton returned to music, performing with Musica Elettronica Viva, an Italian group, and in the ensemble Circle with Chick Corea (*Live in Germany,* 1971). In the mid-1970s Braxton lived in Woodstock, N.Y., and toured with his own quartet. He recorded two separate albums called *Creative Music Orchestra* (1972, 1976), and an extended work called *For Four Orchestras* (1978). In addition, Braxton recorded with the Robert Schumann String Quartet (1979), and oversaw a recording of his own composition *For Two Pianos* (1980). In the 1980s and early 1990s Braxton concentrated on his quartet music, touring and recording almost every year.

Braxton has recorded more than any other figure associated with the AACM. In addition to works for quartet and large ensemble, he has recorded extensively for solo saxophone, including *For Alto* (1968), *Series F* (1972), *Improvisations 1979,* and *Composition 113* (1983). He has also recorded duets with many figures from the AACM, as well as with drummer Max ROACH (1978–1979). In 1985, Braxton published *Triaxium Writings,* three volumes of his musical and philosophical ideas. That year he began to teach music at Mills College in Oakland, Calif., where his *Trillium* series of twelve operas was performed. More recently, Braxton has taught music at Wesleyan University in Middletown, Conn.

REFERENCES

LOCK, GRAHAM. *Forces In Motion: Anthony Braxton and the Meta-Reality of Creative Music.* London, 1988.

SMITH, BILL. "The Anthony Braxton Interview." *Coda* 11, no. 8 (April 1974): 2–8.

JONATHAN GILL

Breakdancing. An elaborate social dance form originated by teenage African-American males in the South Bronx of New York City, breakdancing appeared during the early to mid 1970s. It began as a form of gang fighting, a mixture of physically demanding movements that exploited the daredevil prowess of performers and stylized punching and kicking movements directed at an opponent. A descendant of *capoeira,* the Brazilian form of martial arts disguised as dance, breaking developed as the movement aspect of RAP music when breakdancers—"B-Boys"—filled the musical breaks between records mixed by disk jockeys at parties and discotheques. Breakdancing was part of a young urban culture built

upon innovations in languge, hip-hop music, fashion (unlaced sneakers, hooded sweatshirts, nylon windbreakers), and visual arts (graffiti).

The elaborate spins, balances, flips, contortions, and freezes performed by breakdancers required extreme agility and coordination. Real physical danger surrounded movements such as the "windmill," in which dancers spun wildly, supported only by the shoulders, or the "suicide," in which an erect dancer would throw himself forward to land flat on his back. The competitive roots of breakdancing encouraged sensational movements such as multiple spins while balanced on the head, back, or one hand. Dancing "crews" met on street corners, subway stations, or dance floors to battle other groups with virtuosity, style, and wit determining the winner. Breakdancing came to be divided into several classifications of movement, including "breaking" (acrobatic flips and spins with support by the head and arms, with the shoulders as a point of balance), "uprock" (fighting movements directed against an opponent), "webbo" (extravagant footwork that connected breaking movements), and "electric boogie" (robotlike dancing movements borrowed from mime). The "electric boogie" style, reminiscent of a long tradition of eccentric African-American dances, developed in Los Angeles concurrent with electronically produced disco music. In this style dancers typically appeared to be weightless and rubber-limbed, performing baffling floating walks, precise body isolations, and panto-mimed robotic sequences. This form includes the "moonwalk," popularized on national television by Michael Jackson, in which the dancer's feet appear to be floating across the floor without touching it. Other boogie moves include the "wave," in which the body simulates an electric current passing through it, and "poplocking," a series of tightly contained staccato movements separated by freezes. An "Egyptian" style, which imitated ancient wall paintings, was also briefly popular.

Breakdancing found a mainstream audience through several films that cashed in on its sensational aspects and minimized its competitive format. Charlie Ahearn's *Wild Style* (1982), the first film to document emergent hip-hop culture, was eclipsed by a thirty-second breaking sequence in *Flashdance* (1983), which brought the form to international attention; *Breakin'* (1984), which starred Shabba Doo (Adolfo Quinones), an important breakdance choreographer from Chicago; and Harry BELAFONTE's *Beat Street* (1984), which featured the New York City Breakers. Breakdancing dropped out of the public limelight in the late 1980s, only to reemerge as a social dance form practiced by teenagers in nightclubs during the 1990s.

REFERENCES

BANES, SALLY. "Breakdancing." In Nelson George et al., eds. *Fresh: Hip Hop Don't Stop*. New York, 1985.

ROSENWALD, PETER J. "Breaking Away '80s Style." *Dance Magazine* 58, no. 4 (April 1984): 70–74.

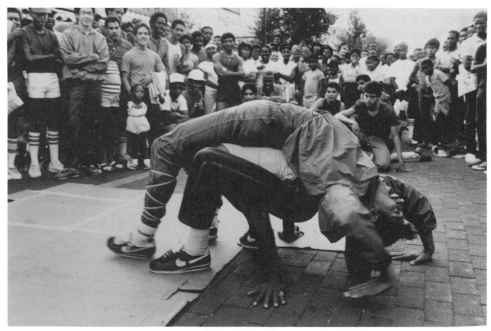

A group of breakdancers performing outdoors in Jamaica, N.Y., 1984. (© Martha Cooper/City Lore)

THOMPSON, ROBERT FARRIS. "Hip-hop 101." *Rolling Stone* (March 27, 1986): 95–100.

THOMAS F. DEFRANTZ

Breedlove, Sarah. *See* Walker, Madam C. J.

Bricktop. *See* Smith, Ada Beatrice Queen Victoria Louise Virginia "Bricktop."

Bridge. Despite a history of discrimination by larger white-controlled bridge associations, bridge has been a popular form of recreation among the black middle class. The American Bridge Association (ABA) was founded in 1932 as a specifically African-American bridge club. Formed by black bridge enthusiasts in New York City, it held its first meeting in Buckroe Beach, Va. At its height, the ABA claimed 7,000 members, with seven regional and 250 local groups. The organization also published a bimonthly bulletin, which, under the editorship of William R. Tatem, became one of the most prominent publications devoted to organized bridge in the country.

However, discrimination against black bridge players continued, and in some ways intensified. In 1949 the American Contract Bridge League voted to ban African Americans, with only two states dissenting: Minnesota and Michigan. Michigan was the first to reinstate blacks with a vote to include blacks in its state organization in 1958. At this time, the ABA began debating whether it would integrate its organization; it finally did so in 1967.

In 1972, Federal Appellate Court Judge Amalya KEARSE became the first African American to win a national bridge title when she won the National Women's Pairs at the American Contract Bridge League tournament. She also wrote an important, comprehensive bridge guide in 1980, *Bridge at Your Fingertips*. In 1979, Ron Smith won the championship at the American Contract Bridge League's national tournament, becoming the first African American to win a major open title.

REFERENCES

"Blacks Banned from American Contract Bridge League." *Chicago Defender,* October 18, 1949.
Papers of the American Bridge Association, Schomberg Archives, New York.

JOSEPH W. LOWNDES

Briggs, Bunny (February 26, 1922–), tap dancer. Bunny Briggs grew up on the streets of Harlem in New York City at a time when tap was widely popular. Discovered by orchestra leader and pianist Charles "Luckey" ROBERTS, he became a singer and dancer at the age of eight, performing for New York's social elite. In his teens he spent some time as a member of the WHITMAN SISTERS ensemble. When he was twenty, he began touring with the big swing bands of Earl "Fatha" HINES, Tommy and Jimmy Dorsey, Charley Barnet, and Count BASIE.

Distinguished for his immaculate style of paddle-and-roll tapping (a rapid toe-toe/heel-heel roll which can be varied and embellished), Briggs was dubbed by Duke ELLINGTON as "the most superleviathonic rhythmaturgically syncopated tapsthamatician-isamist." After Briggs's performances with Ellington at the 1963 Newport Jazz Festival, Ellington used him in a series of religious concerts in the United States and abroad. A deeply religious man, Briggs danced a rhythmically hypnotic tap solo, "David Danced Before the Lord with All His Might," in Ellington's *Concert of Sacred Music*. Briggs is one of three tap dancers whose biographers are documented in the film *No Maps on My Taps* (1979). In 1989 he was one of the featured dancers in the public television documentary *Tap: Dance in America* and, in the same year, he appeared with other tap masters in the film *Tap*. In the late 1980s, Briggs performed in Europe with *Sweet Saturday Night*; on Broadway he appeared in *My One and Only* (1983) and *Black and Blue* (1989). Briggs was also featured in Robert Altman's 1992 documentary about *Black and Blue*.

REFERENCES

DUNNING, JENNIFER. "On Stage and on Screen, Tap-Dancing's Encore." *New York Times,* February 20, 1989.
FRANK, RUSTY. *Tap! The Greatest Tap Dance Stars and Their Stories, 1900–1955.* New York, 1990.
STEARNS, MARSHALL, and JEAN STEARNS. *Jazz Dance: The Story of American Vernacular Dance.* New York, 1968.

CONSTANCE VALIS HILL

Briggs, Cyril Valentine (1888–October 18, 1966), activist. Cyril Briggs was a radical publicist of the NEW NEGRO movement and one of the black charter members of the COMMUNIST PARTY OF THE U.S.A. (CPUSA). As the political organizer of the African Blood Brotherhood for African Liberation and Redemption—better known, simply, as the AFRICAN BLOOD BROTHERHOOD (ABB)—a semisecret

propaganda orgaization founded in September 1919, in reaction to the unprecedented racial violence of the RED SUMMER of 1919, Briggs was also the first to enunciate in the United States the political principle of armed black self-defense.

A native of the tiny island of Nevis in the Leeward Islands chain of the British West Indies, Briggs was the son of the planter-manager for one of the island's absentee landlords. Extremely light of complexion, he was later dubbed "Angry Blond Negro" by George W. Harris of the *New York News.*

Briggs received his early start in journalism working after school with the *St. Kitts Daily Express* and the *St. Christopher Advertiser.* As a young man in St. Kitts, he also came to be much influenced by the published lectures of the great American orator Robert Green Ingersoll, whose irreverent wit and questioning of the tenets of Christian belief earned him the sobriquet "the great agnostic."

Briggs came to the United States in July 1905. His involvement in the fight for African-American rights began in earnest in October 1915, when he was appointed editor of the *Colored American Review,* mouthpiece of the Harlem black business community, which stressed black economic success and racial pride. When his editorship came to an abrupt end with the second issue, Briggs resumed work with the New York AMSTERDAM NEWS, which had hired him as an editorial writer shortly after it began publication in 1912.

During and after World War I, Briggs's outspoken *Amsterdam News* editorials, directed against what he perceived to be the hypocrisy of American war aims in view of the mistreatment of black soldiers and the continuing denial of democracy to African Americans at home, came under increasing official censorship. It culminated in detention by the U.S. Post Office of the March 12, 1919, issue containing Briggs's editorial denouncing the League of Nations as a "League of Thieves." Two months later, Briggs finally severed his ties with the newspaper for which he had been not only editorial writer but also city editor, sports editor, and theater critic.

Resignation from the *Amsterdam News* now enabled Briggs to devote his entire time to the *Crusader,* which he had begun publishing in September 1918. With a free hand to promote the postwar movement through the *Crusader,* Briggs joined such black radical figures as Hubert H. HARRISON, Marcus GARVEY, A. Philip RANDOLPH, Chandler OWEN, William Bridges, and W. A. Domingo in giving voice to expression of the era's black militancy.

Initially emphasizing the racial theme of "self-government for the Negro and Africa for the Africans," the *Crusader* proclaimed itself in its early issues as the publicity organ of the Hamitic League of the World, which had been started by the brilliant young racial vindicationist author George Wells Parker, in Omaha, Neb. By the first anniversary of its publication, however, the editorial line of the *Crusader* changed radically. Whereas its original focus was on postwar African issues, it now espoused the revolutionary ideology of Bolshevism.

Starting with the issue of October 1919, the *Crusader* became reoriented as the official mouthpiece of the ABB, which at the same time functioned clandestinely as the CPUSA's first black auxiliary. In keeping with the group's ideological position, Briggs emerged during 1921–1922 as the most outspoken critic of the leadership of Marcus Garvey, against whom he supplied some of the critical evidence that would lead eventually to the federal government's successful prosecution of Garvey for mail fraud.

When the *Crusader* ceased publication in early 1922, Briggs set about organizing the Crusader News Agency. In February 1924, he was involved in the formation of the NEGRO SANHEDRIN movement, under the leadership of Kelly MILLER, with the aim of creating a federation of black organizations. Briggs had by this time become a full-time functionary of the CPUSA. Throughout the 1920s and '30s, he was actively involved in organizing a succession of black auxiliaries of the CPUSA, most notably the American Negro Labor Congress (ANLC) and the League of Struggle for Negro Rights. In December 1929 he was made editor of the *Harlem Liberator,* the official organ of the ANLC.

Briggs was also directly involved in planning and implementing the CPUSA's role in the famous SCOTTSBORO CASE defense campaign in the early thirties. But in 1938, after becoming embroiled in a dispute with James W. Ford, at the time the leading black figure in the CPUSA, Briggs was expelled from the party, along with Richard B. MOORE, and Otto Hall, for alleged "Negro nationalist way of thinking." In 1944 Briggs moved to Los Angeles, where he rejoined the communist party in 1948. During the fifties, he was employed as an editor with the *Los Angeles Herald-Despatch.*

REFERENCES

DRAPER, THEODORE. *American Communism and Soviet Russia: The Formative Years.* New York, 1960.
HILL, ROBERT A., ed. *The Crusader.* 3 vols. New York and London, 1987.

ROBERT A. HILL

Brimmer, Andrew Felton (September 13, 1926–), economist. Born in Newellton, La., Andrew F. Brimmer attended high school in Louisiana before moving to Bremerton, Wash., in 1944. Shortly thereafter, he joined the U.S. Army and

served in Hawaii from 1945 until 1946. Subsidized by the G.I. Bill, Brimmer was able to attend the University of Washington; he received his B.A. in 1950 and his M.A. in 1951. As a Fulbright Fellow, Brimmer traveled to India during 1951 and 1952 for a year of postgraduate work at the University of Bombay. Returning to the United States, he completed a Ph.D. in economics at Harvard University in 1957.

Brimmer began his career as an economist at the Federal Reserve Bank of New York (1955–58). During his time at the bank, he was one of the several economists sent to the Sudan in late 1956 and early 1957 in order to aid the Sudanese in establishing a central bank. Brimmer then taught at Michigan State University (1958–1961) and at the University of Pennsylvania's Wharton School of Business (1961–1966). President John F. Kennedy appointed Brimmer as a deputy assistant Secretary of Commerce for economic policy in 1963; two years later, he became assistant secretary for economic affairs. In 1966, President Lyndon B. Johnson named him to the Board of Governors of the Federal Reserve Bank. The first black member of the board, Brimmer was an expert on international monetary issues. While at the Federal

Reserve, he consistently advocated a tight monetary policy, favoring the restriction of the money supply and interest rates in order to control inflation. Serving only half of his fourteen-year term, Brimmer resigned in 1974 to take a teaching position at Harvard's Graduate School of Business. Two years later, he left Harvard and founded Brimmer and Company, Inc., an economic consulting firm in Washington, D.C.

A prolific writer, Brimmer has authored numerous books and articles on various economic topics, ranging from public utilities to international trade and finance. Since 1978 he has regularly written the "Economic Perspectives" article in *Black Enterprise*. In his writings, Brimmer has consistently argued that the disparity in income between whites and blacks results only in part from differences in educational achievement; underlying the differential, he says, is persistent racial discrimination, which "hampers access" for African Americans to higher-paying jobs. At the same time, he has contended that other problems afflicting the African-American community, such as the high rate of teenage pregnancy and the high rate of unemployment among young black people, result mainly from behavior instead of outside forces such as the economy. A proponent of encouraging African Americans to look beyond small business to larger markets and increased capitalization, he took part in President Bill Clinton's economic summit in December 1992.

Brimmer has served on the boards of numerous corporations and organizations, including United Air Lines, Du Pont, and the Tuskegee Institute. He has twice been president of the ASSOCIATION FOR THE STUDY OF AFRO-AMERICAN LIFE AND HISTORY, been cochairman of the INTERRACIAL COUNCIL FOR BUSINESS OPPORTUNITY, and is a member of many professional organizations. Among the many honors Brimmer has received are awards from the National Economic Association, One Hundred Black Men, and the New York Urban Coalition.

REFERENCES

BRIMMER, ANDREW. "The Economic Cost of Discrimination." *Black Enterprise* 24, no. 3 (November 1993): 27.

WILLIAMS, JUAN. "Economist Calls Lag in Skills Blacks' Main Obstacle." *Washington Post,* March 22, 1985, p. A3.

ALANA J. ERICKSON

Andrew F. Brimmer, first African-American member of the Board of Governors of the Federal Reserve System. (Photographs and Prints Division, Schomburg Center for Research in Black Culture, The New York Public Library, Astor, Lenox and Tilden Foundations)

Bristow, Lonnie R. (April 6, 1930–) physician and medical administrator. Lonnie Bristow received a B.S. degree from the College of the City of New York in 1953 and an M.D. from New York Univer-

sity College of Medicine in 1957. He completed his internship in 1958 at San Francisco City and County Hospital and served his residency in internal medicine at the U.S. Veterans Administration (USVA) Hospital in San Francisco, the Francis Delafield Hospital in New York City, and the USVA Hospital in the Bronx in New York City. In 1967, Bristow joined the staff at Brookside Hospital in San Pablo, Calif.

In 1977, Bristow was elected to membership in the Institute of Medicine of the National Academy of Sciences. In 1979, he was elected to the American Medical Association (AMA) House of Delegates by the Society of Internal Medicine and became a member of the AMA's Council of Medical Service. In 1985, Bristow was elected to the board of trustees of the AMA.

From 1987 to 1989, Bristow served on the Institute of Internal Medicine's Committee on the Effects of Medical Professional Liability of the Delivery of Maternal and Child Health Care. In 1988, he was appointed by the surgeon general to serve on the Federal Interagency Committee on Smoking and Health. Bristow was the secretary-treasurer of the AMA Education and Research Foundation from 1986 to 1988 and its president from 1988 to 1990. In 1989, he was appointed by the secretary of Health and Human Services to serve on both the Center for Disease Control's HIV Prevention Advisory Committee and the 1989 Quadrennial Advisory Council on Social Security.

Bristow became a member of the AMA Executive Committee in 1990. He served as chair of the AMA board of trustees from 1993 to 1994 before being elected the AMA's first African-American president in 1994.

REFERENCES

"First Black to Head AMA Welcomed." Editorial, *Chicago Defender,* June 14, 1994.
RUSSELL, SABIN. "San Pablo Doctor to Head AMA." *San Francisco Chronicle*, June 14, 1994, p. A20.

JOSEPH W. LOWNDES

British West Indian Emancipation Act. *See* Slave Trade.

Broadside Press. The Broadside Press, one of the most influential black presses to emerge during the BLACK ARTS MOVEMENT of the late 1960s and early 1970s, began operation in 1965 in an attempt to secure copyright privileges to "Birmingham Ballad," a song commemorating the bombing deaths of four young black children at a Birmingham, Ala., church in September 1963. Located originally in the Detroit home of its founder, poet Dudley F. RANDALL, Broadside quickly grew in size, requiring larger offices, and attracting manuscripts from black artists across the country. The press was particularly successful in publishing poets, many of whom explored the characteristic Black Arts Movement themes of self-pride and anger against white-dominated institutions.

After publishing such poets as Gwendolyn BROOKS, Nikki GIOVANNI, and Audre LORDE, Haki MADHUBUTI, Sonia SANCHEZ, and others, Broadside suffered reverses during the recession of the mid-1970s. By 1975, Broadside's tenth anniversary, operations at the press had to be scaled back. Its finances were in poor condition, forcing Randall to put the press up for sale. In 1977, Randall sold Broadside to the Alexander Crummell Memorial Center, an activist organization within the Episcopal Church.

After several years, however, Randall regained control. He sold the press again in 1985, this time to Detroit schoolteacher and poet Hilda Vest and her husband, Donald, who became the editors and publishers. During the late 1980s and 1990s, the press concentrated on helping Detroit poets and authors publish and distribute their works. It also continued the tradition of featuring the work of poets of the Black Arts movement by publishing its Broadside Classics series.

REFERENCE

JOYCE, DONALD FRANKLIN. *Gatekeepers of Black Culture: Black Owned Book Publishing in the United States, 1817–1981*. Westport, Conn., 1983.

JOHN C. STONER

Brock, Louis Clark "Lou" (June 18, 1939–), baseball player. Born in El Dorado, Ark., Lou Brock and his family moved to Louisiana, where Brock attended all-black schools in Mer Rouge. In 1957, he received a scholarship to Southern University in Baton Rouge where he attracted the attention of big league baseball scouts. He played outfield for the Chicago Cubs from 1961 to 1964, before being traded to the St. Louis Cardinals, where he played for the next fifteen years, leading the team in base hits in 1967 and '68, and in 1969 he led the Cardinals in batting with a .298 average and 195 hits.

Despite his batting record—he retired in 1979 with more than 3,000 career hits to his credit—Brock is

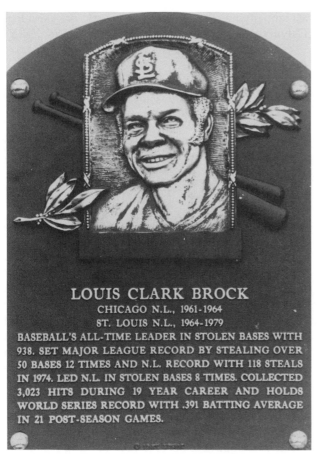

LOUIS CLARK BROCK
CHICAGO N.L., 1961-1964
ST. LOUIS N.L., 1964-1979
BASEBALL'S ALL-TIME LEADER IN STOLEN BASES WITH
938. SET MAJOR LEAGUE RECORD BY STEALING OVER
50 BASES 12 TIMES AND N.L. RECORD WITH 118 STEALS
IN 1974. LED N.L. IN STOLEN BASES 8 TIMES. COLLECTED
3,023 HITS DURING 19 YEAR CAREER AND HOLDS
WORLD SERIES RECORD WITH .391 BATTING AVERAGE
IN 21 POST-SEASON GAMES.

Plaque honoring St. Louis Cardinal outfielder Louis Clark Brock upon his induction into the Baseball Hall of Fame, Cooperstown, N.Y., in 1985. (AP/Wide World Photos)

best remembered for his speed and superior base-stealing ability. In 1974, at the age of thirty-five, Brock set a major league record of 118 stolen bases for one season, erasing the record of 104 set by Maury WILLS in 1962. Brock's career spanned a total of nineteen years, during which he played in three World Series (1964, '67, and '68) and on three All-Star teams (1967, '72, and '74). He stole 50 or more bases twelve consecutive seasons. He stole a total of 938 bases during his career, which at that time was a major league record. In 1985 he was inducted into the Baseball Hall of Fame.

REFERENCE

BROCK, LOU, and FRANZ SCHULZE. *Stealing Is My Game*. Metuchen, N.J., 1976.

LINDA SALZMAN

Brooke, Edward W., III (October 26, 1919–), U.S. senator. The first popularly elected African-

American member of the Senate when he entered that body in 1966, Edward W. Brooke served two terms as an independent Republican and distinguished himself as a proponent of civil rights legislation.

Brooke was born in Washington, D.C., to Edward William Brooke, a lawyer, and Helen Seldon Brooke. He gained his education first at Dunbar High School and later at Howard University, where he completed a bachelor of science degree in 1941, the same year in which his ROTC obligations called him to active combat duty after the Japanese attack on Pearl Harbor. During the course of World War II, Brooke served behind enemy lines in Italy and later defended soldiers in court-martial cases. This last experience inspired him to enter Boston University Law School on his return to the United States in 1945.

In 1962, Brooke won election as the Massachusetts attorney general, after three unsuccessful previous campaigns for public office. In that position he quickly attracted both local and national attention by aggressively prosecuting corrupt politicians and their cohorts outside of government. As a liberal Republican, Brooke helped lead the failed opposition to the nomination of arch-conservative Barry Goldwater at the 1964 party convention. He remained neutral in the following general election.

Edward Brooke, a two-term Republican senator from Massachusetts, was first elected to the U.S. Senate in 1966. (AP/Wide World Photos)

In the senatorial elections in 1966, the voters of Massachusetts chose Brooke and his moderate program. After the ghetto riots of the following summer, President Lyndon B. Johnson appointed the freshman senator to the President's Commission on Civil Disorders, a position that led him to champion and steer through Congress one of the commission's primary recommendations: the guarantee of open housing contained in the 1968 Civil Rights Act. Despite Brooke's advocacy of such legislation, he frequently encountered criticism from CIVIL RIGHTS MOVEMENT leaders when he disagreed with their positions on issues or their tactics.

Brooke supported Republican nominee Richard Nixon's victorious 1968 and 1972 presidential campaigns, notwithstanding the deep differences between the two men. They were on opposite sides of such issues as the pace of racial integration, the Vietnam War, economic policy, and the arms race. Their greatest conflict came, however, in 1969–1970, when Brooke helped defeat two successive Nixon nominees to the U.S. Supreme Court: Judges Clement F. Haynsworth, Jr., and G. Harrold Carswell. After these fights, Brooke and his fellow senators unanimously approved Nixon's third proposed high court member, Judge Harry Blackmun. Brooke won a landslide victory in his 1972 reelection bid, and in the wake of the revelations of the Watergate scandal he became the first Republican to call on President Nixon to resign. Brooke lost his seat in an attempt for a third term in 1978, whereupon he returned to the practice of law, first in Boston and later in Washington, D.C.

REFERENCE

CUTLER, JOHN HENRY. *Ed Brooke: Biography of a Senator.* Indianapolis, Ind., 1972.

STEVEN J. LESLIE

Brooks, Arthur (November 25, 1861–September 7, 1926), White House staff member. Born in Port Royal, Va., Arthur Brooks sought employment at an early age in Washington, D.C. He served in a variety of civilian positions in the federal government, from stabler in the Quartermaster Department to messenger for the War Department, and was selected by President William H. Taft as the doorkeeper for the White House. Known for his loyalty and strict discipline, he continued working in a variety of White House positions.

Brooks was also active in the National Guard, commanding the First Separate Battalion from 1897 until 1912, when he reached the rank of lieutenant-colonel. He died after suffering a heart attack while accompanying the presidential party to President Calvin Coolidge's summer camp at White Pine, N.Y.

REFERENCES

Official Register, Persons in the Civil, Military and Naval Service of the United States. Washington, D.C., 1921.
Washington Evening Star, September 8, 1926, p. 9.

DAVID B. IGLER

Brooks, Gwendolyn Elizabeth (June 7, 1917–), poet, novelist, teacher, and reader/lecturer. Taken to Topeka, Kans., to be born among family, Brooks was reared in Chicago, where she continues to reside. In her autobiography, *Report from Part One* (1972), she describes a happy childhood spent in black neighborhoods with her parents and younger brother, Raymond. "I had always felt that to be black was good," Brooks observes. School awakened her to preferences among blacks, the "black-and-tan motif" noted in her earlier works by critic Arthur P. Davis. Her father, David Anderson Brooks, was the son of a runaway slave, a janitor with "rich Artistic Abilities" who had spent a year at Fisk University, Nashville, hoping to become a doctor, and who sang, told stories, and responded compassionately to the poverty and misfortune around him; her mother, Keziah Wims Brooks, had been a fifth-grade teacher in Topeka and harbored a wish to write. They nurtured their daughter's precocious gifts. When the seven-year-old Gwendolyn began to write poetry, her mother predicted, "You are going to be the *lady* Paul Laurence DUNBAR." Years later, Mrs. Brooks took her daughter to meet James Weldon JOHNSON and then Langston HUGHES at church. Hughes became an inspiration, friend, and mentor to the young poet.

Brooks was graduated from Wilson Junior College (now Kennedy-King) in 1936. She was employed for a month as a maid in a North Shore home and spent four months as secretary to a spiritual adviser (see the "Prophet Williams" section of the story "In the Mecca"). In 1939, she married Henry Lowington Blakely II, a fellow member of Inez Cunningham Stark's poetry workshop in the South Side Community Art Center and himself a poet and writer. Motherhood (Henry, Jr., 1940; Nora, 1951), early publishing (*A Street in Bronzeville,* 1945), warm critical reception, careful supervision of her career by her editor at *Harper's,* and a succession of honors and prizes helped her overcome her reticence about public speaking. The first African American (or "Black," her articulated preference) to win a Pulitzer Prize, for poetry (*Annie Allen,* 1950), Brooks also received two

Gwendolyn Brooks during her term as poetry consultant to the Library of Congress in 1986. In 1950 Brooks became the first African-American recipient of a Pulitzer Prize. (AP/Wide World Photos)

Guggenheim Fellowships. Upon the death of Carl Sandburg (in 1968), she was named the poet laureate of Illinois. She was the first black woman to be elected to the National Institute of Arts and Letters (1976); to become consultant in poetry to the Library of Congress (1985–1986, just before the title was changed to poet laureate); to become an honorary fellow of the Modern Language Association; and to receive the Poetry Society of America's Shelley Memorial Award and its Frost Medal. She was elected to the National Women's Hall of Fame and given the National Endowment for the Arts Lifetime Achievement Award in 1989. In Illinois, the Junior High School at Harvey, the cultural center at Western Illinois University, and the center and a chair as Distinguished Professor of English at Chicago State University all bear her name. The number of her honorary doctorates already exceeds seventy.

Brooks's work is notable for its impeccable craft and its social dimension. It marks a confluence of a dual stream: the black sermonic tradition and black music, and white antecedents such as the ballad, the sonnet, and conventional and free-verse forms. Influenced early by Hughes, T. S. Eliot, Emily Dickinson, and Robert Frost, she was propelled by the Black Arts movement of the 1960s into black nationalist consciousness. Yet her poetry has always been infused with both humanism and heroism, the latter defined as extending the concept of leadership, by both personality and art. In 1969 she moved to Dudley RANDALL's nascent, historic Broadside Press for the publication of *Riot* and subsequent works.

Brooks's books span six decades of social and political changes. *A Street in Bronzeville* addresses the quotidian realities of segregation for black Americans at home and in World War II military service; *Annie Allen* ironically explores postwar antiromanticism; *Maud Martha,* her novel (1953), sketches a bildungsroman of black womanhood; *Bronzeville Boys and Girls* (1956) presents sturdy, home-oriented black children of the 1950s; *The Bean Eaters* (1960) and new poems in *Selected Poems* (1963) sound the urgencies of the civil rights movement. In 1967, at the second Fisk University Writers' Conference at Nashville, Brooks was deeply impressed by the activist climate, personified by Amiri BARAKA. Though she had always experimented with conventional forms, her work subsequently opened more distinctly to free verse, a feature of the multiform *In the Mecca* (1968), which Haki R. MADHUBUTI calls "her epic of Black humanity" (*Report from Part One,* p. 22).

Upon returning to Chicago from the conference at Fisk, Brooks conducted a workshop with the Blackstone Rangers, a teenage gang, who were succeeded by young writers such as Carolyn M. RODGERS and Madhubuti (then don l. lee). Broadside published *Riot* (1969), *Family Pictures* (1970), *Aloneness* (1971), and *Beckonings* (1975). Madhubuti's Third World Press published *The Tiger Who Wore White Gloves* (1974) and *To Disembark* (1981). In 1971 Brooks began a literary annual, *The Black Position,* under her own aegis, and made the first of her two trips to Africa. Beginning with *Primer for Blacks* (1980), she published with her own company *The Near-Johannesburg Boy* (1986), the omnibus volume *Blacks* (1987), *Gottschalk and the Grande Tarantelle* (1988), and *Winnie* (1988, a poem honoring Winnie Mandela). Her books are also being reissued by Third World Press. The adult poems of *Children Coming Home* (1991) express the perspective of contemporary children, and may be contrasted with the benign ambience of *Bronzeville Boys and Girls* among her works for children.

Brooks supports and promotes the creativity of other writers. Her annual Poet Laureate Awards distribute considerable sums of her own money, chiefly to the schoolchildren of Illinois. She visits prisons, where her readings have inspired poets such as the

late Ethridge KNIGHT. Lauded with affectionate respect in two tribute anthologies, recognized nationally and internationally as a major literary figure, Brooks continues to claim and to vivify our democratic heritage.

REFERENCES

KENT, GEORGE E. *A Life of Gwendolyn Brooks.* Lexington, Ky., 1990.

MELHEM, D. H. *Gwendolyn Brooks: Poetry and the Heroic Voice.* Lexington, Ky., 1987.

———. *Heroism in the New Black Poetry: Introductions and Interviews.* Lexington, Ky., 1990.

SHAW, HARRY. *Gwendolyn Brooks.* New York, 1980.

D. H. MELHEM

Broonzy, William Lee Conley "Big Bill"

(June 26, 1893–August 14, 1958), singer, guitarist, fiddler, songwriter. William Broonzy was born in Scott, Miss., one of seventeen children, and spent much of his childhood moving between Mississippi and Arkansas.

Music was part of Broonzy's life from an early age, through spirituals in church and work songs in the fields. When he was ten years old, he learned to play violin and guitar on homemade instruments and was proficient enough by 1907 to play at picnic dances for blacks and whites in Scott, Miss., which he did until 1912. After working as a preacher and a sharecropper, Broonzy joined the army during World War I. By 1920 he had relocated to Chicago, where he worked at odd jobs, including a stint with the Pullman Company, and pursued part-time jobs in music.

In Chicago during the 1920s, Broonzy performed at parties and at local clubs with musicians such as Papa Charlie Jackson. He recorded a few tunes in the 1920s ("House Rent Stomp," 1927), but it was not until the 1930s, after a decade of live appearances, that Broonzy became a recognizable figure on the country blues scene and a desirable prospect for record companies. In the 1930s, he continued to play at nightclubs but he also recorded widely with the Champion, Bluebird, Vocalion, Oriole, and Melotone labels, further expanding his listening audience. Over the next twenty years he became one of the most prolifically recorded blues singers in America, with a style that linked traditions in country and urban blues music. His guitar playing was characterized by a light, lilting style. His songs could be wistful and mournful, as in "Big Bill Blues" (1932) and "Friendless Blues" (1934), or in a more humorous mode, as in "Keep Your Hands Off Her" (1935) and "Good Jelly" (1935).

In the late 1930s and '40s, Broonzy played in small ensembles in a manner reminiscent of Leroy Carr and Snapper Blackwell, and he was one of the first blues singers to introduce trumpet and saxophone in small band accompaniments. Performing and recording with numerous groups throughout the 1930s, Broonzy was invited to play in promoter John Hammond's 1938 "From Spirituals to Swing" concert at Carnegie Hall. He then began touring extensively in America and Europe, greatly benefiting from the post–World War II folk music revival. One of his most famous songs from the postwar period was "Black, Brown, and White Blues," in which he explicitly addressed the struggle for civil rights, singing, "Now if you's white, you's right, but if you's brown, stick around, and if you's black, oh brother, git back, git back, git back."

Broonzy reached his greatest popularity during the 1950s. He performed with such artists as Pete Seeger, Sonny TERRY and Brownie MCGHEE, appeared on radio and television, and traveled to Africa, South America, and the Pacific region. It was not until 1953 that Broonzy earned his income as a full-time musician, giving up his cook, janitor, and porter positions. He died of cancer in 1958.

REFERENCES

BRUYNOGHE, YANNICK, and WILLIAM BROONZY. *Big Bill Blues.* London, 1955.

HARRIS, SHELDON. *Blues Who's Who: A Biographical Dictionary of Blues Singers.* New York, 1979.

LIEBERMAN, ROBBIE. *My Song Is My Weapon: People's Songs, American Communism, and the Politics of Culture, 1930–50.* Chicago, 1989.

OBRECHT, JAS. "The Legend of Big Bill Broonzy." *Guitar Player* (August 1986): 68–74.

OLIVER, PAUL. "Big Bill Broonzy." *The New Grove Dictionary of American Music.* Vol. 1. New York, 1984.

STAMBLER, IRWIN, and GRELUN LANDON. *Encyclopedia of Folk, Country and Western Music.* New York, 1969.

DANIEL THOM

Brotherhood of Sleeping Car Porters.

The Brotherhood of Sleeping Car Porters (BSCP), organized in secret on August 25, 1925, became the first successful African-American labor union (*see* LABOR AND LABOR UNIONS). From its inception in 1867, the Pullman Company had employed black porters because company officials believed their subservience could be depended upon and because they would work for low wages. Pullman thereby created an occupation over which African Americans had a mo-

nopoly. While steady employment and travel experience made porters the elite of black labor, they were not unionized and were often exploited and underpaid. Capitalizing on the fact that he was not a porter and hence could not be fired, socialist journalist A. Philip RANDOLPH seized on the porters' complaints, educated them about collective bargaining and the value of trade unionism, and began organizing them in 1925. The question of unionization to the average porter, however, meant a choice between steady, albeit low, pay and reprisals by the company, so organizing had to be carried on covertly and employees' wives were often utilized for the job. Loyal assistants, like Milton P. Webster in Chicago, Ashley Totten and Benjamin McLauren in New York, C. L. Dellums in Oakland, and E. J. Bradley in St. Louis, took care of the daily details and organizing while Randolph obtained outside publicity and funding.

Porters had legitimate complaints, working long hours for little pay. They made the railroad car ready, assisted with luggage, waited on passengers, converted seats into beds that they then made up, polished shoes, and remained on call twenty-four hours a day. Nevertheless, because they had been inculcated with the idea of company benevolence, and because of their fear of reprisal, most porters were reluctant to jeopardize their jobs by joining the union. Many did not understand the difference between the company union, the Employee Representation Plan (ERP), and a trade union like the BSCP.

Still, despite obstacles, BSCP membership increased, and Pullman attempted to undermine its success with a series of retaliatory measures, including frame-ups, beatings, and firings. The company had previously dealt with labor unions, but now resisted bargaining with African Americans as equals. Company propaganda identified Pullman as a benefactor of African Americans, which led many prominent blacks to oppose the BSCP. Organized labor was anathema to others because they believed, with justification, that black workers were discriminated against by white unions.

Although initially opposed to its craft-union stance, Randolph began taking a more conciliatory tone toward the American Federation of Labor (AFL) in his writings as early as 1923. After he began organizing the porters, Randolph continually sought the advice of William Green, head of the AFL. The BSCP first applied for an international charter from the AFL in 1928. Because of jurisdictional disputes with white unions, most likely prompted by racism, the AFL refused the international charter, granting instead federal charters to individual locals. Brotherhood officials were unhappy with federal status, but the weak BSCP needed the support of the AFL. For his part, Green, concerned about Communist infiltration of black labor, considered the BSCP an acceptable alternative, not only to communism but also to masses of African-American laborers remaining outside the federation, where they acted as potential strikebreakers.

Realizing that the success of the union ultimately depended on its ability to correct grievances and provide job security, Randolph employed various strat-

Officers of the Brotherhood of Sleeping Car Porters, (left to right) unidentified, Bennie Smith, Ashley Totten, T. T. Patterson, A. Philip Randolph, Milton P. Webster, C. L. Dellums, and E. J. Bradley, c. 1930s. (Photographs and Prints Division, Schomburg Center for Research in Black Culture, The New York Public Library, Astor, Lenox and Tilden Foundations)

egies to force the company to the bargaining table. First, in 1926, he attempted to bring the dispute before the federal Board of Mediation under the Watson-Parker Railway Labor Act. Although the board recommended arbitration, under the act arbitration was voluntary and the company demurred. Second, believing that depending on tips was a degrading practice and because the uncertainty of the amount to be expected was one of the porters' primary grievances, Randolph brought the tipping system before the Interstate Commerce Commission in 1927. A ruling prohibiting tipping in interstate travel would have compelled a wage increase, but the ICC ultimately decided it did not have jurisdiction. Thus the BSP was forced to call a strike in 1928, but, accustomed to finding jobs as strikebreakers, African Americans knew other blacks would be eager to take what many considered a plush position and consequently were reluctant to actually walk off the job. In response to a rumor that Pullman had nearly five thousand Filipinos ready to take the places of brotherhood members, Willie Green advised Randolph to postpone the strike.

After the aborted strike, membership dropped and the BSCP almost ceased to exist. The more favorable labor legislation under President Franklin D. Roosevelt, however—especially passage of the amended Railway Act of 1934, which outlawed company unions—revived the BSCP. Although Pullman responded by replacing its ERP with the Pullman Porters and Maids Protective Association, the situation for labor had changed. The AFL granted the brotherhood an international charter in 1935. After twelve years, the Pullman Company finally signed a contract with the BSCP on August 25, 1937, bringing improved working conditions and some two million dollars in income to the porters and their families.

Beginning with the 1932 AFL convention, Randolph started denouncing racism within the federation and attacking federal unions designed for African Americans. Although well disposed to John L. Lewis and the industrial unionism of the unions that left the AFL in 1937 to form the Congress of Industrial Organizations (CIO) Randolph—who had long advocated industrial unions—held the BSCP in the AFL, saying he thought it wiser to remain and fight for equality than to leave and let the federation continue its racist policies undisturbed. BSCP officers contented themselves trying to prevent the split in the union movement and later working for reunification, but competition from the CIO forced the AFL to a more egalitarian position on racial equality. When the two federations merged in 1955, Randolph became a vice president of the newly created AFL–CIO, and the BSCP became instrumental in pushing the combined federation to financially back civil rights activity.

Not only did the BSCP successfully negotiate a series of favorable wage agreements between Pullman and its porters through the years, but the union provided support for civil rights activity by contributing its labor and some fifty thousand dollars to Randolph's various equality movements as well. By the fall of 1940, fueled by defense contracts, the American economy was beginning to emerge from the Great Depression. But because of racial discrim-

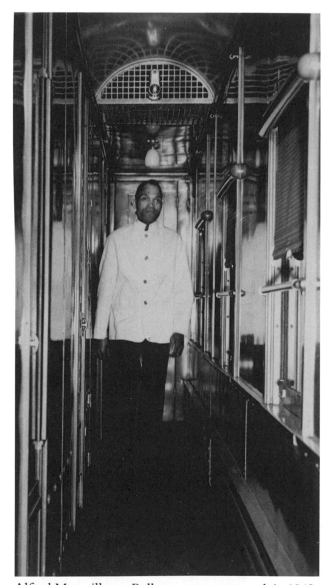

Alfred Macmillan, a Pullman porter, at work in 1942. The Brotherhood of Sleeping Car Porters, which reached a labor agreement with the Pullman Company in 1937, was the most influential of black unions. The success of the union led to increased wages and improved working conditions for porters such as Macmillan. (Prints and Photographs Division, Library of Congress)

ination, African Americans found themselves locked out of the new job opportunities opening in defense industries. Randolph, backed by the brotherhood, threatened a march on Washington of one hundred thousand blacks the following July 1, to demand jobs in defense plants and integration of the armed forces. While integration of the military was not achieved, the Roosevelt administration was sufficiently concerned to issue Executive Order 8802 in June 1941, creating the wartime FAIR EMPLOYMENT PRACTICES COMMITTEE (FEPC) in exchange for cancellation of the march. Although weak, the FEPC did provide job training and economic improvement for many African Americans. In 1948, the porters' union assisted, albeit more reluctantly, Randolph's threat of a black boycott of universal military training; the Truman administration capitulated with integration of the military by Executive Order 9981. The BSCP supported Randolph's prayer pilgrimage in 1957, marches in Washington for integrated schools in 1958 and 1959, and the march on Washington for Jobs and Freedom in 1963. (Many organizers for the BSCP went on to assume important roles in the CIVIL RIGHTS MOVEMENT, such as E. D. NIXON, who played an instrumental part in the Montgomery bus boycott of 1955–1956.)

BSCP officers realized early on the threat to Pullman travel presented by the rise of commercial aviation; the drop was precipitous after World War II, with the porters becoming a diminished and aging group. Bowing to the decline of the railroad industry, in 1978 the BSCP merged with the Brotherhood of Railway and Airline Clerks. The brotherhood, however, had served its members well. Although porters were often absent from home because of long runs and usually missed holidays as well, the brotherhood helped the porters' domestic situation by providing job security, higher wages, and improved working conditions. Furthermore, during its heyday, under Randolph's leadership the BSCP became more than an instrumentality of service to the porters. From its inception in 1929 Randolph utilized the union's organ, the *Black Worker,* in the fight against communism to educate porters to fight for civil rights and to cajole them to abide by such middle-class virtues as thrift, cleanliness, and abstinence from alcohol. He organized the porters' wives into a Ladies' Auxiliary and their children into Junior Auxiliaries. The union thus encircled its members' lives and built their self-esteem. Trained in trade-union methods of collective bargaining, porters refused to beg for favors from the white power structure. Hence, the BSCP stimulated black participation in unions and fought to end discrimination in organized labor. The BSCP left an important legacy to both organized labor and the struggle for civil rights.

REFERENCES

BRAZEAL, BRAILSFORD REESE. *The Brotherhood of Sleeping Car Porters: Its Origin and Development.* New York, 1946.

HARRIS, WILLIAM H. *Keeping the Faith: A. Philip Randolph, Milton P. Webster, and the Brotherhood of Sleeping Car Porters, 1925–37.* Urbana, Ill., 1977.

PFEFFER, PAULA F. *A. Philip Randolph, Pioneer of the Civil Rights Movement.* Baton Rouge, La., 1990.

SANTINO, JACK. *Miles of Smiles, Years of Struggle: Stories of Black Pullman Porters.* Urbana, Ill., 1989.

WILSON, JOSEPH F. *Tearing Down the Color Bar: A Documentary History and Analysis of the Brotherhood of Sleeping Car Porters.* New York, 1989.

PAULA F. PFEFFER

Brown, Anne Wiggins (1911–), concert singer. Anne Brown was born in Baltimore, the daughter of a physician, Harry F. Brown, and Mary Wiggins

Anne Wiggins Brown, an acclaimed recitalist in the United States and Europe, is best known for creating the role of Bess in George Gershwin's *Porgy and Bess.* (Photographs and Prints Division, Schomburg Center for Research in Black Culture, The New York Public Library, Astor, Lenox and Tilden Foundations)

Brown. She attended Morgan College in Baltimore and Teachers College of Columbia University in New York, she received three diplomas from the Juilliard School of Music in New York, and won the Margaret McGill Scholarship for postgraduate study, the first African American to do so.

Brown made several concert tours in the United States and performed in London with Lew Leslie's *Blackbirds*. In 1935, she secured the role of Bess in the original production of George Gershwin's *Porgy and Bess*. Her first straight dramatic role was in *Mamba's Daughters* (1939). She sang with the New York Symphony, appeared at the Hollywood Bowl, performed on radio, and sang with the NBC Symphony under the baton of Leopold Stokowski.

Brown appeared in the 1942 revival of *Porgy and Bess,* as well as in Swedish productions in 1947 and 1948. She settled in Oslo, Norway, in 1948, continuing her concert career. She produced and directed several productions of *Porgy and Bess* in France, and narrated performances of the opera for radio in Norway. She is active in Oslo theaters as a vocal coach and teacher.

REFERENCES

ALPERT, HOLLIS. *The Life and Times of Porgy and Bess.* New York, 1990.
SOUTHERN, EILEEN. *The Music of Black Americans: A History.* 2nd ed. New York, 1983.

JAMES STANDIFER

Brown, Cecil Morris (July 3, 1943–), novelist and screenwriter. Cecil Brown was born to Cecil and Dorothy Brown, tobacco sharecroppers in Bolton, N.C. When he was eighteen Brown entered Agricultural and Technical State University in Greensboro but soon transferred to Columbia University, where he majored in English and earned his B.A. in 1966. One year later, he completed his M.A. at the University of Chicago. By 1969 Brown had published articles, earned a second-place screenwriter's credit for Richard PRYOR's film *Which Way Is Up,* and published his best-known novel, *The Life and Loves of Mr. Jiveass Nigger*. In the 1970s he worked on several projects as a screenwriter for Universal Studios and Warner Brothers, and in 1982 he published his second novel, *Days Without Weather.*

A writer of often hilarious, but fundamentally serious, social satire, Brown is deeply concerned with the pervasive stereotyping of African Americans. *Jiveass Nigger* chronicles the adventures of a young black student named George Washington, who is stranded in a European city and tries to make his way

through a society where everyone—including the character himself—has preconceived ideas about his identity. *Days Without Weather* is the story of a young comedian whose two uncles represent the two choices he faces as a black performer: one was killed for laughing at a white man to his face; the other is a prosperous Hollywood "hack" who writes for money, happily filling orders for whoever will pay him—and mocking the African-American experience in the process.

Brown has been outspoken in his criticism of Hollywood and the entertainment industry. In an article published in *Mother Jones* in 1981, Brown argued that producers, directors, and writers uphold racial stereotypes, not only in their products, but also by preventing blacks from making films themselves. In 1993 Brown published *Coming Up Down Home: A Memoir of a Southern Childhood,* in which he describes the harsh conditions he experienced growing up in rural North Carolina during the 1940s and '50s.

REFERENCES

BRIGHT, JEAN M. "Cecil Brown." In *Dictionary of Literary Biography,* vol. 33, *Afro-American Writers After 1955.* Detroit, 1984.
BROWN, CECIL. *Coming Up Down Home: A Memoir of a Southern Childhood.* Hopewell, N.J., 1993.

LYDIA MCNEILL

Brown, Charlotte Hawkins (June 11, 1883– January 10, 1961), educator. One of the premier educators of her day, Charlotte Hawkins Brown was also a key figure in the network of southern African-American club women who were active in the late nineteenth and early twentieth centuries. Brown was born Lottie Hawkins in Henderson, N.C. When she was five her family moved to Cambridge, Mass., where her mother and stepfather operated a laundry and boarded Harvard students. During this period the family retained close ties with its Carolina roots.

Hawkins studied hard and was active in church and youth groups in Cambridge. She also developed an interest in art and music that became lifelong. As a high school student, Hawkins met Alice Freeman Palmer, the second president of Wellesley College, who took an immediate interest in her. Palmer was so impressed with Hawkins that she financed her education at the State Normal School in Salem, Mass., where Hawkins enrolled in 1900 to earn a teacher's certificate. She left school in 1901 to take a position with the AMERICAN MISSIONARY ASSOCIATION at a small school in North Carolina. Although the school soon closed because of inadequate funding, Hawkins

determined to dedicate herself to education in her home state.

By October of 1902 Hawkins had secured a donation of land, a building, and funds to open the Alice Freeman Palmer Memorial Institute in Sedalia, N.C. In 1909 she married Edward Brown, a graduate of Harvard, who taught at the Palmer Institute briefly before the couple separated and divorced. Over the years, under Charlotte Hawkins Brown's leadership, Palmer developed into a highly respected institution for preparatory training. From its early focus on vocational education, the school moved to a strict academic curriculum. The campus, the student body, and the faculty grew steadily, and Palmer sent many of its graduates to institutions of higher learning. Brown's work as an educator received recognition within her home state and across the country.

Brown was a key figure among black club women, serving as president of the North Carolina State Federation of Negro Women's Clubs. She was also active in interracial work as a member of the national board of the YWCA and also worked with other organizations. She campaigned against lynching and toured widely as a lecturer. Brown also assisted in the founding of other schools in North Carolina, including the Dobbs School for Girls and the Morrison Training School, and she helped to establish scholarship funds for the college education of African-American women.

In addition to her work as an educator and activist, Brown raised her brother's three children and three of her young cousins. She also published two works, *Mammy: An Appeal to the Heart of the South* (1919) and *The Correct Thing to Do, to Say and to Wear* (1941). Brown remained the president of the Palmer Memorial Institute until 1952 and died nine years later. Although the institute ceased operation in 1971, the state of North Carolina has kept the memory of Brown's contributions and achievements alive in a memorial to her and to her institution.

REFERENCES

DANIEL, SADIE IOLA. *Woman Builders*. Washington, D.C., 1970.
MARTEENA, CONSTANCE HILL. *The Lengthening Shadow of a Woman: A Biography of Charlotte Hawkins Brown*. Hicksville, N.Y., 1977.

JUDITH WEISENFELD

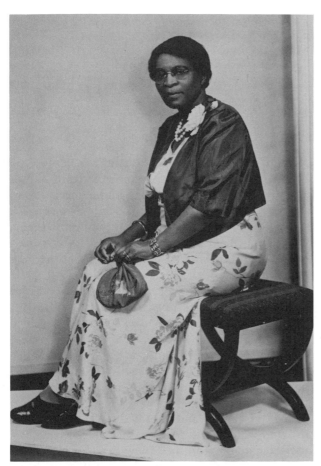

Charlotte Hawkins Brown, director of the Palmer Memorial Institute in McLeansville, N.C., for fifty years, was also an active clubwoman and the author of several books on etiquette. (Photographs and Prints Division, Schomburg Center for Research in Black Culture, The New York Public Library, Astor, Lenox and Tilden Foundations)

Brown, Clara (1800–October 23, 1885), pioneer. "Aunt" Clara Brown was born a slave in Virginia. Three years later she was sold with her mother to Ambrose Smith, a tobacco farmer in Spottsylvania County, Va. In 1809 Smith moved to Kentucky with his family, taking Clara and her mother with them. Clara took care of Smith's two sons during his service in the WAR OF 1812. Shortly after Smith returned, he purchased a carpenter named Richard, who became Clara's husband. They had four children: Richard, Margaret, and the twins Paulina Ann (who drowned during childhood) and Eliza Jane. When Smith died in 1835, Clara's family was separated at auction; she herself was sold to Smith's friend George Brown, a hatter from Russellville, Ky. Clara served the Brown family for the next twenty years, taking her surname from them. George Brown, in turn, tried unsuccessfully to help Clara locate her husband and children, particularly Eliza Jane, the only surviving child with traceable records.

In 1857 George Brown died, and his heirs gave Clara her freedom. Kentucky law mandated that all manumitted slaves leave the state within a year, so

the Brown heirs sent Clara to a friend in St. Louis, Mo., named Jacob Brunner, who hired Clara as a cook. In 1857 Brunner took his wife and Clara to Leavenworth, Kans. The next year, when the Brunners moved to California, Clara chose to stay behind until she could travel to Pike's Peak in Colorado, because of rumors that her daughter might be in the vicinity.

In 1859 she and a wagon train of gold prospectors journeyed to Denver, Colo., near Pike's Peak, where she helped found the Union Sunday School. Shortly afterward she moved to Central City, Colo., still with the hope of locating her family and earning enough money to purchase them from slavery. In Central City, Brown opened a laundry, served as a nurse, and organized the city's first Sunday school. By 1866 she had earned ten thousand dollars, much of which came from her successful investments in mining claims. In 1882, in Council Bluffs, Iowa, Brown finally had a reunion with her long-lost daughter. Brown transported several other African-American migrants and their families to Colorado, and worked to ensure that black suffrage was guaranteed in Colorado's state constitution. Brown died in Denver.

REFERENCE

BRUYN, KATHLEEN. *"Aunt" Clara Brown: Story of a Black Pioneer.* Boulder, Colo., 1970.

SUSAN MCINTOSH

Brown, Claude (February 23, 1937–), writer. Claude Brown was born in Harlem in New York City, one of four children of a railroad worker and a domestic. Brown displayed behavioral problems and at age eight was sent to Bellevue Hospital for observation. By the time he was ten, he had an extensive history of truancy and expulsion and was sent to the Wiltwyck School, a school for emotionally disturbed boys, and then to the Warwick reform school. After his release from reform school, Brown performed a series of odd jobs and enrolled in night courses at Washington Irving High School. He graduated in 1957 and returned to Harlem, where he sold cosmetics and played piano for a living. In 1959 he won a grant from the Metropolitan Community Methodist Church to study government at Howard University, which awarded him a B.A. in 1965. While in his last year of college, Brown was encouraged by a mentor from the Wiltwyck School to write an article about growing up in Harlem for *Dissent Magazine.* An editor at Macmillan Publishing Company saw the article and offered Brown an advance to write what

would become his celebrated 1965 memoir *Manchild in the Promised Land.*

The book was an uncensored account of coming-of-age in the turbulent setting of Harlem and was praised by critics for its honesty in its depiction of his difficult childhood. The bestseller made Brown a celebrity and consequently interfered with his studies at Stanford University Law School. He transferred to Rutgers Law School, which he left in 1968 without obtaining his degree. In 1976, Brown's second book, *Children of Ham,* about a group of Harlem youths struggling to succeed, was published, but it failed to have the same impact as his first book.

Since the 1970s, Brown has worked as a freelance writer, commenting on the status of urban America. His articles have been published in a number of periodicals including the *New York Times,* the *Los Angeles Times, Esquire,* and the *New York Times Magazine.*

REFERENCES

BROWN, CLAUDE. *Manchild in the Promised Land.* New York, 1965.
METZGER, LINDA, ed. *Black Writers: A Selection of Sketches from Contemporary Authors.* Detroit, 1989.

KENYA DILDAY

Brown, Clifford "Brownie" (October 30, 1930–June 26, 1956), jazz trumpeter. Born in Wilmington, Del., Brown studied trumpet as a youngster, playing in his high school band. By the age of eighteen, he was playing in and around Philadelphia, where he met and was encouraged by Fats NAVARRO. In 1949 he was awarded a mathematics scholarship to Maryland State College, later transferring to Delaware State College to pursue a music degree. His budding musical career was interrupted from June 1950 to May 1951 when he was hospitalized after an automobile accident.

In March 1952, Brown made his first professional recordings with Chris Powell's Blue Flames, a rhythm and blues band with which he toured from 1952 to 1953. In 1953 he played and recorded with Lionel HAMPTON and Tadd DAMERON. In 1954, Brown recorded with Art BLAKEY's Jazz Messengers at Birdland and won the "New Star Award" in the *Downbeat* Critics' Poll. From 1954 to 1956, he began a musical relationship with drummer Max ROACH. The resulting Clifford Brown–Max Roach Quintet was one of the most important jazz groups of the 1950s, recording extensively under its own name as well as recording *Sonny Rollins Plus Four* under Sonny ROLLINS's leadership. Rollins replaced tenor saxo-

phonist Harold Land in the Brown-Roach Quintet in late 1955. Brown died on June 26, 1956, in an automobile accident.

Brown's improvisational techniques can be traced to Miles DAVIS, Dizzy GILLESPIE, and Fats Navarro, whose influences synthesized to create a style propelled by a rich tone, virtuoso technique, long-flowing phrases, and a wealth of original ideas. The music Brown performed, including his own compositions, relied heavily on harmonic patterns that were typical of the bebop style. Tunes like "Brownie Speaks," "All the Things You Are," and "What Is This Thing Called Love?" are examples of Brown's playing in this genre. Although he was known primarily as a trumpeter, he also wrote several jazz classics, including "Brownie Speaks" and "Gerkin for Perkin."

REFERENCES

BAKER, DAVID. *The Jazz Style of Clifford Brown: A Musical and Historical Perspective.* Hialeah, Fl., 1982.
"Some Characteristics of Clifford Brown's Improvisational Style." *Jazz Forschung* 11 (1979): 135–149.

EDDIE S. MEADOWS

Brown, Dorothy Lavania (January 7, 1919–), surgeon and educator. Dorothy Brown was the first black female surgeon to practice in the South. Born in Philadelphia, she moved with her mother to Troy, N.Y., when she was an infant. Her mother soon found she was unable to provide for her daughter and placed her in the Troy Orphanage. At age thirteen, Brown was removed from the orphanage by her mother, but on five occasions she ran away and returned to the Troy Orphanage, which she had come to consider her home.

From the age of five, when her tonsils were removed, Brown wanted to become a doctor. She was determined to get a high school education, and at age fifteen she ran away and enrolled in high school in Troy. After she graduated at the top of her class, the Women's Division of Christian Service of the Methodist Church nominated Brown for a scholarship to Bennett College in Greensboro, N.C. Despite formidable obstacles, Brown received her B.A. in 1941 and enrolled at Meharry Medical College in Nashville, Tenn., in 1944.

Brown completed her residency at Meharry in 1954. Despite almost universal resistance to her decision to pursue surgery, Brown became an assistant professor of surgery in 1955. She became the first black female Fellow of the American College of Surgeons, and from 1957 to 1983 she was chief of surgery at Nashville's Riverside Hospital.

Throughout her life Brown displayed an unwavering commitment to the social and political betterment of African Americans. Her desire to aid an unwed mother led her to become the first single woman to adopt a child in the state of Tennessee. In 1966, Brown became the first black woman in the Tennessee State Legislature. Two years later, she ran for the state senate but was defeated, in part because of her authorship of an expanded abortion rights bill which she claimed had the potential to save the lives of many Tennessee women.

Through the early 1990s, Brown remained an active teacher and physician as well as a national and international lecturer.

REFERENCES

INNES, DORIS F., ed. *Profiles in Black: Bibliographical Sketches of 100 Living Black Unsung Heroes.* New York, 1976.
ORGAN, CLAUDE H., and MARGARET M. KOSIBA. *A Century of Black Surgeons: The U.S.A. Experience.* Norman, Okla., 1987.

SUSAN MCINTOSH
ROBYN SPENCER

Brown, Hallie Quinn (1850–1949), educator, activist, and writer. Born in Pittsburgh, Pa., Brown was a child of former slaves. Her family moved to Ontario and then Ohio, where she received a B.S. from Wilberforce University in 1873. Brown had a long and varied teaching career: at plantation schools in the South during Reconstruction; at public schools in Dayton, Ohio, during the 1880s; and at Tuskegee Institute, where she served as principal for one term (1892–1893).

Brown joined the faculty of Wilberforce University in 1893 as professor of elocution (i.e., public speaking). From 1894 to 1899, she traveled throughout the United States and abroad to gain financial support for Wilberforce. Her dramatic and entertaining presentations on African-American folklore and on black life in America brought her fame as a public speaker. Also a proponent of the temperance movement, Brown addressed the world conference of the Women's Christian Temperance Union held in London in 1895. On another trip to England, she represented America at the 1899 International Congress of Women, and was twice received by Queen Victoria.

Returning to America, Brown founded the NATIONAL ASSOCIATION OF COLORED WOMEN, the first national club for black women. Besides serving as its president from 1920 to 1924, she also worked for the Warren G. Harding REPUBLICAN presidential

Educator Hallie Q. Brown taught at Wilberforce University for many years. From 1920 to 1924 she was president of the National Association of Colored Women. She is nearly a hundred years old (center left) in this photograph taken at the dedication of a library in her honor at Wilberforce University in 1948. (Moorland-Spingarn Research Center, Howard University)

campaign in 1920. She served as director of Colored Women's Activities at the national campaign headquarters in Chicago, and spoke at the Republican National Convention in Cleveland.

Brown wrote several books, including *Bits and Odds: A Choice Selection of Recitations* (1920) and *Homespun Heroines and Other Women of Distinction* (1926).

REFERENCES

LOGAN, RAYFORD W. and MICHAEL R. WINSTON, eds. *Notable American Women 1607–1950.* New York, 1971.

OHLES, JOHN, ed. *Biographical Dictionary of American Educators.* Vol. 1. Westport, Conn., 1978.

LINDA SALZMAN

Brown, Henry "Box" (c. 1815–?), abolitionist. Henry "Box" Brown was born a slave on a plantation near Richmond, Va., around 1815. As a young man, he worked in a tobacco factory in Richmond. The sale of his wife and three children to a North Carolina clergyman in 1848 provoked him to attempt an audacious escape. In March 1849, he had himself crated in a wooden box and shipped to Philadelphia by Adams Express. He survived the torturous twenty-seven-hour journey and created a sensation when news of his escape reached the public.

Brown took his salary and his "box" on the antislavery lecture circuit. The threat of slavecatchers—heightened by the enactment of the FUGITIVE SLAVE ACT OF 1850—compelled Brown to leave the United States for England in the fall of 1850. To enhance his antislavery presentations, he commissioned a panorama entitled "Mirror of Slavery." Boston artists painted several thousand square feet of canvas to illustrate slave life in the South and Brown's dramatic escape to freedom. With his panorama and a narrative published in 1851, Brown became a well-known abolitionist lecturer during his four years in England.

REFERENCE

RIPLEY, C. PETER, ET AL., eds. *The Black Abolitionist Papers.* Vol. 1, *The British Isles, 1830–1865.* Chapel Hill, N.C., 1985.

MICHAEL F. HEMBREE

Brown, Hubert G. "H. Rap" (October 4, 1943–), writer, activist. H. Rap Brown was born in Baton Rouge, La. He became involved in the CIVIL

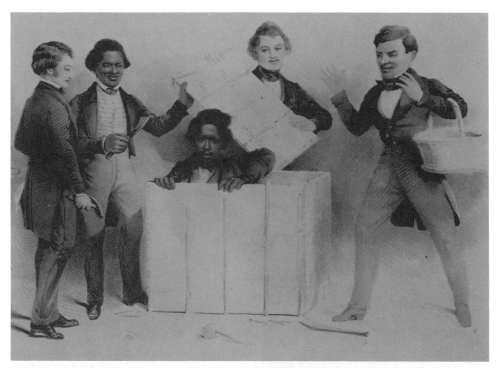

The successful completion in 1849 in Philadelphia of Henry "Box" Brown's remarkable escape from slavery in a closed express crate, as depicted in an 1850 lithograph. See page 446. (Prints and Photographs Division, Library of Congress)

RIGHTS MOVEMENT while a student at Southern High School. He attended Southern University in Baton Rouge, but in 1962 he left school and devoted his time to the civil rights movement. He spent summers in Washington, D.C., with his older brother, Ed, and became a member of the Nonviolent Action Group (NAG). In 1964, Brown was elected chairman of NAG. Simultaneously, he became involved with the STUDENT NONVIOLENT COORDINATING COMMITTEE (SNCC).

In May 1966, he was appointed director of the SNCC voter registration drive in Alabama. Brown increased his involvement with SNCC, and in June 1967 he became Stokely CARMICHAEL's successor as National Chairman of SNCC, where he continued its militant stance. In 1968, Brown also served as minister of justice for the BLACK PANTHER PARTY during a brief working alliance between the two BLACK POWER organizations.

As urban rebellions expressing black discontent spread across the United States, Brown's militant advocacy of black power made him a popular public speaker; his advocacy of black self-defense and condemnations of American racism—perhaps most memorably in his oft-quoted aphorism that "violence is as American as cherry pie"—made him a symbol of resistance and black pride within the Black Power movement. His rhetorical and vituperative talents—the source of his adopted name, "Rap"—were dis-

played in his one book, *Die Nigger Die!* (1969), a semiautobiographical account of his experiences with white racism. Brown embraced the term "nigger" as an embodiment of black resistance against racism.

Brown was consistently harassed by the police, and was targeted by the FBI's Counter Intelligence Program (COINTELPRO) because his speeches supposedly triggered volatile situations and violent outbreaks. On July 24, 1967, he was accused of "counseling to arson" in Cambridge, Md., because a city school that had been set on fire twice before was burned a third time after one of his speeches.

On August 19, 1967, Brown was arrested for transporting weapons across state lines while under indictment, despite the fact that he had never been formally notified that he was under indictment. In May 1968, Brown resigned as SNCC chairman. Later that year, he was found guilty of the federal weapons charges and sentenced to five years in prison. He was released on bond in order to stand trial on the Cambridge, Md., charges. Brown never appeared at the Maryland trial; two of his friends had recently been killed in a suspicious automobile explosion, and his defense attorney claimed that Brown would be endangered if he appeared. Brown went into hiding, and in 1970 he was placed on the FBI's Ten Most Wanted List. He was apprehended in 1972, and was released four years later.

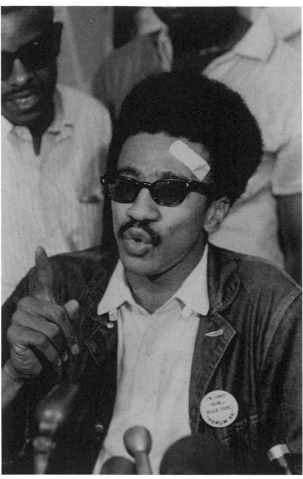

H. Rap Brown, national chairman of SNCC from 1967 to 1968, was one of the most prominent advocates for Black Power during its heyday. (Prints and Photographs Division, Library of Congress)

Brown converted to Islam while in prison and took the name Jamil ("beautiful") Abdullah ("servant of Allah") Al-Amin ("the trustworthy"). Upon his release from jail, he moved to Atlanta, Ga. In the early 1990s, Al-Amin continues to reside in Atlanta as the proprietor of a grocery called the Community Store and as the imam (leader) of the Community Mosque. He is the spiritual leader of hundreds of Muslim families in Atlanta and in thirty other cities, including Chicago, New York, and Detroit. Al-Amin practices a strict Sunni interpretation of the Koran, and his followers maintain a spiritual distance from the larger society. His mosque operates its own 300-student school, and his followers make aggressive outreach efforts to college campuses, malls, and surrounding housing projects.

REFERENCES

HASKINS, JAMES. *Profiles in Black Power.* New York, 1972.

VAN DEBURG, WILLIAM. *A New Day in Babylon: The Black Power Movement and American Culture, 1965–1975.* Chicago, 1992.

MANSUR M. NURUDDIN
ROBYN SPENCER

Brown, James Joe, Jr. (May 3, 1933–), singer and songwriter. Born near Barnwell, S.C., to Joe Brown, a turpentine worker, and Susan Behlings. After his mother left the family when the boy was four years of age, Brown spent his formative years in a brothel run by his aunt Handsome Washington in Augusta, Ga. After the authorities closed the brothel in 1943, he lived with his aunt Minnie Walker, receiving occasional tutoring on drums and piano from neighbors and showing early promise on harmonica and organ. He absorbed the music of the black church and of the minstrel shows that passed through Augusta; he heard the blues his father learned in the turpentine camps, and he listened to pop music on the radio. Fascinated by "soundies" (filmed musical numbers that preceded the feature at movie theaters), he paid close attention to those of Louis JORDAN and His Tympany Five, who performed jump blues and novelty songs with great showmanship. Singing Jordan's "Caldonia," Brown entered and won local talent contests while not yet in his teens. At thirteen, he formed the Cremona Trio, his first musical group, performing the songs of such RHYTHM AND BLUES artists as Jordan, Amos Milburn, Wynonie Harris, Charles Brown, and the Red Mildred Trio.

These early musical endeavors were cut short when Brown's habit of stealing clothes and other items from unlocked automobiles earned him a harsh eight-to-sixteen-year prison sentence, which he began serving at Georgia Juvenile Technical Institute (GJTI) in Rome, Ga., in 1949. In GJTI, he formed a gospel quartet (*see* GOSPEL QUARTETS) with three other inmates, including Johnny Terry, who would later become one of the original Famous Flames. After serving three years, he was paroled in Toccoa, the small town in northeast Georgia to which GJTI had been moved. He soon formed a gospel group with several youthful Toccoa musicians including Bobby Byrd, a talented keyboard player, who would remain a central figure in James Brown's musical endeavors into the early 1970s.

The fledgling gospel group soon began playing rhythm and blues and performed for dances and in small clubs throughout eastern Georgia and neighboring areas of South Carolina until LITTLE RICHARD's manager induced them to come to the vital music scene centered in Macon, Ga. At a Macon ra-

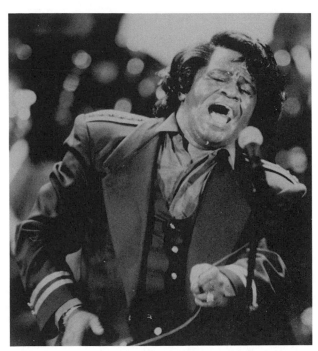

James Brown performing in 1991. Brown's emotional and energetic style earned him such sobriquets as "the Godfather of Soul" and "the hardest-working man in show business." (AP/Wide World Photos)

dio station, the group, soon to be known as the Famous Flames, recorded a demo of "Please, Please, Please," which attracted the attention of Cincinnati-based King records. Rerecorded in Cincinnati and released in 1956, the song eventually climbed to number six on the rhythm and blues record chart. During the next two years, Brown sought to duplicate the success of "Please," essaying a number of rhythm and blues styles and occasionally imitating the differing approaches of Little Richard and King labelmates Hank Ballard and the Midnighters and the Five Royales. In 1958, with the recording of "Try Me," a pleading ballad steeped in gospel, he achieved the number one position on the rhythm-and-blues chart, and began to realize his own distinctive style.

Brown soon became a headliner at Harlem's APOLLO THEATER and toured tirelessly, playing as many as 300 dates annually and presenting a stage revue complete with comedians, warmup acts, dancers, and a full orchestra. As a singer, he developed a powerful shouting style that owed much to gospel, but his rhythmic grunts and expressive shrieks harked back farther still to ring shouts, work songs, and field cries. As a band leader, he developed one of the most disciplined bands in entertainment and maintained it for more than three decades. He reimported the rhythmic complexity from which rhythm and blues, under the dual pressure of rock 'n' roll and pop, had progressively fallen away since its birth from jazz and

blues. As one of the greatest vernacular dancers in rhythm and blues, he integrated the latest dance crazes with older black popular dance styles and integrated them into a seamless whole that came to be known as "the James Brown." He became one of the most exciting live performers in popular music, capping his performances with a collapse-and-resurrection routine that became his trademark.

With the album *Live at the Apollo* (1963), Brown brought the excitement of his stage show to record buyers throughout the world. Through the mid-1960s, he enjoyed enormous success with such compositions as "Out of Sight" (1964), "I Feel Good (I Got You)" (1965), "Papa's Got a Brand New Bag" (1965), and "Cold Sweat" (1967). These infectious, rhythmically complex dance hits propelled him to international stardom and heralded funk, his most original and enduring contribution to popular music around the world. Dispensing almost entirely with chord changes, Brown, by the late 1960s, stripped the music to its rhythmic essence. Horns, guitars, and voices—including Brown's rich assortment of grunts, groans, shrieks, and shouts—were employed percussively. Rhythmic emphasis fell heavily on the downbeat at the beginning of each measure, imparting a sense of overwhelming propulsiveness to the music while leaving ample room for complex rhythmic interplay.

From the late 1960s through the mid 1970s, Brown and his band, assisted by gifted arrangers Pee Wee Ellis and Fred Wesley, produced powerful, polyrhythmic funk music that included inspired dance tracks as heard on albums such as *Sex Machine* (1970) and *Super Bad* (1971). He also wrote inspirational, political and social commentary such as the anthem of black pride "Say It Loud—I'm Black and I'm Proud" (1968). Brown also became something of a political figure; several presidential candidates sought his endorsement. Following the murder of the Rev. Dr. Martin Luther KING, Jr. in April 1968, Brown helped quell riots in Boston and Washington, D.C. In 1971 he produced a single about the dangers of drug use, "King Heroin."

Although Brown's records sold well through the early 1970s, the magnitude of his accomplishment was obscured by the rise of disco. Plagued by personal problems, including the break-up of his second marriage, the death of his oldest son, a federal tax case, and troubles with his numerous business enterprises, he briefly went into semiretirement, though he never entirely stopped performing, and he recorded numerous albums during this period, including *Hot* (1976) and *Bodyheat* (1976).

In the early 1980s he staged a successful comeback. He made cameo appearances in numerous motion pictures such as *The Blues Brothers* (1980). A series of

retrospective albums, including *The Federal Years* (*Part 1 and 2*, 1984) and *Dead on the Heavy Funk* (1985) traced the development of his music from 1956 to 1976, and he returned to extensive recording and performing. His music was also widely sampled by rap artists. In 1986 he performed "Living in America" in the film *Rocky IV* and that year became one of the first performers inducted into the Rock and Roll Hall of Fame.

In 1988, after leading police in Georgia and South Carolina on a high-speed chase that ended when the police fired some two dozen bullets into his truck, Brown was sentenced to six years in prison for failing to stop for a police officer and aggravated assault. Although the lengthy sentence sparked a national outcry for Brown's pardon, he remained incarcerated for more than two years, earning early release in 1991. Nevertheless, he re-emerged to be seen as one of the towering figures of popular music throughout the world. His musical innovations inform rock and jazz-funk hybrids, dance pop, reggae, hip-hop, and much African and Latin popular music. Critics, formerly ignoring him, now generally recognize him as one of the most influential American musicians of the past half century. His output has been prodigious, including more than seventy albums. In 1991 he released *Star Time*, a 71-song, 4-CD compilation of his greatest hits. He has also produced hundreds of recordings by other artists and continues to record (*Love Over-Due*, 1991).

REFERENCES

BROWN, JAMES, with Bruce Tucker. *James Brown: The Godfather of Soul.* New York, 1986.
HIRSHEY, GERRI. " 'We Sang Like Angels' " and "Superbull, Superbad." In *Nowhere to Run: The Story of Soul Music.* New York, 1984, pp. 54–63, 265–293.

BRUCE TUCKER

Brown, James Nathaniel "Jim" (February 17, 1936–), football player and actor. Born on St. Simons Island in Georgia, Jim Brown moved to Long Island, N.Y., with his mother when he was seven. He excelled in sports at Manhasset High School, where he won thirteen varsity letters. Named all-state in football, basketball, and track, he averaged 38 points a game on the basketball court, and 14.9 yards a carry on the football field. At Syracuse University (1954–1957), Brown received letters in football, track, basketball, and lacrosse. In 1957 he set a major college record for running backs when he scored 43 points in one football game against Colgate. In his final collegiate game, Syracuse played Texas Christian University in the Cotton Bowl. Though Syracuse lost, Brown rushed for 132 yards, scored 21 points, and was named most valuable player. He was Syracuse's first all-American running back.

Brown also had a successful college career in lacrosse, although he had never played the game before arriving at Syracuse. In 1957, he was the first black player in the North-South Game. Playing only half the game, he led the North to a 14–10 victory, scoring five goals and two assists. He was named all-American in the sport and was elected to the Lacrosse Hall of Fame. In addition, Brown helped Syracuse's basketball team by scoring 563 points in 43 games, and he competed in the decathlon for the track team.

In 1957, Brown turned down a three-year, $150,000 offer to become a professional fighter, and refused offers from the New York Yankees and the Boston Braves to play baseball, as well as an offer from the Syracuse Nationals to join their basketball team. Instead, Brown signed with the Cleveland Browns, who had chosen him in the first round of

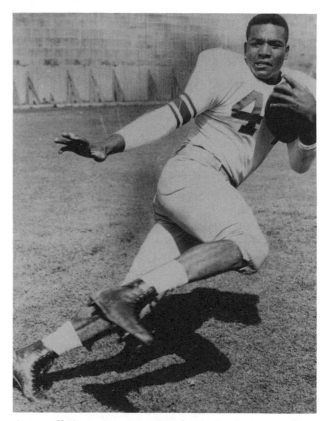

As an all-American running back for Syracuse University from 1955 to 1957, Jim Brown already displayed the running ability that would make him a legendary performer in the history of the National Football League. (Photographs and Prints Division, Schomburg Center for Research in Black Culture, The New York Public Library, Astor, Lenox and Tilden Foundations)

the National Football League draft. Generally regarded by sports journalists as the greatest NFL fullback of all time, Brown rushed for a lifetime total of 12,312 yards and scored 126 touchdowns in just nine seasons. In his NFL career he averaged 5.2 yards a carry, a record that still stands, and he averaged 102 yards rushing every game. Brown was named NFL Rookie of the Year in 1957. He was named to the Pro Bowl every year he played, and was elected to the Football Hall of Fame in 1971.

In 1965, a year after he appeared in *Rio Concho*, Brown retired from the NFL at age twenty-nine to concentrate on his film career. He appeared in *The Dirty Dozen* (1967) and *Ice Station Zebra* (1968), as well as in a number of black action films such as *Black Gunn* (1972), *Slaughter* (1972), and *Slaughter's Big Rip-Off* (1973), and in *Take a Hard Ride,* a black western (1975). As head of his own independent movie production company, he was executive producer of *Richard Pryor Here and Now* (1983). He also made appearances on such television shows as "I Spy" (1965), "Chips" (1983), "T. J. Hooker" (1984), and "The A-Team" (1986).

Off-screen, Brown led a turbulent personal life, winding up in trouble with the police several times following violent altercations. In 1978, he was found guilty of a misdemeanor battery charge for punching a competitor in an argument during a golf match, and in 1986 he was arrested for assaulting his fiancée, but charges were never pressed.

Brown has always been outspoken in his involvement with civil rights and other political issues. Accordingly, when he retired from football, he founded the Black Economic Union to assist black-owned businesses. In February 1990, he threatened to have his name removed from the NFL Hall of Fame to protest "favoritism, good old boyism, cronyism, and racism" in the selection process, as he felt that some deserving black players had been bypassed. In the 1990s Brown created Amer-I-Can, a program to raise self-esteem among Los Angeles gang members. He arranged for transportation of the young men to his own home, where they participated in "life management skills" classes and support-group meetings, and had access to job-placement services. Brown also hosted benefits at his house for the widows of gang members. The program was designed to be sold to school administrators and state prison officials. In 1991, Amer-I-Can classes were being taught in ten California penal institutions, and in 1993, an Amer-I-Can representative was hired by the Chicago Housing Authority to develop a gang intervention program there.

Brown has written two autobiographies, *Off My Chest* (1964) and *Out of Bounds* (1989). As the Cleveland Browns' honorary captain for life, he is often involved in promotional events for the NFL.

REFERENCES

ASHE, ARTHUR R., JR., *A Hard Road to Glory: A History of the African-American Athlete Since 1946.* New York, 1988.

BOGLE, DONALD. *Blacks in American Films and Television: An Encyclopedia.* New York, 1988.

"Going like Gangbusters." *Newsweek,* June 17, 1991.

LYDIA MCNEILL

Brown, Jesse (March 27, 1944–), cabinet official. Born in Detroit, Jesse Brown spent his teen and early adult years in Chicago and graduated with honors from Chicago City College in 1963. That year, he enlisted in the Marine Corps, and later he served a tour of duty in Vietnam. While in Vietnam he was wounded, and he returned to the United States with a Purple Heart and a partially paralyzed right arm. He quickly became active in the veterans' rights movement, and in 1967 was hired by the Chicago office of the Disabled Veterans of America and argued the cases of veterans before hearing boards. In 1973, Brown moved to the Washington office, where he became a legislative advocate. His administrative abilities and strong devotion to the cause earned him recognition. Brown was influential in devising legislation aiding veterans suffering from exposure to Agent Orange, and worked for recognition of post-traumatic stress disorder as a statutory disability. In 1989, he became the first African-American director of the Disabled Veterans of America. As director, he made aid to homeless and drug-addicted veterans a major priority.

In 1993, after his nomination by President Bill Clinton, Brown became secretary of veteran's affairs, the government's second largest department with 220,000 employees, including 200,000 hospital employees and an annual hospital budget of $13.8 billion. He was a popular choice among veterans' groups, who considered him a defender of the benefit system.

REFERENCE

BARRINGER, FELICITY. "Defender of the Rights of Veterans Masters Thickets of Regulations." *New York Times,* December 14, 1992.

JAMES BRADLEY

Brown, Joe "Old Bones" (May 18, 1926–), boxer. Born in New Orleans and raised in Baton Rouge, La., Joe "Old Bones" Brown fought one professional fight in 1943 before entering the U.S. Navy in 1944. In 1945 he won the all-service lightweight title. Although he resumed his professional career in 1946, he was labeled a finesse boxer rather than a

hard puncher, and did not earn a title match until April 8, 1955, when he fought Wallace "Bud" Smith. Brown, who self-deprecatingly called himself "Old Bones," broke his right hand in the second round of his lightweight title bout against Smith; nevertheless, he went on to knock Smith to the canvas in the fourteenth round (with a right) and won the decision.

Brown successfully defended his lightweight title in ten fights, until he lost to Carlos Ortiz on April 21, 1962. Brown continued to box until 1970, though he was never again a serious contender for the title. Between 1943 and 1970, Brown had a total of 161 professional fights, winning 104 (47 by knockouts).

Since retiring in 1970, Brown has lived quietly in New Orleans.

REFERENCE

The Ring Record Book and Boxing Encyclopedia. New York, 1987.

SHIPHERD REED

Brown, John. *See* John Brown's Raid at Harpers Ferry, Virginia.

Brown, John Mifflin (September 8, 1817–March 16, 1893), educator and bishop. John Mifflin Brown was born in Cantwell's Bridge (now Odenta), Del. Little is known of his family. At age ten he moved to Wilmington, where he lived with the family of William A. Seals, a Quaker. During his stay at Wilmington, he attended a Presbyterian church and Sunday school, where he, like all black worshipers, was relegated to the gallery. Resenting this, Brown enrolled in a Roman Catholic Sunday school, which received him without objection. After two years in Wilmington, an older sister brought him to Philadelphia and placed him in the home of attorney Henry Chester, who gave him educational instruction and religious training. In 1835 Brown moved within Philadelphia to the home of Frederick H. Hinton, a barber.

In January 1836, Brown joined the Bethel AME Church in Philadelphia. Two years later, he entered the Wesleyan Academy in Wilbraham, Mass., to prepare for college. However, in 1840, an illness forced his return to Philadelphia for recuperation. The following year, Brown resumed his education at Oberlin College in Ohio but was not able to complete a degree. In the fall of 1844, he moved to Detroit and opened the first school for black children in that city.

That same year, he became the pastor of a Detroit AME Church, a position he held for three years. In 1849 the Ohio conference of the AME church appointed Brown pastor to a church in Columbus, Ohio. Two years later, he assumed the office of principal of nearby Union Seminary. Brown had a successful tenure at Union, but was forced out when WILBERFORCE UNIVERSITY (which had acquired the seminary) chose to abolish the school to raise money for other departments.

In 1853, Brown secured an appointment at the Morris Brown Mission in New Orleans and moved to Louisiana with his wife of one year, Mary Louise Lewis. On at least one occasion during his five years in New Orleans, Brown was imprisoned for allowing slaves to attend services. In 1858 he was assigned to the Bethel Church in Baltimore. Six years later he was elected corresponding secretary of the Parent Home and Foreign Missionary Society of the AME church. Brown was rewarded for his work in these endeavors by being consecrated a bishop of the church in 1868. He was first assigned the South Carolina district, which he served until 1872. Brown then began organizing AME conferences in other parts of the country, including west Texas, south Arkansas, and west Tennessee. From 1876 to 1880 he served the third district, which consisted of parts of Virginia, Maryland, and the Carolinas. Afterward, he was appointed to the first district, which included Philadelphia, Baltimore, New York, New Jersey, and New England, and then to the fourth (1884–1892), which covered substantial sections of the Midwest. Throughout his term as bishop, Brown organized a number of regional conferences and helped to increase church membership. In his writing, Brown emphasized what he saw as the radically egalitarian nature of the gospels. The Holy Spirit, he insisted, took no notice of race, gender, or social class. Brown was an early proponent of the ordination of women, though his views were rejected by the majority of the episcopate. Brown died at his home in Washington, D.C.

REFERENCES

ANGELL, STEPHEN WARD. *Bishop Henry McNeal Turner and African-American Religion in the South.* Knoxville, Tenn., 1992.
MURPHY, LARRY G., J. GORDON MELTON, and GARY WARD, eds. *Encyclopedia of African American Religions.* New York, 1993.

JO H. KIM

Brown, Lawrence (August 3, 1907–September 5, 1988), jazz trombonist. Born in Lawrence, Kans., Lawrence Brown was raised in Pasadena, Calif.,

where he learned piano, violin, and tuba as a child. He took up trombone before studying medicine at Pasadena Junior College, where he played in the school orchestra. He also began to perform professionally and eventually left school. He worked with Paul Howard, with whom he recorded "Cuttin' Up" (1929) and "Gettin' Ready Blues" (1930), as well as with Leon Herriford and with Curtis Mosby's Blue Blowers. In the early 1930s Brown joined the house band at Sebastian's New Cotton Club, a Culver City, Calif., nightclub. There he played with Louis ARMSTRONG and Lionel HAMPTON, appearing in "I'm a Ding Dong Daddy" (1930) and in other Armstrong recordings.

In 1932 Brown joined Duke ELLINGTON's orchestra, beginning an association that would last almost forty years. As the leader of Ellington's famed trombone section, Brown's solo voice was distinguished by a graceful, melodic style on many Ellington masterpieces, including "The Sheik of Araby" (1932), "Slippery Horn" (1933), "Yearning for Love (Lawrence's Concerto)" (1936), "Rose of the Rio Grande" (1938), "Braggin' in Brass" (1938), "Blue Light" (1938), "Across the Track Blues" (1940), and "Main Stem" (1942). Brown left the Ellington band in 1951 to join Ellington saxophonist Johnny HODGES's group, with whom he recorded "Rabbit's Jump" (1951) and "Used to Be Duke" (1954). From 1955 to 1960 Brown worked in New York as a freelance and as a studio musician at the Columbia Broadcasting System (CBS). Brown rejoined Ellington in 1960 and took over the plunger mute chair, with its requisite growling and talking effects, that Joe "Tricky Sam" NANTON had made famous. Brown recorded *The Duke Meets Coleman Hawkins* (1962) with Ellington and *Inspired Abandon* (1965) as a leader before departing again in 1970. Brown, who lived in Teaneck, N.J., then worked for three years as a business and political consultant before retiring. He lived in California from then until his death at age eighty-one.

REFERENCES

ELLINGTON, DUKE. *Music Is My Mistress*. New York, 1973.

WILMER, VALERIE. "Lawrence Brown Talks to Valerie Wilmer." *Jazz Monthly* 11, no. 2 (1965): 18.

JONATHAN GILL

Brown, Morris (February 12, 1770–May 9, 1849),

clergyman. Born a free person of mixed parentage in Charleston, S. C., Morris Brown acquired an education and converted to Methodism as a youth. He was a shoemaker by trade, but poured his energies into preaching and gathered a congregation that numbered approximately fourteen hundred people in 1816. Though not represented at the 1816 conference establishing the AFRICAN METHODIST EPISCOPAL CHURCH (AME Church), the Charleston congregation gave its support and asked to be considered part of the new denomination.

Brown fled Charleston in 1822 because the authorities suspected that he had been involved in VESEY'S CONSPIRACY. Though the nature of his personal involvement is uncertain, the rebellion was planned and nourished in part in his church; consequently, the church was closed until after the Civil War. Brown settled in the Philadelphia area and continued his pastoral labors among AME churches. In 1828, he was elected bishop and served as an associate to Richard ALLEN, the aging AME bishop and leader. When Allen died in 1831, Brown succeeded him and guided the denomination through an important period of growth and maturation, until he suffered a stroke in 1844.

REFERENCE

PAYNE, ALEXANDER. *History of the African Methodist Episcopal Church*. Nashville, Tenn., 1891.

TIMOTHY E. FULOP

Brown, Pete (February 2, 1935–), golfer. Pete

Brown was the first African-American golfer to win a Professional Golfers Association (PGA)–sanctioned tournament (1964). He was born in Port Gibson, Miss, and began caddying at the Livingston Park Golf Course in Jackson at the age of eleven. While blacks were not legally allowed to play on this public course, Brown and his fellow caddies managed to sneak onto the course and play a few holes when no one was around. At eighteen, he learned of a public course, City Park in New Orleans, where blacks were allowed to play on Mondays. He and his friends drove all night Sundays to tee off early on Monday morning and play all day for $3.

At Park City, Brown regularly beat older black golfers, who told him about the Lone Star Open in Houston, an annual tournament coordinated by the United Golfers Association (UGA), the national clearinghouse for regional black tournaments at the time. Financed by some of the white golfers at Livingston in 1954, Brown came in second in the Lone Star Open to Charlie Sifford, a young golfer who was beginning to make his name on the UGA Tour. Brown went on to win this tournament four straight years.

In 1956, financed by Rudolph Wallace, a well-to-do black businessman, Brown traveled to Detroit in hopes of playing more tournament golf. There he contracted a form of polio, and for a year was hospitalized and told that he would not play golf again.

He returned to Jackson, where he regained his health and his golf game, and in 1961 and 1962 won the annual UGA Open. He won the Michigan City Open in 1962, and in 1963 gained his PGA class "A" certification. In 1964 he won the Wako-Turner Open in Oklahoma, a satellite tournament, becoming the first black golfer to win a PGA-sanctioned event. Brown went on to compete on the PGA Tour for the next fifteen years, winning the Andy Williams San Diego Open in 1970.

Brown competed on the PGA Senior Tour sporadically in the early 1980s and became the manager of Madden Golf Course, a municipally run course in Akron, Ohio.

REFERENCE

La Marr, C. L. "Black Pros." *Black Sports* (July 1973), 36–37.

Lawrence Londino

Brown, Ronald H. (August 1, 1941–), politician. Born in Washington, D.C., to William H. and Gloria Osborne Carter Brown, Ronald Brown graduated from Middlebury College in 1962 and joined the U.S. Army. He served from 1963 to 1967 and was discharged with the rank of captain. In 1970, he graduated from St. John's University School of Law and went to work at the NATIONAL URBAN LEAGUE, where he served as general counsel, chief Washington spokesperson, deputy executive director, and vice-president of Washington operations from 1968 to 1979. In 1980, Brown became chief counsel to the U.S. Senate Judiciary Committee, and in 1981 he was general counsel and staff director for Sen. Edward M. Kennedy.

Brown joined a private law practice for the first time in 1981, when he became a partner in the Washington firm of Patton, Boggs, and Blow. His desire to return to politics was realized in 1989 when the Democrats selected him as their national chairman, the first African American to chair a major political party. Brown was assigned the task of rebuilding a dispirited party after the unsuccessful presidential campaign of 1988. His diplomacy and organizational skills were praised by both participants and observers following the 1992 Democratic National Convention in New York. In 1993, he was appointed secretary of commerce by President Bill Clinton.

REFERENCE

Who's Who Among Black Americans, 1990–91. Detroit, 1990.

Christine A. Lunardini

Brown, Roscoe Conkling, Jr. (March 9, 1922–), educator. Roscoe Brown, Jr., was born in Washington, D.C. He attended Dunbar High School, a segregated academic high school in Washington also attended by such significant black figures as William HASTIE, Charles DREW, and his father, Roscoe Brown, Sr. (who was to become head of the National Negro Health Movement in ROOSEVELT'S BLACK CABINET). After graduating from Dunbar in 1939, the younger Brown went to Springfield College in Massachusetts, graduating as valedictorian in 1943.

That year, Brown enlisted in the Army Air Force. He was commissioned a second lieutenant in March 1944, and in July joined the 100th Fighter Squadron in Italy. From July 1944 to May 1945 he flew sixty-eight combat missions and was credited with one of the first downings of a German jet. Near the end of the war, Brown was promoted to captain and served as squadron commander of the 100th Fighter Squadron of the 332nd Fighter Group. For his achievements in combat he was awarded the Distinguished Flying Cross and the Air Medal with eight oak-leaf clusters.

After leaving the service, Brown worked as a social investigator for the New York Department of Welfare before accepting a position in September 1946 at West Virginia State College as a teacher and basketball coach. Two years later, he was awarded a Rosenwald Foundation grant to attend graduate school at New York University. He received a Ph.D. in education in 1951 and accepted a teaching position at NYU, where in 1964 he established and became director of the Institute for African-American Affairs, a position he held until 1977. While at NYU he wrote and edited four books, including *Negro Almanac* (1967), and hosted three major New York television series, one of which, *Black Arts,* received an Emmy Distinguished Program Award in 1973.

In 1977 Brown became president of Bronx Community College in New York, where he remained until his retirement in 1993. From 1985 to 1993, he also served as president of One Hundred Black Men, helping to make the organization a major advocacy force for African Americans in New York. In the fall of 1993, he accepted a position as university professor at the Graduate Center of the City University of New York.

REFERENCE

Low, W. Augustus, and Virgil A. Cliff, eds. *Encyclopedia of Black America*. New York, 1981.

JACK SALZMAN

Brown, Roscoe Conkling, Sr.

Brown, Roscoe Conkling, Sr. (October 14, 1884–December 28, 1962), public health leader. Roscoe Conkling Brown was born in Washington, D.C., to John Robert and Blanche Maguire Brown. He graduated from M Street (later Dunbar) High School (1903) and the Dental School of Howard University (1906). From 1907 to 1915, he practiced dentistry in Richmond, Va., taught chemistry at Virginia Union College, wrote health articles, and helped develop the first public health nursing program in the state.

During World War I, Brown served under the Surgeon General of the Army and his travels in the United States and South America convinced him of the widespread health problems of African Americans. He gave up his private dental practice for a long career (1919–1954) in the U.S. Public Health Service, where he held such titles as Chief of the Office of Negro Health Work and Chief of the Special Programs Branch. While in the Service, Brown was instrumental in having National Negro Health Week transferred from the Tuskegee Institute to the Public Health Service, in 1921, and worked on turning the Health Week into a constant yearlong program to be implemented by state and city administrators.

Brown was affiliated with numerous organizations, including the Works Progress Administration (later WORKS PROJECT ADMINISTRATION), National Negro Student Health Association, National Medical Association, NAACP, and many other health, educational, and fraternal societies. His awards included a gold medal for emergency service in World War I (1918), an Alumni Award from Howard University (1946), and a National Dentistry Association Bronze Plaque (1956). He was also a member of President Franklin D. Roosevelt's informal black cabinet.

After his retirement from the Health Service, Brown continued to agitate for greater public awareness about health issues in the African-American community, writing articles, scripts, and even poetry on the subject. His pioneering service as a health leader earned him the title, "Mr. Public Health."

REFERENCE

"Portrait of a Pioneer: Biography and Odyssey of Dr. Roscoe Conkling Brown." In *Obituaries on File*. New York, 1979.

DEREK SCHEIPS

Brown, Ruth

Brown, Ruth (1928–), popular singer. Born in Portsmouth, Va., where her father conducted a church choir, Brown grew up in a musical family. Though Brown gained her early singing experience in church, she was to make her mark as a singer of RHYTHM AND BLUES. She sang briefly with Lucky Millinder in 1948 and came to New York City the following year. She soon became a leading performer of R&B, recording over eighty sides for Atlantic Records in the late 1940s and '50s. Her bluesy style was featured on a number of hit recordings, including "So Long" (1949), "Teardrops from My Eyes" (1950), "5–10–15 Hours" (1952), and "Mama He Treats Your Daughter Mean" (1953). Her popularity crested in the middle of the 1950s, and by the early 1960s she was working as a domestic and a bus driver to support herself. Brown's career resumed in the late 1980s, and she received a Tony Award in 1989 for her role in *Black and Blue* and a Grammy Award the same year for her album *Blues on Broadway*. The next year she began to host a syndicated radio program, "Blues Stage," featuring blues performers. "Miss Rhythm," as she was popularly known, was one of the most bluesy and soulful of R&B performers of the early 1950s.

REFERENCES

Ebony (May 1952): 53.
Sepia (May 1957): 26–30.

CHRISTINE A. LUNARDINI

Brown, Samuel Joseph, Jr.

Brown, Samuel Joseph, Jr. (April 16, 1907–), artist and educator. Samuel Brown was born in Wilmington, N.C. but grew up in Philadelphia. His interest in working as an artist developed early, and he worked as a silkscreen printer during his high school years. He attended the Pennsylvania Museum and School of Industrial Art (now the Philadelphia College of Art) from 1926 to 1930, where he studied public school art education. He later received an M.F.A. degree from the University of Pennsylvania. Brown taught art in technical high schools in Philadelphia and Camden, N.J., until 1971.

From 1933 to 1935 Brown created watercolors for the Philadelphia regional office of the WORKS PROJECT ADMINISTRATION (WPA). His work was displayed at a 1934 Public Works Administration exhibit at the Corcoran Gallery of Art in Washington, D.C., and he was the only African-American artist whose work was included in the Museum of Modern Art's 1939 show, "New Horizons in American Art," an exhibition of WPA art.

Brown has worked in several media, including painting, sculpture, and prints. His oeuvre includes historical scenes and abstract images (*Abstraction #1,* c. 1934), but he is probably best known for the dignified strength of his portraits, which were characterized by his use of exaggeration and distortion of faces and bodies in order to evoke a sense of pain and struggle (*Mrs. Simmons,* 1936; *The Twins,* 1945). Brown has exhibited at the Philadelphia College of Art, Howard University, Philadelphia Museum of Art, and the Baltimore Museum of Art. A retrospective of Brown's work was shown at the Balch Institute for Ethnic Studies in Philadelphia in 1983.

REFERENCES

The Barnett-Aden Collection. Exhibition catalogue. Washington, D.C., 1974.

PORTER, JAMES. A. *Modern Negro Art.* New York, 1943.

REYNOLDS, GARY A., and BERYL WRIGHT. *Against the Odds: African-American Artists and the Harmon Foundation.* Princeton, N.J., 1989.

JANE LUSAKA

Brown, Sterling Allen (May 1, 1901–January 13, 1989), poet, scholar. Sterling A. Brown, who expressed the humor and resilience of the black folk tradition in his poetry, teaching, and public persona, was born on the HOWARD UNIVERSITY campus. Except for a few years spent elsewhere as student and teacher, he remained at Howard most of his life. His father, Sterling Nelson Brown, born a slave, became a distinguished clergyman in Washington, D.C., as pastor of the Lincoln Temple Congregational Church and professor of religion at Howard, beginning in the 1890s. Rev. Brown died shortly before his son followed his example by joining the Howard faculty in 1929, a post that he held until his retirement forty years later, in 1969.

As a youngster Brown attended the Lucretia Mott School and Dunbar High School, which was generally acknowledged as the finest black high school in the country. Upon graduation Brown accepted the scholarship that Williams College in Massachusetts offered to the Dunbar valedictorian each year. At Williams he joined the debating team, earned Phi Beta Kappa membership, and became the doubles tennis partner of Allison Davis, subsequently a distinguished social scientist and University of Chicago professor. After graduating from Williams in 1922, Brown earned his master's degree in English from Harvard University the following year. Before returning to Howard in 1929, he taught for three years

Sterling Brown, poet, critic, and anthologist, was one of the first scholars to study the history of African-American literature systematically. He taught for many years at Howard University, where he was photographed. (Moorland-Spingarn Research Center, Howard University)

at Virginia Seminary in Lynchburg, Va., for two years at Lincoln University in Missouri; and for a year at Fisk University in Nashville.

Brown achieved an enduring reputation as a poet, scholar, and teacher. His most celebrated volume of poems was *Southern Road* (1932). Unlike such HARLEM RENAISSANCE contemporaries as Claude MCKAY and Countee CULLEN, who wrote sonnets imitating Keats and Shakespeare, Brown eschewed traditional high literary forms and subjects, preferring instead the folk-ballad form and taking common black people as his subjects. In this he was like Langston HUGHES. Brown was influenced by realist and narrative poets such as A. E. Housman, Edwin Arlington Robinson, and Edgar Lee Masters, as well as by African-American folklore, blues, and work songs. The characters of Brown's poems, such as Slim Greer, Scrappy, and Old Lem, are tough, worldly, and courageous. Some are fighters and troublemakers; some are pleasure-seekers or hardworking farmers; and some are victims of racist mobs. At once unsentimental and unapologetic, these charac-

ters embody the strength and forthrightness that was typical of Brown's work in every genre.

As a scholar, Brown is best remembered for two books: *The Negro in American Fiction* (1937) and *Negro Poetry and Drama* (1937). These are both exhaustive works that document the African-American presence in American literature from the beginnings to the 1930s. The former book has been especially influential as the first and most thorough work of its kind, and has been a foundation for all subsequent studies of blacks in American fiction. From 1936 through 1940 Brown served as national editor of Negro affairs for the FEDERAL WRITERS' PROJECT (FWP). In this position he was involved with reviewing how African Americans were portrayed in the publications of the FWP, especially the series of state guidebooks. Although the task was frustrating—especially where the Deep South states were concerned—the appointment reflected how highly Brown, not yet forty, was regarded. During this same period, Brown also edited, along with Arthur P. Davis and Ulysses Lee, *The Negro Caravan* (1941), which remains one of the most useful and comprehensive anthologies of African-American writing ever published. All in all, the 1930s was the most intensely productive decade of Brown's life.

As a teacher, Brown has been broadly influential. He was a pioneer in the teaching of African-American literature, and a startling number of black writers, scholars, and political figures have studied with him. Outside the classroom, Brown for many years held informal listening sessions, using his own massive record collection to introduce students to jazz, the blues, and other black musical forms. Alumni of those sessions include LeRoi Jones (Amiri BARAKA) and A. B. Spellman, both of whom subsequently wrote important books about JAZZ. Similarly, Stokely CARMICHAEL and Kwame Nkrumah were students of Brown who have often acknowledged their debt to him. His power as a teacher derived in part from his erudition but especially from his rare ability to combine the vernacular, scholarly, and literary traditions of the United States with progressive political values and a blunt, unpretentious personal style.

Brown's literary productivity decreased after the 1940s, partly due to recurrent illnesses. He nonetheless remained active as a guest lecturer and poetry recitalist, and taught at several universities during his forty-year tenure at Howard, including Vassar College, ATLANTA UNIVERSITY, and New York University. In 1980 Michael S. HARPER edited Brown's *Collected Poems,* which was awarded the Lenore Marshall Prize for the oustanding volume of poetry published in the United States that year. Brown's memoir, "A Son's Return: 'Oh, Didn't He Ramble,' " published

in *Chant of Saints* (1979), recounts his early years, especially his life at Williams College, and is, despite its short length, one of the most compelling of African-American literary memoirs. Brown died in Takoma Park, Md.

REFERENCES

BROWN STERLING A. "A Son's Return: 'Oh, Didn't He Ramble.' " In Michael S. Harper and Robert B. Stepto, eds. *Chant of Saints.* Urbana, Ill., 1979.

GABBIN, JOANNE V. *Sterling A. Brown: Building the Black Aesthetic Tradition.* Westport, Conn., 1985.

REDMOND, EUGENE B. *Drumvoices: The Mission of Afro-American Poetry.* Garden City, N.Y., 1976.

STUCKEY, STERLING. "Introduction." In Michael S. Harper, ed. *The Collected Poems of Sterling A. Brown.* New York, 1980.

DAVID LIONEL SMITH

Brown, William Anthony "Tony" (April 11, 1933–), television producer. Tony Brown was born in Charleston, W. Va. After graduating from high school, he served in the Army from 1953 to 1955. He entered Detroit's Wayne State University in 1955, earning his B.A. degree in 1959 and an M.S.W. degree in 1961. He then began practicing as a psychiatric social worker and wrote columns occasionally for the Detroit *Journal,* an African-American newspaper, eventually becoming the paper's city editor. He established a reputation as an outspoken champion of African Americans in broadcast and print media during the late 1960s as president of the National Association of Black Media Producers. In 1972, Brown became the first dean of Howard University's School of Communications. He held his position until 1974.

In 1970, Brown was hired as executive producer of the African-American public-affairs program BLACK JOURNAL, which had been conceived in 1968 by executives of National Educational Television (NET), but had suffered from internal dissent and the departure of two producers in as many years. *Black Journal* initially aroused controversy among viewers who thought the program had a black nationalist agenda, and Brown encountered difficulties in selling the show to some southern and rural markets. Nevertheless, the show was a success and picked up its major corporate sponsor, PepsiCo, in 1976. *Black Journal* became *Tony Brown's Journal* in 1978 and has continued successfully in the 1990s on more than 250 public broadcasting stations nationwide.

Brown has been a controversial figure within the black community for his long-standing advocacy of such issues as economic nationalism (see BLACK

NATIONALISM) and for questioning the direction of the CIVIL RIGHTS MOVEMENT and the leadership of groups such as the NAACP. In 1985, *Tony Brown's Journal* criticized the film *The Color Purple,* arguing that the movie depicted black men in a stereotypical way and chided the novel's author, Alice WALKER, for creating characters that divided black women from black men. Brown has also hosted a number of programs on AIDS that questioned the link between the disease and the human immunodeficiency virus (HIV). Brown has consistently used his media exposure to further interest in historically black colleges and universities. In 1980, Brown formed the Coalition for Black Colleges to organize Black College Day, which drew 20,000 supporters to Washington, D.C., on September 29 for a march and rally.

Brown founded Tony Brown Productions in New York City in 1977. A syndicated column, "Tony Brown's Comments," ran in several African-American newspapers. Brown also published *Tony Brown's Journal* (1983–), a quarterly magazine based on the television show.

In 1985, Brown initiated the "Buy Freedom" campaign in Cleveland, Ohio, which urged African Americans to keep at least 50 percent of the $250 billion they earned annually within their own communities. True to his philosophy of self-help, Brown hired a mostly African-American cast and crew for his 1989 film, *The White Girl* (a slang term for cocaine). In 1991, Brown joined the REPUBLICAN PARTY, claiming they offered a more realistic view of African-American economic problems than the Democrats.

A sought-after keynote speaker, Brown received the Beverly Hills/Hollywood NAACP's Special Image Award in 1988 and the American Psychiatric Association's Solomon Carter Fuller Award for "pioneering efforts in education, broadcasting, and movie distribution" in 1989. In 1993, the International Academy of Achievement of the Sales and Marketing Executives International (SMEI) honored Brown's efforts with its Ambassador of Free Enterprise Award, citing his commitment to community leadership and the ideal of self-help.

REFERENCES

DUPREE, ADOLPH. "Business More Than Usual: A Day with Tony Brown." *about . . . time,* 17, no. 8 (August 1989).

"Mr. Black Journal." *Sepia* (March 1972): 51–58.

LYDIA MCNEILL

Brown, William Wells (c. 1814–1884), novelist and historian. Born in Kentucky around 1814, William Wells Brown was the son of a slave woman

and a white relative of her owner. The diverse jobs that Brown filled as a youth gave him the rich first-hand knowledge of the slave-era South that informs his autobiographical and fictional narratives. Moreover, it was while working for a printer named Elijah Lovejoy (who was later murdered by antiabolitionists) that he took his first halting steps toward literacy.

Brown escaped from slavery in January 1834. During his flight, he received aid from an Ohio Quaker named Wells Brown, whose name he subsequently adopted in the course of defining his new identity as a free man. Brown settled in Cleveland, where he married Elizabeth Schooner, a free black who bore him three children, two of whom—Clarissa and Josephine—survived to adulthood. Brown's antislavery activities began during these years as he helped numerous fugitive slaves escape to Canada. After moving to Buffalo, he continued his participation in the UNDERGROUND RAILROAD and also spoke publicly on behalf of abolition, women's rights, peace, and temperance. By 1847 Brown had settled in Boston, where he published *Narrative of William W. Brown, a Fugitive Slave* to considerable success.

In 1849 Brown traveled to Europe to attend the Paris Peace Congress and to solicit support for American abolition. While abroad, he delivered over a thousand speeches and wrote some of his most important work, including the first African-American travelog, *Three Years in Europe; or, Places I Have Seen and People I Have Met* (1852; issued in the U.S. in 1855 as *The American Fugitive in Euope*). In 1853 he published in London what has long been considered the first African-American novel, *Clotel; or The President's Daughter: A Narrative of Slave Life in the United States* (revised and reprinted three times in United States under different titles). After leaving Europe in 1854, when supporters purchased his freedom from Enoch Price, his last master, Brown turned to drama, producing the satirical *Experience; or, How to Give a Northern Man a Backbone* in 1856 and, in 1858, *The Escape; or, A Leap for Freedom,* the first play published by an African American.

Brown's wife had died during his European sojourn, and in 1860 he married Annie Elizabeth Gray. Meanwhile he continued his political and literary activities, supporting black recruitment efforts during the CIVIL WAR and writing *The Black Man: His Antecedents, His Genius, and His Achievements* (1863), ten editions of which appeared within three years. His other historical works include *The Negro in the American Rebellion: His Heroism and His Fidelity* (1867), a landmark study of blacks in the Civil War, and *The Rising Son; or The Antecedents and Advancement of the Colored Race* (1874). His final book—*My Southern Home; or, The South and Its People*—appeared in 1880.

William Wells Brown. (Photographs and Prints Division, Schomburg Center for Research in Black Culture, The New York Public Library, Astor, Lenox and Tilden Foundations)

Brown died in 1884, after working for much of his later life as a physician in the Boston area.

If his fiction is sometimes overly sentimental and structurally flawed and his histories can be insufficiently documented and repetitive, Brown's writing also manifests a sharp eye for telling detail, a skilled use of irony, and a clear, accessible prose style. Above all, he was an extraordinary pioneer; as such, he holds a crucial place in the African-American literary tradition.

REFERENCE

FARRISON, WILLIAM EDWARD. *William Wells Brown: Author and Reformer.* Chicago, 1969.

RICHARD YARBOROUGH

Brown, Willie Lewis, Jr. (March 20, 1934–), politician. Willie Brown was born and raised in Mineola, Tex. After graduating from high school in 1951,

he moved to San Francisco, where he received a B.A. from San Francisco State University in 1955 and a J.D. from the Hastings College of Law in 1958. In 1959 Brown opened the law firm of Brown, Dearman, and Smith.

In 1964 Brown was elected to the California state assembly. In 1974 he unsuccessfully campaigned to become speaker of the assembly; he won the post in 1980, becoming the first African American to hold what is one of the most powerful positions in California politics. Since then Brown has established himself as the most prominent and influential black politician in the state. Although his early, left-liberal politics were toned down upon his rise to the speakership, Brown has consistently championed California's public education system and supported minority, gay, reproductive, and workers' rights.

Despite his credentials as a populist defender of liberal reforms, Brown has been criticized for his expensive taste in clothes and cars, and his various alliances of convenience with Republican politicians and big business. As senior partner of Brown, Dearman, and Smith, his clients have included some of California's most powerful businesses, and Brown has often been charged with conflict of interest, particularly when he has endorsed tax breaks for corporations and real estate developers. In 1984 Republican opponents took advantage of Brown's image as an opportunist and autocrat by sponsoring Proposition 24, which would have significantly reduced the

Speaker of the California Assembly from 1980 to 1995, Willie Brown, a master politician and expert parliamentarian, has been a dominant force in the proceedings of the California legislature. (AP/Wide World Photos)

speaker's power; but it was rejected by the state's voters.

Brown has also been an influential figure in national Democratic politics. He served as campaign chairman and raised more than $11 million for Rev. Jesse JACKSON's campaign during the 1988 primary election.

Brown was again made a target during the 1990 election, when the state's voters passed Proposition 140, limiting members of the Assembly to three two-year terms and state senators to two four-year terms. Brown thus would have had to relinquish his office by 1996 anyway, provided the law is not overturned by various pending court challenges against it.

REFERENCES

GROODGAME, DAN. "Jesse Jackson's Alter Ego." *Time* (June 13, 1988): 28.
VON HOFFMAN, NICHOLAS. "Willie Brown in Deep Doo-Doo." *Gentleman's Quarterly* (March 1990): 292–295.

THADDEUS RUSSELL

Browne, Marjorie Lee (September 9, 1914–October 19, 1979), mathematician. Marjorie Lee Browne was reared in Memphis, Tenn., by her father, Lawrence J. Lee, a railroad postal-service worker, and stepmother, Lottie Taylor Lee, a schoolteacher. Her father was an avid reader who shared with her his excitement for travel, visualization, and learning through the written word. Reading—first the classics, then mysteries—became an obsession with her and provided excellent preparation for the development of the analytic reasoning skills she would later employ in her mathematical studies. She was an excellent tennis player, and won many City of Memphis women's singles tennis championships. She was also a singer of some repute and a lover of music, as well as a gifted mathematics student.

Browne was a 1935 cum laude graduate of Howard University and received master of science (1939) and Ph.D. (1949) degrees in mathematics from the University of Michigan. She was one of the first two African-American women to receive a Ph.D. in mathematics (the other was Evelyn Boyd GRANVILLE from Yale). Her teaching career at North Carolina Central University in Durham spanned thirty years (1949–1979), and under her leadership as mathematics department chairman (1951–1970), the university achieved many firsts. In 1961, she received a $60,000 IBM educational grant to establish the first academic computer center at the university; in 1969, she received the first of seven Shell Foundation scholarship grants for outstanding mathematics students.

Browne directed the first National Science Foundation (NSF) Undergraduate Mathematics Research Participation Program (1964–1965), and was a principal investigator, coordinator of the mathematics section, and lecturer in thirteen NSF Institutes for Secondary School Teachers of Science and Mathematics (1957–1971).

In 1974, the North Carolina Council of Teachers of Mathematics awarded Browne the first W. W. Rankin Memorial Award for Excellence in Mathematics Education in recognition of her efforts in improving the quality of the mathematics preparation of secondary-school teachers in the state. She was one of six African-American women included in the 1981 Smithsonian traveling exhibition "Black Women: Achievements Against the Odds."

Pursuing what she would later call "the life of an academic nomad," she completed four postdoctoral fellowship programs that included studies and research in combinatorial topology (her specialty), the applications of mathematics in the behavioral sciences, numerical analysis and computing, differential topology, Lie groups, and Lie algebras. These activities were undertaken at universities in this country and abroad, including Cambridge University (1952–1953), Stanford University (summer 1957), UCLA (1958–1959), and Columbia University (1965–1966).

Browne's published works include "A Note on the Classical Groups" (*Mathematical Monthly,* August 1955) and four manuscripts: "Sets, Logic and Mathematical Thought," 1957; "Introduction to Linear Algebra," 1959; "Algebraic Structures," 1964; and "Elementary Matrix Algebra," 1969. At the time of her death in 1979, she was pursuing a research project titled "A Postulational Approach to the Development of the Real Number System."

During the 1950s, Browne was an ardent advocate for the integration of the previously segregated professional organizations in which she held membership, including the North Carolina Teachers Association, the Mathematical Association of America, and the American Mathematical Society. She also held membership in Beta Kappa Chi, the Society of Sigma Xi, Pi Lambda Theta Honorary Societies, the Woman's Research Society, and Alpha Kappa Alpha Sorority. She was a faculty consultant in mathematics with the Ford Foundation (1968–1969) and served three terms as a member of the advisory panel to the NSF Undergraduate Scientific Equipment Program (1966, 1967, and 1973). In 1979, four of her former students established the Marjorie Lee Browne Trust Fund at North Carolina Central University to support the Marjorie Lee Browne Memorial Scholarship, awarded annually to a mathematics student who best exemplifies those traits that Browne sought to instill in young people.

Browne was a mathematical purist who, like many great mathematicians of the nineteenth century, viewed mathematics as an art form, as an intellectual quest, free from the limitations of the physical universe, in search simply for truth and beauty.

WILLIAM T. FLETCHER

Brown Fellowship Society. An elite social club and mutual-aid society founded on November 1, 1790, by five free mulattoes in CHARLESTON, S.C., the Brown Fellowship Society symbolized the existence of class and color consciousness within Charleston's African-American community.

Membership in the society was not to exceed fifty persons and was limited to "free brown men" and their descendants who could afford the $50 membership fee. Traditional lore claims that no person whose skin was darker than the door of the meetinghouse would be considered for membership. Many of the society's members were skilled craftsmen who had developed significant contacts with influential white Charlestonians, and some were slave owners who further identified with the values of the antebellum white aristocracy. This association with prominent whites was reflected in the bylaws of the organization, which prohibited the discussion of controversial subjects such as slavery.

At the same time, the Brown Fellowship Society reflected the desire of Charleston's free blacks to control important aspects of their own lives. Operating under the motto "Charity and Benevolence," the society not only provided a school for its members and their families but also subsidized the Minors' Moralist Society for the education of impoverished free black children. It paid insurance and death benefits to the widows and orphans of deceased members and oversaw the burial of dead members in a private cemetery maintained by the society. In addition, the society served its members as a bank by extending loans at the interest rate of 20 percent.

The organization changed its name in 1890 to the Century Fellowship Society and added a women's auxiliary (the Daughters of the Century Fellowship Society) in 1907. Although little is known of the organization's later history, it continued to operate well into the twentieth century and maintained its character as a socially exclusive institution within Charleston's African-American community.

REFERENCES

FITCHETT, E. HORACE. "The Traditions of the Free Negro in Charleston, South Carolina." *Journal of Negro History* 25 (April 1940): 139–152.

WIKRAMANAYAKE, MARINA. *A World in Shadow: The Free Black in Antebellum South Carolina.* Columbia, S.C., 1973.

JAMES M. SORELLE

Brownsville, Texas, Incident. On the night of August 13, 1906, some 250 rounds of ammunition were fired into several buildings in Brownsville, Tex. One man was killed and two others were wounded. The townspeople's suspicions immediately fell upon the members of Companies B, C, and D of the First Battalion of the United States 25th Infantry, Colored. The African-American soldiers had arrived sixteen days before the shooting and were stationed at Fort Brown, just outside of town and near the site of the incident. Tensions between the black troops and some openly racist Brownsville residents flared. Although the soldiers and their white commander consistently denied any knowledge of the "raid," as it came to be called, subsequent investigations sustained the townspeople's opinion of their guilt.

President Theodore Roosevelt appointed an assistant inspector general to investigate. Two weeks later the inspector reported that it "can not be doubted" that the soldiers were guilty but that their white officers were not responsible. He recommended that "all enlisted men" be discharged from service because some of the soldiers "must have some knowledge of the guilty parties." Roosevelt then appointed Gen. E. A. Garlington inspector general to discover the guilty soldiers; all continued to proclaim their innocence. In his report, Garlington referred to "the secretive nature of the race, where crimes charged to members of their color are made." By the end of November all soldiers in the battalion were discharged without honor from the U.S. Army, because no one would point a finger at the supposed guilty parties. Those who were able to prove their innocence of participation in the raid were allowed to reenlist, and fourteen did so.

However, when an interracial civil rights organization, the Constitution League, reported to Congress that the evidence demonstrated the innocence of the soldiers, Senate hearings were held and Brownsville became a national issue. In March 1910 a Senate committee issued a majority report concluding that the shooting was done by some of the soldiers, who could not be identified, and upheld the blanket discharge of the battalion. Two minority reports were also issued. The first asserted that there was no evidence to indict any particular soldier, and that therefore there was no justification for discharging the entire battalion. The second minority report

argued that the weight of the testimony showed that *none* of the soldiers participated in the shooting. Military courts-martial of two white officers found them not guilty of responsibility for the affray.

The incident had assumed national importance largely because Sen. Joseph Benson Foraker of Ohio charged that Theodore Roosevelt had allowed a decision based on flimsy evidence to stand. Thus, the Brownsville affray became an issue in Foraker's lengthy but ultimately unsuccessful campaign against Roosevelt for the 1908 presidential nomination.

The Brownsville incident also divided the African-American community. A split in 1905 that had resulted in the establishment of the anti–Booker T. WASHINGTON group, the NIAGARA MOVEMENT, forerunner to the NATIONAL ASSOCIATION FOR THE ADVANCEMENT OF COLORED PEOPLE (NAACP), sharpened appreciably. Washington's unwillingness to criticize Roosevelt publicly—although privately he tried to dissuade the president from discharging the soldiers—induced many of his previous supporters to desert him. On the Brownsville issue, the division soon became those committed to the Republican party versus everyone else.

It is possible that some of the soldiers of the Twenty-fifth Infantry were guilty of the attack; it is also possible they were not. What is clear is that the soldiers were not proved guilty. When the incident was over, Roosevelt and Washington, if not unscathed, at least survived. Foraker risked his career on a bid for the presidency and lost. The black community lapsed into political silence. The soldiers of the Twenty-fifth remained penalized until 1973, when they were granted honorary discharges. Only one soldier was still alive.

REFERENCES

LANE, ANN J. *The Brownsville Affair: National Crisis and Black Reaction.* Port Washington, N.Y., 1971.
TINSLEY, JAMES A. "Roosevelt, Foraker and the Brownsville Affray." *Journal of Negro History* 41 (January 1956): 43–65.

ANN J. LANE

Brown v. Board of Education of Topeka, Kansas.

Brown, 347 U.S. 483 (1954), was the most important legal case affecting African Americans in the twentieth century and unquestionably one of the most important Supreme Court decisions in U.S. constitutional history. Although directly involving segregated public schools, the case became the legal underpinning for the CIVIL RIGHTS MOVEMENT of the 1950s and 1960s and the dismantling of all forms of statutory SEGREGATION.

Brown combined separate cases from Kansas, South Carolina, Virginia, and Delaware that turned on the meaning of the FOURTEENTH AMENDMENT's requirement that states not deny their citizens "equal protection of the law." The Court also heard a similar case from Washington, D.C., *Bolling* v. *Sharpe,* which involved the meaning of the Fifth Amendment's due process clause.

In 1954, laws in eighteen states plus the District of Columbia mandated segregated schools, while other states allowed school districts to maintain separate schools if they wanted to do so. Although theoretically guaranteeing blacks "separate-but-equal" education, segregated schools were never equal for blacks. Linda Brown, whose father, Rev. Oliver Brown, sued the Topeka, Kans., school system on her behalf, had to travel an hour and twenty minutes to school each way. If her bus was on time, she was dropped off at school a half hour before it opened. Her bus stop was six blocks from her home, across a hazardous railroad yard; her school was twenty-one blocks from her home. The neighborhood school her white playmates attended was only seven blocks from her home, and required neither bus nor hazardous crossings to reach. The *Brown* companion cases presented segregation at its worst. Statistics from Clarendon, S.C., where one of the cases began, illustrate the inequality of separate but equal. In 1949 and 1950, the average expenditure for white students was $179, but for blacks it was only $43. The county's 6,531 black students attended school in 61 buildings valued at $194,575; many of these schools lacked indoor plumbing or heating. The 2,375 white students in the county attended school in twelve buildings worth $673,850, with far superior facilities. Teachers in the black schools received, on average, salaries that were one-third less than those of teachers in the white schools. Finally, Clarendon provided school buses for white students in this rural county but refused to provide them for blacks.

The plaintiffs could easily have won orders requiring state officials to equalize the black schools, on the grounds that education was separate but *not* equal. Since the 1930s the Court had been chipping away at segregation in higher education, interstate transportation, housing, and voting. In *Brown* the NAACP Legal Defense Fund, led by Thurgood MARSHALL, decided to directly challenge the whole idea of segregation in schools.

Marshall's bold challenge of segregation per se led the Court to reconsider older cases, especially PLESSY V. FERGUSON, that had upheld segregation. The Court was also compelled to consider the meaning of the Fourteenth Amendment, which had been written at a time when most states allowed some forms of segregation and when public education was undevel-

oped in the South. The Court ordered attorneys for both sides to present briefs and reargument on these historical matters. In the end, the Court found the historical argument to be

> at best . . . inconclusive. The most avid proponents of the post-War Amendments undoubtedly intended them to remove all legal distinctions among "all persons born or naturalized in the United States." Their opponents, just as certainly, were antagonistic to both the letter and the spirit of the Amendments. . . . What others in Congress and the state legislatures had in mind cannot be determined with any degree of certainty.

After reviewing the histories of the Fourteenth Amendment, public education, and segregation, Chief Justice Earl Warren, speaking for a unanimous Court, concluded, "In approaching this problem, we cannot turn the clock back to 1868 when the Amendment was adopted, or even to 1896 when *Plessy* v. *Ferguson* was written. We must consider public education in the light of its full development and its present place in American life throughout the Nation." Warren found that "in the field of public education the doctrine of 'separate but equal' has no place. Separate education facilities are inherently unequal." *Brown* did not technically overturn *Plessy* (which involved seating on railroads) or the separate-but-equal doctrine. But that technicality was unimportant. *Brown* signaled the end to the legality of segregation. Within a dozen years the Supreme Court would strike down all vestiges of legalized segregation.

Brown did not, however, lead to an immediate end to segregated education. The Court instead ordered new arguments for the next year to determine how to begin the difficult social process of desegregating schools. The NAACP urged immediate desegregation. However, in a second case, known as *Brown II* (1955), the Court ordered its mandate implemented with "all deliberate speed," a process that turned out to be extraordinarily slow. Linda Brown, for example, did not attend integrated schools until junior high; none of the plaintiff children in the Clarendon County case ever attended integrated schools.

REFERENCES

FINKELMAN, PAUL, ed. *Race Law and American History*. Vol. 7, *The Struggle for Equal Education*. New York, 1992.
KLUGER, RICHARD. *Simple Justice*. New York, 1975.
TUSHNET, MARK. *The NAACP's Campaign Against Segregated Education*. Chapel Hill, N.C., 1987.

PAUL FINKELMAN

Bruce, Blanche Kelso (March 1, 1841–March 17, 1898), politician. Blanche K. Bruce was the second African American to be elected to the U.S. Senate, and the first to serve an entire six-year term. Born a slave on a plantation near Farmville, Prince Edward County, Va., he enjoyed an unusually privileged upbringing. His mother, Polly, was a slave owned by Pettus Perkinson, who may have been Bruce's father. Perkinson took an interest in Bruce and allowed him to be educated by his son's tutor. While growing up, Bruce moved with Perkinson and his family several times between Virginia, Missouri, and Mississippi. By all accounts, his childhood was pleasant, comfortable, and virtually free from punishment.

Nevertheless, Bruce refused to accept his status as a slave. At the beginning of the CIVIL WAR, he ran away to Kansas. In Lawrence, Kans., he founded and taught in a school for black refugees. In 1864 he moved to Hannibal, Mo., where he started the state's first school for blacks, and apprenticed briefly to a printer. After studying at Oberlin College in Oberlin, Ohio, in 1866, Bruce returned to Missouri to work as a porter on a steamboat.

Born a Mississippi slave, Blanche K. Bruce was the first African American to serve a full term in the U.S. Senate. After Reconstruction he left Mississippi politics and moved to Washington, D.C., where he became a leader of that city's black social elite. (Prints and Photographs Division, Library of Congress)

Like many ambitious blacks and whites, Bruce recognized that the South during RECONSTRUCTION offered many opportunities for both political power and economic advancement. He settled in Mississippi in 1869 and immediately became active in the state's Republican party. Bruce served in a series of appointive public offices, including voter registrar for Tallahatchie County, sergeant-at-arms of the state senate, and tax assessor for Bolivar County. Gaining a reputation for honesty and efficiency, he was elected sheriff and tax collector of Bolivar County in 1871. Bruce also filled positions as county superintendent of education and as a member of the district board of levee commissioners. In addition to his electoral base among black voters, Bruce won the support of many white planters for his competence and promotion of political and economic stability. The dominant political figure in Bolivar County, Bruce also became an important landowner, with a 640-acre plantation and city lots in the county seat of Floreyville.

Bruce was elected to the U.S. Senate in 1874, taking office on March 5, 1875. He served on the Pensions, Manufactures, and Education and Labor committees, as well as on the select committee on Mississippi River Improvements. As chairman of the investigating committee into the bankrupt Freedman's Savings and Trust Company, Bruce conducted an impressive inquiry into the corrupt and inept handling of nearly $57 million in deposits of former slaves. Cautious by nature and moderate politically, Bruce nevertheless often spoke and voted in defense of the rights of African Americans. At the same time, he believed that blacks were best advised to pursue advancement through education and self-help. He opposed the mass movement of African Americans from the South to Kansas, as well as efforts to promote emigration to Liberia. Nevertheless, he reminded southern conservatives that the exodus was prompted by increasingly hostile conditions in the former slave states, and he sponsored legislation to aid EXODUSTERS suffering hardships in Kansas.

Bruce was cultured and intelligent, with refined manners and shrewd political judgement. In Washington, the light-skinned and sophisticated senator moved easily in elite circles, both black and white. On June 24, 1878, he married the elegant and beautiful Josephine Willson, daughter of a prominent Cleveland dentist. At first, the couple associated with the leading members of white Washington society, as well as with leading blacks. However, after Bruce left the senate in 1881 and as the color line in the capital began to harden, they had less contact with whites, becoming mainstays of Washington's African-American "aristocracy." The Bruce's only child, Roscoe Conkling Bruce (April 21, 1879–August 16, 1950) later became a prominent educator and manager of the famous Dunbar Apartments in Harlem.

By the end of Bruce's term in the senate, Democrats dominated Mississippi, and no Republican could hope to win a state election. By retaining control of the state's Republican party, however, Bruce remained an important figure in national party affairs. He served as register of the treasury under presidents Garfield, Arthur, and McKinley (1881–1885 and 1897–1898), and as recorder of deeds for the District of Columbia under Harrison (1889–1893), two of the highest patronage positions in the federal government traditionally reserved for blacks. A member of the boards of the Washington public schools and HOWARD UNIVERSITY, Bruce was also a sought-after lecturer, amassed close to 3,000 acres of land in the Mississippi Delta, and operated a successful agency in Washington for financial investment, claims, insurance, and real estate. In 1895, he was worth an estimated $150,000, making him one of the wealthiest men in the capital.

Bruce died after years of deteriorating health.

REFERENCES

GATEWOOD, WILLARD B. *Aristocrats of Color*. Bloomington, Ind., 1990.

HARRIS, WILLIAM C. "Blanche K. Bruce of Mississippi: Conservative Assimilationist." In Howard N. Rabinowitz, ed. *Southern Black Leaders of the Reconstruction Era*. Urbana, Ill., 1982.

SHAPIRO, SAMUEL L. "Blanche Kelso Bruce." In *Dictionary of American Negro Biography*. New York, 1982.

DANIEL SOYER

Bruce, John Edward (February 22, 1856–August 7, 1924), journalist, historian. John Edward Bruce, who achieved a wide reputation as a journalist under the pseudonym of "Bruce Grit," was born into slavery in Piscataway, Md. His father was sold when he was three, and Bruce and his mother were subsequently sent to Fort Washington, where his mother served as a cook for the Marines. In 1860, while following soldiers marching from Maryland to Washington, D.C., Bruce and his mother were freed. While his mother found domestic work, John Bruce was educated in local public schools and by private instructors and later took a three-month college course at Howard University.

Bruce was hired as an office assistant in the Washington, D.C., correspondent's office of *The New York Times* in 1874. Shortly afterward, he began his career as a journalist and publisher. He founded three periodicals in quick succession, a Washington weekly called the *Argus* in 1879, the *Sunday Item* in 1880, and the *Washington Grit* in 1884. He also began to write commentaries for the *New York Times* and mainstream newspapers, including the *Boston Transcript*,

the *Washington Evening Star,* and the *St. Louis Globe-Democrat.* Taking the name "Bruce Grit" in 1884 for his column in the *New York Age* and the *Gazette* of Cleveland, Bruce acquired the pseudonym by which he would become widely known in his journalistic career. In addition to writing for T. Thomas FOR-TUNE's *New York Age,* Bruce also assisted Fortune throughout the 1890s as a member of the Afro-American League and the Afro-American Council.

In 1879, Bruce and Charles W. ANDERSON (Book-er T. WASHINGTON's lieutenant in the New York City Republican party) cofounded the *Chronicle* in New York City. Bruce moved to Albany, N.Y., in 1900 and later cofounded the *Weekly Standard* in Yonkers with Anderson in 1908. Despite his ties to the Washington camp, Bruce was an independent in the black political wars of the early nineteenth century. He was a sometime supporter of Washington's bitter opponent, William Monroe TROTTER, and attended the conference that founded the NIAGARA MOVEMENT in 1905. Around 1908 he took a job with the Port of New York Authority to have a more consistent means of financial support than his peripatetic newspaper publishing provided.

In his articles, Bruce urged black readers to take greater pride in their African ancestry. He vehemently attacked what he saw as the attempts of lighter-skinned black "aristocrats" to deny their African heritage. For instance, in an 1877 essay entitled "Colored Society in Washington," Bruce ridiculed the "colored aristocracy" for avoiding the company of darker-skinned blacks and thereby creating a "color line" within the black community itself. Bruce believed that all Americans of African descent, regardless of color, ought to be called "Negro" rather than "Afro-American" or "colored." The other terms, he thought, were attempts by the "black aristocrats," to differentiate themselves from working-class darker-skinned blacks. To reinforce racial pride among black Americans, Bruce published *Short Biographical Sketches of Eminent Negro Men and Women in Europe and the United States* in 1910 and founded the Negro Society for Historical Research with Arthur Schomburg in 1911. In 1916, he published a fiction work, *The Awakening of Hezekiah Jones,* and subsequently published such pamphlets of social commentary as *The Making of a Race* and *A Tribute for the Negro Soldier.*

A popular and powerful orator, Bruce argued for racial solidarity and self-help as the best means of combating segregation and lynching. His hopes that an Allied victory in World War I would bring African Americans greater political equality were disappointed in 1919 by the ensuing riots in East St. Louis and other cities. Bruce joined Marcus GARVEY's Universal Negro Improvement Association (UNIA), sympathetic to its antipathy toward lighter-skinned African Americans and its skepticism about the prospects for civic equality in the United States. Bruce became a contributing editor for two of the UNIA's periodicals, *The Negro World* and the *Daily Negro Times.*

Bruce retired from the Port of New York Authority in 1922 and died at Bellevue Hospital on August 7, 1924.

REFERENCES

GATEWOOD, WILLARD B. *Aristocrats of Color: The Black Elite, 1880–1902.* Indianapolis, Ind., 1990.
GILBERT, PETER, ed. *The Selected Writings of John Edward Bruce, Militant Black Journalist.* New York, 1971.

DURAHN TAYLOR

Bryan, Andrew (1737–1812), minister. Born a slave at Goose Creek, S.C., Andrew Bryan was brought to Savannah, Ga., where he was converted to the Christian religion after hearing George LIELE, a pioneering black preacher along the Savannah River plantations who had established a black Baptist church in 1777. Bryan was baptized by Liele in 1782. After Liele left for Jamaica with the evacuating British the next year, Bryan reorganized the remnant of one of Liele's congregations at nearby Yamacraw with the aid of his brother Sampson and the encouragement of Jonathan Bryan, his evangelical white master. Abraham Marshall, a white Separate Baptist minister, and Jesse Peter, a black minister, ordained Bryan in 1788, and his congregation was certified as "the Ethiopian church of Jesus Christ" and constituted as the First African Baptist Church in Savannah.

Bryan bought his freedom for £50 and also raised enough money to buy his wife's freedom and to construct a church meeting house. With 850 members by 1802 and a member of the interracial Savannah River Association, Bryan's congregation was divided to form the Second and then the Third African Baptist daughter churches. Many whites feared that Bryan's well-attended religious services, attracting mainly slaves but also some whites and free blacks, would lead to insurrection. As a result, Bryan and some church members were frequently imprisoned by the authorities and Bryan himself severely whipped; he "was cut and bled abundantly," a contemporary account reported. The church flourished, however, and Bryan continued as pastor until his death.

REFERENCE

DAVIS, JOHN W. "George Liele and Andrew Bryan, Pioneer Negro Baptist Preachers." *Journal of Negro History* 3 (1918): 119–127.

TIMOTHY E. FULOP

Bryant, Hazel (September 8, 1939–November 7, 1983), singer, actress, and producer. Born in Zanesville, Ohio, to AFRICAN METHODIST EPISCOPAL Bishop James Bryant and Edith Holland Bryant, Hazel Bryant received her early musical training in church choirs. She went on to study music at the Oberlin Conservatory, where she earned her bachelor of arts degree in 1962. After graduating, Bryant traveled to Europe, where she trained at the Mozarteum in Salzburg, Austria. She remained in Europe singing and touring for several years.

Bryant returned to the United States to pursue a career as an actor. She moved to New York City, where in 1968 she began the Afro-American Total Theater, a group dedicated to supporting blacks in every aspect of the arts from theater to film to music. During her career, Bryant acted, wrote, directed, and produced for her own company as well as other organizations, including the NEGRO ENSEMBLE COMPANY. Her plays include *Black Circles, Black Spirits* (1970), a discussion among four women in a beauty parlor on the politics of Angela DAVIS, and *Making It* (1970), the experiences of a young, small-town man as he attempts to enter show business. In 1971 Bryant was the subject of a short documentary, *Hazel, Hazel, Hazel, Hazel, Hazel.*

In 1975 Bryant began the Richard Allen Center for Culture and Art, named after the founder of the AME Church (*see* Richard ALLEN). The Richard Allen Center absorbed the Afro-American Total Theater and continued its mission of cultivating black arts. The center was situated in a succession of New York City locations until its demise in 1988. During its final years of existence, it was renamed Hazel Bryant's Richard Allen Center for Culture and Art.

Bryant had a history of heart disease, and on November 7, 1983, she became ill after giving a speech on theater arts at the United Nations. She died of heart failure later that evening at her home in New York City.

REFERENCES

PETERSON, MAURICE. "Hazel Bryant: Theatrical Innovator." *Essence* (September 1971): 31.
WILLIAMS, MANCE. *Black Theatre in the 1960s and 1970s.* Westport, Conn., 1985.

KENYA DILDAY

Bubbles, John (February 19, 1902–May 18, 1986), tap dancer. Known as "the father of rhythm tap" (*see* TAP DANCE) John Bubbles was born John William Sublett in Louisville, Ky., and raised in Indianapolis. At the age of ten, he teamed up with six-year-old Ford Lee Washington (1906–1955) in an act billed as "Buck and Bubbles." Bubbles sang and danced while Buck, standing at the piano, played accompaniment. The duo won a series of amateur-night shows, and subsequently began playing engagements in Louisville (where the two sometimes appeared in blackface), Detroit, and New York City. When Bubbles's voice changed at the age of eighteen, he focused on dancing.

Bubbles developed a new style of tapping that was spiced with extremely difficult innovations, such as double over-the-tops (normally a rough figure-eight pattern executed with the appearance of near self-tripping; Bubbles would do them with alternate legs, traveling backwards and forwards and from side to side). By 1922, Buck and Bubbles reached the pinnacle in vaudeville by playing at New York's Palace Theatre. Bypassing the black THEATRE OWNERS BOOKING ASSOCIATION (TOBA) circuit, they headlined the white-vaudeville circuit from coast to coast.

The dapper John W. Bubbles, long a successful tap dance and theatrical performer, in a photograph from 1935, shortly after he created the role of Sportin' Life in George Gershwin's *Porgy and Bess.* (Prints and Photographs Division, Library of Congress)

Their singing-dancing comedy act, in which Buck's easy piano style contrasted with Bubbles's witty explosion of taps, was featured in the *Broadway Frolics of 1922*, Lew Leslie's *Blackbirds of 1930* and the *Ziegfeld Follies of 1931*. Bubbles secured his place in Broadway history when he created the acting, singing, and dancing role of Sportin' Life in George Gershwin's opera *Porgy and Bess* in 1935.

During the 1930s Buck and Bubbles played the London Palladium, the COTTON CLUB, and the APOLLO THEATER; they were also the first black performers to appear at Radio City Music Hall, breaking color barriers in theaters across the country. Motion pictures in which they appeared include *Varsity Show* (1937), *Cabin in the Sky* (1943), *Atlantic City* (1944), and *A Song Is Born* (1948). The duo remained together until shortly before Buck's death in 1955. On his own, Bubbles appeared with Bob Hope in Vietnam and recorded several albums, including *From Rags to Riches* (1980). After being partly paralyzed by a stroke in 1967, Bubbles made one of his final public appearances as a singer in 1980 in the revue *Black Broadway*.

Bubbles's rhythm tapping, later called "jazz tap," revolutionized dancing. Before him, dancers tapped up on their toes, emphasizing flash steps (difficult, acrobatic steps with extended leg and body movements), and danced to a quicker tempo (two beats to a bar). Bubbles cut the tempo in half and extended the rhythm beyond the normal eight beats, dropped his heels, and hit unusual accents and syncopations. "I wanted to make it more complicated, so I put more taps in and changed the rhythm," said Bubbles about his style, which prepared for the new sound of bebop in the 1940s and anticipated the prolonged melodic line of "cool" jazz in the 1950s.

REFERENCES

GOLDBERG, JANE. "A Hoofer's Homage: John Bubbles." *Village Voice*, December 4, 1978.
SLIDE, ANTHONY. *The Vaudevillians: A Dictionary of Vaudeville Performers*. Westport, Conn., 1981.
SMITH, BILL. *The Vaudevillians*. New York, 1976.
STEARNS, MARSHALL, and JEAN STEARNS. *Jazz Dance: The Story of American Vernacular Dance*. New York, 1968.

CONSTANCE VALIS HILL

Buggs, Charles Wesley (August 8, 1906–), microbiologist and educator. Buggs was born in Brunswick, Ga., the son of John Wesley Buggs, a physician, and his wife, Leonora Vane Clark. After graduating in 1924 from St. Athanasius High School in Brunswick, he majored in zoology at Morehouse College and earned his A.B. in 1928. He taught at Dover State College in Delaware before entering the University of Chicago for graduate work in 1929. When his studies were interrupted due to lack of funds, he returned to teaching, this time at Douglass High School in Key West, Fla. His wife, Marguerite Lee Bennett, whom he married in 1927, worked as a housekeeper and cook to help put him through the graduate program in bacteriology at the University of Minnesota. He earned an M.S. in 1931 and, with additional support from the Julius Rosenwald Fund, a Ph.D. in 1934.

Buggs's special research interest was the resistance of bacteria to antibiotics. He conducted highly regarded studies on streptomycin, penicillin, and sulfa drugs, and developed a novel technique for treating burn and wound trauma from the inside of the skin out. A dedicated teacher, he served as professor of biology at Dillard University (1935–1943, 1949–1956); associate professor of bacteriology at the Wayne University College of Medicine (1943–1949); and professor of microbiology at Howard University (1956–1971). He was the first African American appointed to a full-time faculty position at Wayne University. In 1949, with support from the federal government, he prepared a seminal report on the inadequacy of existing opportunities, facilities, and curricula for blacks seeking a premedical education.

Following his retirement from Howard University in 1971, Buggs continued an active career in teaching and research as dean of the Faculty of Allied Health Sciences, Charles R. Drew Postgraduate Medical School, Los Angeles (1972), and professor of microbiology, California State University, Long Beach (1973–1983).

REFERENCE

BUGGS, CHARLES W. *Premedical Education for Negroes: Interpretations and Recommendations Based upon a Survey in Fifteen Selected Negro Colleges*. Washington, D.C., 1949.

PHILIP N. ALEXANDER

Buhaina, Abdullah Ibn. *See* Blakey, Art.

Bullins, Ed (July 2, 1935–), playwright. Born in Philadelphia, Pa., Ed Bullins attended public schools there and received a B.A. from Antioch University

in San Francisco, in 1989. He did graduate work at San Francisco State University. In 1976 Columbia College in Chicago awarded him an honorary Doctor of Laws degree. From 1952 to 1955 he served in the United States Navy.

During the 1960s on the West Coast, Bullins was one of the leaders of the BLACK ARTS MOVEMENT and a founder and producer from 1965 to 1967 of Black Arts/West, an African-American theater group in San Francisco. He was also a cofounder of the Black Arts Alliance and Black House, a militant cultural-political group that included Eldridge CLEAVER, Huey NEWTON, and Bobby SEALE, all three of whom later became BLACK PANTHER PARTY leaders. Bullins served briefly as minister of culture of the Black Panthers in California. He left Black House after a disagreement over ideology. As an artist, Bullins was interested in cultural awakening, whereas the revolutionaries thought that creative work should be incendiary enough to stir people to action. While he was on the West coast, some of his earliest plays were written and produced: *Clara's Ole Man* (1965),

The provocative playwright Ed Bullins is the author of the *The Taking of Miss Janie,* among other dramas. (Photographs and Prints Division, Schomburg Center for Research in Black Culture, The New York Public Library, Astor, Lenox and Tilden Foundations)

Dialect Determinism (1965), and *How Do You Do?* (1965).

At the New Lafayette Theatre in Harlem from 1968 to 1973, Bullins was playwright-in-residence and, later, associate director. He was also editor of *Black Theatre* magazine. After the New Lafayette Theatre closed, he was writer-in-residence at the American Place Theatre in 1973 and on the staff of the New York Shakespeare Festival's Writers' Unit from 1975 to 1982. Best known as a playwright, Bullins has also written fiction, poetry, and essays.

Inspired by Amiri BARAKA (LeRoi Jones), whose plays *Dutchman* and *The Slave* he saw in San Francisco during the 1960s, Bullins has written many plays on the African-American experience, dealing with ordinary African-American life and, in some cases, race relations. A pioneer interested in developing new theater forms, he writes in many styles: realism, naturalism, satire, and farce, as well as absurdist and other avant-garde methods. He has written black rituals, street-theater plays, and agitprop plays, but his main dramatic works have been what he terms "theater of reality" plays, which are mostly naturalistic.

Bullins's productivity as a playwright and his writing about the African-American experience have given him considerable influence. New York theater practitioners such as Robert Macbeth, founder and director of the now-defunct New Lafayette Theatre, embraced Bullins, along with audiences, critics, and publishers. For his plays he has earned the Drama Desk–Vernon Rice Award (1968) and Obie awards (1971 and 1975). *The Taking of Miss Janie* (1975), one of his best-known plays, received the Drama Critics Circle Award as the best American play of 1974–1975 and was selected as a Burns Mantle Best Play for the same year.

In addition to the theater awards, Bullins has been the recipient of Rockefeller grants (1968, 1970, 1973, and 1983), Guggenheim fellowships (1971 and 1976), and National Endowment for the Arts grants (1972 and 1989). His plays have been produced throughout the United States and abroad. He has taught at various colleges and universities, including New York University, City College of San Francisco, and the University of California at Berkeley.

REFERENCES

HAY, SAMUEL A. " 'What Shape Shapes Shapelessness?': Structural Elements in Ed Bullins' Plays." *Black World* (April 1974): 20–26.
SANDERS, LESLIE CATHERINE. " 'Like Niggers': Ed Bullins' Theater of Reality." In *The Development of Black Theater in America*. Baton Rouge, La., 1988, pp. 176–228.

JEANNE-MARIE A. MILLER

Bullock, Annie Mae. *See* Turner, Tina.

Bullock, Matthew Washington (1881–1972), educator and athlete. Matthew Bullock was born to former slaves who fled the South and moved to Massachusetts shortly after his birth. He attended high school in Everett, Mass., where he excelled as a student and was elected captain of his school's baseball, FOOTBALL, and track teams his senior year. Following high school graduation in 1901, Bullock enrolled at Dartmouth College, where he was actively involved in several student clubs, a member of Dartmouth's senior honor society, and a letter man in track and football. As the noted sports historian Edwin Henderson observed: "Bullock was one of the brainiest men of football ability the game has had."

Upon graduation from Dartmouth in 1904, he entered Harvard Law School, from which he received an LL.B. degree in 1907. To finance his law school education he coached the football teams at Massachusetts Agricultural College (now the University of Massachusetts) for the 1904, 1907, and 1908 seasons and at Malden (Mass.) High School for the 1905 and 1906 seasons. Bullock was thus one of the first salaried college coaches in America, and the first African American to hold the position of head football coach at a predominantly white collegiate institution.

After completing law school, Bullock joined the faculty (which included W. E. B. DU BOIS) at Atlanta Baptist (later Morehouse) College, where he served as athletic director and, with Edwin Henderson, established the annual selection of All-College Negro teams. He also taught economics, history, Latin, and sociology. Bullock accepted the position of dean of the faculty at the Agricultural and Mechanical College in Normal, Ala., in 1915. He soon moved again to Boston after gaining admission to the Massachusetts bar in 1917. However, before practicing law, he served in World War I with the American Expeditionary Forces in Europe as a YMCA War Work Physical Director.

During the course of his long law career (1919–1965) Bullock served as executive secretary of the Boston Urban League (1919–1921), a Massachusetts special assistant attorney general (1925–1926), and as a member (later chairman) of the Massachusetts Board of Parole (1927–1948). Upon his retirement Bullock spent much time, money, and effort, including worldwide travel, on behalf of his religion, the Baha'i faith. In recognition of his distinguished ca-

reer, Dartmouth awarded Bullock an honorary doctorate of laws at its 1971 commencement.

JOHN W. LOY
JACK W. BERRYMAN

Bumbry, Grace Ann Melzia (January 4, 1937–), opera singer. Born in St. Louis, Bumbry displayed her musical talents at an early age. At seventeen she won first prize in a radio-sponsored contest which entitled her to a $1,000 scholarship to the St. Louis Institute. Due to segregation she was unable to attend the institute, but after winning a local talent contest, performed on the Arthur Godfrey television show. She attended Boston University (1954–1955), Northwestern University (1955–1956), and the Music Academy of the West, in Santa Barbara, Calif. (1956–1959), where she studied with famed soprano Lotte Lehmann. A mezzo-soprano, Bumbry made her European debut as Amneris in Verdi's *Aida* in Paris in 1960. In 1961 she became the first African American to sing at the Bayreuth Festival, devoted to the operas of Wagner, when she sang Venus in *Tannhäuser*. This was the same role she sang when she made her American debut at the Chicago Lyric Opera two years later. In 1965 she made her debut at the Metropolitan Opera as Princess Eboli in Verdi's *Don Carlo*. In the 1970s she began replacing most of her mezzo roles with soprano roles. Possessed of a rich and highly expressive voice, she has sung the role of Selika, an African princess, in Giacomo Meyerbeer's *L'Africaine,* and the title role in Richard Strauss's *Salome*. At the Metropolitan Opera in 1985, Bumbry sang Bess in George Gershwin's *Porgy and Bess*. She has appeared on numerous recordings, including Bizet's *Carmen,* Handel's *Messiah,* Massenet's *Le Cid,* Mozart's *Requiem,* Verdi's *Aida, Don Carlo,* and *Macbeth,* and Wagner's *Tannhäuser*.

REFERENCE

STORY, ROSALYN M. *And So I Sing: African-American Divas of Opera and Concert.* New York, 1990.

A. LOUISE TOPPIN

Bunche, Ralph Johnson (1904–1971), scholar, diplomat, and international civil servant. Ralph Bunche was born in Detroit, Mich., to Fred and Olive Johnson Bunch. His father, a barber, abandoned the family when his son was young. Bunche moved with his mother to Albuquerqie, N. Mex., where she died in 1917. He then went to Los Angeles to be

raised by his maternal grandmother, Lucy Taylor Jackson. During his teen years, he added a final "e" to his name to make it more distinguished. Bunche lived in a neighborhood with relatively few blacks, and he was one of only two blacks in his class at Jefferson High School, where he graduated first in his class, although Los Angeles school authorities barred him from the all-city honor roll because of his race. Bunche's valedictory address was his first public speech. Bunche entered the University of California at Los Angeles (UCLA) on scholarship, majoring in political science and philosophy. He was active on the debating team, wrestled, played football and baseball, and was a standout basketball player. In 1927, he graduated *summa cum laude* and again, first in his class.

Assisted by a tuition fellowship and a $1,000 scholarship provided by a group of African-American women in Los Angeles, Bunche enrolled at Harvard University in 1927 to pursue graduate study in political science. He received a master's degree in 1928, and then accepted an invitation to join the faculty of Howard University. Bunche was only twenty-five when he created and chaired Howard's political science department. His association with Howard continued until 1941, although he pursued graduate work at Harvard during leaves.

Bunche's graduate work combined his interest in government with a developing interest in Africa. He conducted field research in western Africa in 1932 and 1933, and wrote a dissertation on the contrast between European colonial and mandatory governments in Africa. The dissertation, completed in 1934, won a Harvard award as the best political science dissertation of the year, and Bunche was awarded the

first Ph.D. in political science ever granted an African American by an American university. Bunche undertook postdoctoral studies in 1936 and 1937, first at Northwestern University, then at the London School of Economics and at South Africa's University of Cape Town. In 1936 he published a pamphlet, *A World View of Race.* His notes, taken during fieldwork in South Africa and detailing the political and racial situation were published in 1992 under the title *An African American in South Africa.*

During Bunche's time at Howard in the 1930s, he was deeply involved in civil rights questions. He believed that black people's principal concerns were economic, and that race, though significant, was secondary. While he participated in civil rights actions—notably a protest he organized against segregation in Washington's National Theater in 1931—Bunche, a principled integrationist, warned that civil rights efforts founded on race would collapse over economic issues. He felt that the best hope for black progress lay in interracial working-class economic improvement, and he criticized Franklin Roosevelt both for his inattention to the needs of black people and for the New Deal's failure to attack existing political and economic structures. In 1936, Bunche and others founded the NATIONAL NEGRO CONGRESS, a broad-based coalition he later termed "the first sincere effort to bring together on an equal plane Negro leaders [and] professional and white-collar workers with the Negro manual workers and their leaders and organizers." The Congress was eventually taken over by Communist Party workers. Bunche, disillusioned, resigned in 1938.

In 1939, Bunche was hired by the Swedish sociologist Gunnar Myrdal to work on what would become the classic study of race relations in the United States, *An American Dilemma: The Negro Problem and Modern Democracy* (1944). Over the next two years Bunche wrote four long research memos for the project (one was published in 1973, after Bunche's death, as *The Negro in the Age of FDR*). The final report incorporated much of Bunche's research and thought. The unpublished memos, written for the Carnegie Corporation, have remained an important scholarly resource for researchers on black America, both for their exhaustive data and for Bunche's incisive conclusions.

In 1941, after the United States entered World War II, Bunche left Howard to work for the Office of the Coordinator of Information for the Armed Service, and later joined the newly formed Office of Strategic Services, the chief American intelligence organization during World War II, precursor of the Central Intelligence Agency. Bunche headed the Africa section of the Research and Analysis Branch. In 1944, Bunche joined the U.S. Department of State's Post-

Ralph Bunche speaking during a civil rights march. (© Ivan Massar/Black Star)

war Planning Unit to deal with the future of colonial territories.

From this point forward, Bunche operated in the arena of international political affairs with an ever-increasing degree of policy-making power. In 1945, he was appointed to the Division of Dependent Area Affairs in the Office of Special Political Affairs, becoming in the process the first African American to head a State Department "desk."

In 1944, Bunche was a member of the U.S. delegation at the Dumbarton Oaks Conference in Washington, D.C., which laid the foundation for the United Nations. Appointed to the U.S. delegation in San Francisco in 1945 and in London in 1946, Bunche helped set up the U.N. Trusteeship system to prepare colonies for independence. His draft declaration of principles governing all dependent territories was the basis of Chapter XI, "Declaration Regarding Non–Self-Governing Territories," of the United Nations Charter.

Bunche went to work in the United Nations Secretariat in 1946 as head of the Trusteeship Department. In 1947, he was assigned to the U.N. Special Commission on Palestine which was a United Nations Trusteeship. The outbreak of the First Arab-Israeli War in 1948, and the assassination of U.N. mediator Folke Bernadotte by Jewish militants, propelled Bunche, Bernadotte's assistant, into the position of acting mediator. Bunche brought the two sides together, negotiating with each in turn, and succeeded in arranging an armistice. Bunche's actions earned him the 1950 Nobel Prize for Peace. He was the first United Nations figure, as well as the first African American, to win a Nobel Prize. Bunche also won the NAACP's Spingarn Medal (1950), and other honors. In 1953 the American Political Science Association elected him its president, the first time an African American was so honored. In 1950, President Truman offered him the post of Assistant Secretary of State. Bunche declined it, and in a rare personal statement on racism, explained that he did not wish to raise his family in Washington, a segregated city.

Bunche remained at the United Nations until shortly before his death in 1971. In 1954, he was appointed United Nations Undersecretary General for Special Political Affairs, and served as a roving specialist in U.N. work. Bunche's most significant contribution at the United Nations was his role in designing and setting up U.N. peacekeeping forces, which supervise and enforce truces and armistices and have arguably been the U.N.'s most important contribution to global peace. Building on the truce supervising operation he put into place after the 1949 Middle East armistice, Bunche created a United Nations Emergency Force in 1956, after the Suez crisis. U.N. peacekeepers played a major role in Leba-

non and Yemen, later in the Congo (now Zaire), in India and Pakistan, and in Cyprus. Sir Brian Urquhart, Bunche's assistant and successor as U.N. Undersecretary General for Special Political Affairs, said: "Bunche was unquestionably the original principal architect of [what] is now called peacekeeping . . . and he remained the principal architect, coordinator, and director of United Nations peacekeeping operations until the end of his career at the U.N."

While Bunche remained primarily involved as an international civil servant with the United Nations, promoting international peace and aiding developing countries, he also remained interested in the civil rights struggle in America. Indeed, Bunche demanded and received special dispensation from the United Nations to speak out on racial issues in the United States. Bunche served on the board of the NAACP for many years, and served as an informal adviser to civil rights leaders. In 1963, he attended the March on Washington, and two years later, despite poor health, he traveled to Alabama and walked with the Rev. Dr. Martin Luther KING, Jr., in the front row of the Selma-to-Montgomery Voting Rights March.

REFERENCES

BUNCHE, RALPH. *An African-American in South Africa.* Athens, Ohio, 1992.
———. "A Critical Analysis of the Tactics and Programs of Minority Groups." *Journal of Negro Education* (July 1935). In August Meier, Elliot Rudwick and Francis L. Broderick, eds. *Black Protest Thought in the Twentieth Century.* Indianapolis, Ind., 1971.
MANN, PEGGY. *Ralph Bunche, U.N. Peacemaker.* New York, 1975.
RIVLIN, BENJAMIN, ed. *Ralph Bunche: The Man and His Times.* New York, 1988.

C. GERALD FRASER

Bureau of Refugees, Freedmen, and Abandoned Lands,

the federal agency that oversaw Emancipation in the former slave states after the CIVIL WAR, commonly known as the "Freedmen's Bureau." Officially designed to protect the rights of the ex-slaves against intrusion by their former masters, now seen by many historians as paternalistic. In this view, the Freedmen's Bureau pursued "social control" of the freedpeople, encouraging them to return to work as plantation wage laborers.

The Freedmen's Bureau developed out of wartime private relief efforts directed at the "contrabands" who had fled to Union lines. At the suggestion of the American Freedmen's Inquiry Commission, a body

set up by the War Department to investigate issues relating to the freedpeople, Congress established the bureau on March 3, 1865, as a military agency. Intended as a temporary organization to exist for one year after the official end of the rebellion, the bureau had "control of all subjects relating to . . . freedmen from rebel States." In addition, it would undertake white refugee relief and manage confiscated Confederate property. The commissioner of the bureau, Oliver Otis Howard, was known as the "Christian general" for his philanthropic interests and Congregationalist religious enthusiasm. Howard eventually presided over a network of almost 1,000 local military and civilian agents scattered across the South, nearly all of them white.

Initially, Howard and his subordinates hoped to provide the rumored FORTY ACRES AND A MULE to at least some freedpeople from plantations seized by the government during the war. The legislation creating the bureau had authorized some land redistribution, and Howard's office drafted Circular 13, which would have implemented the distribution of land in bureau possession. However, Pres. Andrew Johnson countermanded the proposal, and his policy of widespread pardons for ex-Confederates restored most

The South Carolina Sea Islands, captured by Union forces in 1862, provided a "rehearsal for Reconstruction," testing many federal programs that would be applied to the remainder of the South after the Civil War. The Office for Freedmen in Beaufort, S.C., photographed here in 1864, was a forerunner of the Freedman's Bureau established the following year. (Photographs and Prints Division, Schomburg Center for Research in Black Culture, The New York Public Library, Astor, Lenox and Tilden Foundations)

property to its former owners. Stymied, Howard then felt obliged to evict the freedpeople from the lands given them during the war under the "Sherman grant." These were located on the Sea Islands and coastal areas of South Carolina and Georgia. Thus, by the late summer of 1865, Howard abandoned land redistribution and turned his attention to more attainable goals.

The bureau's remaining areas of activity were broad. It assumed the responsibility for aiding the destitute—white and black—and for the care of ill, aged, and insane freedpeople. It also subsidized and sponsored educational efforts directed at the African-American community, developed both by the freedpeople themselves and by the various northern missionary societies. The postwar years witnessed an explosive growth in black education, and the bureau encouraged this development in the face of white southern opposition. The bureau's agents also assumed the duty of securing minimal legal rights for the freedmen, especially the right to testify in court.

Perhaps the bureau's most enduring, and controversial, aspect was its role in overseeing the emergence of free labor. While it attempted to protect the freedpeople from impositions by their former masters, the freedpeople were also enjoined to labor diligently. The favored bureau devise for adjusting plantation agriculture was the annual labor contract, as approved by the local bureau agent. Tens of thousands of standardized contracts were written and enforced by the bureau in 1865 and 1866. The contracts it approved generally provided for wage labor under circumstances reminiscent of slavery: gang labor, tight supervision, women and children in the work force, and provisions restricting the physical mobility and deportment of the freedmen.

In practice, bureau agents spent much of their time encouraging diligent labor by the freedmen, quashing rumors of impending land redistribution, and even punishing the freedmen for refractory behavior. In some cases, agents issued and enforced vagrancy codes directed at the freedpeople. Despite encouraging the freedmen to act as disciplined wage laborers, the bureau soon incurred the enmity of the planters. It insisted that corporal punishment be abandoned, and backed this policy up with frequent arrests. It also established a dual legal structure, with local agents acting as judges in those instances where the civilian courts refused to hear blacks' testimony or committed flagrant injustice. Finally, the bureau and the military opposed the efforts of the conservative presidential RECONSTRUCTION governments to reimpose harsh vagrancy laws, through the BLACK CODES and similar legislation. President Andrew Johnson heeded the complaints of the planters, and in Febru-

ary 1866 vetoed legislation providing for the extension of bureau activities.

The Freedmen's Bureau became a focus of the emerging political struggle between Johnson and Congress for the control of Reconstruction. With the increasing power of the Republican party and especially the Radical faction, the bureau secured powerful political sponsorship. Its functions were extended over Johnson's veto in July 1866. With the enactment of congressional Reconstruction in March 1867, Freedmen's Bureau personnel tended to become involved with the political mobilization then sweeping the black community. For example, in South Carolina, Assistant Commissioner Robert K. Scott was elected the state's first Republican governor, and in Alabama four of the six Republican congressmen elected in February 1868 were bureau officials. Though they were widely denounced as "carpetbaggers," bureau officials exercised an important role in the politicization of the freedpeople through Republican groups such as the UNION LEAGUE.

The restoration of most of the southern states under the military Reconstruction acts furnished the immediate cause of the bureau's demise. With southern governments now granting the freedpeople equal legal rights, there no longer appeared any need for interference in local legal functions. The expansive powers of the Freedmen's Bureau had long violated states' rights taboos, and, moreover, the expense of the bureau's programs proved unpopular with the northern public. The renewal bill of July 1866 provided for the organization's essential termination in two years' time. Later legislation changed that date to the end of 1868, and after that time only the bureau's Education Division and efforts to secure bounties owed to black veterans continued. On June 30, 1872, these operations ended, and the Freedmen's Bureau ceased to exist.

Many of the bureau's aims were certainly laudable, and its accomplishments in promoting black legal rights and education substantial, but the overall record is mixed. In abandoning land redistribution, and in promoting the return of ex-slaves to plantation agriculture as hired labor under the contract system, the bureau also assisted in the survival of the plantation economy.

REFERENCES

BENTLY, GEORGE R. *A History of the Freedmen's Bureau*. Philadelphia, 1955.

FONER, ERIC. *Reconstruction: America's Unfinished Revolution, 1863–77*. New York, 1988.

MCFEELY, WILLIAM S. *Yankee Stepfather: General O. O. Howard and the Freedmen*. New York, 1968.

MICHAEL W. FITZGERALD

Burials. *See* Cemeteries and Burials.

Burke, Selma Hortense (December 31, 1900–), sculptor. Born in Mooresville, N.C., to Neal Burke, a Methodist minister, and Mary Jackson Burke, an educator, Selma Burke is best known as the sculptor of Franklin Delano Roosevelt's profile on the bronze plaque placed in the Recorder of Deeds Building in Washington, D.C., in 1945. Her other major works are in the round, made of stone (*Grief*), wood (*Falling Angel*), alabaster (*Mother and Child*), and brass (*Torso*).

As a child, Burke liked to whittle and model in clay, but her first career was nursing. She attended St. Agnes Training School for Nurses in Raleigh, N.C., graduating in 1924. She continued medical studies at the Women's Medical College there until 1928. After a nursing stint in New York, Burke returned to art. She received a master of fine arts degree from Columbia in 1941, working there with Oronzio Maldarelli, a leader of the modernist-classicist direct-carving school. She also studied ceramics under Pvolney in Vienna in 1933–1934 and sculpture with Aristide Maillol, in Paris in 1937. Her influences include

Bust of Mary McLeod Bethune by Selma H. Burke. (National Archives)

Matisse, Frank Lloyd Wright, and Josef Hoffmann. She also studied at Cooper Union and Sarah Lawrence College. Burke taught at the Harlem School of the Arts, Livingstone College, Swarthmore, and Harvard, and established the Selma Burke Art School in New York in 1946. Her works are in the Metropolitan and Whitney museums, among others. She has received many awards and honorary doctoral degrees. The Selma Burke Gallery, containing her art collection, is at Johnson Smith University in Charlotte, N.C.

Romantically involved with Claude MCKAY, the poet and novelist, in the 1930s, Burke later married Herman Kobbe, an architect.

REFERENCE

BONTEMPS, ARNA ALEXANDER, ed. *Forever Free: Art by African-American Women 1862–1980.* Alexandria, Va., 1980.

BETTY KAPLAN GUBERT

Burke, Yvonne Brathwaite (October 5, 1932–), lawyer and congresswoman. Yvonne Brathwaite was born and raised in South Central Los Angeles. She received an associate's degree from Berkeley in 1951, a bachelor's degree in political science from UCLA in 1953, and a law degree from USC in 1956, the year in which she was admitted to the California bar and began a private law practice. In 1965, Burke was appointed by California Governor Edmund G. "Pat" Brown as attorney for the McCone Commission, which investigated the LOS ANGELES, WATTS RIOTS.

In 1966, Burke was elected to the first of her three two-year terms representing the Sixty-third District in the California State Assembly. California's first black assemblywoman, she focused on prison reform, child care, equality for women, and civil rights. In 1972, she served as vice chairperson of the Democratic National Convention, where she received national attention as a promoter of changes in the party's rules enabling greater participation by minorities. The same year, she was also elected to the first of three terms representing the Thirty-seventh District in the United States House of Representatives, and became the first black Congresswoman from California. In Congress, she again focused on social issues, especially housing and urban development. In 1975, she was appointed to the powerful House Committee on Appropriations, and in 1976 she became chair of the Congressional Black Caucus.

Although her early political career made her one of the most prominent black women in American pol-

itics, her political campaigns in the late 1970s were unsuccessful, and she then concentrated on her career as a lawyer and senior partner at the Los Angeles firm of Jones, Day, Deavis, Bogue. In 1978 she returned to California to run for state attorney general, winning the Democratic nomination, but losing the general election to Republican George Deukmejian. On July 6, 1979, Governor Edmund G. "Jerry" Brown, Jr., appointed her to a vacancy in the Los Angeles County Board of Supervisors, a position she held until an election defeat in 1980. She resumed her political career in 1992, when she became the first African American to be elected to the Los Angeles County Board of Supervisors.

REFERENCE

BURKE, YVONNE BRATHWAITE. "New Arenas of Black Influence." Transcript of interview by Steven Edgington, 1982. Oral History Program, Powell Library, University of California, Los Angeles.

SIRAJ AHMED

Burleigh, Henry Thacker "Harry" (December 2, 1866–September 12, 1949), singer and composer. Harry T. Burleigh was born into a musical family in Erie, Pa., whose musical interests included FOLK MUSIC, SPIRITUALS, church music, and European-American art music (*see* CONCERT MUSIC). Fatherless at six, he was raised by an extended family, the most important influences being his mother, stepfather, and grandfather. His mother, Elizabeth Burleigh Elmendorf, graduated from Avery College in Pennsylvania. His grandfather, Hamilton Waters, was a former slave who valued education and music and had been active in the UNDERGROUND RAILROAD. In 1892, Burleigh began studies in New York at the National Conservatory of Music and taught there for two years after graduating. While a student, he was greatly influenced by Antonín Dvořák, the conservatory's director, for whom he often sang. Well established by 1893, he sang that year at the World's Columbian Exposition in Chicago. From 1894 to 1946 he was baritone soloist at Saint George's Episcopal Church in New York; from 1900 to 1925 he was soloist at Temple Emanu-El. These two wealthy religious institutions provided many opportunities for Burleigh as a composer and singer.

From 1911 until his death, Burleigh was an editor for the music publisher Ricordi. He became a charter member of the American Society of Composers, Authors, and Publishers (ASCAP) in 1914. By 1915 his art songs were well known; in 1916 his solo arrange-

Harry T. Burleigh. (Photographs and Prints Division, Schomburg Center for Research in Black Culture, The New York Public Library, Astor, Lenox and Tilden Foundations)

ment of the spiritual "Deep River" was said to be the most-performed song of the New York concert season. Burleigh published over forty spirituals in the next ten years. His success brought awards such as the NAACP's SPINGARN MEDAL in 1917, honorary degrees from Atlanta University in 1918 and Howard University in 1920, and the Harmon Foundation award in 1929. Burleigh's multifaceted career included singing, composing, arranging, and giving frequent lectures on spirituals, which he called the "greatest evidence of a spiritual ascendancy over oppression and humiliation." He was greatly admired for his support of young artists such as Paul ROBESON, Roland HAYES, and Marian ANDERSON.

Burleigh was a pioneer in the arrangement of spirituals for solo voice with piano accompaniment, and his sophisticated arrangements helped preserve the genre. Although some early critics stood opposed to his rich harmonies and innovative piano accompaniment for moving the spiritual away from its original improvisatory nature, Burleigh's arrangements have remained in the repertory for much of the twentieth century, in both solo and choral form; the most famous of these arrangements is undoubtedly "Deep River."

Burleigh's art songs, often sung by John McCormack, Ernestine Schumann-Heink, Nellie Melba, and other great singers of his day, are being rediscovered. Noted works include the song cycles *Saracen Songs* (1914), *Passionale* (1915), and *Five Songs on Poems of Laurence Hope* (1915) and the songs "Jean" (1903), "Mammy's Little Baby" (1903), "Ethiopia Saluting the Colors" (1915), and "Lovely Dark and Lonely One" (1935).

REFERENCES

SIMPSON, ANNE KEY. *Hard Trials: The Life and Music of Harry T. Burleigh.* Metuchen, N.J., 1990.
SNYDER, JEAN. Harry T. Burleigh and the Creative Expression of Bi-musicality: A Study of an African-American Composer and the American Art Song. Ph.D. diss., 1992.

ANN SEARS

JEAN SNYDER

Burnett, Charles (April 13, 1944–), filmmaker. Charles Burnett was born in Vicksburg, Miss. He moved with his family to Watts in South Central Los Angeles during World War II. In 1971 he received a B.A. in theater arts from the University of California at Los Angeles (UCLA), where he made his first film, *Several Friends* (1969), about a group of young African-American men who are unable to see or understand that something has gone wrong in their lives. Burnett completed his M.F.A. at UCLA as well. As a graduate student in 1977, he made a fourteen-minute film, *The Horse,* about a boy in the South who has to witness the death of an old horse. It won first prize at the fifteenth Westdeutsche Kurzfilmtage Oberhausen in West Germany.

Killer of Sheep, his first feature film, was made the same year as *The Horse,* at which time he not only satisfied his M.F.A. thesis requirement but was also awarded a Louis B. Mayer Grant, given to the thesis project at UCLA that shows the most promise. Touted for its neorealist approach, *Killer of Sheep* received critical praise and a life in the festival circuit. The film was a winner of the Berlin International Film Festival Critics Prize in 1981. In 1990, *Killer of Sheep* was selected for the National Film Registry at the Library of Congress. Each year twenty-five American films deemed culturally and historically significant are selected for the registry.

Finding inspiration outside the Hollywood formulaic aesthetic, Burnett's *Killer of Sheep, My Brother's Wedding* (1984), and *To Sleep with Anger* (1990) focus on the dynamics, tensions, and frustrations of urban black families, with a particular emphasis on the re-

lationships between fathers, sons, and brothers. His films strive to reflect the black American culture and the black American experience he knows. According to Burnett, "To make filmmaking viable you need the support of the community; you have to become a part of its agenda, an aspect of its survival. A major concern of storytelling should be restoring values, reversing the erosion of all those things that make a better life."

In 1980, Burnett received a Guggenheim Fellowship to do preproduction work on *My Brother's Wedding.* In 1988, he was the recipient of one of the Mac-Arthur Foundation's "Genius" Awards, which provided the resources for a production company and a professional cast, including Danny GLOVER, for *To Sleep with Anger,* his most critically acclaimed work. The film earned a special jury prize at the 1990 Sundance Film Festival in Park City, Utah. Following that film, Burnett began work on *America Becoming,* a documentary about new immigrants funded by the Ford Foundation. Burnett's film *The Glass Shield,* which depicts the travails of the first black cop in an all-white police squad, opened to enthusiastic reviews in 1995.

REFERENCES

KENNEDY, LISA. "The Black Familiar." *Village Voice,* October 16, 1990, p. 62.

KLOTMAN, PHYLLIS RAUCH, ed. "Charles Burnett." In *Screenplays of the African American Experience.* Bloomington, Ind., 1991, pp. 94–98.

FARAH JASMINE GRIFFIN

Burnett, Chester Arthur. *See* Howlin' Wolf.

Burns, Anthony (c. May 31, 1829–July 27, 1862), fugitive slave and pastor. Anthony Burns was born a slave and reared in northern Virginia, where he taught himself to read and write, converted to the Baptist faith, and became an unofficial preacher to other slaves. While hired out, he accidentally broke his right hand; although it healed, he feared being sold to the South or "down the river" where he suspected he would be mistreated because of his weakened hand and his consequent inability to perform physically demanding manual labor. He therefore decided to escape. While working as a stevedore, he enlisted the aid of a sailor who stowed him aboard his Boston-bound ship, but his owner learned of his whereabouts in Boston and had him arrested on May 24, 1854. The arrest prompted Boston's Vigilance Committee to stage a mass protest meeting in Faneuil

Hall that abolitionists Wendell Phillips and Theodore Parker addressed. At its midpoint, a militant faction within the meeting interrupted the proceedings to lead an armed attack to rescue Burns from the municipal courthouse where he was being held. Before they were driven off, the armed rioters killed a specially deputized guard.

The next morning, Burns's owner, Col. Charles Suttle, agreed to sell Burns to a group of Bostonians (who then would free him), led by the black minister Leonard A. GRIMES, who had raised the money. But U.S. Attorney B. F. Hallett, citing the killing of the guard as his justification, stopped the sale until after the law had been executed and the fugitive returned to Virginia. Though defense counsel Richard Henry

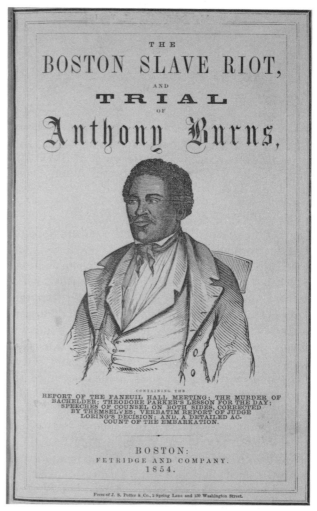

One of the most notorious cases arising from the Fugitive Slave Law of 1850 was the return of Anthony Burns from Boston to slavery in Virginia on June 2, 1854, despite strenuous legal and extralegal efforts of Boston area blacks and abolitionists. Burns's freedom was purchased the following year, and he later became a clergyman. (Prints and Photographs Division, Library of Congress)

Dana emphasized the defects in the record, the commissioner appointed by the federal courts to decide fugitive slave cases used Burns's replies to his master on the night of his arrest to identify him and issued the certificate for removal. After the courthouse attack, the federal officials had mustered a posse of regulars to guard the prisoner; then, pending the decision, they persuaded the mayor to call out more than 1,000 militiamen to keep the peace while the federal force marched their prisoner to the wharf to be shipped back into slavery in Virginia. The U.S. government paid the city $14,165.78 for their costs; an estimated 50,000 persons witnessed the rendition.

Burns was punished and sold; luckily, Bostonians learned of his whereabouts and arranged to buy his freedom from his new owner David McDaniel, who defied a southern mob to sell the "Boston Lion" for $1,300, raised by Grimes. Now a freedman, Burns decided to study for the ministry and through the aid of a benefactor attended the Preparatory Department of Oberlin College at times from 1855 to 1862. He became pastor of a black Baptist church in Indianapolis, but left the state in part because of the racially discriminatory Black Laws in Indiana. He moved to St. Catharines, Canada West (now Ontario), became pastor of its fugitive slave community, and died there of tuberculosis in July 1862.

The timing of the Burns case, coinciding with the passage of the Kansas-Nebraska Act and the Sherman or Booth fugitive slave rescue case earlier that year, contributed to the rise of antislavery parties throughout the North, and eight states passed new personal liberty laws, making the rendition of fugitive slaves more difficult. In Massachusetts, the outcry against Edward Loring's decision in the case led to the loss of his Harvard Law School professorship and his removal from his state probate office. After Burns's ordeal, no owner ever recovered a fugitive slave in Boston again.

REFERENCES

The Boston Slave Riot, and Trial of Anthony Burns. . . . 1854. Reprint. Northbrook, Ill., 1972.
PEASE, JANE H., and WILLIAM H. PEASE. *The Fugitive Slave Law and Anthony Burns.* Philadelphia, 1975.
STEVENS, CHARLES E. *Anthony Burns: A History.* 1856. Reprint. New York, 1969.

DAVID R. MAGINNES

Burroughs, Margaret Taylor (November 1, 1917–), artist, educator, and museum director. The daughter of Octavia Pierre Taylor and Alexander Taylor, Margaret Burroughs was born in St. Rose Parish, La. In 1920, in search of better lives, her parents migrated to Chicago, where Burroughs made significant, lasting contributions to her community and beyond.

In 1946, she earned her bachelor's degree in art education at the Art Institute of Chicago and began teaching at DuSable High School in Chicago. A committed, impassioned teacher of art, she held this job for twenty-two years until retiring in 1968 to oversee the development of the DuSable Museum of African American History. The museum—which she originally founded as the Ebony Museum of Negro History with her second husband, Charles Gordon Burroughs, in their home on Michigan Avenue—today occupies more than 60,000 square feet in Washington Park on the South Side of Chicago. Managed by Burroughs and a staff of twenty-one, it contains more than 50,000 items, including art, books, papers, artifacts, and memorabilia.

Since the 1940s, Burroughs's art has been displayed in galleries and exhibitions in the United States and abroad. In 1952 and 1953, she was given a one-woman show in Mexico City, where she lived and studied for that year. Influenced by the "new realism" movement of the 1930s and inspired by the works of Mexican muralists Diego Rivera and José Clemente Orozco, Burroughs sought to fuse art with politics, thereby using it as a vehicle for deeper social awareness and, ultimately, social change. This purpose has remained with her throughout her long career as both a visual artist and, later, a poet. She has described her central mission as "the betterment of life for all mankind and especially my people."

Burroughs's sculpture is the product of a "subtractive" style, by which the artist carves the image from large blocks of marble or stone, rather than shaping or molding a cast. Her works are characterized by bold, heavy lines that straddle the boundary between realism and abstraction. Certain Burroughs sculptures, for example, portray the heads of African-American women in a manner reminiscent of African and ancient Egyptian art. Her poetry, which draws on folk traditions and contemporary events and focuses on the African and African-American experiences, is written in similarly "broad" strokes of simple, direct language. She is the author of *Jasper, the Drummin' Boy* (1947); *Did You Feed My Cow?—Rhymes and Tales from City Streets and Country Lanes* (1955; revised, 1969); *What Shall I Tell My Children Who Are Black?* (1968); and *Africa, My Africa* (1970).

In 1980, Burroughs was one of the ten black artists honored by President Jimmy Carter at the White House; in 1982, she received an Excellence in Art award from the National Association of Negro Museums; and in 1986, Mayor Harold WASHINGTON proclaimed February 1 as "Dr. Margaret Burroughs

Day in Chicago." She has received a vast number of other awards, citations, and honorary degrees. Still dedicated to guarding and enriching the African-American tradition, Burroughs, now director emerita of the DuSable Museum, lives in Chicago.

REFERENCES

BONTEMPS, ARNA ALEXANDER, ed. *Forever Free: Art by African American Women 1862–1980.* Alexandria, Va., 1980.

LEININGER, THERESA A. "Margaret Taylor Burroughs." In Jessie Carney Smith, ed. *Notable Black American Women.* Detroit, 1992, pp. 133–137.

NANCY YOUSEF

Burroughs, Nannie Helen (May 2, 1879–May 20, 1961), educator. Nannie Helen Burroughs was born in Orange, Va. Her father, born free, attended the Richmond Institute and became a preacher. Her mother, born a slave in Virginia, left her husband and took her two young daughters to Washington, D.C. to attend school. At the Colored High School (later Dunbar High), where she was deeply interested in domestic science, Burroughs came in contact with Mary Church TERRELL and Anna Julia COOPER, two women who became her role models. In 1896, after graduation, she got a job at the Philadelphia office of the *Christian Banner* while also working part-time for the Rev. Lewis JORDAN, an official of the NATIONAL BAPTIST CONVENTION (NBC). When Jordan moved to Louisville, Ky., Burroughs also relocated there. In Louisville she initiated her career of activism by organizing a women's industrial club that offered evening classes in bookkeeping, sewing, cooking, and typing.

In 1900, at the annual meeting of the National Baptist Convention in Virginia, Burroughs gave a speech, "How the Sisters Are Hindered from Helping," which gained her national recognition and served as a catalyst for the formation of the largest black women's organization in the United States, the Woman's Convention (WC), an auxiliary to the NBC. The WC was the result of long-standing efforts by women in the Baptist Church to develop an organization to represent them. It provided a forum for black women to deal with religious, political, and social issues, and took the lead in their religious and educational training. From 1900 to 1948 Burroughs served as corresponding secretary to the WC, and from 1948 until her death in 1961 she served as president. Because of her hard work and leadership, the membership of the WC grew dramatically, reaching one million members in 1903 and 1.5 million in 1907.

Nannie Burroughs, educator, clubwoman, civil rights activist, and Baptist lay leader. (Prints and Photographs Division, Library of Congress)

Burroughs spent nearly her entire adult life in the public arena challenging racial discrimination and encouraging African Americans to maintain pride and dignity. An eloquent public speaker, she toured the country denouncing lynching, segregation, employment discrimination, and colonialism. She supported the efforts of the NAACP to attain legal equality for blacks, and criticized President Woodrow Wilson for his silence on lynching. She was a staunch feminist who believed women's suffrage was a route to racial advancement as well as a safeguard against male domination and sexual abuse. Like many women of her time, Burroughs believed in the moral superiority of women and the positive impact they could have on the public life of African Americans. Referring to the ballot, she wrote, "The Negro woman needs to get back by the wise use of it what the Negro man has lost by the misuse of it." She was convinced that if given political power, black women would take an uncompromising stand against racial discrimination and political disfranchisement.

In 1896 she joined other women and formed the NATIONAL ASSOCIATION OF COLORED WOMEN (NACW) to promote the political mobilization of black women. She became deeply involved in partisan politics, and in 1924 she and other clubwomen founded the National League of Republican Colored Women. Burroughs became a much sought-after participant by the REPUBLICAN PARTY's national speakers bureau. When Herbert Hoover was elected president in 1928, he chose Burroughs to head a fact-finding commission on housing. Even after the election of Franklin D. Roosevelt in 1932, when most African Americans transferred their political loyalty to the DEMOCRATIC PARTY, Burroughs continued her steadfast support of the Republicans.

In addition to opposing institutional racism, Burroughs was also a tireless advocate for black pride and self-help. She believed that progress was ultimately a question of individual will and effort, and that with enough self-esteem and self-confidence people could overcome racial barriers. In 1909 in Washington, D.C., she founded the National Training School for Women and Girls, which was renamed the Nannie Helen Burroughs School in 1964. The core of their training was what Burroughs called the "three B's": Bible, bath, and broom. The school also offered industrial training in a wide variety of occupations, such as printing, bookkeeping, housekeeping, stenography, dressmaking, and cooking. Burroughs encouraged black women to work hard and excel, whatever their position in society. Through her religious and educational work, she hoped to imbue black women with moral values, such as thrift and hard work, as well as prepare them to become self-sufficient wage earners. Burroughs died in Washington, D.C., at the age of eighty-two.

REFERENCES

GIDDINGS, PAULA. *When and Where I Enter: The Impact of Race and Sex on Black Women in America.* New York, 1984.

HIGGINBOTHAM, EVELYN BROOKS. *Righteous Discontent: The Women's Movement in the Black Baptist Church, 1880–1920.* Cambridge, Mass., 1993.

PAM NADASEN

Bush, Anita

Bush, Anita (c. 1883–February 16, 1974), actress. Born in Brooklyn, N.Y., Anita Bush was introduced early to a theatrical career through her father, a tailor to show business performers. At sixteen she became a chorus girl in the popular Williams and Walker musical comedy shows on Broadway. Taught dancing by Aida Overton Walker, Bush specialized in ingenue roles. After George Walker's illness broke up the company, Bush worked with Bert Williams and appeared with him in *Mr. Lode of Koal* (1909).

In 1914, Bush organized the Colored Dramatic Stock Company, later renamed the Anita Bush Stock Company, to introduce serious drama to African-American audiences. Originating at Harlem's Lincoln Theatre, the company moved in 1915 to the Lafayette Theatre, where, as the Lafayette Players, they performed for seventeen years. With a repertory of 250 plays, some three hundred actors and actresses worked with Bush over the years. Plays included *The Girl at the Fort*, *Over the Footlights*, and *About 2 O'Clock*. Members of the company included Dooley WILSON, Charles S. GILPIN, Carlotta Freeman, Lawrence E. Chenault, and Ida Anderson. Bush herself continued to act when the company failed to survive the depression. She appeared in several pioneering black films, including *The Crimson Skull* (1921), one of the first all-black westerns, and *The Bull Dogger*, based on the career of black cowboy Bill PICKETT. In 1937 Bush was in *Swing It*, sponsored by the government's Works Progress Administration. Following a long retirement, she died in 1974.

REFERENCE

THOMPSON, FRANCESCA. "Final Curtain for Anita Bush." *Black World* 23 (July 1974): 60–61.

ELIZABETH RUBIN

Business, Black. *See* Black Business Community.

Butler, Octavia Estelle

Butler, Octavia Estelle (June 22, 1947–), novelist and short-story writer. Butler is one of a select number of African Americans whose writing deliberately discards the realistic tradition to embrace a specialized genre—SCIENCE FICTION. The only surviving child of Laurice and Octavia M. Guy Butler, she was raised in a racially and culturally diverse neighborhood of Pasadena, Calif., and educated in the city. College consisted of a two-year program at Pasadena City College and subsequent course work at both California State College and UCLA. Dyslexic, extremely shy, and therefore solitary, Butler began writing as a child, convinced she could write better science fiction stories than those she saw on television.

Respected by the science fiction community of writers, critics, and fans as an important author ever

since her first books earned excellent reviews, Butler has produced many novels and several highly regarded short stories. Her first published novel (although plotwise the last in its series), *Patternmaster* (1976), is one of the five books in her past-and-future-history Patternist saga, a series of interrelated stories using genetic breeding and the development of "psionic" powers as a unifying motif. The saga reaches from precolonial Africa to a post-holocaust Earth of the distant future. In the proper reading order, the books in the tale are *Wild Seed* (1980), *Mind of My Mind* (1977), *Clay's Ark* (1984), and *Survivor* (1978).

In each of these novels, as in *Kindred* (1979)—her only novel outside a series—Butler conspicuously introduces issues of race and gender to science fiction. Her female protagonists are African, African-American, or mixed-race women operating principally in nontraditional modes. This depiction of women as powerful, self-sustaining, and capable, able either to adapt or to nurture and heal, equally equipped to fight or to compromise, gained Butler the critical approval of two additional audiences—black readers and scholars, and white feminists.

Butler's Xenogenesis series—*Dawn* (1987), *Adulthood Rites* (1988), and *Imago* (1989)—which was deemed "satisfying . . . hard science fiction" by Orson Scott Card, continues an examination of women in differing roles as it explores issues of human survival in another grim post-holocaust future where aliens have landed. Here Butler continues to explore her interest in genetics, anthropology, ecology, and sociobiology. Also central are issues of family, alliances or networks, power, control, and hierarchical structures fueling what Butler designates the "human contradiction," the capacity for self-destruction if humanity refuses to change.

Although she is primarily a novelist, Butler's short stories have won two coveted science fiction awards. "Speech Sounds" (1983) received a Hugo; "Bloodchild" (1984) earned both a Hugo and a Nebula. Each first appeared in *Isaac Asimov's Science Fiction Magazine*. "The Evening and the Morning and the Night" (1987) initially appeared in *Omni*. "Bloodchild" explores a forced human adaptation to change through the metaphor of male pregnancy; "Speech Sounds" examines a violent near-future cityscape whose inhabitants contract a sometimes deadly illness that dramatically affects language. "The Evening . . ." recounts the impact of a terrifying genetically based disease and the efforts of those affected to eradicate or control it.

REFERENCES

CARD, ORSON SCOTT. "Books to Look For." *Fantasy and Science Fiction* (January 1992): 51–54.
FOSTER, FRANCES SMITH. "Octavia Butler's Black Female Future Fiction." *Extrapolation* 23 (1982): 37–49.
GOVAN, SANDRA Y. "Connections, Links, and Extended Networks: Patterns in Octavia Butler's Science Fiction." *Black American Literature Forum* 18 (1984): 82–87.
MCCAFFERY, LARRY. "An Interview with Octavia Butler." In *Across the Wounded Galaxies*. Urbana, Ill., and Chicago, 1990, pp. 54–70.

SANDRA Y. GOVAN

Butts, Calvin O., III (July 22, 1949–), minister. Born in New York City, the son of a restaurant chef and an administrator of welfare services, Calvin Butts attended public schools, becoming class president at Forest Hills High School in 1967. He attended Morehouse College in Atlanta, graduating in 1971, and then entered New York's Union Theological Seminary. In 1972, while at Union, he was recruited by leaders of the four-thousand-member ABYSSINIAN BAPTIST CHURCH, the largest and most prestigious church in the city's Harlem section. The church's influential pastor, Congressman Rev. Adam Clayton POWELL, Jr., had just died. Butts was hired as assistant to the new pastor, the Rev. Samuel Proctor.

During the 1970s and '80s, Butts earned a reputation as a community leader and activist, as Powell had before him. Butts accepted the chair of Harlem's YMCA branch, toured neighborhood schools to report on education, called for hearings on police brutality, and in 1988 marched in the city's Bensonhurst section following the shooting of an African-American teenager. He also aroused controversy through his denunciations of liquor and tobacco billboard advertisements in black communities, and his attacks on New York's political leaders, both white and black (Butts once referred to New York's then mayor Ed Koch as a "racist" and "opportunist"). In 1986, one-third of the membership of the New York Philharmonic Orchestra refused to participate in the orchestra's annual concert at Abyssinian when Butts refused to distance himself from Louis FARRAKHAN after the NATION OF ISLAM leader was accused of anti-Semitic remarks.

On July 1, 1989, following Proctor's retirement, Butts was elected chief pastor of Abyssinian. During the following years, he devoted increased time to managing the church's endowment, employment, and welfare programs, and attempting to attract investment in the community. One notable project in which Butts was involved was the effort during the early 1990s to reopen the FREEDOM NATIONAL BANK,

The Rev. Calvin Butts of the Abyssinian Baptist Church in Harlem, N.Y., carried his anti-smoking campaign from Harlem to Paterson, N.J., on October 14, 1990. During his crusades he would whitewash billboards and picket tobacco companies that encouraged young people to smoke. (© Collette Fournier)

Harlem's leading financial institution, after it went bankrupt. However, Butts retained his activist posture, continuing his campaigns against alcohol and cigarette advertising and gambling. In 1993 he began a well-publicized crusade against RAP music, which he denounced as violent and pornographic. Butts called for his congregation to bring in rap recordings, which he would "crush by steamroller." Butts also attracted significant attention through his maverick political stance, particularly his support of independent presidential candidate Ross Perot in 1992.

REFERENCE

POOLEY, ERIC. "The Education of Reverend Butts." *New York* (July 26, 1989): 42.

GREG ROBINSON

Byas, Don (Wesley, Carlos) (October 21, 1912–August 24, 1972), jazz tenor saxophonist. Born and raised in Oklahoma, Don Byas began as an alto saxophonist before switching to tenor in 1933. He moved to California in 1935, working in dance bands led by Lionel HAMPTON and Buck Clayton. In 1937, he relocated to New York and performed with such national bands as those led by Andy Kirk and Benny CARTER. In 1941, he replaced Lester YOUNG as the primary tenor saxophone soloist in the Count BASIE band. His well-known two-chorus solo on "Harvard Blues" (1941) combined an eloquent simplicity with a sophisticated knowledge of harmony.

After leaving Basie in 1943, Byas worked primarily with small groups, recording prolifically for the many independent recording companies specializing in jazz that sprang up in the mid-1940s. He also performed with Dizzy GILLESPIE's groundbreaking Onyx Club band in 1944. His affinity for chromatic harmony and agility on the saxophone made him one of the few swing-era soloists welcome in the company of bebop musicians. In 1946, Byas expatriated to Europe, where he stayed for the remainder of his career except for a brief return to the United States in 1970. A tenor saxophonist with a rich and plangent sound, Byas was one of the most versatile and ubiquitous musicians on the New York City jazz scene in the 1940s.

REFERENCES

BYAS, DON. "In My Opinion." *Jazz Journal* 14, no. 3 (1961): 5.
OWENS, THOMAS. "Don Byas." In *The New Grove Dictionary of Jazz,* vol. 1. New York, 1988, p. 176.

SCOTT DEVEAUX

Byrd, Henry Roeland. *See* Professor Longhair.

C

Caesar, Adolph (1934–March 6, 1986), actor. Born in Harlem, Adolph Caesar graduated from George Washington High School in New York City before enlisting in the United States Navy, where he achieved the rank of chief petty officer. After retiring from the Navy, he studied dramatic arts at New York University. In 1970 Caesar joined the NEGRO ENSEMBLE COMPANY in New York, and performed in many of their productions, including *The River Niger, The Brownsville Road,* and the one-man show *The Square Root of Soul.* He performed with other repertory theater groups such as the New York Shakespeare Festival, the Lincoln Center Repertory Company, the American Shakespeare Company in Stratford, Conn., and the Center Theater Group at the Mark Taper Forum in Los Angeles. Caesar worked as a voice-over announcer for television and radio commercials, as well as a narrator for the PBS documentary series *Men of Bronze* (1977) and *I Remember Harlem* (1981).

Caesar came to prominence in 1981 with his strong performance in the Negro Ensemble Company's production of the Pulitzer Prize winning drama *A Soldier's Play.* His portrayal of Sgt. Vernon C. Waters, an abusive officer in the U.S. Army's segregated forces during World War II, earned him an Obie and a New York Drama Desk Award. He reprised the role in *A Soldier's Story,* the 1984 film version of the play, and was nominated for an Oscar as best supporting actor that year. His subsequent film work included roles in Steven Spielberg's adaptation of Alice WALKER's *The Color Purple* (1985) and *Club Par-*

Adolph Caesar adapted *The Square Root of Soul* from the text of an anthology of verse by black writers in 1976. (Reprinted from *In the Shadow of the Great White Way: Images from the Black Theatre,* Thunder's Mouth Press, © 1957–1989 by Bert Andrews. Reprinted by permission of the Estate of Bert Andrews)

adise (1986), but in 1986 he suffered a fatal heart attack while filming *Tough Guys.*

REFERENCES

BOGLE, DONALD. *Blacks in American Films and Television: An Encyclopedia.* New York, 1988.
Obituary. *New York Times,* March 7, 1986.

CHRISTINE A. LUNARDINI

Caesar, Shirley (October 13, 1938–), gospel singer. Born in Durham, N.C., Caesar began singing as a child, inspired by her father, "Big Jim" Caesar, a singer in the Just Come Four gospel quartet. Nicknamed "Baby Shirley," she made her first recording, "I'd Rather Have Jesus," in 1951, and sang throughout the South during her teenage years. In 1958 she began to gain national recognition as a soloist with the Caravan Singers, which included Albertina Walker and Inez Andrews. Although at the time a Baptist, Caesar adopted the "sanctified" style of gospel singing, characterized by fast tempos and extensive improvisation. Recordings from this period include "I've Been Running for Jesus a Long Time, and I'm Not Tired Yet" (1958), "Hallelujah, It's Done" (1961), and "I Won't Be Back" (1962). In 1966, she left the Caravan Singers and formed the Caesar Singers. She continued to perform and record, but her style became less energetic and ornamental. Instead, she favored the "song and sermonette" approach then popular with gospel singers.

In addition to performing and recording ("Don't Drive Your Mama Away," 1969; "No Charge," 1978; "Faded Roses," 1980), Caesar, who by 1993 had won five Grammy Awards, has had several other careers. She received a B.S. in business education from Shaw University in Raleigh, N.C., and went on to serve from 1987 to 1991 on the Durham City Council. She then became pastor of the Mt. Calvary Word of Faith Church in Raleigh, as well as president of Shirley Caesar Outreach Ministries, an emergency social services organization. Her husband, Harold T. Williams, is bishop of the Mt. Calvary Holy Churches of America, a small African-American holiness denomination.

REFERENCES

"The First Lady of Gospel." *Ebony* (September 1977): 98–102.
HEILBUT, TONY. *The Gospel Sound: Good News and Bad Times.* New York, 1975.
"Putting the Gospel Truth Into Politics." *Ebony* (December 1988): 66–70.
"Shirley Caesar, the Queen of Gospel." *American Gospel* (March–April 1992): 18–27.

KATHY WHITE BULLOCK

Gospel singer Shirley Caesar performing at Passaic Community College, December 1990. (© Collette Fournier)

Cain, Richard Harvey (April 12, 1825–January 18, 1887), clergyman and politician. Freeborn in Greenbriar County, Va. (now W. Va.), Richard Cain moved with his African-born father and Cherokee mother to Gallipolis, Ohio, in 1831. While still a young boy he worked on the steamboat service on the Ohio River. In 1841 he converted to the Methodist Episcopal Church, and four years later became licensed to preach in Hannibal, Mo. He returned to Ohio soon thereafter and joined the AFRICAN METHODIST EPISCOPAL CHURCH (AME) in Cincinnati, where he was ordained as a deacon in 1859. The following year he studied at Wilberforce University in Xenia, Ohio, before transferring to Brooklyn, N.Y., where he served as a minister for four years.

At the end of the Civil War in 1865, the AME church council assigned Cain to Charleston, S.C., to minister to recently freed slaves. In 1866 he became editor of the *Missionary Record,* a black newspaper, a position he held until 1872. During that time he launched a political career wherein he became known as a fiery and eloquent campaigner for the REPUBLICAN PARTY, a land reformer, and a vigorous civil rights advocate. In 1868 he was sent as a delegate to the South Carolina Constitutional Convention, where he advocated for Congress to appropriate funds to purchase land for freed blacks. In July of that year Cain was elected to the state senate where he served for one

term. Soon thereafter he became involved in an ambitious plan to buy three thousand acres of land to sell in small plots to freedmen. The project went bankrupt and Cain was indicted on charges of fraud; however, the case was never brought to trial. In 1872 Cain was elected to the U.S. House of Representatives where he spent much of his time lobbying on behalf of a civil rights bill. He did not run for reelection in 1874 but he ran in 1876 and was again elected. In that session he campaigned for women's suffrage and for more funding for education. But by that time Cain's outlook on the possibilities for political advancement by blacks in the United States had diminished, and he supported the renewed Liberia emigration movement, and put more of his energies into his ministry.

In 1880 Cain was elected fourteenth bishop of the AME church and assigned to Louisiana and Texas. He helped found Paul Quinn College in Waco, Tex., and served as the college's second president. He returned to his post as bishop in 1880, and presided over the New York, New Jersey, New England, and Philadelphia districts. He died in Washington, D.C., in 1887.

REFERENCES

CHRISTOPHER, MAURINE. *America's Black Congressmen.* New York, 1971.

FONER, ERIC. *Freedom's Lawmakers: A Directory of Black Officeholders During Reconstruction.* New York, 1993.

LOGAN, RAYFORD W., and MICHAEL R. WINSTON, eds. *Dictionary of American Negro Biography.* New York, 1982.

LYDIA MCNEILL
JOSEPH W. LOWNDES

California. The lure of instant wealth, the salubrious climate, and the promise of high-paying jobs have drawn African Americans, like many other people, to California. Many African Americans viewed the state as a promised land in which prejudice and discrimination would be less severe than in other parts of the United States. Despite their faith in this "California myth," black people in California have had to wage a constant struggle for their civil rights.

Some blacks came to California during the Spanish and Mexican eras. Most of these people were integrated into Spanish-speaking society. Significant numbers of blacks from the United States came into California during the Gold Rush, which began in 1849. By 1860, four thousand African Americans resided in the state. Some of those who arrived during the Gold Rush came as slaves. The majority of California's African Americans, however, were free.

African Americans enjoyed greater economic opportunities in California than they had in most of the East, but the state's politicians frequently abridged the rights of black Californians. Some delegates to the state's constitutional convention in 1849 sought to prevent black people from migrating to California. Lawmakers again attempted to restrict black immigration in 1857. Although these measures failed, the state did refuse to allow African Americans to vote or to testify against a white person in court.

California's African Americans did not accept the discrimination passively. Black leaders formed the Franchise League, California's first black civil rights organization, in San Francisco in 1852. In 1855 the first statewide Colored Citizens Convention was held in Sacramento. Convention participants succeeded in 1863 in gaining African Americans the right to testify in court, but black men were not allowed to vote until the FIFTEENTH AMENDMENT to the U.S. Constitution was ratified in 1869.

Although the California myth persisted throughout the late nineteenth century, only a small number of black people migrated to the state before the early twentieth century. Tens of thousands of African Americans came to California during the Great Migration of the 1910s and '20s. Despite the GREAT DEPRESSION, this migration continued into the 1930s. By 1940, nearly 125,000 African Americans called California home. Three-fifths of these new residents went to LOS ANGELES, which boasted the largest black community in the West. By 1918, enough black people lived in Los Angeles that the community was able to elect Frederick Roberts, a Republican, to the state assembly.

Most of the blacks who lived in California before 1940 found low-paying jobs in the service sector. Many men worked as cooks, janitors, or unskilled laborers. Women most frequently worked as domestic servants. An increasing number, however, found better-paying jobs within the small but important ethnic economy. The University of California did not exclude black students, and several physicians, lawyers, and other professionals served the residents of African-American communities after their education at the university.

Jobs in defense-related industries lured nearly 250,000 African Americans to California during and after World War II. Most black newcomers again went to Los Angeles, the home of several large shipyards and much of the nation's aircraft industry. But substantial numbers went to cities on San Francisco Bay, where new shipyards produced thousands of merchant ships. Large numbers of black workers settled in San Francisco, Oakland, and Richmond.

The migration should have finally destroyed the California myth. The newcomers to the state faced

staggering housing and employment discrimination. The NAACP reported that African Americans occupied only 337 of the 46,000 private housing units built in Los Angeles between the attack on Pearl Harbor (1941) and the beginning of 1945. Despite a serious labor shortage, employers resisted hiring and promoting black workers; several unions also discriminated against blacks. The International Brotherhood of Boilermakers, for example, assigned black shipyard workers to an all-black auxiliary union. Although members of the auxiliary paid full dues, they had no voice in union affairs.

The wartime migration showed how deeply prejudice permeated California society, but the war also gave black Californians more power to end discrimination. The President's FAIR EMPLOYMENT PRACTICES COMMITTEE (FEPC), created in 1941, investigated and condemned discrimination against black workers in California's shipyards. The FEPC had little power to enforce its rulings, however, and the boilermakers' union continued to relegate African Americans to segregated auxiliary locals. In 1944, however, the California Supreme Court ruled that the segregation was illegal. Eventually the union ceased its discrimination.

In the postwar period, African Americans continued to move to California in large numbers. Although their increasing population gained them greater political representation, discrimination persisted. Black Californians in several cities complained about police brutality; the legislature refused to outlaw employment discrimination until 1959. Housing discrimination was even more difficult to combat. The state passed a fair-housing law in 1963, but the voters repealed it in 1964. Despite the continuing discrimination against African Americans, the California myth persisted. In 1964, an Urban League survey declared Los Angeles the best city in the country for black Americans.

Discrimination and police brutality sparked a rebellion in the Los Angeles neighborhood of Watts in 1965 (see LOS ANGELES WATTS RIOT OF 1965). Some African Americans and many white leaders responded to the Watts rebellion by trying to integrate black people more completely into California society. Within two years after Watts, the number of African Americans in California's legislature had increased from four to six, and white elected officials made a point of selecting more black people for appointed offices.

Other African Americans drew a different lesson from Watts. The BLACK PANTHER PARTY, with its heart in Oakland, argued that integration was futile. The Black Panthers provided important social services, such as child care, for residents of the ghettos in Oakland and San Francisco. They also carried weapons in an attempt to discourage police brutality. The Panthers' angry rhetoric frightened local, state, and federal officials, who used spies and harassment to weaken the nationalist party. State persecution combined with factionalism to leave the Black Panthers in disarray by the early 1970s.

After Watts, black political power increased steadily. Two black Californians were elected to statewide office: Wilson Riles as superintendent of public instruction, in 1970, and Mervyn Dymally as lieutenant governor, in 1974. Willie Brown, a San Francisco Democrat, was elected speaker of the state assembly in 1980. Tom BRADLEY, elected mayor of Los Angeles in 1972, narrowly lost his bid for the governorship in 1982.

Although black political representation increased during the 1970s and 1980s, discrimination did not dissipate. The unemployment rate among African Americans soared during the 1980s, and residents of the sprawling south central Los Angeles ghetto faced an epidemic of drug abuse, crime, and gang violence. At the end of April 1992, rebellion engulfed Los Angeles following the acquittal of three out of four police officers accused of brutally beating an African American, Rodney King.

The 1992 rebellion in Los Angeles underscored the hollowness of the California myth. Many Californians had believed that their state was a center of "multiculturalism," where people from all back-

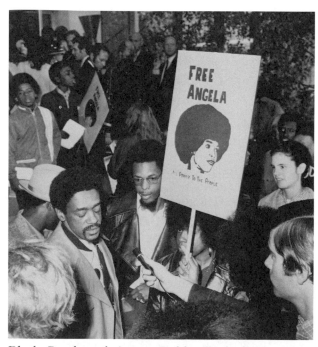

Black Panther chairman Bobby Seale being interviewed at a rally in support of Angela Davis outside the courthouse, Palo Alto, Calif., December 1971. (AP/Wide World Photos)

grounds could live together in peace. They had overlooked the prejudice and discrimination that kept many African Americans and Latinos outside the seemingly prosperous society.

REFERENCES

DANIELS, DOUGLAS. *Pioneer Urbanites: A Social and Cultural History of Black San Francisco.* Philadelphia, 1980.

DE GRAAF, LAWRENCE BROOKS. *Negro Migration to Los Angeles, 1930 to 1950.* San Francisco, 1974.

GOODE, KENNETH G. *California's Black Pioneers: A Brief Historical Survey.* Santa Barbara, Calif., 1974.

LAPP, RUDOLPH M. *Afro-Americans in California.* 2nd ed. San Francisco, 1987.

———. "The Negro in Gold Rush California." *Journal of Negro History* 49 (April 1964): 81–98.

KEVIN ALLEN LEONARD

Americans from elections and officeholding. Despite the reluctance of local California governments to enact their proposals, the California Colored Conventions helped California blacks organize around specific objectives for attaining full citizenship rights.

REFERENCES

BELL, HOWARD H. "Negroes in California, 1849–1859." *Phylon* 28 (Summer 1967): 151–160.

———. "Some Reform Interests of the Negro During the 1850's as Reflected in State Conventions." *Phylon* 21 (Summer 1960): 173–181.

WHEELER, B. GORDON. *Black California: The History of African-Americans in the Golden State.* New York, 1993.

DURAHN TAYLOR

California Colored Convention.

Four California Colored Conventions were held in Sacramento and San Francisco between 1855 and 1865. The conventions originated because African Americans in California found that efforts to protest or address issues of discrimination at the local level were ineffective. The first convention, held in Sacramento in 1855, concentrated almost exclusively on the denial of citizenship rights to blacks, particularly the right to testify under oath and the right to vote. Delegates resolved to create a state publication, and *The Mirror of the Times,* California's first black newspaper, was established. The second convention, held in Sacramento in 1856, covered a broader range of issues, including education. Grade school education was given immediate priority, while the issue of college education was deferred. The 1856 convention included a conflict over whether to "hail with delight" the United States's march of progress, in light of the persistence of slavery. San Francisco delegate William H. NEWBY, editor of the weekly newspaper, *Mirror of the Times,* said he favored any possible means of freeing blacks, even if it meant the invasion of the United States by a foreign country. This debate was inconclusive; both Newby's radical position and the motion to praise national progress were defeated.

The third convention, held in 1857, proposed that the school-age black children in California be counted so that an appropriate portion of state funds could be allotted for their education. Parents were asked to take responsibility for educating their children until public schools became available for them. The fourth and final convention, held in Sacramento in 1865 and attended by many emancipated slaves, addressed discriminatory state laws and the banning of African

Calloway, Cabell "Cab"

(December 25, 1907–November 18, 1994), jazz singer and bandleader. Born in Rochester, N.Y., Calloway was raised in Baltimore, Md. In high school he sang with a local vocal group called the Baltimore Melody Boys. The Calloway family, including Cab's sister, singer Blanche Calloway, then moved to Chicago, where he attended Crane College. Calloway began his career as a singer, drummer, and master of ceremonies at nightclubs in Chicago and other midwestern cities. In the late 1920s in Chicago, Calloway worked with the Missourians, a big band; in the male vocal quartet in *Plantation Days*; and as leader of the Alabamians. In 1929, he took the Alabamians to Harlem's Savoy Ballroom, and that same year was featured in Fats WALLER and Andy Razaf's *Hot Chocolates* revue.

In 1929 Calloway began to lead the Missourians under his own name ("St. James Infirmary," 1930). In 1931, they replaced Duke ELLINGTON as the COTTON CLUB's house band. During the 1930s Calloway became a household name, the country's prototypical "hipster," renowned for his infectious vocal histrionics, his frenzied dashing up and down the stage in a white satin zoot suit, and leading audience sing-a-longs, particularly on his biggest hit, "Minnie the Moocher" (1931). That song, with its "Hi-de-ho" chorus, was a million-copy seller and earned him the nickname "Hi-de-ho Man."

Calloway's talents were not limited to comic entertainment. During the swing era Calloway's band was one of the most popular in the country ("At the Clambake Carnival," 1938; "Jumpin' Jive," 1939; "Pickin' the Cabbage," 1940), and he nurtured some of the best instrumentalists of the day, including saxophonists Ben WEBSTER and Chu BERRY, trumpeters

Cabell "Cab" Calloway. (Moorland-Spingarn Research Center, Howard University)

Jonah Jones and Dizzy GILLESPIE, bassist Milt HINTON, and drummer Cozy COLE. The orchestra held its own in competitions throughout the 1930s with the bands of Count BASIE, Duke Ellington, Chick WEBB, and Jimmy LUNCEFORD. Calloway's orchestra left the Cotton Club in 1934 for a European tour. In addition to its success in nightclubs and on the concert stage, the Calloway orchestra also appeared in movies, including *The Big Broadcast* (1932), *The Singing Kid* (1936), *St. Louis Blues* (1939), and *Stormy Weather* (1943). Calloway disbanded the orchestra in 1948, and worked with a sextet before touring England as a solo.

Calloway returned to his roots in musical theater in 1952 for a two-year run in the role of Sportin' Life in a touring version of George Gershwin's *Porgy and Bess*. Throughout the 1950s and 1960s, Calloway continued to perform both as a solo act and as the leader of big bands. In the mid-1960s he toured with the Harlem Globetrotters comic basketball team. In 1974 Calloway appeared in an all-black version of *Hello, Dolly!*, and two years later he published his autobiography, *Of Minnie the Moocher and Me.* Calloway appeared on Broadway in *Bubbling Brown Sugar* in 1975, and his cameo in *The Blues Brothers*

(1980) brought a revival of interest in him. In 1984 he sang with his vocalist daughter, Chris, in an engagement at New York's Blue Note nightclub. In 1987 he again appeared with Chris Calloway, this time in *His Royal Highness of Hi-de-ho* in New York.

REFERENCES

PAPA, J. *Cab Calloway and His Orchestra.* Zephyrhills, Fla., 1976.
SIMON, G. T. *The Big Bands.* New York, 1981.

MICHAEL D. SCOTT

Calloway, Nathaniel Oglesby (October 10, 1907–December 3, 1979), chemist and physician. Nathaniel Calloway was born in Tuskegee, Ala., the son of James and Marietta (Oglesby) Calloway. He graduated from Iowa State College in 1930. In 1933, when he earned a Ph.D. in organic chemistry (also at Iowa State), Calloway became the first African American to receive an academic doctorate from an institution west of the Mississippi. He taught chemistry until 1940 at Tuskegee Institute and then at Fisk University. In 1935, he prepared the first English-language review of the so-called Friedel-Crafts reaction (1877), a phenomenon in organic chemistry with important applications in the plastics, perfume, textile, and petroleum industries. Calloway's work was widely cited.

In 1940, he enrolled in the medical course at the University of Chicago. When told that he would not be permitted to treat white patients during his ward work, he transferred to the University of Illinois, graduating with an M.D. in 1943. During World War II, he directed a government-sponsored study of convalescence practices. He became a staunch advocate of early ambulation, the theory (now generally accepted) that postoperative patients improve more rapidly when not confined to their beds. After 1947, his research focused on topics in gerontology and geriatrics. He proposed a "general theory of senescence" (or aging) in 1964. Over the next ten years, he published twenty-six articles in the *Journal of the American Geriatrics Society*.

Calloway served as medical director of PROVIDENT HOSPITAL in Chicago until 1949, when he founded Medical Associates of Chicago, a black group-practice in the inner city. After fourteen years as president of Medical Associates, he became chief of medical services for the Veterans Administration Hospital, Tomah, Wis. A civil rights activist, he was president of the Chicago Urban League from 1955 to 1960 and of the Madison, Wis., branch of the NAACP in 1969.

REFERENCE

CALLOWAY, N. O. "The Friedel-Crafts Syntheses." *Chemical Reviews* 17 (1935): 327–392.

PHILIP N. ALEXANDER

Cambridge, Godfrey MacArthur (February 26, 1933–November 29, 1976), actor. Godfrey Cambridge was born in New York City in 1933 and grew up in Harlem with his parents, Sarah and Alexander. He attended Flushing High School, where he excelled as both a student and a leader of extracurricular activities. Cambridge won a scholarship to Hofstra College (now Hofstra University) on Long Island, where he majored in English and had his first acting experience, appearing in a school production of *Macbeth*. After racial threats forced him to leave Hofstra during his junior year, Cambridge attended City College in New York City. Upon graduating, he worked at a number of jobs including stints as an airplane wing cleaner, a judo instructor, a cab driver, and clerk for the New York City Housing Authority.

In 1956 Cambridge landed his first professional role, as a bartender in an Off-Broadway revival of Louis Peterson's *Take a Giant Step*. The play ran for nine months and led to television appearances in shows such as *The United States Steel Hour, Naked City,* and *You'll Never Get Rich* (with Phil Silvers as Sergeant Bilko). In 1961 Cambridge appeared in Jean Genet's *The Blacks*, a savage drama about racial hatred, and for his efforts received the *Village Voice*'s Obie Award for best performer of 1961. The following year he appeared in Ossie DAVIS's *Purlie Victorious*, for which he earned a Tony nomination. Cambridge went on to perform in other plays, including *A Funny Thing Happened on the Way to the Forum* (1962), *The Living Promise* (1963), and *How to Be a Jewish Mother* (1967), in which he played every part but the title role.

After a successful appearance on *The Jack Paar Program* in 1964, Cambridge was able to choose his roles and began turning down film parts which stereotyped him. Instead he played a wide variety of movie characters, including a reprise of his role in the film version of *Purlie Victorious*, entitled *Gone Are the Days* (1963), an Irishman in *The Troublemaker* (1964), a Jewish cab driver in *Bye, Bye, Braverman* (1968), and a concert violinist in *The Biggest Bundle of Them All* (1968). Cambridge is probably best known for his leading roles in the popular films *Watermelon Man* (1970) and *Cotton Comes to Harlem* (1970).

In addition to his film appearances, Cambridge was a successful stand-up comedian. His sense of humor, while not alienating to white audiences, did not lack bite. Essentially a social satirist, his comedy often dealt with ordinary people, black and white, struggling with the problems of everyday life.

During the CIVIL RIGHTS MOVEMENT, Cambridge performed at rallies and organized support for the employment of more African Americans in the entertainment industry. A compulsive eater who at times weighed as much as 300 pounds, in 1976 Cambridge collapsed and died on the set of the TV movie *Victory at Entebbe*, in which he played the Ugandan dictator Idi Amin.

REFERENCES

BOGLE, DONALD. *Blacks in American Films and Television.* New York, 1988.
New York Times Biographical Services. November 30, 1976, p. 1521. New York, 1976.

THADDEUS RUSSELL

Campanella, Roy (November 19, 1921–June 26, 1993), baseball player. In 1948, the year after Jackie ROBINSON crossed BASEBALL's color line to become a member of the Brooklyn Dodgers, Roy Campanella joined him in Brooklyn and became the major league's first African-American catcher. Campanella and Robinson were the vanguard of major league baseball's first contingent of black superstars, soon to be joined by Willie MAYS, Ernie BANKS, and Hank AARON.

The son of John Campanella, an Italian fruit-stand owner, and Ida Campanella, his black wife, Roy Campanella was born in Philadelphia. His athletic talents were noticed early, and by the time he was sixteen he was offered a position with the Bacharach Giants, Philadelphia's black semipro team. After playing with the Giants for only a few weeks, Campanella transferred to the Baltimore Elites, one of the most important teams in the Negro National League, with whom he excelled both defensively and at the plate.

In 1946 he signed a contract with Branch Rickey, owner of the Dodgers, and after two years in the minor leagues became the Dodgers' second black player. During his ten seasons with the club, Campanella won three Most Valuable Player awards and set new slugging records for a catcher. He also became the first player to catch at least one hundred games for nine straight seasons. A frequent All-Star, Campanella helped lead the Dodgers into five World Series.

An automobile crash after the 1957 season left Campanella partially paralyzed. He fought back from the accident to become a community-service worker

and instructor for the Dodgers. He was elected to the Baseball Hall of Fame in 1969.

REFERENCE

CAMPANELLA, ROY. *It's Good to Be Alive*. New York, 1959.

ROB RUCK

Campbell, Delois Barrett (March 12, 1926–), gospel singer. Possessing a voice that could have embraced classical art song as easily, Delois Barrett Campbell became an internationally acclaimed gospel singer. The seventh of ten children, she was born and educated in Chicago, where she married Rev. Frank Wesley Campbell and had four children. Having sung since the age of five, Campbell began her professional career as a soloist with the Roberta MARTIN Singers in the 1940s. "Roberta Martin was the greatest influence on my singing career; she gave me my start," said Campbell. The group included Bessie Folk, Robert Anderson, Willi Webb, Eugene Smith, and Norsalus McKissick. In 1963, Campbell and her two sisters, Billie Barrett GreenBey and Rodessa Barrett Porter, began singing together professionally. Blending rich, powerful voices, the Barrett Sisters created an exciting sound that captivated thousands with their arrangements of traditional gospel, hymns, and contemporary songs. By 1992 the singers had made eighteen recordings and several films and had developed a huge following in Europe and Africa, particularly with such favorites as "I'll Fly Away" and "Climb Ev'ry Mountain."

REFERENCE

HEILBUT, ANTHONY. *The Gospel Sound: Good News and Bad Times*. New York, 1971.

KATHY WHITE BULLOCK

Campbell, Elmer Simms (January 2, 1906– January 27, 1971), artist. E. Simms Campbell was born in St. Louis, Mo., in 1906. His father was a high school principal and his mother was a painter who instructed her son in drawing techniques. At the age of fourteen, Campbell left home to attend the University of Chicago, and he eventually earned a degree from the Art Institute of Chicago. While studying, he worked nights as an illustrator for a humor magazine called *College Comics*. In 1932 he attended the Art Students League in New York City, and after a brief time back in St. Louis working for an advertis-

ing agency, he returned to New York and began selling illustrations to *Esquire* on a regular basis. He created "Eski," the bug-eyed, round-nosed woman-watcher who appeared on many *Esquire* covers.

Campbell's illustrations also appeared regularly in *The New Yorker*, *Playboy*, and *The Saturday Evening Post*. He also illustrated a number of children's books, most notably *Popo and Fifina* by Langston HUGHES. Although Campbell's remarkable professional success seemed to defy discriminatory practices common in the decades before the civil rights movement, he did not escape discrimination altogether. In 1938, he lost a U.S. Supreme Court application that would have compelled mortgage trustees in White Plains, N.Y., to sell him a twelve-acre estate. Campbell eventually moved to Switzerland, where he spent the last fourteen years of his life.

REFERENCE

LEWIS, SAMELLA. *Art: African-American*. New York, 1978.

NANCY YOUSEF

Campbell, Thomas Monroe (February 11, 1883–February 8, 1956), agronomist. Thomas Campbell was born in Elbert County, Ga., in 1883. In 1899, against the wishes of his father, and after having run away from their farm, Campbell enrolled in the agricultural course at Tuskegee Institute, completing it in 1906. He then went on to advanced study at the same institution and graduate study at Iowa State College in 1910.

At the end of 1906, upon recommendation of Booker T. WASHINGTON and George Washington CARVER, Campbell was hired to operate Tuskegee's newly created Jesup Agricultural Wagon—or the "Movable School"—for agricultural extension work (that is, bringing advances in scientific agriculture directly to farmers). Under the joint employ of Tuskegee and the United States Department of Agriculture (USDA), Campbell was the first African-American demonstration agent in the United States. In 1909, he was promoted to district agent, and in 1918 he became field agent for the USDA, with a territory that included seven southern states. The concept of agricultural extension developed by Campbell spread to Europe, Africa, India, and East Asia, and his contribution was essential in the development of Tuskegee as the center of extension work with African Americans in the deep South.

Campbell wrote numerous articles for prominent journals of agriculture, as well as an account of his work, *The Movable School Goes to the Negro Farmer*

(1936). In 1945 he coauthored a study of African agricultural methods based upon his travels entitled *Africa Advancing*. Campbell received the Harmon Award in 1930. A marker was dedicated to him at Tuskegee on January 13, 1952. He retired in 1953 after a forty-seven-year career, and died three years later.

REFERENCE

CAMPBELL, THOMAS MONROE. *The Movable School Goes to the Negro Farmer*. 1936. Rev. ed. published as *The School Comes to the Farmer*. New York, 1947.

SIRAJ AHMED

Canada. The territories of British North America, which would be united into Canada in 1867, had their own long history both of blacks and slavery. Enslavement of indigenous Indians as well as Africans started in the early years of French settlement. The first recorded black in the colony of New France (later the Canadian province of Quebec) was Olivier Le Jeune, an African from Madagascar sold as a slave in 1629. He later died a free man. During the following 130 years, about one thousand blacks were brought from New England or the West Indies to serve as slaves in French Canada. While slavery was tolerated, it was never an important institution and no slave code was ever passed. Most slaves served as domestics. In 1759 there were 3,604 slaves in New France, 1,132 of whom were blacks, the rest largely Indians. In 1763 the British took over the French possessions on mainland North America. They gave legal status to the existing slave system. In 1783, at the close of the AMERICAN REVOLUTION, a group of white Loyalists emigrated to Nova Scotia, bringing some two thousand enslaved blacks with them.

In 1793, about the same time the United States passed the first Fugitive Slave Law, which legalized slave catching in free northern states, Upper Canada (later Ontario) passed the Upper Canada Abolition Act, which gradually abolished slavery by providing for the emancipation of slave children at age twenty-five and the barring of further enslavement. Court decisions soon extended the ban on slavery into Lower Canada (later Quebec). By 1820 slavery was also largely extinct in the Maritime Provinces of Nova Scotia, New Brunswick, and Prince Edward Island. In 1833 the British Parliament officially abolished slavery everywhere in the British Empire.

The year 1783 brought the first of three years of blacks fleeing slavery in America to British North America. A group of thirty-five hundred African Americans, assured of emancipation once victory was achieved, had fought on the British side in the American Revolution. Forced to flee the United States, these "Black Loyalists" were granted land in the Maritime Provinces of Nova Scotia and New Brunswick. The blacks were scorned by and segregated from local whites, who placed them at the bottom of the economic and social ladder, a step above local black slaves. Many were unused to the harshness of the climate. Some were granted ownership of farms, but had difficulty supporting themselves on the small, infertile plots without government aid. Most were forced into hired farm labor, and were paid lower wages than the white laborers they were in competition with. This catalyzed white resistance to their presence. After the British colony of Sierra Leone was created in West Africa in 1791, eleven hundred Nova Scotia blacks emigrated there, and more followed in 1800. But those who stayed remained deeply loyal to Canada as their land of freedom, and many joined militias to defend against the United States in the WAR OF 1812.

A second wave of some two thousand black refugees from the United States was settled in Nova Scotia from 1813 to 1816, after escaping from slavery with the British forces in the Chesapeake area during the War of 1812. Originally welcomed in Nova Scotia as a source of cheap labor, these emigrants, known as the "Refugees," eventually faced the same economic difficulties and racial exclusion their Loyalist forebears had. Refugee land grants were clustered together in segregated sections outside towns. The black community outside Halifax was dubbed "Africville." In 1819 the British government established a refugee colony at Oro, with refugee tracts joined on a single street. Blacks were allowed to farm small, poor grants of land, but were denied full ownership of the property, and were tied to the land without being able to live off of it. Deeply impoverished, some blacks sold themselves back into slavery or into indentured labor. In 1815 Nova Scotia legislators tried unsuccessfully to ban black immigration. Between 1809 and 1839, the governor of the island of Trinidad extended a welcome to "black Canadians," as well as African Americans, who might care to emigrate. In 1820, ninety-five families left Nova Scotia for Trinidad. The rest remained in Nova Scotia as poor farmers and laborers. Some became British patriots; in the 1850s, for example, William Hall, a black Canadian of Refugee ancestry, won the Victoria Cross for service in the Crimean War and the Indian Sepoy Mutiny.

With the abolition of slavery, beginning in 1793, Canada became the main refugee for escaped slaves from the United States. Throughout the antebellum period, Canada represented the land of freedom for African Americans. In the early 1800s, black sought

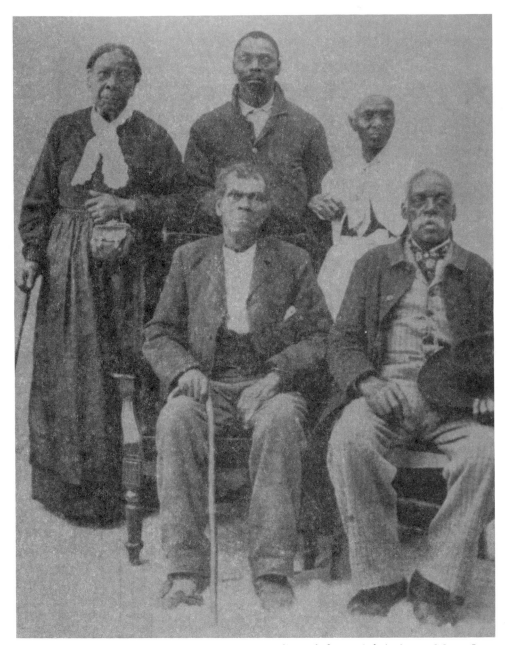

Refugee settlers in Windsor, Ontario. (Standing, left to right) Anne Mary Jane Hunt, Mansfield Smith, Lucinda Seymour; (seated, left to right) Henry Stevenson, Bush Johnson. (Photographs and Prints Division, Schomburg Center for Research in Black Culture, The New York Public Library, Astor, Lenox and Tilden Foundations)

freedom in the American North, and few came to Canada, although in 1821 one group of refugees settled in Amherstburg, Upper Canada, and started a briefly profitable tobacco-growing industry.

After 1840, Canada became the main destination of enslaved blacks fleeing the United States by the UNDERGROUND RAILROAD. Following the precedent set in the Jesse Happy extradition case of 1838, Canada refused to recognize "self-theft" as a crime or to extradite fugitive slaves, and this policy was ratified in the Webster-Ashburton Treaty of 1842 between Great Britain and the United States. Approximately thirty thousand enslaved African-American fugitives escaped to Canada West via the Underground Railroad from 1830 to 1860. Some came directly from the American South, but most had previously sought protection in the North. In addition, about ten thousand free-born African Americans emigrated to Canada during this period. Almost all were destitute on arrival, and were forced to seek agricultural or un-

skilled wage labor. Some migrated west during the 1850s as farmers or workers on the Great Western Railway. Where blacks settled depended greatly on the route they had taken. Most settled in Upper Canada (known as Canada West between 1837 and 1867) near the American border, around towns such as York (renamed Toronto in 1833), Windsor, Niagara, Hamilton, and St. Catherine's.

During the antebellum period, several black settlements were created in Canada, by both blacks and white philanthropists. The most famous is Wilberforce, established as a refuge for a group who left Cincinnati. In 1829 Cincinnati authorities decided to enforce Ohio's Black Code (see BLACK CODES), and ordered all free African Americans to pay a $500 tax within thirty days or leave the city. Members of the African-American community, "encouraged" by whites to leave Cincinnati, sent Israel Lewis and Thomas Cresap to Canada to find a resettlement site. They purchased four hundred acres of land on Lake Huron from the Canada Company with funds from Indiana and Ohio Quakers. Canadian whites severely rebuked the Company for "encouraging the settlement of Blacks." Lewis and Cresap returned to Cincinnati, but were able to convince only two hundred blacks to join the settlement. The settlers traveled to Canada and set up their community, which they named Wilberforce, after the famous abolitionist. Poorly planned and funded, it remained in existence until 1836, then disbanded.

Another notable settlement was Dawn, located near Chatham. It was conceived as part of a proposed system of manual training schools for new fugitives, who would be taught skills necessary for survival in a hostile environment. With the support of white abolitionist Hiram Wilson, forty-three Oberlin College students, and funds from the Canada Mission of the largely Congregational American Missionary Association (AMA), the British-American Institute, containing a training school and sawmill, was established in Chatham in 1843. The project was directed by Josiah HENSON, a former slave preacher and abolitionist. The surrounding black settlement, named Dawn for the settlers' positive hopes, soon prospered and attracted over five hundred people during the succeeding years. New arrivals were given food and clothing, and classes began to be taught. Unfortunately, by 1849 Dawn's funding had diminished, and the American Baptist Free Mission Society took over the project. Henson traveled to England to display settlement products and raise money. Dawn Settlement closed in the 1850s, and financial difficulties crippled and ultimately killed the British-American Institute in 1868.

Other settlements of note include Elgin, established by the Elgin Association in 1850, over violent opposition from local whites. Elgin provided classical rather than manual education, with classes taught by Knox College students. By 1852, seventy-five families had settled in Elgin, and soon after, the number doubled. As the community grew, it prospered economically, and eventually contained a general store, school, two-story brick hotel, potash and pearl-ash factory, and substantial residences. Elgin's success was interrupted in 1873 by a smallpox epidemic which killed many families and led others to flee. The town dissolved soon after.

The Refugee Home Society, established near Amherstburg by Henson, Henry BIBB, and a few others, grew out of an earlier effort, the Sandwich Mission. One hundred fifty fugitive slaves were given two thousand acres on which to settle. Funding came primarily from white philanthropists in the United States. Black critics, such as Mary Ann Shadd (see Mary Ann Shadd CARY), who opposed black settlements as separatist, charged that contributions by whites insured continued black dependence, and decried the corruption of Refugee Home Society agents. Limited resources, coupled with poor management and widespread criticism, caused the termination of the project in 1876.

Throughout the antebellum years blacks discussed plans to stimulate mass African American emigration. Many blacks who opposed settlement in Africa supported Canadian emigration for two reasons: Canada was geographically and culturally closer to home, and so allowed families to maintain ties; and emigration to Canada was a choice blacks made for themselves, as opposed to forced African exile. Blacks such as Richard ALLEN campaigned for black settlement in Canada as early as the 1830s, and in 1834 a committee of the Negro Convention officially endorsed settlement in Canada, although disagreements over timing and possible sites prevented further action. Meanwhile, Josiah Henson, arguing that the protection of British law offered greater opportunity for blacks than they could find in the United States, became involved in the emigration movement. During the 1850s, Mary Ann Shadd's journal, *The Provincial Freeman,* propagandized for emigration. Her 1852 pamphlet, *Notes on Canada West,* hailed the economic possibilities and integrated churches and schools of the region. In 1854 Henry Bibb and James Holly organized a National Emigration Convention in Cleveland to organize efforts for Canadian migration. However, many influential abolitionists, notably Frederick DOUGLASS and J. W. C. PENNINGTON, opposed emigration. They argued that African Americans were Americans and should work to improve conditions at home rather than leave. They maintained that emigration, whether to Canada or Africa, would reduce abolitionist pressure on slave

owners. Opponents pointed to the fiascos of the Wilberforce settlement and the Refugee Home Society as evidence that large-scale colonization was impractical.

The passage of the Fugitive Slave Act of 1850 spurred renewed interest in mass settlement in Canada, and during the following decade perhaps ten thousand African Americans emigrated north to safety in Ontario and elsewhere. In these years, African Americans built a large expatriate movement in Canada. While they were aware of the need to fight prejudice in Canada, black expatriates maintained their focus across the border. Leaders such as Jermain LOGUEN, Samuel Ringgold WARD, H. Ford Douglas, William Howard Day, and Henry Bibb continued their antislavery activities, collected funds to assist émigrés, discussed building settlements, and wrote newspaper pieces arguing for black emigration. Lecturers such as William Wells BROWN and Isaac Cary toured the province. Minister William H. Jones built a large British Methodist Episcopal Church in Chatham. Harriet TUBMAN settled in St. Catherine's, and set up an interracial Refugee Slaves' Friends Society. Another notable émigré was the physician and abolitionist Martin DELANY, who settled in Chatham in 1854, and continued his speaking and medical career. Delany was delighted to be able to find a good school for his children and to be able to vote in provincial elections.

In 1858 and 1859, a group of seven hundred blacks, tired of discrimination in California, moved to Vancouver Island in the Canadian northwest. Many were educated and experienced in business and skilled trades; the region's economic boom, brought on by the Fraser River Gold Rush, had led to a labor shortage they quickly helped fill. When white Americans living on Vancouver organized a movement for annexation by the United States, the African Americans formed a volunteer militia company, the Victoria Pioneer Rifle Company (better known as the African Rifles) to defend the territory against an American takeover.

The affection and loyalty blacks displayed toward Canada reflected their belief in the myth of the "North Star," by which Canada was not only the land of freedom but also of equality and interracial amity. Blacks did indeed enjoy legal equality and suffrage rights in Canada. A few blacks living in the western Canadian areas that became Alberta, British Columbia, and Saskatchewan were either elected to office or appointed to administrative positions in the 1860s. For example, Mifflin GIBBS sat on the Victoria (British Columbia) Common Council in 1866 and 1867.

However, most blacks faced harsh difficulties. Many white Canadians, however they felt about slavery, opposed large-scale black settlement. While some African-American skilled craftsmen, artisans, and professionals emigrated, the general impoverishment and dependence of most black refugees left them tarred by negative images of laziness and helplessness. Their slave past and low-wage labor brought them disdain and resentment from whites, particularly in areas where they settled in large numbers. Furthermore, as segregation grew in the American North, it spread to Canada. Blacks were excluded or separated from whites in saloons, theaters, and concert halls and in a few places were kept from voting or jury service. In 1850 Canada West passed the Common School Act, which permitted separate schools, or where they did not exist, separated classrooms. Separation and discrimination were enforced by rioting. Racial violence, for example, broke out in Chatham, Ontario in 1860, when a black man married a white woman, and when blacks sat downstairs in the main section of the local theater. Even the proud African Rifles, symbol of black attachment to Canada, were excluded from parades and public ceremonies, and kept separate from the white Vancouver Island Volunteer Rifle Corps. Most white Canadians considered blacks outsiders, to be tolerated but never considered true Canadians. Having become disillusioned with Canada, most black refugees moved back to the United States after the CIVIL WAR, reinforcing white Canadians' view of blacks as essentially foreign.

In response to separation, during the antebellum years black Canadians formed close-knit communities in their settlements, to shield blacks from white prejudice and guard against kidnapping by American slave catchers. Excluded from white churches, blacks formed their own, mostly Baptist and Methodist. As in America, churches formed the center of black life. With the aid of missionary groups and British charitable organizations, as well as paltry government funds, communities set up schools. Community members also formed temperance societies, self-help societies, antislavery committees, and other groups. There were a few black Canadian newspapers, the first being Henry Bibb's *The Voice of the Fugitive,* begun in 1851.

After the passage of the THIRTEENTH AMENDMENT in 1865, many blacks in Canada returned to the United States. Following Confederation in 1867, Canada sought immigrant white laborers for Western settlement. While a few black homesteaders did arrive from America, the percentage of blacks in the population dwindled, and Canada's self-image as a welcoming refuge for blacks faded. Canada resembled the American North. Blacks were widely regarded as inferior and dangerous. Segregation, while never legally mandated, was common. While a few

prominent figures, such as real estate tycoon Wilson Abbott, his physician/journalist son Anderson AB-BOTT, and William HUBBARD, city councilman and later acting mayor of Toronto at the turn of the century, were successful, most blacks remained trapped in poor educational systems and low-wage, low-status jobs.

Canadian reaction to a new wave of African-American migration clearly demonstrated the changed conditions. In 1910 African Americans from Oklahoma, mostly skilled farmers whose social and legal condition had dramatically deteriorated in 1907 after Oklahoma became a state, decided to leave. Approximately thirteen hundred blacks moved to the provinces of Alberta and Saskatchewan over the following two years, most settling together near Edmonton. Though they were legal immigrants, the move unleashed a storm of protest from white Canadians, who feared an influx of African Americans. They organized a giant petition and lobbying movement to press the Canadian government to segregate existing black immigrants, and to ban further migration. Although the Liberal government prepared an order-in-council to prohibit black immigration for a year, it did not proclaim it for fear of alienating the United States and losing black Canadian votes. However, Canadian railway agents and border officials were instructed to curb immigration through various methods, and black migration to Canada was swiftly halted without recourse to open official action.

The history of blacks in Canada in the twentieth century effectively mirrors that of blacks in the northern United States. The first fifty years were the nadir. De facto segregation was widespread. Immigration authorities excluded nonwhites. Black volunteers during World War I were initially rejected, then sent to Europe as a segregated noncombat labor force. Provincial courts repeatedly upheld segregation in public accommodations. In 1940 the Supreme Court of Canada upheld the exclusion of a black man from a Montreal tavern. Housing discrimination was widespread, especially in cities. During the 1930s, when the depression forced rural blacks into urban areas to look for work, they were forced into poor housing and ghetto areas closely resembling those of American cities. In addition, both private employers and the federal government routinely practiced job discrimination.

Black Canadians (who long preferred the use of the term "colored" to describe themselves) protested the denial of equal rights, although they were unable to build a united group. The NIAGARA MOVEMENT, which had a few Canadian adherents, had its first meeting in Niagara, Ontario in 1906. In the 1920s, black sleeping car porters began a thirty-year campaign for equal promotion. In 1924, with the support of the Baptist church, the Canadian League (later the Association for the Advancement of Colored People) was founded.

In the second half of the twentieth century, the condition of black improved. Provincial civil rights groups such as the Nova Scotia Association for the Advancement of Colored People, formed in 1945, conducted educational and protest campaigns and lobbying. Court decisions and legislation overturned discrimination in housing and employment. In 1960 a federal Bill of Rights was passed, which outlawed racial discrimination. Over the following years the provinces enacted human rights ordinances to combat inequality.

By 1980, as a result of increased educational opportunity for Canadian-born blacks and of new immigration from Africa and the West Indies, people of African descent—who comprised about 3 percent of the twenty-seven million persons in Canada by 1990—had a higher average educational attainment than whites in most provinces. Racial discrimination, still entrenched in Canada, became increasingly glaring and difficult to rationalize, and racial tensions grew during the 1970s and 1980s. Black gains prompted a racist backlash. The KU KLUX KLAN and other white supremacist groups emerged in large numbers for the first time, and large numbers of white Canadians were forced to deal with their own racist views. During the late 1980s and early 1990s, police shootings of blacks in Montreal and Toronto led to mass protest. In June 1992, Toronto blacks reacted to a police shooting and the verdict in the Rodney King case from Los Angeles by confronting police, breaking windows and looting shops along downtown Yonge Street.

During the twentieth century, black Canadians grew more visible and active in the society. Several black Canadians attracted international renown, such as JAZZ musician Oscar PETERSON, track star Ben Johnson, and baseball pitcher Ferguson Jenkins. Conversely, African-American athletes became an important part of the Canadian landscape. Black football players, from George Dixon and Cookie Gilcrist to Warren Moon and "Rocket" Raghib Ismail, starred in the Canadian Football League. In 1992 Cito Gaston, manager of the Toronto Blue Jays, became the first African-American manager to win a World Series, as well as the first manager of a Canadian team to accomplish the feat.

REFERENCES

CLAIRMONT, DONALD H., and DENNIS W. MAGILL. *Nova Scotia Blacks: An Historical and Structural Overview.* Halifax, Nova Scotia, 1970.
DREW, BENJAMIN. *The Refugee: Narratives of Fugitive Slaves in Canada.* 1856. Reprint. New York, 1968.

HILL, DANIEL. *The Freedom Seekers: Blacks in Early Canada.* Agincourt, Ontario, 1981.

HOWE, S. G. *The Refugees From Slavery in Canada West: Report of the Freedmen's Inquiry Commission.* Boston, 1864.

RIPLEY, C. PETER, ET AL., eds. *The Black Abolitionist Papers.* Vol. 2, *Canada.* Chapel Hill, N.C., 1987.

SHEPHERD, R. BRUCE. "The Origins of the Oklahoma Black Migration to the Canadian Plains." *Canadian Journal of History* 23 (April 1988): 1–23.

SILVERMAN, JASON H. *The Unwelcomed Guests: Canada's Response to American Fugitive Slaves 1800–1865.* Millwood, N.Y., 1985.

SPRAY, WILLIAM. *The Blacks in New Brunswick.* Fredericton, New Brunswick, 1972.

WALKER, JAMES W. ST. G. *The Black Loyalists.* New York, 1979.

———. *A History of Blacks in Canada.* Ottawa, Ontario, 1980.

———. "Racial Discrimination in Canada: The Black Experience." *Canadian Historical Association Pamphlet #41.* Ottawa, Ontario, 1985.

WINKS, ROBIN W. *The Blacks in Canada: A History.* New Haven, Conn., 1971.

E. VALERIE SMITH

Cannon, George Dows (October 16, 1902–1986), physician and civic activist. George Dows Cannon was born in Jersey City, N.J., the son of George Epps CANNON, a physician, and Genevieve (Wilkinson) Cannon. After attending Jersey City public schools, he earned an A.B. at Lincoln University, in Pennsylvania, in 1924.

Cannon attended the College of Physicians and Surgeons, Columbia University, for a year prior to entering Rush Medical College of the University of Chicago in the fall of 1926. In 1929, four months before graduation, he contracted tuberculosis and was forced to abandon his studies temporarily. He earned an M.D. in 1934, supported by a grant from the Rosenwald Fund.

Following an internship at Waverley Hills Sanatorium in Kentucky, Cannon went into private practice in Harlem. Later he was appointed to the radiology staff at Triboro Hospital and the Hospital for Joint Diseases. By 1948, he and five other African Americans had been elected to the prestigious New York Academy of Medicine. He was a leader of the Physicians' Forum, a group that pressed for progressive health reforms and the elimination of discrimination against black physicians. From 1962 to 1984, he served as secretary of the board of directors of the NAACP Legal Defense and Educational Fund. Although he declined suggestions that he run for political office himself, he was active in several campaigns, most notably as the Harlem chairman of Henry Wal-

lace's Progressive party presidential campaign in 1948. Cannon joined the board of trustees of Lincoln University in 1947, later serving as board chairman for fourteen years.

REFERENCES

CANNON, GEORGE D. "Secondary Aspergillosis (*Aspergillus niger*) Superimposed Upon Bronchiectasis." *Journal of Thoracic Surgery* 4 (June 1935): 533–535.

JAMES, DANIEL. "Cannon the Progressive." *New Republic* 119 (October 18, 1948): 14–15.

PHILIP N. ALEXANDER

Cannon, George Epps (July 7, 1869–April 6, 1925), physician and activist. George Cannon was born in Fishdam (later Carlisle), S.C., the son of Barnett Glenn Cannon, a farmer, and his wife, Mary Tucker Cannon. After attending Brainerd Institute in Chester, S.C., he taught public school in his native town for two years.

Cannon followed his older brother John to Jersey City, N.J., where he obtained a Pullman-porter job assigned to the private railcar of David Dows, a wealthy grain importer. With his savings, he attended Lincoln University in Pennsylvania, receiving an A.B. in 1893. He earned an M.D. at New York Homeopathic Medical College in 1900. In 1901, he married Genevieve Wilkinson, daughter of John F. N. Wilkinson, assistant librarian of the U.S. Supreme Court. The Cannons had two children, George Dows and Gladys. Cannon built a large private practice, patronized by both blacks and whites.

The Cannon household was a center of social, professional, civic, and political activity. Cannon was a member of the Odd Fellows and Elks, and headed the John Brown Building and Loan Association. He was active in the National Medical Association, North Jersey Medical Association, and Academy of Medicine of Northern New Jersey. A Republican, he became the first black member of the prestigious Lincoln Association. At the Republican National Convention of 1924, he seconded the nomination of Calvin Coolidge for president. As chairman of the executive board of the National Medical Association, he took a leading part in the successful struggle to appoint black physicians to the Tuskegee (Ala.) Veterans' Hospital.

REFERENCE

DICKERSON, DENNIS CLARK. "George E. Cannon: Black Churchman, Physician, and Republican Politician." *Journal of Presbyterian History* 51 (1973): 411–432.

PHILIP N. ALEXANDER

Cardozo, Francis Louis (February 1, 1837–July 22, 1903), minister, educator, and politician. Francis L. Cardozo was born in Charleston, S.C., in 1837. His father, Isaac N. Cardozo, a prominent Jewish businessman and economist, was married to a free black woman. Cardozo's parents' wealth enabled him to be educated at a free Negro school in Charleston until he was twelve. His mother and father subsequently apprenticed him to a carpenter, and after completing his apprenticeship, Cardozo pursued this vocation for several years. When he was twenty-one, he went to Great Britain, where he studied for the ministry. Upon returning to the United States in 1864, he became a Congregational minister. Like a number of black churchmen, Cardozo went south after the Civil War. The conclusion of hostilities between North and South opened a vast missionary field for black ministers who wanted to work with freedmen.

Francis L. Cardozo, photographed in Columbia, S.C., had a productive and stormy career in the post–Civil War governments in that state, a career that included terms as secretary of state and state treasurer. After Reconstruction, he moved to Washington, D.C., where he was principal of a high school. (Prints and Photographs Division, Library of Congress)

Returning to Charleston as a missionary of the American Missionary Association, Cardozo became principal of the Saxton School, replacing his younger brother, Thomas, who had been forced to resign after a sexual indiscretion at his previous post was revealed. Cardozo did not remain long at this position; in 1866 he helped establish the Avery Normal Institute in Charleston and became its first superintendent. Avery was founded to train black teachers, and in the post–Civil War South the school played a prominent role in the education of blacks.

Serving as both educator and minister, Cardozo was drawn into the web of RECONSTRUCTION politics. Cardozo began his career as a politician inauspiciously as a delegate to the 1868 South Carolina state constitutional convention. He then served as South Carolina's secretary of state from 1868 to 1872, the first black in South Carolina's history to hold government office. He was state treasurer from 1872 to 1877. Compared with other black preacher-politicians during Reconstruction, Cardozo was fairly moderate. He did not alienate his white Republican peers in the ways that R. H. CAIN, Tunis G. Campbell, and Henry McNeal TURNER did. For example, Cardozo did not urge the freedmen to seize their former masters' land, as Campbell did in Georgia. When the Reconstruction government of South Carolina was overthrown in 1877, Cardozo moved to Washington, D.C., where he became a member of the city's black elite. He died there in 1903.

REFERENCES

DRAGO, EDMUND L. *Initiative, Paternalism, and Race Relations: Charleston's Avery Normal Institute.* Athens, Ga., 1990, pp. 49–56.
FONER, ERIC. *Freedom's Lawmakers.* New York, 1993, p. 39.

CLARENCE E. WALKER

Carey, Archibald J., Jr. (February 29, 1908– April 20, 1981), minister, politician, and judge. Archibald Carey, Jr., the son of an African Methodist Episcopal (AME) Church bishop and descendant of three generations of ministers, was born in Chicago and had a distinguished career as a minister, politician, and judge. He was educated in Illinois, at the Holy Name Technical School (now Lewis University) in Romeoville, from where he received a B.S. in 1929, and at the Garrett Theological Seminary.

The AFRICAN METHODIST EPISCOPAL CHURCH (AME) ordained Carey in 1930 and he became pastor of the Woodlawn AME Church in the same year. After receiving a J.D. from Chicago Kent College of Law in 1935, Carey pursued a second career as a

lawyer while continuing to preach. In 1949, he was appointed to Quinn Chapel, the oldest black congregation in Chicago.

Carey developed a reputation as a powerful pulpit orator and, in 1954, an *Ebony* poll named Carey one of the ten most popular African-American ministers in the country. He was also a civil rights activist with the CONGRESS OF RACIAL EQUALITY (CORE) in Chicago in the 1940s, and later was an associate of the Rev. Dr. Martin Luther KING, Jr.

A lifelong Republican, Carey became actively involved in politics in 1947, when he was elected an alderman from the third ward of Chicago. He was reelected in 1951, but lost his bid for a third term four years later. His most famous speech was his address to the 1952 Republican National Convention on the subject of racial equality: "From the Ozarks in Arkansas, from the Stone Mountain in Georgia, from the Blue Ridge Mountains of Virginia . . . from every mountainside, let freedom ring!" This speech was one of the rhetorical models for part of Martin Luther King's "I Have a Dream" speech to the 1963 March on Washington.

In 1953, Carey was appointed an alternate member of the U.S. delegation to the eighth session of the United Nations. In 1955, President Dwight D. Eisenhower named him vice chair of the Committee on Government Employment Policy. Carey was made chair in 1957, becoming the first African American to head a presidential committee. He resigned when Eisenhower left office in 1961.

In 1962, Carey was elected to the Probate Court of Cook County, Ill. When he became a judge on the circuit court, in 1966, he gave up his pastoral duties at Quinn. Carey served on the circuit court until he retired in 1978. He was recalled in 1980 to be a special senior judge in the law-jury division. On April 1, 1981 Carey declined a reappointment due to ill health and died in Chicago later that month.

REFERENCES

CHRISTMAS, WALTER. *Negroes in Public Affairs and Government.* Yonkers, N.Y., 1966.
FARMER, JAMES. *Lay Bare the Heart: An Autobiography of the Civil Rights Movement.* New York, 1985.
LESTER, JULIUS. "An Inspiration by Earlier Tongues." *The Washington Times,* January 2, 1992, p. D3.
MILLER, KEITH D. *Voice of Deliverance: The Language of Martin Luther King and Its Sources.* New York, 1992.

PETER SCHILLING

Carey, Lott (c. 1780–November 28, 1828), missionary. Lott Carey, America's pioneer missionary to Africa, was born in slavery around 1780 on the plantation of William A. Christian in Charles City County, some thirty miles south of Richmond, Va. In 1804 he was hired out to work in Richmond at the Shockoe tobacco warehouse. From the segregated gallery of Richmond's First Baptist Church, Carey was converted to the Christian religion in 1807 by the preaching of John Courtnay, a white man. He was baptized by him, and joined the church. Carey determined to enter the ministry and learned to read and write. Permitted to preach to both blacks and whites in the area, Carey formed the African Missionary Society, which raised $700 in five years to send him and Collin Teague to Africa. At the tobacco warehouse he earned an extra $850 by 1813 with which he purchased his own and his children's freedom (his first wife had recently died).

In January 1820 (or possibly 1821) Carey and Teague sailed on the *Nautilus* for Africa. Teague retired after a year to Sierra Leone, but Carey was instrumental in establishing the colony of Liberia, and forming a Baptist church in Monrovia. He became the country's health officer, and in 1826 was named vice agent of the colony under the AMERICAN COLONIZATION SOCIETY. Carey identified with the effort to build a black republic, and said, "I am an African. . . . I wish to go to a country where I shall be estimated by my merits, and not by my complexion; and I feel bound to labor for my suffering race."

Carey was killed November 28, 1828, in an accidental explosion of gunpowder while he was engaged in making cartridges to fight off attacking native Liberians. In 1897 the Lott Carey Baptist Foreign Missionary Society was established in his memory.

REFERENCE

FITTS, LEROY. *Lott Carey: First Black Missionary to Africa.* Valley Forge, Pa., 1978.

LEROY FITTS

Carmichael, Stokely (July 29, 1941–), activist. Born in Port of Spain, Trinidad, Stokely Carmichael graduated from the Bronx High School of Science in 1960 and Howard University in 1964. During his college years, he participated in a variety of civil rights demonstrations sponsored by the CONGRESS OF RACIAL EQUALITY (CORE), the Nonviolent Action Group (NAG), and the STUDENT NONVIOLENT COORDINATING COMMITTEE (SNCC). As a freedom rider, he was arrested in 1961 for violating Mississippi segregation laws and spent seven weeks in Parchman Penitentiary. After college, he worked with the Mississippi Summer Project, directed SNCC voter-registration efforts in Lowndes County,

Stokely Carmichael, chairman of the Student Non-violent Coordinating Committee (SNCC), during James Meredith's Freedom March in Mississippi, June 12, 1966. (© Charmian Reading)

Ala., and helped organize black voters through the Lowndes County Freedom Organization.

Elected SNCC chairman in 1966, he proffered an outspoken, militant stance that helped distance SNCC from the moderate leadership of competing civil rights organizations. A chief architect and spokesperson for the new Black Power ideology, Carmichael coauthored (with Charles V. Hamilton) *Black Power* (1967) and published a collection of his essays and addresses, *Stokely Speaks* (1971). He left his SNCC post in 1967. The next year he was made prime minister of the BLACK PANTHER PARTY; in 1969, he quit the Black Panthers and became an organizer for Kwame Nkrumah's All-African People's Revolutionary Party. Studies with Nkrumah of Ghana and Sékou Touré of Guinea confirmed his Pan-Africanism and, in 1978, moved him to change his name to Kwame Toure. Since 1969, he has made Conakry, Guinea, his home. He has continued his work in political education, condemning Western imperialism, and promoting the goal of a unified socialist Africa.

REFERENCES

CARMICHAEL, STOKELY. *Stokely Speaks: Black Power Back to Pan-Africanism.* New York, 1971.
CARMICHAEL, STOKELY, and CHARLES V. HAMILTON. *Black Power: The Politics of Liberation in America.* New York, 1967.

WILLIAM L. VAN DEBURG

Carney, Harry Howell (April 1, 1910–October 8, 1974), saxophonist. Harry Carney was born in Boston. His early musical studies focused first on piano, followed by clarinet and alto saxophone. Carney was musically active in Boston before moving to New York in 1927, and then joined the orchestra of Duke ELLINGTON. With only a few brief leaves, Carney remained with the Ellington orchestra until his death in 1974, only a few months after the death of the bandleader. Carney's almost fifty years with Ellington was one of the longest and most fruitful collaborations in jazz history. With Ellington he was able fully to explore his skills as a reed player, especially on alto and baritone saxophone and bass clarinet. In addition to his rich tone and circular breathing technique—both of which contributed to the rich Ellingtonian musical palette—through Ellington, Carney also became known as a soloist; for example, his bass clarinet solo in "The Saddest Tale," and several baritone saxophone solos, including those in "Slippery Horn" and "In a Sentimental Mood." Carney died in New York on October 8, 1974.

REFERENCES

ELLINGTON, MERCER, with Stanley Dance. *Duke Ellington in Person: An Intimate Memoir.* Reprint. New York, 1979.
HOSIASSON, JOSÉ. "Harry Carney." In *The New Grove Dictionary of Jazz.* Vol. 1. New York, 1988, p. 187.

EDDIE S. MEADOWS

Carney, William H. (c. 1840–December 9, 1908), first black winner of the Congressional Medal of Honor. William Carney was born to a slave woman and her free husband in Norfolk, Va. When his master died, Carney, aged fourteen, and his mother were manumitted. Carney studied for a time at a school run secretly by a minister. He also worked at sea with his father. In 1856, Carney's family moved to New Bedford, Mass. He joined a church there and studied for the ministry. In February 1863, Carney enlisted in the FIFTY-FOURTH REGIMENT OF MASSACHUSETTS VOLUNTEER INFANTRY, the first African-American regiment recruited by the United States Army.

On July 18, 1863, the Fifty-fourth Massachusetts led the charge against FORT WAGNER on Morris Island, S.C. Carney caught the Union colors when the flag bearer was wounded by an exploding shell. Carney made his way alone to the outer wall of the fortress, until advancing Confederate troops forced him back. Although he was shot twice and had to crawl on his knees, he kept the flag aloft until he reached his company. While he crept back in retreat under fire, he was shot again before reaching safety. Upon reaching Union lines, Carney is reported to have said, "Boys, the old flag never did touch the ground."

The Battle of Fort Wagner signaled a turning point in the federal government's use of black troops. The Fifty-fourth Massachusetts dispelled doubts about the reliability of black soldiers; by the end of 1863 there were sixty African-American regiments in combat or being organized. After the war, the battle flag Carney had carried was enshrined in the Massachusetts statehouse.

Carney was discharged with the rank of sergeant in 1864. He lived for two years in California, but eventually returned to New Bedford, where he worked as a mail carrier until 1901. He was a popular speaker at patriotic celebrations, including a convention of black veterans in 1887. For his valor, Carney was the first African American cited for the Congressional Medal of Honor on June 18, 1863, although he was not issued the medal until May 20, 1900. He retired in 1901 and moved to Boston, where he served as a messenger in the statehouse. He died in 1908.

REFERENCES

QUARLES, BENJAMIN. *The Negro in the Civil War.* 1953. Reprint. New York, 1968.

WESTWOOD, HOWARD C. *Black Troops, White Commanders, and Freedmen during the Civil War.* Carbondale, Ill. 1992.

SIRAJ AHMED
ALLISON X. MILLER

Carpetbaggers. Devised by opponents of RECONSTRUCTION as a term of abuse for Northerners who came to the South after the Civil War and joined the REPUBLICAN PARTY, the word *carpetbagger* has remained part of the lexicon of American politics. Today it refers to those, regardless of region, who run for office in a district to which they have only recently moved.

During Reconstruction, the term implied that Republican newcomers were men from the lower echelons of northern society who had packed all their belongings in a suitcase and left their homes in order to reap the spoils of office in the South. This image was reinforced by anti-Reconstruction scholars early in the twentieth century, who charged that carpetbaggers poisoned the South's allegedly harmonious race relations by turning gullible African Americans against their former masters and using them as stepping-stones to office.

Some carpetbaggers undoubtedly were corrupt adventurers. The large majority, however, hardly fit the traditional image. Most tended to be well educated and middle-class in origin. Some had been lawyers, businessmen, newspaper editors, and other pillars of northern communities. The majority (including fifty-two of the sixty who served in Congress during Reconstruction) were veterans of the Union army who simply decided to remain in the South when the war ended in 1865. At this time, blacks did not enjoy the right to vote, and the possibility of office for northern newcomers was remote.

For most carpetbaggers, the lure of the South was the same that drew thousands of Americans to settle in the West during the nineteenth century—economic opportunity. With cotton prices high and the South starved of capital, numerous army veterans purchased land or went into business with impoverished southern planters. They hoped to combine personal economic gain with a role in helping to mold the "backward" South in the image of the modern, industrializing North, substituting, as one wrote, "the civilization of freedom for that of slavery." Other groups of carpetbaggers were teachers, Freedmen's Bureau officers, and those who came to the region genuinely hoping to assist the former slaves.

A variety of motives led these Northerners to enter politics in 1867. Crop failures had wiped out many who had invested in cotton land, and politics offered a livelihood. Some had earned the former slaves' goodwill, or proved more willing to work politically with African Americans than were native-born white Southerners. Indeed, in some localities, carpetbaggers were the only Republicans with political experience, and a number ran for office because they had been asked to do so by the former slaves. Generally, carpetbaggers were more likely than white southern Republicans to support black aspirations for equality before the law, and laws prohibiting racial segregation in public accommodations. As proponents of the North's "free labor" ideology, they strongly favored Reconstruction programs promoting railroad development and economic modernization, and tended to oppose measures to use the power of the state to distribute land to the former slaves.

No accurate figures are available as to how many Northerners came to the South during Reconstruction, but in no state did those born in the North represent even 2 percent of the total population.

Nonetheless, carpetbaggers played a major role in Republican politics. Generally representing Black Belt constituencies, they held a major share of Reconstruction offices in Florida, Louisiana, and South Carolina, whose Republican parties attracted little support from white Southerners. Their ranks included such Republican governors as Robert K. Scott (who came south from Ohio with the Army and directed the Freedmen's Bureau in South Carolina) and Henry C. Warmoth and William P. Kellogg of Louisiana (army veterans from Illinois). In Mississippi, when black leaders became dissatisfied with the moderate policies of "scalawag" Gov. James L. Alcorn (see SCALAWAGS), they turned to Maine native Adelbert Ames, who had demonstrated a commitment to equal rights when he commanded the fourth military district under the Reconstruction Act of 1867. Ames was elected governor in 1873. Another prominent carpetbagger was Albion W. Tourgée, who, as a judge in North Carolina, waged a courageous campaign against the Ku Klux Klan.

Although the term *carpetbagger* generally applies to whites, a considerable number of black Northerners also came south during this period. Reconstruction was one of the few occasions in American history when opportunities for black men of talent and ambition were greater in the South than in the North. The ranks of "black carpetbaggers" included veterans of the Union army, ministers and teachers who had come south to work for the Freedmen's Bureau or for northern aid societies, and the children of southern free blacks who had been sent north years before for an education. Quite a few were veterans of the antislavery struggle in the northern states or Canada.

Over 100 public officeholders after the Civil War were African Americans who had been born in the North or lived there for a substantial period before the war. Born in Philadelphia, Mifflin GIBBS and Jonathan Gibbs held major positions in Arkansas and Florida, respectively. Tunis G. Campbell, who had lived in New York before the Civil War, was the political "boss" of McIntosh County, Ga., during Reconstruction, and Stephen A. Swails, a veteran of the FIFTY-FOURTH REGIMENT OF MASSACHUSETTS VOLUNTARY INFANTRY, became the most prominent political leader in Williamsburg County, S.C. A number of "black carpetbaggers" had been born abroad, including South Carolina congressman Robert B. ELLIOTT, apparently a native of Great Britain, and Martin F. Becker, a South Carolina constitutional convention delegate, who hailed from Dutch Guiana (now known as Suriname).

After the end of Reconstruction, most white carpetbaggers appear to have returned to the North, as did many of their black counterparts.

REFERENCES

CURRENT, RICHARD N. *Those Terrible Carpetbaggers: A Reinterpretation.* New York, 1988.
FONER, ERIC. *Freedom's Lawmakers: A Directory of Black Officeholders During Reconstruction.* New York, 1993.
HARRIS, WILLIAM H. "The Creed of the Carpetbaggers: The Case of Mississippi." *Journal of Southern History* 40 (1974): 199–224.
OVERY, DAVID H. *Wisconsin Carpetbaggers in Dixie.* Madison, Wis., 1961.
POWELL, LAWRENCE N. *New Masters: Northern Planters during the Civil War and Reconstruction.* New Haven, Conn., 1980.

ERIC FONER

Carr, Wynona (August 23, 1924–May 12, 1976), gospel singer. Wynona Merceris Carr was born in Cleveland, Ohio, the daughter of Jesse and Beulah Carr. She studied at the Cleveland Music College and sang, played piano, and directed church choirs in Cleveland and Detroit. In 1945 she established the Carr Singers, a traveling gospel quintet, and sang also with the Wilson Jubilee Singers. Her first records, made in 1949, were "Each Day" and "Lord Jesus." Carr's style was more bluesy than traditional gospel, and her strong contralto voice would have been perfect for torch songs.

Carr's best-known song, her own lively composition, is "The Ball Game," recorded in 1952, in which the elements of baseball are transformed into religious images: Satan is the pitcher, Solomon the umpire; the bases are Temptation, Sin, and Tribulation; and "Jesus is standing at the home plate, and he's waiting for you to come in." The evangelical utilization of the vernacular for religious metaphor continued with her compositions "Dragnet for Jesus," based on the popular television program; "Fifteen Rounds for Jesus," a boxing analogy; and "Operator, Operator," with its line "Give me Jesus on the phone."

Carr never achieved real popularity as a gospel singer, perhaps because her voice was so blatantly earthy and her piano playing so quintessentially honky-tonk. She switched to secular music, and immediately recorded a rhythm and blues hit, "Should I Ever Love Again," in 1957. She contracted tuberculosis soon afterward, however, and was unable to work and thus to capitalize on her success. When she was able to perform again, she was not well received, and after singing sporadically in supper clubs, she died virtually unnoticed.

Wynona Carr's voice was a mixture of toughness and sexuality; with better management she might

well have become a highly successful performer. Around 1954 she made a spectacular recording of "Our Father" in New Bethel Baptist Church in Detroit, where she was working as choir director. Without doubt she influenced the minister's fourteen-year-old daughter—who made her own first (and, some think, her best) recordings the same year—Aretha FRANKLIN.

RICHARD NEWMAN

Carrington, Walter C. (July 24, 1930–), ambassador. Walter Carrington, the elder of Marjorie Hayes Carrington and Walter R. Carrington's two children, was born in New York City. His father, a racing official at a greyhound racetrack in Portland Meadows, Ore., came from a large Barbadian family. His mother's family had roots in South Carolina. After the dissolution of his parents' marriage, Carrington and his mother moved to the Everett, Mass., home of his grandmother, Annie Hayes. He attended local schools and excelled academically. During his teen years he developed a close relationship with his paternal aunt, Angela Carrington Kelly, and her husband, Edward Kelly. The couple, proponents of black nationalism, had lived in Nigeria for twenty years, and their experiences triggered Carrington's interest in Africa and African people.

Carrington graduated from Harvard in 1952. He completed his law degree there in 1955. While at Harvard he was active in the youth organization of the NATIONAL ASSOCIATION FOR THE ADVANCEMENT OF COLORED PEOPLE (NAACP). He served as president of the organization's Harvard chapter and in 1952 was elected the first student member of the NAACP National Board.

After completing military service in the U.S. Army, Carrington returned to Boston. He was an active civil rights attorney when he was appointed to the Massachusetts Commission Against Discrimination. At age twenty-seven Carrington was the youngest person ever appointed a commissioner in Massachusetts. He held that post until 1961, when R. Sargent Shriver invited him to join the staff of the Peace Corps. Among its first African-American staff members, he served over a ten-year period in several capacities: as country director in Sierra Leone and Senegal; as deputy director for Tunisia; as special assistant to the director for equal employment opportunity; as deputy regional director for Africa; and as regional director for Africa, overseeing Peace Corps operations in twenty-four African countries.

In 1971 Carrington became executive vice president of the African-American Institute (AAI), an organization that fosters human resource development in Africa and promotes understanding between Africans and Americans. He left the AAI in 1980, when President Jimmy Carter appointed him U.S. Ambassador to Senegal. Serving one year, Carrington left after Carter's electoral defeat.

Thereafter, Carrington accepted the post of director of the Department of International Affairs at HOWARD UNIVERSITY, where he was responsible for expanding its international activities and developing overseas university links. He also received academic appointments at Washington University, Marquette University, and the Massachusetts Institute of Technology.

Carrington was consultant on international affairs for the Joint Center for Political and Economic Studies before taking on responsibilities at the U.S. House of Representatives. There he served as chief of staff for California representative Mervyn Dymally of Los Angeles (1981–1992), later chair of the subcommittee on Africa.

In August 1993 Carrington was sworn in as ambassador to Nigeria, appointed by President Bill Clinton.

REFERENCES

ESSIEN-UDOM, E. U. *Black Nationalism: A Search for an Identity in America.* Chicago, 1962.
REDMON, COATES. *Come As You Are: The Peace Corps Story.* New York, 1986.

ENID GORT

Carroll, Diahann (July 17, 1935–), singer, actress. Diahann Carroll was born Carol Diahann Johnson in New York, the daughter of John Johnson, a subway conductor, and Mabel (Faulk) Johnson. Her mother had her take voice and piano lessons, and at the recommendation of a guidance counselor she enrolled in the High School of Music and Art. She modeled for *Ebony* and other magazines, and at fourteen, appearing under the name "Diahann Carroll," she won first prize on the popular television show *Arthur Godfrey's Talent Scouts.* Carroll enrolled at New York University, but left during her first year, after winning a talent contest on the television show *Chance of a Lifetime.* Over the following years she toured as a singer in various important hotels and nightclubs. Her light, swinging style was influenced by Frank Sinatra and Ella FITZGERALD. She released several albums, including *Fun Life* (1961).

In 1954 Carroll began an acting career when she was chosen for the role of Ottilie in Harold Arlen and Truman Capote's *House of Flowers.* While small, the role included the song "A Sleepin' Bee," which Carroll popularized. She received a Tony Award nomi-

nation for the role. The same year, she made her screen debut in a small role in the film *Carmen Jones.* She went on to perform in such films as *Porgy and Bess* (1959), *Paris Blues* (1961), and *Goodbye Again* (1961). She returned to Broadway in 1962, as the lead in Richard Rodgers's musical *No Strings,* for which she won a Tony Award. Twenty years later she again appeared on Broadway, this time in the drama *Agnes of God.*

In 1968 Carroll became the first African-American woman to have her own television series, when she starred in the series *Julia.* Carroll played a widowed mother who worked as a nurse. The role aroused a storm of opposition among some blacks, who felt that the character was too "white," and represented white liberal images of African Americans rather than being authentically black. Nevertheless the program was a success.

Carroll remained with the program for three seasons; then, tired of the controversy, she asked to be released from her contract. In a reversal of her image, Carroll next played a single ghetto mother in the film *Claudine* (1974), for which she was nominated for an Academy Award and won an NAACP Image Award. In 1976 she was inducted into the Black Filmmakers' Hall of Fame.

Starting in the 1970s, Carroll revived her singing career, starring in nightclubs and in such places as the Kennedy Center for the Performing Arts (1971). Her solo album *Diahann Carroll* (1974) won her a Grammy Award nomination.

During the late 1970s and 1980s Carroll also returned to television. In 1979 she appeared in the miniseries *Roots: The Next Generation,* and in the television film *I Know Why the Caged Bird Sings.* In 1984 she took the role of Dominique Devereaux on the television series *Dynasty,* thus becoming the first African American to star in a nighttime soap opera. Carroll felt that her portrayal of a character as conniving and mean-spirited as her white peers was both her best work and an important step forward for black actors. In the 1990s she appeared frequently on the TV series *A Different World,* as the mother of Whitley Guilbert.

REFERENCE

CARROLL, DIAHANN and ROSS FIRESTONE. *Diahann: An Autobiography.* New York, 1986.

VASANTI SAXENA

Carroll, Vinnette (c. 1922–), director, actress, and playwright. Vinnette Carroll was born in New York City and moved with her family to Jamaica,

West Indies, at the age of three. She moved back to New York when she was eleven years old. A graduate of Long Island University (B.A., 1944), and New York University (M.A., 1946), Carroll studied psychology and completed all required coursework for a Ph.D. at Columbia University. Part-time acting classes at the New School for Social Research, however, changed the direction of her career.

In the early 1950s, Carroll taught drama at the High School for Performing Arts, New York City, and was the director of the Ghetto Arts Program. She was also a member of the New York State Council on the Arts. As an actress, her roles included parts in *Caesar and Cleopatra* (1955), *Small War on Murray Hill* (1956), *The Octoroon* (1961), and *Moon on a Rainbow Shawl* (1962). Carroll won an Obie for the latter role.

One of the first black women to direct on Broadway, her directing credits include *Black Nativity* (1962), *Don't Bother Me, I Can't Cope* (1971), and *Your Arms Too Short to Box with God* (1975). In addition to winning an Obie, Carroll has been the recipient of numerous awards, including an Emmy in 1964. In 1972 she was awarded the New York Critics Award for directing, the Los Angeles Drama Critics Directing Award, and the NAACP Image Award. In 1986 she founded and became artistic director of the Vinnette Carroll Repertory Company in Fort Lauderdale, Fla.

REFERENCE

CLOYD, IRIS, ed. *Who's Who Among Black Americans, 1990–1991.* Detroit, 1991.

CHRISTINE A. LUNARDINI

Carter, Bennett Lester "Benny" (August 8, 1907–), jazz saxophonist and bandleader. Born in New York City, Carter was raised in the San Juan Hill Section of Manhattan, near the present-day location of Lincoln Center. He first took up the trumpet but later began to play the alto saxophone, though he continued to play both instruments. After 1923 he played with a number of ensembles, including one led by Earl HINES. In 1925 he went to Wilberforce University in Ohio, intending to study theology, but soon went back to the life of a touring musician. By 1928 he had organized his own band, which he would lead, with several interruptions, through the mid-1940s. He was also much in demand as an arranger, and during his career did extensive arranging for Fletcher HENDERSON, McKinney's Cotton Pickers, Duke ELLINGTON, Count BASIE, as well as for many prominent singers. From 1935 to 1938 he worked in Europe.

In 1943 Carter moved to Los Angeles, where he helped break the color barrier in studio work and became the first successful African-American film composer and arranger. He also composed scores for television series, including *The Mod Squad, Ironside,* and *It Takes a Thief.* Though never inactive as a jazz musician, he has become increasingly visible since the early 1970s, playing both in small groups and as a leader of larger ensembles.

In his extraordinary long and versatile career, Carter achieved great renown for both his distinctive lyrical alto saxophone style and his smooth and powerful arranging style. In the 1970s and 1980s he became an honored figure in the jazz world. In 1974 he received an honorary degree from Princeton University. Among other awards was his selection in 1990 as Jazzman of the Year by *Down Beat* magazine.

<div align="right">WILLIAM C. BANFIELD</div>

Carter, Betty (May 16, 1930–), jazz singer. Born Lillie Mae Jones in Flint, Mich., Betty Carter began her professional career in Detroit and as a teenager sang with Dizzy GILLESPIE and Charlie PARKER. From 1948 to 1951, she both sang and arranged for the Lionel HAMPTON band. She first performed under the name Lorraine Carter; Hampton dubbed her Betty Bebop, and she thereafter became known as Betty Carter. After leaving Hampton and settling in New York in 1951, she sang in numerous clubs and theaters, including frequent appearances at Harlem's APOLLO THEATER. She toured with Ray CHARLES (1960–1963) and visited Japan (1963), London (1964), and France (1968).

Carter organized her own trio in 1969, and formed her own recording company, Bet-Car Productions, in 1971. She appeared in the musical *Don't Call Me Man,* and performed with David Amram's string orchestra in New York (1982) and Boston (1983). Although Carter's jazz roots can be traced to both Billie HOLIDAY and Sarah VAUGHAN, her vocal inflections and improvisational ability place her style closer to horn players than to vocalists. She is best known for her bop-style improvisations of popular tunes and jazz originals.

REFERENCES

KERNFELD, BARRY. "Betty Carter." *The New Grove Dictionary of Jazz.* Vol. 1. New York, 1988.
KUHL, C. "Betty Carter: Interview." *Cadence* 11, no. 2 (1985): 5.
LOCKE, G. "Betty Carter: In Her Own Sweet Way." *Wire* 24 (1986): 31.

<div align="right">EDDIE S. MEADOWS</div>

Carter, Ronald Levin "Ron" (May 4, 1937–), jazz bassist. Born into a musical family in Royal Oak, Mich., Ron Carter began playing the cello at age ten. He switched to bass in 1954, after encountering difficulties in his career due to his race, and won a scholarship to attend the Eastman School of Music in Rochester, N.Y., where he received a bachelor's degree in 1959. He went on to receive a master's degree in bass performance from the Manhattan School of Music in 1961. During this period, Carter performed regularly with several classical orchestras, including the Rochester Philharmonic, becoming one of the first African-American bassists to perform regularly with major orchestras. While working on his master's degree, Carter performed in various jazz ensembles, working with Chico Hamilton, Eric DOLPHY, and Thelonious MONK. He worked with Miles DAVIS's quintet from 1963 to 1968, in a rhythm section that included Herbie HANCOCK and Tony Williams.

Following his tenure with Davis, Carter made several recordings, most notably a collection known as the V.S.O.P. recordings, featuring Hancock, Williams, Wayne SHORTER, and a young Wynton MARSALIS. He continues to perform, mostly as the leader of his own ensemble, and taught and conducted seminars frequently. Carter wrote three books on jazz bass technique, including *Building a Jazz Bass Line.* He has taught at Washington University in St. Louis, the Manhattan School of Music, and the University of Buffalo. Carter's work as a sideman with the Davis quintet is often seen as the model of bass playing in the bop and modal jazz styles. His solid, interactive playing and astonishing technique propelled the rhythm in a manner sympathetic to his musical surroundings.

REFERENCES

HINTON, MILT. "New Giant of the Bass." *Jazz Magazine* 2, no. 2 (1978): 46.
JESKE, L. "Ron Carter: Covering All Basses." *Down Beat* 1, no. 7 (1983): 22.

<div align="right">WILLIAM C. BANFIELD</div>

Carver, George Washington (c. 1864–January 5, 1943), scientist and educator. Born in Diamond, Mo., George Washington Carver did not remember his parents. His father was believed to be a slave killed accidentally before Carver's birth. His mother was Mary Carver, a slave apparently kidnapped by slave raiders soon after he was born. He and his older brother were raised by their mother's former owners, Moses and Susan Carver, on their small, largely self-sufficient farm.

Denied admission to the neighborhood school because of his color, Carver was privately tutored and then moved to nearby Neosho to enter school in the mid-1870s. He soon realized he knew more than the teacher and left with a family moving to Fort Scott, Kans. After witnessing a lynching there, he left that town and for over a decade roamed around the Midwest seeking an education while supporting himself by cooking, laundering, and homesteading.

In 1890 Carver enrolled in Simpson College in Indianola, Iowa, where he was an art major and the only African-American student. After his teacher convinced him that a black man could not make a living in art, Carver transferred to Iowa State College at Ames in 1891 to major in agriculture. Again the only black student on campus, Carver participated fully (except for dating) in extracurricular activities and compiled such an impressive academic record that he was hired as a botany assistant to pursue postgraduate work. Before he received his master of agriculture degree in 1896, he was placed in charge of the greenhouse and taught freshmen students.

An expert in mycology (the study of fungi) and plant cross-fertilization, Carver could have remained at Iowa and probably would have made significant contributions in one or both fields. However, he felt an obligation to share his knowledge with other African Americans and accepted Booker T. WASHINGTON's offer to become head of the agricultural department at Tuskegee Normal and Industrial Institute in 1896 (*see* TUSKEGEE UNIVERSITY).

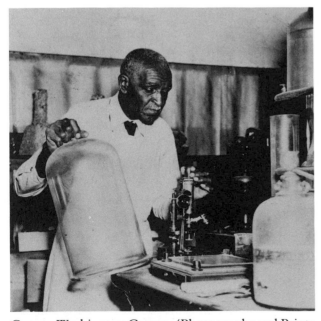

George Washington Carver. (Photographs and Prints Division, Schomburg Center for Research in Black Culture, The New York Public Library, Astor, Lenox and Tilden Foundations)

When he arrived at Tuskegee, Carver intended only to stay a few years and then pursue doctoral work. Instead, he spent his remaining forty-six years there. Although he once considered matrimony, he never married and instead "adopted" many Tuskegee students as his "children," to whom he provided loans and guidance. For the first half of his tenure, he worked long hours in administration, teaching, and research. The focus of his work reflected the needs of his constituents rather than his personal talents or interests. As director of the only all-black-staffed agricultural experiment station, he sought answers to the debt problems of small-scale farmers and landless sharecroppers. Thus, in his teaching, extension work (carried on with a wagon equipped as a movable school), and agricultural bulletins, Carver preached the use of available and renewable resources to replace expensive, purchased commodities. He especially advocated the growing of peanuts as a cheap source of protein and published several bulletins with peanut recipes.

After twenty years at Tuskegee, Carver was respected by agricultural researchers but largely unknown to the general public. His rise to fame began with his induction in 1916 into Great Britain's Royal Society for the Arts and the growing realization of his usefulness by the peanut industry. In 1921, a growers' association paid his way to testify at tariff hearings in Congress. There his showmanship in demonstrating peanut products drew national press coverage. Two years later, some Atlanta businessmen founded the Carver Products Company, and Carver won the Spingarn Medal of the NAACP. Although the company failed, it generated publicity. Then in 1933 an Associated Press release exaggerated Carver's success in rehabilitating polio patients with peanut-oil massages. Soon he was perhaps the best known African American of his generation.

The increasing publicity caught the attention of numerous people who found Carver's rise from slavery and his personality appealing. Articles began to appear describing the flowers in the lapels of his well-worn jackets and his rambles in the woods to commune with his "Creator," through which he expressed his devout but nonsectarian belief. Because he took no public stand on political or racial matters, many diverse groups could adopt him as a symbol of their causes. Thus he was appropriated by advocates of racial equality, the "New South," religion, the "American Dream," and even segregation. His significant work as an agricultural researcher and educator was obscured by the myth of the "peanut wizard."

Relishing the publicity, Carver did little to correct the public record, aside from general statements of his "unworthiness" of the honors that came with in-

creasing frequency. Some symbolic uses of his life helped to perpetuate white stereotypes of African Americans, but most of the publicity had a positive impact on both white and black Americans. Indeed, Carver became a potent tool for racial tolerance after the Commission on Interracial Cooperation and the YMCA began to sponsor his lecture tours of white college campuses in the 1920s and 1930s. On these tours, Carver added dozens of whites to his adopted "family." To them he was no "token black" but a trusted father figure to whom they wrote their innermost thoughts. Many, such as white clergyman Howard Kester, became outspoken advocates of racial justice.

Because of his compelling personality, Carver had a profound impact on almost everyone—black or white—who came in contact with him. His "special friends" ranged from white sharecroppers to Henry Ford. Most of his major publicists were true disciples of Carver's vision of the interrelatedness of all human beings and their environment. Because of his extreme frugality, he was also able to leave a substantial legacy by giving about sixty thousand dollars to establish the George Washington Carver Foundation, which continues to support scientific research at Tuskegee University. Although his scientific contributions were meager relative to his fame, and he could not single-handedly save the black family farm, Carver's work and warmth greatly enriched the lives of thousands.

REFERENCES

KREMER, GARY R. *George Washington Carver in His Own Words.* Columbus, Mo., 1987.

MACKINTOSH, BARRY. "George Washington Carver: The Making of a Myth." *Journal of Southern History* 42 (1976): 507–528.

MCMURRY, LINDA O. *George Washington Carver: Scientist and Symbol.* New York, 1981.

LINDA O. MCMURRY

Cary, Mary Ann Shadd (October 9, 1823–June 5, 1893), teacher and journalist. Mary Ann Shadd Cary was born in Wilmington, Del., the daughter of free blacks, Abraham and Harriet Parnell Shadd. After attending a Quaker school in West Chester, Pa., she returned to Wilmington, where at age sixteen she opened a school, the first of several she was to establish during the following decades. After passage of the Fugitive Slave Law of 1850, Mary and her brother Isaac went to Windsor, Canada, where she founded a school for both black and white pupils. In 1856, she married Thomas F. Cary of Toronto. She resumed

teaching in Chatham (1859–1864) under the auspices of the American Missionary Association.

Cary's most noteworthy achievements center on the *Provincial Freeman,* a weekly Canadian newspaper, published with varying regularity between 1853 and 1859. Although men (Samuel Ringgold War and the Rev. William P. Newman) served as titular editors, Cary was recognized by her contemporaries as the real editor. She is generally acknowledged to be the first woman publisher of a newspaper in Canada and the first black newspaperwoman in North America. A crusading journalist, Cary became embroiled in particularly bitter quarrels—notably with Henry BIBB—over the issue of integration (the question of whether blacks were exiles or new citizens of Canada) and about the activities of the Refugee Home Society, whose land-purchase scheme, she claimed, offered no advantage over the Canadian government's offers and was sometimes more costly.

During the Civil War, Cary returned to the United States to recruit for the Union army, working in

Journalist and author Mary Ann Shadd Cary was a leader of the antebellum Canadian emigration movement. Throughout her long career, she was uncompromising in her commitment to integration and the full equality of African-American men and women in every aspect of public life. (Moorland-Spingarn Research Center, Howard University)

Indiana, Ohio, and Michigan. Between 1869 and 1874, she taught public school in Detroit and in Washington, D.C., where she also served as a principal (1872–1874). An activist for women's suffrage, Cary addressed the annual convention of the National Woman Suffrage Association in 1878 and was founder of the Colored Women's Progressive Association (Washington, D.C.). She received her LL.B. degree from Howard University Law School in 1883; she was the first woman to receive the degree from that school and only the second black woman to earn a law degree.

In addition to her work for the *Provincial Freeman,* Cary was the author of an advisory pamphlet, *Hints to the Colored People of the North* (1849), espousing her ideals of self-help; of *A Plea for Emigration, or Notes on Canada West, in Its Moral, Social, and Political Aspect* (1852), a booklet describing opportunities for blacks in Canada; and (with Osborne ANDERSON, one of the five survivors of John Brown's raid) of *A Voice from Harpers Ferry* (1873). She contributed to Frederick DOUGLASS's *New National Era* and John Wesley Cromwell's *Advocate* as well.

REFERENCE

SILVERMAN, JASON H. "Mary Ann Shadd and the Search for Equality." In Leon Litwack and August Meier, eds. *Black Leaders of the Nineteenth Century.* Urbana, Ill., 1988, pp. 87–100.

QUANDRA PRETTYMAN

Catholicism. *See* Roman Catholicism.

Catlett, Elizabeth (April 15, 1919–), printmaker and sculptor. The youngest of three children, Elizabeth Catlett was educated at Dunbar High School in Washington, D.C. Her father, John Catlett, taught at Tuskeegee Institute and in the D.C. public schools. He died before her birth. Her mother, Mary Carson Catlett, worked as a truant officer.

Catlett graduated cum laude from Howard University School of Art in 1937, studying with James HERRING, James PORTER (drawing), James WELLS (printmaking), and Lois Mailou JONES (design). In 1940, Catlett earned the M.F.A. degree from the University of Iowa. She studied with painter Grant Wood and changed her concentration from painting to sculpture. In 1941, her thesis project, a marble sculpture, *Mother and Child,* took first prize in the American Negro Exposition in Chicago.

From 1940 to 1942, Catlett was head of the Art Department at Dillard University. Among her students was Samella Sanders (Lewis), who became a life-long friend and her biographer. In the summer of 1941, Catlett studied ceramics at the Art Institute of Chicago. She met and married Charles WHITE. Over six years they spent time in Chicago, where she worked at the South Side Art Center; New York,

Elizabeth Catlett at work on her sculpture. (Photographs and Prints Division, Schomburg Center for Research in Black Culture, The New York Public Library, Astor, Lenox and Tilden Foundations)

where she studied with sculptor Ossip Zadkine (1942 and 1943); and Hampton Institute, where she taught sculpture (1943). She came to believe that graphics was the appropriate medium to reach large, diverse audiences, and in 1944 she took lithography at the Art Students' League in New York.

In 1945, Catlett received a Julius Rosenwald Foundation award to do a series on African American women. She and Charles White traveled to Mexico to work at the Taller de Grafica Popular. She also studied sculpture at the Escula de Pintura y Ecultura with Francisco Zumiga and wood carving with José L. Ruiz. After a brief period in New York when she divorced, she returned to Mexico. In 1947, she married Mexican artist Francisco Mora. They have three sons, Francisco, Juan, and David. The two artists remained part of the Taller de Grafia Popular until 1966.

In 1958, she became the first woman to teach at the National University of Mexico's School of Fine Arts. From 1959 until her retirement from teaching in 1976, she served as the head of the school's sculpture department.

Catlett's work combines realism and abstract art. Much of her work deals with African-American women: the mother and child theme is strong and recurring. Her art reflects her concern with the needs and aspirations of common people, the poor, and the oppressed. The influence of Mexican as well as African-American culture is evident. Her sculpture ranges from monumental to small. It is in wood, bronze, stone, terra cotta, or marble. Works on paper are lithographs, linocuts, woodcuts, collographs, and serigraphs. Among the most well known are *Sharecropper* (1968) and *Malcolm X Speaks for Us* (1969).

Beginning in 1940, her work has been shown in numerous solo and group exhibitions. It is included in over two dozen prestigious public collections and in many books, catalogs, periodicals, and film and video productions. She has received awards in several countries. Elizabeth Catlett correctly has been called a pioneer and one of the greatest artists of the twentieth century. She and her husband live in Cuernavaca and New York City.

REFERENCES

LEWIS, SAMELLA. *The Art of Elizabeth Catlett*. Claremont, Calif., 1984.

LEWIS, SAMELLA, and RICHARD POWELL. *Elizabeth Catlett: Works on Paper, 1944–1992*. Hampton, Va., 1993.

LEWIS, SAMELLA, and RUTH WADDY. *Black Artists on Art*. Vol. 2. Los Angeles, 1971.

SIMS, LOWERY STOKES. *Elizabeth Catlett: Sculpture*. New York, n.d.

JEANNE ZEIDLER

Catlett, Sidney "Big Sid" (January 17, 1910– March 25, 1951) jazz drummer. Born in Evansville, Ind., Sidney Catlett grew up in Chicago, where he fell under the sway of such drummers as Zutty SINGLETON, Joe Russek, Jimmy McHendrick, and Jimmy Bertrand. Jazz still had a vaudeville gloss in the 1920s, and Catlett became a consummate showman—dancing around his drums and bouncing his sticks off the floor, throwing a stick in the air, lighting a cigarette, and catching the stick without missing a beat. He also became an expert stage-show drummer, demonstrating a finesse that earned him the devotion of every dancer, comedian, and singer he worked with.

Catlett came to New York in 1930 with Sammy Stewart's band. He was already an impressive figure: six feet, three inches tall with broad shoulders and fingers the size of dinner forks. During the next eight years, he appeared with Elmer Snowden, Benny CARTER, Rex Stewart, McKinney's Cotton Pickers, Jeter Pillars, Fletcher HENDERSON, and Don Redman. Late in 1938, he joined Louis ARMSTRONG's big band, where he began to come into his own. Armstrong's band was plodding and poorly disciplined, and Catlett immediately made it swing. He remained with Armstrong until the spring of 1941, when he was hired by Benny Goodman.

Catlett was the first African-American drummer to appear full-time with a predominantly white band, but his stay with Goodman was, in Catlett's words, "one long nightmare." Put off by Catlett's take-charge power and showmanship, Goodman fired him after four months, and Catlett returned briefly to Armstrong. Between 1942 and 1944, he was featured with Teddy Wilson's sextet at the Café Society Uptown in New York. He won a critics' poll of *Esquire* in 1944 and 1945, and was the principal drummer in the famous Metropolitan Opera House concert early in 1944.

After leaving Wilson, Catlett assembled a quartet and took it across the country, and in 1946, together with Jack Teagarden and Earl HINES, he became a founding member of Louis Armstrong's All-Stars. Catlett stayed until 1949, when heart trouble, probably brought on by his heedless personal habits, forced him out of the band. He spent the last two years of his life freelancing and as the house drummer at Jazz Ltd. in Chicago.

Catlett's style was fully formed by the late 1930s. It was notable for his infallible timing and taste, his ability to play with groups of any size or kind, and his originality as an accompanist and soloist.

Catlett got a beautiful sound out of his drums, and he lifted every soloist he backed with a unique panoply of effects: ingeniously placed snare-drum and bass-drum accents; delicate, unerring cymbal work;

an irresistible swing. His long solos, many of them recorded in 1947 and 1948, were subtle, funny, surprising, melodic, and flawlessly structured; his short breaks were often exhilarating. Catlett played comfortably with every type of musician, from Billie HOLIDAY and the blues singer Petie Wheatstraw to Charlie PARKER and Dizzy GILLESPIE, to Art TATUM and Duke ELLINGTON, to Sidney BECHET and Jelly Roll MORTON. He also influenced many important drummers, among them Max ROACH, Kenny CLARKE, and Art BLAKEY. Though never as famous as Gene Krupa and Buddy Rich, Catlett is often considered the greatest of all jazz drummers.

REFERENCES

BALLIETT, WHITNEY. "Big Sid." In *American Musicians: 56 Portraits in Jazz*. New York, 1986, pp. 179–187.
———. "B.G.—and Big Sid." In *Goodbyes and Other Messages: A Journal of Jazz, 1981–1990*. New York, 1990, pp. 175–178.
KORALL, BURT. "Sid Catlett." In *Drummin' Men*. New York, 1990, pp. 163–203.

WHITNEY BALLIETT

Cayton, Horace Roscoe, Jr. (April 12, 1903–January 22, 1970), sociologist and educator. Horace Cayton was born in Seattle, Wash., the son of activist and newspaper publisher Horace R. Cayton, Sr. and Susie Revels Cayton (daughter of former U.S. Senator Hiram REVELS). Cayton dropped out of high school in his junior year and signed up as a messman on a coastal steamer, and in the four succeeding years traveled to California, Mexico, and Hawaii. At the age of twenty, he returned to Seattle. After enrolling in a YMCA preparatory school, he entered the University of Washington, supporting himself by working as a detective. In 1932 he graduated with a degree in sociology.

Invited by eminent sociologist Robert Park to the University of Chicago, Cayton became a research assistant and did graduate work there. In 1934 he became an assistant to the U.S. Secretary of the Interior, and helped draft a study of black workers in Birmingham, Ala. In 1935 he was named instructor of Economics and Labor at Fisk University in Nashville. In 1936 he returned to Chicago, where he headed a WORKS PROJECT ADMINISTRATION (WPA) research project that focused on Chicago inner-city life. He also worked as a columnist for the PITTSBURGH COURIER and various magazines. In 1939, he and George S. Mitchell coauthored a book, *Black Workers and the New Unions,* which discussed preju-

dice in the labor movement and examined the integration of blacks into steel, railroad, and meatpacking unions. The following year, after a study tour in Europe financed by a Rosenwald Foundation grant, Cayton was named director of Chicago's Parkway Community House, a black settlement and study center. During WORLD WAR II, Cayton refused to serve in a segregated army, and enlisted in the Merchant Marine.

Cayton's best-known scholarly work is *Black Metropolis* (1945), which he cowrote with St. Clair DRAKE. Focusing on African-American life in Chicago, the book was hailed as an original study of urbanization in the United States. It received the Anisfield-Wolf Award, and was named the Outstanding Book on Race Relations for 1945 by the New York Public Library.

In 1950 Cayton left Parkway Community House and was briefly a research assistant for the American Jewish Committee. Some time after, he was hired as a researcher by the National Council of Churches. He continued to write scholarly articles on such subjects as the sociology of mental disorders and the psychology of prejudice. In 1955 he and Setsuko Matsanuga Nishi cowrote *The Changing Scene: Current Trends and Issues,* a discussion of the attitudes of different churches towards social work. During this period, he also served as the *Pittsburgh Courier*'s correspondent at the United Nations. In 1959 Cayton was hired as professor of sociology by the University of California at Berkeley, a position he retained until his death. He published an autobiography, *Long Old Road,* in 1964.

In the late 1960s, Cayton became interested in writing a biography of his friend, the writer Richard WRIGHT (who had written the introduction to *Black Metropolis*). In 1968 he edited a special issue of *Negro Digest* devoted to Wright, and the next year traveled to France to do research for a biography. He died while in Paris, collecting material on Wright.

REFERENCES

FABRE, MICHEL. "The Last Quest of Horace Cayton." *Black World* 19 (May 1970): 41–45.
PAGE, JAMES A. *Selected Black American, African, and Caribbean Authors.* New York, 1985.

GREG ROBINSON

Celia. In 1855, Celia, a slave, stood trial in Fulton, Mo., for the murder of her master, Robert Newsom, a prosperous Callaway County farmer. The events that led to her arrest, her trial, and her ultimate fate provide a fascinating case study of the sig-

nificance of gender in the slaveholding South and the manner in which the southern legal system was manipulated to ensure the slaveholders' power over their human chattel while creating the illusion of a society that extended the protection of the law to its slaves.

Purchased a year after the death of Newsom's wife in 1849, Celia served as his concubine for five years, during which time she bore him two children. She lived in a brick cabin he built for her behind the farmhouse, where Newsom lived with two adult daughters, one of whom had two children of her own. By the mid-1850s, Newsom's two sons had established their own farms near that of their father. Sometime in 1854, Celia began a relationship with George, another of Newsom's slaves. When she became pregnant for the third time, George demanded that Celia cease to have sexual relations with her master. Celia appealed to the Newsom women to prevent their father from sexually abusing her. The daughters, however, were in no position to control the actions of their father, who continued to view sexual relations with Celia as his privilege.

On a June night in 1855, Newsom demanded sex of Celia, who responded by beating him to death with a club and disposing of his body by burning it in her fireplace. The family's efforts to find the missing father led George to implicate Celia in his disappearance, and under threat to her children, she confessed and was arrested and tried. Missouri law assigned her public council, led by John Jameson, a noted attorney and democratic politician. Jameson based his defense on the claim that Celia, under Missouri law, had the same right to use deadly force to defend her honor as did white women. This defense not only recognized the crime of rape against slave women, something the legal system of no southern state did; but it also threatened a slaveholder's control over the reproductive capabilities of female slaves. For precisely these reasons it was disallowed by the presiding judge, who agreed with the prosecution's traditional contention that a female slave had no right to use force to reject her master's sexual demands. A jury of local farmers convicted her, and the Missouri Supreme Court rejected her attorneys' appeal for a new trial. On December 23, 1855, Celia was hanged in Fulton.

REFERENCES

McLAURIN, MELTON A. *Celia, A Slave.* Athens, Ga., 1991.
State of Missouri Against Celia, A Slave. File 4496, Callaway County Court, October Term, 1855: Callaway County Courthouse, Fulton, Mo.
WILLIAMSON, HUGH P. "Document: The State of Missouri Against Celia, A Slave." *Midwest Journal* 8 (Spring/Fall, 1956): 408–20.

MELTON A. McLAURIN

Cemeteries and Burials. One of the most direct and unaltered visual manifestations of the African influence on the culture of African Americans in the United States is found in the social behaviors associated with funerals. In many rural graveyards across the South, and in quite a few urban cemeteries in the North and far West, too, black Americans mark the final resting places of their loved ones in a distinctive manner. While they use standardized stone markers and floral arrangements, the personal property of the deceased is frequently placed on the grave as well. Sometimes a single emblematic item, like a glass pitcher or vase, sits atop the mounded earth, while in other places a grave may be covered with a veritable inventory of the dead person's household goods.

In addition to glass and ceramic containers (which might also serve as holders for flowers), one may also find cups, saucers, clocks, salt and pepper shakers, spoons, toothbrushes, light bulbs, soap dishes, flashlights, razors, toys, cigar boxes, false teeth, marbles, and piggy banks. Such material assemblages do not merely contrast with the usual Euro-American ideal of a sedate cemetery landscape; they establish a link to customary practices known not only on southern plantations but in West and Central Africa.

In 1843, the daughter of a Georgia planter recalled that "Negro graves were always decorated with the last article used by the departed, and broken pitchers and broken bits of colored glass were considered even more appropriate than the white shells from the beach nearby. Sometimes they carved rude wooden figures like images of idols, and sometimes a patchwork quilt was laid upon the grave." This antebellum scene not only matches much of what can be found today in black graveyards but could be substituted for descriptions of African practice as well. E. J. Glave, who travelled through Zaire in 1884, wrote that "the natives mark the final resting-places of their friends by ornamenting their graves with crockery, empty bottles, old cooking pots, and so on, all of which articles are rendered useless by being cracked or penetrated with holes."

Another traveler in nearby Gabon observed, "Over or near the graves of the rich are built little huts, where are laid the common articles used by them in their life—pieces of crockery, knives, sometimes a table, mirrors, and other goods obtained in foreign trade." While the stability of these behaviors across such lengthy spans of time and space might at first seem astonishing, it must be recalled that funerary customs were one of the few areas of black life into which slave owners tended not to intrude. Thus, in spite of the massive conversion of Africans to Christian faiths, they retained many of their former rituals associated with the veneration of the dead.

They remembered, for example, that the spirit of the deceased person may linger near the body for a period of time before moving to the spirit world. Believing further that the needs of the spirit are similar to those of a living human, they maintained that the potential fury of an individual's spirit could be soothed by presenting it with the various items that the individual had used while alive. One resident of the Georgia Sea Islands testified, "I don't guess you be bother much the spirits if you give-em a good funeral and put the things what belong to 'em on top of the grave." Another added, "Spirits need these [things] same as the man. Then the spirit rest and don't wander." Statements from other Deep South black communities support this belief in the lingering spirit and warn that "unless you bury a person's things with him, he will come back after them." Left unsaid here is a more threatening corollary belief that roaming spirits can exact a further toll; they could, if disturbed, cause another person's death.

Placing personal items on graves is, then, more than an emotional gesture aimed at providing the bereaved with the ritual means to reconnect with a loved one (although this behavior does indeed serve that function). For those who retain the African-derived belief in a soul with two parts—one that travels immediately to the afterworld and one that lingers for a while near the body—the burial mounds that bristle with bowls, lamps, mirrors, plaster statues,

and other hardware not only keep the deceased at rest but contribute to the physical well-being of the community. However, for those African Americans whose beliefs are derived from a more orthodox Christian position, the vessels placed atop burial mounds (often broken just slightly) are explained simply as metaphors of death, and proverbs like "The pitcher that goes often to the well shall at last be broken" are cited as a plausible rationale for their use as grave decorations.

In addition to personal objects, some African-American graves in the South are decorated with white seashells and pebbles. These suggest a watery environment at the bottom of either the ocean or a lake or river. While some might see the allusion to water as derived from the Christian association of water with salvation (as in the sacrament of baptism), these objects are more likely signs of the remembrance of African custom. In Kongo belief (in South Carolina, nearly 40 percent of all slaves imported between 1733 and 1807 were from the Kongo-speaking region), the world of the dead is understood to lie not only underground but underwater. This place is the realm of the *bakulu,* creatures whose white color marks them as deceased. Shells and stones signal the boundary of this realm, which can be reached only by penetrating beneath two physical barriers. Their whiteness, moreover, recalls that at least in Central Africa, white, not black, is the color of death. Also

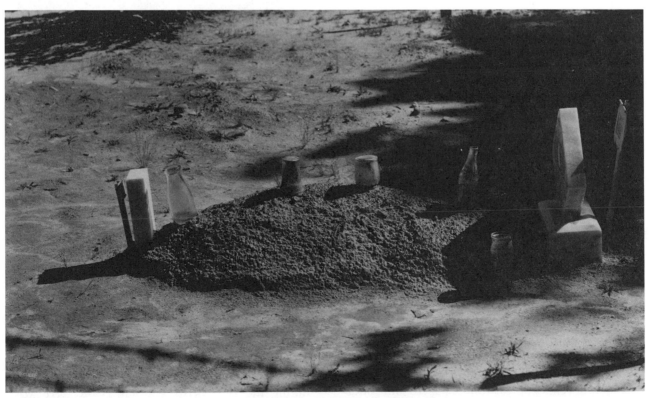

A sharecropper's grave in Hale County, Ala., 1935. (Prints and Photographs Division, Library of Congress)

found in black cemeteries are a number of other features traceable to Kongo sources: pipes driven into burial mounds to serve as speaking tubes that may allow beneficial communication with the deceased, statues of chickens that recall animal sacrifices offered to the deceased, and mirrors that are said to catch the flashing light of a spirit and hold it there. Any of these features alone might indicate only the action of a single imagination engaged in the task of decorating a loved one's final resting place. But when several occur together, as is so often the case in graveyards of the black Sea Islanders of South Carolina and Georgia, we have powerful evidence of allegiance to a venerable African tradition.

In the light of these signs (all of which may be interpreted as elements of cultural continuity), it is not surprising that black burial sites in the Bay Area of California should resemble those seen in South Carolina. When given the opportunity, any people will carry its heartfelt customs from place to place as indispensable cultural baggage. Nor is it strange that a Mr. Coffee machine should turn up in a black cemetery in Mississippi. Among the more tradition-minded of the African-American faithful, the significance of a modern-day coffee maker in a graveyard is very clear: "Spirits need these same as the man."

REFERENCES

JONES-JACKSON, PATRICIA. *When Roots Die: Endangered Traditions on the Sea Islands*. Athens, Ga., 1987.

PUCKETT, NEWBELL NILES. *The Magic and Folk Beliefs of the Southern Negro*. Chapel Hill, N.C., 1926.

THOMPSON, ROBERT FARRIS, and JOSEPH CORNET. *The Four Moments of the Sun: Kongo Art in Two Worlds*. Washington, D.C., 1981.

VLACH, JOHN MICHAEL. *The Afro-American Tradition in Decorative Arts*. 1978. Reprint. Athens, Ga., 1990.

JOHN MICHAEL VLACH

Cenelles, Les. *See* Les Cenelles.

Chamberlain, Wilton Norman "Wilt" (August 21, 1936–), basketball player. Born in Philadelphia, Wilt Chamberlain was one of nine children of William Chamberlain, a custodian/handyman, and Olivia Chamberlain, a part-time domestic. Large even as a child, he grew to 7'1" by the age of eighteen, and developed great running speed and endurance. At Overbrook High School, he starred in track

and field. Dubbed "Wilt the Stilt" and "The Big Dipper" for his great height, he became the premier high school basketball player of his era. The Philadelphia Warriors of the National Basketball Association (NBA) drafted him before he finished high school, but Chamberlain elected to go to college. After fierce competition among colleges, he chose to attend the University of Kansas. While at Kansas, he starred in track, and his amazing basketball skills and dominance led to many changes in the college rule book including the widening of the foul lanes, in order to hamper him. Despite these impediments, in his first year with the varsity Chamberlain led Kansas to the National College Athletic Association (NCAA) finals. However, the constant harassment, fouling, and triple-teaming upset him, and after another year he left Kansas, saying basketball was no longer fun. Not yet eligible for the NBA, he spent a year touring with the Harlem Globetrotters (playing at guard!).

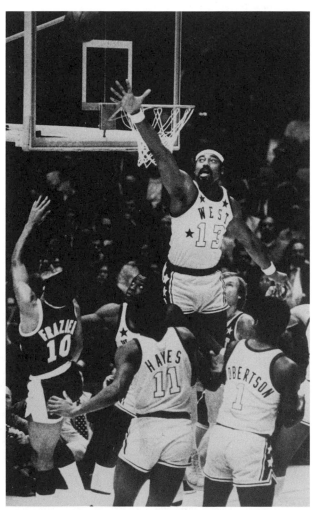

Wilt Chamberlain in a typically commanding position near the basket, blocking a shot by Walt Frazier during the 1972 NBA All-Star Game. (AP/Wide World Photos)

Chamberlain entered the NBA with the Philadelphia Warriors in 1959–1960 and was an immediate sensation. In his rookie year, he broke eight NBA scoring and rebounding records, and was named both Rookie of the Year and Most Valuable Player. In 1960 he made a record fifty-five rebounds in a game. The following season, Chamberlain had the greatest individual scoring performance the game has ever seen. He scored 4,029 points, an average of 50.4 points per game, and on March 2, 1962, scored 100 points in a game.

Chamberlain went on to play fourteen seasons with the Philadelphia/Golden State Warriors (1959–1965), the Philadelphia 76ers (1965–1968), and the Los Angeles Lakers (1968–1973). He won four MVP awards, and was named to the All-Star team thirteen times (every year he was in contention). He revolutionized professional basketball, ushering in the era of the dominant centers, usually seven feet or taller. A sensational scorer during his early years, he relied on a graceful jump shot and popularized the "dunk" shot. His lifetime scoring totals—31,419 points and an average of 30.1 points per game—stood for many years. He also excelled at shot blocking and defense. While Chamberlain led his teams to NBA championships in 1967 and 1972, his teams lost several times in playoff finals, and he was unfairly derided by fans as a "loser." A controversial figure, he complained at the lack of recognition of his talents, stating "nobody roots for Goliath." In 1973 he left the Lakers, and was hired as a player-coach by the San Diego Conquistadores of the American Basketball Association (ABA). The Lakers obtained an injunction in court forbidding him from playing, and he passed the year unhappily as a coach, leading the team to a 38–47 record, and then retired. He was elected to the Naismith Memorial Basketball Hall of Fame in Springfield, Mass., in 1978.

After his retirement, Chamberlain, a volleyball enthusiast, helped start the International Volleyball Association and also sponsored track-and-field meets. He has at various times pursued a performing career. He acted in the film *Conan the Destroyer* (1984) and appeared as himself in several commercials. During the 1960s he owned the Harlem nightspot Big Wilt's Small Paradise, and he now owns Wilt Chamberlain's Restaurants. He achieved considerable notoriety for his claims of extraordinary sexual promiscuity in his 1991 book, *A View from Above*. Whatever his exploits off the court, he remains one of the greatest basketball players of all time.

REFERENCES

CHAMBERLAIN, WILT. *The View from Above*. New York, 1991.

CHAMBERLAIN, WILT, and DAVID SHAW. *Wilt: Just Like Any Other 7-Foot Black Millionaire Who Lives Next Door*. New York, 1973.

GREG ROBINSON

Chaney, James Earl (May 30, 1943–June 21, 1964), civil rights activist. James Chaney was born in Meridian, Miss., to Ben Chaney and Fannie Lee Chaney. His parents instilled a strong sense of racial pride in him, and in 1959 he, along with a group of his friends, was suspended from high school for wearing a button meant to criticize the local NAACP chapter for its unresponsiveness to racial issues. One year later, he was expelled from school and began to work alongside his father as a plasterer. Chaney's experiences traveling to different job sites throughout Mississippi on segregated buses, at the same time that Freedom Rides mounted by civil rights organizations aimed at challenging segregated interstate transportation were occurring throughout the South, further spurred his activism. In 1963, he became directly involved in civil rights activities and joined the CONGRESS OF RACIAL EQUALITY (CORE). One year later CORE joined forces with the Mississippi branches of the STUDENT NON-VIOLENT COORDINATING COMMITTEE (SNCC), and the NATIONAL ASSOCIATION FOR THE ADVANCEMENT OF COLORED PEOPLE (NAACP) to form the COUNCIL OF FEDERATED ORGANIZATIONS (COFO) to spearhead a massive voter registration and desegregation campaign in Mississippi called the FREEDOM SUMMER.

During Chaney's work with COFO, he met Michael Schwerner, a white Jewish liberal who had been a New York City social worker before he joined CORE in 1963 and relocated to become a field worker in Mississippi, and Andrew Goodman, a young Jewish college student who had volunteered for the Mississippi Freedom Summer project. Assigned to work together in Meridian, on June 21, 1964 the three men went to Longdale—a black community in Neshoba County, Mississippi—to investigate the burning of a church that had been a potential site for a Freedom School teaching literacy and voter education. The KU KLUX KLAN was firmly entrenched in large areas of Mississippi, and it was widely suspected that the Klan had burned the church down to prevent civil rights activities. As the three men were driving back to Meridian, they were detained by the police in Philadelphia, Miss. Chaney was arrested for speeding and Schwerner and Goodman were arrested as suspects in the church bombing. None of the men was allowed to make a phone call or pay the fine that would have facilitated his release from the Neshoba County jail.

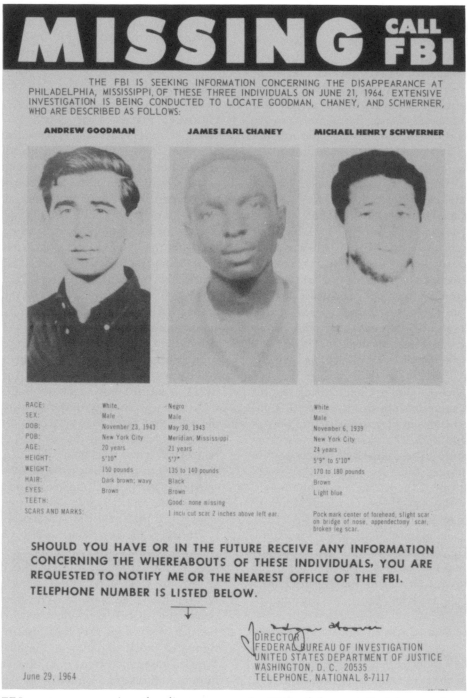

FBI poster announcing the disappearance in 1964 of three civil rights workers during the Freedom Summer in Mississippi. Six weeks after they were reported missing, their brutally battered bodies were discovered at an earthen dam near Philadelphia, Miss. From left to right are Andrew Goodman, James Chaney, and Michael Schwerner. (Photographs and Prints Division, Schomburg Center for Research in Black Culture, The New York Public Library, Astor, Lenox and Tilden Foundations)

The arrest of Chaney, Schwerner, and Goodman was no accident. Civil rights workers were constantly harassed by white night riders and local policemen who were often Klan members more committed to maintaining the racial status quo than to upholding justice. Schwerner was the first white civil rights worker to be stationed outside of Jackson, Miss. His activities and presence had made him well known to Meridian whites and his success in initiating civil rights programs and his Jewish background had made him a target of the Klan, who had nicknamed him "Goatee" because he wore a beard. After Neshoba County Deputy Sheriff Cecil Ray Price confirmed the fact that the car Chaney had been driving was registered to CORE, he alerted local Klan leader, Edgar Ray Killen. Killen quickly organized a posse of Klansmen and formulated a plan of action with as many as twenty conspirators. Later that same night, Price released the three men from jail after Chaney paid the fine. They were followed out of town by a Klan posse, forcibly removed from their cars, driven to an isolated wooded area a few miles away and killed. Their bodies were buried in an earthen dam in the immediate vicinity of Philadelphia, a burial site that had been chosen beforehand.

Attempts to locate Chaney, Schwerner, and Goodman had been initiated by COFO when the trio had not called or reached their destination at the allotted time. As it became increasingly apparent that harm had befallen them, COFO renewed their longstanding request for assistance from the Justice Department, and mobilized a campaign among their membership to put pressure on governmental officials. Social violence against black people in Mississippi was commonplace, and despite the high proportion of lynchings that took place in Mississippi, no white person had ever been convicted of murdering a black person in the history of the state. The heightened interest in civil rights, and the likely involvement and disappearance of two white men commanded national attention, and federal response. President John F. Kennedy and Attorney General Robert Kennedy met with the families of the missing men, and FBI agents were dispatched to the scene to mount an extensive investigation. When the charred remains of Chaney's car were found a few days after the incident, Neshoba county was flooded with journalists who reported to the shocked nation the hostility of Mississippi whites who seemed to epitomize southern racism.

The FBI recovered the bodies of the three civil rights workers from the earthen dam on August 4, 1964, and four months later nineteen men were charged with the conspiracy. The federal government was forced to use a RECONSTRUCTION era statute to charge the men with conspiring to deprive Chaney, Schwerner, and Goodman of their civil rights because the social consensus behind the lynch mob's actions made state prosecution for murder unlikely.

Recalcitrant judges, defense delays, and problems with jury selection hampered the due process of law for three years. In 1966, the U.S. Supreme Court stepped in to reinstate the original indictments after the case had been thrown out of court, and in February, 1967 the long delayed trial finally began. Despite various confessions and eyewitness accounts, only seven defendants, one of whom was Deputy Sheriff Price, were convicted nine months later. Only two men were convicted of the maximum sentence of ten years under the law. Two of the other men received sentences of six years, and three received three-year sentences. The conspirators were all paroled before serving full jail terms and most returned to the Mississippi area by the mid-1970s.

The murders of Chaney, Schwerner, and Goodman became a milestone in the CIVIL RIGHTS MOVEMENT. Although an important precedent for federal intervention on behalf of civil rights workers was set, this incident was memorialized by many in the civil rights movement, not only as an instance of southern injustice but as the result of many years of federal indifference to the plight of African Americans.

REFERENCES

CAGIN, SETH and DRAY, PHILIP. *We Are Not Afraid: The Story of Goodman, Schwerner, and Chaney and the Civil Rights Campaign for Mississippi.* New York, 1988.
HUIE, WILLIAM BRADFORD. *Three Lives for Mississippi.* New York, 1964.

ROBYN SPENCER

Charles, Ezzard (July 7, 1921–May 28, 1975), boxer. Charles was born in Lawrenceville, Ga. When a child, his family moved to Cincinnati, where he became interested in BOXING. By the time he was sixteen, he had taught himself the rudiments of boxing so well that he won forty-two amateur fights in a row—including two Golden Gloves and the AAU National Championship in 1939—before turning professional in 1940. His ascending career was interrupted by service in the U.S. Army, but after Joe LOUIS announced his retirement as undefeated world heavyweight champion in 1949, a title match was set up between Charles and Jersey Joe Walcott. Charles won the title in a fifteen-round decision on June 22, 1949. He held the title from 1949 to 1951, successfully defending it in 1950 against Joe Louis. Despite this victory, Charles did not receive the recognition

many felt he deserved. He depended on his boxing skills and ability to score points rather than delivering one powerful knockout punch and thus was criticized by some for lacking a harsh fighting instinct.

Charles lost his heavyweight title on July 18, 1951, when he was knocked out by Joe Walcott in the seventh round of their third fight. Three years later, on June 17, 1954, he lost a grueling fifteen-round decision to Rocky Marciano, and in a rematch later that year was knocked out by Marciano in the eighth round. Charles retired from boxing in 1956, with two brief, unsuccessful comeback attempts in 1958 and 1959. From 1940 to 1959 he had fought in 122 bouts, winning 96 of them. In 1966 he was stricken with a muscle-debilitating disease, amyotrophic lateral sclerosis, and was confined to a wheelchair. Charles died on May 28, 1975, at the age of fifty-three. In 1987 he was named the ninth greatest heavyweight of all time by *The Ring*.

REFERENCES

RUST, ART, JR. *Art Rust's Illustrated History of the Black Athlete*. Garden City, N.Y., 1985.
Obituary. *New York Times*, May 29, 1975, p. 38.

LINDA SALZMAN

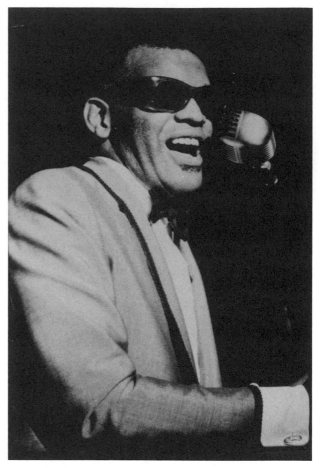

Ray Charles. (© Steve Schapiro/Black Star)

Charles, Ray (Robinson, Ray Charles) (September 23, 1930–), musician. Ray Charles's achievement over the past forty-five years marks him as one of the most important and influential figures of American music in the postwar period. He is often called the "Father of Soul," both for his innovative blending of gospel, blues, and jazz, and his enormous versatility as a singer, pianist, songwriter, composer-arranger, saxophonist, and band leader.

Born into a poor family in Albany, Ga., Ray Charles was raised in Greenville, Fla. At the age of five he contracted glaucoma; left untreated, it soon blinded him. His mother, Aretha, sent him to the School for the Deaf and Blind in St. Augustine, where he spent the next eight years studying composition, learning to write musical scores in braille, and mastering various instruments (the trumpet, alto saxophone, clarinet, organ, and piano). After his mother died in 1945, he left school to form a combo; after he had saved enough money, he moved to Seattle, where he played in a number of jazz trios, gradually developing a piano and vocal style heavily influenced by Nat "King" COLE. At around this time, Ray Charles decided to drop his surname in order to avoid being confused with prizefighter Sugar Ray Robinson.

Charles developed a significant following in Seattle, and soon began to record for various labels. His first hits, "Baby Let Me Hold Your Hand" (1951) and "Kiss Me Baby" (1952) were recorded for the Swing Time label. In 1952 Charles began to record for Atlantic Records, where he made his first musical breakthrough with "I've Got a Woman" (1955), a blend, startlingly unconventional for the time, of a coarse bluesy sexuality with the intense emotionality of gospel. Many of his musical ideas in this period were taken from gospel music, but his adaptations provoked much criticism for their combination of the vocal techniques of "testifying" with sexually explicit lyrics. This style nevertheless provided Charles with some of his most successful songs, among them, "Hallelujah, I Love Her So" (1956), "The Right Time" (1959), and "What'd I Say" (1959).

As his fame increased, Charles increasingly found favor with white audiences. In 1959 he left Atlantic for ABC/Paramount; the move signaled a turn toward country-and-western music and popular standards. While his early recordings with ABC (such as "Georgia on My Mind," "Hit the Road Jack," and "I Can't Stop Loving You") are generally considered

the equals of those of his Atlantic period, some critics charged that his music was gradually becoming conventional and uninspired. Nevertheless, throughout the 1960s Charles turned out scores of Top-Ten hits (including "You Are My Sunshine," "Let's Go Get Stoned," and "Here We Go Again"), and a number of successful LPs.

Charles's rise to fame was not without its struggles. Along the way he developed an addiction to heroin, and in 1955, 1961, and 1965, he was arrested for the possession of narcotics. He never served a long prison term, but he stopped performing for a year after his last arrest, during which time he worked successfully to overcome the seventeen-year-long addiction. Since then the record shows a steady series of successes and honors. In 1966, the U.S. House of Representatives passed a special resolution honoring Charles for his musical achievement. In the late 1960s he founded his own record label and music publishing firm. In 1979, Hoagy Carmichael's "Georgia on My Mind," perhaps Charles's best-known recording, was adopted as the official song of Georgia. In 1986, Charles was among the first ten artists inducted into the Rock and Roll Hall of Fame.

During his career, Charles has appeared in several films, including *Blues for Lovers* (a.k.a. *Ballad in Blue,* 1965) and *The Blues Brothers* (1980), and has performed on the soundtracks of many more, including *The Cincinnati Kids* (1965) and *In the Heat of the Night* (1967); his song "What'd I Say" was the subject of *Cosmic Ray,* an experimental film by Bruce Conner, in 1961.

In recent years, Charles has been active in various social causes, including civil rights issues, African famine relief, and aid to the disabled. In 1985, he attributed the presence of several bombs found under a bandstand where he was to perform to his public statements opposing racism. In 1987 he made an appeal to Congress for federal aid for the deaf and established the Robinson Foundation for Hearing Disorders with an endowment of $1 million.

In addition to making frequent concert appearances and appearing in several popular commercials (most notably the phenomenally successful Diet Pepsi ads in the early 1990s), Charles has remained active in producing and recording his own albums. His LP *Friendship* rose to number one on the country-and-western charts in 1985. In 1990, he performed with B.B. KING in the Philip Morris Superband, and released an album, *Would You Believe?* Charles's autobiography *Brother Ray* (1978, with David Ritz), was published in a revised and updated edition in 1992. Charles has won eleven Grammy Awards, the title of Commander de l'Ordre des Arts et des Lettres from the French Republic, an NAACP Hall of Fame Award (1983), and a Lifetime Achievement Award from the National Academy of Recording Arts and Sciences (1989).

REFERENCES

BALLIETT, WHITNEY. *American Singers.* New York, 1979.
BRELIN, CHRISTA, and WILLIAM C. MATNEY, JR., eds. *Who's Who Among Black Americans.* 7th ed. Detroit, 1992.
MARSH, DAVE. "Ray Charles." In *The New Grove Dictionary of American Music.* H. Wiley Hitchcock and Stanley Sadie, eds. London and New York, 1986.
SHAW, ARNOLD. *Black Popular Music in America.* New York, 1986.

ROBERT W. STEPHENS

Charleston, Oscar McKinley (October 12, 1896–October 6, 1954), baseball player and manager. Charleston, the man regarded as the best centerfielder of his time, was often called "the black Ty Cobb." Others responded that Cobb was the white Oscar Charleston. As fast, defensively adept, and tenacious as Cobb, Charleston had considerably more force. A left-handed power hitter who hit over .400 five times in the Negro Leagues (*see* BASEBALL), Charleston attained a lifetime .361 average for Cuban League play that is the highest ever recorded. He was also known for playing the most shallow centerfield imaginable.

Charleston was born in Indianapolis, the son of Tom Charleston, a jockey and construction worker, and Mary (Jeanette) Charleston. He ran away from home at the age of fifteen and served in the Negro Twenty-fourth Infantry Regiment in the Philippines before joining the Indianapolis ABCs and starting as their centerfielder in 1915.

After a stint with the Homestead Grays, he became player/manager for the Pittsburgh Crawfords and managed and played in the first East-West Classic in 1934. A lifetime .351 hitter in the Negro Leagues, Charleston led the Negro Leagues and Cuban play in batting, home runs, and stolen bases, and was fourth all-time in the total number of Negro League home runs. Charleston, who played for or managed at least ten different Negro League teams, was inducted into the Baseball Hall of Fame in 1976.

REFERENCES

ASHE, ARTHUR R., JR. *A Hard Road to Glory: A History of the African-American Athlete, 1919–1945.* New York, 1988.
HOLWAY, JOHN B. *Blackball Stars: Negro League Pioneers.* Westport, Conn., 1988.

ROB RUCK

Charleston, South Carolina. The presence of blacks in Charleston dates from 1526, when a Spanish expedition from the West Indies arrived in the low country. For the next hundred years blacks fought alongside both the French and the Spanish as these two competed for the region, but an English colony of settlers from Barbados arrived to found the first permanent settlement (Charles Towne) in 1670. The Barbadians had long relied on slave labor from AFRICA to grow food, and the early presence of Africans and West Indians brought as slaves, mixed with European elements, helped in creating the unique cultural mix that distinguishes the city and the surrounding Sea Islands area.

The successful introduction of rice in the late 1690s paralleled the emergence of a fixed reliance upon African slave labor that resulted in the colony's having a black majority population by 1700. Legend has it that an African enslaved woman brought rice to the colony aboard ship. Certainly, there were Africans skilled in the cultivation of rice, a staple crop in parts of West Africa, and both the baskets for collecting the crop and the methods of cleaning it were of African origin. Africans from different tribes had skills in ironwork, carpentry, and other trades. This expertise was desperately needed in a colony with a small white labor force, and one less able than Africans to withstand the humid, malarial climate. Along with the slaves came African styles of art, cloth, and cuisine. Perhaps the most enduring carryover from Africa is the GULLAH language still spoken by some low-country African-Americans, related to the Krio tongue of Sierra Leone.

Charleston, meanwhile, was growing in size and in importance, both as a center of trade and as a port. White Charlestonians traded heavily with their West Indian partners, and much of the traffic was in slaves (see SLAVE TRADE). An estimated 40 percent of all enslaved persons brought to the English colonies between 1700 and 1775 came through Charleston's Sullivan Island harbor. The customs and quarantine facilities on the island have caused it to be dubbed "the Ellis Island of Black America."

Enslaved blacks lived in the city and surrounding areas in large numbers. Neither the STONO REBELLION of 1739, in which an armed group of slaves killed 31 whites in an engagement, nor the American Revolution, with its egalitarian message, provoked widespread abolitionist sentiment in Charleston. During the antebellum period, some three-quarters of the city's white families owned slaves, as did a small number of mulatto families. Enslaved blacks generally lived in their masters' houses, or in nearby cabins. Within the large city, enslaved blacks often hired themselves out as laborers or craftsworkers, sometimes saving enough money to buy their freedom. The City Council made repeated efforts to control the enslaved population through labor registries and ordinances against blacks dressing "up" above their station.

Charleston also boasted a large free black population. Miscegenation was relatively open and widespread, and many white men kept black mistresses. After 1800, a free, mixed-race "brown elite" grew up around mutual aid and benevolent organizations such as the BROWN FELLOWSHIP SOCIETY and Friendly Moralist Society. Most free women of color worked as domestics, and men worked as carpenters, bakers, sawyers, among other jobs. Prior to the Civil War, between eighty and ninety percent of Charleston's skilled trades were entrusted to black labor. Charlestonian Edward JONES, a second-generation free black whose parents operated the renowned Jones Boarding House, was one of America's first black college graduates (Amherst, 1839). The free blacks were second-class citizens, and after 1815 they faced increasing pressure and legal disabilities, including "black taxes" on nonresidents, and denial of all-black church services, as whites grew frightened of slave revolts. In 1822, a conspiracy was uncovered. A free black carpenter named Denmark Vesey was charged with having plotted with slave assistants to start an uprising to kill all the whites in Charleston. Though the extent of the plot has long been disputed by historians, Vesey and twenty-two slaves were hanged. More often slaves resorted to arson, poisoning, work stoppage, and running away to resist enslavement.

As a result of the DENMARK VESEY CONSPIRACY, further harsh laws were imposed on free blacks, including the notorious order providing for the detention of black sailors while their ships were in port. Nevertheless, the free black population had developed sufficient personal ties with influential whites to feel reasonably secure. After 1822, white immigration was encouraged. By 1860, Charleston had a white majority population and was fervently secessionist. Even before the Civil War began in the city, the secessionist backlash led to harassment of the free black population. White workers resenting black competition instigated a "crackdown" on free blacks. White groups instituted house-to-house searches, and those blacks unable to show identification proving their status were enslaved. Many free people of color fled the city.

Charleston was hit hard economically by the Civil War and the Union naval blockade, and the port never regained its former importance after 1865. After the Civil War ended, newly freed blacks poured into Charleston from the ravaged countryside, seeking work. The city became a center of African-American life. Blacks, finally able to found their own churches, split from whites to found St. Mark's

Church (Episcopal), Centenary Methodist Church, Morris Street Baptist Church, and other congregations. These became the centers of black life. The black community also set up many businesses and community institutions. The AVERY NORMAL INSTITUTE, founded in 1865, was the symbol of white elite efforts to aid black uplift, producing academically superior students and teachers until it closed in 1954. The Longshoremen's Protective Association, which lasted until 1905, was a majority black group whose efforts assured dockworkers the highest wages of all South Atlantic ports. Blacks from Charleston and the low country, such as Robert B. ELLIOTT and Robert SMALLS, were influential in the state's black majority state assembly, which first met in the city in 1866. Richard Harvey CAIN, a state senator later elected to Congress, in 1871 founded Lincolnville, a colony for free blacks, just outside the city. While the corruption in South Carolina's government was later held up by whites as an example of black incompetence, and the state was "redeemed" by white Democrats in 1870, the progressive state constitution that blacks had helped to draft remained in force until 1895.

After its "redemption," Charleston continued as a black center. Blacks continued to occupy postmaster and customs jobs through the 1880s, and there were no fewer than seven black newspapers in the nineteenth century's last two decades. The Wainwright Printing Company (1897) exists as the oldest surviving black business. Institutions such as the Jenkins Orphanage (1892; it was later famous for its band) and the Charleston Training School for Colored Nurses (1897) were founded. Only after 1895, under the racist regime of Ben Tillman, was large-scale segregation instituted. Discrimination was rampant. When Theodore Roosevelt appointed Dr. William D. CRUM, an African American, as Collector of the Port in 1903, white opposition in the city drew national attention. Crum's appointment was eventually rescinded, and he was made ambassador to Liberia, the African nation first settled by black Charleston expatriates in 1820.

During most of the twentieth century, Charleston was a small southern town with a unique integrated housing pattern. Unlike the image of blacks living in rundown tenements such as Cabbage Row (immortalized as Catfish Row in DuBose Heyward's *Porgy*), black Charlestonians lived throughout the city, and many owned their homes. Total social segregation existed nevertheless. Public schools were poor, and job discrimination kept most blacks in menial labor. Low cotton and agricultural prices forced many blacks to migrate. According to some sources, the "geechee dance," which black Charlestonians brought to northern cities, gave rise to the popular 1920s dance the Charleston. Some prominent twentieth-century

Charlestonians include HARLEM RENAISSANCE portrait painter Edwin HARLESTON (founder of the local branch of the NAACP), famed marine biologist Dr. Ernest E. JUST, and the human rights activist Septima Poinsette CLARK.

Change started in the 1940s, when Federal Judge J. Waties Waring abolished the state's Democratic "white primary" and ordered the equalization of teachers' pay. The NATIONAL ASSOCIATION FOR THE ADVANCEMENT OF COLORED PEOPLE (NAACP), with support from other organizations like the SOUTHERN CHRISTIAN LEADERSHIP CONFERENCE led the CIVIL RIGHTS MOVEMENT in the city. Community members worked with Mayor Palmer Gaillard to peacefully integrate the city. Gaillard picked black aldermen to run with him, and ensured that desegregation laws were obeyed. In 1970, Herbert Fielding became the first black Charlestonian since Reconstruction elected to the state assembly, and Lonnie Hamilton was elected to the city council. The economic problems of the city's blacks remained, and were highlighted by the 1969 strike of the largely black workforce at the Medical University of South Carolina and Charleston County hospitals, which fought for better wages and union recognition.

In the 1990s, Charleston is paying greater attention to its rich black past, with the Avery Research Center for African American History and Culture, housed in the original Avery Institute building on the College of Charleston campus, being the chief institutional agent. However, the preservationist movement has aroused opposition as well as appreciation from blacks, who fear that their neighborhoods and homes may be invaded and taken over by those seeking to preserve the past at the expense of genuine black economic development.

REFERENCES

DRAGO, EDMUND LEE. *Initiative, Paternalism, and Race Relations: Charleston's Avery Normal Institute.* Athens, Ga., 1990.

NEWBY, I. A. *Black Carolinians: A History of Blacks in South Carolina from 1895–1968.* Columbia, S.C., 1973.

ROSEN, ROBERT N. *A Short History of Charleston.* San Francisco, 1982.

WOOD, PETER H. *Black Majority: Negroes in Colonial South Carolina from 1670 Through the Stono Rebellion.* New York, 1974.

MILLICENT E. BROWN

Charleston, South Carolina, Riot of 1919.

The Charleston, S.C., Riot, one of the many racial incidents of the 1919 RED SUMMER, began as a confrontation on May 10 between local African Ameri-

cans, a majority population in the city, and white sailors from the city's naval base. Stories differ as to how the riot started. According to one account, an armed white sailor invaded an African-American pool hall and was attacked and shot by blacks, possibly trying to disarm him. Other accounts describe a street brawl, in which a black was shot and killed by two white sailors, as the triggering incident. As word spread about the violence, masses of sailors entered the city, and violence broke out around the black area of Market and West streets. Sailors raided shooting galleries for guns, beat and shot blacks, and looted and set fire to property, such as a black-owned barbershop. Blacks defended themselves, reportedly through sniper fire from cars. Marine troops were called in to augment the police force. The Marines were unable to stop the sailors' march, and some joined in the violence. By 1 A.M. more Marines and Navy provost troops were summoned. They marched the sailors back to their base. Blacks began firing at the retreating sailors and were ordered off the streets. By the next day, when the violence had subsided, two blacks were dead and seventeen injured; one policeman and seven sailors had been seriously wounded. Later, two more people died; altogether, sixty received medical aid.

The next day, the mayor of Charleston met with Navy officials. At the request of black leaders, he demanded that damage to black property be recompensed by naval authorities, and warned that if blacks were not protected he would declare martial law. A coroner's jury subsequently placed blame for the incident on the sailors and absolved all blacks of wrongdoing. As a result of this decision, along with careful neutrality by the city force, further violence was prevented. Following demands by the NATIONAL ASSOCIATION FOR THE ADVANCEMENT OF COLORED PEOPLE, the Navy charged six sailors and convicted three on rioting and other charges. The sailors were sentenced to a year in prison and were given dishonorable discharges. Such fairness was as rare as it was welcome to southern blacks.

See also URBAN RIOTS AND REBELLIONS.

REFERENCE

WILLIAM, L. E. "The Charleston, S.C., Riot of 1919." In Frank Allen Dennis, ed. *Southern Miscellany: Essays in History in Honor of Glover Moore.* Jackson, Mich., 1981.

GAYLE T. TATE

Chase, Hyman Yates (November 24, 1902–February 5, 1983), zoologist. Hyman Chase was born in Washington, D.C. A graduate of Dunbar High School, he entered Howard University in the fall of 1922 as a premedical student and earned a B.S. in 1926. Because he could not afford to attend medical school, he took a high-school teaching job in North Carolina. Chase returned to Howard in the fall of 1929, one of the first five students in the new master's level program in zoology. Their teacher was the renowned black zoologist Ernest E. JUST. In 1930, Chase and William Bright became the first to earn master's degrees in zoology at Howard. Chase began doctoral studies under Just at Howard and, with the support of a fellowship from the General Education Board, completed his Ph.D. at Stanford University in 1934.

Chase taught zoology at Howard for six years (1934–1940). His research, following along lines suggested by Just, was in experimental embryology and the physiology of development. He published four papers in *Biological Bulletin,* official organ of the Marine Biological Laboratory in Woods Hole, Mass. These papers presented the results of experiments carried out primarily at the Hopkins Marine Station in Pacific Grove, Calif. (affiliated with Stanford). Chase studied the fertilization reaction in various marine organisms, e.g., *Urechis caupo.* He demonstrated correlations between temperature and sperm activity in the egg, and analyzed injuries to the egg-cortex by exposure to ultraviolet rays.

Chase left Howard in 1940 to pursue a career in the military. An officer in the U.S. Army Reserve since 1925 (second lieutenant—infantry), he went on active duty as a captain in December 1940. He rose through the ranks, retiring as a colonel in 1960. That year, he returned to Howard to teach military science and tactics as part of the university's ROTC program.

REFERENCE

CHASE, H. Y. "The Effect of Temperature on the Rate of the Fertilization Reaction in Various Marine Ova." *Biological Bulletin* 69 (December 1935): 415–426.

KENNETH R. MANNING

Chase-Riboud, Barbara Dewayne (June 26, 1939–), sculptor, poet, and novelist. The only child of middle-class parents, Barbara Chase was born in Philadelphia and raised in that city. After earning a B.A. in fine arts from Temple University in 1957, Chase traveled to Rome, Italy on a John Hay Whitney Foundation fellowship. There she worked for the first time in bronze and entered her sculptures in exhibitions at the Spoleto Festival (1957) and at

the American Academy in Rome and the Gallery L'Obeliso (1958). During the winter of 1957, Chase spent three months in Egypt, receiving what she later termed a "blast of Egyptian culture." The visit marked a turning point in her artistic career, as Chase, newly exposed to nonclassical art, was forced to re-evaluate the academic training with which her works had previously been infused. "Though I didn't know it at the time," she said, "my own transformation was part of the historical transformation of the blacks that began in the '60s."

After receiving an M.F.A. from Yale University (1960), Chase traveled to London before finally settling in Paris. In 1961, she married the French photographer Marc Riboud; shortly thereafter, the couple journeyed to China, Chase-Riboud being one of the first American women to visit the country after the onset of the Cultural Revolution. Her notes from the trip, which also included visits to Nepal and Inner Mongolia, were later transformed into a collection of poems, issued under the title *From Memphis to Peking* (1974).

Although Chase-Riboud's interest in Asian art can be traced to sculptures dating from as early as 1960, it was not until the latter half of the decade that she began fully to incorporate this and African influences into her own work. She became known for using radically different materials—such as bronze and wool, steel and synthetics, and bronze and silk—in compositions that were both abstract and expressive, elegant and minimalist. Hemp, wood, raffia, leathers, metals, and feathers were also used in figures reminiscent of African masks. Chase-Riboud exhibited her work internationally at such festivals as the New York Architectural League Show (1965), the Festival of Negro Art in Dakar (1966), and the L'Oeil Ecoute Festival of Avignon (1969).

By the early 1970s, Chase-Riboud's work had achieved worldwide renown. She was awarded a National Endowment for the Humanities fellowship in 1973 and an outstanding alumni award from Temple University in 1975. In addition to participating in group shows at the Boston Museum of Fine Arts, the Smithsonian Institute of Washington, D.C. (National Gallery of Art), New York's Whitney Museum, the Centre Pompidou of Paris, and other museums, Chase-Riboud held solo exhibitions at the Betty Parsons Gallery in New York, the Museum of Modern Art in Paris, and the Kunstmuseum in Düsseldorf, among others.

Chase-Riboud came to prominence as an author in 1979 with the publication of her first novel, *Sally Hemings,* a historical work based on Thomas Jefferson's relationship with his slave mistress (*see* Sally HEMINGS). She won the Janet Heidinger Kafka Prize for fiction for that volume. Her claim that Jefferson

had fathered seven children with Hemings proved extremely controversial, and she was both widely commended and criticized for her endeavor. In 1981, Chase-Riboud divorced Marc Riboud and married Sergio G. Tosi, an Italian art dealer and publisher. Four years later, she published a second volume of poems, *Love Perfecting,* and another novel about slavery, *Valide,* in 1986. Two additional works followed, a collection of poems titled *Study of a Nude Woman as Cleopatra* (1988) and a novel, *Echo of Lions* (1989).

Chase-Riboud, who was awarded an honorary doctorate from Temple University in 1981, continued to exhibit her artwork throughout the 1980s, holding one-woman shows at the Musée Reattu in Arles (France), the Kunstmuseum in Freiburg, the Bronx Museum in New York, the Museum of Modern Art in Sydney (Australia), and the Studio Museum in Harlem. While maintaining permanent residences in Paris and Rome, she has continued to travel widely, to write, and to produce visual art. In the spring of 1990, she was artist-in-residence at Pasadena City College in California.

In 1994 Barbara Chase-Riboud returned to the subject of Thomas Jefferson and Sally Hemings with another novel, *The President's Daughter,* about Harriet Hemings, the slave daughter of Sally Hemings and Jefferson.

REFERENCES

McHenry, Susan. " 'Sally Hemings': A Key to Our National Identity." *Ms* (October 1980): 35–40.

Munro, Eleanor. *Originals: American Women Artists.* New York, 1979, pp. 370–376.

Wilson, Judith. "Sculpting Out History." *Essence* (December 1979): 12–13.

PAMELA WILKINSON

Chavis, Benjamin Franklin, Jr. (January 22, 1948–), civil rights activist. Born and raised in Oxford, N.C., the Rev. Dr. Benjamin F. Chavis, Jr., came from a long line of preachers. His great-great-grandfather, the Rev. John Chavis, was the first African American to be ordained a Presbyterian minister in the United States. Chavis first became involved in the struggle for civil rights at the age of twelve, when his persistence in seeking privileges at a whites-only library in Oxford started a chain of events that led to its integration. In 1967, while a student at the University of North Carolina (UNC) at Charlotte, Chavis became a civil rights organizer with the SOUTHERN CHRISTIAN LEADERSHIP CONFERENCE (SCLC); he remained active with the organization

until he graduated from UNC in 1969 with a B.A. in chemistry. After a year spent as a labor organizer with the American Federation of State, County, and Municipal Employees (AFSCME), Chavis joined the Washington field office of the United Church of Christ's Commission for Racial Justice (UCCCRJ).

On February 1, 1971 Chavis was sent to Wilmington, N.C., in response to a request from Wilmington ministers for a community and civil rights organizer. The racial climate in Wilmington had become explosive when court-ordered desegregation began in 1969. In January 1971 black students began a boycott of Wilmington High School; Chavis was sent to help organize this student group. Within two weeks of his arrival, Wilmington erupted in a week-long riot.

The Rev. Benjamin Chavis first attracted national attention in 1972 as one of the Wilmington Ten, arrested after a civil disturbance in Wilmington, N.C. He was later convicted on very questionable conspiracy charges and imprisoned from 1975 through 1980. From 1993 to 1994 he had a short and stormy tenure as executive director of the NAACP. (Photographs and Prints Division, Schomburg Center for Research in Black Culture, The New York Public Library, Astor, Lenox and Tilden Foundations)

In March 1972, fourteen months after the riot ended, Chavis and fifteen former students were arrested for setting fire to a white-owned grocery store and shooting at firemen and policemen who answered the call. Chavis, eight other black men, and a white woman were convicted for arson and conspiracy to assault emergency personnel. Chavis and the nine other defendants became known as the Wilmington Ten. In 1975, after his appeals were exhausted, Chavis entered prison. Because of the weak nature of the evidence against them, Amnesty International designated them political prisoners in 1978, the first time the organization had done so for any U.S. convicts. Their case received national and international support.

In 1977 all three witnesses who testified against the Wilmington Ten admitted they had given false testimony and had been either pressured or bribed by the Wilmington police. Despite this new evidence, the defendants were denied the right to a new trial. Chavis, the last of them to be paroled, was released in 1980, having served more than four years of his thirty-four-year sentence at Caledonia State Prison. On December 4, 1980, a federal appeals court overturned the convictions, citing the coercion of prosecution witnesses.

While in prison, Chavis taught himself Greek, translated the New Testament, wrote two books (*An American Political Prisoner Appeals for Human Rights*, 1979, and *Psalms from Prison*, 1983) and earned a master of divinity degree magna cum laude from Duke University. After his release, he earned a doctor of ministry degree from the Divinity School of Howard University. In 1986 Chavis became the executive director of the UCCCRJ. In this capacity, he focused on combating both what he calls "environmental racism"—the government and industry's practice of burdening poor and predominantly black neighborhoods with toxic waste dumps—and gang violence. In 1993, Chavis became the seventh executive director of the NATIONAL ASSOCIATION FOR THE ADVANCEMENT OF COLORED PEOPLE; his election at age forty-five made him the youngest person ever to lead the organization. He pledged to revitalize the organization, whose aging membership has been a source of concern, and to sharpen its focus; he also cited the longer-term goal of expanding membership to include other minorities.

Chavis's policies during his tenure as executive director proved extremely controversial. In an attempt to reorient the NAACP toward young urban blacks, he held dialogues with militant black leaders, including Louis Farrakhan. In the summer of 1994, he acknowledged that he had used NAACP funds in an out-of-court settlement with a female NAACP staff member who accused Chavis of sexual harassment. Amid these and other charges of financial impropri-

ety, the board of directors relieved Chavis of his position as executive director on August 20, 1994.

REFERENCES

CHAVIS, BENJAMIN, JR. "Foreword." In Robert D. Bullard, ed. *Confronting Environmental Racism*. Boston, 1993.

KOTLOWITZ, ALEX. "A Bridge Too Far? Ben Chavis." *New York Times Magazine* (June 12, 1994): 40–43.

MANSUR M. NURUDDIN
ALEXIS WALKER

Chavis, John (1763–June 13, 1838), educator and minister. Born in Granville County, N.C., John Chavis enlisted with Captain May Cunningham, and fought in the Revolutionary War at White Plains, N.Y., and Yorktown, Va. He attended Princeton University and Washington Academy (Lexington, Va.), where he studied under John Witherspoon, the president of the Academy, and became a theologian. In 1801, Chavis, the first African American to be commissioned for interracial Christian leadership, was licensed by the Presbyterian Church as a missionary to whites as well as slaves in the South. Chavis's ministry spanned thirty years, from 1802 to 1832, and he was considered a thoughtful and forceful speaker. He preached to whites during the day and to blacks at night.

Chavis taught school in Fayetteville, N.C., in 1805, and by 1808 he was principal of his own school, where he taught both black and white children. Two of his students became state governors, and two others, U.S. congressmen. Chavis was politically active, but he opposed immediate emancipation, fearing undue hardship to the blacks. After the Nat Turner Rebellion in 1831, Chavis was restricted from teaching, and concluded his ministry. A large recreational park and federal housing project in Raleigh, N.C., memorializes Chavis and his achievements.

REFERENCES

LOGAN, RAYFORD, ed. *Dictionary of American Negro Biography*. New York, 1982.

LOW, W. AUGUSTUS, ed. *Encyclopedia of Black America*. New York, 1981.

NEIL GOLDSTEIN

Cheatham, Henry Plummer (December 27, 1857–November 29, 1935), congressman. Henry P. Cheatham was born on a slave plantation near Hen-

derson, N.C., in 1857. Following Emancipation, he was educated in North Carolina public schools. He decided to pursue higher education and in 1883 he received his bachelor's degree from Shaw University in Raleigh, N.C. He prepared to qualify for the bar, but instead of becoming a lawyer he became principal of the State Normal School at Plymouth, N.C., and by 1888 he had been elected register of deeds for Vance County.

In April 1888, Cheatham ran for Congress as a Republican and won the election by a narrow margin. He made a variety of motions during his first term, ranging from the reimbursement of Freedmen's Bank depositors, compensation for Robert SMALLS and the crew of the *Planter* (a black captain and crew who had escaped the Confederacy during the Civil War), and appropriations for public buildings in North Carolina. None of these measures was taken up by the House. Reelected in 1890, for most of his congressional tenure he was the only African American in Congress, and his colleagues had little concern with black interests. In his second term, his initiatives included efforts to add a brochure about African-American history to the exhibits of the 1893 Colombian Exposition. He also worked to have histories written of black Army troops and of blacks in colonial America.

Cheatham was defeated in his bid for a third term in 1892 by Democrat Frederick A. Woodard (due in part to a third-party competition from the Populist party). He lost a bid for the Republican nomination in 1894 to his brother-in-law George H. White, another black politician. President William McKinley appointed Cheatham recorder of deeds for the District of Columbia in 1897. Cheatham held this position until 1901, when he returned to North Carolina and created the Oxford Orphanage, which provided housing and education for the 200 black youths. Cheatham remained superintendent of the orphanage until 1935, when he died in Oxford at the age of seventy-seven.

REFERENCES

CHRISTOPHER, MAURINE. *Black Americans in Congress*. New York, 1976.

CLAY, WILLIAM L. *Just Permanent Interests: Black Americans in Congress, 1870–1991*. New York, 1992.

DURAHN TAYLOR

Checker, Chubby (Evans, Ernest) (October 3, 1941–), rock-and-roll singer, Chubby Checker's recording of "The Twist" launched an international dance craze in the early 1960s. He was born in South

Carolina and raised in Philadelphia, where he attended high school and worked at a poultry market, singing as he plucked chickens. Impressed by his voice, his boss introduced him to producers at the local label Cameo-Parkway, where he signed a recording contract in 1959. His imitations of Fats DOMINO and the COASTERS caught the attention of Dick Clark, the host of *American Bandstand,* a nationally televised dance show for teenagers that originated from Philadelphia.

Evans was rechristened "Chubby Checker" by Clark's wife, playing on the name "Fats Domino." At Clark's urging, Checker recorded "The Twist," a song first recorded by Hank Ballard and the Midnighters, and he appeared on *Bandstand* to perform the mildly suggestive dance that accompanied it. "You move your hips like you're drying yourself with a towel," he explained. Boosted by television, Checker's record shot to the top of the pop charts in September 1960. An early example of the decade's fascination with youth culture, the Twist subsequently caught on with adults, who equated its uninhibited frivolity with sophistication, and it became a pop phenomenon. In January 1962, Checker's record returned to the top of the charts, the only time a song has reached number one on two separate occasions.

In successive years, Checker recorded numerous spinoffs (including "Slow Twisting" and "Let's Twist Again") and other novelty dance numbers (including "The Limbo," and "Pony Time," which hit number one in February 1961), but none equaled the Twist's impact or success. In 1988 he appeared on "Yo! Twist," a rap tribute single by the Fat Boys.

REFERENCES

GEORGE, NELSON. *The Death of Rhythm and Blues.* New York, 1988.

STAMBLER, IRWIN. *The Encyclopedia of Pop, Rock, Soul.* Rev. ed. New York, 1989.

BUD KLIMENT

Chemistry.

Opportunities for African Americans to participate in the chemistry profession were primarily limited to employment in racially segregated high schools and colleges until the mid-1930s. Although most African-American chemists held only bachelors degrees, many of those who held graduate degrees obtained them from the most prestigious institutions. Keeping current on the rapidly advancing literature in chemistry was particularly problematic in the South because African Americans were denied access to public libraries.

In 1916, St. Elmo BRADY became the first African American to earn a Ph.D. in chemistry from an American university. The first African-American female believed to have earned a Ph.D. in chemistry was Marie M. Daly, who earned her degree in 1947 from Columbia University. By 1935, at least fifteen U.S.-born African Americans had earned doctorates in chemistry and chemical engineering. During this period, the attainment of a master's degree was an exceptional academic achievement for blacks. Nevertheless, African-American chemists continued to be fewer in number and proportion to other disciplines when compared to the overall population of college-educated blacks.

By 1945, some forty-three African Americans held Ph.D.s in chemistry and chemical engineering. The Rosenwald Fellowships and the General Education Board Fellowships played a major role in increasing the number of African Americans earning Ph.D.s. It was during the 1940s that an increasing number of African-American Ph.D. chemists began conducting research. WORLD WAR II and the resulting war effort appear to have provided the first major opportunities for African Americans to gain employment outside predominantly black colleges and universities. This situation resulted from an acute labor shortage of scientific and technical personnel. It was during this period that industrial laboratories and federal agencies began to employ African-American scientists, especially chemists, on an experimental basis. The apparent success of these scientists led to increased employment opportunities for others.

Perhaps best known and most successful of the African Americans who worked as industrial chemists during this period were Percy L. JULIAN of the Glidden Company in Chicago and Lloyd A. Hall of Griffith Laboratories, also in Chicago. Julian's appointment as head of research at Glidden is considered by most scholars to be the turning point in employment for African-American scientists in industry. African-American chemists were also employed at Eastman Kodak, Bell Telephone, the National Bureau of Standards, and on the Manhattan Project.

It should be noted, however, that many of the opportunities for African Americans in the industrial and governmental sectors did not come without political intervention. The FAIR EMPLOYMENT PRACTICES COMMITTEE (FEPC) played a critical role in the increased opportunities for the employment of African Americans in government service and in war industries by enforcing anti-discrimination laws. Upon its transfer to the War Manpower Commission, the FEPC initiatives actually improved, and so did its success. Pressure was put on the United States Employment Service to give preference to employers who did not discriminate against minorities.

The 1940s also witnessed a period of increased productivity in chemistry research at predominantly black colleges and universities, where most African-American Ph.D. chemists were employed. Major chemistry research projects were being conducted at HOWARD UNIVERSITY, Tuskegee Institute (*see* TUSKEGEE UNIVERSITY), and Tennessee State University.

By 1969, there were approximately 186 African-American Ph.D. chemists. Throughout their history, African-Americans have been underrepresented in chemistry in general and among doctorate chemists in particular. Historically, African Americans have composed less than 3 percent of all chemistry degree recipients and less than 1 percent of those earning doctorates in chemistry in the United States. Between 1981 and 1991, there were 164 Ph.D.s awarded to African Americans in chemistry (42 of these degrees were earned by women). Of the 1,311 chemistry doctorates awarded by American universities to U.S. citizens in 1991, fourteen and four went to African-American males and females, respectively. Federal figures for African-American holders of chemistry bachelors' and masters' degrees are usually included in the general category of physical scientists, most of whom are chemists. These data reveal that African Americans earned 708 bachelors and eighty-two masters degrees in the physical sciences in 1988 and 1989.

A similar situation prevails for those employed as chemists. The most recent figures reveal that in 1988, 4,800 of the 197,000 employed chemists and 1,700 of the 148,500 employed chemical engineers were African Americans. Among the 44,000 employed doctoral chemists, 500 were African Americans. During the same year, there were 100 African Americans among the 6,900 employed doctoral chemical engineers. For comparative purposes, consider that African Americans account for roughly 11 percent of total U.S. population, approximately 10 percent of the total work force, and about 7 percent of all employed professional and related workers.

Despite their underrepresentation in the chemical professional in the United States, African Americans have achieved tremendous success and recognition in the scientific community. For example, in 1973 Percy L. Julian was elected to the National Academy of Sciences. In 1975 Walter Lincoln Hawkins was elected to the National Academy of Engineering. In 1992 President Bush awarded him the prestigious National Medal of Technology for inventing plastic coatings for communications cable. The late Henry A. Hill was the first African American elected president of the American Chemical Society, where he served from 1975 to 1977. Two African-American chemists have been honored with United States commemorative postage stamps: George Washington CARVER in 1948 and Percy L. Julian in 1993.

REFERENCES

FERGUSON, L. N. "Negroes in Chemistry." *Industrial Trends* (October 1949): 17–19.

NATIONAL SCIENCE FOUNDATION. *Women and Minorities in Science and Engineering.* Washington, D.C., 1990.

RIES, P., and D. H. THURGOOD. *Summary Report 1991: Doctorate Recipients from United States Universities.* Washington, D.C., 1993.

SMITH, E. "African American Chemists in the American Chemical Society." *Workforce Report: Professionals in Chemistry.* Washington, D.C., 1991.

WILLIE J. PEARSON, JR.

Cherry, Donald Eugene "Don" (1936–), trumpeter, composer. Born in Oklahoma City, Cherry helped Ornette COLEMAN create free jazz in the 1950s, and went on to gain renown as an apostle of "world music" in the 1970s and 1980s. Cherry moved to Los Angeles at age four, and studied trumpet as a child. While still in his teens he gained a reputation as a promising hard-bop trumpeter, eventually joining the group of Los Angeles musicians gathered around the still-unknown Ornette Coleman, and assimilating Coleman's early "harmolodic" methods, which rejected fixed chord changes and traditional harmonies. In 1957 Cherry led his own quartet, playing Coleman compositions, in Vancouver, and made his first recording with Coleman, *Something Else!,* in 1958. Playing a pocket cornet, Cherry came to New York with Coleman the next year as part of the Coleman quartet's famous two-and-a-half-month engagement at the Five Spot Café, and over the next two years recorded on Coleman's albums *Tomorrow Is the Question!, The Shape of Jazz to Come, This Is Our Music,* and the landmark *Free Jazz,* which ushered in and gave name to the dominant avant-garde style of the 1960s. Cherry left Coleman in 1961, lending his tart, whimsical style to ensembles with Sonny ROLLINS and John COLTRANE. He recorded with the New York Contemporary Five in 1963, and played with Albert Ayler in Copenhagen in 1964, and in that year Cherry contributed to the free improvisations used in the soundtrack for the film *New York Eye and Ear Control.*

In the mid-1960s Cherry traveled extensively in Europe and Africa, performing with Spanish saxophonist Gato Barbieri and South African trumpeter Johnny Dyani, and eventually recorded two albums for large ensemble: *Complete Communion* and *Symphony for Improvisors,* both of which included such developments as collective improvisation and ensemble solos. It was during this time that Cherry began to integrate folk and non-Western instruments into

his performances, a style that became known as world music. In 1969 he participated in Charlie Haden's *Liberation Music Orchestra.* In the late 1960s Cherry taught, performed, and recorded at Karl Berger's Creative Music Studio in Woodstock, N.Y., and was active in the Jazz Composers Organization, and in 1970 he taught at Dartmouth College. Cherry lived in Sweden from 1970 to 1974, before returning to live in New York, where he became involved with the punk and new wave scenes, and recorded with Lou Reed. In the mid-1970s Cherry reunited with Haden, Ed Blackwell, and Dewey Redman to record *Old and New Dreams,* the first of a series of albums paying homage to Coleman. Cherry also formed Codona, a world music trio, with Collin Walcott and Nana Vasconcelos. In the 1980s, Cherry remained active with Old and New Dreams and Codona; he also reunited in concerts and recordings with Coleman, SUN RA, Haden, and Blackwell, and recorded *Art Deco* with his own small ensemble. In the late 1980s, he moved from New York to San Francisco, and continued to record and perform throughout the world, on pocket cornet as well as on African and Indian flutes, and the doussn'gouni, an African guitar. His stepdaughter, Neneh Cherry, is a leading pop musician.

REFERENCES

DAVIS, FRANCIS. *In the Moment: Jazz in the 1980s.* New York, 1986.

GRAY, JOHN. *Fire Music: A Bibliography of the New Jazz, 1959–1990.*

BILL DIXON

Cherry, Frank S. (c. 1880–1965), religious leader. Frank S. Cherry, a former seaman and railroad employee, was the leader of Philadelphia's Church of God. This sect was one of the first modern religious groups to take the name of Black Jews (see JUDAISM). Much of what we know about Cherry, generally known as Prophet Cherry, comes from Arthur Huff FAUSET's pioneering 1944 study, *Black Gods of the Metropolis.* According to Fauset, Cherry, who was originally from the South, was already elderly in the early 1940s. Familiar with Yiddish and Hebrew, Cherry advocated a curious mixture of black nationalism, Christian and Jewish practice, and a millennial ideology in his sermons. Plainly dressed, the self-educated Cherry commonly belittled educated African Americans as a group and specifically targeted black ministers and preachers, whom he labeled "damn fools."

The Church of God claimed that blacks were the original Israelites whose rightful position had been usurped by white Jews. Cherry further argued that blacks would eventually ascend to their rightful position in society. There was also a strong millennial theme running in his theology. Prophet Cherry predicted that the end of the world would come in 2000.

In the Church of God, eating pork, drinking to excess, secular dancing, and divorce were all prohibited. Church members were baptized and exhorted to follow the Ten Commandments, but the church celebrated the Jewish Sabbath and Passover. At the peak of its success, the church had about 400 members. When Cherry died in 1965, he was succeeded by his son Benjamin. The church lapsed into obscurity in the 1970s.

REFERENCE

FAUSET, ARTHUR HUFF. *Black Gods of the Metropolis: Negro Religious Cults of the Urban North.* 1944. Reprint. Philadelphia, 1971.

JOHN C. STONER

Chesimard, Joanne. *See* Shakur, Assata.

Chesnutt, Charles Waddell (June 20, 1858–November 15, 1932), writer. Born in Cleveland, Ohio, to freeborn mulattoes, Chesnutt was raised mostly in Fayetteville, N.C., by his father, Andrew; his mother, Ann Maria, died when he was only thirteen. Though Chesnutt attended the Howard School and received a fairly sound general education, he proved to be a model autodidact, teaching himself advanced mathematics, ancient languages, history, and shorthand. His first teaching assignments in Charlotte, N.C., and Spartanburg, S.C., from 1875 to 1877, served as a proving ground for what he had learned. He rose in 1879 from being first assistant to the principal of the State Colored Normal School of North Carolina to become its principal, serving also as Sunday-school superintendent of the renowned Evans Chapel African Methodist Episcopal Zion Church. Despite his success, Chesnutt was determined to escape the harsh racism of the South. In 1883, peddling his shorthand skills, he sought work with northern newspapers, such as the *New York Mail and Express;* he stayed there only five months before moving on to Cleveland to try his luck in this city of his birth, soon to become his permanent place of residence. While working in the law offices of a railroad company, Chesnutt studied law, and in 1887

passed the Ohio bar examination. Pleased with his accomplishments, he began operating a stenographic service for the courts and was well rewarded for his efforts. Having secured a foothold on this trade, he sent for his wife, Susan, whom he married in 1878, and his children, who were left behind in Fayetteville while he traveled from the South to the North and back again—a pattern of departures and returns that would later play a subtle role in most of his fiction.

Rankled by racist or insensitive southern white writers and their depictions of miscegenation and the black experience, Chesnutt vowed to render a more accurate and faithful account of the issues. In 1887, his tale of magic, witchcraft, and slavery "The Goophered Grapevine," brought him to the nation's attention, though by now he had already published approximately sixteen short stories in a variety of magazines and newspapers. With the heavy-handed

Novelist and short-story writer Charles W. Chesnutt was one of the few African-American authors in the early twentieth century whose works were widely published. Chesnutt's evocative depictions of black southern life received widespread critical acclaim. (Mary O. H. Williamson Collection, Moorland-Spingarn Research Center, Howard University)

assistance of his publisher's editors, Chesnutt produced *The Conjure Woman* (1899), a collection of tales connected by their plots' depiction of magical events and unified by their portrayal of the horrors of slavery while raising troubling questions regarding the complex attachments that linked the ex-slaves to their slave forebears and to their masters. It was a stunning success, preceded a few months earlier by *The Wife of His Youth and Other Stories of the Color Line* (1899)—a collection of tales wherein irony and inexplicable coincidences, rather than magic, represent the controlling literary technique, and where blacks confront the lessons of the "color line": color prejudice among blacks, which is as much about race as it is about kinship and familial affiliation. This too was very well received.

Though Chesnutt appears to have been steadfast against any temptation to pass as white himself, he flirted very much with this topic in his fiction. Thus, the pathos aroused in his first novel, *The House Behind the Cedars* (1900), is created by the choice a young woman must make between passing as white, thereby enjoying the apparent benefits of white society, and remaining with her mother to live among those of the black race with whom she was raised, but among whom she would be forever blocked from enjoying the fruits due her as an American citizen.

In the wake of his early successes, Chesnutt closed his stenographic offices and devoted himself full-time to writing fiction. By now it appeared that he had joined that diverse group of regional writers called "local colorists"; but with a compulsory life of Frederick DOUGLASS (1899) behind him, his next literary efforts proved too realistic and bitter for his newfound audience. Though readers may be moved by the sibling rivalry of two women, one black and one white, depicted in *The Marrow of Tradition* (1901), in his second novel, their kinship is eclipsed by the highly charged politics of the post–Civil War period, a polarized time that left little room for moderating sentiments in the North or the South. The plot depicts strange bedfellows brought together by political goals based more on postbellum fears than on any alliance they might have forged during the antebellum era or any indignity they might have suffered in common. Forced by poor sales, Chesnutt returned in 1901 to stenography, consequently remaining sorely underrated during his lifetime.

As a witness to events that took place in the South during the 1890s, Chesnutt could no longer believe that paternalistic, well-meaning whites were able or willing to do anything more for blacks. In his last published novel, *The Colonel's Dream* (1905), the white colonel returns to his southern home with the belief that he can forestall the return to slave conditions into which many blacks and poor whites are

falling. Having failed, the colonel returns north with the belief that blacks cannot win the war of "Redemption," as this era was dubbed, with or without the assistance of white patrons. With Reconstruction over, blacks were, during this nadir of their odyssey in America, on their own.

Chesnutt's light complexion, erudition, sophistication, and accomplishments, however, gave him an entrée into the upper ranks of Cleveland society, where he observed activities satirized in that highly ironic short story "Baxter's Procrustes." As one of the wealthiest black men in the city, Chesnutt was among the most successful political forces in Cleveland, though he never held political office. He often took the middle ground in racial affairs, whether the issue was between blacks and whites or among blacks: He was a member of both the NATIONAL ASSOCIATION FOR THE ADVANCEMENT OF COLORED PEOPLE (NAACP), founded in part by the militant W. E. B. DU BOIS, and the Committee of Twelve, steered by the cautious and conciliatory Booker T. WASHINGTON.

Nevertheless, until his death, Chesnutt was so outspoken in defense of blacks against discrimination and illegal practices that in 1928 he was awarded the NAACP Spingarn Medal for the most "distinguished service" of any black person that year who had acted to advance the cause of blacks in America.

Besides his two published collections of short stories, Chesnutt wrote and/or published an additional twenty-nine short stories, sixteen "tales," ten "anecdotes," seven occasional poems, and numerous essays, articles, and book reviews. He continued to write and publish until 1930 ("Concerning Father" was his last short story), despite poor critical reception and sales, not to mention poor health. As Chesnutt's reputation grows, he will be seen as the first African-American master of the short story.

REFERENCES

ANDREWS, WILLIAM L. *The Literary Career of Charles W. Chesnutt.* Baton Rouge, La., and London, 1980.

———. "A Reconsideration of Charles Waddell Chesnutt: Pioneer of the Color Line." *CLA Journal* 19, no. 2 (December 1975): 137–151.

CHESNUTT, HELEN. *A Biography of Charles Waddell Chesnutt.* Chapel Hill, N.C., and New York, 1952.

RENDER, SYLVIA. *Charles W. Chesnutt.* Boston, 1980.

———. Introduction to *The Short Fiction of Charles W. Chesnutt.* Washington, D.C., 1974.

THOMPSON, GORDON. Charles W. Chesnutt, Zora Neale Hurston, Melvin B. Tolson: Folk and Non-Folk Representation of the Fantastic. Ph.D. diss., Yale University, 1987.

GORDON THOMPSON

Chess. African Americans have never played a prominent role in the history of chess in the United States, but starting in the 1980s chess programs in predominantly black public schools yielded many strong players. By the early 1990s, at least one of the dozens of African-American international masters, Maurice Ashley, was poised to become the first black international grandmaster.

The earliest documented African-American chess expert was Theophilus Thompson (1855–?), who was born in Frederick, Md. He first learned about chess at the age of seventeen through observing a local match. Thompson was soon playing chess and working on chess problems. He contributed articles to the *Dubuque* (Iowa) *Chess Journal,* and in 1873 he published *Chess Problems,* a book on chess strategy.

From the sudden apparent disappearance of Johnson in 1873 until the 1940s, there were virtually no black participants in major chess competitions in the United States. The next African-American chess player to gain prominence was William A. Scott III, the circulation manager of the *Atlanta Daily World.* Scott became well known in the late 1950s for his success in tournament play, often participating in interracial matches in the South in violation of restrictions on such activities. In 1960 Walter Harris became the first African American to be rated as a master by the United States Chess Federation (USCF). Harris achieved that goal at the age of eighteen by defeating several masters and placing fifth in an Omaha, Nebr., junior championship. The number of blacks in chess grew steadily in the 1960s and '70s and included such players as Vincent Livermore and Ervin Middleton.

Chess experts differ as to the reasons why there are so few African-Americans—or women of any race—at the top levels of chess. Some believe that the difficulty of receiving invitations to tournaments that participate in international ranking systems work against racial integration at the highest levels of the chess world, as do stereotypes that assume blacks have no interest in playing serious chess. Nonetheless, the 1990s have seen many male black chess masters. These include Alfred Carlin; Morris Giles; Norman Rodgers; Emory Tate, who won the Armed Forces chess championship four times in the 1980s; and Okechukwu Umezinwa, a Nigerian who has lived in the United States since the late 1970s. Maurice Ashley, a native of Jamaica who has resided in this country for many years, reached the level of master in 1993. By 1994 he had accomplished one of the three "norms," or qualifications necessary to attain the ranking of grandmaster. Ashley has also gained popularity as a flamboyant announcer at Professional Chess Association matches.

Aside from the Kingsmen Chess Club of Brooklyn, which won the Metropolitan Chess League

Chess players in Washington Square Park, New York City. (© Martha Cooper/ City Lore)

championship in 1989, there have been few formal African-American chess organizations. However, the 1970s and '80s witnessed the rise of many successful chess clubs at predominantly black junior high schools. These include the club at School 27 in Indianpolis, Ind.; the Bad Bishops of Philadelphia's Vaux Junior High School, winners of a string of titles at the USCF's National Junior High School Chess Championships; and the Raging Rooks of Harlem's Adam Clayton Powell, Jr., Junior High School, which has been coached since 1989 by Maurice Ashley.

REFERENCES

BUTTS, CAROLYN. "First Black Chess Series Offers Challenges for Pros." *Amsterdam News,* March 7, 1992, p. 30.

RADCLIFF, ROBERT K. "Theophilus Thompson: Recognized Chess Player." *Negro History Bulletin* 45, no. 1 (January–February–March 1982): 7.

TIERNEY, JOHN. "Harlem Teenagers Checkmate a Stereotype." *New York Times,* April 26, 1991, p. A1.

JONATHAN GILL

Cheswill, Wentworth (1746–1817), soldier, officeholder. Born free in Newmarket, Rockingham County, in the colony of New Hampshire, Wentworth Cheswill became probably the first African-American elected official. Cheswill was the mulatto grandson of a slave and son of Hopestill Cheswill, a free black builder. Well educated, Cheswill was appointed county justice of the peace, and recorded wills, deeds, and legal papers in 1768 (one year after his marriage).

In 1775, Cheswill was chosen to send a message to a patriot group in Exeter that a squad of minutemen was on its way from Newmarket to Portsmouth. The next year, his name appeared on a patriot petition drafted by the New Hampshire Committee of Public Safety. In 1777, he joined a state volunteer military company as a private, and was present at the American victory at Saratoga.

In spring 1778, Cheswill was chosen to represent Newmarket at a state constitutional convention, but evidently did not make the trip. In March 1780, the town of Newmarket elected him as a selectman (town administrator), and from 1783 to 1787 he served three further terms as selectman, and four as assessor. Over the following years, he held numerous local offices, and prospered as a builder and landowner. In 1806, he ran for the state senate, and carried the town of Newmarket by a large margin, but lost in the rest of the district. He remained a prosperous citizen, and died in his "mansion" in 1817. Three years after his death, during the controversy over the MISSOURI COMPROMISE, antislavery New Hampshire senator David Lawrence Morrill cited Cheswill as an example of a "competent" long-term officeholder and distinguished African American, and noted the absurdity of laws forbidding even such respectable and propertied blacks as Cheswill from entering Missouri.

REFERENCE

KAPLAN, SIDNEY, and EMMA NOGRADY KAPLAN. *The Black Presence in the Era of the American Revolution.* Rev. ed. Amherst, Mass., 1989.

GREG ROBINSON

Chicago, Illinois. Chicago's African-American community emerged in the 1840s, sixty-one years after the arrival of Jean Baptiste Pointe du Sable, an Afro-French immigrant and Chicago's first non–Native American settler. Excluded from most manufacturing and mercantile employment and lacking capital to establish businesses, black Chicagoans filled less promising and rewarding roles in the city's growing economy. Resisting marginalization, these African Americans agitated against slavery, formed vigilance committees to defend fugitives, lobbied for the repeal of the Illinois Black Laws, and developed a skeletal institutional life.

The implications of RECONSTRUCTION legislation forced state legislators to reconsider legal constraints on black citizens: Black men won the franchise (1870), while legislation overturned de jure school segregation (1874) and prohibited discrimination in public accommodations (1885). Integrationist in orientation, business and professional leaders had strong ties to white Chicagoans and established the legitimacy of black participation in civic life. They published Chicago's first black newspaper, built churches, and engineered the election of the city's first black public official in 1871.

Between 1890 and 1915, migration—largely from the upper South—tripled Chicago's black population to fifty thousand. Employers' assumptions regarding particular aptitudes of the various races relegated eastern and southern European immigrants to the least skilled jobs in the dynamic industrial sector; African Americans—supposedly incapable of regular, disciplined industrial work—were virtually excluded except as temporary strikebreakers. Black men overwhelmingly labored in service positions. Black women, more likely than other women to enter the paid labor force, were even more concentrated in these dead-end occupations.

African Americans earned less than their white counterparts, but paid higher housing prices in Chicago's increasingly rigid dual housing market. Racially distinct blocks gradually consolidated into enclaves during the late nineteenth century. Limited to residences in these areas, black Chicagoans concentrated in two emerging ghettos—a long thin sliver on the South Side and a smaller area on the West Side.

In response to exclusion coupled with population growth, Chicago's black male leadership turned inward. Between 1890 and 1915 a new generation of leaders focused its energies on developing black institutional life. Women were more likely than men to be active in interracial reform movements, but men occupied positions of power within the community. Oscar DEPRIEST, the first black alderman in a city where power resided in the city council, won election in 1915. By then black Chicago had its own YMCA, settlement houses, hospital, military regiment, and bank, and a vital business and entertainment district along the State Street "Stroll."

Looking inward did not imply a retreat from nineteenth-century traditions of asserting citizenship rights. Chicago's black leadership honored both Booker T. WASHINGTON and W. E. B. DU BOIS. George Cleveland HALL presided over the NATIONAL NEGRO BUSINESS LEAGUE one year and sat on the NAACP committee on grievances the next. CHICAGO DEFENDER editor Robert ABBOTT venerated Tuskegee Institute and its founder, while advising black Southerners to answer white violence with armed opposition.

The economic and demographic dislocations of World War I transformed Chicago and other manufacturing centers. Industrial demand jumped while immigration dwindled, forcing industrialists to lay aside assumptions about black workers. To black Southerners, the North offered opportunities to fulfill aspirations for complete citizenship; the new jobs made the move possible. Approximately sixty thousand black Southerners—largely from the deep South—relocated in Chicago.

With men earning factory wages and women maintaining high rates of labor-force participation, the material base for a "black metropolis" complemented the existing South Side institutional infrastructure. Men worked in steel mills, packinghouses, other heavy industries, and traditional service niches. Women worked in light industry and domestic service. Postal workers and Pullman porters anchored a middle class defined more by lifestyle and institutional affiliation than by income. Chicago had more black-owned stores by the end of the 1920s than any other city in the United States. A thin professional and business elite occupied the top of an attenuated class structure. Black politicians sat in the city council, the state legislature, and, by 1929, the U.S. House of Representatives.

This community's rapid growth exacerbated tensions rooted in competition over neighborhood turf, political influence, and unionization. Middle- and upper-class white Chicagoans mobilized financial and legal resources to "protect" their neighborhoods from black "invasion"; the white working class

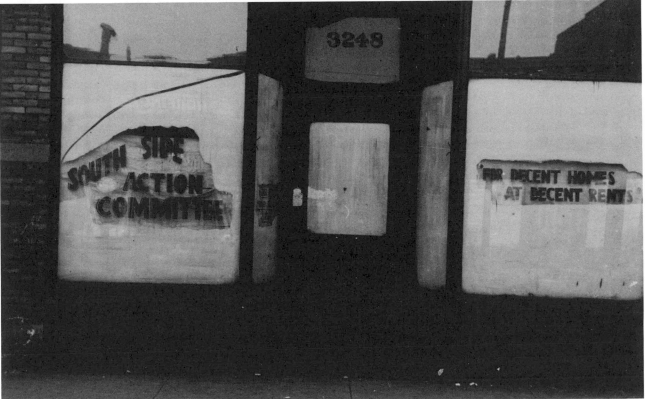

(Top) South Side Chicago between the World Wars had a wide range of housing types, including elegant row houses. (Bottom) Southside Action Committee. (Prints and Photographs Division, Library of Congress)

looked to political clout and physical intimidation. Violence escalated during the Great Migration, erupting into a massive riot in 1919 (*see* CHICAGO RIOT). Retaliating after whites attacked black citizens, first at a beach and subsequently on streetcars and in the streets, black Chicagoans suffered the brunt of both the attacks and the arrests.

The weight of the GREAT DEPRESSION fell with similarly unequal force. Last admitted through the factory gates, black workers were the first sacrificed to the business cycle. Eviction often followed unemployment. Little new housing opened for black Chicagoans until the first public-housing project was completed in 1940.

Black Chicagoans responded to the depression with renewed activism. Resurrecting "Don't Buy Where You Can't Work" campaigns initiated during the 1920s, ghetto residents successfully picketed stores and office buildings. Black politicians, however, found their clout diminished, as a dominant Democratic organization replaced competitive politics. No longer brokers between black voters and white factional leaders, a new generation of black politicians accepted places in William DAWSON's "submachine." Eschewing confrontation, black politicians concentrated on expanding the community's niche in government employment.

The New Deal, industrial recovery during WORLD WAR II, and the emergence of the Congress of Industrial Organization (CIO) opened new economic and political opportunities. By the end of the war, thousands of black Chicagoans held union jobs, and a new generation of black activists emerged from the CIO and, later, the Negro American Labor Council.

This energy had its counterpart in the arts, producing a cultural efflorescence often referred to as the "Chicago Renaissance." Extending beyond the jazz and blues innovations customarily associated with Chicago musicians like MUDDY WATERS and Dizzy GILLESPIE, this creative terrain included literature (Richard WRIGHT, Arna BONTEMPS, Willard MOTLEY, Margaret WALKER, and Gwendolyn BROOKS), dance (Katherine DUNHAM), and art (Archibald MOTLEY, George Neal, Richmond BARTHÉ, and Margaret Taylor Goss [BURROUGHS]).

Migration from the South surged during the 1940s and 1950s, with the ghetto expanding along its margins. Attempts to leapfrog across boundaries, whether by individuals or within the context of Chicago Housing Authority initiatives, attracted violent resistance. By the early 1950s a reconstructed housing authority had shifted from being a force for integration to becoming a developer of high-rise ghettos constructed in black neighborhoods. In 1959 the U.S. Commission on Civil Rights labeled Chicago "the most residentially segregated city in the nation."

Residential segregation combined with gerrymandered public-school districts to dominate the agenda of Chicago's postwar civil rights movement. The formation of the Coordinating Council of Community Organizations in 1962 established an institutional foundation for accelerated mobilization, focusing mainly on school desegregation and led by Albert Raby and Dick GREGORY. The entrance of the SOUTHERN CHRISTIAN LEADERSHIP CONFERENCE and the Rev. Dr. Martin Luther KING, Jr., in 1965 and 1966 shifted the focus toward open housing. Marches through white neighborhoods encountered violent opposition, bringing Mayor Richard Daley to the bargaining table, but black leaders lacked the resources to secure more than rhetoric and promises. By 1967 only Jesse JACKSON's employment-oriented OPERATION BREADBASKET was winning tangible concessions. Riots in 1966 and 1968 articulated rage and provoked temporary civic concern about racial injustice and poverty, but left mainly devastation in their wake.

Continued organizing efforts paid dividends in 1983, with the election of Chicago's first African-American mayor, Harold WASHINGTON. Frequently stymied by an obstructionist city council, Washington had begun to wield effective power only two years before his death in 1988. Washington's coalition divided after his death, but its elements remained a force in city politics and within the black community into the 1990s.

In the 1990s, Chicago's African-American population remained largely on the South and West Sides. Block after block of working-class bungalows and apartment buildings housed families struggling to maintain their standard of living amid deteriorating public schools, a declining industrial base, and a vulnerable public sector. The implications of unemployment or low-wage service jobs were visible nearby, in neighborhoods characterized by deteriorated housing and dwindling business activity. Public-housing projects held a population skewed toward children and unemployed or underemployed women. But prosperous middle-class neighborhoods, while losing some residents to increasing opportunities in the suburbs, continued to include a black elite that has maintained its commitment to black institutions while taking its place among the city's power brokers.

REFERENCES

DRAKE, ST. CLAIR, and HORACE CLAYTON. *Black Metropolis: A Study of Negro Life in a Northern City.* New York, 1945.

GROSSMAN, JAMES R. *Land of Hope: Chicago, Black Southerners, and the Great Migration.* Chicago, 1989.

JAMES R. GROSSMAN

Chicago Art League.

The Chicago Art League was a civic arts organization founded in 1923 by artist Charles Clarence Dawson (1889–1981) through the Educational Department of the Wabash YMCA in Chicago. The league comprised nine members who were full-time artists, one architecture instructor, five public school teachers, a lawyer, and a member of the staff of the Chicago Public Library. The group aimed to inspire young people to pursue the study of art, to encourage African Americans to visit the Art Institute of Chicago, and to use art as a means to "clean up and beautify" local communities. The Chicago Art League stressed that "art is fundamental to good citizenship," and that their art education programs would begin to solve Chicago's social problems, providing an example which the rest of the country could follow. The League secured paintings for several schools and public buildings in Chicago, published articles on art, provided art instruction, held lectures, displayed exhibits, organized mural painting projects, and established a scholarship fund to send promising students to the Art Institute of Chicago. The Chicago Art League included such African Americans as Lawrence Wilson, Claude Guess, Arthur Diggs, Ellis WILSON, E. M. Lewis, I. B. Brewster, G. Glover, P. Callis, and M. Brackett. The league had its heyday during the 1920s; the precise date of its dissolution is unknown.

REFERENCES

FARROW, WILLIAM MCKNIGHT. "The Chicago Art League." *Crisis* (December 1927): 344, 358.
REYNOLDS, GARRY A., and BERYL J. WRIGHT. *Against the Odds: African-American Artists and the Harmon Foundation.* Newark, N.J., 1989.

RENEE NEWMAN
NANCY YOUSEF

Chicago Defender.

The *Chicago Defender* was founded in 1905 by Robert Sengstacke ABBOTT, a journalist and lawyer from Georgia. He started the newspaper with almost no capital and worked out of the dining room of his landlady, who supported him during the first years of operation. The paper was initially a four-page weekly that Abbott peddled door-to-door on the South Side of Chicago. Through his work with the *Defender*, Abbott began a new phase in black journalism. He did not appeal primarily to educated African Americans, as earlier black newspapers had, but sought to make the paper accessible to the majority of blacks. Although the *Defender* adopted a policy of muckraking and sensationalism, covering topics such as crime and scandal as well as prostitution in the black community, Abbott used the *Defender* primarily as a vehicle for achieving racial justice. He refused to use the word *Negro* because of its supposedly derogatory connotation, preferring the word *race*. The paper also took a militant stand against segregation and discrimination and encouraged blacks to protest. In 1907, it "pledge[d] itself to fight against [segregation, discrimination, and disfranchisement] until they have been removed." It believed in the importance of political participation and stated that blacks should use their vote as leverage to win concessions from both the Republican and Democratic parties.

The *Chicago Defender* gained national prominence during the Great Migration during WORLD WAR I,

A copy reader at the *Chicago Defender* in 1942. With a circulation of some 160,000 in the mid-1940s, the "World's Greatest Weekly" was read avidly by Chicagoans as well as by a national black audience. (Prints and Photographs Division, Library of Congress)

when large numbers of African Americans left the South to move North (see also MIGRATION/POPULATION). The paper covered brutal incidents of racism in the South and encouraged African Americans to leave the rigid segregation, poor pay, and violence of the South. In 1915, in response to the rising incidence of LYNCHING, the *Defender* advised, "If you must die, take at least one with you." It promised better-paying jobs and more freedom in northern cities. Although Abbott decried World War I as "bloody, tragic, and deplorable," he believed there were some benefits from it for African Americans noting that "Factories, mills, and workshops that have been closed to us through necessity are being opened to us. We are to be given a chance."

Many black Southerners wrote to the *Defender* asking for job-placement help. The *Defender* also tried to address the problems of migrants. The paper aided migrants by helping to form clubs that arranged reduced rates on the railroad. It counseled newly arrived African Americans, helped them find jobs, and sent them to the appropriate relief and aid agencies. To alleviate the acute housing shortage, the *Defender* supported the construction of housing for African Americans and opposed restrictive covenants. The paper was repeatedly attacked by white Southerners, who attempted to control its distribution by preventing its sale in many southern towns and harassing and intimidating anyone who possessed a copy. Despite this, copies of the paper were distributed by railroad porters and shipped to more than 1,500 southern towns and cities. The circulation of the *Defender* increased dramatically during World War I, climbing from 33,000 in 1916 to 125,000 in 1918. Branch offices were opened across the country and around the world.

Like most newspapers, the *Defender* was hurt by the GREAT DEPRESSION. By 1935, circulation had dropped to 73,000. It continued to cover black civil rights issues, but also included cartoons, personals, and social, cultural, and fashion articles. In 1939, the year before he died, Abbott passed control of the paper to his nephew John Sengstacke. Under Sengstacke's leadership, the *Defender* continued to be an advocate for social and economic justice. During WORLD WAR II, its editors wrote, "In pledging our allegiance to the flag and what it symbolizes we are not unmindful of the broken promises of the past. We ask that America give the Negro citizen the full measure of the democracy he is called upon to defend." The paper covered the racial violence and riots during the war, but made a special effort to see that its coverage was not provocative. Editors refused, for example, to publish photographs of the 1943 Harlem riot. In 1945, its total Chicago and national circulation was 160,000. In 1956, the paper became a tabloid issued four times a week with a national weekend edition.

During the CIVIL RIGHTS MOVEMENT, the *Defender* took a strong stand in favor of racial equality. It criticized the Civil Rights Act of 1964 because it did "nothing" for the North. The paper advocated open housing and argued that "the nation must sooner or later come to the grim realization that residential segregation is the root cause of the racial unrest." In addition, the *Defender* supported nonviolent direct-action demonstrations and protests as a method of change. Of Chicago protests, editors wrote, "The demonstrations, so loudly denounced by City Hall and most of the press, have proved their justification beyond the shadow of a doubt. . . . It was the demonstrations and the inflexible determination of Negro leadership as spearheaded by the Rev. Dr. Martin Luther KING, Jr., that caused the city of Chicago to acknowledge its mistakes and agree to rectify them." Although the *Defender*'s political tone had become more moderate by the early 1990s, it continued to cover both national and local news and speak out against what it considered unfair housing, employment, and educational policies.

REFERENCES

GROSSMAN, JAMES. *Land of Hope: Chicago, Black Southerners, and the Great Migration.* Chicago, 1989.
WOLESLEY, RONALD. *The Black Press.* Ames, Iowa, 1971.

JOSHUA BOTKIN

Chicago Riot of 1919.

During the summer of 1919, known as RED SUMMER, racial violence broke out in unprecedented proportions throughout the United States. The most serious riot occurred in Chicago, starting on July 27.

The tremendous influx of black southern, largely rural workers to Chicago from 1915 to 1920 caused a reshaping of the city. By 1919, the city's black population had reached 250,000, creating housing and employment conflicts with whites, who resented black laborers undercutting wages and acting as strikebreakers and opposed affluent African Americans moving into formerly white areas next to the expanding black ghetto. Fearing declining property values, they resisted encroachment with threats and firebombed their new neighbors. African Americans, in turn, saw a solid wall of prejudice, and they were angry that no bombing suspects were arrested or punished.

On July 27, at Chicago's Twenty-ninth Street beach, a seventeen-year-old African American, Eu-

gene Williams, went into the water for a swim and unwittingly crossed the invisible boundary segregating the beach. As he tried to approach the shore, he was stoned by angry whites. Forced to stay in the water for fear of his life, Williams drowned. Blacks identified the whites responsible. Police called to the scene declined to arrest any whites, but arrested a black man on a minor charge. Rumor and fact quickly produced a large black crowd, whose members exchanged gunfire with police. Fights broke out between bathers.

Soon the riot spread beyond the beach, into white and black sections of the city. While whites were largely responsible for starting the violence, blacks engaged in active self-defense efforts and antiwhite violence. However, there was little looting or destroying of property by blacks. Gangs of black and white youths fought bloody battles, and attacked, stabbed, and killed people in the "wrong" section. On July 28, the violence grew. The Chicago branch of the NATIONAL URBAN LEAGUE, which had predicted a possible riot, asked Mayor Hale Thompson to have police arrest both black and white rioters, especially those involved in the original swimmer's death. Instead, police largely ignored white attacks on blacks, and police power was concentrated on controlling black areas.

On the fourth day of the rioting, at the request of black leaders, Thompson called in the Illinois militia. With the help of two days of rain, order was finally restored. One week after the beginning of the riot, fifteen whites and twenty-three blacks were dead, 537 people were injured, thousands of blacks were homeless following widespread bombings and arson in their neighborhoods, and over a million dollars worth of property was damaged. The National Urban League, the NATIONAL ASSOCIATION FOR THE ADVANCEMENT OF COLORED PEOPLE (NAACP), the Negro YMCA, the Cook County Bar Association, and the Joint Emergency Committee worked alongside public officials to heal the city. Gov. Frank Lowden appointed a group, the Chicago Commission on Race Relations, to report on the causes of the riots. The commission's 1922 report, *The Negro in Chicago,* was one of the first studies to warn of the persistence of segregation and discrimination in the city; it warned that the pervasive barriers to black economic and social equality could spark other riots.

See also URBAN RIOTS AND REBELLIONS.

REFERENCES

Chicago Commission on Race Relations. *The Negro in Chicago,* 1922.

TUTTLE, WILLIAM. *Race Riot: Chicago in the Summer of 1919.* New York, 1970.

GAYLE T. TATE

Children's Literature. The portrayal of African Americans in mainstream American children's literature has been, on the whole, demeaning and unrealistic. From the inception of children's literature as a separate genre in the early nineteenth century, African Americans were presented by white authors as mindless, superstitious, and shiftless. This treatment was particularly evident in two nineteenth-century works, Thomas Nelson Page's *Two Little Confederates* (1888) and Joel Chandler Harris's *Free Joe and the Rest of the World* (1887). A further example of this kind of racism can be found in Helen Bannerman's *Little Black Sambo* (1928).

These stereotypical portrayals continued throughout the early decades of the twentieth century; however, by the late 1930s, several works emerged that tried to convey the African-American experience in an informed manner. Among the first were African-American author Arna BONTEMPS's *You Can't Pet a Possum* (1936) and *Sad-Faced Boy* (1937). However, most of the material published for children during this period continued to depict stereotypes of African Americans.

By the mid- to late 1940s, books began to portray a slightly more realistic picture of blacks and began to address civil rights and other issues relevant to the African-American community. Carter G. WOODSON, the father of modern black historiography, wrote several books for children in the 1940s documenting the African-American heritage, among them *African Heroes and Heroines* (1944) and *Negro Makers of History* (1948). During the 1950s, Langston HUGHES wrote a series of educational books for children, among them *The First Book of Negroes* (1952), *Famous American Negroes* (1954), and *The First Book of Jazz* (1955). Pulitzer Prize–winning poet Gwendolyn BROOKS wrote *Bronzeville Boys and Girls,* a book of poems for children depicting the lives of the urban poor, in 1956. (Brooks would write another children's book, *The Tiger Who Wore White Gloves,* in 1974.) Other titles from this period include Jesse Jackson's *Call Me Charley* (1945) and Dorothy Sterling's *Mary Jane* (1959).

By the 1960s, some well-written material portraying African Americans was being published. Examples include white author Ezra Jack Keats's *The Snowy Day* (1962) and Ann PETRY's *Tituba of Salem Village* (1964). But in 1965, Nancy Larrick was still able to present significant evidence in her analysis of the literature that omissions and distortions were widespread. She surveyed sixty-three mainstream publishers who had published a total of 5,200 children's books between 1962 and 1964. Her investigation revealed that only 6.7 percent included a black child in either the text or the illustrations (Larrick 1965, p. 64).

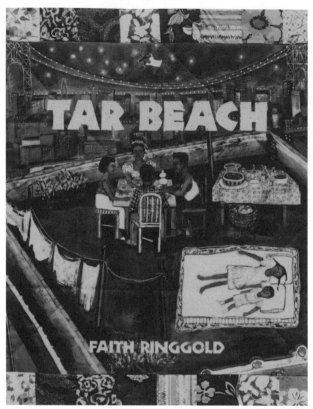

Artist and author Faith Ringgold's *Tar Beach* (1991), based on one of her original quilts, the story of a young girl who dreams of flying above her Harlem apartment. (Random House)

Larrick's article, coupled with the rise of the CIVIL RIGHTS MOVEMENT and the increased availability of funds for schools and libraries, motivated publishers to produce more materials about African Americans. In 1969 the Coretta Scott King Book Award was established in order to recognize African-American authors and illustrators for outstanding contributions to children's literature. As a result, more realistic portrayals began to emerge, presenting the diversity of black life, culture, and experience in both fictional and nonfictional works.

Louise CLIFTON wrote her first book for children, *Some of the Days of Everett Anderson,* in 1970; she has since written many books of poetry and stories for children that are widely praised as realistic portrayals of black children's experience and as valuable introductions to African-American heritage. During this period, June JORDAN also began writing books for children and young adults that were acclaimed for their political relevance and for the intensity of their reproduction of the African-American experience; examples include *His Own Where* (1971), which was nominated for a National Book Award; *New Life: New Room* (1975); and *Kimako's Story* (1981). By incorporating elements of black Southern folklore with a contemporary political consciousness, Julius LESTER brought a special emphasis to his children's literature; his works for children and young adults include *To Be a Slave* (1968), which was nominated for a Newbery Medal, *Black Folktales* (1969), *The Knee-High Man and Other Tales* (1972), and *The Long Journey Home: Stories from Black History* (1972), a nonfiction collection of SLAVE NARRATIVES that was a finalist for a National Book Award. International authors of children's literature also began to gain recognition in this period; a notable example is Chinua Achebe, the celebrated Nigerian author, whose best-known children's book is *How the Leopard Got His Claws* (1973). Other significant authors and illustrators from the period include Virginia HAMILTON, Walter Dean Myers, John Steptoe, Eloise Greenfield, and the artist team of Leo and Diane Dillon.

This positive trend continued to the end of the next decade, as evidenced in the 1979 study conducted by Jeanne S. Chall, which updated Larrick's investigation. Her study indicated that in 4,775 children's books published between 1973 and 1975, 14.4 percent represented black characters in the text or illustrations—more than double the percentage found by Larrick in 1965 (McCann 1985, p. 215).

As the civil rights movement waned in the late 1970s and '80s, the publication of books on the African-American experience diminished. New African-American writers could no longer break into the mainstream easily, and even established authors found themselves struggling to find publishers. Despite this trend additional new authors emerged. Ossie DAVIS, for example, wrote two books for children based on major figures in black history: *Escape to Freedom: A Play About Young Frederick Douglass* (1978) and *Langston, A Play* (1982). Mildred Taylor also entered the scene with *Song of the Trees* (1975) and the Newbery Award–winning *Roll of Thunder, Hear My Cry* (1976).

With the retrenchment of mainstream publishers in the 1980s, alternative presses emerged to fill the void. Black Butterfly Press, Just Us Books, and the Third World Press were among the few houses that published African-American authors who were shut out of the mainstream. By the 1990s they had expanded in response to the public's demand for African-American materials. Mainstream publishers are also again responding to the interest in these materials and one now finds numerous African-American titles on the lists of all the major publishing houses.

With the increase of these publications, debate has arisen over whether non–African Americans can write effectively about the black experience. While the cultural background of an author/illustrator is important, the crucial issue is one of perspective (i.e.,

the author's mind-set and point of view in creating the work). An important consideration is whether, at the time of creation, the author/illustrator—regardless of his or her own cultural background—was thinking as a member of the group or as an outsider (Lachmann, 1992, p. 17). If the former perspective is operative, it allows the creator to produce sincere and meaningful portrayals of his/her subject. Examples of white authors and illustrators who have successfully portrayed the BLACK IDENTITY include Ann Cameron, William Loren Katz, Ann Grifalconi, and Ezra Jack Keats.

The early 1990s have seen a number of African-American titles; among them are Mildred Taylor's *Mississippi Bridge* (1990), Angela Johnson's *When I Am Old with You* (1990, winner of an Honorable Mention at the 1991 Coretta Scott King Book Awards), Eloise Greenfield's *Night on Neighborhood Street* (1991), Lucille Clifton's *Three Wishes* (1976), and Rosa PARKS's *Rosa Parks: My Story* (1992, with James Haskins). The literature now offers a rich complexity in depicting ethnic experience. This situation is beneficial not only to the African-American community, but to the larger society, since it furnishes insights that can help to further communication and understanding. This trend should serve to increase the quantity and quality of African-American literature for children.

REFERENCES

BRODERICK, DOROTHY. *Image of the Black in Children's Fiction.* New York, 1973.

LACHMANN, LYN MILLER. *Our Family, Our Friends, Our World: An Annotated Guide to Significant Multicultural Books for Children and Teenagers.* Metuchen, N.J., 1992.

LARRICK, NANCY. "The All-White World of Children's Books." *Saturday Review* (September 11, 1965): 63–65, 84–85.

McCANN, DONNARAE, and GLORIA WOODARD. *The Black American in Books for Children: Readings in Racism.* Metuchen, N.J., 1985.

ROLLOCK, BARBARA. *Black Authors and Illustrators of Children's Books.* 2nd ed. New York, 1992.

SIMS, RUDINE. *Shadow and Substance: Afro-American Experience in Contemporary Children's Fiction.* Chicago, 1982.

HEATHER CAINES

Childress, Alice (October 12, 1920–), playwright. Born in Charleston, S.C., Childress was reared in Harlem with her grandmother, Eliza Campbell. Childress grew up economically poor but culturally rich because her grandmother exposed her to the arts, fostered in her a desire for excellence, and

introduced her to testimonials at the Salem Church in Harlem. It was her grandmother who encouraged her to write by creating a game that allowed Childress to develop fictional characters. Childress was forced to drop out of high school when her grandmother died. But she decided to educate herself by reading books borrowed from the public library.

Childress began her writing career in the late 1940s while involved in helping develop and strengthen the AMERICAN NEGRO THEATRE (ANT), where she studied acting and directing. Her decision to become a playwright was a natural outgrowth of her experiences at ANT. She has written and produced thirteen plays, including *Florence* (1949), *Trouble in Mind* (1955; winner of an Obie Award in 1956 for the best original Off-Broadway play—the first time the award was given to a black woman), *Wedding Band: A Love Hate Story in Black and White* (1966; televised on ABC in 1974), *Wine in the Wilderness* (1969; produced on National Educational Television that year), *Mojo: A Black Love Story* (1970), and *Moms* (1987). Childress's plays treat the plight of the poor and the oppressed. She champions underdogs and shows their dignity and will to survive.

Childress is an equally dynamic novelist, having published five novels, including *Like One of the Family: Conversations from a Domestic's Life* (1937), *A Hero Ain't Nothin' but a Sandwich* (1973), *A Short Walk* (1979), *Rainbow Jordan* (1981), and *Those Other People*

Alice Childress, 1970. (Reprinted from *In the Shadow of the Great White Way: Images from the Black Theatre,* Thunder's Mouth Press, © 1957–1989 by Bert Andrews. Reprinted by permission of the Estate of Bert Andrews)

(1990). Her novels, like her plays, champion the poor and explore the inspiriting influences of the community.

In addition to the Obie she received in 1956, Childress has received several honors and awards, including a John Golden Fund for Playwrights grant (1957), a Rockefeller grant (1967), and an appointment to Harvard's Radcliffe Institute for Independent Study (1966–1968).

REFERENCE

BROWN-GUILLORY, ELIZABETH. *Their Place on the Stage: Black Women Playwrights in America.* Westport, Conn., 1988.

ELIZABETH BROWN-GUILLORY

Chinn, May Edward (April 1896–December 1, 1980), physician, teacher, and performer. Born in Great Barrington, Mass., May Chinn was the only child of a former slave. Her father, William Lafayette Chinn, escaped from the Chinn plantation in Virginia at the age of eleven. Her mother was born on a Chickahominy Indian reservation in Norfolk, Va. The family moved to New York when May was three. She attended boarding school at the Bordentown Manual Training and Industrial School, in Ironside, N.J., where her mother sent her at the age of five. Mrs. Chinn went into service with the Tiffany family in Tarrytown, N.Y. When May developed osteomyelitis and had to leave Bordentown, she went to live on the Tiffany estate. She attended classes with the Tiffany children, and her musical talent was encouraged and developed.

Chinn continued to take piano lessons while attending grammar school in New York and while her mother encouraged her to pursue her education, she dropped out of high school and became a piano teacher. She resumed her education after passing a high school equivalency test, entering Columbia University Teachers College in 1917 to study music. She continued to perform with Paul ROBESON, among others, but as a student her interest shifted to science. After graduating from Columbia in 1921, Chinn became the first African-American woman to earn a medical degree from Bellevue Hospital Medical College (in 1926). The first to be accepted into the internship program at Harlem Hospital, she was also the first woman to ride with the Harlem Hospital ambulance crew. In 1928 she joined Edgecombe Sanitarium, an alternative to the predominantly white New York City health care system. While continuing to practice at Edgecombe, Chinn returned to

Columbia and earned a master's degree in public health in 1933.

For much of her professional career, Chinn was engaged in the early detection and diagnosis of cancer. She was associated with the Strang Clinic until her retirement in 1977. After retiring, Chinn continued her work at several Harlem day care centers and served as a member of the Surgeon General's Advisory Commission on Urban Affairs. Chinn, whose warmth, energy, and generosity endeared her to friends and colleagues, returned to Columbia in 1980 to receive an honorary Doctor of Science degree.

REFERENCES

"May Edward Chinn, M.D." *Black Women Oral History Project.* Interview with Ellen Craft Dammond. Schlesinger Library, Radcliffe College. Cambridge, Mass., 1979.
Obituary. *New York Times,* December 3, 1980.

CHRISTINE A. LUNARDINI

Chiropody. *See* Podiatry.

Chisholm, Shirley (November 30, 1924–), politician. Shirley Chisholm's career places her among the most significant black politicians of the twentieth century. Born Shirley St. Hill in Brooklyn, she lived with her family in Barbados for some years before returning to the United States. She graduated cum laude from Brooklyn College in 1946 and then earned a master's degree from Columbia University's Teachers College. After her marriage to Conrad Chisholm in 1949, she taught nursery school and became involved in Democratic party work.

In 1960, Chisholm helped to form the Unity Democratic Club in New York, and in 1965 she ran a successful campaign for a seat in the New York State Assembly. During her tenure there she pressed her interest in education and helped to establish the Search for Education, Equity, and Knowledge (SEEK) program to assist poor students in New York. She also helped win a maternity-leave policy for teachers.

In 1969, Chisholm won a seat in the House of Representatives, becoming the first African-American woman to be elected to Congress. While in the House she served on a number of committees, including Veterans' Affairs, Education and Labor, and House Rules. She was an outspoken opponent of the war in Vietnam, and continued to fight for economic justice and women's rights.

Shirley Chisholm campaigning for president, Tallahassee, Fla., January 1972. (© Dennis Brack/Black Star)

In January of 1972, Chisholm announced her candidacy for the Democratic party nomination for president. She was the first African American ever to do so. While her campaign was unable to gain the support of the CONGRESSIONAL BLACK CAUCUS or the major women's groups with which she had long worked, Chisholm's effort was nonetheless groundbreaking.

Shirley Chisholm retired from Congress in 1982. She has since taught at Mount Holyoke and Spelman colleges. She continues to be active in politics as the founder of the National Political Congress of Black Women and as its first president.

REFERENCES

BROWNMILLER, SUSAN. *Shirley Chisholm, A Biography*. Garden City, N.Y., 1970.

CHISHOLM, SHIRLEY. *The Good Fight*. New York, 1973.

———. *Unbought and Unbossed*. Boston, 1970.

SCHEADER, CATHERINE. *Shirley Chisholm: Teacher and Congresswoman*. Hillside, N.J., 1990.

JUDITH WEISENFELD

Chong, Albert (November 20, 1958–), photographer. Albert Chong was born in Kingston, Jamaica, West Indies, into a family of mixed African and Asian heritage. The son of a justice of the peace, Chong grew up in a culturally diverse environment in which he was exposed to Roman Catholicism, Rastafarianism (*see* RASTAFARIANS), Obeah, and Santeria.

Chong began his photographic career as a teenager in Kingston. At nineteen, he won the silver and bronze medals for photography at the 1977 Jamaica Festival of Arts. Chong's work has consistently explored his identity as a Jamaican person of a mixed racial and religious background.

In 1977, Chong emigrated to the United States. He settled in Brooklyn, N.Y., and studied photography at the School of Visual Arts in Manhattan, earning a B.F.A. with honors in photography in 1981. Chong's early work (1980–1985) consists of a series of family and self-portraits, or "I-traits" as he calls them. In works like *Natural Mystic* (1982), he presents himself naked and seated on a ritual chair against a composed "natural" background of tree branches and burlap cloth. With the use of time-lapse photography, Chong's figure appears blurred and ghostlike. The mysterious image plays with the idea of actual bodily presence versus religious vision.

Since 1986, Chong has created still-lifes and photographic assemblages that revolve around the themes of personal memory and ancestor worship. An Obeah practitioner, Chong infuses his work with mystical meanings through the use of Jamaican and African ritual objects. *Passages and Totems* (1990) combines Chong's personal effects (his dreadlocks and his Jamaican passport) with the Obeah religious

The Sisters by Albert Chong, silver gelatin print, 1986. (© Albert Chong)

symbol of a condor's claw; these biographical objects are all enclosed in a shrinelike circle of rocks. In *Addressing the Chinese Jamaican Business Community* (1992), Chong creates a personal iconography by juxtaposing an old photograph of his father and his own driver's license against the background image of a Kingston business banquet. These official temporal markers of a family identity are strewn with African cowrie shells and dried flowers, organic objects of natural and totemic significance. Other well-known biographical assemblages include *The Sisters* (1986) and *Throne for the Justice* (1990), which pay tribute to the memory of Chong's mother and father respectively.

In 1988, Chong moved to La Jolla, Calif., and earned an M.F.A. from the University of California at San Diego in 1991. He has taught photography at the School of Visual Arts, the University of Colorado at Boulder, and at Mira Costa College in California. Chong has won numerous awards and fellowships including the Creative Artists Program Service (C.A.P.S.) Fellowship in 1982 and 1983. Since 1982, his work has been featured in more than fifty major exhibitions throughout the United States and the Caribbean. Selected solo exhibitions include "Yin/Yang, Us/Them, Black/White, Good/Bad," an installation at the Bronx Museum of Art in 1993, and "Ancestral Dialogues" at the Ansel Adams Center for Photography in San Francisco in 1994.

REFERENCES

Ancestral Dialogues: The Photographs of Albert Chong. Text by Quincy Troupe. San Francisco, 1994.
WILLIS-THOMAS, DEBORAH. *An Illustrated Bio-Biography of Black Photographers, 1940–1988.* New York, 1989.

DEIRDRE A. SCOTT

Christian, Charles "Charlie" (1916–1942), jazz guitarist.

Born in Bonham, Tex., Charlie Christian grew up in Oklahoma City, the son of a blind guitarist and singer. He began playing trumpet at a young age, switching to guitar at twelve and performing with many popular local groups shortly thereafter. He is reported to have begun playing an amplified acoustic guitar as early as 1937, introduced to the idea by Eddie Durham. Promoter John Hammond, who had heard of Christian's ability, took him to Los Angeles for an audition with Benny Goodman in August 1939. Christian became a part of Goodman's band, relocating to New York to perform and record with both the big band and with the

The tragically short-lived Charlie Christian introduced the electric guitar to jazz as an important solo instrument. This photograph of him is from 1940, during his 1939 to 1941 stint with Benny Goodman. (Frank Driggs Collection)

smaller sextet. His work with Goodman was highly successful, establishing Christian as one of the most brilliant soloists of his time. He began attending the after-hours jam sessions at Minton's Playhouse in Harlem, playing with Dizzy GILLESPIE, Charlie PARKER, Kenny CLARKE, and other innovators of bebop. He contracted tuberculosis in mid-1941 and was sent to Seaview Sanitarium on Staten Island, where he died shortly thereafter.

Though his career was short, Christian was one of the greatest jazz guitarists ever. He brought the electric guitar to prominence in jazz, allowing the guitar to step out of the rhythm section and solo with the dynamic range and volume of wind instruments. His odd phrasing and extensive use of chromaticism were precursors of bebop style. Though his recorded output was relatively small, he is still cited as one of the eminent swing-style players and his influence on contemporary jazz guitarists was enormous.

REFERENCES

GITLER, IRA. *Swing to Bop.* New York and Oxford, 1985.
SIMON, BILL. "Charlie Christian." In *The Jazz Makers: Essays on the Greats of Jazz.* 1957. New York, 1979.

DANIEL THOM

Christiana Revolt of 1851. One of the major episodes of African-American resistance to enforcement of the FUGITIVE SLAVE ACT OF 1850 (*see* FUGITIVE SLAVE LAWS), and the first in which blood was shed, occurred on September 11, 1851, near the tiny Quaker village of Christiana, Pa. That morning, Maryland slave owner Edward Gorsuch, several of his relatives, and three U.S. marshals bearing federal warrants surrounded the house of William Parker, a local black leader. The posse demanded the surrender of two of Gorsuch's slaves, who had run away from the Gorsuch farm two years before and were hiding inside Parker's home. Parker and his guests sounded an alarm to which local citizens responded. Although two Quakers advised the posse to retreat, Gorsuch refused, declaring, "I will have my property or go to hell." Shots rang out, and when the smoke cleared, Gorsuch lay dead and three members of his party were wounded.

Within hours, the incident assumed national significance. A Lancaster, Pa., paper proclaimed: "Civil War—The First Blow Struck." One representative of the southern press, warning of secession, announced that "unless the Christiana rioters are hung . . . THE BONDS WILL BE DISSOLVED." Sensing the event's political importance, President Millard Fillmore dispatched a company of U.S. Marines and some forty Philadelphia policemen to the village to apprehend those involved. After combing the countryside, they arrested more than thirty blacks and half a dozen whites. Even so, the five blacks most responsible for Gorsuch's death escaped; three—Parker, and Gorsuch's two runaway slaves—fled to Ontario. Although federal officials sought their extradition, Canadian authorities refused.

Hoping to make examples of the rioters, federal prosecutors charged them not only with resisting the Fugitive Slave Act but with treason. A federal grand jury indicted thirty-six blacks and two whites, some with tenuous links to the incident, and imprisoned them pending trial before the U.S. circuit court in Philadelphia. Federal attorneys used the trial of Castner Hanway, a white Quaker alleged to have directed the rioters in their attack on the posse, as a test case upon which to decide the fate of the other thirty-seven. The trial—which, ironically, convened on the second floor of Independence Hall—took on comic overtones. One defense attorney chided the government for arguing "that three harmless non-resisting Quakers and eight-and-thirty wretched, miserable, penniless negroes armed with corn cutters, clubs, and a few muskets . . . [had] levied war against the United States." The available evidence proved insufficient to substantiate the charges and, after acquitting Hanway in early December, the government dropped all remaining indictments and released the rioters.

The Christiana incident raised serious questions about the ability of the federal government to enforce the Fugitive Slave Act. But it did even more. Southerners were outraged by the results of the trial. At the same time, federal efforts to punish the rioters had increased sympathy for the abolitionists throughout the North. By galvanizing public opinion—North and South—on the question of enforcement of the law, the Christiana riot moved the nation closer to civil war.

REFERENCES

KATZ, JONATHAN. *Resistance at Christiana.* New York, 1974.

SLAUGHTER, THOMAS P. *Bloody Dawn: The Christiana Riot and Racial Violence in the Antebellum North.* New York, 1991.

ROY E. FINKENBINE

Christian Church (Disciples of Christ). *See* Disciples of Christ.

Christianity. *See* Bible and African-American Culture, The; Religion; Religious Education; *and articles on particular Christian denominations.*

Christian Methodist Episcopal Church. The Colored Methodist Episcopal Church in America (CME) was organized December 16, 1870, in Jackson, Tenn., by former slaves who had been members of the Methodist Episcopal (ME) Church, South. After their emancipation, however, they realized that continued membership in the church of their former masters was neither desirable nor practical and requested their own separate and independent church "regularly established," as Isaac Lane said, "after our own ideas and notions." With careful attention to what was pointed to as the "desires of our colored members," the ME Church, South, provided the basic ecclesiastical, legal, and practical means that enabled them, in the words of Lucius H. Holsey, to establish their "own separate and distinct ecclesiasticism."

Between 1866 and 1870 several hundred black preachers were ordained, an official periodical, *The*

Christian Index, began publication, five black annual conferences were established, delegates empowered to set up their "separate ecclesiastical jurisdiction" were called to meet, the ordination of bishops was authorized, and transfer to the new church of all properties that had been used by slave congregations was sanctioned. On December 21, 1870, William H. Miles and Richard H. Vanderhorst—two black preachers elected bishops and ordained by Robert Paine, Senior Bishop of the ME Church, South—assumed the Episcopal oversight of the new jurisdiction, and an independent church of African Americans became a reality.

The CME Church soon emerged as one of the more influential churches in African-American communities throughout the South. Beginning with approximately 78,000 members, competent leaders, several hundred congregations, and title to hundreds of pieces of church property, it had, by the turn of the century, expanded beyond the Mason-Dixon Line following the migrations of African Americans to the North, Midwest, and the Pacific Coast. At the close of World War I, the CME Church was established wherever significant numbers of African Americans were located. After World War II, as CMEs found themselves in more racially inclusive communities and the civil rights struggle intensified, the term "colored" took on the stigma of discrimination and JIM CROW-ism. Consequently, in 1954 the name was changed to the Christian Methodist Episcopal Church. By 1990 it had more than 812,000 communicant members, congregations throughout the United States, and conferences in Nigeria, Ghana, Liberia, Haiti, and Jamaica.

The CME Church is the ecclesiastical outgrowth of the grafting of nineteenth-century Protestantism, as practiced by American METHODISTS, and African slave religion, as found in the peculiar institution of SLAVERY. In confronting slavery, Protestant denominations endeavored to "save" the souls of slaves rather than free them from their bondage. Preaching the Gospel to the slaves was the means to this end. The Methodists were highly effective in slave evangelism. Methodism, begun by John Wesley in England and established on the American continent in 1784 as the Methodist Episcopal Church, was appealing to slaves. Methodists preached a plain and simple Gospel that gave meaning and hope to the desperate conditions of the slave experience, practiced styles of preaching and worship that encouraged the expression of deep feelings and strong emotions, and provided a system of licenses and ordination that enhanced the status of slave preachers.

Early American Methodists had opposed slavery, but as more Southerners and slaves joined the church, irreconcilable conflicts developed, and in 1844 Methodism split over the slavery issue. The southern branch of Methodism promoted such an extensive program of slave evangelism that by the beginning of the Civil War more than 207,000 slaves—almost 50 percent of all slaves who embraced Christianity—were members of the ME Church, South. Among them were those who would organize the CME Church in 1870.

The Christianity that the slaves embraced, however, was reshaped in accordance with the realities of their slave experiences and the remnants of their African heritage. Residual elements of African religion such as belief in one supreme being, the union of the spiritual and the material, a strong affirmation of the present life, and certitude of life after death, molded the Gospel preached to the slaves into African-American religion, the most powerful force of African-American life. Though the scion of African-American religion would flourish from the sap of orthodox Christian faith, it would nonetheless have a shape all its own. And it would sprout the varied branches of African-American religion, such as the CME Church, as former slaves, finally set free, established their separate churches, giving institutional meaning to the religion that had sustained them in the darkest days of slavery.

The CME Church perceived the social concerns of African Americans to be a significant part of its mission. CMEs have been in the vanguard of black America's "stride toward freedom" in demanding their own church, sharing in RECONSTRUCTION governments, protesting the enactment of Jim Crow laws, helping establish and support civil rights organizations, and participating fully in the civil rights struggle. It has been a leader in the education of black youth as many of its early church buildings were used as schools. Twenty-one educational institutions have been under its auspices; and four colleges and a school of theology are presently under its sponsorship. CME churches helped to meet the needs of African Americans through ministries such as low-income housing projects, credit unions, senior citizens' homes, child care centers, Project Head-Start, and antipoverty and drug prevention programs. The CME Church has been a pioneer participant in the ecumenical movement through the National Council of Churches, the World Council of Churches, and the National Congress of Black Churches.

Influential African Americans of the CME Church include William H. MILES, its first bishop; Lucius H. HOLSEY, the leader in establishing CME schools; Charles H. Phillips, the major influence in expanding the church; Helena B. Cobb, founder of an institute for black girls and an early proponent of women's rights; Channing H. TOBIAS, chairman of the board

of the NAACP; John Hope FRANKLIN, historian of African Americans; William Y. Bell, who served as Dean of the School of Religion of Howard University; B. Julian Smith, a leader in the ecumenical movement; Joseph A. Johnson, Jr., a black theologian; and Alex HALEY, author.

REFERENCES

LAKEY, OTHAL HAWTHORNE, *The History of the CME Church.* Memphis, Tenn., 1985.

PHILLIPS, C. H. *The History of the Colored Methodist Episcopal Church in America.* Jackson, Miss., 1900.

OTHAL HAWTHORNE LAKEY

Christian Recorder.

The official organ of the AFRICAN METHODIST EPISCOPAL CHURCH was established as the *Christian Herald* in 1848 and renamed the *Christian Recorder* in 1852. Through the nineteenth century, several AME clergymen served as editors for the weekly journal: Augustus R. Green (1848–1852); Molliston Madison Clark (1852–1854); Jabez Pitts Campbell (1854–1858); Elisha Weaver (1861–1867); Benjamin TANNER (1868–1884); Benjamin F. Lee (1885–1892); H. T. Johnson (1893–1902).

As an AME periodical, the *Christian Recorder* focused primarily on church matters and moral and religious topics. But as a voice of African Americans, it served a broader audience and addressed a wider range of community concerns. During the Civil War, the *Recorder* served as a communications link between black communities and their soldiers in the field. A weekly "information wanted" column helped reunite families torn apart by slavery, war, and economic distress. Reports from AME clergymen working in southern missions provided information on the condition of the freedpeople during Reconstruction.

Correspondence from black communities across the continent created a composite picture of American race relations in the decades following the Civil War. The *Christian Recorder,* as the oldest surviving publication of the black periodical press, provides a valuable historical record of African American life and culture.

REFERENCE

WILLIAMS, F. LEONARD, et al. *The Holdings of Mother Bethel African Methodist Episcopal Church Historical Museum in Manuscript and Print.* Philadelphia, 1973.

WRIGHT, RICHARD R., JR., *Encyclopedia of African Methodism.* 2nd ed. Philadelphia, 1948.

MICHAEL F. HEMBREE

Chubby Checker.
See Checker, Chubby.

Church, Robert Reed, Jr.
(October 26, 1885–April 17, 1952), businessman, civic leader. Born in Memphis, Tenn., Church was the youngest son of Robert Reed CHURCH, SR., a wealthy Memphis businessman, and Anna (Wright) Church. The younger Church was brought up in luxury, living in a large mansion and taking trips to Europe. His schooling was arranged through private tutors and Episcopal parochial schools. He attended Oberlin College, graduating in 1904, and then went to work in a Wall Street bank in New York City. In 1907, he returned to Memphis to work as cashier in the family's Solvent Savings Bank. In 1909 his father made him the bank's president. By 1912, when the senior Church died, the bank held over $100,000 in deposits. Uninterested in finance, Church resigned from the bank and turned his attention to managing his father's three hundred properties.

A dignified, sensitive man, Church turned his attention to political activity. In 1916, he founded the Lincoln League as a source of power, and soon became a heavy contributor and director of the Tennessee Republican Party. He was named a delegate to eight Republican National Conventions, and was an Official on the National Advisory Committee for Negroes. During the 1920s, when the REPUBLICAN PARTY held national power, Church dominated southern party patronage, led voter registration efforts, and lobbied for black advancement. Since he paid his own travel and campaigning expenses and declined all monetary payment, he kept his autonomy in Tennessee Republican circles, even in the face of constant opposition from an antiblack "lily-white" party faction. Possessed of an autocratic temper, he nonetheless inspired followers by his activism in protecting voting rights and protecting blacks from police and other harassment. He and Memphis's powerful machine leader, "Boss" Edwin Crump, despised each other, but Crump aided blacks in return for favors from Church.

During the 1930s, however, Church's power declined. The Republican party was turned out of office, and Church lost much of his patronage power. An economic conservative, he opposed the New Deal and remained loyal to the Republicans while large numbers of blacks turned to the Democrats. Finally, his always uneasy relationship with Crump dissolved. City inspectors harassed Church, finding endless minor violations in buildings he owned. In 1938, Church campaigned against Crump's candidate for governor. Crump responded the next year by charging Church with $89,000 in back real estate taxes, an amount unpayable during the depression. While Church was away from the city, Crump seized Church's property, which was worth far more than the tax owed, and sold it at a tax auction. He later

burned down the Church estate under the pretext of testing new firefighting equipment, and renamed Church Park, a public park that had been named after his father, Beale Street Park. Church, his finances severely strained, moved to Chicago, from where he attempted unsuccessfully to control Memphis Republican politics. After 1940, Church took a less active role in politics, but he remained a Republican party adviser. He died twelve years later, while campaigning for Dwight D. Eisenhower.

REFERENCES

BILES, ROGER. *Memphis in the Great Depression.* Knoxville, Tenn., 1986.
CHURCH, ANNETTE E., and ROBERTA CHURCH. *The Robert Churches of Memphis.* Memphis, Tenn., 1975.

GREG ROBINSON

Church, Robert Reed, Sr.

Church, Robert Reed, Sr. (June 18, 1839–August 12, 1912), businessman. Born a slave in Mississippi, Robert "Bob" Church was the son of a white riverboat owner and captain, and an African-American slave mother. When Church's mother died in 1851, his father took him aboard the steamboat as a steward. After the end of the Civil War, Church settled in the growing community of Memphis, Tenn. He invested his savings in a saloon and pool hall. Spending as little as possible, he invested in saloons and other businesses in the black waterfront area of Beale Street, personally visiting and monitoring each one. He made a name for himself as the "Boss of Beale Street." In 1879, following a yellow fever epidemic that ravaged the city and drove real estate prices down, Church invested in property throughout the city. Through shrewd investments his personal fortune skyrocketed, and it is likely that Church was the first African American to become a millionaire.

Conscious of his lack of education and unsavory business activities, as well as the need to keep harmonious business relationships with whites, Church generally avoided political and civil rights issues, although he served as a delegate to the Republican National Convention of 1900. He did encourage his children, who included activists Mary Church TERRELL and Robert R. CHURCH, JR., to fight for education and respect for blacks. Church participated in civic affairs on a nonpartisan basis. Concerned about leisure facilities for black Memphians, who were excluded from city parks, he provided land for a public park, which was named in his honor. He also sponsored the construction of a large auditorium and con-

cert hall. Church's most significant community enterprise was the Solvent Savings Bank and Trust Company (1906), which he started in part to encourage saving, and which enjoyed enormous success before folding during the GREAT DEPRESSION. Church died suddenly in Memphis in 1912, following a brief illness.

REFERENCES

CHURCH, ANNETTE, and ROBERTA CHURCH. *The Robert Churches of Memphis.* Memphis, Tenn., 1975.
SIGAFOOS, ROBERT ALAN. *From Cotton Row to Beale Street: A Business History of Memphis.* Memphis, Tenn., 1979.

GREG ROBINSON

Church of Christ. *See* United Church of Christ.

Church of God in Christ.

Church of God in Christ. In 1895, the Rev. Charles Harrison MASON and the Rev. Charles Price JONES, both former Baptists, organized a Holiness church in Lexington, Miss. Mason named the new body the Church of God in Christ, based on 1 Thess. 2:14. A national organization was chartered in Memphis two years later with Jones as general overseer. Mason and Jones heard of the great religious revival that broke out on Azusa Street in Los Angeles in 1906, and Mason, along with ministers D. J. Young and J. A. Jeter, traveled to California in March 1907 to investigate.

They met the Rev. William Joseph SEYMOUR, the African-American leader of the revival, whose Pentecostal sermons proclaimed a new doctrine: "Baptism in the Holy Spirit" was essential to salvation and sanctification, and evidence of this baptism was glossolalia, or speaking in tongues. Mason and Young accepted the Pentecostal doctrine (see PENTECOSTALISM), but Jones and Jeter did not and Mason and Jones separated over the issue. Lawsuits ensued over ownership of church properties, and when they were concluded in 1909, Mason controlled a national church in which local congregations had lost much of their independence. Jones and his followers established the Church of Christ (Holiness) U.S.A. in 1910 in Selma, Ala.

The church included both black and white members, reflective of the interracial character of Azusa Street. Many early preachers received their credentials from Mason, and some white members split off to form independent or Assembly of God churches. Mason and the church supported conscientious ob-

The Church of God in Christ has grown rapidly since its 1910 founding in the aftermath of the Azusa Street Pentecostal revival and in 1995 is the second-largest black denomination in the United States. In this photograph, Elder Kelsey, accompanied by a guitar, is preaching in Washington, D.C., in 1942. (Prints and Photographs Division, Library of Congress)

jectors during World War I, which resulted in spying by the FBI and harrassment by the federal government.

Bishop Ozro Thurston Jones, Sr. (1891–1972), succeeded as leader of the church at Mason's death in 1961. He had been national leader of the youth department. He was followed by Bishop J. O. Patterson, Sr. (1912–1989), Mason's son-in-law, who established the C. H. Mason Theological Seminary, a unit of the Interdenominational Theological Center in Atlanta, in 1970. During Patterson's administration, ministers' standard dress of dark suits and ties began to be replaced as bishops and elders in the pulpit started wearing robes and vestments. Patterson was instrumental in founding the World Fellowship of Black Pentecostal Churches in 1984. Bishop Louis Henry Ford (1914–) of Chicago became leader in December 1989. Ford's administration reopened The Saints Academy School in Lexington, Miss. in September 1993.

Mason had appointed Mother Lizzie Roberson as national supervisor of women, and she was followed by Mother Lillian Coffey, Mother Annie L. Bailey, and Mother Mattie Carter McGlothen. The church's headquarters building, Mason Temple in Memphis, was the site of Rev. Martin Luther KING, Jr.'s last speech, in support of striking garbage workers, and is now a historic landmark.

The Church of God in Christ, as the major African-American Pentecostal denomination, has participated in the phenomenal growth of worldwide Pentecostalism since Azusa Street. In 1925 the church's membership was 250,000. In 1945 there were 1,850 churches in the United States. By 1961, membership was 382,679 in 4,500 congregations, and in 1982 the church reported 9,982 congregations and 3,709,661 members. By 1991 there were 5.5 million members in 30,000 churches in the United States, plus an additional two million members in other countries.

REFERENCES

DuPree, Sherry Sherrod. *Biographical Dictionary of African-American, Holiness-Pentecostals, 1880–1990.* Washington, D.C., 1989.
DuPree, Sherry Sherrod, and Herbert C. DuPree. *Exposed!: Federal Bureau of Investigation (FBI) Unclassified Reports on Churches and Church Leaders.* Washington, D.C., 1993.
Kelley, Frances, and German R. Ross. *Here Am I, Send Me: The Dramatic Story of Presiding Bishop J. O. Patterson.* Memphis, Tenn., 1970.
Official Manual with the Doctrine and Discipline of the Church of God in Christ. Memphis, Tenn., 1973.

SHERRY SHERROD DUPREE

Cincinnati, Ohio. Cincinnati is located in the southwest corner of Ohio, adjacent to Indiana and across the Ohio River from Kentucky. One of the white settlers of 1788 named the proposed town Losantiville, from the Latin *os* (mouth), Greek *anti* (opposite), and French *ville* (city), because of its position opposite the mouth of the Licking River. On January 2, 1790, Governor St. Clair, a loyal member of the old Revolutionary Army Society of Cincinnatus, changed the name to Cincinnati. In the early nineteenth century, the city was nicknamed "Porkopolis" because of its large pork industry. By 1900, Cincinnati was better known as a flourishing arts and business center and called "the Paris of the Midwest," "the Queen City," and "Blue Chip City."

In 1800, 337 African Americans, many of whom had been slaves fleeing to free states, were living in Ohio. In 1802 the state constitution of Ohio upheld the Northwest Ordinance of 1787, which prohibited slavery in the state but divested African Americans of political and civil rights. Two years later, Ohio's first Black Law (*see* BLACK CODES) prohibited African Americans from settling there without written proof of freedom. In 1807, the next Black Law required African Americans to post bond of five hundred dol-

lars as guarantee of good behavior and forbade testimonials against white men in court.

Despite discriminatory legislation, African Americans began to develop religious and educational communities in Cincinnati. In 1810, numbering 80 out of the total city population of 2,540, they built the first African-American church, with William Allen as its preacher. Reportedly a station of the UNDERGROUND RAILROAD from 1812 to 1815, the church was burned and rebuilt three times. In 1824, pastors from the Bethel Church formed the AFRICAN METHODIST EPISCOPAL CHURCH. It was renamed the Allen Temple A.M.E. Church, and followers later built a permanent place of worship at Sixth and Broadway. In 1825, Henry Collins established the first African-American school in an old pork house one block away. In the 1820s, most African Americans lived in wooden shanties in "Bucktown," "Little Bucktown," or "Little Africa," the small area between Fifth and Seventh streets and Broadway and Eggleston avenues. Within twenty years the crowded, disease-infested district was known as "the Swamp."

Fearing the rapidly growing African-American population (9.4 percent in 1829), 120 white men of the Cincinnati Colonization Society, begun in 1826, advocated its deportation to Africa. They insisted on more rigid enforcement of the Black Laws and demanded bond payment in 1829. During a three-day riot, whites insulted, attacked, and killed African Americans who could not pay within the allotted sixty days. Between 1,000 and 1,200 African Americans then fled to Canada and established the settlement of WILBERFORCE. Two years later, Black Laws were passed forbidding African Americans to serve in the state militia or on juries in Ohio.

Sympathetic white abolitionists at Lane Seminary hosted eighteen nights of antislavery debates. When ordered to suspend their activities in 1834, students staged a walkout. The Lane rebels then enrolled at Oberlin College in Oberlin, Ohio, which subsequently became an abolitionist center and accepted students of all races. The same year, Virginia-born Owen T. B. Nickens founded the first successful African-American elementary school in Cincinnati.

By the 1840s, most African Americans worked as day laborers, barbers, menial servants, roustabouts, and steamboat laborers along the riverfront. Many lived in "Bucktown" between the Ohio River and Third Street east of Sycamore, bordered by Broadway and Main. The neighborhood gained a reputation for drinking, gambling, thieving, and prostitution. At the same time, wealthy African Americans lived on the "fashionable thoroughfare" of McAllister Street (north of Fourth Street).

Fearing the advancement of African Americans, Charles McMicken bought 10,000 acres in Africa between Liberia and Sierra Leone (which he called

"Little Ohio") for their emigration in 1836. After his colonization plan failed, he inserted a clause in his will excluding African Americans from sharing his endowment to the University of Cincinnati (he also granted his slaves freedom after his death if they chose to go to Liberia). In spite of McMicken, African Americans became some of the University of Cincinnati's most successful graduates. They include William H. Parham (first African-American graduate of the law school, in 1874), biologist Charles TURNER (1891), and educator Jennie D. Porter (U.C.'s first African-American Ph.D., 1928, and founder of the Harriet Beecher Stowe School). In 1969 Lawrence Hawkins, assistant supervisor of Cincinnati public schools since 1967, became U.C.'s first African-American dean.

In 1844 the Rev. Hiram S. Gilmore, an English clergyman, established Cincinnati High School, Ohio's first private African-American high school. He was succeeded by McMicken's mulatto son, John. The institution's role was later eclipsed by the partial repeal of a Black Law in 1849, providing African Americans with free public education. Elected African-American trustees were unable to organize their educational system, however, when local authorities refused to provide funds. African American John I. Gaines, a wealthy provision-store owner, led the case to victory at the Supreme Court in 1852, and a colored school board and superintendency were created. In 1857 the first African-American public high school, Gaines High School, was founded in his honor. Attendance there dwindled after 1887, when a new law permitted the integration of white common schools.

Throughout the nineteenth and early twentieth centuries, African Americans struggled for education and freedom of speech. Bloody riots erupted in Cincinnati in 1836 and 1841, when whites destroyed the press of the antislavery *Philanthropist* newspaper published by James G. Birney, a former southern slave owner. African-American Cincinnatians published their own newspapers thereafter, including the *Disfranchised American* (begun 1843), *Colored Citizen* (1866–1873), *Declaration* (founded in 1866), *American Catholic Tribune* (1844–1894), and the *Cincinnati Herald* (founded in 1953).

White philanthropists aided African Americans in their struggle for equality. Levi Coffin, arriving in Cincinnati in 1847, became the "national president" of the Underground Railroad. He led slaves across the Ohio River to free states. One woman whom Coffin aided was immortalized as Eliza Harris in UNCLE TOM'S CABIN. This novel by white Cincinnatian Harriet Beecher Stowe played a crucial role in igniting antislavery activity. White abolitionists also commissioned portraits from African-American artists such as painter Robert S. DUNCANSON and daguerreotypist James P. BALL. Their patronage allowed Dun-

canson, one of the most acclaimed landscape painters of the nineteenth century, to study abroad. Duncanson painted murals of the Ohio Valley in the home of his benefactor Nicholas Longworth; these are now in the Taft Museum.

Although Cincinnati's African-American population had decreased substantially with the emigration to Canada in 1829, it slowly rose to 2.7 percent (5,900 of 216,239) in 1870. While African-American men began to enter professional occupations, women worked primarily as domestics, washers, seamstresses, and prostitutes from the 1850s to the 1880s. A middle-class white clientele paid for their services in "Rat Row" (between Walnut and Main) and "Sausage Row" (between Broadway and Ludlow), where African Americans and poor whites lived. One-third of African Americans resided in single-family homes, 12 to 15 percent were live-in domestics, and the remainder lived in multiple-family tenements. Although African Americans began to move to the West End and Walnut Hills in the 1860s, one-third of all transport workers still lived in "Bucktown" by 1880. By 1900, however, industrial and commercial buildings displaced most African Americans to the West End.

African-American Cincinnatians began to gain political power after the EMANCIPATION PROCLAMATION of 1863, with the men among them acquiring the right to vote in Ohio in 1870. Historian George Washington WILLIAMS became the first African American elected to the Ohio Legislature, in 1879, and the Black Laws were completely repealed in 1887. Yet African Americans still experienced gross political inequality.

In 1893, Wendell Phillips Dabney (Cincinnati's first African-American paymaster) helped found the Douglass League, a Republican organization, to pressure for reforms. His newspaper, the *Union* (1907–1952), kept African Americans informed. In 1915 Dabney became the first president of the Cincinnati chapter of the National Association for the Advancement of Colored People. While he and his associates fought for civil rights, others, who believed racial equality was impossible in the United States, worked for a faction of Marcus GARVEY's "Back to Africa" movement. (The Ohio Colonization Society had sent the last African-American emigrant to Liberia in 1902.)

Under the African-American leader William Ware, membership in the Cincinnati chapter of the UNIVERSAL NEGRO IMPROVEMENT ASSOCIATION reached almost 8,000. Ware then founded the Welfare Association for Colored People, in 1917. On one day in that year, at the height of the Great Migration, 1,022 migrants arrived in the city. Cincinnati's African-American population nearly doubled within a decade; by 1920, it had reached 7.5 percent (30,079 of

401,207). Almost 60 percent of these people, many of whom worked in paper mills and factories during the 1920s, lived in the West End. They later resided in federally funded houses in the Laurel Homes and Lincoln Court projects, built in the 1930s and 1940s.

As the African-American population grew (to 12.2 percent in 1940), so did its political representation, with the City Council elections of Frank A. B. Hall in 1931, Jesse D. Locker in 1941 (President Eisenhower appointed Locker ambassador to Liberia in 1953), and Theodore M. Berry in 1942. In 1944 the Lincoln Heights community became incorporated as the nation's only city with a 100 percent African-American population. In 1963, William A. McClain was appointed to the city's top legal post as city solicitor. African-American mayors of Cincinnati include Berry (1972–1975), J. Kenneth Blackwell (1979–1980), and Dwight Tillery (elected 1991). In 1975 Berry was one of the founding members of the Committee of Fifty, a group of anonymous African Americans who demanded justice for the city council's vice-mayor, William Chenault, accused of embezzlement. The committee was also concerned about the general well-being of African Americans in the city. Many had been forced to move to the suburbs in the 1950s because Queensgate Project I demolished more than half the housing in downtown's West End for industry development and the Mill Creek Expressway. Between 1935 and 1970, 62,500 persons were removed from the area. Most resettled in the Over-the-Rhine and Mt. Auburn neighborhoods, where race riots erupted during the summer of 1967, as in 116 other cities across the nation. The Queensgate Project II of 1973 displaced still more families. By then, African Americans made up 27.7 percent of Cincinnati's population. That figure rose to over a third (138,132 of 364,040) in 1990.

Other notable African-American Cincinnatians include Granville T. WOODS (inventor of a steam-boiler furnace and fifteen appliances used by electric railways); artist Antonio Blackburn, Jr. (awarded the medal of the Swedish State School of Arts, Crafts, and Design, 1960); jazz musician Artie Matthews (founder of the Cosmopolitan Conservatory of Music, 1921–1958); poet Nikki GIOVANNI; and athletes William DeHart HUBBARD (Olympic broad-jump champion, 1924), Ezzard CHARLES (world heavyweight boxing champion, 1949–1951), Wallace (Bud) Smith (world lightweight boxing champion, 1955–1956), and Oscar ROBERTSON (All-American athlete, 1958).

REFERENCES

DABNEY, WILLIAM PHILLIPS. *Cincinnati's Colored Citizens: Historical, Sociological, Biographical*. 1926. Reprint. Cincinnati, 1988.

EDWARDS, ETHEL. *Ringside Seat on Revolution.* Cincinnati, 1972.

HURLEY, DANIEL. *Cincinnati, the Queen City.* Cincinnati, 1982.

KOEHLER, LYLE. *Cincinnati's Black Peoples: A Chronology and Bibliography.* Cincinnati, 1986.

MCKEE, DAN M. *A Comparison of Appalachian, Black, and White Neighborhoods of Cincinnati, 1960–1970.* Cincinnati, 1977.

TAYLOR, HENRY LOUIS, JR. The Building of a Black Industrial Suburb: The Lincoln Heights, Ohio Story. Thesis, State University of New York, Buffalo, 1979.

WASHINGTON, MICHAEL, SR. *Segregation in Cincinnati During the Early Twentieth Century.* Cincinnati, 1985.

THERESA LEININGER-MILLER

Cinema. *See* Blaxploitation Films; Film.

Citizenship Schools. During the mid-1950s through the 1960s, citizenship schools—established under the auspices of the HIGHLANDER CITIZENSHIP SCHOOL—played a vital role in promoting literacy, increasing voter registration, and cultivating community leadership skills among African Americans in the South. Under the direction of Myles Horton (1905–1990), a white Appalachian, the Highlander Citizenship School—which focused on labor education since its founding in 1932 in Monteagle, Tenn.— had emerged as a champion of racial equality and integration by the early 1950s. Horton believed that the progress of unionization in the South was stymied by a lack of racial cooperation and that illiteracy was one of the greatest barriers between black people and first-class citizenship. In 1953, a grant from the Schwartzhaupt Foundation gave Horton the resources to create adult education programs that would focus on providing African Americans with the tools they needed to become informed voters. These programs became known as citizenship schools.

Horton participated in discussions with black community activists in Highlander workshops to devise education strategies that would encourage and sustain their voter registration efforts. In attendance at one of the early workshops were two activists from South Carolina who played central roles in defining the ideology behind the citizenship school program: Septima CLARK and Esau JENKINS. Clark, an NAACP activist and Johns Island schoolteacher who would be appointed Highlander's director of education in 1957, believed that the goal of citizenship schools should not be limited to increasing literacy among African Americans.

Clark was a staunch advocate of black political empowerment, and she argued that citizenship schools should teach students that they had a right to be part of the body politic and had the power to change the government. She believed that a central goal of the program was to create and nurture black activism and that the schools themselves should be built upon the groundwork laid by local activists.

Clark brought Horton's attention to the poverty and isolation of black residents on the Sea Islands and the efforts of Esau JENKINS, a former student who had developed into a local leader and activist, to increase black voter registration on Johns Island. Through discussions with Jenkins and Clark, Horton became convinced that Johns Island should be the site of the first citizenship school. After many months of community-based meetings and events to mobilize support for the project, the Johns Island Citizenship school was founded in 1957.

The school had an initial enrollment of fourteen students registered for classes held two times a week during the three-month layover between crops. Unable to afford formal structures or a paid staff, classes were held in the back room of a small cooperative store and Bernice Robinson, Septima Clark's niece, volunteered to be the first teacher of the school. Robinson, an NAACP member who had attended Highlander workshops, was committed to breaking down traditional classroom hierarchies. She allowed her students to play an integral role in determining what was taught to them. She created a culturally familiar environment in her classroom by incorporating music based on the traditional folk culture of the Sea Islands (*see* GULLAHS) into her lessons.

Students were taught practical skills that they needed in their daily lives—such as reading the Bible, signing their names, and filling out money orders and voter registration forms. However, the classroom curriculum centered on teaching students to address the social conditions in their community and challenge their oppression. The school served as a site of political discussion, where students were encouraged to speak up and take a more critical view of the world. The knowledge students gained at the school allowed them to tackle problems differently and make better uses of local resources. As the school began to "graduate" successful new voters and community political awareness grew, enrollment rapidly increased. Due to the efforts of Robinson, the philosophy of Clark, and the support of Jenkins and other Sea Island blacks, the school was a success. From 1956 to 1960, voter registration on Johns Island increased 300 percent.

Citizenship schools were created on the other South Carolina Sea Islands as the success of the Johns Island's school became evident and the CIVIL RIGHTS MOVEMENT spread throughout the South. Teacher-training workshops at Highlander brought together experienced teachers with new and prospective teachers. Teachers varied widely in experience, training, and age, and included farmers, domestic workers, and college students. The workshops were forums for discussions of current events and local politics and created a sense of community and shared problems among participants. By early 1961, eighty-two teachers had been trained by Highlander and were teaching in citizenship schools in Alabama, Georgia, South Carolina, and Tennessee.

Believing that voting was only the first step toward the empowerment of African Americans, Esau Jenkins traveled throughout the South encouraging citizenship school students to initiate "Second Step" political action groups for developing strategies to address community problems. Associations following this philosophy sprang up alongside citizenship schools on six islands and on two mainland communities. By 1961, citizenship schools had registered hundreds to vote and could be credited with helping to develop and sustain the tide of black protest of the early civil rights movement.

Just as the citizenship school program seemed poised for major expansion, the Tennessee legislature's persistent efforts to disrupt Highlander's activities and undermine their programs increased in pace. In February 1961, Horton, anticipating that the citizenship school program would soon outgrow Highlander's funding capabilities, negotiated the transfer of the program to the SOUTHERN CHRISTIAN LEADERSHIP CONFERENCE (SCLC) to ensure the program's survival and continuance. An obscure turn-of-the-century law prohibiting integration in private schools was used to revoke the school's charter and confiscate its property a few months later.

Septima Clark joined the staff of SCLC in July 1961 as director of workshops and, with Andrew YOUNG and Dorothy Cotton, two committed SCLC activists, administered the newly renamed Citizenship Education Project (CEP). Later that year, SCLC opened the Dorchester Cooperative Community Center in Dorchester, Ga., to serve as a CEP teacher-training center. During this same time period, the Kennedy administration pledged to support voter-registration projects in an attempt to steer the focus of the civil rights movement away from volatile direct action protests. CEP became a central part of the Voter Education Project organized in 1962 by the CONGRESS FOR RACIAL EQUALITY, SCLC, and the NAACP, to promote black voter registration in the South. Despite receiving little promised federal support or protection, by 1966, the project had trained more than 10,000 citizenship school teachers.

Citizenship schools grew to become a key grassroots base of support for the civil rights movement throughout the deep South. They provided African Americans with the knowledge they needed to challenge southern voter registration laws and the racial status quo. By 1970, thirteen years after the first citizenship school was formed with only fourteen students, 800 citizenship schools graduating more than 100,000 African Americans in the South—including some of the veterans of the civil rights movement like Fannie Lou HAMER—had been formed.

As time progressed, however, many civil rights movement participants on the front line of southern racial violence became disillusioned with the pace of social change, and involvement in local politics was no longer a central goal of the splintering movement. Despite the continued overall success of CEP in training teachers, many of the schools closed, due to a lack of funding and because there was often little long-term commitment to doing follow-up work with the students. Septima Clark often complained that too much of SCLC's energies were focused on the excitement of protests rather than on the daily rigors of citizenship education. These factors, combined with the passage of the VOTING RIGHTS ACT of 1965, led to the decline of CEP. By 1970, the schools faded out of existence, and Clark retired from her position in SCLC.

REFERENCES

GLEN, JOHN M. *Highlander: No Ordinary School, 1932–1962.* Lexington, Ky., 1988.
HORTON, AIMEE. *The Highlander Folk School: A History of Its Major Programs, 1932–1961.* Brooklyn, N.Y., 1989.

MICHAEL A. COOKE